# THE GENIUS OF JACOPO BELLINI

HARRY N. ABRAMS, INC., PUBLISHERS, NEW YORK

IN ASSOCIATION WITH

BRITISH MUSEUM PUBLICATIONS, LONDON

DUMONT BUCHVERLAG, KÖLN

ÉDITIONS NATHAN, PARIS

LEONARDO EDITORE, MILANO

JULIO OLLERO, EDITOR, MADRID

# THE
# GENIUS
# OF
# JACOPO BELLINI

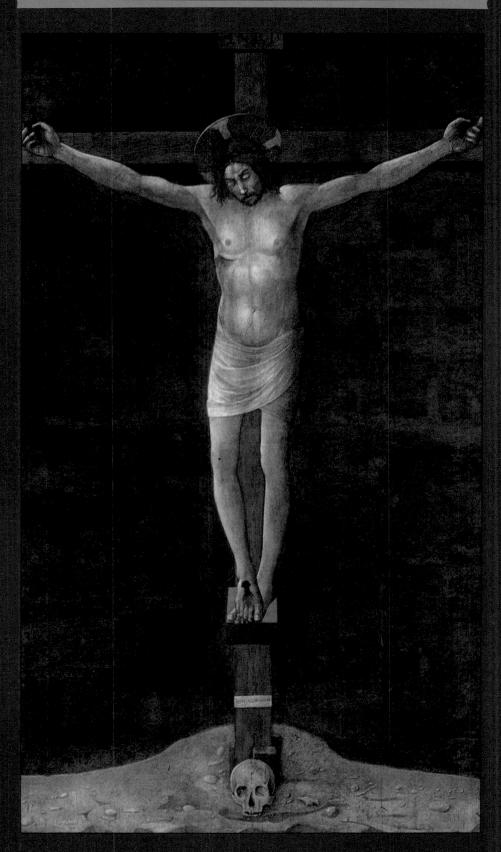

## THE COMPLETE PAINTINGS AND DRAWINGS

## COLIN EISLER

EDITOR:

PATRICIA EGAN

DESIGNER:

CAROL ANN ROBSON

PHOTO RESEARCH:

BARBARA LYONS

Library of Congress Cataloging-in-Publication Data

Eisler, Colin T.
    The genius of Jacopo Bellini.

    Bibliography: p. 519
    Includes index.
    1. Bellini, Jacopo, ca. 1400–ca. 1470—Catalogues
raisonnés.   I. Title.
N6923.B45A4   1988      741.945      88-3286
ISBN 0–8109–0727–5 (Abrams)

ISBN 0–7141–1644–0 (BMP)

ISBN 3–7701–2524–X (DuMont)

ISBN 2–09–290–558–2 (Nathan)

ISBN 88–355–0058–3 (Leonardo)

ISBN 84–86197–69–4 (J. Ollero, ed.)

Published in the United States of America in 1989 by Harry N. Abrams, Incorporated, New York,
a Times Mirror Company

Simultaneously published in Great Britain by British Museum Publications, Ltd, London; in the
Federal Republic of Germany, Austria, and Switzerland by DuMont Buchverlag, Köln; in France
by Éditions Nathan, Paris; in Italy by Leonardo Editore s.r.l., Milano; and in Spain by Julio
Ollero, Editor, Madrid

# Contents

Jacopo erobert nicht, er besitzt, seine Kunst wird nicht, sie ist.
(No conqueror, Jacopo is a possessor; his art does not become, it is.)

Theodor Hetzer, *Venezianische Malerei von ihren Anfängen
bis zum Tode Tintorettos*, Stuttgart: 1985

Quante domande! Quante incertezze! Quante prove che la prova manca!
(So many questions! So many doubts! So many proofs where proof is missing!)

Corrado Ricci, *Jacopo Bellini e i suoi libri di disegni*, Florence: 1908

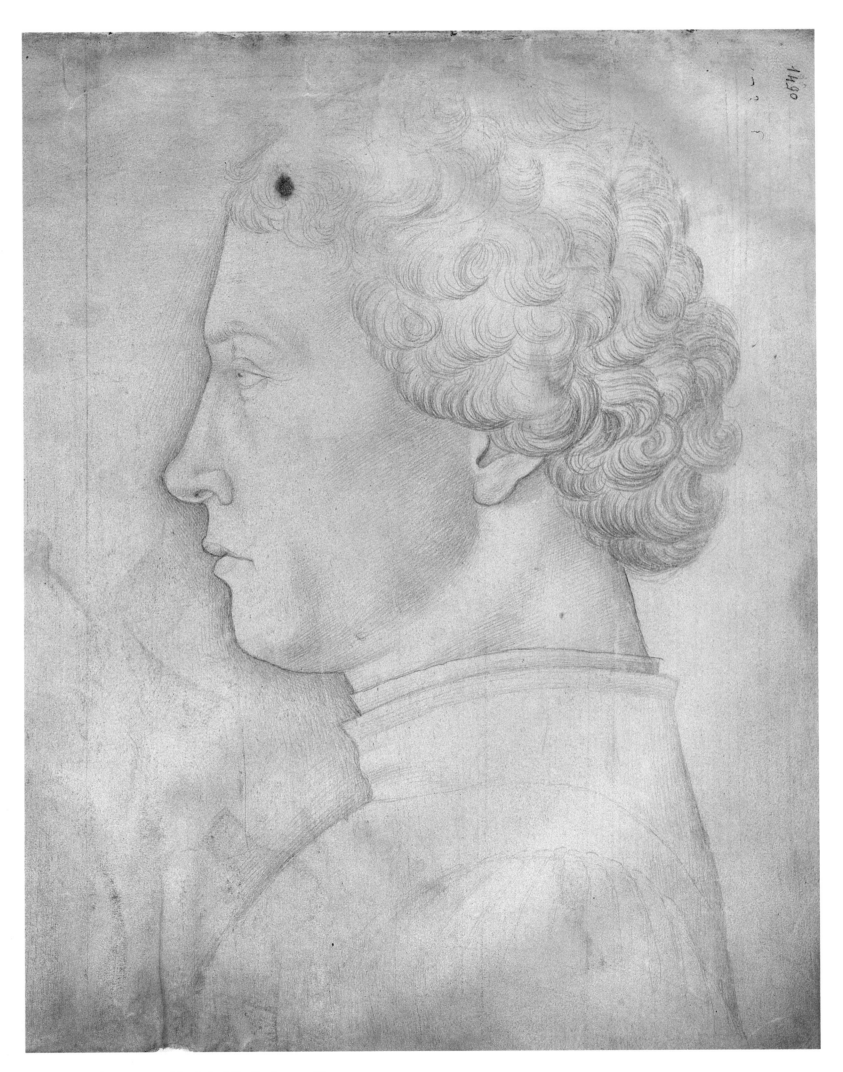

Plate 1. *Young Man in Left Profile*. Louvre 23

# THE GENIUS OF JACOPO BELLINI

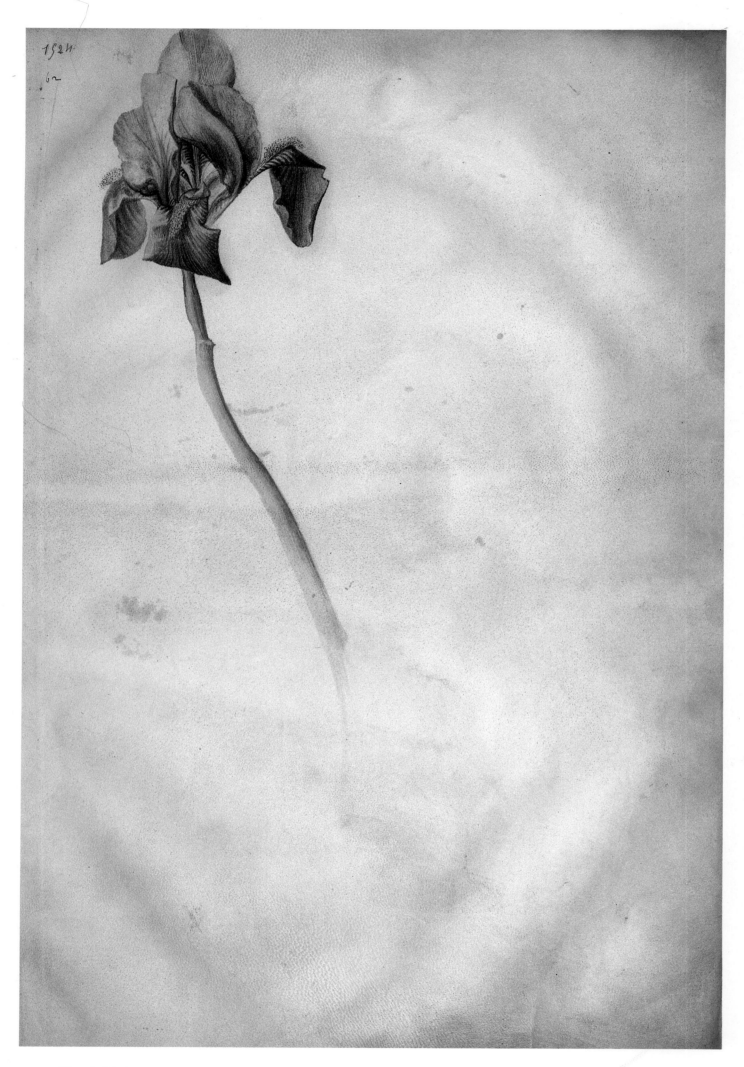

Plate 2. *Iris*. Louvre 62

# PREFACE

To be a *professore* in the old-fashioned sense of the word is to be an enthusiast. This book is to be that kind of teacher's guide to the gifts of Jacopo Bellini, or, as it would be said in Italian, to his *ingenio*. For the first time all of his known paintings and drawings are brought together to be appreciated as a collective achievement and to be viewed along with essays on their role in the artist's life and other chapters on the painter's response to landscape and everyday life, to antiquity, to the bible, to architecture, and to the Serenissima's celebration of the military, all subjects playing major roles in his oeuvre. These considerations make up the "front half of the book."

The Appendices, the second section of the text, deal with specialized issues, beginning with Albert J. Elen's codicological study of the artist's drawing Books. I am most grateful to him for letting this important investigation appear here for the first time. Other appendices compiling the artist's paintings and drawings, separating those that still seem acceptable from those that don't, along with a compilation of documents and other material, are also available in the "back half of the book."

With Goloubew's lavish facsimiles of the Paris and London drawing Books close at hand, a long-treasured gift from my wife, I have been able to riffle through these works almost as if the originals were my own. Students at the Institute of Fine Arts have most kindly made their research available to me. I much appreciate the help of the following participants in our seminar: Sara Bertalan, Joan Carpenter Bruccoli, Maureen Burke, Alison DeLima Greene, Rosemary Hoffman, Angela Howard, Ock-Kyung Lee, Barbara Pollard, Christopher J. Riopelle, Gail Solberg, Susan Taylor, Jeffrey Weiss, and Shelley Zuraw. A travel grant from the Gladys Kriebel Delmas Foundation made possible a summer trip to Venice.

The photographic services of the British Museum, the Musée du Louvre, and the Bibliothèque Nationale were all essential in providing the many new negatives that contribute so much to this publication. I am extremely indebted to the technical and administrative staffs of these institutions for their cooperation.

Friends and colleagues have been generous with their time in solving many major and minor problems, alerting me to sources new and old, and providing essential encouragement. I especially wish to thank Clifford Brown, Christa and Peter Bürger, Carol Burns, Linda Carrol, Keith Christiansen, Piero Corsini, Father George Fedallo, Norberto Grammaccini, Irving Gumb, Margaret L. King, Patricia H. Labalme, James H. Marrow, Michael McGann, Helmut Nickel, Tiziana Plebani, Steven Prince, Stuart Pyrrh, Janice Shell, and Federico Zeri.

The editorial solicitude and *caritas* of Patricia Egan have been ever welcome. Susan Babineau has worked through many hideous manuscripts with patience.

My warmest thanks go to Cynthia Deith for her dedicated, sustained work on this book, far above and beyond the call of any duty. I am deeply indebted also to Elisabeth Dunn for her remarkable organizational gifts and drive, so instrumental in getting this Bellini show on the road.

COLIN EISLER
ROBERT LEHMAN PROFESSOR OF FINE ARTS
NEW YORK UNIVERSITY — INSTITUTE OF FINE ARTS

# I

# VENICE IN PERSPECTIVE

## BACKGROUND

1 Petrarch, *Epistolae seniles*, trans. D. Rosand, IV, 3.
2 Quoted by Muraro, 1970, 42.

The chosen people of the Serenissima were perpetually saved by their surrounding waters, and enriched beyond measure by the seas from which Venice, like Venus, was born. As soon as she could do so the Republic began to "sacralize" herself, to cultivate the myth of Venice as divinely founded and miraculously sustained. Her site, might, and right all partook of Trinitarian, Marian, and saintly privilege; the Serenissima's independent church and state seemed defined by God's grand design, for she was created as a Christian refuge on the Feast of the Annunciation, which was also the very day Rome fell, 421 A.D.—at noon on Friday, March 25th—thus commemorating both the Incarnation and, by extension, the Creation of Adam.

A uniquely successful mercantile economy soon brought enormous powers to the small city-state of Venice; her doge was seen as the equal of pope and Holy Roman emperor, being so recognized at the Peace of Venice in 1177 by the submission of Emperor Frederick Barbarossa to Pope Alexander III on the steps of San Marco. This interweaving, invisible and visible, of Christian symbolism and republican authority invested the capitalist fibers of this most commercial of states with divine protection, making Venice an eternal miracle of faith and wealth. Petrarch's poetry proclaimed her as "most august city of Venice, today the only abode of liberty, peace, and justice, the one refuge of the good and haven for those who, battered on all sides by the storms of tyranny and wars, seek to live in tranquility: city rich in gold and richer in fame, mighty in its resources but mightier in virtue, built on solid marble but based on the more solid foundations of civic concord, surrounded by salty waters but more secure through her saltier councils."[1]

Venetian splendor stemmed from an unparalleled sense of self, nurtured by her own theology and mythology and celebrated by a perpetual urban theater of ceremony and triumph. Her confidence in Christ, Saint Mark, and capitalism brought the Serenissima nearer to the glory of antiquity than any other city west of Byzantium, and made of her a new Jerusalem rising from the mudflats and lagoons. She saw herself as heir to Greece and Rome as well as to both Testaments, and these supposed blood ties "justified" her claims to Mediterranean territory, helping her gain a mercantile empire to East and West.

Early trade links and linguistic ties to France brought that most classical of northern nations especially close to the Serenissima, whose first literature was in the French tongue. The Germanic Holy Roman Empire also enjoyed special privileges in Venice, and from it she appropriated the literature and legend of the Round Table, that vibrant, mystical bond between the military powers of classical times and the militant strength of medieval Christianity.

Equally the beneficiary of chivalry and antiquity, Venice always knew how to make the best of both, and of all worlds. Like the city-states of ancient Greece, she was governed by the votes in the Grand Council of her largely self-perpetuating aristocracy, powerful families who sometimes let new money buy into their shared and guarded authority. The many relics in Venetian possession insured her spiritual security, but it was the sense of social order, continuity, and harmony, though more illusory than real, that helped win for Venice her sobriquet of "Serenissima." She had her share of riot and rebellion, of workers' protests against hieratic, autocratic government, but she maintained the illusion of infallible solidarity which inspired a Paduan scholar to exclaim: "O happy commune of Venice, whose citizens have their mutual interest so much at heart in all they do that the name of Venice is held to be divine."[2]

One of her wise ways of survival was the license she gave to the guilds to participate in the splendor of the state; the workers' contributions were recognized in monument and festivity; scenes of their essential activities were carved in the reliefs on the arch surrounding the central portal of San Marco, and nearby on the stone base supporting the Republic's banner poles in the Piazzetta. Doge Lorenzo Tiepolo, newly elected in the late thirteenth century, was greeted by guild leaders in grand attire, the pork butchers in scarlet silk and the fishmongers in robes lined with vair [squirrel]. In Jacopo Bellini's time, each guild set forth its finest wares under the Foscari loggie of San Marco in a trade fair of unique grandeur. Venice combined labor and prestige, ceremony and profit, in a mystical marriage performed by the arts of craft, commerce, and governance.

Designed for captivation, Venice contrived to make all those who came also see, and be conquered. As the French ambassador reported to his king, late in the fifteenth century, awed by the spectacle of so open a metropolis, "It is the most triumphant city that I ever saw." Her finest art was almost always one of enchantment. Beyond Baedeker's praise, this was a culture of scintillation, not explanation, offering a serene guide to the unperplexed.

Even before her days as the self-proclaimed pacific highness of the seas, Venice was profitably suspended between the mercantile and the militant. Swooping upon whatever she wanted, she sacked Byzantium as relentlessly as if it were a pagan stronghold. A law unto herself, independent of emperor or pope, the Republic sailed through the centuries raiding, trading, fighting, and dealing, growing ever richer and grander. The affluent tides began to turn in the late fourteenth century. It was then, more than ever before, that Venice began to use all her arts—and those of the east, west, north, and south—to spin her gold of daunting beauty into a cloth designed to awe and disarm her own "lower orders" as well as her rivals.

Triumph—perpetual and inevitable—was the theme of the Serenissima's art and life. Her palaces, churches, and civic and commercial buildings were ever on parade, celebrating the victory of the Venetian fleet, army, and commerce. Exposed to sky and sea, Venice professed her vulnerability so blatantly as to make her seem invincible. While much of the West was still mired in medieval squalor, shrewd Venetian traders and manufacturers were carving out their vast, profitable empire; skilled sailors and craftspeople filled a great fleet—a floating marketplace—with fine goods mostly "Made In Venice," trading and bringing back gold and stuffs from all other known lands. Through this steady, efficient, mercantile cycling of wealth she became the first modern economic state.

Seven centuries before Boston, Venice had perfected the same ways to wealth that built a renaissance in New England. Mercantilism at its best, its shipping, manufacture, and export and import carefully controlled, and close to a monopoly of Near Eastern trade (shared with Genoa) brought more gold into Venetian coffers than into those of any other Western state. Even the flinty Florentines came to Venice to learn the best of bookkeeping.

"For God and for profit" was the slogan Tuscan merchants placed at the top of their ledgers, but the Venetians truly married the two in their many scuole, that intricate system of Christian lay societies. In the scuole were merged hospitals and charitable organizations for their membership, wisely designed to care for them from the cradle to the grave.

Long before Luther, Venice found her own way around the pope (even when he was one of her's) to God. The Serenissima largely managed her own church, giving most of the important offices to sons of leading local families. The moral qualms assailing the rest of Italy seldom struck Venice—singularly few saints and reformers arose from her marbled mudflats—whose convents and monasteries were infamous for their creature comforts. Within Bellini's lifetime Venice enjoyed unprecedented papal power, three of her sons wearing the tiara: Angelo Correr, Pope Gregory XII from 1406 to 1414; Pope Eugenius IV (Condulmer) from 1431 to 1447; and his nephew Pope Paul II (Barbo) from 1464 to 1471. Pope Eugenius lived in Florence between 1434 and 1443, consecrating Brunelleschi's great dome and presiding over the Council of Ferrara and the later council meetings in Florence.

Constantly enriching the Republic's commerce and culture were the large "foreign colonies" in her midst. Merchants and craftsmen, scholars and pilgrims, came from Greece and Flanders, England and France, Hungary, Dalmatia, and the Orient. All had their own churches, trade centers, and hostels, surrounding themselves with the rituals and fashions peculiar to their traditions. Venice became a showcase of comparative religions, arts, and crafts, the ultimate city as souvenir.

Routes over land and sea went up to Nuremberg and down to Africa. Venetian merchant ships sailed around the boot of Italy, through the Iberian strait and up the coast of Portugal, France, and the Netherlands to the cities of the Hanseatic League. These trade connections guaranteed fresh sources of financial and visual exchange. The Venetian commercial empire throve on imitating foreign skills, ever ready to steal the crafts and secrets of any

profitable manufacturer. From the east she learned to work leather, metal, paper, and textiles, including marvelous silks, brocades, velvets, and damasks; from the north the making of glass and mirrors, and wool weaving. A Trecento pattern book of orientalizing weaving designs, bound into the Louvre's Bellini Book, may well reflect influence from Lucca in silk weaving. More famous at first for her crafts than her arts, Venice brought the trades she learned abroad to new technical heights. Even the wool industry, usually the prerogative of Bruges—that Venice of the North—and its surrounding Flanders, became an important Venetian manufacture.[3]

Equally drawn to the arts in the Gothic north as in the classical south, Venice was hostess to many early Netherlandish and German masters, merchants, and artisans. The intense infusion of these foreign skills shows up in the Republic's painting toward the mid-fourteenth century in odd pockets of Netherlandish realism, Byzantine idealism and tranquil abstraction, Tuscan classicism, and motifs of late medieval arts and crafts. Venetian art of this period, its interest in space and nature studies typically North Italian, became suffused with glowing color that would come ever closer to northern Europe's mastery of the oil technique.

The painters' guild in the Serenissima was Europe's oldest, but her penchant for importing high-priced foreign talent did not make the local artists' life happier. This practice changed by the mid-fifteenth century, the time of Bellini's Books, but the Serenissima's own painters were not celebrated until the sixteenth century, when they found new ways to dash off their canvases with dazzling speed and virtuosity. These works became another export item, shimmering messages of the flesh and the spirit to lighten the gloom in Habsburg courts and in houses of the rich throughout the West. Earlier, Venice had set her sons to more profitable stuff; too busy making money to make art, she preferred to hire the best hands from Greece, northern Europe, or mainland Italy.

An odd mix of Gothic and renaissance elements prevailed, intensified by the Serenissima's strange, evocative isolation; like a great ocean liner, Venice in an earlier century was perpetually refurbished in drydock, as if in her own Arsenale, Europe's largest shipbuilding center.

Conspicuous consumption was rarely employed to better political effect than by the Republic. It was central to her foreign policy, manifesting itself in parades and triumphal entries, pageantry of state and faith. This display was the Serenissima's most powerful art form, making the entire city become a stage and her populace supernumeraries. Cloth-of-gold and silken banners, glittering armor and prancing steeds, all were used for both dazzle and defense, equally cost effective in war or peace.

The public event, whether for greeting an ambassador, a newly elected doge, or a victorious *condottiere*, was an exercise in the culture of occasion, and from it the Serenissima's passion and ingenuity reaped the highest visual rewards. Beautiful people and their horseflesh, all arrayed in splendid textiles, metalwork, and jewels, moved with martial splendor or gathered against the arcaded grandeur of the Piazza di San Marco, the Doge's Chapel, and the Doge's Palace.

Art in the Serenissima came from twinned opposites: mysticism and realism reconciled, faith and humanism harmonized in a new vision of nature.

FOREGROUND

Bellini came of age close to 1421, the thousandth anniversary of the foundation of Venice; a special ode was dedicated to the doge, making much of the Republic's pretension of Roman origin. In the decade before Jacopo's birth, Venice had won a great sea battle against her maritime rival, the Republic of Genoa, when it anchored its fleet near the lagoons of Chioggia. That massive victory brought Venice the coveted Genoese sea routes along the Ligurian coast, and together with constant Turkish advances in Greece and the eastern Mediterranean, it convinced the leaders under doges Steno and Tommaso Mocenigo to turn west toward the Italian mainland, the *terra firma*, to win or win back the lands she had claimed there in the Trecento. Though never as rich as she had been before the Black Death of 1347, Steno's and Mocenigo's Venice regained a sense of well-being as the largest and most populous and profitable of the Italian powers, and even of the five or so wealthiest Western states. Only Spain, England, Burgundy, and France had more in their coffers than Venice had during Mocenigo's time (r. 1414–23).[5]

3 Pullan, 1971, 17.
4 M. Poppi, "Un'orazione del cronista Lorenzo de Monacis per il millenario di Venezia (1421)," *Atti dell'Istituto Veneto di Scienze, Lettere ed Arti,* CXXXI (1972–73), 463–97.
5 Kretschmayr, II, 126.

New saints, heroes, and professions sprang to the fore on the *terra firma*. The sacred knights George and Eustace, Theodore and Isidore, their swords ever at the ready to rescue princesses or principalities, aroused fresh loyalty; renewed enthusiasm for Arthurian chivalry, long popular in Italian courts, provided Venice with a romantic model for roaming the land rather than the sea. Steeds, not sails, became the new means for capturing lands from fellow Christians rather than foreign infidels. In 1423, when young Jacopo Bellini may have been in Florence assisting Gentile da Fabriano, the octogenarian Doge Mocenigo made a prophetic speech, combining an accountant's matter-of-fact precision with the rolling Churchillian rhetoric of a grand old man fighting for his country's survival. Speaking from his death bed, he gave to the highest government officers an extraordinary report on the State of the Venetian Union, recalling the results of the nine years of his rule:

6  M. Sanudo, I, col. 598 (trans. J. J. Norwich, New York: 1982, 298–99). The entire text is in Kretschmayr, II, 617–19.

> During that time we have reduced our national debt, arising out of the wars of Padua, Vicenza and Verona, from ten million ducats to six [million] . . . and now our foreign trade runs at another ten millions, yielding an interest of not less than two millions. Venice now possesses 3,000 smaller transports, carrying 17,000 seamen, and 300 large ones, carrying 8,000. In addition we have 45 galleys at sea, with crews amounting to 11,000; we employ 3,000 ship's carpenters and 3,000 caulkers. Among our citizens we number 3,000 silk-workers and 16,000 manufacturers of coarser cloth. Our rent roll amounts to 7,050,000 ducats . . .
>
> If you continue in this wise, your prosperity will increase still further and all the gold of Christendom will be yours. But refrain, as you would from a fire, from taking what belongs to others or making unjust wars, for in such errors God will not support princes. Your battles with the Turk have made your valor and seamanship renowned; you have six admirals, with able commanders and trained crews enough for a hundred galleys; you have ambassadors and administrators in quantity, doctors in diverse sciences, especially that of the law, to whom foreigners flock for consultations and judgements. Every year the mint strikes a million gold ducats and 200,000 in silver . . .
>
> Beware, then, lest the city decline. Take care over the choice of my successor, for much good or much evil can result from your decision. Messer Marino Caravello is a good man, as are MM. Francesco Bembo, Giacomo Trevisan, Antonio Contarini, Faustin Michiel, and Alban Badoer. Many, however, incline towards Messer Francesco Foscari, not knowing him for a vainglorious braggart, vapid and light-headed, snatching at everything but achieving little. Ser Francesco Foscari spreads lies . . . and swoops and soars more than a hawk or falcon. If he becomes Doge you will find yourselves constantly at war; he who now has ten thousand ducats will be reduced to one thousand; he who possesses two houses will no longer have one; you will waste, with your gold and silver, your honour and your reputation. Where now you are the masters, you will become the slaves of your men-at-arms and their captains.[6]

The warning of the dying doge proved true. Venice's conquests of Padua and nearby regions early in the century were as far as she should have gone. Foscari, elected in 1423 despite Mocenigo's passionate *caveat*, swung the economy toward that of a military state not well suited to the Serenissima. As Mocenigo had predicted, Venice was in for turbulent, aggressive leadership; vast military expenditures brought many gains, but finally more radical losses. By mid-century the loss of prodigious sums and many lives left the Serenissima no better off than long before the doge began his expansionist policies. Foscari, reared during his father's miserable Alexandrian semi-exile and poorly educated, fought his way up as a shrewd politician, and having made a second, wealthy marriage, he was ready to lead Venice.

Venice signed a treaty in 1430 with Florence and Siena, her fellow republics, that united their opposition to Lombard expansion. Bellini's work, novel in Venice for its new Florentine elements, reflects this political link with the Tuscan states. These tendencies are first seen after 1430 in his mosaics for the Mascóli Chapel (Figs. 53, 54). Foscari donated the chapel to San Marco as an ex-voto for a foiled assassination attempt. When a thief later raided the chapel's treasury by digging through the Baptistery wall, this lively doge opposed his death sentence, saying that so bold a man was worth saving. The Vatican, however, would soon excommunicate Foscari himself as a thief for withholding benefices from Venetian churches.

The doge manifested at once his flair for self-promotion and love of pageantry in his lavish triumphal parade from his house to the Doge's Palace. He staged one of the most

extravagant celebrations in Venetian history, costing 100,000 ducats, when his son, the notorious, corrupt Jacopo, married Lucrezia Contarini; Bellini may well have been employed in designing such opulent festivities.[7] It was during Foscari's reign that the doge first used the imperial "we" in referring to himself; in 1438 he began the building of his own monument, the new, triumphantly arched portal to the Doge's Palace.[8]

7 R. Cessi, "L'Investitura ducale," *Atti dell'Istituto Veneto di Scienze, Lettere ed Arti*, 1967–68, 10–26, 251–94.

8 Pincus, 1976, 76.

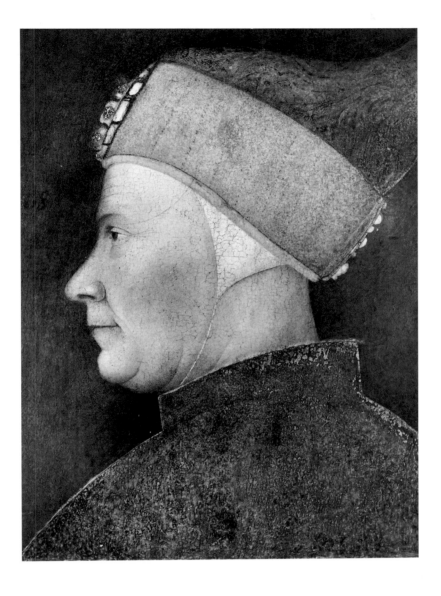

Figure 1.
Michele Giambono (studio?).
*Doge Francesco Foscari.*
15th century.
Tempera on panel.
Milan, Baldo Collection

The scrutiny of antiquity had always been part of the Venetian tradition, but Foscari's alliance with Florence allowed for a new influx of Tuscan art and artists into the Veneto that cast the Serenissima in a more rigorously classical framework, far from Byzantine or Gothic fancy. The Holy Roman emperor Sigismund helped to cement the Republic's newly won military claims by declaring the doge to be also the duke of Treviso, Feltre, Belluno, Ceneda, Padua, Brescia, Bergamo, Casalmaggiore, Soncino, and San Giovanni in Croce, and heir to all the fortifications of Cremona and Lombardy east of the river Adda. Needless to say, such largesse entailed a handsome present to Emperor Sigismund, cloth-of-gold worth a thousand ducats every Christmas.

Pageantry peaked in Venice with the great Council of Florence and Ferrara in 1438, when leaders of the Eastern and Western churches and the Holy Roman empire came together in Christian union. This council, long planned, was finally convened by Venetian-born Pope Eugenius IV, and largely paid for under the Republic's auspices. Nearby Ferrara was selected as one of its sites in tribute to the Serenissima, since that marquisate was connected to Venice by waterways and with the rest of Italy. John VIII Palaeologus and his court traveled from Constantinople to Venice, Ferrara, and Florence to meet with the pope and the western powers, in the effort to protect his threatened eastern realms, so soon to be destroyed.

9 J. Gill, *The Council of Florence*, Cambridge, Mass.: 1959, 99–100. The contemporary quotation is taken from Gill's earlier presentation of the Latin account (*Quare supersunt actorum graecorum Concili Florentini*, Rome: 1950, 2 and 4).

10 See Labalme, 1969, 114–25, for Bernardo Giustiniani's funerary oration for Foscari.

11 *The Two Foscari*, a poetic tragedy, in *The Works of Lord Byron*, XIII, London: 1833, 226.

Foscari's reception for the Byzantine emperor on February 8th, 1438, was among the most glittering events in Venetian history. Twelve splendid barges accompanied Foscari's Bucentaur, grandest of the official barges, to greet John Palaeologus. Lavish *tableaux vivants* were staged on the barges and probably at San Marco as well, possibly with Jacopo's assistance. "Towards sunset, after being rowed up and down the canals of Venice for much of the day . . . [the Greeks] set foot on Venetian soil to the sound of music of all kinds and the acclamations of the crowd in gala mood and dress . . . [they] felt that it was a glorious and marvelous Venice, verily marvelous, marvelous in the extreme and rich and varied and golden and highly finished and variegated and worthy of limitless praise, that wise and indeed most wise Venice."[9]

In that year a brilliant *condottiere*, Erasmo da Narni, known by his *nom de guerre* Gattamelata or "honey-cat," scored for Venice a major victory at Verona. Bellini may have worked for the general during his lifetime, and he, with both his sons, painted a large altarpiece in the late 1450s for the general's funerary chapel in the Santo, Padua (Fig. 47).

Vicenza had turned to Venice for protection after Giangaleazzo Visconti's death in 1402, and when the last Visconti duke died in 1447, Piacenza and Lodi followed suit, moving the Republic's border farther westward. To put to rest the fears in the Ambrosian Republic of Milan that the Serenissima might want to take it over as well, Venice claimed Milan's new leader—rather than his land—as her enemy: that leader was Francesco Sforza, married to Visconti's daughter though formerly a *condottiere* for Venice. Sforza soon won back Piacenza from Venice, and in 1448 he defeated the Serenissima in a smashing victory at Caravaggio. The Venetians were forced to come to terms with the brilliant soldier at the Treaty of Lodi in 1454.

Whenever Foscari's military schemes seemed to falter, he came before the Grand Council radiant in cloth-of-gold and rallied the Republic to fight on. Three times he offered to resign, only to be voted in. With Venice weakened by the fall of Constantinople in 1453, and the doge by his unswerving support of his rascally son Jacopo (four other sons had died of plague), Foscari lost his political grip and was forced to resign in 1457, at the age of 84. He died within ten days and was given a doge's burial despite his widow's bitter objections—in her view, thankless Venice had no right to bury her husband with false fanfare.[10]

In many of Bellini's pages should be seen the "Foscari style," allied with Florence and extravagant, celebratory, and militant. The fiery Foscari was larger than life, a romantic hero, to be immortalized long after in Byron's summary of his indomitable rebuilding of the Venetian empire: "I found her Queen of Ocean and I leave her Lady of Lombardy."[11]

A great loggia along the façade of the Doge's Palace, facing the Piazzetta, was built during Foscari's reign, filigree-like in its fenestration. Here the dogaressa was crowned and goods from all the guilds were exhibited annually. Urban renewal took up a large part of the building budget, wooden bridges replaced by masonry crossings, and the canal system expanded with hydraulic engineering that meant heavy expenditures. Much domestic architecture was also built, but like Foscari's own palace, it tended to be in a mild, conservative form of renaissance design, nearer to the traditional Venetian manner than to the innovational revival in Florence of the ancients' ways.

Jacopo's last painting may have been a portrait of Caterina Cornaro, who became engaged to Jacques II Lusignan, king of Cyprus, in 1468, thereby raising Venetian hopes, but in 1470, the year of Bellini's death, Venice lost Negroponte in Greece and Famagosta in Cyprus, her major ports in the Aegean and eastern Mediterranean, to the Turkish sultan Mehmed II, "the conqueror." To save and make face, the Republic sent her official painter-son, Gentile Bellini, to Istanbul in 1479 to be Mehmed's court portraitist for two years and to mend a few fences after the disastrous defeat. Under Doge Moro Venice won an occasional battle against the Turks, but other tides had turned and Florence took over many of the Republic's ties with eastern trade. Plans were made for a last, vast crusade that never came about.

Only through her art did the Serenissima recapture the sight of the Holy Land in the vicarious pilgrimages to sacred centers of Christian faith provided by Jacopo's Passion cycles for the scuole of Venice and his drawings of these subjects in his Books. Best of crusaders, the painter won by the pen what the sword could only lose: an untarnished triumph of the experience of faith, the seasonal beauties of the *terra firma*, and the wonders of Venice—all the beatitudes of the Serenissima.

# II

# ART IN THE LIFE OF
# JACOPO BELLINI

Genius—that gift to and from the spirit—is invoked by Jacopo Bellini in the inscription on his *Madonna* of 1448 (Fig. 40), and it has long been found in his art. Roger Fry wrote of him: "a great and acknowledged genius, whose work proclaims him master of a delicately humorous fancy, of a brain stored with quaint and unexpected conceits, and above all, of a supreme sense of pure beauty; he was a man, too, of rich experience . . . who was intimate with the courtly circles of the Estes at Ferrara and was known to art patrons throughout Northern Italy."[1]

Until the deliberate destruction in 1759 of his best-known painting, the *Crucifixion* fresco in the cathedral of Verona (Appendix D, 1), Jacopo was the most famous artist of the early Venetian renaissance. Soon his works were lost sight of, so much so that they were no longer securely identified a few decades later, and Jacopo was known only as the father of his painter sons, Giovanni and Gentile, and for his drawing Book that is now in London.

Yet Jacopo was active for over half a century, from before the 1420s until he died, after January 7th, 1470, and before November 25th, 1471 (Appendix E), his career bridging the years from the late Gothic style to the early golden age of Venetian art. Within Venice, his patrons included three of the great scuole (Venetian societies of mutual benevolence), the cathedral of San Pietro, and works for families and churches; he had commissions also from nearby princely states and from the Republic's *condottieri* (soldiers of fortune).

Bellini benefited from the uniquely long reign of Francesco Foscari (Fig. 1), doge from 1423 to 1457, whose policy of alliance with Florence gave Jacopo unprecedented access to the art and artists of that great center of neo-classicism and spatial innovation. No direct links are known between Bellini and the doge's patronage; he was not the city's official painter—that was Michele Giambono's role—but he probably worked closely with Giambono. Venice's expansion onto the mainland, winning Padua, Verona, Brescia, Vicenza, and other cities on the *terra firma*, had been early in the century; now, under Foscari's militant leadership, the region opened a new sphere of patronage to Jacopo. All of these cities boasted paintings by him. Only one drawing, described in the Index as showing the doge and his councillors (Appendix C, No. 61), but now missing from the Paris Book, is testimony to Jacopo's having known Foscari; it can be surmised from other drawings that the doge must have engaged him as pageant master to stage celebrations and parades, to order the pomp and circumstance, the grandeur and apparatus, of an empire on the rise.

No other early Venetian artist showed an interest as wide as Bellini's in contemporary art created beyond the lagoons. This is most evident in his drawing Books, and in his paintings made in the late 1430s and early '40s. Jacopo's grasp of new styles—from artists' travel notebooks, small portable works, and paintings he saw *in situ*—made him become the founder of the Venetian renaissance of the fifteenth century. Links between the arts of the Serenissima and the Arno valley are central to Jacopo's remarkably progressive style. Whether or not he journeyed to Florence, Siena, or Rome—suitable travels for a master of his stature—the steady stream of Florentine artists Venice-bound brought the Tuscan renaissance to him.

The painter as a hydraulic engineer, architect, antiquarian, cartographer, pageant master, curator, scenographer, designer and decorator of metalwork and sculpture, conservator, and deviser of jewelry, silver, tooled leather, saddles, banners, armor, ceramics, costumes, textiles, musical instruments, and what Hollywood calls "special effects," was the rule in the fifteenth century rather than the exception. The absence of documentation

1 Roger Fry, *Giovanni Bellini*, London: 1900, 1.

2 Sagredo, *Sulle consorterie del-l'arti edificatore in Venezia*, Venice: 1856, No. III, 283.

3 Vasari–Milanesi, III, 149.

4 Joost-Gaugier inclines to a birth date in the 1390s (1974, 37, n. 52); Testi (1915, II, 143–44) suggests 1398 and Ricci (1908, I, 247–48) seems to agree. See also Borenius' comments in Crowe and Cavalcaselle (1912, 100, n. 4).

5 See Billanovich, 1973, 359–89. The existence of Jacopo's brother Giovanni was uncovered by Paoletti. See Appendix E, Doc. Sept. 13, 1440.

6 Robertson, 1968, 10, n. 3.

7 Degenhart and Schmitt, 1980, Part 2, Sec. 3, pls. 79, 86, cat. no. 664; Sec. 1, 178–84.

and the loss of "lesser" works and ephemera have led to our impoverished image of the early renaissance artist. Painters were engaged in a great variety of tasks, including the design of tombstones for beloved pets. Bellini's Books show him to be among the most versatile artists, sharing the same variety of courtly concerns, embracing stage and parade ground, and reflecting his activity in almost all the decorative arts and crafts.

Officially a republic, Venice was also a massive elective duchy. If it recognized but one "official painter," others also had their slice of the patronage pie, from activities connected with court splendors to those of the scuole and of wealthy individual patrons.

Many documents concerning Bellini's career are missing or ambiguous; even major events and achievements remain open to speculation, as seen in Appendix E. His own birth date and those of his three children, and of three leading contemporary painters in the Veneto—Giambono, Pisanello, and Domenico Veneziano—are all lost. Nor is the teacher known of those three painters, but like Jacopo, they may have been trained by Gentile da Fabriano, the Marchigian master (from the Marches). The long inscription on Bellini's frescoed *Crucifixion* in Verona Cathedral testified to his being the proud yet humble pupil of that great artist (Appendix D, 1), an apprenticeship he perhaps began as early as age ten.[2] Vasari wrote that Gentile loved Jacopo like a son, and the grateful apprentice responded in kind, naming his oldest son after his teacher.[3]

When was Bellini born? Beginning with Vasari, most scholars settled for a date happily coinciding with the birth of his century.[4] It is appealing to identify his birth with the year 1400, but a date in the late 1390s may prove more nearly correct. Jacopo's mix of old and new is surprisingly close to that of the Florentine painter Paolo Uccello, who was born in 1397, and the two share many interests—both passionate *animaliers* and consummate painters of military history, both obsessed with reciprocal definitions of form and space, through the rational mystique of perspective.

Also born in 1397 was the Paduan tailor, embroiderer, and finally painter Francesco Squarcione, influential for his humanistic pretensions and for his academy, the first to elevate painting from a craft to a liberated art. His career interacted with Jacopo's for decades, and his star pupil and adopted son, the prodigy Andrea Mantegna, became Bellini's son-in-law.

Documents drawn up in the face of death tell the most about the facts of Jacopo Bellini's life. His own testament is lost, but not that of his father, Niccolò (Appendix E, Doc. April 11, 1424), two of his wife, Anna (Appendix E, Docs. 1428, 1471), and that of their son, Gentile Bellini (d. 1507). Niccolò left an illegitimate son named Giovanni, who, like Jacopo, became a painter, the half brothers working in partnership until 1440.[5] Jacopo too had an illegitimate son, the great artist Giovanni Bellini (d. 1516; wills may omit such facts, for bequests to bastards were not honored, settlements being made instead during the father's lifetime).[6] The first certain reference to Jacopo as a painter occurs in his father's will of 1424, and by then he was old enough to have substantial debts to settle before receiving his share of the estate. Niccolò was clearly a successful and provident man, living in a more prosperous quarter of Venice than those parishes where the name Bellini abounded in the Trecento. The old man was ungenerous to Jacopo and his sister, the wife of a boatman (both brother and sister were his children from his first wife, Giovanna), leaving the bulk of his estate to his second wife, Franceschina.

In Venice, whose painters' guild was the oldest in Italy, the style of art in Bellini's youth was strong yet provincial. Jacobello del Fiore and Niccolò di Pietro had a simple, forthright approach, rustic and almost sculptural; both were masters of small-scale portraiture and vivid genre elements. Bellini may have been taught by either artist before Gentile da Fabriano. Perhaps a pattern book sometimes attributed to Niccolò gives a clue as to the look of Jacopo's earliest drawings.[7]

The first record of Gentile da Fabriano in Venice is in 1408, when he worked for the same patron, Francesco Amadi, as Niccolò di Pietro and Niccolò's *garzon*—possibly that apprentice was Jacopo, who then left the sturdy local master for Gentile's more sophisticated sponsorship. Alternatively, Jacopo could have begun under Jacobello del Fiore, longtime dean of the painters' guild, whom Bellini surely knew, for he bought an inlaid wooden panel, an *intarsia*, at Jacobello's estate sale in 1439 (Appendix E, Doc. 1439). From Jacobello he could have learned that popular craft, so important for the early practice of perspective.

A few manuscripts, mostly by Cristoforo Cortese, testify to the presence in Venice of a more sophisticated style, contemporary with the somewhat naive manner seen in local painting on a larger scale. Although Gentile officially "arrived" only in 1408, it is now believed by some that he was trained in a Venetian manuscript atelier; the same could be true for Jacopo, in whose atelier may have been produced the finest Venetian manuscripts

true for Jacopo, in whose atelier may have been produced the finest Venetian manuscripts of the mid-fifteenth century (Appendix F, Ills. 1, 2).

The International Style of the late Gothic, central to Gentile's and Jacopo's early art, is little more than a knowing, fanciful return to Simone Martini's urbane and chivalric manner, and it adroitly fuses realism with idealism, tact with monumentality, decoration with immediacy. Though Giotto's greatest known works in the Arena Chapel at Padua were a mere half-day trip down the Brenta Canal, his daunting images were less imitated or followed than those by Simone or Gentile, which often celebrate conspicuous consumption and worldly success, qualities reassuring to Venice, Italy's wealthiest state.

Even if Gentile da Fabriano was not trained in Venice, he received there his earliest known commission, the *Madonna* (Perugia, Galleria Nazionale dell'Umbria) probably painted between 1406 and 1408.[8] A master of spatial construction, his artful, dollhouse-like interiors, elegant city squares, and lovely landscapes all work well in staging the requisite action. The Marchigian's skills are seen best in his painting for a Florentine patron, the Strozzi Altar of 1423 (Fig. 67). If Jacopo was one of the several assistants Gentile brought with him to Florence for this project, he may have helped with its many genre details— ships, flowers, animals, and decorative bits such as the attendant's one-feather headdress that would become practically a Bellini motif.

8 Christiansen, 1982, cat. no. 1, 83–84.

9 See L. Anelli, "Ricognizione sulla presenza bresciana di Gentile da Fabriano dal 1414 al 1419, "*Arte Lombarda*, 1986, 75/77, 31–54.

10 A recent study by Hirthe (1980) sees the Paduan frescoes as the source for all of Jacopo's space constructions other than his framing triumphal arch.

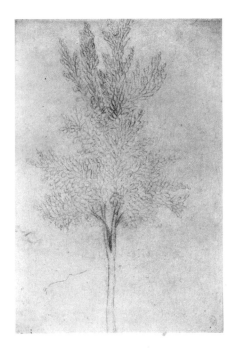

Figure 2.
Jacopo Bellini (or studio?). *Tree Study*.
Leadpoint on board, 29.5 x 14.5 cm.
Paris, Louvre 2267 (Codex Vallardi)

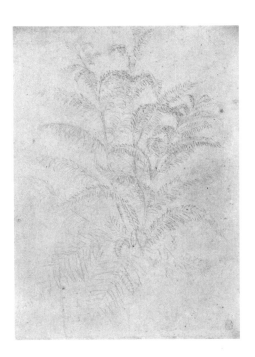

Figure 3.
Jacopo Bellini (or studio?). *Fern Study*.
Leadpoint on board, 29.2 x 19.5 cm.
Paris, Louvre 2268 (Codex Vallardi)

Just when and where Jacopo received his training from Gentile is not surely known. Carlo Ridolfi, writing in his *Meraviglie dell'arte* in the mid-seventeenth century, was the first to locate this instruction in Venice. Between 1408 and 1414 Gentile painted a fresco of a naval battle in the Sala del Maggior Consiglio, a great room in the Doge's Palace lined with frescoes, and young Jacopo's first lessons in landscape and seascape may have come from working on this strongly atmospheric subject (Appendix D, 1).

Gentile left for Brescia in 1414 to decorate a splendidly adorned private chapel for the *condottiere* Pandolfo Malatesta. Jacopo may have gone with him; its chief subject, *Saint George and the Dragon*, often appears in Bellini's Books. Details in the landscapes recently recovered from this ruined Broletto Chapel are close to those in Jacopo's early works, such as the Louvre *Madonna of Humility* (Fig. 31).[9] But for more searching ways to realize form and space, more profound than Gentile's, Bellini turned to the achievements of Altichiero of Verona and his followers in the later Trecento. The young painter, while surely grateful for what came to him of the Marchigian's suave skills, did not ignore the lessons of the great earlier masters, so accessible in their many Paduan frescoes.[10]

11 Boskovits, 1985, 117.

12 See Christiansen, 1982, 172–73 for a discussion of the ties between both artists and the Lateran series.

13 For a contemporary Venetian painter and sculptor, see the "Life of Jacopo Moranzone" (Testi, 1915, II, 72–75).

14 The *Crucifix* is at Castel del Mezzo, in the Marches. See Testi, 1909, I, 400. Wolters, 1976, I, 101, wrote that the Castel del Mezzo *Crucifix* was painted by Gentile da Fabriano.

15 See Appendix E, Docs. 1424, 1425; Christiansen, 1982, 165.

16 Vasari–Milanesi, III, 20, and 149, n. 1. The documents were recently published in their entirety by Christiansen, 1982, doc. IX, 164–66.

Antonio Pisanello, long presumed one of the Marchigian's best-known "junior associates," was described recently as of "Venetian origin and Gentile's formation."[11] Son of a Pisan father and a Veronese mother, he supposedly spent his formative years in Verona under the guidance of Stefano da Verona. But the earlier leading artists from that city, Altichiero and Jacopo da Verona, received major commissions in Padua, and doubtless also painted in Venice—true, too, for Pisanello, who worked on a fresco in the Sala del Maggior Consiglio of the Doge's Palace, completing it before 1424. The stylistic harmony of Pisanello and Gentile is proven by the choice of Pisanello in the early 1430s to complete Gentile's Lateran frescoes in Rome, left unfinished at his death in 1427.[12]

Venice received the Tuscan artist closest to her sensibilities when she requested (or asked Ghiberti to choose) young Paolo Uccello to design mosaics for San Marco in 1425. Evidently the Serenissima's establishment deemed no local master worthy of this task, holding her own painters in low esteem; Uccello, Jacopo, and Pisanello, like Gentile all shaped by the International Style, were superb *animaliers* and masters of the blond, courtly coloring that celebrated chivalric fashion and romance.

Since Bellini's first known commission—an altarpiece and its curtain, both showing Saint Mark—was painted for the Scuola di San Marco in 1421 (Appendix E, July 19, 1421), his status when Uccello arrived four years later was that of an independent master. Thus the perspectival learning he may have acquired from the Florentine was as a peer, not a pupil; it has been suggested that Uccello, conversely, may have benefited from Jacopo's example. Pisanello's pictorial values remained more conventional, rooted in the tried and true of the late Gothic style, except for his medals of the later 1430s and '40s.

While Jacopo's career was taking shape during the 1410s and '20s, a major campaign was under way to complete the sculptural embellishment of San Marco, that the Doge's Chapel might rival the projects for great figure-encrusted church façades at Bologna, Florence (the Serenissima's ally), and Milan (her arch enemy). Venetian painters must have learned much from so massive an outpouring of richly worked stone. This populace in relief and in the round, frozen in dramatic gesture, confrontation, and emotion, acted on them like the plaster casts of antiquities on artists' academies two decades later. Local artists, possibly including the youthful Bellini, doubtless drafted working drawings and guides to show the civic patrons how these costly sculptural ensembles would look before the financial outlay went further.

The painter-as-sculptor is central to the Italian tradition, and Tuscan artists were often active in both fields. Such virtuosity was rare in the Veneto,[13] though some of the finest statues originated in artists' designs and ended with their coloring. Others, among the most powerful sculptural images, were never turned over to stonecarvers or woodcutters but were "modeled" in shades from black to white. Though the exact date when Venetian facades were first covered by such make-believe sculptures is unknown, this festive practice was widespread by the late fifteenth century, and possibly current in Bellini's youth. Perhaps some of his most elaborate architectural renderings, encrusted with statuary, should be understood as painted facades rather than real sculpture (Plates 92, 182). Conversely, they could have served as points of departure for sculpture in the round.

Polychromy was so prized in the generation of Jacopo's teachers that painters signed their names to statuary along with sculptors.[14] Gentile da Fabriano was clearly concerned with sculpture, since his apprentice, sometimes identified with Jacopo, was described in the Florentine lawsuit of the early 1420s as guarding "certain sculpture and painting of the greatest importance" set out in the open air to dry.[15] Many details in the Strozzi Altar (Fig. 67) are worked in relief (*pastiglia*) in gesso, then gilded for the requisite lavishness. Jacopo followed the same method in his lost Verona *Crucifixion* of 1436 and in the *Saint Peter* (Fig. 56), whose book is treated in this decorative fashion.

Scholars have debated for over a century whether that feisty apprentice/servant of Gentile's, listed as "Iacobi Pieri pictoris de Venetii" in Florentine legal documents of the early 1420s, could be Jacopo Bellini. The greatest of art-historical archivists, Gaetano Milanesi, published the documents while preparing his monumental edition of Vasari's *Lives*.[16] At the trial of Jacopo di Piero varying accounts of the incident were given, but all agree that the assistant encountered a Florentine youth who threw stones into the courtyard where Gentile's works were kept; quick to protest, Jacopo said to the iconoclast Bernardo, a notary's son, "Being now as big as a man, you have done a very bad thing."

Opinions differ as to what happened next. Bernardo's lawyer stated, "Jacopo armed himself with a wooden club with the intention of committing the following wrongdoing . . . whirling the stick around several times he landed only one blow on Bernardo's

left arm, without causing bloodshed"; in another account, Jacopo was following his master's instructions in reproaching Bernardo, who, infuriated by the Venetian's words, mocked Jacopo and challenged him to a fight "with bare hands, with no other weapons." Jacopo, supposedly realizing that his actions could end in a trial, shortly boarded a galley in the service of Florence.

The best arguments against identifying Jacopo Bellini with Jacopo di Piero are the father's name given in these documents, Piero (rather than Niccolò), and the extreme poverty of the youth on trial, who chose a year of rowing on a Florentine galley just to get away. None of this seems appropriate to Bellini, a valued and talented young artist and the witness of his father's will, that of a modestly well-off man, in 1424, not long after these troubles. It also seems unlikely that Bellini, if identical with "Jacopo di Piero," would have kept the gratitude he was known to have had for Gentile da Fabriano, who remained aloof throughout these proceedings.[17] Nor would the young painter have been given the lowly title of *famuli*, or servant.

The Florentine trial documents, backed by Milanesi's authority, made scholars leery of accepting Jacopo's commission at the Scuola di San Marco in 1421, even though the scuola's inventory listed it as by "maistro Iacomo Belin pentor" (Appendix E, July 19, 1421). If Jacopo was born in the 1390s he would have been old enough to undertake such a work and still accompany Gentile to Florence. Gentile traveled from Brescia to Florence with a retinue of eight, and more than one of the Venetian assistants he probably took along could have been named Jacopo, a very common name: at mid-century, Venice had several Jacopo Bellinis. Artists, moreover, did not hesitate to shift back and forth between independent commissions and work with associates.

The key question is not "Was Jacopo Bellini identical with poor Jacopo di Piero?" (the best-educated estimates now incline to the negative), but "Was Jacopo Bellini in Florence with Gentile in the early 1420s?" If Christiansen's recent attribution to Jacopo is correct, of the execution of a dossal in Florence, designed by Gentile for San Niccolò sopr'Arno (Appendix D, 1), it would provide the needed evidence. Unfortunately the painting has been so severely damaged that its authorship remains conjectural. But the ascription is interesting, for the outermost panels are close to Masolino, and his art, as Longhi recognized, was important for early renaissance painting in Venice.[18]

Perhaps Bellini joined his teacher in Florence, to help with Palla Strozzi's important commissions (Fig. 67). Joost-Gaugier suggested that Jacopo went with Gentile to Siena in 1424 and to Rome as well, giving him the chance to see Masolino's earlier works.[19] A subsequent journey would have shown him the Brancacci Chapel, where Masolino painted with Masaccio (Florence, Carmine), and the *Saint Catherine* cycle and *Crucifixion* in San Clemente in Rome, the church of Masolino's major patron, Cardinal Branda Castiglione. Masolino's fresco cycle of famous men, painted for Cardinal Giordano Orsini in Rome, would have helped shape Bellini's view of history, just as Masolino's lofty, panoramic landscapes, his effective, boxy interiors, and his brisk graphism contributed to Jacopo's approach to scene, space, and line. Though Masolino probably died in the mid-1430s, drawings after his work doubtless circulated for decades. Also in Cardinal Branda Castiglione's employ was the young Sienese painter and sculptor Vecchietta, another channel for bringing the new arts of Tuscany to the Veneto.

✣  ✣  ✣

Apart from small yet welcome exceptions such as Niccolò di Pietro's bright-eyed kneeling cleric in his *Madonna* of 1394 (Venice, Accademia), little remains to indicate much interest in the art of likeness among Venetian painters active during Jacopo's youth. In that field his major lesson probably came from Gentile, well known as a portraitist, who brought two such pictures from Fabriano to Venice. Portrait-like, many figures in the Strozzi Altar assert Gentile's skills as a master of physiognomy, gifts that he fostered in Jacopo. Bellini's earliest recorded portrait, if painted from life, must have been a profile of Gentile (who died in 1427) that was in a Paduan collection at the century's end.

A life-size self-portrait of Jacopo was said to have been included in a lost Passion cycle painted for Verona at an unknown date. Jacopo's earliest pictures that survive are from the late 1420s and early '30s, and in them he is closest to Gentile. The first is his *Annunciation* in San Alessandro, Brescia (Fig. 19), the second the *Madonna of Humility* in the Louvre (Fig. 31).

17 Of the leading early Bellini scholars, A. Venturi (1885) accepted Milanesi's identification, as did Ricci (1908). L. Venturi (1907) accepted and Testi (1915) rejected Milanesi's identification. Joost-Gaugier (1974) opposed it, Christiansen (1982) believed it, as did Degenhart and Schmitt (1984); Boskovits (1985) was opposed.

18 For the dossal, see Christiansen, 1982, cat. no. XV, 105–7.

19 Joost-Gaugier, 1974, 26. She provides a valuable study of the possibilities of such travel and an excellent appraisal of the documents.

20 A Florentine, Giovanni Martino da Fiesole, was director of works (*capomaestro*) at San Marco in those early years. See G. R. Goldner, "Niccolò Lamberti and the Gothic Sculpture of San Marco in Venice," *Gazette des Beaux-Arts*, 89, 1977, 41–50. See also Wolters, *La scultura veneziana gotica (1300–1460)*, 1976, I, ch. VIII.

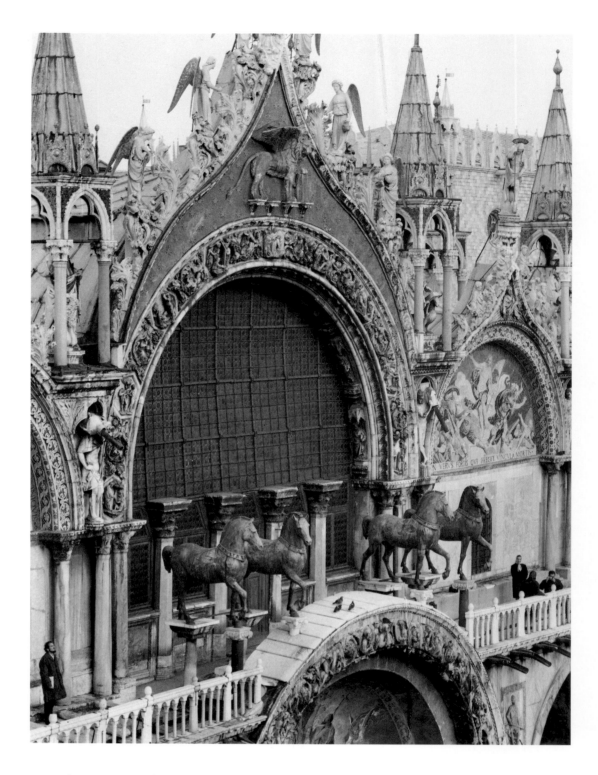

Figure 4.

Horses of San Marco.

4th/3rd century B.C.

Venice, Façade of San Marco

The two vertical panels that form the *Annunciation* are no longer in their original frame (Fig. 18). Although the circumstances of this commission remain obscure, probably the Bridgettines or another order in Venice paid for it for their chapter in Vicenza, and some ten years later the painting was sent on to Brescia; Vicenza and Brescia were both Venetian protectorates. The *Annunciation* may be Jacopo's most exquisitely painted work. Rendered with remarkable fluency and finesse, it could have been begun by Gentile da Fabriano, as the broad concept and many details pertain to his vision and hand. Among Jacopo's later works, only the *San Bernardino da Siena* and the *Tadini Madonna* come so close to his master's manner (Figs. 59, 38).

The Florentine sculptor Niccolò di Pietro Lamberti came to Venice in 1416, about two years after Gentile da Fabriano left for Brescia; far from innovative, he replaced Gentile's graceful style with his more rugged approach, in the vanguard of many Tuscans who came to enrich San Marco's exterior under the direction of a Florentine master builder. Great nude, athletic males, alien to the Venetian tradition, carved as rainspouts for the chapel's gutters, may have given Jacopo his first lesson in Tuscan muscular Christianity. A fine large *Annunciation* group carved for the façade by another Florentine master in the 1420s could also have helped Jacopo reformulate his style. [20]

Figure 5.
*Two Lions*.
Leadpoint on paper, 17 x 15 cm.
Paris, Louvre 2384 (Codex Vallardi)

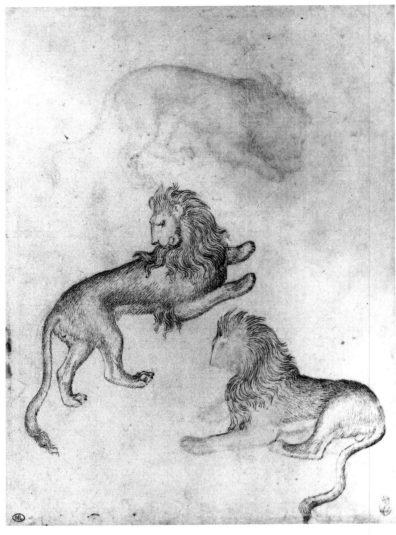

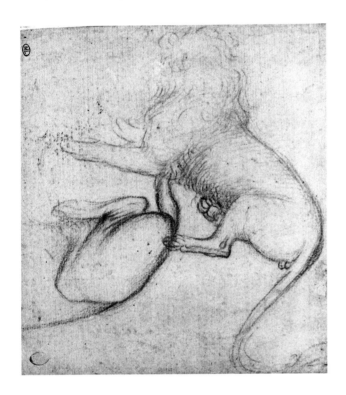

Figure 6.
Jacopo Bellini (or studio?).
*Three Lions*.
Leadpoint on paper,
partially reworked in pen.
Paris, Louvre 2385
(Codex Vallardi)

Figure 7.
Unknown Venetian artist.
*Lion Studies*, beneath Jacopo Bellini's
silverpoint drawing of
*Seven Lions and Three Stags*.
Ink on vellum.
Paris Book, fol. 78v
(Plate 6).
c. 1400.

21 Wolters, 1976, I, 100; II, cat. no. 232, fig. 770.

22 Krautheimer and Kraut-heimer-Hess, 1956, 349.

23 Gibbons (1963, 56) believed the daughter was the first-born, Gentile next, and Giovanni last. The latter, according to him, was born later than Mantegna, whose birth year was c. 1430. See also Robertson (1968, 10–11) and Meyer zur Capellen (1985, 9–10).

24 Röthlisberger and Gramaccini have noted these sources. See Appendix D, 1.

25 For other inferior *Madonnas of Humility* ascribed to Jacopo, see Appendix D, 3: "New York" and "Verona."

It is certain that Bellini worked in close cooperation with sculptors, but how closely cannot be answered until new documents are discovered. A seated marble *Madonna* incised in Latin as by Master Nicholas of Vicenza is so near to Bellini's art as to suggest his design, a forerunner of his *Mater Omnium* (Plate 138).[21] The Veneto imported sculptors during the later 1420s and '30s to produce the impressive new tombs whose classicizing architectural details and figure styles Jacopo followed in his Berlin *Saints* (Figs. 55–58) and in his many graphic sculptural projects (Plates 133, 137, 136).

Ghiberti, Michelozzo, and Quercia had all made several trips to the Veneto well before the 1440s. The works they did there are not known but their presence must have been a challenge to the soft, sleepy style of most local sculptors. *Samson* (Plate 151), among Jacopo's most monumental figure studies, is close to one on the frame of Ghiberti's second Doors, possibly seen by Bellini in the sculptor's studio or *in situ*; Krautheimer detected this dependence, suggesting that a Ghibertian notebook may have circulated in the Veneto, where Bon, the leading sculptor, occasionally made a feeble *reprise* of the Florentine's motifs.[22]

Jacopo was open to Ghiberti's art throughout his career. The *Baptism* (Plate 186), its chiseled intricacy so close to a relief in precious metal, illustrates another of his perpetual returns to the Florentine's style, one of many reasons why his pages are often hard to date. Part of Jacopo's work experience may have run parallel with that of painters active in Ghiberti's studio—Masolino, Uccello, or Gozzoli—in translating form toward relief or the round. Bellini's peers—Pisanello and Giambono—continued the medieval practice of surrounding richly carved and colored wall tombs with their frescoes, which Jacopo too may have done.

✢   ✢   ✢

By 1428 Bellini was married. His wife, Anna, made a will in that year, describing herself as pregnant, married to the painter, resident at S. Geminiano (Appendix E, Doc. 1428). Death in childbirth was so tragically frequent that women often prepared wills near their time. Since the usual practice was to name the firstborn after the child's paternal grandfather, the couple's first surviving child was probably either Niccolosia (who would marry Mantegna in 1453) or the little-known Niccolò.[23] Some time later Jacopo's other legitimate son, Gentile, was born, followed by Giovanni, who is listed in early texts as born after Gentile, probably about 1435. Not mentioned in Anna's second will, Giovanni may have been named for Jacopo's mother or for Jacopo's illegitimate half brother, referred to as a painter on September 13th, 1440; though it is not certain, the great Giovanni Bellini seems also to have been illegitimate.

In 1430 Jacopo was receiving well paid, major commissions in the Veneto. His first recorded work outside Venice, now lost, was a *Saint Michael* for the church of that name in Padua, placed above the high altar (Appendix D, 1). Its price was evaluated by Giambono, who had the role as leader of Venetian painters after Jacobello del Fiore's death in 1439; possibly Pisanello was also an appraiser.

Bellini may have gone to Ferrara about 1430 to paint Lionello d'Este, the very young man in right profile blessed by the infant savior in the Louvre *Madonna of Humility*, if that kneeling figure is indeed Lionello (Fig. 31). Niccolò III d'Este had selected Lionello to succeed him, from among his many bastards; though the marquis was to rule for another eleven years, he had Pope Martin V legitimize Lionello in 1429, thus proclaiming him heir apparent. The princeling's plump features are modeled with an almost medallic luster. In the Louvre *Madonna* Jacopo is following not only his teacher, but also aspects of the art of Uccello and Pisanello, both active in Venice in the 1420s. Light, texture, and motion, aerial city views, the skills of the narrator and the *animalier*—all are impeccably enunciated in this little votive panel. It is our only painting by Bellini having such an extensive landscape, with equestrian figures (Fig. 16), a hermit reading, and a wellhead, beehive, and deer (Fig. 8). The city views recall those by Gentile, Fra Angelico, and Ghiberti.[24]

In another *Madonna of Humility* (Milan, Museo Poldi Pezzoli), inferior in quality and a few years later, the figure is placed before a traditional, plain gold background (Fig. 33).[25] A third *Madonna* recently discovered in Genoa, sadly battered and now missing again, may also be from the artist's studio in the early 1430s (Fig. 34).

The delicate effects of light hinted at in the landscape of the Louvre *Madonna* must have been more highly evolved in his lost Verona *Crucifixion* fresco of 1436, the scene shown at the moment of eclipse, of the death of Christ. In both drawing Books events from the Passion are presented as nocturnes, including four of the seven *Flagellations*.

Bellini staged many other scenes at night, especially those of pagan sacrifice, for the dramatic isolation that only a nocturne can provide. The *Crucifixion* fresco was clearly still in the International Style; angels with swirling draperies filled the darkened sky, enframing prophets abounded with speech scrolls, and gilded, raised decorative elements were shaped in gesso.

Judging from many lengthy, admiring descriptions over the centuries, this fresco was the vehicle for Jacopo's richest visual and verbal tribute to Gentile da Fabriano, emulating the variety and virtuosity of his master's art. The bishop-patron may also have had the Marchigian's manner in mind—works like his *Naval Battle* in the Doge's Palace or the jewel-like chapel he had decorated so lavishly for Pandolfo Malatesta in Brescia eighteen years before, both possibly with Jacopo's assistance. The lost *Crucifixion* was close to the manner of Salimbeni, earlier in the century, whose elaborate way of working was still going strong in the 1440s in gilded, ornately patterned frescoes by the Zavattari at Monza; its style may also have resembled that of Giovanni d'Alemagna's *Crucifixion* of 1437. The *Adoration of the Magi* by Vivarini and D'Alemagna (formerly Kaiser-Friedrich Museum, Berlin) was also a nocturne, the angels' long twisted drapery suggesting that described in Bellini's lost fresco.

The connections with early Netherlandish painting seen in several of Jacopo's religious pages in his Books are not surprising in view of the many trade links between both lands. Similar Northern influence may also have appeared in his earlier lost narrative paintings. The vertical, compact composition of Jacopo's London *Adoration of the Magi* (Plate 177) recalls Flemish compositions of that theme. Only the heroic scale of the shepherd in the far right foreground and the classical row of soldiers in the Magi's retinue shift this scene from north to south.

Jan van Eyck may have come to Venice at least once, if indeed he made a pilgrimage to the Holy Land in 1426 for Philip the Good. Living in Bruges, he was acquainted with its many Italian residents. Fine Eyckian paintings of the Crucifixion and of genre subjects were in Venetian and Paduan collections in the fifteenth century where Bellini could have seen them, works later prized by the very connoisseurs who hung his own works on their walls. He would also have known works by the great Flemish master Roger van der Weyden, who came to Italy in the Holy Year of 1450.[26] Dieric Bouts, of the same generation as Jacopo, was represented in Venice by several fine paintings on linen by the master or his studio. If their Foscari provenance, recorded in the nineteenth century, indeed goes back to the fifteenth,[27] it is likely that Jacopo knew these works.

The most Italianate of the early Netherlandish painters, Petrus Christus, was probably active in Venice in the early 1450s, as he was paid for a major altarpiece for the Scuola della Carità in 1451, a year before Jacopo was commissioned to paint a great banner for the same scuola.[28] In the Fleming's paintings Bellini could have found his source for the narrative Gothic reliefs that enframe the *Saint John* (Plate 283); by adding the metal strut across the arch framing the Baptist, Bellini "naturalized" the Netherlandish formula to make the opening resemble Italian building practices.

Art historians at the turn of this century, dazzled by the archivists' brilliant, extensive research into the courtly life of the Este of Ferrara, tended to see in Jacopo's richest chivalric references his links to that precious place where in 1441 he bested Pisanello in a portrait contest for the likeness of Lionello. After Lionello's accession in that year Ferrara began to be an important center for renaissance art, starting with the humanist Alberti's residence and the development of the university. Splendid Este pleasure palaces had been built about 1400, but the advent of the revival of antiquity took its time in Ferrara.

Criss-crossed by canals, Ferrara was something of a little Venice. The Este had long provided the Serenissima with *condottieri*, some seen in Jacopo's Books. Like Venice, Ferrara long depended on imported artistic talent for major local commissions. Pisanello and Bellini may have worked on triumphal decorations for the glittering meeting of the churches of East and West at the great Council of Ferrara in 1438.[29] Though the Ferrarese aspect of Jacopo's chivalric subjects has been exaggerated, he may well have been employed on competitions or projects for Este monuments—equestrian statues honoring the marquises as military leaders (Plates 131, 132). Pages in the London and Paris Books could refer to designs either for the tomb of Niccolò III (d. 1441) or for Lionello's (d. 1450). Borso (r. 1452–1471) had a less lively military career, though he prided himself on being a great huntsman. Bertoldo d'Este, who fell battling the Turks in 1463, may also have been the subject of a funerary project by Jacopo; a *gisant* on a sarcophagus lid (on a strip cut from the Paris Book; Plate 136) suggests a monument erected to the young general, and the prominent eagles may pertain to the Este arms. His portrait was listed in an early sixteenth-century Venetian collection as by Bellini.[30]

26 See S. Osano for a fine study of "Roger van der Weyden e l'Italia; problemi, riflessioni e ipotesi," *Antichità Viva*, 1981, Part I, 14–21; Part II, 5–14.

27 See the Notebook of Sir Charles Eastlake, 1858, Part 1 (Milan), quoted by M. Davies, *Les Primitifs Flamands. The National Gallery*, London, Antwerp: 1953, 27.

28 G. Fogolari, "La Chiesa di Santa Maria della Carità di Venezia," *Archivio Veneto-Tridentino*, 5, 57–119, esp. 103; cited by L. Campbell, Review of P. H. Schabacker, *Petrus Christus, Burlington Magazine*, 117, 1975, 676. Perhaps the newly acquired paintings by Christus in Bruges are from the Carità Altar.

29 See Gundersheimer, 1973, chs. 4, 5, 7, for a discussion of the Council of Ferrara, the great meeting of the churches of East and West, called in large part by Venice. See also J. Gill, *The Council of Florence*, Cambridge: 1959.

30 *Anonimo Morelliano*, Williamson, 1903, 18, 23; and A. Heiss, *Les médailleurs de la renaissance*, I, Paris: 1883, 18.

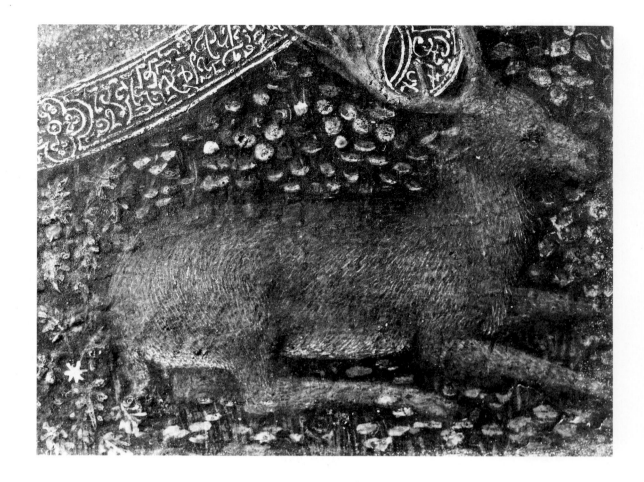

Figure 8.
Jacopo Bellini.
*Deer*, detail of
*Madonna of Humility
with Donor* (Fig. 31).
About 1430.
Tempera on panel.
Paris, Louvre

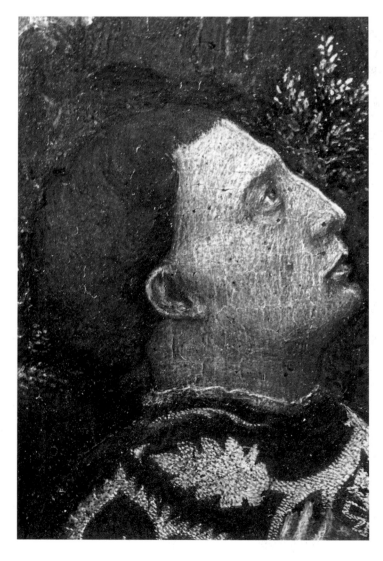

Figure 9.
Jacopo Bellini.
*Donor* (Lionello d'Este?), detail of
*Madonna of Humility with Donor* (Fig. 31).
About 1430.
Tempera on panel.
Paris, Louvre

An important question in Bellini's biography is the duration of his working relationship with Giambono, who was some years his senior and died in 1462, about a decade before Bellini did.[31] The older painter may already have had a supervisory role at San Marco before 1423, when Foscari was still protonotary. On the vault mosaic of the most progressive monument to the early renaissance style in Venice, the Mascoli Chapel in San Marco, only Giambono's name appears, but many of its ongoing features were the contribution of other artists. Its construction probably began in 1430, the same year as Jacopo's painting of *Saint Michael* in Padua.

Giambono assumed the duties if not the title of *pittore di stato* to the Venetian Republic in 1439, on Jacobello del Fiore's death. Paid 300 ducats annually by the Procurators of San Marco, the state painter had charge of the restoration and protection of the Republic's paintings, the designing of mosaics, and doubtless the preparation of decorations and scenery for holidays and ceremonies. He painted the official portrait of the doge (Fig. 1), placed in the location designated by law, and his votive image. In the 1450s and '60s Jacopo, as the Republic's leading artist, took on many of these duties without the titles.

Son of an *intarsia* maker in Treviso, Giambono began his artistic training at home. In Venice he and Bellini both lived in the same parish, San Geminiano, and belonged to the same scuola, San Giovanni Evangelista; he joined in 1422, Jacopo was a member by 1437 (Appendix E, Doc. 1437). The predella panels painted around 1441 for the Brescia *Annunciation* (Figs. 20–24) share the styles of both painters, but possibly Jacopo painted them with his half brother Giovanni; he canceled his partnership with Giovanni on September 13th, 1440, preparatory to a planned partnership with Donato Bragadin (Appendix E, Doc. Sept. 24, 1440), apparently never realized.

Giambono's manner was usually conservative, though he could paint a Donatellesque *Man of Sorrows* (Padua, Museo Civico), or an Uccellesque *San Chrysogono* (Venice, San Trovaso) once ascribed by Berenson to Jacopo Bellini.[32] He also propelled into the Venetian *lingua franca* the most popular theme of the International Style, the queenly, radiant "Beautiful Madonna" type, in deliciously animated paintings such as his *Virgin* (Rome, Herziana) of the 1430s. The textile background in Bellini's *Lochis Madonna* (Fig. 32) is similarly decorative, and a bird perches on Mary's arm as in Giambono's *Virgin*. Jacopo's image is more monumental, recalling Gentile da Fabriano's gravest manner with a hint of Byzantine heritage in its pensive dignity. Formal and centralized, this *Madonna and Child* is enlivened by the baby's pose.

From a contract with Jacopo's nephew, Leonardo (Appendix E, Doc. 1443), it is clear that the boy had been in Jacopo's studio since 1430, when he was twelve years old. By 1443 Jacopo may have had several apprentices, their work largely responsible for the enthroned *Madonna and Child* (Gazzada, Fondazione Cagnola; Fig. 36). Though undistinguished in detail—note the awkward treatment of the Virgin's bony hands—the painting has an appealing emotional directness. Standing on his sad mother's lap, the overdressed little savior too looks miserable as he tugs at her mantle for nurture. She recalls Gentile da Fabriano's most pensive Madonnas; the setting, with its small shell niche, pointed entablature, and foliate motifs, is very Venetian Gothic in manner.

In a grand but much abraded life-size, bust-length *Madonna*, its arched framework original, Bellini is shifting from the International Style, discarding the easy charms of the late Gothic tradition (New York, Metropolitan Museum of Art; Fig. 35). The medieval gold background is still there, but the Madonna has a grave expression typical of Jacopo's art and he has endowed the child with a rare and independent monumentality, Florentine in origin.

By the 1430s, Jacopo's major local rival, another painter open to new currents, Domenico Veneziano, had departed the region, leaving Jacopo, Giovanni d'Alemagna, and Antonio Vivarini as the leading Venetian masters responsive to Tuscan developments. Yet all three also stayed close to aspects of Gentile da Fabriano's art, modernizing his heritage by taking on Masolino's luminism and perspectival concerns. Masolino's subtle command of light, his mastery of the nude and quiet quotations from antique sources, and his concern with perspective all appealed to the Venetian artists, who could have met the older Florentine on his travels to and from his Hungarian commissions. They may have known his remarkable frescoes at Castiglione Olona, near Milan, the nude brilliantly and freshly treated in vivid scenes from the life of Saint John the Baptist.[33]

Ghiberti's artful fusion of past and present, Gothic and classical, traditional and innovational, made the major contributions of the early renaissance seem so easy, so readily imitable in relief sculpture, and Masolino's was the same synthesis in painting, resolving old and new in powerful yet often decorative works in Hungary, Lombardy, and Rome as well as in the Arno valley.

31 Pesaro, 1978, 47, proposes 1395 for Giambono's birth. See a helpful resumé in Palluchini (1956?), 89–116, and the dissertation on Giambono by Land, 1974.

32 Berenson, 1895, 25.

33 See Wohl, 1980, 9; Longhi, 1940, 170–71; and A. Natale, "Il Vecchietta a Castiglione Olona," *Paragone*, 407, 1984, 3–14.

Figure 10.
Jacopo Bellini.
*Satyr and Vase*,
detail of right margin,
Paris Book, fol. 77
(see also Fig. 17)

*Right:*
Figure 11.
Possibly Jacopo Bellini.
*Seated Putto.*
1451 (date nearby).
Drawing in *terra verde* on wall
of chapel, formerly
mosaic workers' studio.
Venice, San Marco

*Above right:*
Figure 12.
Probably Giovanni Bellini.
*Antique Offering.*
Pen and ink on paper,
25.6 x 20 cm.
Munich, Staatliche Graphische
Sammlung

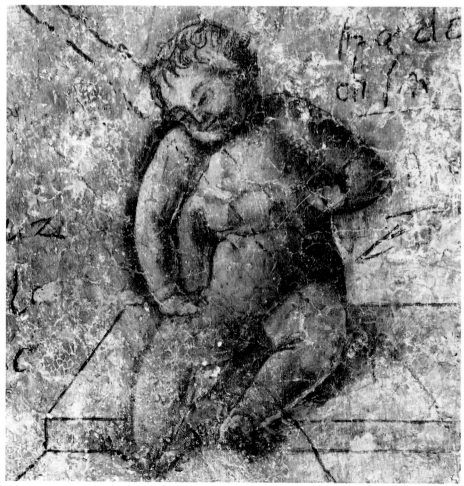

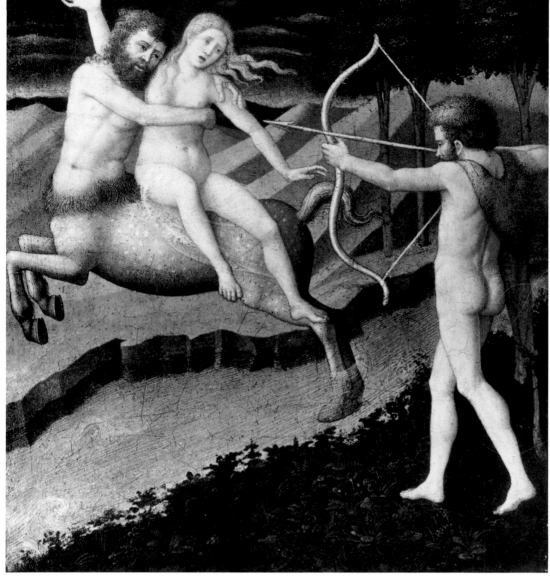

Figure 13.
Jacopo Bellini (studio).
*The Rape of Deianira*.
1460s (?).
Tempera on panel,
41 x 37.5 cm.
Present location unknown.

Figure 14.
Jacopo Bellini.
*Chariot Bearing Nude Male
Prisoner*.
Paris Book, fol. 56

35

34 Meiss, 1957, 84, n. 3.

Thanks in part to the alliance between the two republics, many Tuscan masters found themselves in the Veneto during the century's first four decades. Even the awesome Brunelleschi journeyed briefly to nearby Ferrara and Rimini in 1438, probably to design fortifications and canals; Bellini too may have worked in those areas. A powerful young Florentine painter, Fra Filippo Lippi, his art of the 1430s nearest to Masaccio's in monumentality, was active in Padua: in 1434 he frescoed there the chapel of the Venetian governor (or Podestà) and worked at the Santo, the Franciscan sanctuary of Saint Anthony.

The best paintings ascribed to Bellini show his vibrant sense of color, as suits their Venetian heritage, found even in the earliest of these, the Brescia *Annunciation* of about 1430 (Fig. 19). The dazzling, gold-embossed textiles worn by the angel and the Virgin and the star-studded ceiling powerfully illuminate the main scene. The predella panels, possibly added to the work in Vicenza in 1441, also have strong chromatic qualities—notably the *Visitation* before an intensely blue sky, possibly meant to be read as a nocturne (Fig. 22).

The *Crucifixion* (Verona, Museo del Castelvecchio; Fig. 46), probably from the later 1430s or early '40s, also takes place against an almost monochromatic, deep blue sky, but here the "almost" makes the difference: the color has a vibrancy that pushes the body and the cross into the third dimension, into a tragic isolation endowed with a novel element of Tuscan rigor, of absolute and eternal sacrifice.

It is sometimes thought that the same Bishop Memmo who commissioned the lost *Crucifixion* fresco also ordered this *Crucifixion* on canvas, but this seems unlikely: the patron who wanted that ornate and historiated rendering of the death of Christ would not have cared for this austere, realistic image, light-years away from the ductile gentility of the votive scene in his chapel in Verona Cathedral.

The body of Christ projects an unusually intense physicality, reminiscent of the sculptured crucifixes and cruciform panels of earlier centuries. There is a hint of the new modeling of Masaccio's generation but little sense of the subsequent muscularity of Castagno or Donatello. The vital, "life-size" corporeality of the image (also in the Metropolitan Museum's *Madonna*; Fig. 35) is in keeping with the documented drive in contemporary devotion that stressed Christ's exact mortal measure as central to the humanity of his divine sacrifice.

Bellini balances the physical with the metaphysical in his great Verona canvas by the mystical illumination that comes from the left through the darkness: this light "is above the order of the physical universe, that illumines a day not followed by night, and that reacheth from one end [of the world] to the other . . . a sun which shines from the North and thereby proclaims that it can never go down" (Book of Wisdom, VII, 30; VIII, 1). The artist's votive presence—his name inscribed on the tablet at the foot of the cross—dedicates the image to the realm of sacred illusion.

Of the works on canvas surviving from the Veneto, the *Crucifixion* is the earliest that approaches the renaissance style. Also on a textile support is D'Alemagna and Vivarini's *Sacra Conversazione* of 1446 for the Scuola della Carità (Venice, Accademia); like Jacopo's picture, theirs may also show a hint of Donatello's art. Painting on finely woven canvas helped to change the face of European art. Long a substitute for costlier panel supports, and used for banners and lightweight processional images, strong fabric was taken on for altarpieces in the fourteenth century, when the technique came to Italy from the North. Canvas permitted faster preparation and execution, far less cumbersome and time-consuming than painting on panels, and it also freed the artist from the "slow haste" that fresco technique demanded, with its creative tension between careful planning and the speedy painting of small sections before the plaster dried. With Jacopo's use of the flexible support, first recorded in 1421 (Appendix E, Doc. July 19, 1421), his vast *Crucifixion* canvas comes close to initiating a new school of Venetian painting. Far from Byzantine convention or the decorum of the International Style, this stirring image of the human condition revealed by divine light is perhaps the first to show and to share the *genius loci* of the Serenissima's renaissance.

✤　✤　✤

In 1441 Jacopo won out over Pisanello in a portrait contest held in Ferrara, his victory celebrated in two poems by Ulisse degli Aleotti (Appendix E, Doc. 1441, Ferrara). Praising Bellini as the equal of great sculptors and painters of classical antiquity, the poet intimates that Jacopo worked in both media. He lauds the artist for his speed and virtuosity, describing him as a great portraitist and comparing his triumph to those of great painters and sculptors in classical antiquity. Similar comparisons were made by Petrarch for Simone Martini and by Jacopo's probable patron Marcello, writing of Michelino da Besozzo.[34] All three could have been active as designers and polychromers of sculpture, as Michelino certainly was.

Figure 18.
Jacopo Bellini.
The *Annunciation* Altar.
Early 1430s–1440s.
Brescia, San Alessandro

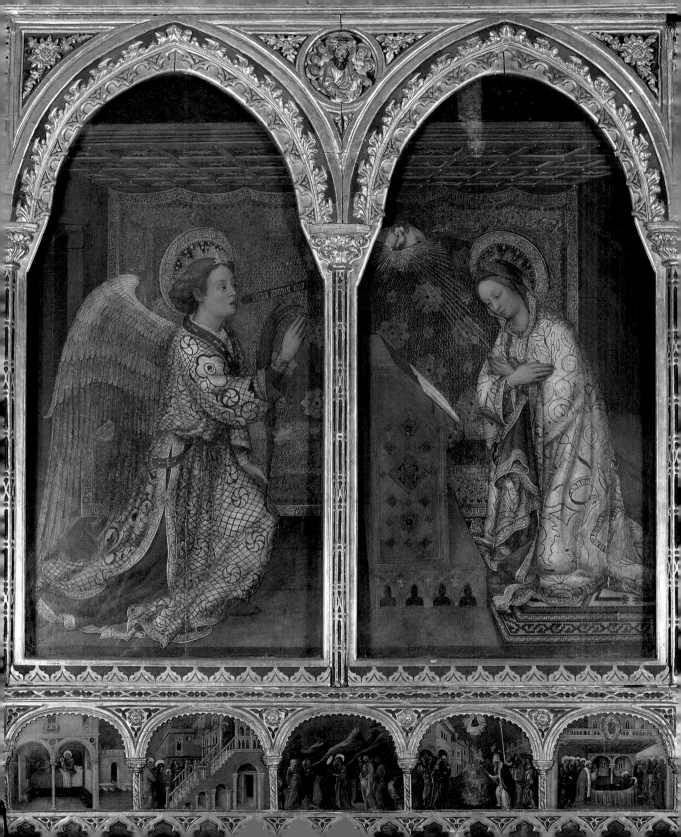

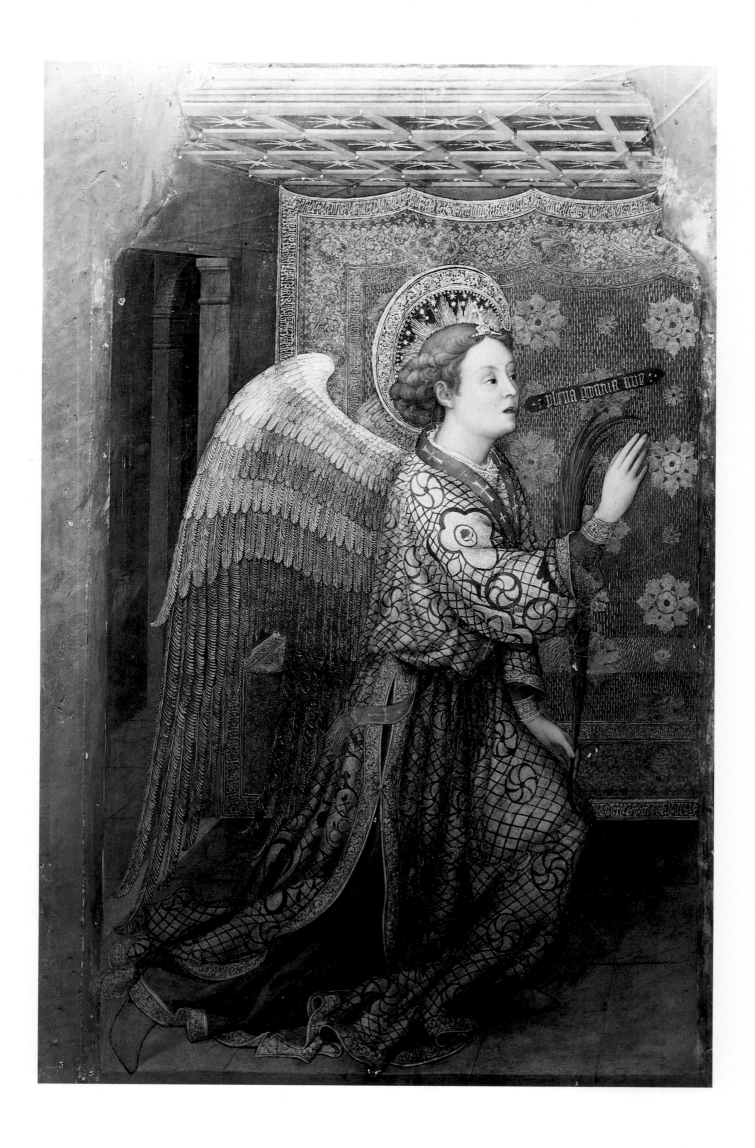

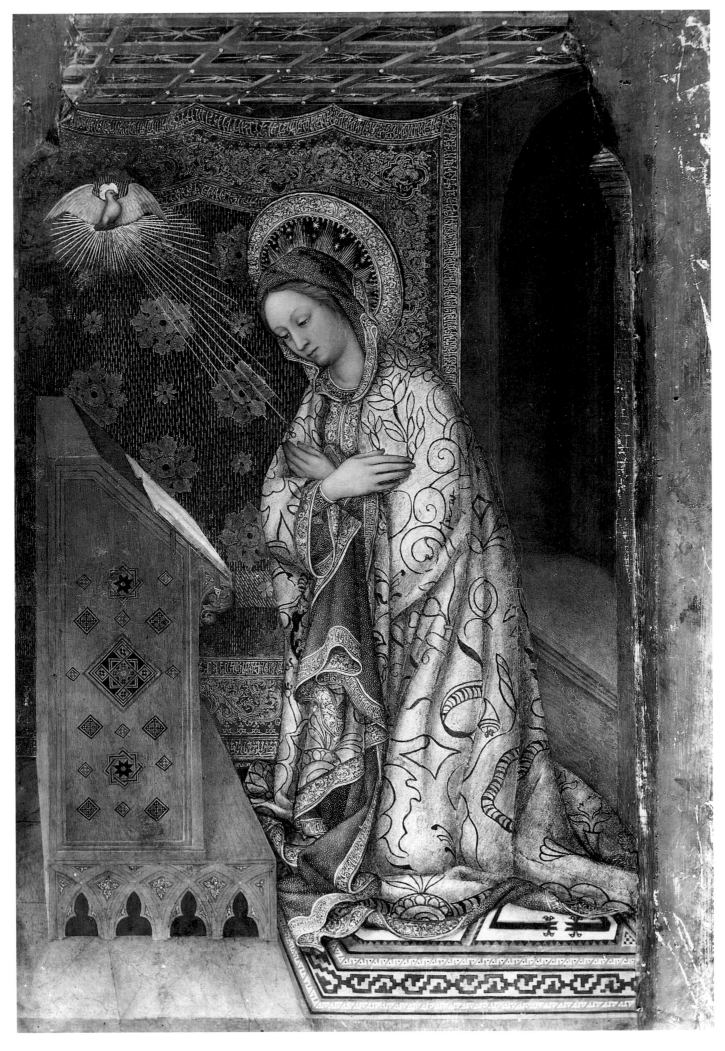

Figure 19.
Jacopo Bellini. *Annunciation*, central panel. Early 1430s.
Tempera on panel, each 219 x 98 cm.
Brescia, San Alessandro

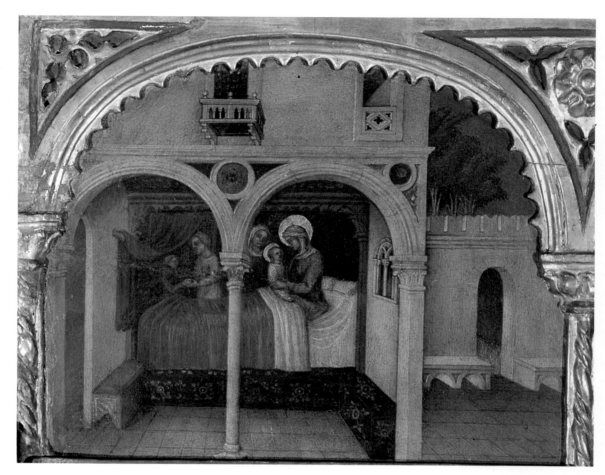

Figure 20.
Jacopo Bellini (studio).
*Birth of the Virgin*,
predella of *Annunciation*
Altar (Fig. 18).
Early 1440s.
Tempera on panel,
about 35 x 40 cm.
Brescia, San Alessandro

Figure 21.
Jacopo Bellini (studio).
*Presentation of the Virgin
at the Temple*,
predella of *Annunciation*
Altar (Fig. 18).
Early 1440s.
Tempera on panel,
about 35 x 40 cm.
Brescia, San Alessandro

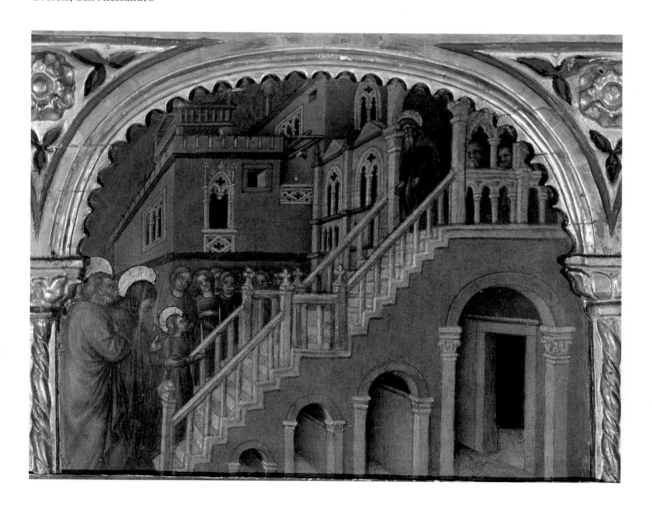

*Opposite, above left:*
Figure 22.
Jacopo Bellini (studio).
*Visitation*, predella of
*Annunciation* Altar
(Fig. 18). Early 1440s.
Tempera on panel,
about 35 x 40 cm.
Brescia, San Alessandro

*Opposite, above right:*
Figure 23.
Jacopo Bellini (studio).
*Miraculous Snowfall at
the Founding of Santa Maria Maggiore*,
predella of *Annunciation*
Altar (Fig. 18). Early 1440s.
Tempera on panel,
about 35 x 40 cm.
Brescia, San Alessandro

*Opposite, below left:*
Figure 24.
Jacopo Bellini (studio).
*Death of the Virgin*,
predella of *Annunciation*
Altar (Fig. 18). Early 1440s.
Tempera on panel,
about 35 x 40 cm.
Brescia, San Alessandro

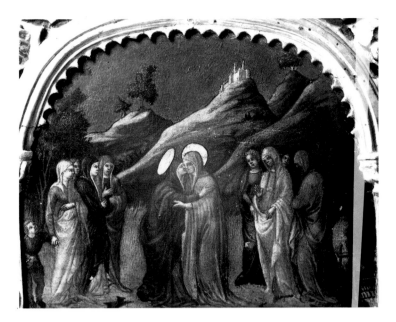 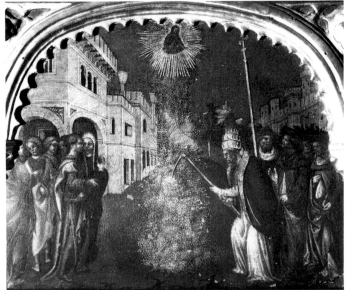

Both Pisanello and Bellini competed for the likeness of Niccolò III's son and heir, Lionello d'Este, their work judged by the sitter's father. Bellini's portrait is lost, but his *Madonna of Humility* may include an earlier image of the future marquis (Fig. 9); Jacopo's victory in the early 1440s shows that he was already highly regarded among portrait painters, and he imparted that skill to both sons. Later in the 1440s, he was working, probably with several assistants, on such routine commissions as the altarpiece of standing saints (Poughkeepsie, Vassar College Art Gallery; Fig. 61); while conventional in composition, these may have had some effect on Mantegna's youthful works. One of the scientist-scholars from the University of Padua, Giovanni della Fontana (1395–1455), dedicated to Jacopo his text on aerial perspective (probably written before 1444), describing him as "the famous painter of Venice."

Jacopo was the outstanding master in the Veneto of *trompe l'oeil*, or striking illusionism. Though soon overtaken in this area by two young geniuses, pupils of Squarcione's—Niccolò Pizzolo and Andrea Mantegna—Jacopo was clearly the Republic's most accomplished pioneer in perspective. This is evident in his drawing Books, certainly begun by this decade, and in the fact that Jean Fouquet, greatest Northern master of perspective at mid-century, drew his command of the method from Bellini's art, studied on his Italian journey in the 1440s. The contract of 1443 (Appendix E, Doc. 1443) between Bellini and his nephew—the painter and illuminator Leonardo—suggests that the nephew's activity had special importance for the artist's studio toward 1450 (Appendix F, Ills. 1, 2).

*Below center:*
Figure 25.
Jean Fouquet.
*Visitation*, miniature in
*Hours of Etienne Chevalier.*
1452–56.
Tempera on vellum, 16 x 12 cm.
Chantilly, Musée Condé

*Below right:*
Figure 26.
Jean Fouquet.
*Marriage of the Virgin,*
miniature in *Hours
of Etienne Chevalier.*
1452–56.
Tempera on vellum, 16 x 12 cm.
Chantilly, Musée Condé

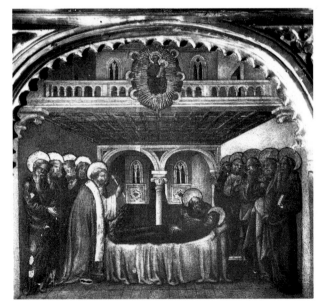  

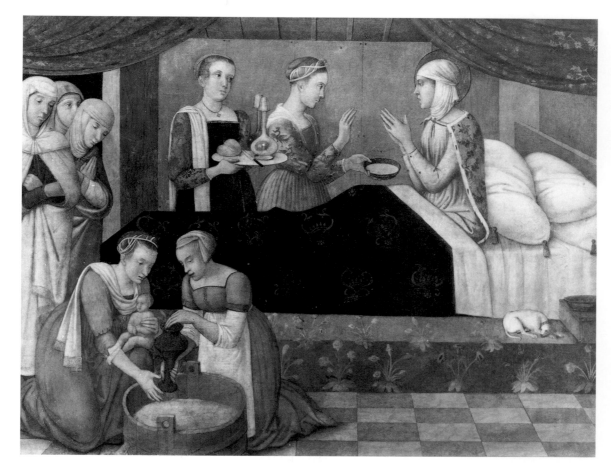

Figure 27.
Jacopo Bellini (studio).
*Birth of the Virgin*.
Before 1465(?).
Tempera on canvas,
112 x 152 cm.
Turin, Galleria Sabauda

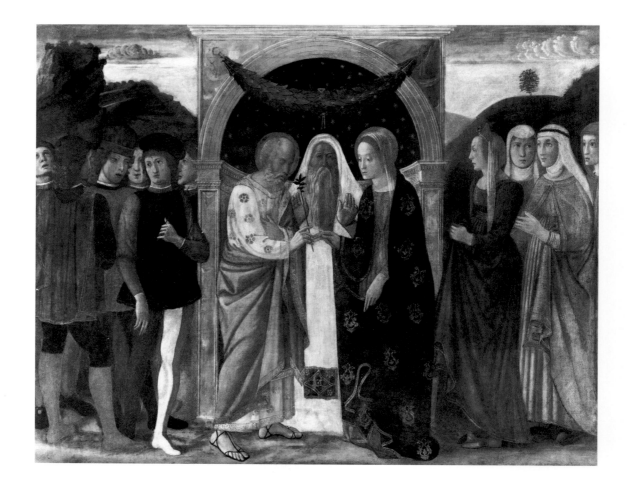

Figure 28.
Jacopo Bellini (studio).
*Marriage of the Virgin*.
Before 1465(?).
Tempera on canvas,
111 x 151 cm.
Prado, Madrid

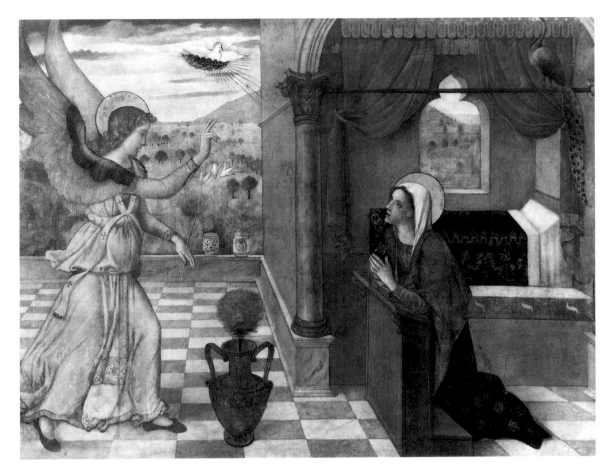

Figure 29.
Jacopo Bellini (studio).
*Annunciation*.
Before 1465(?).
Tempera on canvas,
112 x 152 cm.
Turin, Galleria Sabauda

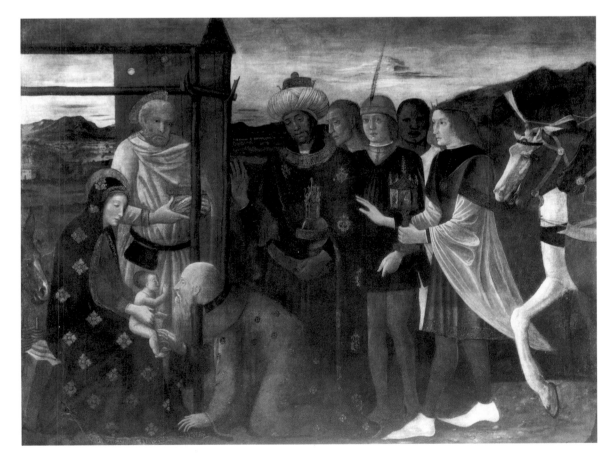

Figure 30.
Jacopo Bellini (studio).
*Adoration of the Magi*.
Before 1465(?).
Tempera on canvas,
111 x 151 cm.
Prado, Madrid

35 H. Schrade, *Ikonographie der christlichen Kunst*, I, Berlin: 1932, 254.

36 For the basin, see D. Robin, "Unknown Greek Poems of Francesco Filelfo," *Renaissance Quarterly*, 37, 1984, 17–207, nn. 14, 1175.

Padua rather than Venice may have directed Bellini toward new sources in antiquity and in Florentine art. With his important commissions there since at least 1430, and his friendship with one of the university's best-known graduates, the scientist and perspectivist Giovanni della Fontana, Jacopo was surely well aware of the center's interests in the world of science and humanism.

The presence in Padua of Palla Strozzi (Florentine supervisor of Ghiberti's first Doors and patron of Gentile da Fabriano's major surviving altarpiece; Fig. 67) may explain the remarkable commissions given by the Santo and other Paduan centers in the 1430s and '40s to leading young Florentine painters such as Fra Filippo Lippi and Uccello. Jacopo's mastery of Florentine classicism at mid-century came from this Tuscan presence in the Veneto. But of first importance was that of the most passionate, profoundly expressive sculptor of the early renaissance—Donatello. With his decade-long residence in Padua (1443–1453) the focal point of artistic activity moved from Florence to the Veneto. Donatello was as great a pictorial artist as he was a sculptor: his often very shallow reliefs in marble, turbulent bronze, or polychromed terra cotta were among the most important pictures of their time.

Donatello established himself in Padua to work for the heirs of the *condottiere* Erasmo da Narni, "Il Gattamelata," on his massive equestrian statue (Fig. 69) for the graveyard of the Santo, and on the elaborate high altar and bronze crucifix within. The basic renaissance message was Donatello's, not only because he was always among the first and the best, but because he never lost touch with the familiar force of Italy's medieval heritage. His reliefs shared the architecture of the sculptor's closest friend, Brunelleschi, and contributed to the paintings by Masaccio, the two artists' junior associate. Casts, copies, and drawings after the founding fathers' works could have come to the Veneto by the 1420s. When Donatello settled in Padua with his studio, the renaissance moved with him.

Bellini's most deeply expressive *Madonnas* (Figs. 39, 42), those farthest from the *geisha*-like Virgins of the International Style (Fig. 43), bear the stamp of Donatello's tragic art; others (Fig. 41) return to the sculptor's decorative manner of the 1430s. Mantegna's early assimilation of Donatello's art could have helped the young artist achieve his own, more monumental manner. Bellini's compositions have also been traced to other Tuscan sculptural sources, the *Resurrection* (Plate 225) to a relief of the 1440s by Luca della Robbia.[35]

Many of Jacopo's designs come close to the comfortably decorative style evolved in Florence toward mid-century, along the harmonious lines of the images the Medici ordered from artists such as Fra Angelico, Fra Filippo Lippi, Domenico Veneziano, and Benozzo Gozzoli. Retrospective and aristocratic, their manner harks back to the richly detailed narrative tradition of the later Middle Ages, tactfully updated by a Ghibertian and Donatellesque language of elegant, often classically inspired ornament.

In the 1440s and '50s Jacopo probably acquired the patronage of Jacopo Marcello. Vastly wealthy, Marcello was an aristocrat, humanist, elected supervisor (*provveditore*) of *condottieri*, senator, ducal councillor, and elector, and head of Venice's Council of the Ten. The date of his birth—about 1399—is close to Bellini's, his death about six years before the painter's. His specialty was military matters, so prominent in both of Bellini's Books. The strong interaction between antiquity and warfare in Bellini's drawings parallels Marcello's life, battle companion to Gattamelata and then advisor to his widow. She ordered Jacopo and his sons to paint the altarpiece for the family's funerary chapel at the Paduan Santo (Fig. 47).

Marcello's wife was a Paduan noblewoman. His favorite residence at Monsélice was near her native city, site of so many of Jacopo's major commissions. Bellini's remarkable paired pages of classical antiquities (Plates 84, 86) include a drawing at the far right after an ancient relief inscribed with the name Marcello; several other ancient monuments that Jacopo drew from or copied were on or near that nobleman's idyllic country villa, built onto the hilltop fortress of the Carrara. Manuscripts sent by Marcello to René d'Anjou in the 1450s (Appendix F, Ills. 1, 2) are also close to the style of the Paris Book.

Alberti, an amateur sculptor as well as painter, may have been another vital source of information for Bellini's classical relief-like narrative compositions. The humanist's associate, the sculptor Agostino di Duccio, who came to Venice in 1446, possibly also purveyed the newly ancient approach. Agostino had just been working with Michelozzo, himself a former partner of Donatello and a frequent traveler to the Veneto. The presence of these classicizing Tuscan sculptors in the Serenissima and her environs in the 1430s and '40s must have buttressed Bellini's most daring modernity in the years when he was probably enjoying Marcello's patronage. A study for a silver basin (Plate 87) may resemble one Marcello gave to Filelfo in thanks for consoling Latin verses at his young son's death.[36] Another of Bellini's drawings of a footed dish (Plate 85) is close to vessels held by figures in funerary monuments, and by Bacchus (Plate 77).

Figure 31.

Jacopo Bellini.

*Madonna of Humility with Donor* (Lionello d'Este?).

About 1430.

Tempera on panel,

60.2 x 40.1 cm.

Paris, Louvre

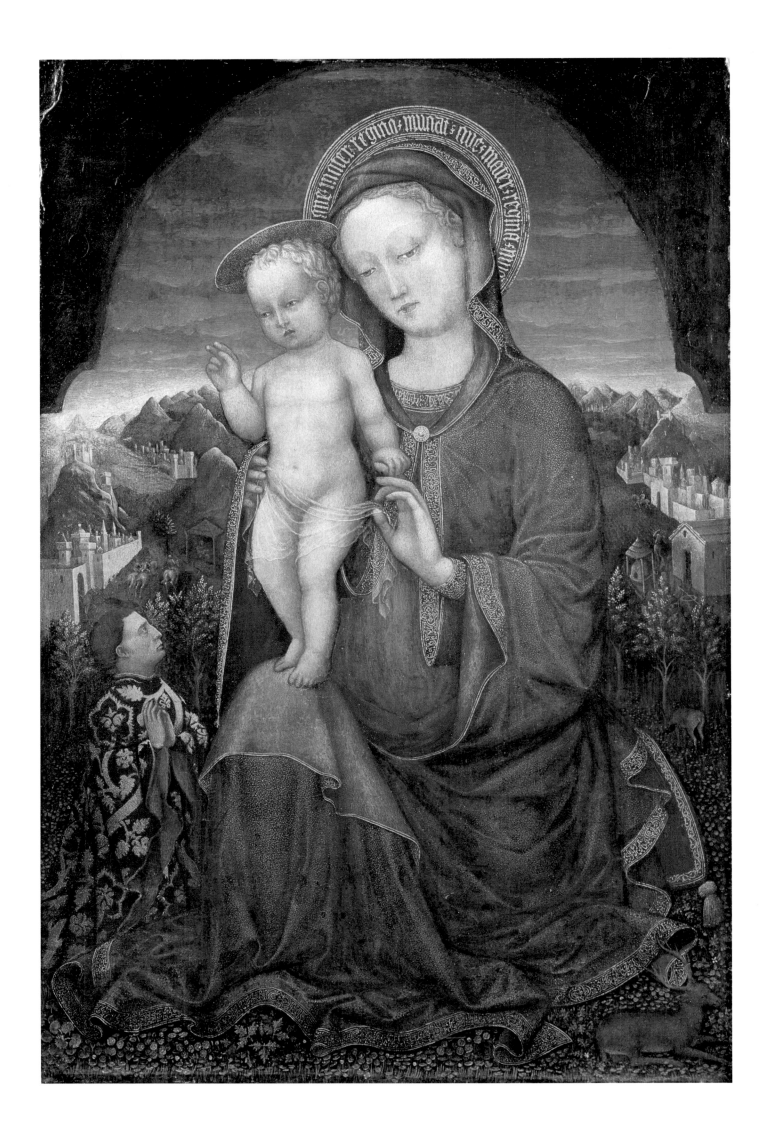

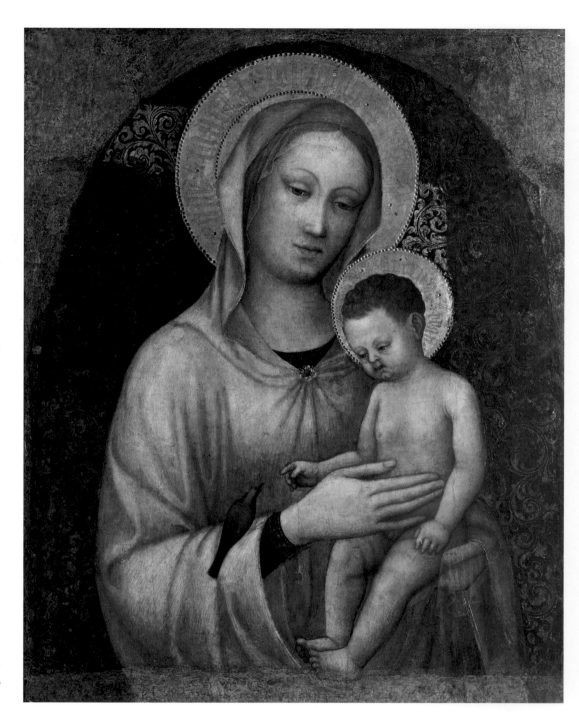

Figure 32.
Jacopo Bellini.
*Madonna and Child.*
Late 1420s–early 1430s.
Tempera on panel, 63 x 53 cm.
Bergamo, Accademia Carrara,
Lochis Bequest

Posed as a living statue, the *Saint John the Baptist* (Plate 283) stands in a niche with three impossibly shallow narrative reliefs below it (like that on the professor's tomb; Plate 134) that show the artist's fascination with the sculptor's calling, here rivaled on paper. His concern for the power of statuary is also seen in his narrative pages, an almost obsessive interest soon to be shared by Mantegna. Both painters often showed sculptors at work, Jacopo in his *Way to Calvary* (Plate 140) and in a city square (Plate 50). Like Pisanello, Ghiberti, and Squarcione, Jacopo and his son-in-law owned collections of antiquities. Sculpture has always enjoyed a special magic, an objective reality, the authority of the idol—qualities that painting, for all its more complex illusionism, quite literally cannot touch.

A year or two before Donatello arrived, Andrea del Castagno, the most powerful young painter active in Florence, came to the Veneto. With Castagno the strong Venetian heritage seemed to be restored, intensified by new Tuscan rigor and virility. For Castagno's art, much of it of Domenico Veneziano's making, used the glowing colors of the Serenissima, now strengthened by a Florentine armature and carapace. Castagno's forms, far more violent and evolved than Uccello's, inspired those of Mantegna. How long Castagno resided in Venice and how often he came there are not known, but his fresco in San Zaccaria (apse, Chapel of San Tarasio), painted with Francesco da Faenza, is dated 1442. It could have been then that he composed the *Death of the Virgin* for the Mascoli Chapel in San Marco (Fig. 54).

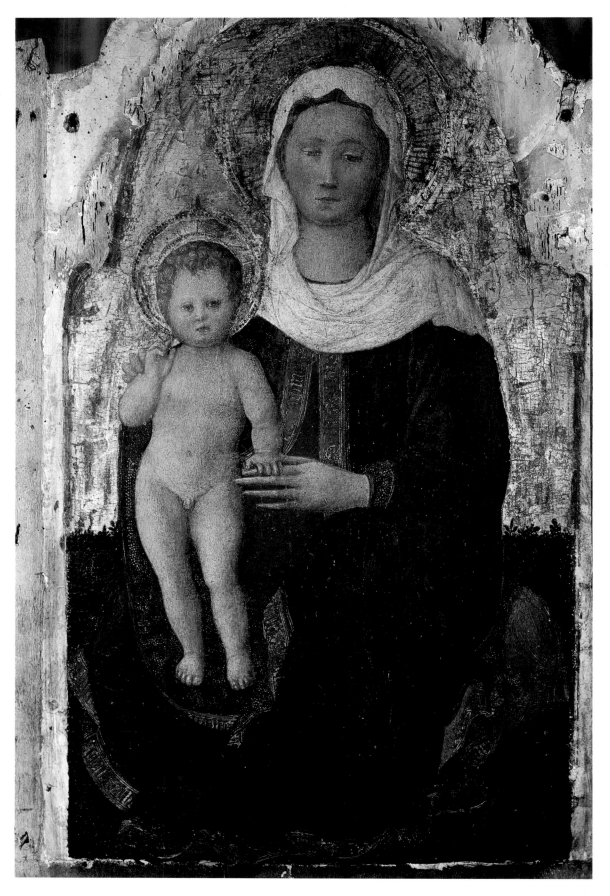

Figure 33.
Jacopo Bellini (studio).
*Madonna of Humility.*
1430s.
Tempera on panel, 70 x 36 cm.
Milan, Museo Poldi Pezzoli

Excitement was generated in Padua in the later 1440s by the young Niccolò Pizzolo's macho art, along with that of his partner, the prodigious Andrea Mantegna, the team well named the "desperadoes of Padua" by Roberto Longhi. Together with Bono da Ferrara and Ansuino da Forlì, they worked on the great fresco cycle in the Ovetari Chapel of the church of the Eremitani. These frescoes and Donatello's sculptural achievements at the Santo were the two primary ensembles at mid-century, of unrivaled power and authority. Painting and sculpture in Padua shared the fullest expression of the vocabulary of humanism and the victory of new space through proportion and perspective.

Figure 34.
Jacopo Bellini (studio).
*Madonna and Child.*
Early 1430s.
Tempera on panel, 61 x 47 cm.
Present location unknown
(Genoa?)

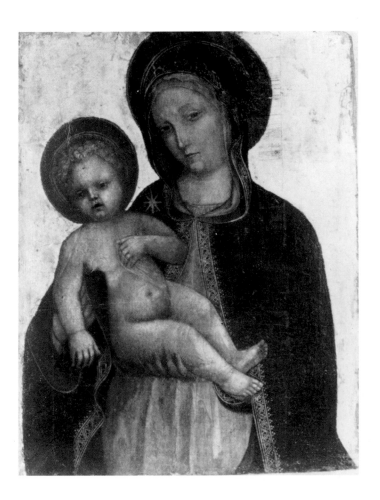

Jacopo's partnership with his half brother Giovanni, and his possible associations with Domenico Bragadin and Michele Giambono, account for some of the difficulties in isolating or defining his hand. In Venice, still rooted in the cooperative workshop tradition, individuality was far less emphasized than in Florence. This corporate aspect of Venetian artistic endeavors confuses the problems of dating Bellini's works, and of sorting them out from his sons' early works. Both sons must have stayed in his studio for a long time, and in Gentile's case this makes for an almost nonexistent *Jugendwerk*. It also compounds the complexity of analyzing the working campaigns in the drawing Books; different hands probably contributed to drawing and redrawing them, including both sons and several studio assistants.

Profoundly conservative, Venetian art and culture changed slowly. Among the works of the 1440s, the *Coronation of the Virgin* of 1444 (Venice, San Pantaleone) by Giovanni d'Alemagna and Antonio Vivarini follows an earlier panel of the same subject by the leading painter of the previous generation, Jacobello del Fiore (Venice, Accademia). But the partners' painting, though incorporating Burgundian features (such as distinctly Sluteresque God the Father), breaks radically with local tradition by bringing in a totally new pictorial element: on the lowest level of the throne are a crowd of wingless *putti* with the symbols of the Passion, first sign of the Venetian embrace of the Tuscan cult of *amorini*, that humanistic kindergarten of Donatello and Michelozzo. To crowd their prancing nude cherubs in this startlingly Teatro Fenice-like setting is like housing the heavenly host in the Serenissima's rococo opera house.

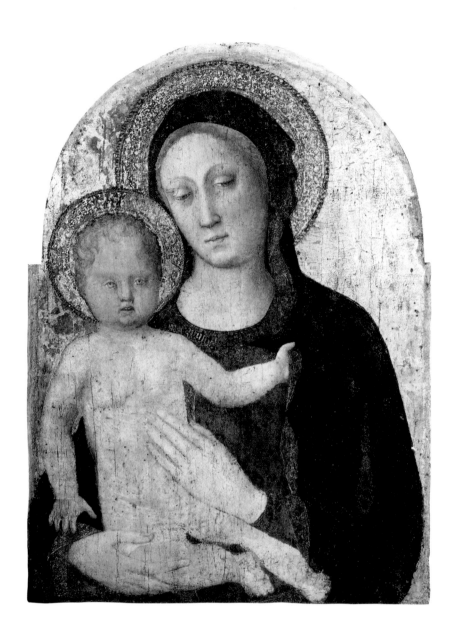

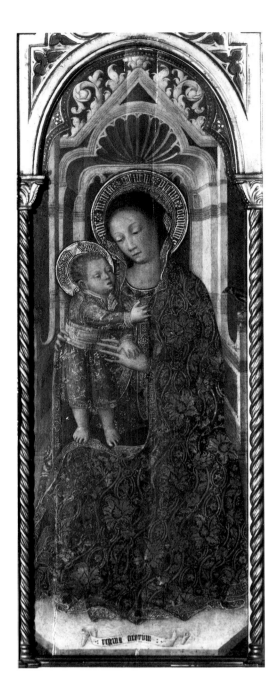

Two of Bellini's *Madonnas*, probably dating from the early 1440s, show similar contact with Tuscan currents as the altarpiece in San Pantaleone. The background of his *Virgo Lactans* is thronged with *putti* bearing Passion instruments (Fig. 39). Painted in various shades of red (the color of the child's suffering to come), this small picture has a spiritual intensity and emotional depth far beyond Gentile da Fabriano's courtly decorum and leading toward Giovanni Bellini's chromatic triumphs. Like some of Jacopo's other earlier works, it may be inspired by Northern devotional currents, in the pietistic spirit of a pictorial meditation on the Passion. The *Madonna of the Cherubim* also has a background of mourning angels symbolic of divine wisdom (Fig. 42).

In 1454 Jacopo was reappointed deacon of his scuola for the San Marco area; an earlier appointment was in 1441. The artist lived there, near his parish church of San Geminiano, Gentile's and Giovanni's parish also into the sixteenth century. Radically rebuilt in the early sixteenth century and destroyed early in the nineteenth, the church was probably embellished by Bellini's art.

Jacopo was the most famous local portraitist of his generation, its leading practitioner for about half a century. Sadly, no secular example survives in paint; only the small Lionello d'Este(?) kneeling by the Virgin in the *Madonna of Humility* (Fig. 31), and the popular Franciscan preacher Bernardino da Siena in a posthumous, still very Gentilesque image (Fig. 59), made after his beatification in 1450, provide a sense of the Venetian's grasp of character, of his strong painterly skills in that field.

*Above left:*
Figure 35.
Jacopo Bellini.
*Madonna and Child.*
Later 1430s.
Tempera on panel, 87.6 x 63.5 cm., including frame.
New York, Metropolitan Museum of Art

*Above:*
Figure 36.
Jacopo Bellini (studio).
*Enthroned Madonna and Child.*
Early 1430s.
Tempera on panel, 131 x 46 cm.
Gazzada (Varese), Fondazione Cagnola

Eager cataloguers and dealers often name unsigned but stylistically identifiable masters after whatever quality distinguishes their works; had Bellini not inscribed the *Tadini Madonna* (Fig. 38), the artist of this painting and others in Bergamo, Brescia, and the Uffizi (Figs. 32, 19, 43) might have been named "Master of the Beautiful Venetian Madonnas." These serene yet pensive Virgins, often rather large-faced, also appear in his Books—standing, like the massively calm *Mater Omnium* (Plate 138), or riding as tranquilly on the *Flight into Egypt* (Plate 180).

Longhi stressed the still Byzantine, silvery purple aspects of Bellini's coloring, yet this conservatism had advantages for the artist, allowing him a striking painterliness in conveying his love for overlapping veils and subtle transparencies. Near mid-century this elegant restraint was replaced by a brighter tincture, reminiscent of Domenico Veneziano's works and close to Alberti's concept of the "Friendship" among colors, recalling the remarkable fresh tonalities in the Mascoli Chapel's *Visitation* and *Death of the Virgin* (Figs. 53, 54).

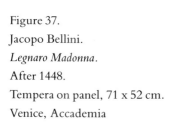

Figure 37.
Jacopo Bellini.
*Legnaro Madonna*.
After 1448.
Tempera on panel, 71 x 52 cm.
Venice, Accademia

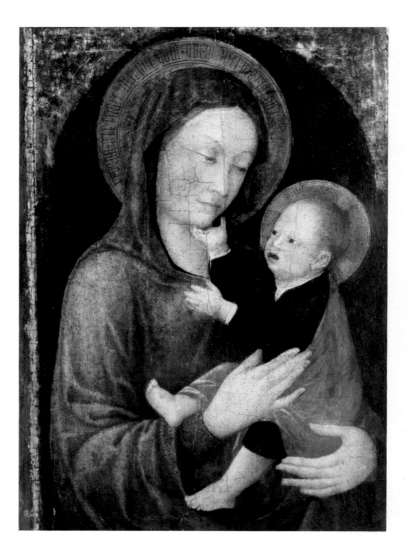

Bellini's Madonnas fuse the novel with the traditional, at once Gothic, Byzantine, and renaissance. More than any other Venetian's, the tale they tell of transition typifies the Republic's most advanced art early in the Quattrocento and personifies the Serenissima's feminine ideal at mid-century—brows plucked into perfect Dietrich arches, cupid's-bow lips painted with Hollywood's calculated precision. Their cosmetic glamour is fortified by a Byzantine sobriety, however, a rigorous sense of absolute grace shared by the Madonnas of Domenico Veneziano and the Vivarini, and by Giambono's best. More like a lady than Our Lady in their decorous resignation, some of Jacopo's exquisite Madonnas—as in Bergamo or Florence (Figs. 32, 43)—may lack the *terribilità* of Mantegna's or Castagno's genius, but their Edwardian blandness often comes from intervening restorers such as the Raphaelesque Cavenaghi. At their loveliest—as in the radiantly colored Uffizi *Madonna*—these images presage the finest achievements of Piero della Francesca and Mantegna, and by Jacopo's sons. Memory of these Virgins echoes in the art of northern Europe and of lesser masters of the Veneto. Jean Fouquet, in his *Virgo Lactans* (Antwerp, Museum of Fine Arts), recalls the full splendor of the Venetian Madonna, immutable yet strongly sexual.

Figure 38.
Jacopo Bellini.
*Madonna and Child.*
Late 1440s.
Tempera on panel, 98 x 58 cm.
Lovere, Galleria dell'Accademia
di Belle Arti Tadini

Jacopo never lost touch with his master's art. Technical refinements in both the signed *Tadini Madonna* (Fig. 38) and the *San Bernardino da Siena* (Fig. 59), though painted near mid-century, are still close to Gentile da Fabriano's. The composition of Bellini's *Madonna* goes back to the Marchigian's panel (New Haven, Yale University Art Gallery, Jarves Collection), but the lapidary classicism of her drapery reflects Donatello's presence in Padua, as does the toddler's rigid pose as Salvator Mundi: these figures may well have influenced Mantegna's art.

37 Fiocco (1926), Muraro (1961), Hartt (1966), Merkel (1973). For a fine survey of the Mascoli Chapel's history, see Wohl, 1980, 174. He follows Fiocco and Merkel in finding that Jacopo drew all the most advanced architectural settings c. 1451. Bellini's name was first linked with these by Thode (1898, 307 ff.), who ascribed to him the background of the *Visitation*'s architecture, but Fruet (1975) found it entirely in keeping with the artist's skills. Fiocco (1926) and Merkel (1973) saw Bellini, possibly with Mantegna's aid, having a considerable hand in completing the *Death of the Virgin* design. Muraro's (1961) proposed dating for the mosaics, following an interpretation of documents and events, was largely refuted by Hartt (1966).

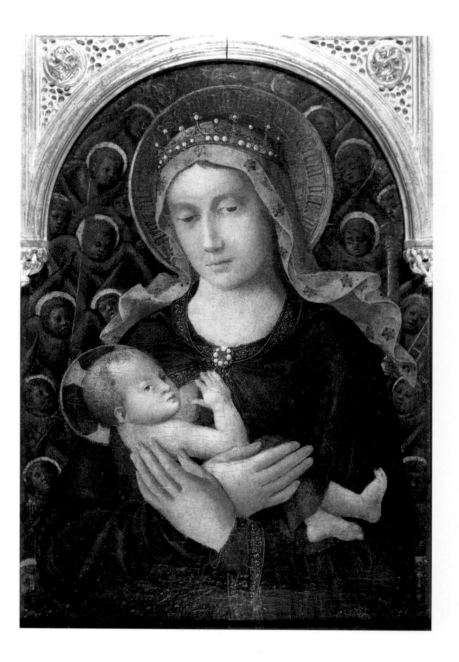

Figure 39.
Jacopo Bellini.
*Virgo Lactans*.
Early or mid-1440s.
Tempera on panel,
69.8 x 49.5 cm.
Present location unknown

Focal point for the Venetian early renaissance is the barrel-vaulted Mascoli Chapel, built about 1430 in San Marco, probably at Doge Foscari's behest as an ex-voto for his escape from an assassination attempt.[37] Undistinguished as a patron of the visual arts, Foscari turned to Giambono to design the major mosaics of the Life of the Virgin on the chapel vault. The artist's name is on a *cartellino* between the two most old-fashioned mosaics, the *Birth of the Virgin* and her *Presentation*, probably begun in the early 1430s.

Castagno's presence in Venice in the early 1440s has long been linked, rightly, with the powerfully illusionistic architectural setting and emotional force in the *Death of the Virgin* mosaic (Fig. 54), and sometimes with the equally advanced architectural background of the *Visitation* (Fig. 53). The two were evidently made in different campaigns, their Tuscan sophistication combined with Venetian conservatism. But apart from the clearly Castagnesque Virgin, the apostles at the left, and the marbled panel behind them, much of the *Death of the Virgin* indicates that other hands completed it. The apostles at the right are often given to Giambono or Bellini; Christ bearing the Virgin's soul to heaven is close to

Mantegna's painting of that subject (Madrid, Prado; Ferrara, Pinacoteca Nazionale). Enframing this composition is the triumphal arch that Jacopo often used; perhaps he worked with Giambono in completing the *Death of the Virgin*, possibly assisted by young Andrea Mantegna. A similar collaboration is suggested in the *Visitation*, the setting sometimes given to Domenico Veneziano but the figures, less evolved in style, to Giambono's circle.

Much has been made of a *graffito* or rough sketch of a seated infant (Fig. 11) drawn on the wall of the chapel behind the *Visitation*, along with the inscription "Maistro Jacopo de la Capela de San Marco" and the date 1451 written nearby. Fiocco and Merkel saw in this an indication that Bellini took over the project from Giambono in that year.[38] The style of the drawing is somewhat like that in Jacopo's classical pages of the *Vintage* and *Putti with Deer* (Plates 73, 74).

In the mid-1450s Jacopo must have been among the best-established painters in the Veneto, with Giambono nearing the end of his career and Antonio Vivarini's talent flickering after his partner's death. Ties between Florence and Venice were slowly loosening as the allies' campaigns failed against Milan. The Serenissima's ensuing loss of lands once extending halfway across the northern Italian peninsula may have lowered her hospitality to imported artists, and by 1453 Donatello had moved back to Florence, his great Paduan commissions completed.

38 Fiocco (1926), Merkel (1973). Others have related the inscription to Jacobello della Chiesa, the mosaic designer whose death in 1425 led to Uccello's being invited that year to complete the mosaics for San Marco's façade.

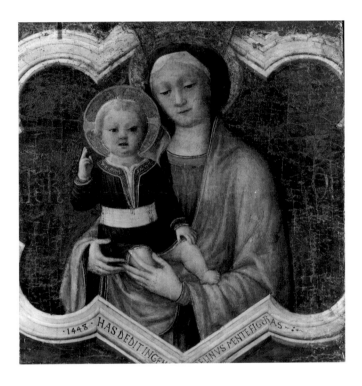

Figure 40.
Jacopo Bellini.
*Madonna of 1448.*
1448.
Tempera on linen glued to panel,
50 x 45 cm.
Milan, Brera

In 1452 Jacopo and his wife's relative Niccolò Inversi brought legal proceedings against an unknown party (Appendix E, Doc. Feb. 14, 1452). He was commissioned that year by the Scuola Grande della Carità, one of the Republic's most prominent scuole, to paint a banner of unusual splendor and size, using the finest materials, ultramarine and gold, and measuring seven braccia; for this he received the very substantial sum of 140 ducats (Appendix E, Doc. June 19, 1452), exclusive of the material costs. Bellini was forbidden to leave the city until the banner was completed; he would receive a bonus if he finished it by March 1453, or reduced payment if it was late. Jacopo was to execute the entire work, but the scuola added the realistic proviso that this applied especially to the rendering of hands and faces. Strangely, the very long contract does not specify the banner's subject, an omission suggesting that the image must have been of the Virgin to whom the scuola was dedicated, possibly the *Mater Omnium*, the Augustinian Mother of Us All, which he drew in the Paris Book (Plate 138).

Jacopo had the assistance by the 1450s of both his sons and his nephew Leonardo, who changed his surname from his father's, a boatman, to his uncle's. "Bellini," a plural form of the Italian word for beautiful, must have become almost synonymous in Venice with the art of painting, Jacopo, Gentile, Giovanni, and Leonardo forming a new dynasty of pictorialism comparable to the Trecento leadership of Paolo Veneziano, whose name, with those of his sons Giovanni and Luca, was on the covering of San Marco's Pala d'Oro, the Serenissima's central shrine.

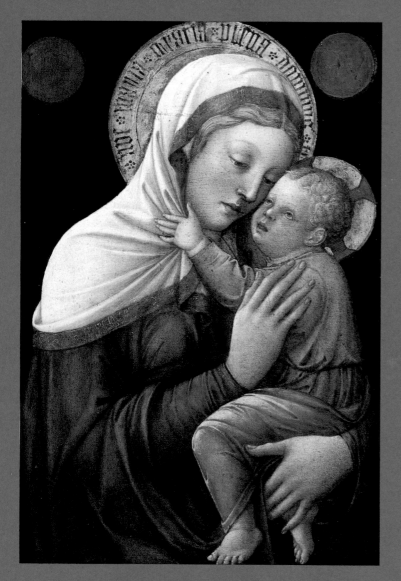

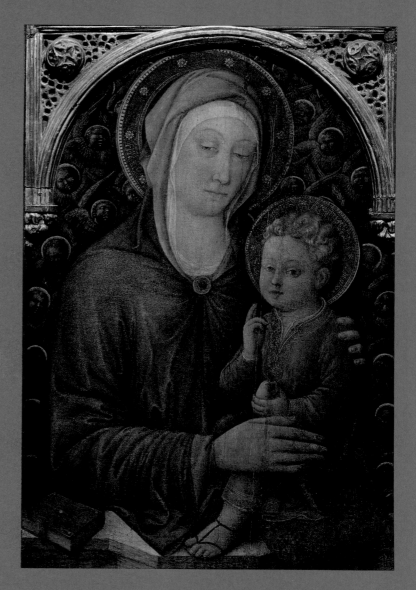

Figure 41.
Jacopo Bellini.
*Madonna and Child*.
About 1453.
Tempera on panel, 70 x 47 cm.
Los Angeles County Museum of Art

Figure 42.
Jacopo Bellini.
*Madonna of the Cherubim*.
About 1450.
Tempera on panel, 94 x 66 cm.
Venice, Accademia

*Opposite:*
Figure 43.
Jacopo Bellini.
*Madonna and Child*.
About 1450.
Tempera on panel, 69 x 49 cm.
Florence, Uffizi

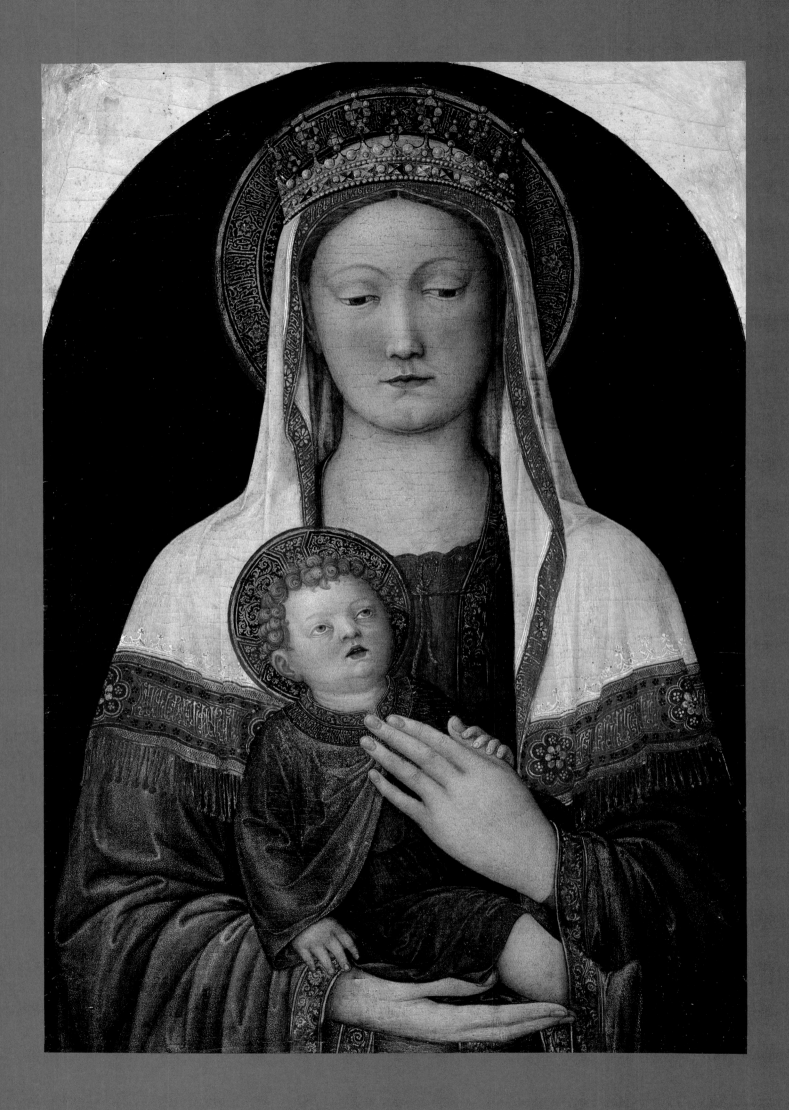

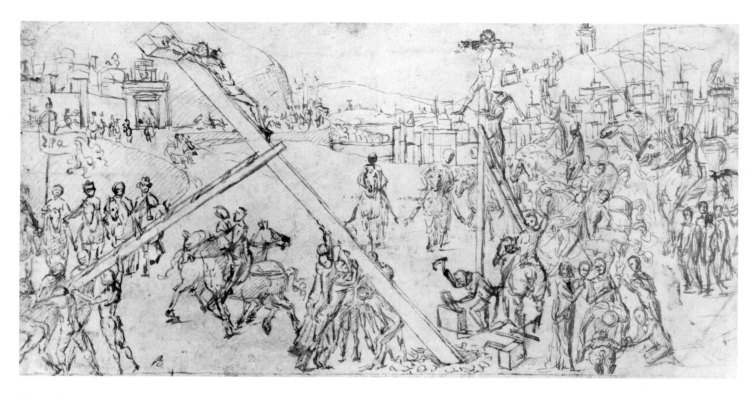

Figure 44.
Follower of Jacopo Bellini. *Raising of the Cross.*
Pen and ink on paper. Oxford, Christ Church

39 Lightbown, 1986, 32.
40 Vasari–Milanesi, V, 274.
41 Meiss, 1957, 25.
42 Knabenshue, 1959, 72 f.

Bellini may have met Mantegna as early as 1447, if not shortly before. Mantegna was then living in a rented Venetian house with his master and adoptive father Squarcione, and that year he brought his first suit against Squarcione for his share of the payment for certain projects; he lost, possibly because he was still a minor.[39] One of the two arbitrators was Ulisse degli Aleotti, a poet who praised Bellini in 1441, and in 1452 the leader of the Scuola Grande della Carità, which commissioned Bellini to paint its banner.

Vasari wrote derisively of Bellini's scheming to get Mantegna to marry his daughter Niccolosia, eager to add the young artist's luster to his family of painters. Mantegna, whose intellect was as powerful as his art, could scarcely have been hoodwinked into marrying any woman in whom he did not see a tribute to his talents or an auspicious future. In 1453 Jacopo's scuola gave him a subvention of 20 gold ducats toward his daughter's dowry (Appendix E, Doc. 1453); her marriage to the prodigious Mantegna is the most important datable indication of Jacopo's artistic preeminence at mid-century.

Kristeller believed Bellini was a teacher of Mantegna. The miniature-like quality of the Paris Book's pages often recalls Mantegna's manner of painting frescoes and panels with a high degree of finish and detail, like that in illuminations or in Northern art. Signs point to Jacopo's having directed the production of major manuscripts in his studio, though some scholars believe that Mantegna illuminated these pages (see Appendix F, 1). Concerning Jacopo's role in the manuscript world, Vasari mistakenly noted his influence on Liberale da Verona, a leading manuscript illuminator and painter.[40] The Tietzes suggested that Jacopo may have had influence on Mantegna as early as 1441; Meiss saw Bellini's direction as taking place in the 1450s, when he "helped Mantegna move beyond the bulging, strained, over-animated style visible in . . . his first works in the Eremitani Chapel."[41]

The availability of Jacopo's drawings could, in a sense, have made Mantegna marry Niccolosia for her father's Books. Their pages offer an unrivaled graphic mastery of landscape and narrative, antique sculpture and architecture, numismatics and inscriptions, the younger master soon outstripping the elder in these skills. A Latin inscription in the Paris Book (Plate 84) appears in one of Mantegna's Eremitani church frescoes (in corrected form); both painters may, of course, have taken it from a common transcription.[42]

Two paintings of the *Agony in the Garden* by Giovanni Bellini and Andrea Mantegna (both London, National Gallery) show the awesome proximity of the brothers-in-law to one another's art in the 1460s—a unique example of creative synergy without loss of individuality, both compositions being close to Jacopo's drawing (Plate 193). Piero della

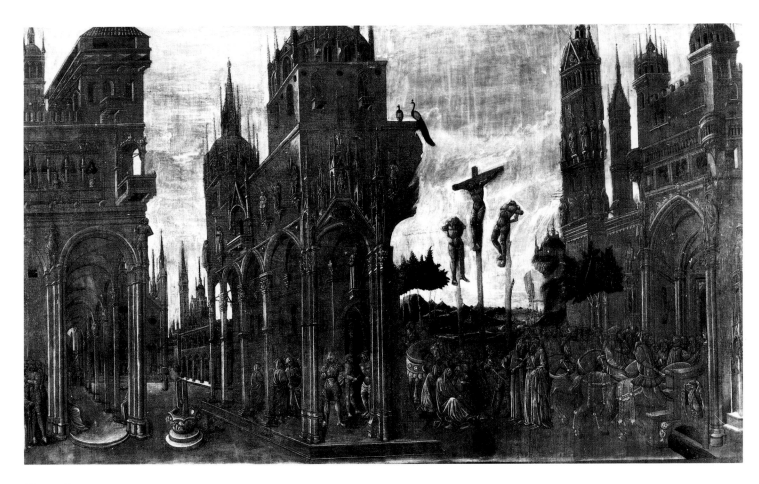

Figure 45.

North Italian. *Flagellation and Crucifixion*. Second half 15th century.

Tempera, *semi-grisaille*, on panel. Monsélice, ex-Collection Cini

Francesca may also have learned from Jacopo's approach to landscape.[43] Far more than "scenography," these sweeping explorations of valley and plain, agrarian terrain, mountain and open sky, are among art's keenest responses to nature's powers. An *Adoration of the Magi* (Florence, Uffizi) that Mantegna probably painted in the early 1460s is still close to Bellini's themes, the Magi's camelback journey recalling those in the Books. Many themes throughout Mantegna's earlier works show cognizance of his father-in-law's.[44] The prodigy's panoramic *Adoration of the Magi* is painted on an inwardly curved panel to increase the illusion of depth, a perspectival device more modestly applied in a series of altarpieces made in Jacopo's studio in the early 1460s for the Scuola della Carità (Figs. 63–66). The two artists were making similar experiments at the same time.

In 1455–56 Mantegna sued again in the Venetian courts to free himself from Squarcione, this time winning the decision; the two were soon back on good terms again.[45] At about this time the young painter may have portrayed himself at the right in the *Presentation in the Temple* (Berlin, Dahlem Museum) and Niccolosia at the left to commemorate the birth of their child.[46] Giovanni Bellini repeated his brother-in-law's composition (Venice, Galleria Querini-Stampalia), portraying himself and his brother Gentile at the right, with Jacopo's wife, Anna, standing at the left by Niccolosia.[47]

Until academies ruled supreme, all artists were teachers. They depended on apprentices to help with the work, and instructed them in exchange for services rendered. In Jacopo's case we know that the practice began at least as early as 1430, when Leonardo entered his studio, and he certainly taught both his sons. Other candidates for Jacopo's instruction or influence include Cima da Conegliano, Carpaccio, Bastiani, and Crivelli, as well as Francesco da Negroponte.

Jacopo, to judge by his drawing Books, may have designed many funerary images. Documentation points to one possible commission in 1456 when Jacopo received sixteen ducats from the city's patriarch (Venetian equivalent to a bishop) for a "figura" of his predecessor Lorenzo Giustiniani (d. Jan. 8, 1454), to be placed above his tomb in San Pietro di Castello (Appendix E, Doc. 1456–57). Scholars have speculated that "figura" might mean a drawing preparatory to sculpture, but the rigid, archaizing bust that is near Giustiniani's

43 See Klauner, 1958, 126–28. See also Oertel, 1977, 348 ff., for the same influences.

44 Lightbown, 1986, 28 f., 35, 38 ff.

45 Kristeller, 1902, doc. VIII.

46 Lightbown, 1986, 63, following W. Prinz, *Berliner Museen*, 12, 1962, 50–54.

47 See Lightbown, 1986, 405.

48 According to A. M. Schulz, 1978, 23, "The free-standing marble tomb stood at the center of a richly decorated funerary chapel erected probably also by Marino [Orsato's nephew and heir], to house the tomb. The chapel was located in the old church of the later 15th-century church of S. Andrea della Certosa." Only the personifications of the five Virtues survive. Giustiniani's effigy is in the Florentine humanist formula. The tomb was drawn by Johannes Grevembroch, *Monumenta Veneta ex Antiquis ruderibus*, Museo Correr; see A. M. Schulz, fig. 47. She noted (23) that "the greater part of the work on the tomb still remained to be done" in 1466.

Sanudo referred to the statue as above Giustiniani's sarcophagus, showing "La sua imagine di marmo in piedi," suggesting an upright, standing figure (reference courtesy of Dr. Debra Pincus, March 16, 1986). See also Labalme, 1969, 315; G. Gruyer (*L'art ferrarais à l'époque des princes d'Este*, 2 vols., Paris: 1897); Hubala, 1965, 924; and Gronau (1895, 54 ff.). Tietze and Tietze-Conrat (1944, 106) suggested that the commission was to design a sculpture, related to a page in the London Book (Pl. 137). Meyer zur Capellen (1981, 11–12) pointed out that the drawing was not in accord with the commission, which he believed to refer to the carving in San Pietro in Castello.

49 Wolters, 1976, I, cat. nos. 252, 292–94.

50 For a discussion of this motif, see also A. M. Schulz, 1978.

tomb is more in the style of Gentile Bellini (who also designed sculpture).[48] If the image is indeed original, then Jacopo's commission must have been for a portrait in pictorial form, now lost.

Sculpture is approached in a variety of ways on Jacopo's pages, as if he were seeking effective graphic equivalents to its impact. He doubtless collaborated closely with stone-carvers and metalworkers, competing in designs for monuments and assisting with vast temporary projects—catafalques and other works commemorating victory in battle or over death. His projects anticipate the bronzes, *all'antica* or realistic, that were so popular in late fifteenth-century Padua. Some renderings suggest alternative sculptural and pictorial treatments of the same figure (Plates 150, 147). Two altars were definitely drawn with sculpture in mind or its illusion (Plates 241, 240). *Twelve Apostles* (Plate 239) suggests a relief, as does a rather crude study of *Adam and Eve with God the Father* (Plate 142).

Jacopo may have had a hand in determining the broad outlines of Doge Foscari's tomb, possibly providing a portrait for sculptors to work from, unless they used a death mask.[49] His *Christ in a Mandorla* (Plate 237) could have been the source for that figure at the top of the tomb.[50] One year later, the bishop-patriarch gave Bellini twenty-one ducats for a "pala grande" on canvas with three figures—Saints Peter and Paul are stipulated, the third possibly Saint Mark—to be installed in the Salone del Patriarca of San Pietro di Castello (Appendix E, Doc. 1456–57).

Giovanni Testa Cillenio, poet at the Ferrarese court of Ercole I (r. 1471–1505), included Bellini in his poem of about 1500: after lauding the divine Piero della Francesca ("Borgo mio divino"), he mentions the "great Giovanni" and the "good Gentile" as also worthy of celestial honors, then praises their father as a great teacher (Appendix E, Doc. c. 1500). Antiquities that Jacopo owned may, as in Squarcione's Paduan academy, have been used to teach drawing, anatomy, and the wise ways of the ancients.

Signs of other local talent were scant though occasionally meteoric, such as the magnificent *Enthroned Madonna* by Francesco da Negroponte in San Francesco della Vigna from the 1460s; these proved more complementary than competitive to Jacopo's achievement. Close in content and style to Bellini's art, Francesco's altarpiece is also inspired by Mantegna's *San Zeno* Altar (Verona, San Zeno; 1457–59); he was not one of Jacopo's "graduates," but his painting shows how deeply Bellini's achievements and concerns permeated the Venetian art scene during his last decade. Possibly the little-known Francesco is identical with "Antonio Falirio pictore habitatore Negroponte," "Antonio Falirio, a painter living at Negroponte," whom Bellini sued to recover funds in 1469 (Appendix E, Doc. Mar. 3, 1469). Antonio's work follows Jacopo's three major allegiances: to the spirited romance of Gentile da Fabriano, to the harmonious humanism of the Veneto, and to the bounty of nature as delineated in Lombard and northern European sources.

Near to 1460, Jacopo, working with both sons, painted the altarpiece for the funerary chapel of Gattamelata (Erasmo da Narni) in the Santo, the Franciscan sanctuary of San Antonio, in Padua (Fig. 47). Signed by all three Bellinis, the picture was ordered by the *condottiere*'s widow, who, with her son, would also be buried there. Judging from Jacopo's proud inscription on the altarpiece as the work of himself and his sons, he probably saw his family as the parallel of Paolo Veneziano's in the Trecento. A vertical side panel from the dismantled altarpiece shows Bernardino da Siena with Saint Anthony Abbot (New York, private collection; Fig. 48). The facing saint from the missing panel at the far right may have been the Franciscan Saint Anthony of Padua, paired with Saint Francis. A *Madonna and Child* was probably at the center, composed along the lines of Gentile Bellini's, painted shortly after 1467 (London, National Gallery).

The Gattamelata Altar's three predella panels strikingly recall in their compositions and single figures those drawn on paper or parchment in Bellini's Books. They are painted not by Jacopo's hand but by Giovanni Bellini's, who follows the paternal canon and design. These horizontal compositions of the Life of Christ formed the bottom register: *Adoration of the Magi*, *Crucifixion*, and *Christ in Limbo* (Figs. 49–51).

Another horizontal panel of seven standing saints is also Giovanni's (Fig. 62), again capturing the faces and figures of those in Jacopo's Books. Expensive small-scale individual devotional altars such as this, uncommon in Tuscany, seem to have been fashionable among rich patrons in northern Italy, especially in Ferrara, the Marches, and the Veneto. It is tempting to see in this little altar a commission of Bartolommeo Colleoni, the *condottiere* whose career crested in 1458, a reasonable date for this panel. Heir to Gattamelata's military mantle, Colleoni may have wished to emulate Gattamelata's widow in her patronage of the Bellini.

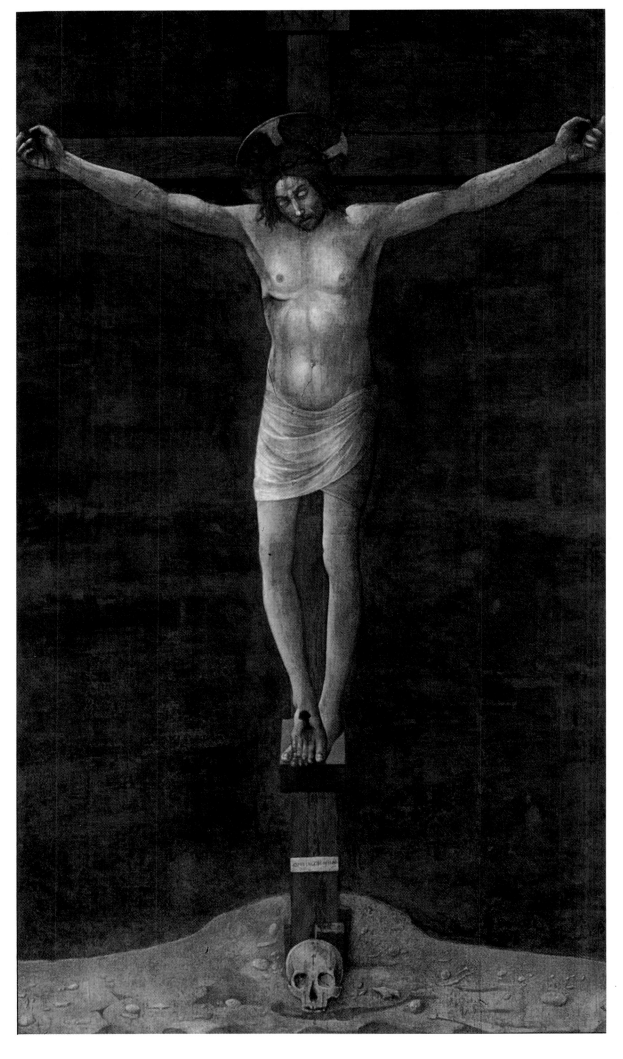

Figure 46.
Jacopo Bellini.
*Crucifixion*.
Early 1440s.
Tempera on canvas,
310 x 180 cm.
Verona, Museo del
Castelvecchio

51 Longhi ("The Giovanni Bellini Exhibition," *Burlington Magazine*, 101, 1949, 274–83) took a dim view of sorting out Giovanni Bellini's early works from his father's studio production. He and Pallucchini (1949) questioned opening the Giovanni Bellini exhibition with the Correr *Crucifixion* (Fig. 50). "The intention is, in fact, to discover there a Giovanni still in the lap of his father: this is a problem of prehistory, to which infancy belongs, and hence insoluble. If this painting . . . were executed, as the catalogue says, around 1450, how is it that by this time Giovanni had not yet 'found himself' . . ."

52 A. M. Schulz, 1983, 23, nn. 17, 34. Pope-Hennessy has written the author that he believes Giovanni Bellini to be the design source for Rizzo's *Adam and Eve*. For the reliefs, see Muraro, 1961, pl. 118, figs. 20, 22; pl. 120, fig. 30. G. Mariacher ("Profile di Antonio Rizzo," *Arte Veneta*, 1948, 67–84) noted the drawings of Jacopo as precursors of Rizzo's architecture, but cited Codussi as Rizzo's major source.

53 Paoletti, 1893, II, 143, 145. R.
(continued on following page)

Legends of undiminished artistic fertility in the mythically long lives of Giovanni Bellini and Titian could have grown from Jacopo Bellini's career. Born in the 1390s, with a signed altarpiece in 1421, his greatest flurry of commissions came in the 1460s, after some fifty years of sustained productivity. That he was still a potent pictorial force within a few years of death must be a tribute to Jacopo's confident, genial temperament and his well-organized workshop, and to the fidelity of Gentile and Giovanni, who continued to work with him from time to time after leaving his studio. [51]

A remarkably uniform series of four funerary altars (Figs. 63–66) seems to have been ordered from Jacopo's workshop between 1460 and 1464, triptychs placed above tombs in the choir of the Carità. They were in one of the Serenissima's first "modern" settings, the masonry work specified as fashionably classical in style with the frames of the triptychs, now lost, doubtless following suit.

Among the sculptors working in this new manner for whom Bellini perhaps designed in the 1460s was the Lombard Antonio Rizzo. He assisted Rizzo in architectural and ornamental projects, as would his son Gentile. Rizzo's *Eve* (Doge's Palace) and his reliefs for San Marco have been related to the Bellini style. [52] Both men could have collaborated in portraiture too, Jacopo drafting the kneeling figure of Vittorio Cappello in his funerary monument by Rizzo. [53]

Richest of the painter's sculptural renderings are his fountains, rivaled only by those in later fifteenth-century prints and by the Genoese *fin-de-siècle* sculpture sent all over Europe. Fountains abound in Bellini's biblical and urban scenes (Plates 154, 179, 51). They attest not only to his role as a visionary sculptor but to his possible activity as a hydraulic engineer, the skill shared by many renaissance artists north and south of the Alps. The Paduan scientist Giovanni della Fontana (his now-lost perspectival treatise dedicated to Jacopo) was so named for his fountain designs, though his crude plans do not touch Bellini's for complexity or beauty. Prophetic, Bellini's graphic statuary anticipates the entire Venetian achievement, from the stoical classicism of Tullio Lombardo in 1500 to Canova's cool, neo-classical madness in 1800 and back again.

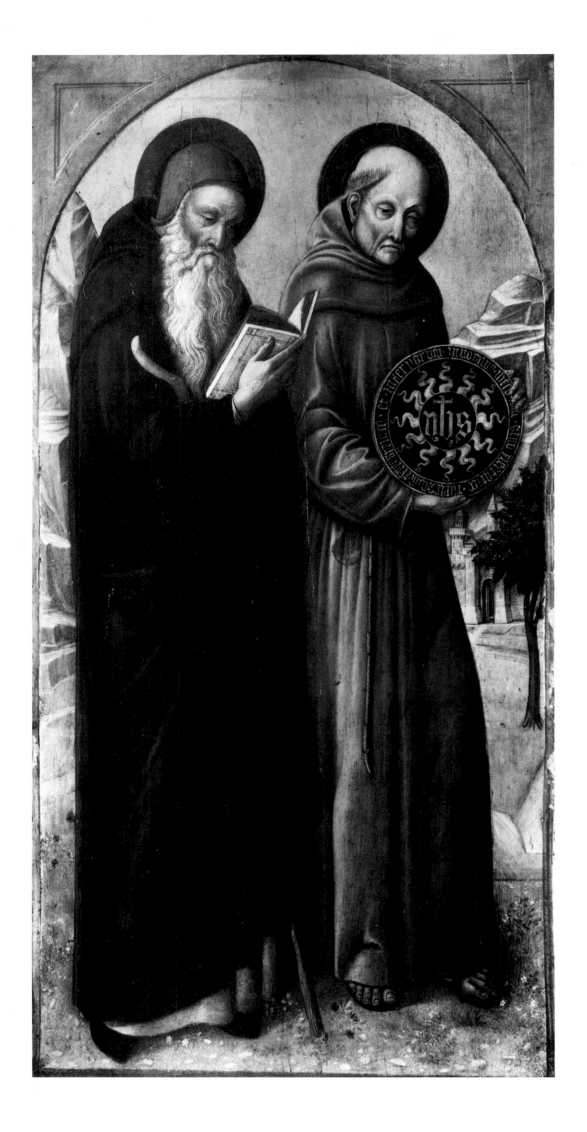

Munman, "The Monument to Vittorio Cappello of Antonio Rizzo," *Burlington Magazine*, 113, 1971, 138–44, supports Paoletti's view, but more recent scholarship has often assigned it to other masters. For a survey of these attributions, see A. M. Schulz, 1978, 46–47, nn. 92–98. She ascribes the group to Niccolò di Giovanni Fiorentino.

*Opposite:*
Figure 47.
Reconstruction of
Gattamelata Altar,
Santo, Padua

Figure 48.
Gentile Bellini,
after Jacopo's design.
*Saints Anthony Abbot and Bernardino da Siena,*
left panel of Gattamelata Altar.
1459/60(?).
Tempera on panel, 110 x 57 cm.
New York, Private Collection

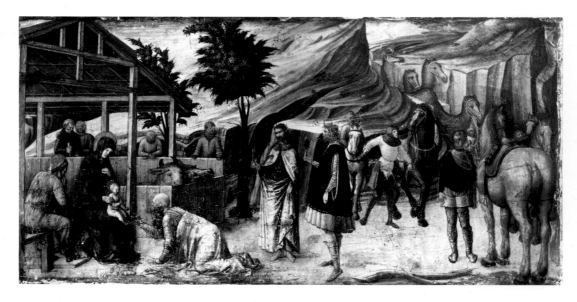

Figure 49.
Giovanni Bellini, after Jacopo's design. *Adoration of the Magi,* predella of Gattamelata Altar. 1459/60(?).
Tempera on panel, 28.5 x 57 cm. Ferrara, Pinacoteca Nazionale, Vendighini–Baldi Bequest

Figure 50.
Giovanni Bellini,
after Jacopo's design.
*Crucifixion,*
predella of Gattamelata
Altar. 1459/60(?).
Tempera on panel,
28.6 x 57 cm.
Venice, Museo Correr

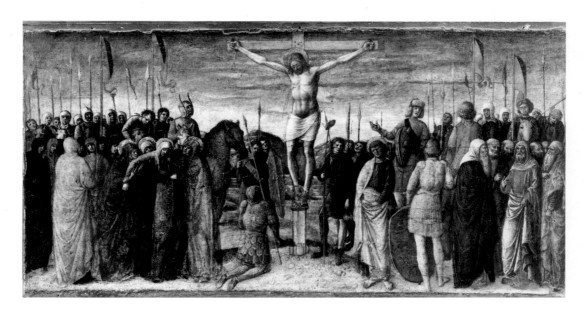

Figure 51.
Giovanni Bellini, after Jacopo's design. *Christ in Limbo,* predella of Gattamelata Altar. 1459/60(?).
Tempera on panel, 28.5 x 58 cm. Padua, Museo Civico

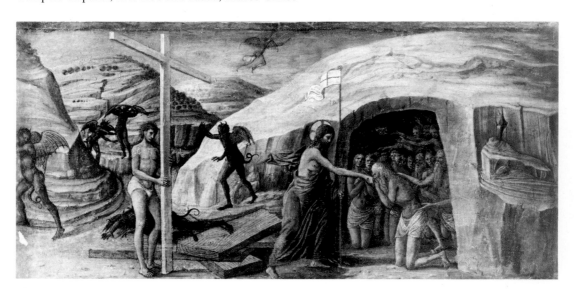

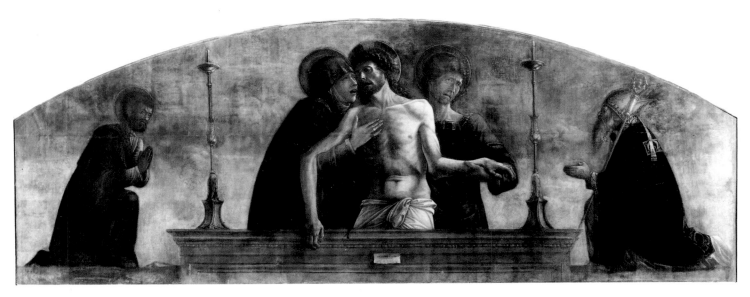

Figure 52. Jacopo, Gentile, and Giovanni Bellini. *Lamentation with Saints Mark and Nicholas*. Dated 1472. Tempera on canvas, 115 x 317 cm. Venice, Doge's Palace, Sala degli Ambasciatori

Though the Venetian scuole had long been important centers for patronage, many of them waited until the later fifteenth century to embark on large-scale narrative cycles in the persuasively dramatic style so successfully evolved in Jacopo's drawings. He provided at least two such groups, a lost pair of vast Passion canvases for his sons' Scuola di San Marco and a large Marian series—some eighteen scenes—for his own Scuola di San Giovanni Evangelista.

Jacopo's first known commission was for the Scuola di San Marco (Appendix E, Doc. July 19, 1421). The building was extensively refurbished in the mid-1450s, and in 1466 the scuola, probably reviving its earlier plan, commissioned Bellini to paint a *Crucifixion* with many figures and a *Way to Calvary*. For these two scenes the artist would receive the very large sum of 375 golden ducats, with an advance of 25 ducats. On January 10th, 1467, two more painters were brought in (Appendix E, Doc. 1467), their works to follow his in manner.

For Jacopo's largest known commission, the Scuola di San Giovanni Evangelista series, final payment was made on January 31st, 1465.[54] Four canvases reasonably associated with this group suggest Bellini's late style: the *Birth of the Virgin* and *Annunciation* now in the Galleria Sabauda, Turin (Figs. 27, 29), and the *Marriage of the Virgin* and *Adoration of the Magi* now in the Prado, Madrid (Figs. 28, 30); five others survive, owned by Lord Oxford and/or his son. Clearly, for a series of this size, the artist being well into his sixties, extensive studio assistance was necessary that probably included both sons. The subjects are set in domestic interiors and abound in genre details; a little dog drowses on the tapestry-covered step to Saint Anne's bed as richly dressed attendants bring food and drink on a *desco da parto* to the new mother, a partial restatement of the Brescia predella from the early 1440s (Fig. 21).

Sweeping stylistic judgments on these battered canvases must be tempered with caution, as the works are much restored. Like many of Jacopo's drawings, the canvases for his scuola share a sense of the stage, with its drop and flats, and have the appeal of a serial. They were installed opposite one another along the scuola's great hall (see Appendix D, 1, Ills. 1, 2), and their viewer walked from scene to scene in physical participation with the sacred events, as a pilgrim viewed sculptured Passion shrines outdoors or as pageant wagons passed before the spectator of mystery plays.

Art in Venice is alive with the gift of dramatic narrative, beginning with the early mosaics in San Marco. No other Italian school is quite so suggestive of series and event. Even a single view may often bring a sense of sequence, like one glimpse from a gondola or a scene spied from a balcony.

Jacopo, adroitly adding story-telling devices from the past to the new compositional views codified by Alberti, contributed to a peculiarly vital recitation by expanding the local repertory of subject and ornament. Reweaving the great pictorial wall coverings of the Veneto's later Trecento, he intensified their cinematic manner; novel Tuscan perspectival devices were introduced, and neo-classical and Northern outlooks freshly infused his resources of posture, gesture, and setting. Hundreds of Jacopo's drawings, vivid descriptions of his lost paintings, and his stunning *Crucifixion* canvas (Fig. 46), all testify to his stirring art, telling in its detail without blunting focus or direction.

54 Paoletti, 1894, 9; Testi, 1915, II, 162–64.

The confluence of narrative traditions in Jacopo's art occasionally produces a style not far from that of his much younger Florentine contemporary Benozzo Gozzoli, to whom at least one of the Venetian's drawings was long ascribed (Plate 135). Gozzoli's interest in "pure landscape" (in the Medici-Riccardi Chapel's remarkable panels of shepherds and their flocks) recalls the concern for trees and topography in some of the Books' verso pages, where people, if present, play minor roles.

On December 1st, 1466, Jacopo's name appears once again as a witness, and two weeks later his son Gentile agreed to prepare additional paintings to those by his father (Appendix E, Doc. Dec. 15, 1466) for the Scuola di San Marco. On October 13th, 1467, Jacopo is again listed as a witness.

55 Kristeller, 1905, doc. VIII.

Figure 53.
After Andrea del Castagno,
with Michele Giambono
and Jacopo Bellini.
*Visitation*.
About 1450.
Mosaic.
Venice, San Marco, Mascoli Chapel

Gentile Bellini was ennobled in 1469 and his brother-in-law Mantegna had been knighted a decade earlier;[55] Jacopo too may have been seeking a loftier station when he applied in 1469 for an honorary secretaryship in the confraternity of the ancient, aristo-cratic Benedictine church of San Niccolò di Lido (Appendix E, Doc. 1469). Or possibly this was a gesture of filial piety for his father, named for Saint Nicholas, patron of seamen and prostitutes, both important professions in Venice. Several other Bellinis appear on the list of applicants.

Jacopo was still alive on January 7th, 1470, for a contract of that date refers to *David* canvases for the Scuola di San Marco by another artist (Appendix E, Doc. 1470), continuing Bellini's series with scenes possibly related to his drawings (Plates 145–147, 150). The works of few painters before Jacopo evince the poignant brevity and emotional immediacy of those years near the end of life when the style of old age becomes manifest. Most of his late drawings are in the London Book, coarse yet radiant in style like those by Titian and Rembrandt as old men. Bellini shows this final manner in two treatments, graphic and pictorial, of the penitent *Saint Jerome* (Plate 273; Fig. 60): a sense of impatience, of going back to basics, is evident in both, the brusquely effective, Lear-like quality of each image a final confrontation.

In a large *Lamentation* canvas for a chapel at San Marco (Fig. 52) the presentation of the artist's terminal energies is more complex, the composition based on a page in the Paris Book (Plate 218). Though Giovanni's name and the date 1472—about a year after Jacopo's death—were long visible on this work, it is in essence a posthumous restatement of the father's art as painted by both brothers, Gentile apparently contributing the small figures of kneeling saints at left and right.

Jacopo had died before November 25th, 1471, the date of Anna Bellini's will that identifies her as the painter's widow (Appendix E, Doc. 1471). The absence here of Niccolosia's name (as well as Giovanni's) suggests that she had predeceased Anna. Anna left her clothing to her son Niccolò; her father-in-law's will had also contained such "cross-dressing by bequest," his personal effects left to his second wife (Appendix E, Doc. April 11, 1424).

Jacopo's sons turned and returned to their father's art throughout their lives, reminded of his achievements by quite literally reworking them. This re-creative process soon began when the cycle in the Sala del Maggior Consiglio, where Jacopo had probably assisted Gentile da Fabriano early in the century, was severely damaged by moisture. Gentile Bellini, official painter to the Serenissima, had the supervision of all such restorations in

56 Chambers, 1970, 78–81.

Figure 54.
After Andrea del Castagno,
with Michele Giambono
and Jacopo Bellini.
*Death of the Virgin*.
About 1450.
Mosaic.
Venice, San Marco, Mascoli Chapel

the Doge's Palace; he, his brother, and other artists continued to restore the Sala del Maggior Consiglio for the rest of their lives, the project becoming known as "delle tre Bellini," of the father and his sons. Gentile passed on the task to Giovanni for two years (paid monthly, together with Alvise Vivarini) when he went to Istanbul in 1479.

Jacopo's paintings in the Sala dell'Albergo of the Scuola di San Marco were destroyed by fire in 1485. The brothers took over its repainting in 1492, doing so, in their own words, "in devotion and memory of their late father Messer Jacopo Bellini, who worked in the said hall. . . . this they offer to do not from desire for gain, but only to the end that it should be for the praise and triumph of omnipotent God . . ."[56] The retrospective nature of these projects may have made them consult Bellini's drawings from professional necessity. Not only did the brothers rework their father's paintings, they also restored in pen, brush, and color many of his drawings (including those in his Books) which, by the century's end, had become faded (Appendix D, 2).

Jacopo's are a singer's skills. His art does not have the resonating silence of Piero della Francesca's or the motion slowed by Mantegna's monumental genius, but it is a more personal recitation, free from the powerful, stoical finality of those two artists who learned so much from him. The narrative force in the Books and the Verona *Crucifixion* is still sensed in Tintoretto's vast bird's-eye view of *Calvary* (Venice, Scuola di San Rocco), painted exactly a century after Jacopo's *Way to Calvary* and *Crucifixion* for his own scuola.

With Giovanni Bellini's transfiguration of his father's themes by adding Northern oil glazes to the traditional tempera, that revelatory glow, long so close to the Byzantine bones of Venetian art, became ever more accessible, now emanating from the illusion of nature. His novel, mirror-like images gave way in the next century to the almost impressionistic *sprezzatura* of the "action painters"—Titian and Tintoretto. With them the era of modern art began, founded on memories of Bellini's vision, seen once again in their own.

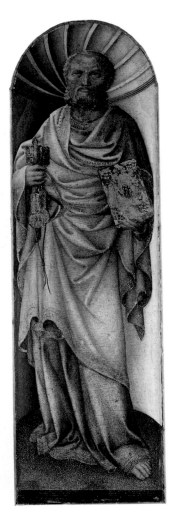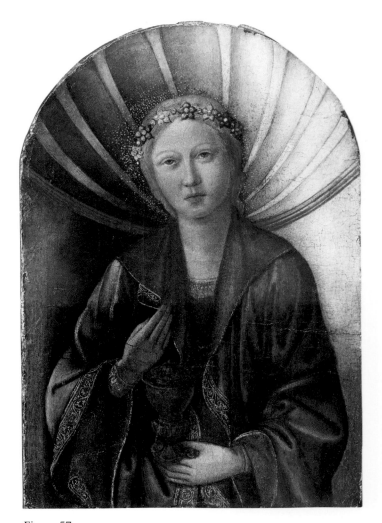

Figure 55.
Jacopo Bellini (studio).
*Bearded Saint Reading.*
Probably mid-1430s.
Tempera on panel, 85 x 24 cm.
Berlin, Staatliche Museen,
Preussischer Kulturbesitz

Figure 56.
Jacopo Bellini (studio).
*Saint Peter.*
Probably mid-1430s.
Tempera on panel, 85 x 24 cm.
Berlin, Staatliche Museen,
Preussischer Kulturbesitz

Figure 57.
Jacopo Bellini (studio).
*Female Saint with Floral Wreath and Covered Vessel.*
Probably mid-1430s. Tempera on panel, 39 x 26.8 cm. (cut down).
Berlin, Private Collection

Figure 58.
Jacopo Bellini (studio).
*Saint Jerome.*
Probably mid-1430s.
Tempera on panel, 31 x 23 cm. (cut down).
Berlin, Staatliche Museen,
Preussischer Kulturbesitz

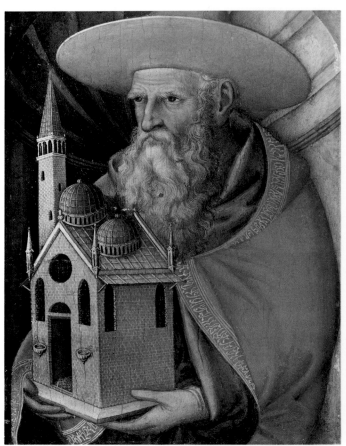

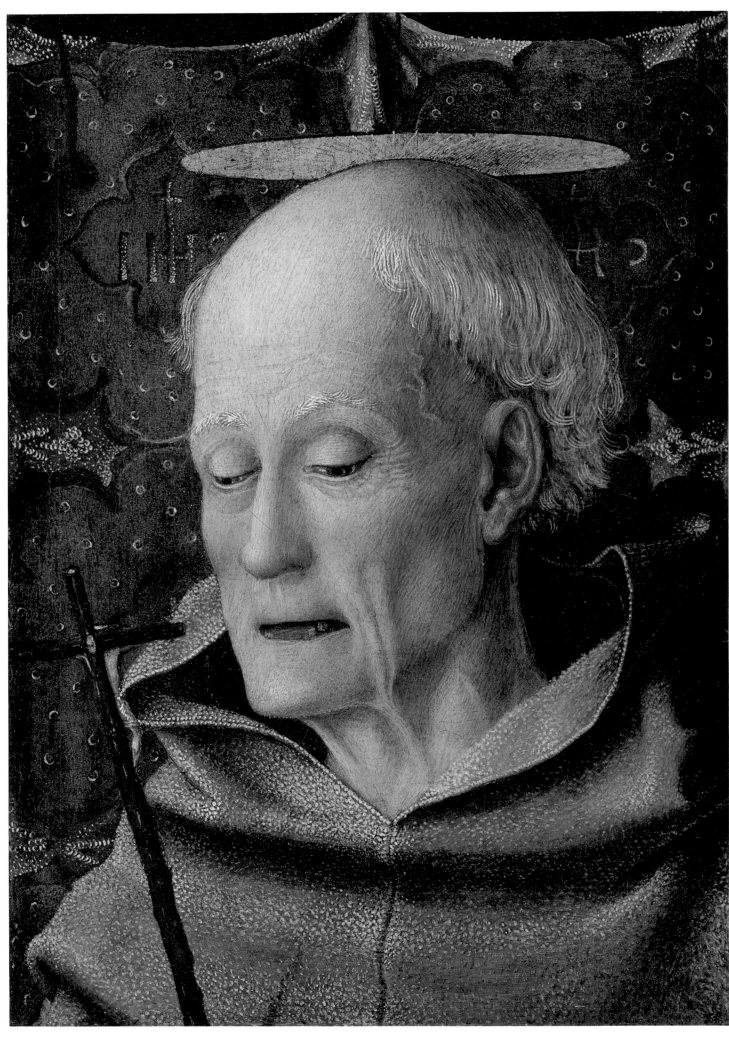

Figure 59.

Jacopo Bellini. *San Bernardino da Siena*. Shortly after 1450.

Tempera on panel, 31 x 22 cm. New York, Coll. Dr. and Mrs. John C. Weber

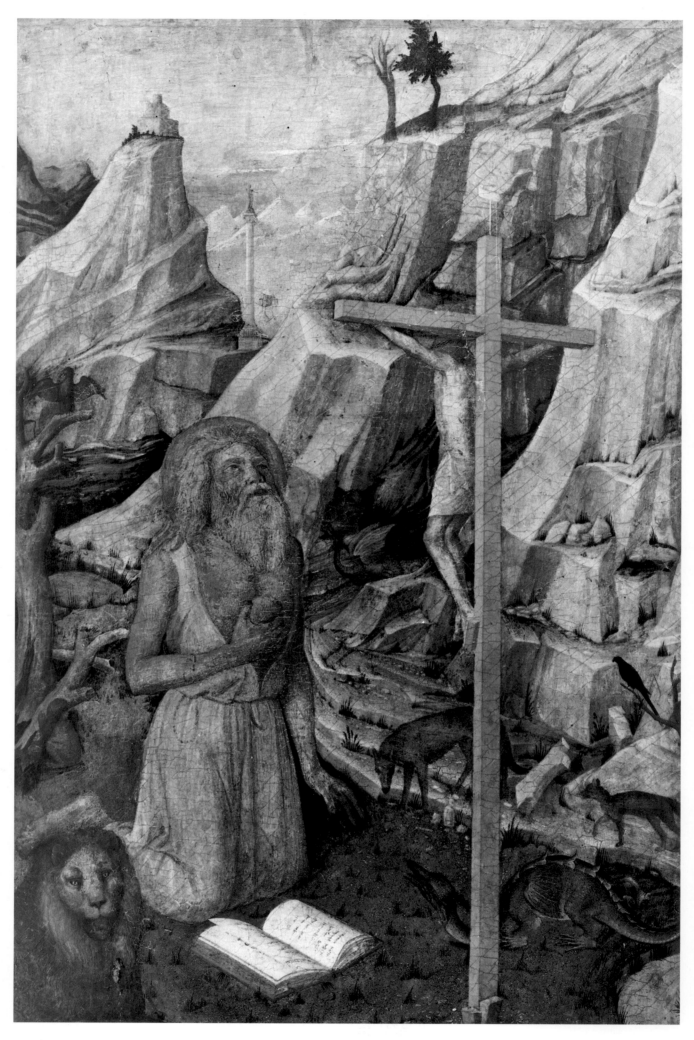

Figure 60.

Jacopo Bellini. *Penitent Saint Jerome in the Wilderness*. 1460(?).

Tempera on panel, 96 x 64 cm. Verona, Museo del Castelvecchio

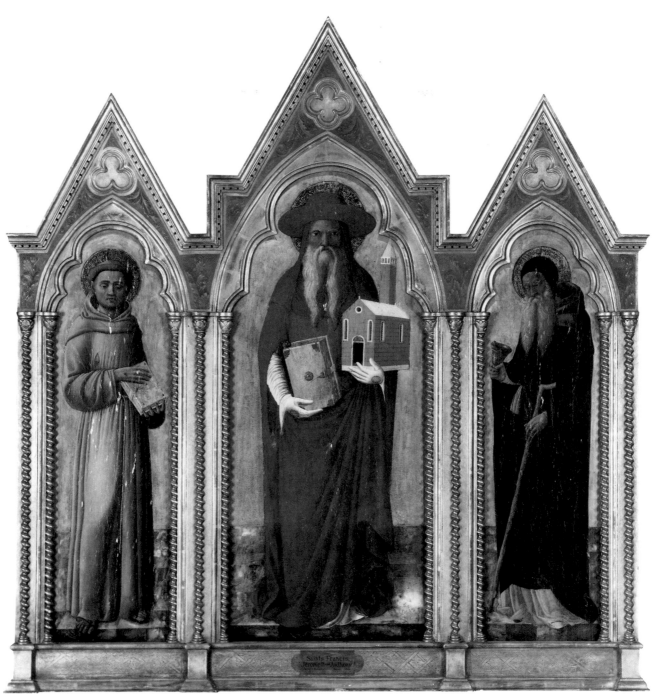

Figure 61.

Jacopo Bellini and studio. *Saint Jerome with Saints Francis and Anthony Abbot.* 1440s.

Triptych: tempera on panel, center panel 136 x 54 cm., left and right wings 116 x 36 cm. each. Poughkeepsie, N.Y., Vassar College Art Gallery

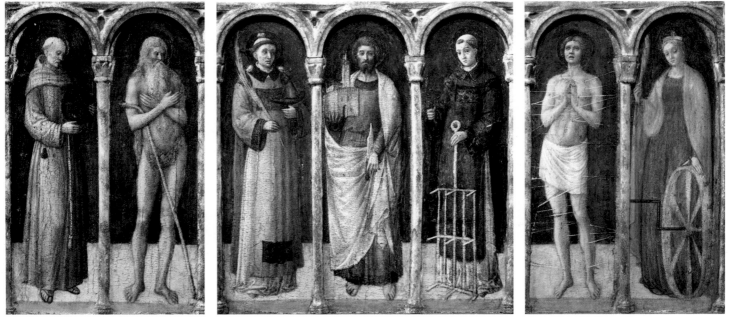

Figure 62.

Giovanni Bellini, after Jacopo's design. *Miniature Altar Frontal with Seven Saints.* About 1460.

Tempera on panel, 29 x 60 cm. Matelica (Macerata), Museo Piersanti

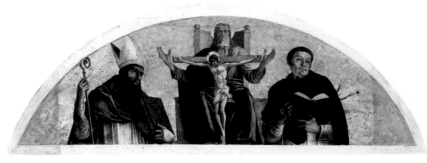

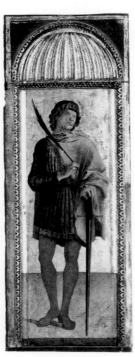

Figure 63.
Jacopo Bellini (studio).
*Nativity* Triptych: *Saint Francis* (left wing),
*Saint Victor* (right wing); *Throne of Grace* (lunette)
between *Saint Augustine* (left), *Saint Dominic* (right).
Early 1460s.
Tempera on panel: main panels each 127 x 48 cm.,
lunette 60 x 166 cm.
Venice, Accademia

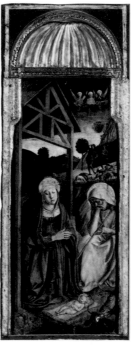

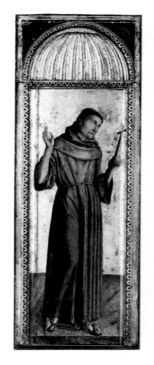

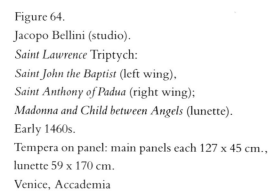

Figure 64.
Jacopo Bellini (studio).
*Saint Lawrence* Triptych:
*Saint John the Baptist* (left wing),
*Saint Anthony of Padua* (right wing);
*Madonna and Child between Angels* (lunette).
Early 1460s.
Tempera on panel: main panels each 127 x 45 cm.,
lunette 59 x 170 cm.
Venice, Accademia

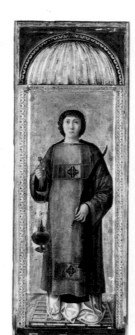

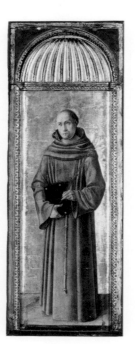

72

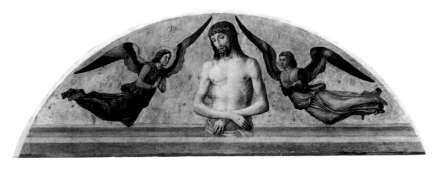

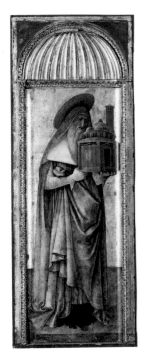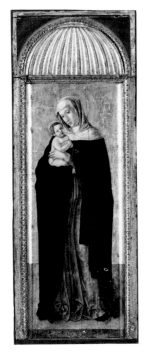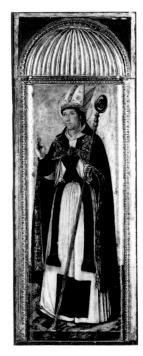

Figure 65.
Jacopo Bellini (studio).
*Madonna* Triptych: *Saint Jerome* (left wing),
*Saint Louis of Toulouse* (right wing);
*Man of Sorrows between Angels* (lunette).
Early 1460s.
Tempera on panel: main panels each 127 x 48 cm.,
lunette 59 x 168 cm.
Venice, Accademia

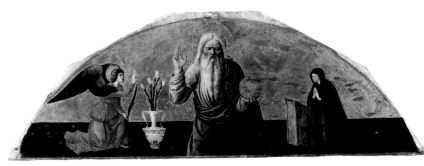

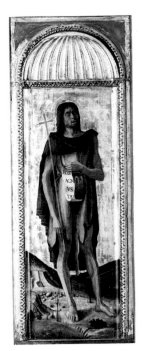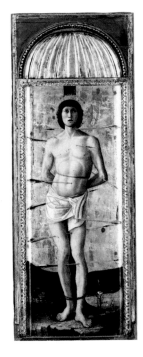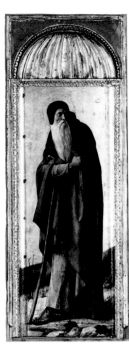

Figure 66.
Jacopo Bellini (studio).
*Saint Sebastian* Triptych:
*Saint John the Baptist* (left wing),
*Saint Anthony Abbot* (right wing);
*God the Father* (lunette),
with *Annunciation* (left and right).
Early 1460s.
Tempera on panel: main panels each 127 x 45 cm.,
lunette 57 x 151 cm.
Venice, Accademia

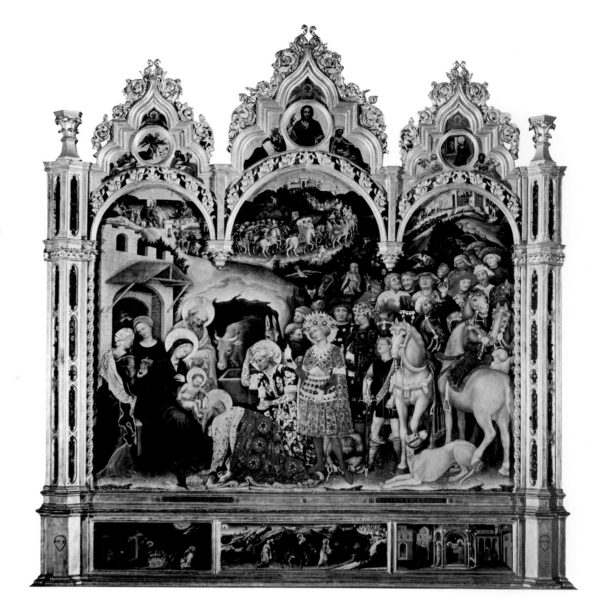

Figure 67.
Gentile da Fabriano.
*Adoration of the Magi*
(Strozzi Altarpiece).
Finished 1423.
Tempera on panel,
300 x 282 cm. (center panel)
Florence, Uffizi

Figure 68.
After Jacopo Bellini(?).
*Figures in a Barrel-vaulted Room in Perspective.*
Pen and hematite
on tinted rose board,
25.1 x 17.4 cm.
Paris, Louvre 2520 (Codex Vallardi)

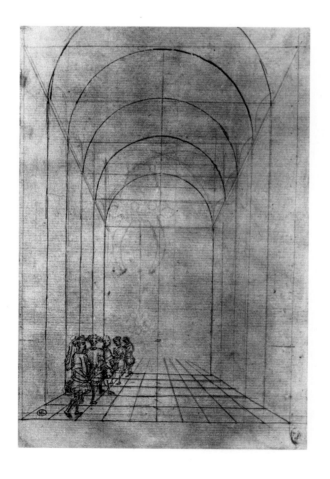

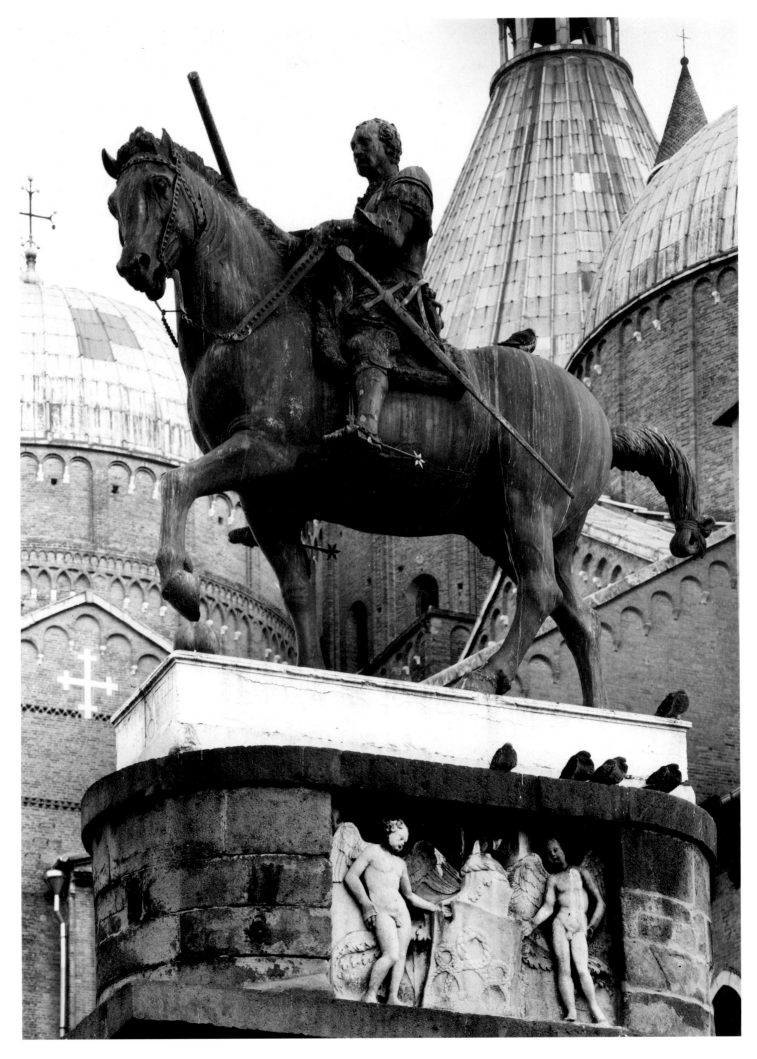

Figure 69.
Donatello. *Equestrian Monument of Gattamelata*. 1445–53. Bronze, height of sculpture 371 cm. Padua, Piazza del Santo

Plate 3. *Palace Zoo*. British Museum 89v

# III

## THE GRAPHIC EYE

### DOUBLE VISION: ON PAPER AND PARCHMENT

Halves of the same graphic vision, Jacopo Bellini's two Books, one in London, the other in Paris, are as unique as the culture from which they came. Goethe's remark about Venice, that she could only be compared with herself, is true for these volumes too, sole graphic guides to a largely lost world, the early renaissance in Venice.

Here, rather than reproducing the renderings once again as they appear in the Books, both Books' drawings have been integrated by theme, to illuminate each other's treatments of similar subjects and to follow the artist's images of sacred and secular events from the near and distant past. This permits his pages of vision and design to inform one another with new resonance, the feats of the founding father of Venetian renaissance art viewed "in the round." Freed from their often arbitrary succession in the Books, Bellini's achievements emerge as those of a gentle Prometheus unbound; his graphic skill spins events of faith and chivalry, town and country, the ordinary and the extraordinary, into a seamless web, one of the first and finest of the Serenissima's pictorial spellbinders.

Each Book opens with a *Calvary* (Plates 141, 205). These are among the artist's most carefully rendered drawings, as if he considered them opening prayers, comparable to Cennino Cennini's invocation in *Il Libro dell'Arte* to God, the Virgin Mary, and many saints, seeing his work as a votive act of personal piety.[1]

As a graphic "one-man show" of unprecedented range, Bellini's Books, as well as whatever others he passed along to his wife and son, are also a *Liber Studiorum*, a book of studies prepared for the benefit of the artist, his apprentices, patrons, and heirs. Somewhere between a catalogue, a motif-bank, an almost cinematic guide to chivalric narratives and biblical literature, and a mirror of genre, courtly and classical events and achievements—all these are in the Books for the opening, past and present solutions to a host of pictorial problems, and guides as well to perspective and physiognomy, motion and repose.

Bellini is the earliest Venetian painter to "get it all together," evidenced by the Books' adroit synthesis of styles from antiquity, Florence, Lombardy, and the North. One reason why scholars have differed so widely in dating them is the Books' occasional retrospective quality, especially in the Paris volume. An autobiography of works and days, some of Bellini's pages recall his initial modes and achievements, along with those of his teachers, first rivals, and forerunners.

Just as the Paris Book was much reworked later in the fifteenth century to make its pale parchment pages more visible, so the faded London drawings have been strengthened for this publication, though all the lines here are Jacopo's own, their visibility increased through infrared photography rather than restoration. Not since the fifteenth century have the London Book's soft leadpoint drawings been seen in their entirety; now their every stroke, from first to last, comes out in these new photographs specially prepared by the British Museum. They demonstrate the genesis of each page, its entire graphic development retraced. Even more revealing than the artist's changes in outline and placement are his boldly planned, authoritative initial strokes of perspectival attack, those first divisions toward the illusion of space so clear on many pages. The vast operatic casts that enact Bellini's biblical and classical dramas are ranged along graphic areas hitherto invisible. In the Paris Book, those briskly inked passages occasionally add a printlike precision and almost mechanical definition to Bellini's pages; something of the London Book's shimmering, warm white surfaces and varying intensity of line is necessarily sacrificed to the new visibility through infrared photography. But the palest, most fugitive of leadpoint lines rise

1 Cennino Cennini, *The Craftsman's Handbook, "Il Libro dell'Arte,"* trans. D. V. Thompson, Jr. (New Haven: 1933), reprinted New York: 1954, 1 f.

again to the surface in the delicate landscapes, whispered auguries of vistas to come by Giorgione, Campagnola, and Titian, to be revived by Watteau, Gainsborough, and Corot.

Bellini's unprecedented pages belong among those drawn a little later by Leonardo and Fra Bartolommeo. Beyond time, his are lyrical celebrations of the seen, of what *is*, as if freed from the artifice of art and the invention of idea. They mean the most for dealing with the least, like a Chinese scroll or a Rembrandt sketch. Almost without object or ego, the artist's Arcadian images and urban *vedute* seem to breathe themselves upon the page, coming into being by ethereal renaissance photography.

These landscapes, mostly on the London Book's left facing pages, may prove to be Jacopo's highest achievement—or likelier, to be those of his sons. The British volume's sylvan scenes, if by the father, require that renaissance art history be rewritten to cede him the pride of pioneering the graphic landscape in light and space. Only Masaccio's recovered renderings in the 1420s for the *Tribute Money* (Florence, Brancacci Chapel), or Donatello's shallow relief of *The Giving of the Keys* (London, Victoria and Albert Museum; made for the same chapel), rival Bellini's landscapes.

In his guide to *Venetia, città nobilissima et singolare* of 1581, Francesco Sansovino wrote, "It is held by some that this word Venetia signifies VENI ETIAM, that is, come again and again, for however oft you come, you will always see new things and new beauties." The same may be said for the Books, their pages never ceasing to surprise, delight, or inform. Like a favorite novel or film, some line or scene always comes through with new meaning or appeal upon reading or seeing it again.

## A TALE OF TWO BOOKS

Set in Paris and London, like Dickens' *A Tale of Two Cities*, one of Jacopo's two drawing Books is on precious parchment, in the Louvre's Cabinet des Dessins, the other on heavy white paper, in the British Museum. Both France and England had long been exceptionally close to Venetian culture. France had founded her own early renaissance on that of the Serenissima; Jean Fouquet, her greatest fifteenth-century painter, was a disciple of Bellini's. First of the Books to be well known was London's; it remained in the Veneto until 1855, when it was acquired for the Museum. Today composed of some 101 folios, it contains 134 drawings, all in leadpoint, a few worked over in pen and wash, and three blank pages.

France bought what is now the Louvre's Book almost thirty years later. Its graphic variety is technically much more complex, heightened by the different media used and by the pages having tinted and toned backgrounds for the metalpoint. It now has 93 parchment sheets (at least thirteen were removed; three of these have been recovered) and one paper insert (Plate 261). The drawings in each Book were possibly first prepared and kept in smaller gatherings—in *quaderni*, a frequent term in the fourteenth and fifteenth centuries meaning simply notebooks which could be filled in a month.[2]

Of all their works, artists' drawings are often closest to their souls and secrets. Long jealously guarded, these sheets of parchment and paper were kept for use as studio records and guides, known in Venice as *disegnadure* or *quaderni*.[3] The earliest of such compilations are called pattern books, many motifs crowded or boxed onto each page in catalogue-like fashion, and often drafted to assist a patron's choice or an apprentice's performance. Drawings of special merit could enjoy unusually long lives; those by the Paduan genius Niccolò Pizzolo were still being rented out twenty years after the young artist's death.[4]

Early drawing books and their more freely rendered successors in the renaissance are among the greatest graphic rarities, treasured as examples of Art for Art's Sake in the sense that they were not for sale but drafted for the painter himself, unusually personal as well as intensely professional. This quality of intimacy and immediacy, of a dialogue between artist and design, had special appeal to sophisticated collectors in the market for drawings and early pattern books. Ownership of such a work made the connoisseur privy to the secrets of creation, almost as if possessing the soul of the artist who drew the design or *disegno*, his first idea or inspiration.

Among Europe's wealthiest patronage centers in the later Middle Ages, Venice enjoyed an unusually urbane culture. She embellished her artificial setting with the best skills that money could buy, and the first documented collectors of drawings since antiquity lived there.

2 J. Shell, *Painters in Milan 1490–1530*, Ph.D. dissertation, New York University, Institute of Fine Arts: 1987, 5.

3 For the definitive study of artists' pattern books and related graphic gatherings, see Scheller (1963); see also Rushton (1976). For the use of drawings in renaissance artists' studios, see Ames-Lewis (1981; 1983). Early drawings in Venice are discussed by Testi (1909; 1915), Tietze and Tietze-Conrat (1944), and Degenhart and Schmitt (1980).

4 The drawings were borrowed by Calzetta, who provided frescoes for the Gattamelata Chapel at the Santo, Padua. See Tietze and Tietze-Conrat, 1944, 7. The Bellinis, father and both sons, painted an altarpiece for the same chapel. See Appendix D: Padua, Santo, Gattamelata Chapel.

The earliest recorded acquisition of Venetian drawings comes from the diary of a local moneylender and art lover, Oliviero Forzetta, who noted in 1335: "Remember finally to collect all the drawings which belonged to poor Perenzolo, the son of Master Angelo; they are now held as security by Masters Francesco and Stefano of San Giovanni Novo, together with the notebooks of Perenzolo, in which he drew all the animals (and all of them beautifully); and also collect all the sculptures and all the other drawings, wherever they may have been put, deposited or pledged. . . . Also ask about the many drawings of Perenzolo which his widow has. Remember that Martino di Gallera likewise has many things of poor Perenzolo's: lions, oxen, birds, nude figures, fragments of statues, or humans and animals."[5]

But for Perenzolo's poverty, his life and work were much like Jacopo's. Both were great *animaliers*, and both collected sculpture, probably ancient marbles, along with casts kept as silent models. Above all, it is their drawings for which both are best known, though Perenzolo's are lost. Jacopo Bellini, like Angelo Tedaldo, Perenzolo's father, may have included in his own gatherings many drawings by his sons, some of these now in his London and Paris Books. Giovanni and Gentile also left their own mark on the Books after their father's death, contributing, along with their apprentices, partial reworkings in pen and brush.

Manuscript illustrations, and some sad scraps of later fourteenth- and early fifteenth-century pattern books, are all that remain of the Serenissima's earliest graphic art. Most show decorative motifs to guide the embroiderers and silk weavers then active in the Veneto, the figures rather crude. The name of Niccolò di Pietro, a prominent early fifteenth-century painter, has been linked to a battered, incomplete pattern book of twenty-one parchment pages. Too crudely drawn to be Jacopo's, the leaves show some of his same subjects—rustic figures, saints, warriors, and biblical scenes.[6]

Paradoxically, the best early pattern book lies almost totally obscured, bound in part into Jacopo's Paris volume. Only a few of its folios (Plates 7, 297) may be seen there today, the others covered by grounds of various colors to be reworked in metalpoint by Bellini, his sons, and studio assistants. Most of the incomplete older book's pages originally bore luxuriant orientalizing textile patterns, so securely penned that they recall Islamic calligraphy.[7]

Pattern books were often consulted when an artist was designing in collaboration with a sculptor, builder, silver- or goldsmith, or a master of mosaic or *intarsie*, those skillfully crafted illusionistic wooden inlays. All such costly projects required extensive preparatory work and usually the approval of patrons, who wanted to know in advance where their money was going. Bellini's Books show that his career encompassed many and varied activities, requiring a large graphic repertory of pictorial resources.

The older pattern book held little if any interest for Jacopo. Kept solely for cannibalizing, several of its parchment pages were bound upside-down in his Book; possibly it came from his master, Gentile da Fabriano, and the finest folios of animals may even be by that Marchigian, for they are close to those in his Strozzi Altar (Fig. 67), on which young Jacopo may have assisted him. Perhaps the Venetian artist inherited this pattern book from Gentile, who, though he left a daughter, may never have married.

Only a few pages of lions seem to have held Jacopo's interest in the old pattern book: one was left uncoated (Plate 7), another painstakingly reworked (Plate 6; Fig. 7). His son Giovanni adapted one of these lions in his early signed *Saint Jerome* (Birmingham, England, Barber Institute).[8] Among the best and the worst of the Paris Book's drawings are on these coated pages, as if kept for use by the most and the least gifted of Jacopo's apprentices, best of the former his son Giovanni.

Early playing-card designs are recalled in some pages of the pattern book, the animals arranged in decorative ranks. These folios, though lively, remain more formal than those from late fourteenth-century Lombardy, whose naturalistic, often brilliantly colored birds and beasts are rendered with extraordinary spontaneity, the finest by Giovannino de'Grassi (Bergamo, Biblioteca Civica). Artists from Lombardy often came to work in the Veneto, and young Jacopo may have learned of that region's free graphic style from manuscripts by Giovannino's most gifted follower, Michelino da Besozzo. One of Italy's major masters, Michelino came to Venice in 1410, and had a commission in 1416 from a leading family there. Some of his highly praised animal studies were in the same sixteenth-century collection as Jacopo's. Clearly the Republic's patrons always appreciated a fresh approach to nature.

Are Jacopo's two great Books still in the late medieval tradition of the consultative pattern book? Or in designing them has he made a definitive break with the past? Robert

5 Translation from Muraro, 1970, 23–24, 74–75. See also Gargan, 1978, 47.

6 Ms. 53, Franciscan Library, San Lorenzo, Sebenico (modern Sibenik), Yugoslavia, a coastal area north of Split long under Venetian influence. See Degenhart and Schmitt, 1980, cat. nos. 64, 178–84, pls. 79–86, figs. 303–4, who describe it as "Dalmatian." For Niccolò, see Christiansen, 1982, 60–71.

7 Weinberger (1941) was the first to suggest that these pages were by an earlier artist than Jacopo. See Degenhart and Schmitt (1980, cat. nos. 652–63) for an exhaustive study of this book within a book. Their figs. 252, 259, and 262 work out repeats for the textile patterns on the older book's pages, including our Pl. 297.

8 Noted by Robertson, 1968, 15.

Plate 4. *Lions and Cubs*. British Museum 15v

Plate 5. *Cheetah Studies*. British Museum 92v

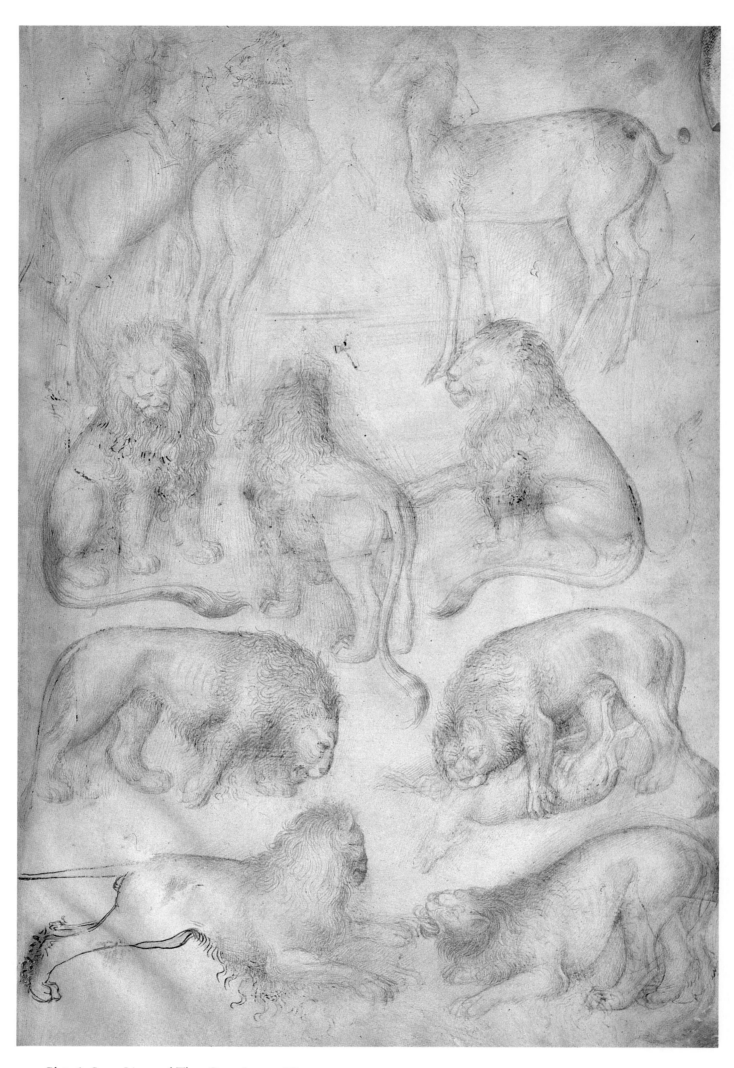

Plate 6. *Seven Lions and Three Stags*. Louvre 78v

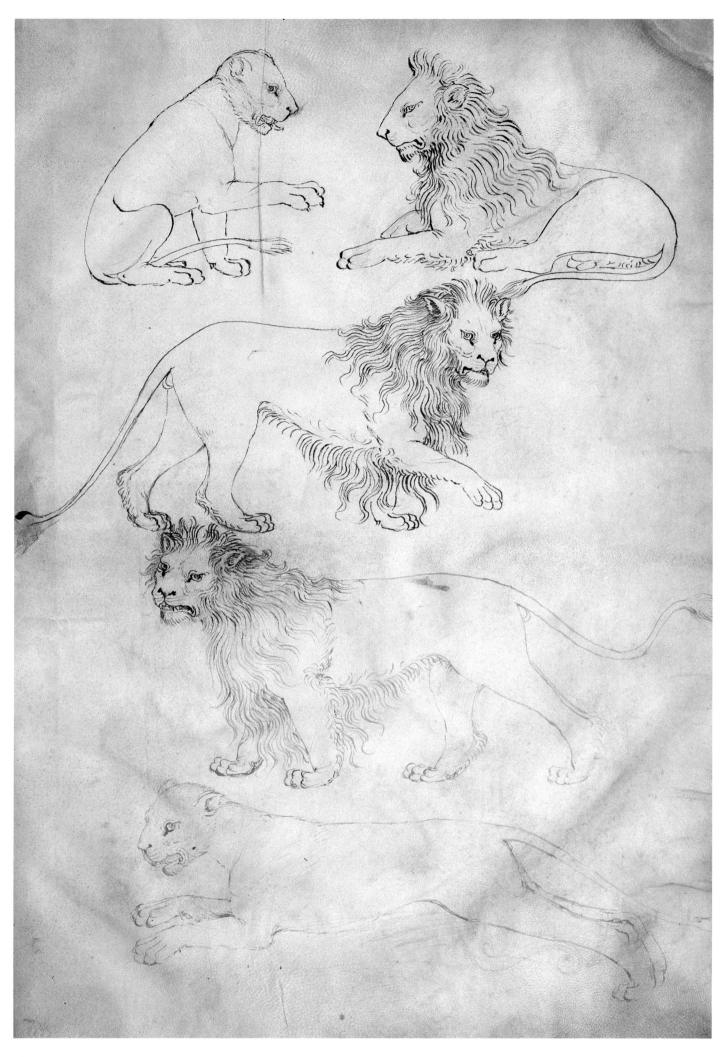

Plate 7. *Five Lions*. Louvre 77v

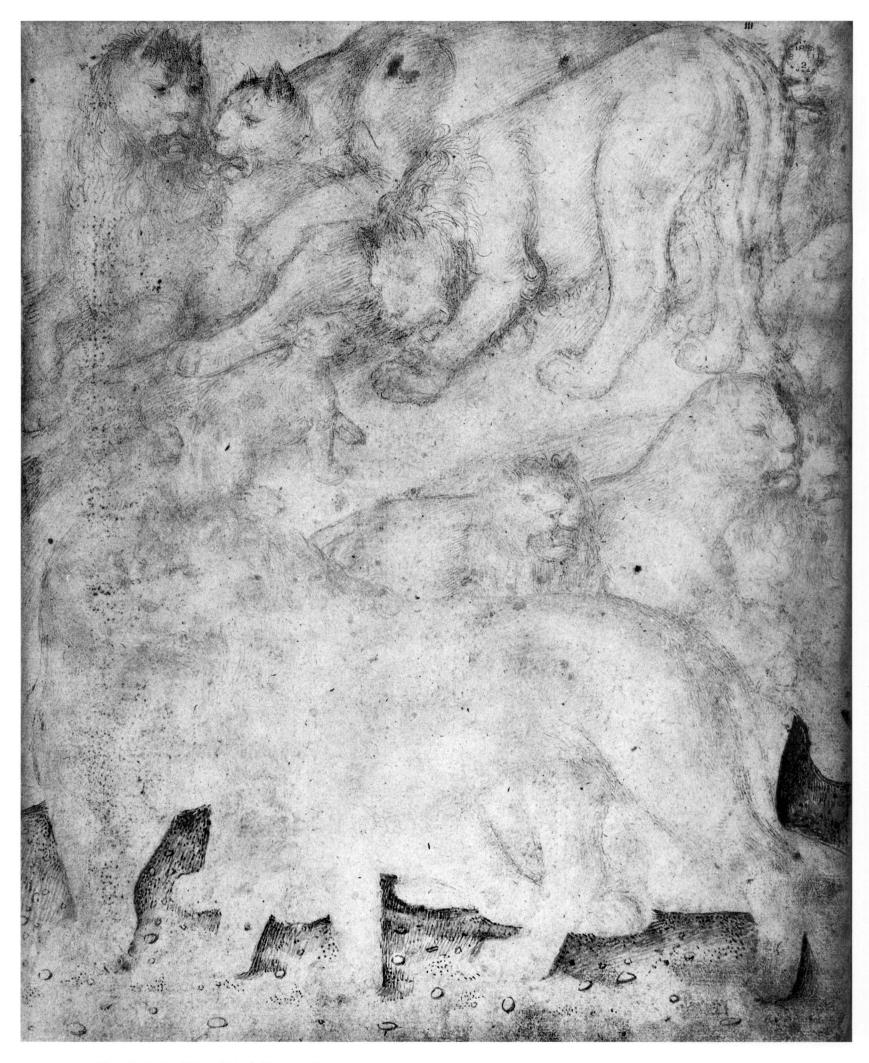

Plate 8. *Study of Lions*. British Museum 3

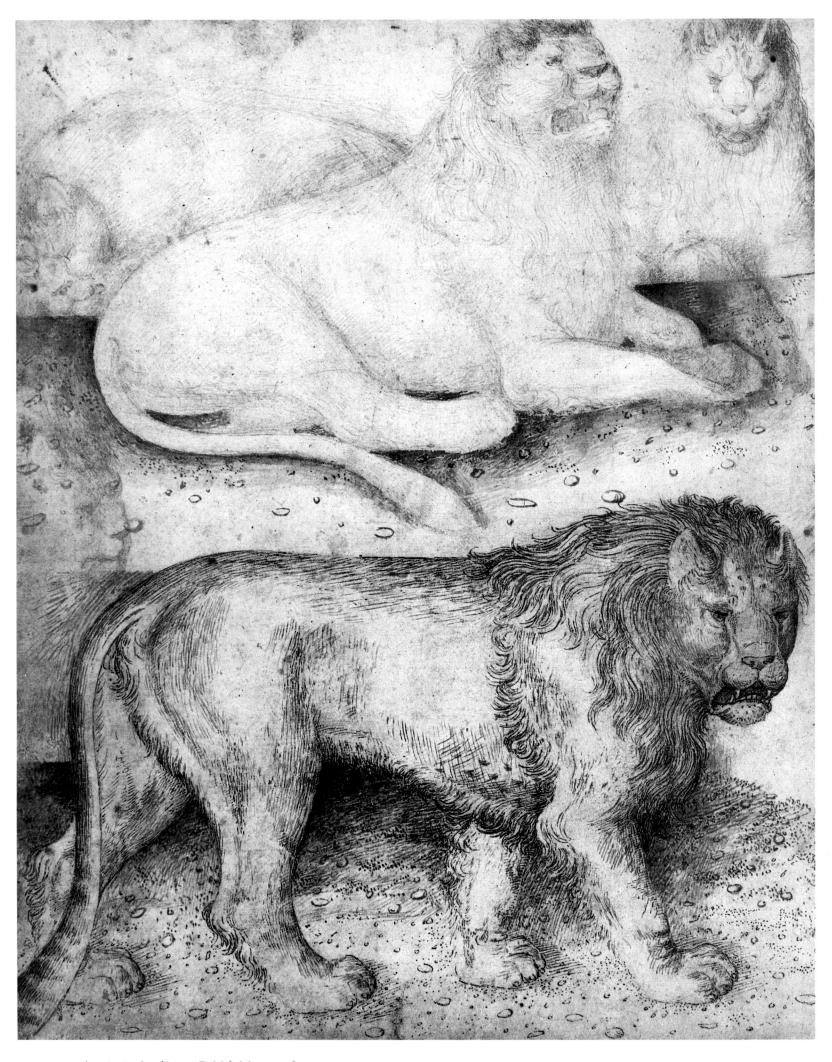

Plate 9. *Study of Lions*. British Museum 2v

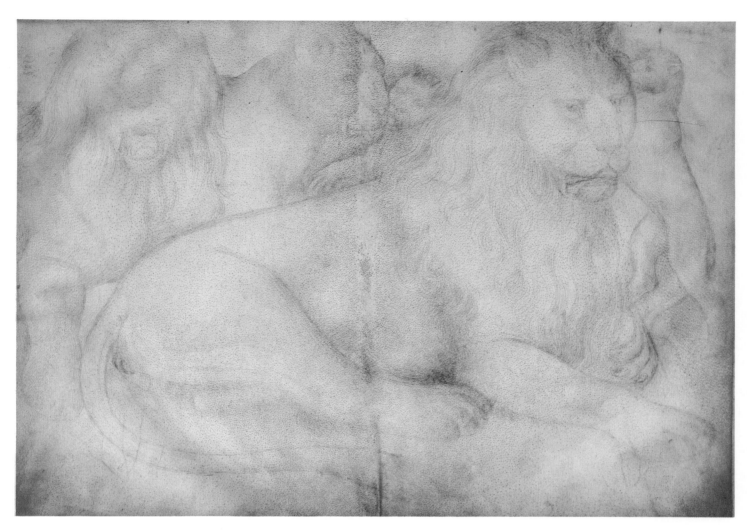

Plate 10. *Two Lions, a Lioness, and Two Cubs.* Louvre 65v

9 Scheller, 1963, 214.
10 Ames-Lewis, 1981, 215.
11 Tietze and Tietze-Conrat, 1944, 105.
12 "Bastiani, Lazzaro," *Dizionario Biografico degli Italiani*, VII, Rome: 1965, 167 f.
13 "Bellini, Gentile," *Dizionario Biografico degli Italiani*, VII, 698 f.

Scheller, who studied this question closely, concluded that they must be seen as belonging within conservative studio practice, but he placed them at the end of his catalogue of pattern books, different in their "unmedieval orderliness."[9] Yet the last of one genre may often be the first of the next, as this scholar well knew, recognizing progressive as well as traditional aspects of Bellini's drawings.

Jacopo's Books, along with the few finished drawings by his son-in-law Mantegna, "are the sole surviving examples of what was probably standard studio property," their pages described as "mostly compositional drawings, produced . . . for his own interest and self-conscious concern with his own abilities. [Bellini's] form the largest group of compositional drawings of any quattrocento artist, a record to be inherited by later generations of a family workshop and to establish an artistic tradition in compositional design. . . . This attitude was probably especially characteristic of the Venetian workshop, which was generally family based and dependent upon the inheritance of styles and techniques over generations."[10]

With their grand format and clearly delineated compositions, the Books would have been especially useful for Venice's large-scale collaborative pictorial cycles. A *Crucifixion* (Plates 206, 40) has been cited as possibly pertaining to Bellini's work at the Scuola di San Marco.[11] The series, worked on by the old Jacopo, was continued by a much younger artist, probably his student Bastiani, whose contract specified that his canvases should be in keeping with Jacopo's, though their subject was from the Old Testament. The scuola required that he submit renderings for their approval.[12] Bastiani may well have followed Bellini's drawings (Plates 138, 163, 166, 167) for his own *David*; similarly, Jacopo's son Gentile, working on a huge canvas for that scuola's Sala dell'Albergo, promised to follow "zerto modelo in disenjo," "a preparatory design."[13]

Bellini has been compared to Squarcione, whose painting "academy" in Padua provided instruction in the art and science of perspective and the achievements of classical antiquity. Prints, casts, and drawings were part of many studios' furnishings, used, among other purposes, for education by imitation, these models known as *exemplaria*. They are referred to in a letter by the humanist Barzizza, whose school in fifteenth-century Padua

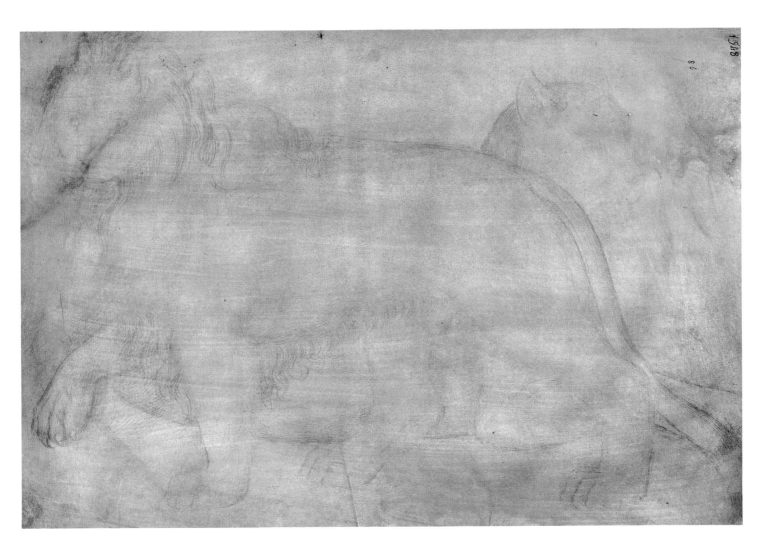

Plate 11. *Two Lions.* Louvre 86

provided Leon Battista Alberti with his earliest training. Barzizza, describing his way of teaching literature, wrote: "I myself would have done what good painters practice toward their pupils; for when the apprentices are to be instructed by their master before having acquired a thorough grasp of the theory of painting, the painters follow the practice of giving them a number of fine drawings and pictures as models (*exemplaria*) of the art, and through these they can be brought to make a certain amount of progress even by themselves."[14]

Jacopo was long in close contact with Padua, where he received many commissions. One of its university's graduates, Giovanni della Fontana, dedicated to Bellini his treatise, now lost, on the use of color for aerial perspective, describing him as the famous painter of Venice. That fame must also have brought him students, for the artist was celebrated in the next century as a teacher. So his Books, teeming with perspectival subjects, classical references, and historical scenes, may, in part, have been drafted with an eye to their use as teaching devices, presentations of perspective applied to narrative subjects of many sorts. Squarcione's contract with a pupil's father proves the importance of demonstration drawings in teaching that profitable spatial skill.[15]

Though the Books are more empirical and less narrowly Albertian than Fröhlich–Bum thought (see page 102), they may still have had a didactic dimension as an informal graphic version of portions of the Florentine humanist's *On Painting*.[16] For all its seeming eccentricities, Jacopo's drawn perspective has recently been shown to be mathematically consistent, usable as a teaching tool.[17]

Bellini probably maintained a large studio. In addition to his sons, the artist may have instructed Bastiani, Cima da Conegliano, Foppa, and other masters active in the later fifteenth century. Several worked as miniaturists, including his nephew Leonardo (Appendix E, Doc. 1431). Ames-Lewis pointed out that the Books gave "a range of compositional systems from which workshop assistants could extrapolate their painted compositions"[18]— not an impossible suggestion, but if so, the remarkably clean condition of these *exemplaria*, as noted by Joost-Gaugier, is unique.

14 This letter is quoted by Baxandall, 1965, 183.
15 Lipton, 1974, 383 f., doc. 87.
16 Fröhlich-Bum, 1916.
17 See Collins, *Pantheon*, 1982, 300–304.
18 Ames-Lewis, 1981, 129.

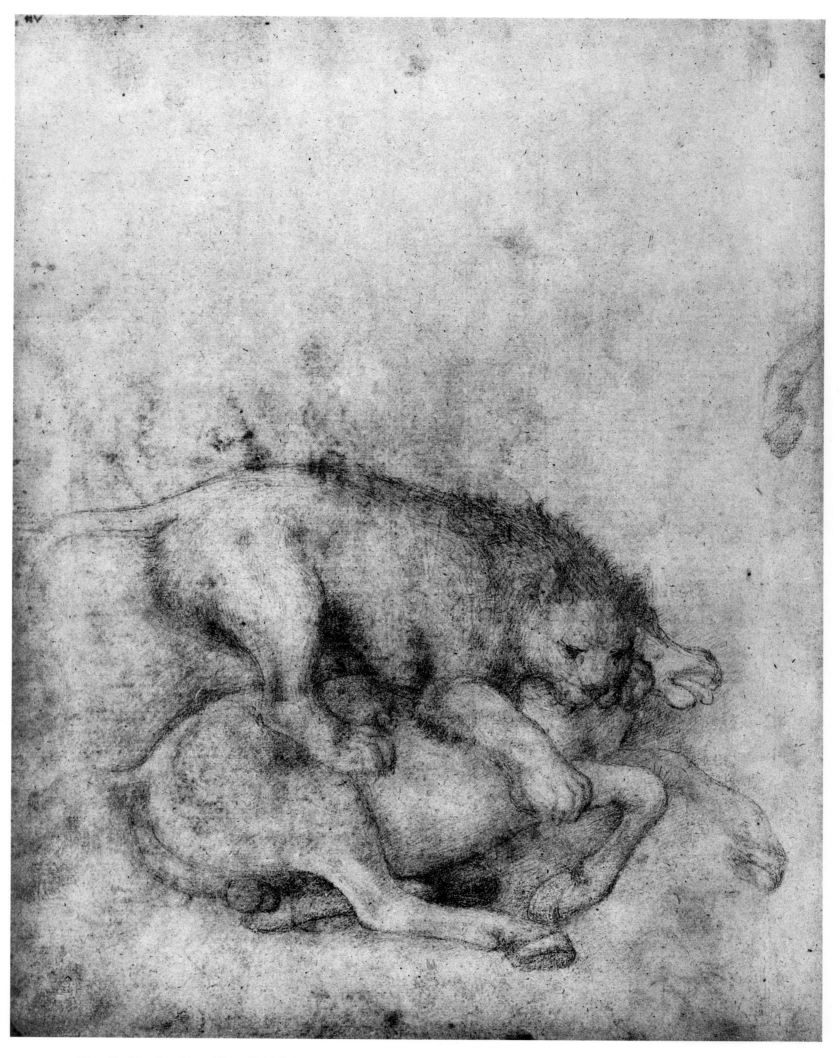

Plate 12. *Lion Attacking a Horse*. British Museum 7v

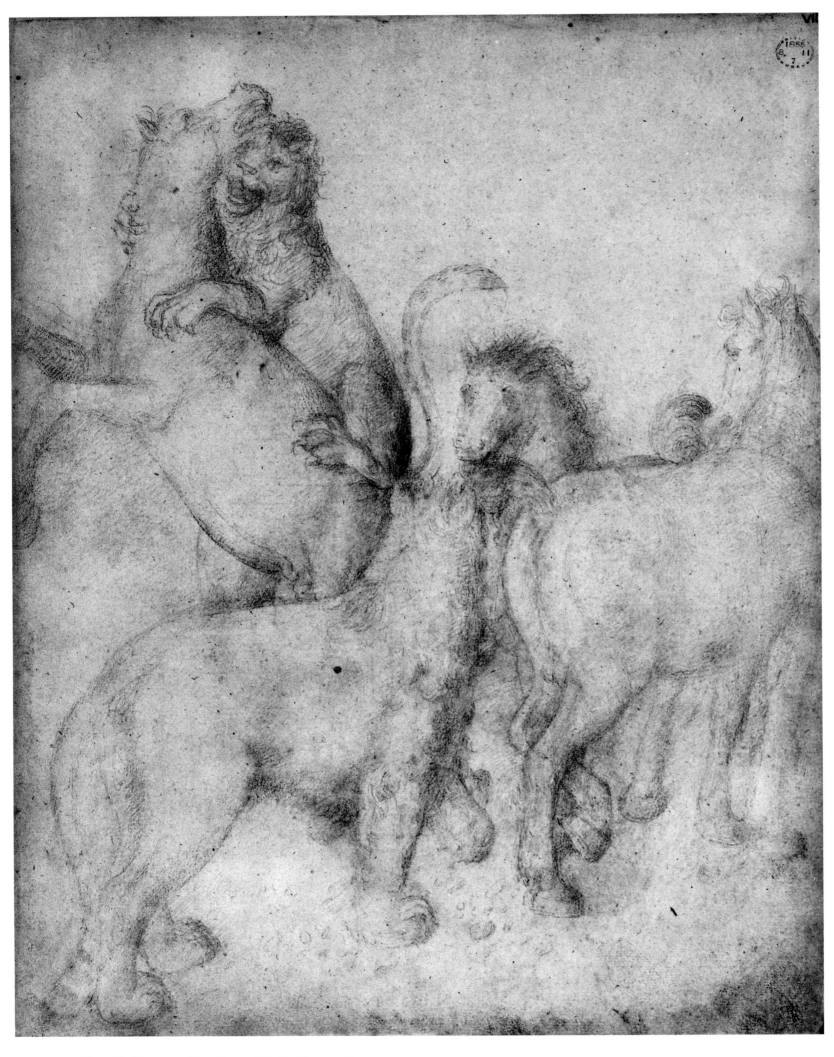

Plate 13. *Lions Attacking Horses*. British Museum 8

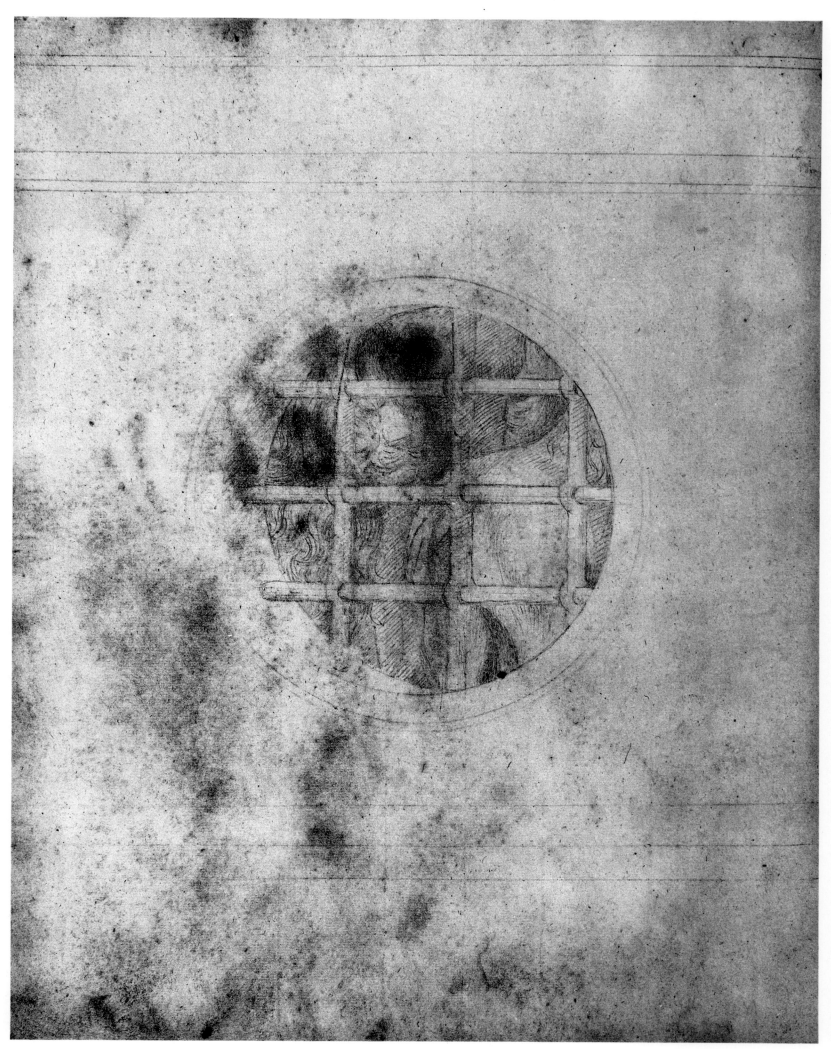

Plate 14. *Caged Lions Seen through Circular Grill* (faces *Man Wrestling Lion in Enclosure*, Plate 15). British Museum 8v

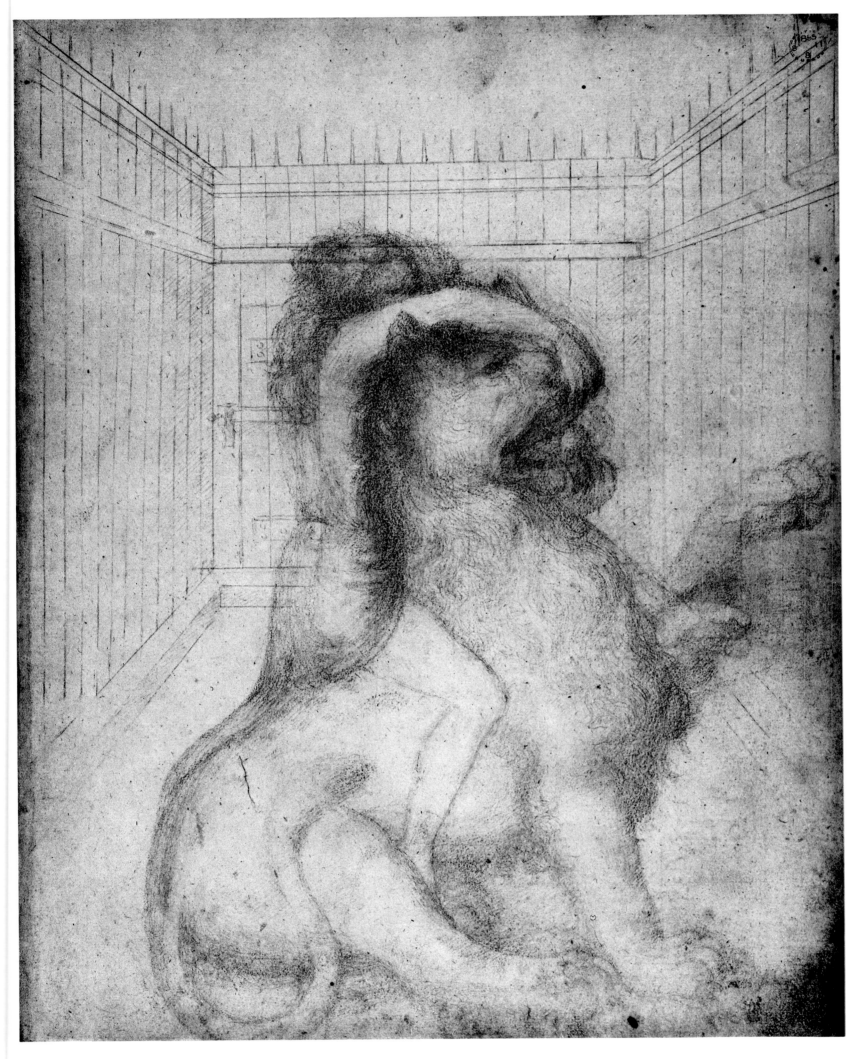

Plate 15. *Man Wrestling Lion in Enclosure*. British Museum 9

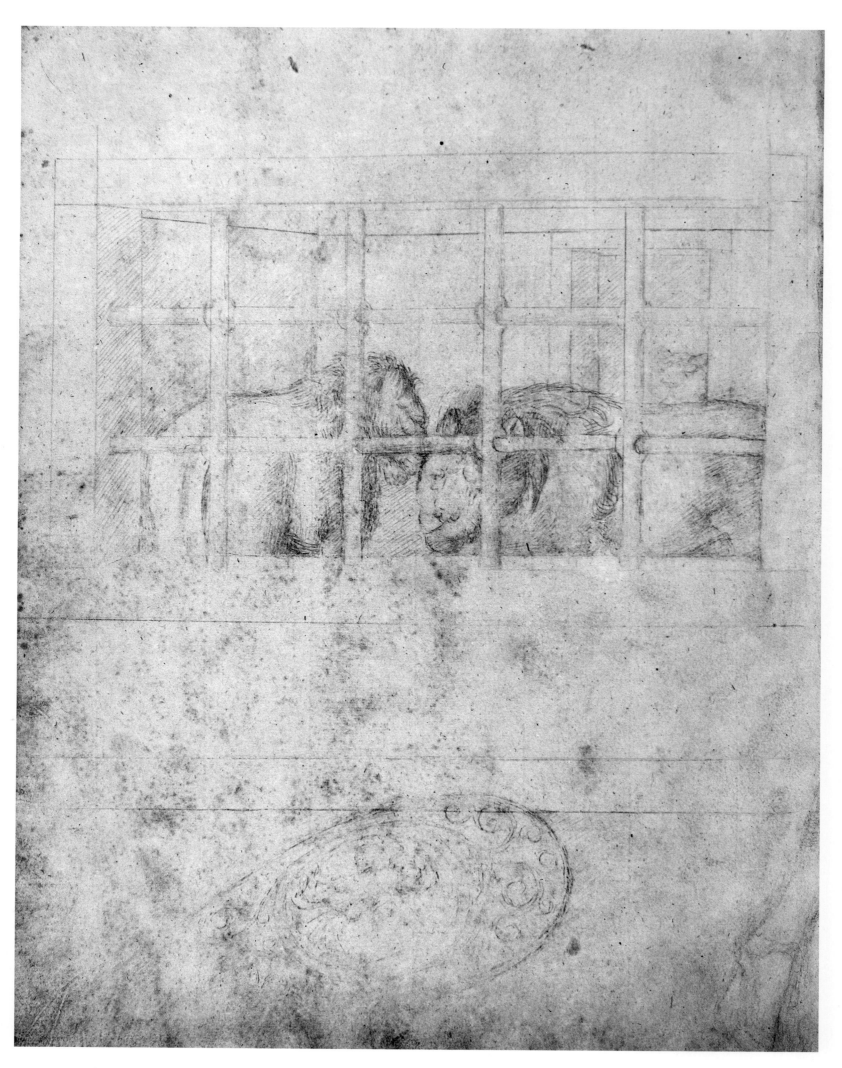

Plate 16. *Two Lions Seen through Rectangular Grill* (continuation of *Man Piercing Rearing Lion*, Plate 17). British Museum 20v

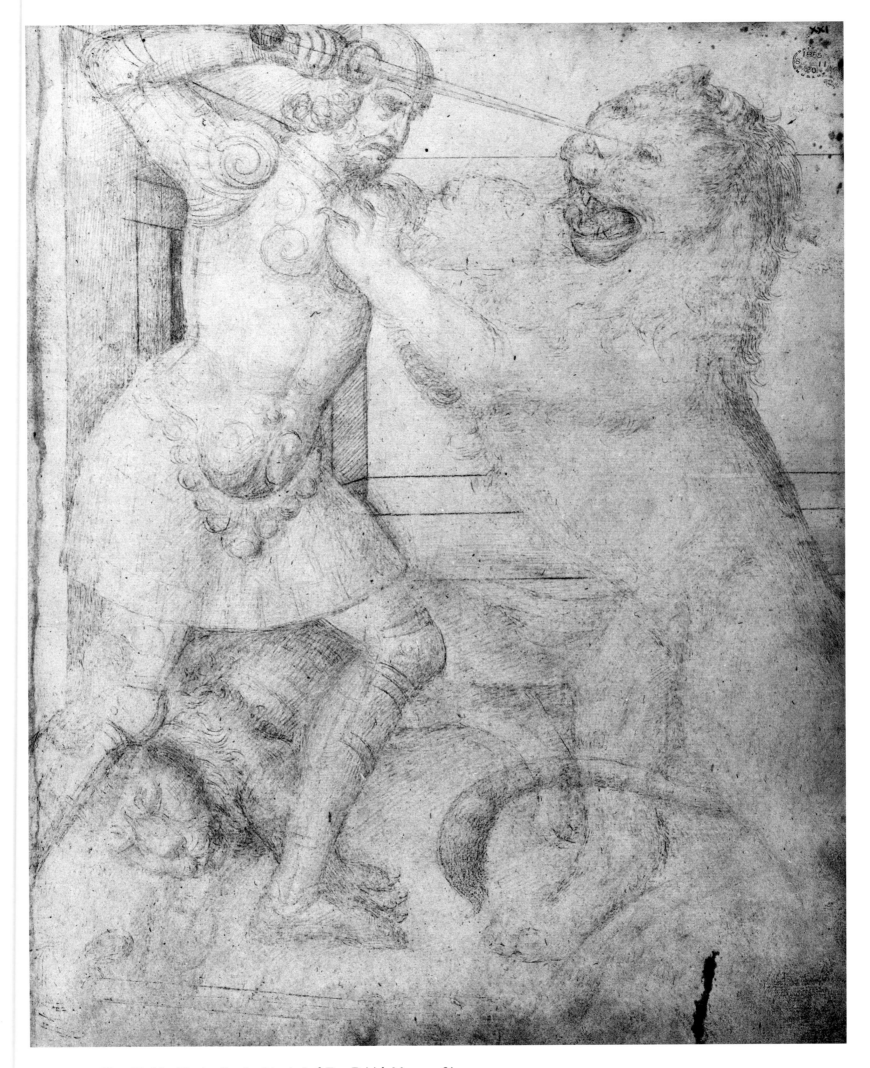

Plate 17. *Man Piercing Rearing Lion in Left Eye*. British Museum 21

19 One of these is bound into the otherwise parchment Paris Book, a *St. George and the Dragon* (Pl. 261). His other page is the *Funerary Procession of the Virgin* (Pl. 233). A third page, possibly drawn by Giovanni, is close in format to the London Book (Fig. 12).

20 The view of Ames-Lewis (1981, 4, 113, 128) favors finished drawings; Degenhart and Schmitt (1984) argue for the Books.

21 See Thuasne, *Gentile Bellini et le Sultan Mohammed II, Notes sur le séjour du peintre venitien à Constantinople*, Paris, 1888.

22 See De Ricci, 1923, 88–98.

23 Suggested by Tietze and Tietze-Conrat (1944) and Degenhart and Schmitt (1972).

24 Giovanni Maria Angiolello is a likely candidate. He was Mehmed's treasurer and his son's tutor. See Müntz, 1892, 274–90. See also F. Babinger, "Angiolello, G. M.," *Dizionario Biografico degli Italiani*, III, 275–78.

25 For Sasso and Strange, see F. Haskell, *Patrons and Painters*, New York: 1963, 373–74. Letters from Strange to Sasso are in the Epistolario Moschini, Biblioteca Correr, Venice. For the provenance of the Paris Book, see Cicogna (1857, 757–58), Testi (1908, 189 f.).

26 For the passage of books from Soranzo's library, see H. Wellesley's Preface (vi–xiv, esp. vii) to A. Mortara, *Catalogo dei manoscritti italiani che sotto le denominazioni di codici . . .*, Oxford: 1864. A partial three-volume catalogue of Soranzo's holdings, prepared by successive librarians, is now in the Biblioteca Marciana (Ms. ital. X. 137–39, colloc. 6568–6570): Jacopo's Book was No. 431. For the Soranzo Library, see also G. Moschini, *Della letteratura veneziana del secolo XVIII fino a nostri giorni*, Venice: 1806, II, 59–60; III, 279.

Strangely, Jacopo's studio effects went to his widow, Anna, mother of his painter sons Gentile and Niccolò, not to either of these legitimate male heirs. Jacopo's will is lost, but Anna's last will (Appendix E, Doc. Nov. 25, 1471), drawn up a few months after her husband's death, mentions "all" rather than "both" books of drawings; there may well have been a number of such gatherings, for certain basic religious subjects are absent from the Books: the Coronation of the Virgin, her Assumption, and several saints popular in Venice, such as Mark. Further clues to additional drawing books in the artist's estate are three extant drawings on paper different in type and larger in size than the London Book's.[19]

In addition to "omnes libros de dessigniis," Anna's will itemizes marbles and casts, along with "quadros dessignatos." The latter term suggests finished drawings, possibly framed, like those made by Andrea Mantegna, but some scholars believe it refers to the Books;[20] Perenzolo's drawings had been described long before as a "quadernum."

Gentile could have taken both Books, and possibly others, to Istanbul in 1479–80, when he was court artist to Mehmed II. As official painter of the Venetian Republic, he was invited by "The Conqueror" to make propagandistic images of that great ruler; he traveled to Istanbul with other Italians who prepared portrait medals and instructed the Turkish army in modern warfare.[21] During this visit Gentile probably gave or sold to his patron what is now the Louvre's Book. He also painted erotic images for the palace seraglio, possibly basing these on drawings in London's Book (Plates 69, 70). Paris' volume presumably remained in the seraglio library until 1677, then became the possession of a Smyrnese family.[22]

London's Book abounds in the sort of architectural "portraiture" that would preoccupy Venetian artists like Gentile Bellini and Carpaccio, who depended upon such drawings for their often vast and detailed canvases that tell their tales through compelling cinema-like projections of elaborate settings and ceremonies. Typical of these enormous pictures calling for extensive graphic consultation is *Saint Mark Preaching in Alexandria* (Milan, Brera), begun by Gentile for the Scuola di San Marco (to which he and Giovanni belonged). In 1507 Gentile, preparing his will in his last week of life (Appendix E, Doc. 1507), left to Giovanni their father's drawing book on condition that he complete the *Saint Mark* canvas. Giovanni may have welcomed the Book not only as a souvenir of his father's life and work, but as a way back to a perspective he had long since rejected, now needed to complete the scuola's panoramic canvas. Gentile's will also bequeathed to his apprentices "Roman" drawings of classical subjects, probably by Jacopo, since Gentile's art shows no interest in antiquity.[23]

If the book Gentile bequeathed to his brother was the one now in London, then some of its loveliest verso landscape pages could be Giovanni's own, drawn in the 1460s toward the end of his father's life or even later. Folios rendered in silverpoint rather than leadpoint, seemingly also by him, are in the Paris Book—including a young man in profile (Plate 1) and a statue of a Roman pugilist (Plate 67).

The earliest attempts to catalogue or identify each volume must have been made after the Books left the ownership of the artist's heirs; by then their origins or subjects had become less certain, requiring identification for purchasers. First to leave the family was the Book now in Paris. Shortly after Mehmed's death in 1481 an inventory of his possessions was doubtless made, a likely time also for the Book's first foliation and Index (Appendix C), with occasional errors that would not have happened in the artist's studio. These were probably the labors of a Venetian at the court of Mehmed II, since the Index still uses the Serenissima's spelling.[24]

The first Britisher to bid on London's Book may have been John Strange, given the title of English Resident, who was probably the unidentified Englishman known to have wanted to purchase it around 1800 from Bonetto Comiani; he was also a client of the major Venetian art dealer Giovanni Maria Sasso, the Book's next owner, whose death in 1803 ended any negotiations.[25]

Sasso had bought the Book for 30 *zecchini* in May 1802 from Bonetto Comiani, heir to Count Bonomo Algarotti, the older brother of Francesco Algarotti, famous and infamous as writer, collector, and secret agent. While in Algarotti's hands it was perhaps known to a scholar of Venetian art, Francesco Aglietto, also a distinguished physician and historian. Aglietto edited Francesco Algarotti's collected works but made no reference to Bellini as a draftsman until his eulogy of Jacopo and Giovanni Bellini was published in 1815. Bonomo Algarotti had supposedly acquired the Book from the executor of Bishop Marco Cornaro of Vicenza (d. 1779), who had bought it (along with many fine early works) from the great library of another Venetian aristocrat, Senator Jacopo Soranzo (1686–1761).[26]

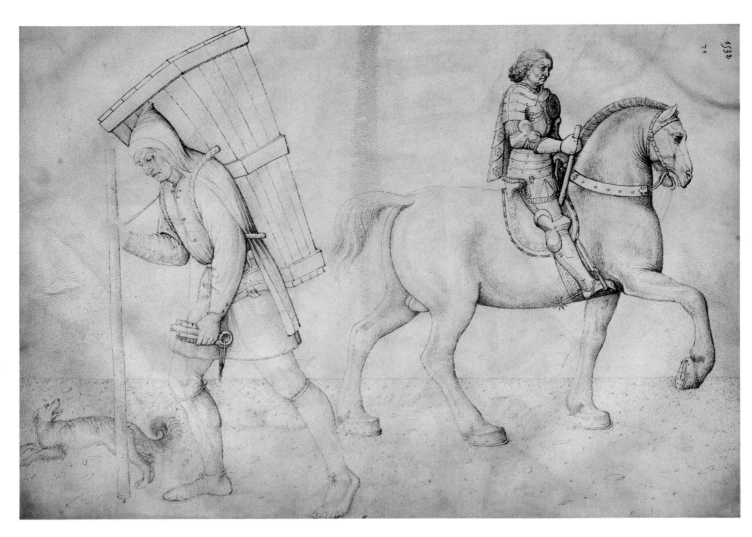

Plate 18. *Coal Bearer and Military Officer on Horseback*. Louvre 70

A letter by a Paduan scholar of about 1800[27] tells of "a series of drawings by Jacopo Bellini . . . a treasure. Abbot Morelli wants to buy it for the Library of San Marco. I don't know who owns it. The price is not exorbitant and is certainly less than the true value of the book which is on heavy white rag paper [*carta bambace*]. An English man [Strange?] wants to pay 80 *zecchini*. Nevertheless the owner demands 100; he might be persuaded to reduce it to 80 or possibly less. It displeases me that this codex should pass into other [i.e., foreign] hands."

In the great Venetian library which he directed, Abbot Morelli had just discovered an important anonymous manuscript, published in 1800 and named for him—the *Anonimo Morelliano*—until Marcantonio Michiel was identified in 1884 as its Paduan author. Prepared about 1530, this was a guide to the holdings of the major North Italian collections of the day. By studying it Morelli found that Sasso's book of Bellini drawings was then owned by a leading collector, Gabriele Vendramin. Sasso, for a projected *Venezia pittrice*, had Bellini's *Entombment* (Plate 216) engraved and fitted out with a fancy provenance from "the excellent Cornaro family of the Ca' Grande."

The Book was bought by Don Giovanni Mantovani from Sasso's executor, Giacomo della Lena; then, if not before, Aglietti saw it, and described and published Jacopo's drawings in 1815.[28] When Don Giovanni entered the Jesuit Order in 1816, he sold his codex for 60 *zecchini* to his brother, who in turn left it to his son, also named Giovanni Mantovani. The Book became internationally known in Johannes Gaye's long descriptive article for Dr. Schorn's *Kunstblatt* of 1840. Gaye believed in the date "1430" inscribed on the Book's first folio.

Soon an eccentric English resident of the Serenissima, Rawdon Lubbock "Doge" Brown, an agent for Britain's burgeoning museums, heard through a man named Visona that the Book was again available. Four hundred gold napoleons, delivered on February 11th, 1855, bought for the British Museum one of the world's two largest, finest collections of early Venetian renaissance drawings. Though Brown sold off many of the Serenissima's

27 The letter was sent to Tommaso degli Obizzi by F. Caldani (the first name probably Floriano), Paduan successor to his uncle Leopoldo Marcantonio Caldani, the great scientist. I am indebted to Dr. Albert Elen for calling this to my attention; first published by Lorenzoni, 1935, 6, n. 1. See Appendix A.

28 Aglietti, 1815.

greatest art works, he so loved the city that his will stipulated that his body be wrapped in her standard for burial. He also guided Ruskin around the "Stones of Venice," and the enormous success of Ruskin's book in 1851 must have encouraged the British Museum trustees to buy Bellini's four years later; many of Jacopo's pages celebrate the architecture so beloved by Ruskin and his readers. It was almost as though Britain, recently much rebuilt in the Venetian image, had readied herself to receive the Republic's graphic delineation.

Almost all that is known of the Paris Book prior to the Louvre's acquisition of it in 1884 comes from a letter sent in 1728 by a French agent—Guérin—to the librarian of Louis XV, the abbé Bignon, reporting that a resident of Smyrna owned a codex of remarkable beauty but refused to part with it at any price. Guérin then transcribed the Index, making up his own descriptions for the first twelve folios, illegible through water damage (Appendix A, Ill. 6). By listing all the drawings in order, Guérin's letter is a key document in reconstructing the Book's original condition before rebinding, as given here in Albert Elen's Appendix A.

The king's agent may have found himself bidding against Louis' ambassadors to Turkey—De Nointel and De Girardon, or De Villeneuve. Which of them succeeded in separating the manuscript from the lady of Smyrna is unknown. Within a few years of 1728 the Book probably came to France, where it underwent rebinding and the removal of at least seven folios. Four of these are still missing, probably taken out in the eighteenth or early nineteenth century; they showed, according to the Index, *Studies of Horses*, *Various Ships*, *A Setting with Doge Foscari and Others*, and a *Falling Horseman*.

Happily, the other three folios found their way to the Cabinet des Dessins of the Louvre even before the Book came there: the *Flagellation* (Plate 203), *The Three Living and the Three Dead* (Plate 135), and the *Effigy of a Nude Military Hero* (Plate 136), identified as Jacopo's in 1866 by Galichon for their correspondence to pages in the London Book. [29]

Nothing is known of the Louvre Book's whereabouts between Guérin's letter and the volume rediscovered in the attic of the château of Marquis de Sabran-Pontevès, whose family believed that a forebear had brought it back from Turkey in the eighteenth century. [30] With the Louvre's Book in eighteenth-century France, and London's brought to England in 1855, collectors and scholars had the widest array of pages from the early Venetian renaissance to examine, almost all that are yet known but for Pisanello's.

Unlike the Paris Book's exotic history, London's probably stayed in the artist's family until Giovanni's death in 1516. [31] His will is lost and the Book's whereabouts briefly unknown until Michiel recorded it in 1530 in the collection of Gabriele Vendramin. The mistakenly early date inscribed on its first folio may have been placed there in the interim (Appendix A, Ill. 10); penned in a notarial hand, it reads: "De mano de ms. iacobo bellini veneto 1430 in venetia"—"By the hand of Mr. Jacob Bellini the Venetian, in Venice, 1430." [32] The Book can be identified by Michiel's description: "El libro grande in carta bombasina de disegno de stil de piombo fu de man de Jacomo Bellino," "The large book of drawings in leadpoint on rag paper was from the hand of Jacopo Bellini." [33]

Heirs to a soap fortune, the Vendramin were among the city's powerful *parvenu* families (known as the *Case Nove* or the *Curti*, in contrast to the *Longhi*) whose status peaked with Andrea Vendramin's election as doge in 1476. His grandson Gabriele later formed the splendid collection linked with the family's name.

Belonging to the same Scuola di San Marco as Jacopo, Gabriele Vendramin may have had special interest in the London Book because so many of its religious scenes pertained to the artist's decorations for that society. The bachelor collector had Titian portray him along with his brother Andrea and the latter's six sons, all worshiping the scuola's most prized relic (National Gallery, London). Strangely enough, Titian's name was even written on the label formerly affixed to the spine of the Louvre's Book, doubtless inscribed when only the Venetian origin of its artist was known. [34]

The drawings specified in Gabriele's will of January 3rd, 1548 (drawn up four years before his death), were singled out for mention by Francesco Sansovino in 1565. [35] In 1540, Serlio praised Vendramin's knowledge of ancient architecture in a postscript to his *terzo libro*, "To the readers." [36] As architect and theorist, Serlio was closely concerned with scenographic perspective, and this topic could also have interested Vendramin, attracting him to the London Book. It must have fascinated him too for its abundant perspectival effects and the strength of its classical fantasies, his own collection famous for its antiquities.

29 The drawings went from the Lenoir collection to the His de la Salle collection. For their provenance, see Appendix A. Lenoir also possessed a self-portrait by Vittore Belliniano and another portrait by that artist, of his teacher, Giovanni Bellini (both drawings now at Chantilly, Musée Condé, 111 *bis* and 1135): E. Galichon and R. de Mas-Latrie, "Jacopo, Gentile et Giovanni Bellini; documents inédits," *Gazette des Beaux-Arts*, 20 (1866), 281–88, esp. 282.

30 De Ricci (1923, 92–93), who studied the matter in great detail, suggested that the marquis' family might have received it from the descendants of Marquis de Villeneuve, French ambassador to Istanbul in 1730.

31 For the provenance of the London Book, see Cicogna (1853, 756–58), Vasari-Milanesi (III, 176, n. 2), Ricci (I, 1908, 42), Testi (II, 1915, 188–89), and Sutton (1979, 364–73). Dr. Elen kindly communicated the last reference as well as the most important article, by A. Lorenzoni (1935).

32 Goloubew (1912, I, Introduction) compared the inscription with the handwritings of Giovanni and Gentile to show that neither could have written it. He suggested a date in the late 15th century. The odd emphasis on Venice in the inscription suggests that the line might have been penned outside the Veneto, where the artist's residence would not be so well known.

33 See Michiel, ed. Frizzoni, 1884, 222.

34 This was removed and lost when the binding was restored. See Appendix A.

35 Sansovino, 1565, 21. Cited by J. Anderson, "A further inventory of Gabriel Vendramin's," *Burlington Magazine*, 121, 1979, 639–48, esp. 640, n. 9.

36 Anderson, 1979, 639, n. 4.

Vendramin bequeathed his treasures to his nephews, enjoining them to keep it intact, [37] but Luca, the eldest, soon began to sell some of his uncle's antique coins and drawings secretly to local dealers. His "younger brothers instituted legal proceedings against him and demanded that an inventory should be made of the collection, as their uncle Gabriel had instructed in his will, . . ." so that his paintings could be sold. [38] The bulk of Gabriele Vendramin's paintings and antiquities left Venice in the seventeenth century as part of a complicated sale to the Reynst brothers of Amsterdam. A small *Venus pudica* and a female allegory of *Abundance*, very like figures drawn in Jacopo's Books, are among the marbles illustrated in the Reynst catalogue; both may have belonged to Jacopo. [39]

But the London volume left the Vendramin collection at an unknown date. Leading candidates for its subsequent ownership are, first, the last duke of Mantua, Ferdinando I Gonzaga, who died in Paduan exile in 1708 (his ancestor had considered buying the faded Venetian view drawn by Bellini). [40] Much of the duke's library went to the great Venetian bibliophile Giambattista Recanati (1687–1734), and many of Recanati's finest books later entered the famous library of another of the Serenissima's patricians, Senator Jacopo Soranzo. [41] Soranzo surely owned the London Book, for Marco Cornaro, the future bishop (d. 1779), purchased it from him.

So ends the tale of the London Book's provenance before it went to Bonomo Algarotti after 1779. The rest is art history!

## BOTH BOOKS COMPARED: STYLE AND SPIRIT

The Books' variations spring from different aspects of renaissance discovery rather than from differences in time; some of the most conservative leaves of the Paris Book postdate the markedly modern character of the London Book's (apart from its verso pages). The merchants of Venice often followed those of Florence in pursuing a Gothic fairy-tale world, with no Grimm in its spinning.

So, the old-fashioned look of many pages in the Paris Book does not mean that the whole was earlier than London's. Aristocratic nostalgia for the good old, bad old, days was a powerful element in the art of Florence and Venice during the later years of their alliance. Ever more romantic, escapist, and conservative in mood, the bankers on the Arno now had little use for the challenging, innovative art so evident earlier in fifteenth-century Florence. Abandoning the deceptively austere life style of their plain-speaking (if not -acting) forebears, the Medici came to see themselves as North Italian princelings, surrounded by Arthurian trappings that linked their lineage to the bluest of British, German, or French blood. Bellini's Ferrarese patrons, the Este, saw themselves in the same romantic light.

The Paris volume has much of the exquisite intricacy of an *objet de vertu* that never ceases to amaze and delight. Its closest student was, appropriately, a Russian prince, Victor Goloubew, who described the very parchment as like that used by scribes in the service of kings and great lords. The sense of small-scale exploration in many of its images is still close to lavish manuscript illuminations. As if seen through the wrong end of a telescope, some of the Paris folios satisfied the same clientele that would later sponsor Fabergé or the *bonsai* craft, magically smaller than life. The world seems fitted into a graphic *Wunderkammer*, reduced by enchanted cartography—and map making was possibly another of the artist's concerns (see Appendix F).

Formulating the tried if not always true, the Louvre Book cherishes the conventional wisdom of the panorama and revels in chivalric narrative. A courtly patron seems to look over the artist's shoulder as he drafts these decorative, decorous folios, many close to a *divertissement*, a Passion play, or a Book of Hours, and all devised to suit a privileged perspective. The variety of tints and inkings in the Paris Book, the greater range of its subjects, and its festive appearance project a richer sense of spectacle than London's.

Yet in sharpest contrast to these contrived, romantic elements, the Paris Book also includes one vividly tinted study from nature—the *Iris* (Plate 2)—and a closely watched portrait in profile (Plate 1), as well as a responsive, discerning rendering of ancient statuary that is without precedent (Plate 67), very different from the more fanciful antiquities found elsewhere in the volume. An easy and probably correct explanation is to assign these inconsistent pages to another hand, possibly Giovanni's.

37 See A. Logan, *The "Cabinet" of the Brothers Gerard and Jan Reynst*, Amsterdam: 1979. See also Anderson, 1979.

38 Anderson, 1979, 641. She points out that this inventory, rather than protecting the works of art or their sale *en bloc*, simply led to the illegal sale and piecemeal export of items from the collection.

39 Jacopo used the *pudica* pose for his *Eve* in the Book that Vendramin owned (Pl. 143). Many of the facades embellished with antique sculptural elements in the Paris Book include statuettes similar to the *Abundance*.

40 An inventory of his sale, drawn up in 1709, is in the Archivio di Stato, Verona, Ms. 609; an exact copy is in Mantua (Gonzaga busta 400). See Fehl, 1985, 128, n. 51.

41 See above, n. 26.

42 See Oertel, 1977, 348 f.

43 The first list below includes, in their order of appearance, the nine major compositions drawn over two pages in the Louvre Book. "H" indicates a horizontal, "V" a vertical use of the Book's opened pages: *Feast of Herod and Beheading of St. John the Baptist* (V; Pls. 284/285). L. 16v, 17.
*Christ among the Doctors* (V; Pls. 181/182). L. 17v, 18.
*Annunciation* (V; Pls. 164/165). L. 30v, 31.
*Vision of St. Eustace* (V; Pls. 251/252). L. 41v, 42.
*Classical Scene: Soldiers and Peasant; Destruction of Pagan Altar by Roman Soldiers* (H; Pls. 90, 91). L. 46v, 47.
*Martyrdom of St. Isidore* (V; Pls. 270/271). L. 49v, 50.
*Venetian Wooden Balcony; Falling Horseman,* missing scene below (V; Pl. 58). L. 50v, 51.
*The Three Crosses and Sarcophagus Lid; Lamentation* (H; Pls. 217/218). L. 57v, 58.
*Susanna and the Elders before Daniel* (V; Pls. 155/156). L. 92v, 93.

The second list below is adapted from Joost-Gaugier (1975, 10, n. 13), who stresses (1973, 240, n. 16) that each scene "has its own implied or explicit perspective." Unrelated drawings on facing pages in the British Museum Book include the following openings ("a" indicates recto, "b" verso):

*Monument with Eagle on Orb, Reclining Male Figure below* (Pl. 81); *Satyr Riding Winged Unicorn Bearing Corpse* (Pl. 79). B.M. 3b; 4a(?)
*Two Men in Semi-classical Garb (?) Standing on Bridge over Canal* (Pl. 23); *A Falconer, Coal Carrier, and Gardener* (Pl. 22). B.M. 13b; 14a.
*Study for Equestrian Monument* (Pl. 131); *Study for Altar* (Pl. 240). B.M. 27b; 28a.
*Rider and Standing Figures by Corpse* (Pl. 129); *Throne of Grace* (Pl. 238). B.M. 55b; 56a.
*Wingless Putti at the Vintage* (Pl. 73); *Adoration of the Magi* (B) (Pl. 173). B.M. 59b; 60a.
*Polygonal Temple* (Pl. 64); *Annunciation* (B) (Pl. 163). B.M. 75b; 76a.
*Three-tiered Funerary Monument* (Pl. 132); *St. John the Baptist Preaching* (Pl. 280). B.M. 79b, 80a.
*Bernardino of Siena Preaching* (A) (Pl. 242): *Flagellation* (D) (Pl. 198). B.M. 80b; 81a.

*(continued on following page)*

Required to "think big" as well as "small," most artists before the later renaissance, especially those with the richest patrons, had to encompass the monumental manner as well as the miniature, to be ready to move from designing in the sumptuary arts—jewelry, embroidery, costumes, and tableware—to over-life-size figures in fresco or tapestry. So the differences within and between the Books represent the parameters of the artist's patronage and reflect the major and minor modes of the painter's profession. In the precious parchment folios a sampler and a survey are combined, cosmic vistas of the International Style with intimations of the new harmony between Gothic devotion and the classical order, a congruence to be established securely in the generation of the artist's son-in-law, Mantegna.

London's Book bespeaks many of the basic breakthroughs of the heroic phase of the early Florentine renaissance from the 1410s and '20s, sharing some of the stoical, monumental perspectives of a Brunelleschi, a young Donatello, or Uccello. Its pages often proclaim a radical economy, audacity, and modernity, an almost Cubist sense of the absolute, a timeless directness. This breadth of spirit, reappearing in Castagno, is seen also in Piero della Francesca and Mantegna, the painters whose work matured in the late 1440s and '50s, influenced by Jacopo's art as well as that of Tuscany. [42]

But for a few attempts at restoration, the British volume retains the faded yet still silvery gray strokes of its leadpoint, now brought to the surface in Alexander Findlay's infrared photography. The volume proves equal if not superior to the Louvre's for its forceful confrontation, attaining a newly intense understanding and unrivaled exploration of land- and cityscape. The Paris Book, in contrast, presents a last hurrah of courtly triumph, a final flowering of mystical recitation and experience, and a souvenir guide to chivalry, different from the bolder intimacy of the British Museum's.

Few of the Louvre's folios rival London's friezelike equestrian parades and the sense of scrutiny that so many of its figure studies afford. Motion as well as emotion was first closely analyzed in the British Book's paper pages, the results of such study often translated to the Paris parchment in scenes of leaping horses and sudden, sometimes tragic, encounters (Plates 105/106, 121/122).

Facing folios form major two-page spreads in only nine openings of the Paris Book, making it the more monocular of the two; its one-point perspective is more inviting than the wide screen of London's, where all but nine of the many paired pages show boxier, more obviously spatially unified views. Most of these were first drawn on the right page as independent vertical compositions, then expanded onto the left facing page, opening up the narrower compositions into horizontal vistas. For all its bolder, broader look, the London Book is fully as concerned with complex foreshortening and accomplished perspectival construction. [43]

The style of many of the facing left pages in London is more spontaneous, expansive, and luminous than in the right pages. When were these remarkably innovative left pages worked? Some scholars believe that those on the right were drawn first, all the way through to the end of the Book, and then the facing blank verso pages were drawn in similar order. But how much later? Did this second step take place as soon as the right pages were filled up, as Röthlisberger suggests? Or after an interval of years, not months? These questions have no sure answers, yet a considerable delay in drawing some of the left pages would help to explain their striking stylistic divergences. Alternatively, the most progressive verso pages could be attributed to the artist's most gifted son, Giovanni, and the more planar views to Gentile Bellini, or to apprentices.

Where some of the classical elements in the Louvre volume are steeped in Gothic chivalry or marked by romantic, quixotic antiquarianism (Plates 84, 86), those in London's have a passionate immediacy, a confident identification with the classical experience, and a fervor never before seen in northern Italian art. The Veneto had long employed ancient themes as erudite propaganda, part of her Paduan heritage, but liberated images like Bellini's satyrs (Plate 76) are unprecedented. Antiquity becomes *now* in London's *all'antica* pages, drafted with unrivaled empathy and directness (Plate 79).

Jacopo's two *Presentations of Christ in the Temple*, one in each Book (Plate 178, London; Plate 179, Paris), illustrate the volumes' contrasting goals and styles. The Paris scene, wildly spired, stresses the festive and the celebratory, a sacred fantasy so proclaimed by the swag with fluttering ribbons across the top. An architectural caprice is this imaginary combination of a roadside shrine, a baptistery, and the Pantheon, a happily improvised synthesis typifying the pageant master's craft, drawing on the most decorative effects of Donatello, Michelozzo, and Alberti.

The *Presentation* in the Louvre's Book, like so many of its pages, abounds in distant vistas, amorous settings, and enchanting detail, quoting animals from earlier pattern

books. Precociously, it encompasses classical sources in the *Spinario*-like little boy (seen again in the *Saint John Preaching*; Plate 282), based on Italy's most popular antiquity, a Roman life-size bronze figure. In the background Venus rises atop a column above a fountain basin ringed with nude male statues, its antiquarianism going beyond the temple's adroit design, following decorative Florentine sources. The fountains in the London Book seem much nearer (Plates 26, 51), more for an artist's instruction than a viewer's delectation. The sophistication of this Paris page is close to the idyls of Giovanni Bellini and Giorgione, and in no sense "early"; equally conversant with nature and with classical antiquity, the artist is at the peak of his career.

The broader, bluffer rendering of London's *Presentation* differs in almost every way. Like most of the drawings in this volume, especially the recto pages, it seems drafted toward practical, collective needs rather than individual fancy. Rational and immediate, it has no "once upon a time" quality; the leadpoint drawing is made for the comfortably off, not the fabulously wealthy.

The Venetian church in this *Presentation* looks contemporary, in the transitional style. Its pulpits, probably originally on the exterior, have been brought inside. Unlike the exposed, extravagant pavilion in Paris, this church façade has been cut away to reveal a large, stagelike interior which, with slight changes, could be used for any biblical subject taking place in a temple; the nude athletic statues make this Solomon's Temple as defiled by Roman occupation.

In the London Book's biblical scenes, space is the primary framework and scaffolding: buildings first, people second. Bellini builds up the perspective with leadpoint two-by-fours, lined up or nailed in place before anything else can happen. This is the sequence in two facing pages that show a cherubic *Vintage* (Plate 73) and an *Adoration of the Magi* (Plate 139). On the verso, in an airy boxlike arbor where staves support the vines, wingless *erotes* pick their ecstatic crop while others trample the vintage below. On the recto, in the *Adoration*, a different festival of love takes place in the holy family's vast, church-size stable that presents some of the same spatial challenge as the *Vintage*'s. A large ox near the center of the *Vintage* introduces the remote possibility that the drawing was begun as a Nativity.

In another pair of facing pages (Plates 64, 163), the centrally planned temple and facing *Annunciation*, though the structures are less similar, may have to do with a projected Life of the Virgin cycle, but the two have no complex, deliberately symbolic relationship, as some critics have suggested.[44]

The Louvre's parchment folios are the first sails toward the Venetian picturesque, anticipating the spirit of the rococo. Bellini's eye for the telling angle and persuasive detail created a new vision, the city as urban landscape, where architectural contrivance and control become as compelling as any force of nature. Each of the Books, regardless of the precise date and authorship of every page, is a key to the double-locked door of the early Venetian renaissance.

## THE NATURE OF THE BOOKS: STRUCTURE, DATE, TECHNIQUE

Time has exaggerated the differences between Bellini's Books, strikingly alike in their variety of subjects and uniquely large format, and each, as Elen shows in Appendix A, composed of about a hundred folios. Initially such correspondences were even more apparent, before London's drawings faded and the additions were made to the Paris pages.

The major physical factor separating the two is their support; of the finest parchment, the Paris volume required the slaughter of an entire herd of goats, some fifty according to Elen's calculations. The London Book's pages on a less expensive support—paper—were also of very considerable cost, and of splendid quality. Elen estimates that the beautiful, heavy, white rag paper was probably a special order, made in the mill at one time. Its watermark was first used in the early 1440s.

The descriptive Index that was added to the Paris Book names some of the media as metalpoint and silverpoint, specifying eighteen folios solely in silverpoint. London's Book, if it is the one itemized as from "our father" in Gentile's will of 1507, is described in the Vendramin collection in 1530 as drawn by Jacopo in leadpoint on "carta bombasina"—the Venetian term for heavy cotton rag paper.

Interest grew in the Books' graphic techniques and condition after the Paris volume was purchased in 1884, with its numerous media: inks in several shades, gouache, tinted

*Altar with Candlestick* (Pl. 80); *Rearing Equestrian Group on Base* (Pl. 78). B.M. 81b; 82a.
*Bernardino of Siena Preaching* (B) (Pl. 243); *Funerary Monument with Crucifixion* (Pl. 137). B.M. 82b; 83a.
*Forge with Anchor* (Pl. 56); *Temple of Jerusalem(?)* (Pl. 161). B.M. 83b; 84a.
*Young Cavalier with Baton and Attendant* (Pl. 93); *Church with Open Façade* (A) (Pl. 62). B.M. 84b; 85a.
*St. Jerome Reading in the Wilderness* (Pl. 272); *Twelve Apostles* (A) (Pl. 235). B.M. 87b; 88a.
*Barn* (Pl. 164); *Church with Open Façade* (B) (Pl. 61). B.M. 88b; 89a.
*Deer and Putti* (Pl. 74); *Church with Open Façade* (C) and Pallbearers (Pl. 128). B.M. 90b; 91a.
*Twelve Apostles* (Pl. 239); *Veduta with Boys Bathing on Float in Canal* (Pl. 53). B.M. 91b; 92a.
*Cheetah Studies* (Pl. 4); *Venetian Gothic Palace* (Pl. 52). B.M. 92b; 93a.
*Four Adults* (Pl. 21); *Triumphal Wagon in Urban Setting* (Pl. 124). B.M. 94b; 95a.
*Three Military Figures* (Pl. 123); *St. John the Baptist Preaching in a Courtyard* (Pl. 281). B.M. 95b; 96a.

Elen adds four more pairs of unrelated drawings to the above list:

*Landscape with Covered Wagon* (Pl. 41); *Presentation of the Virgin in the Temple* (B) (Pl. 160). B.M. 67b; 68a.
Joost-Gaugier (1975, 10 f., n. 14) lists these two drawings as perspectively related, at least to some degree. Despite a similarity in the figure scale, the two drawings—one with an architectural setting on the picture plane, the other with a diagonally receding landscape setting—seem spatially unrelated, as Elen suggests.
*Crucifixion* (C) (Pl. 210); *Virgin Mary in a Mandorla* (Pl. 236). B.M. 86b; 87a.
*Palace Zoo* (Pl. 3); *Flagellation* (E) (Pl. 201). B.M. 89b; 90a.
*Drunken Silenus and Attendants* (Pl. 7); *City Walls with Well* (Pl. 45). B.M. 97b; 98a.

Joost-Gaugier (1975, 10 f., n. 14) lists nine pairs of drawings in the London Book as "related only from a (often partial) perspectival point of view," noting that their close proximity may support Röthlisberger's view that the
*(continued on following page)*

44 See Gilbert, 1952; Moffitt, 1982.

45 Cennino Cennini, 1954, 8.

46 Testi, 1908, 229.

47 This was suggested by Tietze and Tietze-Conrat, 1944, 107.

48 Simon, 1936; Degenhart and Schmitt, 1985.

49 Trans. from Fossi Todorow, 1966, cat. no. 393, pl. CXXII, 184.

50 See Fossi Todorow, 1966, 140.

washes, pen and brush, metalpoints, and one page in watercolor (Plate 2); many leaves of the bound-in pattern book, grounded with different colors, added to the sense of experiment and craft.

For almost a century scholars have tried to determine how the work of drawing was done. In his *Craftsman's Handbook*, written in Padua early in the fifteenth century, Cennino Cennini urged the artist to begin by working in silverpoint, and then, "when you have put in a year, more or less, at this exercise . . . draw on paper with a pen."[45] London's Book, but for some restoration, remains in its initial leadpoint, and Paris' was probably first drawn in silverpoint, leadpoint, and other media, later reworked in pen. Recent special photography of the Louvre Book has revealed this preparatory silverpoint on a few pages (Plate 188). Testi, writing of the volume in the early 1900s, was the first to record various waxy chalklike strokes beneath several of the folios' penned lines,[46] and proposed that the whole Book was initially sketched out with these broader, freely rendered passages. Set down in a temporary, fugitive medium with low powers of adherence, the first outlines faded or blurred, necessitating reworking in pen. One Paris page (Plate 6) shows how drawing in a chalky medium appeared before "relining"; a verso, it escaped inking, overlooked by the restorer.

Testi pointed out that the pages' penwork was a routine studio operation done by apprentices. A key text supporting his view of the Paris Book's early graphic reinforcement is a letter written in 1493 by the Mantuan representative in the Venetian Republic to his employer, Francesco Gonzaga: "I talked with master Gentile Bellini about the view of Venice. He replied that he had one made by his father and offered it to me. Because it is old and therefore impossible to decipher, he tells me that it must be reworked in pen and this task will take two months at least. He begs Your Excellency to inform him if you wish to have the view so that he may have the work begun at once" (Appendix E, Doc. 1493). By then neither of the artist's sons was taking time from his own activities for this almost mechanical work.

The late 1470s or early '80s is the logical period for the Louvre volume's penned "relining," when Gentile probably had it with him in Istanbul; he resided there in 1479–80, with two Venetian assistants, and the Book presumably entered Sultan Mehmed's ownership when he left.[47] The sultan's well-known interest in western history and culture suggests that the Book's chivalric content would have pleased him. Writing in the 1910s and mid-1930s, scholars in Austria and Germany suggested that the Paris Book was begun as early as the 1420s or '30s (a thesis recently revived by Degenhart and Schmitt);[48] its pages could have faded in five decades, ready for restoration in Mehmed's seraglio library.

In a drawing of *Three Lions* in the Codex Vallardi (Paris, Louvre; Fig. 6), close in style to Jacopo's, as noted by Fossi Todorow, early inking can be detected over a first, more expressive rendering in an unstable graphic medium. She observed, "The two lions below have been gone over in pen in mechanical fashion, so that the original design in black hematite could be readily understood . . . the lion at the top, also in black hematite, was not gone over, [and] the outline is much faded and almost illegible."[49] Such graphic reinforcement, as in the Red Album from the Pisanello circle,[50] is often found in fifteenth-century drawings.

Inked over in at least five different graphic styles or levels of competence, the Louvre volume must have been reworked by several hands. Among the best of these is the readily recognizable artist who uses a clear, fluid stroke, calm despite its flourishes. This "reliner" is responsive to light and order in his rational, yet decorative approach. Patiently he retraces (or occasionally adds?) many small classical and other details with remarkable refinement. Typical of his penning is the *Flagellation* (Plate 203) and the centrally planned temple seen by torchlight (Plate 92); several of his best pages include touches of wash (Plate 209).

A second "reliner," interested in more developed graphism, uses dots in *pointilliste* fashion together with very fine hatching for further illusionistic effect in the *Martyrdom of Saint Isidore* (Plates 270/271) and the *Entry of Christ into Jerusalem* (Plate 191). Yet even a conscientious craftsperson can err, confusing Saint Christopher's buttons with his belly button (Plate 246)! An attempt to add color in tempera to another *Saint Christopher* page (Plate 247) was wisely abandoned after blueing the sky. The same restorer inked the beautiful page of the *Nativity* without understanding the thatching on the hut, turning the straw ends into rigid slabs (Plate 170).

Most powerfully individualized is the inking done by an artist who works in short, slashing, expressionistic lines, almost like those of Dutch seventeenth-century graphism, as in the *Leaving Jerusalem for Calvary* and the *Nailing to the Cross* (Plates 140, 141).

Some pages were prepared in separate campaigns, less as restoration than as addition

and often different in mood and esthetic. A superior example of these eloquent second thoughts may be seen in the contrast between the initial drafting of the desiccated professor's cadaver and the almost impossibly detailed relief later penned on the tomb added below (Plate 134). Another contrast of the monumental with the decoratively calligraphed is between the warm-toned silverpoint *Dead Christ* (Plate 219) and its discordant yet handsome cornice and frame, alternatively patterned on left and right. The *Mater Omnium* and *Saint John the Baptist* (Plates 138, 283) also have such additions at the sides.

The graphism takes such divergent forms on some pages that two different restorers must have worked on them. The *Martyrdom of Saint Sebastian* (Plate 296) combines caricatured faces, feebly inked, with far superior pen drawing. Some scholars have associated this page with Crivelli or the young Giovanni Bellini, but its graphic "style" is more inept than individual. The absence of the bowmen's heads at the left, like that of Saint Michael's features (Plate 290), indicates that these features were then still visible, and needed no inking.[51]

In one of Giovanni Bellini's early paintings, *Saint Jerome and the Lion* (Birmingham, England, Barber Institute), the beast is clearly modeled on a Paris page (Plate 6),[52] documenting the son's access to the father's parchment Book.

Probably Giovanni and Gentile felt keen concern for the volumes not only as a treasured heritage, but for the drawings they had both contributed to them. The most advanced of London's verso pages could come from Giovanni's hand, along with Paris' male profile and Roman pugilist (Plates 1, 67), among other pages. The *Saint George* (Plate 261) inserted on paper in the parchment Book may also be his. At least one of the Paris Book's pages bespeaks Gentile's perspective: a view of *Calvary* (Plate 218) brushed in an abbreviated manner utterly alien to Jacopo's graphism, though some scholars still believe it to be his.[53] Another Paris page of a city square (Plate 59), with some odd Goldoni-like characters seen from the back (probably added later), could also be Gentile's. Literally and metaphorically a fine line separates the works of the father from those of the sons, with little certainty as to which one did what, and where, and when.

Originally the bindings of both Books could have been similar, perhaps like others kept in Jacopo's studio. The first binding for the Paris Book is lost, replaced by old boards shown by Elen to be taken from another, larger book (Appendix A, Ills. 8, 9). Thirteen or so of the Louvre's folios were removed; of these, three have survived (also at the Cabinet des Dessins), three are missing, and seven were misbound.

The early sixteenth-century leather binding of London's Book is now set within a larger cover (Appendix A, Ills. 5, 6) to accommodate its increased size, the museum having placed the pages within larger sheets late in the nineteenth century. Except for the faded leadpoint lines and a few clumsy, early attempts to add ink and wash to its pages, the British Book remains much the same as it was in Bellini's studio. Surprisingly, after it was published by Gaye in 1840, critics found it extensively reworked during two campaigns in the sixteenth and eighteenth centuries; restorations seen throughout were supposed to be so drastic as almost to obscure Jacopo's original graphism.[54] Recent infrared photography, however, shows the pages to be extremely well preserved. As noted by Elen (Appendix A), these "overdrawings" and "retouches" are Jacopo's own handling of the leadpoint stylus.

In both Books the inking is sometimes so heavy that it has gone through the page, casting shadow-like forms on the Paris versos and disturbing linear intrusions on London's. It is unlikely that any artist would make such disfiguring "improvements" to his own work. The London *Lions* (Plates 8, 9) have been partially inked, with wash added. *David and Goliath* (Plate 145), too, was crudely strengthened, but the restorer (unlike the young biblical hero) lost his nerve, dropping his pen before much damage was done.

A dramatic example of the fine "before" and dismal "after" in the fifteenth-century redrawing can be seen in the London Book in two double folios having the same subject— knights in combat with a dragon. When strengthened solely by reproduction from the infrared photographs, one pair (Plates 103/104) has all the splendor of an oriental screen or scroll, its swirling leadpoint lines powerfully assured. In the other (Plates 99/100), monotony sets in with the mechanically repetitive inking. The penning of the little Giacometti-like figures at the left has nothing to do with Jacopo's manner, nor does the schematized rendering of the trees on the right. Crude use of a ruler on the facing folio shows this to be the work of a novice; his "restoration" is based on the hatching in Mantegnesque engravings. The graphic formulas which contributed to the circulation of prints by Jacopo's son-in-law have now boomeranged, destroying his own.[55]

The first scholarly consideration of the London Book concerns the early inscription on folio 1 with the year "1430" added in a notarial hand (Appendix A, Ill. 1). Seemingly

51 This explanation for the puzzling omissions was given by Tietze and Tietze-Conrat, 1944, 113.

52 Noted by Robertson, 1968, 15.

53 Degenhart and Schmitt (1984, 20) believe this page to be Jacopo's, inserted at a later date.

54 Gaye was the first to note the "reworking," accepted by Goloubew (I, 1912) and Tietze and Tietze-Conrat (1944). Röthlisberger too found in it extensive retouching, in contrast with what he viewed as the pristine state of the Paris Book (1956, 359).

55 Very poor inking is found in London's scene of military triumph (Pl. 124), so heavy that the lines have gone through to the verso (Pl. 123). Other monuments to military strength have also been partially, mistakenly inked, a severed head being converted into a putto's (Pl. 78). On the two-page Paris *Annunciation* (Pl. 165) is a shadow from the back, as on the *Judgment of Solomon* (Pl. 154) and many other folios.

56 Kristeller, 1901, 32.

57 Adolfo Venturi, 1911, dated one of the Louvre Book's pages in the last decade of Jacopo's life, stressing the influence of Donatello's Santo reliefs in Padua. See also L Venturi, 1907.

58 Pächt, 1941, 85–102

59 Fröhlich-Bum, 1916.

60 J. Meder, *Die Handzeichnung: ihre Technik und Entwicklung,* Vienna: 1919, 170. His phrase is "Bücher im Ganze," "complete books."

61 Antal, 1925, 21, n. 1.

62 Simon, 1936.

63 Tietze and Tietze-Conrat, 1944, I, 110. Their plate numbers have been changed below to conform with those in this book.

On the basis of their studies we make an attempt to group their drawings as follows:

Jacopo's early style: [London Book] Plates 204/205, 8/9, 264/265, 12/13, 14, 249/250, 240, 37/245, 237, 150, 279, 284, 239; [Paris Book] Plates 209, 220, 211.

Jacopo's style in the 1440s and early 1450s: [London Book] Plates 81, 79, 231/232, 94/95, 266/267, 262/263, 23/24, 111, 112, 16/17, 44/236, 215/216, 35/253, 131, 42/180, 69/70, 29/129, 25, 288, 289, 38/146, 39/145, 31/32, 291/292, 121/122, 56/24, 107/108, 115/116, 227/228, 60/187, 34/254, 28, 174/175, 132, 280, 242, 198, 243, 161, 93, 99/100, 210, 272, 21, 123, 75; [Paris Book] Plates 282, 191, 1, 186, 171, 170, 251/252, 83, 105/106, 270/271, 98, 221, 290, 183, 102, 96, 147, 278, 65, 151, 113, 110.

Jacopo's late style: [London Book] Plates 295/296, 48/162, 103/104, 4/185, 274/275, 172/173, 189/190, 268/269, 223/224, 293/294, 33/257, 144, 143, 192/193, 125/126, 90, 127, 139, 166, 273, 229, 41, 160, 46, 183, 199, 286/287, 254, 80, 78, 243, 137, 62, 235, 61, 201, 76/77, 124, 281, 37/26, 168/169; [Paris Book] Plates 282, 179, 234, 188, 222, 158, 226, 170, 217/218, 138, 246.

Jacopo's late style, or by Gentile Bellini: [London Book] Plates 244, 54, 152, 119/120, 227/228, 73, 158, 50, 55, 184, 43/199, 286/287, 44, 163, 40/206, 207, 229, 53, 52, 45; [Paris Book] Plates 195, 202, 275/276, 181/182, 208, 202, 276, 230, 159, 164/165, 283, 194, 88, 89, 92, 255/256, 59, 155/156.

*(continued on following page)*

authenticated by the words that identify the volume as Jacopo Bellini's, the date was long accepted. But in 1895 Gronau's keen eye noted that the drawings' content and style were far too advanced for so early a date, dispelling the legend that Jacopo had been his son-in-law Mantegna's major teacher; by 1901, only Mantegna's biographer still clung to it, and even he had to advance the date somewhat, placing the Paris volume in the 1440s because of its Donatellesque elements.[56]

Ricci, in his facsimile and study of 1908–9, put London's Book at 1450, the Louvre's later in that decade. Goloubew, the first to see both Books as made about the same time, in 1450, had two splendid facsimile volumes prepared in 1908 and 1912, along with much important scholarly commentary; a third volume, promised but undelivered, was to contain a consideration of the artist.

Studies by Adolfo Venturi had already done much to show that life at the court of Ferrara in 1441 might have had an important bearing on the Books' contents.[57] His son Lionello Venturi placed both Books about 1450, with London's the earlier of the two.

The most helpful visual evidence for dating the Books comes from France, in the illuminations made in the early 1450s by Jean Fouquet (Figs. 25, 26). The Austrian scholar Otto Pächt has shown that the style of these pages and especially the perspective clearly depend upon Jacopo's Books.[58] Even if some of Bellini's pages postdate the 1440s, by then he was already the master of their sophisticated spatial and classical resources.

Baffling questions of the date and style of both Books seemed solved in 1916 by a curator at Vienna's Albertina, Lili Fröhlich-Bum, who pointed to a great variety of sources, especially the Florentine masters Ghiberti and Alberti;[59] she explained the Books' disparate contents and styles as random packaging, the drawings sorted into two groups and bound solely for their paper or parchment support. According to her, all the Paris drawings were made between 1425 and 1450, and many of London's before 1441. But the director of the Albertina, Joseph Meder, with his peerless knowledge of graphic techniques, wrote that the drawings in the London Book had been worked into a complete, blank volume, and likewise, by implication, the Louvre's.[60]

In 1925, Friedrich Antal attempted to solve the problem of dating by noting the influence of Andrea del Castagno in the Paris Book:[61] he placed the London Book prior to Castagno's arrival in Venice in the early 1440s and saw in the Paris Book a reflection of the brilliant young Tuscan's achievements in the Veneto. As there is little evidence to make any dating watertight, almost every argument becomes reversible. Often cited, the thesis that some of Jacopo's horses depend on Donatello's *Gattamelata* monument, installed in Padua in 1453, is weakened by the fact that both artists were inspired by the same source, the ancient gilded horses of San Marco (Fig. 4).

H. Simon (1936), accepting some of Fröhlich-Bum's views, extended the Books' genesis over a much longer period: the Louvre's was begun in 1425 and London's later; both were worked on throughout the artist's life. Dividing Bellini's graphism into three phases, she correlated much of the drawn architecture with dated buildings in Venice, not always convincingly.[62]

In general accord with their Austrian and German predecessors' views, the Tietzes (1944) also saw the work of both sons in the Books and gave to the Louvre's the later date because it held more evidence of their participation. Subjects thought to be Ferrarese in London's Book made the Tietzes, like earlier critics, place it earlier. Their observations on the pages' style and sources led to approximate dates for many of the drawings.[63]

In 1950 the curators at the British Museum examined closely the physical structure of their Book and concluded, like Meder, that the drawings must have been made within a bound volume.[64] This view was extended to both Books by a Swiss scholar, Marcel Röthlisberger; after investigating their actual makeup rather than Goloubew's lavish but inaccurate facsimiles, his findings led to an often persuasive denial of Fröhlich-Bum's theory. Applying to both volumes the new science of codicology, a form of archaeology of the book, he explored their structure much as an archaeologist observes stratigraphy, following in this respect De Ricci's related study of 1921. A new codicological analysis of both Books by Albert J. Elen is given here in Appendix A.

Röthlisberger concluded that both volumes were constructed and planned as such from the start, each a formal, orderly assemblage of drawings made in a pre-existing book. He found the first fifty pages of the Paris Book to be divided equally between landscape and architecture, followed by thirty-one pages with large-scale figures.[65] All of London's versos (like the rectos before them) he saw as drawn in one fell swoop from front to back. Ames-Lewis has since noted a similar *modus operandi* in a much earlier Tuscan drawing

book by Parri Spinelli.[66] Some of Röthlisberger's findings had been anticipated by earlier scholars who also noted disparities between many rectos and their facing pages in the London Book.[67]

In insisting that all of London's verso pages were drawn later than the facing rectos, Röthlisberger was too dogmatic. There is little difference between the left and right halves of many of the early animal scenes, and not every extension onto the verso is necessarily later than the subject of the recto. He further concluded that almost every stroke of the pen, brush, or stylus in the Paris volume was exclusively Jacopo's, and asserted that in it absolutely no underdrawing was discernible—but those soft grayish lines described by Testi and Van Marle can still be seen with the naked eye today, and are discussed by Elen in Appendix A.

His date for both Books in the 1450s, with the London one somewhat the earlier, reflected Röthlisberger's belief that Bellini, whom he saw as a derivative artist, had based most of his work on dated monuments in nearby Padua by Donatello, Bono da Ferrara, and Mantegna. He also related many motifs to those of Ghiberti, Luca della Robbia, and earlier Florentine masters. In Röthlisberger's opinion a drawing now divided between the Fogg Art Museum and the Louvre (Plate 233) marked an intermediate stage between the volumes;[68] its technique, drawn in black chalk and worked over in pen, is close to the Paris Book's.

Röthlisberger's views were generally accepted for a decade or so, but slowly questions rose to the surface. Mariani Canova returned in 1972 to the Tietzes' views, ascribing the inking of many Paris pages to Giovanni's reworking of his father's folios, with help by others toward the end of the codex, along with Gentile and lesser talents.[69]

Fasinelli and Joost-Gaugier wondered how, in a heavy, bound codex, some of the large horizontal compositions could have been drawn across two pages. Its rigid bulk would have deprived the artist of needed flexibility when he drew "into" the central margin and across it to the adjacent facing page.[70] Could Bellini have worked with groups of folios still in the form of loose quires, brought together later in a single volume? Fasinelli's letter suggested that the "albums were actually composed of series of sections or units, added to other sections or units, so that there may have been several bindings involved before the final books, as we know them, emerged."[71]

Refuting Röthlisberger's argument that the inks fading from the first to the last page of the Paris Book were a sign that Jacopo had drawn them in one continuous campaign, Joost-Gaugier pointed out that the fading could equally apply to the similar work of a later restorer.[72] She argued in 1973 for dating both Books in the mid-1440s, before the Florentines' major works in Padua and the mosaics in the Mascoli Chapel of San Marco (Figs. 53, 54). Pope-Hennessy believed that Donatello adapted Bellini's architectural drawings, rationalizing and consolidating them in his bronze reliefs for the high altar of the Santo in Padua.[73]

Elen points out in Appendix A that the ink used in the London Book for the inscription on the first page, the foliation, and in most of the reworked pages is identical in tint, an argument against all of these being by Bellini's hand. Recently, a sharp-eyed conservator noted a fold down the center of the Adoration of the Magi (Plate 177), a clear indication that this page was not always in situ.[74]

Degenhart and Schmitt have seen the Paris Book's makeup as more flexible, characterized by "Youthful impetuosity—[Bellini] wishing to draw on a free, randomly chosen sheet between others destined to remain unused for a while—. . . one of the reasons for the irregularity . . ." They suggest that "the eleven gatherings of the Paris album had been drawn on, exchanged, altered, and rearranged by Bellini himself before being bound. The matter is further complicated by sheets from the second gathering having been transferred to the end . . . sometime after 1728."[75] For these two scholars, the Louvre Book was begun around 1430 and worked on over the next thirty years, the latest drawings being contemporary with the first drawings in the London Book, which was begun in the late 1450s and worked on into the 1460s, all of its verso pages being drawn last.[76] While the modernity of the versos is inarguable, many other pages anticipate the complexities seen in the Paris Book and prevent this view, however appealing, from being the final answer.

Drawings that clearly seem to be en suite, such as the two paired studies of riders fancifully armed for a court festivity (Plates 113, 114) and the massive lions in silverpoint (Plates 10, 11), now separated by many folios, must originally have been near to one another. The absence of many key religious subjects suggests that the Books' Christian images are incomplete, part of a larger series.

Gentile Bellini: [Paris Book] Plates 203, 219, 277, 153/154, 174/175, 218, 241.

Giovanni Bellini: [Paris Book] Plates 219, 240, 241, 248, 247, 67.

64 Popham and Pouncey, 1950, 14, singled out as examples fols. 53v–54 and 54v–55.

65 Röthlisberger, 1959, 47.

66 Ames-Lewis, 1981, 128.

67 Popham and Pouncey, 1950, 14; Tietze and Tietze-Conrat, 1944.

68 Röthlisberger, 1956, 363, n. 39.

69 Mariani Canova (1972) gives to Giovanni the Crucifixion (Pl. 208), St. Christopher (Pl. 248), Flagellation (Pl. 202), St. George (Pls. 261, 260), and Way to Calvary (Pl. 202). She gives to a second hand, possibly Gentile's, the City Square (Pl. 59), Condottiere and Coal Carrier (Pl. 18), and St. George or Warrior (Pl. 109).

70 Fasinelli (quoted by Joost-Gaugier, 1973). Fasinelli does not favor Röthlisberger's concept of drawings in sequence with special themes (131), but is closer to Fröhlich-Bum's approach (133).

71 Joost-Gaugier, 1973, 24, n. 16.

72 Joost-Gaugier, 1973, n. 199.

73 Pope-Hennessy, 1980, 124.

74 Observed by Stephen Prins, Paintings Conservator, Museum of Fine Arts, Santa Fe, N.M.

75 Degenhart and Schmitt, 1984, 13.

76 Degenhart and Schmitt, 1984, 13.

77 This is the view of Chastel (1965). Mariani Canova (1972) sees the London Book as begun in the early 1440s (for its Ferrarese elements), and the Paris Book as 1448–50. Wohl (1980) accepts Mariani Canova's date for the latter. Ames-Lewis (1981) puts both Books in the 1450s. Gramaccini (1984) dates the Paris Book c. 1446. Padovani (1971) sees both as begun after 1440 and still being worked on into the 1460s.

78 This last appears as fol. 88, pl. 112, in Degenhart and Schmitt, 1984.

Röthlisberger's reluctance to place one Book "ahead" of the other has much to recommend it, the word "first" being among the most treacherous in any historian's vocabulary. Ultimately he found London's volume to be slightly earlier than Paris', though both within the mid-'50s. Subsequent scholarship has also assigned the two to that decade.[77]

A date in the 1440s for the bulk of the recto pages in the London Book seems reasonable, and the Louvre Book must also have been begun in that decade, for Fouquet made adaptations from it early in the '50s. Some Paris pages must go into the 1460s if the identification of the *Effigy* (Plate 136) with Bertoldo d'Este (d. 1463) is correct. Most of the British Museum's revolutionary versos date from that decade; Simon also placed them late, along with the few pages in the Paris Book that seem to be by Gentile or Giovanni, as did Degenhart and Schmitt.

The evident refinement and sophistication of the Paris Book has long made it seem the later. This view remains half true, for the most complex, challenging studies in space and motion were first worked out in some of the British Museum's recto renderings, to find their final form in the Paris Book. The paper of London's Book lends itself to experimentation and problem solving, a rehearsal for the irreversible extravaganza on parchment in the Louvre's Book.

Weakest of the drawings on parchment are among those on the coated, reworked sides from the earlier pattern book. Hardly by Jacopo or his sons, these feeble folios include the *Chariot with a Prisoner* (Fig. 14), *Saint John the Baptist with a Speechscroll* (Plate 279), and *Courtiers with Animals* (see Appendix B).[78] Yet some reused pages bear the Book's finest drawings, so Jacopo may simply have saved a few pages for himself and turned the rest over to his apprentices, including his sons. As for the London verso pages, the most precise of the city views, almost stereometric in character, could be Gentile's, the more lyrical ones suggesting Giovanni's later *poesie*.

More consciously old-fashioned, the Paris Book caters to a conservative, courtly *milieu*, but this does not make it the earlier of the two. London's is bolder, more calculated toward an artist's needs than to a patron's self-image. That the crisply redefined Paris Book soon became an imperial possession in Turkey, while London's leadpoint pages remained in the family studio for use by the next generation, speaks for the heirs' view of Jacopo's codices: the Paris Book was destined for courtly presentation, London's was kept for creative assistance.

Perhaps it is wisest to see these volumes as a pair of unidentical yet profoundly sympathetic twins whose talents, expressions, and inclinations, drawn from the same gene pool, reinforce each other's achievements.

# IV

## THE VENETO OBSERVED

### DAILY THEMES: THE MANY MESSAGES OF GENRE

Painters working in the later fourteenth century in Padua and Verona and artists who came to Venice were all fond of those details of day-to-day life, casual yet essential, that authenticate the facts of faith and fiction. Such devotion to the ordinary brings to light the extraordinary. Unlike masters of the sublimely simple—Giotto or Piero della Francesca—these artists cultivated the vernacular, cherished the commonplace: Giusto da Menabuoi, Altichiero, Jacopo da Verona, and the illuminators of the British Museum's Paduan Bible. They used an abundance of telling features—crowds of frightened children, fighting dogs, sleeping cats, cheap household goods—whose collective *actes de présence* lent special pathos and immediacy to the workings of the absolute upon daily life.

The native Venetian artists around 1400 moved away from Byzantine imagery, defined by regal restraint and disdain for domesticity. They began to take their cues from Lombard, Paduan, and Veronese masters as well as those from Umbria and the Marches, all of whom were paying fresh attention to the varied nature and incidents of life and light, the texture and luster of dress, the patterns of inlaid furniture and Eastern carpets.

Jacopo Bellini's generation came just after this one. His drawings stand alone as the first full Venetian statement of an ample, all-encompassing scrutiny of the sacred in the profane. This spirit would reach its furthest expansion in Veronese's acres of religious canvases, condemned by the Inquisition for their parrots and monkeys, crowds of beggars, overdressed servants and underdressed mistresses, all so shown to bring the bible close, almost too close, to home in newly refurbished Venice.

Manuscript painting tells more than do the other arts about the region's daily life in the late fourteenth and early fifteenth centuries. When Jacopo was born, Venetian artists were able masters of genre; in a *Registrum* from San Mattia at Murano, dated 1391,[1] scenes of financial dealings are painted with a cold, clear eye, particularly sharp for exchanges in expression as well as cash. Among the very few pictures that survive from the generation of Jacopo's teachers are those by Jacobello del Fiore; though their subjects are miracles of the saints, they are mirrors of their time for the city and country, its professions and its manners. Little-known altar panels by Jacobello tell of the *Life of Saint Peter* (Denver Art Museum), a saint close to Venice as patron of her cathedral and a man of the sea: filled with small yet cosmic views of land and water, dramatically foreshortened and abounding in persuasive details, these scenes of Peter's sanctity have a "secularity" that suggests the origin of Bellini's way to the art of the actual. Jacobello displayed a mastery of marine life before Gentile da Fabriano arrived in Venice with a virtuosity that eclipsed his skills. The Venetian's panels of the Life of Saint Cecilia (Philadelphia Museum of Art, Johnson Collection) include a curious woman looking from a window as a coal carrier enters her house; these characters reappear in Jacopo's Book (Plates 18, 22) and in the mosaic *Visitation* he designed for the Mascoli Chapel (Fig. 53), both made some fifty years later.[2] He admired Jacobello's art, purchasing an inlaid wooden panel at the latter's estate sale (Appendix E, Doc. 1439).

Major paintings of secular subjects in the mid-fifteenth century are few today, though Uccello's *Rout of San Romano* series springs to mind, and later frescoes for the Este and Gonzaga palaces. Only the long narrow panels decorating hope chests—*cassoni* paintings—and some manuscript illuminations rival Bellini's Books for the vitality and range of their subjects. Secular art, unprotected by the mantle of sanctity, is always the first victim of fashion's change; while Italy was covering walls with paintings that are mock tapestries of

1 Venice, Seminario Ms. Busta 956, 17. See Degenhart and Schmitt, 1980, figs. 211–13.
2 Reproduced by G. Kaftal, *Iconography of the Saints in the Painting of North East Italy*, Florence: 1958, figs. 1072–74, 1083, 1087, 1090, 1092, 1093, 1095; p. 247, col. 246.

ancient history, mythology, and episodes from chivalry and romance, the scenes of her daily life, with a few exceptions, have vanished. For this reason the Bellini Books have extraordinary importance for the art of all Italy during the artist's long day, not only for that of Venice.

In country and urban life alike, it is often the landscape of the face and the topography of gesture that reveal levels and nuances of social distinction. Bellini's vignettes of encounter and activity contrast the typology of taciturn coal carrier and grim military leader on their separate ways (Plate 18). He is among the first to show rustic life in its stubborn, crude actuality (Plates 29, 30, 42), devoid of any picturesque, play-acting peasantry. Farmers under an arbor are watched by a rider on an ass, and a strong sense of event, of engagement, makes this page far more than an exercise in perspective (Plate 25). Richly dressed, a young woman rides toward a city, her composed, possibly resigned expression in striking contrast to the broad gestures and lively dialogue among her retinue (Plates 31/ 32). She is quite possibly a bride; the entry of such a bride-to-be into a city was the subject of a fresco in Ferrara, showing the arrival of Eleanora with her prospective husband, Ercole d'Este.[3]

Music came to Venice from far away. Netherlandish musicians brought new harmonies to the choirs of San Marco; Jews taught the rich how to sing and dance. Though music was central to Venice, it is infrequent in Bellini's pages. The paired angels who flank the *Mater Omnium* (Plate 138), playing a lute and a *lira da braccia*, reappear on the left bank of the Jordan at Christ's Baptism, joined by two others on the right bank playing a shawm and a portative, or portable organ (Plate 185). A row of six music-making angels in another *Baptism* (Plate 186) play these instruments and a woodwind and tambourine. Angelic concerts are rare in Baptisms; their presence here celebrates the harmony of heaven and earth at this moment of the Father first acknowledging his Son. Elsewhere (Plate 214), as the Deposition and Lamentation take place in the middle ground, a plump shepherd boy in front plays his pipe beside a young falconer, the sound masking the Virgin's last sorrows; in the foreground lies a great column. Music greets the bride and her retinue in Plates 31/ 32, a bagpiper near the city walls sounding her arrival.

Venetians were enthralled by ceremony, much of their life determined by ritual presentation or exchange. Jacopo, who may often have helped to stage state ceremonies, was attuned to the nuances of expectation. His ambassadors and attendant figures are men and women forever in waiting (Plate 23). Whether in a religious or secular context—the two often blurred or blended in Venetian practice—these persons share qualities of patience and preparedness, the essence of diplomacy, in serving their state, faith, or patron.

Not all of Jacopo's drawings of peasant life and of the professions, crafts, or trades should be seen as documentary or realistic. Often the figures in larger scale suggest preparatory designs for costumes, perhaps for performances such as *intermezzi*, musical entertainments at court. Some of Jacopo's rustic subjects may reflect *momarie*, humorous Venetian plays named for Momus, god of satire, entertainments staged at weddings; first mentioned in accounts of the Foscari–Contarini marriage in 1441, these witty plays were also termed *imitazioni*;[4] those found weighty had the wonderfully onomatopoeic name of *sbarabombe* in Venetian dialect, and family members took part in them.

The elaborate classical bridal poem or *epithalamium* inspired the content of renaissance nuptial paintings.[5] The Hungarian humanist Janus Pannonius composed one of the first of these verses for the mid-century marriage in Ferrara of Jacopo Balbi and Paola Barbaro, daughter of the Venetian humanist Francesco Barbaro. Pannonius was close to the visual arts, writing a poem in praise of Jacopo's son-in-law Andrea Mantegna in 1458, and he was also patronized by the powerful Marcello, as, most likely, was Bellini.

Poems with rustic settings, neo-Virgilian eclogues such as Alberti's *Corimbo* and *Tyrsis*, may have led Jacopo to his loveliest subjects, those fresh fusions of art and nature. Scenes of romance, gardens of love, and the street life in Bellini's Books are in the spirit of the songs and sketches of Leonardo Giustiniani, that Venetian scholar of Greek and Latin and friend of Traversari, Poggio, Filelfo, and Guarino, who also found time, despite important governmental appointments, to write light-hearted works known as the "giustiniani" or "veneziane" and fresh, vital comedies like the *Contrasti*. Though his best-known comedy, *La Veneziana*, postdates Jacopo's life, the subtitle of that play applies to many of Bellini's best pages—"non fabula, non commedia, ma vera historia," "neither a fairy tale nor a comedy, but a true story."[6]

The Este family of Ferrara, who provided Venice with several prominent *condottieri*, particularly favored peasant themes for their court decorations and festivities. A marriage celebration in the 1490s included playlets with actors in peasant garb holding "hoes,

3 See Gundersheimer, 1973, 264.

4 M. T. Muraro, 1981, 315–41.

5 Tassini, 55, discusses these poems.

6 Diego Valeri, "Caratteri e valori del teatro comico," Branca: 1979, 221–32. For suggested links between Bellini's genre-like subject and the various forms of Italian narrative literature, see Joost-Gaugier, 1975, 18–26.

spades, shovels, picks, and rakes and dancing to tambourine accompaniment as another rustic pretended to clear away dung at the stage's edge."[7] Friezelike, Bellini's artfully composed two-page spread of rustic types with a rider holding a bird (Plates 19/20) looks distinctly literary. The couple with three children could be travelers or pilgrims; the beautiful peasant woman with a boy at her side is an idealized figure, perhaps from a rustic dance. A crown of leaves braided into her hair recalls those worn by courtiers in spring festivals. Of all the artist's pages these most closely precede the Palazzo Schifanoia fresco cycle in Ferrara, that encyclopedic, calendrical survey of the months, labors, constellations, seasons, and courtly activities.

The quiet observation without prejudice that emerges as the silent journalism of seventeenth-century art is first sensed in Jacopo's London Book. His studies of labor—of the farrier, the founder, or ironmonger, and of the woman's work that is never done (Plates 54, 56, 57)—are objective but never impersonal. They place Venice in the vanguard of the later contemplative Quietism in France.

Among the first early renaissance studies of men at work were those drawn in Tuscan artist's studios, where masters and apprentices practiced sketching one another in a graphic free-for-all. Something of the concentration in these Florentine drawings is also in Bellini's scenes of craftsmen, with the important difference that he usually places his stories of labor in context; the space or setting of his subjects' work is as important as how they work, or the activity itself. This sense of space and time lends to Jacopo's pages their remarkably contemporary quality, that timelessness which can only be achieved, paradoxically, by visualizing its opposite—motion arrested, the moment seized.

Bellini's father was a tinsmith or plumber and his brother-in-law an oarsman; this may have made him champion the workman's sense of skill, so critical to the craft of all arts. In the Piazzetta adjacent to San Marco, the two granite bases that support the columns of Saint Theodore and of Saint Mark's Lion are carved with images of the fishermen, butchers, cattle dealers, smiths, basketmakers, and wine and fruit vendors who sustain the city's commerce, just as the bases support her first and second patron saints. Similarly the workers at the Arsenale, long the world's largest shipyard, are carved at the top of the entrance to the Doge's Chapel, their labor essential to Venetian prosperity. A capital at the Doge's Palace honors the early Christian sculptors who refused to carve pagan idols, and their very presence is praise for those craftworkers in Trecento Venice; another capital is given to the Republic's trades and crafts, masons, fishmongers, goldsmiths, carpenters, and others.[8] Men and women laboring in the fields or in the city's workshops are delineated with that dignity and sympathy also found in the Trecento, a community shown with its constellation of local endeavors, all within the great chain of being. Perhaps some of Jacopo's drawings belonged to a seasonal series in the late medieval mold, combining the months, their labors, and their astrological significance.

The most telling of all portraits of city life are those old print series known as "The Cries . . ." of Bologna or London, Paris or Rome. These showed the street songs of vendors and peddlers, knifegrinders and dogcatchers, who hawked their wares or services with the pithy calls inscribed below their images. Bellini's pages provide one of the first of these surveys of professions observed, often incorporating an amused understanding. His falconer, coal carrier, gardener, and farrier (Plates 22, 54) are a catalogue of Venetian society, prototypes for Zompini's series, *Le arti che vanno per via nella città Venezia* of 1789. Jacopo's men and women at the forge, spinning, or minding the store (Plates 55–57) all convey the quiet but concentrated industry that would keep shipshape the mercantile empire and its fleet.

Though an autocratic oligarchy, the Republic never failed to admit to the pageantry of civic life the workers whose skills were so necessary to her welfare. Craftspeople, richly costumed, marched in the annual parades that showed Venice as she was, an industrial machine maintained by the best-organized manufacture in Europe. A floating empire of stolen trade secrets—her mirror and glass mastery taken from Germany, leather- and metal-working techniques from Islam, printers and instrument makers imported from the North—Venice became a cosmos of industrial expertise, and her painters such as Bellini, his sons, and his son-in-law were leaders of the *arte*, a word meaning neither more nor less than craft.

7 P. d'Ancona, *Origini del teatro italiano*, Rome: 1891, II, 130.

8 Wolters, I, 1976, cat. no. 48; chap. XVI, "I Mestieri," and chap. XVIII, "I Quattro Coronati," 173–74.

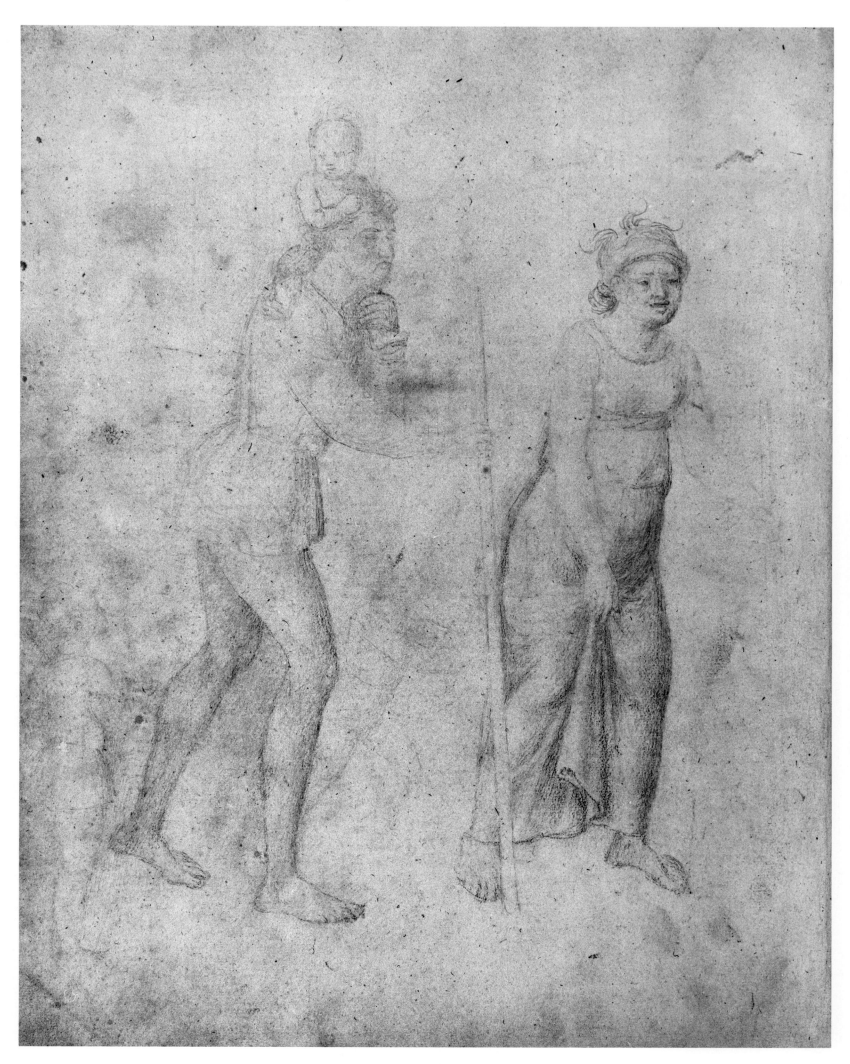

Plate 19. *Rustic Saint Christopher-like Man and Woman*. British Museum 33v

108

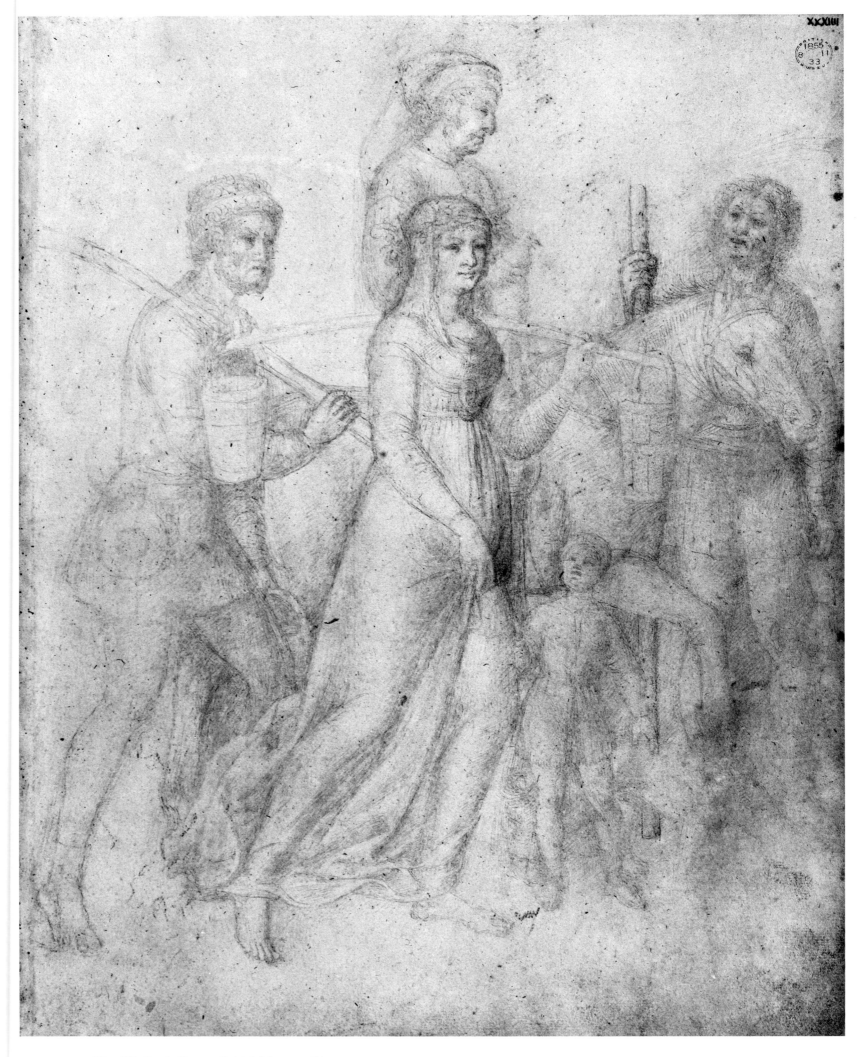

Plate 20. *Rustic Figures*. British Museum 34

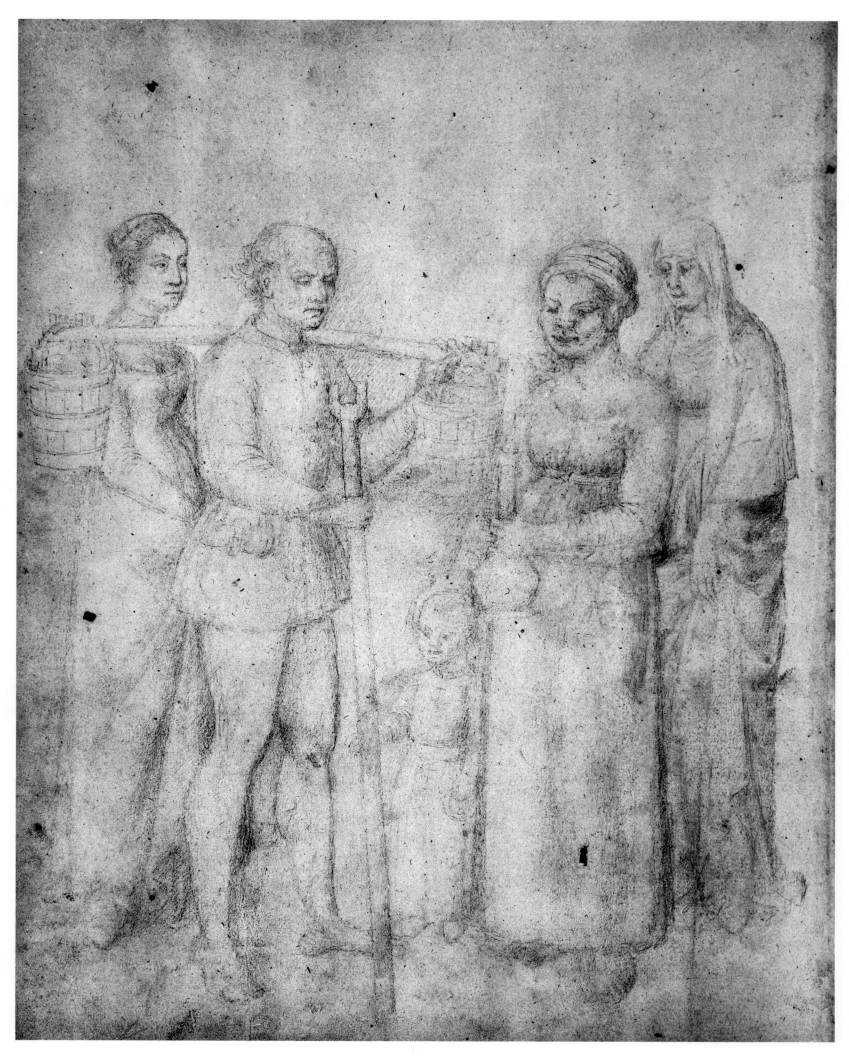

Plate 21. *Four Adults*. British Museum 94v

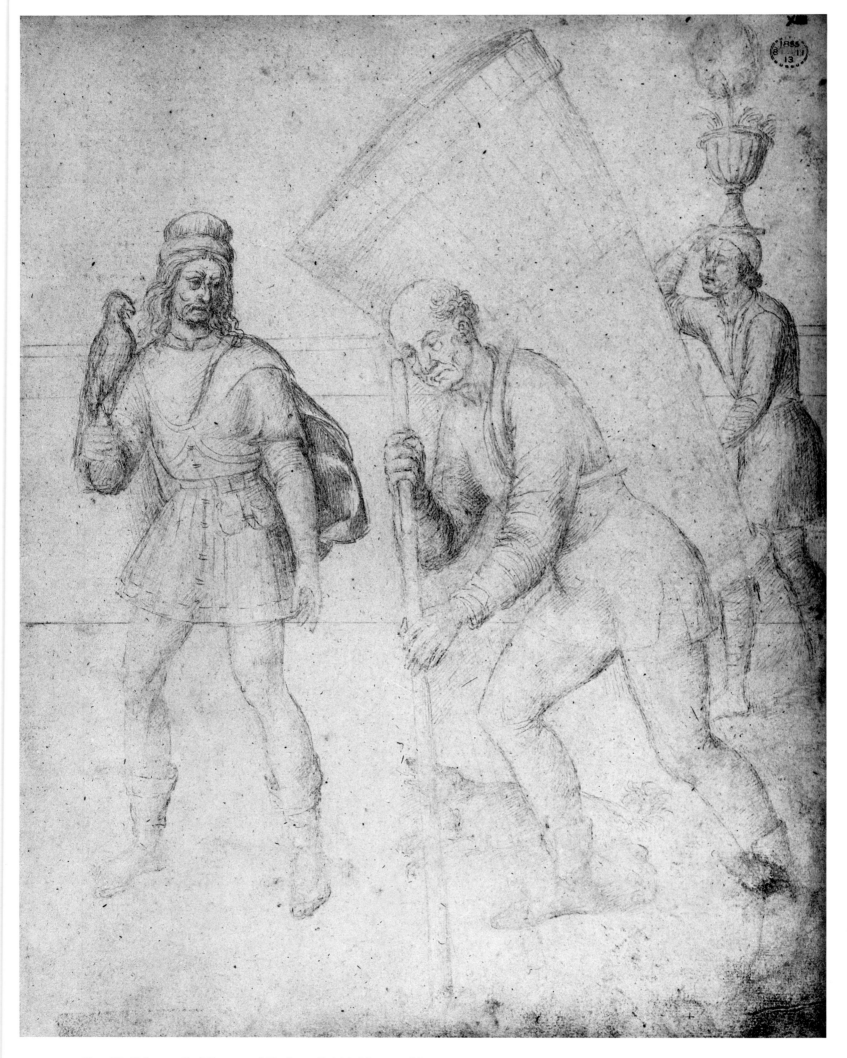

Plate 22. *Falconer, Coal Bearer, and Gardener.* British Museum 14

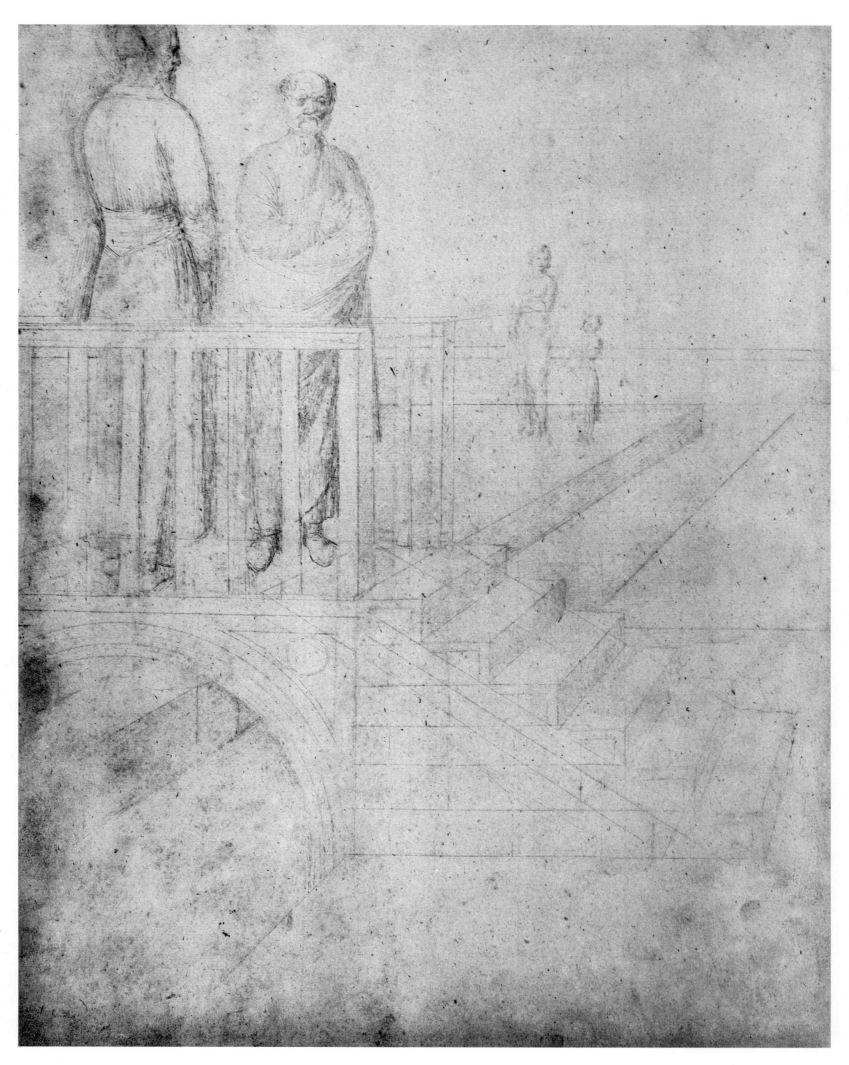

Plate 23. *Two Men in Semi-classical Garb(?) Standing on Bridge over Canal*. British Museum 13v

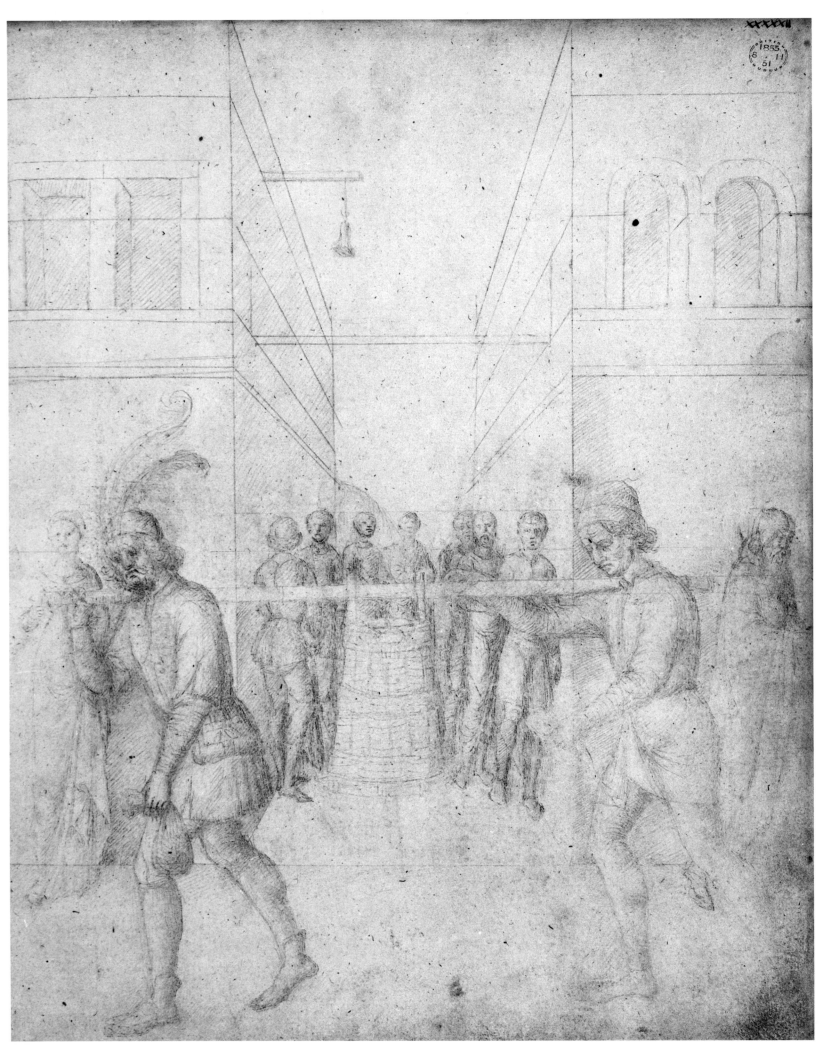

Plate 24. *Two Men Bearing Vintage*. British Museum 52

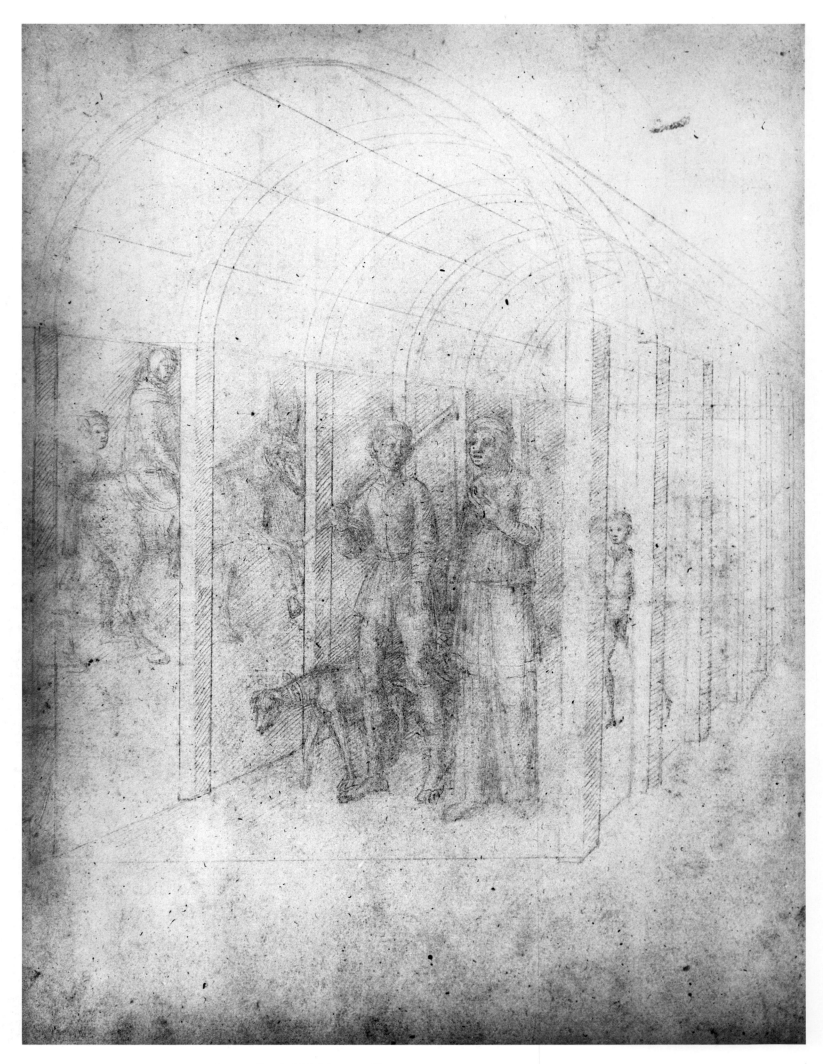

Plate 25. *Rustic Figures under a Trellis*. British Museum 38v

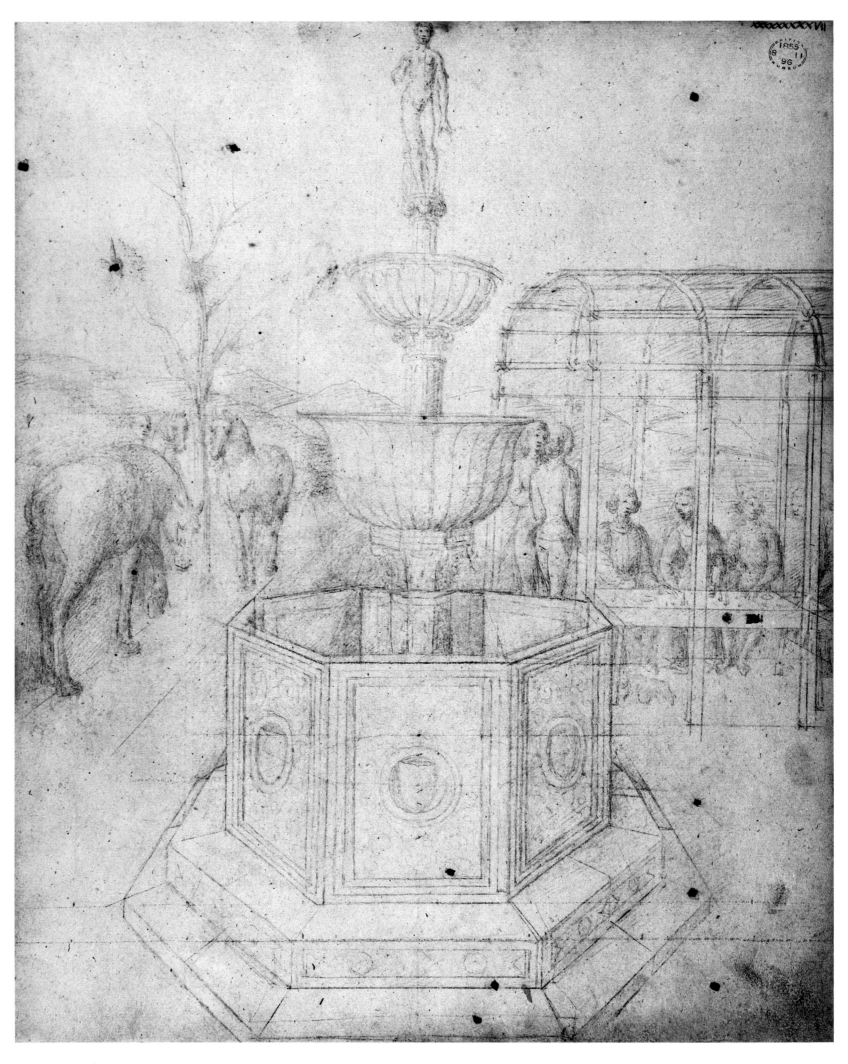

Plate 26. *Fountain Study.* British Museum 97

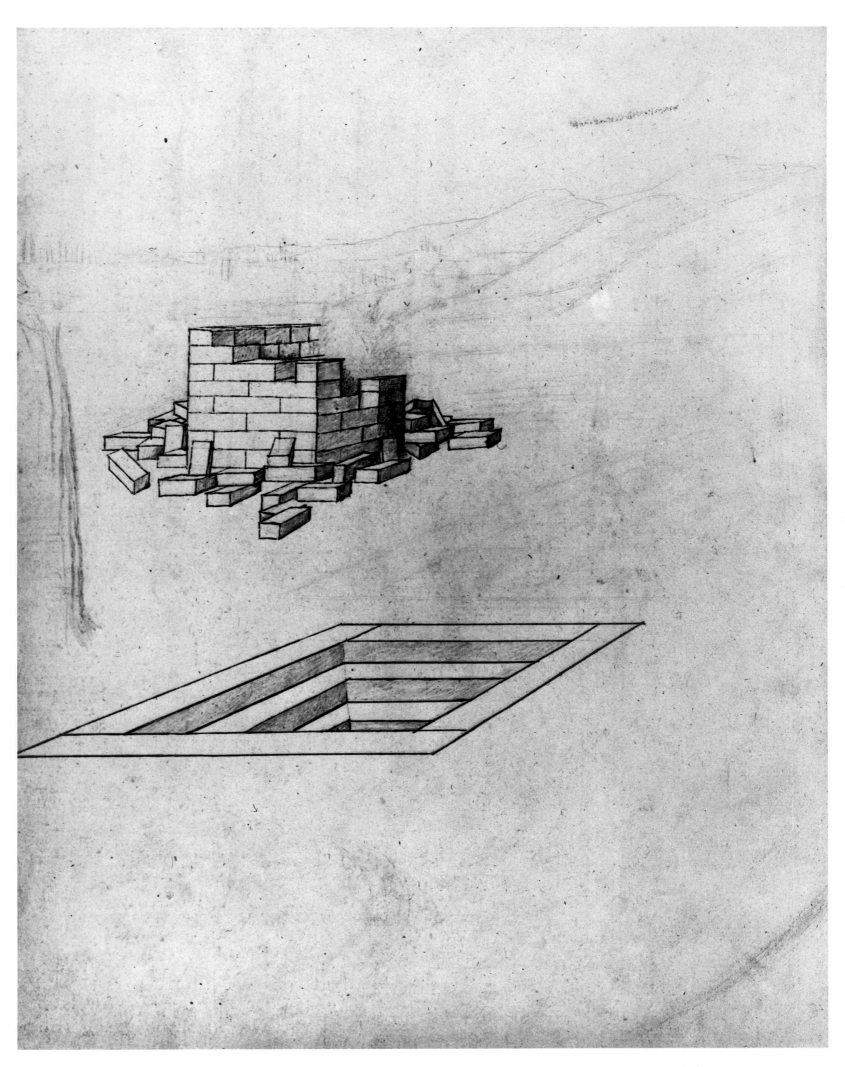

Plate 27. *Landscape with Masonry Structures* (continuation of *Saint Christopher* [A], Plate 245). British Museum 28v

Plate 28. *Concerned Courtiers with Clerics*. British Museum 77v

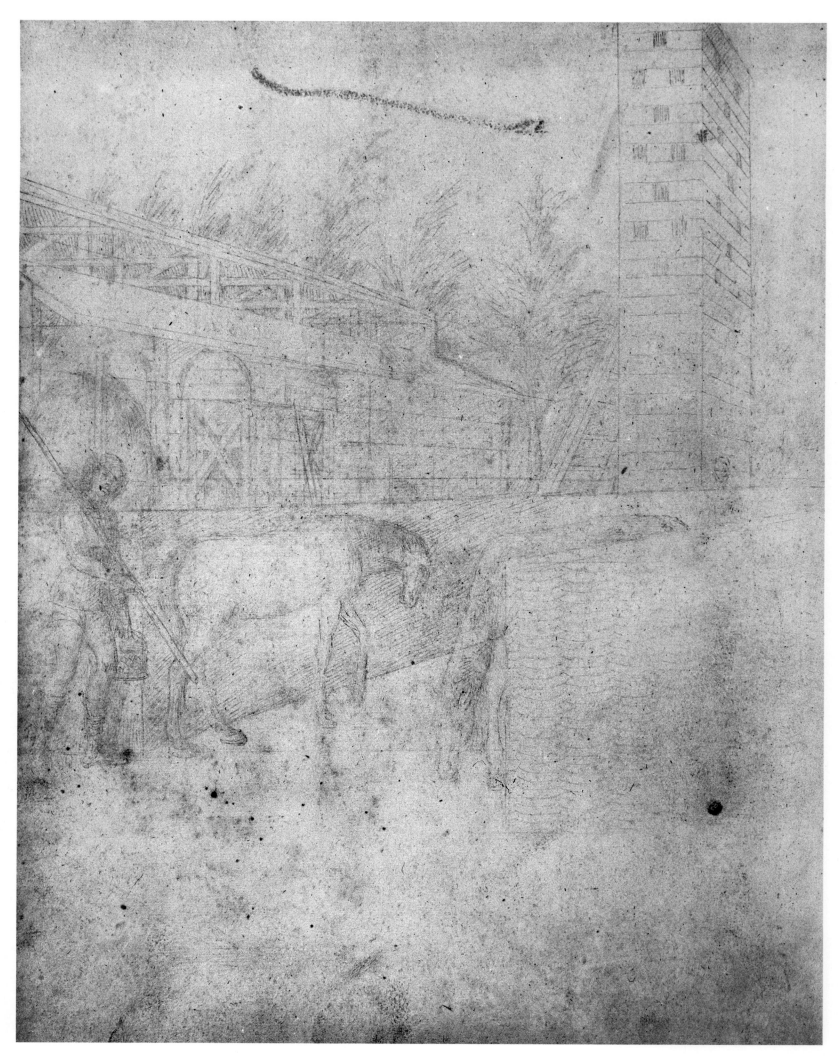

Plate 29. *Farm Youth with Horses* (continuation of *Rustic Scene: Peasant on an Ass with Foal*, Plate 30). British Museum 36v

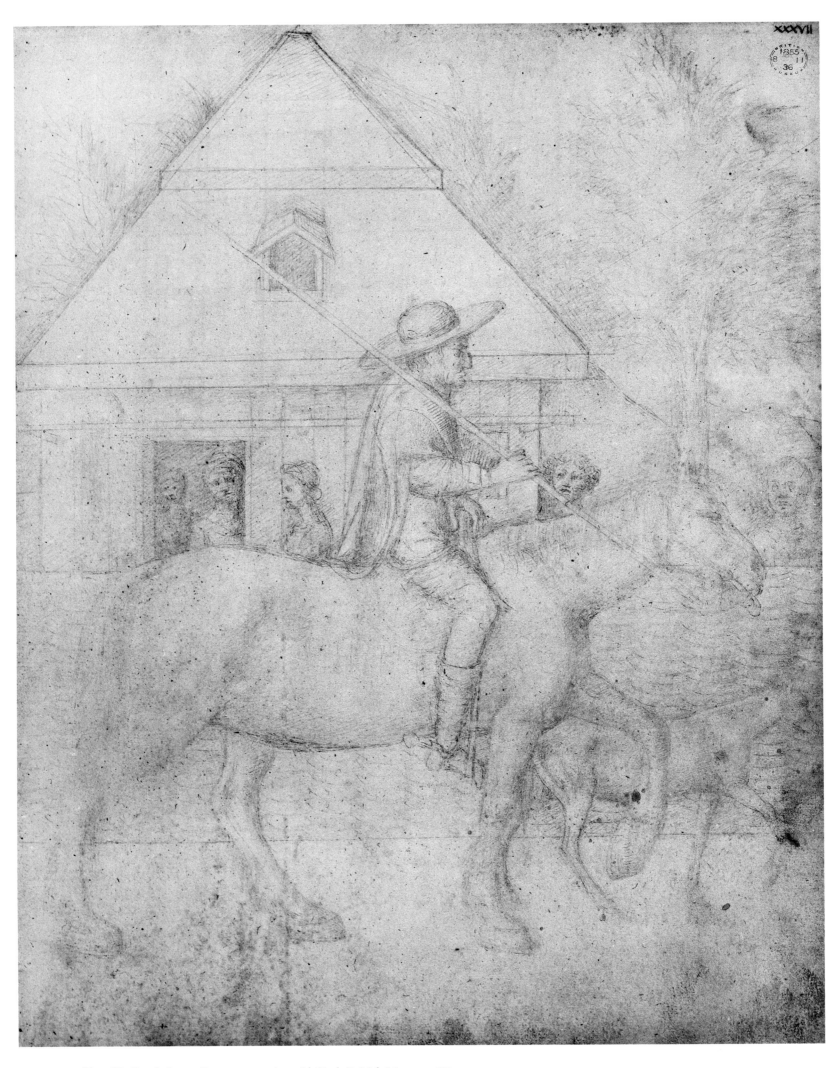

Plate 30. *Rustic Scene: Peasant on an Ass with Foal.* British Museum 37

Plate 31. *City View* (continuation of *Equestrian Lady and Her Retinue*, Plate 32). British Museum 47v

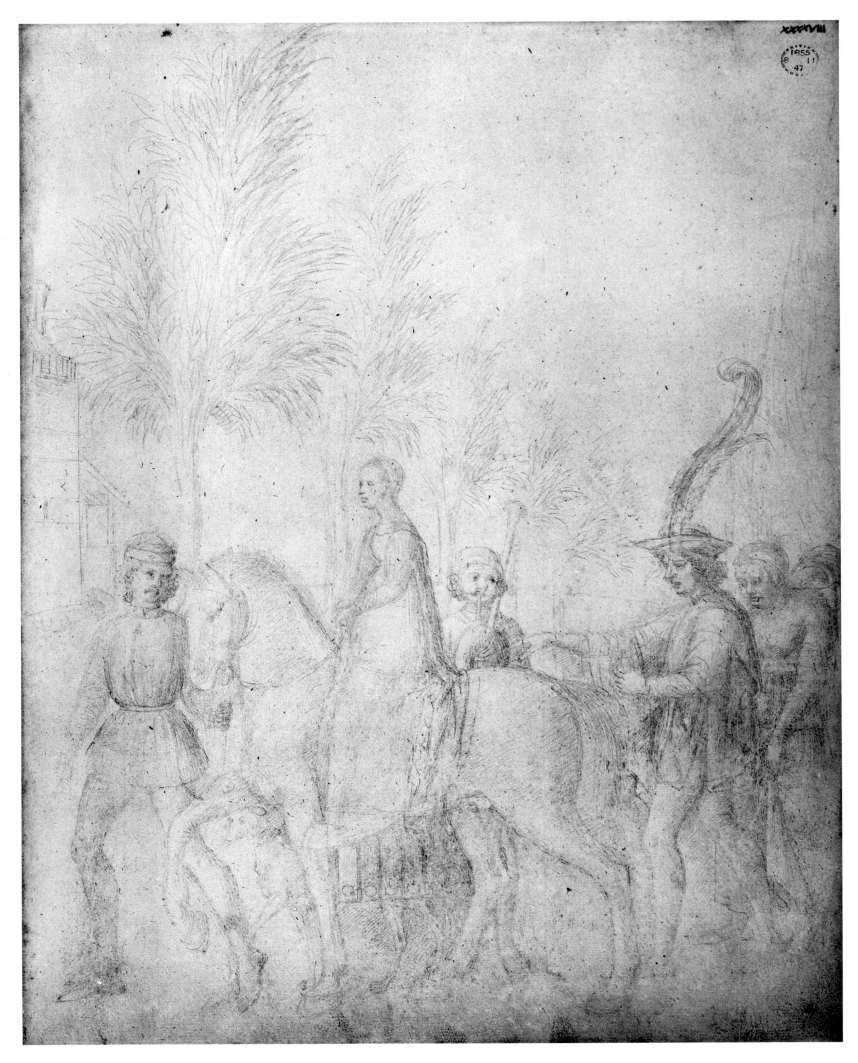

Plate 32. *Equestrian Lady and Her Retinue*. British Museum 48

Plate 33. *Watering Horses in the Woods*. British Museum 41v

Plate 34. *Wooded Landscape* (free continuation of *Vision of Saint Eustace* [B], Plate 254). British Museum 71v

Plate 35. *Rustic Landscape with Tree and Masonry Building*. British Museum 26v

Plate 36. *Landscape with Tree and Riding Figure* (continuation of *Martyrdom of Saint Sebastian*, Plate 295). British Museum 10v

Plate 37. *Landscape with Equestrian Figures and Bare Tree*. British Museum 96v

Long without land of their own, Venetians sought—and found—in their city gardens the ultimate paradise, locked away for private pleasure. Balconies were fragrant with pots of carnations and other flowers blooming below the windows, gardens hanging between sky and water. The *Mystical Marriage of Saint Catharine* (Sanseverino, Galleria Communale) by the Marchigian master Salimbeni is the earliest painting in the Venetian manner with a close study of flora, the ground carpeted with morning glories.

Gentile da Fabriano, also from the Marches, chose the thistle as his emblem, signing his name between its brushlike blooms. His Valle Romita Altar (Berlin, Dahlem Museum), possibly painted in Venice before 1414, abounds in flowers, as do most of his previous works. In his Strozzi Altar of 1423 (Fig. 67) there are naturalistic renderings in the painting, a spray of astonishing blackberries looming behind the midwives' heads, and the frame is a botanical guide all by itself, twenty lancets and quatrefoils filled with no fewer than thirty-six floral vignettes, none of them repeats. Because the iris' sword-shaped leaves symbolize Mary's future sorrows, it appears near the Madonna at the lower inner left of the frame, two flowers with three buds; Bellini may have painted these many years before his *Iris* in the Paris Book (Plate 2). Gentile's botanical studies were an influence in Venice long after he departed, still seen in Bellini's *Madonna of Humility* (Milan, Museo Poldi Pezzoli; Fig. 33) from his studio in the 1430s.[14] Clues to the flowers appearing in early Venetian art are found in an anonymous Ferrarese painting of *Pietro de'Lardi Presented to the Virgin by Saint Maurelio* (New York, Metropolitan Museum of Art),[15] a border of individualized flowers rising above a low brick wall in the background. This panel must have been painted about 1430, near the time of Bellini's first visit to the Este court, when he painted the Louvre *Madonna of Humility* (Fig. 31).

Of the three hundred or so drawings in Jacopo's Books, only one drawing is "in full color," the study of one flower (Plate 2). A life-size purple iris (*Iris germanica*), it looks freshly cut, as if just laid on the parchment folio. This is Bellini's only surviving work in gouache and watercolor, although he is known to have painted at least one portrait in a similar medium.[16] If this dazzling, pastel-like flower study were not described in the late fifteenth-century Index as Number 62—"Uno ziglio azurro," a blue lily—the Quattrocento date of this sketch would be hard to believe, as so few remotely comparable Italian works survive from that century.

Lively botanical studies were first made near Venice around 1400 in manuscript herbals for the Carrara, the despotic rulers of Padua.[17] The prescriptive contents of these healing plants were shown with a new sense of naturalism, their spiraling spontaneity suggesting growth and immediacy. Similar flowers are illuminated a little later in the margins of a Prayer Book (New York, Pierpont Morgan Library) by the Lombard Michelino da Besozzo, the best-known Italian artist of the period, who came to Venice in 1410; Gentile da Fabriano was already there, but Michelino's flowers are the fresher for exploiting the luminosity of the bare white parchment so brilliantly—as Jacopo would also learn to do.

Michelino was in touch with the virtuoso manuscript masters of the Netherlands, whose greatest—the Boucicaut Master and at least one of the Limbourg brothers—came to Italy.[18] These illuminators may have gone to Venice, for, as Meiss suggested, "Many aspects of the paintings of Gentile da Fabriano and his Venetian followers in the third and fourth decades of the century recall the miniatures of the *Très Riches Heures* [of the Duc de Berry; Chantilly, Musée Condé]: the nocturnes with starry skies, the processions and spectacles, the richly textured dress, and the landscapes admitting, between the usual Italian bare hills, rows of trees and patches of green. Perhaps during his early years in Venice or his stay in Brescia (1414–1419) Gentile saw something the Limbourgs had left in Italy or copies of their work now lost."[19]

Northern painters as well as illuminators went to Italy, and their glowing oil technique with its layers of luminous color could have led to the almost impressionistic freshness of Bellini's *Iris*. Jan van Eyck painted the same flower still more brilliantly in the flowery meadow surrounding the Mystic Lamb (Ghent Altar), completed in 1432. The Flemish master probably stopped in Venice on his way to the Holy Land. As his works were prized by several of the Serenissima's collectors, some of whom also owned Bellini's, Jacopo may have had first-hand knowledge of the Northern artist's approach to nature.

14 See Christiansen, 1982, pl. 92; cat. no. XXXIII.

15 See Longhi, 1956, 12, fig. 126.

16 In the *Anonimo*, 1903, 19, the *Profile of the Father of Leonico Tomeo*, in the latter's Paduan collection, is described as being in tempera.

17 See Pächt, 1950.

18 See M. Meiss, *French Painting in the Time of Jean de Berry: The Boucicaut Master*, London: 1968, 7–11, 50–62. See also M. Meiss, *The Limbourgs and Their Contemporaries*, New York: 1971, 245 ff.

19 Meiss, 1974, 246.

Plate 38. *Landscape with Rider Crossing a Bridge*. British Museum 44v

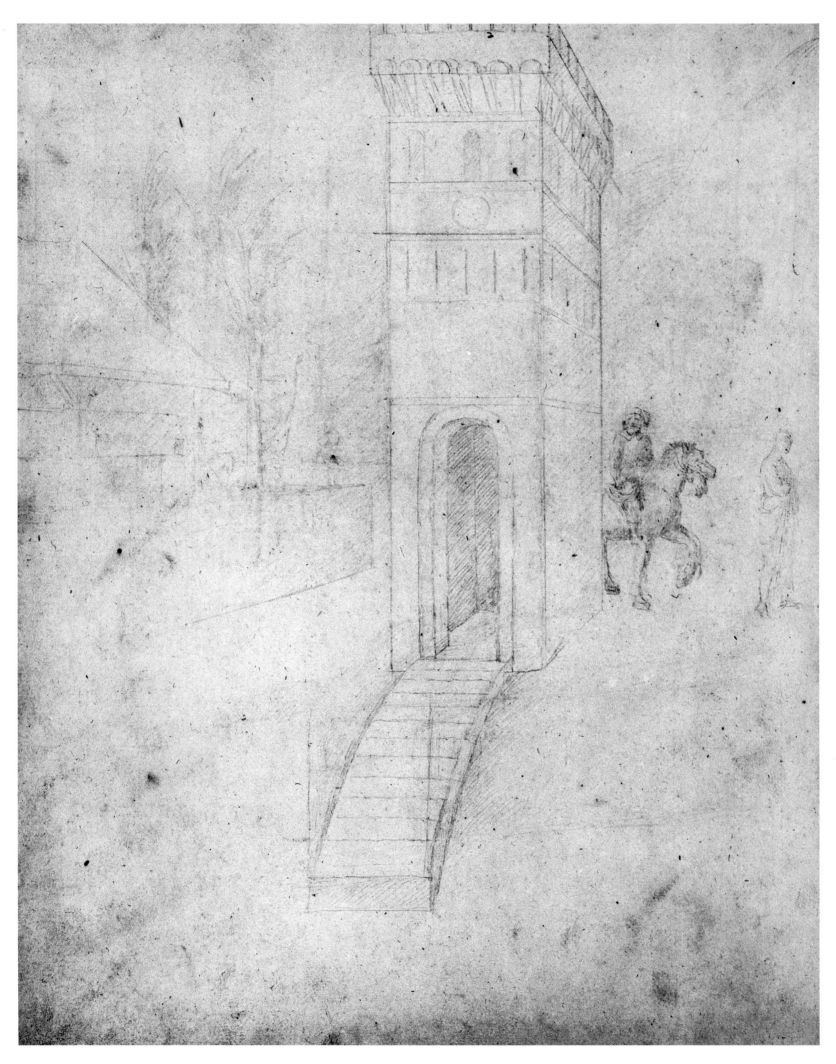

Plate 39. *Rustic Landscape with Fortified Tower.* British Museum 45v

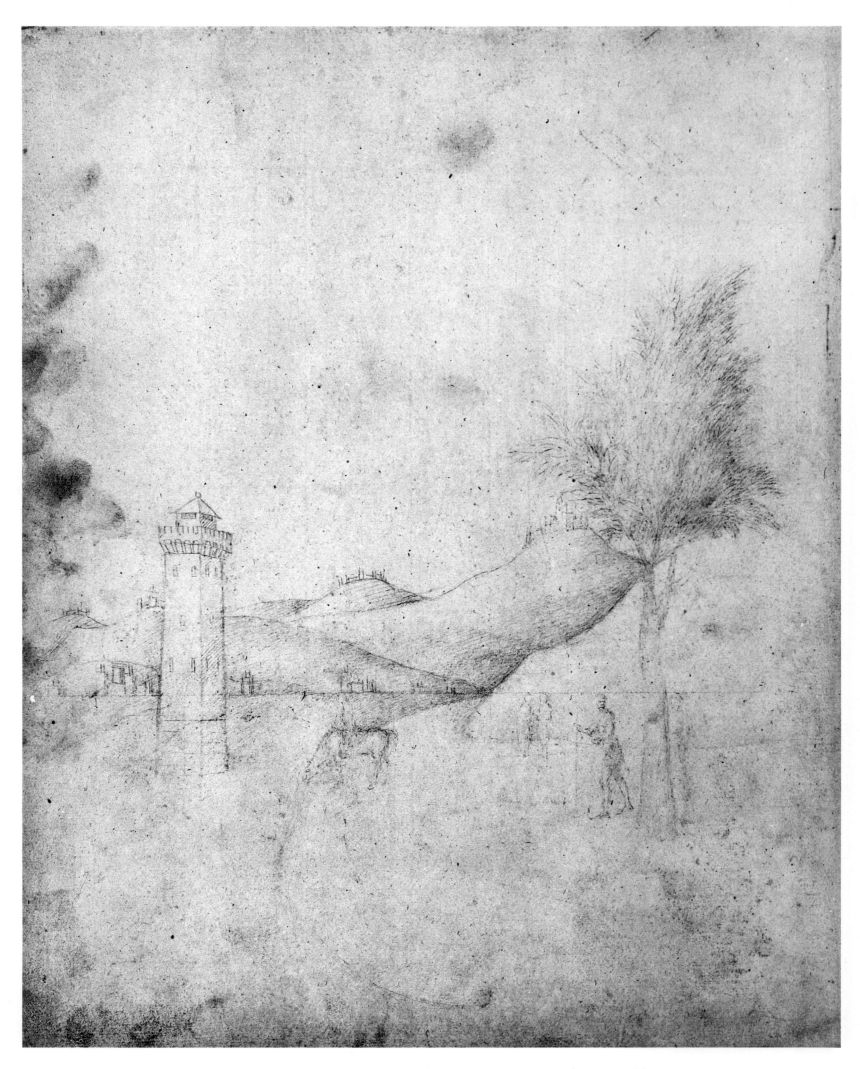

Plate 40. *Landscape with Fortified Tower* (continuation of *Crucifixion* [A], Plate 206). British Museum 76v

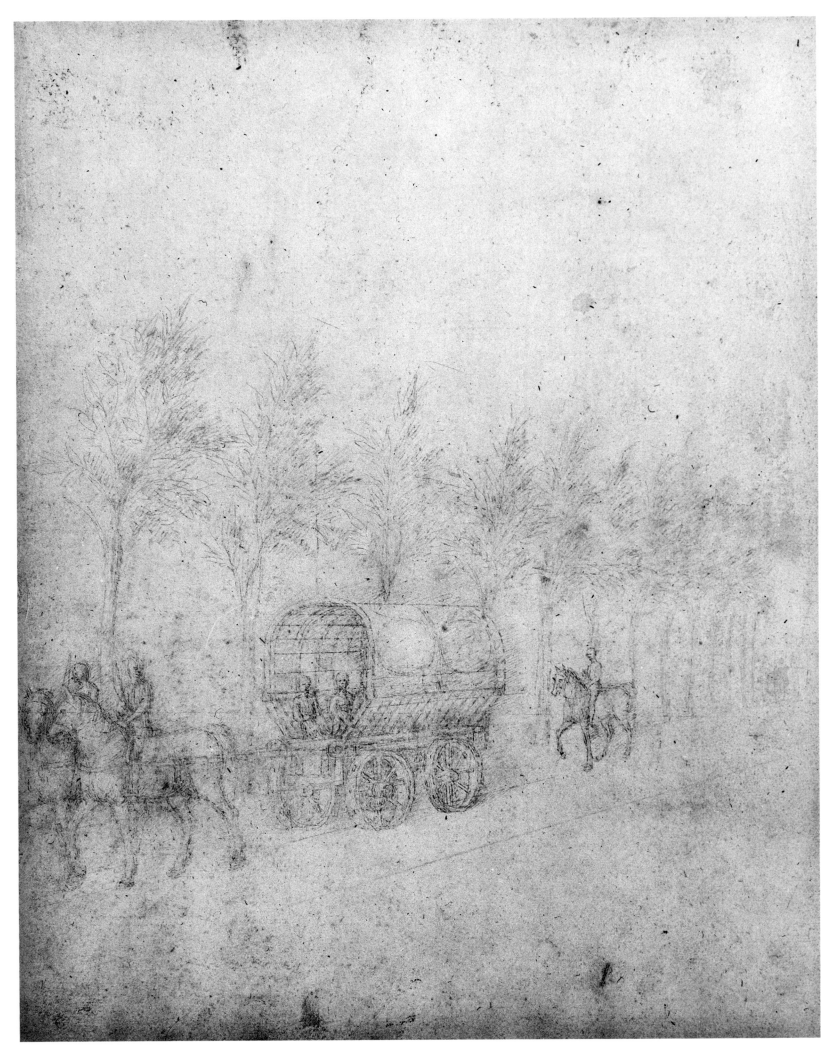

Plate 41. *Landscape with Covered Wagon*. British Museum 67v

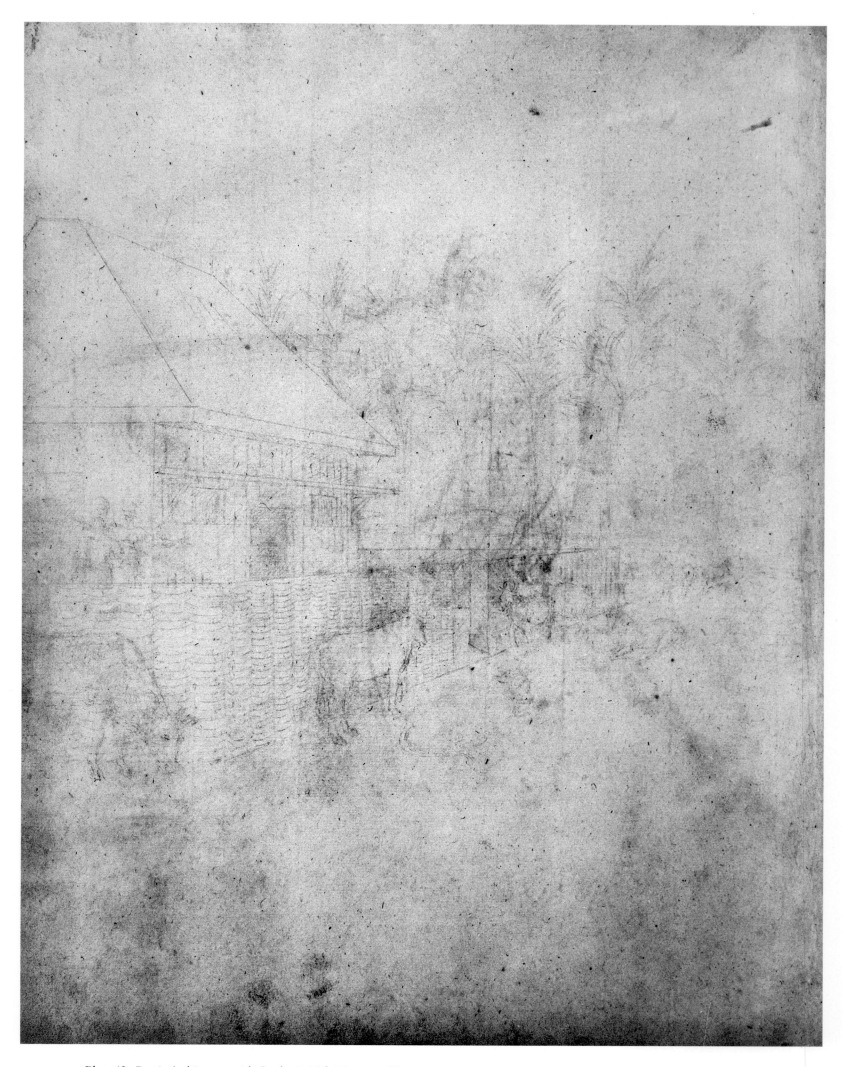

Plate 42. *Rustic Architecture with Cattle*. British Museum 29v

Plate 43. *Palace Courtyard with Wellhead*. British Museum 57v

20 Fossi Todorow, 1966, "La bottega di Sant'Anastasia," cat. no. 101, Bayonne, Musée Bonnat.

21 Both the Frankfurt painting, named for its inclusion of the arms of Florence, and another version (ex-Coll. Cook) came from 19th-century Italy. The first was in the Rosini Collection in Pisa. See M. Davies, *Roger van der Weyden*, London: 1972, 212 f. Earlier, iris was shown in the *Très Riches Heures* (fol. 26v), in works by Campin (Washington, D.C., National Gallery of Art), and later in the Portinari Altar by Hugo van der Goes (Florence, Uffizi).

22 Goloubew, II, text for pl. LVII, suggests that the *Iris* too might have been painted for the Este.

23 The Paris Book, however, had left Venice before Dürer's visits, probably taken to Istanbul by Gentile Bellini. As the Book apparently remained in the Near East for two and one half centuries, it is remotely possible that this page could have been painted by Gentile or even by a Turkish master; such flower studies were extremely popular in Islamic art. See Pächt, 1950, 25 ff.; for Gentile's possible first training in the Veneto, see Huter, 1974, 18.

24 Fossi Todorow, 1966, cat. no. 367, 368, pl. CXXX on p. 178, gives the medium as black hematite, but they look like leadpoint. *The Tree*, Louvre no. 2267, is 29.2 x 14.5 cm.; *The Fern*, Louvre no. 2268, is 29.4 x 19.9 cm. Degenhart, *Pisanello*, Turin: 1945, 55, 60, gave these studies to Pisanello, but Fossi Todorow noted analogies between them and many pages in the London Book: Goloubew, II, 1908, pls. XII, XXV, XXVII, XXXIV, XLV, XLVII, XLVIII, L, LV, LX, LXXX.

25 Noted by De Mandach, 1922, 54.

26 Clues as to the appearance of such rooms may be found in a late 14th-century Pisan manuscript studied by Degenhart and Schmitt, 1980, 175 ff.

27 See Gundersheimer, 1973, 263.

A graphic study of an iris near in date to Bellini's was made in the Veronese workshop of Pisanello, who was also an associate of Gentile da Fabriano; this sketch lacks the vitality of Jacopo's *Iris*, which seems to sparkle in Venetian sunshine.[20] Pisanello and Jacopo were well connected with the Este court in Ferrara, and when Roger van der Weyden came to Italy in 1449, he may have come there, probably painting the triptych of the *Crucifixion and Expulsion* which Lionello d'Este kept at his massive pleasure palace, Belfiore, named after the Este passion for flowers.

Perhaps Roger brought flower studies with him, such as for the iris in his *Medici Madonna* (Frankfurt, Staedel Institut), probably also painted in Italy.[21] In 1447 Lionello commissioned his court painter Angiolo da Siena (Macagnini) to make him a rendering of a single flower each Easter.[22] Flowering bulbs were a symbol of the Resurrection, and paintings of iris, or more frequently daffodils (then known as Easter lilies), were suitable for that holy day. The artist of this annual floral offering along with others at the court learned from Roger, according to the writings of the traveling humanist Cyriaco d'Ancona.

Though Dürer may already have made watercolor studies of nature before he left Germany, his trip to Venice in 1492 opened his eyes to a new world of art and to many novel genres. Deeply impressed by the drawings he saw in Giovanni Bellini's studio, he doubtless saw pages drawn by the father too.[23] Several iris by Dürer survive (in the Escorial), and in his most monumental, Venetian-inspired *Madonna*, known only from copies, a massive iris rises at her side.

Individual trees occupy several pages of the London Book (Plates 35, 36, 44), but they are in landscape settings and paired with facing narrative pages, rather than nature studies, strictly speaking. On two pages of heavy white paper like the London Book's, and worked in much the same technique, are a tree (Fig. 2) and a fern (Fig. 3) against blank backgrounds. Sharing the London Book's qualities of luminosity and scintillation, these lines were drawn by an assistant of Bellini's if not by the artist himself. The leaves, yielding and lambent as if in sun and wind, show none of the clinical outlook of Pisanello's crisp focus.[24] Such pages suggest the contents of the other books of drawings that were in Jacopo's studio at his death.

Typical of Bellini's trees is the large study almost filling a London left page (Plate 107), perhaps drawn first as an independent study, the small figures added for thematic continuity with the facing page. The tree growing outside the city walls (Plate 44) reappears in the predella panel of the *Adoration of the Magi* (Fig. 49), painted by Giovanni after Jacopo's design, and in a vertical panel of that altar (Fig. 48), just above. Trees flanking the *Lamentation* (Plate 218), more than "nature studies," are traditional symbols of good and evil, of life and death. The tree in full foliage is on Christ's right, his "good" side, while the bare branches silhouetted against the sky are on his sinister side, that of death and the damned.[25]

## FAUNA

Possessing no farms or fields, Venetians have always been responsive to domestic animal life. Where else do cats and birds count for so much? Theirs is the run of the city. Bird cages cover tenement walls as wheeling gulls encircle the skies; dusty clouds of pigeons infest the Piazza di San Marco. Inside Belfiore, the Este pleasure palace begun in the late Trecento, the walls teemed with painted panthers, one room decorated exclusively with lions.[26] The splendor of the Este estates would suggest equally impressive zoos, but an exhaustive description of these properties in the 1480s itemizes only a panther, a tame wolf, and a giraffe.[27] Several lions drawn earlier on pages bound into Jacopo's Paris Book (Plates 6, 7) must have been by an artist used to courtly genres; perhaps Gentile da Fabriano left the drawings to Bellini, though Jacopo's cavalier obliteration and reuse of most of these images is inconsistent with his professed regard for his master.

Animals enliven many of the pages with their presence, real or fantastic, domestic or exotic. Bears are chained where Susanna and the Elders are brought before Daniel (Plate 156), in a *Flagellation* (Plate 195), behind a *Saint Christopher* (Plate 248), and at the *Beheading of Saint John the Baptist* (Plates 284/285). Deer wander in and out of other subjects. Like the dwarf's monkey on a chain and the eagle or falcon kept close at hand, these beasts are tribute to their owner's dominion over the caged and the kept, and, by implication, over the many lands furnishing his zoo.

Courts, particularly in northern Italy—the Visconti at Pavia, the Carrara at Padua, the Scaligeri at Verona—were fond of horses, of flowers, of all of nature's diversions. Herb and medicinal gardens, exotic flowers and creatures, dogs trained for the chase or the lap—this opulent climate of courtly pleasures was as near an earthly paradise as money and skills could provide. Only the most powerful could keep lions or other big game, but almost every court enjoyed hunting with birds and the playful, swift, predatory cheetah (Plate 3). Peacocks (Plate 165) proved hardy enough to withstand the climate, and were favorites for their fine feathers. The princely zoos near Venice housed many of these birds and beasts. When Jacopo painted Lionello d'Este's portrait in 1441, perhaps he made studies in the zoo at Ferrara's Castello.

The dwarf below with a cheetah, and the fierce eagles perched on a rod above, reflect King Solomon's wealth and his biblical role as a great hunter as well as wise judge (Plate 152). Venice had purveyed such wildlife to the private zoos of Europe for centuries, her docks crowded with cages of foreign birds and beasts imported from Africa and the Near East.

Medieval Venice, a "zoo without walls," abounded in examples of the *animalier*'s art. Like the fourth-century Roman mosaics at nearby Aquileia, the Byzantine vaults of San Marco teem with sea creatures, the mosaics of the Genesis cycle including much animal life in unrivaled detail. Fishermen pulling in filled nets are carved on the central portal; the porch above supports the great gilded quadriga of classical steeds, grandest example of ancient equine statuary. These creatures personify life—the meaning of *zoo*—for the lagoon dwellers, locked in their floating urban ark. Animal studies were the major work of many painters, sculptors, or craftspeople in late medieval and renaissance times, the variety of creation bringing joy to all.

Perenzolo (Pietro) Tedaldo is the first Venetian painter known to have drawn fauna extensively; his renderings of lions, horses, bulls, birds, and "all animals," described as "all beautiful," were sought by collectors after his death in 1335. His brother Gioacchino was also an *animalier*, the two brothers' skill known from their father's will[28] and from the diary of Oliviero Forzetta, a collector, moneylender, and art dealer who recorded their studies of lions, horses, oxen, and birds, bought in 1335 from the artist's poor widow.[29]

A contemporary of Bellini, Lorenzo Marini da Cattaro, devised a special *prie-dieu* for the Virgin in his *Annunciation* (Luton Hoo, Wernher Collection), a bird cage built into her lectern so doves could coo during her prayers. A Franciscan fellow artist, Antonio da Negroponte, placed at the base of the Virgin's throne a loving audience of frogs, birds, and turtles, all reverently croaking and cheeping, in his altarpiece for one of the Order's largest Venetian churches (San Francesco della Vigna). A *Stigmatization of Saint Francis*[30] by Jacopo's rival, Antonio Vivarini, of about 1450 includes a rich sampling of animal life—a stag, bears, a fox, rabbit, and several birds; also Zanino di Pietro's much earlier rendering of *Saint Francis Preaching to the Animals* (Rieti, Pinacoteca Civica). Bellini's two great drawings of the *Stigmatization* (Plates 255/256, 257) are his own response to the saint's love of animal life. It was thought that Saint Francis had once lived on an island in the Venetian lagoon, and in the Frari his follower, the Beato Pacifico, lies buried.

Jacopo gives us a unique view of one princely zoo (Plate 3): four large birds of prey perch on their bar, each secured by a cord; below, near a stool, a collared monkey looks curiously toward a crouching, catlike creature; and behind an arched opening lounge eight cheetahs in a courtyard. The architectural frontality of this entertaining page suggests that it might be meant for a *trompe l'oeil* panel. Three pages later we see seven cheetahs closer up (Plate 5), presumably drawn after the same animals but possibly copied from an earlier model book. Swift cheetahs were an Este emblem; the back of the Este portrait medals bears a blindfolded cheetah.[31]

Eagles, a heraldic emblem, are scattered throughout the Books and could refer to a number of courts, the Este of Ferrara being the most prominent nearby. The belligerent bird suited many a *condottiere* as a symbol of Imperial Rome; Urbino displays a number of eagles. As the attribute of Zeus, first among the gods, the eagle is associated with supreme power and with the concept of apotheosis, the mortal hero elevated to immortality in heaven on an eagle's wings. The fierce bird inspired Saint John on the island of Patmos, and often holds the Evangelist's pen case in beak or claw; the eagle is also the emblem of Jacopo's scuola, San Giovanni Evangelista.

Arts and crafts in fourteenth- and fifteenth-century Venice, its textiles, painted glass, jewels, and enamels, all used animal studies of every kind, many from vellum pattern books. Strange to say, the finest drawings by an early Venetian *animalier* have survived in

28 Gargan, 1978, 47–49.
29 Gramaccini, 1982, 38–39; Saxl, 1970, 57.
30 Ex-Coll. Carmichael, reproduced by Padovani, 1971, pl. 12. She points out in n. 34 that the panel bears a fragmentary inscription: ". . . de Murano pinxit."
31 See Fossi Todorow, 1966, cat. no. 409, pl. CXXXIV, 188 (Louvre no. 2246 Vallardi), who suggests a Giovanni de'Grassi source. Röthlisberger, 1959, 68, believes that Jacopo worked after the Pisanello drawing.

Plate 44. *Landscape with City View and Tree* (continuation of *Resurrection*, Plate 225). British Museum 21v

Plate 45. *City Walls with Well*. British Museum 98

32 Scheller, 1963. See also Ames-Lewis and Wright, 1983, chap. II, "Modelbooks and Sketchbooks," 96–141, which has an extensive discussion of animal pages.

33 Alberti, *Opere volgari*, Florence: 1843, I, LXXXIX ff.

34 Röthlisberger, 1956, 88.

35 M. Baxandall, "Guarino, Pisanello and Manuel Chrysaloras," *Journal of the Warburg and Courtauld Institutes*, 28, 1965, 183 ff.

Jacopo's Paris Book, bound into it for obliteration and reuse. There is great freedom and sureness in the precious pages that were spared (Plates 6, 7).

Vivid animal studies abounded in the period,[32] the finest still in the notebook (*Taccuino*; Bergamo, Biblioteca Civica) by the Lombard master Giovannino de'Grassi, who worked for the Visconti. His greatly gifted assistant Michelino da Besozzo brought animal studies to Venice in 1410 for Jacopo's generation. One goatskin drawing book filled with animal studies belonged in the sixteenth century to the same great Venetian collector who owned Jacopo's London Book.

The animals in a Florentine notebook of about 1450 (Louvre, Donation Rothschild) combine several sources, some by Gentile da Fabriano, others close to Uccello, both painters who spent many years in Venice. Jacopo della Quercia and Lorenzo Ghiberti, two sculptors frequently in contact with the Veneto, had their own albums of animal motifs. The Sienese master's statuary does not suggest these graphic sources, but motifs on the frames and in many panels of Ghiberti's Baptistery Doors clearly reflect close studies from nature.

The sources for Jacopo's animals can seldom be pinpointed and must range widely, from Venetian, Lombard, and Tuscan pattern books to prints, paintings, manuscripts, and playing cards from Northern Europe. In Verona and Padua, both Venice's cities in Bellini's time, were made remarkably lively, acute investigations of nature, first in Stefano da Verona's drawings and paintings and then in Pisanello's. Most of Jacopo's animals have greater breadth and a more sculptural quality than the elegant sense of the miniature pervading the oeuvre of earlier *animaliers*. His big, bluff beasts mean business, beyond the marginal drollery in a manuscript or the low, caged limitations of a *bas-de-page*.

Providing sustenance, transportation, and amusement, animals had a central role in renaissance culture. Then as now the race horse was a favorite of the wealthy. Vasari's *Lives* stresses the leading painters' affection and even obsession with their pets, including Uccello and Marco Zoppo, among artists who often worked in Venice. Wisest of renaissance animal lovers was the great humanist Leon Battista Alberti, who took the king of beasts for his own first name, suitable to his regal command of all knowledge. The scholar, well known to Bellini by the early 1440s and probably before, declared that "Quadrupeds, birds and other animals of splendid beauty [are] worthy of love, a source of pride to nature who had lavished such grace upon them," and when his dog died he wrote its funerary oration.[33]

If Bellini's animals belong in the rich Venetian tradition, they certainly became more sharply defined during his apprenticeship with Gentile da Fabriano. Crammed into Gentile's *Adoration of the Magi* (Fig. 67) are at least thirty-seven horses, a camel, monkeys, hounds, deer, ox and ass, falcons, doves, leopards, and cheetahs. The three Magi's evident command of this animal kingdom validates their own obeisance before the King of Kings. A movable zoo, this procession also brought living pets for the baby Jesus.

Completed in 1423, possibly with Jacopo Bellini's assistance, the altarpiece is the most brilliant animal assembly of the early renaissance. As an apprentice the young Venetian must have studied the pattern books that went into its making, for his own drawings of fauna can be strikingly like those in the *Adoration*. Pisanello, five or so years Jacopo's senior, is often credited as the definitive *animalier* of the early fifteenth century, but as Röthlisberger suggested,[34] his works may be based on Venetian sources now lost, the very ones Jacopo would also have used.

Both artists were close to Gentile. Praising Pisanello's works about 1427, Guarino da Verona, who also resided in Ferrara, wrote: ". . . you equal Nature's works, whether you are depicting birds or beasts, perilous straits or calm seas; we would swear we saw the spray gleaming and heard the breakers roar. I put out a hand to wipe the sweat from the brow of the laboring peasant, we seem to hear the whinny of a war-horse and tremble at the blare of trumpets. When you paint a nocturnal scene you make the night-birds flit about and not one of the birds of the day is to be seen; you pick out the stars, the moon's sphere, the sunless darkness."[35] These pictorial values were shared by Jacopo, his patrons, and his peers.

### CODEX VALLARDI

The Louvre's Codex Vallardi, that grab bag of fifteenth-century North Italian drawings long given to Pisanello, which includes the only plant studies (Figs. 2, 3) close to Jacopo's manner (apart from those bound into his Books), also contains the only animal pages resembling his (Figs. 5, 6). A Russian scholar, Krasceninnikova, first saw that several of these probably came from Bellini's studio if not from his hand, and boldly took them from

Pisanello's oeuvre.[36] Later an Italian historian, Fossi Todorow, accepted some of these Bellini attributions but reassigned most of them, with others in the Codex Vallardi, to an unnamed Venetian imitator of Pisanello, active in the second half of the century; this artist's drawings were of high quality, with a delicate pictorialism much in Jacopo's manner.

Fossi Todorow[37] may have put the Vallardi animal pages at a certain distance from Jacopo's oeuvre partly because the London Book was generally believed, when she made her study, to predate the Paris Book; thus she dated the Vallardi pages in the second half of the fifteenth century, close to Bellini's "earlier" manner. She found the Vallardi *Two Lions* drawn in black hematite on heavy white paper (Fig. 5) to be close to Jacopo's (particularly to Plates 4 and 7), and the page of lions reworked in pen (Fig. 6) to resemble those in the London and Paris Books. The second page recalls those drawn over with conservative, calligraphic pen lines in the Paris Book, but the original or preparatory sketch is seldom visible beneath the inking, whereas the Vallardi *Lions* were clearly drawn first in black hematite.

Another Vallardi drawing shows a cheetah in a fancy red collar leaping to the left (C.V. 2426), the predatory pet often encountered in the Bellini Books and in earlier pattern books. In the courts this animal was a prized gift, as decorative as it was useful for the chase. The pose of the leaping cheetah along the bottom of Jacopo's London page, among six others (Plate 5), is fairly close to that ascribed to Bellini by Krasceninnikova.

Fossi Todorow gave additional animal studies in the Codex Vallardi to an unknown Venetian artist close to Jacopo, including the *Head of a Hare* (C.V. 2437), a *Crane* (C.V. 2449), the *Cheetah* (C.V. 2414), and a *Cock and Hen* (C.V. 2510).[38] Manet-like in their luminous graphism, the yielding black hematite lines of the Vallardi *animalier* often recall the leadpoint drawings in the London Book.

Such studies were part and parcel of most artists' studio references; the wonderful nature studies by Giovannino de' Grassi have been overemphasized, these remarkably fresh pages becoming *rarae avii* only by the accident of preservation.

Together with the Books' fauna, those in the Codex Vallardi are all that remain of the spontaneous Venetian manner of seizing nature's day that became so central to the art of Giovanni Bellini, Carpaccio, and their successors.

### CATS

Of all animals, cats come closest to the sleek, deceptively easy Venetian character. Benefiting from daily fishing, the beautiful beasts have always abounded in the city's alleys and *sottoportici*, but not in her early art. At least one hides in Bellini's Books, snoozing on the windowsill of a palace kitchen that opens onto a spacious courtyard (Plate 55).

### DEER

Jacopo's art is perhaps first associated with deer in a little *Annunciation* with the arms of the Cornaro family (New York, Metropolitan Museum of Art), sometimes thought to be an early work by him, though this is far from certain. These Venetian aristocrats had Michelino da Besozzo in their early employ, but Bellini, late in his life, painted portraits for their family. Also near to the International Style are the deer in the Louvre *Madonna of Humility* (Fig. 8). A stag seen from the rear in a *Nativity* (Plate 169) reappears reclining by the river as his mate drinks, on the page where the doubting Thomas receives the Virgin's girdle (Plate 236). Another deer lies in the foreground of the page facing *David Triumphant* (Plates 38, 146). Most of these animals are in the London Book. Similar deer based on his father's Books turn up in Gentile Bellini's canvases, as in the foreground of *The Reception of the Venetian Ambassador Trevisan in Cairo* (Paris, Louvre).

### HORSES

Venice is seldom thought of as an equestrian center, removed by her network of canals and marble plazas from the polo field and the parade ground, from stamping hooves and the flashing legs of race or battle. Yet quite the reverse, the Serenissima was a connoisseur of all flesh, and knew her horses well. Jacopo, whatever the date of his equestrian pages, ranks among the finest draftsmen in capturing the steeds' elusive beauty.

The doge's horses were housed in the stables facing the Piazzetta, behind the arches of the *loggia terrena* on the ground floor. Fine steeds were stabled there for the doge and his

36 Krasceninnikova, 1920, 128.

37 Fossi Todorow, 1966, 184.

38 Fossi Todorow illustrates these pages of the Vallardi Codex as nos. 414, 416, 409, and 439, respectively.

Plate 46. *Urban View with Campanile*. British Museum 68v

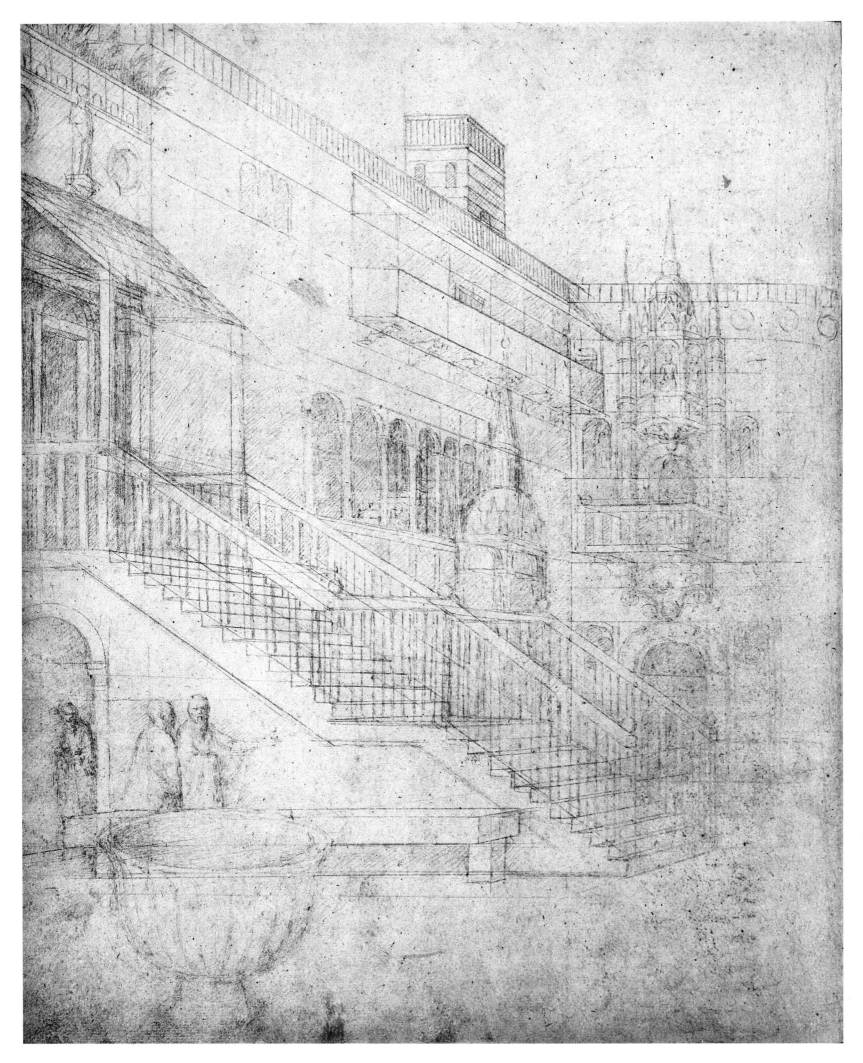

Plate 47. *Urban View with Basin in Foreground.* British Museum 70v

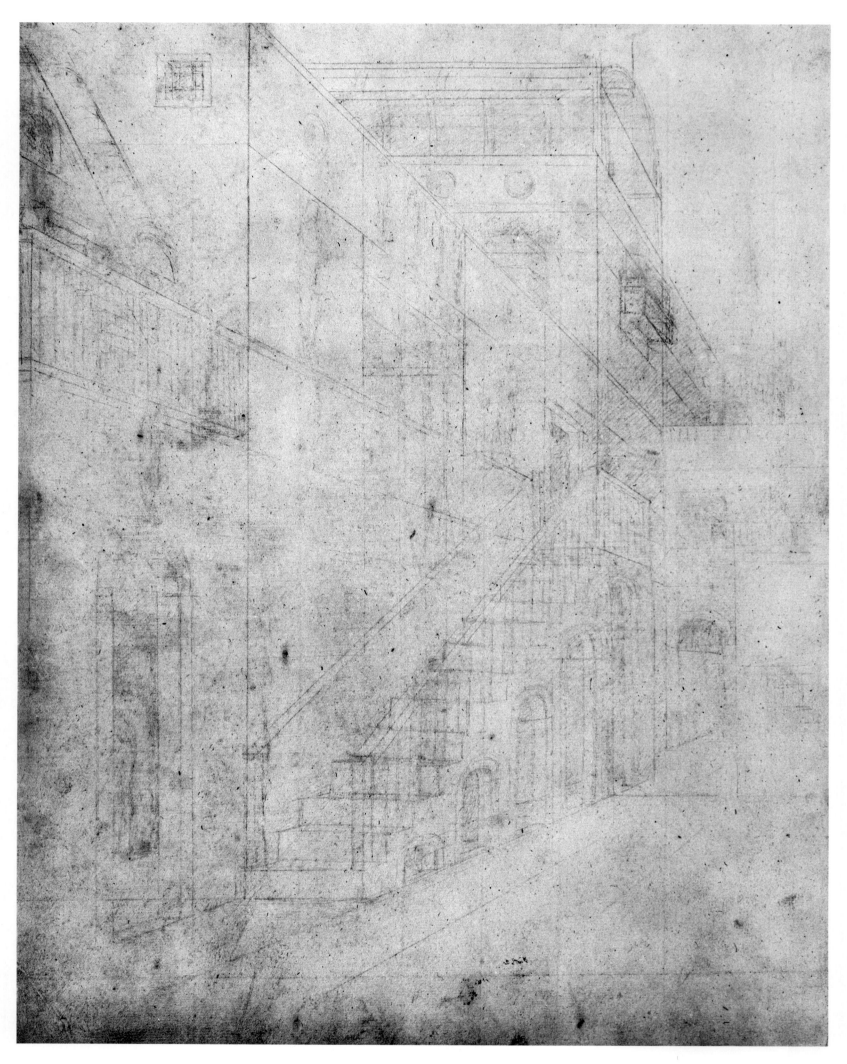

Plate 48. *Venetian Courtyard* (free continuation of *Annunciation* [A], Plate 162). British Museum 12v

Plate 49. *City View with Stairs*. British Museum 56v

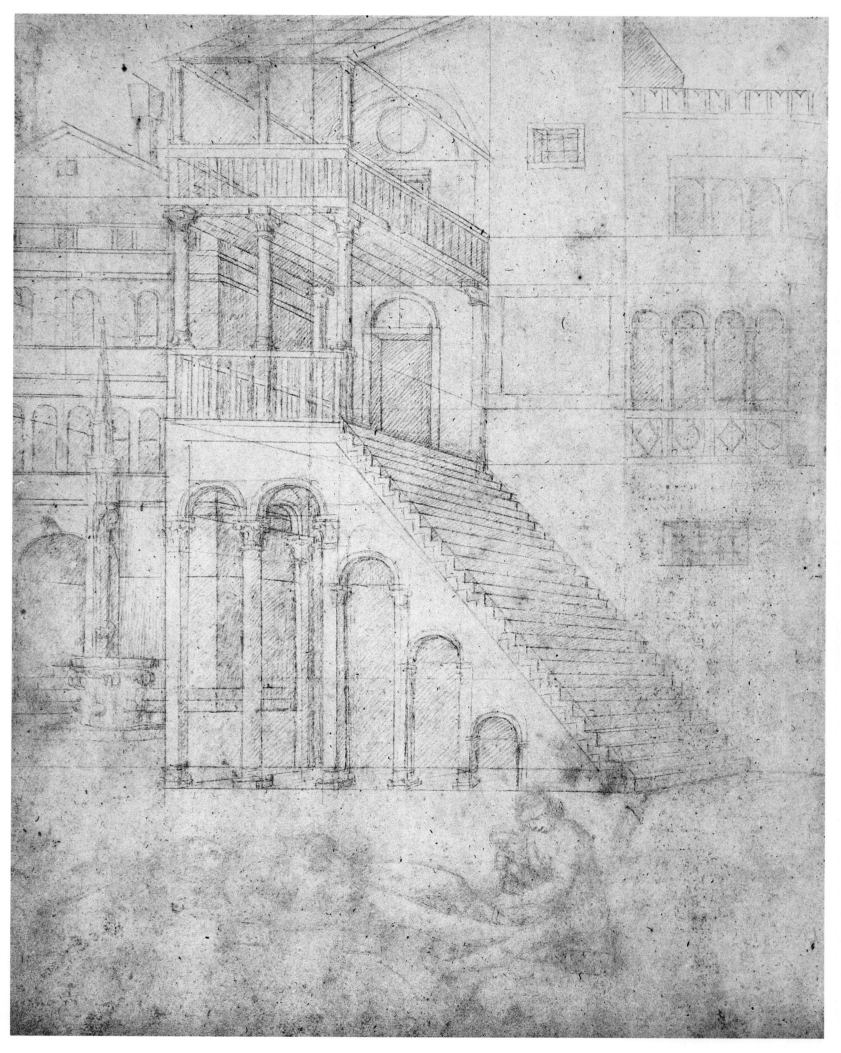

Plate 50. *Courtyard with Sculptor at Work*. British Museum 69v

146

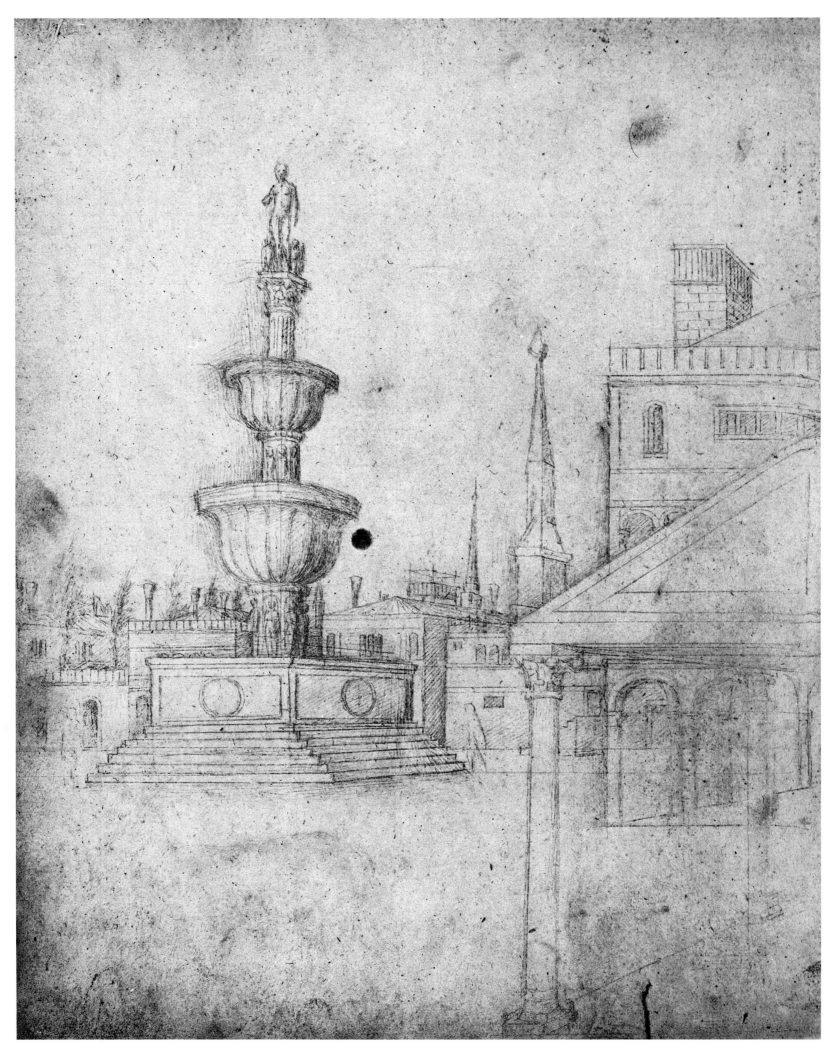

Plate 51. *Venetian Urban View with Fountain* (continuation of *Death of the Virgin*, Plate 229). British Museum 66v

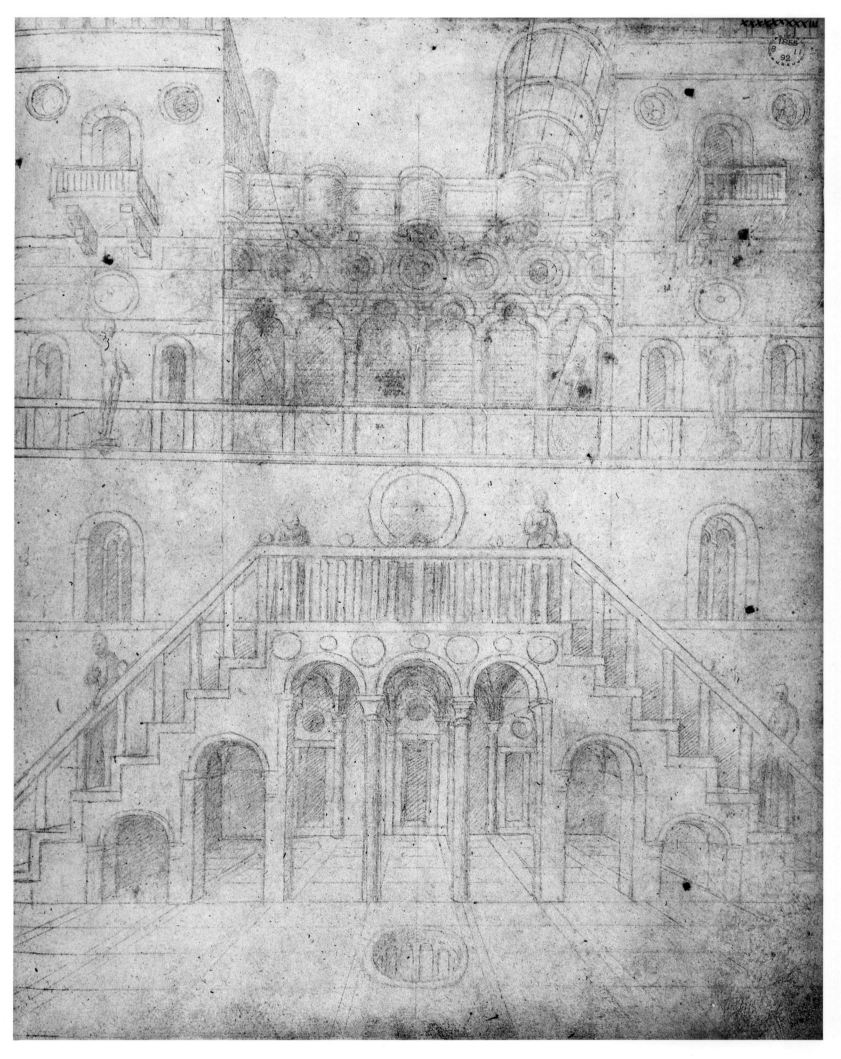

Plate 52. *Venetian Gothic Palace*. British Museum 93

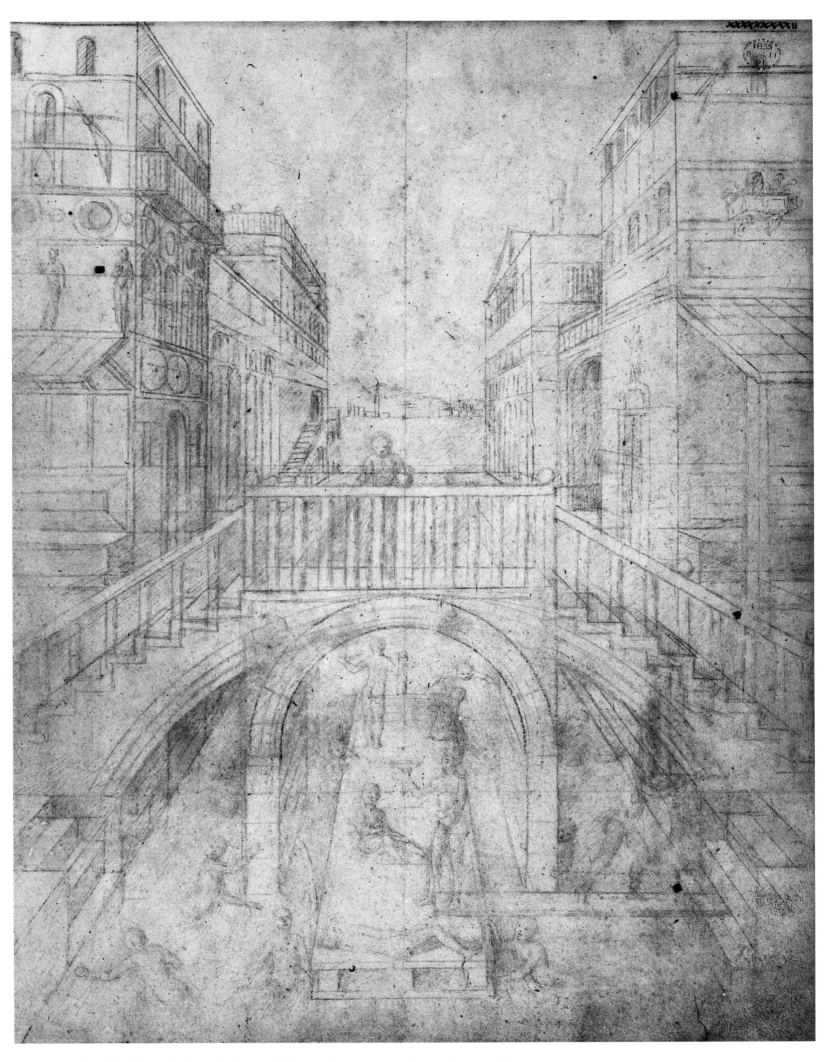

Plate 53. *Veduta with Boys Bathing and Others on Float in Canal*. British Museum 92

39 M. Perry, "St. Mark's Trophies: Legend, Superstition and Archaeology in Renaissance Venice," *Journal of the Warburg and Courtauld Institutes*, 40, 1978, 27–33, partly reprinted by F. Valcanover, in *The Horses of San Marco*, Metropolitan Museum of Art, New York: 1980, 81–99. Valcanover noted that the bronze horse at the far right is adapted for the horse ridden by the Oriental in the Paris *Flagellation* (Plate 195) and is seen again on the Antiquities page, mounted by a *condottiere* and placed upon a pedestal with the Latin inscription from the church of S. Fidenzio in Megliadino, near Montagnana. This drawing, Valcanover believed, like many others, also influenced Donatello's *Gattamelata* as installed in 1453.

40 Perry, 105.

41 M. Harrison and G. K. Boyce, *Italian Manuscripts in the Pierpont Morgan Library*, New York: 1953, 27, n. 29.

attendants, with six beautiful coursers for those distinguished by their service to the state. By Bellini's day many bridges over the canals were arched to permit the passage of gondolas, but previously it had been difficult to traverse the city by boat; with many a street still unpaved, it was far easier to use a horse. The city's equestrian traffic began to lessen only with the ordinance of 1291, when midtown riders had to dismount at the fig tree in Campo San Salvatore at 9 A.M. on the third strike of San Marco's bell, marking the time of the courts' sitting and the opening of most businesses. Racing across the Rialto bridge was forbidden by 1359. But Venice remained a center for riding, the bell known as the *trottera* rung before certain council meetings. Mounted police could quell disorder—in 1310 over eighty horsemen patrolled the Piazza di San Marco when executions followed the Tiepolo–Querini conspiracy. Though Bellini's horsemen often suggest the chivalric tournament, fancy steeds were equally at home in Venice in keeping the peace.

Kingdoms were won on horseback, and those in the Venetian domain were no exception. The Republic was proud of her ties to the blue blood of northern Europe and cast herself, like many Italian principalities, in the chivalric mold of King Arthur, whose adventures, along with those of the French *chevaliers* and the German *Ritter*, were popular Venetian reading. Equestrian monuments of antiquity were emulated in Venice, Verona, and Milan long before they were popular in Tuscany. Though Florence's Duomo would soon house frescoed equestrian statues of her military heroes by Uccello and Castagno, a bronze statue had been raised against Verona's sky by the Scaligeri a century earlier and a wooden example graced the Frari, both following precedents in the Holy Roman Empire.

Equestrian subjects from Venetian history had long figured in local paintings that survive mostly in manuscript form. A rare, fine example in an altar painting is the *Conversion of Saint Paul* by Lorenzo Veneziano (Berlin, Dahlem Museum).

Venice's proudest ancient monument, the four gilded bronze horses from a quadriga that prance above the triumphal arches of San Marco's porch, were loot from her sack of Constantinople in 1204 (Fig. 4). When the great peace treaty of 1177—the *pactum venetum*—put the Serenissima on the map as an international power, a legend arose that the gilded bronze horses of San Marco commemorated Frederick Barbarossa's plan to desecrate the Doge's Chapel:[39] the Holy Roman emperor swore by his red beard to turn San Marco into a stable for his horses after he defeated Venice. But the Venetians defeated his son Otto, scoring a great naval victory while Frederick was recruiting new troops in Germany. Gentile da Fabriano later painted a fresco of that victory for the Sala del Maggior Consiglio in the Doge's Palace, possibly assisted by young Jacopo Bellini. The legend resumes: "the Venetians, out of respect for [Barbarossa] and by reason of his oath, caused four gilded horses to be set up in front of the church of San Marco as an eternal witness of these things. . . ."[40]

Doges and their prominent visitors often sat among these gleaming steeds when surveying tournaments and ceremonies in the piazza below. Of the many graphic recollections of the quadriga in the Books, the strongest quotation is the four horses at the center of the Magi's retinue seen from the front (Plate 177), just as the statues appear on the building.

Venetians, importers of Arabian and other horseflesh since the Middle Ages, were expert judges of equine beauty and speed. For their immense cavalry they came to buy horses in large numbers, mostly from Nuremberg; the Republic's standing army had a thousand cavalry in the Genoese War, not long before Jacopo's birth. The numbers of her mounted soldiers is attested by the loss of ten thousand horses in her defeat by Visconti at Caravaggio in 1448. Concern for expert horsemanship is displayed in the *Fior di Virtu* (New York, Pierpont Morgan Library Ms. no. 383), a text on equestrian combat prepared in Venice with more than 100 illustrations by Liberi, master of pen and sword alike.[41]

Alberti's lengthy treatise on the care, training, and movement of horses—*De equo animante*—was inspired by his patron Lionello d'Este's delight in these costly creatures. Lionello commissioned an equestrian monument about 1441 to be erected in honor of his father, Niccolò III d'Este, and Alberti judged the competition for this work and designed its base. Describing how he came to write his study of the horse, the humanist noted that the bronze horse of Ferrara, first to be cast since classical antiquity, had prompted his decision "to think diligently not only about the beauty and lineaments of horses but also of their whole nature and manner." Jacopo's several projects for such monuments (Plates 78, 131, 132) have been linked with the Este competition and may reflect some of his solutions for that or a later contest.

Though interest in horses was already strong in North Italy, Uccello's arrival in 1425 may have added to the region's equestrian arts. The vigorous Florentine master was then in his mid-twenties, and Bellini would have looked long and hard at his animal pages. Some

of the heavy-set horses in Uccello's great scenes of battles, jousts, and parades appeared earlier, and painted with equal brilliance, in Altichiero's late fourteenth-century Paduan frescoes, and later, in Bellini's Books. Jacopo's delight in the symmetry and majestic movement of these heavy beasts, rendered almost sculpturally, brings his animals close to Uccello's art and taste. Scholars have long noted that many of Jacopo's most monumental horses recall those in Gentile da Fabriano's *Adoration of the Magi* (Fig. 67), where the retinues of the Magi wind over the hills in the background.

The earliest horses in Bellini's art are dashing with their knightly riders into the distance behind the *Madonna of Humility* (Fig. 16). Probably painted from a pattern book, these horses are very different from Gentile's, recalling rather the deer borrowed from such gatherings for the Paris and London Books (Plates 6, 74), their swift, calligraphic passage showing a similar sense of speed and economy.

Some of Jacopo's steeds have the weight and mass needed to support knights in full parade armor; others have a light grace that is more Greek than medieval, suggesting the classical casts and copies brought back for creative scrutiny by travelers in the East. Ancient reliefs could have guided Jacopo's presentation of Christian knights. He may have seen or owned notebooks after Greek carvings, renderings by Cyriaco d'Ancona or other travelers. He also had reliefs closer to home, like that on a stele in a necropolis on the Via Loredan in Padua (now in the Museo Civico) showing an "equus patavinus," a knight of Padua, defeating a Gaul with some of the excitement and action of the mounted *Saint George* in the London Book (Plate 265).[42]

Among the finest Florentine horses cast in bronze, though both were made in the Veneto, were those for the two great *condottieri*, Gattamelata and Colleoni. Donatello was working on the *Gattamelata* in his Paduan studio during the 1440s; Verrocchio brought the full-size model for the *Colleoni* from Florence to Venice in 1483. While in Padua, Donatello also carved a wooden skeleton of a horse, seen by Vasari.[43] Many of Bellini's horses suggest his consultation of the Gattamelata's mount, yet the correspondence is rarely one-to-one. More often they show a general assimilation of the Florentine master's steed, itself inspired by San Marco's bronze quadriga.

Seen side by side, Jacopo's equestrian knight (Plate 18) and Uccello's frescoed *Sir John Hawkwood* (Florence, Duomo) make a striking pair, partly because, again, both depend on the horses of San Marco.[44] Uccello's group is more animated and intense, the horse's rear leg placed slightly differently; the artist's gift for clarified form explains why he was chosen to design mosaics for San Marco. Both painters devised monuments to *condottieri*, and several of Jacopo's designs for similar projects survive. Whether these were to be followed by a monument in the round or by painted replacements for the real thing, like Uccello's *Hawkwood*, is not known.

Young Jacopo may have copied out of Gentile's notebooks or pattern books—the *taccuini*—during his apprenticeship, or the master may have left him some works; apparently Gentile's only child was a daughter (who did not become a painter), and doubtless he bequeathed his notebooks outside the family.

Close to Leonardo and Verrocchio but earlier by at least a decade or more, Jacopo's equestrian drawings are among his strongest. Their mastery of man and beast nears the exalted level of the Parthenon's Panathenaic frieze or that at Tel-el-Amarna. Bellini's command of the light and motion generated by a cavalcade in a landscape (Plates 32, 33, 41, 293) reappears in that of his great French contemporary, Jean Fouquet. Some of the horses, especially those drawn on the facing left pages of the London Book, are so similar to Giovanni Bellini's art in its first maturity that the possibility of his authorship cannot be excluded.

Three unusually massive mounts fill most of their pages: one of these has just toppled his rider in a Venetian square (Plates 119/120), men with staves on the facing verso trying to subdue the steed as others flee to the left; Saint George rides a somewhat similar horse (Plates 258, 263, 265); and a third horse rears over an open grave as its young rider raises his mailed fist in the air (Plates 105/106), his page dashing away in despair on the facing folio.

Jacopo's passion for beautiful horses led to their competing with Christ for the viewer's attention in his great horizontal *Crucifixion* (Plate 209). The equestrian group at far right is the young knight in Plate 105, now seen from behind: again the rider raises his arm to his brow as his horse rears over a tomb with a broken slab, placed this time between a rabbi and a penitent Judas. The little page who fled to the left in Plate 105 reappears near the swooning Virgin. Some of the horses' nostrils have been slashed according to the Oriental belief that this would give them greater speed.

42 Noted by Riopelle, 1979, 23.

43 Vasari–Milanesi, II, 411–12 and n. 1. The skeleton was in the collection of the counts of Capodilista. According to Milanesi, the horse was ridden by a Jupiter and may have been used in tournaments.

44 Vasari–Milanesi, II, 211. The Uccello and Bellini were juxtaposed by Fiocco, 1956, 56 ff.

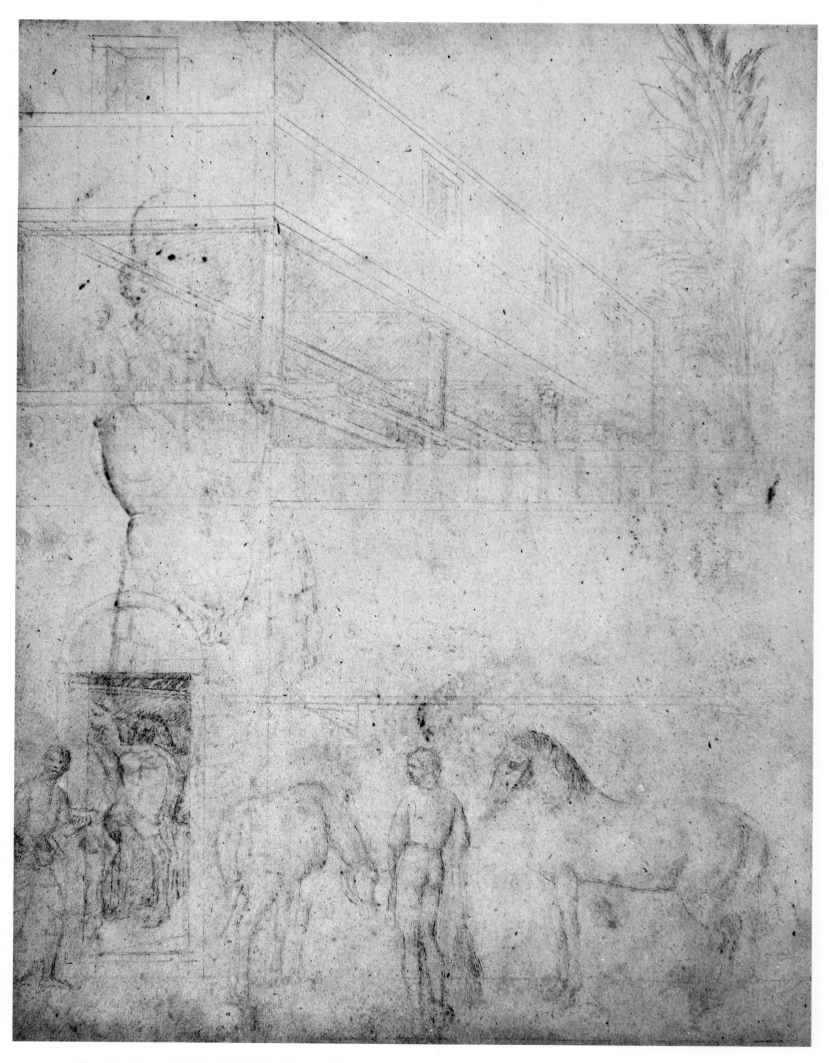

Plate 54. *Solomon's Stables(?)*. British Museum 46v

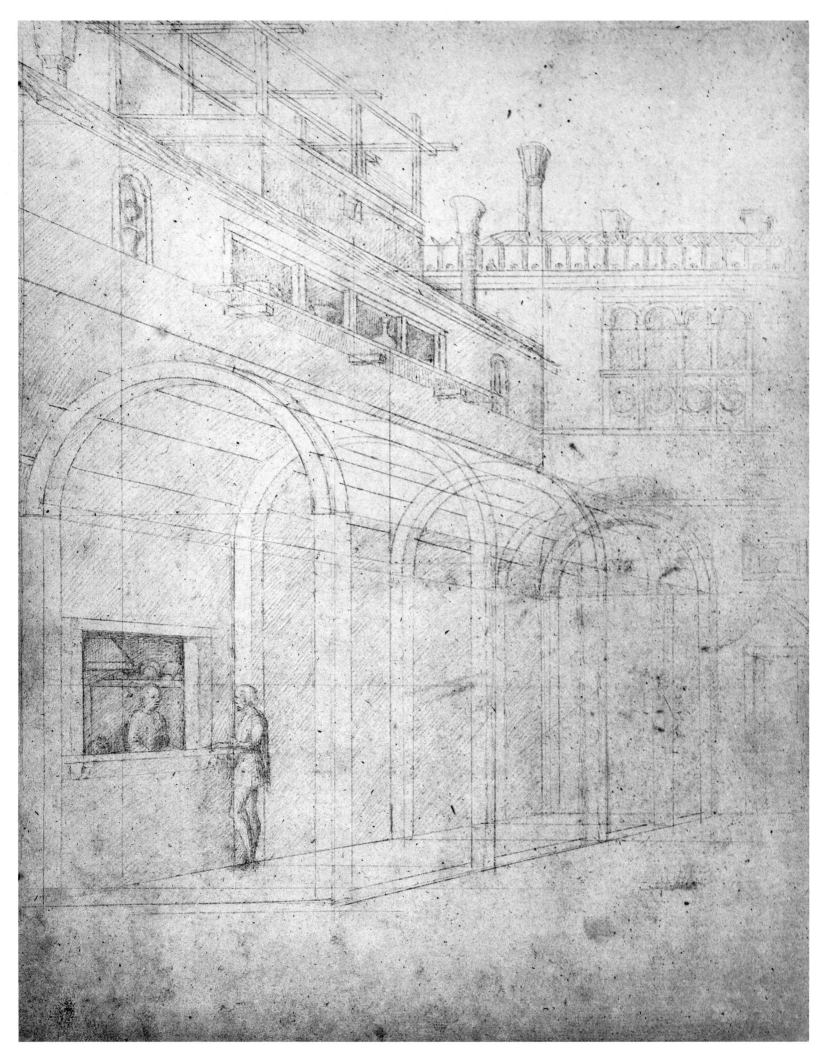

Plate 55. *Urban View with Arcade and Kitchen Window*. British Museum 72v

Great lions prowl about many Venetian buildings, carved in deep or shallow relief, or in the round at the gateway to the Arsenale, where the Republic's ships were built. Confined within roundels, small lions' heads encircle a cornice of the Doge's Palace, close to Buon's carved allegory of *Fortitude*; cast in bronze, they cover the ancient Byzantine doors of the Doge's Chapel next door. The noble beasts flank the entrance to the Scuola di San Marco, where Jacopo and his sons later worked and where Giovanni and Gentile lie buried. On his column Saint Mark's winged lion watches over his city, guarding her faith, her governance, and the religious society hallowed by his master's name.

Palaces often kept lions as symbols of proud dominion, locked in the Este's garden tower at Ferrara or in a barred enclosure in the Doge's Palace. Lions' mating and births were occasions for celebrations. [45] Florence sent Venice three lions to cement their alliance, delivered to Doge Foscari in 1427 by Marcello di Strozzi, whose family would be exiled to the Veneto eight years later.

Like most popular symbols, lions share Christian and classical connotations. That the king of beasts was also the attribute of the Republic's patron, Saint Mark, was a happy coincidence. Benintendi, the humanistic chancellor of mid-fourteenth-century Venice, made of the lion of Saint Mark, "usually a very docile animal sitting at the side of the evangelist in pictures of the Middle Ages, . . . a ferocious brute, slaying with its paw the enemies of the Republic." [46] Alberti prepared an *Apology of the Lion*, that regal creature personifying the life-bound, Aristotelian image of human destiny with which he identified himself. He wrote of his beast's response, on hearing that another lion (the constellation Leo) had already won a place in heaven by his distinctive achievements. [47]

Jacopo's lions arouse the thrills of medieval romance and the Roman arena. As languorous nature studies in familial pride or as foils for or from the days when knights were bold, these noble beasts glow in the new light of humanistic wisdom and the remembered radiance of the Gothic illuminated page.

The consecutive pages of lions in the Louvre Book, long viewed as his most brilliantly penned animal studies, have recently been shown to be the work of a much earlier master, drawn in the pattern book bound in part into Bellini's for recoating and reuse. [48] The first of these older sheets (Plate 7) presents three lions and two lionesses without background (to be the more readily adapted), placed as in the animal suits of playing cards, so popular in the mid-fifteenth century. Strangely enough, the preceding verso page (Plate 6), originally of nine lions (Fig. 7), shows that Bellini, although applying a chalky, tinted ground to the sheet, did not forget the beasts beneath, redrawing the old penned images in silverpoint. Only the two lions at the top were forgotten, replaced by three deer, one ridden by a putto.

Lions attack horses on facing pages in the London Book (Plates 12, 13), looking half like a Roman circus scene and half like images by George Stubbs—this is just what they are, for enlightened as well as renaissance *animaliers* all went back to the same Roman sources: sarcophagi, statuary in the round (Rome, Palazzo dei Conservatori), medals, and cameos. Avid Venetian collectors of classical antiquities could have placed such ancient works at Bellini's disposal for copying.

In mid-century Florence efforts were made to reintroduce the Roman circus as part of the pageantry for greeting distinguished visitors: Uccellesque drawings bear witness to these strange festivities. Early in the sixteenth century the papal and the Portuguese courts, reviving ancient imperial glories, staged combats between exotic beasts from the New World and the East.

Two paired drawings in the London Book contrast versos of caged lions with rectos of men combatting lions in a stockade. In the first pair (Plates 14, 15) the animals on the left crowd behind a barred oculus; facing them, astride the king of beasts, a long-haired barefoot youth in classical garb wrestles open a lion's jaws. In the second pair (Plates 16, 17) lions pace behind a rectangular caged window on the left, and opposite them a warrior in classical armor drives his long, rounded dagger (first used about 1450) through the eye of a rearing lion. The animal's mate lies slain below, near the warrior's battle ax; his fallen shield is on the left page.

A comparable scene of combat is in the Paris Book (Plate 66), the man's nudity again suggesting an ancient subject, possibly *en suite* with the facing *Man Carrying a Capital* (Plate 65). At Samson's feet (Plate 151) lies another clobbered lion. Perhaps these combats were designed for banners or backdrops for some festive or theatrical decor. Such groups are also found in Northern art, often as Samson, sometimes as Hercules. Mantegna's and Dürer's representations of these may follow Jacopo's projects in more finished form.

45 Hodgson, 1910, 347.

46 Saxl, 1970, 47.

47 Gadol, 1973, 238, from *Opusc. morali.*, 393.

48 Degenhart and Schmitt, 1984, 26, pls. 90–91.

Three pages in the London Book (Plates 4, 8, 9) and two in Paris' (Plates 10, 11) bear scenes of leonine domesticity, the proud parents cavorting with their cubs in the wilderness, or at such close quarters that no setting is given. The happy couple playing with their four catlike cubs in rocky terrain (Plate 4) have a thematic link with the *Baptism* on the facing page (Plate 185), for Jesus, as a descendant of the tribe of Judah, had the lion among his ancestral attributes, and is often called King of Kings as the lion is king of beasts: whether this symbolic reference stretches across the continuous landscape setting of the left and right pages is far from certain. Lolling on his back, the male lion plays with a cub as his worried mate watches her sprightly young.

The first pair of facing lion pages in the British Book (Plates 8, 9) have been crudely reworked and colored, but luckily whoever attempted to "finish" these drawings lost his nerve early on.

Though the *caprice*, that uniquely Venetian form of the witty, imaginative vignette, has been linked to the word *capra*, goat, it also goes back to such pages as this, the family life of the king of beasts explored as a spirited commentary on the family of man. Yet in early religious painting wildlife was never accorded the same amount of space as the sacred subject, nor were they larger in scale. Bellini probably returned to the blank page long after completing the *Baptism* and, extending the landscape, gave it to the lions he so loved to draw. These beasts dwarfing the Baptism group, even if the two sides were not planned as a single composition, may have given Titian the artistic license to create similar compositions: his design for a woodcut *Saint Jerome in the Wilderness* gives far more importance to these lions than to the saint, barely discernible in the background.[49] Indeed, Titian's name was lettered onto a label pasted to the spine of the London Book, dating from the sixteenth century, when apparently he was thought to be its author.

Surprisingly, for all Jacopo's Saint Jeromes in fauna-filled wildernesses, none shows the episode of the hermit saint pulling a thorn from a lion's aching paw. An early painting by Giovanni Bellini (Birmingham, England, Barber Institute), its composition and landscape quite close to those in the London Book, models the agonized beast on a lion by Jacopo; Jerome preaches it a sermon before extracting the thorn, raising one hand heavenward and placing the other on his bible as if swearing the lion to good behavior before relieving its pain. This endearing tale was a late medieval fabrication. Saint Jerome actually hated lions, ever equating them with Satan; the church father was popular in the renaissance because humanist scholars readily identified with his guilty love for classical literature. A very late painting by Jacopo Bellini shows the saint penitent in the wilderness, the lion lying before him (Verona, Museo del Castelvecchio; Fig. 60).

Largest of the lion studies are two silverpoint pages horizontally worked in the Paris Book (Plates 10, 11): the first shows two lions, a lioness, and their cubs; the second, a lion and his mate. The solemn grandeur of these "royal families" anticipates the two great images of Saint Mark's beast carved on the façade of his scuola. There is a large Venetian engraving of a lion from the late fifteenth century (Appendix F, Ill. 5) that may well reflect a design from Bellini's studio, similar in its sense of weight and degree of naïveté to the clumsier ones in the London Book.[50]

## FLIGHT TO LAND AND SKY: VENETIAN *VEDUTE*

As Venice was seaborne, a sanctuary from the false security of fortification, her people found the *terra firma* nearer to fantasy than reality. Landscape took on a remote, innately romantic dimension, alien equally to the mercantile facts of the Serenissima's life and to the abstract, mystical orientation of her Byzantine heritage. Her medieval mosaics and manuscript illuminations allowed for sudden perspectives and surprising inclusions of naturalistic details, but seldom led to the broad views long practiced by the Trecento painters in neighboring Padua or in Tuscany.

Bellini's commissions in Padua in 1430 and 1450, and his others in Vicenza, Brescia, Verona, and Ferrara, gave him ample opportunity to explore the lay of the land. The many drawings after Roman antiquities that are listed in his son Gentile's estate, if by Jacopo, make a pilgrimage to the Eternal City likely, as well as travels with Gentile da Fabriano.

Most of Venice's early secular art has vanished (along with almost all the city's fourteenth-century frescoes and canvases); it must have offered much more of landscape and genre than the scant survivals now indicate. Strips of land and sea are seen behind the *Lion of Saint Mark* in paintings by Jacobello del Fiore or Donato Bragadin—the first artist prom-

49 The woodcut is probably by Boldrini, after Titian. P. Dreyer, *Titian und sein Kreis. Holzschnitte*, Berlin: n.d., cat. no. 19.

50 Hind, I, 266, cat. no. 52, says it is "probably North East Italian, about 1490." He compares it to Bellini's lions.

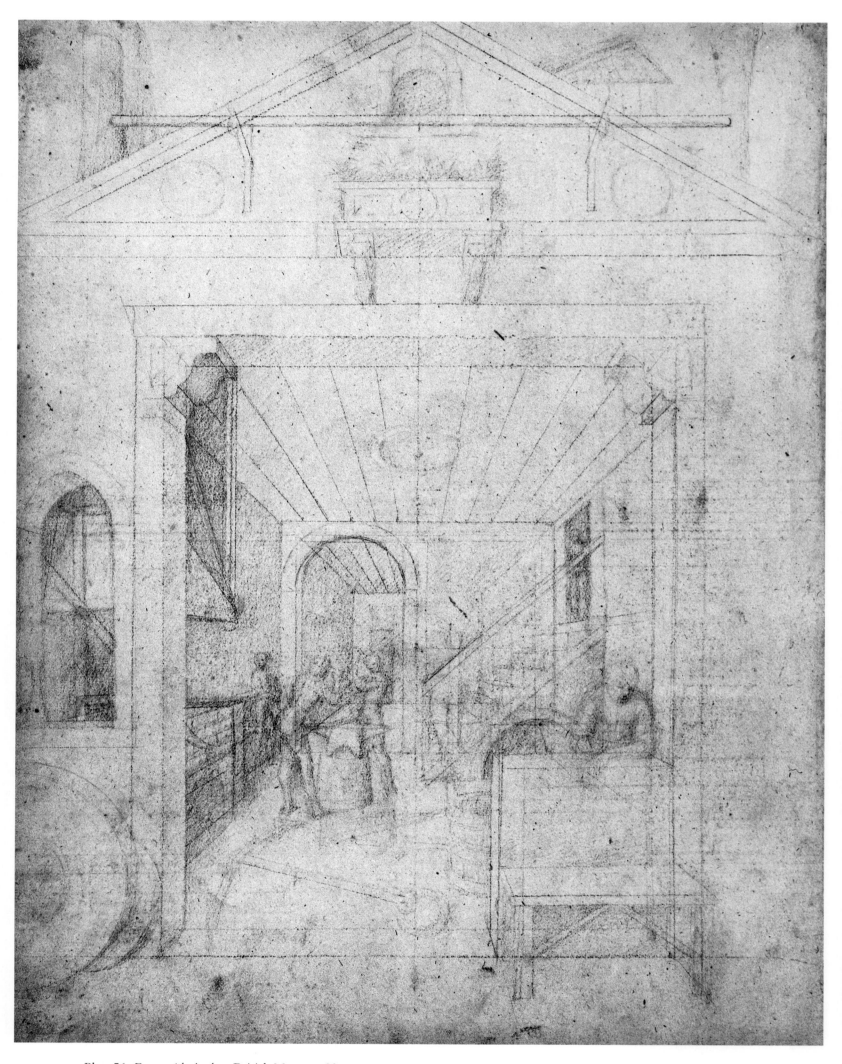

Plate 56. *Forge with Anchor.* British Museum 83v

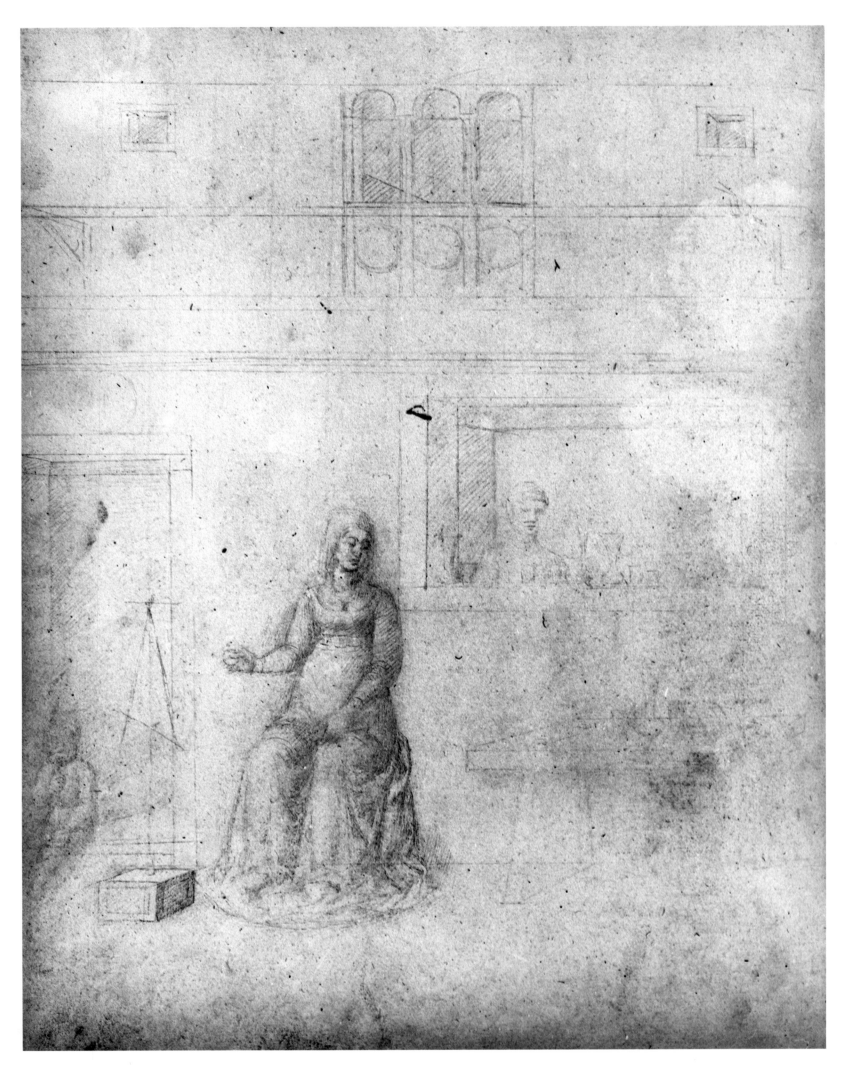

Plate 57. *Shop(?) with Woman Working Wool*. British Museum 51v

inent in Bellini's youth, the second his prospective partner: Jacobello's *Altar of Saint Peter* (Denver, Museum of Fine Arts) includes intense, emblematic keys to nature, but not an expansive view.

An early Virgilian revival that anticipates the arcadian yet convincing landscapes in the London Book, some of its most moving pages, first appears in Petrarch's later Trecento travels around Mantua. Wandering the countryside of Pietola, near Virgil's birthplace, he addressed a letter to the long-dead Latin poet: "I am writing these verses to you in the sweet quiet of your own fields. I tread the rough paths across the meadows, where you were wont to walk. Ever before my eyes are the banks of your stream, the inlets of your lake, the shadows of your woods, the slopes of your little hill, the grassy mound beside the pleasant fountain where you used to sit. And all these sights bring you near to me."[51] This pilgrimage to the birthplace of naturalism in Latin literature continued in early fifteenth-century Paduan writing with Sicco Polenton, active in the Chancellery first under the Carrara and then in Venice, who devoted studies to Cicero in 1413 and became Virgil's first renaissance biographer.

51 Pierre de Nolhac, *Petrarch and the Ancient World*, New York: 1907, 99.

The world of rustic delights appealed more and more as the Republic strengthened its grip on the mainland. Venetian merchants could now play the classical role of country gentleman, the Virgilian rustic squire, warbling Theocritan love songs from a shepherd to his maid. The Serenissima entered into her most expansive and lyrical enjoyment of ancient art and literature since antiquity. To realize her claims on the past, her style of life would become housed in Palladio's villas, palatial yet reasonably like those of ancient Rome, that brought unrivaled and enduring success to Venetian architecture, grafting a working farm onto a classical fantasy.

A landscape image, however old, always contains something of the present, a sudden challenge of contemporaneity that moves into the time of its witness merely by being seen. Without people, landscape offers an innate objectivity, a distancing of sentiment seen on the London Book's best facing pages, many sharing the timeless appeal of a Sung Dynasty scroll or a Turner watercolor.

Landscape is almost always a luxury, that special extra aspect and visual benefit beyond the bare necessities of narrative or the minimal needs of iconic redemption. Extensive vistas are areas of grace and favor that allow for the roving eye or adventurous mind, merciful breathing spaces between martyrdom and massacre, birth and death, adoration and sacrament. Bellini's journeys into space, drawn in both Books and painted in his *Madonna of Humility* (Fig. 31), along with Giovanni's on Jacopo's designs (Figs. 49–51), were more extensively varied than those by any Western artist then known.

Some of this extraordinary achievement is due to the hazards of survival. A rival range might appear had all the drawings survived by a Jan van Eyck or a Masolino da Panicale. As it is, only in the generation following Bellini's are displayed comparable scope and virtuosity in perceiving and conveying the surrounding world; first among those masters to spring to mind is Jean Fouquet, who was in fact influenced by Jacopo's landscapes.

Descriptions of Gentile da Fabriano's lost *Naval Battle* in the Doge's Palace (probably frescoed while Jacopo was his apprentice) suggest that the young Bellini could have learned a lot from his Marchigian master about conveying the variety and atmosphere of natural effects. Gentile's *Saint Nicholas Saving a Ship in Distress* (Vatican, Pinacoteca), with its fish-filled turbulent waters and stormy skies, gives some clue to the appearance of these works. Gentile's high horizons are filled by tapestry-like vistas of distant hill and dale and faraway seas; richly varied Gothic views, like the frescoes in the Tower of the Eagles at Trent, these collective, retrospective visions recall Ambrogio Lorenzetti's cartographic landscape for the Palazzo Pubblico in Siena, painted fifty years before. The landscape background and predella panels of Gentile's *Adoration of the Magi* (Fig. 67), completed in 1423, are superbly attuned to the harmonic requirements of such painting; in the *Flight into Egypt* he catches the cultivated fields and orange trees at sunset; the urban setting for his *Presentation* shows rare sensitivity to the cityscape, its private and public passages—many of them empty—conveying the paradoxical impersonality of most man-made spaces.

If, as has been recently suspected, Gentile developed these rare strengths right in Venice near the century's start, then his skills as a scene painter must have owed something to the Serenissima's heritage. But little survives in mosaics and manuscript illuminations to suggest this strength in her later medieval artists. Oblique insights into the illusion of light over land, found in Venetian and Paduan illumination near the turn of the century, were only fully manifested in tempera by the finest of the Serenissima's early renaissance painters, Domenico Veneziano, but he realized his surviving oeuvre almost entirely beyond her

borders. Probably a fellow student with Jacopo under Gentile da Fabriano, Domenico brought all his regional resources together in his unusually rich approach to landscape, along with those of sophisticated Netherlandish artists of the International Style.

Jacopo accomplished a similar synthesis of North and South by the late 1430s. The splendors of his Paris Book compare with those of the Limbourg's *Très Riches Heures* for the Duc de Berry (Chantilly, Musée Condé); both are large in size and on precious parchment. With their courtly opulence and intimate details, the Paris Book's landscapes are more old-fashioned than the London Book's, in part for the painstaking pen work largely added late in the century. This "overlining" contributes to the quality of careful craft in the Paris Book, far from the freewheeling, impressionistic modernity of the London Book's spontaneous leadpoint lines. Jacopo's *Madonna of Humility* (Fig. 31) of about 1430 and the descriptions of his destroyed *Crucifixion* fresco of 1436 already indicate his feeling for territorial domain, doubtless more fully realized in the *Way to Calvary* and *Crucifixion* painted decades later in the Scuola di San Marco and soon lost to fire. The *Crucifixion* by Antonio Vivarini and Giovanni d'Alemagna (formerly Berlin), though dating from the 1440s, was probably similar in style to Bellini's Verona Cathedral fresco. All these Venetian artists were continuing the panoramic projection they found in International Style frescoes by the Salimbeni masters, in the Marches.

Just as Jacopo took his guidelines for realizing interior space from Masolino's art, so the Florentine artist's approach to landscape may also have been authoritative. Active in Rome, northern Italy, and Hungary, Masolino probably journeyed to and from the court of Mathias Corvinus through Venice, and shared his vision with Bellini.

It is hard to know how innovative were Bellini's landscapes, with so few comparable drawings surviving by other masters. He had an artist's eye for prospect and insight alike, and responded to whatever visual and verbal clues he found. As Venice was among the wealthiest trade centers in the west, her culture was cosmopolitan, with a wide spectrum of talents. Such superb Northern painters as Jan van Eyck, Petrus Christus, and Jean Fouquet (as well as almost all the best Florentine artists) had touched base in Venice by the 1450s, whether as tourists, pilgrims, or in search of work. Jacopo benefited from some of these masters, as well as from those of his teacher's generation.

The slogan for classified telephone books, to "let your fingers do the walking," applies also to Jacopo's pages, for turning them arouses a sensation like cinematic adventure, so widely does he draw upon the achievements of French, Netherlandish, and Tuscan artists. Eyckian works were avidly collected in Italy; one of Bellini's Paduan patrons owned an *Otter Hunt* by the Bruges painter, now lost.[52] Also in that university center, where Bellini had so many commissions, a fine early replica of a Van Eyck *Crucifixion* has long been treasured; another version, of lesser quality, is in Venice today (Ca' d'Oro). Jacopo's sense of near and far, so vividly projected on many pages, could have been heightened by his familiarity with the landscape skills of Petrus Christus, Jan's sole documented follower, who probably worked in Venice for the same scuola as Bellini, the Carità, in the early 1450s.[53]

In the Paris *Presentation* (Plate 179) the remarkably sophisticated classicism of the temple and great fountain contrasts strongly with the evocative rusticity of the surrounding farmlands, fenced in by trees like those still seen in northern Italy. Walled cities and fortifications rise in the background, bordered by a rugged mountain range. In *Saint George and the Dragon* (Plate 261) the setting is more austere, the ground ravaged by fire and the trees stripped by flame.

The praise of a contemporary, Guarino da Verona, for Pisanello's landscapes suggests Jacopo's as well: "If you paint a winter scene everything bristles with frost and the leafless trees grate in the wind." Guarino continues, "If you set the action in spring varied flowers smile in the green meadows, the old brilliance returns to the trees and the hills bloom; here the air quivers with the song of birds."[54] Bellini's sources for his rich urban settings and palaces come from the frescoes by Altichiero in nearby Padua; in the gilded bronze panels of Ghiberti's second Doors he also found models of intricately worked terrain. The Florentine sculptor excelled in shaping landscape to accommodate narrative; fields, rocky lands, hills, and mountains enfold his biblical histories. Jacopo must have seen casts or drawings after these reliefs, if not the Doors themselves. The city view behind the Paris Book's *Crucifixion* (Plate 208), as Röthlisberger noted, is particularly Ghibertian.

Bellini may have drawn some of his landscapes for reliefs, an ever popular medium, rather than after them. The rocky island refuge of *Saint Jerome* (Plate 277), seen against a mountainous shore, is strikingly sculptural. This may be one of the first Venetian sketches made on the blue-toned background that was later used so often; the light-filled color already conveys a sense of space and atmosphere before drawing begins.

52  H. J. Weale, *Hubert and Jan van Eyck: Their Life and Work*, London and New York: 1908, 178.

53  Campbell, review of P. Schabacher, *Petrus Christus*, in *Burlington Magazine*, 117, 1975, 676 f.

54  Baxandall, ''Guarino, Pisanello and Manuel Chrysaloras,'' 1965, 183 ff.

In the *Entry of Christ into Jerusalem* (Plate 191) the topography is unusually rich, permitting the distant shepherd with his flock to echo the role of Christ leading his apostles. One of Bellini's loveliest landscapes borders the winding river where Saint Christopher (Plate 248) stands between its banks. The master has assembled many favorite motifs on this horizontally worked page: plowed fields, aisles and fences of trees, mountains in the distance. A thatched shelter to the right is like that in perhaps his earliest landscape, just beyond the Madonna in the *Madonna of Humility* (Fig. 31). Gramaccini's careful examination has uncovered an important correspondence between this nearby well with a stick across it and the similar well in the Paris Book's *Nativity* (Plate 170).

Jacopo's panoramas, whether on one page or across two, are like those seen in a wide-angle lens, capturing the world's luminous wonders in all their beauty, verdant or arid. Though still close to Masolino's frescoed views at Castiglione Olona, a fresh sense of *poesia* in these pages leads to Giovanni Bellini's finest landscapes, found in his *Madonna with a Monkey* (Milan, Brera; 1510) or the *Sacred Allegory* (Florence, Uffizi). As intimated in his Louvre *Madonna of Humility*, Jacopo must have painted many highly evolved settings by mid-century. Young Mantegna and Piero della Francesca, as well as the artist's sons, may have oriented their approach to land, sea, and sky by these harmonious sources.

In the living rock they delineated with such loving care both Jacopo and Mantegna found biblical messages. Filippo Lippi, another Florentine artist active in the Veneto, was also drawn to the moral drama of the stonescape. Heard at the *Baptism* (Plate 186), the voice of God shatters cliffs and fells a pagan column. The rising rockscape becomes a metaphor of earth reaching heavenward in the towering mountains surrounding his *Lamentation/Entombment* (Plate 220), also in backgrounds of several *Adorations of the Magi* and a *Crucifixion* (Plate 208). Saint Eustace's hunt (Plates 251/252) and the *Martyrdom of Saint Isidore* (Plates 270/271) are set in the mountains, the sky proclaimed by large, daringly blank areas of parchment. Cliffs and crags having no symbolic import tower behind a powerful figure derived from an ancient source (Plate 71); they dramatically animate the background of *The Three Living and the Three Dead* (Plates 125/126).

Saint Christopher stands colossus-like against a curving river bank (Plate 247), its carved steps suggesting an ancient arena in a strange fusion of art and nature. This figure and its setting are often compared with a fresco by Bono da Ferrara in the Eremitani church at Padua, but Bono's seems taken from Piero della Francesca, whose early landscape style has a Venetian look (Domenico Veneziano was his senior associate). *Saint Christopher*'s solid blue sky might invite comparison with that of Jacopo's Verona *Crucifixion* (Fig. 46) were the blue not probably added later in the century.

Blank paper or parchment to suggest the sky's infinite space and light, devoid of the articulation that can only be lent by clouds, is also used shrewdly in much contemporary painting, as in Jacopo's *Madonna of Humility* (Fig. 31), and the predella panels of the Gattamelata Altar, which he designed (Figs. 47–51).

Nature, science, faith, and art converge in a pair of London pages, the *Crucifixion* on the recto (Plate 206), audaciously foreshortened, and the landscape on the verso (Plate 40), its freedom equally innovational. The figures in both follow the principle of isocephaly, their heads aligned along a common horizontal axis. In its pristine bucolic beauty the country view needs no redemption, because it is an extension of the religious subject. Here landscape starts totally afresh, just before the works of Leonardo and Fra Bartolommeo and preceding Albrecht Dürer's revolutionary watercolors by at least two decades. An admirer of Giovanni Bellini's art, Dürer must have pored over a drawing book like the British museum's while visiting Jacopo's sons in their Venetian studio near the end of the century.

The bold treatment of space and light makes it hard to believe that all the London Book's strongest pages predate 1470/1471, when Jacopo Bellini died. Many of the left sides, drawn after the facing scenes on the right were completed, are rendered in this freer, more light-filled manner. Speedy strokes of the silvery leadpoint sketch in the scintillation of atmosphere and luminosity, a quality that appears nowhere else in either Book. Most of these drawings are nature studies that extend, yet are not defined by, the subject on the right. So differently do they evoke the changing mood and movement of light over space and form that the vastly gifted artist of these pages could be younger than Jacopo, one whose feeling for nature leads toward the landscapes of Giorgione and Titian. We may never know who made these lyrical drawings, though it is tempting to see in some of them the hand of young Giovanni Bellini. When could he have added them to his father's pages? Perhaps in the 1460s, or after his brother Gentile, who had inherited them, departed for Istanbul in 1479.

Even the more geometric, rigid vistas of city life in the London Book—characteristic

Venetian open stairways (Plates 47, 49, 50), North Italian fountains (Plate 51), and court-yard views (Plates 46, 52, 53)—are seen in terms of light and reflection as landscapes of urban experience. Architecture is like a force of nature, a fact of life; stairs take flight and squares are anything but square. Such scenes as the *Death of the Virgin* (Plate 229, extension of Plate 51) or the *Presentation of Christ in the Temple* (Plate 178, extension of Plate 46) are drawn with dazzling freedom, almost rococo in their sense of sudden release. Occasionally both pages share this new sensibility, as in the *Crucifixion* (Plates 28, 207), and it is tempt-ing to see them too as by a younger artist close to, if not actually, Giovanni Bellini. Some of the fountains with their several basins may not even have existed in Jacopo's day—man-ufactured in Genoa and not widely known until near the century's end, they were espe-cially popular in northern Italy and even exported to the North.

Like a photographer or film maker, the draftsman of London's verso pages sometimes lets an object take over the foreground in a radically innovative manner, seldom if ever found in the finished pictorial arts of the period. Massive, a sarcophagus lid occupies much of the page facing the *Entombment* (Plate 215), dwarfing the tragic vignette of lamentation above it. Such effects of *trompe l'oeil* are far from the decorum then reserved for religious subjects; only Mantegna could get away with so bold a foreshortening (as in his *Pietà*; Milan, Brera).

Just as *sinopia* drawings, those sketchy, surprisingly free preparatory underdrawings for frescoes, disappear beneath the final painting on fresh plaster, so the freshness of the drawing for a composition on panel is lost in the rendering in tempera. The tree and land-scape areas at the side of a painting of two saints (Fig. 48) make this point, compared with those on a London landscape page (Plate 44): the painted outlines of the countryside and its major features recall those in the London drawing, but tempera has fixed them with a final-ity that is very different from the swift sketch in leadpoint on paper.

Two remarkably naturalistic renderings in the London Book, though not drawn close in time to their facing pages, were clearly inspired by the settings of their biblical subjects. Both are farm scenes. In the first of these "contrasts in continuity," many horses are freely grazing in a woodland clearing beyond a stream that winds its way through the landscape of the adjacent *Stigmatization of Saint Francis* (Plates 33, 257). The setting for that miracle is still in the late medieval manner, its valley flat, with mountains rising precipitously at left and right; too large in scale for his setting, Saint Francis turns like a great Gothic statue toward the seraph to receive his stigmata. The woodland page at the left differs radically in its scale, mood, and style; devoid of archaic Trecento aridity, its impressionistic rendering suggests the free color and rapid brushwork of the later sixteenth century.

The London Book's *Flight into Egypt* makes the same paired contrast with its facing page (Plates 180, 42). Again the more conservatively composed biblical scene is at the right, a wooded background suggested by the rows of trees that diminish in size toward the center. The organization is like a frieze, its isocephaly—the heads aligned—pointing to further concern with perspective. The farm scene on the left has some glancing thematic continuity with the *Flight*—its trees possibly a continuation of those on the right—but no true tie joins the two pages. The left landscape, far from a frieze, is an extraordinarily advanced essay in pictorialism, inventive and daring in its perspective, which vanishes toward the right. Farmhouse and surrounding walls are drawn with a ruler, almost Uccel-lesque in their definition. Now the white paper creates a climate of sparkling variety, totally unlike the serene formality of the Kwan Yin–like Madonna on the facing page.

Two contrasting sensibilities are at work here. If the drawings were all made in the Book by the same hand, then this esthetic divergence must be explained. Decades may separate the drawing on the recto from that on the verso; or several of the recto pages were copied from earlier works in the artist's studio and then "updated" in their extensions to the left, late medieval verticality changed into early renaissance panorama.

Another dramatic example of a revised extension is in the *Crucifixion* page (Plates 204/205), where the determining scene on the right has itself been modified. The artist may have changed what at first was a three-figure composition—or at most four, if the Magda-len was included from the start, which the discordance of her scale and voluminous drap-ery makes unlikely. She, along with the horsemen in the distance and the elaborate cityscape, was probably added when the scene was expanded on the left sheet, where the artist has drawn a pond outside the walls of the rich urban setting and in the foreground a strange ruined, columnar structure. The nude man supported in his grief by a woman standing beside him is one of the few figures the artist planned to dress after copying him unclad from the antique; the same nude reappears as the athlete in the Paris Book (Plate 67), and adapted for an equestrian scene (Plate 105).

Plate 58. *Venetian Wooden Balcony.* Louvre 50v

In vistas of farm life, of woods and barns and cottages, the Books find their freshest, most innovative subjects. Frank rusticity makes these unprettified pages the earliest of those arcadian themes celebrated near the century's end in Venetian song and on canvas. Pure landscape, these come close to scenes by Carpaccio, Campagnola, and Titian, whose poetic presentation of the countryside initiated a mood and mode that were inspired by the literature of antiquity but informed by a new Venetian reverie of time and tide, later shaping those by Rubens and Watteau.

Though striking in their modernity, these country vistas share with those of urban residence, city squares, courtyards, and other public and private spaces, the same novelties of free encounter and eloquent restraint, of silent scrutiny rewarded by art. Some of these scenes may have been used for a splendid decorative scheme or in a scuola's unusually lavish narrative cycle, yet the chances are that most of them belong to the intimate realm of art for the artist's sake, too far in advance of popular taste to be exploited.

Unlike most earlier landscapes, these luminous drawings, together with Masaccio's frescoes and the profoundly shallow reliefs of Donatello and his followers, add up to more than the sum of their parts. Whether painters or sculptors, these artists mastered techniques as innovative as their vision, swift strokes of brush, lead pencil, or chisel conveying their perception of nature with unprecedented freshness. *Schiacciato*, the Italian term first applied to Donatello's low reliefs, comes from the word for "squashed" or "flattened," but its sound has an uncanny similarity to the English "sketch" which these subtle "drawings in marble," along with the London Book's facing left pages, most resemble.

Looking toward those of Claude or Poussin in their evocative economy, Bellini's lead-point lines describe with a simplicity and brisk effectiveness that lends immediate modernity to their landscapes. Even a small passage such as the view to the right of the *Crucifixion* (Plate 205) has an airy vastness almost balancing the looming delineation of Jerusalem that fills five times the space. Similar bold renderings of mountain and valley occur throughout the British Book, the strong and the subtle almost Oriental in their fusion of sure, swift graphic passages.

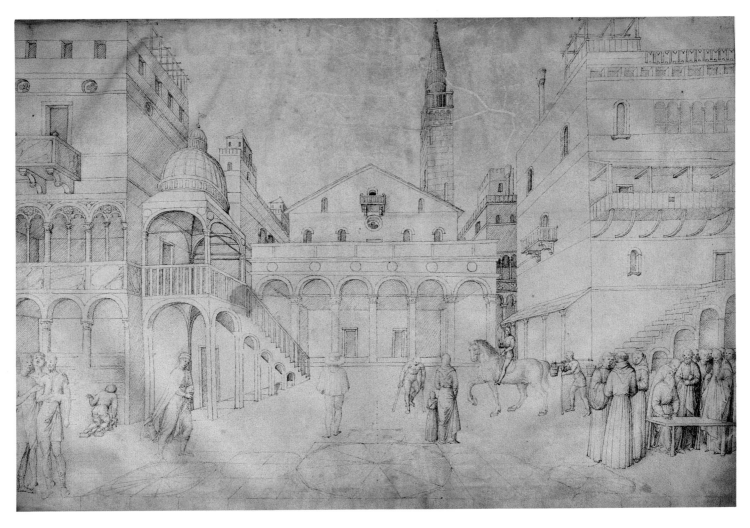

Plate 59. *Urban Square with Church Façade*. Louvre 75v

*Mundo alter,* "another world"—Petrarch's words for Venice—could also be used for the Books' passages to city and country, a world of space and light far beyond all other Western pages of the period. Gozzoli's slender vertical landscape panels (Florence, Medici-Riccardi Palace Chapel) and Mantegna's frescoes in the *camera picta* (Mantua, Ducal Palace) have comparable views, but none can be found on paper. Only in the decade of Bellini's death does Leonardo's graphic vision of the *Arno Landscape* (Florence, Uffizi) rival those in the London Book.

The feathery, light-filled trees are mostly on the verso pages, but there is one on a recto, the riding *Lady and Her Retinue* (Plate 32); trees were not drawn only in the second graphic go-round, with most of the London Book's facing pages. Two studies of a tree (Fig. 2) and of a fernlike plant (Fig. 3), formerly kept with the Louvre's Codex Vallardi and long given to Pisanello, are close to Bellini's style, their sense of potential movement anticipating Titian's art. These drawings resemble the London Book in style and technique, and may have been part of a series of nature motifs, possibly postdating the Book.

Pages such as the London Book's *Saint Jerome in the Wilderness* (Plates 274/275), while reminiscent of powerful Trecento landscapes, are illuminated by a new intimacy close to Netherlandish art, from whose panels radiates a fresh sense of discovery of the world, magical nature encapsulated in a crystalline terrarium. Bellini's new harmony of figure and space also recalls these Northern models. His teacher's early panels of saints within land-scapes (Valle Romita Altarpiece; Milan, Brera) project far less ambience; this is true also for predellas with similar subjects by Jacopo's rival Domenico Veneziano, painted toward mid-century (*Saint John in the Wilderness*; Washington, D.C., National Gallery of Art).

Saint Jerome is small in relation to his surroundings, but not dwarfed by them. Space opened up for his penance and salvation pervades the landscape. Nature, no longer a pas-sive backdrop, now houses the condition of conscience, its dwelling and indwelling pro-viding a dialogue of almost Rembrandt-like intimacy. Inner and outer worlds meet in an agonistic twilight reminiscent of Titian's terminal vision.

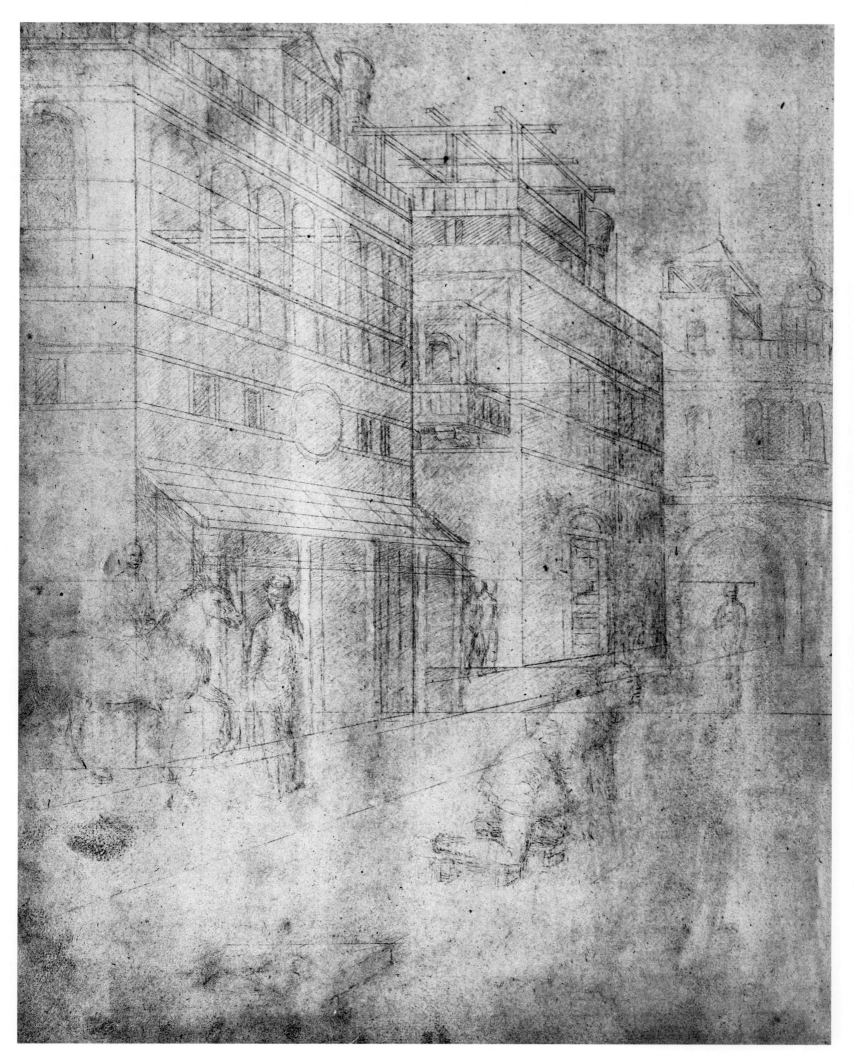

Plate 60. *Urban Setting with Cripple* (continuation of *Raising of Lazarus*, Plate 187). British Museum 65v

Scholars have long puzzled over the precise relationship of Giovanni Bellini's landscape style and Andrea Mantegna's, their startling correspondence most evident in their respective paintings of the *Agony in the Garden* now in the National Gallery, London. Probably these young brothers-in-law both used Jacopo's grand design of the theme (Plate 193) before preparing their independently powerful variants. The two proved finer painters than Jacopo, yet his graphic precedent provided them with more than the bones of many compositions that they brought to greater effect. Jacopo's gift for narrative also furnished the next generation with more than a point of departure. His was a generous platform for their further building.

The challenge of those haunting, empty foregrounds in the London Book was taken up by the painters first active at the century's end, the generation of Giorgione and Titian, for their own reveries. Campagnola, among others, led this approach to landscape a step further. The Florentine Fra Bartolommeo and the painters of the Danube School may have shared some of its benefits. Bellini's fertile voids allow for a subtle transition from the world of the viewer to that of the viewed, an area for projection and exchange. Small wonder that Watteau, most intimate of masters, should have been drawn to this tradition when he copied the early Venetian pages made available to him in Crozat's unrivaled Parisian collection two centuries later, bringing the Serenissima's illuminated lands and lives to the City of Light.

## PORTRAITURE

Portraiture is almost always ranked behind history painting as a necessary evil, paying artists' bills without adding to their glory. Venice was different. There, as in Northern mercantile societies, image-making was highly valued, turning merchants into princes. Nowhere do rich people appear quite so often on canvas as in the Serenissima, crowding into scenes of even the greatest sanctity.

Western portraiture and the Venetian heritage are one and the same. The tradition is surprisingly recent in the history of European art, beginning in the later fifteenth century. Before that the Serenissima—from what survives—specialized in sharp-featured, lively votive images, Swiss in their economical size, of sitters suitably humbled by pious hopes and expectations. Kneeling in prayer and perpetuated in fresco, sculpture, or manuscript illumination, these little men and women seem forever calculating the odds on their ultimate destinations or compounding the interest on what they have left behind.

Thus the Republic's earlier portraits had little glamour; even those in the Byzantine splendor of mosaic look brisk and business-like. With Domenico Veneziano and Bellini came a fresh awareness of two ways to heighten illusion—by Netherlandish technique and Tuscan sculptural values, adding warm light and persuasive modeling—which led to that vitally contradictory concept, an ideal individuality behind a good likeness.

Jacopo was the most famous local portraitist of his generation, its leading practitioner for half a century. Throughout his Books, many of the knights and peasants, squires and lovers, rich and poor, the quick and the dead, confirm his gifts as an understanding observer and compelling master of feature and physiognomical nuance. The Doge's Palace, lined with images of past leaders and Trecento funerary monuments, mosaics, and manuscripts, abounds in sharply observed faces. The finest late fourteenth-century portraiture came from Padua, that humanistic center down the Brenta Canal, where Veronese painters made many vivid, penetrating images. Jacopo's first recorded portrait (if painted from the living model) was a profile of Gentile da Fabriano, who died in 1427; he used the same conservative formula in his earliest surviving portrait, a plump Lionello d'Este (?) kneeling in majestic robes beside a towering Madonna (Fig. 9). This votive panel was probably painted when Lionello was about twenty-two, to commemorate Niccolò d'Este's designating him heir apparent from among Lionello's many bastard brothers. The old marquis would still reign for eleven years, but he had the pope legitimize Lionello in 1429 to make his decision known. Pisanello painted Lionello in the mid-1430s, and competed against Jacopo for another portrait in 1441.[55]

Sadly, none of Bellini's secular portraits survives in paint,[56] for his kneeling Lionello (?) is small beside the *Madonna of Humility* (Fig. 31), and his posthumous image of the popular Franciscan preacher Bernardino da Siena (Fig. 59) postdated Bernardino's beatification in 1450. Both are clearly rooted in the art of Gentile da Fabriano, vividly evoked in Saint Bernardino's parted lips (as if praying to his crucifix), and in the stippled texture and richly worked textiles. One earlier independent Venetian likeness survives, of the pugnacious

55 See Appendix D, 1, Paris, n. 1. Van Marle (1935, XVII, 108–9, fig. 65) believed Jacopo's prize-winning portrait of 1441 to be identical with a profile portrait in the Lazzaroni Collection that was exhibited in Ferrara in 1933 as such (see also A. Venturi, 1929). This painting is alien to Jacopo's art.

56 *The Portrait of a Boy*, Washington, D.C., National Gallery of Art; no longer accepted as by Jacopo. See F. R. Shapley, *Paintings from the Samuel H. Kress Collection*, London: 1968.

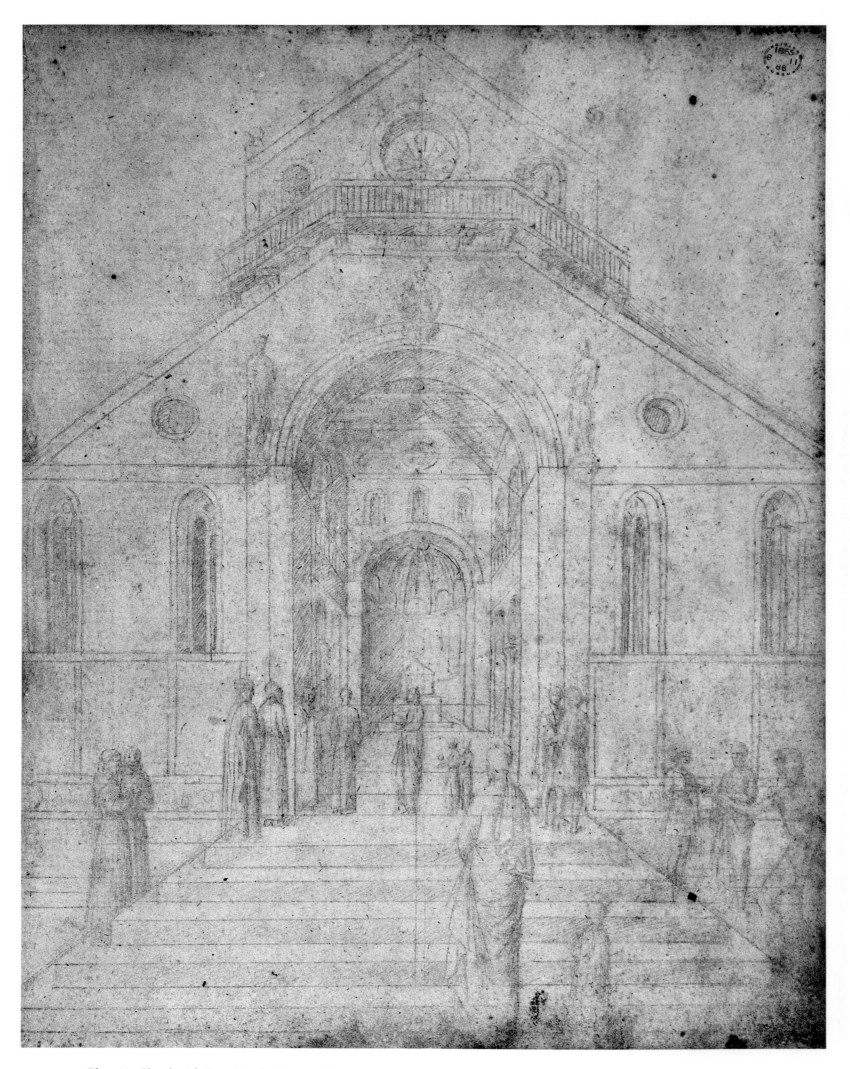

Plate 61. *Church with Open Façade* (B). British Museum 89

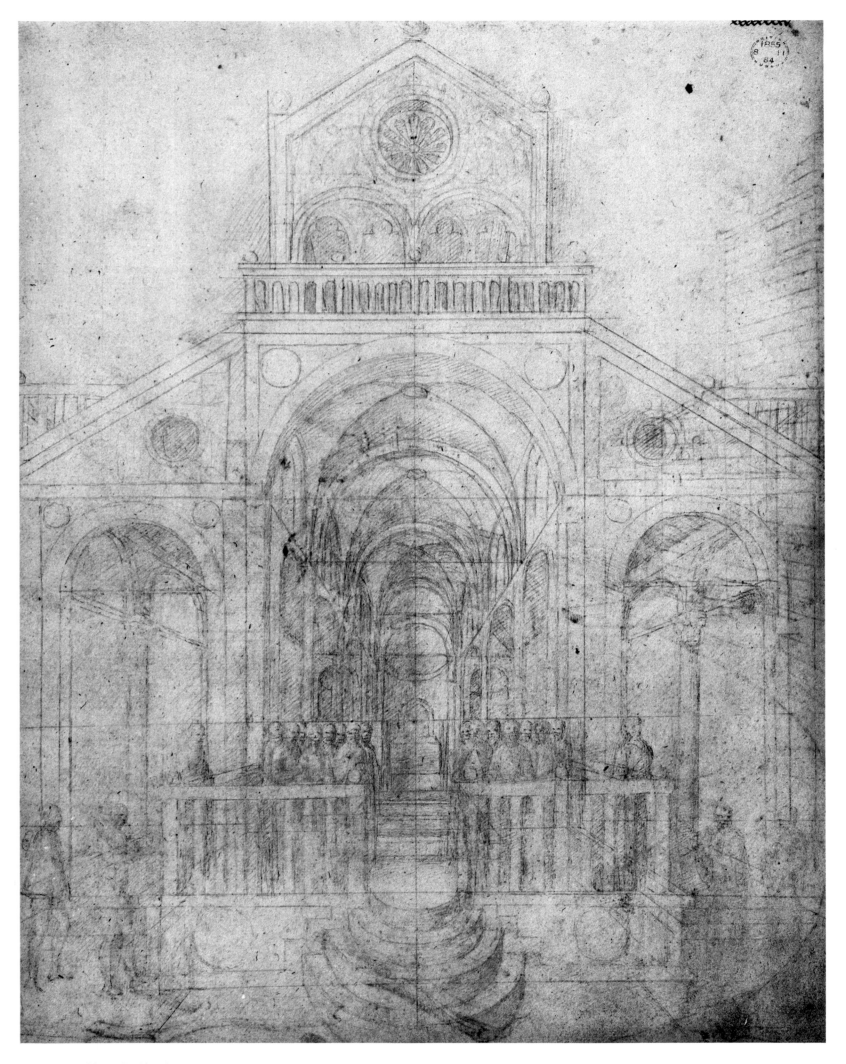

Plate 62. *Church with Open Façade* (A). British Museum 85

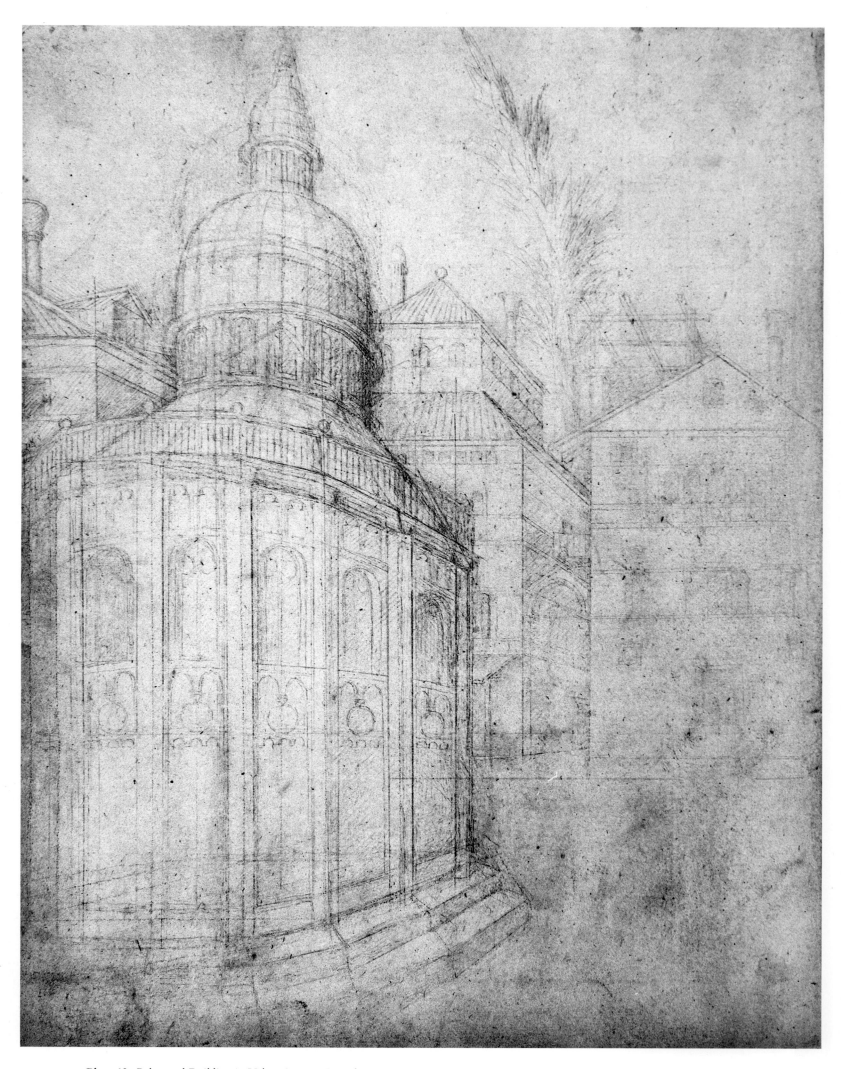

Plate 63. *Polygonal Building in Urban Setting*. British Museum 73v

Plate 64. *Polygonal Temple*. British Museum 75v

Plate 65. *Antique Nude Male Bearing Capital*. Louvre 85

Plate 66. *Samson Wrestling with the Lion*. Louvre 89

Doge Foscari (Fig. 1); his unprecedentedly long reign coincided with Jacopo's peak years, but this painting is more likely by Giambono. Venetians, sensitive to the power of art and fearful of ducal ambitions, forbade any doge to place his portrait inside the Doge's Palace during his lifetime.[57]

Portraiture would be the key element in the sole contemporary scene that has been identified in the Books; though the drawing is lost, it is described in the later fifteenth-century Index of the Paris Book (see Appendix C) as showing Doge Foscari in an interior with his councillors.[58]

In 1441 Niccolò III d'Este of Ferrara summoned Bellini and Pisanello to a contest for the best portrait of Lionello, his son and heir apparent. The marquis selected Jacopo's painting as the winner, a victory celebrated by three poems, two written at the time by the Venetian humanist Ulisse degli Aleotti (Appendix E, 2nd Doc. 1441); the third was prepared about a decade later by the Lombard humanist Angelo Decembrio, of whose brother, Pietro Candido (also a humanist), Lionello ordered a portrait medal by Pisanello. Aleotti, notary to the Grand Council in 1424 and tutor of Doge Foscari's sons, probably knew both artists; his first poem, "The Famous Contest," describes how, though Pisanello labored for six months on his portrait, ". . . from the noble salty shores there came Bellini, the excelling painter, the New Phidias to our unseeing world, who made his true appearance come alive. In the opinion of the loving father, he came forth first, and Pisanello second."[59]

Aleotti's second poem stresses the artist's clear intellect and industrious hand, superior to all in nature's truth. The mention of a second Greek sculptor, Polyclitus, might suggest that Jacopo was known to be a sculptor or designer of sculpture (such versatility was common in the Quattrocento), unless Polyclitus was included in emulation of Petrarch's sonnet praising Simone Martini's portrait of Laura.

While Pisanello's portraits on bronze medals were advanced and inventive, his painted portraits, such as the *Lionello* (Bergamo, Accademia Carrara), were conservative, in strict profile. Jacopo's lost *Lionello* may have taken something from the innovational approaches of Netherlandish and Florentine painting, nearer to the art of Roger van der Weyden that would soon be praised so highly in Ferrara. If the head in Jacopo's portrait was in profile, the figure may have been in three-quarter view, as in portraits ascribed to Uccello and to the Florentine workshop of Domenico Veneziano, Jacopo's only Venetian peer who concerned himself with these issues. Though Pisanello lost the contest, his medallic arts remained much to Lionello's taste, and he made more small roundels of the Este ruler (four) than of any of his other fourteen sitters. Pisanello inscribed his medals OPVS PISANI PICTORIS, leaving no doubt that he saw himself as a painter. Judging by his last picture—a tournament scene for the Gonzaga palace in Mantua, probably from the early 1450s—his career ended in reviving the most conservative of late medieval styles, the tapestry.

The second humanist to write on the portrait contest should have the last word on the comparison—or *paragone*—between Jacopo and Pisanello: Angelo Decembrio's dialogue on the arts. Supposedly spoken by Lionello d'Este at the end of the contest, the future marquis calls them both "the finest painters of our time." This view, pronounced just before Piero della Francesca and Andrea Mantegna emerged in the later 1440s, seems more than fair for northern Italy. Pisanello's name is mentioned first, befitting his slight seniority and his special friendship with the humanist author and their mutual patron Lionello.

Lionello, in Decembrio's lines, distinguishes Pisanello's portrait as "a more emphatic spareness to its handsomeness, while the other [Bellini's] represented it as paler, though no more slender; and scarcely were they reconciled by my entreaties."[60] With so fair and modest a model, how could there be a loser? Jacopo's reward for winning the contest is unknown. Lionello sent him two bushels of wheat (Appendix E, Doc. Aug. 26, 1441), but surely there was a more substantial prize besides. Bellini probably returned to Ferrara later in the '40s to submit a project for an equestrian monument in honor of Niccolò III, perhaps suggested in two of the many pages of such subjects in his Books (Plates 131, 132).

Jacopo's pages are often a form of journalism between the privacy of a diary and the publicity of reporting, closely observed yet impersonal, a pictorial archive. His pages of warlords (Plates 93, 94), farriers (Plate 54), peasants (Plate 20), and iron forgers (Plate 56) all share in freshness and penetration, reserve and perception. Friezelike parades and contests project privilege in all its strength and weakness. Some of his subjects have the quietude of Chardin, others are caught in an Uccellesque game of war and peace. Variously reflective, defensive, and aggressive, cast in equestrian plays of arrogance and intimidation, Bellini's knights take to the battlefield or the tournament with little telling where the one begins and

57 Muraro, 1963, 101.

58 According to Degenhart and Schmitt, the six men with the doge are those of the Small Council. A similar scene, dating from 1471–76, is in the *Carmen Mocenici*.

59 Gilbert, 1980, 174. See also Appendix D, 1, *Ferrara, where this poem is discussed at greater length, and translated by Roger Fry.

60 Baxandall, 1963, 314.

the other ends. Posture and gesture, setting and attribute, play their part in these varied perspectives, but physiognomy has the first and final word.

Three traditions shaped Jacopo's rare sensitivity to the phenomenology of feature. First came the crisp definition of the Gothic arts of portrayal, so vigorously practiced in nearby Padua; this was soon heightened by Bellini's use of Netherlandish light and color. And classical sources were followed, preserved in the ancient coins so avidly copied by artists and collected by wealthy men such as Lionello. These rich resources blend in Jacopo's approach to the human condition, to the reading of feature as essays in *virtus*, as moral commentaries, gothic tales, and novellas old and new. His enigmatic, classicizing scene of a man leaping into or over a yawning tomb (Plates 105, 106) may have had no more than a dramatic exploration of motion and emotion as its *raison d'être*, but the dazzling double page was also a virtual academy of physiognomy, ready for the copying.

Apart from its masterly classical references, this drawing recalls both the intimate scale and diminutive splendor of the finest Northern manuscript illuminators as well as the exquisite little portrait drawings in silverpoint often given to the Bruges master Gerard David, active at the century's end.[61] The amazing encapsulation of detail makes it certain that Bellini had some experience in a manuscript atelier and probably directed such work (Appendix F); he brings together in miniature so many figures, and re-creates their power with no sense of shrinkage or boat-in-a-bottle trickery, that bane of small-scale art.

Bellini is, in effect, the founder of early Venetian renaissance portraiture, which reached its height with his son Giovanni. Only Jacopo's young man in left profile (Plate 1) can be categorized within that new genre, its page divided to leave space for a confronting image. Though his class is not overtly indicated, the sitter is no studio *garzone* holding a pose for his master's practice but someone comfortably situated in Venetian society, his garb perhaps that worn under armor. Serene and harmonious in its definition by light, this image would have invited Giovanni's long, hard study—possibly he even drew it. Some have seen the delicate rendering of the page as preparatory to a relief.

Significantly, the treatment of the young man's hair is close to that in an athlete's statue in the same Book, drawn after the antique (Plate 67). A lost "figura" of Lorenzo Giustiniani, an image of the deceased patriarch made in 1457 as part of his tomb at San Pietro di Castello, is Jacopo's only dated portrait.[62] The celebration of the hero, the victor, the triumphant knight, was a major activity in belligerent mid-fifteenth-century Venice, and to this Bellini's portrait skills were well adapted, as seen in his drawings for funerary monuments, deceased military heroes on their catafalques or tombs. Saddest and most striking of these is the naked corpse of a young, emaciated military leader, his brow wreathed in laurel, stretched out on a sculptured sarcophagus lid (Plate 136), probably Bertoldo d'Este, who fell in the Battle of Morea in 1463.

The only work of art that is remarkably close to the Paris Book and also securely dated is the manuscript *Passion of Saint Maurice* of 1451–52 (Paris, Bibliothèque de l'Arsenal).[63] Scholars disagree as to the artist—whether Giovanni Bellini or Jacopo's son-in-law Mantegna—but most find the illuminator's point of departure in the father's mind and milieu.

Many of Jacopo's powerful knights are not the heroic stereotypes of his age, the strong-jawed, nobly browed, clear-eyed classical leader reborn in Donatello's lion-like Gattamelata. Riders in the great tournaments (Plates 94, 95), or another rider with a huge eagle embroidered on his horse's blanket (Plate 116), or those suddenly confronted by three dead men (Plate 126) or a nude cadaver (Plates 127, 129), all look secure in their unidealized selves, proudly hook-nosed or weak-chinned, with plump cheeks or scraggly locks. Jacopo's commandants have known life's accidents; this intimate scrutiny attests to shared experience, to the artist's proximity to the courts of the *condottiere*, marquis, or *podestà* (military governor). The source of some of the Northern Gothic quality in Bellini's portraits, particularly in scenes of pageantry or combat, may be in Venetian chivalric literature, Arthurian tales retold in the Franco-Venetian dialect. Jacopo's pages show his use of many manuscripts of *chansons de geste*, the endless adventures of Roland, or Orlando as the Italians knew him, switching his combat sites from the Pyrenees to their own peninsula.

Most distinctive among Bellini's women is the peasant to the far left of a water carrier (Plate 21). She has the calm gaze often encountered in seventeenth-century art, her clear and dignified features surprisingly like those in Ottavio Leoni's small portrait drawings. Her face and that of the reflective man alongside her suggest that they were modeled on stand-ins, members of the artist's household who posed as needed. The spinner seated before a shop also evinces a strong sense of self (Plate 57), the ambience of silence and her quality of restraint akin to Piero della Francesca's.

61 M. J. Friedländer, *Early Netherlandish Painting: Hans Memlinc and Gerard David*, New York: 1971, VI, Part II, pls. 228–29.

62 Meyer zur Capellen, 1981, 5–33.

63 Meiss, 1957, 3.

Plate 67. *Study after Antique Statue of Pugilist.* Louvre 82

64 For subjects akin to the Rider among the frescoes at Belfiore, the Ferrarese pleasure palace, see W. L. Gundersheimer, *Art and Life at the Court of Ercole I d'Este. The "De triumphis religionis" of Giovanni Sabadino degli Arienti*, Geneva: 1972, 56–72.

65 A travel notebook from the Pisanello circle (Milan, Biblioteca Ambrosiana 214) includes a drawing after one of the *Horsetamers*. See Fossi Todorow, 1966, no. 182v, 127–28.

66 See D. Rosand, "Venetia Figurata: the Iconography of a Myth," *Interpretazioni Veneziane, studi di storia dell'arte in onore di Michelangelo Muraro*, Venice: 1984, 177–96.

No hard and fast line divides portraiture from other genres; the distinctions are more often social than historical, their separation primarily in the eye and mind of the patron or purchaser. Bellini's pages of women, whether at work or riding with an elegant entourage perhaps on their way to marriage (Plate 32), are close and sympathetic studies. If the latter image was ordered by the lady's affluent husband for a projected pictorial display in the family annals, then it is indeed partly a portrait. But with time this page becomes a social document, an essay in the manifold ways of passage between the individual and society that is seen as life.[64]

The Books' miracles lie less in scenes of faith than in our sense of confronting the face of life; as Bellini draws the moment of biography into eternity onto their pages, over five centuries suddenly pass unfelt.

## NUDES

More than any other Western art center, Venice is linked with the nude, with the ease and grace of paradise regained, where our bodies and souls, stripped of sin and servitude to dressing, are restored to classical innocence, liberty, and harmony. That Jacopo Bellini, founder of the Serenissima's renaissance, included over ten such studies in his Books is more than we could hope for, since most early drawings of these subjects were destroyed. Before Bellini, Italy had produced other masterful nude images in the medieval sculpture of the Pisani and that of the early renaissance masters, as well as in the paintings of Giotto, the masters of the Paduan School, and Masaccio.

Drawings of classical nudes, athletes, and other figures by Jacopo da Verona (Oxford, Christ Church) and Pisanello (possibly his pupil)[65] predate Bellini's work. But the nude figures on the Books' pages, mostly from the middle of the century, are larger, suggesting greater confidence in that genre. Jacopo's nudes make the first timid step toward the "Venetia Anadyomene"—the cult identifying the seaborn Venus with the seaborne city.[66]

Plate 68. *Three Nude Women with Three Children (Judgment of Paris?).* Louvre 88

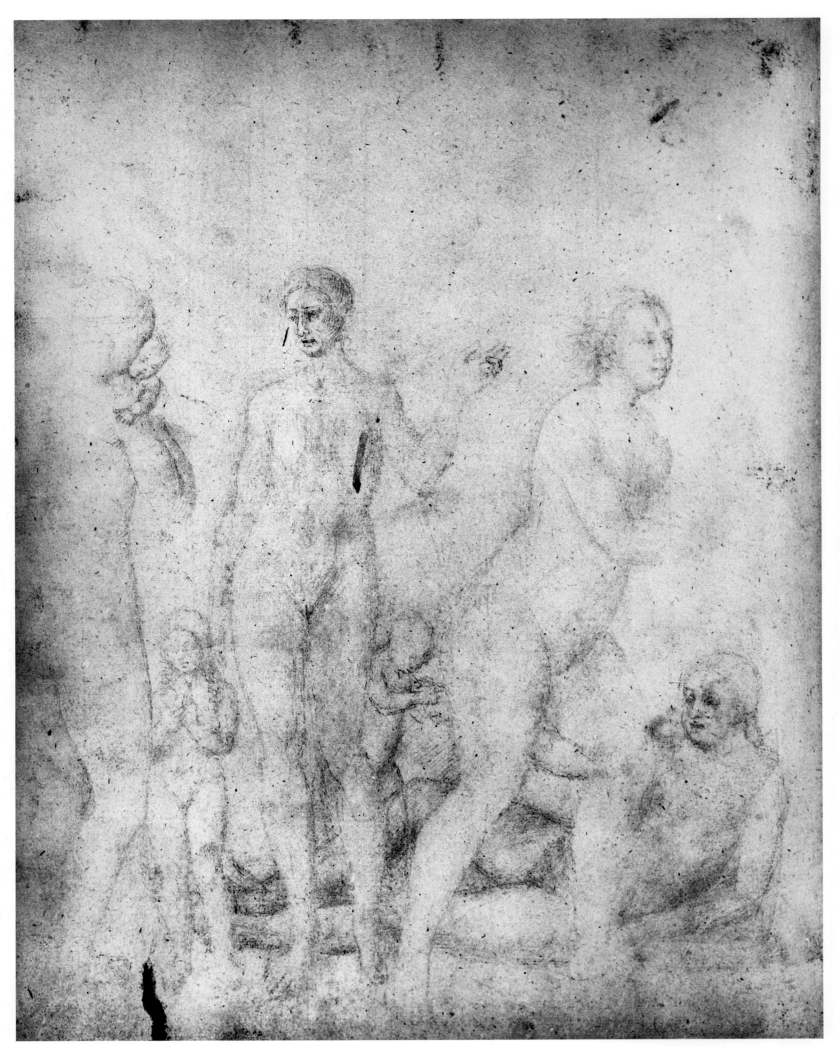

Plate 69. *Nude Women and Children*. British Museum 30v

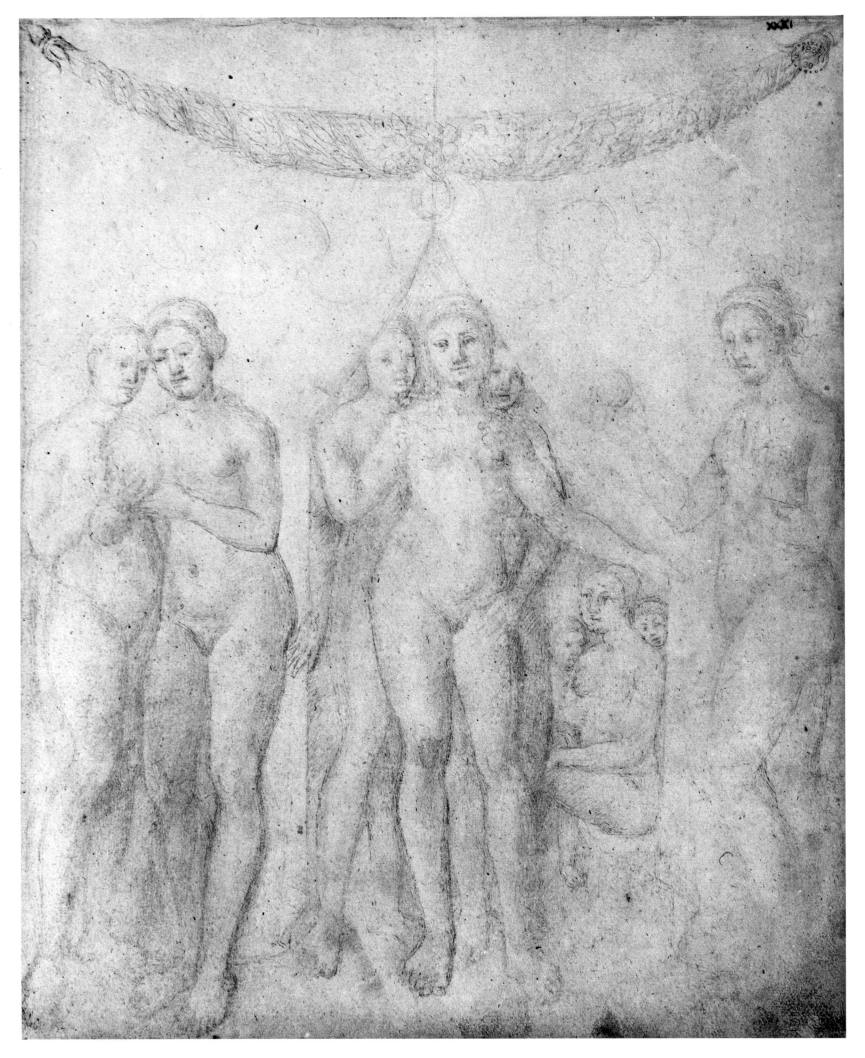

Plate 70. *Nude Women and Children in Bathing Pavilion.* British Museum 31

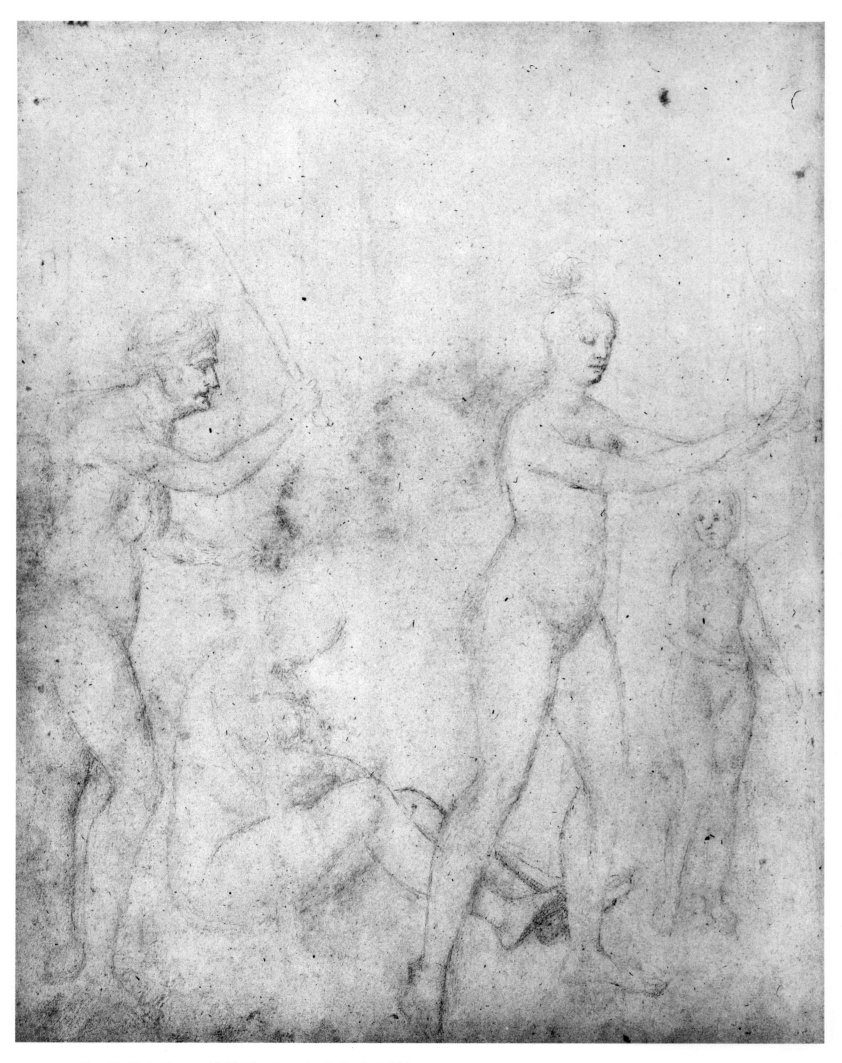

Plate 71. *Nude Women with Children Preparing for Battle.* British Museum 31v

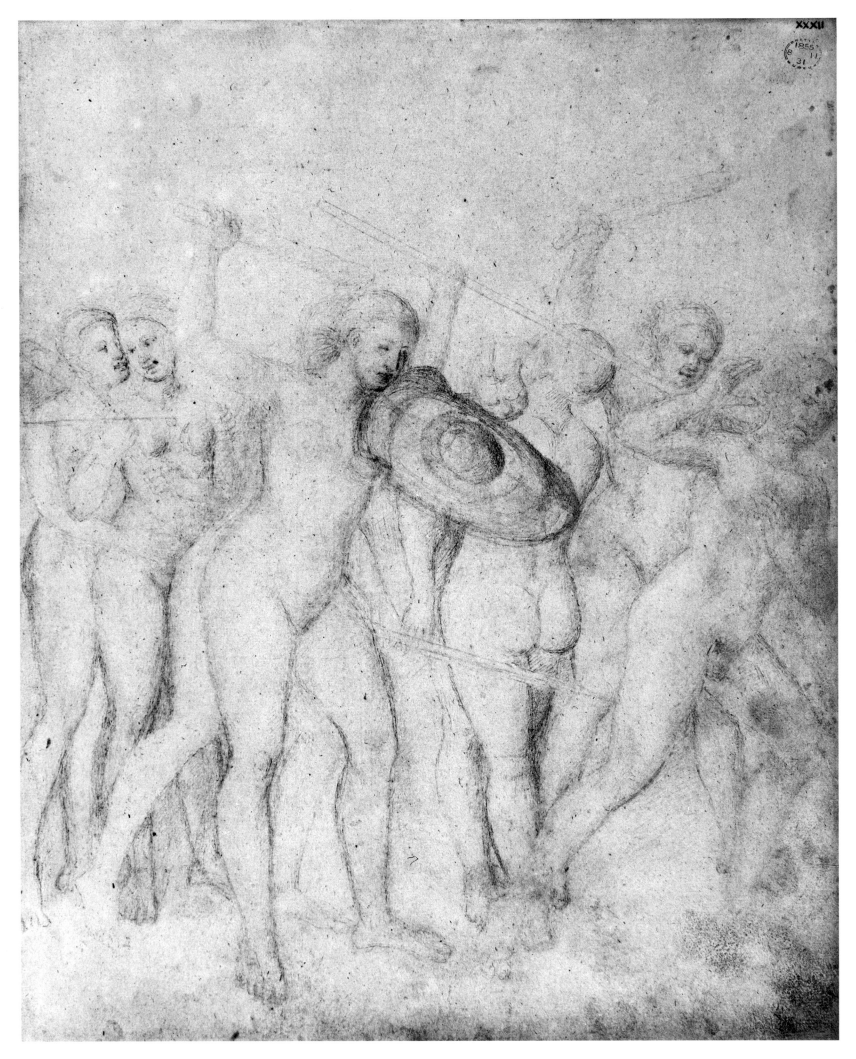

Plate 72. *Nude Women in Combat.* British Museum 32

While Quercia's carved *Adam and Eve* (Siena, Fonte Gaia) and those painted by Masaccio (Florence, Brancacci Chapel) are seen through ancient sources, little separates Bellini's from the naked truth.

Many early renaissance nude figures come from those carved on classical sarcophagi. These ancient reliefs were widely displayed, often sheltered in church porches and even reused for Christian burials. Two drawings on parchment of Venus-like women with infants, clearly grouped after such antique sources, have been attributed to Gentile da Fabriano or Pisanello, but are close to Bellini's figures and compositions (Plates 68/70). Their approach to the nude and to the art of the past is more traditional than Jacopo's, however, and they could have been in an older pattern book of antique motifs kept in Bellini's studio.[67]

Lionello d'Este is credited with saying that the ancients "felt that excellent works of those artists and of [antiquity] would best be judged in a state of nakedness. The story of the goddess laid bare before Paris depends upon a similar point . . . the artifice of nature is superior, no period fashions change it." The marquis stated further, "in any painting it is best for things to be naked . . . everything in poetry and painting is naked, and this is because it is their duty to conform to the skill of Nature."[68] Such a matter-of-fact acceptance of nudity is the first great stride toward the *luxe, calme et volupté* of Venetian art, those three graces who seldom illuminated contemporary Tuscan imagery—Florence's medieval protective figure was Hercules, and the city's erotic art is as often masculine as feminine. Devoted to the splendors of fact, Jacopo's art is a frank affirmation of being, without protective or distancing glosses of antiquity even when both his text and image have classical sources.

A puzzling page with three large nudes drawn in metalpoint on a prepared ground (Plate 68) has been interpreted as a Judgment of Paris, possibly derived from the Three Graces, an antique statuary group. Venus, at the right, is the winner of the beauty contest, holding Paris' golden apple, the apple of discord that led to the Trojan wars. There may be three small putto-like figures below, hard to read in the drawing's faded state. Though female, the two foremost nudes recall Masolino's *Adam and Eve* in the Brancacci Chapel (Florence), where the serpent between them has the head of a beautiful woman; this page too could refer, rather than to a classical subject, to the same late medieval tradition of Adam and Eve with a human, seductive serpent.

The motif of a nude holding an orb recurs in the London Book at the far right of a two-page spread of undressed figures (Plates 69/70). Those on the recto are grouped in a tent or pavilion, plump, self-absorbed beauties à la Ingres' *Bain Turc*. Pages like these may in fact have been used to decorate a harem, since Gentile Bellini probably took the Paris Book to Istanbul and could have consulted it for the erotic subjects he is known to have painted—"cose di lussoria"—for the seraglio of his patron Mehmed II.[69] The group at the left includes a pair of embracing women looking into a mirror, a theme Giovanni Bellini was to perfect later in the century (Vienna, Kunsthistorisches Museum). Bathers are under the planetary influence of Venus, so the connection of the goddess of love with these belles in their bathing pavilion may be overt as well as covert. As the central woman parts the curtains to reveal another woman seated with infants at the right, she is embraced from behind by two nudes to form another group of three, like that in the Paris Book (Plate 68). This is the most indicative of all Bellini's pages of his pursuit of ideal proportions, a typically renaissance concern. All seven women are essentially the same figure, however, being based upon an identical canon, and their effect is similar to Muybridge's multiple photographs of a single nude in motion. The sense of weight and stability approaches the classical solemnity of Piero della Francesca, whose works for nearby courts were also valued in Venice. The festive garland and dangling ribbons enhance the celebration of loving beauty to which this page is clearly dedicated.

Though the reclining nude in Plate 69 is in the classical pose of a river god, those of all the rest are more original, their remarkably realistic presentation free from tradition. This fresh sense of observation, of life study, is particularly strong in the distinguished figure, second from the left.

Nude women expelling a satyr, shown in Plates 71/72, are all drawn closer to the bone, far less uniformly pretty. Varied in type and vintage, these figures provide a female parallel to the popular renaissance theme of the Three Ages of Man.

Jan van Eyck's famous depiction of a nude bather was much admired in Italy for the artist's magical illusionism in bringing his subject to life. Bellini may have seen the panel at the court of Urbino: it showed a woman coming out of a bath, an old woman attendant, a landscape in the distance, and a marvelous mirror that reflected everything within the scene. A description of this work by Facio, earlier the tutor to Doge Foscari's sons and a

67 The parchments were formerly in the Koenigs Collection. See Fossi Todorow, 1966, pl. CIX, nos. 175, 176v. She notes that no. 175 includes a *St. Christopher* that is close to Gentile da Fabriano and to Jacopo's saint in the Louvre Book (Pl. 247). The Koenigs page was ascribed to Gentile da Fabriano by Degenhart but not accepted as such by Christiansen.

68 Baxandall, 1963, 314, 320.

69 Müntz, 1892, 286. See also *Historia turchesca de Gio. Maria Angiolello schiavo e altri schiavi dall'anno 1429 al 1513*, ed. I. Ursu, Bucharest: 1909; and Thuasne, *Notes sur le séjour du peintre à Constantinople*, Paris: 1888.

humanist Bellini probably knew, was published in the 1450s, near the date of Jacopo's drawing.[70] Painted in contemporary bath houses, such scenes repeated voyeuristically the events taking place before them and stimulated these events by anticipating them in art, to arouse a strange reciprocity between the mirror's illusion and the reality of performance.

Dürer, so often concerned with the same images as Jacopo and probably familiar with at least one of his Books, made very popular woodcuts and drawings of men's and women's baths.[71] Northern hope chests decorated with paintings of nude bathers, owned by the Gonzaga of Mantua (the marchioness was a Brandenburg), were sources for the genre, which Jacopo may well have seen in the houses of his courtly patrons.

A second pair of facing pages follows the first pair in the London Book, also showing nudes (Plates 71/72). Again the drawing to the right is the more formally composed, naked women armed with clubs and lances driving away a heavily built man, perhaps a satyr, who flees at the right. Though derived from the antique, the man also suggests the vigorous, virile art of Florence, particularly that of Pollaiuolo, whose great engraving Squarcione used for teaching art in his Paduan school. Perhaps Bellini had access to prints or casts after Pollaiuolo, active as sculptor, silversmith, painter, printmaker, and designer in the decorative arts. He represented the shields at the center with special care, both probably studied after the same fencing buckler with a prominent central boss.

Perhaps a scene like this refers to the celebrations of Venus that had been taking place in Venice since the thirteenth century, tournaments and masquerades honoring "Dame Venus" risen from the nearby seas. The goddess, no amorous bystander, fought in her own tournaments in 1227 and 1272 and may have participated later in the many games centering on the Castello d'Amore, long a popular theme in the Veneto.

Powerful naked men in late medieval art personify the strength that was equated with virtue, the classical *virtus*, manly force for the good and the true. Hercules, the strong man of antiquity, was understood to anticipate Christian justice and sacrifice, and his image was carved on church façades, pulpits, screens, and tombs. Four such strong men (Plates 65, 66, 72, 150, 151) assert Jacopo's familiarity with this concept, available in two ancient reliefs of Hercules' Labors on the walls of San Marco. Whether his drawings represent classical heroes or Old Testament heroes such as David or Samson is not certain, and hardly matters, for all four personify Truth, like their fair sisters the Three Graces (Plate 68).

The sole nude to occupy a full page is a bearded warrior in the London Book (Plate 150), brandishing a falchion or curved broadsword and holding a severed head that looks remarkably like his own. He is sometimes identified as David but appears older than the biblical boy-hero. According to Ames-Lewis,[72] this figure—which he holds to be David—may represent "an imaginative reconstruction from an antique source, rather than a drawing based on observation." Such a page could have served as an anatomical model in Bellini's studio, not necessarily meant to be nude in the finished works. Here the artist may be following Alberti's advice, first to show figures nude and then to dress them. Warriors holding severed heads of course occur in classical literature: Bellini includes three, this David or Perseus-like figure, one that kneels before a ruler (Plate 86), and another on an ancient tomb (Plate 85).

Two pages in the Paris Book could present Hercules or Samson; in one case he wrestles with a lion (Plate 66), the reverse of the struggle on the London page within a stockade (Plate 15), and in the other, brandishing the jawbone of a horse or an ass, he stands over a lion with lolling tongue that has passed out (Plate 151). The inking-over at top and bottom in the latter folio is much like that in the reworked lions on London's facing pages (Plates 8, 9). Graphic pentimenti indicate that the artist first planned the outstretched right arm to be lower and the raised arm higher. This figure resembles one on the frame of the second Baptistery Doors by Ghiberti (who made several journeys to northern Italy), but the approach in the Venetian version is broader. As the early renaissance in Venice was shaped by major and minor "alumni" of Ghiberti's workshop, Jacopo would have had many opportunities to see the sculptor's works in casts or drawings even if he never saw the original.[73] Another Herculean figure carrying an antique capital on his back (Plate 65), more extensively reworked and seen against a rocky landscape, is adapted from the same Dionysiac sarcophagus used in a drawing from Giovanni Bellini's circle (Fig. 15). Proud in the strength of their beauty and in the beauty of their strength, Bellini's men and women are among the first in the annals of Venetian art to clothe naked truths in the nudity of self-confidence.

70 H. J. Weale, *The Van Eycks and Their Followers*, London: 1912, lxxiii–lxxiv.

71 For these subjects, see W. L. Strauss, *The Complete Drawings of Albrecht Dürer*, New York: 1974, VI, 3350, *Men's Bath* (woodcut, B. 128); 3348, *Women's Bath* (drawing).

72 Ames-Lewis, 1981, 113.

73 Krautheimer and Krautheimer-Hess, 1956, 349.

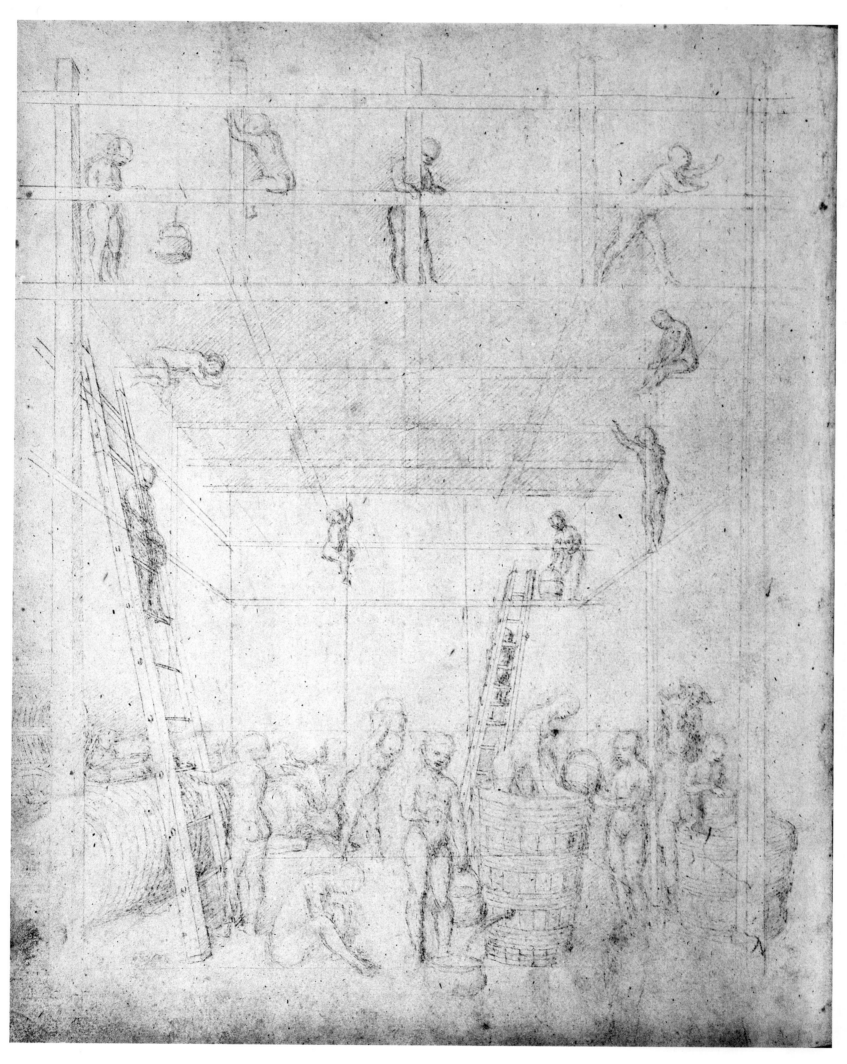

Plate 73. *Wingless Putti at the Vintage*. British Museum 59v

# V

# Venice and the Classical Vision

1  R. Weiss, *The Renaissance Discovery of Classical Antiquity*, Oxford: 1973, 48.

2  M. Muraro and A. Grabar, *Treasures of Venice*, Geneva: 1963, 8.

3  Franzoni, 1974, fig. 1, following Röthlisberger. The Roman relief in Verona, Museo Archeologico, was found in 1886 in the river at the Ponte Nuovo. Franzoni shows on p. 11 that it frames the inscription at lower right on fol. 45 of the Louvre Book. Jacopo was in Verona in 1436 painting the *Crucifixion* fresco, and Franzoni thinks he may have made his studies then.

Venice claimed the bones, the blood, and the culture of ancient Greece and Rome, and said she was founded on the very day Rome fell.[1] Her year, like Rome's, began in March[2] and her leader's title, doge, came from *dux*, a Roman military commander. Padua, just down the Brenta, believed that Trojans had first settled her university center, where a massive ancient sarcophagus was reused as a monument dedicated to her mythical father Antenor, king of Troy.

The Serenissima boasted the birth and burial of major Roman cultural figures: the architect and theorist Vitruvius; the poets Virgil and Catullus; and Livy, the historian. Time and again Livy's bones turned up in Padua. Bellini made a drawing after Vitruvius' supposed tomb in Verona (Plate 86, far right), bringing together the inscription of the Veronese Arch of the Gavi with the carved decorative border of a Roman relief now in Verona's Museo Archeologico.[3]

By loot or by purchase, quantities of antiquities were brought to Venice as ballast. Her walls were encrusted with these bits and pieces of ancient reliefs and statuary, the whole city an informal museum where lapidary surprises from the past may still be found in the strangest places. Byzantine reliefs of Alexander the Great and of Hercules, probably stolen in the Sack of Constantinople in 1204, were set into the façade of the Doge's Chapel to "document" the Greek origin of the Republic. Hercules, the legendary strong man, was the hero of the Venetii, first founders of Venice.

The name Polyxena, daughter of Priam and beloved of Achilles, was a popular one in Venice, given to the niece of Pope Gregory XII (Correr) who became the mother of Pope Paul II (Barbo). Local girls were also called Penthesilea, after the Amazon leader against the Greeks—a subject close to one by Jacopo (Plate 71). A German pilgrim, Felix Faber of Ulm, describing the attire of rich Venetian women on great occasions, noted that they could be better compared with Helen's Trojan attendants, or with Venus herself, than with other ladies of Christian lands. The fighting blood of Jacopo Marcello (Appendix F, Ill. 2), probably one of Bellini's major patrons, flowed all the way back to the Roman general Marcellus, whose funerary monument the artist may have referred to in Plate 84; and the Soranzo, owners of the London Book in the eighteenth century, claimed kinship with the ancient Superanzii of Altinum, north of Venice.

In power lay the basic appeal of ancient Greece and Rome, the heady call to empire as perceived in the realms of Alexander and the Caesars. Monarchs, bankers, merchant princes, soldiers of fortune, and the squabbling little courts of Italy, all greedy to keep or increase their wealth, welcomed Petrarch's marching orders to follow the way of the ancients. They loved his poetry praising classical triumph and military discipline for its assured beauty and learning, and its new vision of affluence and authority, of victorious glory bonded to Christian faith.

The confident beauty and heroic nudity of antique art, the orderly harmony of its architecture and coinage, the splendor of its cities and portraits, all preached the same sermon—power to those who have it or want it. So Venice's new buildings and tombs came to be covered with bits and pieces of ancient architecture and ornament. Manuscripts were garnished with lashings of cupids and centaurs as the fifteenth century moved along. Bellini was among the first to provide these lively syntheses of new and old.

Renewed appreciation of antiquity sprang from the alliance of Venice and Florence early in the century against the tyrannical Visconti of Lombardy. Both republics saw themselves

Plate 74. *Deer and Putti*. British Museum 90v

184

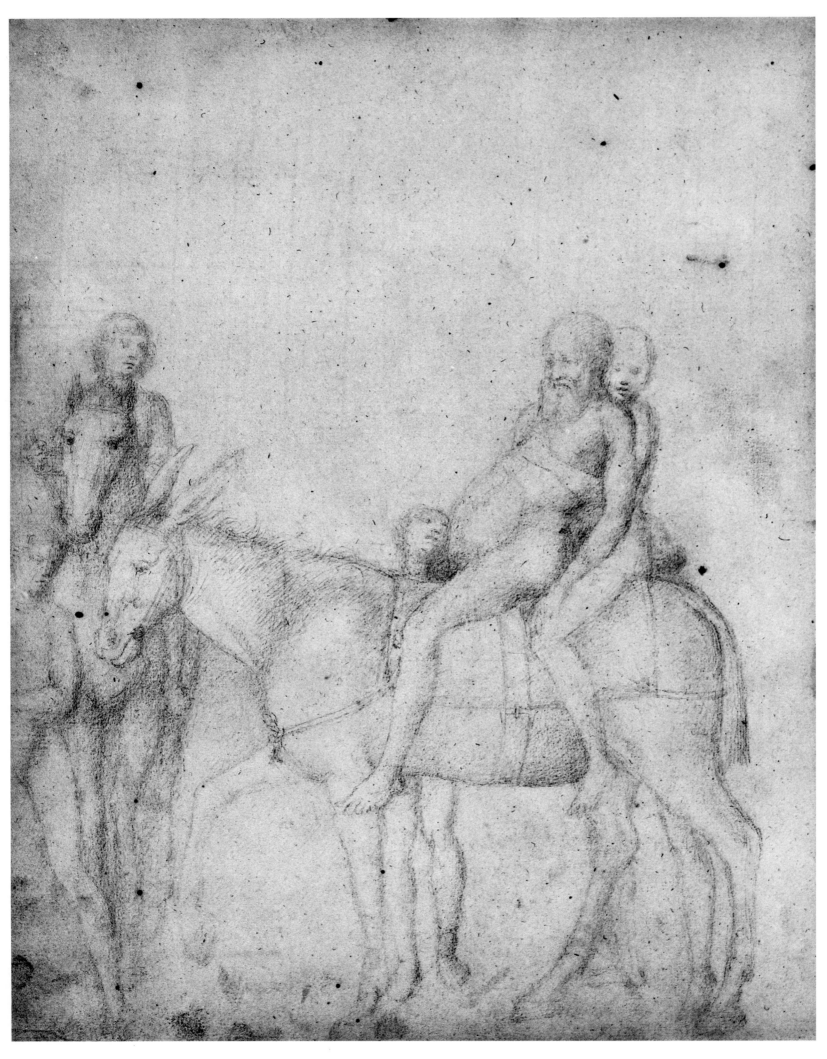

Plate 75. *Drunken Silenus and Attendants.* British Museum 97v

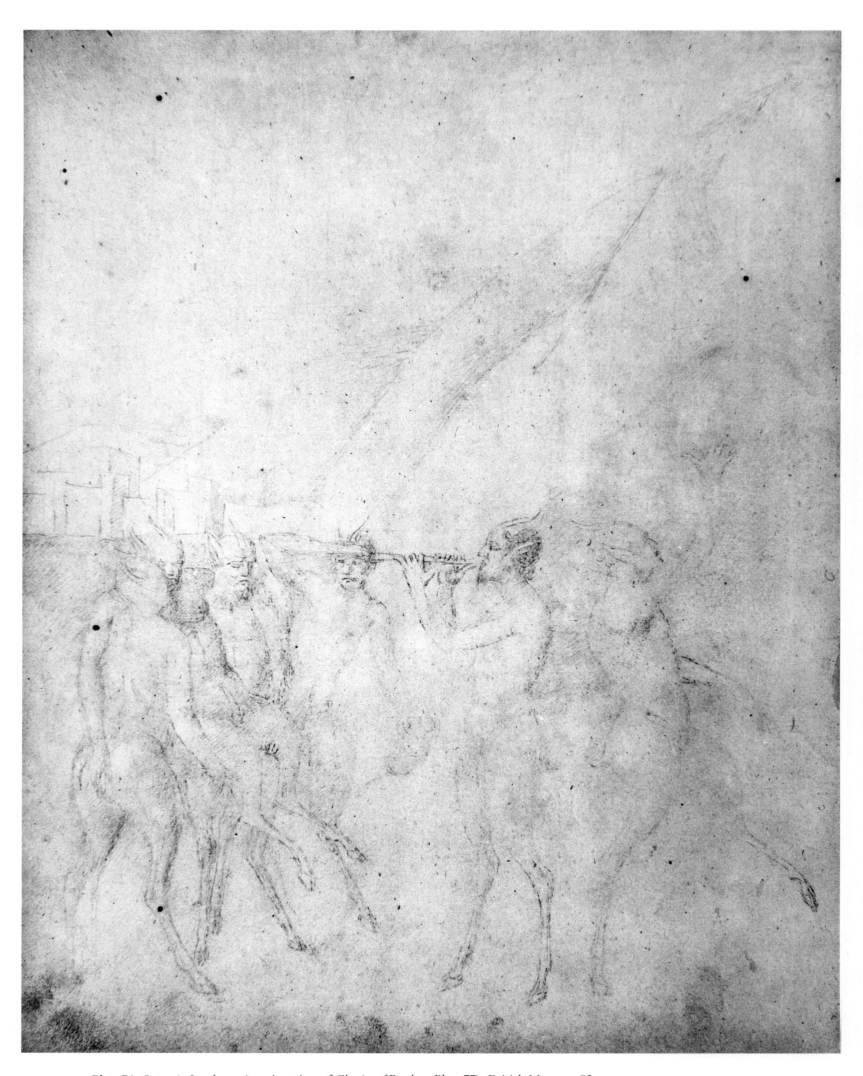

Plate 76. *Satyrs in Landscape* (continuation of *Chariot of Bacchus*, Plate 77). British Museum 93v

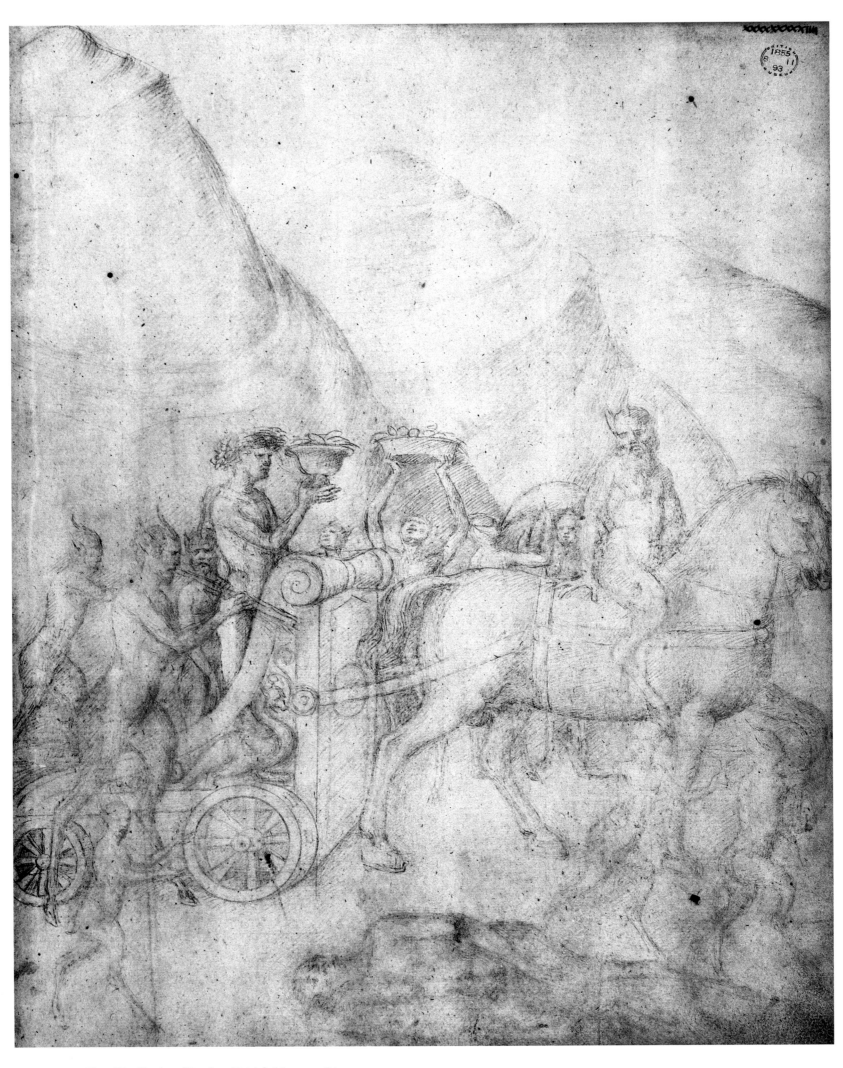

Plate 77. *Chariot of Bacchus*. British Museum 94

Plate 78. *Rearing Equestrian Group on Base*. British Museum 82

188

Plate 79. *Satyr Riding Winged Unicorn Bearing Corpse*. British Museum 4

Plate 80. *Altar with Candlestick*. British Museum 81v

190

Plate 81. *Monument with Eagle on Orb, Reclining Male Figure Below.* British Museum 3v

as fellow fighters for their joint heritage—*libertas italiae*. Pietro del Monte, Venetian bishop of Brescia (later the site of Bellini's major altarpiece; Fig. 18), learned Greek in the 1410s; crammers were teaching the language to those trading with the East. The bishop, writing to the leading Florentine humanist Poggio Bracciolini, called the Serenissima "that strongest fortress" and "inviolable temple of liberty." The fusion of force, freedom, and faith in Quattrocento Venice made classical imagery unusually timely, calling for the abundant antique references on Jacopo's pages.

All in all, humanism amounted to little more than *all'antica* window dressing for the tough-minded, pragmatic merchants of Venice. Though they would be interested in new translations of Plato by Lauro Quirini,[4] their concern with the ancient past was never as profound as that of their fellow republicans in Florence, where neo-Platonism came close to being a way of life. A rare combination of checks and balances made for the success of Venetian governance. In the years near 1450, when Bellini was drawing the many classical scenes in his Books, a Greek scholar (Trapenzuntio) described the Republic as equaling the Athenian ideal; he dedicated his translation of Plato's *Laws* to Venice because she so nearly realized the spirit of that dialogue.

Pioneering pilgrimages in the 1410s by the Venetian intellectual elite to the Florentine humanists were probably followed a few years later by Bellini's own visit. Where a Francesco Barbaro steeped himself in the circle of Leonardo Bruni and Niccolò Niccoli, Bellini absorbed the new Tuscan art that was turning toward antiquity, the classically inspired works of Brunelleschi, Ghiberti, Donatello, Masaccio, Masolino, and Michelozzo. Barbaro chose the humanist Flavio Biondo for his personal secretary, giving him Venetian citizenship in 1424; Biondo ingratiated himself with three of the Republic's leading families, beginning with Lorenzo Giustiniani in the early 1420s and on to Francesco Barbaro's Vicenza employ in 1424, in 1425 to Francesco Barbarigo's in Padua, and to Pietro Loredan's in Brescia in 1432. Any or all of these people were possibly Jacopo's patrons, the humanistic network seemingly stronger outside the Venetian lagoons than within.

With the mystical marriages of the elite to their Republic, of liberty to empire, Venice needed a new art to sustain her claims to past and present and to join the forces of antiquity and Christianity in service to the state. Jacopo's art provided her with a maiden voyage to the Greek and Roman past, a romantic pilgrimage often set within Venetian lands and seas.

Antiquity and Christianity lived in local harmony, the Serenissima's genial perspective allowing for the best of everything, a broad-mindedness profitable in art, science, and trade. She welcomed lively preachers such as Bernardino da Siena, drawn and painted by Bellini (Plates 242, 243; Fig. 59), but most of her major Church appointments went to more easygoing sons of local privilege, who saw little need to renounce the joys of this world, let alone leave home. Theirs was a truly catholic vantage point, classical and Christian achievements complementing one another as so often on Jacopo's pages, keeping their Roman coin collections alongside their Roman Catholic missals.[5]

Until recently, the lines separating early Christian from Roman and Byzantine art were seldom drawn. In all three periods, similar subjects often shared themes and decorative vocabularies. Jacopo may have taken some of his subjects that we now find puzzling from Byzantine mosaics, Roman decorative arts, or early Christian sources, since lost.[6]

The first sign of an individual concern in Venice with classical sources of art and literature appears early in the fourteenth century in the diaries of Oliviero Forzetta, a moneylender, collector, and dealer, describing his search for classical texts, coins, and marbles (some of these still in Venice, Museo Archeologico). He also bought drawings that perhaps had *all'antica* subjects, like those Giotto painted in the Arena Chapel, in Padua.

In 1364, the Scaligeri, rulers of nearby Verona, had the Paduan master Altichiero decorate their palace walls with frescoes of Roman heroes. Paintings inside showed the heroic defense of the Holy Land against Roman invaders, from Josephus' *Jewish Wars*; Bellini probably used this Latin text, recently translated into Italian, to lend authenticity to his biblical settings (Plates 153/154).

Giovanni Dondi dall'Orologio, a Paduan professor and friend of Petrarch, went to Rome to establish the superiority of ancient art by measuring classical buildings, and declared that the sculptors of ancient Rome had improved even upon nature.[7] His interest in the arts and sciences added breadth to the inquiry and learning that made Padua such an important center of study; even Brunelleschi came there to learn about mathematics and perspective, so pivotal for the Florentine renaissance.

The great university city of Padua was governed by the tyrannical Carrara family, their concern for antiquity guided by Petrarch, who devised for them his cycle of Famous

4  B. Nardi, "Letteratura e cultura veneziana del '400'," *La civiltà veneziana del quattrocento*, Florence: 1957, 99–145; idem, "La Scuola di Rialto e l'Umanesimo Veneziano," ed. V. Branca, Florence: 1963, 93–139.

5  Vasari–Milanesi, I, 546. Wilde attributed a lost portrait of Laura to Bellini; see Appendix D, 3.

6  Knabenshue, 1959, 55–56, stresses these sources, along with Cosmati work.

7  R. Weiss, "Lineamenti per una storia degli studi antiquari in Italia," *Rinascimento*, 9, 1958, 141–201, esp. 158–59. For the cultural climate in the Veneto, see also P. O. Kristeller, "Il Petrarca, l'umanesimo e la scolastica a Venezia," in *La civiltà veneziana del trecento*, Florence: 1956, 147–78.

Men.[8] In the family's palace in Reggia the Seven against Thebes, Lucretius, Camillus, Hercules, and similar heroic topics were painted in the second half of the fourteenth century. Many of Bellini's classicizing subjects came from such compilations; in his unidentified heroes are often fused images of classical or biblical men of iron with those of his own day. *Virtus*, personifying the courage of men and women of the past, was a popular theme. Jacopo's cavalier rearing above a yawning tomb (Plate 106) may come from the Roman account of Marcus Curtius' sacrifice, leaping into the chasm to save his city.

A revival of the art of Roman medals took place under Carrara patronage, in celebration of Padua's liberation from the Visconti. Fat, bald, ugly Francesco Carrara assumed ludicrous poses in classical garb, forever *en buste* on his coinage struck in the 1390s. Again, Petrarch stimulated this imitation of the antique, collecting and presenting ancient coins, but well before him a Veronese scholar, Giovanni Mansionario, was studying ancient numismatics and ordering the careful renderings in a manuscript of 1320 (Vatican, ms. Chigi, I, VII). By the early 1400s, rich Venetians were assembling their own coin collections, always good value for their gold and silver content as well as art. In these years Gentile da Fabriano came to Venice, perhaps bringing drawings after antique sarcophagi along with him.[9]

The renewed cult of the medal peaked with the art of Antonio Pisanello. Venice again plays its part in this *all'antica* development, for Pisanello's training, together with Bellini or a few years before, was probably largely there under Gentile da Fabriano. Stefano da Verona, Pisanello's first teacher, was a master of classical subjects, which furthered Pisanello's cultural ties with the Republic; also, he and his sister both married Venetians. Venice saw Pisanello as her own, even exiling him for several years for watching the attempted takeover of his home town Verona from Venetian occupation. He and Bellini shared at first the same approach to the art of the classical past, the chivalric, frenchifying outlook which Warburg labeled "antichità alla franzese," a courtly view of Rome and Greece close to that of the ruling Valois brothers. Longhi describes both painters as caught within an eternally courtly mode, mirrors of the decadence of princes; in their classically inspired works, however, each artist shows himself capable of breaking the knightly confines.

Pisanello was to assemble one of the finest collections of classical numismatics in Italy, and many artists who could afford to probably owned coins and medals. Several pages of Jacopo's Books bear blank circles (Appendix A, Ill. 10), waiting to be filled with drawings after ancient coins, doubtless from his own collection. Bellini might have already given such valuables, unlisted in his widow's will, to his illegitimate son Giovanni, in lieu of the paternal bequest often denied to bastards.

Jacopo's largest number of numismatic studies is in the Paris Book on the two "catalogue pages" of antiquities (Plates 84, 86): Plate 84 shows both sides of a *sestertius* of Domitian, minted in 85 A.D. to commemorate the Roman conquest of Germany, "Germania capta," symbolized by a nude woman (here draped) seated submissively next to a trophy. Germania reappears in the *Presentation of the Virgin* (Plate 159) in a decorative roundel high on the temple of Jerusalem, opposite another roundel based on a Hadrianic coin of Juno, the two indicating that Jerusalem was then under Roman rule. Worked into the temple base below are an unidentified Roman imperial profile and a seated Nikephoros or victory bearer, the reverse of a Pergamenian coin of Lysimachus.

Bellini's classical subjects show the close identification of Venice with Padua that developed after Venice conquered Padua in 1404. The university city became Venice's Left Bank, a law of 1434 requiring the Republic's college-bound to study there, to keep tuition money "in the family." One of Padua's leading educational institutions in the 1410s and early '20s was Barzizza's *gymnasium*, or boarding school, its "hands-on" approach far different from traditional higher education. Barzizza sought to vitalize the teaching of his young students, to make them learn by laughter and by doing; unique in his sympathy with the visual arts, he was a forerunner of this century's progressive education.

Like Petrarch before him, Barzizza[10] had come to the Veneto from her rival Visconti center of Pavia in 1410, the same year as the visit of the leading painter from Pavia, Michelino da Besozzo. Both the scholar and the Lombard painter brought to the Serenissima's culture a fresh concern with the visible world: Besozzo by his nature studies and Barzizza by denying snobbery toward the making of art. The school-teacher's role he saw as like the leader in an art studio: "I myself would have done what good painters practice toward their students," he wrote, giving them fine models, *exemplaria*, to measure their progress.[11]

8 T. E. Mommsen, "Petrarch and the decoration of the *Sala Vivorum Illustrium* in Padua," *Art Bulletin*, 24, 1952, 95–116.

9 Two articles by R. Panczenko continue Degenhart and Schmitt's suggestions in this area, both in *Artibus et Historiae*: "Gentile da Fabriano and Classical Antiquity," I (1980), 9–27; "Cultura Umanistica di Gentile da Fabriano," IV (1983), 27–75. The latter article introduces several drawings by Jacopo Bellini, but few of the classical and other sources claimed for these images are credible.

10 G. Martellotti, "Barzizza, Gasperino," *Dizionario Biografico degli Italiani*, VII, 35–39; see also his entry for "Barzizza, Guiniforte," 39–41, and by P. Sambin for "Barzizza, Cristoforo," 32–34.

11 M. Baxandall, "Guarino, Pisanello and Manuel Chrysoloras," *Journal of the Warburg and Courtauld Institutes*, 28, 1965, 183.

Plate 82. *Bacchus and Satyrs.* Louvre 40

12 D. Robin, "A reassessment of the character of Francesco Filelfo (1398–1481)," *Renaissance Quarterly*, XXXVI, 1983, 202–24.

13 For Marcanova and Savonarola as amateur painters, see Lightbown, 1986, 40, and King, 1986, 392–93.

14 See Gundersheimer, 1973, 92–126.

15 See Offner, 1939, and M. Strauss, 1979.

16 Lightbown, 1986, 40.

Many of the humanists' pupils—Alberti, Biondo, and Filelfo[12]—became talented amateur painters; this was true for other Paduan scholars, such as Michele Savonarola and Giovanni Marcanova.[13] Alberti is often cited as a key influence on Bellini's story-telling, space, and structure. The two may have met in the Veneto in the 1420s or '30s, or in Ferrara, where both received Este patronage; perhaps Bellini learned of Alberti's vastly varied and inspired neo-classical concepts in the years when Ferrara's university was becoming a substantial organization.[14] Alberti's more romantic approach to classical themes may be seen in paintings by Fra Carnevale (the Dominican monk Giovanni Bartolommeo Corradini); their design is sometimes given to Alberti (New York, Metropolitan Museum of Art: Boston, Museum of Fine Arts). The Florentine friar seems to have spent some time in Bellini's studio, between studying with Filippo Lippi in Florence, 1445–46, and living in Urbino after 1449.[15] Jacopo's pages have a similar spirit to Corradini's in their lingering, almost mystical reference to pagan mythology; they suggest *grisaille* decorations made for festive occasions or frescoed on Venetian façades, like those in Carpaccio's later *Return of the British Ambassadors* in his Saint Ursula cycle (Venice, Accademia).

Venice tried in 1427 to get Filelfo to set up a school for humanistic studies but nothing came of this until 1446. By then Bellini's classical subjects had been long begun, for the classicism in Fouquet's French manuscripts of the early 1450s already reflects his Venetian master's. Marcanova may have been especially close to Jacopo, not only for their common interest in classical inscriptions but also for their mutual links in the 1450s with Gattamelata's widow: the scholar was composing lines for the *condottiere*'s monument base while Jacopo and his sons were painting the family's funerary altarpiece (Figs. 47–51).[16] Some inscriptions in the Louvre Book (Plates 84, 86) perhaps came also from Marcanova.

In the late 1430s, when Bellini already had important Paduan commissions, that city could boast of a new center for classical studies in addition to Barzizza's, the gift of a major new benefactor, none other than Gentile da Fabriano's patron Palla Strozzi, formerly the richest man in Florence. As a young man Palla had learned Greek from the Venetian pope's secretary, and he built up the greatest private library of classical literature in Italy, soon to

Plate 83. *Cupid Abducting Satyr.* Louvre 43

be copied by his arch rival Cosimo de' Medici. Florence being too small for two such powerful men, Palla chose Padua for his residence in exile in the Veneto after Cosimo's return from his own Venetian exile in 1435. He brought with him his library for Greek codices and made his modest house a center for Greek translation. We read in Vasari that Michelozzo, the Florentine sculptor, architect, and military engineer, accompanied Cosimo to Venice in 1433 and designed the library for the monastic island of San Giorgio as the banker's thank-offering for refuge there, but Vasari may have confused this journey (which does not fit well into Michelozzo's chronology) with a known journey in 1430, when Michelozzo worked for a different Medici, Giuliano, son of Averardo, in Venice, Padua, and Verona. Michelozzo may have been an agent of the advanced Florentine currents, important to Jacopo's art.

The role of Francesco Squarcione, born in the later 1390s, is one of the most controversial in the history of art. Son of a Paduan notary and working first as a tailor and embroiderer, he taught himself to paint, well enough to be soon called on to arbitrate disputes between artists and patrons. A few years before Bellini's important Paduan commission of 1430, Squarcione had abandoned his tailor's shop for travel in the eastern Mediterranean. Reaching his majority—age twenty-five—between 1424 and 1426, he came into an inheritance that freed him to sail; the example of Cyriaco d'Ancona, another wanderer (also certainly known to Jacopo), may have inspired Squarcione to journey to Greece (if indeed he went there). Back in Padua by 1430, Squarcione signed up his first pupil in the following year. [17]

While Barzizza's *gymnasium* was going full tilt, Squarcione, then still stitching, had envisioned his own art school, or as he called it, academy, in the liberated spirit of local higher education, instructing through casts and coins (he owned a fine collection) as well as drawings and Florentine prints. After founding it, he developed a flair for publicity and pedagogy: like a talent scout, he secured his best students, many from poor parents, by the lure of adopting them, which saved them paying guild dues. His academy, along with Bertoldo's in the Medici Gardens later in the century, was perhaps the first where art was taught

17 Bernardino Scardeone, *De antiquitatibus urbis patavii et claris eius civibus*, II–III, Basel: 1560.

beyond craft, breaking down barriers between the liberal and mechanical arts. The fame of both schools rests upon the genius of a single graduate, Squarcione's on Mantegna and Bertoldo's on Michelangelo. Florentines in Padua—notably Donatello—must have contributed the lion's share to Mantegna's new vision of antiquity, but Squarcione and Bellini should be credited in their smaller but effective measure.

Two witticisms sum up Squarcione's odd but significant career and his strange role as *pictorium pater*, teacher of hundreds of students from all over the Venetian empire. We are reminded of George Bernard Shaw's "Those who can, do, those who can't, teach" by the pedestrian works surviving from Squarcione's hand; his academy is best described by André Chastel's quip, "boutique fantasque."[18] Padua's fifteenth-century "School," epitomized by Mantegna's achievements of the later 1440s, was nevertheless the most humanistically oriented in the realm of Venetian art.

One strength Bellini and Squarcione shared was the continuity of their influence. Jacopo's sway as founding father of the Republic's early renaissance extended throughout most of the fifteenth century; Squarcione could claim to having taught (and taken) perhaps 137 young painters between the 1430s and the '70s, the same span as Jacopo's securely documented activity.

Bellini has been seen as another Squarcione, his antiquarian pages parallel to the Paduan's concerns.[19] Jacopo too was a collector of antiquities, and a gifted teacher as well, with his sons and nephew among his students near mid-century and others during the 1450s and '60s. Vasari's description of Jacopo's method of teaching his talented sons, by encouraging a spirit of competition, has a certain classical edge that recalls Ghiberti's division of time into four- or five-year Olympiads, when competitive Greek games were held for the gods.

Many of the master's most classical images or details are determined by what Longhi wisely called "the metaphysics of archaeology," a rational faith which Jacopo and Squarcione alike passed on to their major pupils, to Mantegna and to the obscure but talented Antonio da Negroponte, known for one masterpiece, the *Enthroned Madonna* in San Francesco della Vigna. The Virgin is seated amid the wonders of art, conveyed by her wildly antique setting, and of nature, a surrounding, worshipful zoo—the dual miracle of creation.

Because Jesus was born under the Caesars' rule, Bellini fills his settings for Christ's life and death with classical references, some to lend local historical color, others for special symbolic readings. Riopelle has discovered that in many ways the antique elements in the Books "comment directly on Christian subject matter. For example, a roundel showing a seated figure embedded in the city wall for the *Entry into Jerusalem* [Plate 191] is inscribed with the word *pietas*, meant to instruct in the virtue which those who acclaim the Lord on Palm Sunday themselves display."[20] Antiquity was to be seen as an artistic prophecy of a new faith, almost an equivalent visually to Old Testament proclamations of Christ's coming. Sometimes the authority of ancient empire, as in the massive triumphal context of Christ's Passion, may be intended as an ironic commentary on the contrast between the old and new orders, prophesying that the last shall be first: Christ dwarfed by the hollow victory of Roman architecture in the judgment hall of Pilate's palace and by the settings for the Flagellation.

Yet remarkably few early Venetian humanists had any profound intellectual interest in contemporary visual arts. Unlike the Veronese Felice Feliciano—well born but poor, a modest collector and friend to many artists—most of the Serenissima's gentlemen scholars saw painters and sculptors as too far below their own social station to merit any sort of intimacy, relegating them to the status of decorator-craftsmen. Bellini referred to genius in the inscription on his *Madonna* of 1448 (Fig. 40), but such high-flown wording was not common in the Republic until the next century, when the classical concept of intimacy between imperial patron and artist, as between Alexander and Apelles, took on local meaning.

In Bellini's century most "Venetian nobles . . . noted as humanists . . . [were] men whose political careers had been largely taken up with mainland affairs and who had been actively involved with the army."[21] But this group also included men of the cloth, such as the dynamic bishop Pietro Donato of Padua, famous for his interest in manuscripts,[22] and Gregorio Correr of Verona, close to Paduan scholars. Author at eighteen of the first renaissance Latin tragedy, Correr was Mantegna's patron, ordering the great altarpiece for his abbey of San Zeno in Verona, and he should have succeeded Bishop Donato.[23] Cardinal Lodovico Trevisan, an early Venetian collector of art and antiquities, also tied his fortunes to Padua, his adopted "home town."[24] Another wealthy Venetian, Francesco Contarini, who received his law degree in Padua in 1442, settled there, and embellished his house with classical inscriptions and statuary, that, in description, recall Jacopo's pages.

18  A. Chastel, *I centri del Rinascimento. Arte italiana 1460–1500, Il mondo della figura*, trans. G. Veronesi. Milan: 1965, 132 ff.

19  Moschini, 10; Chastel, 1965.

20  Riopelle, 1979, 1. See also Saxl, 1970.

21  Hale and Mallet, 1983, 204.

22  See King, 1986, 370–72.

23  Lightbown, 1986, 65.

24  For Trevisan as collector, see Lightbown, 1986, 81.

Bishop Pietro Donato of Venice was Padua's Christian leader from 1428 until 1447. As Barzizza's student, he became a humanist deeply interested in the new scholarship, the friend of Guarino, Traversari, and Francesco Barbaro, and must have helped to keep the city open to vigorous, progressive artistic currents as in the Trecento. Only one Lectionary survives from his collection to indicate Donato's taste in manuscripts (New York, Pierpont Morgan Library), but in it his enlightenment becomes clear indeed.

On the *terra firma*, foremost among rich, powerful Venetian students of antiquity who might qualify as Bellini's humanistic patrons is Jacopo Marcello, the *provveditore*, or elected supervisor, of the Republic's *condottieri*. Several of the classical inscriptions on the "catalogue pages" in the Paris Book (Plates 84, 86) are taken from Roman reliefs long in the churches at Monsélice, the lovely hilltop site near Padua where Marcello built his idyllic villa[25] against a Carrara fortress. His is possibly the name on the altar on the first page. Bellini's design for a vessel (Plate 87) recalls the silver- and gold-embossed basin that Marcello gave to Filelfo for the poet's Latin lines of consolation on the death of Marcello's young son; similar poetry in Greek or Latin may lie behind Jacopo's images of military mourning. [26] In the courts near Venice—Ferrara, Mantua, Pesaro, Rimini, and Urbino—the passion seldom flagged for the *frisson* of humanistic pursuit of classical arts and letters, with its mix of the philosophical, the beautiful, and the erotic. Lionello d'Este noted, "It is scarcely believable how many of our people have almost turned into Greeks, and learned how to work with the Greek language and with Greek books. It is like being in Attica." The Ferrarese court poet Boiardo replied, with unusual candor, "You will soon seem like a barbarian yourself, Lionello, if you continue to use Latin to tell us about the Greeks." [27]

A new emphasis on vision, on the joys of the seen as equal to those of the heard, initiated by Petrarch's inspiration from ancient monuments and followed by Barzizza's teachings, is found at the Este court, where Lionello supposedly said: "I often take great pleasure in looking at the heads of Caesars on bronze coins . . . and they impress me no less than the descriptions of their appearance in Suetonius and others. For the latter are apprehended by the mind alone." [28] Jacopo, active in Ferrara in the early 1440s and probably both earlier and later, too, was privy to this outlook.

Humanists in Ferrara—such as the poet Ulisse degli Aleotti, who celebrated Bellini's victory over Pisanello in the portrait contest (itself conceived in classical terms: see Appendix E, Doc. 1441, Ferrara)—may have shaped Bellini's antique references. Aleotti's first poem characterizes the painter as a new Phidias, his second as a teacher of illusion in the ways of Apelles and Polyclitus. Some have read in these lines an indication that Bellini was a sculptor; though he may have designed sculpture, the reference is rather to the power of his pictorial form, and possibly to *grisaille*, the illusionistic re-creation of sculpture.

Leon Battista Alberti, the ultimate renaissance humanist, was also at the Ferrarese court. His cosmic concerns included an unusually direct and practical fascination with painting, sculpture, and architecture, his humanistic heritage from Barzizza's *gymnasium*. He dedicated the Italian edition of *On Painting*, his little book on how to be a renaissance painter, to his sculptor friend Donatello in 1435. Perhaps Alberti's vast command of ancient knowledge informed Bellini's pages; close in age, Alberti may have met Bellini as early as about 1430, and possibly they collaborated on Alberti's lost aerial *View of San Marco*, with figures credited by Vasari to unnamed Venetian painters.

Alberti's forged comedy in Latin, *Philodoxeus*, written in 1424, was dedicated to Lionello d'Este in 1436. Underlying Jacopo's most puzzling pages could be such pseudo-classical dramas, especially if he had a hand in their staging. Plays by Pier Candido Decembrio (whose brother, a fellow humanist, praised Jacopo about 1450) were popular in Ferrara. Playwrights in residence—masters of Greek and Latin, such as Porcellio Pandone and Basinio da Parma—wrote in the classical manner; Basinio's satires of the 1440s and Jacopo's satyrs belong in the same genre, drawn from ancient rustic drama.

Bellini surely valued most, more than the humanists' often arcane dramas, their scrutiny of the visual survivals of antiquity, from carved gems to colossi. Some of these battered ancient works were reinvented in reflective scholarly words, humanist writers often imagining the bones as well as the flesh of absent or fragmentary sources. Bellini was likewise free to dream into being a renewed world of antique reference, and in his search he often found what never was. Pathos infuses some of Jacopo's ancient scenes out of his fierce need to realize them, to have the past on one's side. Masterly exercises in wishful thinking, his classical pages hold in many surprising ways the essence of what academic art is about: ideal pursuit.

25  For Monsélice, see the *Enciclopedia Italiana*, "Monsélice," and Meiss, 1957, 88, n. 3.

26  D. Robin, "Unknown Greek Poems of Francesco Filelfo," *Renaissance Quarterly*, 37, 1984, 173–207, and 203, n. 14.

27  Gundersheimer, 1973, 115.

28  Baxandall, 1963, 324.

Plate 84. *Studies of Roman Tombs and Altars*. Louvre 48

Plate 85. *Footed Shallow Vessel*. Louvre 64

Plate 86. *Studies of Three Classical Monuments*. Louvre 49

Plate 87. *Metal Bowl*. Louvre 65

199

Actual antiquities are tucked away as plaques, statues, medals, and reliefs large and small decorating Bellini's buildings. In the spandrels above the *Flagellation* (Plate 195) two roundels show Hercules about to shoot the centaur absconding with Hercules' wife, Deianira, the subject also of the only painting of a classical theme that is close to Jacopo's style (Fig. 13) and of a drawing from his circle in the Louvre (Appendix D, 2: no. 12); a roundel in the *Death of the Virgin* (Plate 230) shows the Flaying of Marsyas; a bacchic fountain embellishes Solomon's palace (Plate 154). Views of Jerusalem (Plates 191, 209), dreamlike and implausible in their assemblage of antiquities, could have been inspired by views of Constantinople,[29] well known to Italian travelers and, until its fall to the Turks in 1453, the center of Eastern trade.

In several pages antique monuments in the Veneto are used for contemporary as well as ancient scenes and figures, sometimes works that Donatello also studied after he arrived: the same figure of an athlete turns up in a vertical marble altar relief in the Santo and in the Paris Book (Plate 67). Jacopo could have used an ancient stele of a knight subduing a Gaul (Padua, Museo Civico) for his drawings of riders; a Roman relief that includes a vase bearer (Venice, Museo Archeologico) may lie behind the Paris page of a man bearing a column capital (Plate 65). The two "catalogue pages" (Plates 84, 86) incorporate many local antiquities, some fantastically combined.

"The Head of Hannibal Presented to Prusias, King of Bithynia" is the subject given for a Louvre drawing (Plate 88) in the late fifteenth-century Index (Appendix C). As no such event ever occurred, the page may depict a gory offering to Hannibal that took place in a military encampment,[30] according to medieval retelling in the *Romuleon* (Bibliothèque de l'Arsenal, Ms. 667). Another page that originally showed a rider bearing a severed head, wrongly restored as a cherub head later in the century (Plate 78), may also be related to this subject.

Roman architecture still abounded near Venice and Jacopo may have made drawings for future use after triumphal arches and coliseum gateways in the cities where he was commissioned for paintings—Verona, Padua, and Vicenza. The Serenissima's conquered Dalmatian coast was rich in ancient building. Traveler's notebooks and Bellini's own journeys placed antiquity at his fingertips. His most dramatic architectural setting, the massive triumphal arch of a palace in *Christ Led before Pilate* (Plate 194), is based on the Arch of the Sergii at Pola. The scrolled keystone with its torch-bearing putto comes from another arch, possibly of Septimius Severus in the Roman Forum.[31]

The many-figured frieze above the arch of Pilate's palace has been associated with the horsemen on the Parthenon's Panathenaic frieze, as sketched by Italian travelers to Greece. Yet Jacopo may have devised this decoration himself, drawing on Greek motifs; the same is true of the relief on the base below the *Winged Unicorn* (Plate 79), which has also been seen as a Panathenaic composition.[32]

Cosimo de' Medici and Palla Strozzi may have made humanistic studies more permissible for the Venetian aristocracy, but most of the Serenissima's leaders who went in for such things lived outside of Venice proper. One humanist active in the Veneto was Flavio Biondo, another of Barzizza's graduates; a friend of the artists of his day, Biondo was portrayed in Fra Angelico's Vatican fresco and in Giovanni Bellini's lost work for the Doge's Palace. After dedicating his history of early Venice to Doge Francesco Foscari in 1454, Biondo began his last work, *Roma triumphans* (1459),[33] following Varro's *Antiquitates* for his Roman reconstruction that divides classical culture into Sacred, Public, Military, Private, and Triumphal. These five headings could be applied to the graphic riches in Jacopo's Books, which fall into surprisingly similar categories.

The chief links between the classical past and the renaissance were not the study-bound humanists but a weird group of adventurers who brought back the resources of ancient Greece and Rome from their Eastern travels. First and foremost of these was Cyriaco d'Ancona, who combined scholarly pleasures with business. When he was thirty, "Cyriaco's insatiable curiosity suddenly crystallized into the master passion of his life; to discover antiquities. Thereafter, wherever his business took him, he would be off like a whippet to sniff them out; clambering over ruins in remote parts of Asia Minor, exploring the Greek Islands, eager to record every monument he saw, to measure it, draw it, copy out inscriptions into his notebooks in Greek or Latin. . . ."[34]

Cyriaco made his eastern Mediterranean journeys in 1417–18, 1425, and early in the 1430s. Initial ignorance of Greek and Latin did not keep him from copying inscriptions. "As he traveled his eye missed nothing—a pyramid, a boar-hunt, a sequestered cavern, an elephant, a giraffe, a snaky crocodile; and these he would describe, sometimes with a draw-

29 E. Müntz, 1888, 318–28. Meyer zur Capellen (1965) still believed the source of the studies to go back to Gentile Bellini, but this is not convincing.

30 Suggested by Tietze and Tietze-Conrat, 1944, 112.

31 Identified by Degenhart and Schmitt, 1972, 154.

32 Tamassia (1956, 164) argued for the Squarcione source; Van Essen's rebuttal is on the same page. Fiocco, like Van Essen, noted that if indeed the source were the Parthenon, then Cyriaco d'Ancona was the more likely source of transmission. Riopelle (1979, 17) has argued for the relief as a free invention of Bellini's.

33 A. Mazzoco, *Flavio Biondo and the antiquarian tradition*, Berkeley: 1973, 270. For Biondo at Florence, see Gill, 324–25.

34 Mitchell, 469.

ing, in self-advertising extravagant letters to friends or to the great and learned in Italy, Filippo Visconti, or Lionello d'Este, Cosimo de' Medici, his old friend and patron [Pope] Eugenius IV, Pietro Donato, Bishop of Padua, Leonardo Bruni, or his fellow mercurial Filelfo."[35]

"Not until Jacopo Bellini's generation does mythology play any large part in Venice," noted Saxl; Jacopo's drawings "show clearly how he was attracted to much that was contrary to Christian ethics. The sensuality of paganism meant for him the enjoyment of life untroubled by the thought of the hereafter."[36] "Fantasies" is Saxl's word for Bellini's inventions in the antique spirit, and a good word it is for the free mixture of classical and contemporary elements he brings together for his themes of love, life, and death. The scholar pointed out how singularly free from the written word were Jacopo's drawings of the past, typifying "Venetian humanism, inventing great mental scenes *all'antica* which cannot be related to texts or marbles, but which interpret classical subjects in a new and highly subjective language."[37] Lionello Venturi characterized Jacopo's free classical images as "figurative humanism."[38] At least fifteen of Jacopo's pages are devoted to such themes; others combine chivalric references with haunting suggestions of the ancient world, possibly inspired by medieval Latin tales in the *Gesta Romanorum*, Arthurian cycles, the *Romuleon*, or any of countless other adventure stories such as Roland's.[39] Though probably cast in antiquity, Jacopo's pages, like his sources, tend to scramble classical and much later references with picturesque abandon.

After Florentine humanism arrived in Padua, the bacchic vocabulary of Donatello and his partner Michelozzo supplied the final element needed for Bellini's repertoire. His studies of these sculptors' art are in his Books (Plates 67, 74, 75, 77, 83, 86) and in what is possibly a school piece (Fig. 13). Such alien images—like many others from Tuscany—were delivered almost to the artist's doorstep by Michelozzo in the Veneto in 1430 and with Donatello's 1443–53 Paduan residence.

Some of Bellini's bacchic scenes may have been inspired by Dionysiac entertainments supposedly staged in Padua in 1447. For these "Feasts of Roland" (Orlando) or "Bacchanaliorum" the guests wore wild animal skins, and the celebrations featured chariots of Bacchus, and of satyrs and fauns.[40] Ferrara, where Bellini was perhaps often active, was among the earliest Italian centers to perform Latin comedies annually, staging them at Carnival. These are first documented under Ercole d'Este (r. 1471–1505) but were probably taking place long before.

Wild folk, bacchic subjects, and rustic scenes in Jacopo's Books may have been drawn for Carnival decorations in Venice. Pretentious dialogues credited to Lionello d'Este include one praising nature and the nude. His description of a bacchic subject suggests Jacopo's (Plates 77, 82): "if you saw . . . leopards and tigers bridled and harnessed to a chariot with the triumphant Bacchus and him half-naked, you would pay more attention to the subtlety of the features of the face and bare body than to the clothes and trappings. You would study the law in which sinews and muscles fit together, the circuits and tensions of veins, the representation of skin, hair or plumage."[41]

Donatello devised radical ways to laughter and tears by using the comedy and tragedy of ancient bacchic imagery. Ecstasy and inebriation, sacrifice and joy, frenzy and abandon—these intimate, ultimate themes are conveyed by his satyrs and centaurs, putti and maenads, all in Bacchus' thrall. They presage the joys and sorrows of faith, classical or Christian, of passion or Passion. Putti embellish the armor Donatello devised for Holofernes and Goliath; trampling the vintage or dancing their way around altars or pulpits, they are messengers of fate and song, of genius and inspiration. Erotic and angelic, the putto's ambiguity lies at the heart of Donatello's art. And his tragicomic message had been brought there by his many admirers by word of mouth, by casts, and by copies, long before he settled in Padua.

The fervor and animation of Jacopo's winged folk, ranging from satanic demons to neo-Platonic daemons, along with his fauns, satyrs, and centaurs, brought life to art and art to life, weird creatures that scholars, patrons, and priests loved to hate or love. Included throughout the passage from birth to death, they turn up in woodlands and on tombs, fireplaces and frontispieces, medals and marbles. Few characters bridged the chasm between pagan abandon and Christian piety to greater effect than Bacchus and Co. Creatures of passion and inspiration, moody, musical, and intensely sexual, satyrs give themselves to the moment, their lives a performance in the arts of intoxication and ecstasy.

35 Mitchell, 469.

36 Saxl, "Jacopo Bellini and Mantegna as Antiquarians," 1970, 64.

37 Saxl, 1970, 65–66. Degenhart and Schmitt (1972, fig. 17) have found a small terracotta at Mogilev in Russia to be a partial prototype for Bellini's *Unicorn*, but of course the artist has added many elements and transformed his model with his usual panache.

38 L. Venturi, 1907, 118.

39 R. Lejeune and J. Stiénnon, *La légende de Roland dans l'art du moyen âge*, Brussels: 1966, 367. The manuscript is Biblioteca Marciana cod. fr. XXI.

40 Antonio Bonaventura Sberti, *Degli spettacoli e delle feste che si facevano in Padova*, Padua: 1818, 44, 105.

41 Baxandall, 1963, 316.

41 Chastel, 1959, 54–62.

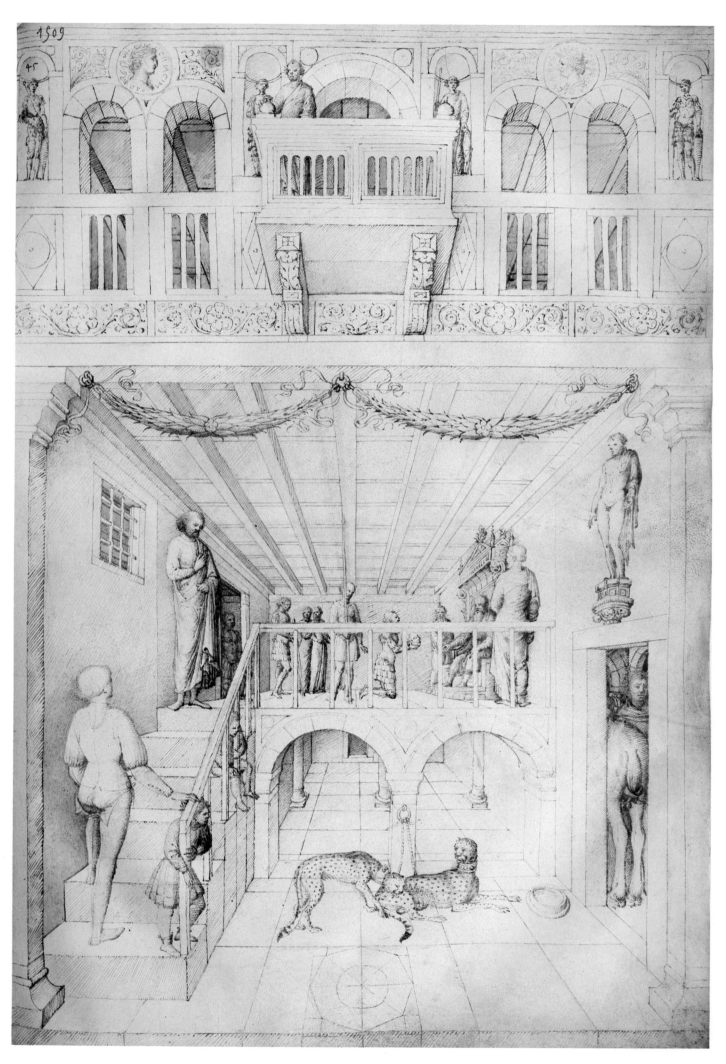

Plate 88. *Enthroned Ruler Presented with Severed Head.* Louvre 45

202

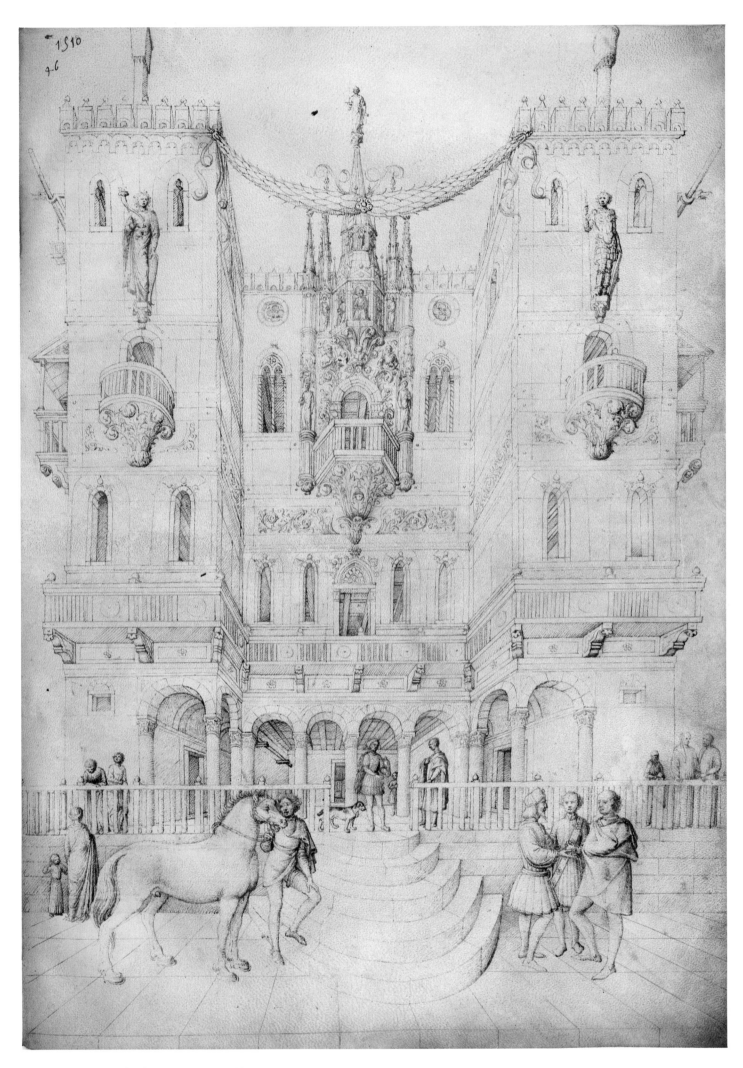

Plate 89. *Departure for the Hunt*. Louvre 46

42 *The Poems of Catullus*, trans. F. W. Cornish, LXIV, Cambridge/London: 1956, 251 ff.

43 Many scholarly attempts have been made to find specific antique sources for Bellini's classical motifs. Few of these are convincing except those cited by Goloubew and by Degenhart and Schmitt (1972). Apart from some numismatic identifications, Tamassia's exhaustive studies are unpersuasive.

44 Degenhart and Schmitt, 1972, 153.

Renaissance satyrs were believed to understand their exclusion from salvation; part man, part beast, between comedy and tragedy, they took on a new dimension—pathos. All their qualities of burlesque and absurdity, abandon and revelry, are realized in Bellini's pages, wonderful and wondering hymns to these hybrids beyond heaven and destined for hell, beloved and detested for what they could and could not be.

Clusters of *bambini*, some winged, others not, abound in renaissance art. Such were the irreverent babies first seen in antiquity and brought back for Christian duty in Donatello's art, crowded into choir lofts and outdoor pulpits. Later these pagan cherubs tumble over the frontispieces of humanistic texts, irrepressible evidence of the surviving classical spirit. Bellini takes on the Hellenistic subjects of putti at the vintage (Plate 73) with the abundant good spirits that will be brought to their peak in Titian's beloved Infant Bacchanals.

Drawn in each Book, Bacchus' two triumphal retinues (Plates 77, 82) differ so radically from one another that it is hard to see either as the earlier—each has its own modernity. The Latin poet Catullus' lyrical account of an ancient tapestry showing the "youthful Bacchus wandering with the rout of Satyrs and the Nysaborn Sileni, seeking thee, Ariadne, and fired with thy love . . ." may have fired Jacopo's imagination for the London page. [42] Born in Verona, Catullus was well known to Veneto humanists, his manuscripts treasured at the Biblioteca Marciana and in fourteenth-century Verona. Giovanni Bellini later painted a similar subject, a plump Bacchus standing in a chariot drawn by putti, offering his bowl of fruit to a lean warrior (Venice, Accademia).

Jacopo's Paris rendering on vellum of Bacchus' triumph looks almost like a neoclassical relief, reworked with a certain slickness near the end of the century. The scrawny Bacchus on London's paper is far tougher, embodying an immediacy and economy toward a more matter-of-fact, less academic look. The mountainous background is identical with many biblical subjects in that Book. The Louvre's wine god, copied from an ancient relief, offers his fruit bowl to Pan, who lowers his pipes to sample it. Bacchus' fluted dish and the footed dish held by a faun have the classical simplicity of two vessels drawn in that Book (Plates 85, 87).

Jacopo gave to the drunken Silenus (Plate 75) the wise face of an apostle or philosopher. Oldest of the satyrs, Silenus rides on an ass, the same that carries the Virgin and Child to Egyptian refuge (Plate 180) and Christ into Jerusalem (Plate 190). A fatherly woodland god, he raised the infant Bacchus and taught him to cultivate the vine and harvest honey. A constant supply of wine supports Silenus' usual good spirits and gifts of song and prophecy. The old satyr also appears on Filarete's bronze doors for Saint Peter's, in Rome, among the earliest renaissance examples of this theme, made at mid-century for a Venetian pope.

Each Book's classical subjects have their own modernity—Paris' a smoothly sensuous academic manner anticipating that of late Quattrocento sculptors, London's the expressive, individual presence that comes with old age and the need for economy and brevity, each line a last breath, will, and testament.

A third chariot scene in the antique style is now scarcely visible (Fig. 14). A naked prisoner stands in the chariot, tied to a stake, a torturer before him. What little can be seen is in feeble silverpoint over a coated sheet of vellum from the reused pattern book with textile designs. The orientalizing pattern which has worked its way through the coating along the side of the sheet must originally have resembled the uncoated one still in the Book (Plate 297). A bacchic sarcophagus found in the Quattrocento in front of Rome's basilica of Santa Maria Maggiore (London, British Museum) was the source for several of the classical scenes in the London Book. [43]

Worked horizontally (Plate 83), one Paris page suggests a court entertainment, Cupid on horseback abducting a young satyr whose hooves are tied. Cupid too has a cord around his ankle, but he holds the reins and keeps his bow and arrow, evidently the faun's captor, and embraces him protectively. From each fetlock of the horse grow small webbed wings. Scholars have seen in this lively pair an allegory of love, anticipating the spirit of Giorgione. [44] When reworked later in the fifteenth century the words "Pegasus" and "Medusa" were inscribed below, referring to the winged horse born from Medusa's blood. This sea- or sky-worthy horse suggests the mermen and hippocamps by Mantegna and Jacopo de'Barbari. Bellini was among the first to evoke marine mythology, so appropriate to the Serenissima's maritime concerns. De'Barbari's fauns and satyrs printed at the century's end are still close to those in the Books, which he may well have known.

Cupids without wings (often so shown in antiquity) appear with the stags sacred to Diana (Plate 74) and at the vintage (Plate 73), where they harvest one of their two crops, grapes and wheat. The vintage, central to Bacchus' cult, takes place in a carefully squared setting which Mantegna may have studied before designing the grape arbor for his fresco

in the Ovetari Chapel (Padua, Church of the Eremitani). An anonymous engraving is closest to Bellini's page: some cupids let down baskets of fruit, others hold ladders and vessels, while a third group, as in the drawing, treads the grapes.[45]

Though these trampled grapes are for their next orgy, Bellini's putti could be anticipating the angels' labor toward filling the communion cup. Such ambiguity, twice blessed by classical authority and Christian doctrine, explains the special popularity of these cheery folk and their leader, Bacchus, carefree god of the vine and of healing, with his entourage of satyrs and maenads, centaurs and sileni.

Antique works, true and false alike, had long been popular among Venetian collectors. The son of Tolomeo, Jacopo's portrait subject, owned a great marble head of the god of wine and a marble relief of three centaurs, two standing, another asleep on his back. Similar figures in Jacopo's Books may well have been inspired by the tastes of these patrons or by their marbles and those in the artist's own possession, along with available casts, ancient coins, and medals.

Since much of Bellini's art is concerned with theater and performance, he must have known of Vitruvius' ancient guide to building, especially honored by Venetians because they claimed the Roman author for their own. Vitruvius' *De architectura* credits Bacchus' satyr play, the *satyricon*, with the invention of theater, as Alberti noted in his own book on architectural matters, *De re aedificatoria*. Celebration of military victory, one of Jacopo's key themes, was traced back to bacchic revelry in the first printed and illustrated book on the art of war, Valturio's *De re militare*, published in 1472 in Verona.

The bacchic subjects sandwiched among Bellini's Christian narratives and pietistic images also occur in sacred settings in the mid-fifteenth century, even decorating an episcopal palace, the residence in Treviso of the Venetian humanist Ermolao Barbaro. In them were shown ancient Roman revels, according to a letter of 1453 sent by another Venetian bishop, who probably wanted the same scenes for his own palace on the Dalmatian coast.[46] Such pagan decorations in episcopal settings approach the subjects that abound in the *Hypnerotomachia Poliphili*, written by a Dominican monk, that is close to many of Bellini's scenes.

Bellini's Bacchanals are usually light-hearted, without the stolid drunkenness of Mantegna's, engraved after his designs. Jacopo was the Venetian pioneer in rediscovering ancient revelry.[47] Bacchus and his satyrs abound in the art of Cima da Conegliano and Giovanni Bellini later in the century, both using Jacopo's works as models. A book of drawings entirely devoted to satyrs is listed in a Gonzaga inventory of 1476, by an unknown artist.[48] Jacopo may have assembled such gatherings himself, left unspecified among the drawing books in his widow's will.

Drawings of several ancient and Christian scenes in the Books include urinating boys or men, some as living figures (Plate 214), others as statuary groups on fountains (Plate 179). Similar figures were painted for good luck on early renaissance birth salvers.

Two antique torchères, oddly intrusive, their bases ornamented with satyrs and aloes, rise at the left and right of a shrine devoted to Saint John the Baptist (Plate 283). Another satyr appears next to a vase of aloes on the far right of the sheet that shows a decapitated figure in armor on the far left (Figs. 10, 17); onto the central area was once pasted a large parchment patch, the entire sheet listed in the late fifteenth-century Index as Judith and Holofernes. Here, as in the Saint John, the pagan subjects seem marginal, possibly drawn in as graphic afterthoughts, but Donatello's *Judith and Holofernes* (Florence, Piazza della Signoria) teems with demonic and bacchic symbols; the two have often occurred together.

Satyrs are mourners in Bellini's funerary fantasy in the London Book, his most personal and powerful in the antique manner (Plate 79). A study of remarkable individuality and fervor, this design for a statuary group commemorates a dead hero whose naked corpse lies outstretched on the back of a galloping, winged unicorn; the beast's fetlocks are also winged, like those of "Pegasus" in the Paris Book (Plate 83), and a short horn curves forward from his brow. Riding the mythical beast is a bearded satyr, his right arm raised as if holding a whip. A massive battle relief decorates the sarcophagus-like base—perhaps the hero's body is buried within. Just above it a tall satyr leads his chorus in a circular dance of lamentation, his head visible below the rider's hoof; he holds aloft a severed head. A statuette in Mogilev of a dead or wounded Amazon, her horse kneeling under the dead weight of the fallen rider, reflects a lost major monument, an ancient source for Bellini's *Unicorn*.[49] Dürer, who probably saw the fiercely drawn beast when the London Book was in Giovanni Bellini's possession, used it for his own etching of a similar subject.[50]

The centaur, like many popular, forceful images, is a combination of extremes. He could represent the wisest of creatures, such as Chiron, or the wildest, personifying

45 By the Master of the Tarocchi E Series. See A. Hind, I, E. III, 18.

46 It was then that Maffeo Vallaresso requested drawings after Barbaro's subjects, to be prepared by an otherwise unknown painter named Donatello, presumably for the embellishment of his own residence (Cod. Vat. Barb. lat. 1809, cart. 309; quoted by Testi, 1915, II, 208, n. 3). Fabriczy, *L'Arte*, 1903, 303, suggested that these drawings were done by Jacopo's brief partner, Donato Bragadin, but this seems unlikely.

47 E. Battisti, "Il Mantegna e la letteratura classica," *Atti del VIᵉ Convegno Internationale di Studi sul Rinascimento: arte, pensiero e cultura a Mantova nel primo rinascimento in rapporto con la Toscana e con il Veneto*, Florence: 1965, 25–31. The poet Fiero described this Bacchanal, possibly painted for the Palazzo di Revere on the Po, probably built before 1462.

48 C. M. Brown, "Gleanings from the Gonzaga Documents in Mantua," *Mitteilungen des kunsthistorischen Instituts in Florenz*, XVII, 1973, 153–59.

49 Degenhart and Schmitt, 1972, 153; see their fig. 17 for a reproduction of the statue.

50 Suggested by H. Tietze and E. Tietze-Conrat, *Der junge Dürer*, Augsburg: 1928, cat. no. 74.

drunken lust, the worst ways of man and beast. Cennino Cennini, writing near 1400 in Padua at the beginning of the renaissance, described the wedding of man and beast in the centaur as being the peak of the imaginative act, a resolution of opposites so persuasive and beautiful that only an artist could effect it.

Several of Jacopo's designs for monuments that include centaurs may have been funerary in function, part of the pageantry and temporary decoration for a triumphal farewell. For the obsequies of Federico da Montefeltro, for example, the deceased was shown "on a wagon drawn by two centaurs, united with the great men of antiquity, Scipio and Caesar. . . ."[51]

In a drawing after classical antiquities in Rome (Paris, Louvre; Fig. 15), close to the art of Giovanni Bellini,[52] centaurs stand at the right and left of a sarcophagus. Satyrs and a vase-bearing figure that recalls the Herculean man in the Paris Book (Plate 65) are also on the sheet. Jacopo could have gone to Rome and made drawings after these monuments, or copied renderings by others. Another page drawn after Roman antiquities, possibly from the late phase of Jacopo's studio, shows motifs from the Arch of Constantine at Rome and the Palace of Diocletian at Spalato (Munich, Graphische Sammlung; Fig. 12).[53]

Two monumental fantasies in the London Book are centered on Roman altars. In the first, docile centaurs holding shields flank the altar (Plate 80), on which is a relief of a third centaur in mortal struggle with two nude swordsmen. The flanking centaurs are very like those in the Munich drawing, and similarly placed; the relief is derived from a Roman sarcophagus now at the Vatican, Jacopo adding a cherub and the decorative garland.

A carved equestrian relief decorates the altar base in the second drawing (Plate 81); crowning it is an orb topped with an eagle. Reclining in the pose of a river god, the large bearded elder points toward the orb. This page suggests a theatrical reconstruction of ancient monuments; it has the stuff of a triumphal entry or of pageantry for some civic festivity—possibly the apotheosis of an Este, whose devices include the eagle. Above another sarcophagus (Plate 78) a victorious rider from classical antiquity brandishes a severed head. Whoever inked over this head did not know it belonged to a defeated leader, and gave it cherubic features.

Highly personal in their adaptation of ancient models, Bellini's *all'antica* pages often reflect the same genial, relaxed spirit as in the archaeological picnic described by the Veronese antiquary Felice Feliciano in 1464, to an island in Lake Garda. On this September outing went Feliciano, Mantegna, another Mantuan painter, and a second humanist, probably Marcanova, Feliciano's employer, who made many fanciful drawings after antique monuments. The jaunt was "to refresh our spirits," and to see the island's antiquities, admired for their exquisite inscriptions, "litterae ornatissimae," many copied by Feliciano. There, among "wooded gardens so like paradise they might have sprung up as an abode of the most charming of the Muses . . . we saw a great many antique remains, and on the island of the friars this inscription on a marble column in the most handsome of letters. . . ." Plucking at his zither on the way back, the Mantuan painter played at being an emperor, with Mantegna and Feliciano his consuls. When they returned to the mainland, all thanked the Virgin and her Son—"the supreme Thunderer" (Jesus as Zeus)—at a wayside shrine "for granting them the wisdom and the will to seek out such delightful places and such venerable ancient monuments."[54]

To the uninitiated, classical inscriptions merely confirm ignorance, but for Latinists, no form of ancient art was more direct, addressing ear and eye alike. Voices from the ancient past, these incised Roman stones, so often set within church walls, spoke in the same tongue as the service itself. Their messages from the deities and from the dead, beautifully carved, seemed to erase intervening time, and humanists seeking out ancient inscriptions believed themselves to be agents of resurrection. Cyriaco d'Ancona, poking around a church at Vercelli, replied to a sacristan when asked what he was doing, "It is sometimes my business to awaken the dead out of their graves; it is an art I learned from the Pythian oracle of Apollo." Searching for copies of ancient texts among the dusty, neglected books of medieval libraries, scholars claimed to hear the voices of their long-lost authors calling out: "O ye, who love the Latin tongue, suffer us not to perish, release us from our prison."[55]

When Jacopo used a mediocre little ancient model to draw his splendid unicorn page (Plate 79), he must have felt as Cyriaco did, though he saw rather than heard the original grandeur caught in his small source. The same voices speak from two succeeding pages of Jacopo's Paris Book (Plates 84, 86), crowded "catalogues" of eight funerary inscriptions, mostly recorded in the vicinity of Este, on seven largely fanciful re-creations of classical monuments, their words as authentic as some of the assemblages that bear them are not.

51 Described in a letter of Benedetto Capilupo to Marchese Federico Gonzaga, cited by Licht, 1968, 78.

52 First published by Fiocco (*Arte Veneta*, 2, 1949, 47) as by Giovanni Bellini, but Degenhart and Schmitt (1972, 139–66) ascribe it to Jacopo's circle. Their study traced the ancient sources upon which the motifs depend, two bacchic sarcophagi, in Berlin and in Rome, Museo delle Terme.

53 First published by J. Dvorak (*Umeni* 16, 1968, 351 ff.) as by Giovanni Bellini. Degenhart and Schmitt (1972, 139–66) give it to Jacopo.

54 For a recent discussion of this excursion, see Lightbown, 1986, 95–96.

55 J. E. Sandys, *A History of Classical Scholarship*, 2, Cambridge: 1908, 40 and 26. The second quotation is from Cencio Rustico.

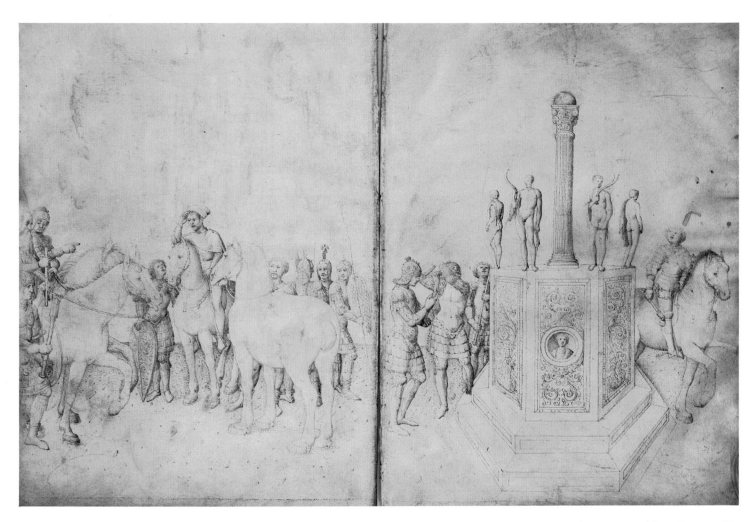

Plate 90. *Classical Scene: Knights and Peasant.* Louvre 46v       Plate 91. *Destruction of Pagan Altar by Roman Soldiers.* Louvre 47

These ancient lines may have been gathered by one of the many humanists attached to the Este court at Ferrara (Bellini was there in the early 1440s), or by Marcanova, for those at the far left of Plate 84 also appear in Marcanova's codices of images and texts, a syllogai dated 1465 (Modena, Biblioteca Estense).[56] Or the two folios could reflect Cyriaco's collection of inscriptions, made in 1443 for Pietro Donato, Padua's humanist bishop. On the first sheet the lower part of the image and inscription at far left reappears, with slight changes in style and wording, in Mantegna's *Trial of Saint James* (Padua, Ovetari Chapel) from the early 1450s.[57] Both artists probably took it from a transcription of Marcanova's.[58]

Both pages must be read horizontally. The first shows three inscribed funerary monuments and a Roman altar. The monument at far right is a cylindrical altar topped by two dancing maenads, and was compiled from three sources: the maenads, in the round, are adapted from a relief on a Roman funerary altar (Padua, Museo Civico); the base is from a bacchic altar (Venice, Seminario Patriarcale); the inscription to Marcello was formerly at Este and then at nearby Monsélice, before it entered a Paduan jurist's collection and was finally purchased for the Museo Nani (Venice, Museo Archeologico). The monument suggests that these pages might reflect some grand scheme honoring Jacopo Marcello, the Venetian military leader who could have ordered his fine manuscripts from Jacopo's studio (see Appendix F).[59]

The funerary relief with a rabbit, to the left of the altar, is also based on a Roman antiquity once at Monsélice (San Jacopo). Next to the left is a relief now lost, but once at Monte Buso near Este. The monument at far left (minus Jacopo's top medallion of portraits and putti) held special interest for antiquarians for its inscription and funerary portraits; it was kept in San Salvatore, near Brescia, and it too appears in Mantegna's fresco.

The scale of the second Paris "catalogue" page is larger than the first, and includes only three antique bases. Again, the bases are more or less authentic, while the upper statuary approaches fantasy. An equestrian monument at the far left, faintly reminiscent of the *Marcus Aurelius* (Rome, Capitoline Hill) or one of the ancient horses on the porch of San Marco but more renaissance in feeling than these, is often compared with Donatello's *Gattamelata* and dated after the completion of that statue or its *modello*. The base actually reflects a relief

56  The inscription to Mettelia Prima and family was in Bellini's time in the church of S. Salvatore near Brescia (*Corp. Inscr. Lat.* [hereafter C.I.L.], V, no. 4653), since lost. Next to the left, to T. Pullio, also lost, was at Monte Buso near Este (C.I.L., V, no. 2528). The Pomponenus inscription was at San Jacopo at Monsélice (C.I.L., V, no. 2669). The Marcello inscription is C.I.L., V, no. 2553.

57  Billanovich, 1969, 242–44, wrote that Jacopo Bellini was the source of Mantegna's inscriptions.

58  See Knabenshue, 1959, 67 and 73, as certainly from Marcanova. Lightbown, 1986, 40, suggests the possibility of earlier sources for Mantegna, as Marcanova used these himself: men such as Cyriaco d'Ancona, who assembled inscriptions for Donato in Padua in 1443, or Feliciano, another possible candidate for Mantegna's version. See also Testi, II (1915), 641, n. 1.

59  For Marcello, see King, 1986, 393–97.

60 Inscriptions on the second page, from the left: the Eppius Rufrus is from S. Fidenzio at Megliadino (C.I.L., V, no. 2623); the Lucretiae is from a monument near Este (C.I.L., V, no. 2542); the Caesar inscription comes from the obelisk in Rome before St. Peter's (C.I.L., V, no. 882), and the inscription below it, honoring C. Gavius Strabon, is C.I.L., V, no. 3463. The assembly of antiquities at the right is imaginary; the sculptures atop the two monuments at center and left were added by the artist.

61 Mitchell, 474.

62 Mitchell, 474.

63 Degenhart and Schmitt, 1984, 13.

64 For a summary of scholarly literature concerning 16th-century images resembling Bellini's, see W. S. Sheard, *Antiquity in the Renaissance*, exhib. cat., Smith College, Northampton, Mass.: 1978, cat. nos. 30, 33, 34.

set into the wall of the church of San Fidenzio (Megliadino), re-created in the round by Bellini. In the center, a David-like nude youth holding a severed head stands on the funerary monument of "the placid seamstress Lucretia," kept at Este. On the largest monument, at right, are combined Latin inscriptions from two sources, the upper one from the great obelisk now in front of Saint Peter's in Rome, the lower one from what was believed to be Vitruvius' tomb in Verona.[60] Much of the ornament on this page prophesies an elegantly decorative approach to the neo-classical that differs from the graver outlook at Florence; it is the harbinger of the late fifteenth-century art of Tullio Lombardo or Bambaia, or, for that matter, the refinements of the French Empire style. Filled with imaginative assemblages of classical sources, the unique pair of cluttered "catalogue pages" in the Paris Book anticipate the attitude toward antiquity that came to a boil in Paduan antiquarianism at the century's end.

Although Bellini belonged to the generation of Cyriaco, most of the *all'antica* pages from his middle and later years are closer to the spirit of the next generation, that of Felice Feliciano, aged twenty-two when Cyriaco died in 1455 and Giovanni Bellini's friend in the 1450s. Feliciano's way to the past was less documentary: "a born eccentric, a renaissance vagabond, [he was] a brilliant professional scribe whose pages outshine Cyriaco's with a harlequin rainbow of coloured inks . . . a printer and draughtsman, familiar of artists, a dabbler in alchemy, a cleric in minor orders. . . ."[61]

Feliciano's scholarship, like Jacopo's art, marked "a shift of interest from antiquity on the site to antiquity in the mind, from a world of fact to a world of imagination. . . ." His fellow humanist, the Venetian-born physician Marcanova, shared this free perspective in his codices showing "a Rome altered and transfigured by his imaginative concept."[62] Completing his Paduan studies in 1440, Marcanova stayed on the faculty until 1453, and during these years Bellini probably drew many of his most classical pages.

Among the earliest works of art in the Veneto to bear inscriptions according to rigorously classical style are Mantegna's fresco in the Ovetari Chapel, Padua, from the early 1450s, and the tombstone of a Brescian physician, Bartolommeo Lamberti (d. 1457; Brescia, Museo Cristiano). Based on these, together with Flavio Biondo's texts and Marcello's manuscripts (Appendix F, Ills. 1, 2), a date in the 1450s is reasonable for the most sophisticated of Jacopo's *all'antica* pages. Venice established her first official chair in Greek studies in the 1450s, given to Demetrius Chalcondyles, and Cardinal Bessarion, the distinguished scholar from Constantinople, donated his library to San Marco.

Degenhart and Schmitt's hard and fast characterization of the London Book as later and more stylistically advanced than the Louvre's is not altogether acceptable, but the authors were surely correct in noting the antiquarian approach of the Paris Book (for them, begun about 1430), with its latest drawings from the 1450s leading to the London Book, which possesses "the invention of living images in the spirit of the ancient world," begun in the late 1450s and worked on into the 1460s.[63]

Of all Bellini's pages inspired by antiquity, one alone (Plate 67) is stunningly precocious for its mastery of ancient art, anticipating the assured classicism found early in the high renaissance.[64] Drawn after an antique statue of a boxer, his left hand bound with protective cloth strips, it is worked in metalpoint, on vellum coated to obscure the orientalizing textile design beneath. The silvery surface and subtle texture of this study bring out the supple modeling of the ancient marble. The battered antiquity is shown as it was, with one arm lost, yet the boxer shares the quality of animation found in later academic drawings after a model posed as an antique work of art, who so becomes a living statue.

Beginning with Bellini's pages, these drawings from ancient ideals hover between flesh and marble, their artist a Pygmalion whose skilled dedication turns art into love. Bellini and Donatello may have followed the same ancient work, probably in Padua, the sculptor using it for an altar relief at the high altar of the Santo, where Jacopo and his sons painted an altarpiece in the later 1450s for Gattamelata's funerary chapel. This page could prove to be by Giovanni Bellini rather than Jacopo, for it is close in feeling to some of the ancient statuary in his earlier paintings, such as the Pesaro Altar (Pesaro, Museo Civico). Similar figures of classical athletes based on this one, which has a whole page to itself, appear in other scenes on a smaller scale, as living witness to a tumultuous horse and rider (Plates 105/106), or as small decorative statues (Plate 89) on the wall of a building to identify the subject as an ancient one.

Like Ghiberti, whose life and work he must have admired, Bellini collected examples of ancient art, as did his son Gentile and his son-in-law Mantegna. Such works are listed in

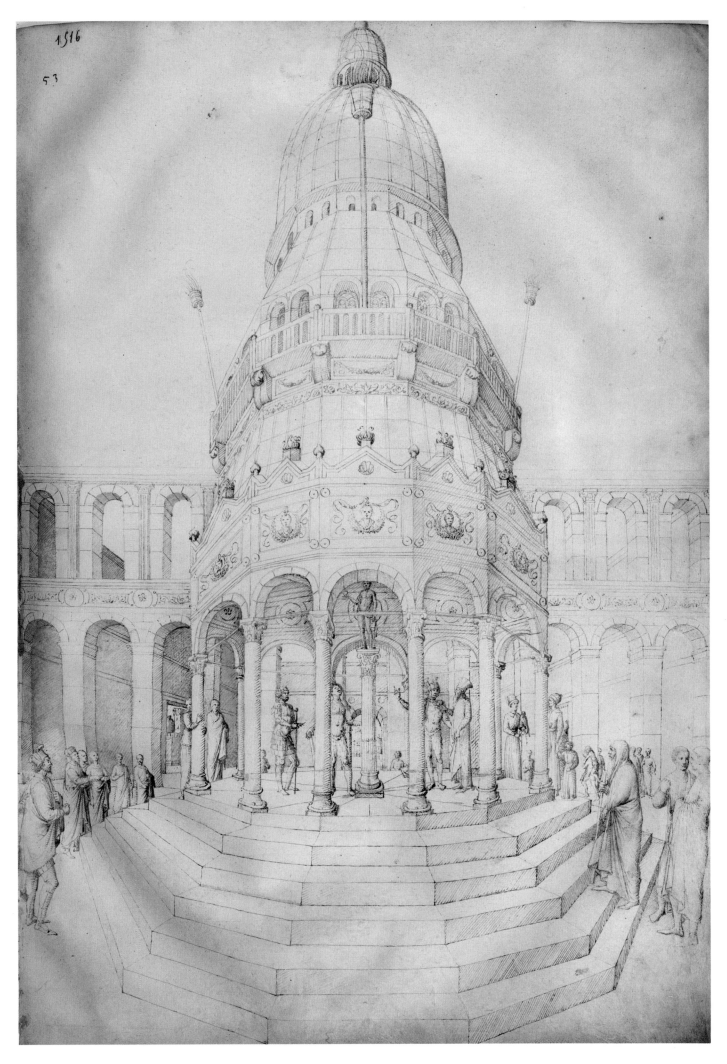

Plate 92. *Central-plan Temple with Idol.* Louvre 53

65 C. M. Brown, *Art Bulletin*, 51, 1969, 372–77. Isabella d'Este, seeking to buy the head of Plato, corresponded with Giovanni and Niccolò Bellini about its purchase.

66 See Degenhart and Schmitt, 1972, 170. B. Ziliotto, *Raffaele Zorenzoni: La vita, i carmi*, Trieste: 1950: the poet Zorenzoni of Trieste wrote songs in Latin to Gentile and Giovanni Bellini and to Zoppo; song no. 135 is on Gentile's *Venus*.

67 J. G. LeGrand, *Notice historique sur la vie et les ouvrages de J. B. Piranesi*, 1799 (repr. *Piranesi et les Français*, Rome: 1978).

68 For a fine recent study of Francesco Colonna, see G. Pozzi and G. Gianella, "Scienza antiquaria e letteratura. Il Feliciano. Il Colonna," in Arnaldi–Stocchi, I, 1980, 459–98 (for Colonna, 467 ff.). Sole document concerning the writer is one of c. 1470 by the Triestino poet Raffaele Zorenzoni, an epigram describing him as "antiquarius." The bibliography in Pozzi and Gianella's study covers until 1974, with the addition of E. Kretzulesco-Quaranta, *Les jardins du songe, "Poliphile" et la mystique de la Renaissance*, Paris: 1975. More important is A. Braschi, *Scritti rinascimentali di architettura*, Milan: 1978, 145–76, which relates Colonna's career to actual undertakings. Pozzi and Gianella's analysis of recent scholarship discusses Colonna's Roman or Florentine origin. The two "firm" dates within the *Hypnerotomachia* are the hero's falling in love with Polia in 1462 and the ending of Polifilo's dream on May 1st, 1467; both dates fall within all three Bellinis' lifetimes.

69 J. Burckhardt, *The Civilisation of the Renaissance in Italy*, trans. S. G. C. Middlemore, London: 1898, 416.

the will of Jacopo's widow as "omnia laboreria . . . de marmore et de releviis," "all works of marble and reliefs," including casts like those Squarcione used in his Paduan academy. Jacopo's antiquities went from his widow to their son Gentile, who also owned a *Venus* (ascribed by a Venetian humanist to Praxiteles) as well as a head of Plato, both probably from his father's estate.[65] Scholars seeking a clue in the Books to the appearance of the Bellinis' *Venus* concluded that Eve in the *Expulsion* (Plate 143) of the classical *pudica* type, could have been based on it.[66] Jacopo's casts and reliefs must have included coins and medals, evident in so many drawings.

The Books' ancient inspiration set the stage for the future of the past in the Serenissima's later pilgrimage to the world of Greece and Rome. An easy, precocious familiarity with ancient times is among the pages' many surprises. Forerunners of the arcadian vistas and harmonies of Giorgione and Titian, the statuary and the heroism of Greece and Rome are here reborn in the language and landscape of the Veneto, with the loving authority and affirmative nudity that so became the classical birthright of the Serenissima's art.

Ferocious and tragic as well as calm, Bellini's fantastic encounter with the classical makes him the first forerunner of that most imaginative of all re-inventors of Greco-Roman art, his fellow Venetian Giovanni Battista Piranesi. Jacopo, who probably drew his wildest neo-classical fantasies when old, in the 1450s and '60s, would have been like that eighteenth-century architect and printmaker whose bald head was described as resembling "a volcano, smoking ceaselessly, continually erupting the most extraordinary ideas. . . ."[67]

Seldom intellectual, the view of ancient art in Venice is often one of reverie, far from the cold eye of fact. The achievement of antiquity is set forth as a vision in the romance *The Strife of Love in a Dream*, the *Hypnerotomachia Poliphili*, by Francesco Colonna, a Dominican monk. First printed in 1499, with marvelous woodcut illustrations, it was written in 1467, near the end of Bellini's life. The script is for one of the richest fantasies of antiquity since its fall, a weird and far-from-divine comedy that re-creates monuments of Egypt, Greece, and Rome as the keys to a neo-classical kingdom of self-knowledge, and an allegorical tale of true love.[68] Fraught with emblems, hieroglyphs, and ciphers, all densely medieval in their love of mystery, this Latin text nears the spirit of Bellini's most intricate inventions in the antique manner. His menacing, winged unicorn (Plate 79) suggests the Horse of Misfortune in Colonna's text. A love of inscriptions and of erotic scenography, and the overriding quality of reverie in the illustrations, find equivalents in the text and in Bellini's drawings. Perhaps the writer learned from the painter, or old Bellini was drawn to the passion for antiquity that is central to Colonna's cranky yet blissful text, where ancient monuments inform and enliven the present, as they illumine life's thorny passage. Allegory depicts the five senses that guide body and soul to ecstasy through the labyrinths and ruins of the past. Jacopo's scenes of combat and triumph, his dragons and ruins, anticipate the monk's fantasies.

Scholars suspect that Colonna, while writing his romance, must have kept in view renderings of his images, so elaborately described, intricate yet so consistently presented. His long discussions of their proportions, inscriptions, and detail require that these statues and settings had been worked out in advance—inspired by something like Bellini's vision of antiquity, though no "line-for-line" dependence relates Jacopo's works with Colonna's text and its illustrations. What matters is the new liberation and profound caprice they share. Bellini, like most artists of his time, was probably a *festaiuolo*, a pageant master, fusing the skills of painter, sculptor, and stage manager. An ancient text describing a picture gallery, the *Imagines* by Philostratus, provided fancy subjects of the sort so popular in renaissance court entertainments and drawn in Jacopo's Books. These were the classical divertissements; Shakespeare, in *A Midsummer Night's Dream* (Act IV, Scene 1), gives the name Philostratus to Theseus' master of revels, his "usual manager of mirth," hired "to wear away this long age of three hours, between our after supper and our bed time." Philostratus' recitation of amusements to "ease the anguish of a torturing hour" includes many subjects that read like Bellini's—" . . . the battle with the centaurs . . . the riot of the tipsy bacchanals . . ."—and were also destined for wealthy patrons desperate for diversion. Descriptions of renaissance marriage festivities and receptions are similar grab bags of ancient themes, as that of Eleanora of Aragon, presented in her honor in Rome in 1473:

> There were represented Orpheus with the beasts, Perseus and Andromeda, Ceres drawn by dragons, Bacchus and Ariadne by panthers, and finally the education of Achilles. There followed a ballet of the famous lovers of ancient times with a troup of nymphs, which was interrupted by an attack of predatory centaurs who, in their turn, were vanquished and put to flight by Hercules.[69]

Bellini's noblewoman, seemingly on her way to marriage (Plate 32), may have been greeted with just such *tableaux vivants*. Of his Books' many functions, that of providing motifs for entertainments was far from the least. The will of Bellini's widow does not designate "two" drawing books, just "books" in the plural; he had probably left her many. Was one of these the sketchbook in the Gonzaga inventory of 1476, with "battles of centaurs, of fauna and satyrs, also men and women on foot and on horseback," borrowed by a Florentine patron who could find no centaurs closer to home?[70] Gentile Bellini left other notebooks after Roman antiquities to his assistant, which may also have been by Jacopo. Two early sixteenth-century engravings by the Venetian printmakers Marcantonio Raimondi and Agostino Veneziano, both active in Rome, continue into the high renaissance the theme of Bellini's drawings. Their prints include a powerful classical nude male bearing a column base, his arms crossed at the brow to support the stone burden, like the Hercules drawn in the Paris Book (Plate 65). Perhaps the pages of all three are based on an antique work rediscovered in renaissance Venice.

Sparked by such unrivaled collectors of antiquities as the Venetian Pope Paul II (r. 1464–71), the Serenissima's passion for the past won a new dimension, a pursuit so extravagant that it went beyond political goals, prestige, and propaganda. The Republic's last, great classical image would be the reclining nude, timidly initiated on Jacopo's pages (Plates 69, 70). Now, as Bellini's century drew to an end, Venice was spending lavishly to conquer her own last frontier, and a sparkling white city rose above the old. Hundreds of floating marble palaces, churches, and squares were built or refurbished; acres of canvases were painted, unparalleled for their size and lustrous splendor; Venice, like Bellini's *Madonna* (Plate 138), became the Mater Omnium to her artists, patrons, scholars, and institutions. The novel freedom of the antique scenes in Jacopo's late graphic style in the London Book bespeaks this new age of magnificent, possibly deceptive, abandon. The art of the father of the Venetian renaissance now assumes a renewed infancy of fresh, radiantly classical impulse.

Suitably, his son Giovanni's last (and one of his finest) classical subject, *The Feast of the Gods* (Washington, D.C., National Gallery of Art), still echoes the bacchic spirit of Jacopo's pages. The recollections of antiquity in this large canvas, completed by Titian, combine those of three generations of Venetian artists.

Figures as vital as Bellini's satyrs and centaurs return in the Serenissima's art only in Titian's latest works, dancing in the distant woods, settings for the most powerful force of nature. There Jacopo's panpipes are heard again, sounding the fertile joys of creativity.

70 Lightbown, 1986, 83.

# VI

# ARMS AND THE
# VENETIAN MAN

## THE SOLDIER OF FORTUNE: *ARS ET MARS*

1 M. Bishop, selected and trans., *Letters (Petrarch)*, Bloomington, Ind.: 1966, Book IV, 3 (to Piero da Muglio da Bologna, from Venice, August 10, 1364), 234 ff.

Bellini's longest, strongest song joins with Virgil's "of arms and the man" in a graphic celebration of military victory. His pages contain any number of cavaliers personifying strength and triumph, skill and romance, valor and faith. Even the Roman soldiers witnessing the Passion are treated with a certain awe, if not reverence. Knights of Troy or of the True Cross are seen as one and the same, the first as ancestors of the second.

Many of Bellini's pages suggest a chivalric Battle Hymn of the Venetian Republic addressing the mighty fortress of Lord and warlord alike. His drawings often defy a clear-cut separation between scenes of real combat and those of the tournament, its courtly dress rehearsal. Venetians made love and war with equal ardor, crusading for profit with Christian hand in mailed fist.

Militance, so evident throughout Bellini's Books, also characterized the Republic's spirituality. Lorenzo Giustiniani, her first patriarch-bishop at mid-century and among the earliest of her few saints, approached his faith with a belligerence like that of the Salvation Army. Born to a wealthy family, he compared his renunciation of earthly pleasures to conscription into the service of heaven, a *caelestem militiam* recalling the muscular Christianity of Saint Paul. That Venice could imbue even the Mother and Child, that most loving and vulnerable of images, with martial spirit stemming from Byzantine sources is clear in two East Christian art treasures at San Marco—a relief of the Madonna inscribed with the single Greek word ANIKETOS, The Invincible, and a painted icon known as the Madonna Nikopeia, of victory.

Though the Venetians first won wealth and fame from the waters, they soon aspired to equal strength on land. "This nation of sailors," wrote Petrarch, awed by Venetian power, "was so skillful in the handling of horses and weapons, so spirited and so hardy, that it surpassed all other warlike nations whether by sea or by land."[1] Men of the upper classes were trained as crossbowmen, and this service led the Republic's patrons to their widespread support of military subjects in art. Societies like the Compagnia di San Marco combined high rank with defense. Other gentlemen joined the Black Band, meeting at the Lido for military exercises. Those not active as crossbowmen were trained to command galleys, the Republic's sons keeping her strength supreme at sea.

Warfare marked much of Bellini's lifetime. Venice spent half of the fifty years between 1404 and 1454 in battle, beginning with her success over the Carrara of Padua between 1404 and 1405, and her conquests of Vicenza and Verona. Doge Foscari's decision to concentrate the Republic's forces in land battles against the Lombards called for ever more recruits. By 1439 Venice had enrolled 16,000 cavalry, a year later 20,000. An army of 20,000 foot soldiers was maintained from 1450 to 1454. Her alliance with Naples called for a standing army of 6,000 Venetian cavalry and 4,000 infantry. Among the many lost paintings ascribed to Jacopo, at least one reflects the military subjects that abound in his Books, of a battle outside a besieged city (Appendix D, 1: ★Venice, Palazzo Ducale). The Venetian passion for martial arts and sciences grew stronger in the later renaissance, and more military books were published there than in all of Europe.

Often it is hard to tell whether the generals in the Books belong in a classical or medieval context, or in the artist's own time. Such confusion may be deliberate, today's hero

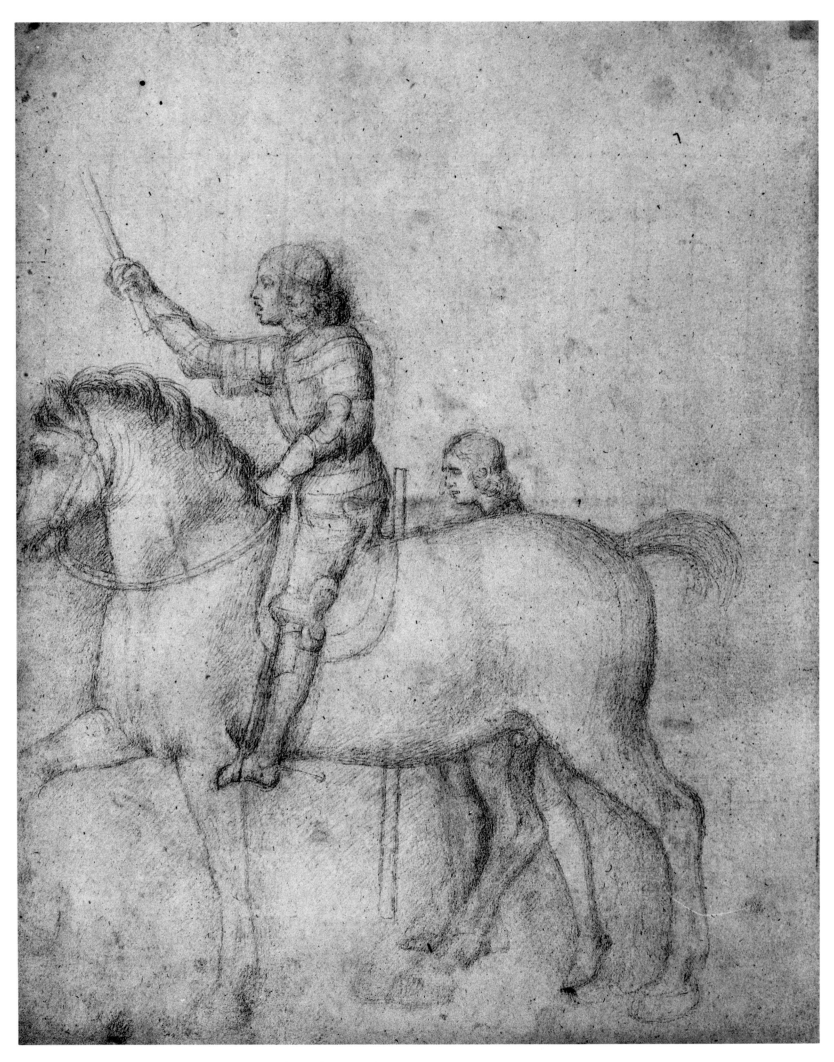

Plate 93. *Young Cavalier with Baton and Attendant*. British Museum 84v

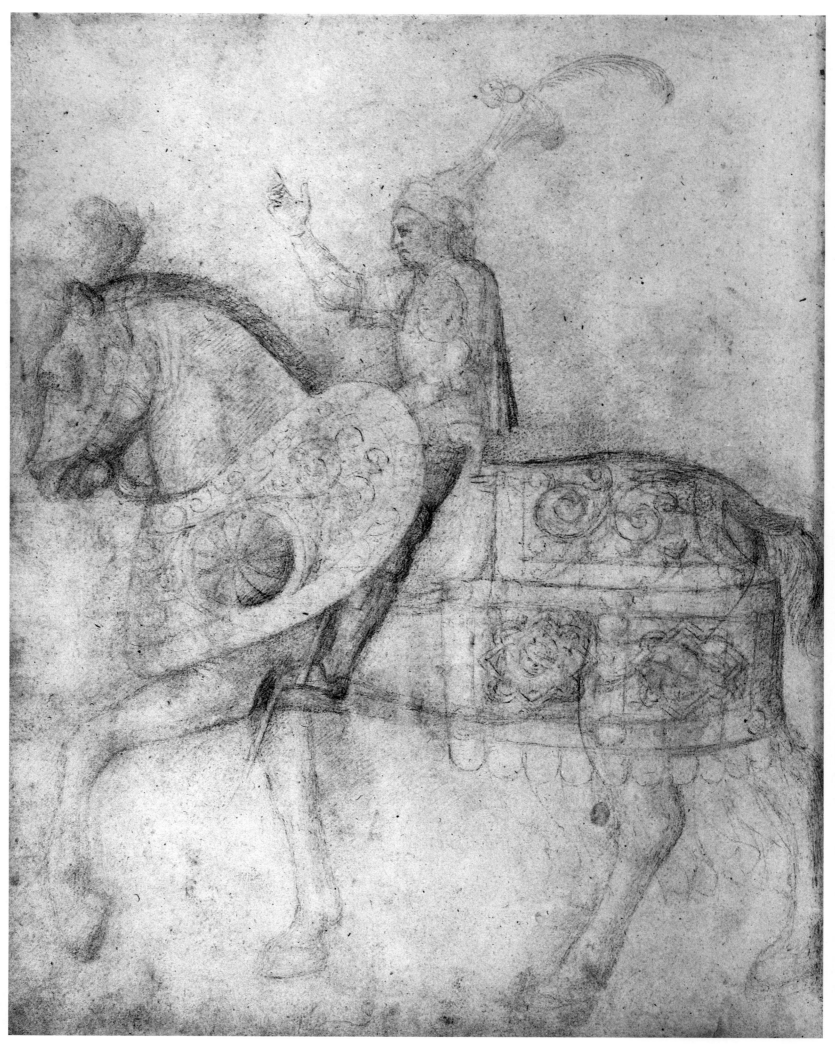

Plate 94. *Knight Ready for Tournament.* British Museum 5v

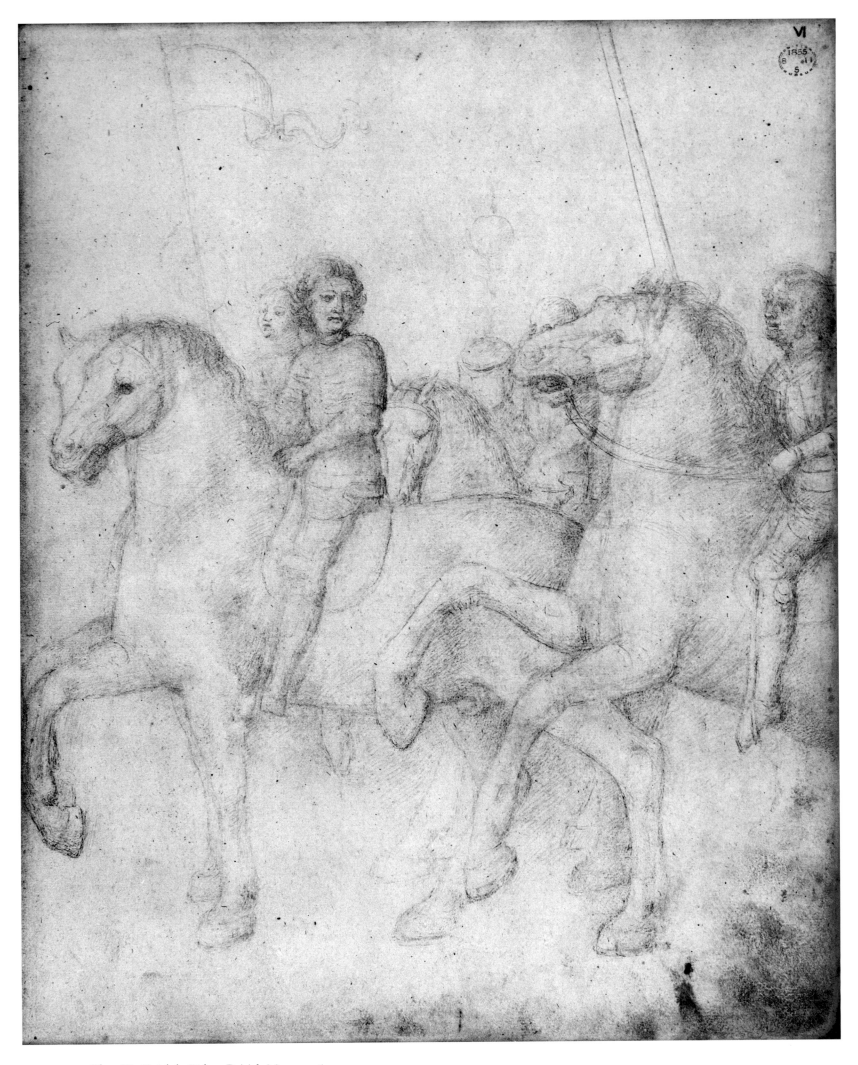

Plate 95. *Knightly Riders*. British Museum 6

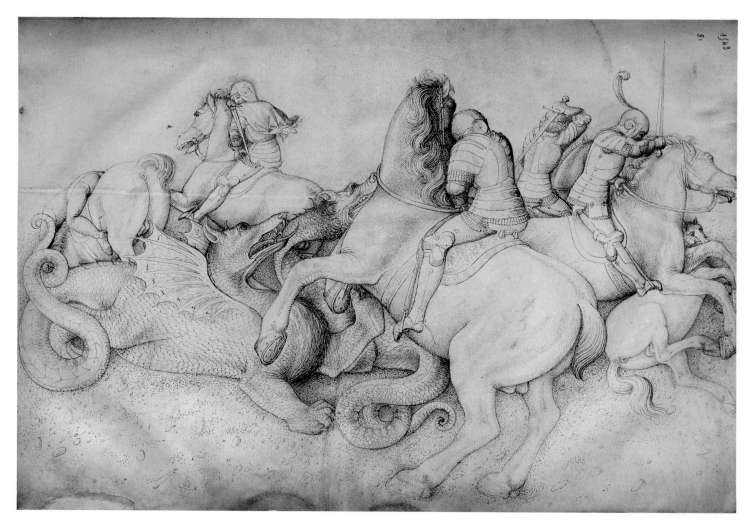

Plate 96. *Six Horsemen Fighting Dragons*. Louvre 81

2 Longhi, 1926, 148.
3 Christiansen, 1982, 16, and
doc. III, 150–59.

glorified by association with past apparatus and grandeur. Soldiers of fortune, the *condottieri* (so named by the contracts that bound them) saw or were soon flattered into seeing themselves as triumphant Caesars, Alexanders reborn, taking on the ceremonial freight of antiquity that their humanists so readily unloaded on them for a few ducats.

Petrarch, ever aware of which side of the past to butter for his patrons, followed Cicero's *De imperio Pompeii* in delineating the attributes of a Roman general and dedicated them to the Venetian warrior Luchino del Verme: scholarship, physical prowess, courage, magnanimity, ferocity in war and grace in peace, temperance, calmness, and equity were among the qualities in order. Doubtless Del Verme saw his own image in Petrarch's model from the past.

Many of Bellini's best portraits are of men of war, their incisive rendering surely drawn from life, although Longhi (ever stressing the artist's old-fashioned, derivative aspects) did not even credit Bellini's *condottieri* with being contemporary, describing them as portraits of warriors long gone.[2] A hook-nosed, bareheaded leader, lance in hand, rides in single-minded pursuit of an unseen rival (Plate 118); another, grasping a baton of command, leads a retinue ready for the tournament (Plate 116). The stability of the Republic made Venice an ideal employer of hired military help. That great soldier of fortune Niccolò Piccinino explained the advantages of serving Venice over Milan: Milan's duke was mortal, while the Serenissima would never die.

In addition to giving her *condottieri* splendid palaces on the Grand Canal, Venice awarded vast mainland estates to them, endearingly known as their "nests." Jacopo, working with Gentile da Fabriano from 1414 to 1419,[3] may have decorated a private chapel of one of these at Brescia. The estates granted to *condottieri* or bought by them were major centers for patronage; Bergamo, Vicenza, Pesaro, Padua, Urbino, and Rimini all became sites for new, often grand residences.

Of Jacopo's Venetian contemporaries, Cardinal Lodovico Trevisan (also known as Mezzarota Scarampo; 1402–1465) had the widest sweep of commanding skills. Paduan-

trained, he was physician to the Venetian pope Eugenius IV, and he also led the Vatican's forces to victories on land and on sea. As archbishop of Florence and chancellor of the University of Rome, Mezzarota maintained lifelong links with such scholars as Poggio Bracciolini, Cyriaco d'Ancona, Francesco Barbaro, and Francesco Filelfo. He could well have been a patron of Jacopo,[4] for he was close to Squarcione, and Mantegna painted him at the Council of Mantua in 1458–60.

Italy's maritime states—Genoa, Venice, and Naples—reveled in related military styles, whether fighting for or against one another. René d'Anjou and Alfonso V of Aragon, successive rulers of Naples, both created an art whose triumphal images recall Jacopo's. In a play staged in Naples in 1441 René was cast as Scipio, general of the Roman Republic, and his enemy Alfonso as Hannibal, the Carthaginian general;[5] similar references may be found in Jacopo's pages (Plate 88).[6]

Bellini is known to have portrayed the *condottiere* Bertoldo d'Este (d. 1463), and another *condottiere*, Bartolommeo Colleoni (d. 1467), is a candidate for Jacopo's depiction. Like Gattamelata, Colleoni left funds for a magnificent Florentine bronze equestrian monument (Venice, Piazza di SS. Giovanni e Paolo), his to be erected in the Piazza di San Marco, site of the pageantry held for his investiture in 1448. Bellini could have produced opulent classicizing *tableaux* and ceremonial settings to celebrate the *condottiere*'s contributions to the Serenissima's strength; he and his sons painted an altar for Gattamelata's funerary chapel in the Santo at Padua, and Giovanni Bellini may have used his father's design in painting a smaller altar for Colleoni (Fig. 62). Many *condottieri* came from noble houses near Venice, lending their lineage along with their military skills. At least three generations of the Malatesta and Este families, and almost as many Gonzagas, were under Venetian contract, the Republic inviting the loyalty of land-poor courts by hiring their leaders. Her most powerful *condottieri*—Colleoni, Carmagnola, Sforza, and Gattamelata—were not from the noble class, however, but selected for their brains and bravery.

The most powerful Venetian military officials were those elected as the *condottieri*'s supervisors, *provveditori*, among whom was Jacopo Antonio Marcello, probably a major patron of Jacopo in the 1440s and '50s. In those years he presented two fine manuscripts (Appendix F, Ills. 1, 2) to René d'Anjou that may have come from the painter's studio.[7]

Plato's dictum in *Laws*, that "the best government is produced from a tyranny," made it easy for "so many Italian despots, *condottieri*, and merchant adventurers to profess an ardent belief" in his philosophy.[8] The visual arts and literature should provide for a wise use of strength, and especially the art of intimidation should effectively combine the heritage of ancient with modern means. Soldiers of fortune, knowing that in the end the pen and brush were mightier (and cheaper) than the sword, enlisted both in the service of their immortality, founding libraries or temples of the muses as guardians of their memory and thus of their eternal life.[9] Many of Italy's greatest artists, sculptors, and architects were in the warlords' service. Donatello, Verrocchio, Pollaiuolo, Uccello, Alberti, Piero della Francesca, Leonardo, and Francesco di Giorgio are but a few of those who flocked to the *condottieri*'s courts; military men assembling important libraries included the Sforza of Milan, the Malatesta of Rimini, Pesaro, and Cesena, Gianfrancesco Gonzaga and his son Ludovico of Mantua, Federico da Montefeltro of Urbino, and Antonio da Marsciano, the Umbrian son-in-law of Gattamelata (a lifelong soldier in the Venetian service).[10]

*Condottieri* boasted of more than flattering classical references, often claiming heritage from the age of chivalry as well; as in Bellini's Books, their poets and painters, builders, medalists, and armorers combined allusions to Arthur and Alexander, Caesar and Launcelot into a courtly romance that moved from strength to strength. Pisanello's collection of classical coins and his medals manufactured in ancient and late medieval styles made him an adroit master of the two manners, evident in the disparate styles on recto and verso of his small bronze roundels, one side classicizing, the other almost Gothic.

Petrarch, in following the ways of the ancients, forged a new alliance between force and literature—*arma et litterae*—that superseded the Roman bond between force and the law—*arma et leges*. The poet's message proved welcome and even profitable; his classical perspective contributed to the *condottieri*'s wisdom in forming their libraries, the contents unifying art with the craft of war. These military leaders, whose skill (like Petrarch's learning) went to the highest bidder, often enjoyed a better education than their employers, humanistic culture being the other side of many a *condottiere*'s coin. The sum of their knowledge was illuminated on vellum, bound in costly leather, and kept in *intarsia* cupboards within marble walls, all emblematic of that ultimate fusion of power, *Ars et Mars*.[11] Bellini's Paris Book, with its similar theme, was once in the library of Mehmed's seraglio, and seems rightly destined for such ownership.

4 For Mezzarota's life and sources, see Kristeller, 1902, 178–79, and P. Paschini, "Lodovico Cardinal Camerlengo (d. 1465)," *Lateranum*, n.s.l., Rome: 1939.

5 B. Croce, "I Teatri di Napoli," *Archivio storico napoletano*, XIV, 1899, 560.

6 But Prusias was the Asian king with whom Hannibal sought refuge on his flight from the Roman forces. Perhaps the severed head in the drawing is of Hannibal's brother, brought to the cruel Roman consul Claudius Nero. This subject was retold and illustrated in the *Romuleon*. See De Mandach, 1922, 56. Tietze and Tietze-Conrat (1944, 112) suggested that Brutus is pointing here to the dead Lucretius and thus leading to the Roman revolt.

7 Meiss, 1957, 34.

8 See E. Wind, "Platonic Tyranny and the renaissance Fortuna: on reading Ficino's reading of Laws IV, 709A–712A," *De Artibus Opuscula XL. Essays in Honor of Erwin Panofsky*, New York: 1960, I, 491–96.

9 See Chastel, 1959, Part 3, Sec. 1, "Les initiatives des 'condottieri': L'art 'humaniste' à Rimini et à Urbin," 353–72.

10 See Chastel, 1959, *loc. cit.*

11 E. H. Kantorowicz, "The sovereignty of the artist. A note of legal maxims and renaissance theories of art," *De Artibus Opuscula XL. Essays in Honor of Erwin Panofsky*, New York: 1960, I, 267–79.

12 E. Gardner, *The Arthurian Legend in Italian Literature*, London: 1930.

13 See M. Boni, "Nuove ricerche intorno ai Monoscritto Marciani della 'Chanson d'Aspremont', *"Memorie dell' Accademia delle Scienze di Bologna*, Classe di Scienze Morali, 7, ser. 5, 1957–59.

14 See the manuscript of c. 1445 (British Library, Ms. Royal, 15, E. VI).

15 This scene appears in the *Romuleon*, Bibliothèque de l'Arsenal, Ms. 667. See H. Martin, *Le Romuleon (Arsenal Ms. 667)*, Paris: 1912, pl. XII.

Northern chivalric literature—those Arthurian "westerns" with erotic overtones and mystical undercurrents (or vice versa)—was enormously popular in medieval and renaissance Italy. Its readers' intermarriage with transalpine nobility or their wish to claim distinguished bloodlines led to importing or locally illuminating hundreds of Northern knightly adventures, and purchasing expensive Flemish tapestries of the Christian romance of Camelot.

As late as 1470, Borso d'Este instructed a friend to send him "as many French books as you can, to wit, some of those of the Round Table, for we shall receive more pleasure and content therefrom than from the acquisition of a city."[12] As Italy's ties to her classical past often became obscured, she ascribed some of her greatest monuments to King Arthur's associates. Verona believed that her Roman amphitheater had been built by Merlin's magical powers just where Launcelot had fought a fierce duel. Torrid Gothic romances seduced Tuscan readers into temptation—poor Paolo and Francesca were forever condemned into the second ring of Dante's *Inferno* for their carnal sin, arising from jointly reading of Launcelot and Guinevere.

Sir Thomas Malory and Jacopo Bellini may sound like an odd couple, but they achieved similar goals, each translating Arthurian texts into their own culture (they also died within the same year). As the language of early Venice, especially in its written form, had absorbed much from the French, the literature of the Knights of the Round Table was as popular there as in Ferrara, Mantua, and Milan, particularly an Arthurian text known as the "Entrée d'Espagne," also called "Spagna" or "Roncisvalle," a *chanson de geste* set in Calabrian Aspromonte and written in Franco-Italian by an unknown Paduan.[13] Confusing in content and obscure in origin, this long romantic tale of young Roland (Orlando) was much read in the Veneto and often illustrated. One manuscript combines the *chanson* with *La Passion de Nostre Seigneur*, the resulting mixture of sacred and profane approaching the collective effect of Bellini's Books.[14]

Boiardo's poetic retelling of Roland's adventure in *Orlando Innamorato*, written in late fifteenth-century Ferrara, draws upon the chivalric literature so popular at that court, where three marquises and their sister (mistress to the despot of Rimini) bore names of knights of the Round Table or their ladies—Lionello, Meliaduse, Gurone, and Isotta. The same Gothic tales then inspired Ariosto's epic *Orlando Furioso*. The poet was supposedly thanked by Ippolito d'Este with the query: "Where did you find so many stories, Maestro Ludovico?" The same question might be asked of Maestro Jacopo, whose Books also teem with chivalric enigmas.

Courtly art of the 1440s and '50s displays nostalgia for past glories, for the good old, bad old days when knights were bold, unsoftened by humanism. In returning to the intricacies of the International Style (itself a late Gothic revival), Bellini's most retrospective, romantic manner is all the more glamorous and persuasive for utilizing the new illusionism of modern perspective developed in Padua and Florence, and the technical refinements of Northern art.

Antonio Pisanello blazed new trails back to Burgundian and ancient glory. He and his colleague Jacopo were both close at first to Gentile da Fabriano, later becoming rivals in Ferrara. Pisanello was a favorite artist at the *condottieri* courts and the kingdom of Naples. Though he revived the classical tradition of making bronze medals, Antonio also created Gothic images: his Arthurian fresco cycle for the Gonzaga simulated a tapestry, lining their Mantuan hall with scenes of knightly derring-do.

Bellini, Uccello, Gozzoli, and many other masters shrewdly manipulated their neo-medieval style at mid-century, its cunning conservatism flattering their patrons' pretensions. The Visconti, the Sforza, the last dukes of Burgundy, the Medici, the house of Aragon, and René d'Anjou all cherished an affirmative esthetic action toward the not-so-distant past.

Thematically, Bellini's knights fighting dragons may be his earliest combats, from the mythological Silver Age, the classical world's still-threatening second phase of history when warriors fought monsters. Such strife reappeared much later in the *Romuleon*, a medieval retelling of Livy, where Cato of Utica fights the same fierce creatures that taxed Saint George.[15] A catchall of ancient and medieval sources, the *Romuleon* combined Saint Augustine's *City of God*, Valerius Maximus' accounts of great and good men and women, and writings by Lucan, Suetonius, and Orosius in a rich brew that told the story of Rome

from the Fall of Troy to the Age of Diocletian. Compiled by Benvenuto da Imola, who lived much in Ferrara and died there in 1380, this turgid but popular text was doubtless well known in the Veneto, and in many other similar literary gatherings classical and Christian elements were mixed in ways not unlike Bellini's.[16]

Jacopo's Books contain three major types of dragon fights. The scene in the Paris Book (Plate 96) of horsemen battling two monsters has the quality of a relief—the more so as it was delicately inked over at an early date to increase the page's visibility, and the penlines' sharp definition lends a lapidary quality to the surface. The horsemen dashing into the distance in his *Madonna of Humility* (Fig. 16) show his early mastery of riding figures, painted about thirty years before these in the Louvre's Book.

On two pendant pages that follow in the same Book (Plates 97, 98) three men on foot fight a dragon who is clearly getting the worst of it, both combats possibly designed for court entertainments. Heraldic beasts—lions and an eagle—decorate three shields, two of them massive turtle shells perhaps implying the conquest of animals over water. Three warriors wear winged helmets (signifying air?), one of feathers and two of webs similar to the dragons'. The knee attachments of three suits of armor also resemble webbing; those of another suit are formed by lion heads.

On foot three warriors again corner a beleaguered dragon outside his lair, on the right of a related double page in London (Plates 99/100), while two men flee toward a city on the left page, abandoning their weapons on the way. The devastated trees tell the story of the dragon's ferocity. Though some of the right page was done in wash, both pages have been heavily inked in the crisp outlines of early Italian engravings. The rendering before this addition may have been made in chalk, as the soldiers' raised arms were not penned.

A second double page in the London Book (Plates 103/104) has the splendor of an Oriental scroll, happily "unimproved" by harsh penwork. Four horsemen battle a dragon; one rider has fallen from his mount and runs away on the facing left page. Three men on the left side of another London double page (Plates 107/108) resemble the runaway, Muybridge-like in their arrested motion, all three clearly drawn after the same model. Like many of the London Book's left pages, this one may be slightly later than the right page; possibly the large, beautiful tree is a separate study.

In two images of horsemen in the Paris Book, very much a pair (Plates 101, 102), the fantasy and vivacity of Bellini's pages seem missing. Both were drawn in silverpoint, on a pink chalk ground covering the textile designs on the older pattern-book pages, by an apprentice influenced by the colossal *Horsetamers* on Monte Cavallo in Rome, well-known antiquities long ascribed to Phidias and Praxiteles.

One of Bellini's finest double pages (Plates 105/106) has a bizarre fusion of classical and Christian elements. Astride a rearing, Uccellesque mount, a bareheaded knight raises his mailed fist heavenward in an odd gesture of mingled pledge and defiance. He seems about to fall into a Gothic tomb, its broken slab inscribed "Here lies the noble knight Tommaso Loredano," as a messenger (the badge of his profession on his breast) looks up at him in horror. On the facing sheet the fleeing page boy and the barking dog may have been in the knight's retinue (the page boy reappears in another scene; Plate 121). Eight other male figures are grouped in an Albertian showcase of contrasted ages, expressions, callings, and concerns, all of them contemporary except for the impassive nude athlete in classical pose. The youth with a broken staff resembles the knight, and a young military leader seems to make a pledge with one hand on his breast, the other on his sword handle. The old soldier behind the Tuscan altar-like wall also raises his right hand (but touches the athlete's thigh with his left); on his armor is a breastplate attachment, as on the knight's, to support a lance.

The wall and the *all'antica* column base[17] in the foreground may set the scene in antiquity, possibly referring to the well-known episode in Livy, retold in the *Gesta Romanorum*, of a chasm that opened in the Roman Forum and of the gods' requirement, that Rome must sacrifice "her greatest treasure" if she were to survive. Perhaps the messenger has brought this demand. Marcus Curtius, in the fusion of ego and service typical of a virtuous knight, saw himself as the "treasure" and leaped armor-clad into the breach on his horse. Ricci, writing of this subject, quotes a popular Italian saying, "A man on horse is an open grave."

Perhaps the scene brings together this full roster of types for study purposes. But why does the tomb's inscription refer to the Loredano, a noble Venetian family? As yet, it defies identification: no Venetian document between 1316 and 1466 lists Tommaso Loredano as a knight (*miles*).[18] The inscription is interesting nonetheless, suggesting a tie between the Bellini and that Venetian family well before about 1501, when Giovanni Bellini painted Doge Leonardo Loredano.[19]

16 De Mandach, 1922, suggested the *Romuleon* as the source for the dragon scenes and for the severed head brought to a ruler (Plate 88). For the *Romuleon*, see H. Martin, *Les Joyaux de l'Arsenal*, II; for the text, see the edition of G. Guatteri, Bologna: 1867, I–II.

17 Degenhart (1972, 144) identified the column base as that of the church of S. Bartolomeo all'Isola, Rome, which appears in several codices, such as Francesco di Giorgio's *Codice Torinese Saluzziano*, 148; see C. Maltese, ed., *Francesco di Giorgio Martini: Trattati di architettura, ingeneria e arte militare*, II, Milan: 1967.

18 Goloubew, II, text accompanying pl. XXXIX.

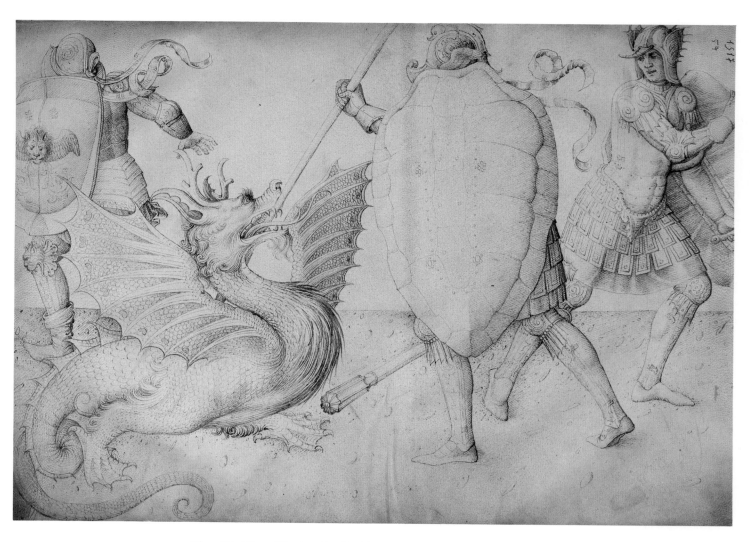

Plate 97. *Three Warriors Battling Dragon* (A). Louvre 54

A cross emblazons the cuirass or roundels of three similar young knights (Plates 109, 110, 111). Many soldiers bore this symbol of salvation; Spenser's Red Cross Knight in *The Faerie Queene* is among the last Christian warriors to be so armed. Bellini's knights are often identified as Saint George, but in the absence of a halo they probably represent the spirit of knighthood, ever consecrated to the Lord's service. Saint George was especially popular in Ferrara, Monsélice, and Venice, which treasured his major relics. It was the Company of Saint George that defeated the Genoese in the Battle of Chioggia, the great Venetian victory of 1380. Some cavaliers wore a crossed cuirass in a military fashion known in Italy as "armatura alla francese," and as "modern armor" in the Paris Book's fifteenth-century Index (Appendix C). Many effigies of knights are so shown, and a *Saint George* (Milan, Museo del Duomo) carved by Giorgio Solari in 1403. It is hard to know whether Bellini's crossed cavaliers are off to fight dragons, to liberate damsels in distress, are crusade-bound, or leaving for a tournament.

Helmut Nickel gives an expert date for the battle dress of the cavalier with a cross on his cuirass (shown twice in the Paris Book; Plates 109, 110) as between 1455 and 1470, favoring the later date, which puts this page near the end of the artist's life. The London Book's youthful cavalier with a short beard and downcast gaze appears twice, on facing pages (Plates 111, 112). On the left, in doublet and hose for wear under armor, he rides a prancing steed while a dwarf or child page fastens his stirrup; a lady with a falcon stands by him. Originally she was drawn farther to the right, and changes were also made in placing the horse's head. On the facing right page he wears armor very like that of the knight in Plate 109, a lance in his right hand.

A youthful knight in battle dress, a circlet on his head, raises a baton and leans forward with mouth open as if in speech (Plate 93); he is accompanied by a foot soldier with a tall staff or lance. Parallel vertical lines behind them suggest a wall or enclosure. Though separate from most of the related pages in the London Book, this unusually beautiful study is

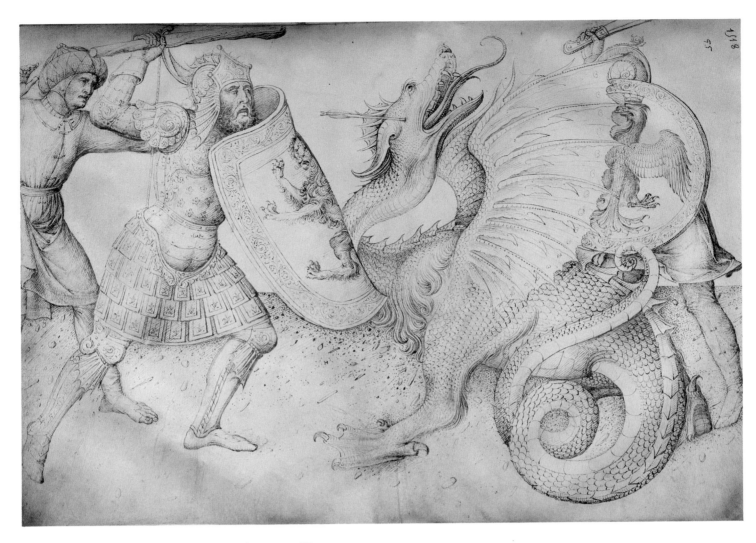

Plate 98. *Three Warriors Battling Dragon* (B). Louvre 55

close in spirit to two depictions of tournament that follow it (Plates 94/95). The first of these (the only page devoted to a single equestrian figure) shows a magnificent sharp-featured rider armed for the tournament (Plate 94), his mount in festive caparison with a plumed headdress (*panache*). Protecting the horse's breast is a curved shield or petrel that terminates in winglike sides to guard the rider's legs, further protected by the great convex bosses very much in the German manner. The hindquarters are shielded by a festive crupper decorated with lozenges that enclose a head covered with a band, possibly an Este device.[20]

Even if a connection with the Ferrarese rulers is correctly identified, this tournament was probably staged in Venice, for Bellini's documented work for the Este court precedes the date of this page. Three Este *condottieri* who served Venice in Bellini's lifetime appeared in great tournaments staged in the Piazza di San Marco (where this group may have been drawn), and two of them, Taddeo d'Este and his son Bertoldo, later died for the Serenissima. The rider (Plate 94) wears a short cape or tabard identifying him as master of the tournament, chief herald, or king at arms, and his lavishly plumed hat is also in the fanciful attire of the joust. On the facing page the four riders are in battle dress (Plate 95), but their horses are not. The tall plumed helmet with a winged orb, held by the furthest rider, resembles those worn in tournaments.

Further on in the London Book is another double page of cavaliers probably headed for the tourney (Plates 115/116). Possibly the leader is the same as before, now wearing the hat of a military officer of high rank and holding a baton; his horse's petrel is decorated with blank scrolls to be filled in with a motto. On the crupper is a great eagle and another is on the knight's helmet, which is carried by a rider to the rear, alongside a lance-bearing rider. Some scholars have seen references to the Este in the numerous eagles in both Books, but the bird's breadth of symbolism precludes any exclusive link with one family.[21]

In an enigmatic double-page composition (Plates 117/118) an individualized knight

19 Appendix E, Doc. 1443.

20 So identified by Goloubew, I, pl. VII, who believes the man to be Lionello d'Este and the banded heads to illustrate QUAE VIDES, NE VIDE. He found the fine horses to be "typically d'Este" in their breeding.

21 Gronau, 1895, 55, identified the rider as Borso d'Este, followed by Ricci, 10, and by Goloubew, I, pl. XLI.

with aquiline profile, armed but bareheaded and astride a homely horse, charges against an unseen opponent beyond the facing left page, the ground littered with broken lances. It is hard to know whether a battle or a tournament is represented. Behind the knight an almost frontal rider raises his right arm as in a sacred vow, his dramatic nobility recalling a figure in Masolino's *Crucifixion* (Rome, San Clemente). Masolino's travels to Hungary must have taken him through Venice several times, offering Bellini the chance to see drawings of his works if not the originals. Other than the extended lance, nothing specifically links the two pages, the brilliant communication of potential as well as actual motion anticipates the art of Leonardo da Vinci, Bellini here using the leadpoint to extraordinarily shimmering, delicate effect. The passage defining the head of the youth above the horse's back shares in the perfection of Umbrian art, remarkably close to the tranquil mastery of Perugino and his student Raphael.

A tournament on a further recto page in the London Book (Plate 120), more conservative in style, was originally an independent vertical composition. The spectators are frontal, the participants in profile, and the setting is derived from the Romanesque arcades of Piazza di San Marco, so often the scene of jousts and tournaments. Petrels protect both horses, and a chamfron on the head of the forward one; its rider carries a shield known as a *targa*, indented to support a lance. Bellini first had the man at lower left holding a lance, but changed his mind when it cut off that corner of the composition, giving him a staff instead and elevating the hand and arm accordingly. Possibly the facing left page (Plate 119) is also inspired by Venetian architecture, its clock tower resembling the one that stood near the Mint from 1410 until Codussi's was built across the piazza in 1496.

One of Jacopo's most powerful double pages contains a horse rearing wildly before a prostrate man on the right and three facing youths who attempt to subdue it, all the action within a North Italian piazza (Plates 121/122). At the far right three men hold ropes tautly connected with the fallen figure.[22] One scholar saw this as an execution scene, but the horse has reins and a belted blanket for riding; conversely, the ropes might be for rescuing the victim.

Many graphic "pentimenti" show Jacopo's difficulties in finally rendering the horse, so close to the steed rearing over a grave in the Paris Book (Plates 105/106); the facing pages share other motifs—the fleeing boy and the general arrangement. The British Book's drawings often postdate in their airy modernity the more precious intricacy of the Paris Book's, but that sequence is untenable here: London's paired pages are clearly the more experimental, preliminary to Paris' suave renderings that are so evidently *faits accomplis*, based on extensive previous practice, on graphic trial and error.

Now widely separated from one another in the Paris Book, two horsemen armed for a joust were clearly drawn in sequence, each with the other in mind (Plates 113, 114). Riding toward the right, one knight wears a knight's hat and is followed by a footsoldier in chain mail and winged helmet, bearing lance and shield. The horse's chamfron ends in a jointed, webbed, winged mane, similar to the webbed, winged fetlocks of Cupid's lionized horse and of the unicorn (Plates 79, 83).

Bareheaded, with a fillet around his hair, the facing rider places his right hand on his breast. The ingeniously articulated chamfron of his steed makes it turn into a dragon, and from the panache rises a winged bowman who may be Cupid, recalling that Venice's first tournaments were the games of Venus. The peytrel too becomes a pair of wings, and a spine of jointed plates runs down the horse's mane and along the back, ending in a long spiky tail. These festive riders may symbolize the elements—the winged elements, air; the dragon's, fire. Two engravings of 1505 by Dürer, the so-called *Small Horse* and *Large Horse*, might share the same symbolism, for he closely studied all three Bellinis' art.

Experts argue about whether these paired horsemen were designed for the theater, as suggested by Newton-Pearce—or for the cavalcade, as described by LeCoq.[23] These genres often blur into one another, and triumphal entries and other pageants partake equally of the equestrian and the theatrical. Horsemen riding at full tilt could not be introduced into rooms designed for speech and dance; Bellini's riders were more probably part of the jousts or carousels that were often staged in large palace courtyards or city squares. Like so many other pages in both Books, these portray the military circuses and *all'antica* spectacles so dear to Venice triumphant.

22 Tentatively identified as Giovanni da Brescia, condemned by Alberto d'Este (r. 1388–98) to be trampled to death by a horse. The man being barefoot—unlike most contemporary riders—might support this explanation, but the horse, contrary to Goloubew's view, is clearly readied for riding. See Goloubew, I, pl. LVIII.

23 S. M. Newton-Pearce, *Renaissance Theater Costume and the Sense of the Historic Past*, London: 1975; LeCoq, 1976. LeCoq (100, n. 38) does not accept the identification of the artist of a manuscript in the Soane Museum, London, as the work of a *festaiuolo* but of an "architecte-romancier"— which is exactly what the *festaiuolo* often had to be. Licht ("A Book of Drawings by Nicoletto da Modena," *Master Drawings*, VIII, 1970, 386, n. 31) has identified the master of the Soane manuscript and another section of it in the Cabinet de Rothschild (Louvre) as the work of Nicoletto da Modena, documented as a *festaiuolo* at the Ferrarese court of Ercole I.

# JOUSTS IN THE PIAZZA

Tourists' bouts with pigeons, waiters, and vendors are the only combats in today's Piazza di San Marco, but for seven centuries this noble space saw Europe's grandest, courtliest entertainments, vast tournaments held in a setting of unrivaled architectural splendor. Long the largest of European squares, the piazza enjoyed the classical authority of hundreds of columns and arches of Istrian marble in its porticoes and loggias, first built in 1176. The Roman Forum had long dwindled into pasturage by then, as Notre-Dame was rising amid Parisian squalor.

A gleaming Romanesque enclosure, the piazza has always conveyed a festive yet mysterious quality of immediate theater—equally dramatic when empty at dawn or when filled at dusk by thousands of spectators, horsemen in shining armor, or a score of rival cocktail orchestras, a source of Pound's *Lume Spenti*, where there are "No ideas but in things," Venice a "forest of marble . . . its light not of the sun."

The Piazza di San Marco was inspired by the Roman public spaces in Verona and in Pola, just across the Adriatic. Marino Sanudo, chronicler of Venice in 1383, noted that her piazza was "bordered by the columns of a theater, a great corridor before the Doge's Chapel." Architectural descriptions by Vitruvius and Alberti presented such places as a stage or *scena frons*, and so the Venetians used the piazza from the start, its handsome arcades setting the stage also for most of Bellini's tournaments.[24]

Tournaments belonged with the Serenissima's celebration of all things military, key to her preparedness and prosperity.[25] The first joust in the Piazza di San Marco was recorded in 1242; the next in 1253, on the election of Doge Zeno; and chronicler Martino da Canal[26] described a third in 1272. Six knights from Friuli ran this event during the last three days before Lent, and on the first day the knights, with a great retinue of horsemen, saluted the doge, who appeared at a window of the palace; meeting a Venetian challenge, they charged with lances set low.

Petrarch watched jousts in the piazza in 1364, proudly seated at the doge's right among the four gilded horses above the porch of San Marco. His are the best descriptions of this chivalric theater that celebrated Luchino del Verme's recent victory in the Battle of Candia.[27] After a solemn high mass of thanks in San Marco, festivity continued in the piazza with a joust between the *condottiere*'s son Giacomo and the king of Cyprus, the victor winning a gem-encrusted crown of heavy gold.

> The first was a race; the second a contest, or joust. In the first the contestants dash down a straight course; in the second they dash against each other. In both the participants are mounted; in the first the riders do not clash but give a warlike note by brandishing spear and shield and carrying fluttering silk banners. The second is a sort of duel in armor. In the first reigns the utmost of elegance, with a minimum of peril. The second is a mock conflict; the French call it, not very properly, "jeu de lance"; this would better fit the first game, for in that they play, and in the second they fight . . .
>
> Both performances were held in that great square, which I doubt has any match in this world, in front of the marble and gold façade of the temple. No outsider took part in the first contest. Twenty-four noble youths, handsome and splendidly clad, were chosen for this part of the ceremony. And Tommaso Bombasi was summoned from Ferrara. Anyway, under his direction the performance was staged so skillfully that you would have said the riders were flying angels. It was a marvelous sight to see all these gallant youths, dressed in purple and gold, checking and spurring their fleet-footed steeds adorned with glittering trappings so that they seemed hardly to touch the ground. They followed their captain's orders so exactly that at the moment one reached the goal another sprang from the mark, and another made ready for his race. With this alternation of uniformed riders there was a constant race. One man's finish was another man's starting point; when one stopped another began; so that, though many coursed in full view, you would have said at the end that just one man had ridden the whole way. Now you would see the spear-points flash through the air, now the purple banners fluttering in the breeze.[28]

24 Though it dates from the early 16th century, a painting by F. Ferramola (London, Victoria and Albert Museum) gives a good idea of the festive, courtly setting for the tournament, framed by triumphal renaissance architecture. The joust is in the Piazza della Loggia in Brescia, long a part of the Veneto and stamped by Venetian taste and practice. Reproduced as the frontispiece in G. Treccani degli Alfieri, *Storia di Brescia*, 2, 1961.

25 Molmenti, *Venice*, trans. A. Wiel, I, Bergamo: 1905, 205.

26 Part II, paragraph CCV *et seq.*

27 Francesco Petrarca, *Prose: Senilium Rerum Libri*, ed. G. Martelotti, Milan and Naples: n.d., 4 (lv, 3), 1077–89. The letter is to his friend Piero da Bologna, rector of the University of Bologna. See M. Bishop, trans., *Letters (Petrarch)*, 1966, 234–39.

28 M. Bishop, trans., *Letters (Petrarch)*, 1966.

Plate 99. *Two Men in Flight, Having Abandoned Arms* (continuation of *Three Soldiers Attacking Dragon*, Plate 100). British Museum 85v

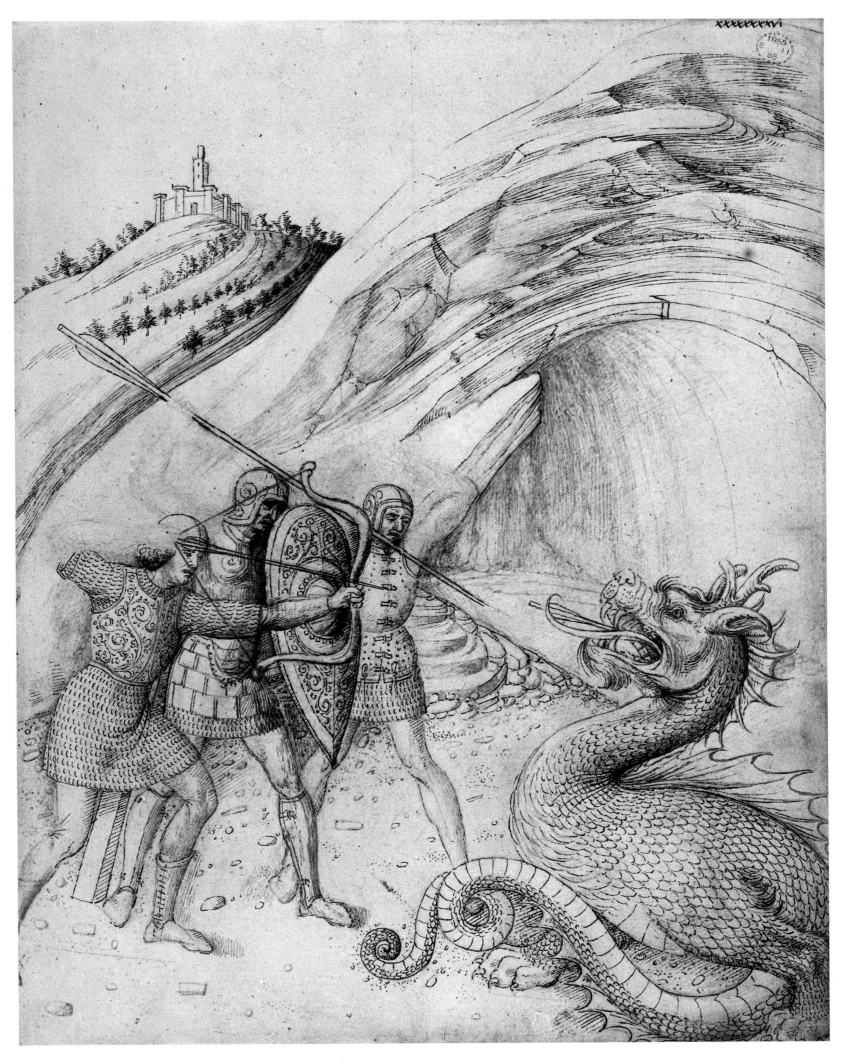

Plate 100. *Three Soldiers Attacking Dragon.* British Museum 86

Plate 101. *Footsoldier Fighting Mounted Horseman*. Louvre 75

Plate 102. *Two Knights and Footsoldier.* Louvre 76v

Plate 103. *Knight Fleeing Dragon* (continuation of *Three Knights on Horseback Combatting Dragon*, Plate 104). British Museum 14v

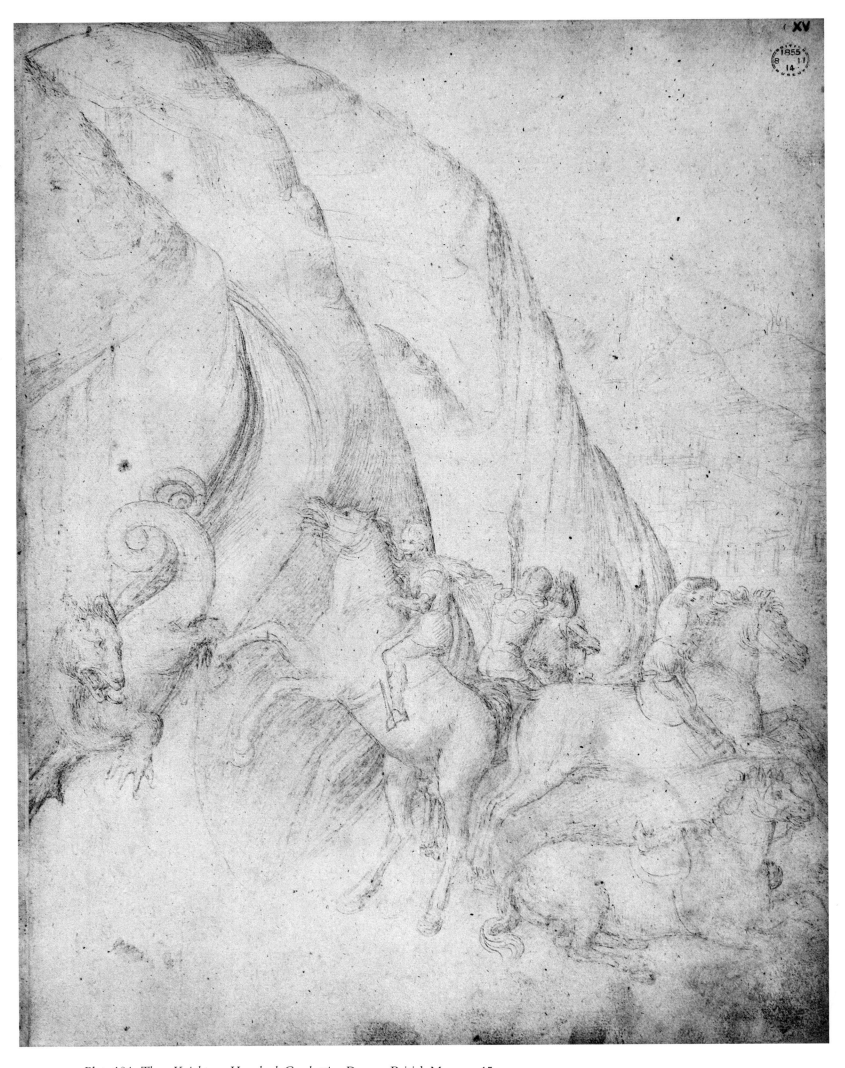

Plate 104. *Three Knights on Horseback Combatting Dragon.* British Museum 15

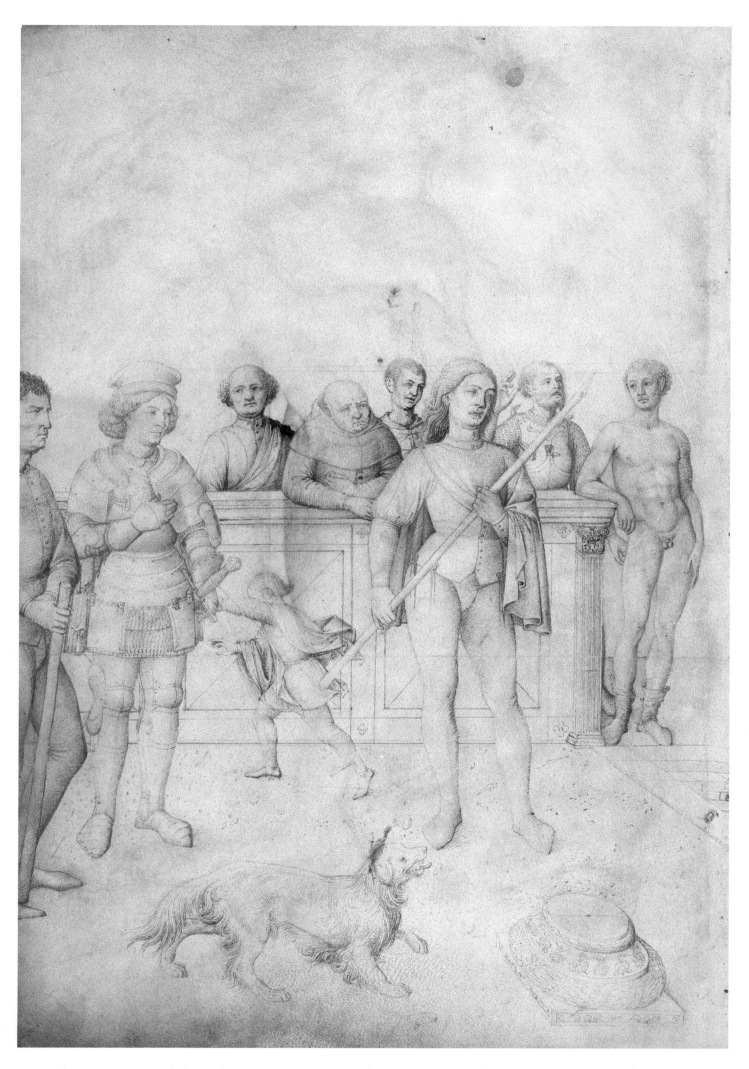

Plate 105. *Various Onlookers and Attendants* (continuation of *Equestrian Knight and Messenger at Open Grave*, Plate 106). Louvre 43v

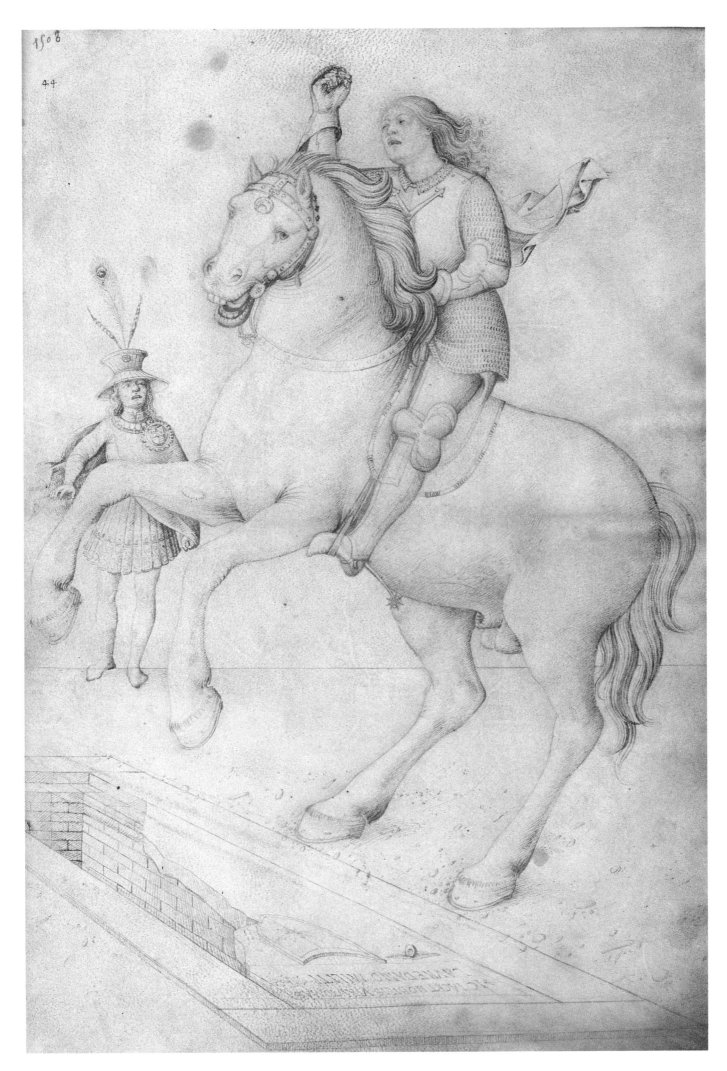

Plate 106. *Equestrian Knight and Messenger at Open Grave*. Louvre 44

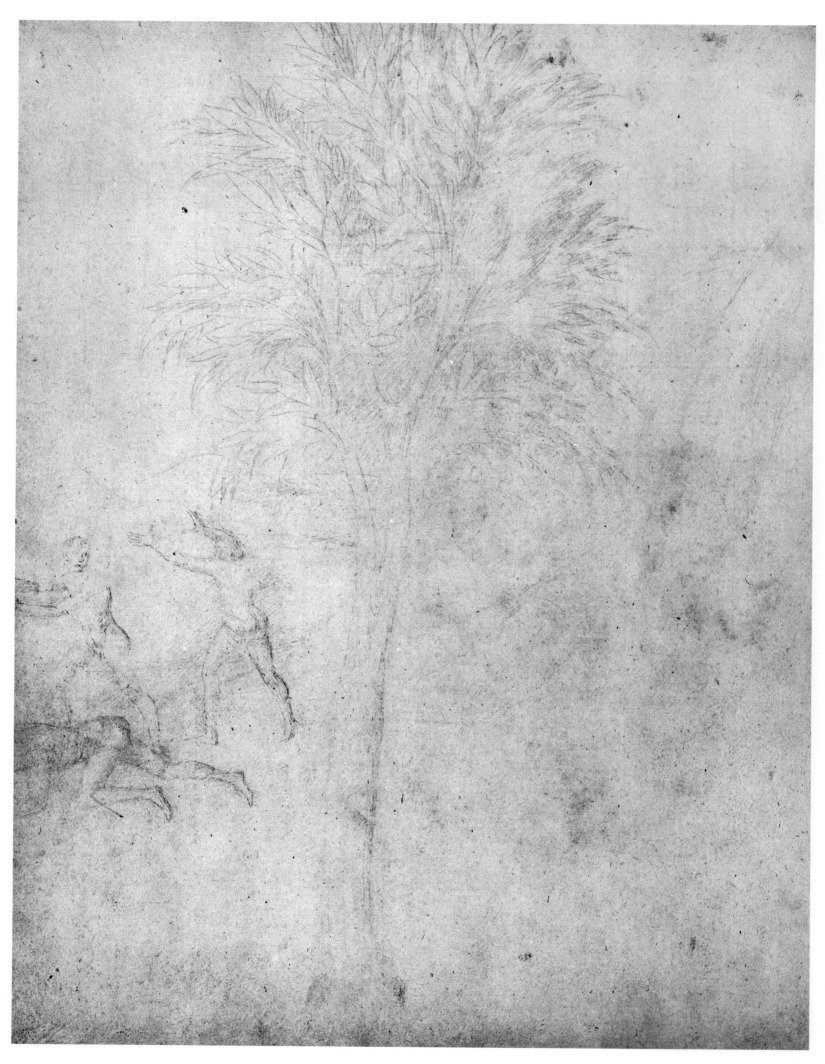

Plate 107. *Fleeing Figures*. British Museum 52v

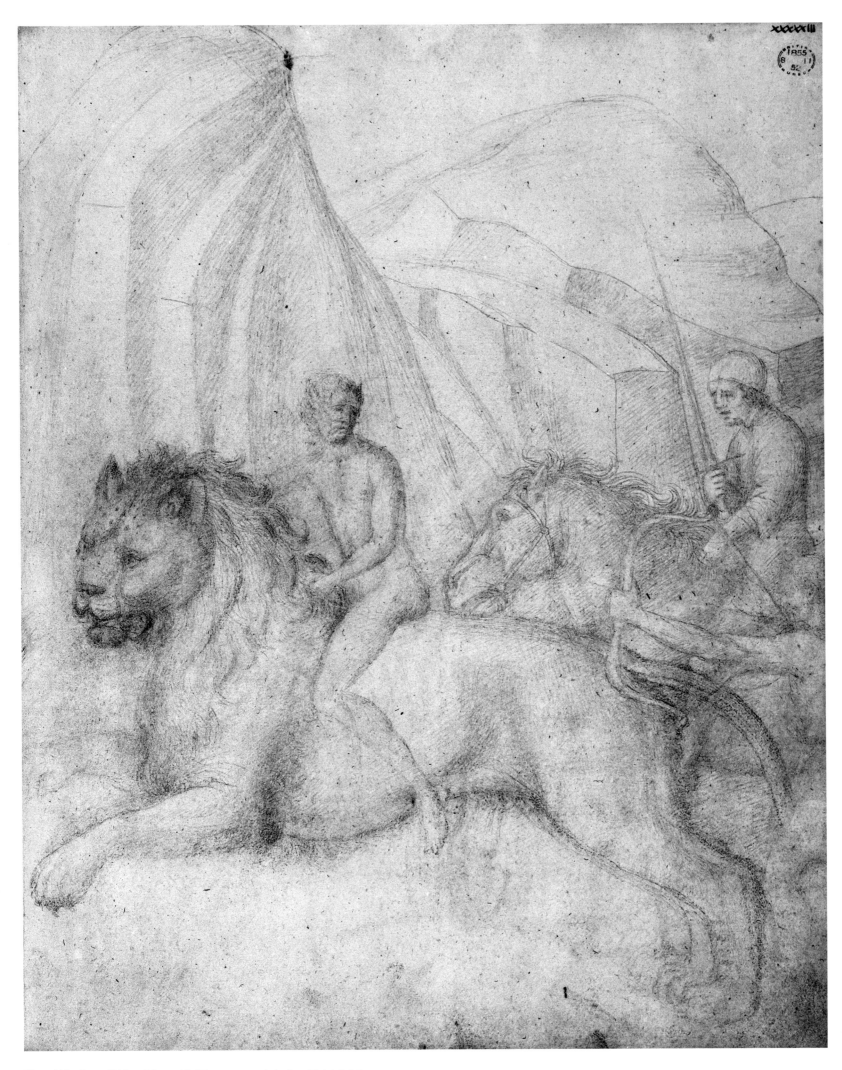

Plate 108. *Satyr Riding Lion with Horseman and Archer.* British Museum 53

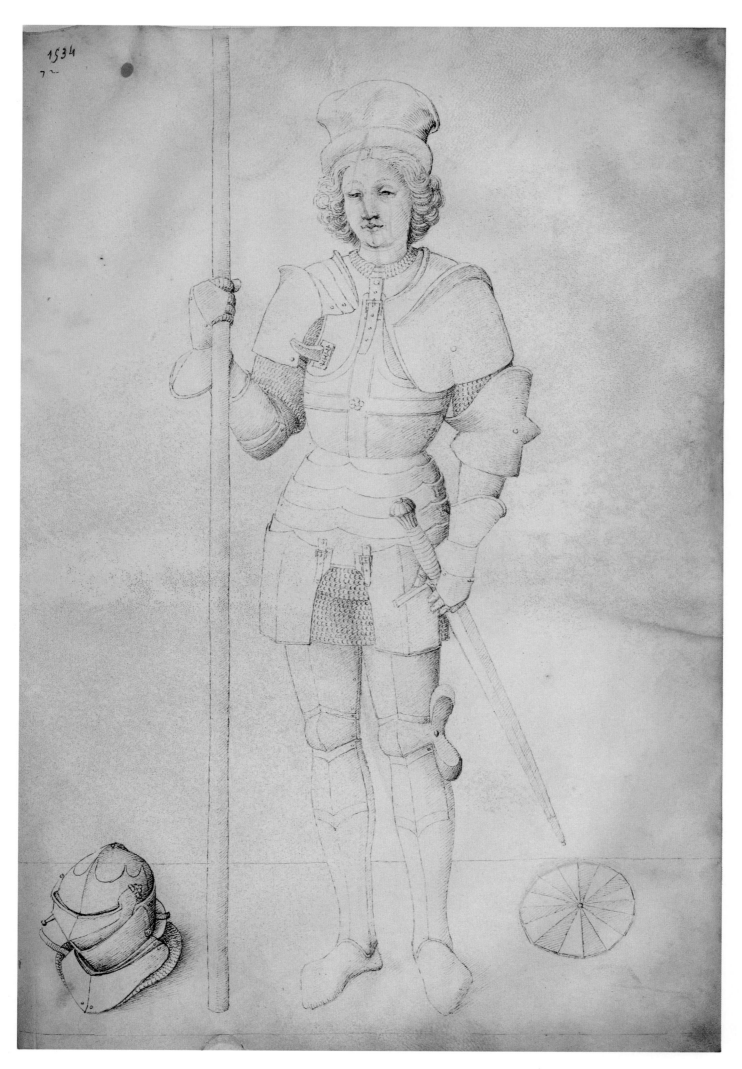

Plate 109. *Knight in Renaissance Armor.* Louvre 72

234

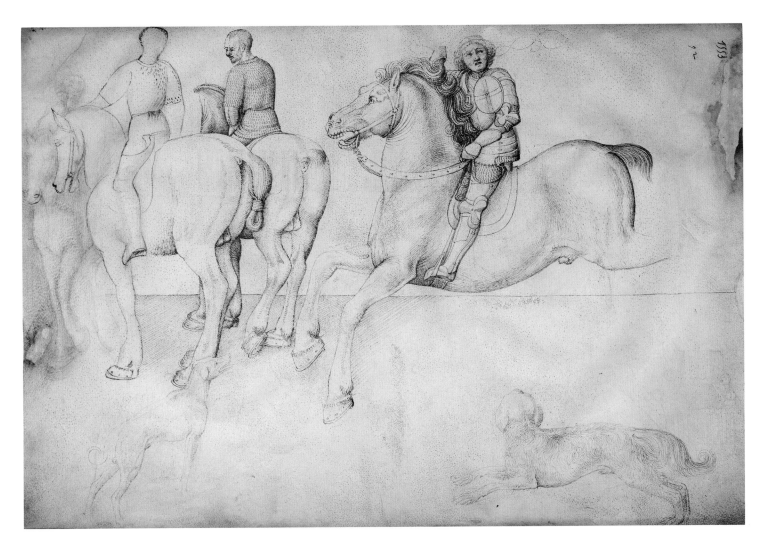

Plate 110. *Four Horsemen and Two Dogs.* Louvre 92

Jousts continued to commemorate the election of doges and the *condottieri*'s promotions and victories. Seventy thousand spectators witnessed the games for the election of Doge Mocenigo in 1413, staged by the goldsmiths and jewelers, with 460 cavaliers taking part and the marquesses of Mantua and Ferrara, both probably *condottieri*, among the champions.[29] The marriage of Doge Foscari's son was celebrated in 1441 with a splendid tournament in the piazza, which may well have employed Bellini's skills as *festaiuolo*. Gattamelata[30] was there, and Francesco Sforza led the tournament, the *condottiere* long in Venetian service against Milan but soon to change sides.

Under Foscari these military games took on a revived sense of official mission. That feisty doge vowed to do away with the dances and bullfights long loved in Venice, and he trimmed the regattas and banned the *momarie*, those popular comedies generally staged before San Geminiano, Bellini's parish church. By scrapping most of these in favor of tournaments and more tournaments, he hoped to indicate the way to war and perpetuate an aggressive spirit of combat.[31]

Some of Jacopo's most magnificent jousts may have been inspired by the double celebration held in 1458, when Colleoni came to Venice to receive the baton of command from Doge Malipiero, Foscari's successor. The combats lasted for three days, and a castle set up in the Piazza di San Marco was fought over by two companies of seventy men each. The *condottiere*, newly appointed "emperor and captain of all our people," received powers and honors that sounded even more splendid than the rank of doge itself.[32]

A carousel today is a merry-go-round of stiff wooden horses, but then it was the field for tournaments, with horse-drawn chariots circulating as part of the pageantry. These, along with the participants' parade armor and other festive accoutrements, were devised and often decorated by artists who painted the fancy armor and designed caparisons that could make of any horse a lion or a dragon by adding wings, pelts, or ingeniously articulated tails and manes (Plates 113, 114).[33] Knights protected themselves with lordly lions rampant on shields, or their heads on armored knee caps (Plates 97, 98). A great gilded lion's-head helmet from Venice (New York, Metropolitan Museum of Art), made in Bellini's lifetime, proves that such battle dress was no graphic fantasy.

29 Molmenti, *Venice* (1905), 205.

30 Trevisan, fol. CCXXI.

31 A. da Mosto, *I Dogi di Venezia nelle vite pubblica e privata*, Milan: 1966, 163.

32 Belotti, *Bartolommeo Colleoni*, Bergamo: 1923, 209–10, 221–30.

33 The nearby court of Ferrara, which employed Jacopo and provided Venice with three *condottieri*, was much drawn to the tournament, often with lavish pageant wagons and triumphal chariots; horses were disguised as lions, and the noble passengers dressed in oriental costume, recalling many of the motifs on Jacopo's pages. See the descriptions given by Zambi, *Diario Ferrarese*, and in the *Diario Anonimo Ferrarese*, L. A. Muratori, *Rerum Italicarum Scriptores*, XX, XXIV, Bologna: 1900.

In *Les Fêtes de la Renaissance* (ed. Jacquot, Paris: 1956), see I. Mamczarz, "Une Fête équestre à Ferrare: Il Tempio d'Amore (1565)," 349–72; references to tournaments under Alfonso I listed in n. 1, 349. The joust of the "lions" was an important 15th-century form, in this instance played out before Ercole I in front of the cathedral of Ferrara. See also Povoledo, 1964.

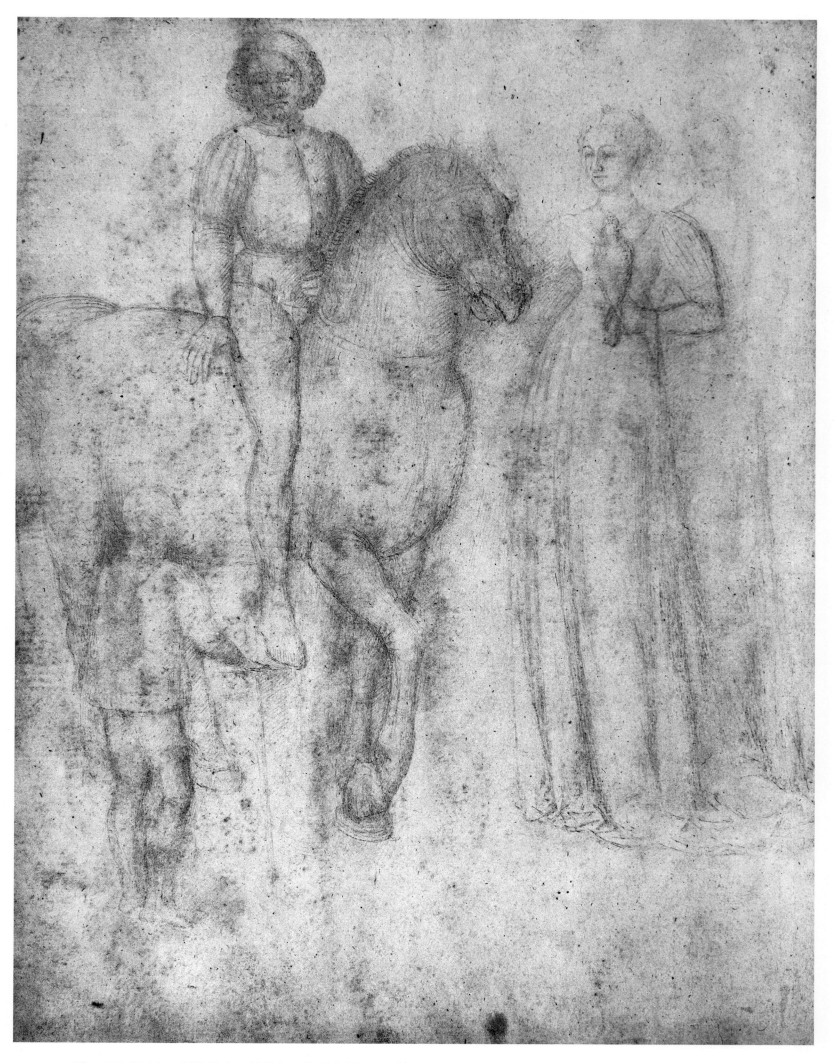

Plate 111. *Knight and His Lady with Falcon.* British Museum 19v

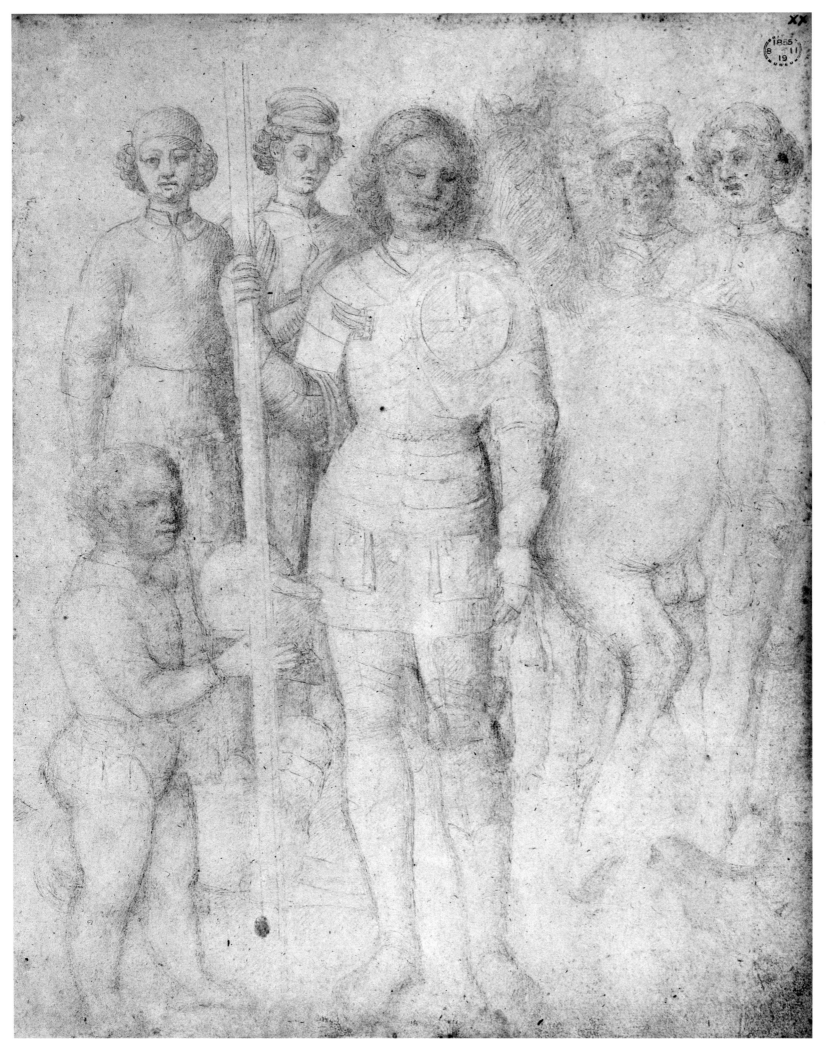

Plate 112. *Knight with Dwarf, Standing by Horse*. British Museum 20

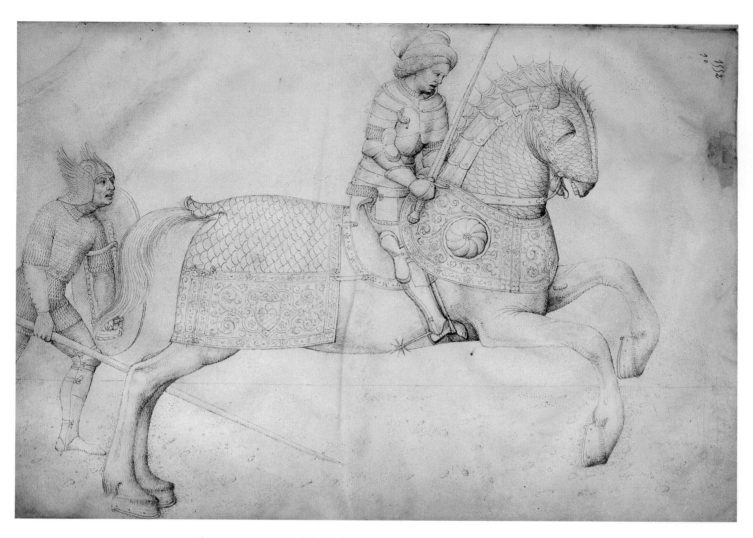

Plate 113. *Knight and Footsoldier*. Louvre 90

Knightly saints abound in Bellini's Books with saintly knights in scenes as indistinguishable from one another as those combining classical, Christian, and secular references. Such associations may have been intentional, allowing these studies to find many uses. At least twenty pages, many in the London Book, are directly oriented toward the chivalric pageantry that accompanied the tournament and the joust, so enthralling to courts in the Quattrocento. The tournament was popular as the theater of war, an overdressed rehearsal for the real thing, with its teasing, exciting tensions. The joust, part parade, part circus, and part military review, was a testing ground for the two most necessary weapons of war, man and horse.

Like the *palio*, the horse race staged in the theater-like, fan-shaped piazza before Siena's Palazzo Pubblico, these tournaments went back to the sacred athletic games of Greece and Rome, symbols of communal fortitude. With their performance the Piazza di San Marco became both a Campus Marcus and a Campus Martius, equally devoted to the saint and the war god.

For painters, the arts of war were often as profitable as those of peace. Artists planned fortifications, made maps, and drafted defenses, working as military engineers and architects. Armies battled by bedazzlement that spurred them on and awed their enemies by reverse camouflage, by the visual splendor of their equipage. Painters, as masters of aggressive arts, embellished banners, shields, tents, and armor.

War games blend with the game of war, ancient or recent, into a diverting narrative on

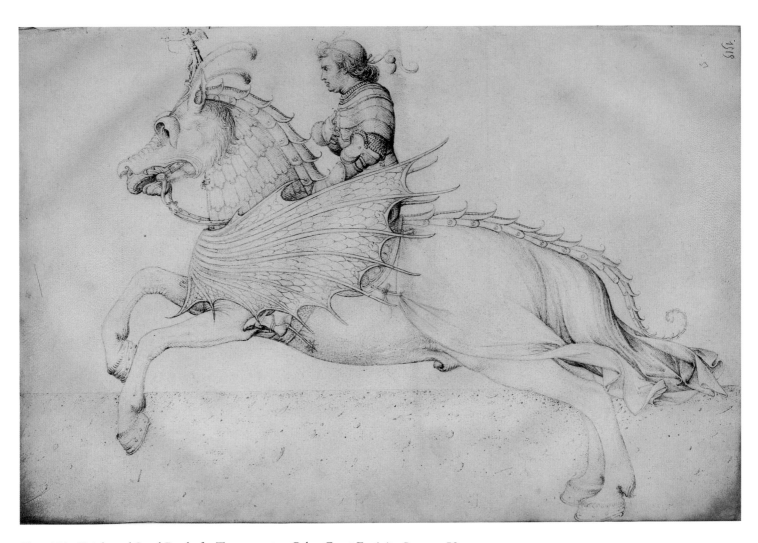

Plate 114. *Knight and Steed Ready for Tournament or Other Court Festivity.* Louvre 52

Bellini's pages, where conflict is often ritualized or socialized. Centurions at the Crucifixion ride horses armored for the joust (Plate 208); steeds follow Susanna and the Elders before Daniel, the young judge who represents the state's military powers (Plates 155/156).

While working on an altarpiece for Padua about 1430, if not earlier, Jacopo came to know a Venetian military and hydraulic engineer and doctor, Giovanni della Fontana, who had already worked with the *condottiere* Carmagnola to free Brescia from the Lombard siege on the shore of Lake Garda. Twenty-five Venetian barques and six galleys sailed up the Adige River to Roveretto; from there, 2,000 oxen pulled them on rollers along a canal to a little lake; once across, they were pulled down the mountainside to Lake Garda and sailed against the Visconti forces. A naval and military campaign of this sort, lavishly engineered through hydraulics, bridge building, and other sciences, was within the ken of Jacopo's friend Fontana. Possibly Jacopo too was involved in such campaigns as cartographer and fortification designer, for renaissance artists commonly included hydraulics and military engineering among their fields of competence.

Bellini's conventionalized, theatrical presentation of war probably came from his work as designer for mystery plays as well as pageants. On the walls of Venice were frescoed countless decorations of ancient battles, their subjects close to the Books' many pages of past victories nostalgically re-created. Varied and adaptable, his chivalric exercises were ready for use in scenes of the distant past or present, glorifying a *condottiere*, classical hero, or Christian militant—or, as was so often the case, all three at the same time.

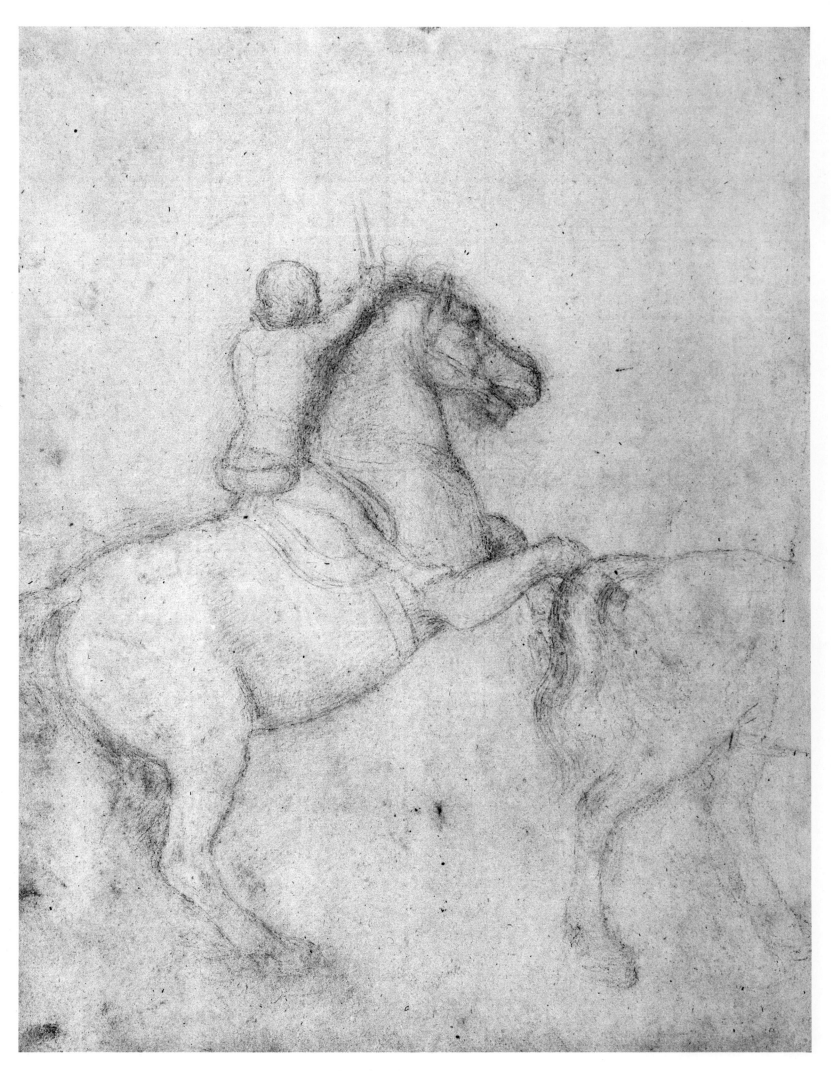

Plate 115. *Rider on Rearing Horse* (continuation of *Knight and Attendants Ready for Tournament*, Plate 116). British Museum 53v

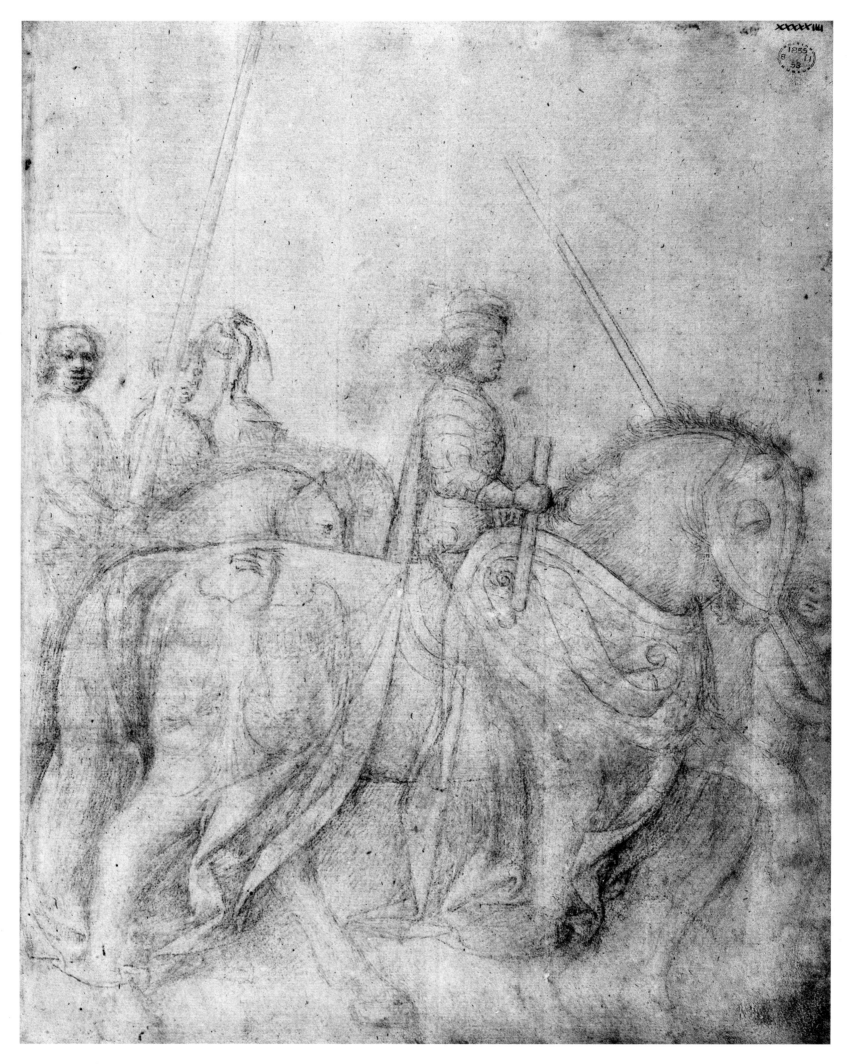

Plate 116. *Knight and Attendants Ready for Tournament.* British Museum 54

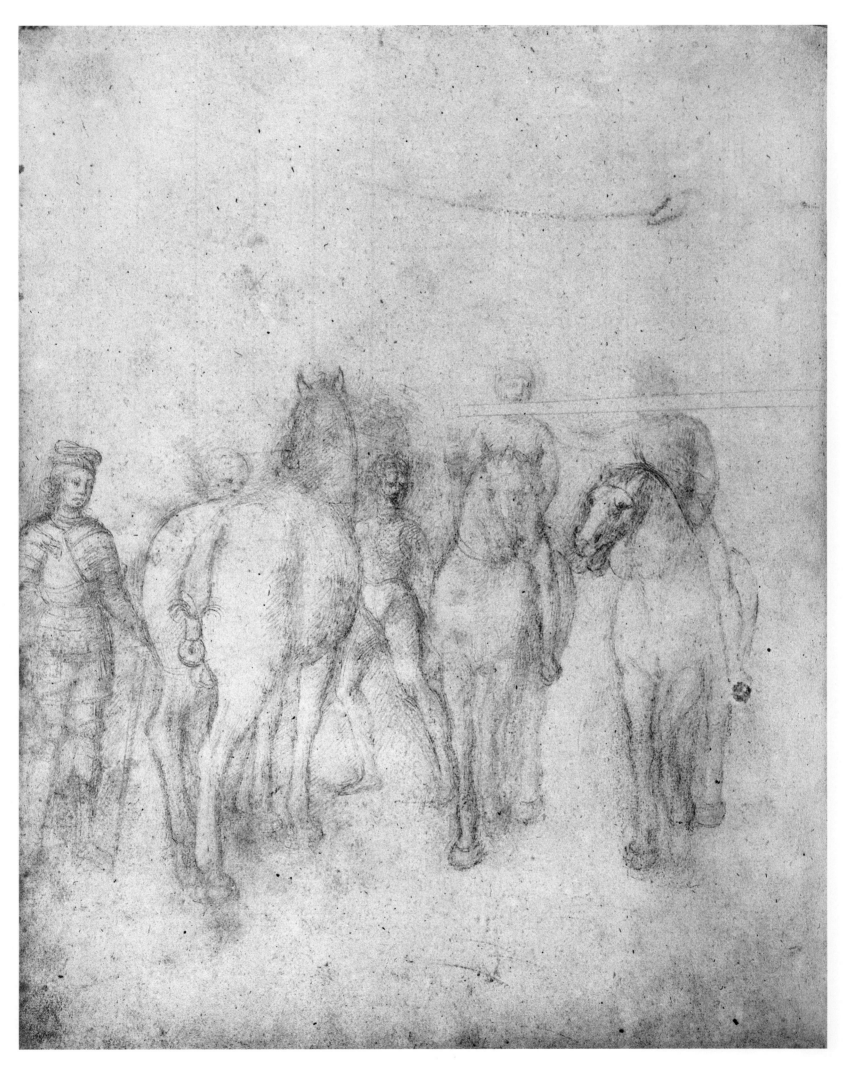

Plate 117. *Knights Preparing for Combat*. British Museum 35v

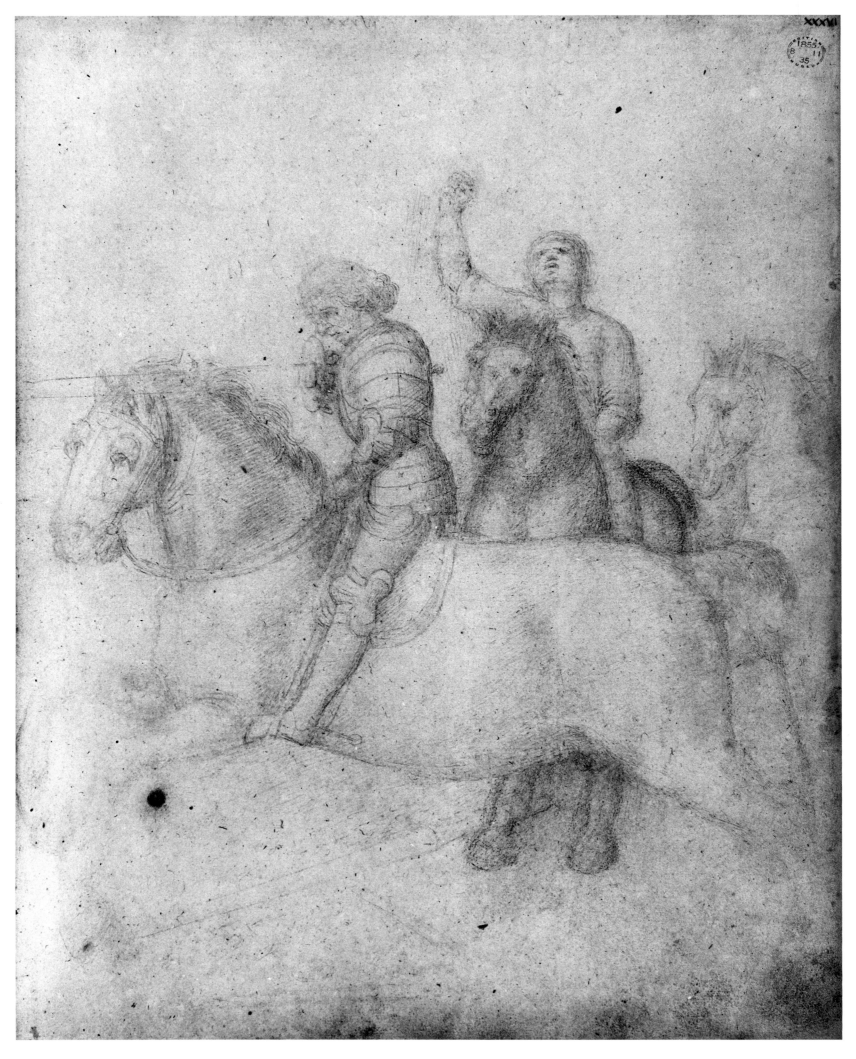

Plate 118. *Charging Knight with Lance*. British Museum 36

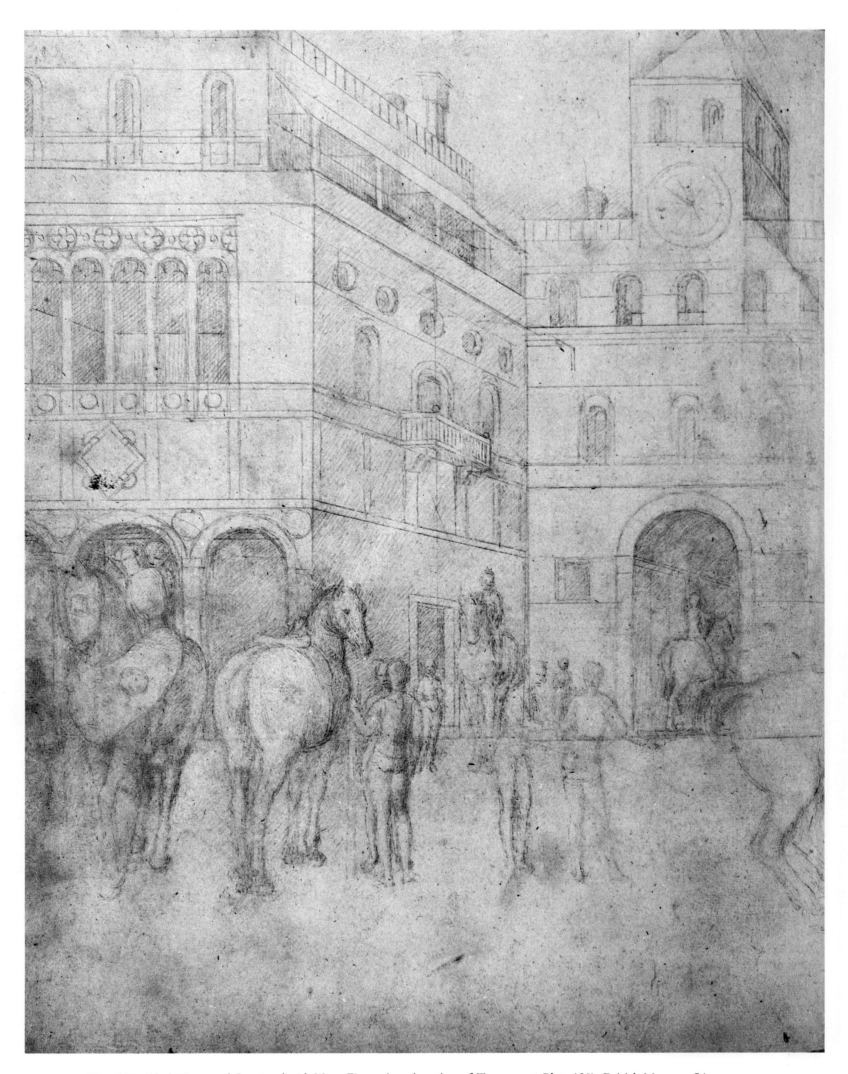

Plate 119. *Clock Tower and Courtyard with Many Figures* (continuation of *Tournament*, Plate 120). British Museum 54v

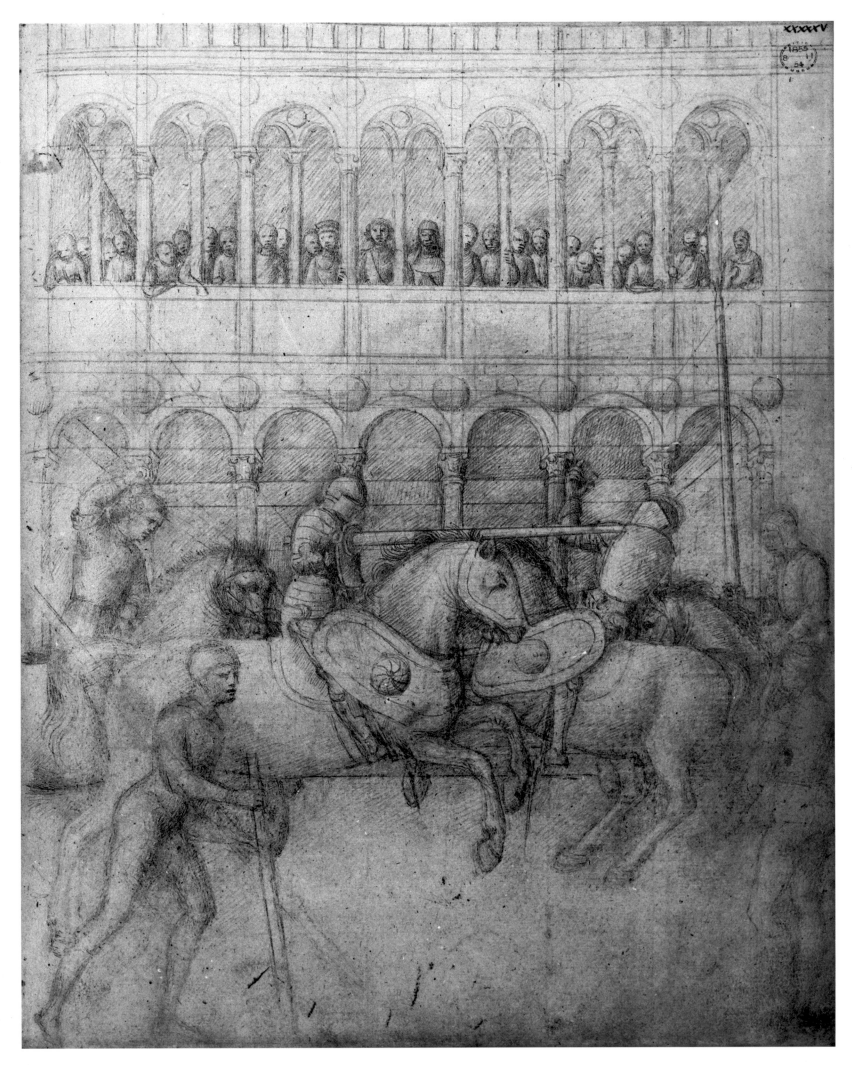

Plate 120. *Tournament*. British Museum 55

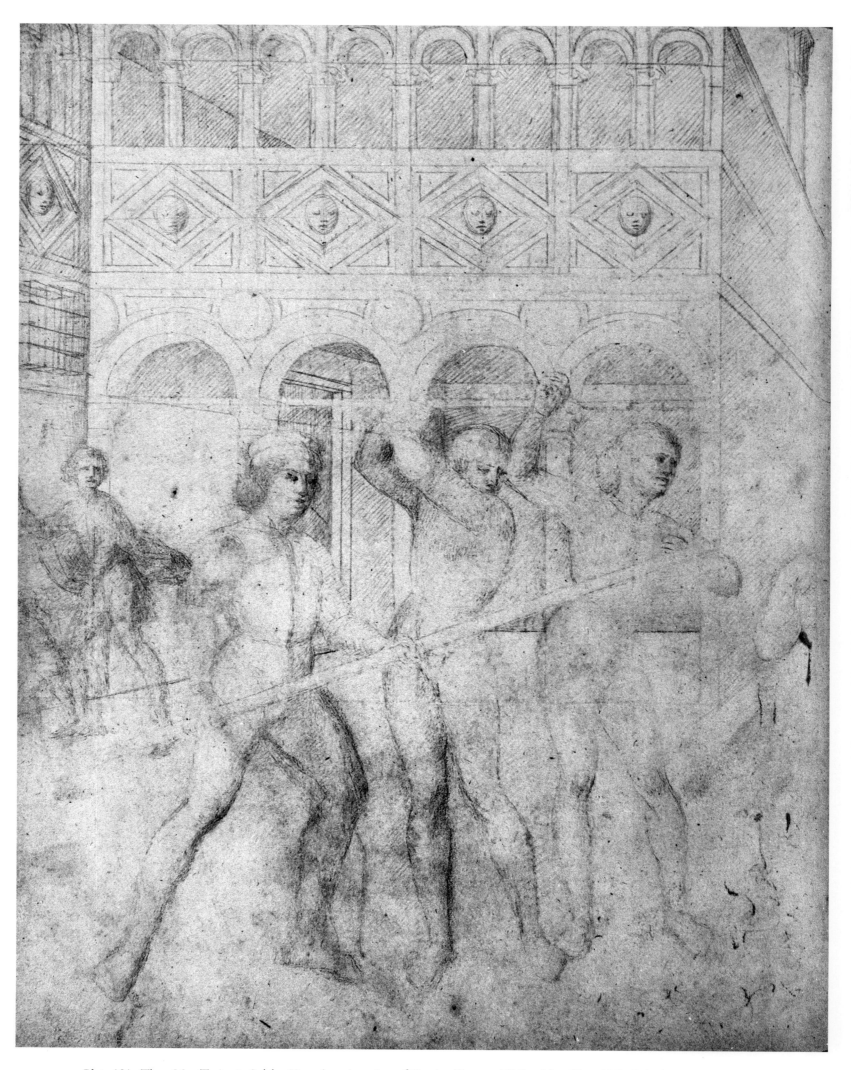

Plate 121. *Three Men Trying to Subdue Horse* (continuation of *Rearing Horse and Fallen Man*, Plate 122). British Museum 50v

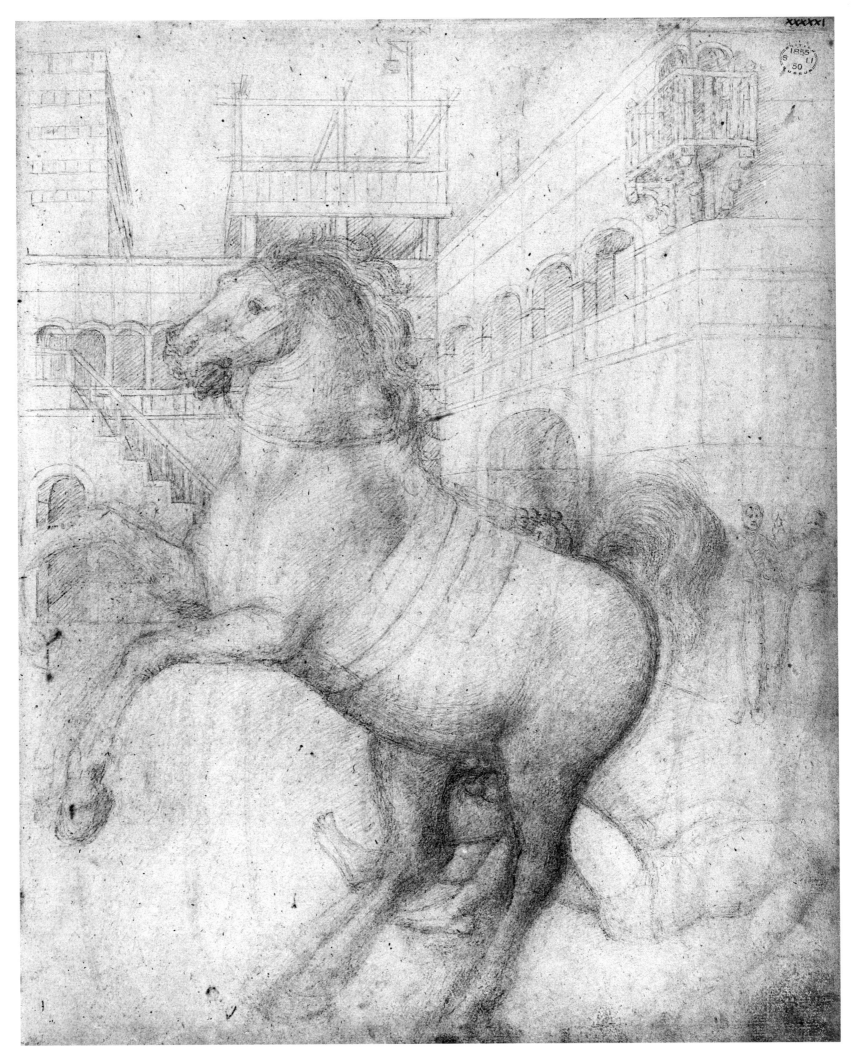

Plate 122. *Rearing Horse and Fallen Man*. British Museum 51

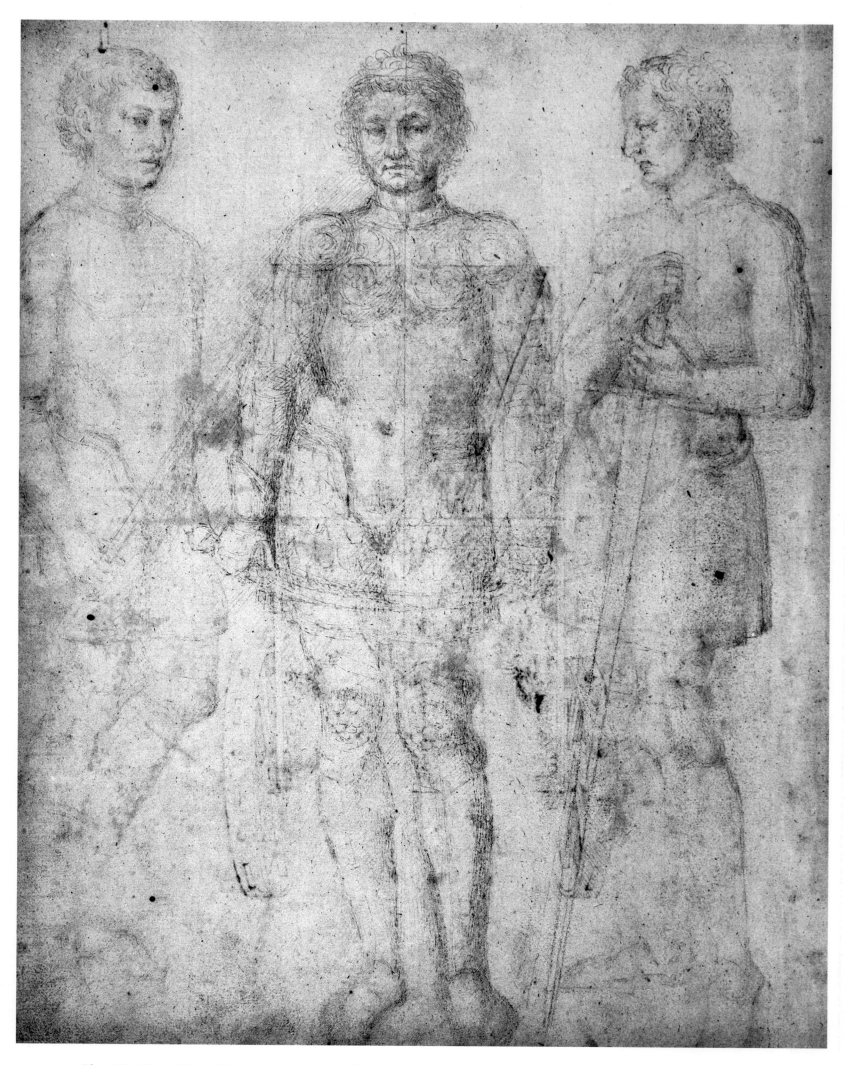

Plate 123. *Three Military Figures*. British Museum 95v

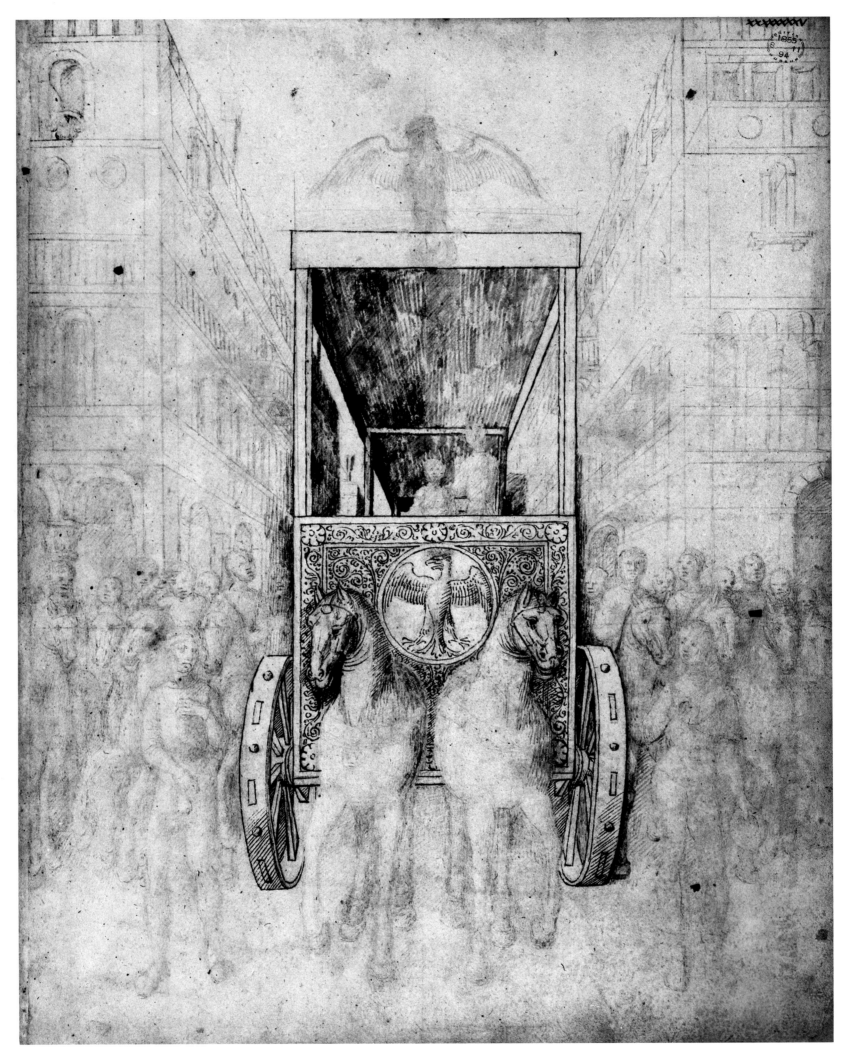

Plate 124. *Triumphal Wagon in Urban Setting*. British Museum 95

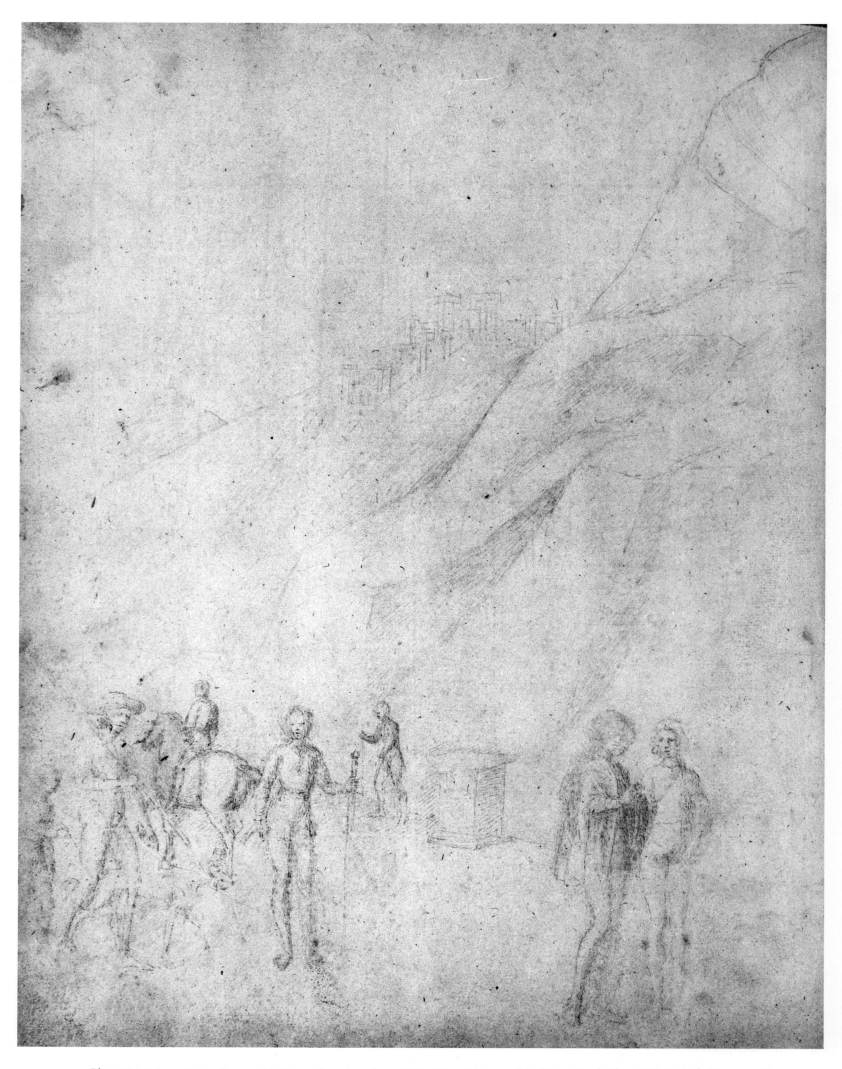

Plate 125. *Mountain Landscape with Figures* (continuation of *The Three Living and the Three Dead*, Plate 126). British Museum 49v

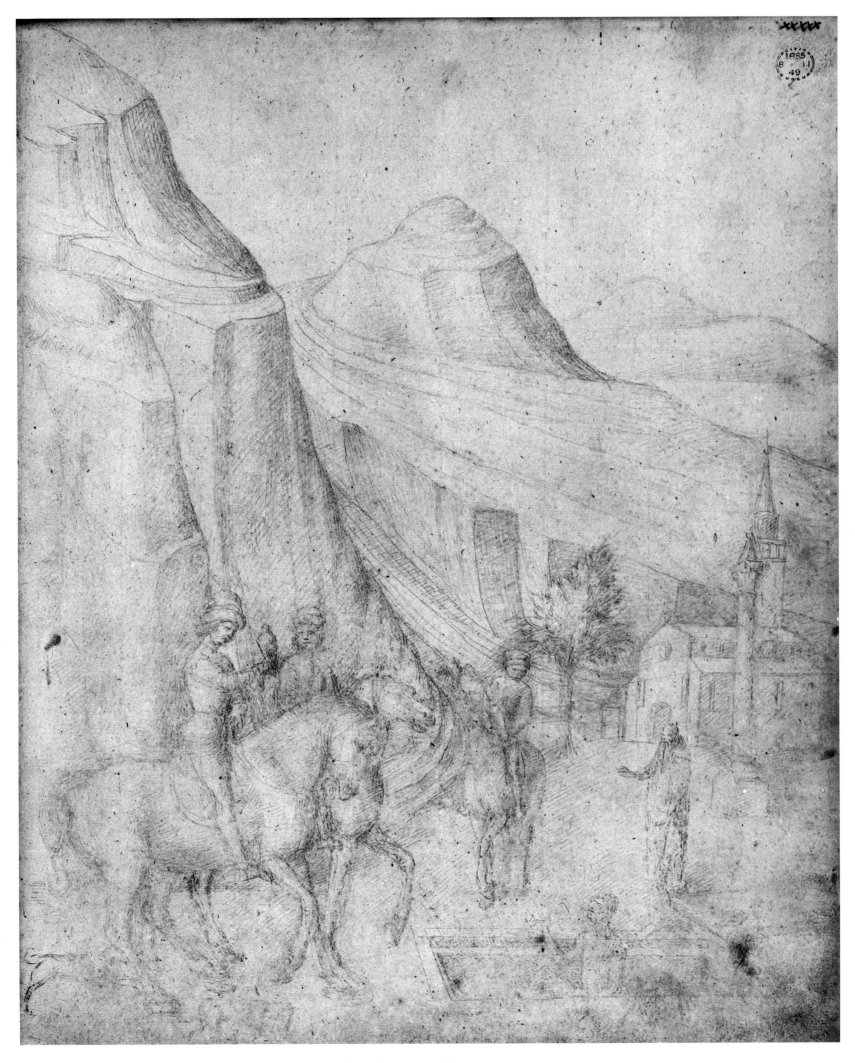

Plate 126. *The Three Living and the Three Dead*. British Museum 50

34 N. Gramaccini, "La Déploration de Niccolò dell'Arca Religion et politique au temps de Giovanni II Bentivoglio,' *Revue de l'Art*, 1983, 21–34 29. The young rider at the left is identified as the hospital's benefactor.

35 See also Eisler, 1985. Traces of this composition may perhaps be reflected in a 16th-century Flemish print by Allaert Claessens, based on a Florentine drawing close to Antonio Pollaiuolo (London, Wallace Collection). The print has long been known as the *Death of Gianantonio Gattamelata*. See E. Tietze-Conrat, "Mantegna or Pollaiuolo?" *Burlington Magazine*, 67 (1935), 217, and her *Mantegna*, 1955, 264.
Lightbown (1986, 78, and cat. no. 67, 458 ff.) accepts the subject of the Wallace Collection drawing as the *Death of Gianantonio Gattamelata* (d. 1456) and believes that Mantegna painted frescoes of this and related subjects c. 1457.

36 Paoletti, 1893, II, 143, 145. R. Munman, "The Monument to Vittorio Capello of Antonio Rizzo," *Burlington Magazine*, 113, 1971, 138–44, supports Paoletti's view, but more recent scholarship has assigned it to other masters. For a survey of these attributions, see A. M. Schulz, 1978, 46–47, nn. 92–98; she ascribes the group to Niccolò di Giovanni Fiorentino (see figs. 51–61).

Venetians knew well the thirteenth-century French poem *Le Dit des trois morts et des trois vifs*, long popular in Italy and elaborately painted in a vast Pisan fresco (Camposanto). In its verses three young knights enjoying the chase come upon three open tombs containing corpses in different stages of decay. Horrified, the horsemen draw back for a speedy getaway, when an old hermit approaches to tell them that the fearful bodies are their own.

This Gothic tale cuts to the bone of the *memento mori*, to self-knowledge through reflection on death, that classical definition of wisdom. Words like the hermit's are given in Masaccio's *Trinity* fresco (Florence, Santa Maria Novella), the inscription above Adam's skeleton reading, "I was what you are. What I am, you will be." The silent lesson of the *vanitas*, this message is personified by the professor's corpse lying above a tomb relief showing him in the midst of life (Plate 134).

Like earlier renderings of the Three Living encountering the Three Dead, both of Bellini's give a panoramic view in a tapestry-like format. The Paris composition (Plate 135), as usual, is the more elaborate and highly finished of the two, probably re-inked later; the hounds have led the three falconers, like figures in a Pisanello medal, to this strange quarry—three crowned corpses. London's composition originally filled only the right page (Plates 125/126). The altar-like monument near the middle of the left sheet shows that Bellini has now absorbed those antique references he focused upon so sharply in the Paris Book (Plates 84, 86).

Bellini drew three enigmatic scenes of military mourning (Plates 127, 129, 130), set in the theater-like confines of the great barrel vault (or *sottoportico*) that he used for his *Death of the Virgin* (Plates 229, 230). These scenes may refer to hospitals established in the later fifteenth century.[34] Most highly finished is the sorrowful grouping in the Paris Book possibly set in eastern territory, to judge from the Levantine garb of the turbaned mourner at the far right (Plate 130). The large central section was pasted over a sheet of the earlier pattern book bound into his Paris volume. The London Book contains a similar scene with a single corpse (Plate128). In the third scene some twenty young male mourners, several of them naked, stand around a table with a young man laid out on it, preparatory to burial (Plate 129). Bellini is probably following Alberti's suggestion that figures should be sketched first in the nude, then "dressed" in the finished project. As the rider in the background wears a military hat often seen in fourteenth- and fifteenth-century Italy, presumably he would have worn armor in the final version, the other figures doubtless in contemporary garb.

There may have been a scene of nude military lamentation in Padua, however; frescoed in the Gattamelata residence was a "*condottiere Pietà*" ascribed to Bellini's son-in-law Mantegna, now lost, that showed Gianantonio Gattamelata mourned after falling in battle in 1455. Certainly Jacopo knew this painting, for he completed the altarpiece in the family's funerary chapel about 1460 (Figs. 47–51).[35] Perhaps the London drawing was made in competition for the fresco commission; it foreshadows the strong Paduan preference for *all'antica* funerary images, so popular in the sculpture of Riccio early in the next century. The dramatic turn of the horse's head suggests recent Tuscan influences from Pollaiuolo and his associate Verrocchio, their works later well known in the Veneto.

Among Bellini's projects are tombs for patriarchs and professors, in drawn form. When Jacopo drew large-scale military monuments he usually showed a man in his prime (Plates 87, 131), but he had funerary designs suited to almost any budget, from the modest sarcophagus for a knight (Plate 133), to a more elaborate wall tomb (Plate 137), to massive, free-standing ensembles (Plate 132).

Force, such a major element of Jacopo's images, meets with death in one of his most moving pages, a monument to a young soldier and hero drawn on a parchment sheet removed from the Paris Book and cut down (Plate 136). An eloquent footnote to the accuracy of Doge Mocenigo's prophesies (see page 20), the tomb is probably that of the young *condottiere* Bertoldo d'Este who fell in the Battle of Morea in 1463. The Republic's captains general are shown in votive poses in Bellini's Books. A *Crucifixion* (Plate 210) in London presents one of them kneeling in witness, possibly a portrait of Vettor Capello, whose funerary monument in Sant'Elena Jacopo may have helped to design in that special fusion of chivalry and piety so characteristic of his art and time.[36]

Two full-page frontal studies of equestrian monuments for a military leader, both in the British Book, document Bellini's role as a designer of victorious statuary (Plates 131,

132). The rider may be the same as the plumed figure seen from the side in Plate 94. The Scaligeri and the Visconti had raised such equestrian funerary works in stone in Verona and Lombardy in the fourteenth and mid-fifteenth centuries, and Venice provided a wooden horse and rider for her *condottiere* Paolo Savelli (Frari), a tribute to his death in the siege of Padua in 1405. Savelli's funerary obsequies had been a state occasion that, as always, filled propagandistic purposes far beyond the commemorating of one man's death in the Serenissima's service. For Gattamelata, Venice allocated 250 ducats for his funeral in Padua, the oration given by the humanist Lauro Querini. When Gattamelata's *condottiere* son Gianantonio fell in a later battle, Marzio da Narni, a humanist and friend of Andrea Mantegna's, gave the eulogy.

Supported on a five-stepped base (Plate 132), Jacopo's major funerary project places two genii on the top step blowing trumpets of eternal fame. (The great antique vase in front of the steps may be a graphic afterthought.) A drawing of three standing warriors (Plate 123) is close in theme to the figures in the lower register of this tomb, the central one almost identical in the two pages. Since the front of the sarcophagus bears an eagle, and eagles are also sketched at either side of the base in the simpler project (Plate 131), this popular emblem used by the Este may indicate their patronage. Eagles are seen again on the rich caparison of a horse whose rider is a prominent military figure, probably Borso d'Este (Plate 116), and on the triumphal chariot of a victor in very small scale (Plate 124). Possibly the four men honored in these images represent the same military leader.

Bellini may have made some of his equestrian groups for a competition in the early 1440s for a monument in Ferrara to Niccolò III. Two Florentine sculptors won;[37] their statue, perhaps the first large bronze equestrian statue cast since antiquity, was placed on a small arch of Albertian design. Jacopo's project includes a large sarcophagus, and seems unsuitable for that contest.[38] Of all the military leaders in Venetian employ, Gattamelata is the likeliest candidate for the monument in this drawing. The unusually prominent sarcophagus, common to Donatello's *Gattamelata* and Jacopo's design, may have been specified for all contestants in the competition for Gattamelata's or some other funerary monument.[39]

Jacopo's most monumental fighting knight, *Saint George and the Dragon* (Plate 265), may be a design for another Ferrarese sculptural competition. The Este court is known to have ordered the heroic saint's statue at mid-century, and the dragon's yawning maw supports the forelegs of the rearing steed in the manner of a statuary group.

Not unlike the young warrior's tomb (Plate 136) in its detailed rendering is Jacopo's project for a *Scholar's Tomb* (Plate 137).[40] Extremely shallow relief was within an able sculptor's competence, but Bellini's pictorial scene would have strained even the greatest carver.[41] This panel and the reliefs below *Saint John the Baptist* (Plate 283) point to the competitive spirit of the *paragone*, the art of painting versus that of sculpture.

The professor's skull rests on the book that, though he perished, he had published. No sculptor could have matched the rendering, in delicate washes, of the parchment-like skin clinging to the bones or the paper-thin jaws, separated as if in silent parody of the lecture he gives below, or rival in stone the professor's sadly desiccated private parts or his toes, curled in an agony of terminal embarrassment. The dried-out body was originally drawn alone, as isolated as the *Iris* (Plate 2), Bellini's other tribute to the brevity of life. He added the wittily drafted relief below as if to tame the cruel candor of the mortal image. Only the tomb front, with its rows of students and overflow auditors standing at the left, was retraced in pen; luckily the deceased was left in peace.

The dead outstrips the living in Jacopo's design; it is a virtuoso exercise, not drawn to be realized in stone or bronze, but as an ironic commentary on a scholar's dream and a sculptor's nightmare, a grimly comic *capriccio* anticipating those of Borromini or Piranesi.

On another tomb base, its front carved with seven patera-like recesses, rests a dead knight in armor (Plate 133). Tombs with armed images of the deceased still abounded in churches of the Veneto in the mid-fifteenth century, even in places as prominent as the Gattamelata funerary chapel.[42] Jacopo Cavalli's tomb (1394) in Santi Giovanni e Paolo has six recesses for symbolic images, and the seven roundels that Bellini drew here could have held the three theological and four cardinal Virtues.

In the London Book the cadaver of a military man on the tomb is a personification of death rather than an individual portrait (Plate 137). His tomb, like those of the French renaissance in the next century, combines modern and medieval references in substance and style. In three narrative roundels below, the deceased is seen in the midst of life, recalling those of the hero's sarcophagus lid (Plate 136).

37 See Tietze and Tietze-Conrat, 1944, 102, 103; Gronau, 1909, 254 f.; C. Ricci, 1908, II, 8.

38 For later Este equestrian monuments, see C. M. Rosenberg, *Art in Ferrara during the Reign of Borso d'Este (1450–1471): A Study in Court Patronage*, Ph.D. dissertation, University of Michigan, Ann Arbor: 1974. Jacopo is not mentioned here. Rosenberg (p. 49) suggests that contestants were expected to present finished models rather than rough sketches.

39 H. W. Janson, "The Equestrian Monument from Cangrande della Scala to Peter the Great," *Aspects of the Renaissance*, ed. A. R. Lewis, University of Texas Press: 1967 (reprinted in *idem, Sixteen Studies*, New York: 1973, 159–88). The original plan was for an interior wall tomb; he suggests that Donatello "escalated the job, substituting a freestanding bronze statue in the cemetery next to the church but no longer containing the tomb." Jacopo's equestrian projects may be partly inspired by Donatello's design. A curious echo of the Bellini equestrian monuments is the project for a tomb of Francesco Gonzaga (d. 1519); see C. L. Frommel, S. Ray, and M. Tafuri, *Raffaello architetto*, Milan: 1984, entry 3.4.1 [sic] prepared by K. Oberhuber.

40 R. Grandi, *I monumenti dei dottori e la scultura a Bologna, 1267–1348*, Bologna: 1982.

41 By the early 16th century extraordinarily shallow funerary reliefs with polychromy were made, but it is unlikely that Jacopo had such works in mind for his drawing. See the tomb of Pietro Canonici (d. 1502) from San Martino (Bologna, Museo Civico), attributed to Vincenzo Onofrio.

42 Wolters, 1976, I, cat. nos. 134, 212; II, fig. 395. No tomb exactly like this one is known to have been built. In San Pietro at Fondi (near Rome), the tomb of Cristoforo Caetani (d. 1441) includes a knight in similar armor lying on his sarcophagus, but his tomb may have been completed considerably after his death.

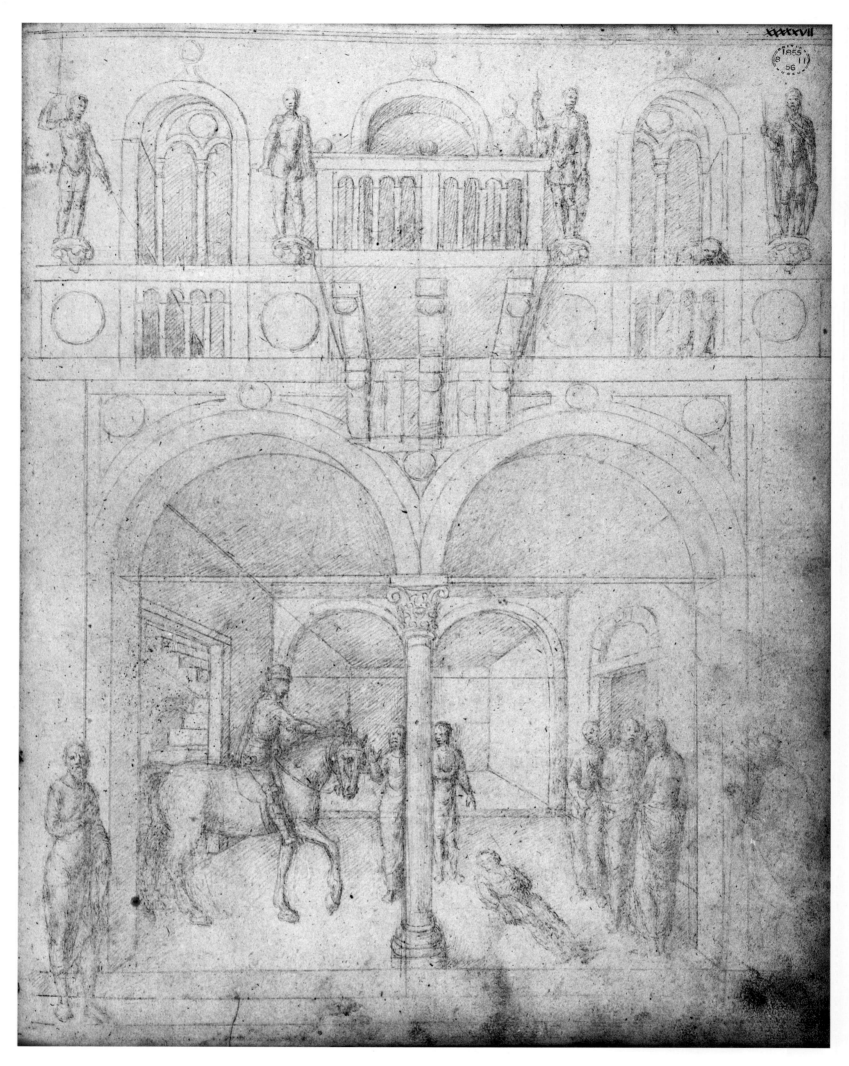

Plate 127. *Rider and Others with Dead Man on Ground.* British Museum 57

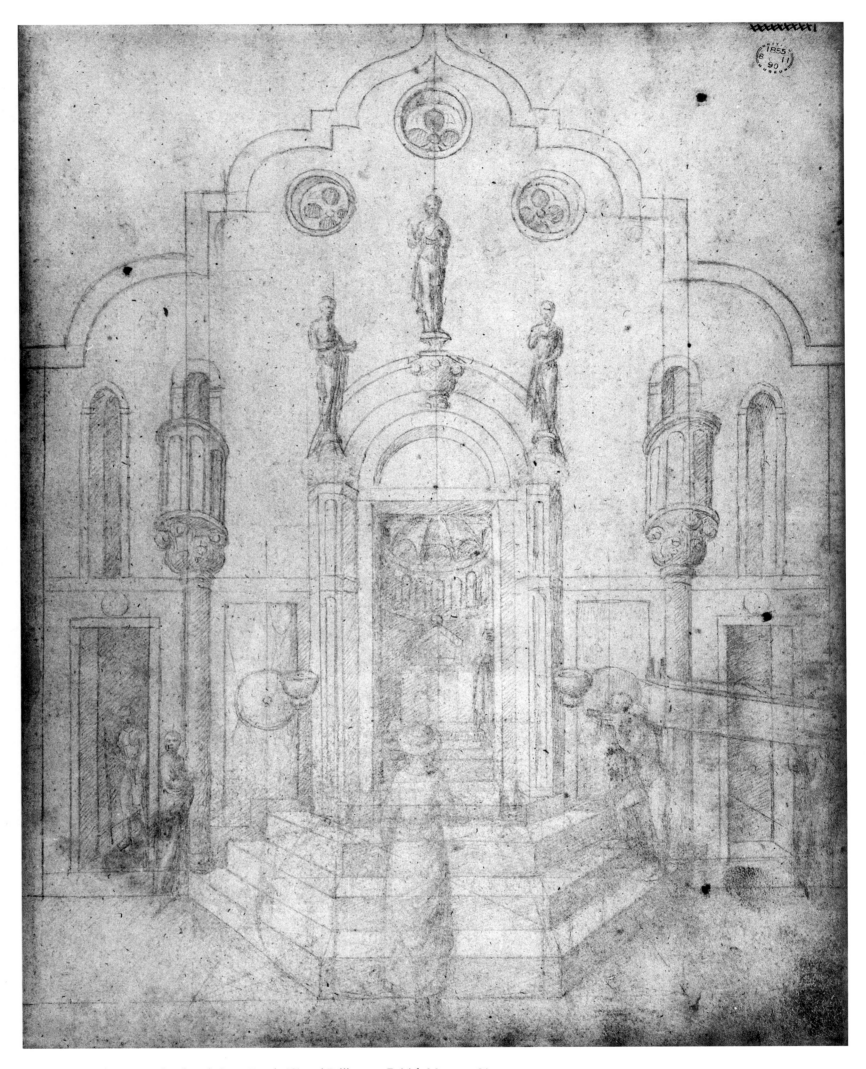

Plate 128. *Church with Open Façade* (C) *and Pallbearers*. British Museum 91

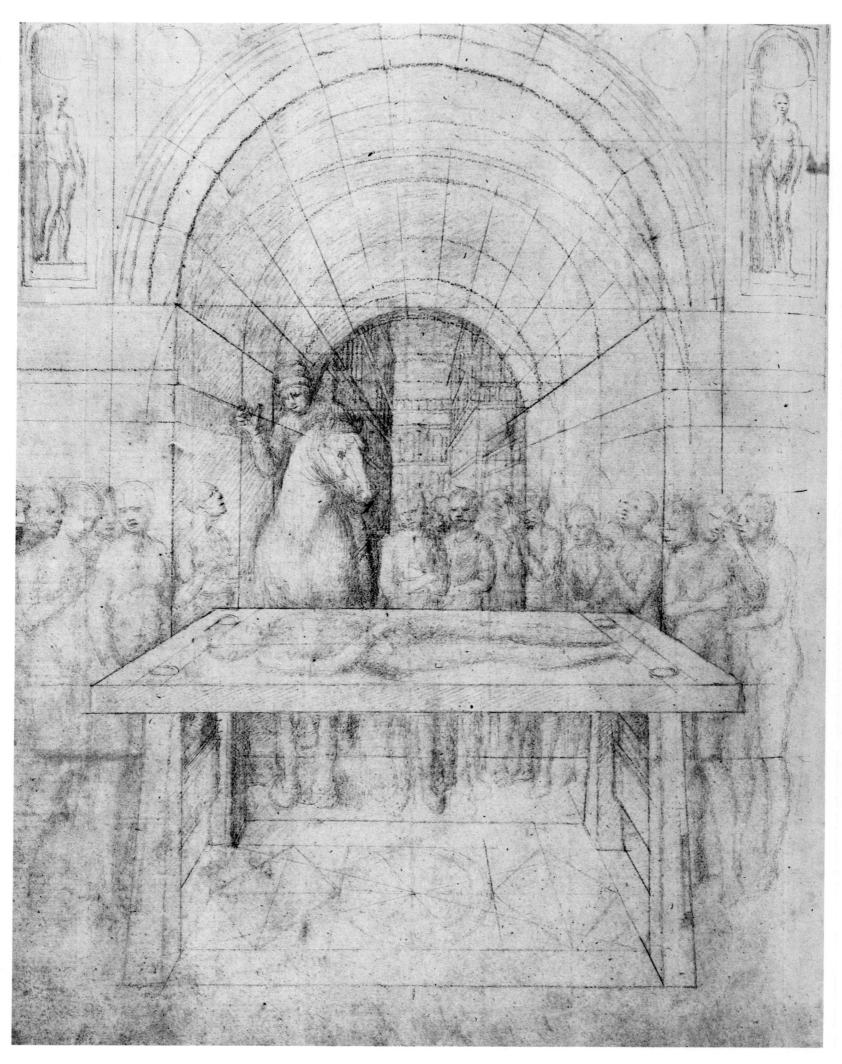

Plate 129. *Rider and Standing Figures by Corpse.* British Museum 55v

256

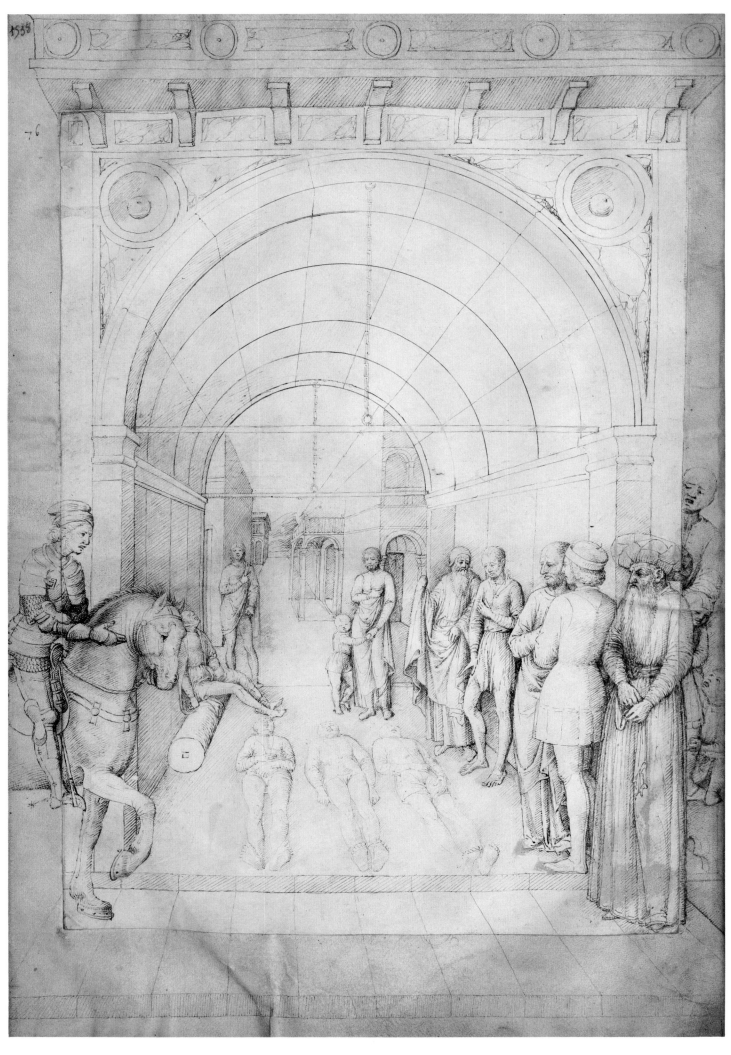

Plate 130. *Three Male Corpses with Equestrian Warrior.* Louvre 76

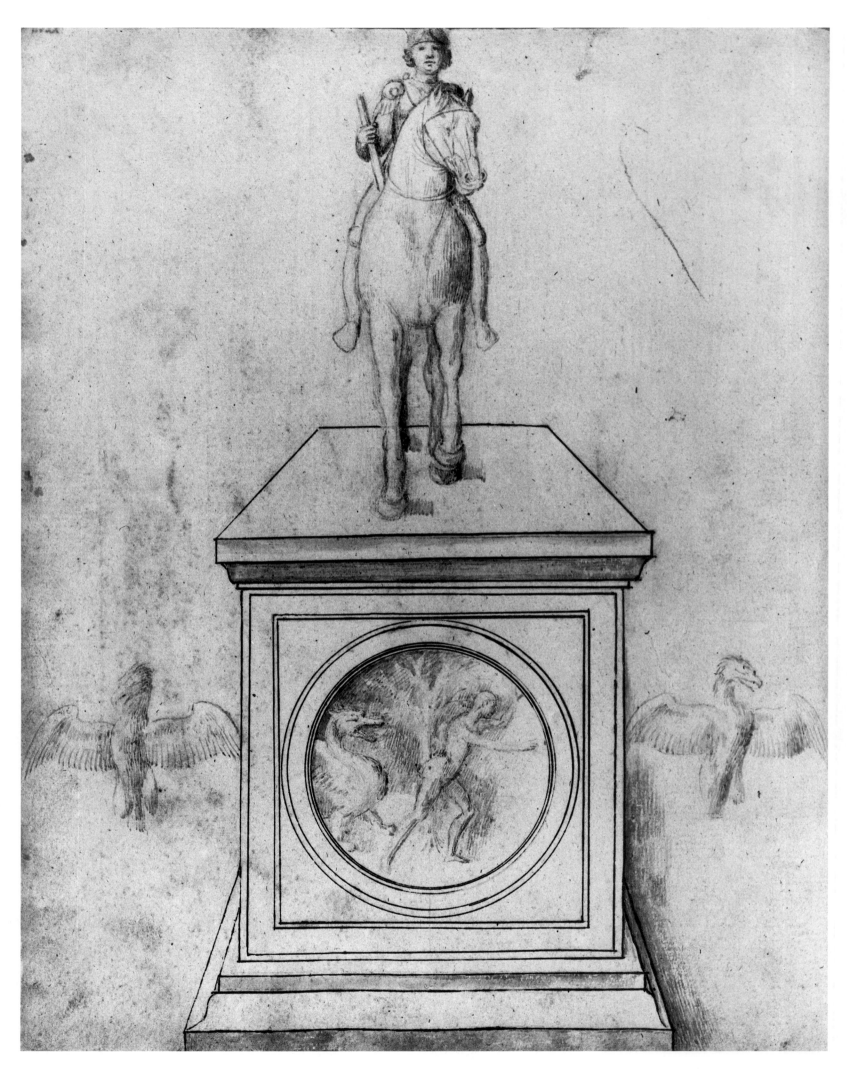

Plate 131. *Study for Equestrian Monument.* British Museum 27v

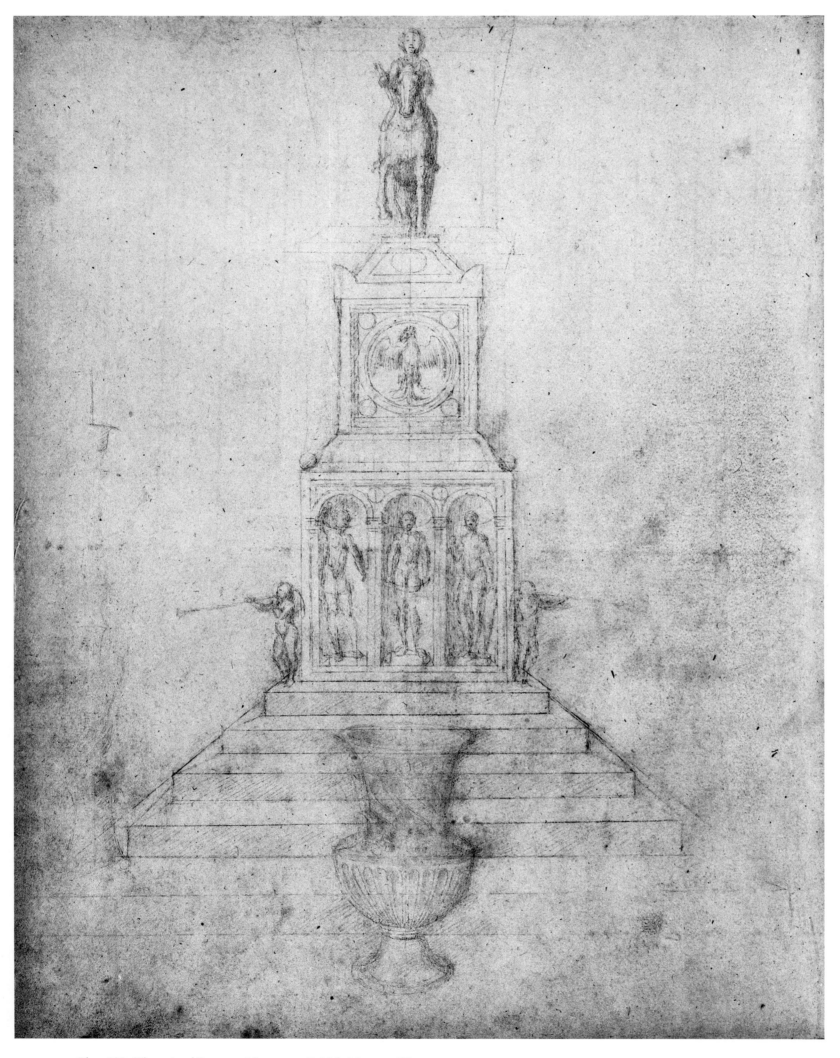

Plate 132. *Three-tiered Funerary Monument.* British Museum 79v

Plate 133. *Knight's Tomb.* Louvre 94

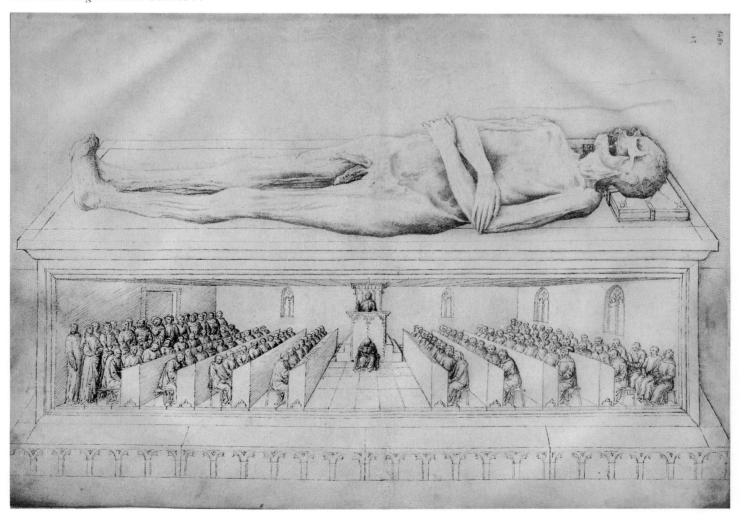

Plate 134. *Tomb of a Law Professor.* Louvre 13

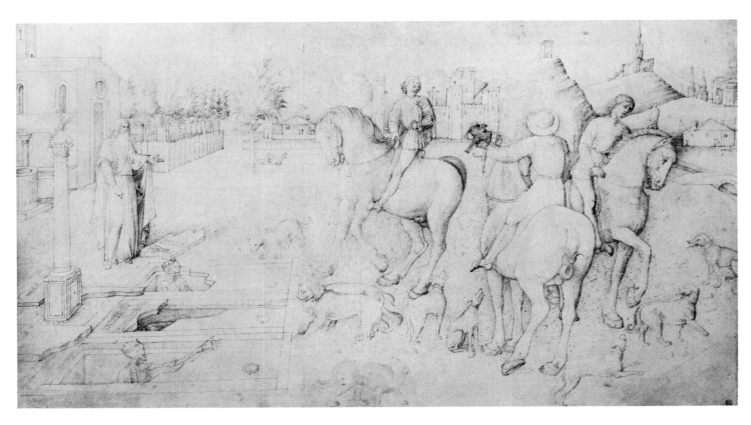

Plate 135. *The Three Living and the Three Dead*. His de la Salle Donation, Cabinet des Dessins, Louvre, R.F. 425 (Louvre 91)

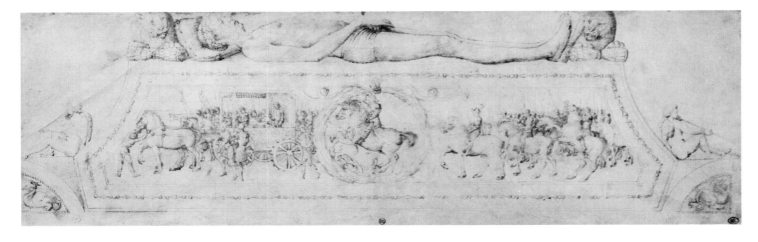

Plate 136. *Effigy of Nude Military Hero*. His de la Salle Donation, Cabinet des Dessins, Louvre, R.F. 428 (Louvre 2)

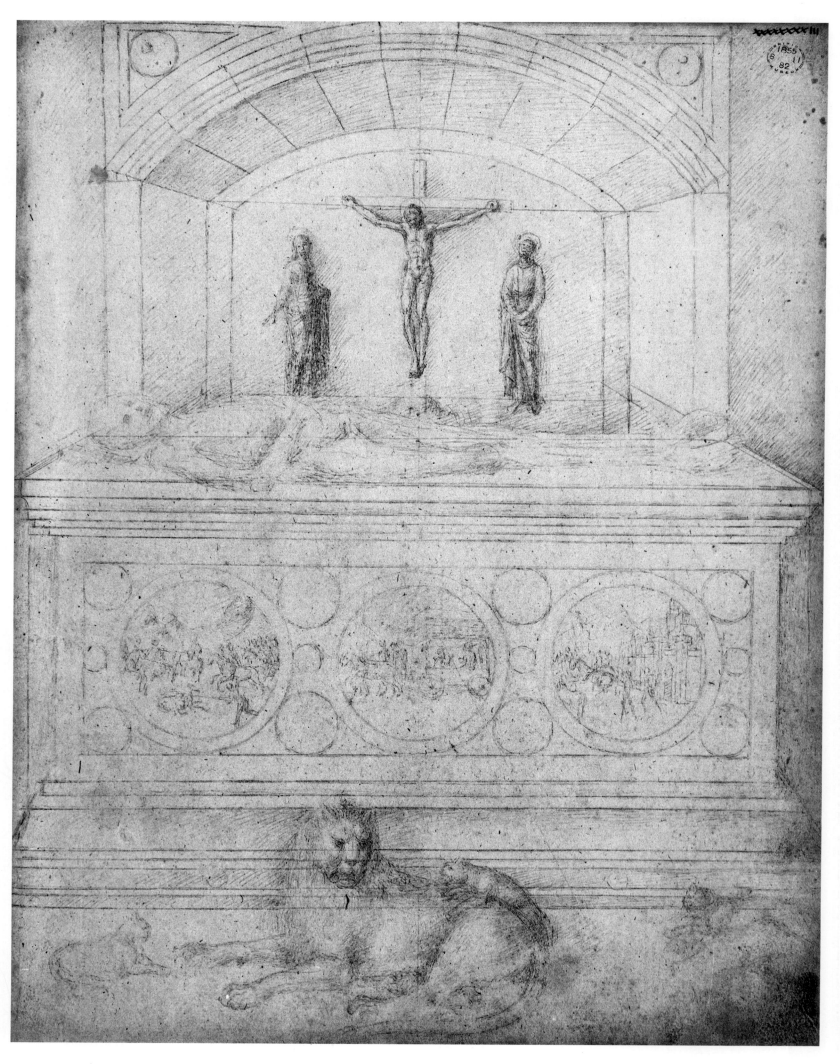

Plate 137. *Funerary Monument with Crucifixion.* British Museum 83

This drawing began with the perspectival construction of an altar-like table or tomb and an arched recess behind enclosing a three-figure statuary *Crucifixion* group, a combination popular in medieval times and the early renaissance. Fugitively sketched are a couchant lion with cubs in the foreground and the cadaver on the altar-tomb. But for the geometrically defined masonry and the centralized statues, this is a free exercise in genres close to the master's art—those of piety, militance, and the *animalier*.[43]

The temporary or ephemeral arts—decorations for funerals and festivals—can often be more daring and innovational than costlier works in permanent materials. Artists were allowed to experiment in such monuments of and to the moment, unconcerned by second thoughts or changes in taste. Some of Jacopo's boldest projects may have been for fugitive media—plaster and lath—possibly like earlier schemes such as young Jacopo della Quercia's, known to us from Vasari's description of an over-life-size equestrian monument of Captain Ubaldini atop a pyramid, prepared shortly after the soldier's death in 1390.[44]

With plenty of ready money, warlords sought their final victory over time in vast funerary sculptures, shown in Bellini's renderings of equestrian monuments. We do not know whether these were for cast or *trompe l'oeil* projects, submitted to contests for a monument to an Este, Gonzaga, Gattamelata, Colleoni, or other personage, yet the Books are almost as dedicated to the military man in death as in life, furnishing models for immortality and mortality alike.

The facts of death are brought home matter-of-factly in a London page (Plate 128), as four pallbearers carry a coffin, the corpse on top, up the steps of a Venetian Gothic church. On the outside are unusual paired pulpits; fonts also flank the entrance. Inside, a figure may be standing by the altar to perform the funerary service. The page appears among several others of urban vistas, all in frontal view (a church, a Venetian bridge, and a Venetian Gothic courtyard; Plates 61, 53, 52). This series was perhaps meant to guide an *intarsiatore*, among the first artists of still life or *natura morta*, in applying perspectival principles.

43 Perhaps the artist adapted pages from imported books of hours or consulted the notebooks of fellow artists with strong transalpine connections or travels. A Venetian candidate for such a role is Gregorio Bono, hired by Amedeo VIII of Savoy, whose French court activities included the drafting of sculptural projects. See C. de Mandach, "Les peintres Witz à l'école de peinture en Savoie," *Gazette des Beaux-Arts*, VI (1911), 405–22, esp. 412. On p. 409 De Mandach describes Amedeo VIII sending Bono to Lyon to make renderings of the sculptured portal. For more recent literature, see articles in *Revue de l'Art*, 71 (1986): F. Deuchler, "Konrad Witz, la Savoie et l'Italie," 7–16, and C. Sterling, "L'influence de Konrad Witz en Savoie," 17–32.

A *grisaille* fresco of 1458 in the church of Saint-Maurice at Annecy (Savoie), of a cadaver on a sarcophagus, is close in concept to Jacopo's pages; see Sterling, *op. cit.*, fig. 18. Links with Venice may be implied by Sterling's identification of the kneeling cardinal-donor in Witz' *Crucifixion* (Berlin, Dahlem Museum) with Bartolommeo Vitelleschi of Corneto (Tarquinia), who was appointed cardinal-priest of San Marco in 1444 by Amedeo VIII, the last anti-pope Felix V (r. 1439–49). Eugenius IV, the Venetian pope, had made Bartolommeo bishop of Corneto in 1438. See Sterling, *op. cit.*, 17, 27.

44 Vasari–Milanesi, III, 110–11.

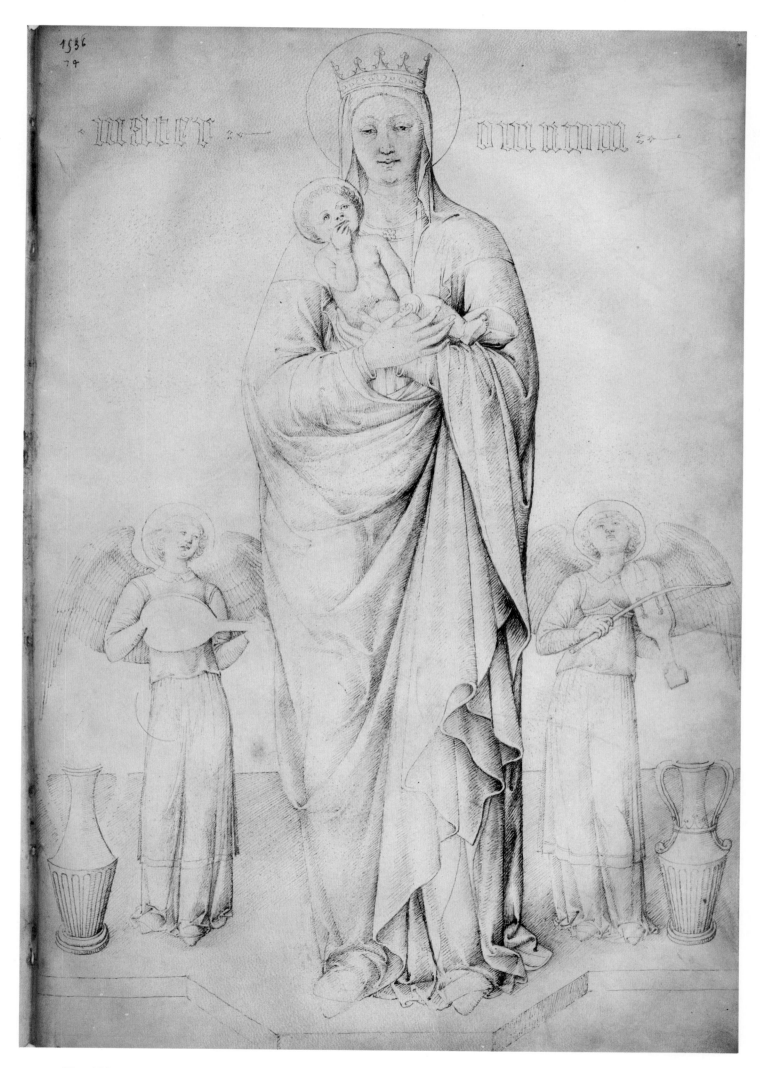

Plate 138. *Mater Omnium*. Louvre 74

264

# VII

## THE BIBLE OF VENETIAN ART

### FAITH IN VENICE: THE PICTORIAL PILGRIMAGE

In his *Stones of Venice*, Ruskin perceived the Serenissima's art as a vision of faith, within a context both literary and illustrative: "Never had a city a more glorious Bible. Among the nations of the North, a rude and shadowy sculpture filled their temples with confused and hardly legible imagery; but for her the skill and treasures of the East had gilded every letter and illumined every page, till the Book Temple shone from afar like the star of the Magi."[1] Ruskin's rhapsody to Venetian luminism and its Byzantine sources could also encompass Bellini's Books, soon to be known as "The Bible of Venetian Art" not so much for their religious content as for their unique role as a graphic monument, twin testaments to Venice's early renaissance. Both Books, especially the Louvre's (on rich vellum), recall precious manuscripts, their religious scenes a dramatic celebration of ceaseless piety, a festival of faith suggesting the cinematic progress of the Passion play.

Bellini was described in Fiocco's flowing Italian as "padre di tutta la pittura narrativa veneziana,"[2] "father of all narrative painting in Venice." The *Odyssey* and the Icelandic sagas are close to the sea, water acting as their connective veins and arteries of adventure, and this is true too for narrative in Venetian art, first found in the rings of biblical mosaics at San Marco. Like verbal or visual scene-shifting, fusions of time, sound, and space made Venetian art move from the sparkling mosaics of glass *tesserae* from Murano to small, multi-paneled altars. As Venice is set between East and West, half classical and half Scheherezade, it is not surprising that narratives—ever important to ancient art—should reach new pictorial heights toward the end of the fifteenth century, as Jacopo's heritage.

Venetian culture rested upon a strong tradition of drama, ceremony, and performance.[3] Typical of the dynamic character of her observance are the twelve major processions, the *andate*, her way of dividing the year. Though these pertain to the Serenissima's history, their significance was also sacred.[4] Ample documentation for miracle plays and related observances goes back to the Middle Ages in nearby Padua and across northern Italy, the most important staged for the Epiphany, Palm Sunday, and the Passion. Religious performances were already popular in Padua in the twelfth century, where a great drama celebrated the feast of Pentecost in 1164, and in the next centuries' elaborate annual Passion plays. By 1278 the *Podestà* had staged in Padua's Arena Chapel an unspecified "misterio con dialoghi, suoni e canta," performed annually from 1331 to 1600.[5]

Documentation for performances of sacred subjects in Venice is disappointingly sparse. Apart from plays that can be securely linked to the fourteenth century—the "Ludus of the Annunciation" staged by "ser Paulus pinctor" in 1342 and the French drama of the "Presentation of the Virgin" given to Jacopo's Scuola di San Giovanni Evangelista—little is known.[6] The great Corpus Christi procession was initiated in 1407 and many of the scuole staged their own performances or contributed to annual holy-day observances. Perhaps the wave of repression in the late 1450s caused the literary sources to seem so unusually close-mouthed about local theater—just when the bulk of Jacopo's drawings were begun. Performances continued in the Piazza di Santi Giovanni e Paolo, but by 1462 they too were forbidden, their sets burned on charges of immorality.

Ferrara, a hothouse of courtly culture, was best known in the mid-fifteenth century for its precious humanism, but its religious dramas may have helped as much as its classicism to shape Jacopo's sacred narrative. Several plays given on the life of the city's patron, Saint George, could have contributed to Bellini's images of the martial martyr. Conversely, Bellini, as prize-winning portraitist at Ferrara, may have helped to devise these

1 J. Ruskin, *The Stones of Venice*, Tauchnitz ed., 1906, 232.

2 G. Fiocco, *L'Arte di Andrea Mantegna*, Venice: 1959, 100.

3 M. T. Muraro, 1964 and 1981; L. Zorzi, "Ferrara il sipario ducale," *Il teatro e la città: Saggi sulla scena italiana*, Turin: 1977, 15.

4 F. Sansovino, *Venezia*, bk. XII.

5 A. B. Sberti, *Degli spettacoli e delle feste che si facevano in Padova*, Padua: 1818, 47, 50–51.

6 P. de Mezières, *The Presentation Play*, trans. and ed. R. S. Haller, Lincoln, Neb.: 1971. See also note 15, below.

performances, described in the *Diario Ferrarese*.[7] The batlike wings of his dragons (Plate 97) suggest those of a mechanical monster designed for a military engine.[8]

In Ferrara Bellini may have met Florentine pageant masters and technical experts in the machinery of the mystery plays. Antonio da Firenze was sent there in 1450, the last year of Lionello's reign, to stage "Paradise." Niccolò Baroncelli, a Florentine sculptor and pupil of Brunelleschi, was later in charge of the same mystery play for Borso d'Este, and Brunelleschi himself staged religious dramas in Florence, engineering an "Annunciation" in the Church of the Carmine.[9] Ferrara, however, was a meeting ground for experimentation in Tuscan imagery, Venetian narrative, and the decorative International Gothic, that fusion much like Jacopo's own.[10]

Even Jacopo's Old Testament subjects suggest a theatrical context. Often triumphal and militant in character, they may have belonged to *tableaux vivants* performed on stage or float. The great procession of the Host on Corpus Christi Day included Old Testament subjects, and several of the *David* figures in the Books (Plates 147, 150) might have been used on such holy days.[11]

Dramas about the saints could be up to four hours long. One for Saint John the Baptist (Castel Durante, Umbria) in 1488 was staged as a performance moving from right to left on a single platform, with settings of temporary architecture along the way for the individual acts.[12]

Bellini's art abounds in a stirring sense of witness, beginning with his lost Verona *Passion* cycle (which included a self-portrait) and the life-size Verona *Crucifixion* on canvas (Fig. 46). When his frescoed *Crucifixion* was destroyed in the mid-eighteenth century, poets were still lauding Jacopo's narrative powers. The sense of motion in his drawings too is almost cinematic, their panoramas reminiscent of sacred dramas.[13]

Venetian buildings shared the roles of the famed structures of Jerusalem, the Doge's Palace doubling as wise Solomon's Temple and impious Pilate's residence. Citizens played the parts of Jews and Romans in the Passion play, that ultimate drama of life, death, and resurrection. The devout shared the lives of Christ and Mary staged in the Serenissima's churches and open places for spiritual pilgrimage and communal emotion. The whole city served as a sacred theater where the tragedy and triumph of the cycle of salvation could unfold.

Some of Bellini's most unusual graphic architecture evokes the topography of Jerusalem. His strange combination of a circular temple with an arcade that resembles an aqueduct (Plate 158) was probably meant to suggest the site of Mount Moriah, for the octagonal Dome of the Rock and the nearby El Agsa mosque (both Islamic monuments) were then thought to be Herod's temple and palace.[14]

In 1455, as Bellini was retracing the *Via Crucis*, the Way of the Cross (Plate 140), his government was deliberating the purchase price for Christ's seamless robe, should that relic ever appear. Some of the same men who established its value at precisely 10,000 ducats were the artist's patrons, owning his works individually and collectively in their homes, churches, and scuole.

Which came first, the pictorial sense that devised the painted images and settings, or the plays that aroused the artistic imagination? The question is beyond resolution, painters and playwrights working together to make literature palpable and visual. Artists planned the sets, the costumes, and the props; they even designed the complex automata and engineered the special hydraulic and mechanical effects that brought sacred history to life.[15]

Within Bellini's lifetime, three radical changes in Venetian faith were realized. First came her new papal power, stemming from the election of three Venetian popes in the fifteenth century. Second, she underwent a new spirituality during the artist's earliest years, the movement beginning among her Church leaders, men drawn mostly from her richest families. With this religious renewal came the third factor, a revival of medieval piety stimulated by innovative Netherlandish and traditional Italian guidelines, all geared toward the worshiper's achieving a new immediacy of faith through personal identification, experiencing the lives and deaths of Christ, Mary, and the martyrs.

Rich narrative renderings of Christian subjects seldom came straight from the bible. Two popular late medieval devotional texts gave artists fleshed-out descriptions of the sacred events. The *Golden Legend*, compiled by Jacopo da Voragine in the thirteenth century, was read all over the West, particularly in northern Italy, for its Dominican author was bishop of Genoa. Closer to Bellini's art are the *Meditations on the Life of Christ* prepared by a fourteenth-century Franciscan monk living in Tuscany. This personal description of the lives of Christ and Mary, addressed to a nun, stressed the humility of the holy family.

7 For the *Diario*, see *Rerum Italicarum Scriptores*, rev. ed., XXIV, part VI, Bologna: 1928.

8 First noted by Goloubew, II, text for pl. VIII.

9 See A. Blumenthal, "Brunelleschi e il teatro del Rinascimento," *Bollettino del Centro Internazionale di Studi di Architettura Andrea Palladio*, XVI (1974), 93–107. Also E. Cruciani, "Gli attori e l'attore a Ferrara: premessa per un catalogo," *La corte e lo spazio: Ferrara estense*, ed. G. Papagano and A. Quondam, IV: *Scena e Festa*, Rome: 1982, 451–66.

10 Zorzi, 1977.

11 See Muir, 1981, 224.

12 See G. Kernodle, *From Art to Theater*, Chicago: 1942, 53.

13 For Bellini and the sacred drama, see Joost-Gaugier, 1977, 70–80. A discussion of the relationship between Venetian art of the high renaissance and the theater is given by D. Rosand, 1982, "The Theater of Piety," 190–206.

14 J. Carpenter, "Architecture in the Bellini Drawing Books," unpublished graduate research paper, New York University, Institute of Fine Arts: 1979, 6.

15 A document of 1342 identified a "ser Paulus pinctor" as designing and painting furniture for the staging of the mystery play of the "Annunciation." Noting that Paolo da Venezia was the *pittore ufficiale* and that furniture painting fell to the Trecento artist, Muraro identified "Paulus" with the great Paolo da Venezia. See Muraro, 1970, 83; also Muraro, *Enciclopedia dello Spettacolo*, 1962, IX, 1531.

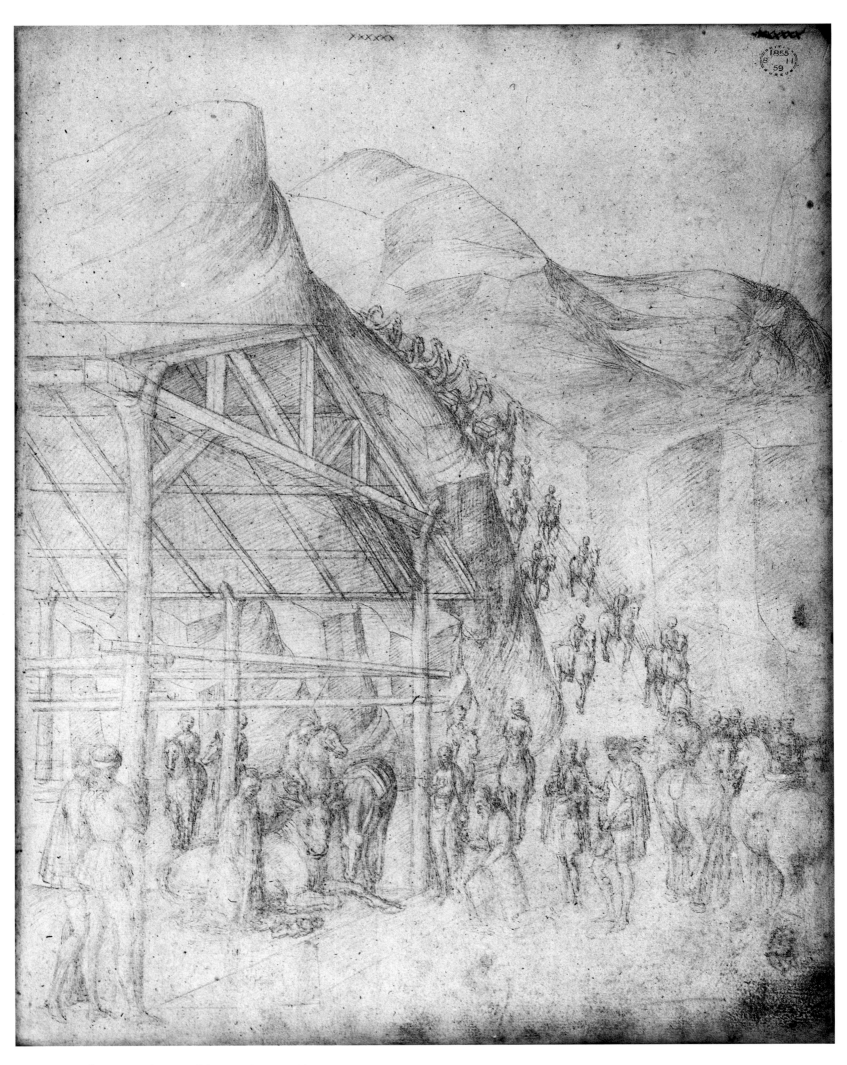

Plate 139. *Adoration of the Magi* (B). British Museum 60

267

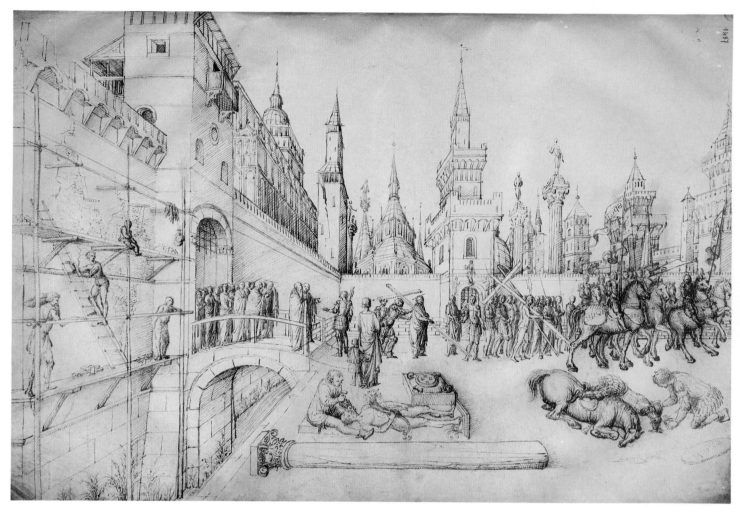

Plate 140. *Christ Leaving Jerusalem for Calvary/Christ Bearing the Cross.* Louvre 20

16 J. de Vincennes, *The Churches of Bruges*, trans. M. Hay, Bruges: 1958.

A spirituality combining the novel Northern religious perspective of the Brotherhood of Common Life with the Franciscan *Meditations* (reissued in Venice in 1450) reached a new vitality with the popular *Imitation of the Life of Christ*, written in 1427 by Thomas à Kempis, who died in the same year as Bellini. Venice, at the crossroads of North and South and the key harbor for pilgrimages to the Holy Land, had so much of Northern art and spiritual outlook that it might be called "the Bruges of Italy."

Burgundy and Venice were both concerned during much of Bellini's lifetime with a new crusade to recapture the Holy Land, their respective dukes each eager for such a campaign.[16] Comparable centers of maritime wealth, art, and craft, Venice and Bruges shared too the urge to re-create the spatial experience of Jerusalem in religious architecture within their urban confines.

In the Serenissima's abundant theater of religious art—in churches and scuole, her lay societies—the lives of Christ and Mary could be witnessed from the Incarnation through the Passion, on up to the Resurrection, Assumption, and Coronation. Her mercantile audience—slaveholders though they might be—could, with the help of Bellini's narrative art, have answered the later plaintive Black lament "Were you there when they crucified our Lord?" with an affirmative "Yes, I *am*."

In the Good Friday service prepared in the fourteenth century, Christ says in the Ninth Response: "My eyes are obscured by my tears . . . See, all you people, if your sorrow is like unto my sorrow. O, all you who pass through the street, look and see if your sorrow is like mine. Take heed, people, and observe my sorrow." That "street of passage" belongs in the present, to daily life, not locked away in ancient history. The Franciscan *Meditations* and other popular devotional literature urged everyone to join the Passion: ". . . feeling yourself present in those places as if those things were done in your presence." Thus Bellini's art stressed the contemporary, staging the Passion in renaissance Venice, in an eternal "now."

Artists and patrons heeding the call "Seek no other consolation than to die with Christ on the Cross" provided images for the fullest exercise of such participation. Filled with references to the life of his own time, Jacopo's religious pages embrace all the rustic and

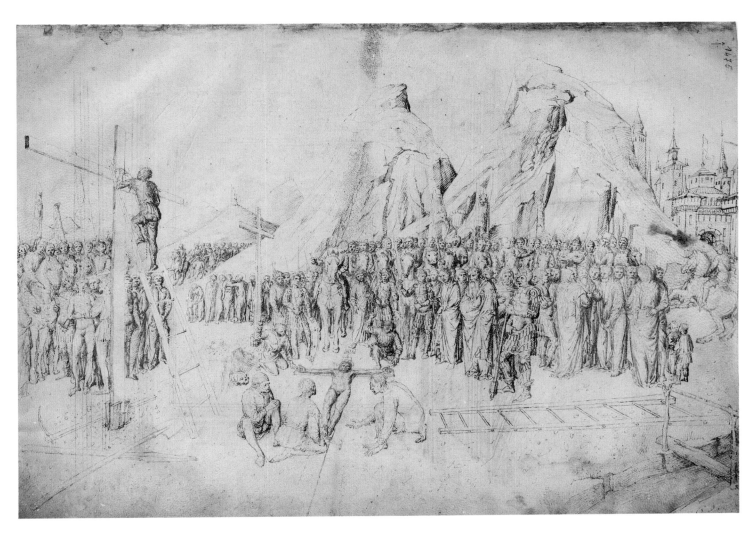

Plate 141. *Christ Nailed to the Cross.* Louvre 1

sumptuous crafts and arts, but these in no way "secularize" his religious art. Rather, he was bringing Christ close to home; he shared the approach of a popular Venetian devotional text *The Garden of Prayer (Zardino de Oration)*, written in 1454 to guide young girls to more effective prayer:

> . . . the better to impress the story of the Passion in your mind . . . it is helpful and necessary to fix the places and people in your mind: a city . . . which will be the city of Jerusalem—taking for this purpose a city that is well known to you . . . find the principal places in which all the episodes of the Passion would have taken place. . . . And then too you must shape in your mind some people, people well known to you, to represent for you the people involved in the Passion . . . moving slowly from episode to episode, meditate . . . , dwelling on each single stage. . . . And if at any point you feel a sensation of piety, stop: do not pass on as long as that sweet and devout sentiment lasts.[17]

The Paris Book often lends itself to such spiritual reverie, letting the eye wander through landscapes of the Veneto and enter the Serenissima's courtyards while biblical events and the lives of the saints unfold. Their small scale may make these worldly actors in the sacred drama seem "incidental" to their setting but never diminishes their significance. Quite the reverse; the very sensation of happening upon a baptism or a beheading provides a jolt of sudden witness more meaningful than any conventional presentation.

A dynamic Florentine preacher, Giovanni Dominici (1356–1419), was among the earliest to foster the new piety in Venice near the fourteenth century's end. Son of a Venetian noblewoman and a Tuscan silk merchant, Dominici was an artist as well as a priest, unusually aware of the force of the visual. The years of his Venetian residence before his expulsion in 1399 were marked by an influx of new Tuscan devotional imagery.[18]

Spirituality in Bellini's youth centered on the renewal of two tumble-down monastic churches at the water's edge, Saint George by the Seaweed (San Giorgio in Alga) and Saint Nicholas at the Lido, the latter damaged in the Battle of Chioggia. An ancient church, San

17 Called to my attention by Jeffrey Weiss. See M. Baxandall, *Art and Experience in Fifteenth Century Italy*, New York: 1972, 45.

18 C. E. Gilbert, "Tuscan Observants and Painters in Venice, ca. 1400," *Interpretazioni veneziane: Studi di storia dell'arte in onore di Michelangelo Muraro*, ed. D. Rosand, Venice: 1984, 109–20.

Giorgio was restored as a Benedictine retreat, its abbey housing one of the first Venetian schools for the poor, admitting ten boys annually. As its fame spread the sons of the rich came too, to be taught the new spiritual values.

In 1397 a fifteen-year-old Venetian aristocrat, Ludovico Barbo (backed by the wealthy Correr family), was made prior of San Giorgio; Marino Querini (another Venetian noble) and his nephew Lorenzo Giustiniani also became linked to it. Barbo's younger brother Pietro entered the Benedictine hermitage, and so did Antonio Correr, nephew of Angelo Correr, the future Pope Gregory XII (r. 1403–17).[19]

Reluctantly, the austere Giustiniani accepted his appointment by Doge Foscari to the Patriarchate of Venice, ever yearning for the peace at San Giorgio. He preached sermons of restraint and charity in his church and to the Venetian citizenry. No two leaders could have been further apart than the bellicose, passionate doge and the ascetic, saintly patriarch. Bellini must have seen Giustiniani on state occasions and heard him preach, also devising his tomb image. Another leading monastic figure, the Franciscan Bernardino da Siena, came to the Veneto several times; twice Jacopo drew him in his London Book (Plates 242, 243), and he painted him about 1450 (Fig. 59). Both men were canonized, Bernardino in 1450 and Giustiniani, one of the Serenissima's few saints, in the seventeenth century.

The scuole, Venice's confraternal societies for lay members, dedicated to penitence, charity, and mutual benevolence, grew ever grander during Bellini's century. More than meeting places and centers for good works and self-help, the scuole became competitive showcases for their memberships' collective faith, often providing gallery space for large cycles of paintings. Bellini had major commissions from three of the greatest scuole, his own San Giovanni Evangelista, the Carità, and San Marco. A number of his drawings must pertain to designs for their series of large-scale sacred subjects, many lost. They suited the scuole's devotions by letting the viewer follow a sequential pilgrimage of the spiritual eye, moving along the scenes, frescoed or on canvas, as if witnessing the original events.

Released from the focused centrality of an altarpiece isolated within the area sacred to the mass, the cycles in the scuole allowed for a fluid narrative that explored more freely the unwinding drama of salvation. Passion and compassion, the birth and death of Christ relived, the Virgin's joy and sorrows, the active or contemplative lives of the saints—the scuole's barnlike sanctuaries held all of these, depicted in a new stream of sacred consciousness.

Renaissance art and theory, opposed to seamless tapestries of sacred happenings, disliked mystical playings on and on of the lives of Christ, Mary, and the saints. These endless cycles of religious experience contradicted the new science of perspective, whose illusionistic wonders worked only under specific conditions, controlled by one or two vanishing points. The viewer had to take in the composition from a fixed distance, even his eye level predetermined.

Jacopo was among the first Venetian painters to wed successfully the mystical essence of medieval art with these newly channeled, rationally devised spatial formulas. Masolino's fresco cycles at Rome and Castiglione Olona and Ghiberti's pictorial reliefs for his second Doors may have supplied him valuable precedents for fusing past artistic practices with present ones. Probably Bellini's canvases for the Scuola di San Giovanni Evangelista and the Scuola di San Marco provided models for Dürer's graphic Life of the Virgin series early in the sixteenth century, and for later decorations in Venetian scuole.

Illustrated prayer books became filled with step-by-step, moment-by-moment scenes in a dramatic progression that allowed the devout to be present at every sacred event. Painting and prayer were calculated to work together in newly programmatic fashion, word reinforcing image, image stimulating word, the devout guided by this joining of eye and ear. Never before had so many episodes of the Passion been illustrated, as if each movement, each breath, each gesture of those who loved or hated Christ required a close-up or special graphic record.

Bellini's lost Passion cycle in Verona may have reflected available examples, possibly one by Gentile da Fabriano near Brescia.[20] A rich early Passion in the Veneto is the cycle in terracotta by Michele da Firenze (Verona, San Anastasia, Pellegrini Chapel) of 1436, modeled while Bellini was painting his *Crucifixion* fresco in that city's cathedral.[21] A lost Passion series by Jacopo's major rivals, Giovanni d'Alemagna and Antonio Vivarini, dates from late in the 1440s. Vivarini's Passion Altar (Venice, Ca' d'Oro, painted for the church of Corpus Domini) may also be similar to Bellini's lost works, both masters sharing elements from Masolino;[22] the Passion Altar includes the rare theme of nailing Christ to the cross on the ground, also seen in the Paris Book (Plate 141).[23]

19 Ludovico later entered the mendicant rule, describing this step as his conversion. He became abbot of the great Paduan monastery of Santa Giustina, soon entrusted with the reform of the Benedictine order as bishop of Treviso. See A. Pratesi, "Barbo, Ludovico," *Dizionario Biografico degli Italiani*, VI, 244–49.

20 Christiansen, 1982, 134–35.

21 G. Fiocco, "Michele da Firenze," *Dedalo*, XII, 1932, 542–62; E. Petrobelli, "Michele da Firenze ad Adra," *Rivista d'arte*, XXIX, 1954, 127–32.

22 See Wurthmann, 1975. See also Pignatti and Pullan, 1981, and C. Huter, "The Ceneda Master—1," *Arte Veneta*, 1973, 27, fig. 41. It had been taken to Vienna and was returned after World War I. Reproduced by Testi, 1915, II, 337.

23 Long mistakenly given to Carpaccio, the Tietzes (1944, 68, 154) were the first to see (Fig. 6; Oxford, Christ Church) the page as close to the early Gentile Bellini, still following his father. K. T. Parker, *Disegni veneti di Oxford*, Venice, 1954, cat. no. 4, 15, listed it as by an "anonymous follower of Jacopo Bellini(?)." J. Lauts, *Carpaccio, Paintings and Drawings*, London: 1962, 77, gave it to "Lorenzo Costa(?)" with a proposed date of c. 1513. Muraro, in his monograph on Carpaccio, ascribed it to Jacopo or Gentile Bellini (1977, 67).

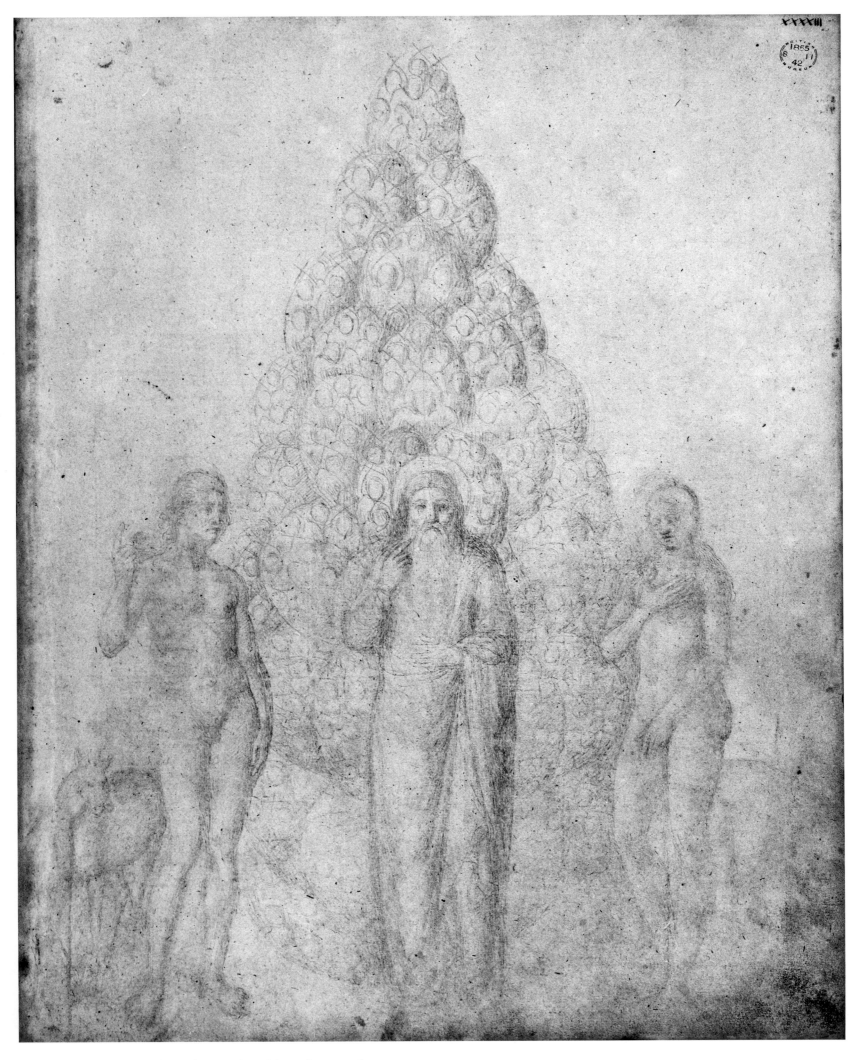

Plate 142. *Adam and Eve with God the Father.* British Museum 43

271

Plate 143. *Adam and Eve with God the Father* (left), *by the Tree of Knowledge* (center), and *Expulsion* (right). Louvre 66v

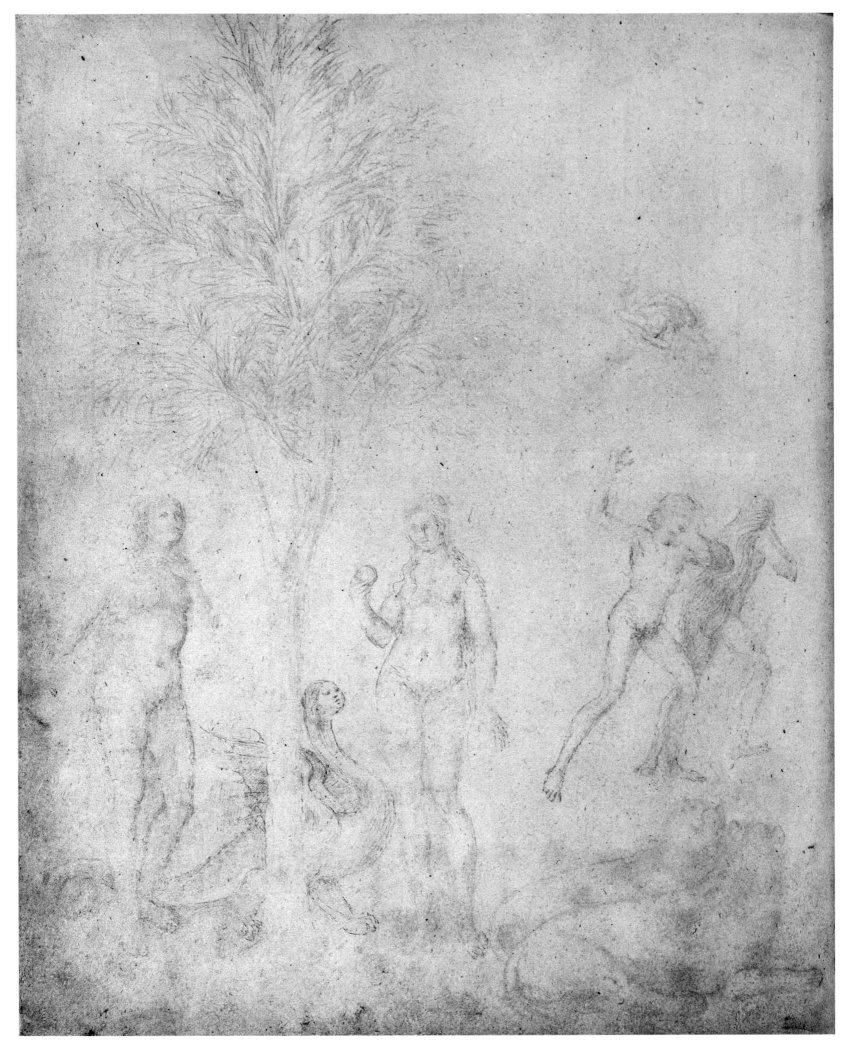

Plate 144. *Temptation, Fall, and Expulsion* (continuation of *Adam and Eve with God the Father*, Plate 142). British Museum 42v

Though the scale of the figures varies in the London Book in many scenes of the lives of Christ and the Virgin, other pages have a striking modular uniformity that suggests they were drawn for or after a single cycle. [24]

Two different avenues to sanctity prevail. In Bellini's graphism, London's Book is bold and large in scale, bringing the believer close to the saint or scene in a more immediate confrontation than history offers. Moments of passion come into focus with clear, broad strokes of leadpoint on heavy white paper. The harsh and the silvery are oddly combined on London's pages, moments of martyrdom or suffering, scenes of birth or presentation sketched out in a rare fusion of proximity and monumentality, ever "nearer my God to Thee."

The theater of faith in the Paris Book is often a sweeping vision on a smaller scale, displayed over a deeper screen. Whether drawn in pen or silverpoint, the effect is less immediate. Courtly politesse and perspectival richness are both distancing conventions that associate these vellum folios with illuminations in a book of hours. Bird's-eye vistas suggest a sacred drama or an accompanying text, perhaps an elaborate commentary that has dictated the scene and now embroiders upon it.

Bellini drew his many panoramas of Calvary and of the ways to and from the Crucifixion as distant scenes of sacrifice and redemption, glimpsed from so far away that the vast casts of Good and Evil alike have the same small scale. Witnesses to these images must search among innumerable figures to find their own way to God. Sometimes Bellini eases their task by perspectival guidelines, but more often than not the painter as preacher forces the viewer to seek before he finds. Partially worked upon concurrently (with London's facing left pages executed last), each volume includes pages close in general sensibility to the other.

With the religious scenes from both volumes assembled in chronological sequence, Bellini's "Bible of Venetian Art" becomes a spectacular sight, a lifetime of his surviving devotional images experienced in its entirety from first to last. Some pages are still early and conservative in style, close to the Gothic art of the Trecento and the masters of the International Style from Jacopo's youth. Other images anticipate the abundant, dramatic future of Venetian narrative art in her high renaissance, a silent oratorio, a wordless opera.

24 Especially noteworthy in the third *Adoration of the Magi* (Pl. 177), *Flight into Egypt* (Pl. 180), the two *Presentations of the Virgin* (Pls. 157, 160), *Adoration of the Magi* (Pl. 173), *Presentation in the Temple* (Pl. 179), *Christ among the Doctors* (Pls. 181/ 182), *Baptism* (Pl. 186), *Entry into Jerusalem* (Pl. 191), *Christ Brought before Pilate* (Pl. 194), the second and third *Flagellations* (Pls. 202, 203), *Leaving Jerusalem for Calvary* (Pl. 140), *Nailing to the Cross* (Pl. 141), the first *Crucifixion* (Pl. 208), the London *Crucifixion* (Pl. 206, though the format is vertical), and *Deposition* (Pl. 214). All are drawn in much the same spirit and scale, and are conceivable as a pictorial cycle.

## OLD TESTAMENT

As well as the "Bible of Venetian Art," Bellini's Books could be called "Venetian Art's Bible," for never before had so many Old and New Testament themes been seen in the Serenissima's early renaissance style. Though there is no planned distribution or sequence of subjects in either Book, each begins with a Calvary (Plates 141, 205), as if this subject were an invocation, a guide to what follows. Compared with the abundant New Testament and saintly scenes, those of the Old are far fewer. This is surprising, for Venice, more than any other Italian center, revered the first Testament: her churches were often named for the prophets, following Byzantine practice. Jacopo surely drew many other Old Testament scenes, possibly keeping them in a separate book, now lost.

The earliest Old Testament scene is in the London Book, from Genesis—an unusual presentation perhaps combining the Fall of Man with the apocryphal subject of the Marriage of Adam and Eve (Plate 142). Nude, the two stand on either side of God, who points to his mouth, reminding them of his instructions. Behind him is a strange symmetrical tree made of clumps of cherub heads. Deer at the far left and right may refer to the love of Adam and Eve. Eve's new knowledge of good and evil makes her take the pose of a *Venus pudica*; Jacopo probably owned the antique *Venus* that was later listed in his son Gentile's collection.

The facing left page illustrates other passages from Genesis (Plate 144). First drawn were the large tree and the two lions at lower right. An odd serpent, shown as a winged dragon with a human face, turns toward Eve, her look-alike. The expelled Adam and Eve may have been an awkward graphic afterthought, yet the angel brandishing a sword over their heads is brilliantly foreshortened. A faint, sketchy lead- and silverpoint drawing in the Paris Book (Plate 143), almost invisible, shows the Fall somewhat similarly, though it is more conventional; coiled around the tree, this serpent also has a human head, and in the right foreground lies a lion.

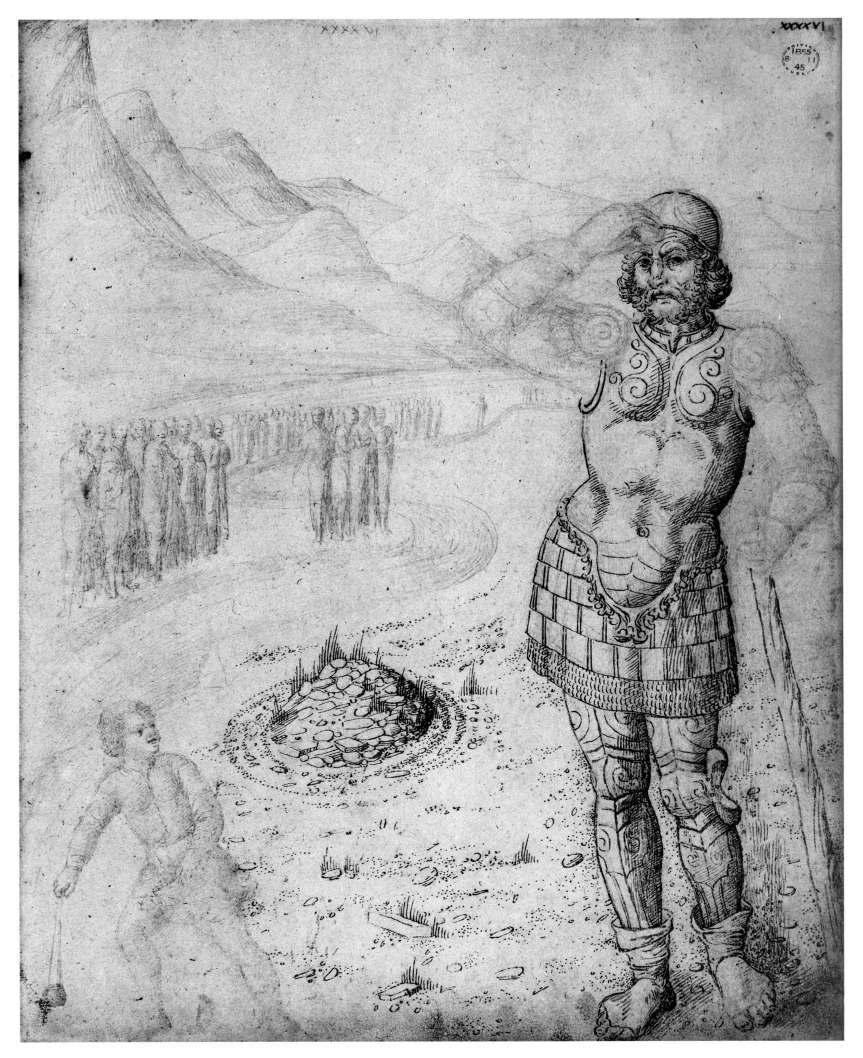

Plate 145. *David and Goliath*. British Museum 46

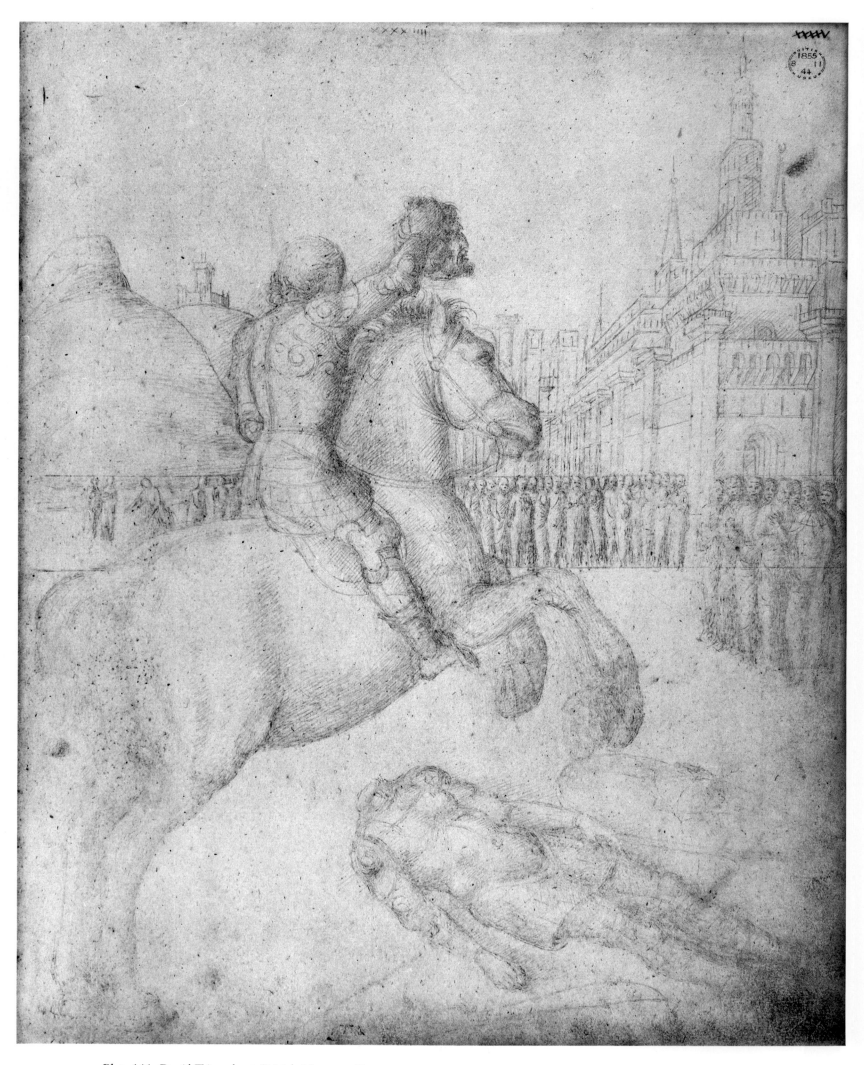

Plate 146. *David Triumphant*. British Museum 45

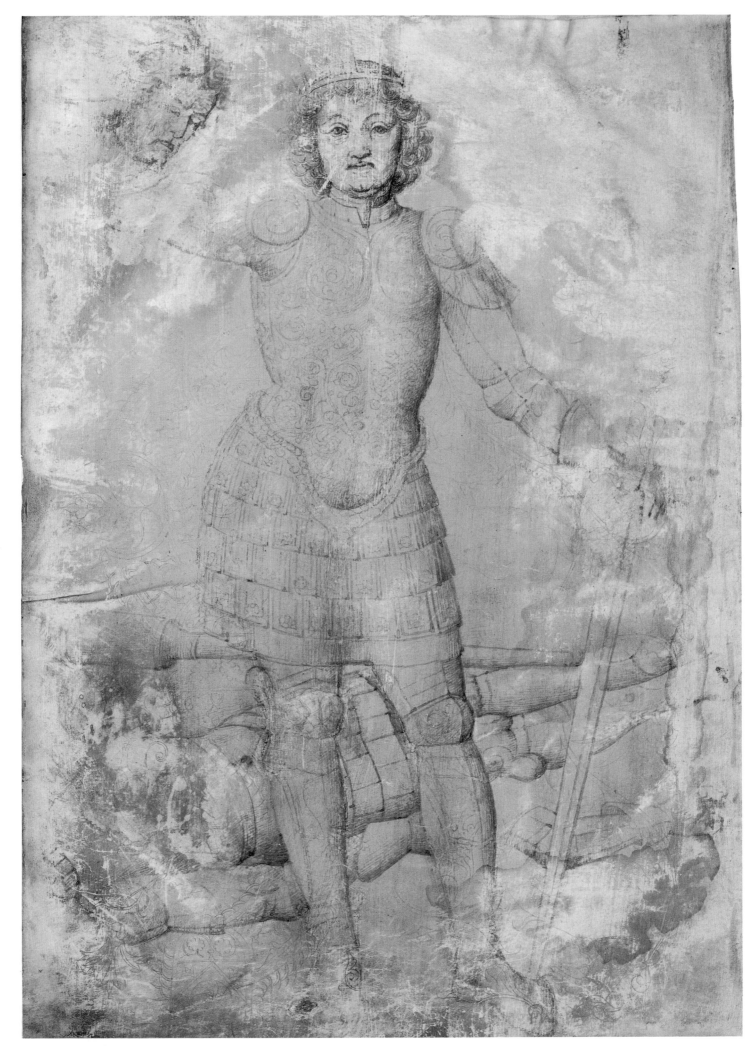

Plate 147. *David with the Head of Goliath*. Louvre 82v

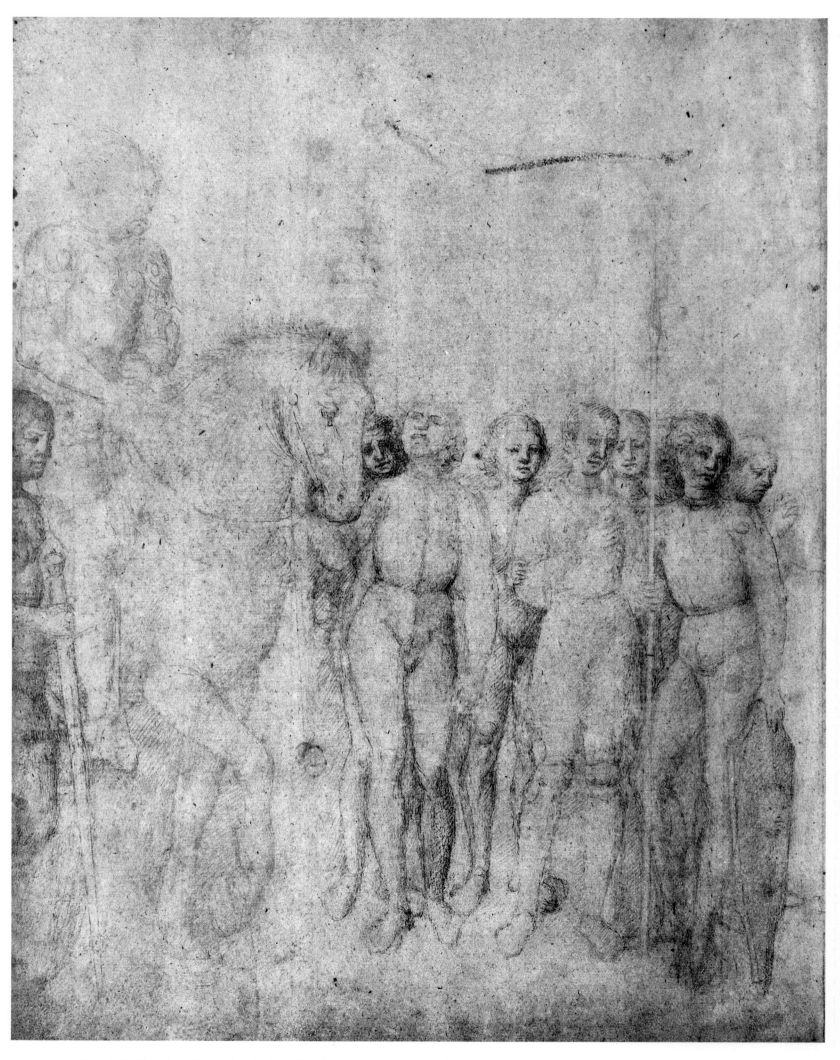

Plate 148. *Holofernes(?) on Horseback, with Soldiers*. British Museum 34v

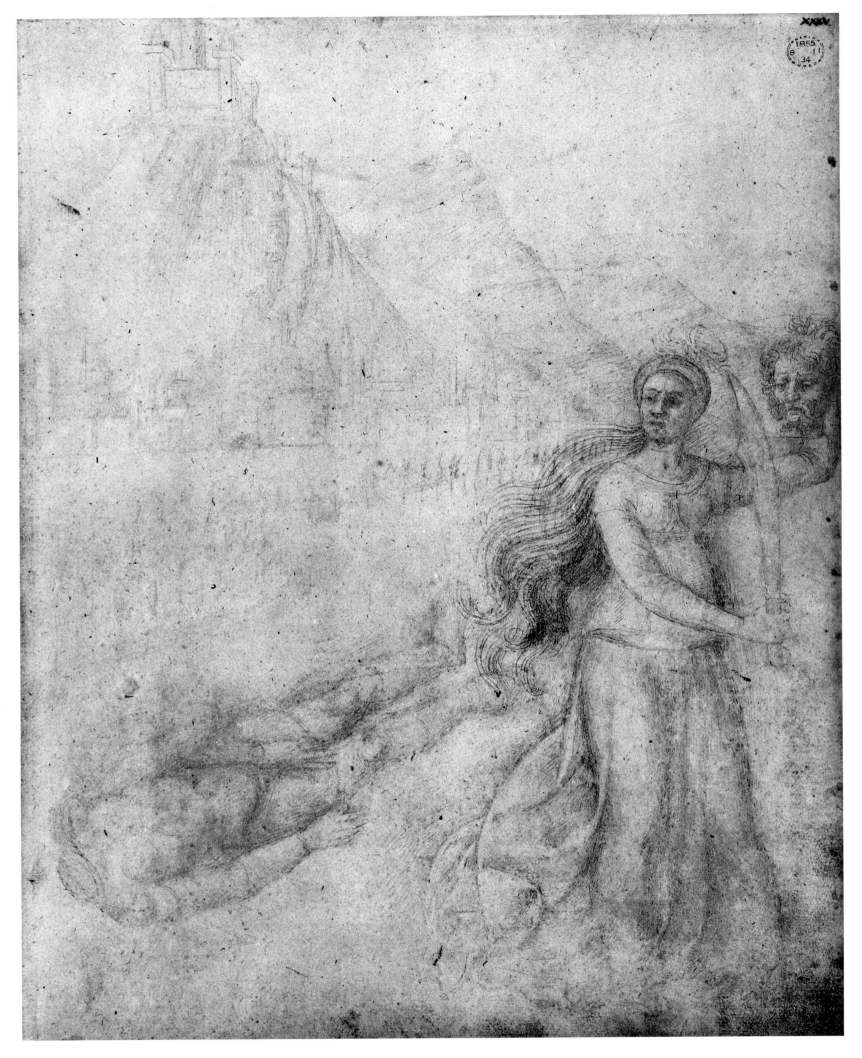

Plate 149. *Judith with the Head of Holofernes*. British Museum 35

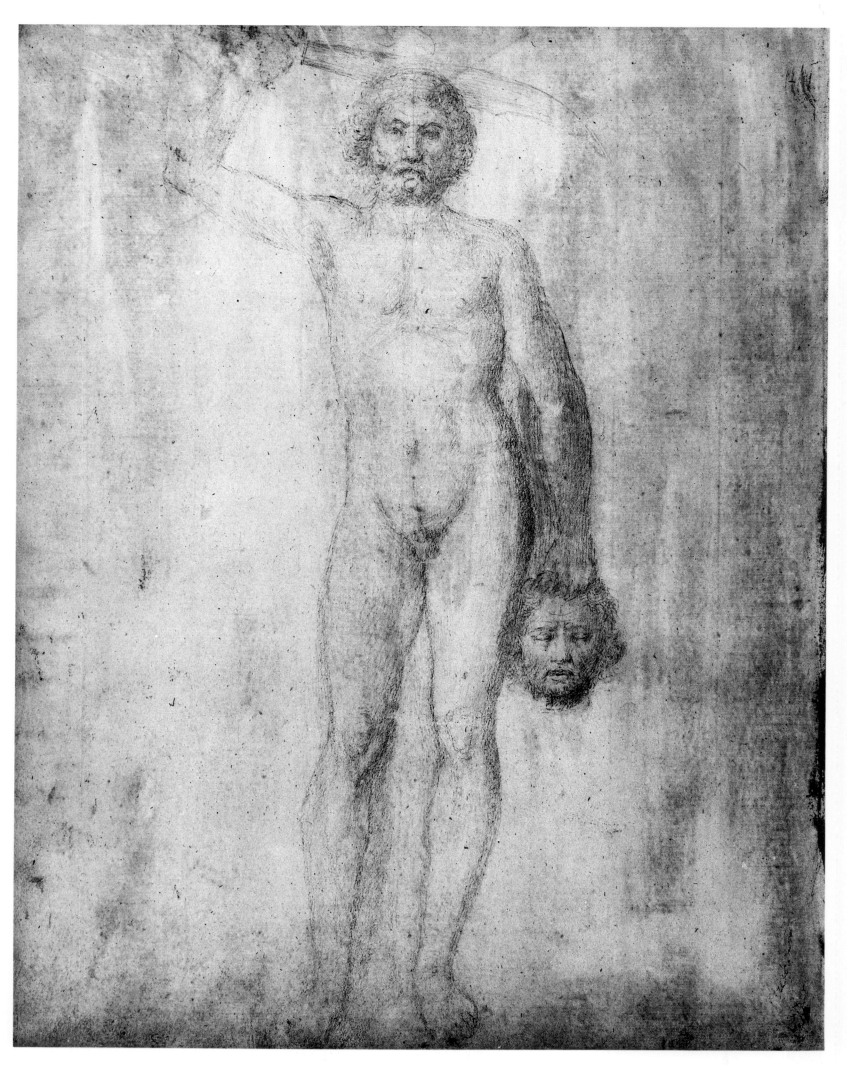

Plate 150. *Nude Bearded Male (David?) Holding Severed Head.* British Museum 61v

280

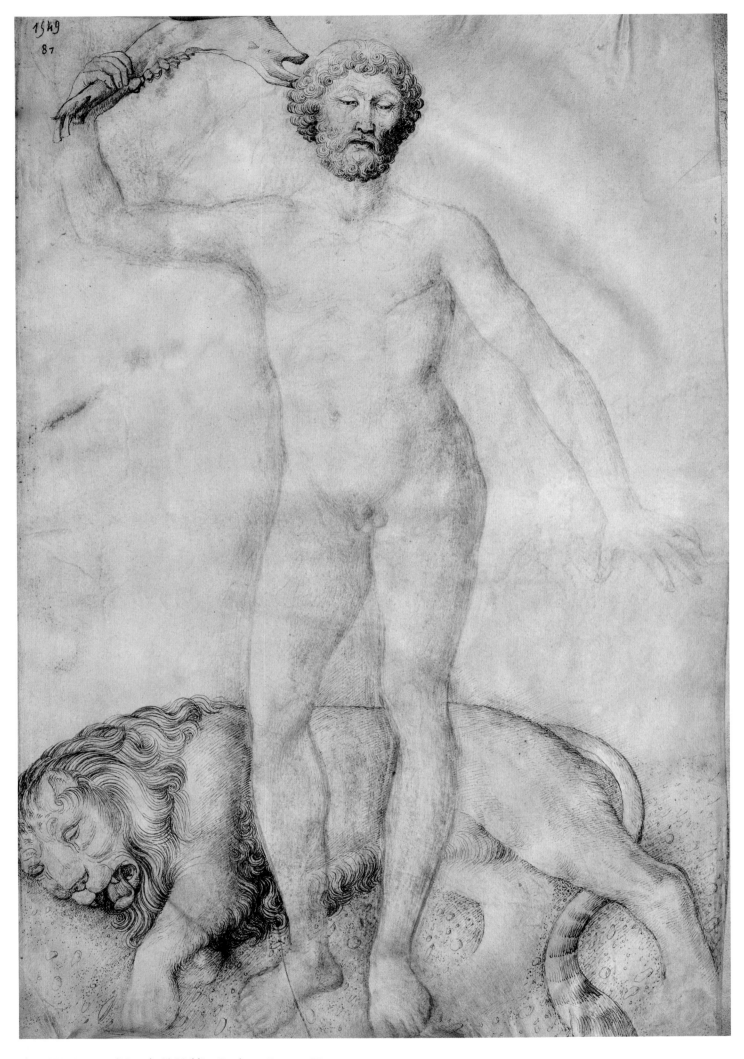

Plate 151. *Samson (Hercules?) Holding Jawbone*. Louvre 87

25 G. Dalli Regoli, "David trionfante: una ipotesi e un disegno poco noto," *Antologia di Belle Arti*, nos. 9–13 (1979), 34–42.

26 The features are somewhat in the style of Gentile da Fabriano, the head more rounded and eyes fuller than Bellini usually shows.

27 Ames-Lewis, 1981, 113.

28 Judith, not always a republican symbol, was shown decapitating Holofernes in Guariento's large fresco painted for the Carrara Palace in Padua in the Trecento. For later Judith symbolism, see V. Herzner, "Die 'Judith' der Medici," *Zeitschrift für Kunstgeschichte*, 43 (1980), 139–80.

29 Ames-Lewis, 1981, 113.

David's passionate life assured him his place among the most popular biblical figures—saint and sinner, the shepherd boy who saved Israel from the Philistine giant, and whose songs, the Psalms, were the beautiful prayers that forged the strongest bonds between the Testaments. David assumed a political role in Bellini's century, representing the victory of the republican spirit over tyranny. Venice may have adopted the cult of David from Florence, her ally.

Recto pages of the London Book show David slaying Goliath and his triumphant reception afterward (Plates 145, 146). Strangely, the later episode precedes the earlier one, and was subsequently inked over in part. Two moments are combined on this page, the little shepherd about to let fly the fatal stone and the giant clutching at his brow, already struck by the missile. The people of Israel witness the combat from the far riverbank, at a safe distance. Though the bible arms Goliath with a sword, Bellini stresses his Herculean strength by giving him a club taller than David and a handsome suit of armor *all'antica*.

In victory David becomes larger, an imposing equestrian figure, again wearing the splendid armor, given him by King Saul, that he had removed before the battle. Crowds gather outside Jerusalem in a wall-like grouping that extends across the middle of the page, all heads aligned in the perspectival device Bellini often used in London's Book. The scene of David's Triumph is rare in the fifteenth century, and the artist does not show the dancing, music-making women who sing: "Saul hath slain his thousands, and David his ten thousands" (I Samuel 18: 6–7).

The pages facing both scenes extend their subjects into open landscapes. On the one opposite David's Triumph is a gallows (Plate 38), often a symbol of injustice, here linked to Goliath's oppression. Rustic architecture on the page facing the confrontation of shepherd and giant might allude to David's humble origin, but was probably sketched later with no biblical significance (Plate 39).

*David* may be the figure drawn in full *all'antica* armor, holding a severed head much resembling his own (Plate 147).[25] Behind him lies a gigantic armed, decapitated figure with a great pole-like jousting weapon nearby. Though it is unusual for the young victor to wear the spiked crown of the older David, this page probably represents the biblical hero.[26] Drawn in silverpoint on a lavender ground, this is one of the reused leaves bound into the Paris volume from an earlier textile pattern book.

Accepting this figure as David, one scholar has noted that the artist was "concerned not with the reality of form but with an imaginative reconstruction of it, and with a sensitive but inventive response to the surface of forms."[27]

Judith, another Old Testament figure who became a renaissance symbol of republican freedom, appears earlier than David in the London Book (Plate 149).[28] Like courageous Queen Esther, she had a book to herself in the Apocrypha: Judith took the law into her own hands for the salvation of Israel. Powerful yet graceful, she grasps Holofernes' severed head and brandishes his sword, her figure suggesting a Florentine origin. On the facing page (Plate 148) the giant Holofernes rides high as Nebuchadnezzar's victorious general in the preceding episode.

A much-damaged page in the Paris Book (Figs. 10, 17) that could illustrate either David's or Judith's victory is identified in the late fifteenth-century Index as "Judith overcoming Holofernes with a satyr" (Appendix C). The drawing was made on a rectangular sheet of parchment pasted over the central section, now lost; all that survives is the fallen warrior penned in one margin and a vase and satyr in the other.

Samson, the Old Testament strong man, was especially popular in Venice for intricate symbolic links uniting his power, his victory over the lion, and the concept of justice. His name, meaning "sun" in Hebrew, was associated with the Sun of Justice, and his lion was also the symbol of the Republic's patron, Saint Mark. Events from Samson's life were compared with Christ's Passion and Resurrection in a much-read medieval text, the *Mirror of Human Salvation*.

The monumental male nude who stands alone in the London Book, sword overhead and holding a severed head that resembles his own (Plate 150), may be Samson; he has also been identified as David,[29] but looks rather too old for that young victor. Perhaps Bellini is tentatively working out a pose, not making a definitive study. The artist first gave his model a weapon like a battle ax, but he ended with one resembling Judith's curved sword. Two related nude studies in the Paris Book, one of a man wrestling with a lion (Plate 66) and the other, two folios before, of a standing man raising the jawbone of an ass, a lion knocked out behind him (Plate 151), may both be of Samson, based in part on an ancient Roman relief. Faded, like the nearby pages of nude Herculean figures (Plates 65, 66), it was partially penned over later in the fifteenth century. This drawing is a bolder version of

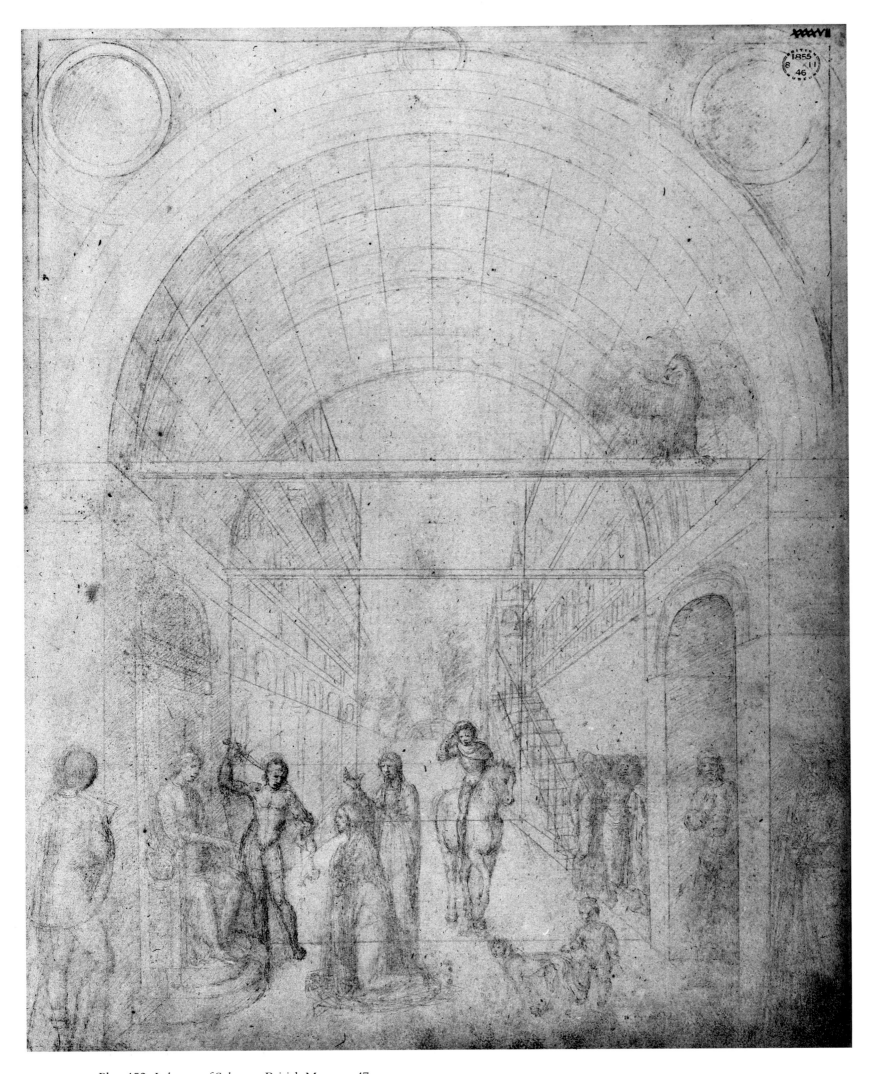

Plate 152. *Judgment of Solomon*. British Museum 47

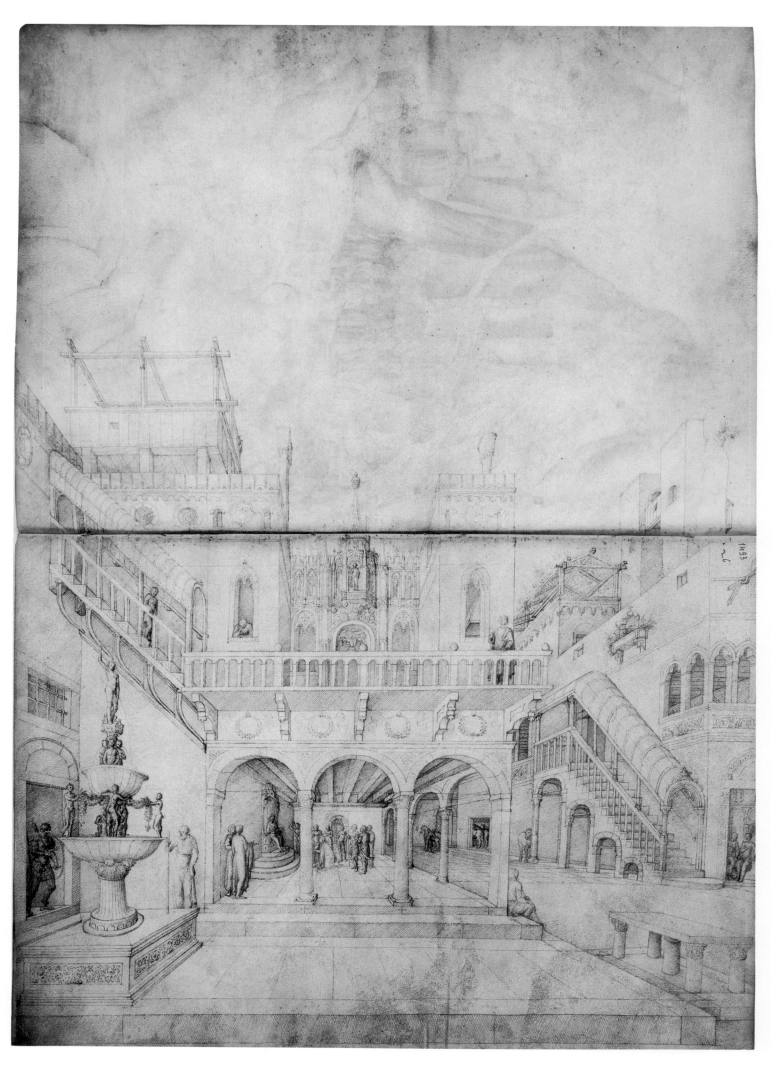

Plates 153/154. *The Judgment of Solomon*. Louvre 25v, 26

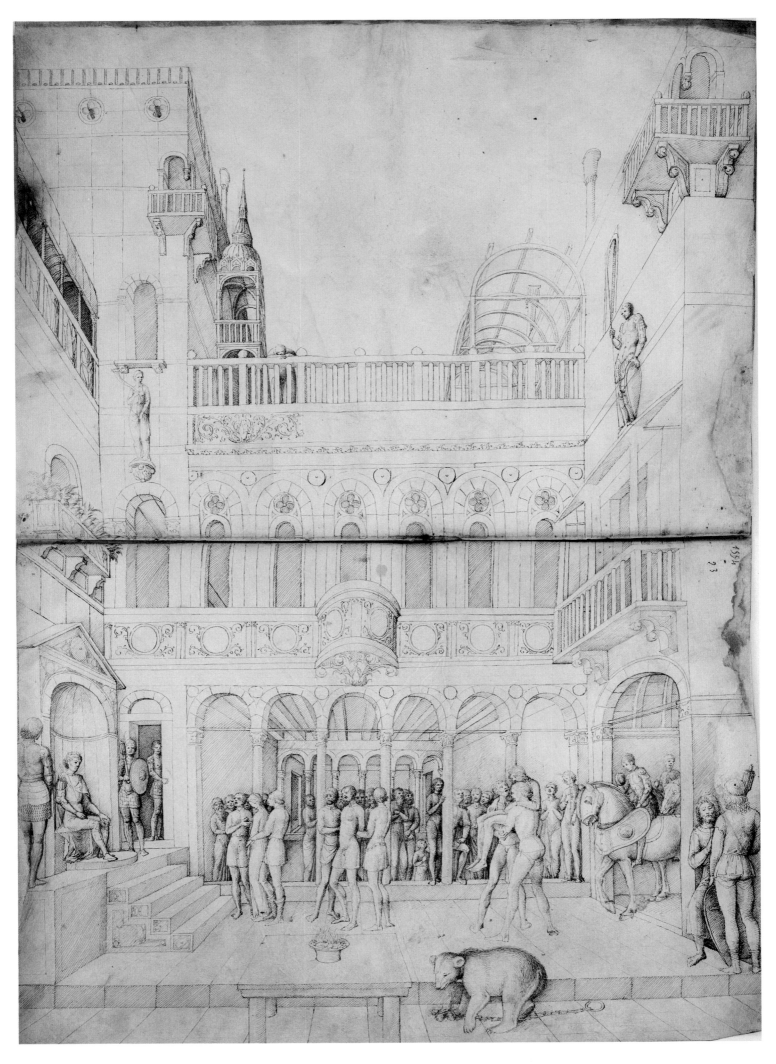

Plates 155/156. *Susanna and the Elders Brought before Daniel.* Louvre 92v, 93

Ghiberti's small gilded bronze *Samson* in a classical style in the border of his second Doors. The Florentine sculptor made several Venetian journeys, one documented in 1424–25, and Jacopo doubtless traveled to Tuscany; drawings or casts could also have brought knowledge of the little figure northward.[30] Venice loved Saint Mark's lion and Samson's leonine strength, seeing herself as heir to both their powers. The proud parents of a future vicar of the Scuola della Carità christened their son Leone Samsone.

David's judicious son Solomon sits enthroned against the side wall of a great triumphal arch bridging the wings of a Venetian palace (Plate 152). A swordsman pretends to divide the baby, whom its two contending mothers have brought to the king for his just decision. The figure reading alone at the far left may be a performer in a Venetian *tableau vivant*, describing this event. The scene's dramatic perspective and visual variety follow Alberti's prescription for a satisfactory narrative rendering, or *historia*. Even the man under the arch at the right, who makes eye contact with the spectator, conforms with the humanist's advice.

The Doge's Palace, where *Solomon's Judgment* is staged, included a prison as well as a court of law, is identified with the wise king by a splendid sculpture of the *Judgment of Solomon*, at the right of the main entrance.[31] Bellini's centralized composition, first drawn to be seen alone, was extended to the left to include a stable that is another reference to Solomon (Plate 54), whose regal love for horseflesh is described in the bible: "[he] gathered together chariots and horsemen: and he had a thousand and four hundred chariots, and twelve thousand horsemen, whom he bestowed in the cities for chariots, and with the king at Jerusalem."[32] The Doge's Palace had a special stable, one of the few in Venice, that quartered a number of horses for the convenience of the doge and distinguished visitors.

The drawing on the following recto page (Plate 32) may represent the Queen of Sheba on her way to pay tribute to Solomon, a frequent subject in mid-fifteenth-century Italy, often reflecting the great councils that met to unite the Eastern and Western churches. The queen personified Byzantium and the wealth and power of the East, Solomon the wisdom and authority of the papacy and monarchies of the West.

Architecturally grander, and closer to the Doge's Palace after Doge Foscari's embellishments, is a vertical two-page composition in the Paris Book of the *Judgment of Solomon*, the diminutive figures deep within a loggia and the stable visible at the right (Plates 153/154). This setting may be based in part on descriptions of Solomon's or Herod's palace in Josephus' *Jewish Wars*, the ancient literary source often used for biblical architecture.[33] The woman looking down from the balcony recalls the one in the *Visitation* mosaic (Fig. 53) of the Mascoli Chapel, its setting often ascribed to Bellini.

An impressive two-page vertical composition has recently been identified as *Susanna and the Elders before Daniel* (Plates 155/156).[34] A popular subject for renaissance judgment chambers, this drawing may reflect a project of Jacopo's for a courtroom, possibly in the Doge's Palace. Typically Venetian is the young prophet Daniel cast as a military figure, surrounded by warriors. Even the horse reflects the joust, wearing the protective covering unique to that knightly sport. Closely identified with the Chosen People, Venice was particularly drawn to Susanna's story with its rich mix of the erotic, didactic, and above all of the detective, and a "happy ending" in an operatic courtroom scene.[35] Suspense is still very much in the air in this drawing, Susanna far from sure that justice will be done. Suitably dejected, one bearded elder is carried by his captors, the other walks ahead, held by soldiers. They already have an inkling of their fate—death—for bearing false witness.[36]

## THE NEW TESTAMENT: THE LIVES OF CHRIST AND THE VIRGIN

Before the Reformation, all Christian communities were closely tied to the Virgin; the cathedral or the leading church was usually dedicated to her. The Serenissima's link with Mary was unusually intimate. The city believed herself to be founded on the feast of the Annunciation, the day celebrating Christ's incarnation, but the myth of Venice as a Marian sanctuary went deeper: floating in the lagoon and immune from attack, she was the virginal city, inviolate. In the *pro duce*, a prayer for the doge, the Republic emerges as *Venetia aeterna*, created by God in all her perfection for eternity, the civic surrogate for Divine Wisdom.[37]

Jacopo's Books, his Brescia *Annunciation* Altar (Fig. 18), the Mascoli Chapel mosaics (Figs. 53, 54), and his *Madonnas* give many clues to how his cycles of the Life of the Virgin must have looked, as do paintings by Giovanni Francesco da Rimini, a follower who

30 The Krautheimers (1956, II, 349, n. 53) describe a Samson "remarkably close to Ghiberti's . . . drawn by Jacopo Bellini." Bellini may have gone directly to the same antique source that probably inspired Ghiberti, a small bronze owned by Cardinal Pietro Barbo—known as the "Cardinal of Venice"—the future Pope Paul II.

31 Giorgione is known to have made a painting of this subject for the judgment chamber of the Doge's Palace about 1506. Also about 1506, Dürer copied a late Quattrocento composition of the theme in a drawing where the spatial construction, though not like Bellini's drawing of the subject, resembles many of his studies in its stagelike presentation of a *cortile* viewed fairly close up, with a row of witnesses in the foreground seen from the back. See W. L. Strauss, *The Complete Drawings of Albrecht Dürer*, New York: 1974, II, 1506/43, 970–71.

32 1 Kings 10:26.

33 Borgo, 1979, 550.

34 Degenhart and Schmitt, 1984, 27.

35 Wolters, 1976, I, 116–17; II, figs. 813–21, 823. See also C. Eisler, "Rembrandt and Bathsheba," *Essays in Northern European Art Presented to Egbert Haverkamp-Begemann on His Sixtieth Birthday*, Doornspijk: 1983.

36 Daniel 13:61–62.

37 See Sinding-Larsen, 1974, esp. 144 ff. See also Rosand, 1982, 327, n. 140.

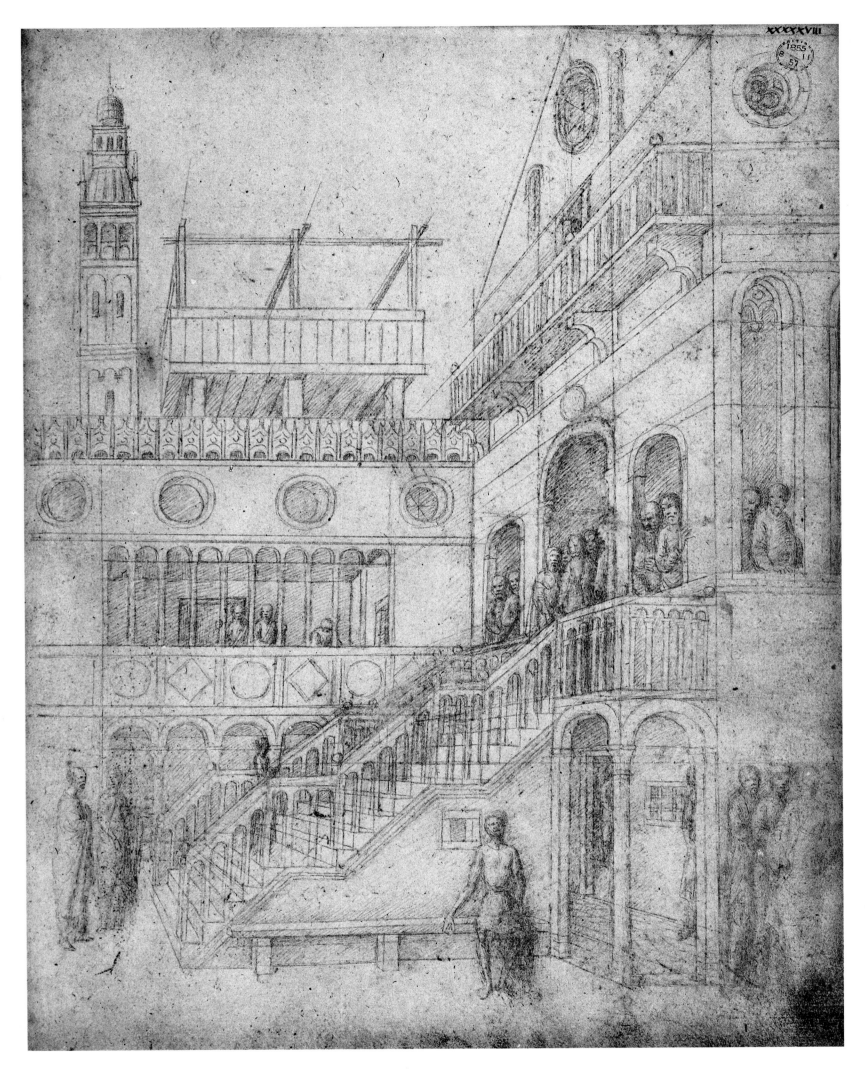

Plate 157. *Presentation of the Virgin in the Temple* (A). British Museum 58

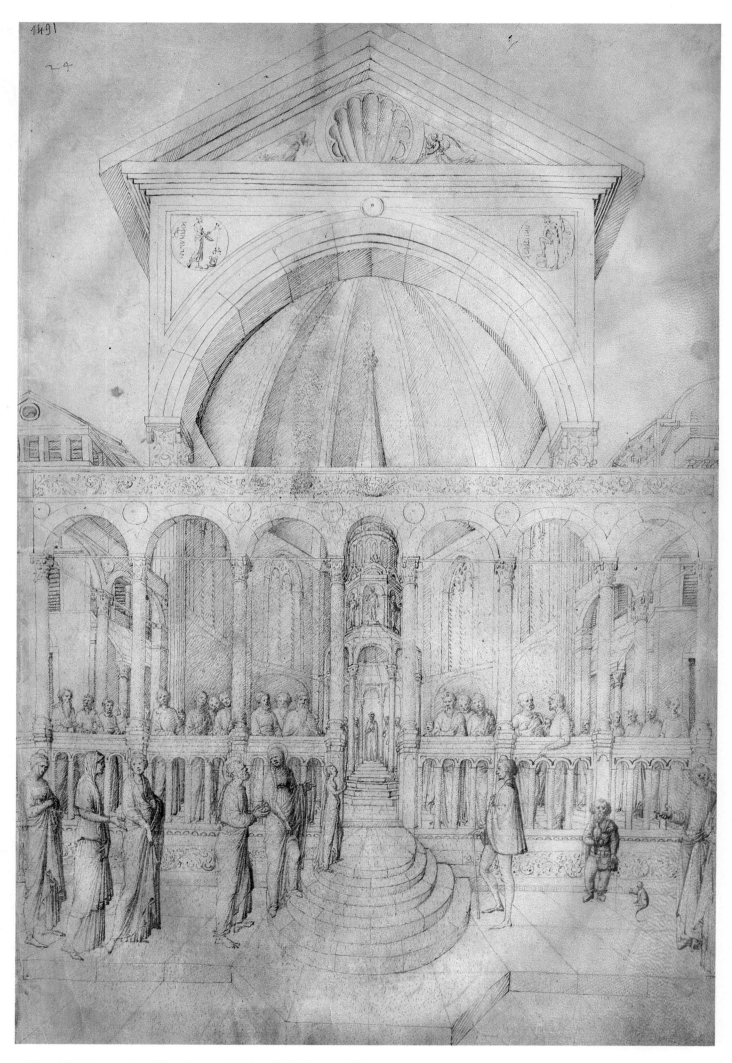

Plate 158. *Presentation of the Virgin in the Temple* (A). Louvre 24

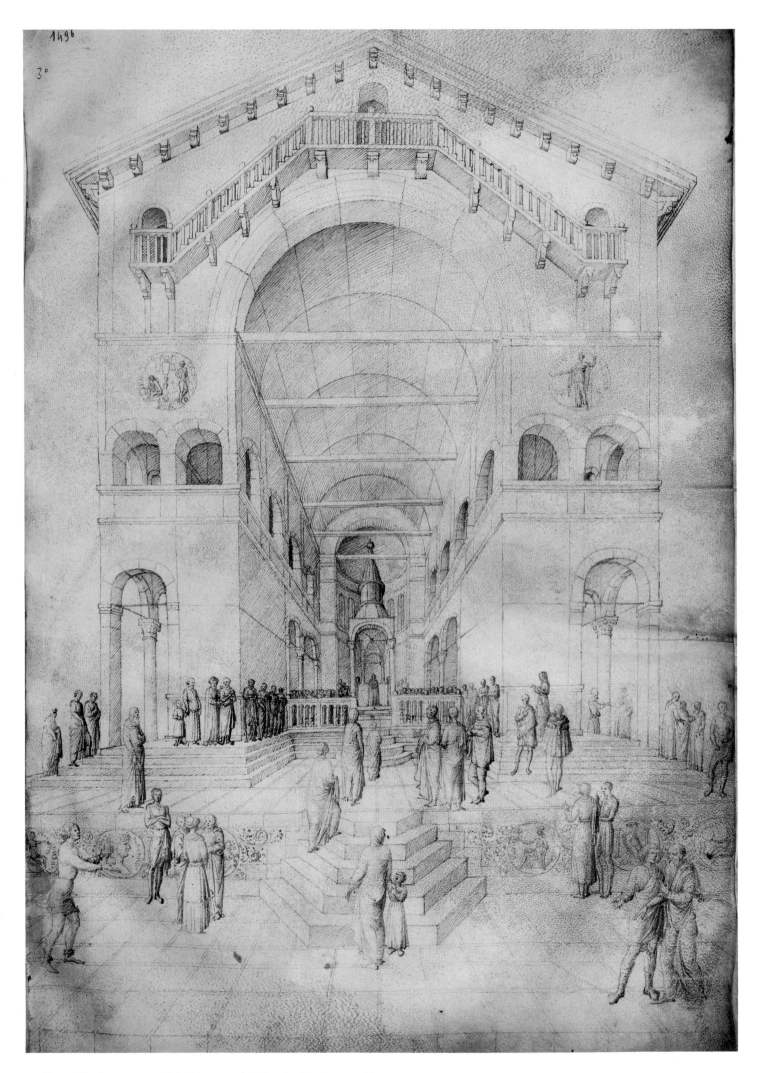

Plate 159. *Presentation of the Virgin in the Temple* (B). Louvre 30

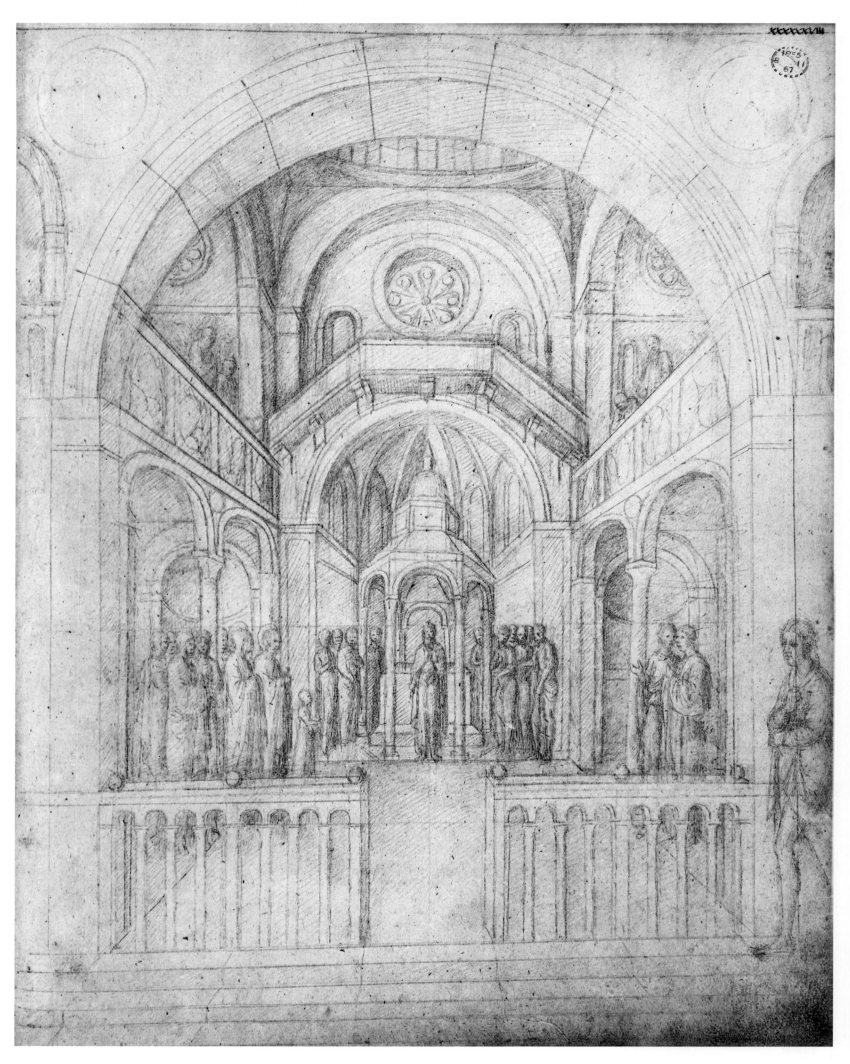

Plate 160. *Presentation of the Virgin in the Temple* (B). British Museum 68

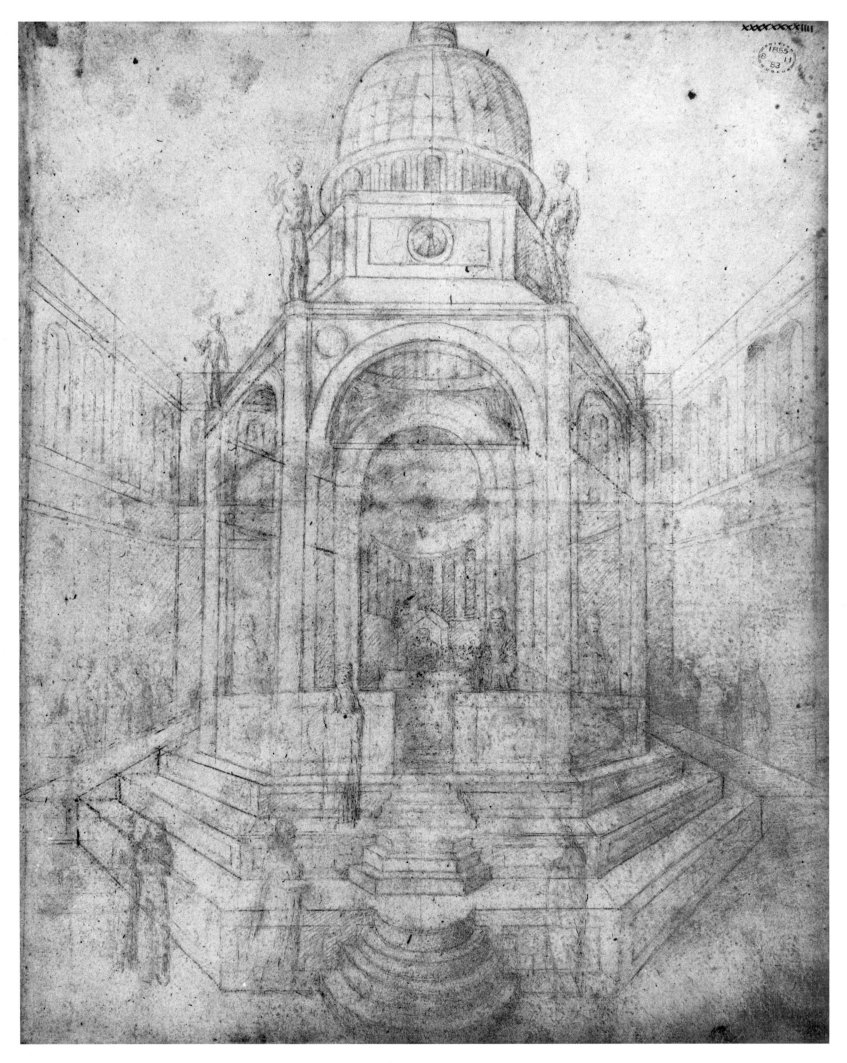

Plate 161. *Temple of Jerusalem(?)*. British Museum 84

entered the Paduan painters' guild in 1441–42: his horizontal *Nativity* (Paris, Louvre) and a Marian cycle of vertical panels (Paris, Louvre; Columbia, Miss., Museum of Art).[38] Another key to Jacopo's lost works is in an altarpiece from the later 1450s, possibly by the young Giovanni Bellini, a series of sixteen little scenes that have been dismembered since it was first published in 1946.[39] More important evidence for Jacopo's missing Marian subjects may be those by Jean Fouquet, who took over many aspects of the Venetian master's art.

The *Meeting at the Golden Gate*. Genre elements in Bellini's canvas (England, Collection Lord Oxford) of the meeting of the future parents of the Virgin, made for the Scuola di San Giovanni Evangelista, are closest to the London Book's. The background of Dürer's woodcut in the Life of the Virgin series may be based upon another *Meeting* by Jacopo.[40]

The *Birth of the Virgin*. Close to Eastern Christianity, the Republic followed Byzantine practice in emphasizing Mary's early years. Bellini probably designed her *Birth* for the Brescia predella (Fig. 20), painted by his workshop in the early 1440s, and he also drafted the Turin canvas (Fig. 27) for the Scuola di San Giovanni Evangelista cycle. Both paintings stress the prosperous house of Joachim and Anna, richly encrusted outside with colored marbles, the inside lavishly draped.

The *Presentation of the Virgin in the Temple*. Drawn in the Books four or five times, this subject is important as first identifying Mary with Ecclesia, with the temple, forerunner of the Church. Long a central subject for Christian devotion, the Virgin's Presentation was made a feast to be celebrated throughout the Church in 1472. Several churches in Venice were especially devoted to the Presentation,[41] and Jacopo's drawings show this new concern. His Scuola di San Giovanni Evangelista had been the beneficiary of a French medieval religious drama on the Presentation by the same donor who gave the confraternity a fragment of the True Cross in 1369.[42]

A London page (Plate 157) reflects Jacopo's Brescia *Presentation* (Fig. 21). Joachim and Anna wait at the foot of a great staircase while their three-year-old daughter climbs up the fifteen steps alone to be received by the rabbis. Solomon's Temple (with other major buildings of Jerusalem) is represented on many pages in terms of the Doge's Palace and Doge's Chapel. Jacopo's composition proved extremely influential; it must have been prominently displayed, for such later masters as Carpaccio and Titian knew it well, their *Presentations* shown from much the same vantage point, steps seen from the side, with similar bits of local color.[43]

Bellini's favorite compositional formula, the triumphal arch, frames a very different *Presentation* (Plate 160) within a Venetian Romanesque church that has a few Gothic features, such as the vaulting over the ciborium. The central dome with galleries recalls San Marco, but this is sacred architecture of fantasy rather than fact, and could as well relate to the set for a mystery play. The large figure in the left foreground may be describing the action within.

In two more elaborate *Presentations* in the Paris Book, figures are smaller in scale, the scenes almost in bird's-eye view (Plates 158, 159). Antique elements are prominent, roundels derived from Roman coins decorating both temple façades. The vanishing point in each scene is at the most sacred spot, the altar, where the high priest beneath a great ciborium awaits the Virgin. A London study of a church (Plate 161) may be another *Presentation of the Virgin*, her figure perhaps among those scarcely visible at the lower right corner.

The festive fusion of Gothic, Romanesque, and classical in the Paris *Presentation* (Plate 158) suggests another fashionable caprice of theatrical design. A dwarf with a falcon, a monkey at his side, provides the sort of courtly diversion Bellini learned from Gentile da Fabriano.[44] Joachim holds a sacrificial offering of turtledoves.

*Mary Weaving the Temple Curtains*. Jacopo included this rare subject in his cycle for the Scuola di San Giovanni Evangelista, completed in 1465, but his composition is no longer known. The Virgin's holy labors in the synagogue were her girlhood preparation for her role as mother of Christ and personification of the Church. The temple curtains were torn at the moment of Christ's death.

The *Annunciation*. Jacopo's earliest and most conservative representation is his Brescia *Annunciation* Altar (Fig. 19). His graphic *Annunciations* stress space over person, as if the world rather than the Virgin were the first beneficiary of the angelic messengers—theologically the correct view, but the Venetian theater of faith, not dogma, dictated Bellini's

38 See Padovani, 1971, 4, 7, who related fols. 57v and 58 of the London Book as sources for the cycle painted by Giovanni Francesco da Rimini. She cites the *Nativity* and *Presentation of the Virgin* (both Paris, Louvre) as based upon Jacopo.

39 Longhi, *Viatico*, 1946, pl. 45, ascribed it to Antonio Vivarini. Sixteen Passion subjects surround the *Nativity with Sts. Clare and Nicholas* (this now Bergamo, private collection). Immediately above and below the horizontal *Nativity* are four scenes from the lives of saints. Pallucchini, *Bellini*, Milan: 1959, 12, ascribed the altar frontal to Giovanni Bellini, reproducing the *Nativity* as his fig. 6. Among other Venetian Marian cycles that relate to Jacopo's mid-century style is a somewhat Vivarinesque altar with six scenes from the Life of the Virgin (Berlin, Dahlem Museum); see Van Marle, XVII, 43, fig. 21.

40 Tietze and Tietze-Conrat, 1928, no. 259. Carpaccio used Dürer's woodcut for his depiction of the *Meeting* (Venice, Accademia), perhaps only because it was a version of an earlier Venetian composition.

41 Rosand, 1982, 85–144 and n. 107.

42 The drama has been translated into English. See R. S. Haller (trans. and ed.), P. de Mezière's *The Presentation Play*, Lincoln, Neb.: 1971; see also D. Rosand, "Titian's *Presentation of the Virgin in the Temple* and the Scuola della Carità," *Art Bulletin*, 58 (1976), 71.

43 Rosand, 1976, 71.

44 Found also at Sant' Egidio in Santa Maria Nuova. See Ames-Lewis, "Domenico Veneziano and the Medici," *Jahrbuch der Berliner Museen*, XXI (1979), 67–90; and H. Wohl, *The Paintings of Domenico Veneziano*, New York: 1980.

interpretation. Placed in settings unique to the Serenissima, the artist's *Annunciations* identify Venice with the Incarnation, the Republic supposedly founded at noon on Annunciation Day, March 25th, 421 A.D.

Many mystery plays dramatized the angel's tidings brought to Mary, that momentous encounter of heaven and earth that launched the cycle of salvation. Artists all over Italy devised sets and machinery for staging the Annunciation so that the angel could descend from heaven and rise again. Performed in Venice since the 1340s, Annunciation plays may have specially interested Bellini, for Paolo Veneziano, then the city's leading painter, designed its first setting.[45] The Annunciation was linked with the lavish expanse of Venetian domestic buildings, its wealth of loggias, arched windows, courtyards, handsome wellheads, and beautiful small gardens. These elements worked successfully with symbolical images of the Heavenly Jerusalem and with many emblems of Marian purity, such as the closed garden, the wellhead, the window, and the closed portal. Peacocks belong at the Annunciation because they refer to the incorruptibility of the Virgin's body (Saint Augustine, *City of God*, XII, 4) that allowed her corporeal ascent to heaven in the Assumption.

The main reason for this residential splendor is that Christ in this moment takes on physical being within the Virgin and thus the Church terrestrial is founded, its splendors mirroring those of heaven. Many regal attributes are seen, such as the lion lying in almost heraldic hauteur on the stone table at the far left (Plate 162). Mary's bed in an open alcove, the *thalamus virginis*, is close to the loggia traversed by the single ray of the Holy Ghost (Plates 162, 163).

Still grander than these two leadpoint studies in the London Book is the two-page *Annunciation* in the Paris Book (Plates 164/165); Mary, no longer kneeling but still holding her prayer book, here turns away from the angel. Her vast palace includes a triumphal entryway and a fenced pit for wild animals, and a bell tower near another palace in the distance.[46] Jacopo's canvas of this theme for his Scuola di San Giovanni Evangelista series, from the 1460s, is probably the painting now in Turin (Fig. 29), the Archangel Gabriel wearing liturgical vestments with crossed stola.

All three palaces show features from the local Gothic as well as Florentine renaissance architecture; those strange square windows in one of the top stories are perhaps Brunelleschian. The overall effect, however, with arcades, small columns, balconies, and decorative roundels, is pure Venetian.

Bellini has turned the Paris Book to combine two folios into one vertical composition. Though self-described as a handmaiden at the moment of her selection, this Virgin is clearly waited on hand and foot, one servant approaching with a classical amphora balanced upon her head. God the Father surrounded by eight incomplete clusters of cherubim, the Holy Ghost on a ray, and peacocks on the ground below are here drawn with less certainty than the other figures. The ray of light supposedly directing the dove toward the Virgin is strangely miscalculated to terminate on the bedroom floor rather than on her body. Like many of the intricately staged Paris drawings, the relatively empty foreground of the *Annunciation* enhances the sense of event, lending telescopic intensity to the small main group and the diminutive figures in the background.[47]

The lunette of a late triptych from Jacopo's studio (Fig. 66) contains an *Annunciation* whose classical Gabriel incorporates Tuscan features.

*The Visitation.* Bellini treats this theme in the early 1440s in the predella of the Brescia *Annunciation* Altar (Fig. 22), painted by his studio assistants. The little footbridge at lower right reappears in many drawings to become practically Jacopo's signature. A *Visitation* in mosaic for the Mascoli Chapel (Fig. 53), dating near mid-century, shows the same subject in his later manner. In the San Giovanni Evangelista series, finished in 1465, the *Visitation* (England, Collection Lord Oxford) includes a third woman, and a beautiful landscape that recalls those in the London Book.

*The Marriage of the Virgin.* An idea of Jacopo's elaborate architectural setting for the Marriage of the Virgin, though lost, is provided by a mid-fifteenth-century manuscript illumination in Jean Fouquet's *Hours of Etienne Chevalier* (Chantilly, Musée Condé; Fig. 26). That French master knew Bellini's art, and his illumination incorporates a great triumphal arch close to the Venetian's concept. A similar *Visitation* composition by Jacopo is reflected in one by his son Giovanni (Florence, Collection Contini-Bonacossi), dated near to the Carità Triptychs of 1460–64. A late canvas of this subject from Jacopo's studio for the Scuola di San Giovanni Evangelista is probably identical with the painting now in the Prado, Madrid (Fig. 28).[48]

45 Muraro, 1970, 83.

46 All three compositions may relate to Uccello's lost *Annunciation* frescoed for a Florentine church. That master was active in Venice, and copies could have been made there of his drawings.

47 Goloubew recognized in the background the design of the Este's Venetian palace, the Fondaco dei Turchi.

48 This subject, if painted by Jacopo, might have resembled the composition of a Venetian mid-15th-century altar frontal reproduced by Testi (1915, II, 404, Berlin no. 1058). The foreshortened suitor on the left breaking his rod suggests the sort of precocious Tuscan influence first evident in the Veneto in Jacopo's art.

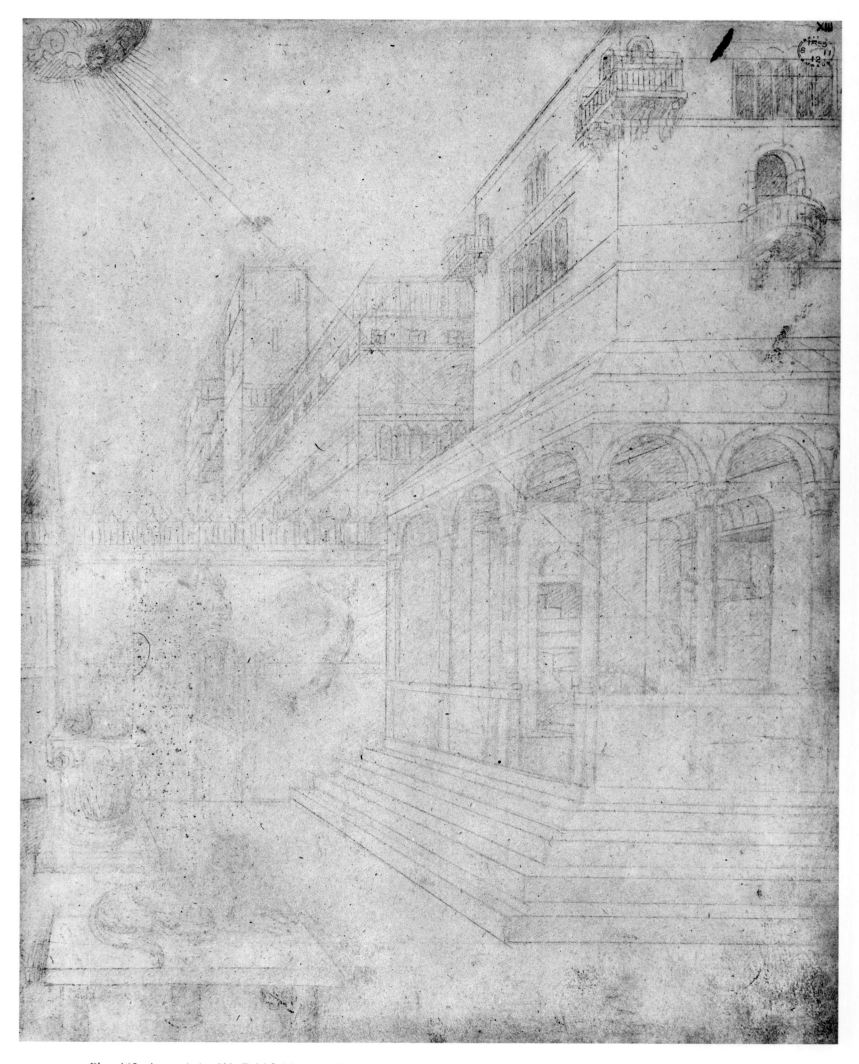

Plate 162. *Annunciation* (A). British Museum 13

294

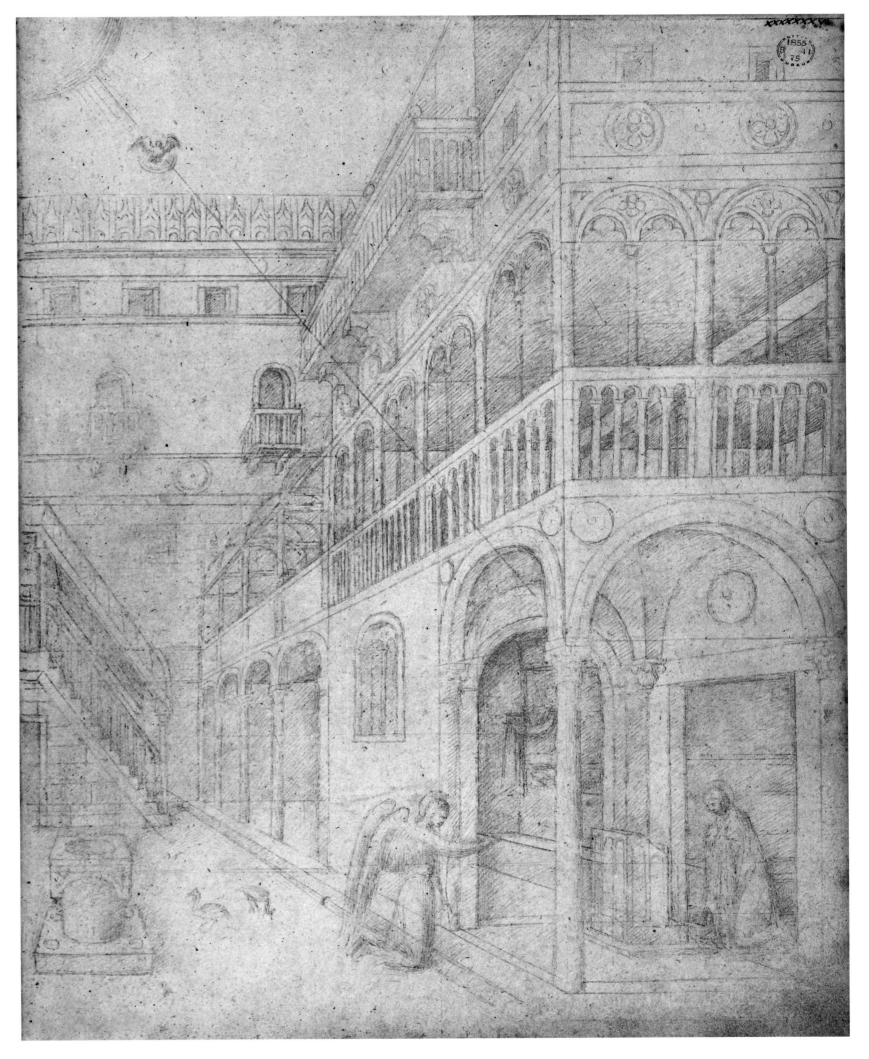

Plate 163. *Annunciation* (B). British Museum 76

Plates 164/165. *Annunciation*. Louvre 30v, 31

*The Mother of Us All.* Almost Oriental in her majestic serenity, this standing Virgin holding her baby embodies an extraordinary confluence of styles and sources that only Venice could then provide (Plate 138).[49] MATER OMNIUM, in Gothic letters at left and right of her crowned and haloed head, bespeaks Mary as the Mother of Us All. This characterization of the Virgin is central to Catholic faith, yet it is rarely written near her image.[50] The term *Mater Omnium* has a ring of biblical authority, but it first occurs in Saint Augustine's *City of God* (XV, 2): "Jerusalem which is above, . . . The Mother of us all."

Mary's sad smile and enlightened resignation portends her role as *Mater Dolorosa*; the crown proclaims her glorious *finale* as eternal Queen of Heaven.[51] Angels garbed as celebrants of the high mass play a lute and a viol, sounding a harmony and concord between heaven and earth. Sacramental service is implied by Mary's formal frontality as she holds up her child in a gesture related to the elevation of the Host and the concept of the priesthood of the Virgin; her crossed arms foreshadow the Crucifixion. The infant points to his lips, also a gesture with eucharistic overtones but associated primarily with the *Nutrix Omnium*,[52] his mother nursing all humanity. The angels, a reduced liturgical choir, sing in the mass of the Church and in the eternal mass of Christ.

Full-length *Madonnas* are rare in paintings, appearing more frequently in sculpture. Bellini's *Mater Omnium* is close to the most popular image of the International Style, the so-called Beautiful Madonna who often wears a bridal crown. Her pose, as if presenting the infant, may pertain to the type of Byzantine Madonna known as the *Hodegetria*, the mother holding the child on one arm in the pose Saint Luke was believed to have invented. The music-making angels lend their late medieval Northern connections to the page, recalling those painted by Robert Campin, similarly placed. Vases at the far left and right may originally have been meant for lilies, a Marian attribute, the flowers here omitted to give the angels more room. Mary's tall proportions suggest Romanesque and Byzantine sources, predating the Gothic tradition.

*Madonnieri*, that disapproving term for painters who turned out repetitive images of the Mother and Child, has some meaning for almost every early Catholic painter. Of Jacopo's surviving paintings and those from his studio, about half are of this subject—and he must have painted many, many more. Only three are signed or bear his name in old inscriptions (Figs. 38, 40, 42); Bellini's earliest *Madonnas* (Figs. 19, 31, 32) are so close to his teacher's style that they were long attributed to Gentile da Fabriano. In two, both *Madonnas of Humility*, she is seated on the ground (Figs. 31, 33), and in the third she is enthroned (Fig. 32), the child playing with a goldfinch perched on her wrist, the bird symbolizing Christ's soul and sacrifice, prepared for death and for ascent into heaven. A fourth (Fig. 38), Jacopo's sole signed *Madonna*, shows the regal mother supporting her son as he stands on a ledge. In all of these paintings, together with a life-size image (Fig. 35) and the Paris Book's *Mater Omnium*, the infant is nude to stress his sacrificial, redemptive, sinless nature.

Traces of an iconic spirit in Bellini's *Madonnas* recall their origin in the half-length, ancient images of the Mother and Child popularly ascribed to Saint Luke.[53] All Christian artists saw themselves as followers of Saint Luke, long believed to have been a painter as well as a physician; a *Hodegetria* icon at San Marco was worshiped as by his hand, and Venice treasured its relic of Saint Luke's right arm. Because the evangelist was so concerned with vivid, eyewitness narrative, his gospel is especially intimate and direct, with keen concern for the Virgin's experiences and emotions as annunciate and mother. His lively style led to the belief that he had portrayed her in art as well as word.

Saint Luke as a painter first makes his appearance in the West in Venice, site of Italy's earliest painters' guild, these often named for the artist/evangelist. Jacopo's almost Mantegnesque *Madonna* (Fig. 41) was also painted with Saint Luke in mind, for the reddish-orange roundels at upper left and right contain the two first and two last Greek letters of the words for Mother of God. The Byzantine *Glykophilousa* formula used here (the loving mother and son shown cheek-to-cheek) was seen as related to Luke's own icon. The evangelist holds just such a little picture of a *Madonna and Child*, turned left, in the great altarpiece painted by Giovanni d'Alemagna and Antonio Vivarini for San Pantaleone in Venice in 1444. In Bellini's Los Angeles panel Christ embraces Mary, but she combines her caress with supporting him at shoulder and leg. Her drapery accentuates her breast with an elegant physicality that goes back to Florentine fashions of the 1430s as defined by Donatello. This *Madonna* is in the style that Bellini probably perfected in the 1450s, when he may have drafted the magnificent *Mater Omnium* (Plate 138).

The child in all of Bellini's other *Madonnas* wears a rich garb that often recalls his future role as priest, offering himself as the sacrament. Popular in the Eastern Christian

49 The standing *Madonna* by Niccolò di Pietro was once in the church of Santa Maria dei Miracoli; Jacopo must have known this unusual format. This work was ordered c. 1409 by the patron who gave Gentile da Fabriano his first Venetian commission in 1408. Another *Madonna* by Niccolò di Pietro (Cambridge, Mass., Fogg Art Museum) has similar music-making angels. The Tietzes (1944, 113) rightly compared the *Mater Omnium* to Bartolomeo Bon's sculptured *Madonna* for the courthouse at Udine, though that is a stodgier, coarser figure.

50 In a *Madonna of Humility* by a follower of Simone Martini the same legend accompanies Mary, who is seated on the ground though invested with the glorious attributes of the Woman of the Apocalypse (Naples, San Domenico Maggiore). See M. Meiss, *Painting in Florence and Siena after the Black Death*, Princeton: 1951, 132–36.

51 The message of Mary as Mother of Grace is often conveyed in art by small-scale images of mankind sheltered in her mantle, as in the relief by Bartolomeo Bon (London, Victoria and Albert Museum) for the Scuola della Carità.

52 See D. Shorr, *The Christ Child in Devotional Images in Italy during the XIV Century*, New York: 1954, 146. For the angelic concept and the role of music in the Heavenly Liturgy, see *Lexikon der Christlichen Ikonographie*, "Liturgie, Himmlische," III, cols. 103–6. See also E. Winternitz, *Musical Instruments and Their Symbolism in Western Art*, London: 1967.

53 See Goffen, 1975, 492, 505 ff. St. Luke's images are all half-length *Madonnas*.

church, this theme reflects the proximity of Venice to Byzantium. In an image dated "1448" the dressed child, held by a crowned Madonna, makes a gesture of benediction in his role as future savior (Fig. 40). Close in date are two *Madonnas* showing influences from Florence and the North, notably in the clusters of cherubim in the background (Figs. 39, 42). The *Madonna* (Fig. 36) in Gazzada is inscribed *regina celorum*, Queen of Heaven, and appropriately she wears a crown. Similar to the standing *Mater Omnium* (Plate 138) is an exquisite, half-length *Madonna and Child* (Fig. 43). Two of the least formal groups show the dressed child as an unusually lively baby; in one he chucks his mother's chin and seems to squirm in her lap (Fig. 37).

Variety is the keynote of Jacopo's Marian compositions; for artistic and devotional purposes, almost every painting is different in approach. The humblest formula attracted Bellini's wealthiest patron, if its kneeling donor is Lionello d'Este. Paradoxically yet predictably, Lionello (heir apparent to the marquisate of Ferrara) or his father Niccolò chose to show Lionello dwarfed by Mary, who kneels close to the earth as her standing infant savior blesses him (Fig. 31).

A standing *Madonna and Child* at the center of a late triptych from Jacopo's studio (Fig. 64) continues the manner of the *Mater Omnium* but with new Tuscan currents; the half-length *Madonna and Child* is in the lunette of another triptych; both were for the Carità (Fig. 65).

*The Nativity.* Three complex studies for the construction of the Nativity's rustic shed in the London Book (Plates 166, 167, 169) illustrate the artist's concern with the pictorial science of perspective. His designs for Jesus' humble home may also be charged with symbolic significance, the cruciform building elements, concealed yet omnipresent, referring at Christ's very birth to the end of his life on earth. Uccello, best known of Quattrocento perspectivists, first developed this theme, the cross included in the *Nativity* as a meditation on the Passion, in a fresco recently rediscovered in Bologna (San Pietro Maggiore), by himself or a close follower, its date in the early 1430s.[54] A foreshortened circular band at the top of Bellini's first London *Nativity* (Plate 166) may represent the ring of an oculus, or round window,[55] the composition planned to fit the space below it. Lying on the ground, the infant is warmed by the breath of ox and ass as described in the *Golden Legend*. The shepherd's adoration conveys the Jews' recognition of the birth of Christ, just as the Magi's adoration on the left facing page (Plate 168) of another *Nativity* (Plate 169) is the Gentiles'. (The arches in the second London *Nativity*, Plate 167, are due to re-inking from the other side, Plate 235). Inked by a later hand, the rustic architecture in the third London *Nativity* overwhelms the slight figures below (Plate 169), but traces of the original guidelines still show Bellini's use of mathematical principles in building space. First an independent vertical composition, this page was converted into an *Adoration of the Magi* by adding the kings and their retinue slightly later on the facing page (Plate 168).

Joseph's sleep in the Paris Book's *Adoration of the Shepherds* (Plate 170) may refer to his dream of an angel warning him to escape Herod's massacre of the innocents by fleeing with his family to refuge in Egypt. Among Bellini's most beautiful drawings, this composition is close to Uccello's frescoed *Nativity* in San Martino della Scala in Florence, known to Bellini from Uccello's drawing books if not from the painting itself, today poorly preserved. The eagle on the roof, unusual in a Nativity but appearing in the two London compositions as well (Plates 167, 169), may refer to a noble (Este?) patron or to Saint John the Evangelist; for his scuola, Bellini's own, the artist made a painting of this subject, now lost. A *Nativity* is compressed into the central section of a late triptych (Fig. 63) from Jacopo's studio, its composition drawn from Jacopo's Books and from other Venetian works of the 1440s, with some Tuscan elements.

*The Circumcision.* No examples survive of this theme (first Sorrow of the Virgin); clues to the composition as drawn in the style of the Paris Book are found in the *Presentation* (Plate 179), and in the *Circumcision* painted by Jacopo's son-in-law, Mantegna (Florence, Uffizi).[56]

*The Adoration of the Magi.* Power tends to be a conservative force, making even very advanced renaissance masters return to Gothic models for the Magi's Adoration. As this subject records the cosmic recognition of Christ by the world's three kings on his thirteenth day of life, each Magus represents one of the three continents then known. Camel trains, dwarfs, and gifts of exotic beasts reinforce the universality of the infant's heritage and his absolute authority. Only the intricate perspectival construction of the birth shed (Plate 171) separates Bellini's image from Gentile da Fabriano's *Adoration of the Magi* (Fig. 67), painted perhaps with Jacopo's assistance in the early 1420s.

54 For the Bologna fresco, see Eisler, 1982, 71–75. One of Bellini's *Nativity* constructions (Pl. 139) is opposite a carefully devised setting for a *Vintage* (Pl. 73), close to the theme of the *Infant Bacchanal* and perhaps begun as a *Nativity* composition.

55 See the area used by a follower of Gentile for the Chapels of Sts. Peter and Paul, cathedral of Pordenone. Christiansen, 1982, cat. XXXVI, 125–26, pl. 97.

56 A mid-15th-century Venetian painting in the Louvre of the *Circumcision* gives some idea of Bellini's probable treatment of the theme. See Testi, 1915, II, 295.

Plate 166. *Nativity* (A). British Museum 64v

300

Plate 167. *Barn*. British Museum 88v

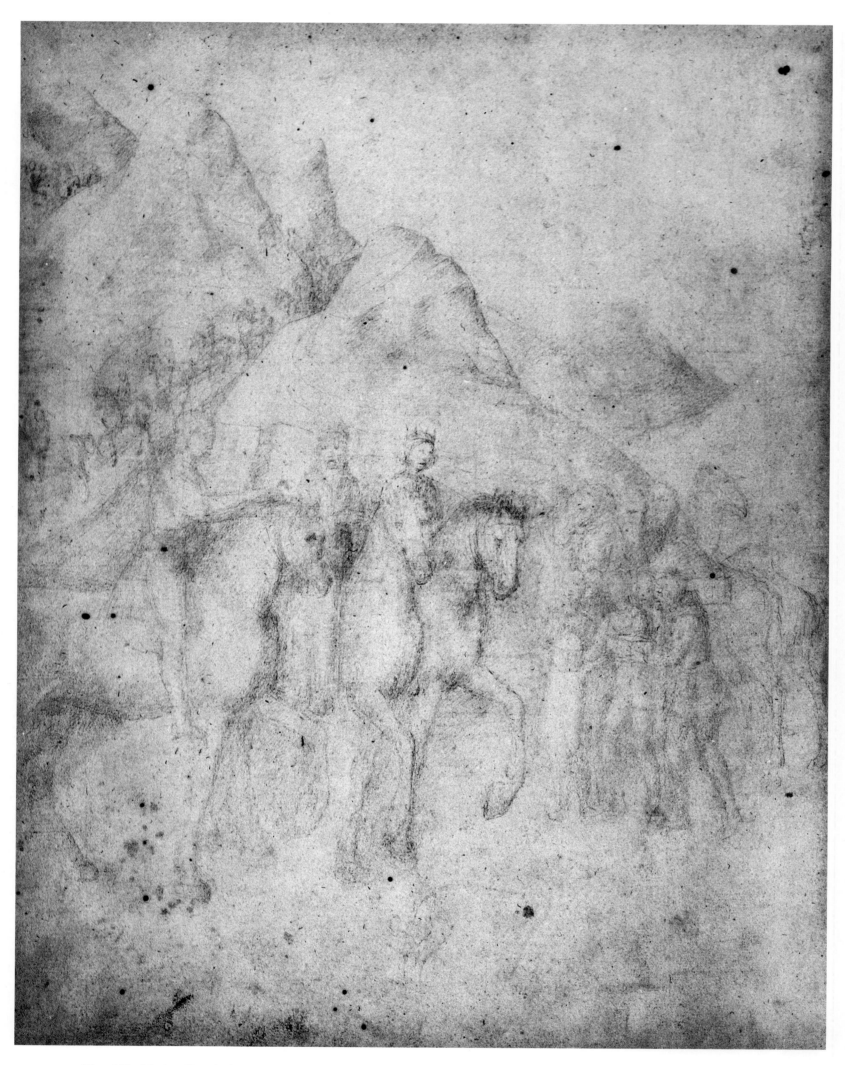

Plate 168. *Magi on Horseback*. British Museum 98v

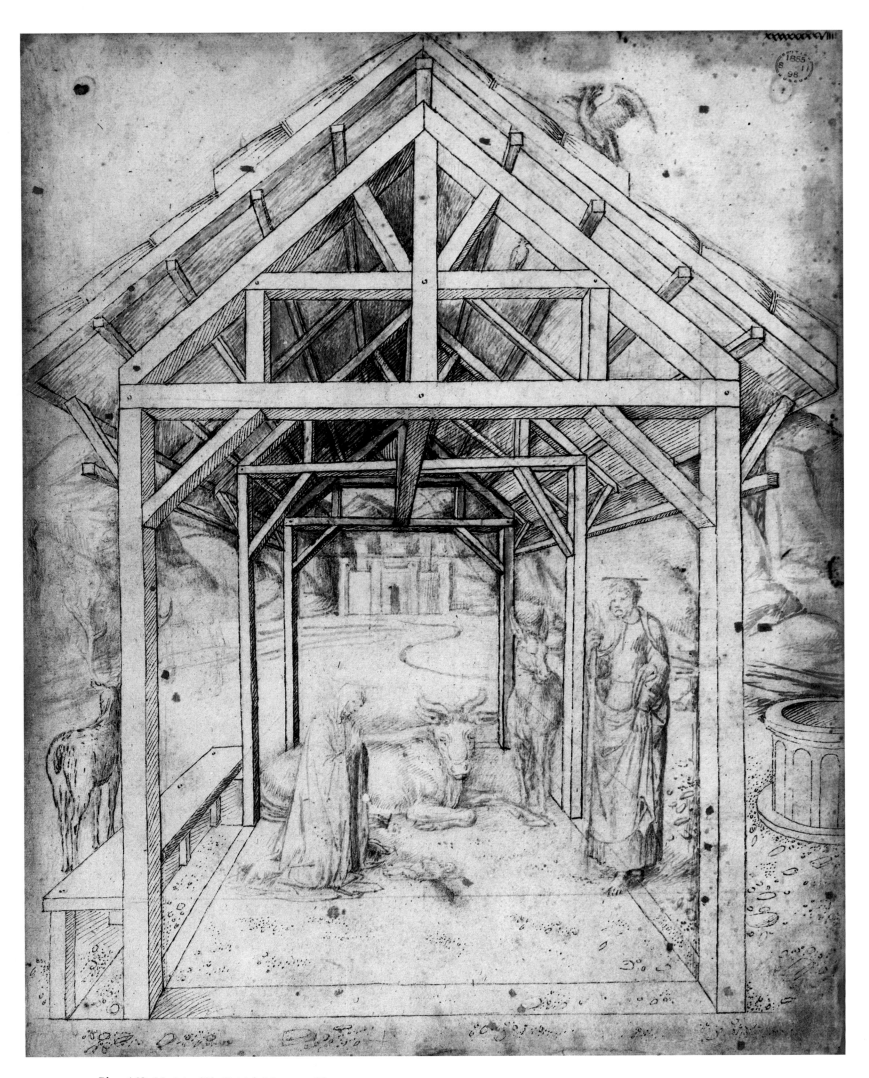

Plate 169. *Nativity* (B). British Museum 99

Plate 170. *Adoration of the Shepherds*. Louvre 37

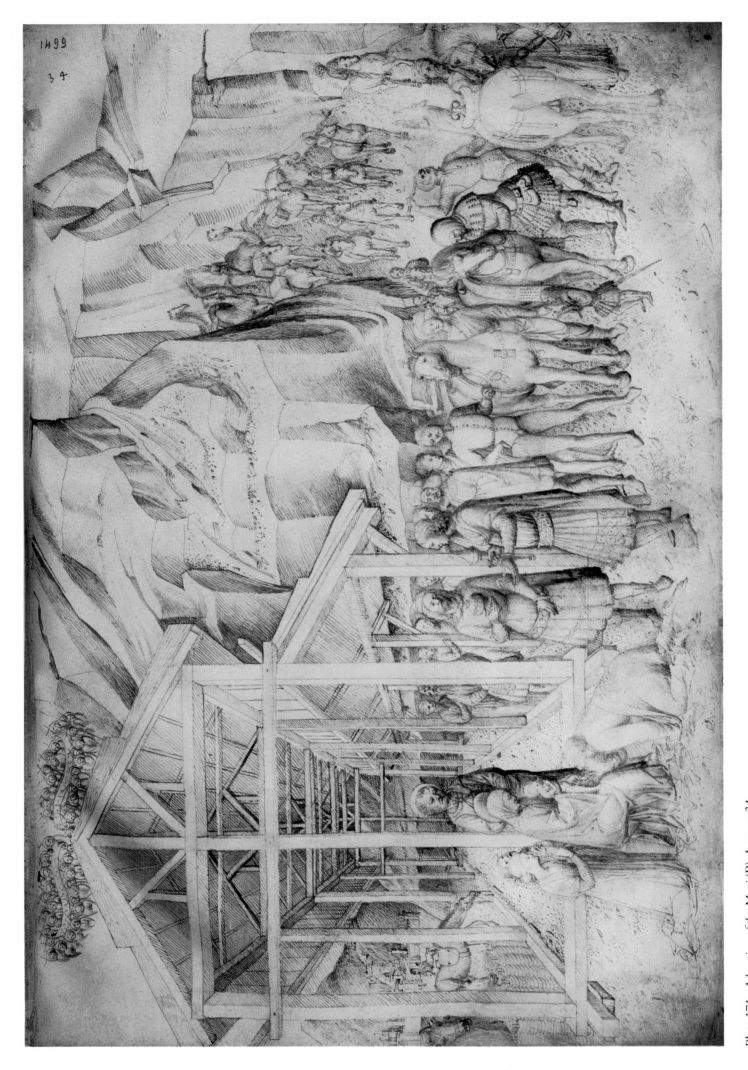

Plate 171. *Adoration of the Magi* (B). Louvre 34

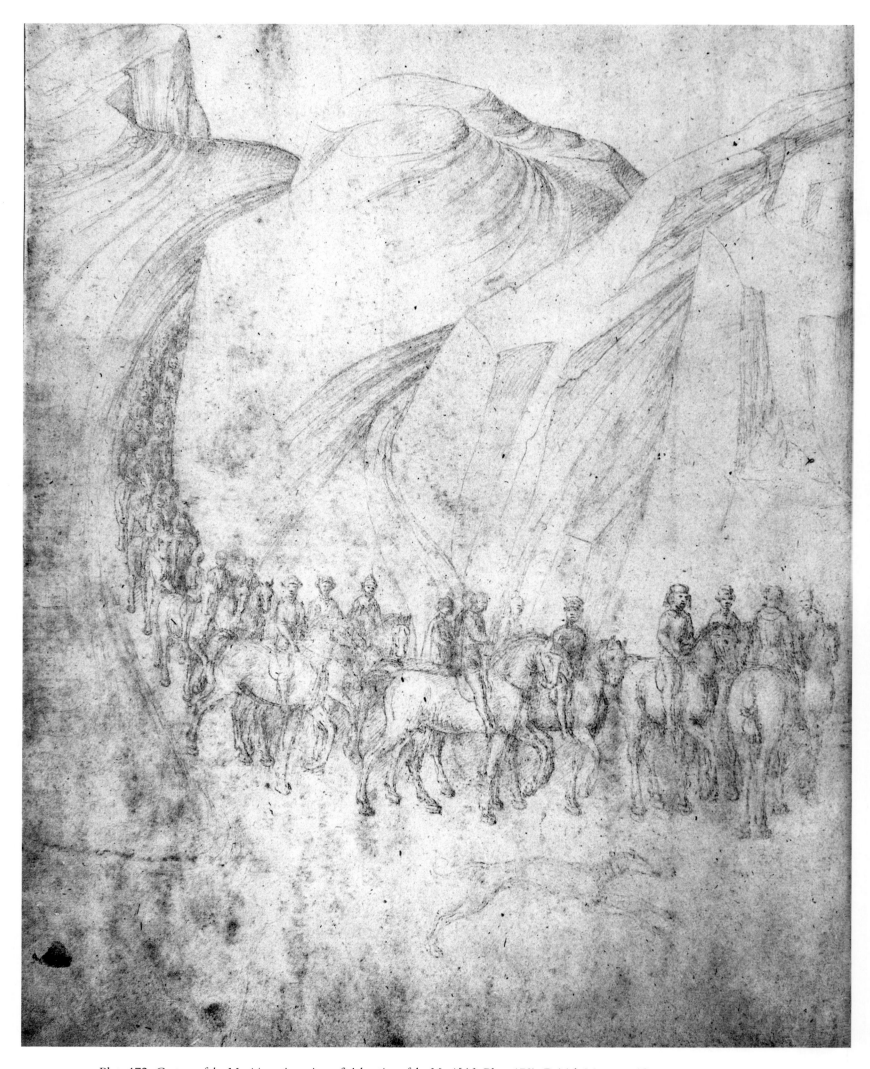

Plate 172. *Cortege of the Magi* (continuation of *Adoration of the Magi* [A], Plate 173). British Museum 18v

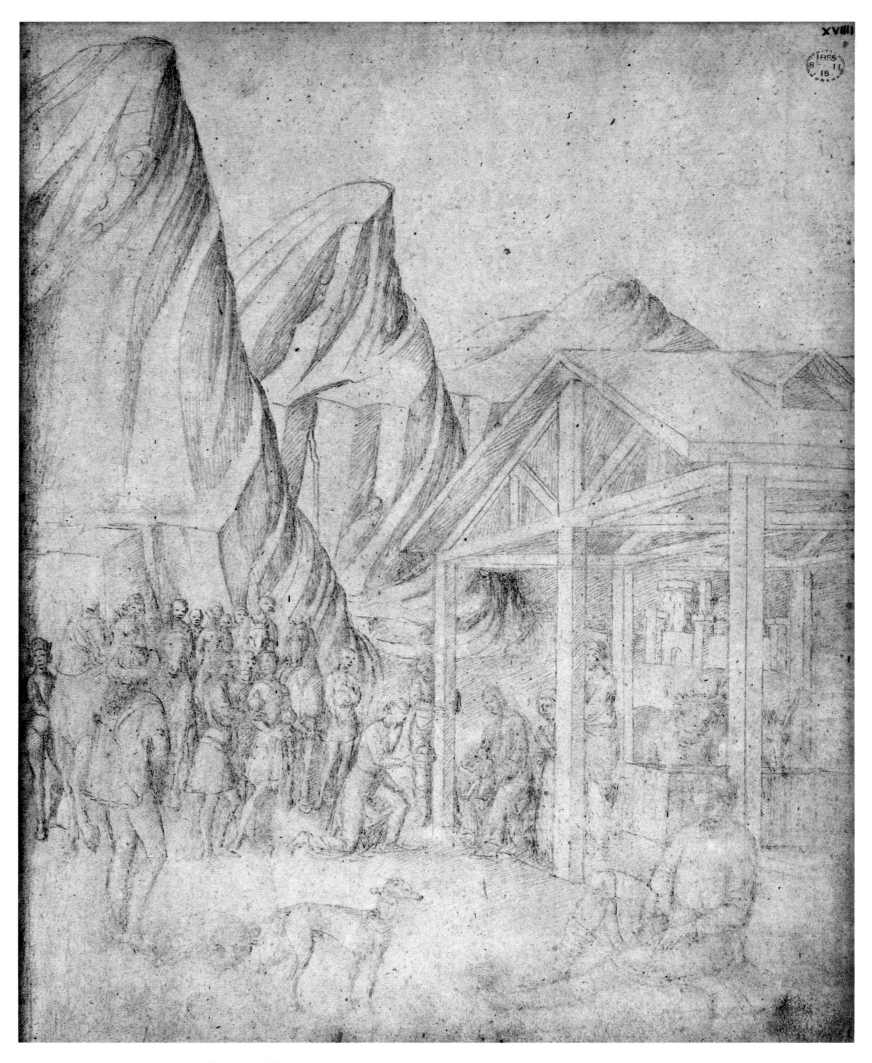

Plate 173. *Adoration of the Magi* (A). British Museum 19

Plates 174/175. *Adoration of the Magi* (A). Louvre 31v, 32

Plate 176. *Rustic Landscape* (free continuation of *Adoration of the Magi* [C], Plate 177). British Museum 78v

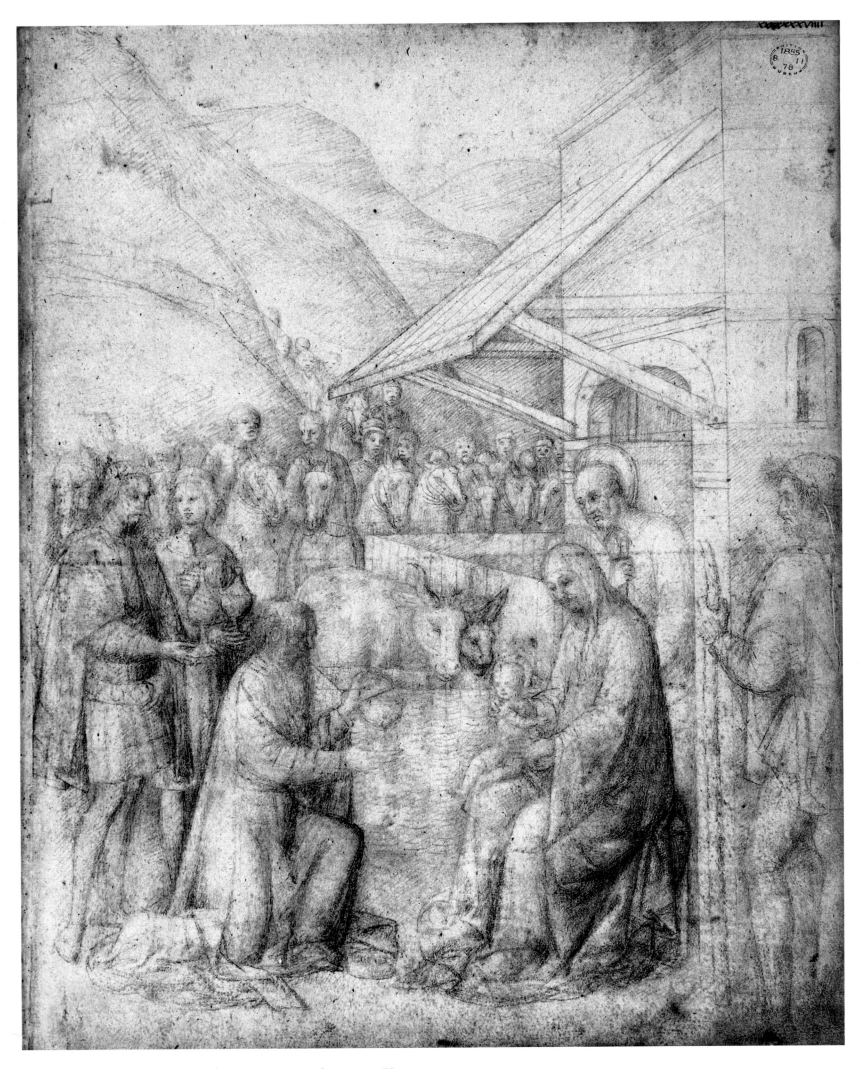

Plate 177. *Adoration of the Magi* (C). British Museum 79

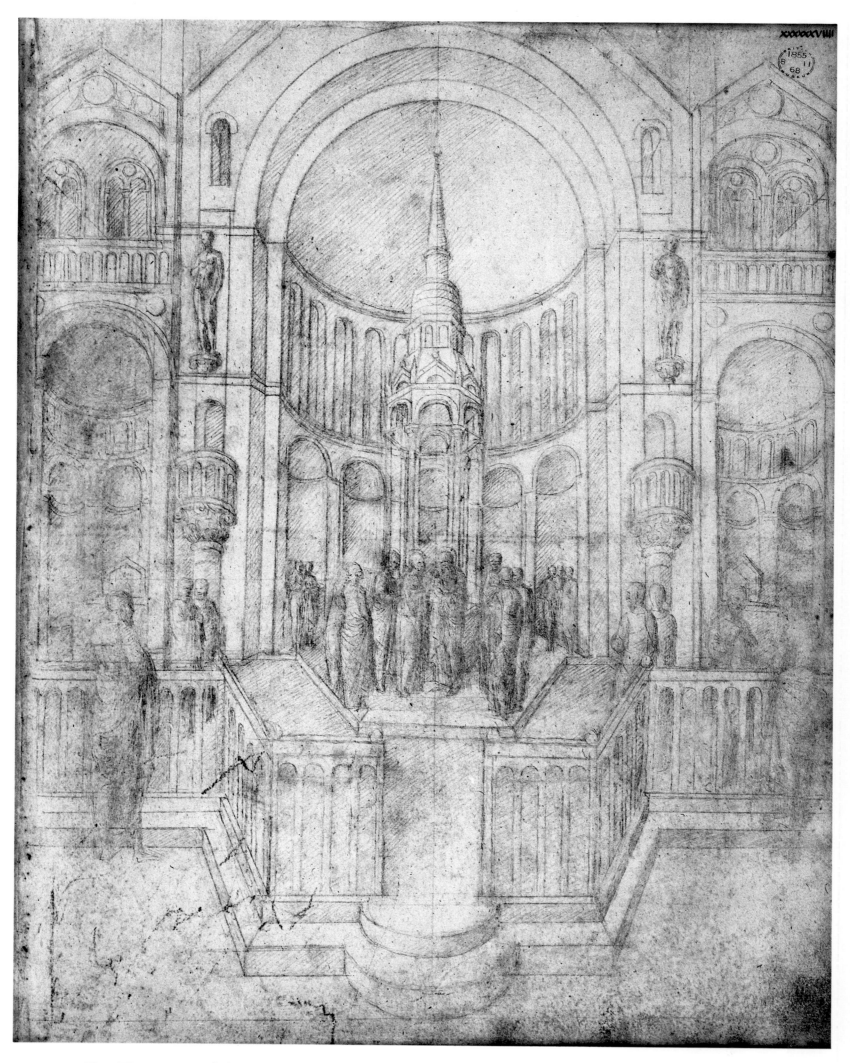

Plate 178. *Presentation of Christ in the Temple*. British Museum 69

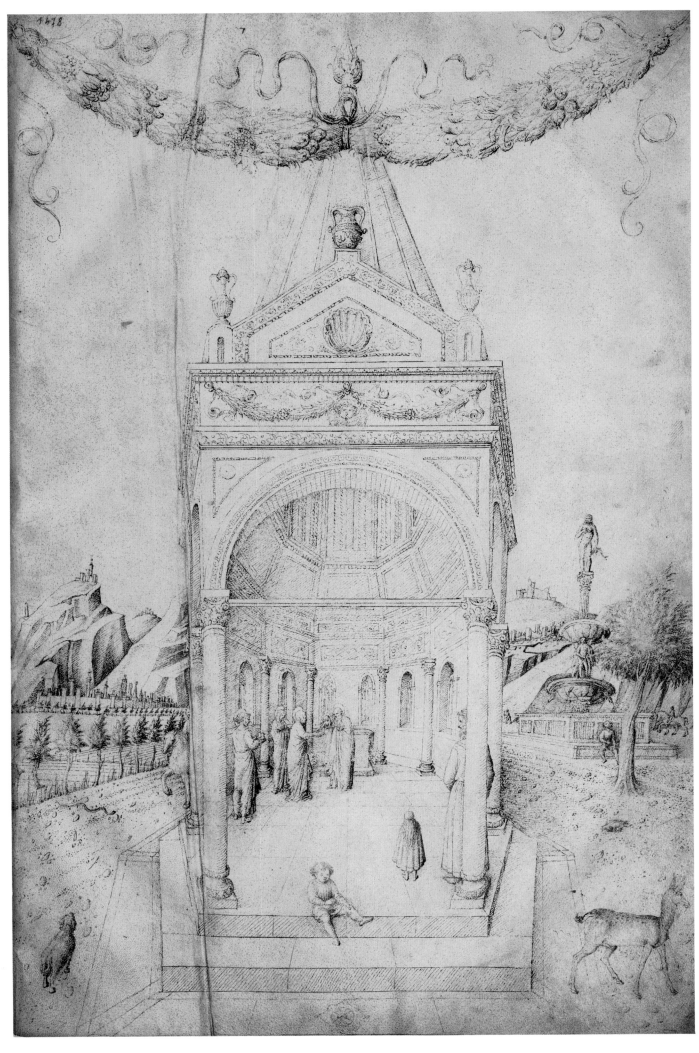

Plate 179. *Presentation of Christ in the Temple*. Louvre 7

313

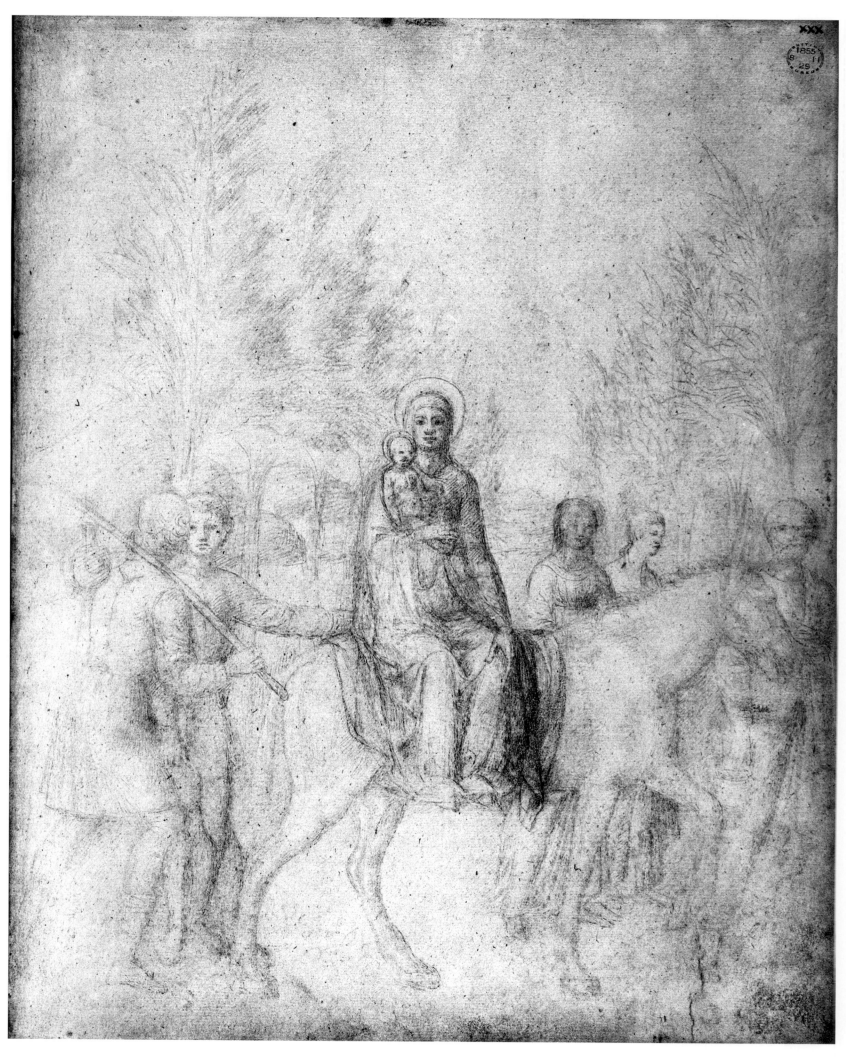

Plate 180. *Flight into Egypt*. British Museum 30

Transitions in scale, awkward in the Paris *Adorations* (Plates 174/175), are smoother in a single London page of the theme (Plate 139), eased by the Florentine art of Fra Angelico and Filippo Lippi. The holy family in a two-page panorama in that Book (Plates 172/173) is dwarfed by a large figure seated in the foreground with a book in his lap. These studies may have fascinated Mantegna, whose *Adoration of the Magi* (Florence, Uffizi) shares their spiraling sense of exotic adventure and sacred exploration.

A London *Adoration* (Plates 176/177), first planned as a single recto page, is a shrewdly devised vertical composition that could have been put to use for other projects having a horizontal format;[57] its Northern look is close to the art of the Netherlands and Germany, and it may reflect an *Adoration* painted by the Bruges master Petrus Christus for the Scuola della Carità early in the 1450s.[58]

*The Purification of the Virgin and Presentation of Christ in the Temple*. February 2, the combined Feast Day of the Purification of the Virgin and the Presentation of Christ in the Temple, was long celebrated by the Serenissima as a multiple "Miss Venice" pageant, twelve of her loveliest, richest maidens being decked out in vestments lent by the cathedral to commemorate a possibly mythical event—Venetian matrons and their jewels carried off by pirates, but rescued on that holy day, gems and all, by local stalwarts.[59] Bellini's *Purification/Presentation* (Plate 179) shares some of the secularity of that annual occasion by its suggestion of a festival banner or backdrop.

The high priest Simeon's recognition of Christ's divinity at his Presentation in the Temple of Jerusalem, and of Mary's future Sorrow, made this an important subject in cycles of the lives of Christ and Mary, including that painted by Bellini for the Scuola di San Giovanni Evangelista before 1465 (England, Collection Lord Oxford), with a chimney sweep at one side. Venice, following the Eastern Christian tradition, had a church dedicated to Simeon. The subject also commemorates Christ's second entry into the temple, first at his mother's Purification forty days after his birth and then at his own Presentation, at that time a double ceremony, the sacrifice of two turtledoves marking the mother's cleansing from impurity according to Mosaic law.

Two frontal, vertical renderings of the *Purification*, one in each Book (Plates 178, 179), demonstrate the radically different approaches often separating these Books. Drawn in leadpoint, the London page has a documentary quality. In its setting, close to contemporary Venice, the *Presentation* is part of the present, its actuality and sanctity increased.

The Paris page is far from factual, a sacred fantasy proclaimed as such by the decorative swag with fluttering ribbons looped across the top and by the wildly spired temple, never meant to be seen as a reconstruction of Jerusalem's.

*The Flight into Egypt*. Among Jacopo's loveliest scenes is his drawing of the second Sorrow of the Virgin (Plate 180). Riding side-saddle, Mary and her son are seen frontally as if enthroned on the ass led by Joseph. In her silent, regal grace the Virgin resembles a Kwan Yin more than a penniless Jewish refugee. By furnishing the Holy Family with four servants to assist them into Egyptian exile, the artist follows Giotto's precedent in Padua; the Holy Family is less lavishly attended in Gentile da Fabriano's *Flight* in his *Adoration* predella (Fig. 67). Jacopo subsequently drew a farm view on the adjoining page (Plate 42), the trees continuing those in the background of the *Flight*. Close in format and scale to the last *Adoration of the Magi* (Plate 177), both subjects are possibly part of a series.

*The Holy Family at Work in Egypt*. Missing from the Books is the subject of Christ in Joseph's Carpenter Shop. A rare theme, the topic illustrated the family working for their keep in Egyptian exile, as described in the *Meditations on the Life of Christ*,[60] and the infant, confronted with wood and nails, having his first presentiment of his crucifixion.[61] One of Jacopo's last canvases was of this subject, painted before 1465 for the cycle at the Scuola di San Giovanni Evangelista. Dürer's woodcut of the subject may go back to this lost picture.

*The Return of the Holy Family to Judea*. The family's leaving Egypt for Judea after Herod's death was another of the eighteen large canvases that Bellini and his sons painted for the Scuola di San Giovanni Evangelista. No drawing of the scene survives; it may have resembled the *Flight into Egypt* (Plate 180), also painted for the scuola.[62] The Tietzes noted that this theme, described by Ridolfi as showing "Jesus as a boy, smiling and walking between his parents," was popular in the seventeenth century but apparently "unknown in the Quattrocento."[63] If Ridolfi's description is correct, the painting showed Jesus returning to Nazareth with Joseph and Mary after they found him in Jerusalem among the doctors (Luke 2:51).

57 A *Nativity* ascribed to Leonardo Boldrini (Venice, Museo Correr) has an architectural setting very like that in this drawing. It was formerly ascribed to Bastiani, several of whose works relate to Jacopo's approach. See G. Mariacher, *Il Museo Correr di Venezia, Dipinti*, Venice: 1957, 60.

58 See G. Fogolari, "La chiesa di Santa Maria della Carità di Venezia," *Archivio Veneto-Tridentino*, 1924, 57 ff.; L. Campbell recognized there a reference to Petrus Christus.

59 Muir, 1981, 140–56.

60 Ragusa and Green, 1961, 68 ff.

61 C. Hahn, " 'Joseph will perfect, Mary enlighten and Jesus save thee': The Holy Family as Marriage Model in the Mérode Triptych," *Art Bulletin*, 68, 1986, 54–66. See also Ridolfi, 54.

62 In the Trecento *Meditations on the Life of Christ* (Paris, Bib. Nat. Ms. ital. 115), the pictorial elements in the *Return from Egypt* are essentially those in the *Flight into Egypt*. See Ragusa and Green, 1961, figs. 67 ff.

63 Tietze and Tietze-Conrat, 1944, 94.

64 The Fallen Idol, more often seen in the landscape of the *Flight into Egypt*, comes from the Apocryphal Gospel of Pseudo-Matthew (chap. XXIII). The Old Testament source is Isaiah 2:18, "And the idols he shall utterly abolish."

*Christ among the Doctors.* The third of Mary's Sorrows came through losing the twelve-year-old Christ during their family visit to Jerusalem to celebrate Passover. Thinking he might have gone back to Nazareth ahead of them, the parents went home but did not find him there, and returned desperately to Jerusalem—and there in the synagogue was Jesus, stunning the rabbis with his wisdom.

By entering the synagogue alone Christ marked his transition from family life to independence and mastery of the Law. This important scene, though seldom painted by itself, was in Bellini's cycle for the Scuola di San Giovanni Evangelista (England, Collection Lord Oxford). It is also drawn in each Book (Plates 181/182, 183): London's page is the more formal and monumental, the temple a Venetian Romanesque palace with an open loggia below. Only the pediments sketched above the windows and the circular appliqués on the façade push the architectural design toward the renaissance. Men move in rapidly from the left and right with books to aid the rabbis' arguments; these figures, Jacopo's invention, bring Christ's victory over the wise elders into the foreground.

Perspective is used more deliberately in the Paris *Christ among the Doctors*, the diminutive Jesus at the focus of the centralized composition as his worried parents approach from the left, just on the verge of finding him. Here the Book is turned and worked vertically, the top floor of the study hall drawn onto the adjacent upper page. The number of figures has greatly increased; a stag and doe have wandered in, as if from some earlier pattern book. Seven statues of seated men in monastic habits may be meant as prophets. Perhaps Bellini intended the Gothic throne-house that shelters Christ to suggest the similar structure (ciborium) that houses the altar.

*The Baptism.* With his baptism at the age of thirty by Saint John, Christ begins his public life as preacher and miracle worker (Plates 185, 186). Musical angels on the banks of the Jordan harmonize heaven with earth at this moment when God the Father is first heard to affirm the divinity of Christ, saying, "This is my beloved Son, in whom I am well pleased" (Matthew 3:17). In the London Book, the Holy Spirit descends on a line from the Father down to the Son. Two angels at the right fulfill the office of deacons, their hands covered (according to the Eastern Christian rite) by Christ's robe. A wilderness with a pride of lions was later drawn in the extended landscape on the facing left page (Plate 4).

The Paris folio (Plate 185) has the refinement of the International Style and of the early renaissance; London's is closer to Trecento monumentality. The nude Christ in the Paris Book is ephebe-like, recalling figures on Ghiberti's second Doors; London's approach is broader, more modern, though the composition is still Gothic in its elongated grace. As usual, the Paris version is the more elaborate. Uncommon for its presence at a baptism, the broken column and its shattered idol symbolize the collapse of paganism faced with the full force of the Trinity.[64]

*The Miracle at Cana.* Christ, seated with Mary at the left end of the trestle, is about to turn water into wine at the wedding at Cana (Plate 184), his first miracle. Downcast servants signal the last of the wine as attendants bring more vessels for filling. The front of the building has been cut out in the form of an arch to reveal the banquet within. Somewhat churchlike, the setting with its angelic Victories may refer to the triumph of the miracle of the eucharist as well as to the wealth of the newly married couple. Considering Veronese's splendid treatment later of this rare subject, the Wedding at Cana as the Party of the Year, Jacopo's austere setting is almost a surprise. On the facing left page (Plate 55) is drawn a courtyard with an arched trellis, perhaps to support vines in keeping with the vintage theme of the marriage. Jacopo included this miracle in his cycle for the Scuola di San Giovanni Evangelista, completed in 1465 (England, Collection Lord Oxford), which has Castagno-like features.

*The Raising of Lazarus.* Four days after his burial, Lazarus, brother of Martha and Mary, is raised by Christ. Drawn in both Books, this miracle takes place at the grave site in Bethany, shown as a square before a modest Venetian parish church, its architecture mostly Gothic. In the London page (Plate 187) a second Christ-like figure stands among the apostles grouped at the left, possibly a study for his figure in the center. Mary Magdalen has thrown herself upon the ground before her brother's open tomb; a bystander covers his face from the stench of the grave. Bellini later extended the vertical composition into a horizontal city view, with beggars on the facing left page (Plate 60). Smaller in scale, the Magdalen kneels away from the tomb in Paris' *Raising of Lazarus* (Plate 188), looking up at Christ and the apostles. Drawn in silverpoint, they are now almost invisible.

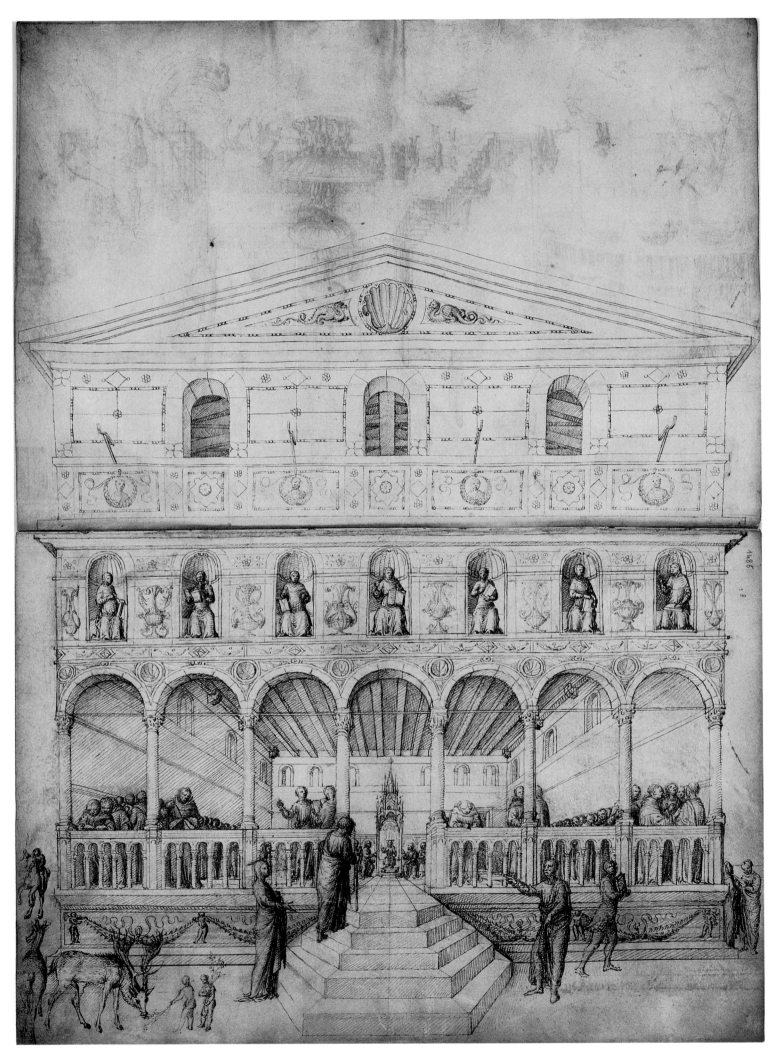

Plates 181/182. *Christ among the Doctors*. Louvre 17v, 18

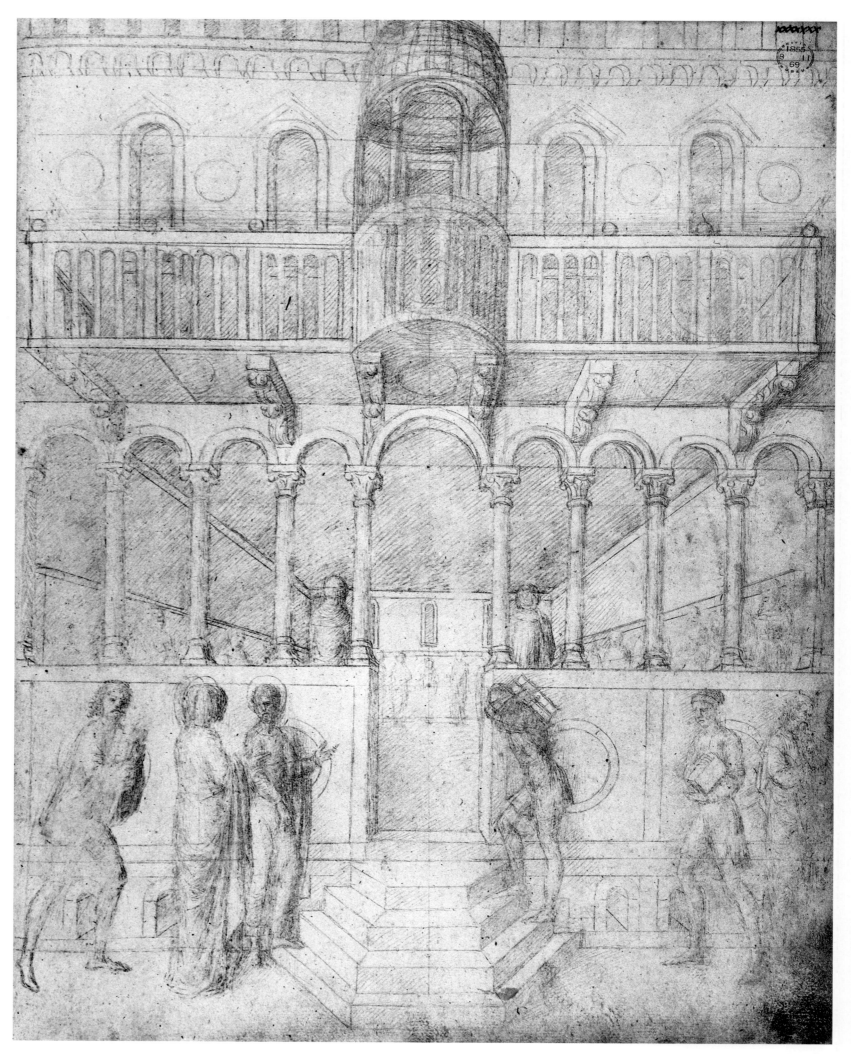

Plate 183. *Christ among the Doctors*. British Museum 70

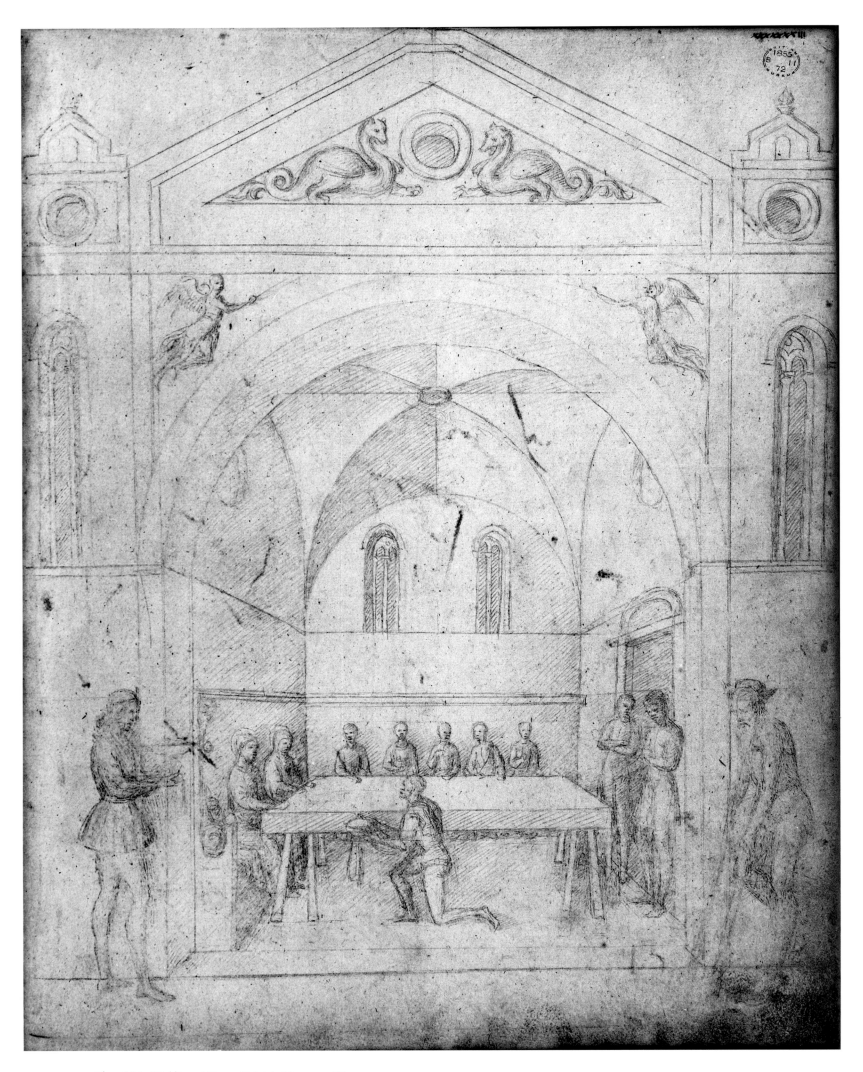

Plate 184. *Wedding at Cana*. British Museum 73

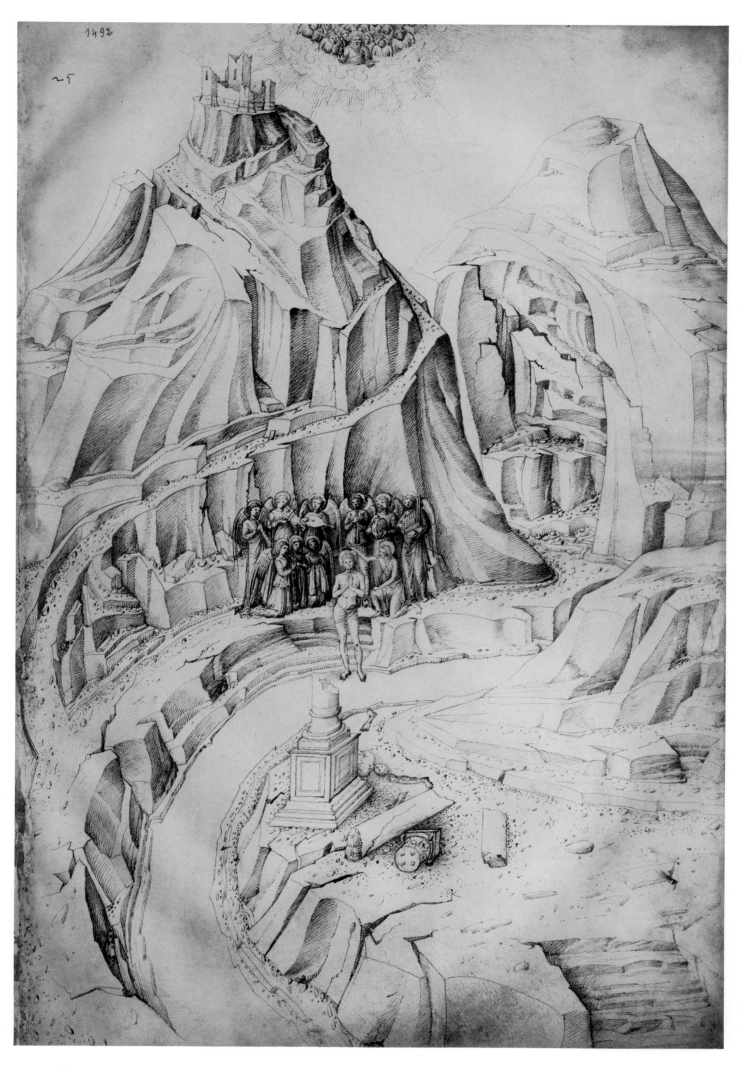

Plate 185. *Baptism of Christ*. Louvre 25

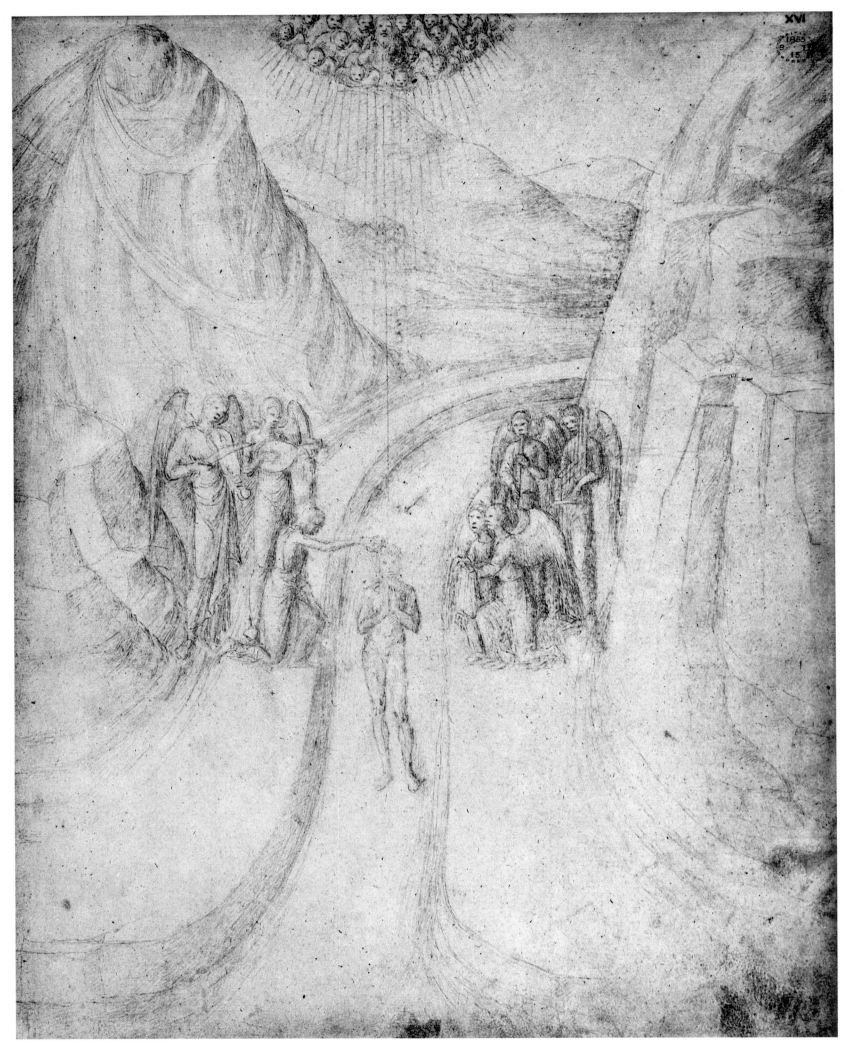

Plate 186. *Baptism of Christ*. British Museum 16

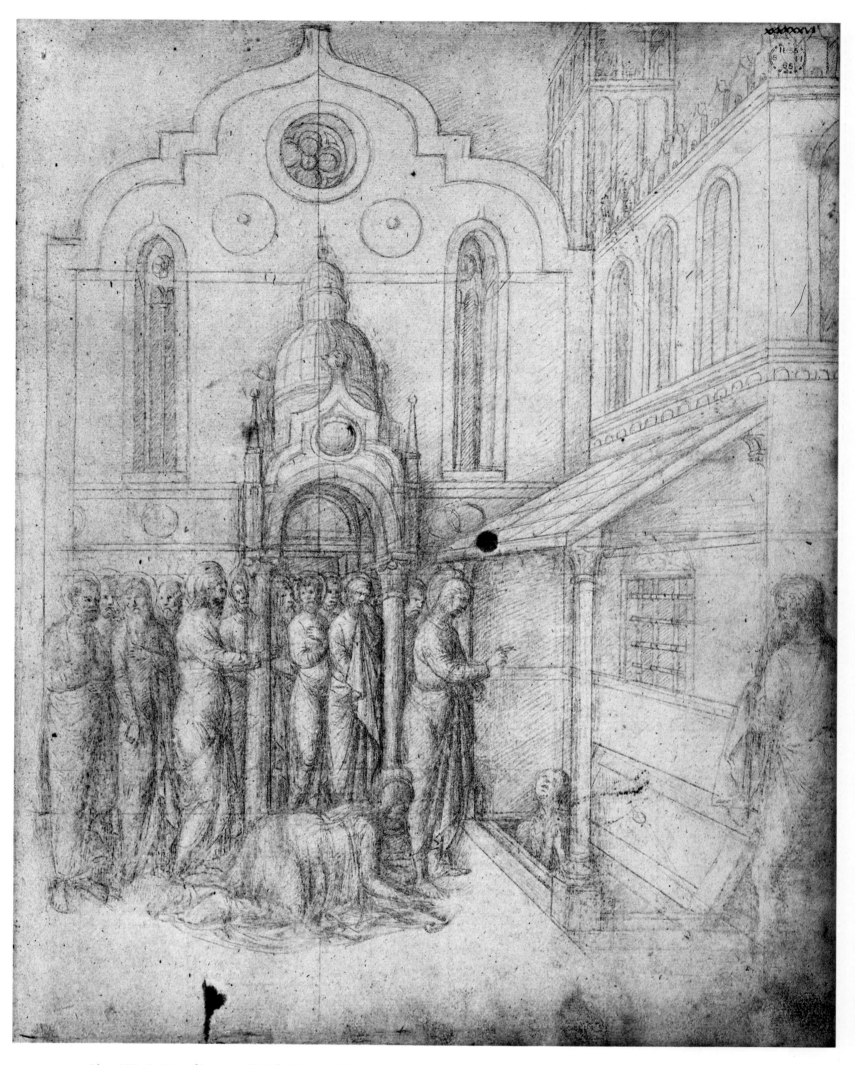

Plate 187. *Raising of Lazarus.* British Museum 66

322

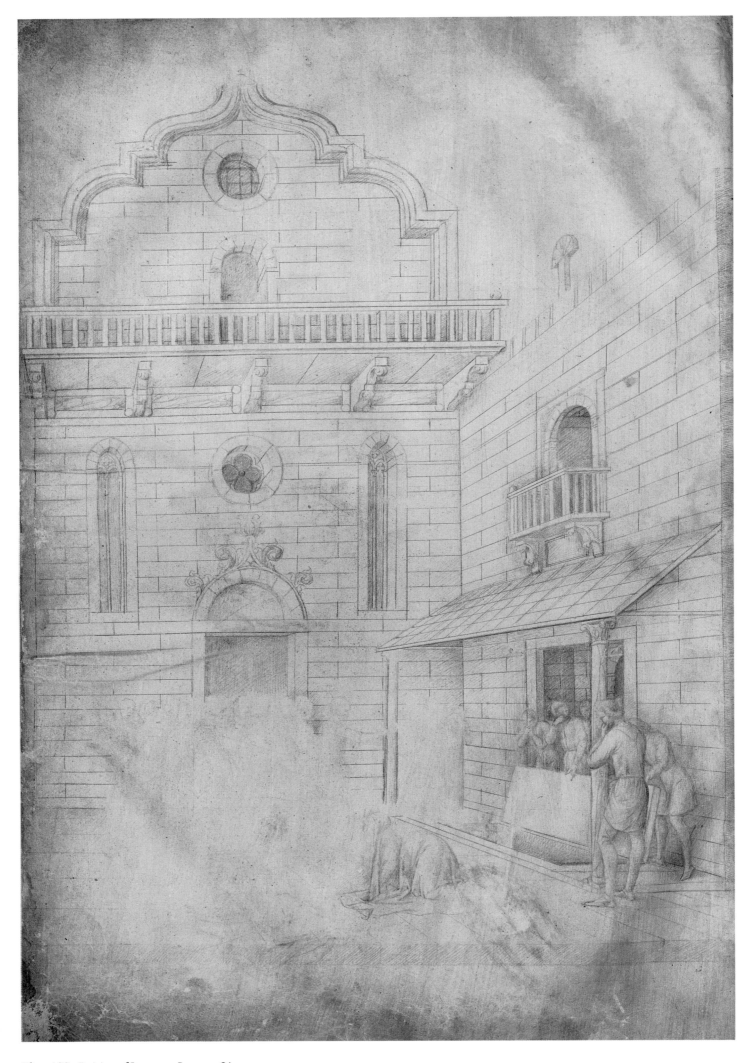

Plate 188. *Raising of Lazarus.* Louvre 21v

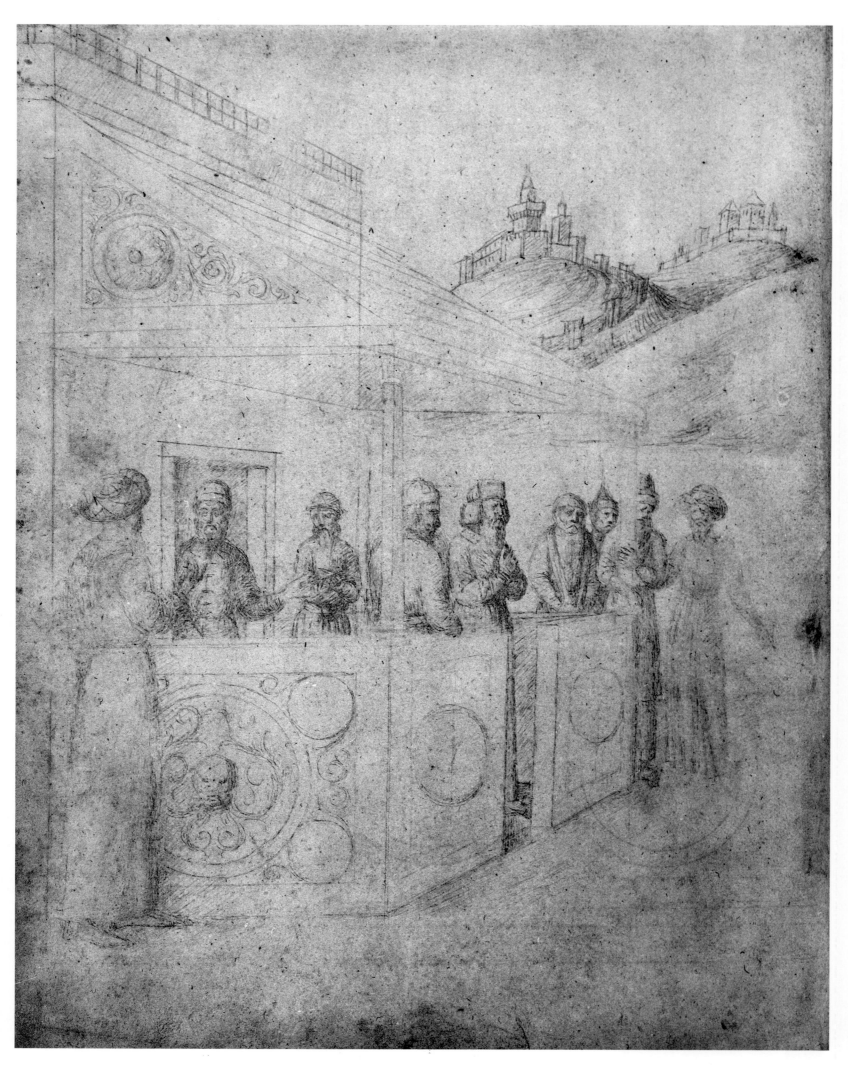

Plate 189. *Nine Figures in Oriental Garb(?), Standing in Portico* (possible continuation of *Entry of Christ into Jerusalem*, Plate 190).
British Museum 23v

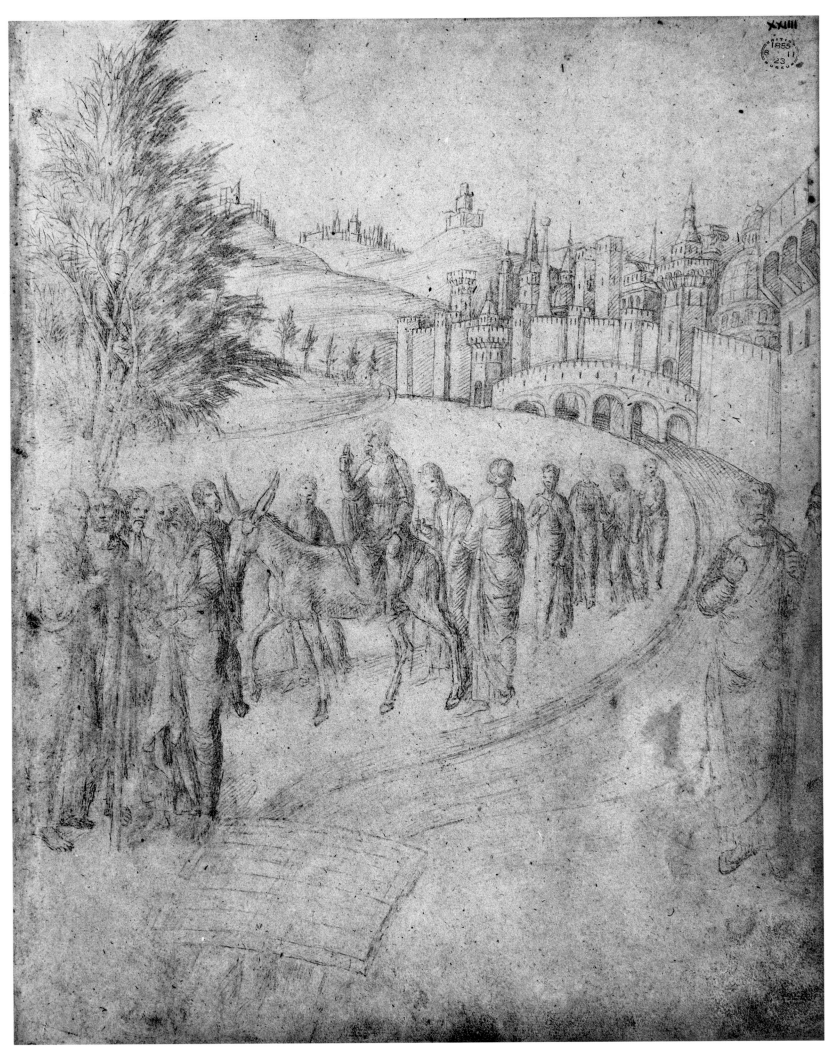

Plate 190. *Entry of Christ into Jerusalem*. British Museum 24

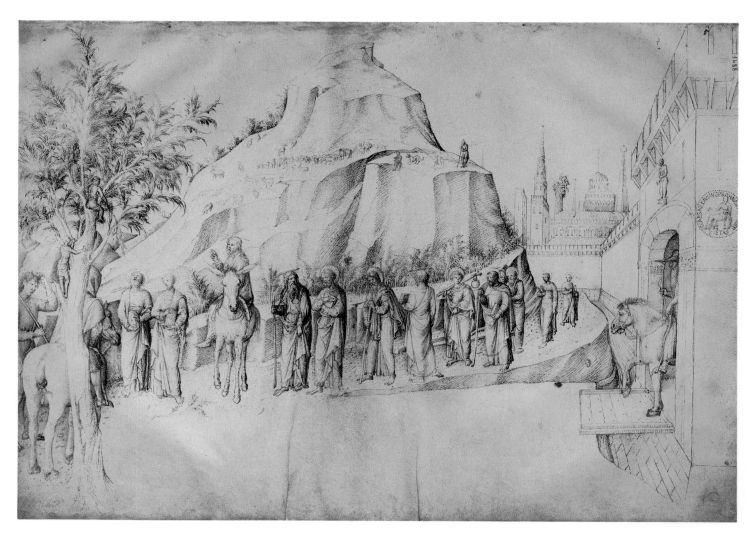

Plate 191. *Entry of Christ into Jerusalem.* Louvre 21

65 Bellini's lost Passion cycle may have been related to that painted between 1414 and 1419, also lost, by his teacher Gentile da Fabriano (possibly with Bellini's participation) for Pandolfo Malatesta's chapel at Brescia. See Christiansen, 134–35. See also G. Fiocco, ''Michele da Firenze,'' *Dedalo*, XII, 1932, 542–62, and E. Petrobelli, ''Michele da Firenze ad Adra,'' *Rivista d'arte*, XXIX, 1954, 127–32. An altar by Vivarini (Venice, Ca' d'Oro) with a *Crucifixion* at the center and six Passion scenes at right and left, for the Venetian church of Corpus Domini, could also relate to Bellini's depictions, both masters sharing Masolinesque elements. It includes the rare theme of *Christ Nailed to the Cross*, on the ground, also found in the Paris Book (Pl. 141). See C. Huter, "The Ceneda Master—1," *Arte Veneta*, XXVII, 1973, 37, fig. 41.

66 Most scholars now see the subject as the *Entry into Jerusalem*. It has been suggested that these Eastern men may be priests awaiting Christ at

*(continued on following page)*

*The Entry of Christ into Jerusalem.* "Public"events of Christ's Passion begin with his ceremonial, triumphant way into Jerusalem, initiating Holy Week.[65] Drawn once in each Book, these horizontal *Entries* present original compositions. The Paris one (Plate 191) stresses the contrast between Roman-occupied Jerusalem and the rustic landscape beyond its walls, distant shepherds and their flocks implying Christ's role as pastor. Riding a white ass, Jesus is an imperial figure. Small branches cut to strew along his way are classical tribute, later symbolizing Palm Sunday.

A circular wall plaque on the city gate, based on a Roman coin of *Pietas*, identifies Jerusalem as under Roman conquest in London's *Entry* (Plates 189/190), echoed by the classical statues. This scene is sometimes identified as Christ entering Jericho (Luke 19:1–6), on his way to Jerusalem, and asking Zacchaeus to climb down from the sycamore tree. Ambassadorial figures in oriental garb on a porch, drawn on the facing left page, may have nothing to do with the *Entry* though the two landscapes are continuous.[66]

*The Last Supper.* No composition by Bellini is known of this subject.

*The Agony in the Garden; Arrest of Christ.* Steplike rock formations rise to the top of the Mount of Olives in a London composition on the right page (Plates 192/193), its forceful approach still basically that of fourteenth-century art. Christ kneels before the chalice and paten which foretell the eucharistic sacrifice; an angel, its face in a double nimbus, has come to strengthen Christ, who, in a bloodlike sweat, confronts the terrible prospect of suffering in the days to come. This subject is Mary's fourth Sorrow. The Betrayal that Christ predicted at the Last Supper takes place on the facing left page, Judas leading a company of Roman soldiers to make the Arrest.

Though instructed to pray against temptation, the three apostles were so grieved that they fell asleep, James at the lower right, Peter above, and John the Evangelist stretched out at the left. Like the two *Agonies in the Garden* by Bellini's son Giovanni and by his son-in-

law Mantegna (both London, National Gallery), both following Jacopo's composition, his drawing was probably meant also to be a nocturne or twilight scene.[67]

*Christ Brought before Pilate.* Pilate's hall is the most magnificent building in Jacopo's Books (Plate 194), the grandeur of the Doge's Palace seen through a triumphal arch like the spectacular set for some biblical film. On the arch are paired colossal Corinthian columns with Victories in the spandrels, and as keystone a genius holding a torch. The massive frieze with scenes of classical warfare and judgment recalls those designed by Pollaiuolo.

Renaissance artists were unusually interested in the design of Pilate's Judgment Hall, the *Praetorium*, for it is one of the few buildings that the bible describes with some specificity as the *Lithostrotos* (John 19:13), paved with tiles or stone slabs. This ancient, presumably squared-off floor covering lent itself to the new renaissance method of creating an effect of pictorial depth, the foreground divided into a checkerboard design subject to a central vanishing point, a system often employed to stress the significant place of Christ or Pilate. So Saint John's description of the hall where Pilate's judgment, Christ's flagellation, the release of Barabbas, and the crowning with thorns all took place could be realized effectively with illusionism based on mathematically devised perspective. Pilgrims to the Holy Land provided further documentation for Pilate's palace, having seen the purported sites of the Passion, many with multilevel courts recalling Venetian buildings.[68]

Though dwarfed by this monumental splendor, Pilate remains visible on his throne of judgment, placed on the central axis at the vanishing point, far at the end of the court. The small figure of Christ surrounded by his captors appears at the left. Roman soldiers with batons and an imperial shield are at the right, along with bearded elders—judges or rabbis. Though vast, the setting has delicate detailing, the bands of floral ornament in the foreground treated like filigree.

*The Flagellation.* Next to the Crucifixion, Bellini shows the Flagellation more often than any other scene from the life of Christ; this third shedding of his blood, Mary's fifth Sorrow, appears four times in each Book.

Northern Italy was the center for the Flagellants' cult, led by a prophesy of Joachim of Flora, a twelfth-century Franciscan preacher inspired by his vision of the Passion. The five leading lay religious societies of Venice were all founded in the late Middle Ages as penitential groups known as the *Scuole dei Battuti*, "of the beaten." Their members lashed themselves in public atonement for their own sins and those of this world, shedding their blood to imitate Christ's suffering.[69]

Physical self-abuse is all the more surprising in the context of the splendid architectural settings where these lay societies met. By Bellini's day this practice had diminished, but flagellation remained a focus of piety to placate God's wrath, and it regained popularity in the Holy Year of 1450.[70] A stone fragment believed to come from the Flagellation column had been in San Marco's largest reliquary since at least the fourteenth century.

Several of Jacopo's *Flagellations* that particularly emphasize a perspectival setting could have been stimulated by a *Flagellation*, now lost, by Castagno, in Venice in the 1440s.[71]

The lashing takes place at night in Pilate's splendidly arched palace (Plate 195), in one example in the Louvre's Book. The setting may have been inspired by pilgrims' travel descriptions of the Holy Land, where Pilate's Judgment Hall was accounted to have a handsome arch. A *Viaggio di Gerusalemme*, following the apocryphal gospel of Nicodemus, quotes that source in describing Christ brought into the *Praetorium* by six men with banners, and of their tying him to a column below a flight of stairs, where he was beaten and crowned with thorns.[72] Bellini seats the Roman procurator and the priest Caiaphas opposite one another beyond a triumphal arch with two roundels of Hercules and the Rape of Deianira; between them is the key subject.

Lanterns are often linked with Peter's Denial of Christ and the Arrest, so the little boy raising a lantern may be reminding us of these events, this suggestion strengthened by the apostle-like figure at farthest left who resembles Peter. The man next to him, clutching desperately at ropes looped around his neck, is probably the penitent Judas; his suicide by hanging, described in Matthew's gospel, was a popular scene in Passion plays, reenacted with gleeful, ghastly fidelity.[73] The robes and turban of the horseman at the right are the Turkish costume worn by Levantine Jews.[74]

Bellini's most monumental Passion scene is the *Flagellation* on a right page in the London Book (Plates 196/197). Unusually large in scale, the Herculean figures seen close up have the dramatic power of a great relief, recalling the heroic art of the early Florentine

the temple, added by Jacopo after his first plan, that of staging the Entry to the right. See Röthlisberger, 1956, 63.
  These drawings could be close to a lost painting of the subject ascribed to Jacopo which came from the Venetian church of San Giorgio Maggiore in 1806 and vanished soon thereafter. See Ricci, XXX–XXXIII, 1908, 62–63.

67 Röthlisberger (1956, 86) believes the London Book's two-page presentation of this subject (Pls. 192/193) is dependent upon Mantegna's San Zeno predella (Tours, Musée), ordered in January 1457 by the protonotary Gregorio Correr, abbot of San Zeno, and completed late in 1459.

68 See M. A. Lavin, *Piero della Francesca: The Flagellation*, London: 1972, 38–39.

69 Pignatti and Pullan, 1981; Pullan, 1971, 50 ff.

70 Gramaccini, 1983, 27.

71 Mantegna also noted Castagno's spatial virtuosity in his own design for an engraved *Flagellation*, seen by Oberhuber and Levenson, 1973, 205, as more highly evolved than Jacopo's.

72 M. A. Lavin, *op. cit.*, 96, n. 21. *Viaggio di Gerusalemme*, Bibl. Vat., Ms. Chigi M.VIII.150, n. 22.96.

73 See O. Goetz, "Hie hencktt Judas," *Form und Inhalt, kunstgeschichtliche Studien Otto Schmitt zum 60. Geburtstag*, Stuttgart: 1950, 105–39.

74 Gilbert, 1952, 208, sees the foreground figures as meaningless bystanders.

Plate 192. *Judas Leading the Roman Soldiers.* British Museum 43v

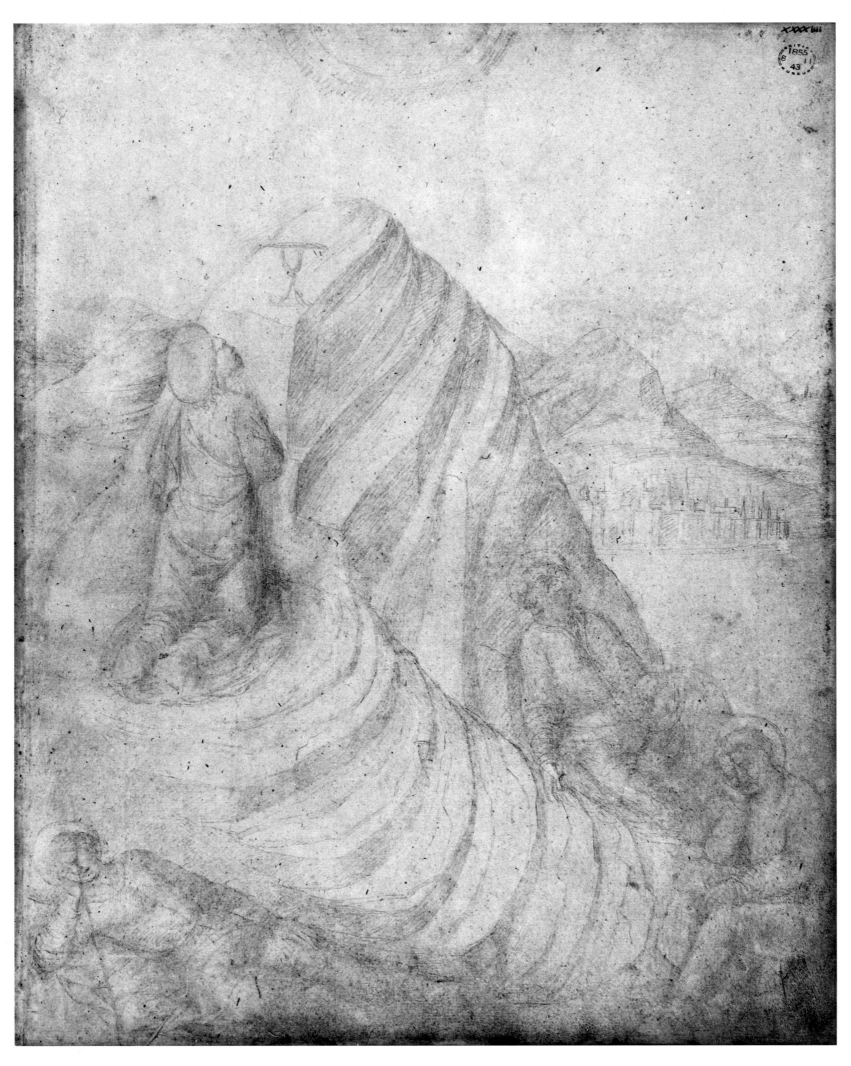

Plate 193. *Agony in the Garden*. British Museum 44

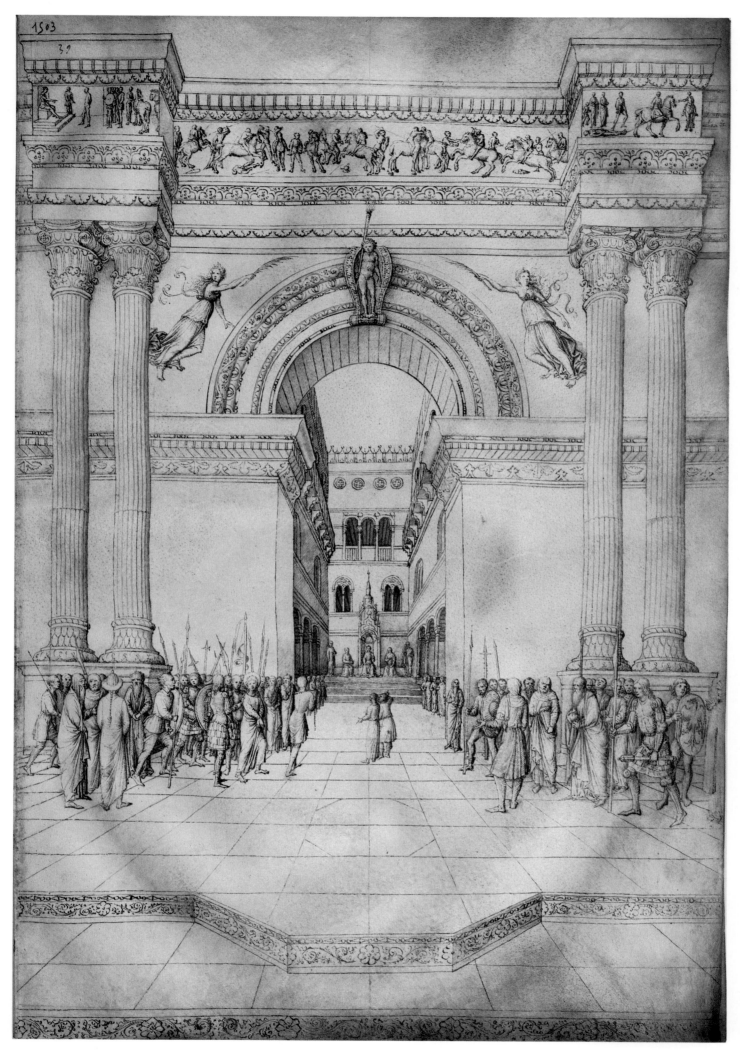

Plate 194. *Christ before Pilate*. Louvre 39

330

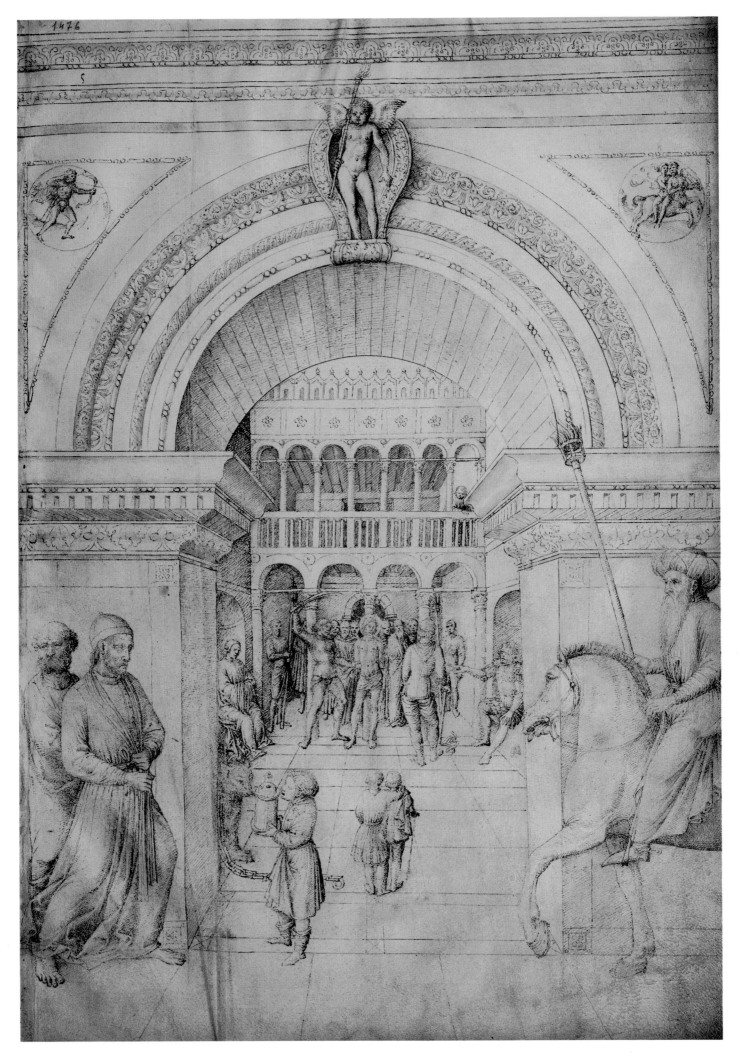

Plate 195. *Flagellation by Torchlight* (A). Louvre 5

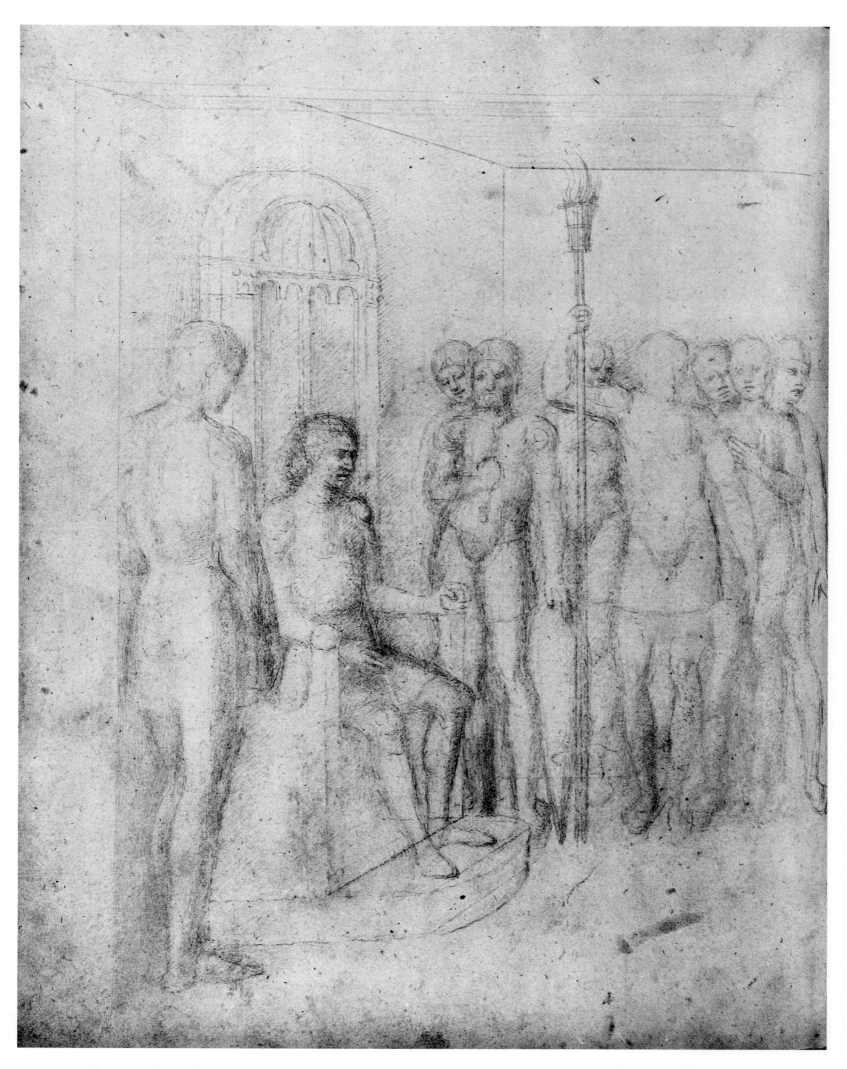

Plate 196. *Pilate Enthroned, Witnessing Flagellation* (continuation of *Flagellation* [A], Plate 197). British Museum 32v

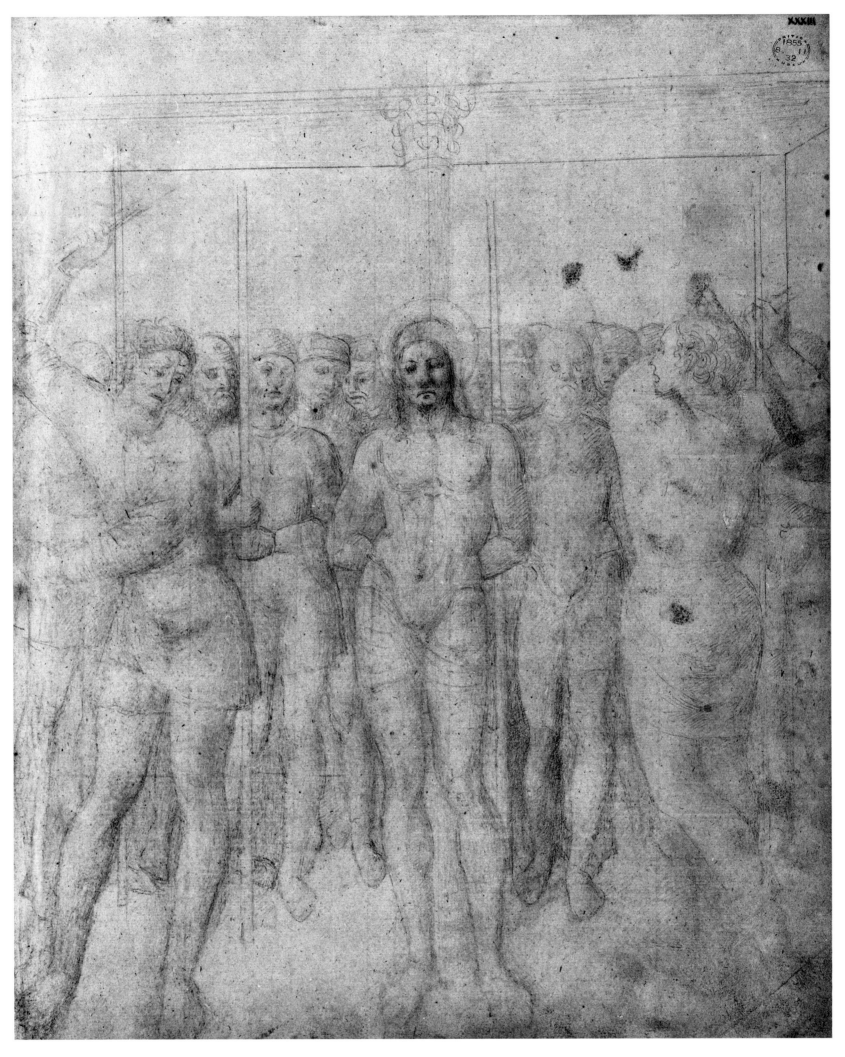

Plate 197. *Flagellation* (A). British Museum 33

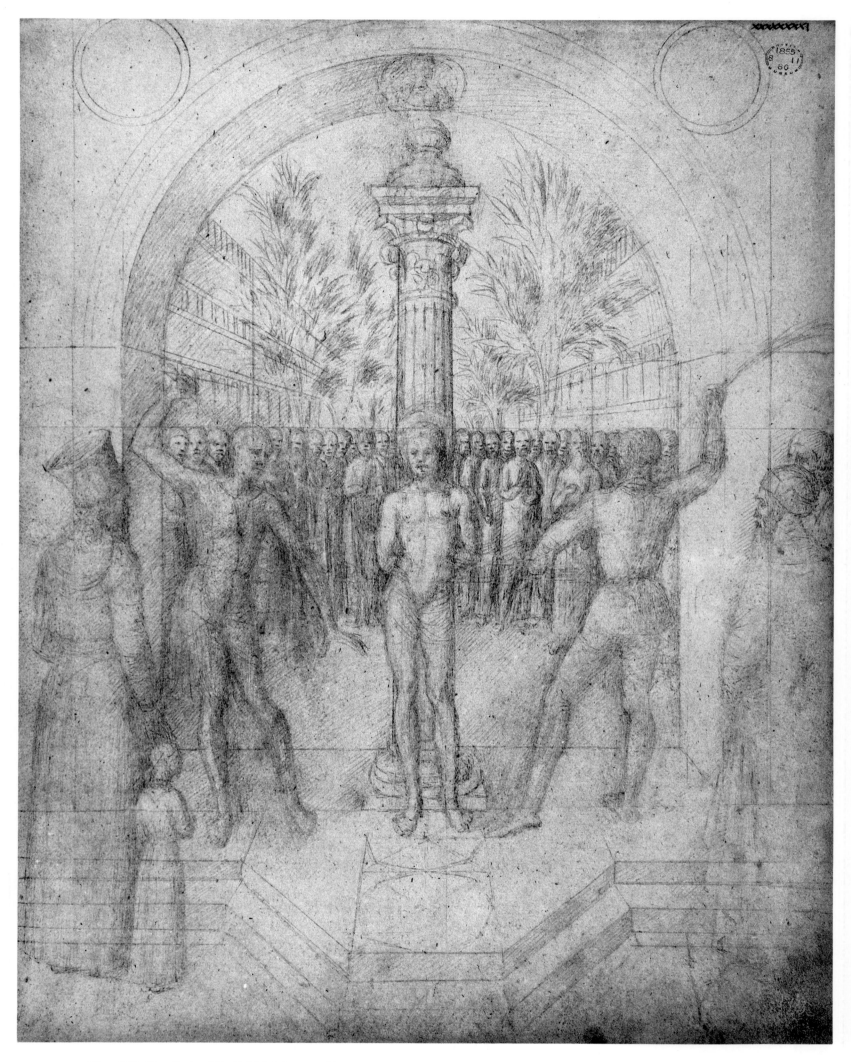

Plate 198. *Flagellation* (D). British Museum 81

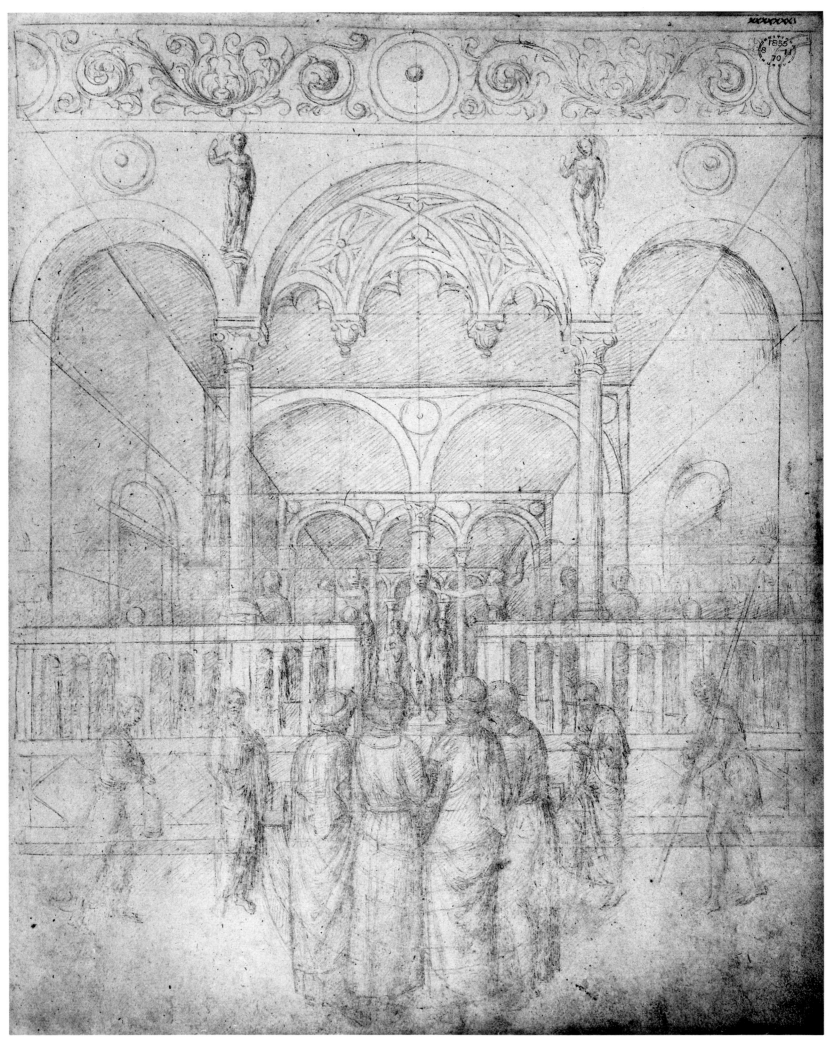

Plate 199. *Flagellation* (B). British Museum 71

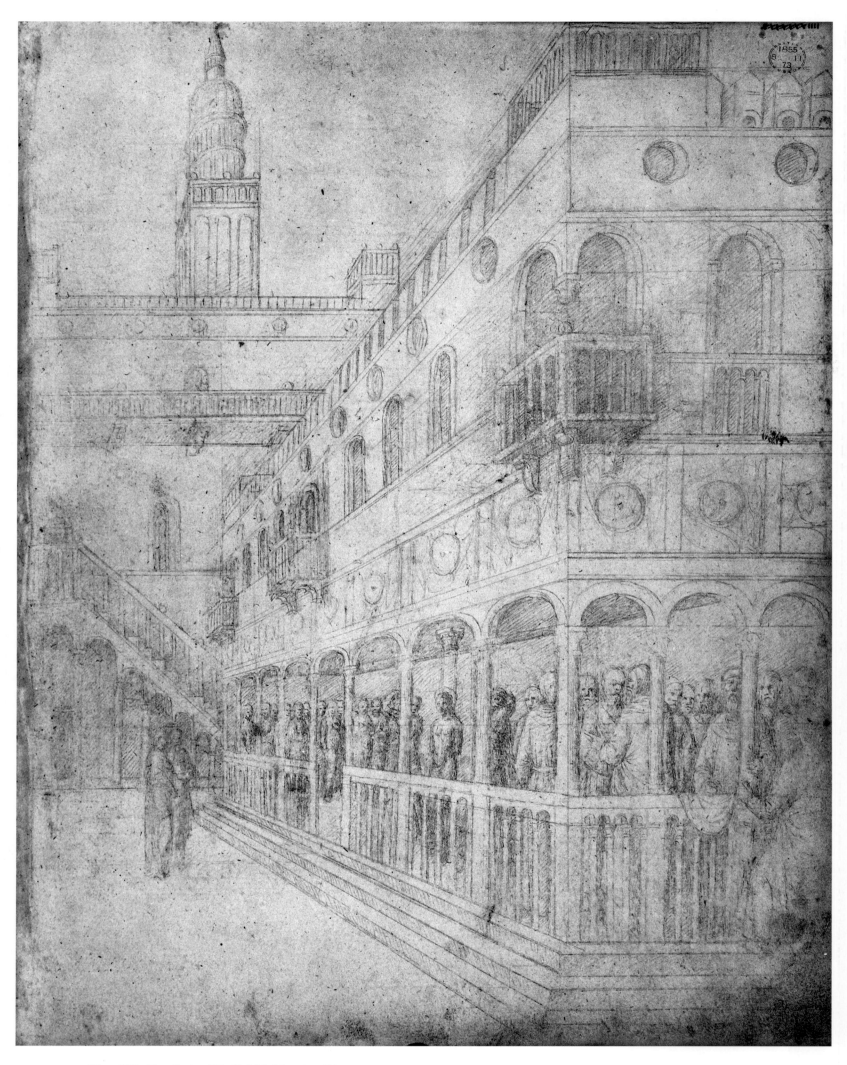

Plate 200. *Flagellation* (C). British Museum 74

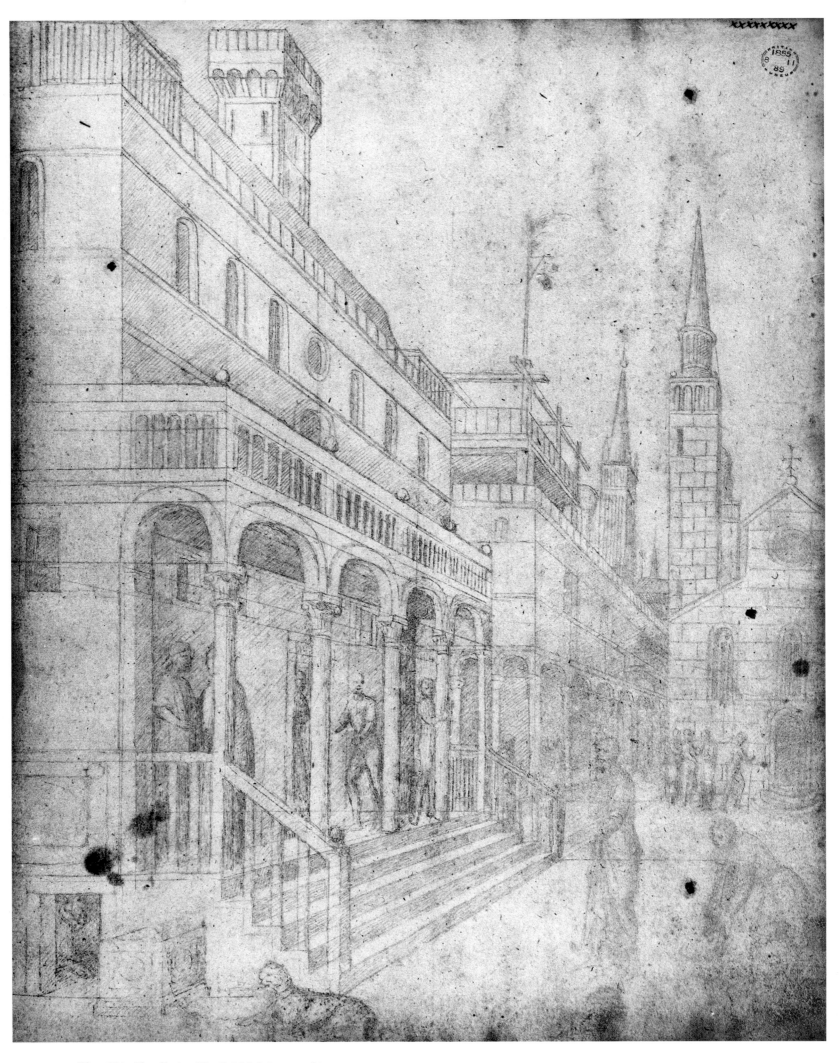

Plate 201. *Flagellation* (E). British Museum 90

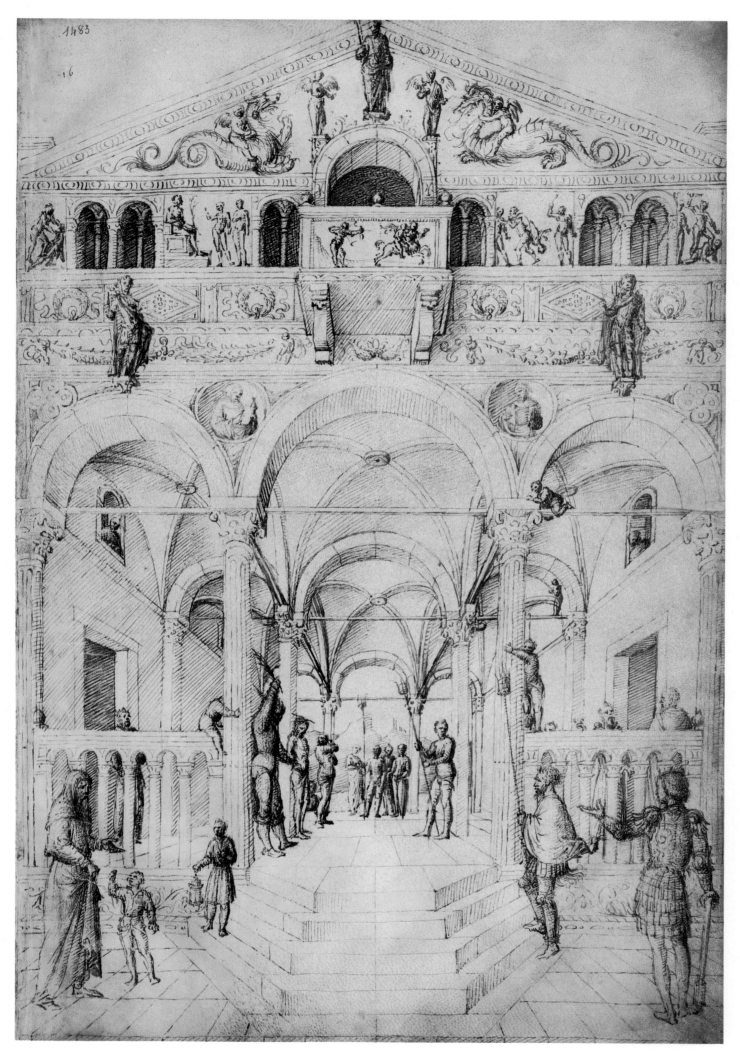

Plate 202. *Flagellation by Torchlight* (B). Louvre 16

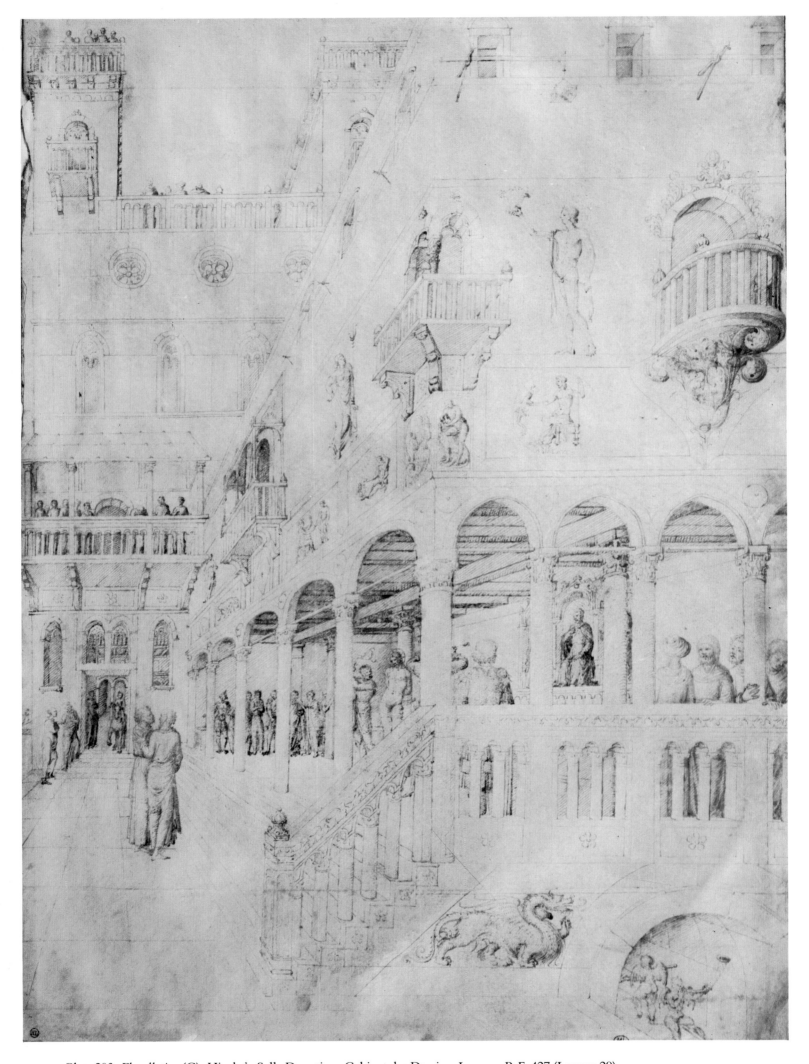

Plate 203. *Flagellation* (C). His de la Salle Donation, Cabinet des Dessins, Louvre, R.F. 427 (Louvre 29)

75 Borgo, 1979, 550.

76 Degenhart and Schmitt, "Marino Sanudo und Paolino Veneto, Zwei Literaten des 14. Jahrhunderts in ihrer Wirkung auf Buchillustrierung und Kartographie in Venedig, Avignon und Neapel," *Römisches Jahrbuch für Kunstgeschichte*, 14 (1973), 1–137. Burchardus' *Descriptio terrae sanctae* was written between 1271–91, after extensive travels in the Near East. The manuscript is in Padua, Seminario Ms. 74, fol. 13v: Degenhart and Schmitt, fig. 19.

77 This monastery was first dedicated to the Assumption of the Virgin.

78 L. Zorzi, 1977, 198–99; L. Cecchetti, "La donna nel medioevo a Venezia," *Archivio Veneto*, XXXI, Part 1 (1886), 67, n. 1. By the 16th century the productions of the Crociferi were largely comic and secular.

renaissance—that of Masaccio and Donatello. Bellini increased the narrative complexity of this group by extending the subject on the facing left page to show Pilate wearing an iron crown; gripped by the suffering before him, he holds on to his throne and baton of command as if seeking reassurance in these symbols of his power.

Two other London *Flagellations* (Plates 198, 199) are formal and frontal compositions. In the first, Christ is again beyond a triumphal arch, possibly a reference to the ultimate victory of his sacrifice or an ironic commentary on the seeming disparity between the forces of good and evil. Architecture in the background recalls that in Donatello's bronze reliefs at the Santo, Padua, cast in the later 1440s.

The second *Flagellation* (Plate 199) is set in an open meeting area somewhat like that for *Christ among the Doctors* (Plate 183). Hiding the semicircular steps in the foregound are the spectators Bellini added to increase the sense of witness. Lantern bearers make it clear that the Flagellation was at night, as Dürer and Titian would show it later.

Twice in the London Book the *Flagellation* is set obliquely, on the porch of a North Italian civic building, a magnificent Venetian palace of justice (Plate 200), and in a more modest Romanesque government house (Plate 201), a cheetah chained to the outer corner and another beast inside. The Flagellation is an event as much ignored as observed in both scenes, and the perspectival location of the buildings encourages this neglect, the viewer's interest led beyond by the insistent flight of lines established by the porch steps. A nearby church and many bell towers suggest the performance of the Passion within the fabric of Christian faith, the callous, contemporary world no less tragically indifferent to the Flagellation than it had been in the first place.

Christ is placed at an angle in two *Flagellations* in the Paris Book (Plates 202, 203), as if the artist were deliberately interposing the architectural fabric of Roman oppression between the savior and the viewer. The building in Plate 202 is embellished with reliefs, statues, and possibly with frescoes, like renaissance Venice's most lavish buildings. Hercules and Deianira reappear in a panel on a balcony amid four other reliefs or paintings of the hero's life. In carved roundels two monastic reading figures may be prophets, the building thus a conflation of Roman and Jewish judgment chambers; the Hercules reliefs could extend that meaning, the hero's labors seen as forerunners of Christian penance and justice.

Plate 203, the last of the Louvre Book's *Flagellations*, was detached from the Book sometime after 1728, but returned to the Louvre as a separate drawing. Pilate witnesses the torture, seated on the porch of a lavishly decorated Venetian palace. Gothic ornament and classical reliefs encrust this building with scenes from the life of Hercules (or possibly Samson) and over-life-size figures of a nude woman and an athlete bearing a votive offering, all subjects designed to stress the antiquity of the judgment chamber and to refer again to Roman and Jewish rule. Like the setting for the *Judgment of Solomon* (Plates 153/154), this unusually elaborate building's design is inspired by the Doge's Palace and by descriptions of Jerusalem in Josephus' *Jewish Wars*.[75]

Jacopo's courtly settings for Passion scenes already occurred in early Trecento manuscript illumination in Venice as illustrations for travel guides to the Near East: similar formulas prepared by a German Dominican, Burchardus de Monte Sion, are used in representing figures and space.[76]

Venetian theatrical activities were long centered at the medieval monastery of the Crossbearers (*Crociferi*), the carrying of the cross being a major scene in mystery plays.[77] Bellini's numerous drawings of the Crucifixion may pertain to the special significance of that scene in the religious theater, his concern echoing throughout the Books.[78] Passion Week reenacts the most sacred of dramas. Jacopo's many images drawn for and from that observance suggest that they were meant to be seen in a theater of faith. Tragic events unfold as if the viewer, walking along the great halls of the city's scuole, were following Passion paintings in his own *Via Crucis* and Imitation of Christ.

Among the finest works sometimes attributed to Bellini is a horizontal projection of the *Flagellation and Crucifixion* (Fig. 45). Rendered in *semi-grisaille*, the picture suggests a theatrical backdrop or flat, an accessory to a pious narration, its artist probably North Italian and familiar with Jacopo's graphic achievements.

*The Way to Calvary.* Christ, placed at the center but in the distance, bears his cross on the way to Calvary (Plate 140). In the foreground, much larger, a sculptor carves an idol to be placed on the column now beside him. The column base, near his feet, is directly below Christ's feet farther back, and Bellini, making an ironic commentary by way of art, con-

trasts the seemingly insignificant Passion with antiquity's illusory monumentality. The absorbed sculptor and the workmen busily patching Jerusalem's walls, all blind to the tragic procession leaving the city gate, may pertain to the meaning in Acts 4:11, "This is the stone which was rejected by you builders, which is become the head of the corner."[79]

The sense of panorama in this page, close to that in late medieval Paduan works, combines with newly rich observations related to recent Netherlandish painting. A bird's-eye view of the *Way to Calvary* by Jan van Eyck may be its source, where Christ is but one player in a cast of thousands, all seen in a landscape of almost infinite variety. Discovered by the searching eye, the Passion is played on a cosmic set, Christ's presence found in a world about to be saved by the loss of his life.

Ridolfi's titles of Bellini's lost *Way to Calvary* in the series for the Scuola di San Giovanni Evangelista, completed in 1465, imply close-up views in some of the compositions; this is true also of several of his other titles, not drawn in the Books, that intimate a special confrontation and proximity. These lost subjects may include "Christ Encountering His Mother on the Way to Calvary," and "Mary Telling Joseph of Christ's Arrest." He describes "The Sorrows of the Virgin" as showing the Virgin fainting as she learns of her son's arrest and arraignment before Annas and Caiaphas; another image was of the Resurrected Christ Appearing to the Virgin.

*The Nailing to the Cross.* Rapidly penned on the hair-side of the vellum page (Plate 141), the reed penwork in the Paris *Nailing to the Cross* has the scratchy immediacy later found in drawings by Bruegel and Rembrandt. The small figures suggest richly wrought miniatures, the vellum's texture giving the inked line a rough passage that adds feeling as it subtracts refinement.

Golgotha, the Place of the Skull, was named for Adam's skull found in the rocky base where Christ would be crucified between the two thieves. Obliquely aligned crosses, first appearing in early fifteenth-century images, are only one of the audacities on this page. Naked, Christ is seen feet first, a view Mantegna would carry to still greater extremes (Milan, Brera). Five torturers nail him to the cross, three grouped like the soldiers who will soon throw dice for his robes.[80] The good thief stands stripped at the far left; Mary, supported by holy women, is in the distance. Daring in its diagonals, sudden foreshortenings, and brilliantly massed "choruses" of Roman soldiers and spectators, this Calvary was probably designed for a vast work, a composition that could have inspired Tintoretto's immense canvas for the Scuola di San Rocco in 1565.

Large and sharply delineated, the instruments of torture (pick and shovel, adze, ladders, and still-earthbound cross) proclaim their awful innocence, in telling contrast with the small size of their victims, sacrificed and sacrificers alike. The simple footbridge over the stream in the right foreground, so frequent in his work that it is almost Bellini's signature, is typical of his glancing awareness of nature's passage, undeterred by man's unique inhumanity.

With its bird's-eye view, the cartographic swoop of this scene brings Bellini's image close to the text of the popular late medieval *Meditations on the Life of Christ*, the Venetian edition reissued in 1450. For the Sixth Hour of the Passion the Franciscan author exhorted the reader: "When the Lord Jesus, led by impious men, reached that foul place, Calvary, you may look everywhere at wicked people, wretchedly at work. With your whole mind you must imagine yourself present, and consider diligently everything done against your Lord and all that is said and done by Him and regarding Him. With your mind's eye see some thrusting the crosses into the earth, others equipped with anvil and hammer, others with ladders and other instruments, others giving orders about what should be done. . . ."

The painter followed the Trecento text, which noted, after describing Christ nailed to the upright cross, "There are, however, those who believe that He was not crucified in this manner, but that the cross was laid on the ground and that they then raised it up and fixed it in the ground. If this suits you better, think how they take Him contemptuously, like the vilest wretch, and furiously cast Him onto the cross on the ground, taking his arms, violently extending them, and most cruelly fixing them to the cross. Similarly consider his feet, which they dragged down as violently as they could."[81]

*The Raising of the Cross.* Since Jacopo drew the highly unusual composition of the *Nailing to the Cross*, he no doubt rendered its sequel. An idea of this lost scene is provided by a Venetian drawing (Oxford, Christ Church; Fig. 44); Bellini was probably its source, also influencing Dürer's studies of this theme.[82]

79 De Mandach, 1922, 51.

80 That this theme may have an Umbrio-Marchigian source is suggested by a fresco of the subject at Sta. Maria dei Laici in Gubbio, ascribed to Giacomo Bedi, a follower of Ottaviano Nelli. See Van Marle, 1934, XIV, fig. 1.

81 Ragusa and Green, 1961, 334.

82 See also P. Rose, "The iconography of the Raising of the Cross," *Tribute to Wolfgang Stechow* (*Print Review*, No. 5, 1976, 131–41), the Lorenzo Costa drawing in Oxford (Fig. 6) discussed on p. 139.

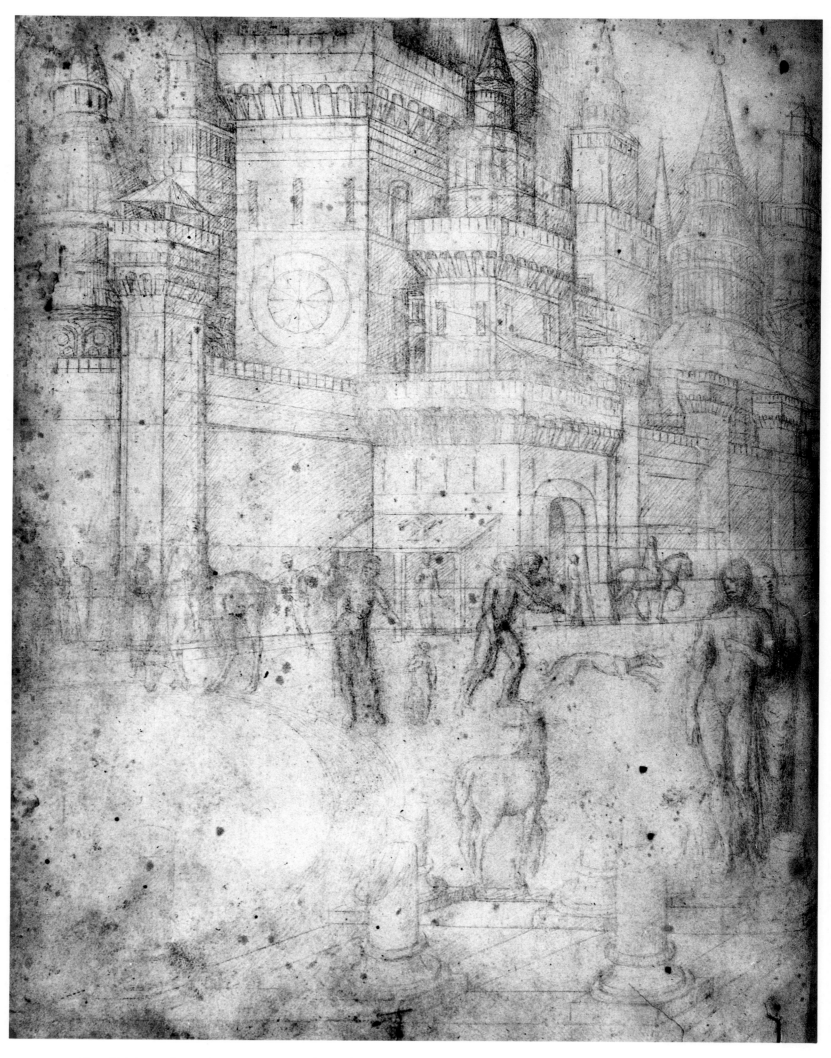

Plate 204. *View of Jerusalem* (continuation of *Crucifixion with Magdalene*, Plate 205). British Museum 1v

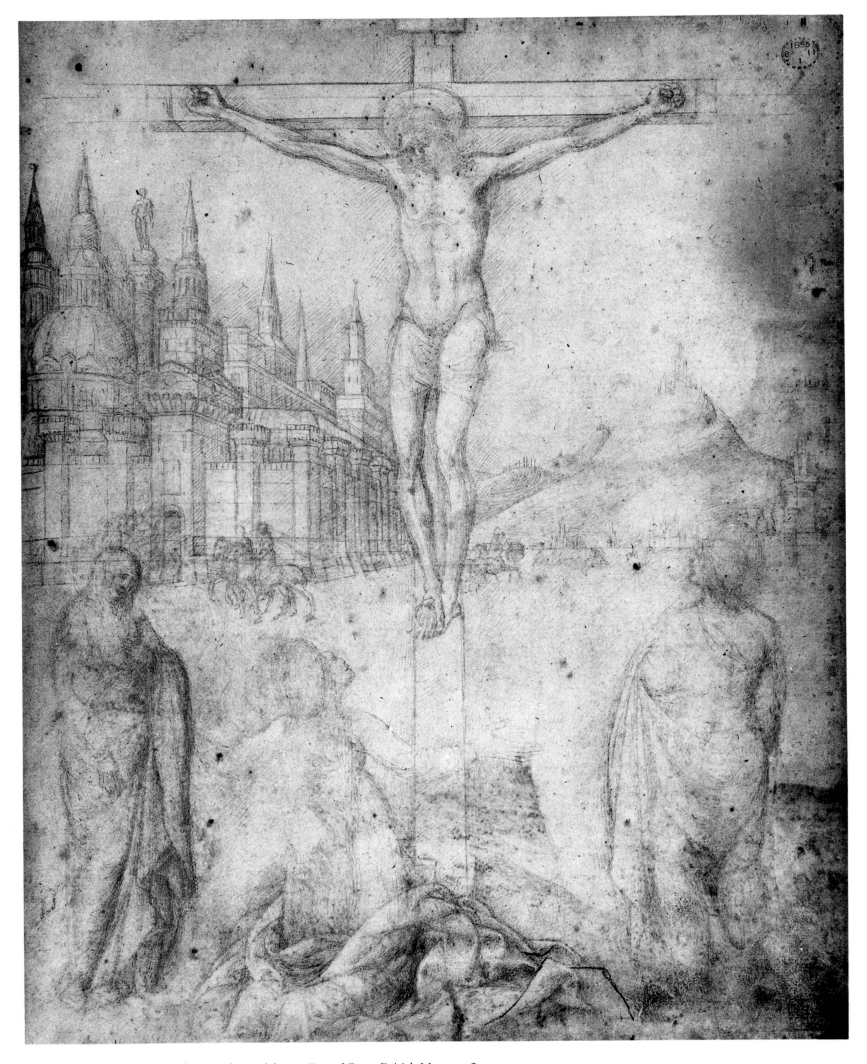

Plate 205. *Crucifixion with Magdalene at Foot of Cross*. British Museum 2

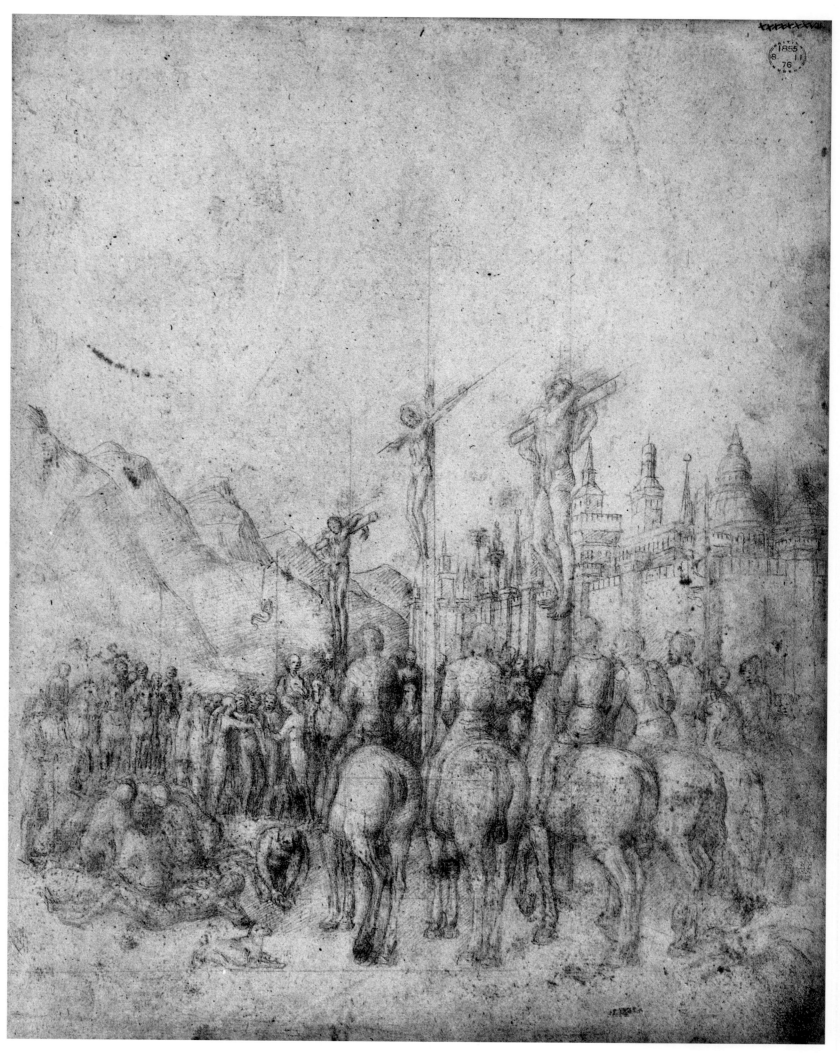

Plate 206. *Crucifixion* (A). British Museum 77

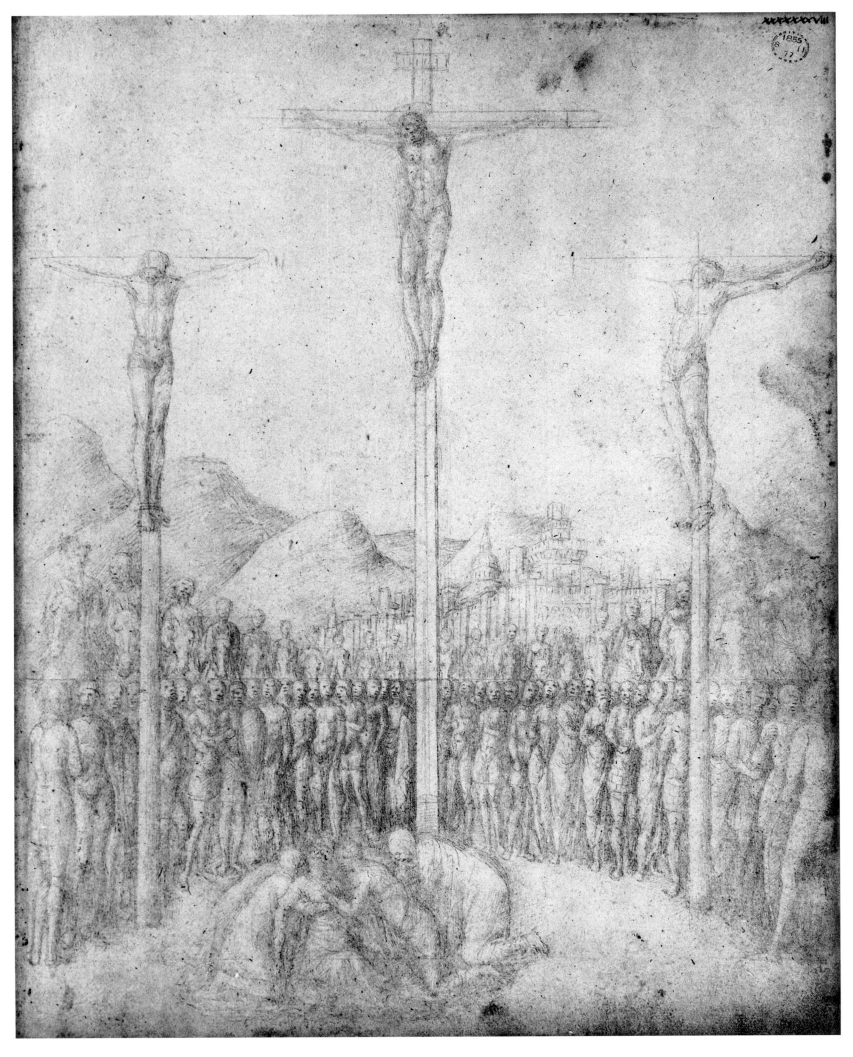

Plate 207. *Crucifixion* (B). British Museum 78

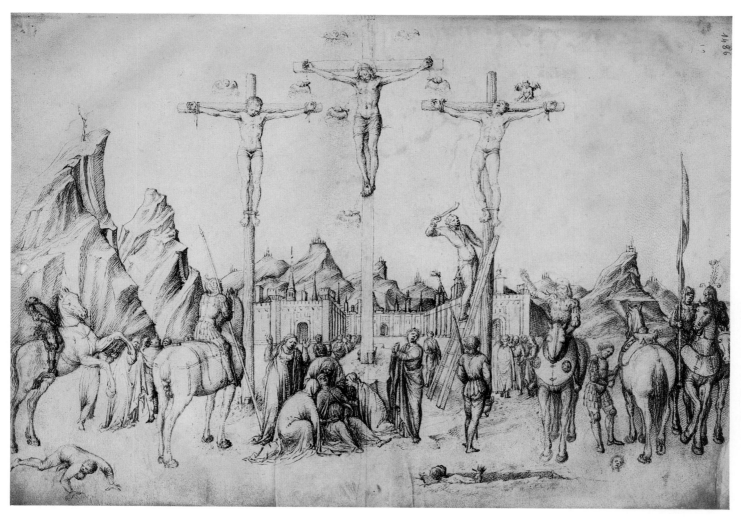

Plate 208. *Crucifixion*. Louvre 19

83 The letter, dated July 1st, 1759, may have been written by Giambattista Cignaroli; published by Ricci, 1908, I, 32.

84 G. Uzzielli, *Le misure lineari medioevali e l'effigie di Christo*, Florence: 1889, and his "L'orazione della misura di Christo," *Archivio storico italiano*, VI (1901), 6; both cited by C. Ginzburg, *The Enigma of Piero*, 1985, 130–31, 148–49.

85 E. Panofsky, *Early Netherlandish Painting*, I, Cambridge, Mass.: 1953, 148. The passage is there applied to Jan van Eyck's *Madonna in a Church* (Berlin, Dahlem Museum).

*The Crucifixion*. Jacopo's best-known early work was a large fresco of the *Crucifixion* for the chapel of Bishop Giulio Memmo in the cathedral of Verona. Painted in 1436, it was much admired before its destruction in 1759 for architectural "improvements." Though lost to us, the fresco is at least described in an anonymous letter of that year.[83] Bellini (like Gentile da Fabriano in the *Adoration of the Magi*; Fig. 67) built up the horses' bridles and bits in gilded relief that added a jewel-like glitter. His still conservative manner was also indicated by the "bearded scribes" at the sides who recorded their thoughts on paper, doubtless prophets.

The body of Christ in Bellini's later Verona *Crucifixion* (Fig. 46) projects an unusual physicality that recalls the large crucifixes, sculpted and painted, and cruciform panels of earlier centuries. This sense of vital corporeality, which also occurs in some of Jacopo's drawings (Plate 212), is conveyed by the "life-size" image in keeping with the documentary drive of contemporary devotions, addressing prayers to Christ that stress his exact measure as central to the humanity of his divine sacrifice.[84] In his grand canvas Bellini balances the physical with the metaphysical, using mystical illumination from the left, a light that is "above the order of the physical universe, that illumines a day not followed by night, and that 'reacheth from one side of the world to the other . . . a sun shines from the North and thereby proclaims that it can never go down' " (Book of Wisdom, VII, 29–VIII, 1).[85] The artist's votive presence, his name on the tablet at the foot of the cross, dedicates the canvas to the realm of sacred illusion.

The opening images in both Books are views of Calvary, as if Bellini were making an invocation. These Calvaries give the parameters of Bellini's vision, between Gothic and renaissance, Venice and Tuscany, North and South; never the victim of these varied references, he is ever their beneficiary.

Initially a vertical view, the leadpoint *Crucifixion* that opens the London Book (Plates 204/205) has an ominous look. Christ is on a tall cross; the Madonna is in the smaller scale that recalls Roger van der Weyden's late style. Slender and almost medieval in its proportions, this composition could have been planned for a conventional devotional painting. Mary places her right hand on her heart as if experiencing the final sword thrust of mater-

346

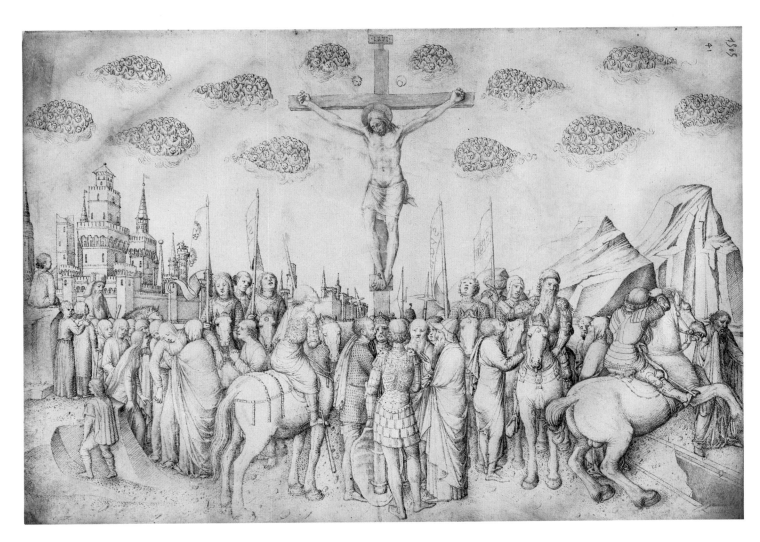

Plate 209. *Christ Crucified.* Louvre 41

nal suffering, first predicted by Simeon at the temple (Plate 178). The two other mourners show their grief in unusual ways. Saint John's pose, seen from the back, his head in profile, combines privacy with individuality. The enormous swoop of the Magdalen's drapery as she kneels, also seen from behind, falls in baroque cascades around the base of the cross in a neo-Gothic extravaganza that points to Grünewald's emotional art. So novel is this figure that Bellini did not complete it, sketching the rest very lightly, her arms extended in imitation of Christ's.

For Jerusalem, Bellini follows the great urban models in Paduan Trecento painting. He may have added this when he continued the scene into the facing left page, where the city becomes still more massive.

Perspectival guidelines move from the right page over to the left to assist in the isocephaly of most of the aligned heads, the device so often employed in the London Book. A ruined altar-like structure resembles the small one on a saint's island (Plate 277). The stag and horsepond at lower left are irrelevant features that would never have been so close to a city wall; they stem from a third drawing phase, copied from pattern books. The nude man is based on a classical statue Bellini often used (Plate 67).

The aerial view of Golgotha in the Paris Book (Plate 213) is based on Jacopo's design, but most of the brushwork, in an abbreviated graphic style, dates from late in the fifteenth century. Though Bellini's Books contain many centrally planned buildings, that in the middle ground is not his. Scholars believe this page was bound into the Book at a later date. [86]

Two *Crucifixion* images on succeeding recto pages in the London Book, both vertical, show Bellini's experiments with staging this scene. The first (Plate 206) follows Paris' oblique placing of the three crosses (Plate 141), now raised near the wall of Jerusalem and behind a large semicircular formation of Roman horsemen seen from the back; a preliminary study of Christ being nailed to the cross is at the lower left. Infrared photography reveals Bellini's compositional guidelines for parallel alignment of the dog and the horse, and his graphic "pentimenti" above the bad thief, originally higher on his cross. The landscape extension on the facing left folio was added later (Plate 40).

86 Degenhart and Schmitt, 1984, 20: "A change is imminent in the late 1450s. Geometric ordering elements take second place behind other space-creating devices like tonal values and light and shade. In the Paris album representatives of this new style of landscape depiction are the exception. One such is the *Golgotha* landscape, which was inserted late into the Paris album, at a point in time when Jacopo Bellini had already started work on the London album of drawings."

87 Sambin, 1949, IV–V.
88 Ragusa and Green, 1961, 339.
89 Seldom shown, this Breaking the Legs is depicted in Altichiero's later 14th-century Paduan fresco. Donatello employed the motif in a bronze relief (Florence, Bargello), which J. Pope-Hennessy (*The Study and Criticism of Italian Sculpture*, New York: 1980, 181) dates after Donatello's return to Florence, c. 1453–56. An enigmatic little painting (Florence, Villa I Tatti), close to the art of the Ferrarese Lorenzo Costa, shows the Breaking with a certain miniature-like precision that some critics trace back to Jacopo Bellini.

The second London *Crucifixion* (Plate 207) is seen from the front, the isocephalic witnesses' heads screening off the grouped cavalry behind. The very tall, slender crosses in this composition recur in paintings by Antonello da Messina, the Sicilian whose mastery of Netherlandish techniques made him an influential presence in Venice in the 1470s.

Such tall crosses are often found in the fourteenth century, especially in Duccio's circle, reappearing a hundred years later in the art of Jan van Eyck, whose paintings (or their copies) came to Italy in considerable numbers—his *Crucifixion* was known in Venice and Padua. A similar work is by the gifted Umbrian painter Giovanni Boccati (Venice, Ca' d'Oro), who was possibly in Jacopo's studio in the 1440s; he was in Padua early in 1448 and entered the painter's guild there in 1450.[87]

Several of Bellini's *Crucifixions* stress the Roman centurion, Longinus, "impious and proud, though later converted, a martyr and saint, extending his lance from a distance, scorning the holy women's entreaties, [he] opened a great wound in the right side of Lord Jesus; and blood and water came forth."[88] This apocryphal figure, converted to Christianity at the Crucifixion, was much venerated in Mantua, his lance among the city's greatest relics. Longinus appears in a Paris *Crucifixion* (Plate 208), one angel gathering blood and water from the lance wound in Christ's side as others collect blood from Christ's hands and feet. The rearing Roman rider may be another centurion converted by the sight of the Crucifixion. A pagelike figure, seen from the back, holds the stick with sponge attached and the bucket of vinegar, given to Christ when he asked for water. The strange U-shaped city plan of Jerusalem recalls Ghiberti's architecture. A torturer breaks the bad thief's legs (John 19:31–33) to hasten his death, and a demon waits to gather his evil spirit; over the good thief hovers an angel to save his soul.[89] Figures rise from their tombs at the death of Christ (Matthew 27:52).

Armed for the tournament, riders to the right strike a strangely festive note in this Crucifixion. Witnesses, participants, and victims share in an operatic finale, courtly grandeur and extravagance alongside with suffering *in extremis*.

Another horizontal *Crucifixion* in the Paris Book, without the two thieves, looks more old-fashioned (Plate 209), the Roman soldiers sweetly juvenile like pages at some North Italian court; cloud banks of cherub heads add to the ingenuous medievalism. To have children present at the Crucifixion is a fourteenth- and fifteenth-century theme in Siena and the Marches (near Venice). The element of romantic blandness, at odds with the ugly, impressively Tuscan Christ, suggests inking by the studio assistant who added the uncharacteristic yellow wash tinting the cross, and the alien, tiny sun and moon signifying the eclipse at the moment of Christ's death.

Longinus prays on horseback as another converted centurion, mounted at the right, points toward Christ. Scuttling away at the right margin is a worried, apostle-like figure, probably Judas on his way to suicide, as in the *Flagellation* (Plate 195). A foot soldier seen from the back carries a shield made of a great turtle shell, unusual armor found again in Plate 97 and in prints and drawings by Mantegna and Dürer. And a horseman leaps over a recently opened tomb, the motif that also occurs in another context (Plate 106).

Two other *Crucifixions* in the Paris Book, though radically different from one another, both go beyond the narrative to become images of contemplation. In one Christ is alone (Plate 212), as Bellini painted him in the great Verona canvas (Fig. 46), a burly, unidealized man sacrificed in perpetuity for humanity's salvation, his physicality also referring to the eucharist—Christ's body becoming bread from heaven. Bellini realizes such force in his art by stressing the Florentine virility that Donatello's sculpture and Castagno's painting brought to the Veneto. This image's tough severity contrasts strikingly with the subtle silverpoint medium that gives it being.

The three sinuous figures of Mary, Saint John, and the crucified Christ return to the restrained yet intense emotionalism of high Gothic art (Plate 211), delicate in posture and gesture like a group realized in some precious substance, ivory or silver. The tall, slender cross rises to support an almost feminine savior, his crown of thorns here an elegant circlet. A semicircle of cherubim fills the top of the vellum sheet. Cascades of folds falling from Mary's raised arms and over John's shoulders accentuate their grief. The mother and the beloved apostle hold their exquisite poses beyond the limits of time, ever ready to receive their viewers' prayers. Delicately inked, this page recalls *grisaille* paintings in shades of gray, forsaking color for the ascetic restraint of Lenten observance.

A kneeling donor of high rank in a London *Crucifixion* (Plate 210) must be a Venetian military leader. Mary seems to gesture from him to her son as two elders (Nicodemus and Joseph of Arimathea) turn from the cross to look at the soldier. Inking at the upper right has come through from the landscape of *Three Warriors Fighting a Dragon* (Plate 100).

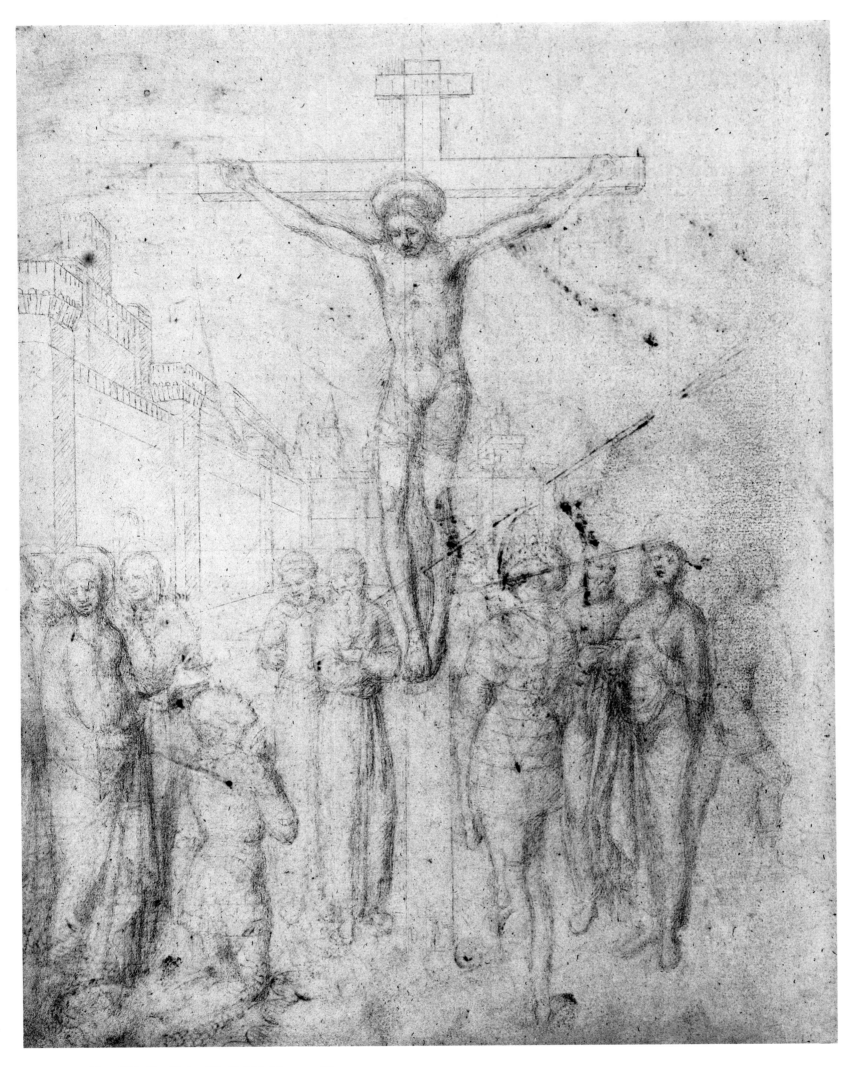

Plate 210. *Crucifixion* (C). British Museum 86v

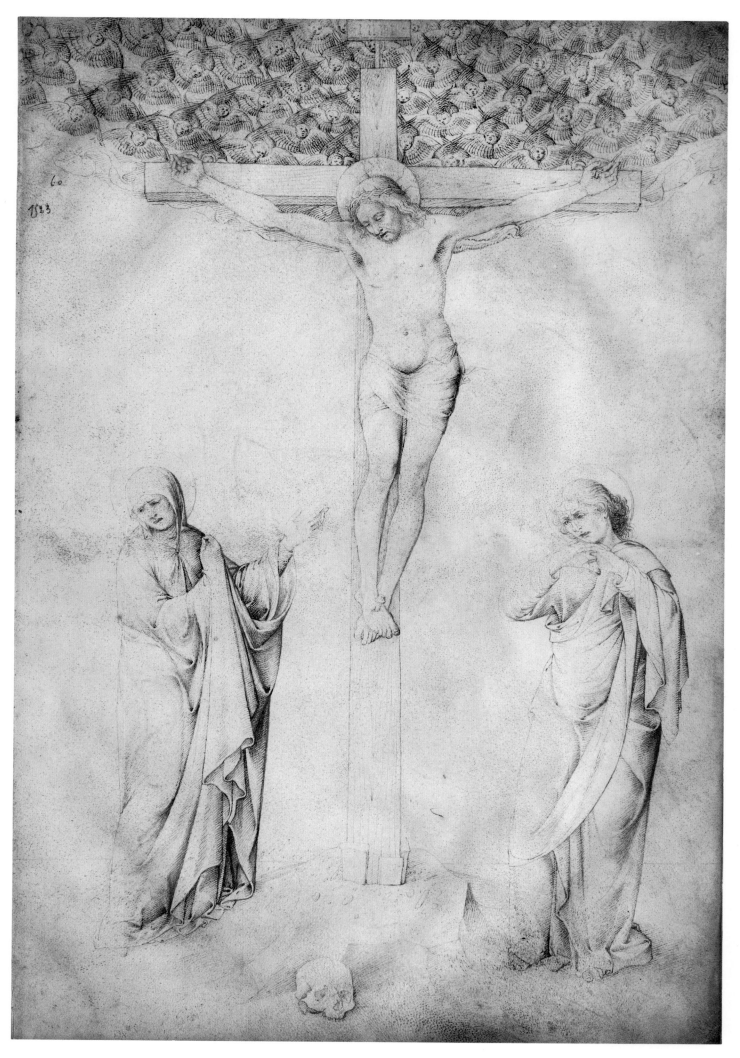

Plate 211. *Virgin and Saint John the Evangelist Mourn Christ Crucified.* Louvre 60

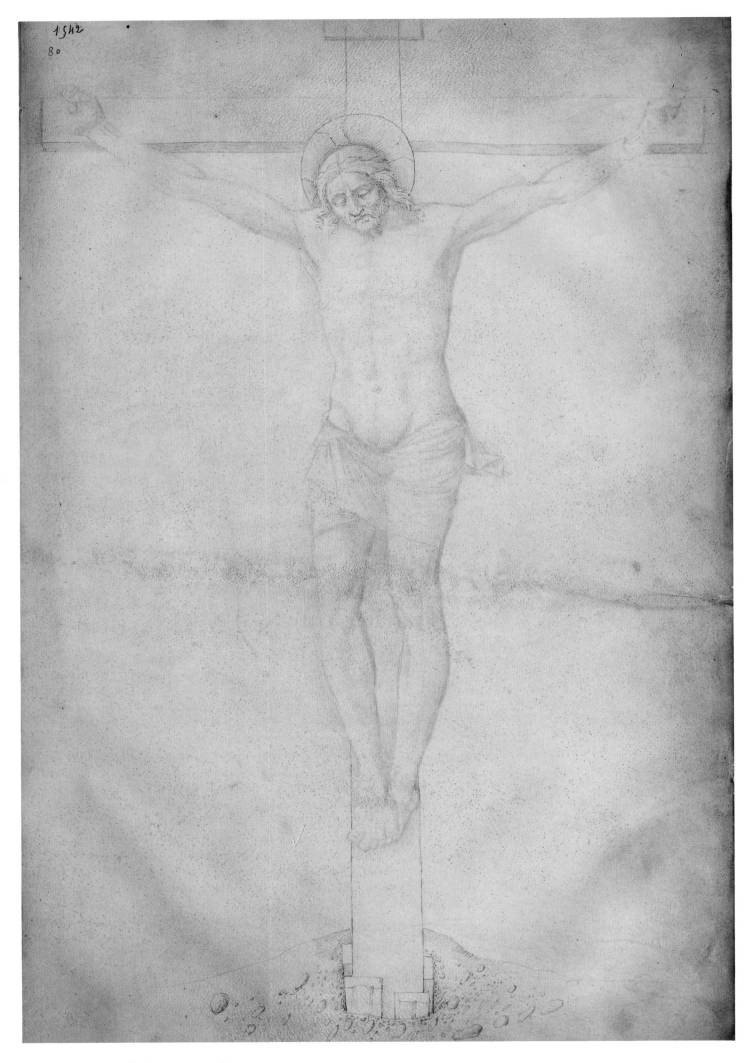

Plate 212. *Christ on the Cross*. Louvre 80

90 Goloubew (1908, II, text for pl. XXXIII) suggested that the artist was inspired by a mystery play performed outside the walls of a city.

91 E. Panofsky, ''Imago Pietatis,'' *Festschrift für Max J. Friedländer zum 60. Geburtstag*, Leipzig: 1927, 261 ff.

*The Deposition and Lamentation.* A rustic reverie on the *Deposition and Lamentation* in the Paris Book (Plate 214) is drawn in the same mystical spirit as the rural vistas of the *Adoration of the Shepherds* (Plate 170) and the earlier Passion studies.[90] This page omits the thieves as different episodes unfold together, beyond time. Four youths in the foreground form an enigmatic, almost classical frieze, turning their backs to the grievous events. One pipes, another holds a falcon, the third stares into a cistern as a fourth urinates into it. A great fallen Corinthian column recalls the one in the *Way to Calvary* (Plate 140).

The two small Lamentation groups show Bellini's love for Gothic art, for the choreography of grief found in French manuscripts such as the Rohan Master's and in statuary groups by itinerant Northerners. On the left the bridge and the statue-topped column are the same as in the left-side extension of the *Agony in the Garden* (Plate 192), suggesting a common locale for the start and the finish of the Passion cycle.

This page lies closest to the elusive essence of Venetian renaissance art, fusing classical and Christian in a lyrical landscape of intense pietism. Difference and indifference, sacrifice and indolence, reverence for nature and a frank yet loving affirmation of human fallibility are all made one, Bellini's selfless skill balancing formality and informality. This vision of the past set in an eternal present is very close to Giovanni Bellini's sacred allegories, sometimes explained as having arcane Gothic spiritual treatises as their source. But what matters is the mystery, not its "solution."

*The Entombment.* Some images hover between the narrative and the contemplative. Bellini's London *Entombment* is nearly a close-up whose time frame will never change, inherited from medieval piety (Plates 215/216).[91] Jacopo revises such images of high religious emotion by following fresh currents, leading toward the most moving of Venetian religious art, his son Giovanni's.

This subject, the grief-stricken moment of abandoning Christ's body to the tomb, was seldom given a major area, usually placed just above or below the central panel of Italian altarpieces. Jacopo, his sons, and his son-in-law Mantegna were among those initiating this shattering episode as an individual, independent painting.

As Christ's body symbolizes the eucharist, so his tomb suggests the altar where the mass will take place. A great sarcophagus, drawn first, allows little space for the mourners to squeeze around it.

The landscape background recalls that of the *Agony in the Garden* (Plate 193), as if the Passion were ending where the Arrest took place. The vertical composition was extended onto the facing page (Plate 215) to show the sarcophagus lid, richly and classically carved, and a distant Lamentation much like that in the Louvre Book (Plate 214).

More gripping is another Paris *Lamentation/Entombment* (Plate 220), for Saint John has leaped into the sarcophagus to hold up the unusually youthful Christ. Asymmetrically composed, the three Marys run in from the Crucifixion site, the Magdalen first, kissing almost greedily the wound in Christ's hand. The power of past achievements is traced in this page by a student or early restorer who could not follow Jacopo's swift graphic notations, his failure most evident in the harshly outlined hands of the mourning woman at far left.

A vertical *Entombment* in Paris (Plates 217/218) is a more concentrated form of the London composition (Plate 216). A pyramidal mountain peaks above the savior. Mary supports the body this time, her face next to her son's. The flourishing and dead trees symbolize respectively eternal life and damnation, on Christ's right and left side at the Last Judgment. Like many pages in the Paris Book this one has been sensitively reworked.

Though two other scenes from the life of Christ extend across two pages in the Paris Book (*Christ among the Doctors*, Plates 181/182; *Adoration of the Magi*, Plates 174/175), only here is the facing page of this vertical composition of Calvary used to maximum advantage, drawn in almost as soon as the *Entombment* was completed. Three empty crosses, two ladders, and a tomb lid tell of the *Deposition* and *Lamentation* as eloquently as the mourning scene on the facing page. A workman trudges homeward with his tools—peasant, mason, or torturer—equally indifferent now to the lumber of crucifixion and the stone of entombment, drawn hieroglyphs of torture and burial. This is the most moving of all the facing pages for its renunciation of motion, the inanimate left to convey ultimate desolation. The Franciscans had a cult of the cross alone, without Christ, but Jacopo may have been the first to give those of the thieves almost equal billing in this quiet, contemplative view of three excruciating deaths.

Though the Paris Book's *Dead Christ* is the smallest mourning scene (Plate 219), delicately rendered in silverpoint, it is the most focused. A close-up of the central group that

cuts off even the sarcophagus ends, it is dominated by Christ's powerful body, suggesting the vigorous plasticity of a relief, possibly meant to be cast as one of the plaques passed around at the end of the mass for the kiss of peace. The frame has a rich cornice, as if to be made of gilded wood or metal;[92] like the torchères flanking *Saint John the Baptist* in the Paris Book (Plate 283), this decorative project, each side different, may have been an afterthought, quickly penned.

Giovanni Bellini developed this composition in many of his early *Pietàs* (Bergamo; Milan; Venice); closest is the great canvas he completed a year or so after his father's death for the Chapel of Saint Nicholas in the Doge's Palace (Fig. 52). The sarcophagus has become an altar with massive candlesticks and kneeling saints added at right and left, a painting that old Jacopo may well have initiated, which once bore the date 1472.[93]

The theme of Christ Mourned by Two Angels is beloved because it signifies the eucharist, his body brought as "angel bread" from heaven to the mass. Angelic lamentation was one of Giovanni Bellini's most beautiful devotional subjects, and he may well have based his images on one by his father, possibly painted before 1465 for an altar at the Scuola di San Giovanni Evangelista that Ridolfi describes. The Man of Sorrows, standing in his sarcophagus and flanked by mourning angels, appears in a late lunette immediately above the image of Christ as an infant in Mary's arms (Fig. 65); the *Dead Christ* in the scuola's altarpiece refers to his eternal sacrifice and to the consecrated host.

*The Descent of Christ into Limbo.* Jacopo da Voragine wrote in the *Golden Legend* that the Descent of Christ into Limbo came before the Resurrection, which occurred on the third day after his Passion. Described only in the apocryphal Gospel of Nicodemus and the Acta Pilati, the Descent took place while Christ's body remained in the tomb. His soul went down to Limbo to liberate the patriarchs, usually led by Adam and Eve and Saint John the Baptist.[94] In both of Bellini's Books Christ is accompanied by the good thief (in the Byzantine manner), who stands behind him holding the cross (Plates 222, 223/224).[95] The devils at the left in the London drawing belong to hell rather than to Hades, yet they look more like the fauns and satyrs who animate many of Jacopo's liveliest classical pages. A predella panel (Fig. 51) of Limbo, probably painted by Giovanni for the Gattamelata Altar, reflects this London page.

*The Resurrection.* Both *Resurrection* compositions in the Paris and London Books (Plates 225, 226) are based on the *Golden Legend*, where Christ is described as rising from a closed tomb.[96] Initially a vertical composition, the London drawing was extended to the left facing page by a mountainous landscape and city view (Plate 44). The panoramic Paris *Resurrection* anticipates Giovanni Bellini's richly anecdotal and classicizing treatment of many religious subjects. The *Resurrection* was in Jacopo's cycle of 1465 for the Scuola di San Giovanni Evangelista.

*The Ascension.* The commemoration of Ascension Day began in the 1170s to join Venice's other important ceremonies combining church and state, faith and force. A magnificent civic barge—the Bucentaur—rowed the doge toward the ocean, where he cast a consecrated ring overboard to celebrate the mystical marriage of the Serenissima with the sea. This ceremony unites earth, sea, and sky, for as Christ enters the heavens, Venice reaffirms her ties to him and to the waters, source of all her goods.

For his drawing of the *Ascension* (Plate 228), Bellini turned to the *Meditations on the Life of Christ*, where the miraculous event is described as taking place on the Mount of Olives. In accord with Christ's wishes, Mary and the apostles followed him there.[97] The medieval text quotes Psalm 103 to convey the subject, a beautiful line that guided Bellini, ". . . who maketh the clouds his chariot: who walketh upon the wings of the wind." The tunnel-like concentric valleys and clouds around Christ may also come from the *Meditations*.

*The Death of the Virgin.* The Death, or as the Eastern Church calls it, Sleep (Dormition) of the Virgin came as a tragic shock to the apostles, their living link with Christ now lost. Mary's obsequies had all the ritual recognition absent from her son's, and this first major Christian funeral service initiated the seventh sacrament. Her death, more often represented in the Eastern Church, was stressed in Venice by that city's ties to Byzantium. Two separate events are usually shown: the laying out of the body, mourned by apostles often unaware that Christ was bearing his mother's soul heavenward; and the funeral procession itself.

92 Goloubew (1908, II), text for pl. II.

93 Robertson, 1963, 47, n. 2, suggested Giovanni's use of his father's drawing for this painting.

94 This theme is found in Trecento art (Duccio's *Maestà*) and on the tomb of the Beato Pacifico (Frari) by an unknown Tuscan sculptor, c. 1437.

95 Though Voragine mentions his presence, the good thief is not usually shown in Western depictions of the Descent, but commonly in those from Byzantium.

96 Noted by Degenhart and Schmitt, 1984, 25.

97 Ragusa and Green, 1961, 374–84. Bellini does not include the Magdalen, though she is present in the *Meditations*. Aspects of the composition follow those by Giotto at the Arena Chapel (Padua) and a Franciscan polyptych by Lorenzo Veneziano (Venice, Accademia).

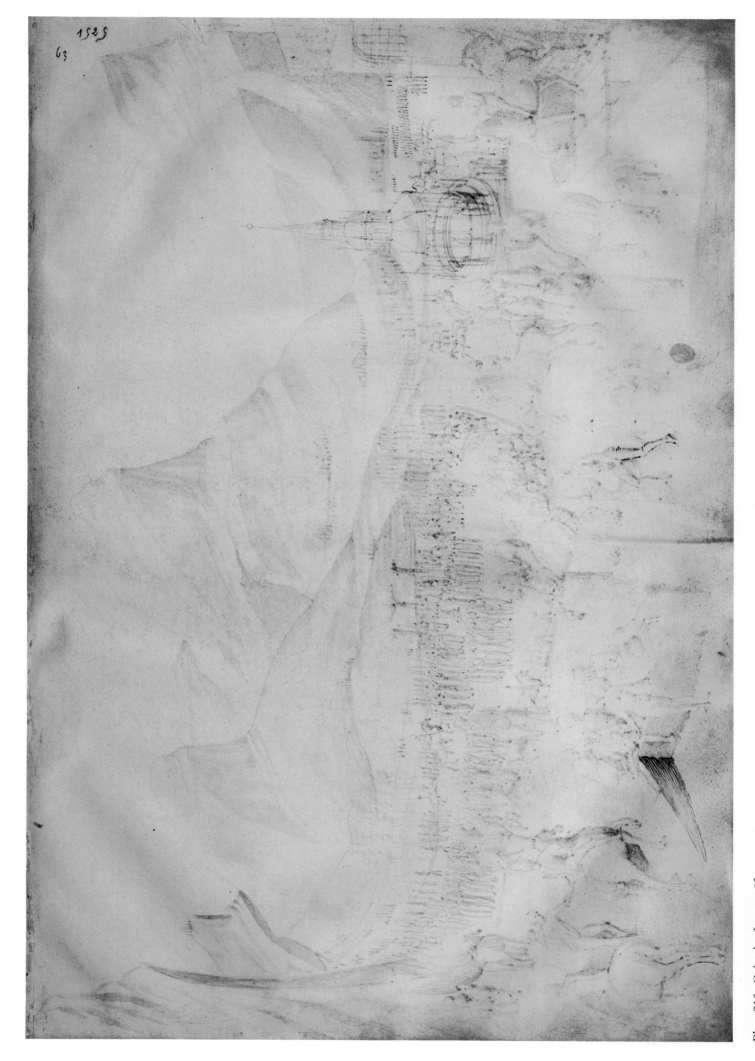

Plate 213. *Golgotha*. Louvre 63

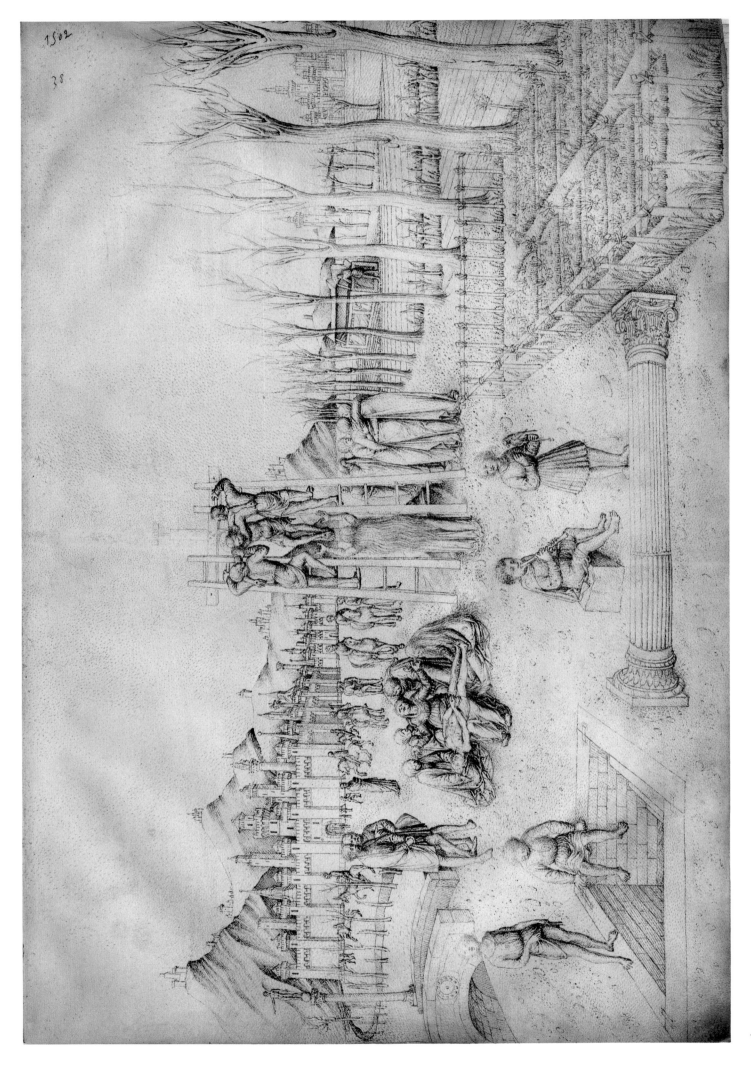

Plate 214. *Deposition and Lamentation*. Louvre 38

Plate 215. *Pietà and Sarcophagus Lid* (continuation of *Entombment*, Plate 216). British Museum 22v

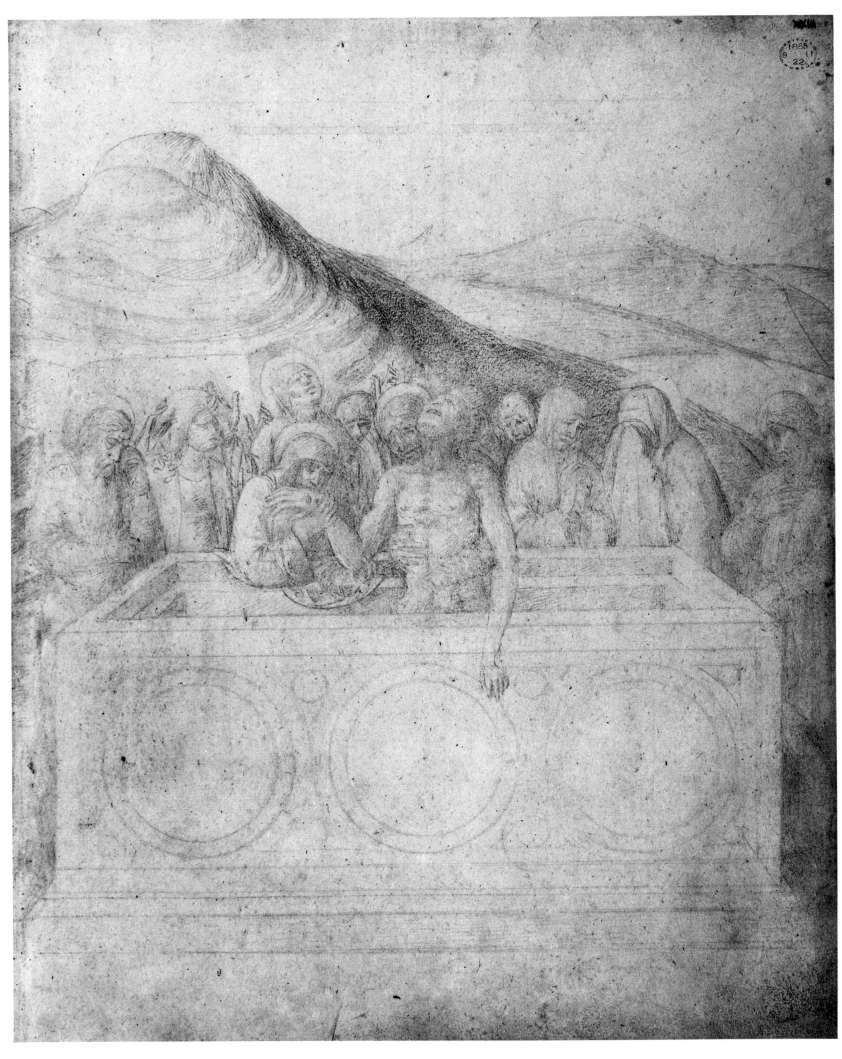

Plate 216. *Entombment*. British Museum 23

Plate 217. *The Three Crosses and Sarcophagus Lid* (continuation of *Entombment*, Plate 218). Louvre 57v

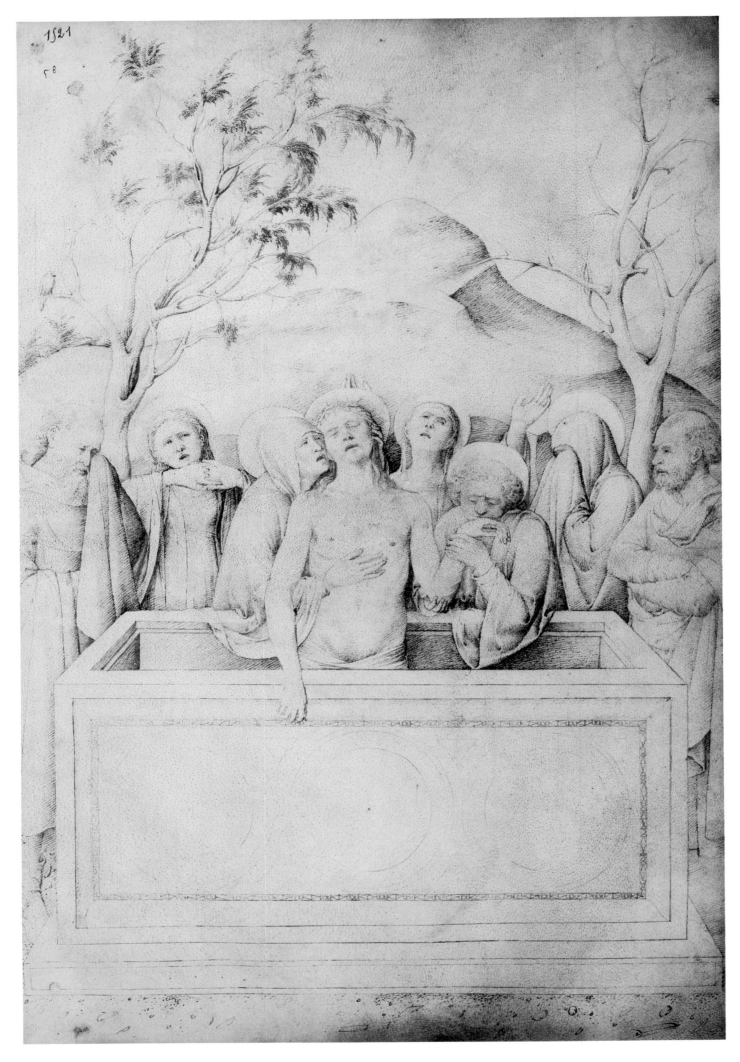

Plate 218. *Entombment*. Louvre 58

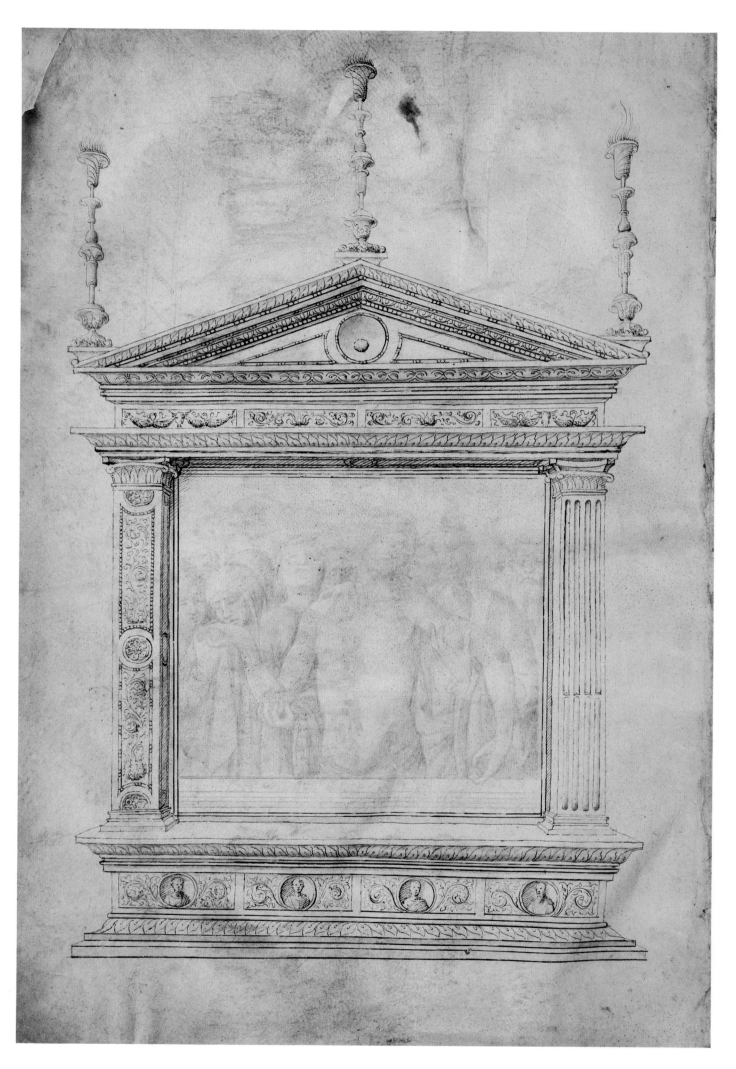

Plate 219. *Dead Christ in Frame.* Louvre 1v

Plate 220. *Lamentation/Entombment*. Louvre 59

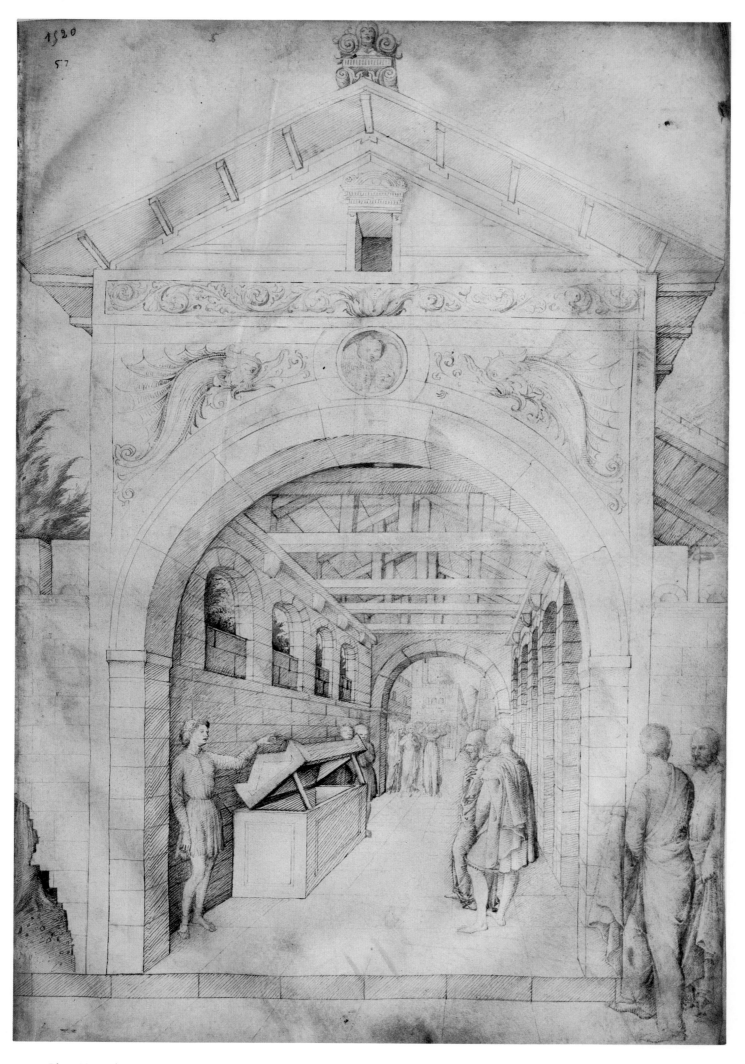

Plate 221. *Three Marys and Other Mourners at the Tomb.* Louvre 57

362

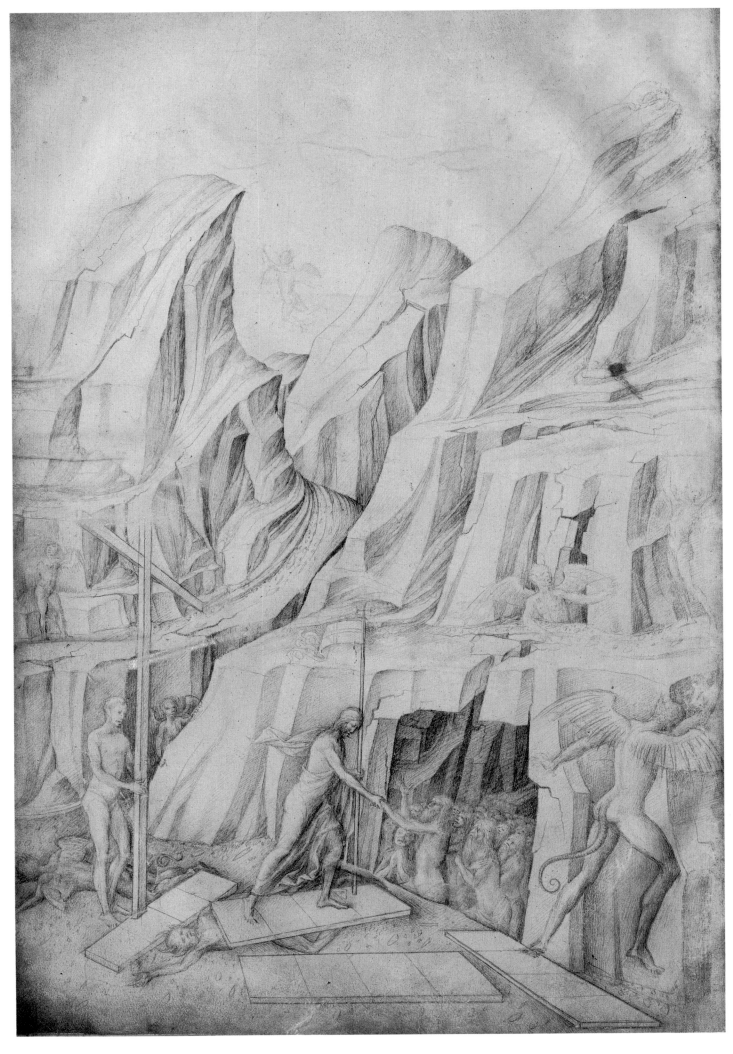

Plate 222. *Christ in Limbo*. Louvre 22v

Plate 223. *Infernal Landscape* (continuation of *Christ in Limbo*, Plate 224). British Museum 25v

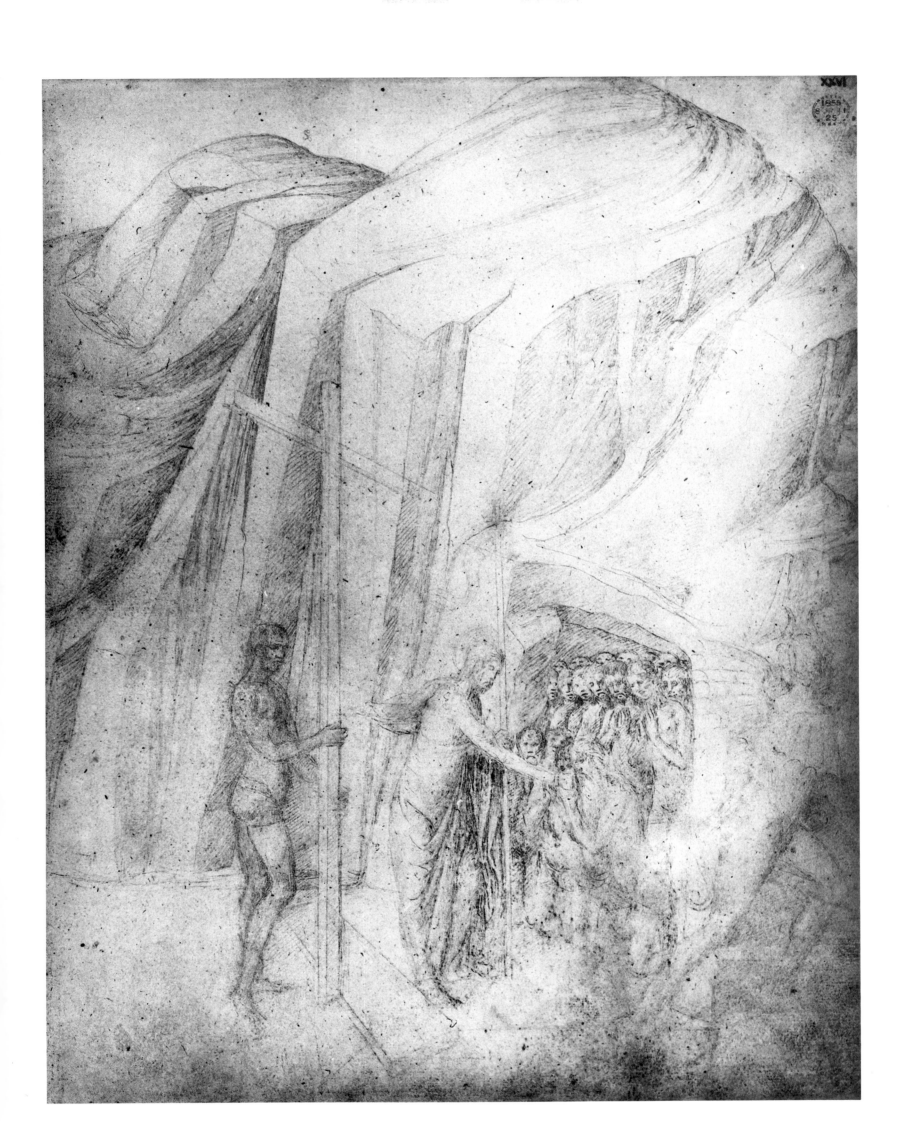

Plate 224. *Christ in Limbo*. British Museum 26

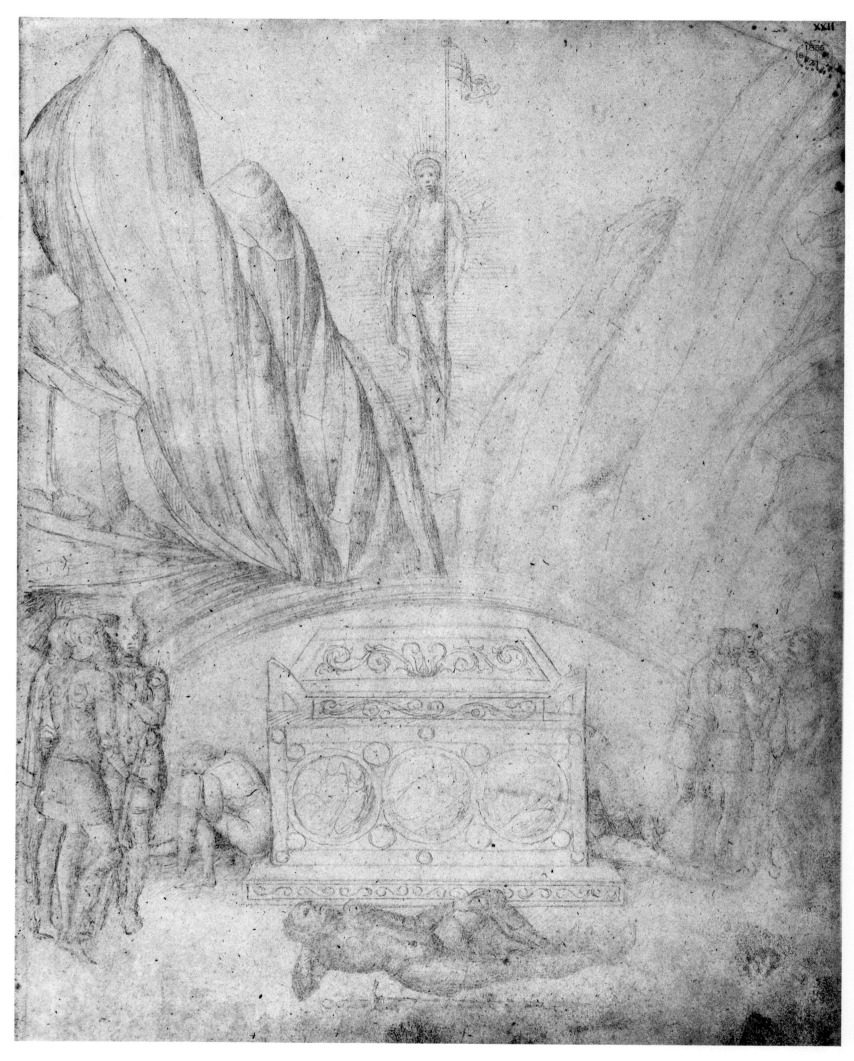

Plate 225. *Resurrection*. British Museum 22

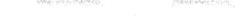

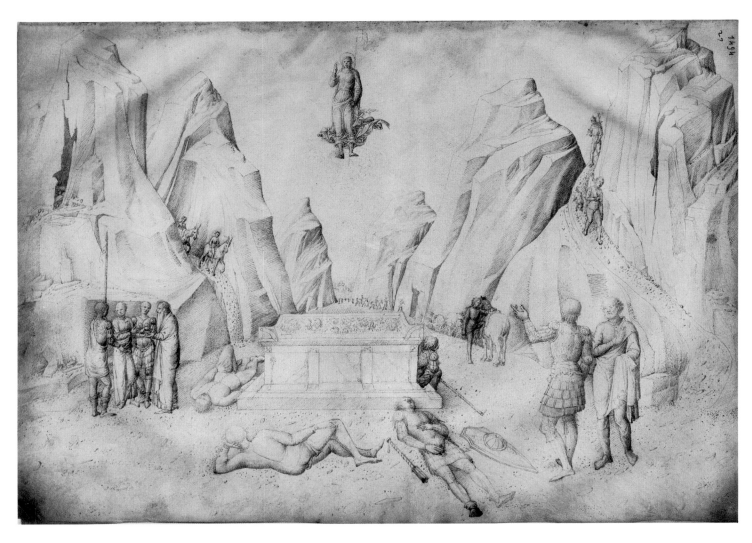

Plate 226. *Resurrection*. Louvre 27

One predella panel of the Brescia *Annunciation* Altar is a *Death of the Virgin* (Fig. 24), painted in Bellini's studio in the early 1440s. Later Bellini evolved a vertical composition, found in his Books and in a painting by Andrea Mantegna (divided between Ferrara, Galleria Nazionale, and Madrid, Prado). Jacopo, with studio assistance, painted a canvas of the subject for the Scuola di San Giovanni Evangelista cycle, completed about 1465.

In both Books' *Death of the Virgin* her body is laid out feet first under a triumphal-arched barrel vault (Plates 229, 230), six isocephalic apostles lining each side and sharing one vanishing point. Christ, high in a mandorla, holds Mary's doll-like soul.[98] The empty foreground of the Paris drawing would work effectively as a manuscript illumination, recalling those of Padua from the later 1450s. Jacopo turned to compositions by Castagno for this theme, and also adapted them for the Mascoli Chapel (Fig. 54).

*The Funeral Procession of the Virgin*. Bellini made three drawings of the Funeral Procession of the Virgin, one each in the Louvre and London Books, and a third, on paper different from London's, that is now divided between the Fogg Art Museum and the Louvre (Plate 233).[99] In Jacopo's *Annunciation* Altar (Fig. 19) the angel holds a palm branch rather than the customary lily; at the Annunciation of Her Death the angel usually brings Mary a palm branch, carried later by Saint John the Evangelist as he leads her funeral procession.

For these processions, Jacopo turned to the great cityscapes painted by Altichiero and Avanzo in nearby Padua.[100] London's is the most direct (Plates 231/232), probably begun as a vertical composition and then extended to the left to add an open landscape and more witnesses. Its grandeur, stark yet radical, conveys the artist's "old-age style," surface refinement gone the way of all flesh, leaving bare bones and the strongest emotions. In the face of death, art may go back to basics, to the powerfully felt statement, time marked in broad strokes of pen or brush; Bellini's bold lines approach the urgency in Titian's or Rembrandt's late works.

98 Originally the architecture in the London drawing had far larger roundels at the upper right and left of the archway.

99 For a fine catalogue entry of the Fogg/Louvre drawing, see Goldfarb, 1976, and L. J. Feinberg, *Old Master Drawings*, Fogg Art Museum Handbook, I, *Selections from the Charles A. Loeser Bequest*, ed. K. Oberhuber, Cambridge, Mass.: 1979.

The rare subject of the Annunciation of Mary's Death was painted by Jean Fouquet in the *Hours of Etienne Chevalier* (Chantilly, Musée Condé); this suggests that Bellini might have represented the scene, since the French artist based several manuscript pages on his art.

100 Taddeo di Bartolo, active in the Veneto at the beginning of the 15th century, may have provided Jacopo with a model for this subject (Siena, Palazzo Pubblico). Giotto did not paint the subject in the Arena Chapel, but a Riminese master added it, including the fallen figures of unbelievers and Saint John holding the shining palm. See R. Pallucchini, *La Pittura Veneziana del Trecento*, Venice: 1964, fig. 296.

367

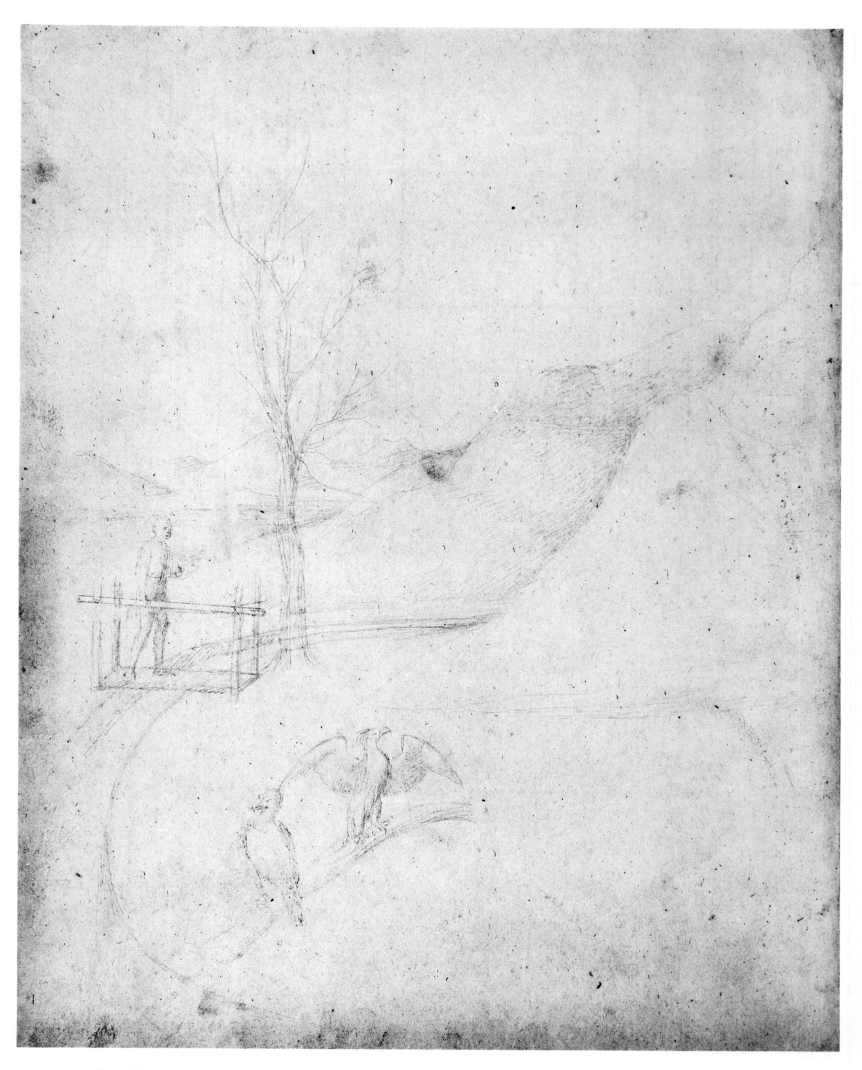

Plate 227. *Landscape with Footbridge and Eagles.* British Museum 58v

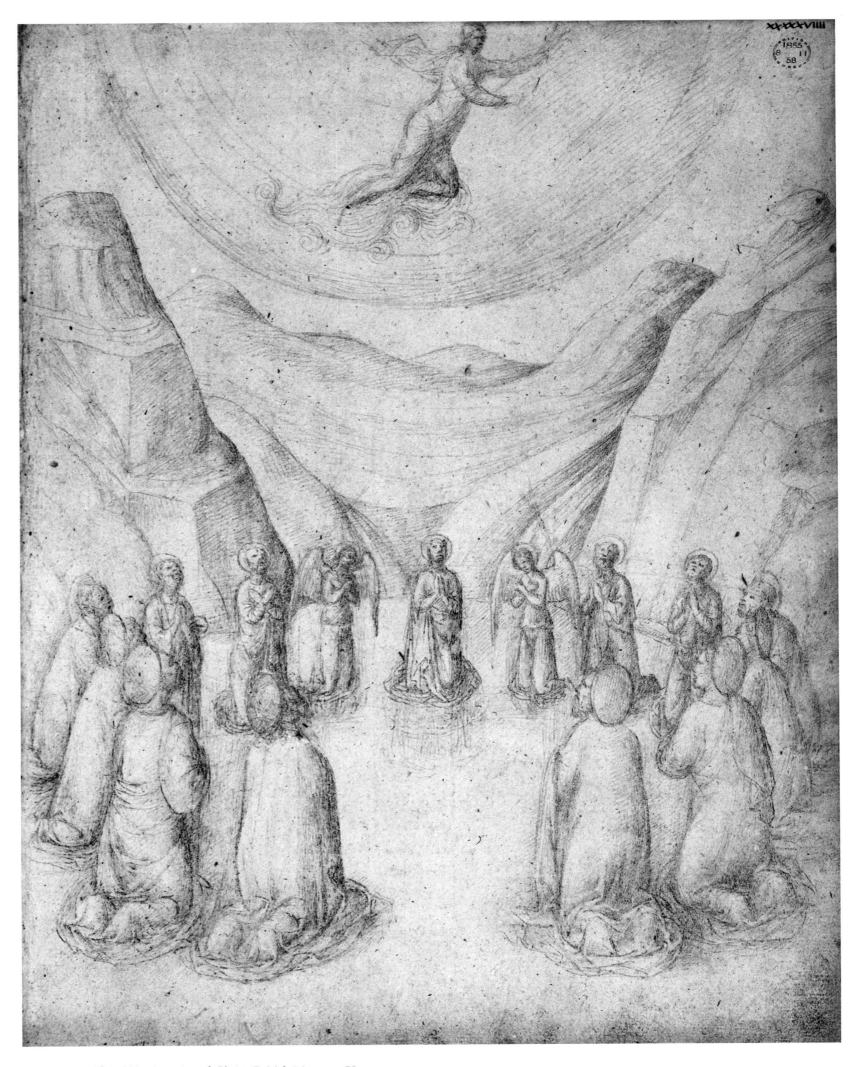

Plate 228. *Ascension of Christ*. British Museum 59

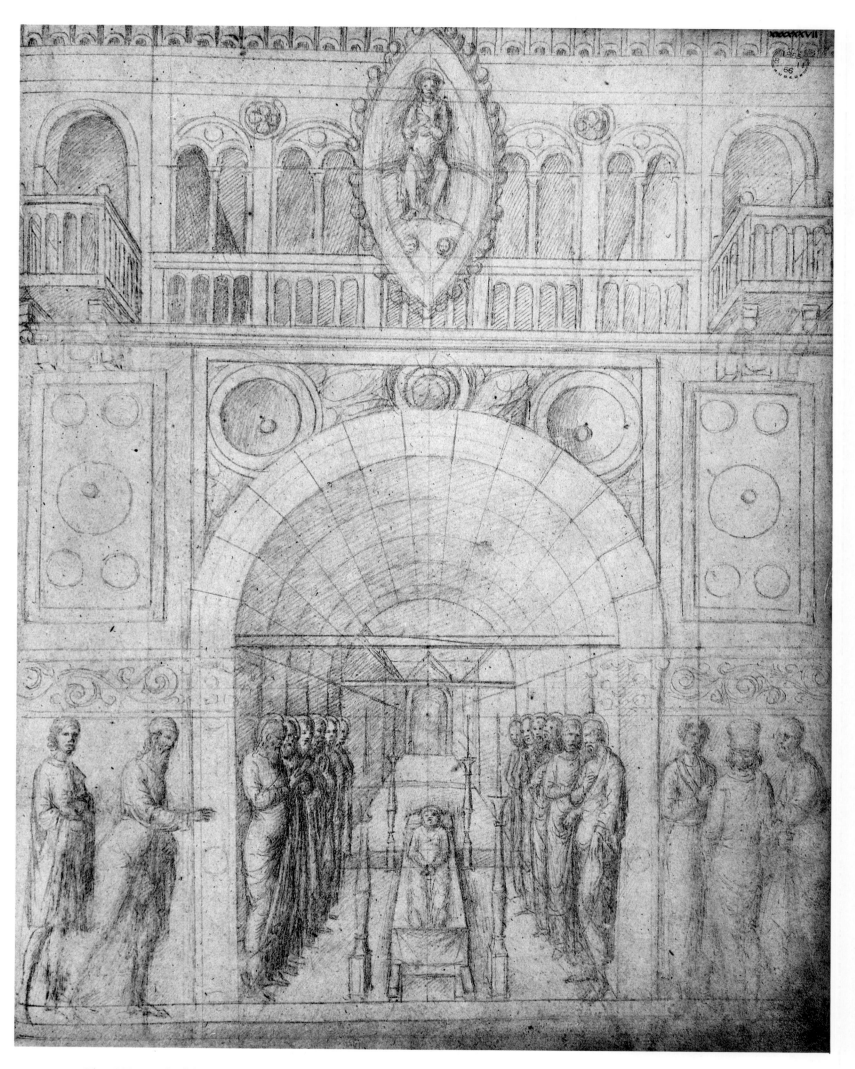

Plate 229. *Death of the Virgin*. British Museum 67

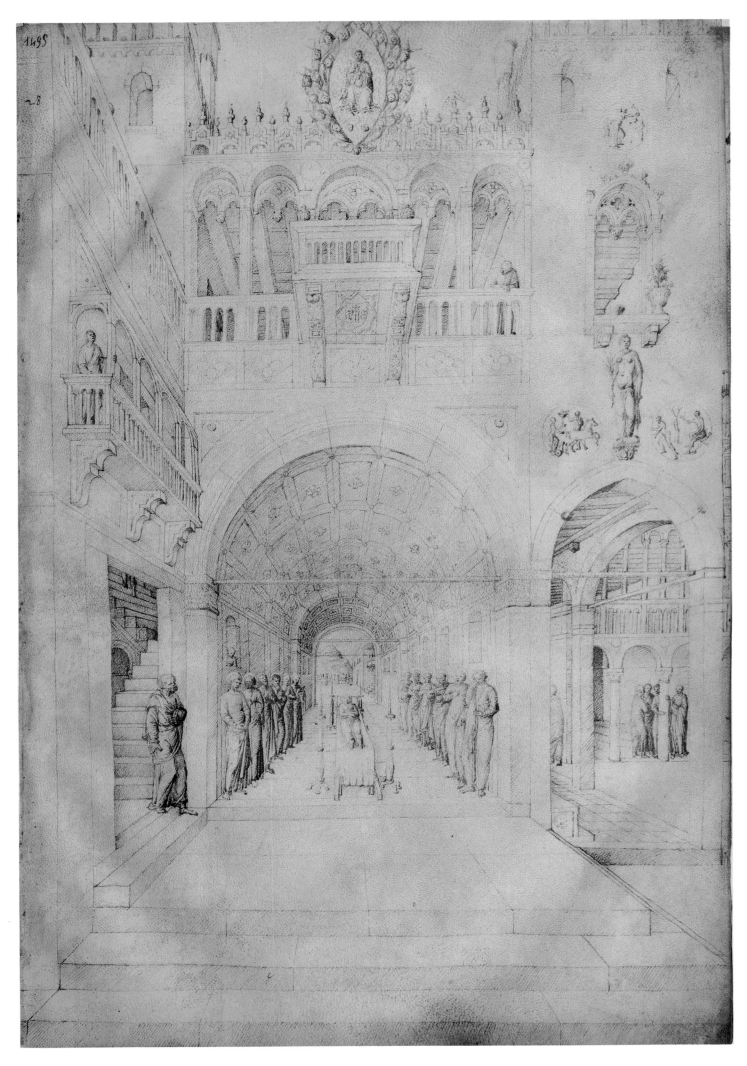

Plate 230. *Death of the Virgin*. Louvre 28

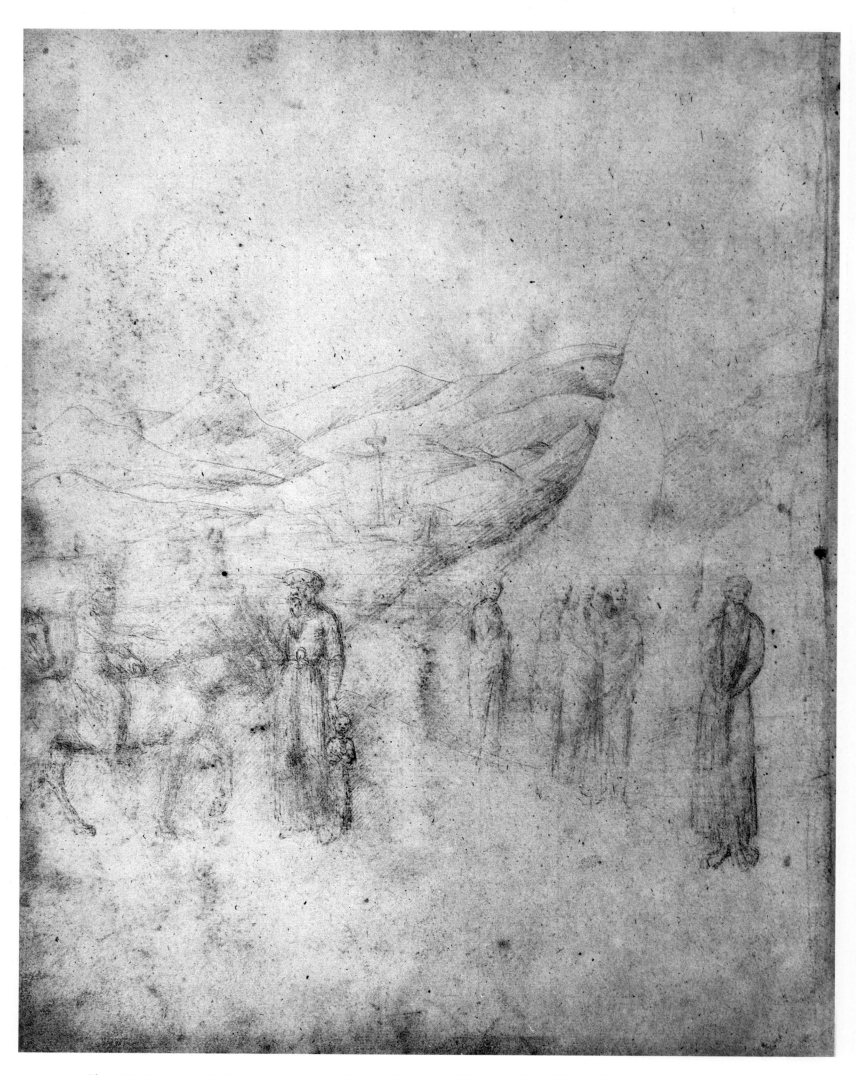

Plate 231. *Landscape with Figures* (continuation of *Funeral Procession of the Virgin*, Plate 232). British Museum 4v

372

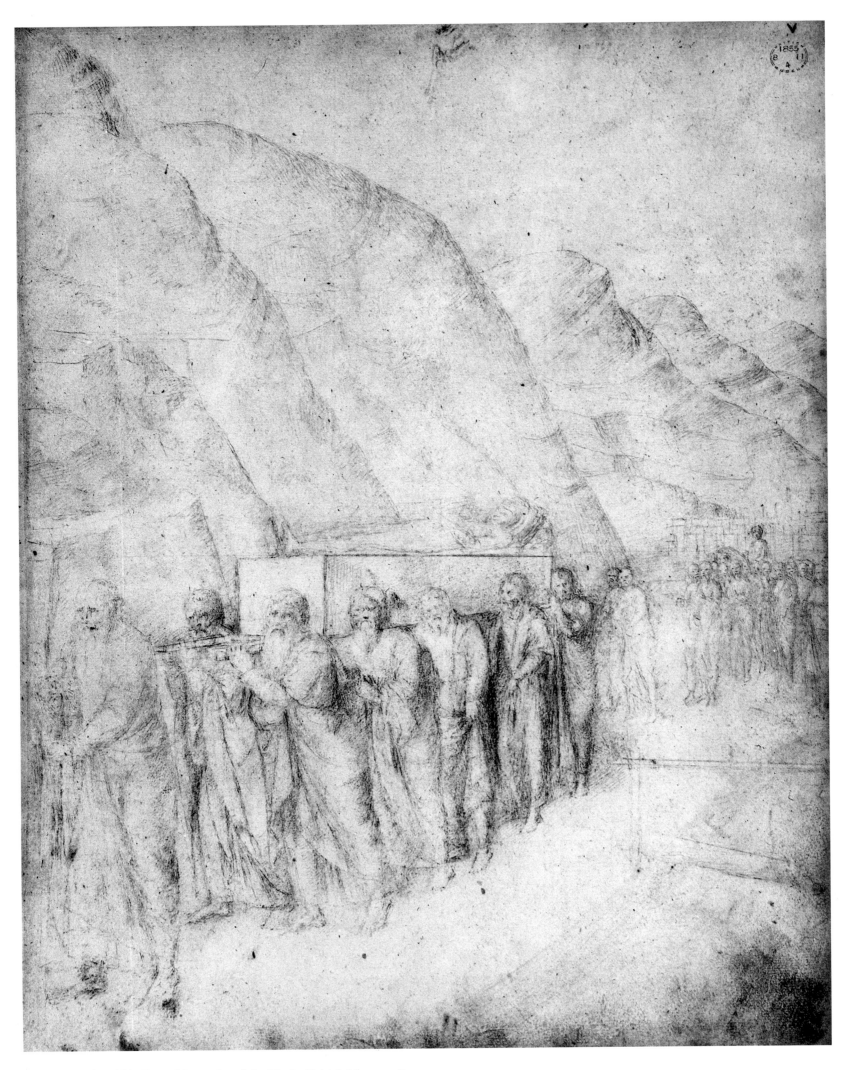

Plate 232. *Funeral Procession of the Virgin*. British Museum 5

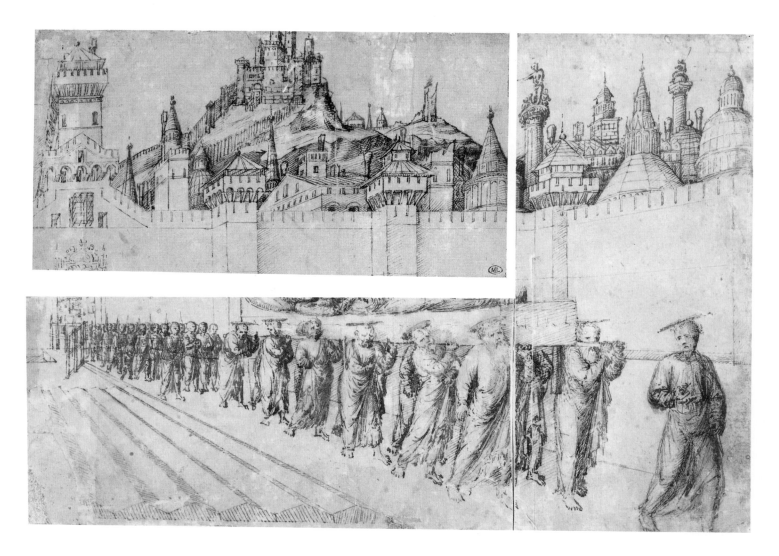

Plate 233. *Funeral Procession of the Virgin.* Right and below: Fogg 1932.275 (Fogg Art Museum, Harvard University, Cambridge, Bequest of Charles A. Loeser); above left: Louvre 28917 (Cabinet des Dessins, Louvre, Paris, Bequest of Walter Gay)

101 Noted by Röthlisberger, 1958–59, 121.

102 Paulinus of Aquilaea (d. 802) prepared this litany. See Musolini, "Culto Mariano," 17 (in Tramontin, 1965).

103 Dated 1488. A. Chastel, *Studios and Styles of the Italian Renaissance*, New York: 1966, 11, recognized this picture's mystery play scenography. G. Robertson, 1968, 54, related it to Giovanni Bellini's lost *Ascension of St. John the Evangelist*, painted for the Carità.

The Fogg/Louvre page was probably inked by a later hand; the foreshortened halos and great urban vista recall the *Saint George and the Dragon* in the Paris Book (Plates 260, 261). The enormously long coffin with Mary's body laid on top is also more like the Louvre Book's horizontal *Procession*, the richest narrative of the three (Plate 234). Apostles moving to the left and the crowd to the right from the gate of Jerusalem diverge in a V-shaped formation, figures of nonbelievers fallen between. Infants fleeing a snapping turtle and playing with a dog may have been adapted from the antique, perhaps out of another drawing book. The broad composition may be taken from Ghiberti's relief on the casket of San Zenobio (1437–38; Florence, Duomo). [101]

*The Assumption of the Virgin.* This subject became part of the ever more popular cult of the Immaculate Conception, particularly important in the liturgy of Venice and long established at San Marco. [102] Bellini must have painted an *Assumption*, probably resembling Jean Fouquet's in the *Hours of Etienne Chevalier* (Chantilly, Musée Condé) or that by Gerolamo da Vicenza (London, National Gallery), close to the settings of mystery plays. [103]

*Our Lady of the Cintola.* In an apocryphal episode, the apostle Thomas, doubter of the Resurrection, also questions Mary's bodily ascension to heaven. Her sash falls from the skies as evidence; in Prato, such a girdle (*cintola*) was a prized relic. The best-known Quattrocento presentation of this event was carved by Nanni di Banco in a relief above the Porta della Mandorla (Florence, Duomo), named for the almond shape of Mary's enclosure, often the frame for heavenly figures made visible on earth. Bellini doubtless knew it from a visit to Florence, and he too drew the Virgin within a mandorla, seated on a curved, rainbow-like throne and holding out to Saint Thomas the sash (Plate 236). The sun and moon at her feet refer to her immaculate conception, and to her role as the Woman of the Apocalypse.

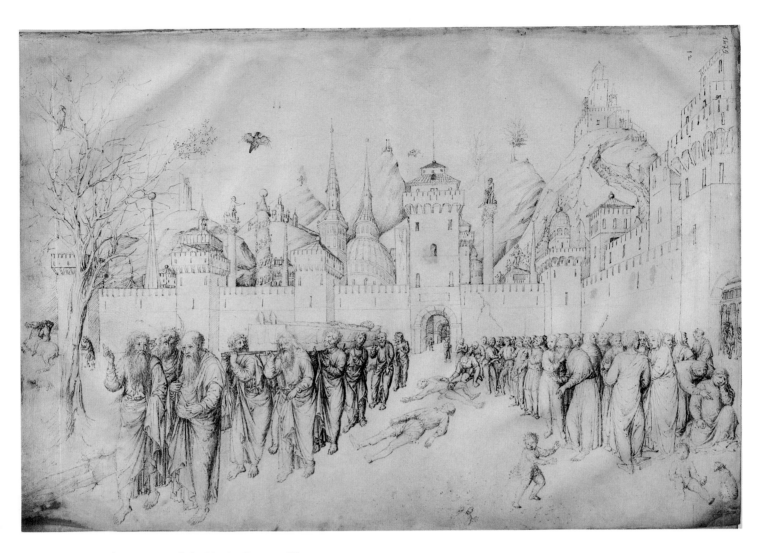

Plate 234. *Funeral Procession of the Virgin.* Louvre 12

This page has been crudely worked over; none of the coarse strokes is Jacopo's, nor is the deer below, all added later and possibly copied from an unknown drawing by Bellini or by an *animalier*. A Venetian church dedicated to the Assumption of the Virgin, such as the Frari, or to the Apostle Thomas (San Tomà, for example) might have made use of this page for a painting, relief, or banner.[104]

*The Coronation of the Virgin.* The most important Marian subject now missing from Jacopo's art is her Coronation, a favorite in Venice. His cycle for the Scuola di San Giovanni Evangelista ended with the *Coronation.* The Serenissima identified herself with this regal, eternal conclusion to the lives of mother and son, choosing it for the enormous painting in the Sala del Maggior Consiglio of the Doge's Palace. Giovanni Bellini's major work of early maturity was a *Coronation of the Virgin* (Pesaro, Museo Civico), whose predella is close to some of his father's drawings,[105] as might also be an important sculpture of the *Coronation of the Virgin,* near in style to Bartolomeo Bon, for the church of the Carità in 1444, where Bon, Bellini, and Vivarini all received major commissions.[106]

*The Savior as Man of Sorrows.* One of the London Book's few pages given to a single New Testament figure shows the magisterial, stoical Christ as imperial savior and Man of Sorrows (Plate 237), these interdependent roles stated by gesture—one hand raised in regal benediction, the other fingering the lance wound in his side. Classical drapery and a frontal stance simultaneously emphasize the figure's power and display all five wounds. Christ stands in the almond-shaped mandorla, this image well known to Venetians from its use on one side of the gold ducat introduced in 1284 and current through Bellini's time.[107] In this drawing the split in Christ's robe that reveals his wound echoes the almond-shaped outline, the doubled form stressing both vulnerability and eternity, Christ's death as a man and his eternal life. Seldom have suffering and survival been so plainly brought together.

104 The feeble framework of cherubim surrounding the mandorla seems alien to Jacopo's art, possibly added later, as also perhaps those around the Throne of Grace (Pl. 238).

105 A more conservative rendering of this subject, as it might have been drawn in the London Book, is suggested by the *Coronation of the Virgin* on an altar frontal in mid-15th-century Venice. See Testi, 1915, II, 404, fig. at top of page, listed as in Berlin, no. 1058.

106 That statuary group now at S. Maria della Salute could have been designed by Vivarini, whose paintings show similar compositions. See Wolters, 1976, fig. 844, cat. no. 246; A. M. Schulz (1978, 62–63) gives the *Coronation* to an "Assistant of Bon."

107 Sinding-Larsen, 1974, 159.

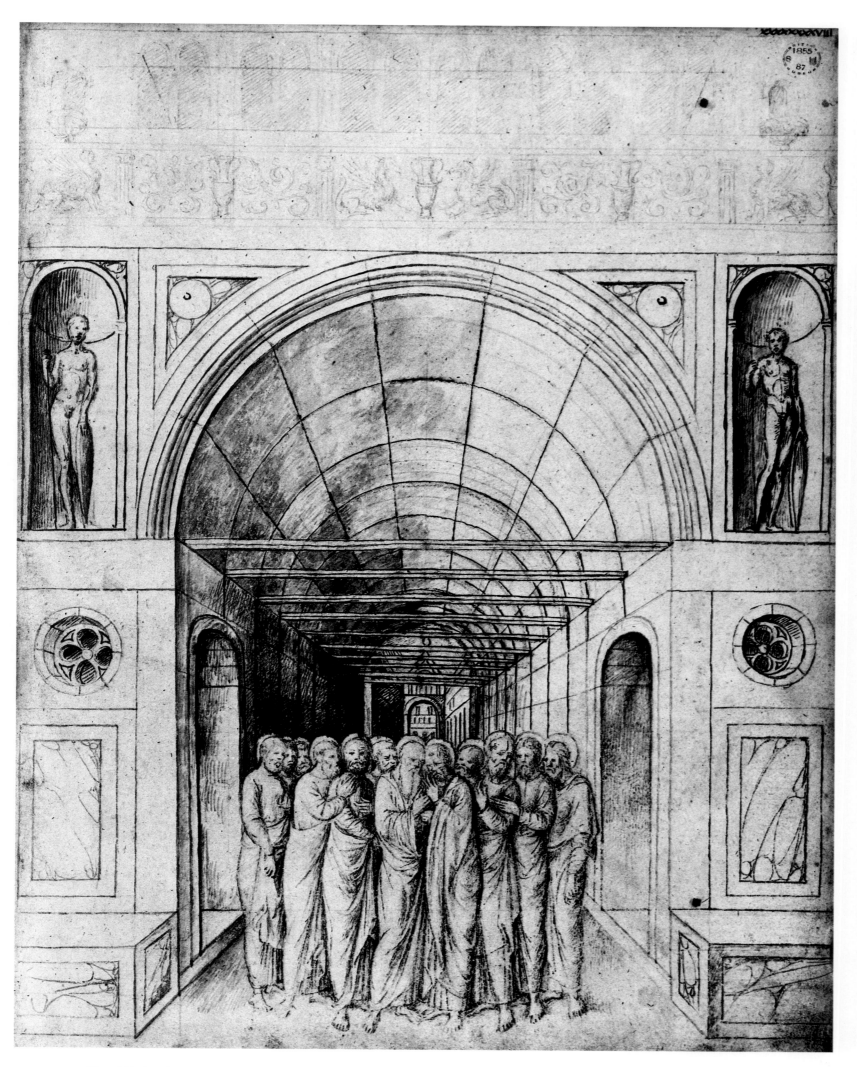

Plate 235. *Twelve Apostles* (A). British Museum 88

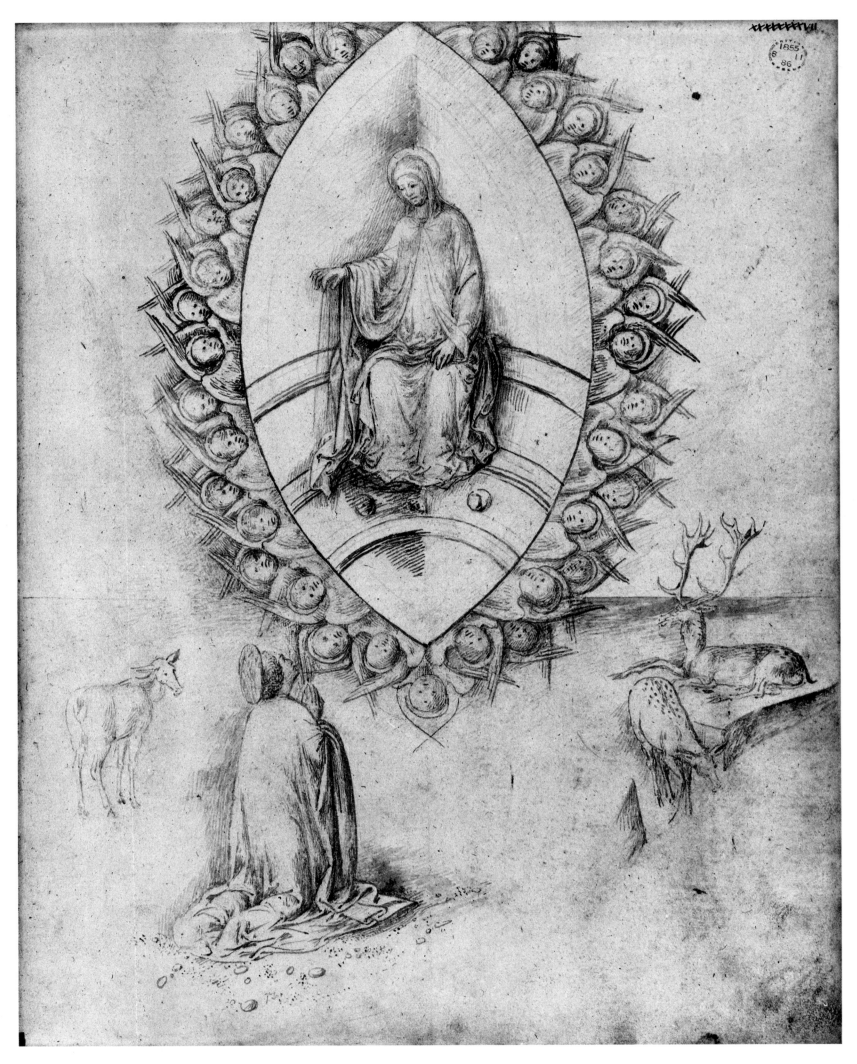

Plate 236. *Virgin Mary in a Mandorla*. British Museum 87

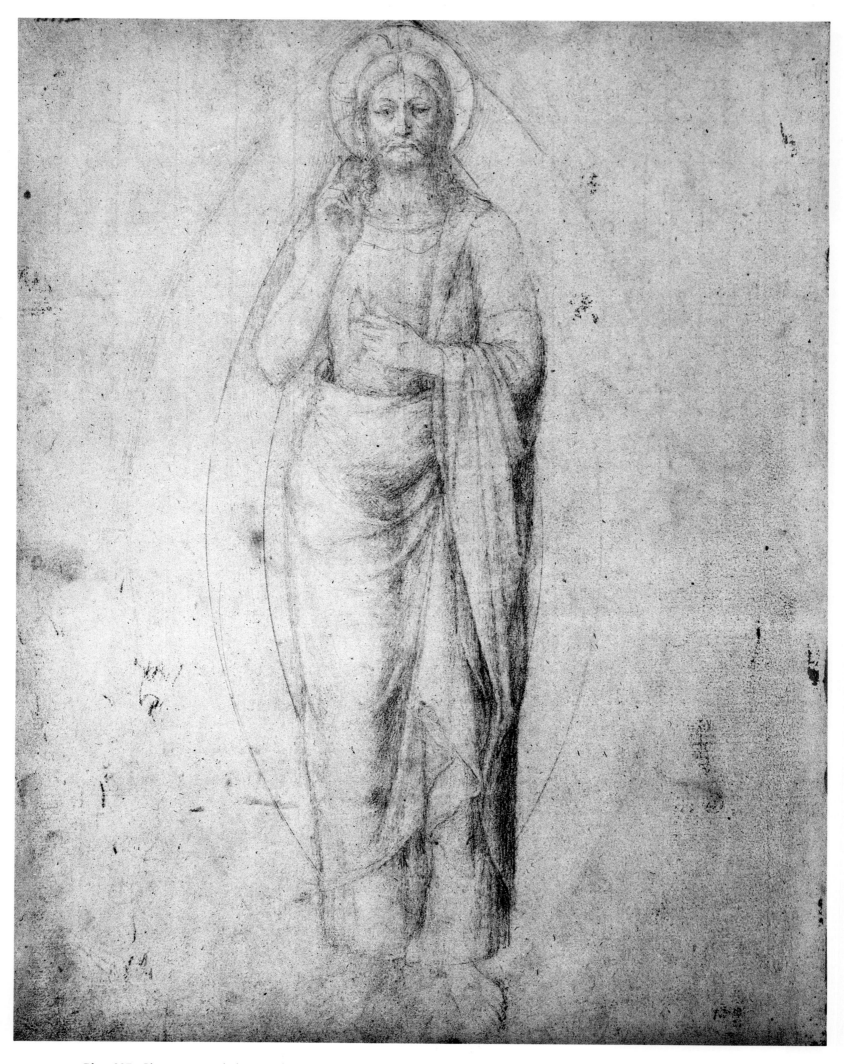

Plate 237. *Christ in a Mandorla*. British Museum 60v

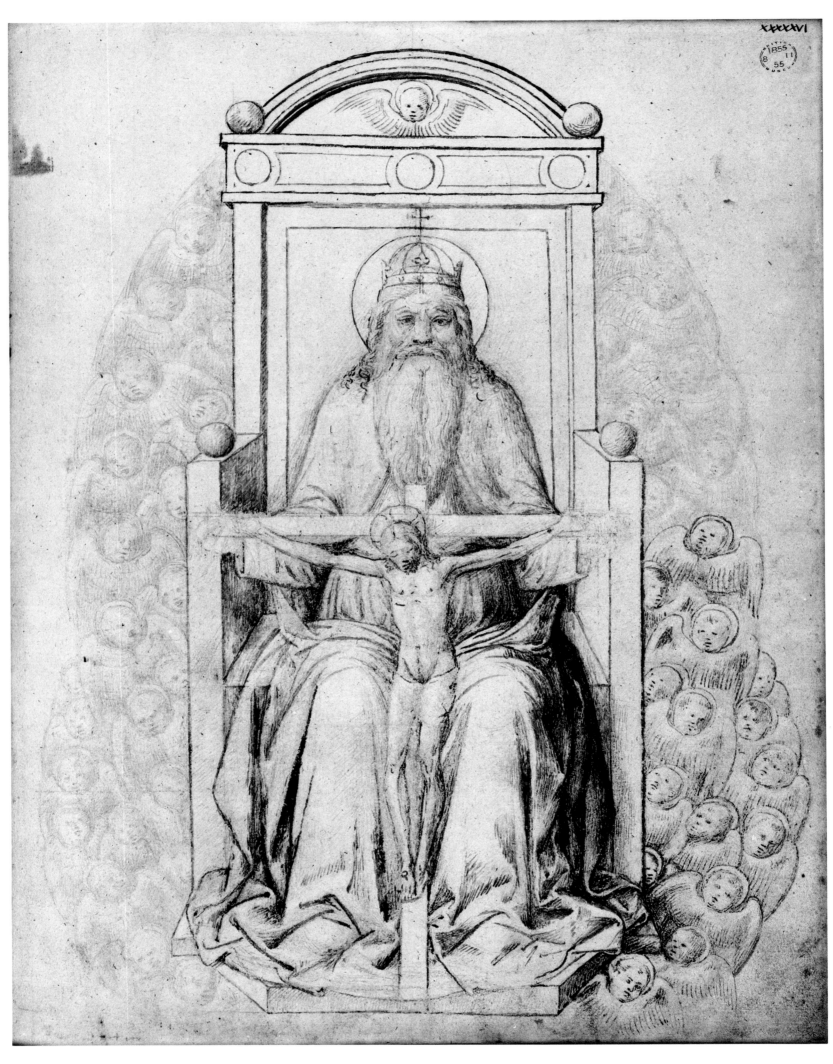

Plate 238. *Throne of Grace*. British Museum 56

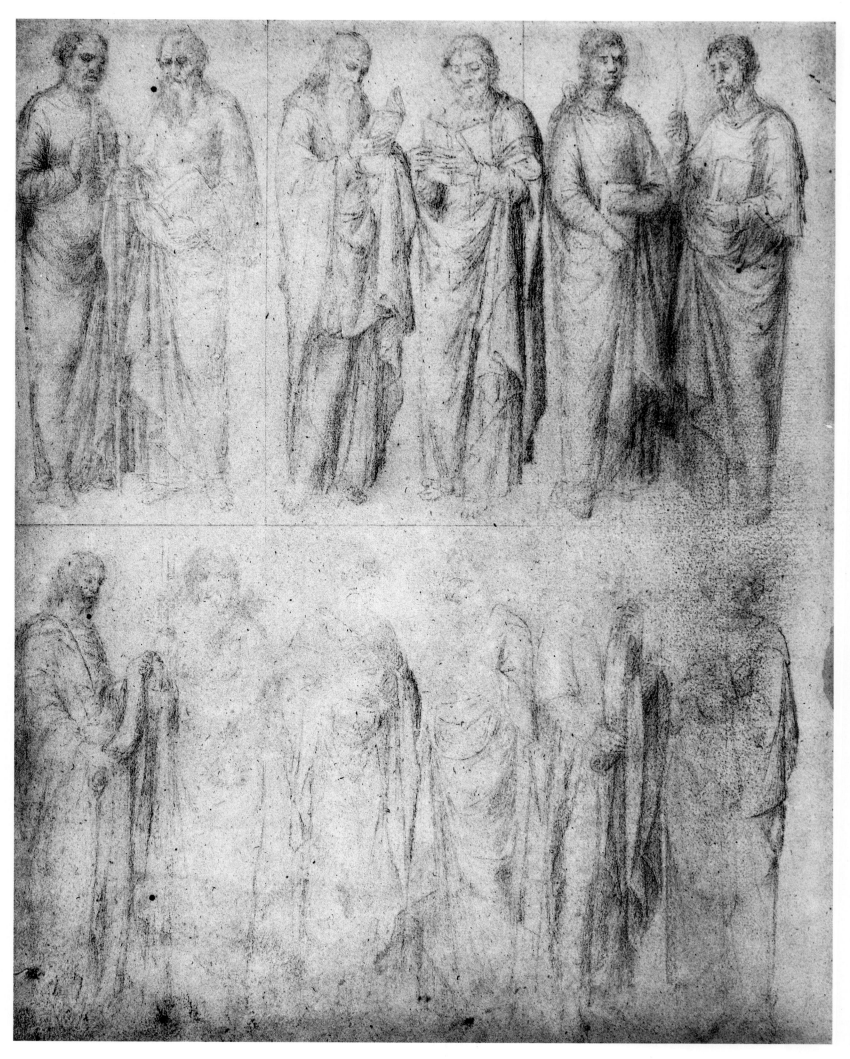

Plate 239. *Twelve Apostles* (B). British Museum 91v

With its clear definition, this page was probably drafted to guide a sculptor for a statue above a tomb, somewhat like the Christ over Doge Foscari's sarcophagus (Venice, Frari), which was in place by 1460.[108] This figure also illustrates Jacopo's critical contribution to the Venetian renaissance: fusing the Florentine classicism of Michelozzo and Luca della Robbia with his own Byzantine and Gothic heritage, he brought new breadth and emotional resonance into local religious imagery, without weakening its strong, traditional resources.[109]

*The Throne of Grace.* Some of Bellini's sacred images are designed to stop time, to keep the faith in an eternal moment of spiritual contemplation. Singular in every sense, these icons are isolated in a frame, each image the Alpha and Omega of devout experience. Among traditional images of piety is the trinitarian formula known as the Throne of Grace (Plate 238); seated and sorrowful, God the Father holds his crucified Son. This group is drawn as if already worked in the round, ready to be placed on a tomb.

God the Father is seated on a Venetian renaissance throne like Solomon's (Plates 152, 154) or Pilate's (Plate 196). Usually a dove represents the Holy Ghost, the third member of the Trinity—here the cherub at the top of the throne may have that role. Still Gothic in style, the full-bearded Father is based on Burgundian sources, much admired in Venice.

The image has been very crudely inked. Originally two great oval clusters of cherub heads were planned, one vertical, the other horizontal.[110] The facing page (Plate 129) and the following recto (Plate 127) show scenes of death and lamentation, themes often linked with the Throne of Grace.[111]

In the lunette of a late triptych from Jacopo's studio is an expressionistic image of the Throne of Grace (Fig. 63); God the Father reappears in another lunette, within an Annunciation (Fig. 66), in the same series of altars for the Scuola della Carità.

*The Resurrected Christ with Saints.* A Crucifixion group in the Paris Book (Plate 240) was designed for sculpture as part of an altar, the five figures to be placed within shell niches like the Berlin *Saints* (Figs. 55–58). The magnificent standing figure of Christ at the center is based on the ancient source also used for the antique athlete in that Book (Plate 67). Here the Man of Sorrows is triumphant, his nudity accentuated by the flanking figures' cascading drapery. Aged by her grief, the towering Madonna resembles the Tuscan tradition.

The date of this altar drawing is close to one painted by Giovanni Bellini after his father's design (Matelica, Museo Piersanti; Fig. 62), also partly inspired by Donatello's art, accessible in nearby Padua.

Of related format is another page in London (Plate 241) with Saint John the Baptist at the center, Saint Peter to the left, and a reading apostle to the right. Florentine in origin, this architectural scheme became popular in the Veneto in the 1420s, often used for tombs, and found in paintings from the Bellini studio that may date in the early 1430s (Figs. 55–58). This design for a sculptured altar has been linked with Bellini's commission for the main hall of the Venetian bishop's palace at San Pietro di Castello.[112]

# THE SAINTS

Just as Venice associated her founding and her being with the life and attributes of the Virgin, so the Serenissima wove the saints into the fabric of her society and strength, their feast days celebrated with her own triumphs and functions. The annual election of magistrates was on the Feast of Saint Jerome, the scholar who first translated the bible into Latin; on the Feast of Saint John the Evangelist and Saint Paul had occurred the great victory at the Dardanelles, and that at Negroponte on the day of Saint John the Baptist's beheading. These occasions equally stressed the coexistence of civic and saintly strengths. That God was with Venice in her endless battles on sea and land during Bellini's active years was a theme echoed by his many militant images.

Protestant hymns, with their ringing martial spirit, seem more in keeping with Bellini's saints than those of his own faith. Venice might well have chosen such lines as "When the saints come marching in" or "A mighty fortress is our God" for her Battle Hymns of the Republic. Ever jealous of her spiritual independence, the Serenissima flourished in guarded isolation, keeping her counsel but for those happy occasions—three in Bellini's century—when one of her own was elected pope.

108 Wolters, 1976, figs. 863, 865, cat. no. 252, pp. 292–94. Christ holds a book.

109 An unfinished *Ecce Homo* (Madrid, Prado), was published by Röthlisberger (1958–59, 87, 89, fig. 40) as by a Bellini follower. This work provides an important clue, along with the drawings, to Jacopo's treatment of the theme. The other side of the painting, a *Madonna and Child Blessing the Giovannino*, is by another hand.

110 For the funerary association of the Throne of Grace, see O. von Simson, "Über die Bedeutung von Masaccios Trinitätsfresko in Santa Maria Novella," *Jahrbuch der Berliner Museen*, 8 (1966), 119–59. For the use of this Burgundian physiognomy in Venice, see G. Troescher, *Burgundische Malerei. Maler und Malwerke um 1400 in Burgund, dem Berry mit der Auvergne und in Savoyen mit ihren Quellen und Ausstrahlungen*, Berlin: 1966.

111 Crowe and Cavalcaselle, ed. Borenius, 113.

112 Tietze and Tietze-Conrat, 1944, 112, believed the drawing to have been for a painting in this location.

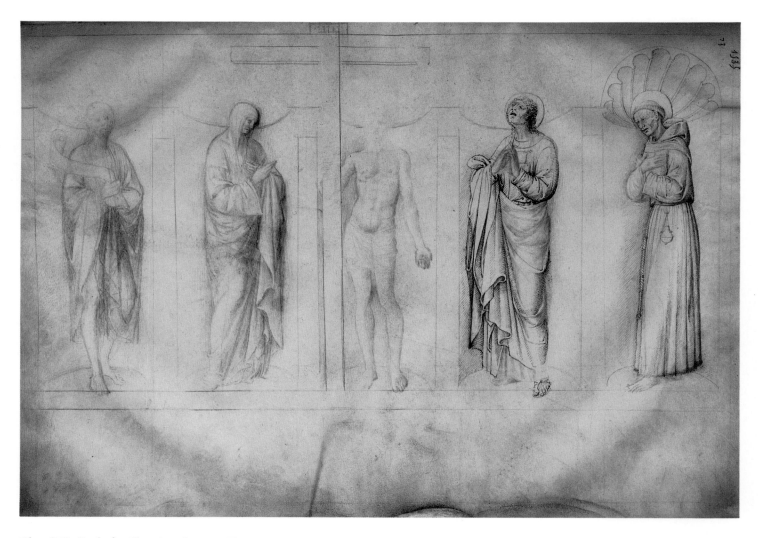

Plate 240. *Study for Altarpiece.* Louvre 73

It is no accident that of the forty saints drawn in his Books, all male, those are most often the warriors of Christ's cavalry, Saints George, Michael, Theodore, and Sebastian. Apart from Mary, the heroic, vengeful Judith is the only holy woman with a page to herself (Plate 149). The Serenissima, as the leading port for pilgrimage and crusade, made money from the comings and goings of the faithful during peace or war. To the Veneto came great relics—the bodies of apostles and saints, supposedly those of Saints Mark, Luke, Isidore, and Nicholas—their physical presences contributing to the Republic's strength and sense of spiritual dominion.

Venice was at war during more than half the years between 1404 and 1454. Jacopo's saints, mounted on fine steeds ready for combat, often wield swords. The ten to twelve *feste di palazzo*, holidays celebrating many a martial saint's day, attracted soldiers whose militance mirrored that of Doge Foscari. In the great church dedicated to Saints John and Paul were buried doges and military leaders, the equestrian statue of the *condottiere* Colleoni in the square outside.

Seldom on happy terms with the papacy, or for that matter with sanctity, Venice produced remarkably few official candidates for canonization: among the earliest was Bellini's contemporary Lorenzo Giustiniani, first patriarch of the Republic, whose funerary "figura" Jacopo designed. Martyrdom, the ultimate act of Christian witness, did not fit the Venetian concern with victory: Bellini shows only Saints Christopher (Plates 249/250), Isidore (Plates 270/271), and John the Baptist (Plates 286/287, 284/285) dying such deaths.

Bellini divides his drawings of men of faith between the active and the contemplative—fighting on the battlefield for God, or, like Saint Jerome, grappling with temptation in hermetic retreat. His favorites are Saints George and John the Baptist, each drawn eight times; the giant Saint Christopher has six drawings, the militant Archangel Michael, three.

Many young heroes in the Books having Christian attributes may belong to this powerful band. Venice worshiped Saints Theodore and Chrysogono, and she venerated many relics of early martyred warriors kept in her first renaissance church, San Zaccaria, including those of Saints Achilleus, Nereus, and Pancras; some of Bellini's unidentified scenes of knightly valor may refer to these young veterans.

Plate 241. *Study for Altar.* British Museum 28

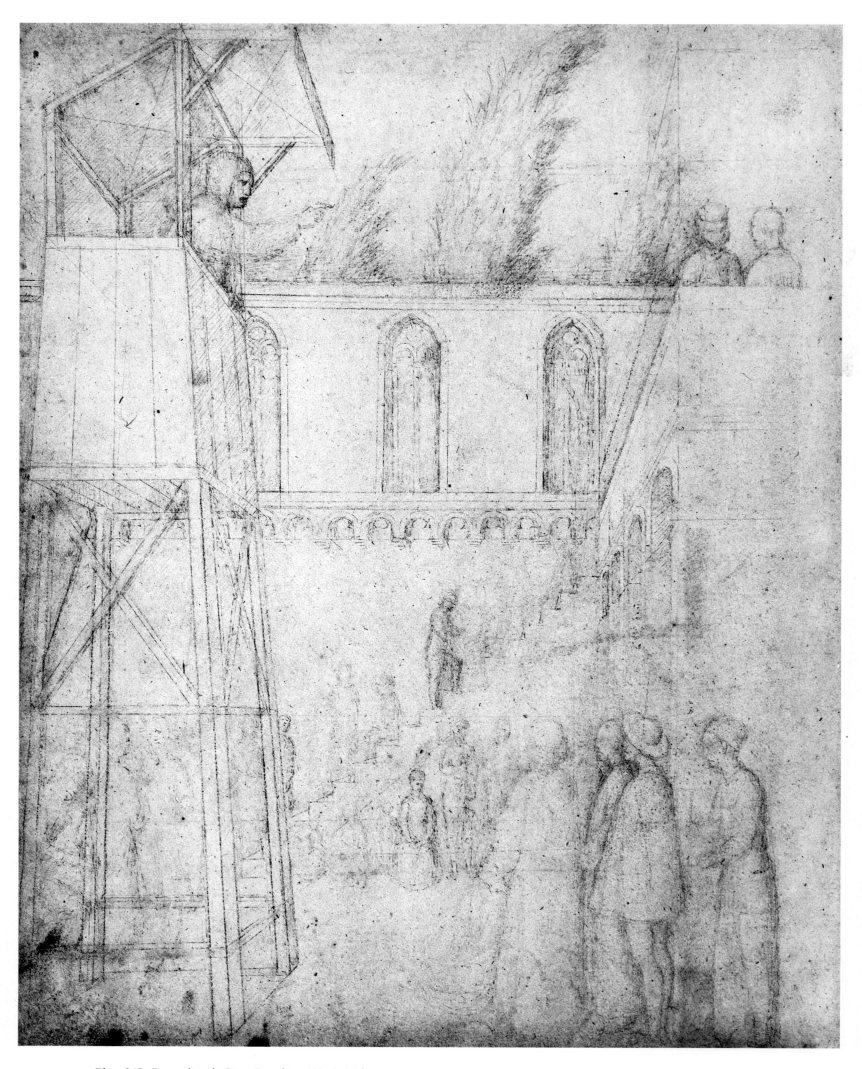

Plate 242. *Bernardino da Siena Preaching* (A). British Museum 80v

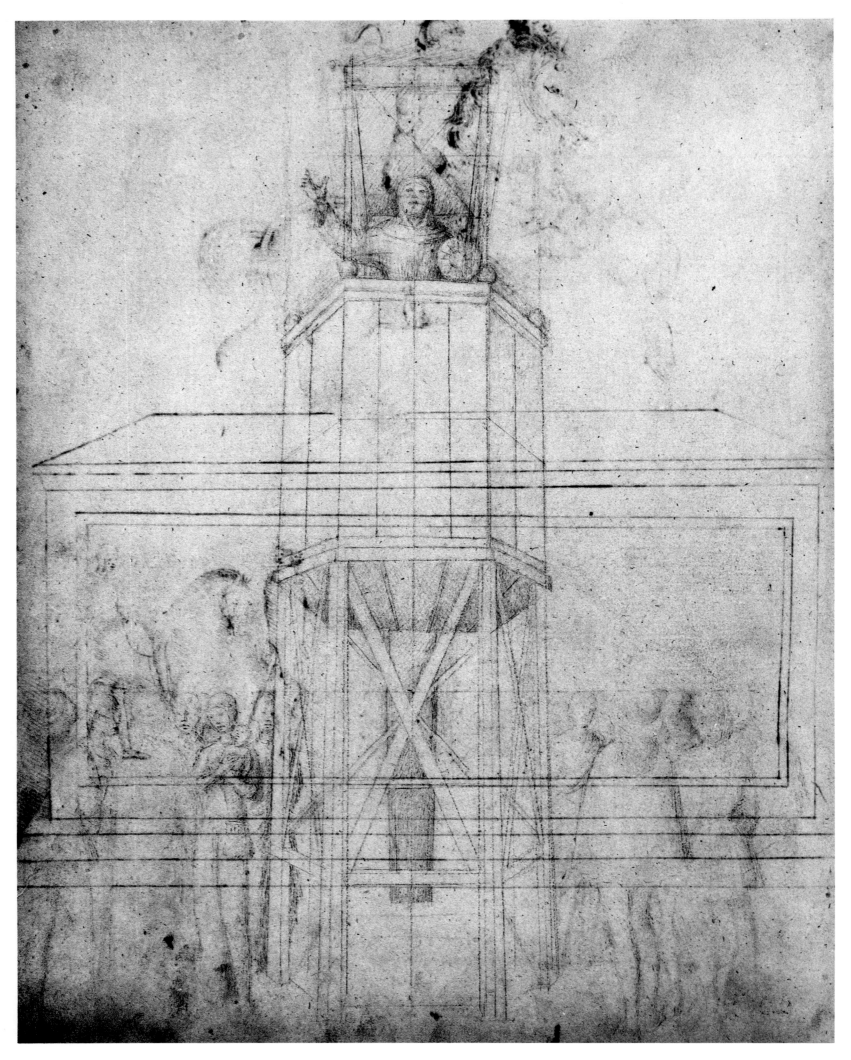

Plate 243. *Bernardino da Siena Preaching* (B). British Museum 82v

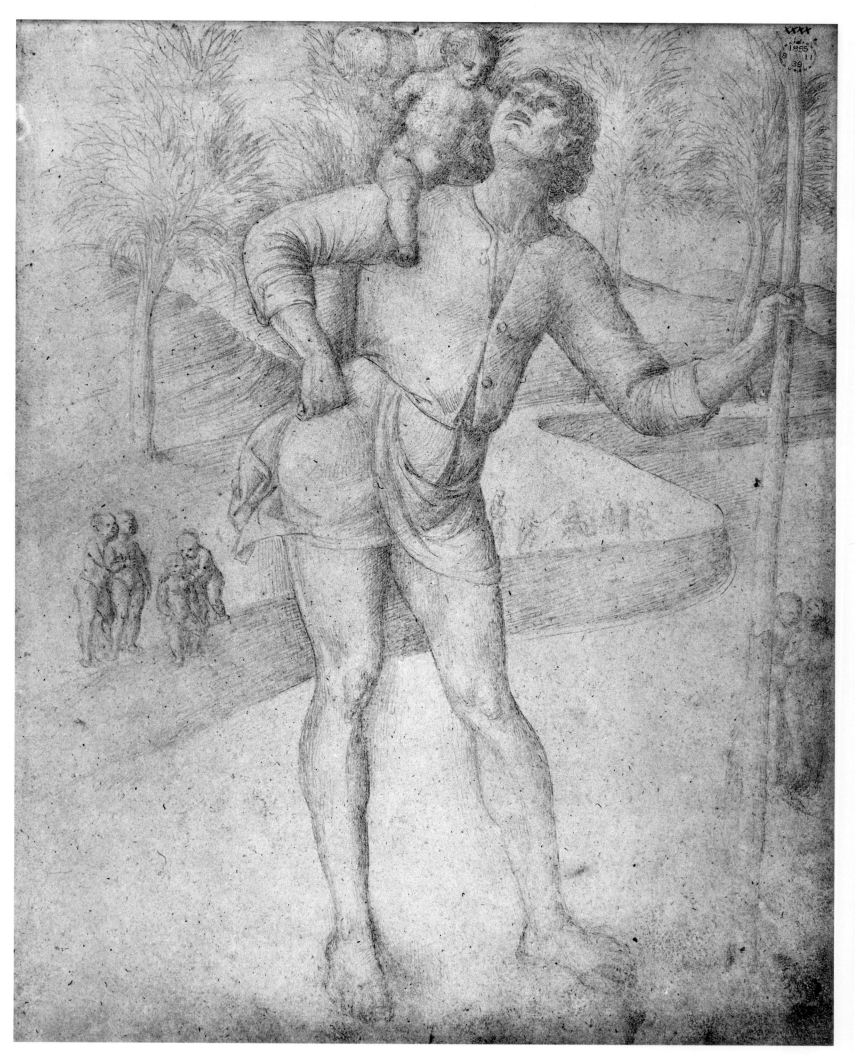

Plate 244. *Saint Christopher* (B). British Museum 40

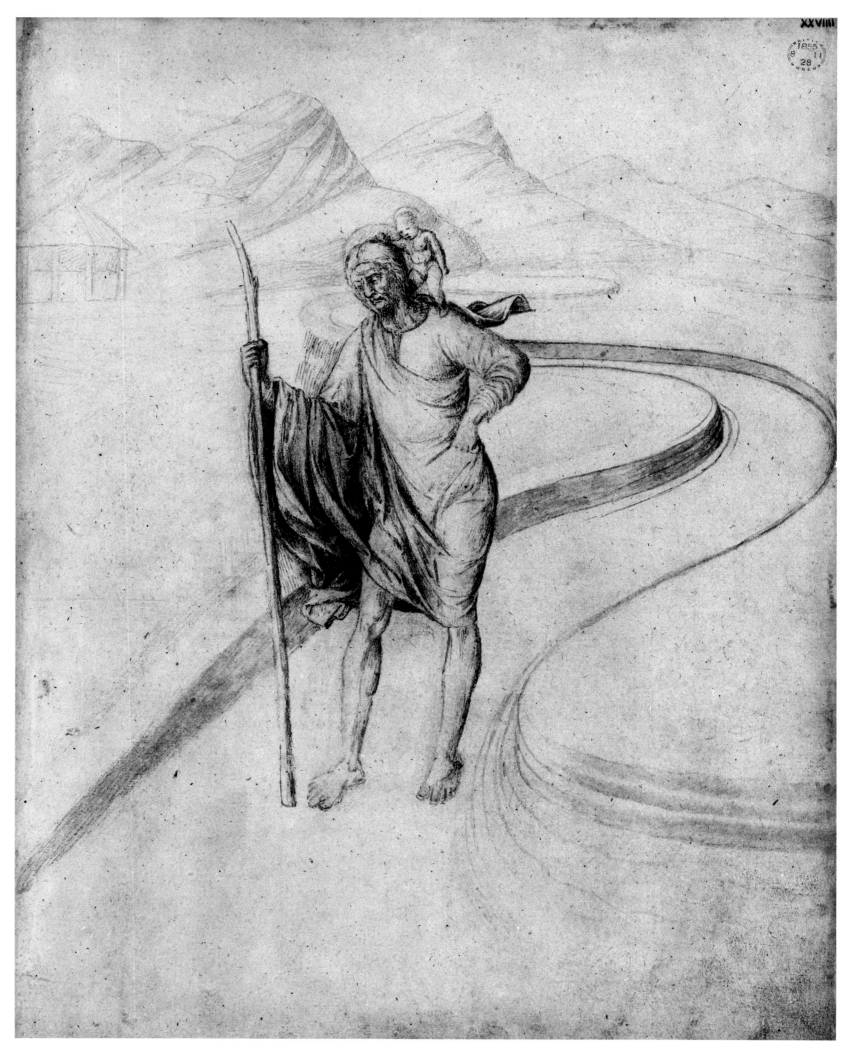

Plate 245. *Saint Christopher* (A). British Museum 29

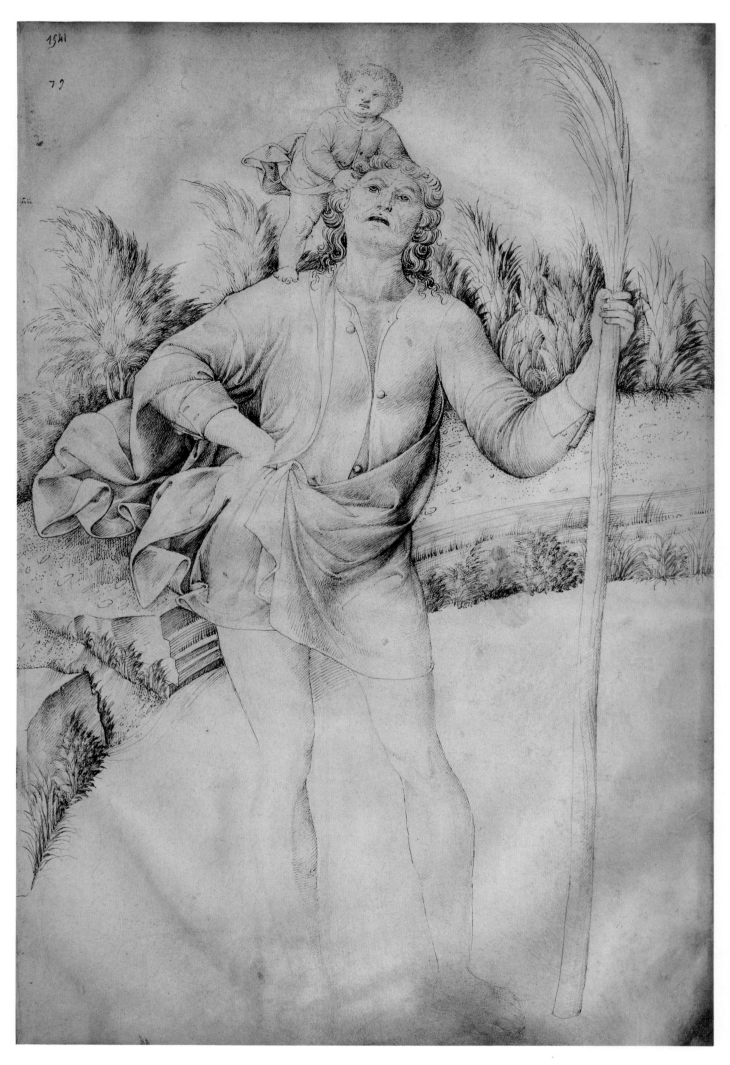

Plate 246. *Saint Christopher* (C). Louvre 79

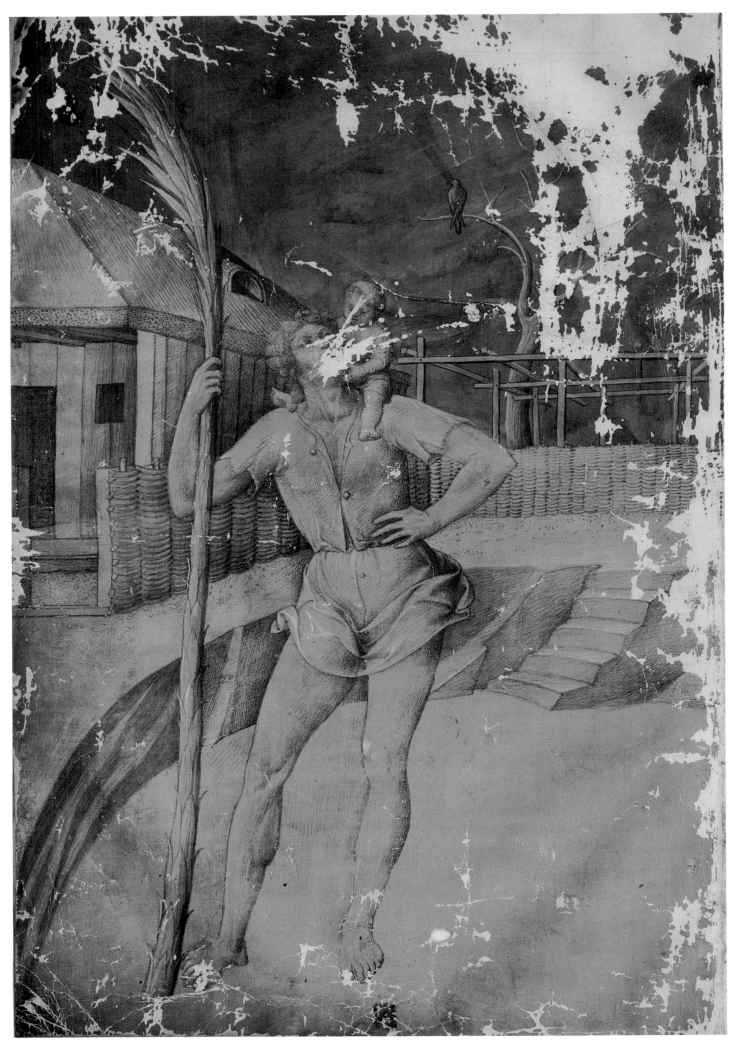

Plate 247. *Saint Christopher* (B). Louvre 56v

113 Gramaccini, 1983, 27.

114 It is not known whether this scene is meant to follow the Crucifixion or the Death of the Virgin. The page has been crudely reworked, and wash added.

115 Röthlisberger, 1958–59, 68.

116 A small *Annunciation* (New York, Metropolitan Museum of Art) with that family's arms is sometimes called an early Bellini. He may have known the Lombard's drawings, since these were prized in Venice, owned in the 16th century by Gabriele Vendramin, who also owned Bellini's London Book (in the 18th century it was owned by another Cornaro, Marco).

Early Christianity was no more active in northern Italy than in the rest of the peninsula, but a greater number of early texts survive from Verona, Aquileia, Padua, Brescia, Milan, Ravenna, Turin, and Como. Jacopo's scenes of idols destroyed in ancient times (Plate 91) may refer to the lives of saints from these centers.

The many biblical and devotional subjects that concerned Bellini intensified, beginning with revival of penitential, ascetic currents marking the Holy Year of 1450,[113] when the Franciscan Bernardino of Siena (Plates 242, 243; Fig. 59) was canonized.

*The Apostles.* The twelve apostles formed the first Christian congregation. Bellini shows them mourning the Virgin (Plate 235), pressed close to one another like figures carved in relief before they take Mary to her burial place (Plates 232–234) and then go their separate ways to convert the world.[114] The apostles were a key to the official church of the Venetian Republic—the Doge's Chapel dedicated to Saint Mark (his body supposedly behind the Pala d'Oro). The chapel treasures relics of all the apostles, and in its medieval rebuilding San Marco followed the church devoted to the twelve in Constantinople.

The formal, conservative disposition of apostles and saints in six pairs on a single page (Plate 239) suggests a source in an earlier work, possibly a drawing book by Michelino da Besozzo.[115] That Lombard master came to Venice in 1410 and worked for the Cornaro family in 1416.[116] Saint Bartholomew at the upper right corner (facing Saint John the Evangelist) holding the knife he was flayed with, resembles the same saint in an altar (Fig. 62) designed by Jacopo which was probably painted by Giovanni (Matelica, Museo Piersanti). Saints Peter and Paul are at the upper left corner. Saint John the Baptist may be at the lower left facing Saint James the Greater, who holds a pilgrim's staff.

*Saint Anthony Abbot.* In a triptych (Poughkeepsie, Vassar College Art Gallery; Fig. 61), Saint Anthony Abbot is at the right, Saint Francis at the left, and Saint Jerome at the center. He stands at the far left in a wing from the Gattamelata Altar (New York, private collection; Fig. 48). A more elongated Saint Anthony Abbot is seen in a late work (Fig. 66). A healing saint whose order maintained hospitals all over Europe, Anthony cured erysipelas and other skin diseases.

*Saint Anthony of Padua.* In Franciscan habit and holding a lily, Saint Anthony of Padua stands to the right in a late triptych (Fig. 64), painted in a style different from Jacopo's, the work of an assistant. One of Italy's best-loved saints, Saint Anthony was buried in Padua, in his sanctuary known as the Santo where Bellini made at least two paintings.

*Saint Bernardino da Siena.* Bernardino appealed to the reality of hard knocks and laughter, using the profane as often as the sacred to bring his hearers to Christ. Best known of Franciscan preachers in Bellini's day, he made several journeys to the Veneto, giving forty Lenten sermons in Padua; in Venice he spoke at the Frari in 1444. Bellini lived near that church and could have heard him there, if not in the mainland city while on one of his commissions—the last was for an altarpiece in the Santo that included Bernardino's image (Fig. 48); he also painted the saint as if preaching (New York, private collection; Fig. 59), and at the far left of the Matelica Altar (Fig. 62). Two drawings in the London Book predate Bernardino's canonization in 1450, showing him without a halo, preaching from an elevated wooden pulpit: in Plate 242 his pulpit is in a typical Venetian courtyard with open staircase and loggia; in Plate 243 he holds a disk with the IHS, a monogram of Christ of his own devising. This is also visible in the Paris Book under the balcony above Mary's body (Plate 230), the sign of her son before he returns to bring her soul to heaven. By imprinting the monogram of Jesus in the Greek form, the IHS surrounded by a sun against a blue background (the color of faith), Bernardino hoped to replace with this one blazon all other coats of arms, seals, symbols, and flags, to eliminate nationalism, factionalism, familial quarrels, and all strife beneath the arms of Christ.

The first image (Plate 242) may have been added to a preexisting biblical drawing—a *Presentation of the Virgin* or a scene from the Life of John the Baptist. The frontal view of Bernardino (Plate 243) is harder to see because heavily inked lines have come through the paper (Plate 78). The youthful, vigorous figure of Bernardino on these pages is not the emaciated, almost skeletal image so popular after his canonization, seen in Jacopo's painting from the later 1450s (Fig. 59).

*Saint Catharine of Alexandria.* Giovanni Bellini follows Jacopo's design for this saint in the figure at far right of the Matelica Altar (Fig. 62).

*Saint Christopher.* Greek for "Christ-bearer," Saint Christopher and his mythic strength meant much to the faithful until the present century stripped him of his sanctity.

117 Röthlisberger, 1958–59, 51.

Proud of his own strength, the Canaanite giant sought to find the mightiest of masters. After long journeys, he was told he would find such a man if he offered to carry needy travelers across the river. One night a child's voice called for his services; when the infant's weight grew ever heavier, almost more than even his back could bear, the giant converted to Christianity, realizing he had at last met the greatest of powers.

Saint Christopher's role as a one-man ferry appealed especially to Venetians, so dependent on water transport by gondola, ferry (*traghetto*), or bridge. Invoked to protect travelers threatened by storms at sea or other hazards, he was everywhere a popular saint, but his cult was especially strong in Florence and Genoa, major mercantile republics whose sons traveled over land and sea. Bellini's renderings of the saint were influenced by the example of Masolino and later Tuscan masters active in northern Italy.

Jacopo made five drawings of the saint carrying Christ and one of the giant's martyrdom, a rare subject that his son-in-law Andrea Mantegna also painted in a great Paduan fresco cycle.

Both Bellini's most old-fashioned and most advanced *Saint Christophers* are in the London Book (Plates 244, 245). In Plate 245 the saint stands in mid-stream, an elongated, bearded figure who wraps his long robe around one arm to keep it dry. The baby stands like an infant Hercules on Christopher's shoulders, pushing the great head forward with his little arm. The landscape is extended to the left page (Plate 27), drawn with great delicacy and verve, close to the International Style. Both pages are obscured by clumsy reworking; additions in wash and the harshly penned brickwork and pool on the facing page were added long after the first drawing.

The far younger, beardless, and muscular Saint Christopher with the nude babe sitting on his shoulder in Plate 244 is in striking contrast to the late Gothic image. The ferryman's long, athletic legs are bare, a plain shirt covering his torso. The little cupids playing blindman's buff on the river banks recall Donatello's fascination with children. In another image in the Paris Book a later hand has colored the sky a rich, dense blue (Plate 247), much of it flaked off, the vellum probably poorly prepared for the added color. This page has been related to Bono da Ferrara's frescoed *Saint Christopher* in the Paduan cycle at the church of the Eremitani.[117] Jacopo, his own major commission under way in the nearby church of Saint Anthony, may have been impressed by the torsion and vitality in the fresco.

A horizontal scene of Christopher's crossing, in the Paris Book, is one of Bellini's most beautiful landscapes (Plate 248), anticipating his son Giovanni's. The eagle prominently perched in a tree, symbol of Saint John the Evangelist, suggests that this page, like the same Book's *Adoration of the Shepherds* (Plate 170), may have been drawn for Bellini's own scuola. In the plowed field at the left is a bear, that burly beast usually symbolizing evil.

The would-be executioners of Saint Christopher (Plates 249/250) are using bows and quivers of Turkish origin. Among the bystanders, the crowned head is probably of the pagan king who condemned the giant to death. The saint's legend tells that none of the arrows met their goal, one flying instead into the king's eye; when Christopher assured the king that his own saintly blood, after beheading, would restore the king's sight, the ruler converted to Christianity.

This crude composition of a rare subject has nothing to do with Mantegna's bravura rendering (Padua, Eremitani); Bellini must have used an earlier source. On the facing page an elderly archer casts his bow aside, impressed by the giant's stoical demeanor, or the heavenly host above, or the arrows' failure.

*Saint Eustace.* The early Christian saint is presented as a huntsman rather than an officer in Trajan's army, in keeping with his legend: Saint Eustace encountered Christ during his few hours off duty while enjoying the pleasure of the chase. Meeting a stag, he saw a crucifix between the animal's antlers and heard a voice questioning his pursuit.

In the two London leadpoint drawings (Plates 253, 254) Bellini experimented with the placing of rider, hounds, and stag. The second, more ambitious, solution is the less satisfactory, with both the stag and the equestrian group foreshortened. In the first composi-

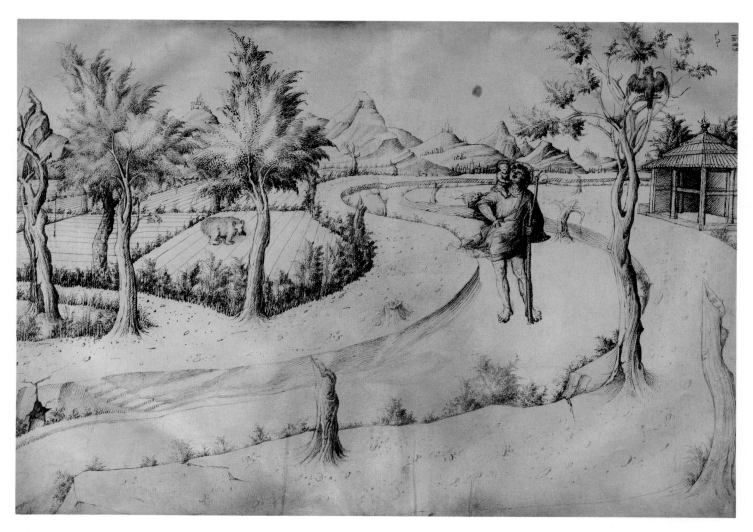

Plate 248. *Saint Christopher* (A). Louvre 22

tion, simpler and more conventional, the rider is seen from the side, approaching the stag head-on. It is obscured by the crude inking over the design for a monument on the other side (Plate 131) that has worked through.

In the two-page Paris composition (Plates 251/252), Saint Eustace wears late Gothic courtly garb. A gallows—symbol of injustice—rises on the right side of the stream. Here, as in the first London drawing (Plate 253), he points toward the stag, who lowers his head at the knight as if in blessing. This drawing or a painting after it may have helped determine young Dürer's print, engraved soon after his first visit to Giovanni Bellini's studio.

*Saint Francis of Assisi.* Among the most beloved saints, Francis had such appeal that Venice sought part of his life for her own, claiming that he preached his sermon to the birds while staying on a little island near Burano. Second in splendor to San Marco is the great Franciscan church of Santa Maria Gloriosa dei Frari, begun in the fourteenth century and completed in 1443. In the Frari were buried many doges (including Jacopo's probable patron, Foscari), and many of the *condottieri* in Venetian employ.

Mourning for Christ, Saint Francis stands at the far right in a drawing for a carved altar (Plate 241), and at the left in a triptych with Saints Jerome and Anthony Abbot (Poughkeepsie, Vassar College Art Gallery; Fig. 61).

Saint Francis' Stigmatization, in two fine double-page compositions, appears in each Book. Originally the Paris scene (Plates 255/256) was vertical, confined to the right page, and based on a monumental Trecento composition close to Giotto's. Seen from the back, Saint Francis faces the seraphic source of his stigmata as Brother Leo reads, oblivious to the miracle. Stray deer are drawn from an earlier pattern book. Bellini modernized the composition with his extension to the facing page, but diminished the saint's authority, the Uccellesque rabbit hunt compelling almost as much interest as the transfer of Christ's wounds.

The London *Stigmatization* (Plate 257) is the more modern and open of the two. Saint Francis faces toward the front, his ecstatic union with Christ now fully visible. For the saint's figure Jacopo has used Gentile da Fabriano's depiction (Italy, private collection),

omitting the lines joining Saint Francis and the seraph. Together with its facing landscape page (Plate 33), the London *Stigmatization* recalls the predella relief of that subject by the Venetian sculptors Dalle Masegne (Bologna, San Francesco, High Altar, 1388–92), a composition with much barren terrain and a few trees. An independent landscape is wholly suitable in the early renaissance as an extension of the *Stigmatization*, for Saint Francis' love of nature wrought a slow change in the perception of landscape, and even in perspective. Singing to the sun and discovering God in creation's infinite variety, the man of Assisi personifies the affectionate scrutiny found in Bellini's finest nature studies.

Saint Francis stands at the far left of a late triptych from Jacopo's studio (Fig. 63), elevating a cross and raising his right arm to display the stigmata.

*Saint George.* The combination of militance and implied romance in Saint George's life appealed to Venice. Damsels in distress, particularly when princesses, suggested a happy ending to the story, though the early Christian soldier-saint from Cappadocia would die a martyr. His relics came early to Venice, possibly from Ravenna. He was worshiped by the Serenissima's large Slavic colony, and to the ancient Benedictine monastery on the Venetian island of San Giorgio Maggiore in the lagoon came his major relic, his head, presented in 1462. A relic of his arm, treasured at San Marco, had come to Venice long before. Saint George was a patron of the Republic, his holiday a *festa di palazzo* as early as 1307. The Isola di San Giorgio, in the lagoon opposite the Doge's Palace, became the city's grandstand for triumphal entries and major celebrations and receptions. Before Saint George, another Roman soldier, Saint Theodore, had been the Republic's leading warrior-saint; Saint Theodore's cult waned as Saint George's waxed, the Serenissima playing it safe by celebrating both their holidays on the same day.

Bellini may have assisted Gentile da Fabriano in decorating the Brescian chapel of Pandolfo Malatesta, the general who won for Venice the title to Dalmatia in 1413. The work began in 1417 and lasted almost five years, including an altarpiece of *Saint George and the Dragon* with Pandolfo posing as the saint.[118] Patron saint of armorers, swordsmen, and soldiers, he also kept up their spirits as the vintner's patron. Jacopo Marcello, the *provveditore*, supervisor of Venetian *condottieri* and probably Bellini's patron, may have ordered a victorious *Saint George* from the painter. The church of San Jacopo at Marcello's hilltop retreat, Monsélice, was believed to house the soldier-saint's body.

Venetian military companies were dedicated to Saint George at least by the later fourteenth century, one fighting under his name in the Battle of Chioggia. The church of Saint George by the Seaweed, San Giorgio in Alga, became the leading center for new ways to sacred knowledge in the late fourteenth and early fifteenth centuries.

A fair young knight with a cross on his breastplate may be a *Saint George*, though without a halo (Plate 109). The early Christian hero wears just such armor, with an additional crossed boss, in Benedetto Bembo's Ponzone Polyptych (Cremona, Museo Civico), and in Gentile da Fabriano's Quaratesi Altar.

As patron saint of Ferrara, among many Italian centers, Saint George's feats were celebrated at that court with mystery plays. Scenes staged in rich settings might relate to Bellini's statuary or theatrical projects for their court, for he had several ties to the Este.

His simplest image is in the Paris Book (Plate 258), *Saint George* drawn on a gray-toned ground that covers the textile design of the earlier pattern book. Water-damaged at the left, the upper part of the rider is not visible. On another page (Plate 259) the princess seems an afterthought, lacking space for her outstretched arms. Horse, saint, and especially dragon are large in scale in this most conservative of Bellini's eight *Saint Georges*, perhaps resembling Gentile da Fabriano's lost altarpiece at Brescia.

Like a page from a Gothic romance (Plate 260), the rearing horse and rider in a third Louvre *Saint George* are backed by fortified city walls. Skulls and bones of the dragon's victims lead toward the monster's lair, and create a sense of space at the right.

What may well be the latest Louvre *Saint George*, drawn on paper, was inserted into the volume's otherwise parchment sheets (Plate 261). It is the only scene that gives the princess stage center, the Uccellesque horse and rider contained at far left. The spaciousness of the winter landscape is artfully augmented by pieces of Saint George's splintered lance and by receding diagonal rows of devastated trees, scorched by the dragon's fire.

Two of London's recto pages (Plates 263, 265) have beautifully balanced groupings of horse, rider, and dragon, realized with so skilled a sense of mass and motion that they suggest statuary. Saint George's armor is in the antique style, his sword arm drawn back, ready for the final thrust. One beast has a satanic face along its neck that suggests a demonic man hiding in its body, lending his arms and legs for it to walk.

118 Christiansen, 1982, 17, and doc. III.

393

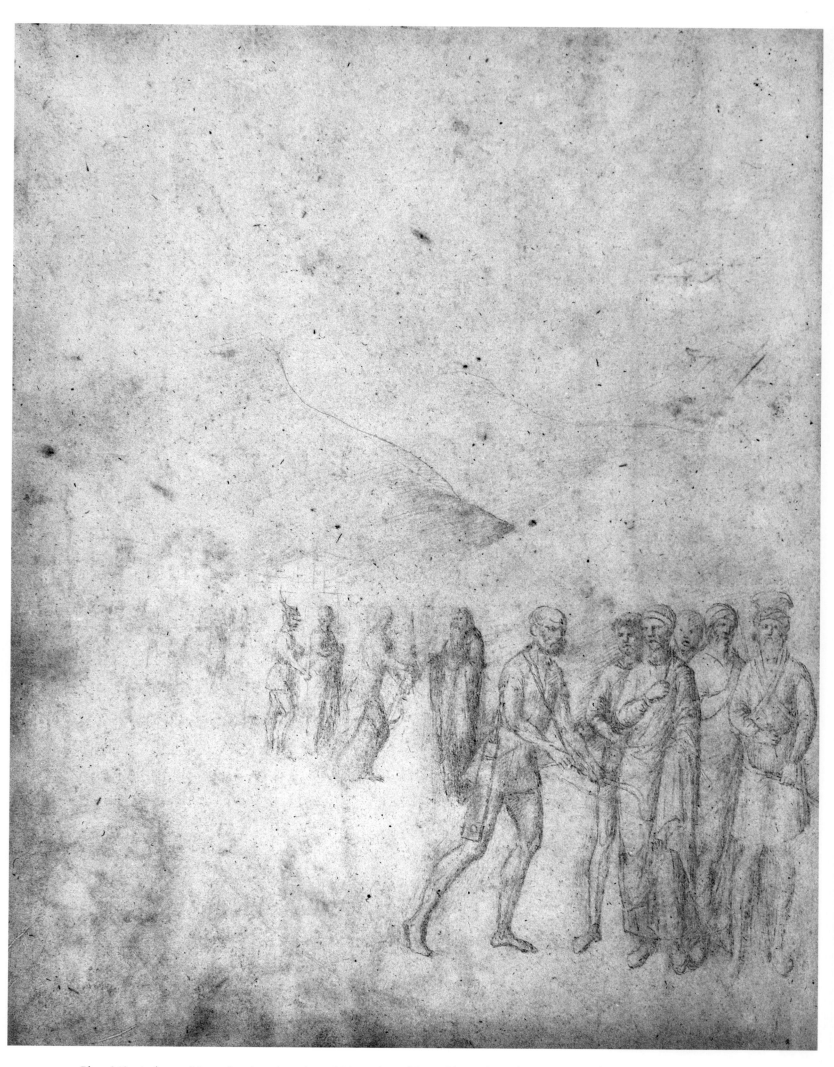

Plate 249. *Archers at Martyrdom* (continuation of *Martyrdom of Saint Christopher*, Plate 250). British Museum 17v

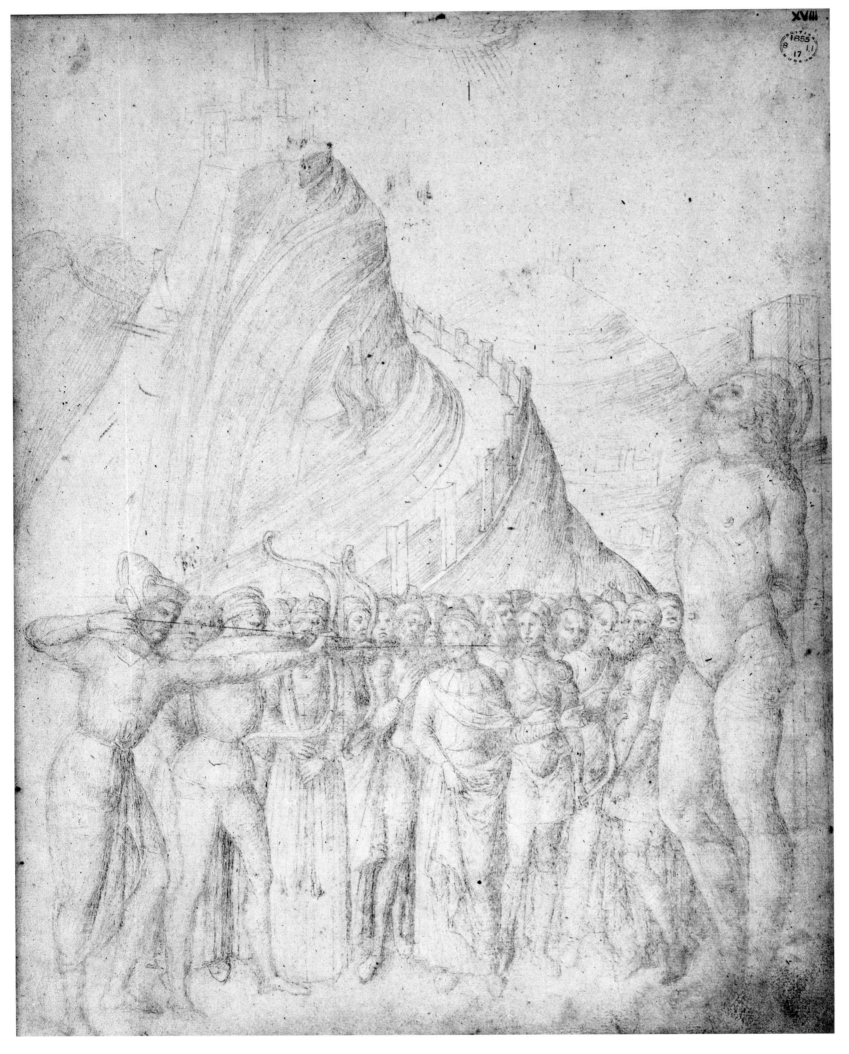

Plate 250. *Martyrdom of Saint Christopher.* British Museum 18

119 M. Baxandall, "Guarino, Pisanello and Manuel Chrysaloras," *Journal of the Warburg and Courtauld Institutes,* 28, 1965, 185.

120 Meiss, 1974, 134.

121 Meiss, 1974, 134–40.

Later the artist opened up these conflicts by extensions onto the facing left pages. The princess in Plates 262/263, a pathetic, Giacometti-like figure, runs toward a devastated renaissance palace. A great city spreads over another page, the small princess praying for deliverance outside the walls before the open drawbridge (Plates 264/265).

Only once does a horseless Saint George face his monstrous opponent (Plates 266/267). Standing in profile and wearing a North Italian sallet (from the second half of the fifteenth century), he raises a Herculean club against his equally upright opponent. The princess finds refuge in a wrecked palace in the background that continues onto the facing page.

*Saint Isidore of Chios.* Protector of the Venetian Republic, Saint Isidore was venerated because his remains were brought in 1125 from Chios, with other plunder, under Doge Domenico Michiel, and reburied in the Doge's Chapel. His feast day also commemorated Doge victory over the infidels and his exposure of Doge Ordelaffo Falier's conspiracy, thereby preserving the Republic.

Only four saints have facing pages in the Louvre Book, permitting large compositions; Saint Isidore is among them (Plates 270/271). An Alexandrian knight in Emperor Decius' service, he was beheaded in 250 A.D.; here a horse and rider drag his nude body toward his martyrdom by a rope tied around his ankles. The torturer, mounted on a horse very like the prancing bronze steeds above the porch of San Marco (Fig. 4), turns back almost impassively, in one of Bellini's most psychologically acute characterizations. These figures are derived from the vivid, mid-fourteenth-century mosaics in the Chapel of Saint Isidore in San Marco, which broke so dramatically with the Byzantine tradition.

*Saint Jerome.* Saint Jerome's feast day was long given special Venetian honors. Observed as a *festa di palazzo,* it was celebrated with a ducal banquet and procession, and notaries were appointed on that day. Though the Republic had more use for the active than the contemplative in its saints and citizens, Bellini's Books contain five drawings of the scholarly, ascetic saint. This church father's special Venetian appeal came from two widely different areas—zoology and antiquity: the patriarch shared his attribute, his faithful lion, with Saint Mark, the Republic's patron saint.

Translation played a critical role in Venice. As a crossroads of the world, she depended upon knowledge of the many languages that linked Byzantium with the West and northern Europe with Italy, and the image of Jerome translating the bible in his study, surrounded by Hebrew, Latin, and Greek books, was well understood there. The patriarch as a scholar of classical literature was also a sympathetic figure, close to the new humanism which created a cult about him. Florence developed the image of the remorseful saint in the wilderness, punishing himself for his excessive love of the beauties of antiquity. Ferrara, the humanist center where Bellini maintained close ties, was the first to take on this theme in northern Italy. His rival, Pisanello, made a painting of the penitent Saint Jerome in 1438, praised by Guarino da Verona.[119] That leading Este scholar may have read to him descriptions from Jerome's letters: "How often, when I was living in the desert, in the vast solitude which gives to hermits a savage dwelling place, parched by a burning sun, how often did I fancy myself among the pleasures of Rome! . . . I had no companions but scorpions and wild beasts . . . the fires of lust kept bubbling up before me when my flesh was as good as dead . . ."[120]

As founder of the first monasteries and convents in the Holy Land, Jerome and his scholarly labors meant much to the new fifteenth-century faith, doubly devoted to humanistic study and hermetic retreat. Carlo Guidi, a Florentine noble long close to the Franciscans, established a new order in the patriarch's name in the hills of Fiesole, and then decided to bring his faith to Verona, Padua, and Venice in northern Italy, all centers where Bellini was most active. Guidi founded the Hieronomite abbey in 1412 on the Venetian island of Santa Maria delle Grazie, and died there five years later. Bellini's drawings of the penitent Saint Jerome as well as his late painting (Verona, Museo del Castelvecchio; Fig. 60) could all reflect Guidi's influence.[121]

But the best-loved episode in Jerome's life was his extracting a thorn from a lion's paw, the grateful beast his faithful guardian ever after. Bellini's surviving oeuvre does not include this scene but it is his son's first signed work (Birmingham, England, Barber Insti-

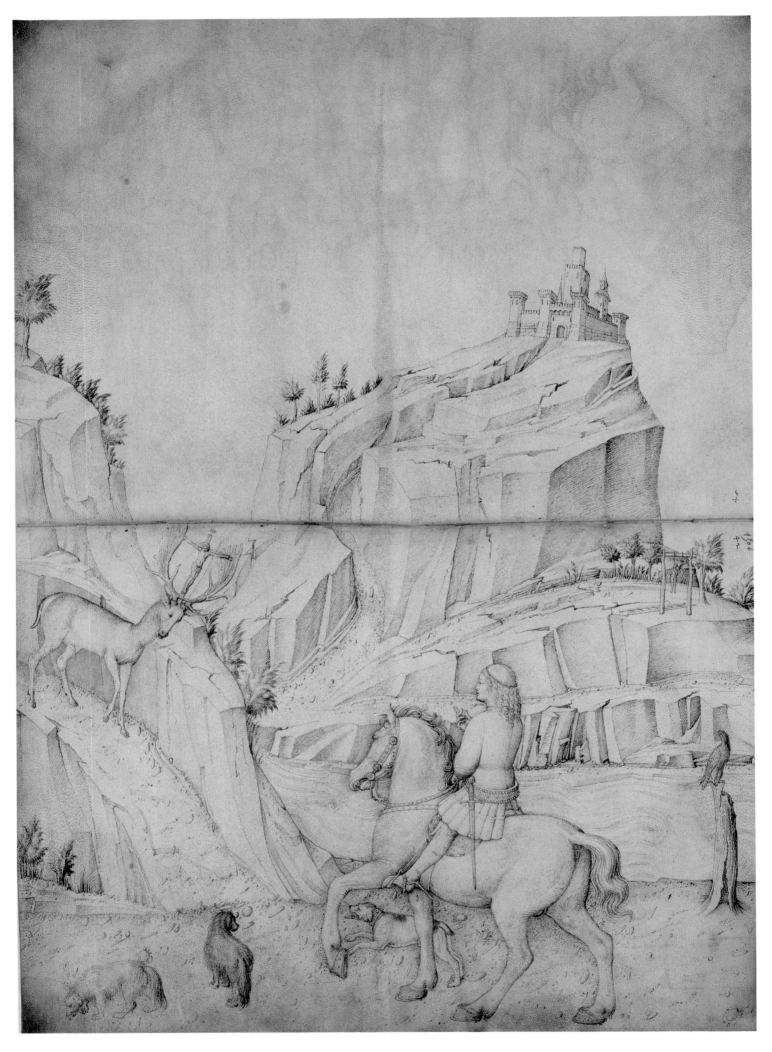

Plates 251/252. *Vision of Saint Eustace*. Louvre 41v, 42

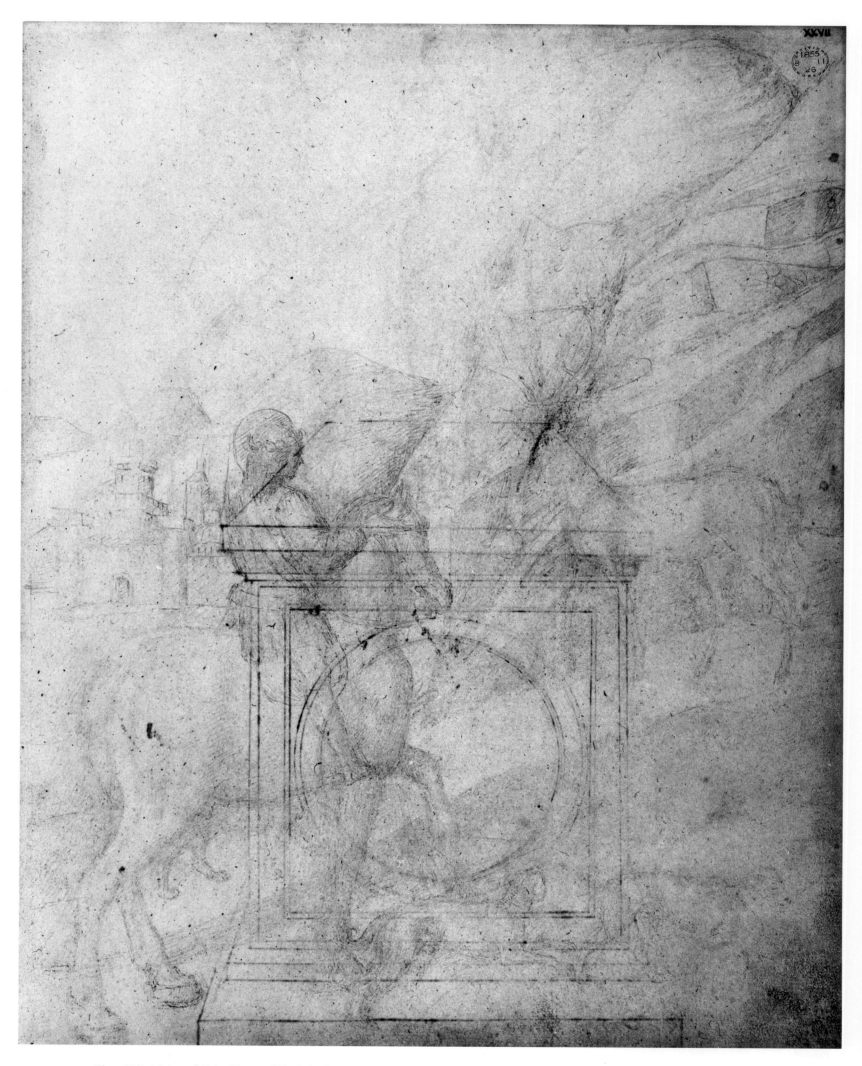

Plate 253. *Vision of Saint Eustace* (A). British Museum 27

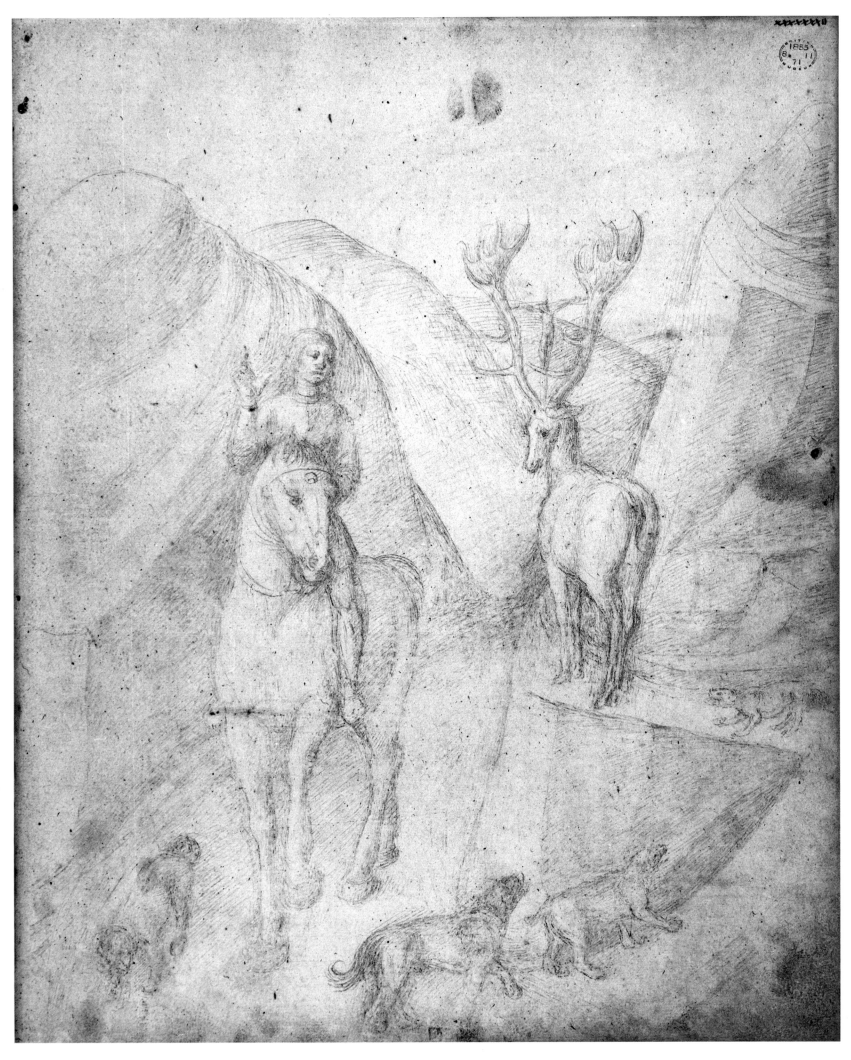

Plate 254. *Vision of Saint Eustace* (B). British Museum 72

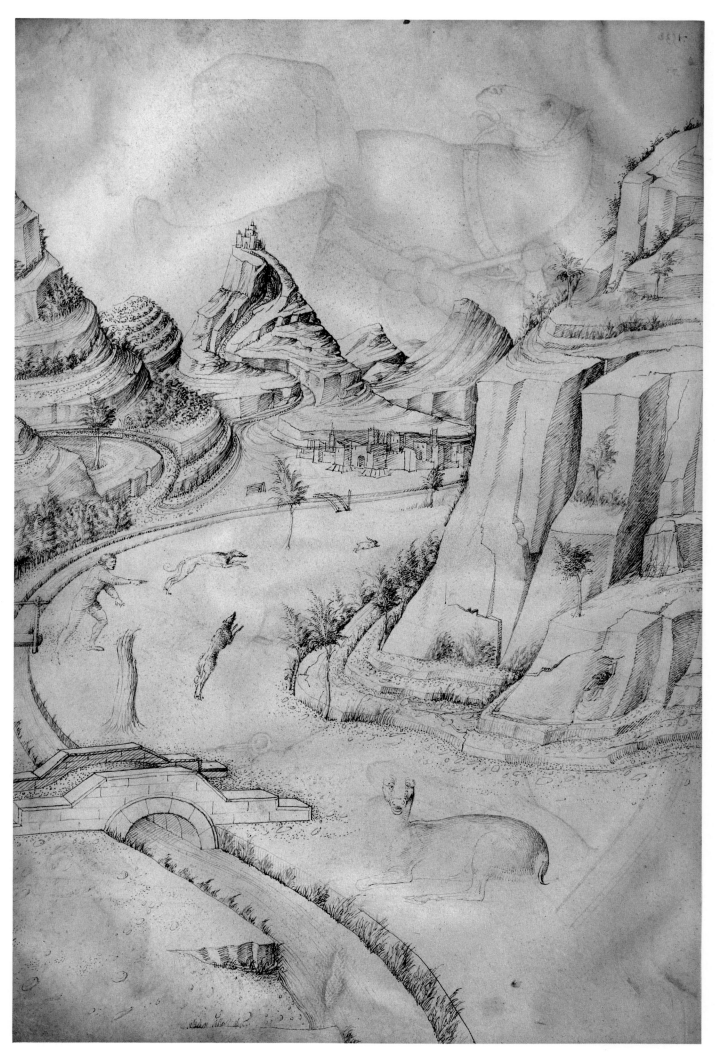

Plates 255/256. *Stigmatization of Saint Francis*. Louvre 70v, 71

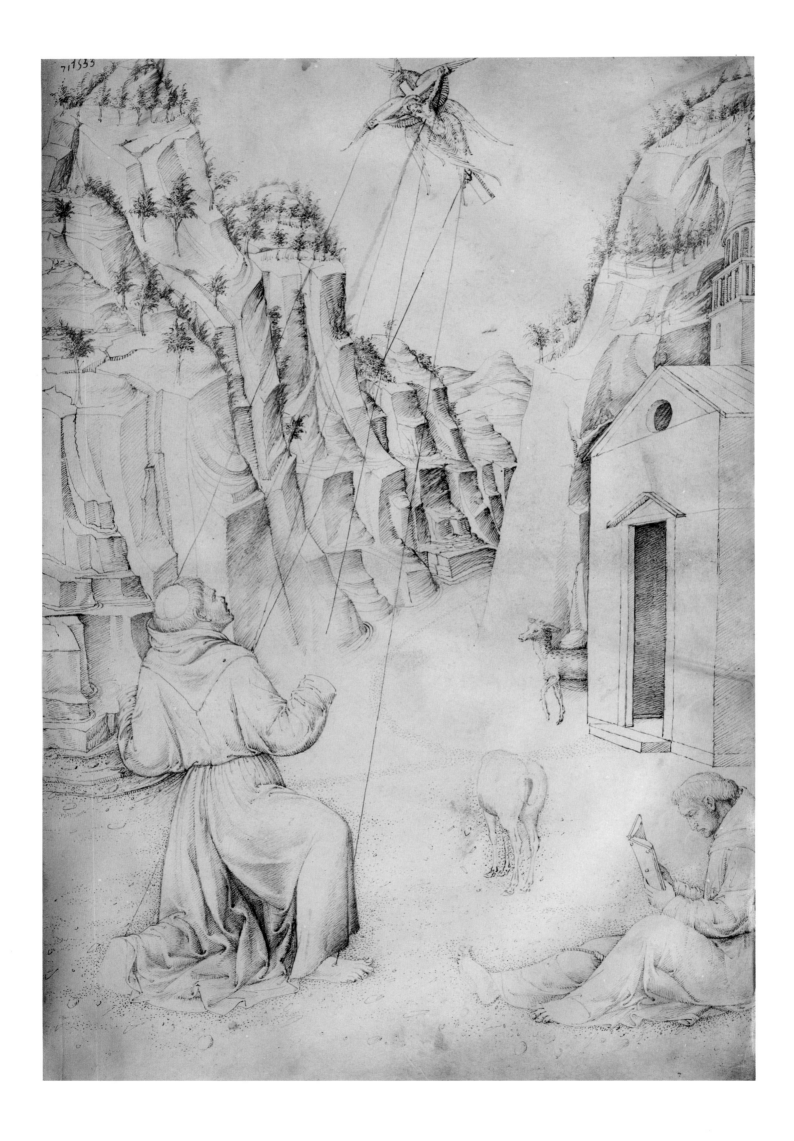

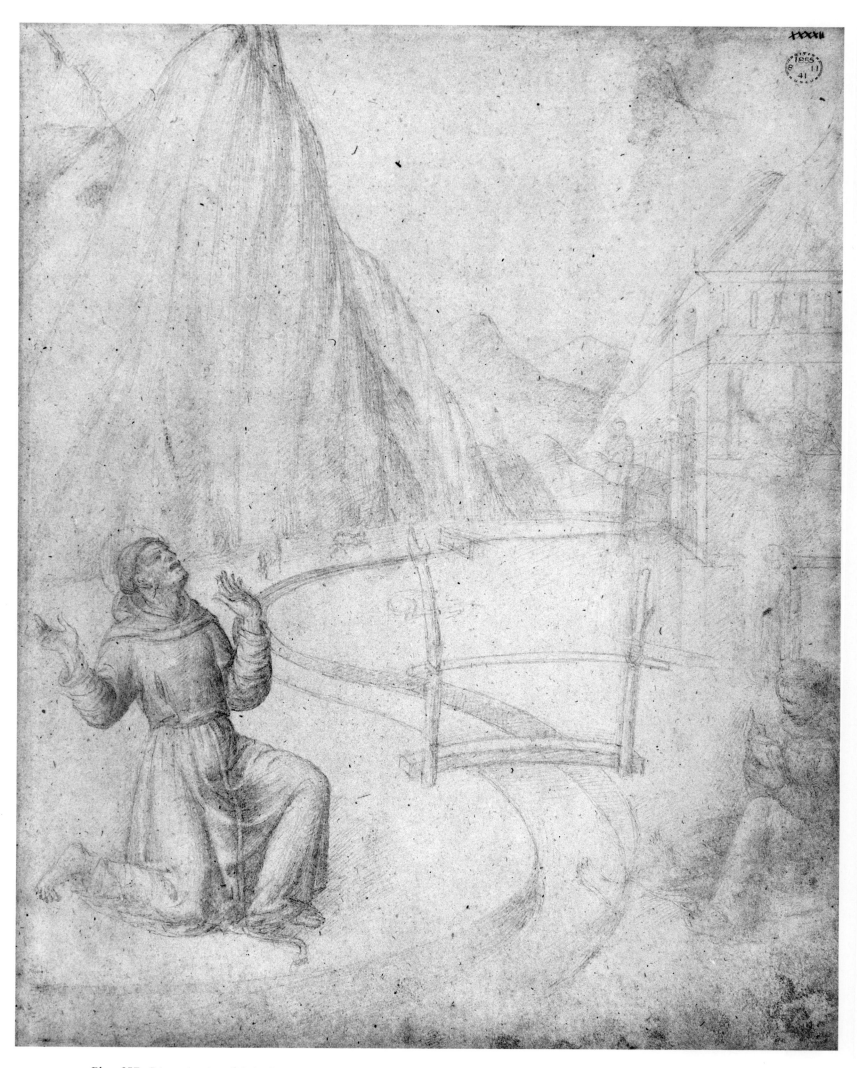

Plate 257. *Stigmatization of Saint Francis*. British Museum 42

402

tute), probably following Jacopo's design. The lion, seated on his haunches and howling in pain, must listen to the patriarch preach before the thorn is taken out. Later Jerome's monks, when their donkey disappears, accuse the lion of eating the pack animal, though desert robbers (according to the popular fourteenth-century tale) had actually stolen the beast, and the lion soon rounded up the thieves, their camel train, and the missing donkey and drove them all back to the monastery. This legend explains the camels behind the reading saint in one of Jacopo's two drawings in the London Book (Plate 272). In the second, Jerome kneels before a crucifix, a holy text on the ground by the sleeping lion (Plate 273). Both drawings are unusual in being on versos, left pages, unrelated in subject to the facing folios at the right.

122 Suggested by Maureen Burke.

A two-page drawing in the London Book (Plates 274/275) shows Saint Jerome beating his breast with a stone as he faces a crucifix, surrounded by wild animals. A broad river—the Jordan—curves across the background and washes over to the facing left page, drawn some time after the recto was completed. Now hard to see, this great landscape has some of the scratchy, impulsive power of *sinopia* drawings, those swiftly brushed sketches beneath early frescoes.

Two *Saint Jeromes* in the Paris Book are smaller in scale, with rich landscape settings that recall the gilded reliefs of Ghiberti's second Doors. Guarded by a pair of lions (Plate 276), Saint Jerome kneels in a natural enclosure while a jackal at the far left confronts a small yet fiery dragon. The other Paris *Saint Jerome*, drawn in silverpoint on bluish-tinted vellum, is set horizontally (Plate 277); this page is a bridge from Pisanello's animal arts to the new illusionism of the young Mantegna's paintings, from the International Style to the new mid-century modes.

Saint Jerome appears in three of Jacopo's paintings as a cardinal holding a church model: in the polyptych in the Dahlem Museum, Berlin (Fig. 58); in a triptych in Vassar College Art Museum, Poughkeepsie (Fig. 61); and in a late altar from his studio for the Carità, which is now the Accademia, where it is found today (Fig. 65).

*Saint Mark.* Ever eager to bring all saints, living or dead, to her shores, Venice cherished the legend that her patron, Saint Mark, was shipwrecked on a nearby island. There is a remote chance that the horizontal *Saint Jerome* in the Paris Book (Plate 277) represents instead that most unlikely episode.[122] Saint Mark may also be the reading saint at the right of a drawing for a carved altar (Plate 240), and the standing saint with a book in Berlin (Fig. 55). Bellini's first recorded work, an altar for the Scuola Grande di San Marco in 1421, called for two images of Saint Mark.

*Saint John the Baptist.* Prophet and Christ's first disciple, Saint John, son of Mary's cousin Elisabeth and Rabbi Zachariah, instituted baptism among the sacraments. A drawing of that act of purification and rebirth, replacing circumcision, is in each Book (Plates 185, 186). One of Venice's oldest churches, San Zan Degolà (San Giovanni Decollato), founded in 1007, was dedicated to the Baptist's beheading; San Giovanni in Bragora was established still earlier. Several major monasteries in the Veneto were devoted to the Baptist. His images in Bellini's Books reflect Saint John's great importance.

Twice he appears alone as the solitary desert dweller, a lean, medieval figure pointing heavenward and holding a blank scroll to be inscribed "Behold the Lamb of God." Stiff and weak, the drawing on the first of these pages may be by a student (Plate 279), possibly assigned this vellum sheet in the Paris Book because attempts to cover the earlier textile design underneath were unsuccessful. This immature artist works in an old-fashioned style. The second *Saint John the Baptist* stands before a steep valley, probably a bank of the Jordan, in the London Book (Plate 278).

Again in the London Book, Saint John preaches to a close-packed crowd in the desert from atop an ancient circular statuary base (or base for a renaissance flagpole), using the gesture of *adlocutio*, of the Roman military leader addressing his troops (Plate 280). He also speaks in an urban setting, standing statue-like on a masonry block (Plate 281). The broad swag of foliage above suggests a feast day, the drawing perhaps designed for a temporary decoration. Stools and serving plates on a low L-shaped table in the courtyard take on a sacramental quality as astonished listeners line the walls.

Most elaborate of the preaching scenes is *Saint John* in the Paris Book (Plate 282), framed by an archway richly carved in an early Netherlandish manner that includes nine

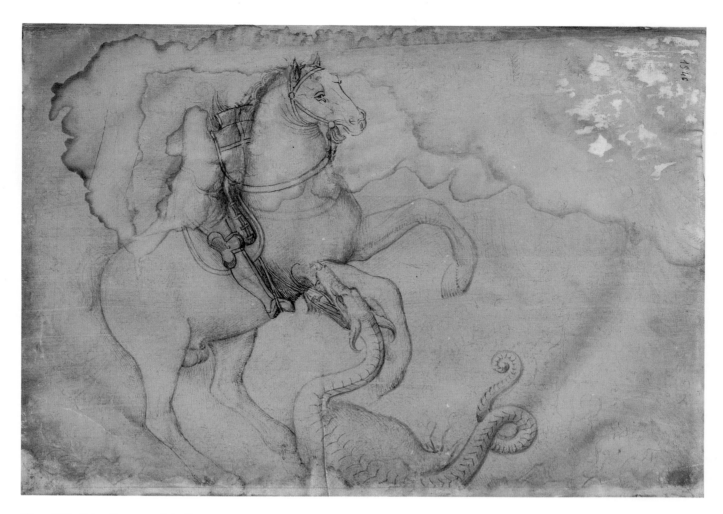

Plate 258. *Saint George and the Dragon* (D). Louvre 84

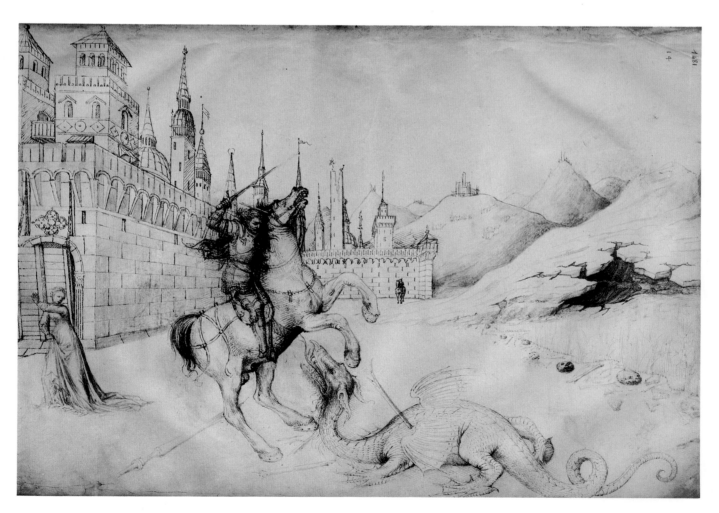

Plate 260. *Saint George and the Dragon* (A). Louvre 14

404

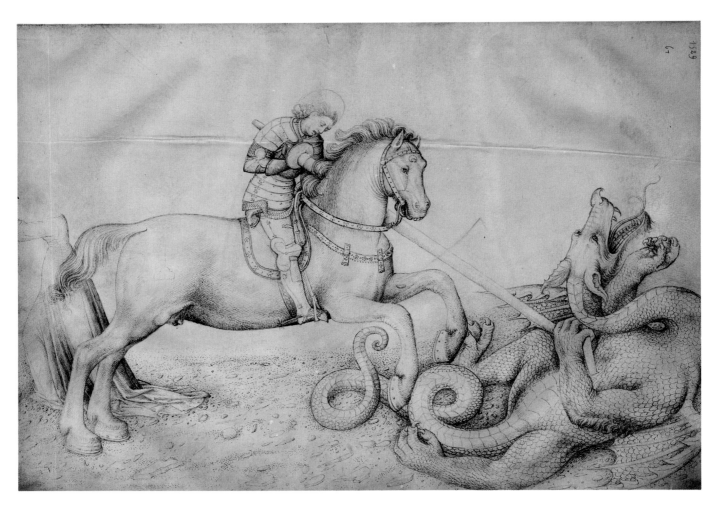

Plate 259. *Saint George and the Dragon* (C). Louvre 67

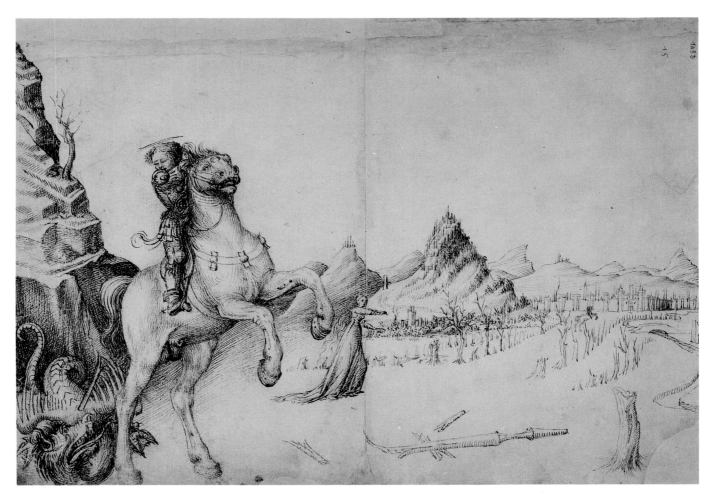

Plate 261. *Saint George and the Dragon* (B). Louvre 15 (on paper)

Plate 262. *Princess Seeking Refuge in Palace* (continuation of *Saint George and the Dragon* [C], Plate 263). British Museum 11v

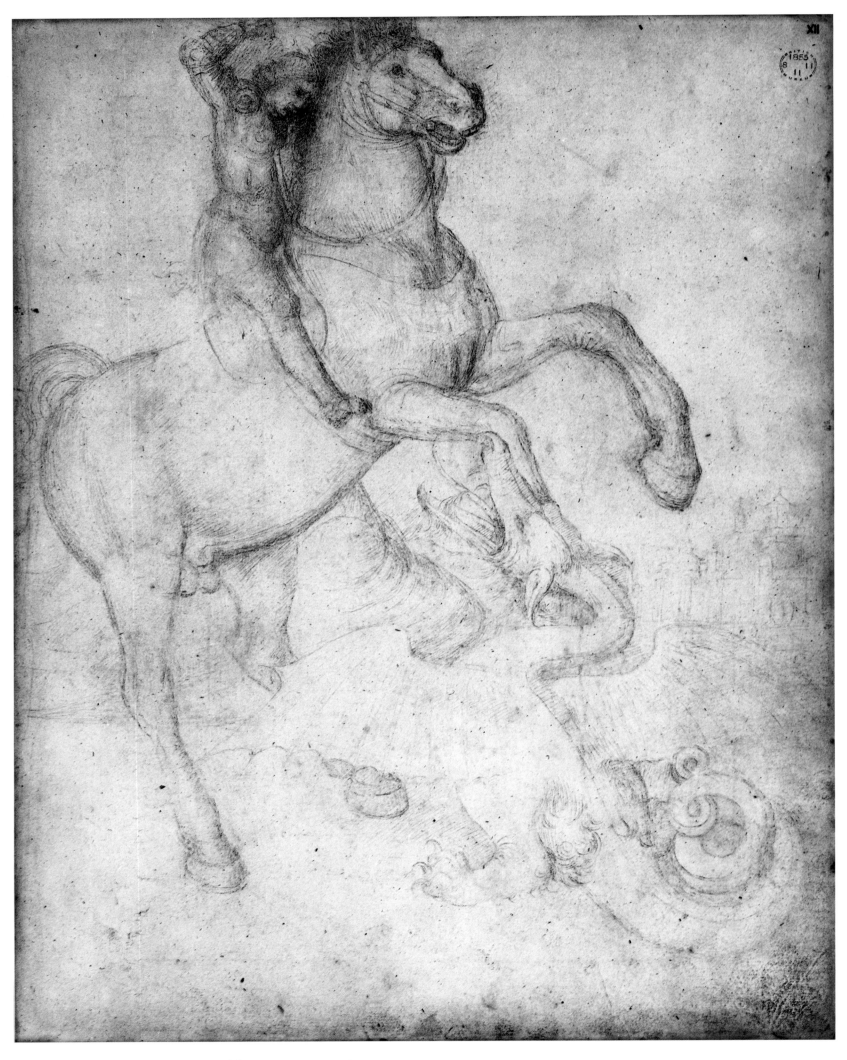

Plate 263. *Saint George and the Dragon* (C). British Museum 12

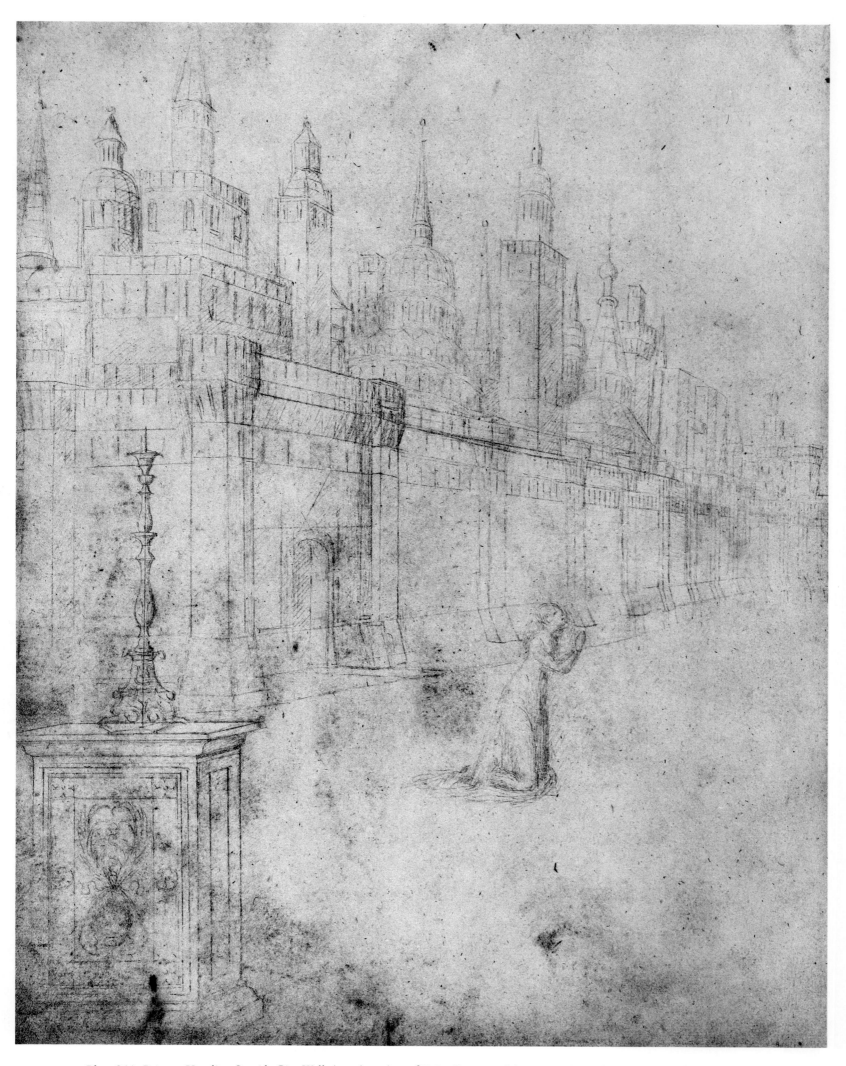

Plate 264. *Princess Kneeling Outside City Walls* (continuation of *Saint George and the Dragon* [A], Plate 265). British Museum 6v

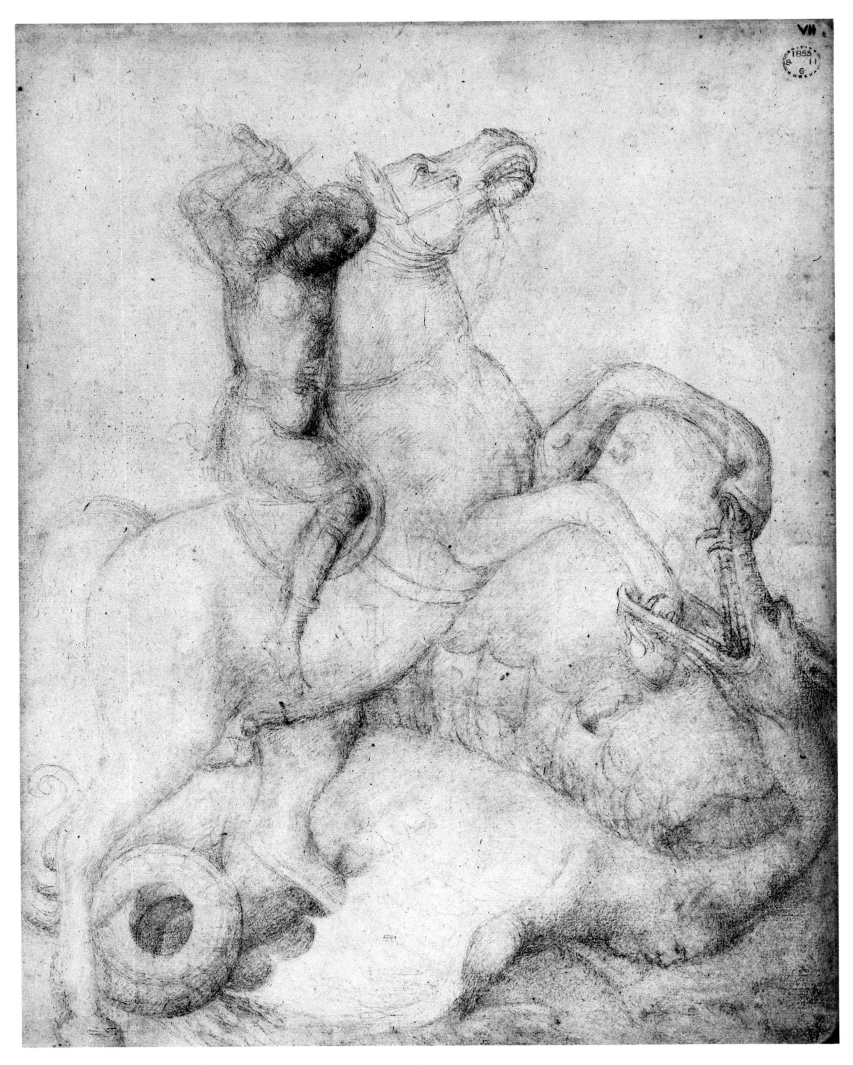

Plate 265. *Saint George and the Dragon* (A). British Museum 7

Plate 266. *Princess Taking Shelter in Castle Entry* (continuation of *Saint George and the Dragon* [B], Plate 267). British Museum 9v

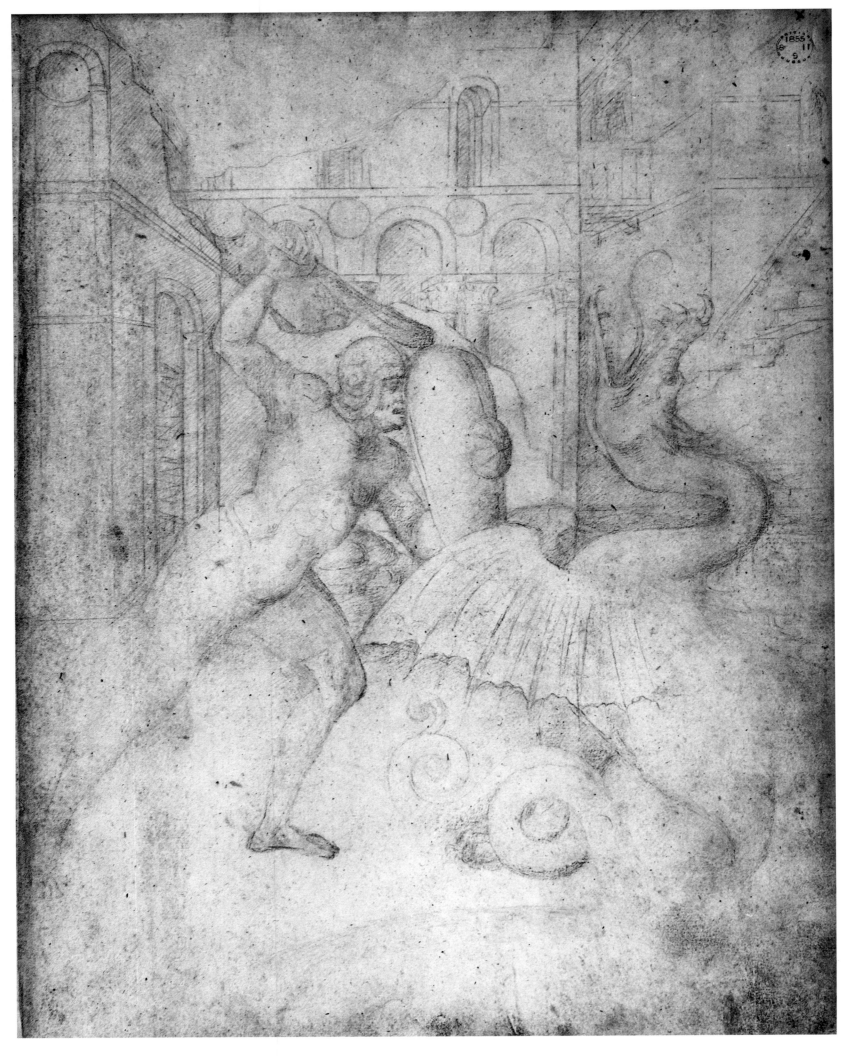

Plate 267. *Saint George and the Dragon* (B). British Museum 10

Plate 268. *Landscape* (continuation of *Saint George and the Dragon* [D], Plate 269). British Museum 24v

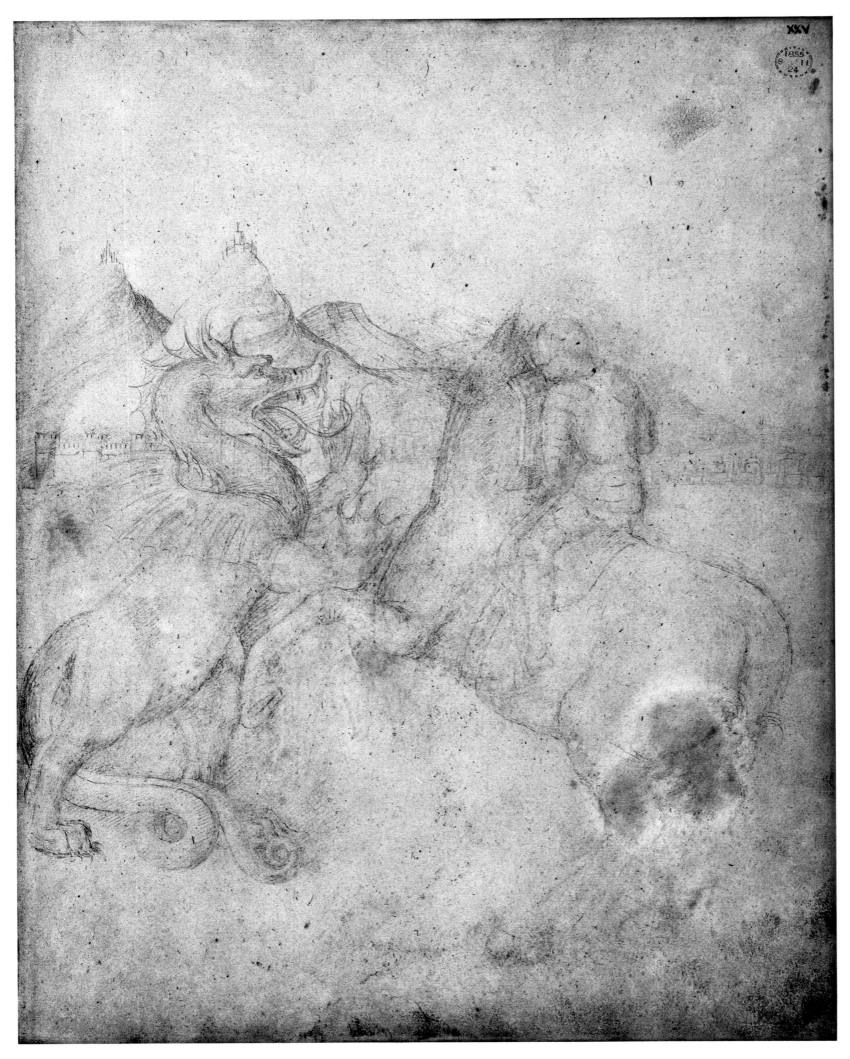

Plate 269. *Saint George and the Dragon* (D). British Museum 25

413

miniature reliefs. None of these pertains directly to the Baptist; dealing with military combat and justice, they may represent a pagan triumphal arch, the old order to be changed by the new faith.

This is one of the Books' rare illustrations of boats, seen in the background. The youth with a book may be Saint John the Evangelist, the other major figures also apostles. Sitting on the ground before the Baptist, a little boy feeds a pet bird from a sugar tit. Close in style to many folios in the Paris Book of the life of Christ, all may have belonged to a single cycle. Among Bellini's most richly developed urban views, this drawing is late in date; elements such as the equestrian figure point to the art of Pollaiuolo and Verrocchio, both known in the Veneto.

Poised like a living statue, a more leonine preaching Baptist stands in a niche above an altar-like base (Plate 283), his athletic build very different from the saint's other, ascetic images. Three scenes below are meant to be in shallow relief, like those on the professor's tomb (Plate 134): at the left is the young Baptist—the beloved *Giovannino*—in the wilderness, an angel bringing him clothing; on the central panel John preaches in the wilderness, Bruegel-like; he is decapitated at the right. Garlanded torchères stand on either side, the left one decorated with satyrs, the right with aloe leaves rising from basins, motifs that appear on another Paris page (Figs. 10, 17) combined with a satyr and a decapitated warrior, possibly Holofernes.

John was imprisoned by the Roman governor Herod Agrippa for preaching against Herod's adulterous and incestuous marriage to Herodias, his brother's wife; she, in revenge, wanted John's head, and arranged for her seductive daughter Salome to dance at a drunken birthday party; Herod, infatuated, granted Herodias' wish. Bellini drew the story twice, staging his earlier, simpler version, in the London Book (Plates 286/287), in a courtyard inspired by the Doge's Palace, so identified by Bon's allegorical sculpture of *Venice as Justice* below a balcony. The beheading takes place under the stairs, a woman (Salome?) waiting there with her salver; she is seen climbing the stairs and again on the dining terrace above, as she also is in the Paris Book.

But here the vellum is worked horizontally (Plates 284/285), with the upper part of the magnificent palace continuing into the facing folio. The martyrdom at the back of the stairs seems incidental to the everyday business of courtly life, almost obscured by the elaborate fountain of Venus, water jetting on high from her breasts. Statues of little cupids encircling all three basins of this pagan monument may symbolize the passions that brought about the Baptist's death.

Two late triptychs from Jacopo's studio (Figs. 64, 66) have images of the standing saint at the left, recalling the Books' most conservative manner.

*Saint Lawrence*. A late triptych from Jacopo's studio showing Saint Lawrence in priestly robes in the center (Fig. 64), standing on the gridiron of his martyrdom, differs in style from the artist's oeuvre. With Saint Stephen, Saint Lawrence was a protomartyr.

*Saint Louis of Toulouse*. The royal Franciscan saint stands in episcopal robes at the far right in a late triptych from Jacopo's studio (Fig. 65).

*Saint Martin*. Patron saint of France, Martin of Tours was one of many early Christian martyrs in whom knightly force and Christian charity were combined, making them popular personifications of loving strength. All three regions where Saint Martin lived were close to the Venetian economy: his Hungarian birthplace, his military training in northern Italy, and his martyrdom in France.

Martin was the patron saint of many of the Republic's large standing armies and extensive cavalry. He also had that role for several professions important to the Serenissima's commerce, patron of drapers, tailors, furriers, and innkeepers. Bellini may have planned this composition for the saint's small church in Venice or for that in Chioggia, or perhaps for San Giovanni Evangelista, which prized a relic of Saint Martin. His cult was established in Venice by the eleventh century but had been founded in Padua long before, perhaps as early as 593 A.D.

In a bold page in the London Book (Plate 288), horse and saintly rider face us on the road outside the walls of Saint Martin's garrison at Amiens. The powerful figure of the cold, naked beggar is in left profile, the single bare tree a statement of winter. Martin

divides his cape—a symbol of military rank—with a swordstroke, the beggar reaching for his half. Christ appeared to the officer in his sleep that night, wearing half of the shared cape.

*Saint Michael Archangel.* Of the seven archangels, Michael comes first, captain general and protector of the Hebrews. His militant power is stressed in Saint John's Revelation as vanquishing Satan, whose form is dragon-like, monstrous. Saint Michael is also a central figure at the Last Judgment, weighing souls and directing the saved and the damned toward God's right or left. As a winged figure, Michael comes close to the classical personification of Victory. His image is painted on the marble slab long guarding the secret burial place of Venice's sacred treasure, the body of Saint Mark. At this site, commemorated by a column in the Doge's Chapel, each newly elected doge was first presented to his people. With drawn sword, Saint Michael guards the southwest corner of the Doge's Palace (beneath the Sala del Maggior Consiglio and above the carving of *Adam and Eve*). He is also the patron saint of Venice's cemetery island.

One study of the saint in the London Book (Plate 289) may repeat Jacopo's painting of 1430 for the Paduan church of San Michele Arcangelo. Guariento's fourteenth-century painted series of the angelic army, in the chapel of the Paduan Podestà, provided Bellini with his decisive image.[123] With sword and old-fashioned buckler (added to the figure later), Saint Michael is about to slay Satan, in the form of a dragon. The archangel's wing tip extends into the facing left page, where fugitive traces of flames and a landscape are now barely visible.

Victor and vanquished are penned in the Louvre Book in a rocky terrain (Plate 290). Saint Michael's head and arms were probably visible when the drawing was reworked later in the fifteenth century; preserved at first by benign neglect, they have since faded away. The angelic avenger in another two-page London drawing (Plates 291/292), flying down to hell, beards Satan in his den as that horned and winged devil cowers in the lower right corner. A blow from Saint Michael's sword has shattered Satan's protective rock, exposing him. Hell, drawn over to the facing page, becomes a fire-ringed landscape at the upper left.

*Saint Onuphrius.* The naked hermit saint stands second from the left in the Matelica Altar by Giovanni Bellini (Fig. 62), based on his father's design.

*Saint Paul.* The Venetian church of Saint Paul (San Polo), founded in the ninth century, is one of her oldest. The saint personifies militant Christianity, and the piazza of his church, second only to San Marco's in size, was often used for military reviews and vigorous local pageantry. Bellini's two-page depiction in the London Book of the *Conversion of Saint Paul* (Plates 293/294), one of his finest, shows the crucial episode on the road to Damascus. The saint's pose, falling backward from his kneeling horse, is traditional for representing Fallen Pride, but the scene is far from conventional. Startled horsemen stare at their suddenly blinded leader who still grasps his sword. Rays descend from Christ as if bringing his query: "Saul, Saul, why persecutest thou me?"

After completing the *Conversion* as a vertical composition, Bellini extended it over the left facing page, adding seven riders at a watering place. Jacopo's son Giovanni may have consulted this *Conversion* before painting the subject in the predella of his Pesaro Altar (Pesaro, Museo Civico) in the early 1470s. Jacopo's great page has also echoes in the North, in the French master Jean Fouquet's *Hours of Etienne Chevalier* (Chantilly, Musée Condé) from the early 1450s.

*Saint Peter.* Saint Peter holds a holy book and the keys to heaven in a series of four saints from a multipaneled altarpiece in Berlin (Figs. 55–58). The same saint in a similar setting is at far left in a project for a carved altar (Plate 240), also at the upper left of the London apostle page (Plate 239).

*The Protomartyrs: Saint Stephen and Saint Lawrence.* These saints appear in a painting by Giovanni based upon his father's design (Fig. 62), at left and right of the central figure.

123 The orientalizing textile pattern book, bound for reuse into the Paris Book, also contained a *St. Michael*, though Bellini would have thought that image far too quaint to copy it. He may also have returned to the powerful mosaics in the Baptistery of San Marco or to a painting from the Guariento circle (Venice, Museo Correr), proposed as Bellini sources by Degenhart and Schmitt, 1980, 153–54. See their fig. 245 for the *St. Michael*.

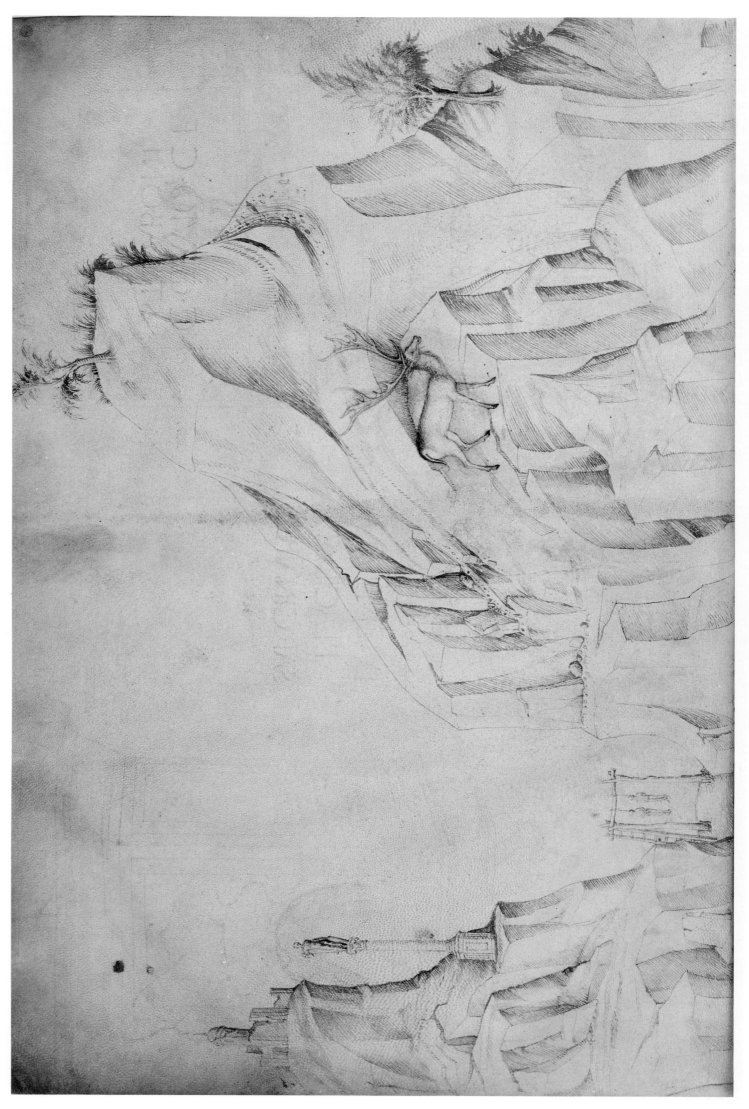

416

Plates 270/271. *Martyrdom of Saint Isidore*. Louvre 49v, 50

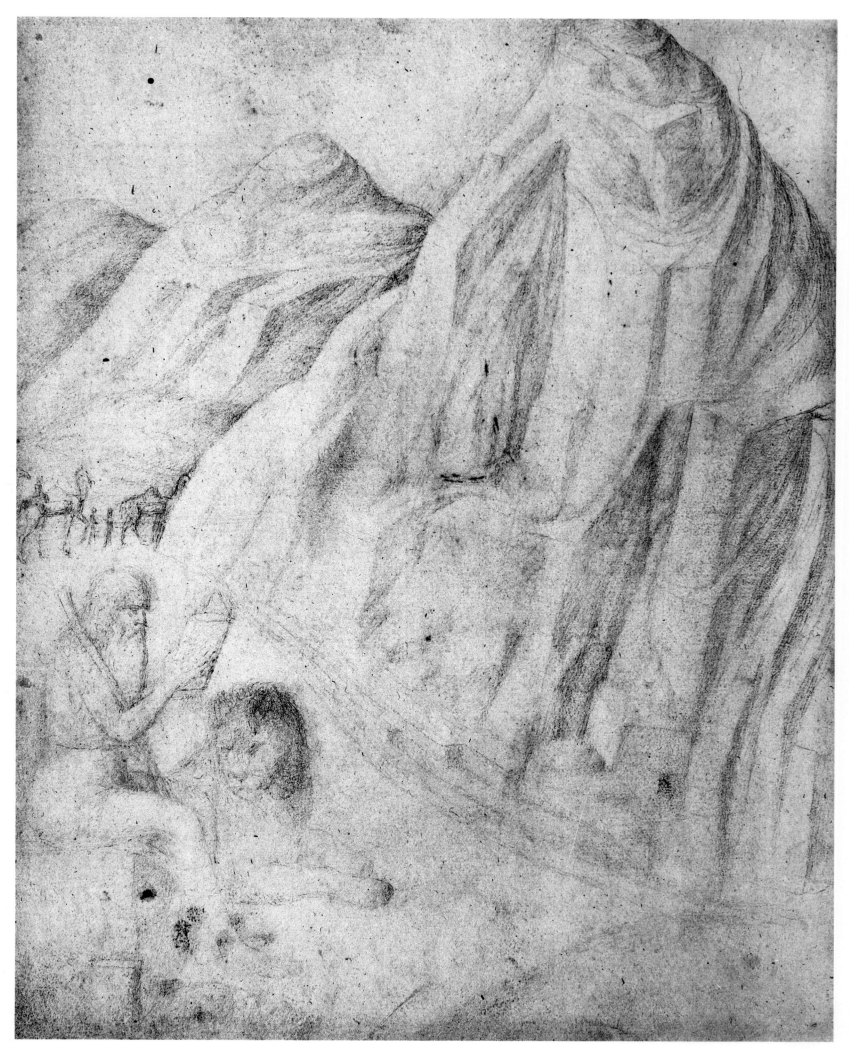

Plate 272. *Saint Jerome Reading in the Wilderness.* British Museum 87v

418

Plate 273. *Penitent Saint Jerome in the Wilderness*. British Museum 63v

Plate 274. *Landscape with Monster* (continuation of *Saint Jerome in the Wilderness* [A], Plate 275). British Museum 16v

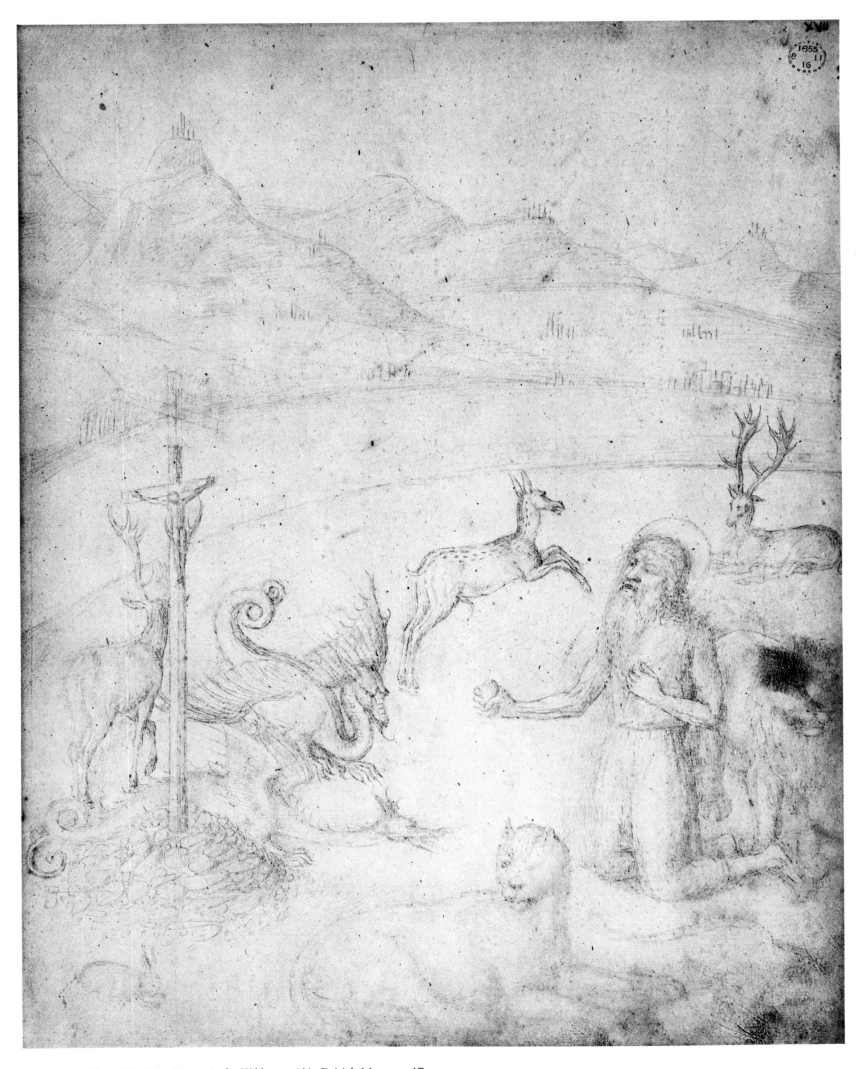

Plate 275. *Saint Jerome in the Wilderness* (A). British Museum 17

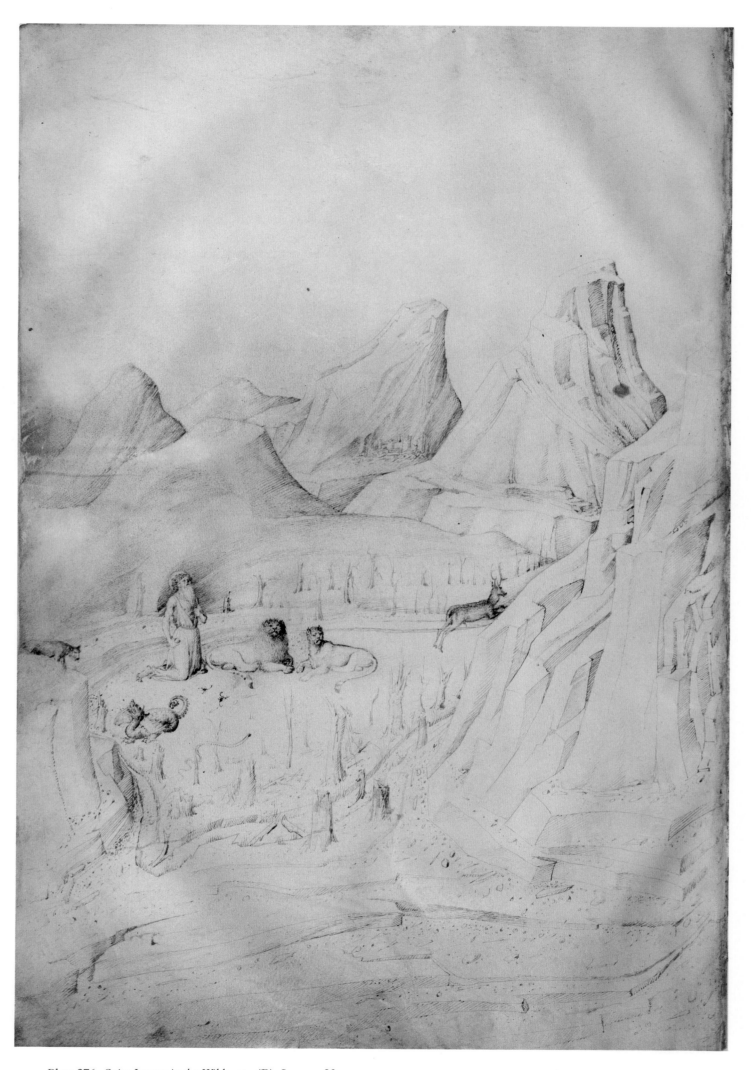

Plate 276. *Saint Jerome in the Wilderness* (B). Louvre 23v

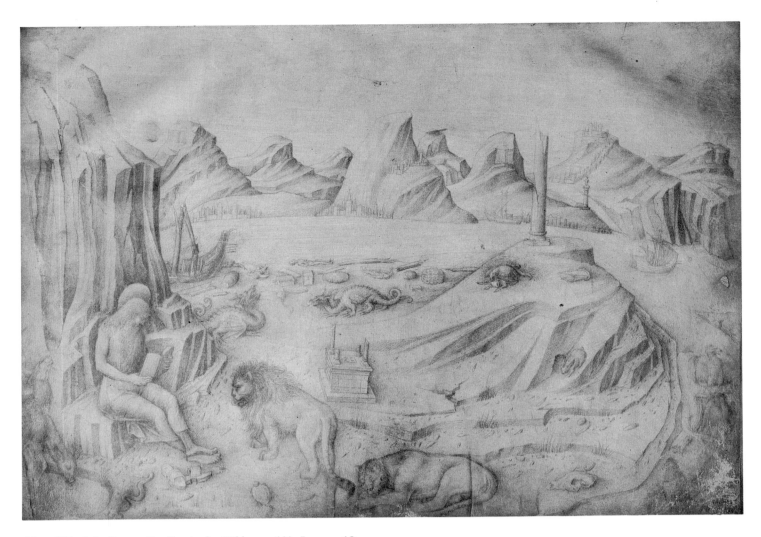

Plate 277. *Saint Jerome Reading in the Wilderness* (A). Louvre 19v

*Saint Sebastian*. Roman soldier and patron of archers, Saint Sebastian was among the best-loved early Christian martyrs, revered as a healer because the volley of arrows piercing his body failed to kill him; Saint Irene removed these, and Saint Sebastian later met his end by decapitation. Surprisingly, Venice seems to have had no major early church devoted to this popular saint, although he was the subject of many altarpieces, including early works by Giovanni Bellini and Mantegna.

Tied to a tall post at the far left of a vertical composition in the London Book (Plate 295), the saint faces a group of Roman soldiers and oriental elders, one holding a Turkish bow, who seems to be debating Saint Sebastian's death sentence. A winding river at the lower left continues on the facing left page, where a beautiful tree is drawn (Plate 36). This extension, made later than the vertical composition, diminishes it.

In the friezelike composition on a Paris folio (Plate 296), all the archers use Turkish bows; one archer has refused to draw his bow, and elders at the left have dubious looks. Saint Irene, behind Saint Sebastian at far right, gazes up mournfully. Crude, later re-inking did not include the heads, now blank, of two archers to the left; like the Paris *Saint Michael* (Plate 290), the lines in these areas were probably well preserved when the others were reinforced.

The saint stands in prayer, second from the right in the Matelica Altar, shot full of arrows (Fig. 62). Giovanni Bellini painted this after his father's design.

Saint Sebastian is the central figure in a late triptych (Fig. 66), similar in style to the Paris Book's image.

*Saint Theodore*. The major Venetian image of her first militant patron saint, Theodore, still stands atop his great column in the Piazzetta, assembled from bits and pieces of Roman sculpture above a Gothic dragon. [124] In two drawings by Bellini a knight battles a dragon with no visible damsel in distress (Plates 258, 259), possibly *Saint Theodore* rather than *Saint George*.

*Saint Victor*. As a young renaissance knight, Saint Victor stands at the far right in a triptych from Jacopo's studio (Fig. 63).

124 L. Sartorio, "San Teodoro statua composita," *Arte Veneta*, I, 1947, 132–34, and, in the same issue, G. Mariacher, "Postilla al 'San Teodoro,' statua composita," 230–31.

423

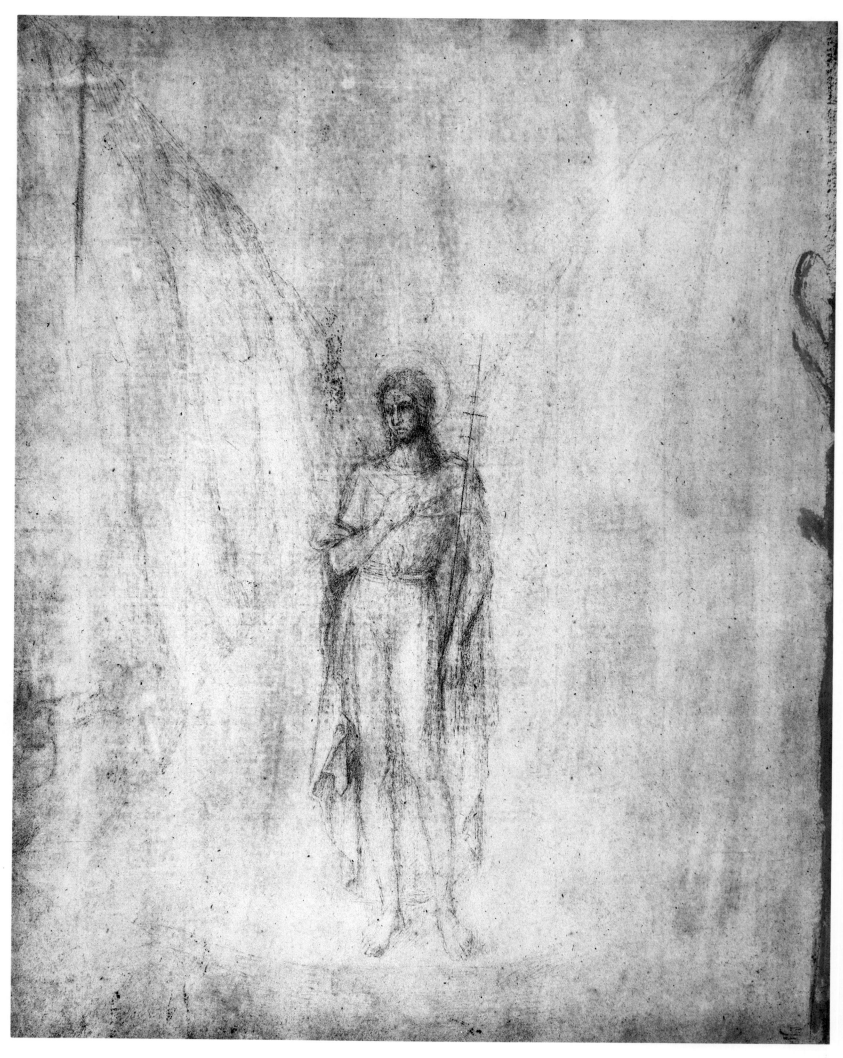

Plate 278. *Saint John the Baptist in the Wilderness.* British Museum 62v

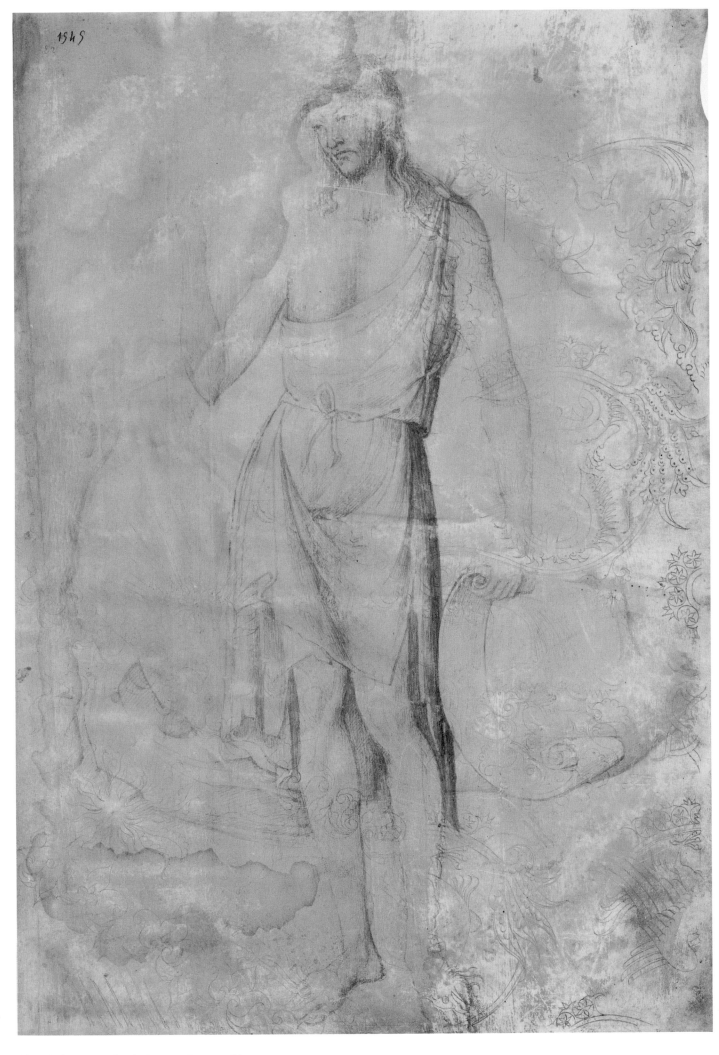

Plate 279. *Saint John the Baptist.* Louvre 83

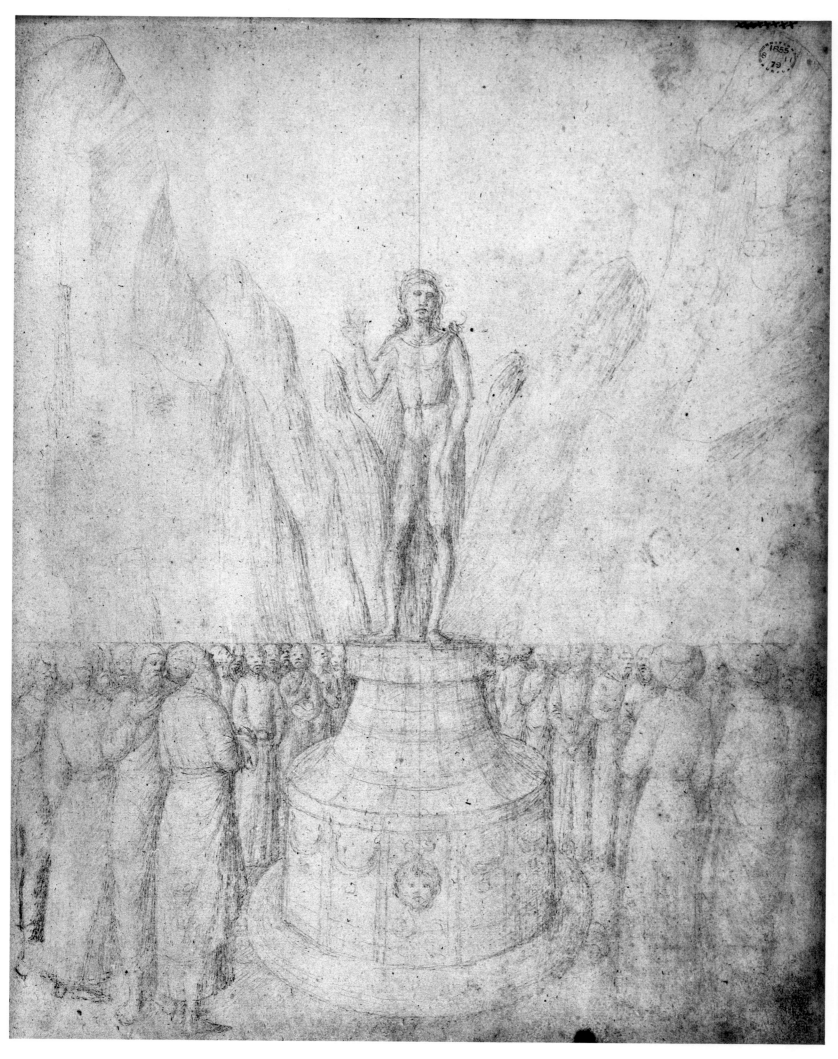

Plate 280. *Saint John the Baptist Preaching*. British Museum 80

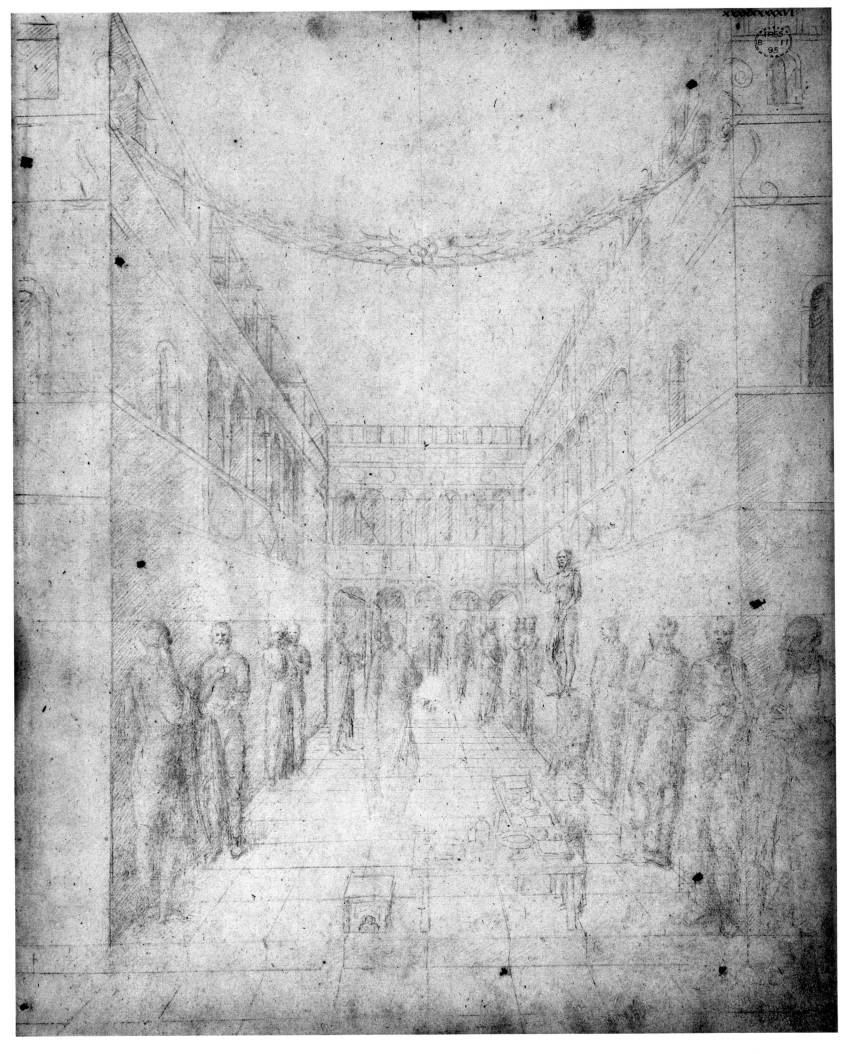

Plate 281. *Saint John the Baptist Preaching in Courtyard.* British Museum 96

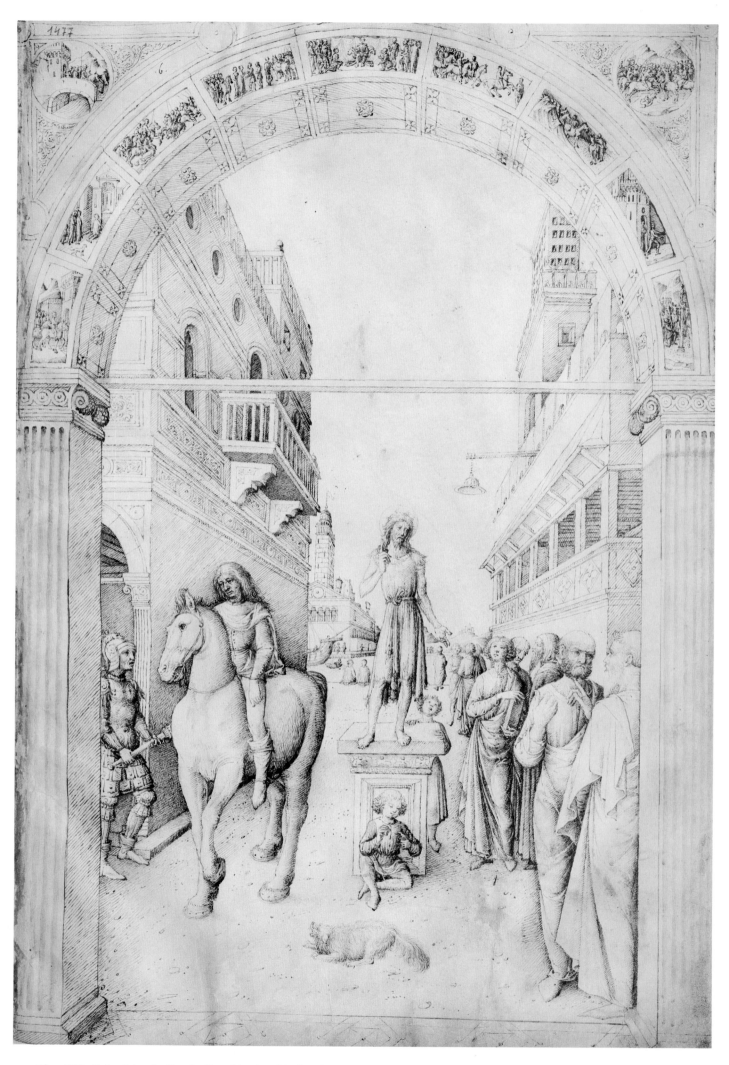

Plate 282. *Saint John the Baptist Preaching in a Harbor City.* Louvre 6

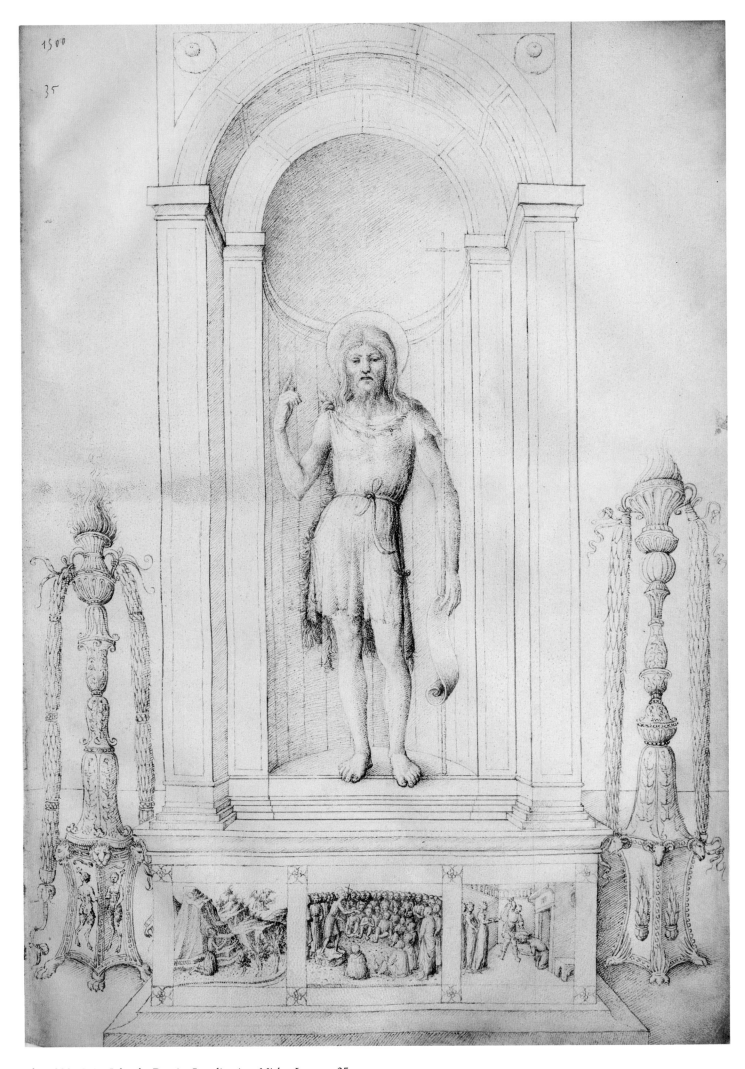

Plate 283. *Saint John the Baptist Standing in a Niche*. Louvre 35

Plates 284/285. *Feast of Herod; Beheading of Saint John the Baptist. Louvre 16v, 17*

Plate 286. *Herod's Palace and Cortile* (continuation of *Beheading of Saint John the Baptist*, Plate 287). British Museum 74v

Plate 287. *Beheading of Saint John the Baptist*. British Museum 75

Plate 288. *Saint Martin Sharing His Cloak with a Beggar.* British Museum 39

Plate 289. *Saint Michael Archangel and the Dragon*. British Museum 41

Plate 290. *Saint Michael Archangel and the Dragon*. Louvre 69

Plate 291. *Mountainous Terrain* (and continuation of wing of *Saint Michael Archangel*, Plate 292). British Museum 48v

436

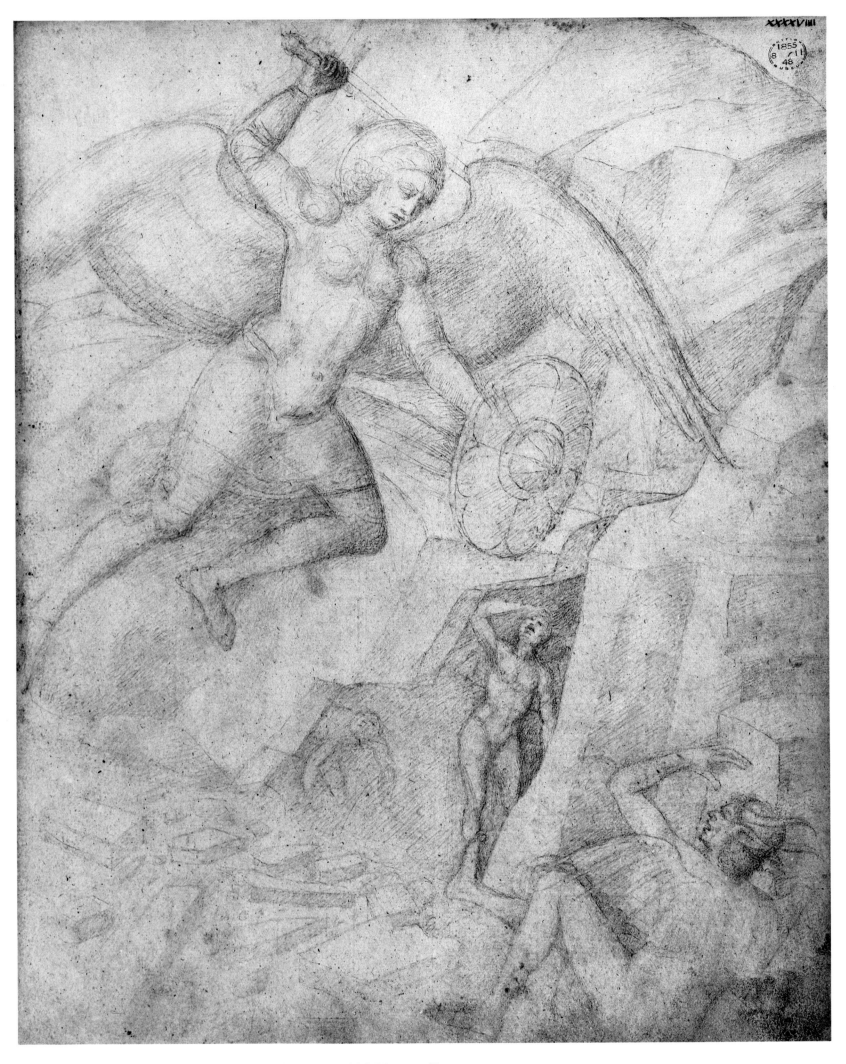

Plate 292. *Saint Michael Archangel and Demons.* British Museum 49

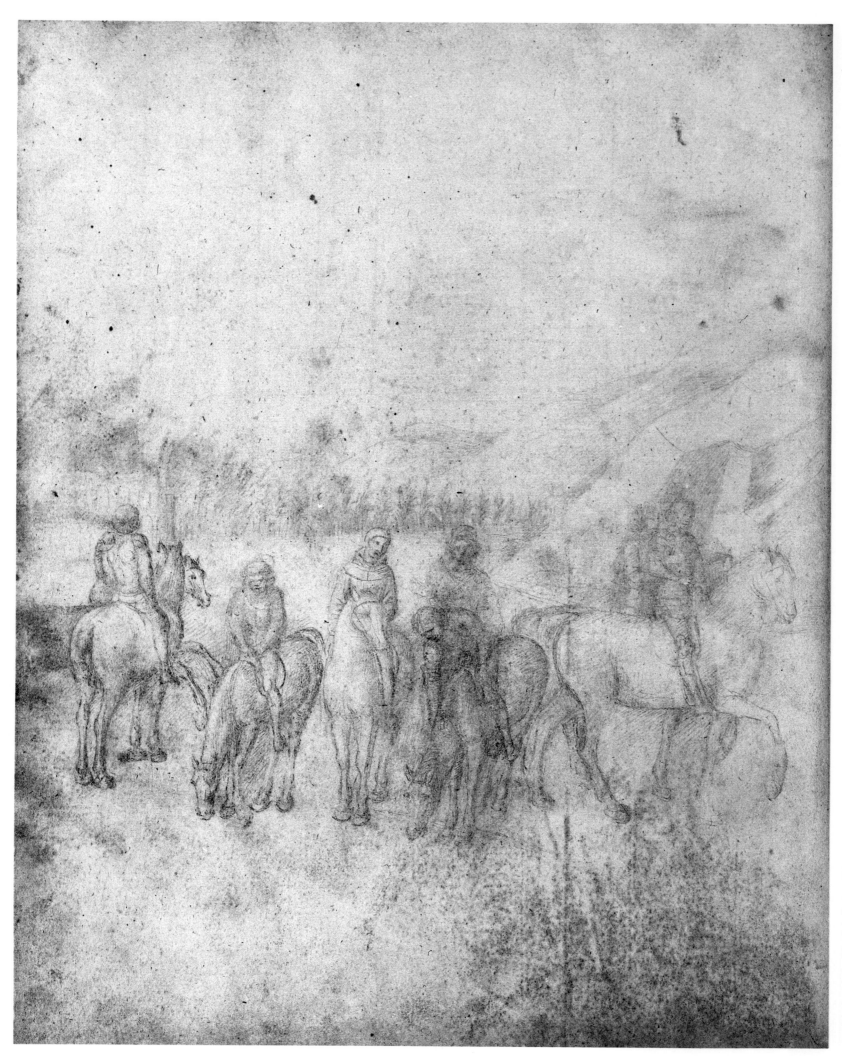

Plate 293. *Military and Other Riders* (continuation of *Conversion of Saint Paul*, Plate 294). British Museum 37v

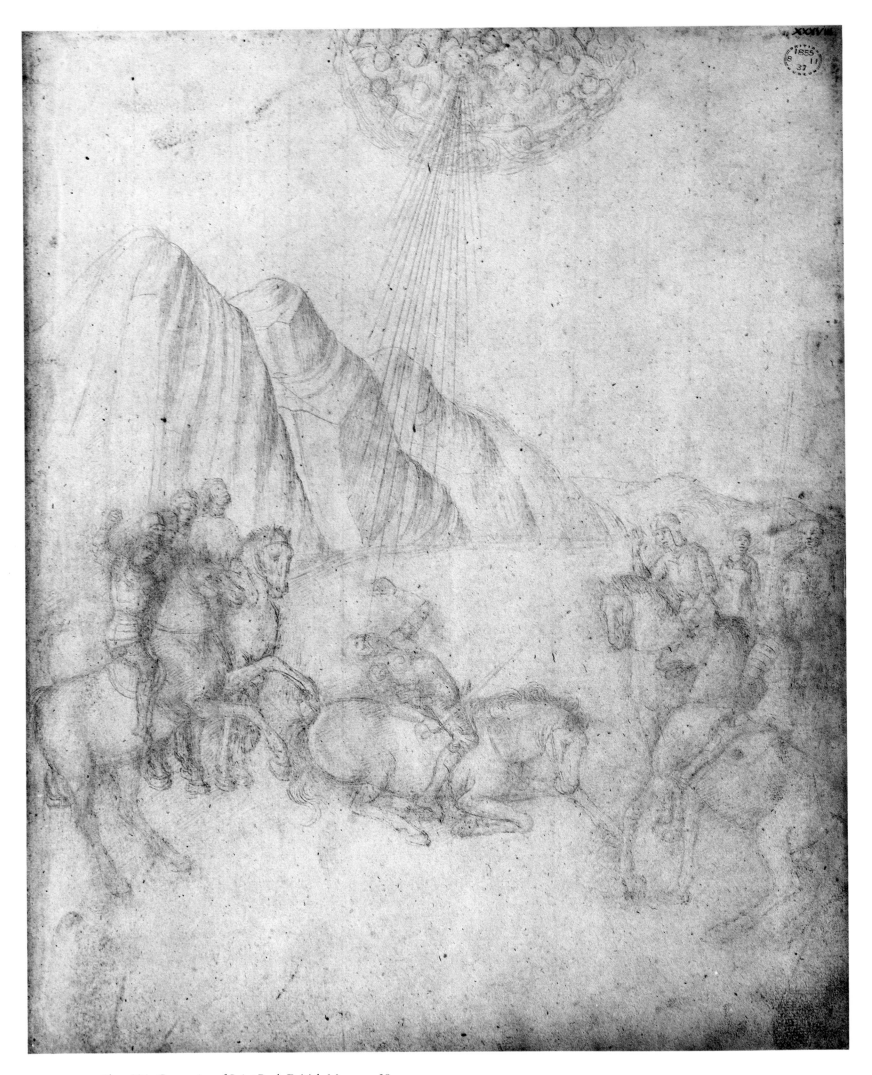

Plate 294. *Conversion of Saint Paul.* British Museum 38

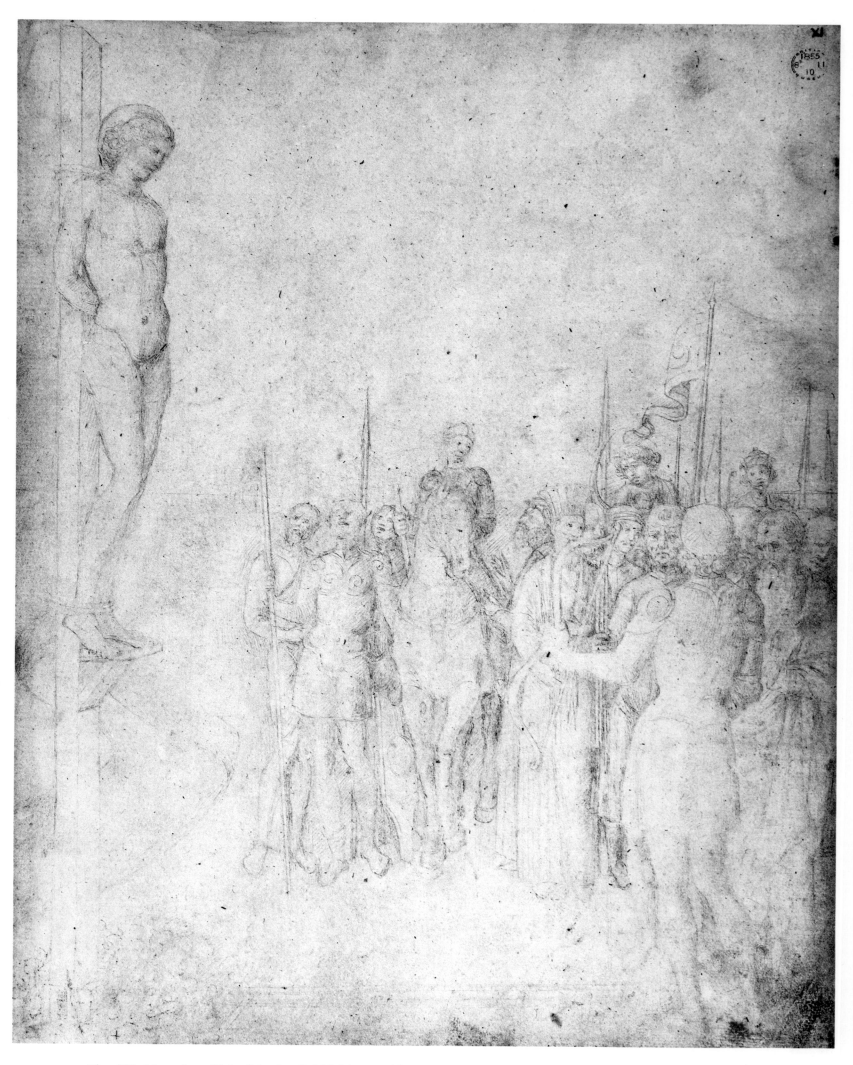

Plate 295. *Martyrdom of Saint Sebastian*. British Museum 11

440

Plate 296. *Martyrdom of Saint Sebastian*. Louvre 68

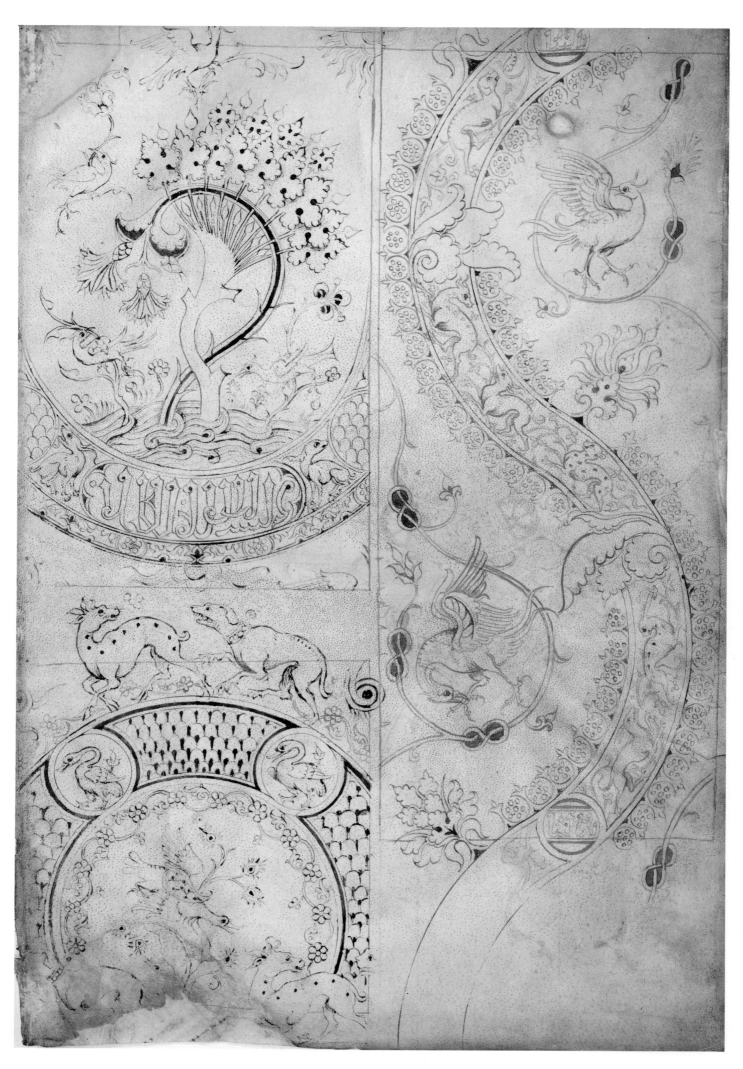

Plate 297. *Orientalizing Textile Pattern*. Louvre 95v

# VIII

## CITY AS STAGE

### PERSPECTIVE AS PERFORMANCE

Writing in 1569 of the Venetian landscape tradition, Daniele Barbaro observed in his *La pratica della perspettiva* that the Serenissima's early masters "left many fine remnants of excellent works, in which we behold not only landscapes, mountains, woods, and edifices, all admirably designed; but even the human form, and other animals, with lines drawn to the eye, as if to a center placed in the most exact perspective. But in what manner and by what rules they proceeded, no author of whom I am aware, has left any account to us."[1]

How far back in the history of Venetian art did Barbaro mean his remarks to go? Lanzi, quoting them in 1796, believed Giovanni Bellini to be the subject, but Jacopo's drawings, unknown to Lanzi, are much better candidates for Barbaro's "fine remnants." These words suggest the qualities of the London Book, then owned by Vendramin, whose collection Barbaro doubtless knew.

Bellini's Books are a unique testament to the graphic uses of perspective in the early Venetian renaissance, a pioneering repertory of the making of spatial illusion. This catalogue-like series of settings, of exterior and interior spaces and their clever combinations, brings together methods new and old from late medieval art and contemporary art in the Veneto and Tuscany.

For all Jacopo's persuasive skill in establishing effects of depth, line, and scale and controlling the viewer's movement toward special areas or axes of interest, he was not an inventive master of perspective. Always interested in the functional, he sometimes uses the old bifocal method—the fourteenth-century formula for constructing space.[2] His pictorialism is essentially craft-oriented, shrewd and empirical rather than theoretical.

The Venetian's command of space is strong in his religious narratives, biblical scenes that suggest mystery plays on paper, stage settings built from the stones of Venice for the lives of Susanna and Daniel (Plates 155/156), Solomon (Plates 153/154), Christ, the Virgin, and many saints. The *Flagellation* (Plate 195) lent itself to presentation "in depth" because its site, Pilate's "house of tiles" or pavements, described in the bible with rare specificity, had rectangular flooring that corresponded perfectly to the checkerboard ground plans long standard for perspectival construction. Repeatedly though not invariably, Bellini turns to the squared ground plan for this and other scenes of the Passion (Plate 194).

Mantegna made dramatic use of the pavement motif in his engraved *Flagellation* by stressing the empty foreground; his starting point may have been two drawings by Bellini (Plates 195, 196/197),[3] perspective powerfully applied toward the scenic arts of the religious theater, and pointing to Piero della Francesca's *Flagellation* (Urbino, Galleria Nazionale delle Marche) and the dramatic spaces in future Venetian art.

Bellini's "stages" sometimes transcend the square by their monocular—or, for a grander image, Cyclopean—mastery of illusion.[4] Optics, the science that includes perspective, was long considered divinely inspired, and pertained to vision in the profoundest sense. Cézanne, in his famous letter to Emile Bernard, advises artists to "see in nature the cylinder, the sphere, and the cone, putting everything in proper perspective, so that each side of an object . . . is directed toward a central point." He continued: "Lines parallel to the horizon give breadth—that is, a section of nature, or, if you prefer, of the spectacle that the *Pater omnipotens aeterne Deus* spreads before our eyes. Lines perpendicular to his horizon give depth."[5]

1 Lanzi, III, 49.

2 Röthlisberger noted that Jacopo never completely assimilated Albertian principles, constructing much of his perspective, as in the *Flagellation* (Plate 195), along Trecento lines; he characterized the artist's spatial skills as "retardataire," keyed only to compositional schemes and never exercised in their own right (1958–59, 750).

3 Levenson, et al., 1973, 202–5. For the complex pavement motif, see also R. Wittkower and B. A. R. Carter, "The Perspective of Piero della Francesca's 'Flagellation,'" *Journal of the Warburg and Courtauld Institutes*, 16 (1953), 292–302. For perspectival treatment of the *Flagellation*, see also Gilbert, 1952, 202–16. Castagno's lost Florentine fresco (Vasari–Milanesi, II, 672–73) may have been a source.

4 See Collins, 1982, 300–304.

5 L. Nochlin, *Impressionism and Post-Impressionism, 1814–1904*, Englewood Cliffs, N.J.: 1966, 9–12.

6 Hirthe, 1980, 59. Painters there were the most sophisticated masters of illusionism in later 14th-century Europe.

7 Reproduced by Degenhart and Schmitt, 1980, Part II, 1, fig. 158, 90. They compare it to the Guariento.

8 G. Boehm, *Studien zur Perspektivität. Philosphie und Kunst in der frühen Neuzeit*, Heidelberg: 1969. Cited by Degenhart and Schmitt, 1984, 19.

9 For Gentile and illuminations in the Veneto, see Huter, 1974. For the Boucicaut Master in Italy, see M. Meiss, *French Painting in the Time of Jean de Berry, the Boucicaut Master*, New York: 1969, 71. For Michelino in Venice, see C. Eisler, *Michelino da Besozzo*, New York: 1981, 15, 18, 19.

10 Seen in Jacopo's *Saint John Preaching* (Pl. 282), where the archway with little narrative scenes could have a Rogerian origin. That Brussels master was in Italy in 1450, and his panels were especially popular in the Este court, which also patronized Jacopo.

11 Campbell, review of P. Schabacher, *Petrus Christus*, in *Burlington Magazine*, 117 (1975), 676.

12 A fine early framing in the Gothic style now encloses that altarpiece, clearly meant for a space less rationally planned than the painting's, which is close to the art of Masolino and Fra Angelico and long ascribed to the latter.

13 Archivio di Stato, Venice, Scuola Grande S.M.C., B. 56, fasc. iv, C. 2v, Dec. 6, 1439; Paoletti, 1894, fasc. 1, 6. See also Pesaro, 1978, 48. The panel is listed again in Jacopo's widow's will.

14 Röthlisberger, 1956, 85.

Just this fusion of practicality and divinity characterized renaissance perspective; illusion and its perception were both seen as the re-creating and experiencing of God's work and world. The central ray of sight, the key factor in medieval optics, was identified with the central line moving to the vanishing point of perspectival construction, now mathematically devised, and Bellini often chose to place there a diminutive figure of sacred significance (Plate 195).

Pictorial, architectural, and theatrical outlooks, all three converge in Jacopo's drawings to create the spatial tension that can only result from the almost magical interaction of the experience of faith and knowledge—perspective's most powerful performance. His effects of dramatic foreshortening, of oblique settings for emotional impact (Plates 200, 201, 203), and of sudden contrasts in scale stress the vulnerable humanity of Christ in ways seldom seen in earlier art.

The creation of illusionistic space was already a keen Venetian concern in the mid-1360s, when Guariento came from Padua to fresco the *Paradiso* with its effective architectural thronework (Doge's Palace, Sala del Maggior Consiglio). A recent study finds the source for almost all Jacopo's architectural and spatial settings in Paduan fourteenth-century painters,[6] then the most sophisticated masters of illusionism in Europe. An early fresco that suggests an independent ecclesiastical structure enframes, like a set, the sculptured wall tomb of Doge Michele Morosini of 1382 (Santi Giovanni e Paolo), anticipating Jacopo's many drawings (mostly in the London Book; Plates 160, 178) that "open up" a church by removing the façade. Morosini's tomb was surely not the only example of realistic painting, though Venetian artists of the preceding generation seem less concerned with complex illusionism. Preparatory renderings for buildings and elaborate metalwork projects could have had a similar didactic function,[7] spatial designs that may have led a scholar recently to see architectural space as underlying even Jacopo's approach to landscape: "Objects are placed in a predesigned space that is three dimensional and infinite, but . . . finds a natural conclusion in the horizon of the picture."[8]

The boxlike stages of Trecento interiors that were the artist's early lessons in spatial design were supplemented by the winding, tapestry-like passages in Gentile da Fabriano's International Gothic approach to narrative, and by the more expressive, active, Lombard style of Michelino da Besozzo, a slightly later visitor to Venice. The Boucicaut Master, that most gifted of Netherlandish spatial illuminators, along with the Limbourg brothers, seems also to have visited the Serenissima early in the century.[9] Gentile da Fabriano and possibly Jacopo too may have first studied in a local manuscript workshop with artists advanced in spatial illusion.

The great Northern masters who could have contributed directly to Jacopo's treatment of space, as we have seen, were Jan van Eyck, Roger van der Weyden,[10] and Petrus Christus. The latter is the likeliest source, probably coming to Venice from Bruges in the early 1450s to work for the Scuola della Carità, for which Jacopo painted a great banner in 1452.[11]

Intriguing, vacant side chambers and unpeopled vistas (unlike the usual busy, doll's-house views) often enrich Bellini's art with mystery and expectation. Such studiously empty, symbolic spaces are in Giotto's Arena Chapel *Annunciation* and in Gentile da Fabriano's *Presentation in the Temple* (Paris, Louvre), and young Bellini may even have worked on the latter, for he has similar empty spaces in his first major painting, the Brescia *Annunciation* Altar (Fig. 18).[12]

Jacobello del Fiore, prominent in early fifteenth-century Venetian art, made clear-cut, effective narrative settings, best seen in an Altar of Saint Peter (Denver Art Museum). Bellini's purchase at Jacobello's estate sale in 1439 may be the clue to a significant source for his training in space arts: he bought not a painting, but a "tavola intarsiada," a panel made of illusionistic wooden inlay. This pictorial skill, so popular in the renaissance,[13] consisted of combining thin pieces of wood, variously stained and shaped, to create an illusionistic design, from geometric patterns to elaborate pictorial effects. Often set into furniture or wall paneling, these inlays brought large sums.

The earliest *intarsia* works to survive in Venice are by Marco Cozzi, 120 inlaid panels for the choir stalls of the Frari, completed in 1468. Many of these are empty urban vistas, sharply defined and stagelike, that share the sense of compelling vacancy in Jacopo's unpeopled pages. The quality of quietness in *intarsia* made Röthlisberger relate it with the calm facing left pages of the London Book.[14]

First of the new Florentine painters to settle in Venice for an extended period was Paolo Uccello, invited in 1424 to supervise the mosaic designs for the San Marco façade. The relationship between Uccello's and Bellini's perspectival arts is not precisely known.

Close in age, each was connected with a leading master of the International Style: Uccello to Ghiberti's massive workshop, where other important painters (Masolino and later Gozzoli) were employed; Jacopo probably accompanied Gentile da Fabriano to Florence in the early 1420s, where so many important spatial developments were taking place. [15]

How sophisticated was Uccello as a master of perspective—his favorite field—when he came to Venice in his late twenties, in 1425? Such a specialty would have appealed to the commissioners of mosaic decorations for San Marco. The most significant link between Uccello and Bellini is in Uccello's underdrawing for a largely destroyed fresco of the *Nativity* (Florence, San Martino alla Scala), for it follows the bifocal system found in some of Bellini's pages. One scholar believes that in Uccello's fresco's design is an awareness of Jacopo's art, and suggests that the Florentine deepened his perspective skills in the Veneto. [16]

An Uccellesque *Nativity* in San Martino, Bologna (possibly dated 1436), and his fresco of *Sir John Hawkwood* of 1436 (Florence, Duomo) are evidence that his illusionistic powers were fully mature by then, and his style is close to the almost tactile illusionism of the *intarsia* workers'. [17] Donatello, seeing Uccello's obsessive graphic re-creation of multifaceted wooden turban rings (*mazzochi*), said to him, "Ah, Paolo, this perspective of yours leads you to abandon the certain for the uncertain; such things are useful only for *intarsie* where chips and oddments, both round and square, . . . are needed." [18] Yet leading artists, including Piero della Francesca and Brunelleschi, designed *intarsie*.

Workshops all over central and particularly northern Italy produced these "paintings in wood"; the Ferrarese court lavishly patronized the *intarsiatori*'s skill, possibly engaging Bellini in designing them. [19] Bellini's diverting "box-within-a-box" perspectives, such as his view of a courtly zoo (Plate 3), could readily be translated into wooden inlay. Many of the London Book's frontal, "head-on" views of urban courtyards (Plate 52) have the potential for conversion from art to craft, as do canals (Plate 53), little people providing incidental punctuation of the major scenario—space.

In supplementing his perspectival construction with more recent Paduan and Tuscan practices, Jacopo's key source was Masolino da Panicale, Masaccio's senior partner. Often active in northern Italy, Masolino also passed through Venice on his trips to and from Hungary. Commenting on Masolino's frescoes at Castiglione Olona, from the 1420s and '30s, White noted, "Such delicate delight in the space-creating possibilities of linear perspective and extreme foreshortening is not found again until the days of Jacopo Bellini. By then the springtime softness of the architectural forms of the first years of the Florentine renaissance has been lost." [20]

By the 1430s Bellini must have come to know Leon Battista Alberti. Endlessly curious about the "how" and "why" of all the arts and crafts, Alberti worked as sculptor, architect, and painter; his interests in cartography, astronomy, and optics contributed to his ability to codify the pictorial experiments in illusionism which had so impressed him in Florence in 1434. Several of Jacopo's perspectival studies approach Alberti's formula in *Della pittura* (*On Painting*), which he either read or learned about from the author himself in Venice or Ferrara. A drawing long ascribed to Pisanello in the Codex Vallardi is better given to Bellini (Fig. 68), and if by him, it is the closest he came to Alberti, made at a time when, according to Edgerton, the humanist had modified his initial formulation. [21] Lotz considered this "the earliest known drawing that shows an interior in perspective constructed precisely according to rule . . . [as] the work of a painter," not an architect, the latter not needing such illusionism. [22]

Röthlisberger may have said it best: "Bellini followed an elementary source according to Alberti's method." Degenhart and Schmitt explored Jacopo's knowledge of the "rationalization of sight" in Florence, achieved by the 1420s through Brunelleschi's use of the Euclidian "visual pyramid," and his subsequent following of Alberti's mid-1430s studies, and concluded: "Jacopo Bellini never achieved in his drawings the 'modern systematized space' of an Alberti, and even his late drawings remain part of a personal perspective." [23]

But another scholar's recent study has shown this perspective to be rigorous, noting the portrayal of even the Virgin's exaggeratedly large coffin (Plate 234) "as it would appear in perspective applied without compromise rather than if drawn freely from the real object or from the memory of it in the mind's eye." [24] The space box is basic to the London Book, used repeatedly.

Longhi found Bellini's perspective simplistic, and suggested that the artist had "purchased a magical little box with converging lines at a Paduan stationer's, designed for use by amateurs so that they could play the game of perspective with pieces and figures of wax and cottonwood, which are found throughout so many of his drawings. They resemble a

15 For Uccello in Venice, see Muraro, 1956, and J. Pope-Hennessy, *Paolo Uccello*, New York: 1950, 197–200.

16 Pope-Hennessy, 1950; Lipton, 1974, 60. Pope-Hennessy (1950, 154–55) observed that Uccello's composition of the S. Martino *Nativity* is more advanced than of the *Flood* (Florence, Sta. Maria Novella), perhaps in the 1450s rather than the '40s though before Baldovinetti's 1460–62 *Nativity* fresco (Florence, S. Annunziata). He noted Uccello's technique of space representation as specifically Florentine, but "the use to which he puts it is reminiscent of North Italy, and especially of the drawings of Jacopo Bellini, from which one of the small figures, of a man suspended from a gallows, in the left background of the fresco perhaps derives." Other scholars (A. Parronchi, *Paolo Uccello*, Bologna: 1974, 30) date Uccello's *Nativity* earlier, just before his *Sir John Hawkwood* of 1436; Chastel, 1980, 47, dates it c. 1440.

For Bellini and Uccello, see also Joost-Gaugier (1973), 286–88, who sees their relationship as the traditional dependence of a Venetian artist on a Florentine, stressing the possible importance of the *Flood*.

17 Eisler, 1982, 71 ff.

18 Vasari–Milanesi, II, 205–6.

19 A. Venturi, "I primordi del Rinascimento artistico in Ferrara," *Rivista Storica Italiana*, 1888, 620. A. Ghidiglia Quintavalle, "Baisio (Abaisi, da Baisio), Arduino da," also "Giovanni da" and "Tommasino da," *Dizionario Biografico degli Italiani*, V, 300–302.

20 J. White, *The Birth and Rebirth of Pictorial Space*, Boston: 1967, 146. Gilbert (1952, 208–9) sees parallels between the perspectival development of Piero della Francesca and Jacopo, both first exposed to earlier Tuscan skills and later developing their science in provincial centers.

21 Edgerton's reinterpretation (1966, 367–79) of Alberti's spatial construction is based on C. Grayson ("L. B. Alberti's 'Construzione legittima'," *Italian Studies*, XIX, 1964, 14–27; he concludes that the establishing of a distance point was an essential second step in Albertian spatial construction, to be located in advance on an area outside the picture plane and then transferred to the work in progress, where the first central point was already

*(continued on following page)*

medium's avocation of a beloved, misunderstood world."[25] His shrewd characterization, meant as a put-down, inadvertently stresses the most important source and function of Bellini's perspective, the theater.

Since antiquity, the stage had brought the art of illusion into focus, the theater's controlled view the essence of perspective. Bellini's "boxes" go back to the little peep shows that Brunelleschi and Alberti made to demonstrate the surprising degree of illusion produced by monocular vision through a small hole, yielding a strong view in perspective, or *prospettiva* in Italian, its closest meaning that of the staged perception. The ancient Greek word for perspective was *skenographia*, a term now applied by architectural historians to urban planning for rich pictorial effects; in Latin, perspective simply meant "to look through or view," while both the Greek and Latin roots of "theater" signify "a place to behold," or viewing room. Vitruvius' *On Architecture* is the first text on scenery of the ancient theater:[26] "There are three styles of scenery: one which is called tragic; a second, comic; the third, satyric. Now the subjects of these differ severely from one another. The tragic are designed with columns, pediments and statues and other royal surroundings; the comic have the appearance of private buildings and balconies and projections with windows made to imitate reality, after the fashion of ordinary buildings; the satyric settings are painted with trees, caves, mountains and other country features, designed to imitate landscape."[27] Many of Bellini's pages may follow the Vitruvian categories, well known in the early renaissance, and their theatrical application.

Dramas staged for church or state often required special effects, elaborately engineered to add new mystery to old. The Serenissima's leading Trecento painter, Paolo Veneziano, furnished settings annually for the "Annunciation," the major church play. For the same drama staged in early renaissance Florence, young Brunelleschi was commissioned for still more complex effects, calling upon his skills as sculptor, goldsmith, engineer, and builder, as well as painter.[28]

Brunelleschi's two little perspectival peep shows became well known. Like hand-held cameras or puppet theaters, one focused on the Florentine Baptistery, the other on houses nearby. First to witness his breakthrough in illusionism were the architect's closest associates, Donatello and Masaccio, but quickest to see the benefits of these optical gadgets were the *intarsiatori*, who noted how the space boxes "gave rise to many good and useful things produced in that art both then and afterward which brought fame and profit to Florence for many years."[29]

These clever "cameras" had theatrical applications as well. A young scholar recently suggested that the view of the Baptistery (long believed to have been a Temple of Mars) furnished the background for Vitruvian Tragedy, and the informally grouped houses nearby that for Comedy.[30] Jacopo's genre subjects, his rustic and urban views, often suggest the comic stage, several of his *all'antica* pages a tragical, theatrical purpose. If Bellini came to Florence with Gentile da Fabriano in the early 1420s he possibly saw Brunelleschi's experiments in perspective, or the great architect may have made early travels and studies in the Veneto.[31] Signs point to Gentile having taken over the Florentine's devices for his Strozzi Altar predella (Fig. 67), perhaps with Bellini's assistance.[32] These "cultural exchanges" may have contributed to Brunelleschi's spatial concepts and to the young Bellini's, many of whose major commissions came from Padua, called the "mother of perspective" in 1440.[33]

With its strong Aristotelian orientation, the university of Padua was Europe's great center for "natural philosophy" and medicine. Paolo Toscanelli, the Florentine mathematician, received his degree there in 1424, and returned home with knowledge that may have contributed to Brunelleschi's and Masaccio's illusionism; just then Uccello was bringing fresh perspectival skills to Venice. Space studies on the Arno and in the Veneto may have been reciprocal in those years of the two republics' alliance against the Visconti menace.[34]

Brunelleschi made several journeys to Ferrara, Mantua, and Rimini in North Italy, courts where Bellini too had strong associations. The artists might well have met on one of these occasions, if not before, or on a later, undocumented visit of Bellini to Florence.[35] Expressive space construction was enriched in North Italian art by the presence of Castagno and Donatello, the latter in Padua from 1443 to 1453; with his drawings, statuary, and reliefs the university city became Italy's leading art center.

Venice, built upon water, had special need of applied hydraulic skills. Possibly hydraulics also linked Venetian and the Florentine artists, since this area was often under their direction. Two clues—one internal, the other documentary—point to Bellini's knowledge: the first suggested by the elaborate and inventive fountains in his Books, the second from

established. The coordinates of this second distance point could then be used to determine the diminution rate of the transversals. He suggests that some of Bellini's pages employed this new Albertian second step.

For Paduan bifocal perspective in the Trecento, see Klein (1961, 211 ff.), who proposed that Fontana's perspective was indebted to Pelacani's, making Bellini too an indirect follower of that Trecento scholar's formulas.

22 W. Lotz, "The Rendering of the Interior in Architectural Drawings of the Renaissance," *Studies in Italian Renaissance Architecture*, Cambridge, Mass.: 1977, I, 1–65, esp. 5–6.

Manteuffel (1909, 163) was the first to remove the perspectival study from Pisanello to the school of Jacopo Bellini (Louvre no. 2520; Fig. 68). Fossi Todorow (1966, 97–98, cat. no. 99) found its approach typical of Jacopo, basing the Pisanellesque study on a Bellini drawing, probably of the early 1440s, when both artists were in Ferrara.

23 Degenhart and Schmitt, 1984, 15.

24 Collins, 1982, 302.

25 Longhi, 1946, 11.

26 For Vitruvian perspective, see E. Panofsky, "La prospettiva come 'forma simbolica'," eds. G. D. Neri and M. Dalai Emiliani, Milan: 1961, 47–54.

27 Vitruvius, *On Architecture*, ed. and trans. F. Granger, Cambridge, England: 1970, Bk. V, chap. VI, 289.

28 See A. Blumenthal, "Brunelleschi e il teatro del Rinascimento," *Bollettino del Centro Internazionale di Studi di Architettura Andrea Palladio*, XVI (1974), 93–104. See also C. Joost-Gaugier, "Jacopo Bellini and the Theatre of His Time," *Paragone*, 3, 1977, 70–80.

29 Vasari–Milanesi, II, 333.

30 S. Lang, "Brunelleschi's Panels," 63–72, in Dalai Emiliani, 1980.

31 See I. Hyman, "The Venetian Connection: Questions about Brunelleschi and the East," *Florence and Venice: Comparisons and Relations*, eds. H. Burns, H. Klotz, P. Sanpaolesi, I, Florence: 1979.

32 Gentile's centrally planned *Presentation in the Temple* has suggested his familiarity with Brunelleschi's device and even with his early architecture. See Christiansen, 1982, 36.

33 For perspective in Padua, see M. Dalai Emiliani, "Per la prospettiva 'padana': Foppa

*(continued on following page)*

the fact that one of his weirder admirers, Giovanni della Fontana, was an expert in hydraulics. Probably the son of a hydraulic engineer, Giovanni studied in Padua between 1418 and 1421, and worked as physician and engineer in Venice and Udine; he also traveled to Crete and befriended Eastern travelers and antiquaries.

That Venetian scientist may be the source behind many of Jacopo's more erudite and arcane drawings. He could well have provided the cryptography in a splendid manuscript, probably from Jacopo's studio in the early 1450s (*Passion of St. Maurice*, Bibliothèque de l'Arsenal, Ms. 940, f. 38v); Fontana's admiration for Bellini is also documented by his lost treatise, *De arte pictoria*, known only from the author's *précis* written in the 1450s. Probably Fontana had written his "little book" for Bellini in the 1430s, while active as a physician in Udine; in that decade Bellini in turn may have "dedicated" his son Giovanni to the scientist (if not to his half brother and painter, also Giovanni). Concerned with aerial perspective and the perception of color and space, its text is Leonardo-like: "If there are clouds between us and the sun, that thinner part of them through which the rays come down to us will seem brighter, being imbued with the light of the rays . . .";[36] after making optical observations and drawing his own conclusions, Fontana wrote, "From this experience with nature the art of painting has derived excellent rules, as I explained with definite rules in a little book dedicated to the outstanding Venetian painter Jacopo Bellini, showing in what ways . . . to apply bright and dark colors, with a system such that not only the parts of a single image painted on a surface should seem in relief, but also . . . they should be believed to be putting a hand or foot outward, or . . . seem miles away from the men and animals and mountains also placed on the same surface. Indeed the art of painting teaches that near things should be colored with bright colors, the far with dark, and the middle with mixed ones. . . ."[37]

Fontana studied optics under the great Blasio da Parma, and must have mastered mathematical perspective.[38] He refers to his lost treatise for Jacopo right after discussing geometric shapes defined by light, a perspectival exercise in a text on measurement dedicated to Domenico Bragadin, the Venetian public lecturer on mathematics who possibly helped Bellini with perspectival issues.

Klein saw Fontana as one—if not the only—"missing link" between Trecento bifocal perspective and Bellini's more modern methods.[39] Mariani Canova also noted the scientist's contributions to the painter's skills in constructing space.[40] Fontana's career is a Faustian blend of black magic and science, alchemy, torture, and murder intersecting in his studies of practical and theoretical resources of the "renaissance man."

The role of military engineer, often undertaken by renaissance artists, was also important to Fontana, employed as a cartographer and a designer of fortresses, ballistics, rockets, and explosives. Many of Jacopo's pages are given to martial matters and vistas that suggest related activities. Fontana was Doge Foscari's emissary to the Republic's *condottiere* Carmagnola a few years before 1432, when that warrior fell for treason; suspected of selling out to Milan, he was ordered beheaded by the Council of the Ten. Foscari probably also utilized Fontana's hydraulic expertise in designing hoists, dredges, and aqueducts for the canal system he was developing.

Bellini's fountains, far more elaborate than those in Fontana's crudely illustrated treatises, called for the same skills the scientist used for table fountains, automata, and other *divertissements* described in his texts—trick drinking vessels, water clocks, and water organs.[41]

While Alberti never uses the word "*prospettiva*" in *On Painting*, his guide to the pictorial construction of space, he was engaged with the concept of theatrical perspective as a playwright, astronomer, and student of optics.[42] Before he came to Florence from Rome in 1434, he too had been working on devising a *camera obscura* to study "the formation of visual images by light rays, making 'artificial images' which his friends thought so natural that they deemed them 'miracles'."[43] One subject "performed" in this box was not unlike the great naval battle painted by Gentile da Fabriano (probably with Jacopo's aid) in the Doge's Palace; others, planetarium-like, showed constellations, with stars and moon rising over mountains.

These theatrical views, dynamic *prospettive*, took over center stage in the Serenissima's high renaissance art with Sebastiano Serlio's guides to dramatic illusion. One treatise by this architect and stage designer, dedicated to Duke Ercole II of Ferrara, told how to establish the primary vanishing point for a set by making "a small box of cardboard and wood, carefully executed to scale." The arts of sculpture, painting, and architecture would converge in Tintoretto's canvases, based on little preparatory theaters peopled with small figures by some of the greatest sculptors.

revisitato," *Arte Lombarda*, 16 (1971), 117–36.

In addition to the great illusionists of the later 14th century, the historian must also have had in mind Bellini's friend Giovanni della Fontana and Fontana's teachers at the university of Padua, long interested in mathematics and optics. Squarcione's achievements were mannered and archaizing as late as the mid-1440s, barely cognizant of the new craft of space: see his altarpiece of 1445 (Sta. Maria in Castello, Artignano); also M. Boskovits, "Una ricerca su Francesco Squarcione," *Paragone*, 3 (1977), 40–70.

34 For Toscanelli and Brunelleschi, see Vasari–Milanesi.

35 Brunelleschi briefly visited Ferrara and Mantua in 1436, the year Bellini probably spent most of his time on the great *Crucifixion* fresco in Verona. Bellini may well have worked in Brescia decorating the palace chapel of the Rimini ruler's brother, also a *condottiere*.

Joost-Gaugier, 1973, 254 ff., considers at length but inconclusively the possible links between Bellini and Brunelleschi; believing that the painter could have known the architect's perspectival studies, she sees Bellini's perspective as "essentially independent from Brunelleschi's procedures" (259), and that the "practical aims of both men differ radically" (267), with "opposite aims" (268).

36 Number 13 in Clagett's catalogue (1959), 24. The first two mentions are in Fontana's *De trigono Balistario* (Clagett, n. 55), a treatise on mensuration; summarized with a dedication praising Bellini in *Liber dei omnibus rebus naturalibus* (Lib. II, c. 14, fol. 74, Venice: 1544), prepared in 1452, according to Birkenmajer (1932).

37 Trans. C. Gilbert, 1980, 174–75.

38 These lectures may have played an important role in Venetian art as well as science.

39 R. Klein, "Pomponius Gauricus on Perspective," *Art Bulletin*, 43 (1961), 213, 225.

40 Mariani Canova, 1972, 16.

41 For Venetian hydraulics, see S. Ciriacono, "Scrittori d'idraulica e politica delle acque," Arnaldi and Stocchi, 1980, II, 491–512. Architects involved in hydraulic engineering included Fra Gioconda da Verona and Michele da Sanmichele. See also F. Marzolo, *L'idraulica veneta e l'apporto dell'università di Padova nelle discipline idrauliche*, Padua: 1954, 96.

*(continued on following page)*

42 For the significant omission of the concept of "prospettiva," see Boskovits, 1962.

43 Gadol, 1969, 6.

44 Pächt, 1941, 90–92.

45 According to Degenhart and Schmitt (1984, 15–16), a logical system of vanishing lines characterizes Bellini's drawings from the outset. All orthogonal lines intersect at the vanishing point, which determines the horizon of the picture; figures are grouped to maintain the horizon line. Jacopo did not have a correct division of depth in his early work in the Paris Book (Pls. 158, 159), the checkerboard foreshortened by eye instead of by mathematics, and stopping where the vertical forms begin.

In 1440–50, he worked toward correct foreshortening and on the proper diminution of transverse lines; discovering Euclid's "visual pyramid," he did not make consistent use of it in the Albertian and Florentine sense—in the Louvre Book's *Death of the Virgin* (Pl. 230) the pyramid starts much farther back. See also Pächt, 1941, 90–92.

46 Fontana's lost treatise may also have been important for Fouquet. See Joost-Gaugier, *Zeitschrift*, 1975. For a recent study of the role of Italy in Fouquet's art, see S. Lombardi (*Jean Fouquet*, Florence: 1983, 51–105): in his final section, "Prospettiva e prospettive," he surveys the French master's different approaches to space—the "fishbone," the "oblique"—and compares them with White's "synthetic or empirical," favoring White's analysis, which is also closest to Bellini's perspective.

C. Schaefer (*Recherches sur l'iconologie et la stylistique de l'art de Jean Fouquet*, Lille: 1972, 374) notes correspondences between Jacopo's *Madonna* (Fig. 39) and Fouquet's in Antwerp. For further links between the two in the *Hours of Etienne Chevalier*, see 376–77. His summary (388) stresses Fouquet's residence in Venice and Padua, a more probable "sosta" and more influential than the supposed journey to Naples.

47 P. Barolsky, *Infinite Jest, Wit and Humor in the Italian Renaissance*, New York and London: 1978, 21.

48 See L. Brion-Guerry. *Jean Pélerin Viator: sa place dans l'histoire de la peinture*, Paris: 1962.

*(continued on following page)*

Bellini moved away from the decorative limitations of the International Style by "internalizing" the theater's illusionism. His stage perspective and mastery of massive architectural effects were equaled by his marshaling of "casts of thousands" through the principle of isocephaly (heads ranged along the same line), an achievement of the 1440s. In that decade a great young French artist, Jean Fouquet, came to Italy and adapted the Venetian master's spatial skills, applying them to powerful effect in the early 1450s. In Pächt's persuasive thesis, Fouquet took over the patterns of recession in Jacopo's *Death of the Virgin* (Plates 229, 230) for his masterly miniatures for the *Hours of Etienne Chevalier* (Chantilly, Musée Condé); Jacopo also supplied Fouquet with the perspective he used for crowded compositions, and for interiors stressed by figures aligning the walls to "form an inseparable unit."[44] Pächt recognized in Fouquet's space the strong theatrical essence in Jacopo's art: "When we look at the scene which is supposed to take place outdoors as if it were a *prospetto*, a theatrical setting, an opening in the *scena frons* . . . the setting looks like a triumphal arch with a tunnel-like passage in the center which plays the part of an interior. . . . It is only within this limited central archway that the third dimension can be felt."[45] Lombardi agreed that Fouquet drew more than superficial instruction from Bellini, and he emphasized the initial importance of Ferrara for the French artist, where Jacopo too was active.[46]

Andrea Mantegna may also have been learning from Jacopo's example in the later 1440s while still attached to Squarcione. The illusionistic, perspectival extremes that Jacopo devised become important in the Veneto, for representing comedy and tragedy, the former in Mantegna's humorous *camera picta* (Mantua, Palazzo Ducale), the latter in the cruelly foreshortened Christ in his *Pietà* (Milan, Brera).[47]

Clues to Jacopo's space building appear in the first printed book on perspective, Canon Jean Pélerin's *De artificiali perspectiva*, published in 1505.[48] This learned churchman was also active as an architect and the author-producer of mystery plays, interests close to Bellini's; as secretary to Fouquet's patrons, King Louis XI and his ambassador Philippe de Commines, he knew Fouquet's art, especially in manuscript illumination. Several of the analytic woodcuts in Pélerin's book come from Fouquet's manuscripts, others are from Dürer's most Venetian images, and some reflect the culture of the Serenissima, which Pélerin visited in the retinue of Philippe de Commines. He was also employed by Duke René II of Lorraine, grandson of King René d'Anjou who had inherited illuminations near to Bellini's art (Appendix F, Ills. 1, 2).[49] Pélerin's treatise was probably partly based on a lost Venetian perspectival text close to Bellini and Fontana.

Famed almost as much as a teacher as for his painting, Bellini may have used his Books in instructing his apprentices, a practice known from the contract of 1467 between Francesco Squarcione and an artist who wanted his son, Giovanni Francesco, to learn perspective in four months. Squarcione promised to teach the pupil "the reason of a plane well delineated according to my method, and to place figures on said plane, one here, one there, in different points of said plane, and to place furnishings—benches, houses, etc., and to understand the placement of these objects on said plane, and to understand the head of a man isometrically foreshortened, and to understand the reason of a nude body measured front and back, and to place eyes, nose, mouth, and ears in this man's head in their proper measured places and to give him to understand all of these things part by part . . . insofar as I have practice and foundation, and to hold before him always an exemplar, one after the other, of various figures with white lead highlights, and to correct for him said exemplars, and to tell him the errors insofar as it will be possible for me and Giovanni Francesco will be capable of learning."[50] In addition to two ducats for the boy's tuition, the father was to provide a goose or two hens for All Saints' Day; wine on St. Martin's Day; two pounds of bitter lemons or pork loin for Christmas; and a quarter of veal! Giovanni Francesco was also liable if he spoiled any of Francesco's drawings.

Jacopo has been faulted as a master of perspective because he turned his two sons' training over to a specialist in this area, Girolamo Malatini, though all three Bellinis are listed as excelling in that skill in Luca Pacioli's *Summa matematicae*.[51] Malatini's tutelage has led some scholars to believe that Jacopo's sons drew or redrew the Books' most perspectivally advanced pages in the 1470s and '80s, after Jacopo's death. While Gentile or Giovanni may have worked on or reworked certain pages, their "performance-oriented" character, as well as the pages' dated links to Fouquet, make such a late date unlikely. Because Jacopo's own art was limited to theatrical and allied crafts, he (like the painter-father of Squarcione's pupil) probably aspired to a loftier academic source for his sons' space education. As the century advanced, the stress increased on painters and sculptors to be masters of the liberal arts; Jacopo's sons abandoned his native, dramatic illusionism for a more mathematical, "State of the Liberal Arts" perspective.

# THE SCENE OF VICTORY

The Serenissima's constant celebration of self—her squares acting with sky and water as stage, lighting, and orchestra—has sounded as a civic tone poem almost since her foundation. This victorious theme, first stated in the long, low triumphal arching of the Doge's Chapel façade, was soon followed by the festive enclosure of its massive piazza.

Most capital cities, by choice of site and design, have been devised to stage their coronations, triumphal entries, festivities, and other ceremonies with maximum impact, but Venice outdid them all in the splendor of her setting. Islands small and large contributed a spectacle of floating marble courts and galleries for performers and processions. Decorated barges and great flights of stairs provided sites for sudden symbolic encounter and reception, grace notes in a massive overture to her sublime self-assurance. These calculated exposures made Venice, once her days of glory were gone, the favorite source for view paintings, *vedute*, those grand pictorial souvenirs perpetuated by Canaletto and Guardi to preserve the delights of the Grand Tour. This city as theater, established centuries before, inspired later guidebooks to be entitled *The Great Theater of Venetian Painting and Views* (1720), and *Theater of the Most Remarkable Buildings . . . of Venice* (1740). In Bellini's day a permanent statement of victory was made by Doge Foscari's building of the Porta della Carta, an arched entry to the Doge's Palace begun in 1438, and the first assuredly classical work, the Porta dell'Arsenale begun in 1460.

Other Quattrocento additions to the Doge's Palace, now largely lost, may have engaged Bellini's skills. Triumphal themes were also staged by the arts of scenic illusion and festivity—floats built, drops painted, and a medieval square transformed overnight into a magical setting for a Caesar's triumphs—metamorphoses created by the pageant master or *festaiuolo*, a post often filled by the leading painter. The pageant master coordinated sight and sound, word and image, city and stage, and his stage and record books preserve the sense of expectancy, of space on paper, waiting in the wings for his needs.[52]

Art influences theater and theater influences the visual arts, the reciprocity rich in resource and performance. The theater's "real imagination" must have been an enthralling dress rehearsal for the paintings' less technically limited fantasy, and vice versa. Fusions of faith and statecraft, of pageantry and propaganda in triumphal entries and like events were the best attended and most popular manifestations of art and craft. Totally accessible, this truly public theater was often on the move—whether on pageant wagons, on floats, or across broad stages.

Though only his surviving art certifies to Jacopo's role as *festaiuolo*, no further evidence is needed. The Books are abundant visual testimony to his abilities as pageant master, stage designer, and builder. Jacopo may have helped to stage the celebrations for the entries of the Byzantine and Holy Roman emperors into Venice and Ferrara in 1438 and 1452;[53] Giulio Romano produced for Charles V's entry into Mantua, in 1530, "beautiful arched sets, scenery (*prospettive*) for comedies, and many other things in which he had no peer, no one as able as he in devising masquerades and making remarkable costumes for jousts, feasts and tournaments. . . . For the city of Mantua he at various times designed temples, chapels, houses, gardens, façades, and was so fond of decorating them . . ."[54] The same festive tradition, doubtless the link between Jacopo's architecture and theater so evident in the Books, is basic to the later Venice seen in Jacopo Sansovino's oeuvre;[55] Serlio's *Second Book* (Paris, 1545) also merges welcoming ritual with antiquity.[56]

The term "chaxamento" (Venetian for "casamento" or housing) occurring in many entries of the later fifteenth-century Index added to Jacopo's Paris Book means architectural settings. Vasari uses the term for stage architecture, and to refer to Brunelleschi's special perspectival effects.[57] Jacopo's sons carried on his rich sense of theatrical spectacle that soon became a key feature of Venetian art, its heights scaled by Titian, Tintoretto, and Veronese, whose art Ridolfi praised as "maestoso teatro."[58]

Church, piazza, and cortile supplied the spaces where early renaissance theater was played. Leonardo's study for the *Adoration of the Magi* (Florence, Uffizi) is a *mise-en-scène*, stairs playing as important a role as in Donatello's dramatic reliefs earlier in the century; sketch and sculpture both return to the stage, where their artists first saw such effective uses of space.

Stairs, drawn from and for Venetian buildings, are often a critical contribution to the perpetual theater in Bellini's pages. Theirs is an architecture of anticipation, awaiting use

49 Discussed by Meiss, 1957; see especially *The Dialogue of Venice and Marcello* (Paris, Bibliothèque de l'Arsenal Ms. 940), and Strabo (Albi, Bibliothèque Rochegude Ms. 4), on a lost perspectival text close to Bellini and Fontana, and using sources such as Bragadin. Fouquet may have had access to such guides, in addition to consulting Jacopo's art.

50 Lipton, *Francesco Squarcione*, 1974, 383 f., doc. 87.

51 See Aglietti, *Elogio*, 1815.

52 At least two such books are known: one in the Soane Collection, London, studied by Licht (1973); the other, in the Edmond de Rothschild Collection in the Louvre, has been published, together with a Ferrarese design for a stage decoration (Florence, Casa Strozzi), by G. Pochat, "Architectural Drawing with Scenographic Motifs from Northern Italy, 1500–1510," in M. Dalai Emiliani, *La Prospettiva rinascimentale: codificazioni e trasgressioni*, Florence: 1980, 267–79. Pincus (1976, 202, n. 30) suggests that some of Jacopo's pages were used like "memory pieces," to guide the performance of stage players. Joost-Gaugier (1977, 75) noted that the theatrical flavor of Bellini's drawings suggests an interest in drama, and that possibly he first advocated complex architectural backgrounds, ideas which later became perspectival scenery. In her study of Jacopo's perspective (1975, 19) she observed that his architectural settings were "influenced by developing conceptions of contemporary Italian dramatic compositions."

53 J. Gill, *The Council of Florence*, Cambridge, Mass.: 1959, 99. Fra Carnevale, whose art is close to Jacopo's, painted Emperor Frederick III's portrait at this time. See M. Meiss, "Contributions to Two Elusive Masters," *Burlington Magazine*, 103 (1961), 57–66.

54 Vasari–Milanesi, V, 546.

55 See W. Lotz, "The Roman Legacy in Sansovino's Venetian Buildings," *Journal of the Society of Architectural Historians*, 22 (1963), 3 ff. In Serlio's *Second Book* (Paris, 1545) classical and festival forms are also interwoven.

56 E. Scoglio, *Il Teatro alla Corte Estense*, Lodi: 1965, doc. 13, 124, describing Ariosto's *Casaria*, performed in Ferrara in 1502. Also, Vasari's discussion of Plautus' *Penulo*: Vasari–Milanesi, IV, 595 ff.

*(continued on following page)*

57 See Vasari's directions to painters for correct preparation of perspectival vistas in introduction to the 1550 edition of his *Vite*, chap. 2 (repr. ed. C. Ricci, Rome: 1927).

58 *Le meraviglie dell'arte*, I, 315, quoted by D. Rosand, "Theater and Structure in the Art of Paolo Veronese," *Art Bulletin*, 55 (1973), 217–39, 224, n. 34.

59 P. Peruzza, *Architettura e Utopia nella Venezia del Cinquecento*, Milan: 1980 (L. Padoan Urban, "Gli Spettacoli Urbani e l'Utopia," 144 ff.). A. Chastel, *The Studios and Styles of the Renaissance in Italy: 1460–1500*, London: 1966, 8–25, includes, under "Festival and Utopia," Gentile Bellini, Mansueti, and the Master of the Barberini Legend (Fra Carnevale).

60 M. T. Muraro, 1964, 85–93.

61 Noted by Susan Taylor.

62 Lomazzo, *Trattato dell'arte . . .*, Milan: 1584, chap. 45.

63 Borgo, 1979, 550.

64 Pincus (14, n. 10) points to the ground-floor stable, prison, and fountains in the *Judgment of Solomon* (Pls. 153/154) as suggesting the Doge's Palace courtyard. She does not finally identify the drawing with the palace, but notes (37) that that part of the Doge's Palace was designated "the palace of justice" in 1422.

but sufficient unto itself as a statement of movement and transition. Flights of spatial imagination, these stairs are images of transcendence and connection alike, the most evocative passages of the builder's craft.

The fleeting world of pageantry links Bellini's pages to the marble palaces and shrines built later in fifteenth-century Venice. Some are stages for human comedy and tragedy, taking their cue from Tuscan art and architecture. Structured by perspective, these drawings ring to the picturesque, measure-by-measure harmonics of the vanishing point.

"Utopian," though a sixteenth-century concept, well describes much of Bellini's "building on paper." Long before Thomas More, Venice strove to anticipate that writer-martyr's balanced republican society of "Nowhere" on an imaginary island. The Doge's Palace, where Jacopo and his sons all worked, housed an exhibition in 1980 of "Architecture and Utopia in Sixteenth-century Venice,"[59] and though the catalogue does not mention them, it is in Jacopo's pages that the Serenissima is first seen as an ideal society in the classical sense. Their visionary re-creations of antiquity—of Rome or Jerusalem, of Venice recast in descriptions by Philo or Josephus—are also predictions of a White City, a New Jerusalem, Venezia Nuova ed Antica at the same time. The best of her Romanesque and Gothic monuments, wed to newly rediscovered antiquity, emerge on the grander scale of architecture as opera, Jacopo Bellini before Vincenzo Bellini. His colossal settings for the Lives of Christ and Mary and for the Judgments of Solomon (Plates 152, 153/154) and Daniel (Plates 155/156) are urban spectacles in the scenographic spirit of latter-day Venice.

Not until the 1470s, with the new influx of Lombard and Tuscan sculptors and builders, did the Republic make a major move toward classicism. Even then, a sense of the intervening past still lingers in Mauro Codussi's lyrical buildings, of the proximate Romanesque and Gothic, of Byzantium and Islam recollected.

Before the sixteenth-century boom in secular and religious theater, public performances are little documented in Venice, though they had a long tradition. Most information is negative: in 1462 theatrical performances were banned in the square before Santi Giovanni e Paolo, condemned for immorality, and all props and sets destroyed. Four years earlier, the Council of the Ten had canceled the lavish staging of festivals, possibly after the unrivaled display at the tournament in May.[60] Conservatism may have set in when the Peace of Lodi dampened Venetian territorial imperatives in 1454, a backlash from Doge Foscari's disastrous taste for military extravaganza.

The sense of particular place and character that Bellini's drawings convey lends itself to theatrical categories of Tragedy, Satire, and Comedy. A late page in the Paris Book (Plate 59), with its prominent stage and variety of figures—peasants, monks, beggars, and others—conforms to the urban, residential requirements of Comedy.[61] In other drawings a deliberate ambiguity may make for flexibility, for adaptation to painting, pageant, or drama. Some pages suggest application to specific scenarios: A Palace, A Court, The Rich Man's House, A City Square, A Rustic Dwelling, The Forest.

Whether Bellini's quieter pages were meant for translation into *intarsia*, painting, scenery, architecture, or "all of the above" is not known, yet they still share their silence with slumbering passages and courts just a step from the noisy Rialto and Piazza di San Marco. Like a stage without a cast, these too yield sudden *vedute* of space living for and by itself.

## BELLINI AS BUILDER

The Italian critic Lomazzo noted in his *Treatise on the Art of Painting* of 1584 how Mantegna, Fra Carnevale, Raphael, and Michelangelo all painted more imaginative buildings than were built by their contemporary architects.[62] On this list Bellini's name should join those of his son-in-law and his probable associate, Fra Carnevale. The painters Lomazzo cited were also active as architects—could this be true too for Bellini?

With little advanced building activity in Venice before the 1460s, Jacopo drew his knowledge of recent architectural developments from travel and various other sources: notebooks, nearby antiquities, the portable arts of manuscript, print, and drawing, and sculpture by Donatello, Michelozzo, and Filarete, all active in the Veneto. There were also the Serenissima's central monuments, pilgrims' accounts and guides, and possibly classical texts, Philo and Josephus.[63] He may have turned to works now lost, such as Petrarch's "Palazzo della Verità," with descriptions by the poet and early humanist of Septimius Severus' judgment halls and the palaces of Domitian, Nero, Chosroes, and others.[64]

Alberti wrote that architraves, bases, capitals, columns, and cornices were devised by the artist.[65] Ever since painters such as Giotto had undertaken to plan major civic projects, architecture had become one of a painter's strengths and resources. Strictly speaking, no individual was exclusively devoted to architectural design earlier in the renaissance.[66]

In Venice, where stone was imported, brick was the primary building material; construction was by *mureri*, brickworkers, and *taiapiere*, stonecutters, who were often sculptors as well.[67] Only with increasing use of stone as the century advanced did the "architetto scultore," such as Antonio Rizzo and Pietro Lombardo (neither a Venetian), become usual.[68] Jacopo might have worked as "architetto pittore" before the 1460s, following Giotto's precedent and then Masolino's, the Florentine artist so important for Jacopo.[69]

Most domestic architecture in the first half of the fifteenth century remains close to the Venetian Gothic style; apart from the Doge's Palace, few major public buildings were initiated.[70] "Urban renewal" meant replacing wooden bridges with stone, and expanding the canal system; possibly Bellini used his rare graphic skills to make presentations to building committees.[71] Such drawings are mentioned in all the contracts of Bartolomeo Bon, the only sculptor-builder whose career resembled Bellini's, beginning in an early Ghibertian manner and moving into a fuller renaissance style, though Bon's adaptations from the same antique sources were more timid.[72]

The two-towered façade in the Paris *Annunciation* (Plates 164/165) follows the old palace formula of the Fondaco dei Turchi, retraced in classical form in Bon's design for the Ca' del Duca. There is an early reference (1462) to a fully *all'antica* structure, built "tot a lantiga," for the choir of the Carità, site of four altars from the Bellini studio (Figs. 63–66).[73] Jacopo da Milano, brought in to create this complex building, refers to a rendering of it, "una poliza," prepared in advance.[74]

The Doge's Palace, repeatedly met on Jacopo's pages, underwent major expansion, planned under Doge Mocenigo in 1422 and begun two years later under Doge Foscari. The palace is so often the Books' spatial reference that Jacopo was possibly involved with its design (Plates 157, 285), the similarity of its courtyard to Bellini's drawings often observed. The Scala Foscari (built in that space before 1453), along with the Loggia Foscari and the Sala del Scrutinoio, could all represent his cooperation if not his exclusive design.

"Practically every fifteenth-century architectural elevation drawing that we possess is, in fact, a perspective of one kind or another . . .": this conclusion of a historian makes it clear that Bellini's gifts in perspectival rendering could have aided the construction of many a local building.[75]

The Books include portraits of *Venetia minore*, the city's more modest residential quarters and their parish churches.[76] Tunnel-like passages, the *sottoportici*, appear as the arched backgrounds in many scenes; everyday living quarters for the middle and working classes often document the settings of biblical events.

Bellini's architecture has been seen to stem from "the desire to endow his settings with representative splendor . . . [to] invent a mixed style of Venetian architecture. These architectural fantasies include motifs from real buildings, sometimes from earlier periods of Venetian architecture . . . not as objective, portraitlike images but as 'optical symbols,' detached from their real context."[77] Yet other architectural settings have a forthrightness that is far from fantasy, ready for application. Jacopo recorded building techniques in renderings so reliable that in the case of the covered wooden balcony, the *liago* in Plate 58, historians use it for reconstructions today.[78] He made close studies of the structure of brick wells (Plate 27) and of ancient building practices, including the metal masonry clamps of a small pool, clearly intended as a Roman bath (Plate 214).

In discussing Bellini's buildings on paper, the Tietzes note that these pages "are a fount of architectural ideas, reflecting in an eclectic manner the currents of the day and offering other artists an amount of architectural stimulus whose importance can scarcely be measured." They end with the question, "Jacopo is a witness of the new style, but is he its pioneer?"[79] Only one surviving work in Venice, the Porta dell'Arsenale, begun in 1460 and not yet completed by 1480, has a classicism as authoritative and imaginative as Jacopo's buildings have on paper, so the answer may be affirmative. But a study of Bellini's drawn buildings has convinced one architectural historian that they are random gatherings of motifs, not edifices that could have been erected.[80]

Alberti's influence on Bellini's architecture has been viewed as important, yet little by Jacopo mirrors Alberti's building.[81] Though Tuscan elements have been stressed in the Books' structural designs, there may be fewer than meet the eye. Architectural historians now recognize the debt of the Tuscan founders of renaissance architecture to the buildings of medieval Venice and Padua, and to those of early Christian Ravenna.[82]

65 W. S. Sheard, "The Birth of Monumental Classicizing Relief in Venice on the Facade of the Scuola di San Marco," *Interpretazioni Veneziane: Studi di storia dell'arte in onore di Michelangelo Muraro*, Venice: 1984, 149–74 (171, n. 27), and S. Wilk, in a forthcoming study of the Chapel of St. Anthony in the Santo at Padua (*Fonti e Studi* series), consider the relationship between perspectival studies connected with Bellini's, and the possible evolution of façade and chapel decorations from triumphal or other temporary decorations.

66 R. Lieberman, *Renaissance Architecture in Venice 1450–1550*, New York: 1982, 12.

67 A. M. Schulz, *Niccolò di Giovanni Fiorentino . . .*, 1978, 3, 7 f.

68 The term is used as early as 1441 by Giorgio Orsini (known as "da Sebenico") in signing the contract for the Sebenico cathedral, this architect's work often compared with Bellini's. See D. Frey, "Der Dom von Sebenico und sein Baumeister Giorgio Orsini," *Jahrbuch des kunsthistorischen Instituts der k. k. Zentral-Kommission*, VII, 13.

69 J. Manca, "Masolino architetto: una interpretazione della sagrestia vecchia di Brunelleschi a Castiglione Olona," *Bollettino d'Arte*, 18 (1983), 61–66.

70 McAndrew, 1983, 195.

71 Kretschmayr, 1928, 498.

72 See Praeger, 1971, 341–60. For Bon's contracts, see Paoletti, 1893, I, 37, 39, n. 1; also D. S. Chambers, *Painters and Patrons in the Italian Renaissance*, Columbia, S.C.: 1970, 66–69; and A. M. Schulz, 1978, 75–77.

73 Paoletti, 1893, II, 139–41.

74 Paoletti, 1893, II, 115.

75 H. Saalman, "Early Renaissance Theory and Practice in Antonio Filarete's *Trattato di Architettura*," *Art Bulletin*, 41 (1959), 89–106. The author notes that his conclusion is based on W. Lotz, "Das Raumbild in der italienischen Architekturzeichnung der Renaissance," *Mitteilungen des kunsthistorischen Instituts in Florenz*, 7 (1956), 193–226. For the Palladio designs, see N. Ivanoff, "Henri III à Venise," *Gazette des Beaux-Arts*, LXXX (1972), 313–30.

76 Hirthe (1980) points to these features throughout his study, referring to E. R. Trincanato, *Venezia minore*, Venice: 1948, for the major discussion of this material.

*(continued on following page)*

77 Degenhart and Schmitt, 1984, 20.

78 A. Zorzi, 1983, fig. 12. These balconies were also originally part of the view of a piazza (Pl. 58), the upper half of a vertical composition; the lower half (now lost) showed a man falling from a horse.

79 Tietze and Tietze-Conrat, 1944, 98–99.

80 McAndrew, 1980, 90. Palluc- chini (1956?), 149–77, 162, follows the Tietzes' views, but says that Bellini invented a renaissance Venice before it existed, that no building in the Books is recognizable. This is not correct; Goloubew as well as Degenhart and Schmitt have pointed out references to the Fondaco dei Turchi in the Paris Annunciation (Pls. 164/ 165).

   For Alberti and later Quat- trocento Venetian architec- ture, see P. Sanpaolesi, "Leon Battista Alberti ed il Veneto," Bollettino del Centro Interna- zionale di Studi di Architettura Andrea Palladio, 1964, 251–61.

81 J. Carpenter, "Architecture in the Bellini Drawing Books," unpublished graduate research paper, New York University– Institute of Fine Arts, 1979, notes that in fol. 85 of the Lon- don Book (Pl. 62) the upper part of the façade may follow Alberti's design, with triangu- lar walls screening the side- aisle roofs. The Tietzes see influence of S. Andrea, Man- tua, on a church façade (Lon- don Book, fol. 98) but the resemblance is slight.

82 I. Hyman, "The Venetian Connection: Questions about Brunelleschi and the East," Florence and Venice: Compari- sons and Relations, eds. H. Burns, H. Klotz, P. Sanpao- lesi, I, Florence: 1979. Hyman (204) dates Brunelleschi's journey to the Adriatic before 1418.

83 A. Parronchi, Studi su la dolce prospettiva, Milan: 1964, 445.

84 The Palazzo Brachi-Brunello in Vicenza and the stairs of the Palazzo della Ragione in Verona of 1446–50 are close to Jacopo's architecture. He had commissions in both centers.

85 Moffitt (1982) perceived Bel- lini's dome in Pl. 64 (London Book, fol. 74v) as onion- shaped and, on that dubious basis, saw it as a reference to the Dome of the Rock, inter- preting this page as indicating the Holy Sepulchre.

86 Carpenter, op. cit., 5, suggests that Bellini's Paris rendering (Pl. 161) may be following Alberti's proposed "portico in the ancient manner" for the façade of a centrally planned church.

Lavishly encrusted with classical relief and statuary, and Gothic and other ornament, many of Bellini's façades (Plates 89, 140, 202) resemble those in panels by the Florentine painter-architect Fra Carnevale, who may have spent time in Bellini's studio before going to Urbino, where his major pictures were installed—paintings that have also been ascribed to Alberti.[83] This attribution is unlikely, but the humanist may have adopted a rich, decora- tive manner to suit his patrons, who usually wanted an ornate yet thrifty manner rather than strict neo-classicism. Typical of elite taste in the period is that of the great condottiere Colleoni, Bellini's possible patron, who chose to rebuild his medieval residence at Thiene in a picturesque mix very like the buildings on Jacopo's pages, with Gothic, Byzantine, Tuscan, and classical elements making strangely harmonious bedfellows.[84]

Architectural space is the star of many of Jacopo's pages. In Christ among the Doctors (Plates 181/182, 183), Christ Brought before Pilate (Plate 194), and the many Flagellations (Plates 197–203) the minuscule figure of Christ is often at stage center, but at a focal point so remote that the housing first seems the hero.

Centrally planned structures, often chosen for churches or baptisteries, have sacred connotations arising from the circle, symbol of divinity and eternity. Bellini's round build- ings (Plates 63, 64, 92, 161) are centers of faith, pagan or Christian. The Dome of the Rock, as the largest building in Jerusalem, was long identified with the Holy Sepulchre.[85]

Repeatedly Bellini wrestles with the graphic problems of constructing such forms on paper. Buildings in the mosaics of the Mascoli Chapel (Figs. 53, 54) may reflect his thoughts or his sources. Six drawings of carefully planned "temples" are divided equally between the Books (London: Plates 63, 64, 161; Paris: Plates 92, 158, 179). Alberti advo- cated this central plan, the church to be elevated, free and clear from the everyday hurly- burly, and decorated simply with statuary and a colonnade—and so Bellini shows it (Plate 161), the dome still Byzantine, like those at San Marco or the Santo in Padua.[86]

The Venice long predicted in Bellini's images was finally coming into being in his last years, the painter probably assisting the sculptor-architect Antonio Rizzo in building a new city, partly from his drawings. Doge Foscari had willingly spent for canals and masonry bridges, but he sent most money to war. Now the world's largest shipyard, the Arsenale, was doubled in size and given a splendid new portal. In the great new church of San Giobbe, among the first to rise in a renaissance style, was buried Doge Cristoforo Moro, who died in the same year as Bellini. The century's third Venetian pope, Paul II (Barbo), was also a harbinger of new glory, his magnificent collections of antiquities and sense of splendor leading toward the high renaissance.

Jacopo is the first known Venetian master of classical architecture, for his buildings on paper prophesy those of a Codussi and Serlio and foretell the dramatic glories of a Palladio, a Longhena, a Piranesi. Nurtured by the spectacles held in San Marco and its piazza, sus- tained by the rituals and ancient pretensions of Venetian church and state in the bold Romanesque spaces of his city, the painter projected all he knew of classical enclosures into his most ambitious, imaginative castles in the Serenissima's sky.

The Utopian architecture on some of Bellini's pages is of the mind and heart, unre- stricted by budget or function. His graphic tableaux are dramatically boxed in camere lucide rather than camere obscure, paper theaters for the sacred and profane. Illuminated by the new Florence and the old Rome, his art presents the once and future Venice, sublime visions of the ultimate Serenissima.

# APPENDICES

# APPENDIX A
## A CODICOLOGICAL ANALYSIS AND RECONSTRUCTION OF JACOPO BELLINI'S DRAWING BOOKS*

### BY ALBERT J. ELEN

## CONTENTS

*Ho trovato a Venezia un codice che merita star vicino al Marcanova. Esso è la serie dei disegni di Jacopo Bellini. . . . E insomma un tesoro. L'Abbate Morelli lo vorrebbe per la Biblioteca di S. Marco. Io ne ho scongiurato il possessore. Il prezio non è esorbitante, e certamente è minore del valore reale del libro che è tutto in carta di bambace. Un inglese voleva pagarlo 80 zecchini; è quantunque il possessore ne dimandi 100 pure sono persuaso che si ridurebbe agli 80 o poco più. Mi dispiacerebbe che questo codice passasse in altre mani.*

PADOVA, 14 APRILE 1801[1]
(F. Caldani, to T. degli Obizzi)

## INTRODUCTION

The most widely known of all Italian drawing books that survive more or less intact today, or can be reconstructed from scattered fragments, are unquestionably the two of Jacopo Bellini.[2] They contain an exceptional number of drawings by a single Italian artist and have been preserved in their original setting, executed on the 192 folios of two separate codices. From the time the two Books were made and filled with drawings, each codex has remained an autonomous, structural entity. Some folios were detached from the drawing Books in the intervening centuries and a few became lost, yet these changes are insignificant when we realize that most medieval and renaissance drawing books—and there must have been many—have not survived at all.[3] Jacopo Bellini's two Books are a unique collection not only for their large number of drawings, but also because so few master drawings from Venice are preserved from the 15th century. Jacopo's drawings have critical importance for the study of early renaissance art in the Veneto, and for evaluating his place in the development of art in northern Italy from the Middle Ages to the early renaissance.[4] Many of his other works are lost to us, including the major paintings that brought him fame in his own time. For these reasons a number of studies on the drawing Books has been published since they were discovered in the last century and purchased, separately, by the British Museum in 1855 and the Louvre in 1884.[5]

The literature on the drawing Books discusses many aspects of the subject: provenance, authenticity, function, iconography, and perspective. Yet little scholarly research has been directed toward the physical condition of the two Books themselves. An accurate analysis of these material and structural aspects is an essential part of the study of such drawing books, for, in contrast to the stylistic approach, it produces concrete data that can, for the most part, be objectively determined. The codicological data give us insight into the present arrangement of the folios in each of the Books and enable us to reconstruct its original appearance. This in turn may illuminate the complications of the drawings' authenticity, chronology, and function.

In view of their different materials and structural characteristics, the study of each Book requires a different codicological approach. For similar reasons, drawing techniques and the authenticity of each volume will also be considered separately. In the Conclusion the Books will be briefly discussed together, especially with regard to their function.

Appendix A,
Ill. 1. British Museum
Book. Folio 1, with
inscription

455

## I. THE BRITISH MUSEUM BOOK
### PRESENT CONDITION

In their present state of preservation, one clear distinction may be made between the two Books. The parchment Book in the Louvre for the most part still exists in its original form, its quire construction easily recognizable (see page 465). The paper Book in London, by contrast, was dismantled after the British Museum acquired it in the last century and the folios, detached from their original binding, were mounted separately onto the paper sheets of a larger book specially made for this purpose. Taken apart for reasons of preservation like other drawing books in the museum, Bellini's volume has lost its original form and appearance,[6] and we might now call it an album. Nevertheless, we will continue to use the term drawing book, as there are clear indications that the pages, now separated, were originally gathered in quires before the drawings were made.[7]

The 19th-century volume presently containing the detached drawings is considerably larger than the original drawing Book. This is clearly noticeable when the book is closed: the center portions of the leather covers of the original binding (measuring c. 360 by 275 mm.) have been inlaid into the centers of the covers of the present leather binding, which measures c. 515 by 410 mm. (Ill. 6).[8]

On the present endpapers are mounted four smaller sheets of 18th-century Italian decorated paper, printed with a woodblock pattern of red, yellow, and violet flowers. Their measurements are approximately those of the drawings, and doubtless they were endpapers added to the drawing Book at an earlier rebinding.[9] When the Book was taken apart the two decorated endpapers were cut at the inner joints and pasted onto the center of the present endpapers.

The loose folios of the former drawing book have been mounted one by one onto 99 large sheets of laid paper (Van Gelder make), the centers cut out to make the sheets into *passepartouts* with each folio mounted to show both the recto and the verso. The verso is not visible quite in its entirety, because some 2 mm. of its margins are pasted around the opening in the *passe-partout* sheet. The folios are not touched when the sheet is turned, perhaps the only positive aspect of this method for preserving a drawing book. Goloubew properly observed:

*. . . Cette façon de traiter les dessins répond à toutes les exigences et peut-être donnée en exemple, mais il aurait mieux valu que l'on s'en abstînt dans le présent cas, car le Livre d'Esquisses ayant été transformé en une Collection d'Esquisses, son apparence première, si caractéristique pour l'époque et l'artiste, est maintenant perdue à jamais.*[10]

At some time during the dismantling of the drawing book and the reassembling of its detached folios, mistakes were made before the loose folios were mounted onto the pages of the present volume. An irregularity in the foliation suggests that folios 62 and 64 were exchanged, and mounted in reverse order: the present succession of folios 61–65 is now 61, 64, 63, 62, 65; folio 61 has moreover been inserted backward, making its recto, which carries the folio number, now face the recto of folio 64. These mistakes probably arose from the rectos of folios 61 through 65 being filled with a pattern of 20 plain double circles (5 by 4), whereas the versos contain Bellini's actual drawings.[11]

All the folios are of the same ivory-white paper;[12] the facsimile editions of Goloubew and Ricci do not give a correct impression of this,[13] and in general the reproductions are unreliable, useful only for iconographical research.

Nearly every folio side (190 out of 198) is filled with a drawing in leadpoint. Some of these have been partly drawn over with pen and ink[14] of an orange-brown color that corresponds exactly with the ink used for the foliation[15] and for the inscription on folio 1r (Ill.1). Seven folios are prepared on one side with a ground, probably of bone dust or chalk suspended in a liquid and applied in vertical strokes with a black-haired brush.[16] Apparently, the artist had his reasons, for five of the seven grounded sides, the rectos of folios 61 through 65, bear the pattern of plain circles that he intended to fill with portraits or motifs after antique Roman coins and medals[17] in a drawing medium, probably silverpoint or goldpoint, that required this grounding. It is not yet clear why he grounded folios 1r and 99v, the first and last folio sides.

Apart from brown discolorations and stains at the edges, the folios have resisted the wear and tear of time reasonably well. Little holes in the first five and last seventeen folios (1–5, 83–99), probably caused by woodworm from the wooden boards of the former binding, have been carefully restored with pulp.[18]

## CODICOLOGICA:
### PAPER SIZES, QUIRES, WATERMARKS, AND GUARDS; RECONSTRUCTION OF THE BRITISH MUSEUM BOOK

The British Museum made no conservation records that would give us insight into the composition of the quires before they were taken apart in the 19th century. We do not even know the year of this operation.[19]

The so-called double-drawings are a clear indication that these folios were in their present order before the dismantling, and likewise the uninterrupted 15th-century foliation. But the original structure of the drawing Book can only be determined by reconstructing the original quire composition and by the homogeneity of the sheets of paper it incorporates. The reconstruction given here is made possible by the intrinsic characteristics of the handmade paper.

The word *codex*, used here with a structural connotation, means a book composed of *quires* of parchment or paper. Each quire consists of a number of double sheets called *bifolios*, often four of these, although most quires in 15th-century Italy are *quinios*, containing, as the Latin term indicates, five bifolios.[20]

A quire may be constructed in several ways, depending on the dimensions of the basic sheets of paper and the format of the codex.[21] Jacopo's volume is remarkably large in comparison to contemporary codices,[22] especially drawing books: it measures 415 by 336 mm.[23] This means that the dimensions of the basic sheets (including the narrow slip about 9 mm. wide along the fold that was cut away and discarded in the dismantling[24]) were about 415 by 681 mm., approximately the standard size of the Bolognese *Reale* (445 by 615 mm.).[25] After the sheets were folded once, a certain number of these bifolios were joined together into a quire, or possibly all of the basic sheets required were stacked and subsequently folded at one time.[26]

The dismantling being unrecorded, it is difficult to determine the number of quires originally in the Book, or the correspondence of one folio with another as halves of the same bifolio. Knowing that the *quinio* was the current type of quire, we may assume that the Book consisted of ten quires, each containing five bifolios. Chart 1 shows the ten reconstructed quires as assembled in the Book and viewed from the bottom.

In establishing the original quires, I will first discuss the "gridiron" wirework of the paper-mould, which lends its intrinsic imprint to handmade paper. This imprint consists of the laid lines and chain lines of the mould, and the watermark attached to it.[27]

When a basic sheet of laid paper is held against the light with a long side up, the vertical chain lines are seen and the horizontal, closely spaced laid lines (Ill. 2); the watermark is usually in or near the center of one half of the sheet when it is folded along the vertical axis; one half will contain the watermark and the other will not,[28] but the direction of chain lines and laid lines does not change with this folding. In Jacopo Bellini's Book, forty-nine of the folios have a watermark while fifty do not; since ninety-nine folios have been preserved, an odd number of sheets was either added to, or removed from, the originally even number in the codex. This interference, moreover, took place before the folios were numbered.[29]

The folios are all of the same make of paper, the single watermark practically identical in all cases. The paper sheets processed into this codex were made at the same paper mill and, what is more, at the same time. The watermark represents a pair of scales in a circle; Goloubew's drawing of it[30] and our tracing are reproduced in Ills. 3, 4. His drawing is not accurate or full-size, and neither the adjoining chain lines nor the density of the laid lines is indicated—all data needed to compare this watermark with corresponding types in standard reference works such as those by Briquet and Piccard.[31] Compared with watermarks of the same type, ours is relatively large, carefully constructed, and symmetrical,[32] and apparently it hardly shifted while the sheets were produced,[33] a clear indication that they were made at one time.[34]

The reconstruction chart of the London Book (Chart 1) indicates the folios that contain the watermark, and whether it is upright or upside-down. No clear system in this can be discerned. During the paper manufacture, the dried sheets were stacked arbitrarily, and the watermark may occur in the center of the left half or of the right half, and upright or upside-down. Chart 1 shows the folios with and without the watermark alternating irregularly, like the sequence of upright or upside-down watermarks.

With this information the quires of the original codex can, in principle, be reconstructed,

Appendix A,
Ill. 2. British Museum Book. Schematic Diagram of Papermould Imprint for Basic Sheet (bifolio 3–6, Quire A).

Verticals: chain lines.

Horizontals: laid lines (full density at right).

Watermark in left half, on added chain line. Center fold line, with edges of present loose folios on either side

Appendix A,
Ill. 3. British Museum Book. Watermark as reproduced by Goloubew, I, 1912

Appendix A,
Ill. 4. British Museum Book. Balance in a Circle, tracing of Watermark (folio 3)

although irregularities may occur from the removal or addition of folios. First the former center bifolio of each quire must be located. Along its fold the thread was once visible that bound its bifolios together, and center folds can be identified by the so-called guards that were applied to it—here these guards were probably narrow strips of parchment about 415 mm. long by 15 to 25 mm. wide. Two guards were customarily attached to each quire, one along the inner fold of the center bifolio and the other outside, along the back fold of the entire quire. The thread that sewed the paper bifolios into a quire was stitched through these two parchment strips as well, the guards preventing the thread from pulling through the paper sheets and endangering the structure.

The actual guards are all lost, probably removed and discarded at the time of the dismantling, but they left traces nonetheless, where they were once attached in the center of nineteen *openings* or facing pages: 4–5, 9–10, 14–15, 19–20, 23–24, 28–29, 33–34, 38–39, 43–44, 48–49, 53–54, 58–59, 63–64, 68–69, 73–74, 78–79, 83–84, 88–89, and 94–95. A system becomes clear in these successive combinations. Each of the openings shows a narrow, orange-brown stripe a few millimeters wide along either side of the fold, where the folios were cut apart in the dismantling.[35] The colored stripe, best seen on the inner margin of the rectos of these openings, probably came from the glue used to attach the guards in the center fold, as well as to the back of the quire, before its bifolios were sewn together.

In some cases the colored stripe seems to interrupt a drawing that must originally have been drawn over the guard that is now gone, an indication that the guards were there when the drawings were made.[36] We must assume that each quire was sewn together before it was drawn upon, but not that the quires were necessarily bound into a codex when Jacopo was making his drawings.

Of the pairs of folios listed above, the first and last (4–5 and 94–95), as well as 14–15, 23–24, 33–34, 43–44, 53–54, 63–64, 73–74, and 83–84, were once center bifolios of the original quires. One folio of each pair contains the watermark and the corresponding folio does not; the same applies to eight of the other nine pairs (in the ninth, folios 28–29 both have a watermark), though these were not bifolios but, on the contrary, the last and first folio of adjacent quires.

The original quires can now be reconstructed. The entire codex appears to have been regularly composed of ten quires, each with five bifolios (*quinios*) except for the last quire, which contained six (a *senio*). Yet, there are three irregularities. From the first and last quires (folios 0 and 100) the first and the last folio respectively seem to be missing; doubtless these were flyleaves or pastedowns,[37] lost when the book received its leather binding or in some other rebinding, or most probably when the book was dismantled.

A folio also appears to be missing from the third quire, once situated between folios 20 and 21. This folio, which we designate 20A, corresponded with folio 27 and contained the watermark. It was removed from the quire with care, not torn out along the fold (and loosening folio 27) but cut to leave a narrow strip that, to judge from the discolorations, was glued to the left margin of folio 21r and kept folio 27 firmly in place. Folio 20A was removed early, before or during the time of drawing in the codex, for its absence interrupts neither the foliation nor the double-drawing on opening 20–21.

This material evidence leads us to conclude that the original codex consisted of 51 basic sheets, each folded once; if two folios became endpapers, 100 folios were left to be filled with drawings. The three folios now missing very probably had no drawings on them, one being already gone when the drawings were made, or before, and the other two becoming flyleaves or pastedowns at front and back.

The double-drawings are indications that the quires existed before the drawings were made, but they are not proof that these quires were bound together. The large size of the sheets and frequent use of ruler and compass in the architectural scenes make it likely that the artist, for practical reasons, was drawing in separate quires[38] that had doubtless been received as an unbound codex. That some drawings apparently continued over the guards suggests that

those quires had been sewn individually. It must be kept in mind that the codex existed before the drawings were made, but its constituent quires had most likely not yet been bound together.

## DRAWING TECHNIQUE AND AUTHENTICITY

Leadpoint, the drawing medium used by Jacopo in the British Museum Book, is easily confused with silverpoint, another metalpoint medium. Silverpoint requires a preparatory grounding of the support; leadpoint does not.[39] Except for the few grounded sides, the British Museum Book does not contain specially coated pages,[40] but the silverpoint drawings in the Louvre Book, by contrast, were made on pages specially prepared for this medium.[41] The sharp silver point produces a thin and delicate line; the line made by the softer lead point, easily flattened by the pressure of use, can increase in tonal value, exactly as we see it in Jacopo's drawings.

The disadvantage of both metalpoint mediums is their lack of durability. Leadpoint, if it is exposed to the light for long, will fade. This has happened to many drawings in the British Museum Book, some practically disappearing.[42] The drawings of figures, mostly on the rectos, have remained fairly visible, but many of the architectural and landscape backgrounds have faded, though not equally. The artist paid special attention to representing people and horses, modeling them strongly and now and then increasing the tonal value of the line or making changes in the poses or other details. This drawing technique, with its numerous retouches and corrections, can be seen in the head of the horse on folio 6r; in Saint George's raised arm with the sword on folio 7r; in the monumental fountain on folio 68r; and in the position of the horse's legs and head on folio 51r; the head was first drawn about a centimeter lower and the left leg a centimeter higher. This dynamic and strenuous use of the leadpoint stylus has made some areas fade less than others, not so intensively drawn.

Many scholars have found the drawings in the British Museum Book to be partly retouched or redrawn by later hands to make them visible again. Goloubew even distinguishes two hands, from the 16th and 18th centuries, respectively.[43] My own examination of the original drawings in the British Museum Book convinces me that the supposedly later "overdrawings" and "retouches" are part of Jacopo's personal han-

Appendix A,

Ill. 5. British Museum
Book. Reconstruction
Diagram of 15th-century
front cover, indicating
original size and place-
ment of bosses

THE BLIND-TOOLED LEATHER BINDING[45]

Of the binding of the London Book, only the decorated center portions of the leather side panels survive. The paper—considering the unusually large, carefully calculated number of folios and the high quality, practically identical watermarks, and sizable format of the basic sheets—was probably made to special order for use as a drawing book. Certainly a leather binding was not furnished ready-made; on the contrary, the codex was probably delivered in loose quires, or as a book-block with a temporary binding. For practical reasons, the first is the more likely possibility. The artist would have found it much easier to execute his architectural drawings, those intricate perspective constructions requiring ruler and compass, in a quire that he could flatten out, rather than in a fully bound codex. If, however, the quires were already sewn together in a book-block, this might have had a cover of limp parchment.

dling of the leadpoint stylus. Probably the poor quality of Goloubew's and Ricci's "facsimiles" misled certain authors into detecting retouches and overdrawings by later artists;[44] in these reproductions the heavily drawn parts come out far too dark, almost black, whereas the tone of these leadpoint drawings is an overall gray.

A small number of the autonomous leadpoint drawings were partly reworked in brown ink with pen or brush (folios 2v, 27v, 28v, 46r, 82r, 85v, 86r, 88r, 95r, and 99r in pen; folios 3r and 56r in brush). These overdrawings occur in arbitrary places as if they were incidental experiments; the brown ink is the same color as that used for the folio numbers and the inscription on the first folio side. Perhaps all these inked additions in pen or brush were made by the same person in the 15th century, either as preliminaries toward completely reworking all the drawings or, at the least, as investigations of that possibility.

During the years that Jacopo was drawing in the codex—whether fully sewn or not and with or without a provisional cover—it must have been kept in some sort of portfolio.[46]

Only when the drawing project was completed were the quires of the codex probably sewn together permanently and covered with a binding. This first binding, however, had no relation to the Book's handsome decorative binding when the British Museum purchased it in 1855. Out of respect for the drawings and their artist, it had been decided at some time to replace the first binding—or provisional vellum covers, perhaps—with the more precious leather binding that we still see a portion of today (Ill. 5). Judging from its blind-tooled decoration, it appears to have been made in North or Central Italy at the end of the 15th or early in the 16th century,[47] and if so, it was presumably commissioned either by Gentile Bellini, who owned the Book from 1471 until his death in 1506, or by Giovanni Bellini (d. 1516), who inherited it from his elder brother.

This binding probably survived intact until the Book was dismantled. The museum inlaid parts of its decorated covers into the covers of their new binding and discarded the rest, the wooden cover-boards and leather spine (Ill. 6).

The decoration of the rather poorly preserved parts of the front and back sides has usually been described as "Moorish,"[48] though in my opinion none of the blind-tooled ornaments can be classified as *mauresque*. Both sides have a pattern of five inscribed rectangles diminishing in size toward the center, the three outer borders and the center rectangle being ornamented.[49]

The front and back sides of the former binding were probably adorned with metal bosses or appliqués at the center and the four corners. Although the two parts retained are no longer full size, a circle-shaped impression in the center and traces of quarter circles at the outer corners indicate that bosses were once attached there. To adorn each side of a leather binding with five metal bosses was then a common practice.

# Chart 1

## The British Museum Book: Reconstruction of the Quire Composition before Dismantling

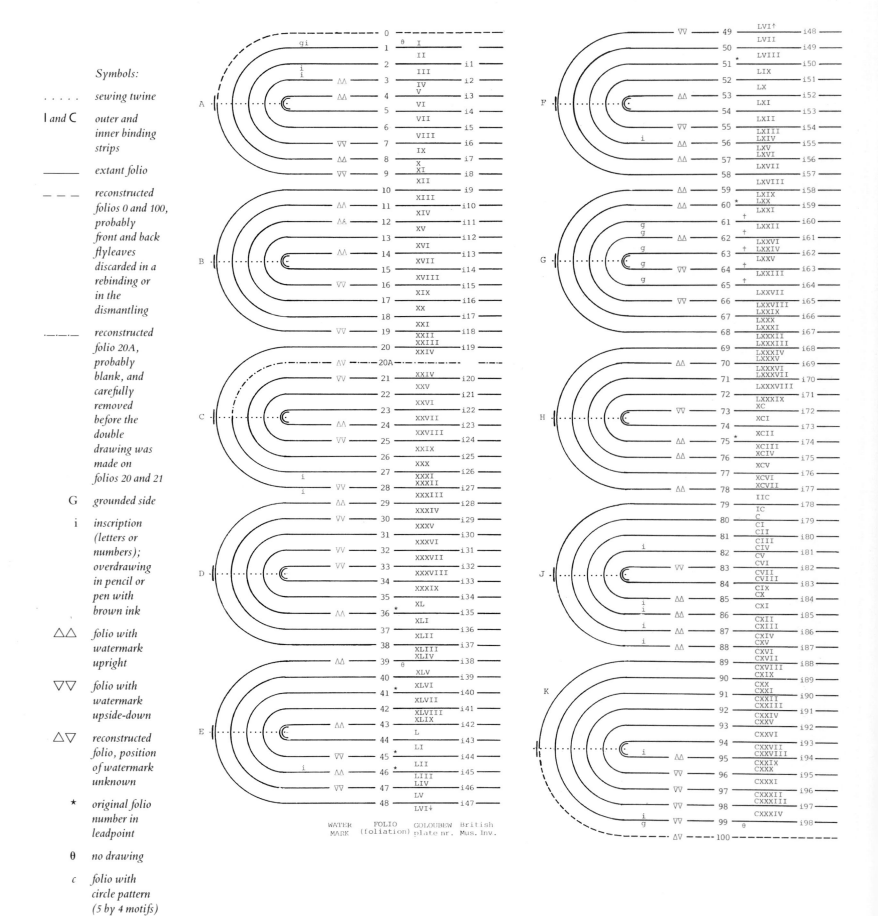

*Symbols:*

. . . . .     *sewing twine*

**I** *and* **C**     *outer and inner binding strips*

————     *extant folio*

— — —     *reconstructed folios 0 and 100, probably front and back flyleaves discarded in a rebinding or in the dismantling*

—·—·—     *reconstructed folio 20A, probably blank, and carefully removed before the double drawing was made on folios 20 and 21*

G     *grounded side*

i     *inscription (letters or numbers); overdrawing in pencil or pen with brown ink*

△△     *folio with watermark upright*

▽▽     *folio with watermark upside-down*

△▽     *reconstructed folio, position of watermark unknown*

★     *original folio number in leadpoint*

θ     *no drawing*

c     *folio with circle pattern (5 by 4 motifs)*

WATER MARK     FOLIO (foliation)     GOLOUBEW plate nr.     British Mus. Inv.

462

# CHART 2

## THE LOUVRE BOOK: QUIRE COMPOSITION

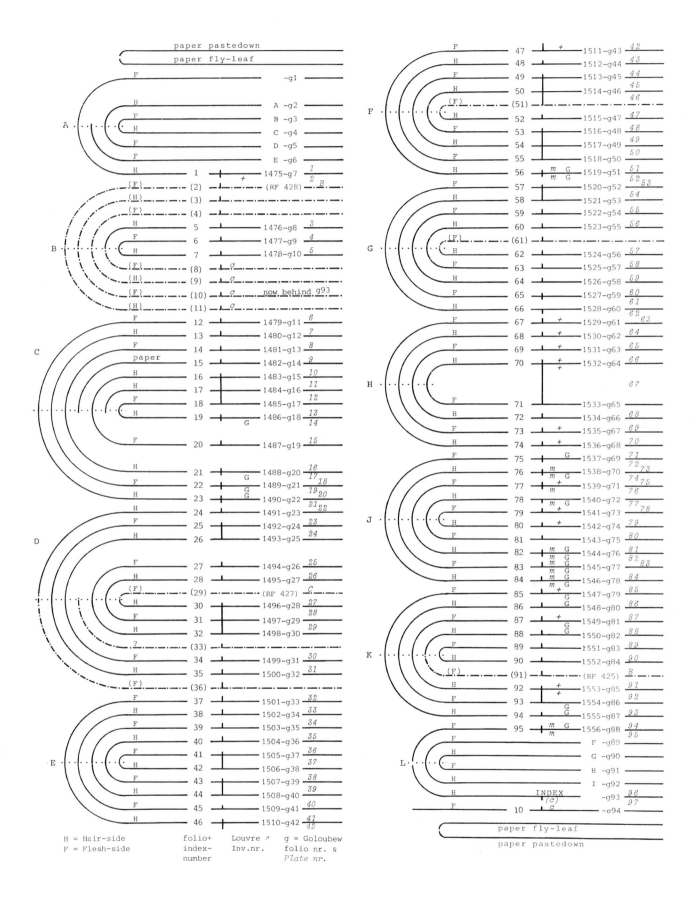

H = Hair-side    folio+    Louvre    g = Goloubew
F = Flesh-side    index-    Inv.nr.    folio nr. &
            number            *Plate nr.*

## THE LOUVRE BOOK: COMPARATIVE TABLE OF QUIRE FORMULAS
## BY ELEN (1984), RÖTHLISBERGER (1958/59), AND DE RICCI (1923)

| A. J. ELEN, 1984 | M. RÖTHLISBERGER, 1958/59 | S. DE RICCI, 1923 |
|---|---|---|
| *Quires* | *Quires* | *Quires* |
| $A^2$ ($+$ g2, g3, g4, g5, g6) | $A^6$ ($+$ g6) | $A^6$ ($+$ g6) |
| $B^{10}$ ($-2$, 3, 4, 8, 9, 10, 11) | $B^{10}$ ($-2$, 3, 4, 8, 9, 10, 11) | $B^{10}$ |
| $C^{10}$ ($+15$, 17) | $C^{10}$ ($+15$, 17, 24) | $C^{10}$ ($+15$, 17, 24) |
| $D^{10}$ ($+24/36$, 33; $-29$, 33, 36) | $D^{10}$ ($+33$, 36; $-29$, 33, 36) | $D^{10}$ ($+33$, 36) |
| $E^{10}$ | $E^{10}$ | $E^{10}$ |
| $F^{10}$ ($-51$) | $F^{10}$ ($-51$) | $F^{10}$ |
| $G^{10}$ ($-61$) | $G^{10}$ ($-61$) | $G^{10}$ |
| $H^{10}$ | $H^8$ | $H^{10}$ |
| $J^{10}$ | $I^{10}$ | $I^{10}$ |
| $K^{10}$ ($-91$) | $K^{10}$ ($-91$) | $K^{10}$ |
| $L^{10}$ ($-$ g2, g3, g4, g5) | $L^6$ (2 bifol., 3 loose fol.) | $L^6$ |
| *Folio numbers refer to Chart 2* *(in most cases, the Index numbers)* | *Transposed from Röthlisberger's Construction Table* | *Transposed from De Ricci's formula (removed folios not specified)* |

Note:
$+$, added folios;
$-$, removed folios

## II. THE LOUVRE BOOK

In the preceding section the material and structural differences between the London and Paris Books were mentioned. While the London Book was taken apart and the loose sheets mounted separately in a large 19th-century volume, the Paris Book remains a structural unit, the folios still composed in quires and protected by a leather binding. A reconstruction of the original Louvre codex would seem to be less complicated than of the London Book. But the Louvre Book presents other problems, since it appears to have undergone several alterations. A number of sheets were extracted from the Book, others were added; also deliberate changes were made in the quire composition during a later rebinding. In the London Book, by contrast, only one folio, probably blank, was missing when the museum acquired it in 1855.

The codicological analysis of the Louvre Book will produce evidence that the structural differences between the volumes concern mainly their present state of preservation; originally their structures were nearly identical.

### PARCHMENT OR PAPER, A MATTER OF CHOICE

Aside from the London Book's having been taken apart, the essential codicological distinc-

tions between Jacopo Bellini's two Books lie in the materials, paper and parchment, of which they are made. Paper consists of vegetable fibers; parchment is the product of skins of animals, usually calves, sheep, or goats.[50] For centuries parchment had been the writing and drawing surface *par excellence*, whereas paper was not made in Italy until the late 13th century.[51]

Many factors could affect a choice between parchment and paper. Parchment was certainly more costly, but paper was not cheap, merely the less expensive of the two. Paper prices gradually lowered toward the end of the 15th century, as it was used increasingly and produced in greater quantity.[52] The price of parchment depended on fluctuations in the livestock market, and could rise to considerable heights; furthermore, the labor required to process the skins was expensive, especially when parchment of fine quality was desired. Yet parchment was often preferred over paper for its durability:[53] tradition demanded its use for model books and manuscripts, especially those that were illuminated, and for important contracts and charters of all kinds.

When the function of the model book was gradually taken over by the sketchbook during the 15th century, durability became a less important factor. An artist's informal, experi-

mental drawings were intended primarily for his own use and for his studio, and there was less reason to use parchment, the more expensive material. For formal drawings and small drawing books, however, artists sometimes kept to the traditional support.

But an artist might also prefer parchment for its texture, a matter of great importance to him; as Meder says, "the nature of the surface on which the artist draws determines the character of the result no less than does the medium he uses."[54] Its ivory white to yellow-brown color, its smooth or velvety surface, and its high absorbency made parchment preeminently suitable for miniatures and delicately finished drawings in metalpoint or pen and ink.

Jacopo Bellini's remarkable choice of these different materials for his two Books probably came from considerations of economy, durability, and surface. Perhaps he had slightly different uses in mind for each volume, or wanted to explore the advantages of each surface.

### THE MAKING OF THE PARCHMENT CODEX; "GREGORY'S RULE"

The bulk of parchment production was not for drawings but for manuscript texts, most of these taking the definite shape of a codex; the artist's drawing book and the manuscript codex, however, are structurally much alike.

Parchment makers would have furnished the necessary amount of material in loose sheets or in quires. The quires were customarily assembled and bound together only after the scribe had finished lettering the manuscript text.[55] The artist, by contrast, did not have to follow the scribe's procedure of transcribing a continuous text into consecutive quires, but could fill a ready-made drawing book with his ever growing repertory of models and patterns in any order, to be used in his paintings or, from the 15th century onward, as a notebook for his artistic ideas. It was convenient to carry around such a book, now and then making sketches, studies, or finished drawings in it, and the small format of most drawing books was well adapted to this use. But this practical consideration did not apply to Jacopo, since both his Books were so large and probably had not been bound when their quires were being filled with drawings. The material of Jacopo Bellini's Paris Book is understandably less homogeneous than that of the London Book because the parchment leaves came from many animal skins, whereas the paper leaves were all made at the same mill, at the same time, and probably in the same pair of moulds, of vegetable fibers from the same vat.

From an average calfskin could be produced a rectangular sheet of parchment measuring about 600 by 800 mm. Goatskin parchment, however, measured only about 400 by 600 mm., the animal being relatively smaller.[56]

Because the folios of the Louvre Book are large, 427 by 290 mm., the basic sheets of the quires could be folded only once, this fact confirmed by the hair-mark along the animal's spine that can be seen in many folios, running across the center horizontally.[57] Thus, five basic sheets of parchment from five animal skins were needed to make one *quinio*. Assuming that the Louvre Book originally consisted of 102 folios, no fewer than 51 animal skins went into manufacturing the codex, which gives an idea of the costs involved.

Today the Louvre Book has 93 parchment folios, many so thin and translucent that the pen lines show through on the other side. The color of the parchment varies from ivory white to yellow-brown, the traces of the hair follicles making some folios look grayish. On the whole, the parchment is well preserved, of fine quality and without conspicuous natural wrinkles or holes. Some folios in the first quire and the last three quires have suffered moisture damage;[58] some of the edges have become hard and brittle from being turned so many times during the last five centuries.

Its animal origin gives to each side of a parchment sheet distinct surface characteristics, known as the hair-side and the flesh-side. The hair-side is the exterior of the membrane, the flesh-side the interior. These differ in their color and surface texture, the hair-side tending to be relatively dark and uneven, with traces of the hair follicles, the flesh-side generally more light and smooth.[59] In parchment of fine quality, however, it can be difficult to tell them apart. Each species of animal—goat, calf, or sheep—has its characteristic marking or "grain pattern"[60] that marks the hair-side and also identifies the animal source. From my comparison of the folios of the Louvre codex with representative parchment samples, the majority of the folios appear to be goatskins,[61] not a surprising conclusion, for scribes around the Mediterranean had used this material for centuries, sheep and goats being readily available.[62]

The distinction between hair-side and flesh-side gives us insight into the manner of constructing the parchment quires. As a rule, the two facing sides of an opening presented the same surface that corresponded in color and texture, both being hair-sides or flesh-sides. When the parchment maker stacked the finished sheets to construct a quire, he laid the first sheet flesh-side down, the second flesh-side up, and so on: hair-side against hair-side (H–H), flesh-side against flesh-side (F–F). When the appropriate number of sheets (in Italy, usually five) had been stacked, they were folded together. Thus a quire begins and consequently ends with a flesh-side, the openings between being alternately two hair-sides and two flesh-sides. Only the center opening (H–H in a *quinio*) is one full side of a folded basic sheet, a bifolio. This rule in quire construction, first described in 1885 by the American-German theologian Caspar René Gregory, is known as "Gregory's Rule."[63] According to Gregory, the unit of construction for the quire was the double-leaf, that is, the bifolio.[64]

As a quire made up in late medieval Italy usually began with a flesh-side, the opening at the meeting of two quires sewn together was of facing flesh-sides. The alternation of hair-side and flesh-side openings proceeded uninterrupted throughout the codex.[65]

With this basic knowledge of codex construction, it is important to note that the removal, shifting, or addition of a folio or bifolio within a quire will automatically affect this regular composition as it brings an opening of a hair-side opposite to a flesh-side.[66] Irregularities of this kind are indications that changes have probably been made in a quire's original structure.[67] Alterations may also be detected in interruptions of the early foliation or, in the present case, when half of a double-page composition is missing.

## ANALYSIS OF THE QUIRE STRUCTURE

Structural analysis of the Louvre Book requires a description of the present condition of the quires and a search for irregularities such as those described above, toward gaining insight into the original structure of the codex and subsequent alterations. With its large number of folios (93 + 1), the material and structural data may best be presented as in Chart 2. Again the quires are shown as though viewing the bottom edge of the closed book.

These material and structural data were compiled during my visits to the Cabinet des Dessins over three years;[68] I last inspected the Book in autumn 1983, some months after it had been restored and rebound at the Bibliothèque Nationale. My references to its former condition will suggest the scope of this restoration; to my knowledge, there is no detailed record of this.[69]

When I first examined the Book in 1981 the binding had come unstuck, some of the quires were loose, and also some of the threads that bound the bifolios together within each quire.[70] Thanks to this circumstance I could inspect the composition of each quire without great difficulty, and the following year I checked these data. In the rebinding of 1983 the quires were sewn tightly together, and now it is next to impossible to examine their internal composition beyond determining the center of each quire where the thread is visible; further analysis may be hampered by changes that the original structure underwent in the past.

At present the Book consists of eleven unequally composed quires, the whole covered by a leather binding over wooden boards. During the 1983 restoration the outermost parchment folios (1 and e94) were detached from the endpapers, to which they had been glued at some previous time,[71] making visible two blank folio sides that had long been hidden.

In turning the 94 folios of the codex today, certain features are immediately striking. The foliation is interrupted in several places, and 13 folios appear to have been removed.[72] Prior to the foliation, moreover, one *paper* folio was inserted in quire C. In the last three quires a number of folios show moisture damage, some of these prepared on one or both sides with a colored ground. The drawings on three other folios are upside-down. In the first and last quires the folios are mostly blank, whereas all the intervening quires are filled with drawings.

The recto sides of the folios were numbered consecutively, in customary fashion. Certain folios that had no drawings on either side were deliberately omitted. The pagination numbers correspond to an Index at the end of the Book (on folio g93r), which numbers and describes all recto drawings,[73] but the groups of blank pages at the beginning and end, which serve as flyleaves, are neither described nor numbered in the Index. The Index proves that the thirteen missing folio numbers were not left out of the foliation by mistake but indeed existed as folios, and thus were removed at a later time.[74] Structural evidence for this will also be demonstrated in the following pages.

Only three of the eleven extant quires (E, H, and J) have a regular composition according to Gregory's Rule. As these quires show no signs of change in their original structure, there is

little doubt that they are intact, but for the surprising fact that quire H contains one less bifolio than quires E and J, both *quinios*.

The adjacent quires F, G, and K are similarly structured, yet a single folio was removed from each of these *quinios*, interrupting their regular composition. The three remaining halves of these disrupted bifolios (51–52, 61–62, and 88–91) were refastened in their proper places. The removal of folio 51 destroyed the composition at opening 50–51, leaving the upper architectural half of the former double-drawing on folio 50v to face an independent equestrian drawing on folio 52r.[75]

Thus, five of the six quires (E, F, G, J, and K) are now, or were once, regularly composed *quinios*; the sixth (quire H) is a *quaternio*. On the basis of these structural data and the knowledge that the *quinio* was the quire most frequently used in renaissance Italy, it can be assumed that the remaining quires were also of that type, an assumption to be tested by a structural analysis of quires B, C, D, and, lastly, A and L.

Today quire B cannot properly be called a quire, since it has been dismantled and folios 2, 3, 4, 8, 9, 10, and 11 are missing. Only the center bifolio 6–7 and the preceding single folio 5 remain, now fastened to quire A. Undoubtedly, quire B was once a *quinio* of bifolios 2–11, 3–10, 4–9, 5–8, and 6–7; the first three bifolios were removed and are now lost except for folios 2 and 10, which are preserved elsewhere.[76] In all probability quire B originally followed Gregory's Rule[77] (Chart 2, reconstructing the quire composition, may clarify this point).

From quire C no folios or bifolios seem to be missing; rather, two single folios were added to the regularly constructed *quinio*. Folio 15 is the most remarkable, being the only paper sheet in the otherwise parchment codex.[78] Folio 17 was also incorporated into quire C after it was put together, but before the folios were numbered. The insertion of these single sheets interrupts the regular alternation of hair-side and flesh-side openings, yet both the recto and verso of folio 17 are halves of two double-page compositions, at openings 16–17 and 17–18, so it was certainly in place before these drawings were made. No such evidence accounts for paper folio 15; this was probably added to quire C after the Book was completed (though before the pagination), because its theme, *St. George and the Dragon*, matches that on folio 16.[79]

Quire D is the most complex structure of all. At present it consists of four bifolios and two single sheets (folios 24 and 30). This quire was originally a *quinio* made up of bifolios 25–35, 26–34, 27–32, 28–31, and 29–30, to be radically transformed by several structural changes. The *quinio*, gathered according to Gregory's Rule, presumably began and ended with flesh-side folios like the adjacent quires C and E. The original flesh-side openings 23v–25r and 35v–37r were disrupted when quire D received an entire bifolio (24–36) outside, though opening 35v–37r reappeared after folio 36 was detached and removed. Folio 24 remained behind as a single sheet glued to folio 25.

Bifolio 24–36 could have been added to quire D either before or after the drawings were made, though prior to the pages' foliation. The second possibility is put forward by Röthlisberger,[80] that single folio 24 (he does not mention that it once probably corresponded with folio 36, as I believe) was inserted afterward, because it interrupts the double-page composition on opening 23–25. I am not convinced that the two landscape drawings on folios 23v and 25r are halves of the same composition. The mountainous backgrounds look similar and seem to fit one another except for discrepancies in certain landscape elements: the mountains on folio 23v are closer to the spectator than those on folio 25r, which recede sharply upward into the background, and the curving paths and stream on folio 25r remain conscientiously within the picture area. Indeed, both compositions appear self-contained rather than continuous. The ink also differs in color on the two sides, being somewhat lighter on folio 23v. Finally, the iconographic combination of *St. Jerome in the Desert* on folio 23v with *The Baptism of Christ* on folio 25r is altogether unusual. I am inclined to accept the first possibility,[81] that the addition of bifolio 24–36 precedes these drawings. No reason for adding it to quire D has been suggested, but I believe it was shifted to this quire from within the Book, probably from quire H, as will be further discussed below.

Another sheet that was added to quire D before the foliation and later removed is the missing folio 33. While it was present, this single folio disrupted the flesh-side opening 32–34; its removal caused only an interruption in the foliation. But at some time after the pages were foliated, the left half of the center bifolio 29–30

(folio 29) was also removed, disrupting the flesh-side opening 28–29 and the hair-side opening 29–30, and making the new opening, 28–30, one of dissimilar parchment sides.

Quire H appears to be a regularly composed *quaternio* with no structural changes apart from having one less bifolio than the other quires (excluding A and L). As quire D has an additional bifolio (24–36) that disrupts its regular composition, one might suspect that it was transferred from *quinio* H to *quinio* D, reducing the former to a *quaternio* and making the latter a *senio*, or six-bifolio quire.[82]

The outermost quires A and L have fewer folios than the others and these are mainly blank, in contrast to the adjoining quires B and K, both filled with drawings. Quire A is a *ternio* (three bifolios) with an additional single folio E.[83] In the absence of drawings, the first six folios of quire A were passed over in the foliation, and so were the last five of quire L, except for the Index written on its final folio. Like quire A, quire L is a *ternio*, keeping in mind that folios 95 and g93, now separated,[84] were probably one bifolio. Quires A and L both contain a folio with drawings on it, as well. Apparently, the Book's first drawing was on the last recto of quire A, for the foliation begins on that page with folio 1; it ends with folio 95, the first folio of quire L. Neither quire is constructed according to Gregory's Rule, though both begin with a flesh-side. These observations lead me to believe that the present composition of quires A and L is not the original one, and that quire A did not exist at first, whereas quire L was a *quinio*. In a dismantling at some time after the Book was completed and bound, bifolios A–D and B–C were removed from the last quire L, which had remained largely untouched, and inserted into bifolio g1–g6, then a single bifolio at the beginning of the codex. Textural similarities that bifolios A–D and B–C share with bifolios F–I and G–H suggest that these bifolios originally belonged together within the same quire.

All four of these bifolios at present bear conspicuous stains from moisture damage; the stains in the two bifolios in quire L, however, are at the bottom of the book, along the fold, whereas they are at the top of the two bifolios in quire A. The opposite location of the stains may be plausibly explained: after dismantling the last quire and removing bifolios A–D and B–C for quire A, bifolios F–I and G–H were rebound upside-down by mistake. Judging from the

stains on folios 95 and g93, which remained in place, the moisture affected the top of the book in the last quire; the damage probably occurred when the volume was stored lying flat.[85] In rebinding bifolios F–I and G–H upside-down, their positions shifted: folio F took the place of folio I, G that of H.

A striking result of shuffling these damaged bifolios, hitherto unnoticed, can be seen at the lower left-hand corner of folio F recto (i.e., folio g89r): amid the stains are visible traces of an inscription. Though undecipherable, these traces are an offprint of the first lines of the Index onto the upper left-hand corner of folio g93r. When the ink of the manuscript became damp, apparently it printed in reverse on the upper right-hand corner of the facing folio side (Ill. 7).[86] This offprint, when rebound upside-down, was shifted to the beginning of the quire.

It is now hardly possible to assess the actual construction of the last quire before it was separated. The above evidence establishes that bifolios g88–g93 and g89–g92 (i.e., bifolio F–I) originally were, and still are, the two outer bifolios of quire L, yet we cannot deduce the order of bifolios A–D, B–C, and G–H, all three being blank. Quire L was evidently not regularly composed, because bifolios g88–g93 and g89–g92 do not face each other with hair-sides. Knowledge of the exact order of the blank folios in the last quire is, however, less essential than for us to know they were there.[87]

From this codicological analysis comes the reconstruction of a drawing book that, in all probability, consisted originally of ten regularly composed *quinios* with one bifolio added at the beginning, a total of 102 folios (see Chart 2). The extra bifolio allowed the two outermost folios to serve as flyleaves while the remaining 100 folios were reserved for drawings. The structural resemblance is clear between the Louvre Book and the paper Book in the British Museum, with its originally almost identical quire composition of 102 folios; the extra bifolio was inserted into the last quire, however, making it a *senio*.

Only Seymour de Ricci (in 1923) and Röthlisberger (in 1958–59) concerned themselves with both the original and the present states of the quire composition of the Paris Book,[88] and neither probed the structural aspects of the subject. They presented their hypotheses in, respectively, a quire formula and a small table; their very

similar opinions mainly differ from mine in their considering the end-quires A and L to be original *ternios*, and folio 24 to be a loose folio added to quire D. De Ricci, to judge from his quire formula, and I agree that quire H was originally a *quinio*, like all the other quires except A and L. To compare our views I have translated their (re-)constructions and mine into three quire formulas of a uniform type (see Chart 2a).[89]

Later changes made in the original structure of the codex are discussed on pages 472–73, to find a solution to the problems of when, where, and for what reasons certain folios were shifted, added, or removed.

### THE OLDER MODEL BOOK

Fourteen folio sides in the second half of the Paris Book contain drawings that are markedly different from the rest.[90] Two of these represent lions in various poses (folios 77v, 78v; Plates 6, 7); the other twelve are textile patterns, eleven later covered with a ground so that new drawings could be made on them.[91] These earlier drawings were generally ascribed to Bellini until Degenhart and Schmitt proved that they came from a late 14th-century model book.[92]

The model-book folios bring a foreign element into the present Book. Because at least half of these were incorporated upside-down, it is evident that the artist was not interested in them, but only in using their costly parchment surfaces for his own drawings.[93] Recycling discarded parchment as palimpsests had long been practiced in medieval scriptoria, older lettering being painstakingly erased to reuse the parchment sheets.[94] Jacopo's method was simpler, covering the older drawings with a coating of bone dust or chalk mixed with water, using a large brush and various pigments. He did not treat them all at once, but covered an older drawing when he wanted its surface;[95] encountering such a page in a quire, he applied the grounding and made his new drawing on it after it had dried. In the case of the model drawing on folio 77r, he pasted a rectangle of parchment over it.[96] But twice he left the model drawings just as they were. In my view, he did not cover the study of lions on folio 77v because he liked it; he made similar drawings himself in both his Books. The textile pattern on folio 95v probably remained uncovered because at that point he had stopped making drawings, and left the rest of the last quire unused.

Eight of these model-book folios belong to six bifolios in quires F, J, and L; quire J contains four of the bifolios, a majority of the grounded pages (nine), and ten sides with model drawings. Of the twenty-four folio sides available to him, only fourteen contain model drawings, the other ten being blank. I am persuaded that the model book from which the six bifolios came was itself not completely filled. Very possibly at least five of these bifolios originally belonged together as a *quinio*, or all six to a *senio*. One might reconstruct a quire having model drawings on both sides of its first seven folios except for the first side, while the last three or four folios were not drawn on.[97] Possibly Jacopo found an old parchment model book, discarded or forgotten, that was hardly or not fully drawn on, and decided to make use of the precious material.[98] But why did he not draw on the blank folios first, and gather the folios with model drawings into the last quire? Probably because he was using them for silverpoint drawings that required special grounding in any case, and was not concerned with what was beneath these coatings.[99]

## LEADPOINT TECHNIQUE AND AUTHENTICITY

Apart from those in silverpoint, all the drawings in the Paris Book were, in my view, originally made by Jacopo Bellini in leadpoint and later drawn over with pen and ink by himself and assistants, notably his sons. I differ from Röthlisberger in seeing traces of leadpoint in certain compositions that were probably overlooked when the underdrawings were rubbed out after the penwork was finished.[100] Moreover, some leadpoint drawings were only partly drawn over, and a few were left undisturbed;[101] these are not preliminary sketches, in my opinion, but finished drawings.

In the partly reworked composition of *Christ and Four Saints* on folio 73r (Plate 241), stylistic discrepancies distinguish the original leadpoint drawings on the left from the elaborate penwork on the right; clearly this reworking, unfinished and almost tentative, was done by a later hand. In addition to such an obvious overdrawing, other compositions in pen and ink look finished at first glance, but contain minor omissions in the penwork. Röthlisberger's argument that these omissions are intentional, that Jacopo wanted to make further studies of these parts, seems improbable to me.[102] Possibly

the artist ignored such details while making the overdrawings because he was short of time, or left them out, meaning them to be finished later, perhaps by a specialist in the workshop.

Unmistakable signs that the overdrawing project was never completed are the presence of several untouched or partially overdrawn leadpoint drawings, the details omitted in some pen drawings, and the concentration of almost all of these in the end-quires of the Paris Book. So vast a work required much diligence, and would have taken too long for one person to accomplish. Initially a one-man undertaking, the work may have become a concerted effort in his shop, thus accounting for the striking stylistic differences among certain groups of pen drawings.[103]

It is difficult to say whether the artist wished from the outset to have the leadpoint drawings redrawn with pen and ink, for the leadpoint drawings that are still completely or partially visible might well have been conceived that way, with no intention to rework them later. Yet, in view of his choice of materials and the use he must have had in mind, he probably meant the leadpoint drawings to be finished in pen and ink, as the most durable medium available. The silverpoint drawings, being executed on grounded pages, would tolerate light for a longer time, and were not drawn over.

Perhaps Jacopo (or his sons) thought of reworking the leadpoint drawings in the London Book too, but directed all efforts to the overdrawing of the Louvre Book because it had to be completed first. The partial overdrawings in pen and ink in the London Book may have been preliminary trials, with plans for reworking the whole Book being considered only later.

## THE LEATHER BINDING[104]

Contrary to what is generally assumed, the Louvre Book's present leather binding (Ill. 8) is not its original one, and has nothing to do with its contents.[105] The leather cover and wooden boards were made for some substantially larger, seemingly contemporary codex, from which they were detached and fitted to the Book. The previous binding must have required replacement and been discarded, either for serious damage, probably from moisture, or for the natural decay of the leather.

To adapt this alien binding to the format of the Paris Book, it had to be considerably

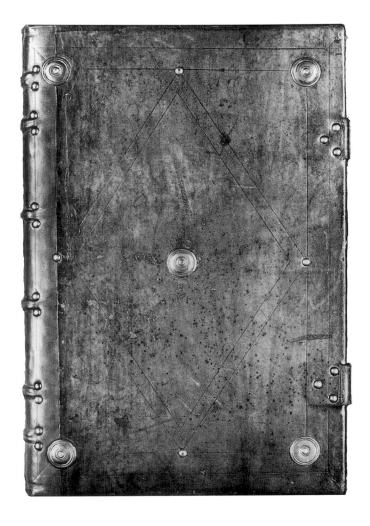

Appendix A,
Ill. 8. Louvre Book.
Leather-bound front
cover after 1983
restoration

Appendix A,
Ill. 9. Louvre Book.
Reconstruction Diagram
of upper right-hand
corner of former bind-
ing (shaded area) and
reduction to present
dimensions

reduced in size, a conclusion based on the fol-
lowing points:

- The distances between the edges of the
  front cover and its outermost blind-tooled
  rectangle are wider at the top and bottom
  (22 mm.) than at the fore edge (12 mm.).
  Evidently, we are dealing with a portion of
  a larger binding.

- The outermost lines of the decoration form
  a neat rectangle, whereas a 15th- or 16th-
  century bookbinder would have continued
  these outer lines to the edges of the cover.
  Either the decoration is not contemporary
  or, more probably, the rectangle was previ-
  ously the inner part of a larger decorative
  scheme.

- At the outer corners of both covers two
  partly visible circular impressions mark the
  places where copper bosses or appliqués
  were mounted. In adjusting the binding to
  the Louvre Book, the wooden boards were
  cut down on two or more sides into a
  format slightly larger than that of the Paris

book-block, and the leather cover lost the
outermost blind-tooled rectangle of its
original decoration. This adaptation led to
moving the copper bosses a few centi-
meters inward, reattaching them at the
corners of the innermost rectangles. The
round copper boss in the center remained
in place (see the reconstruction of the upper
right-hand corner of the front cover (Ill. 9).[106]

- Each cover is about 15 mm. thick, while
  the intervening book-block is only 23 mm.
  thick; together, both covers are thicker
  than the entire book-block, an unusual
  circumstance. It must be concluded that
  the present binding came from a codex
  much more voluminous than Bellini's.

In my opinion, these leather covers were some
35 mm. larger on all four sides, measuring
about 524 by 382 mm.; at present they are about
454 by 312 mm. When this trimmed binding
was fitted to the Paris Book, the upper and
lower raised bands on the spine had to be moved
closer to the adjacent bands.[107]

Judging from the simple decoration and from the two clasps attached to the back cover and fastening on the front, the present binding is possibly Italian. But the evidence is not conclusive: the small copper nails decorating the present binding do not belong to either binding and were added during or after the original covers were replaced, probably in the 18th century.[108]

Recently the badly worn spine of the present binding was entirely restored at the Bibliothèque Nationale with new leather, clearly visible in the photograph taken afterward (Ill. 8).[109]

Although nothing is known of the original binding of the Paris Book, its decoration possibly resembled that of the Book in the British Museum, the two being alike in so many other respects.

## FOLIATION AND INDEX

Only after the drawings were made and the quires sewn together and bound were all the folios (except for the blank ones) numbered consecutively from 1 to 95 in Arabic figures on the recto sides. Clearly this was done in an already bound book, because the wet ink on certain folios (42, 58, 67, 71, and 88) printed in reverse on the facing versos. Especially significant is the pagination number of folio 67, the first folio of quire H; this offprinted onto folio 66v, the last folio of the preceding quire G, proving that those quires were already in their present order at that time.

The foliation corresponds with that in the Index, where all recto drawings are identified in Italian. It is generally believed that the handwriting is Venetian in character, from the late 15th or early 16th century.[110] According to the theory that Gentile Bellini presented this Book to Sultan Mehmed II in Istanbul in 1479, the Index must already have been there. I agree with Goloubew, that the Index and the foliation were made after Jacopo's death in 1470 or 1471 by order of the heirs or the executors of his will.

## EIGHTEENTH-CENTURY ALTERATIONS IN THE QUIRE STRUCTURE

The Index and the foliation are important factors in assessing the folios that were removed from the Book after its completion, and the drawings they bore. The foliation, however, does not document the original structure of the codex, for alterations took place while the drawings were being made or shortly after. Folios 15, 17, and 33 were added to quires C and D, and bifolio 24–36 was probably transposed from quire H to quire D, but no (bi-)folios had yet been removed. The first disturbance in the quire composition may have been the temporary removal of the last folio (g93) from the largely unused quire L, probably separated from its corresponding folio 95 to facilitate inscribing the Index descriptions on its recto side; it was replaced when the Index was completed.[111]

The codex structure was more radically altered between about 1500 and 1884, when the Book was acquired by the Louvre. Interruptions in the foliation tell us exactly which folios were removed, and the absent folios also left traces behind in the quire structure, except for folio 33, apparently a loose folio added to quire D before the foliation.

There is positive proof that at least seven of the missing thirteen folios (three bifolios and a single folio from quire B) were extracted after 1728. In that year the Book is mentioned in a letter by one Guérin, the French *antiquaire du Roi* in Smyrna, who offered to intermediate in acquiring it for the Royal Library.[112] The identification of the Book is assured by its exact description in Guérin's letter and his quotation of the Index. He does not quote the first twelve lines, finding them illegible, but he describes the twelve drawings himself, and his letter proves that no folios were then missing from quire B. The same holds true, in my opinion, for the other six missing folios, although he does not describe them, but quotes the Index descriptions from folio 13 onward; he may not have checked the actual presence of every folio.

Guérin's letter reports that two other highly placed compatriots were interested in acquiring the Book at any price, the French ambassadors De Nointel and De Girardin. No subsequent transactions are known—Guérin's letter is our only relevant document—but we may assume that the Book was soon acquired by either Guérin or one of the French ambassadors and taken or sent to France by the fortunate buyer.[113]

At some time after the Book arrived in France its new owner doubtless decided to have it reorganized, repaired, and rebound,[114] for the three-centuries-old binding and the cords that held the quires together must have been badly worn. This first extensive restoration surely

Appendix A,
Ill. 10. Louvre Book.
Opening g93v–e94r
(formerly 10r), showing
circle pattern offprinting
onto Index verso

brought substantial alterations to the Book's appearance. The thirteen folios now missing were removed at that time, or between Guérin's writing and the rebinding. The last quire, then consisting of four leftover blank bifolios and a divided one, half used for model drawings and half for the Index, was split up, two blank bifolios being shifted to the beginning of the book and inserted into the loose bifolio in front of quire B. Bookbinders in the 18th century commonly reorganized a codex in this way, making two small quires of blank bifolios into flyleaves at front and back. After the codex had been reorganized and the quires newly bound together, the present leather binding was fitted to the book-block.

The reader may now be wondering why the thirteen folios were detached at all, and why at one time, and what became of them? The former folios 8, 9, 10, and 11 contained only patterns of empty circles; this probably prompted their removal from quire B, for they were a foreign element among the delicate pen drawings and moreover conspicuous, being concentrated at the very beginning of the Book. Doubtless the reasons that led to detaching these four folios were esthetic, but the removal raised the problem of refastening the four folios—2, 3, 4, and 5—that remained, a difficulty resolved by fastening folio 5 to bifolio 6–7 and removing folios 2, 3, and 4 along with folios 8, 9, 10, and 11. Quire B had now disintegrated, and the

drawings were no longer interrupted by four pages of uninteresting circle patterns.

One of these detached seven folios still remains in the Book, though far from its original place. Hitherto unnoticed behind the Index folio lies today a loose sheet of parchment filled with a pattern of 30 empty circles (6 x 5); in the upper left-hand corner is the authentic folio number "10." Clearly, this must be the recto of the detached folio 10, probably kept as an example of these pages and glued inconspicuously to the front of the endpaper at the back of the Book. It was unglued from this endpaper during the 1983 restoration. Evidently when the entire verso of folio 10 was glued to the endpaper, the moisture of the glue permeated the parchment and dampened the ink of the circle pattern on the recto side, making this pattern print evenly onto the blank facing verso of the Index folio (Ill. 10). Thus the circle pattern on folio g93v is not an original drawing, but an accidental 18th-century offprint.

Just why the other six folios were removed remains a speculation. Perhaps these drawings particularly pleased the owner, and he intended to make presents of them, or to frame them separately, or to keep them should he decide to sell the Book as a whole. After the folios were detached, five of their loosened corresponding folios (24, 30, 52, 62, and 88) were carefully refastened in their proper places (the sixth, folio

11, was among the circle-pattern folios removed from quire B). Probably folio 88 was mistakenly rebound upside-down at that time, its recto facing folio 89r instead of folio 87v.

My hypothesis that these six drawings and quire B's seven folios were all removed at once is based mainly on the fact that three identifiable folios (2, 29, and 91) ultimately reached the Louvre together in the bequest of A. C. H. His de la Salle (1795–1878), through the collection of Alexandre Lenoir (1761–1839);[115] apparently, all three had remained together ever since they were removed from the Book.[116]

To the six missing drawings may be added one more, executed across a smaller sheet of parchment pasted onto folio 77r. When this sheet was unpasted and removed, at some unknown time,[117] the outermost elements remained on the folio to define the outline of the detached sheet. The Index describes the drawing as *Judith with Holofernes and a Faun*,[118] and the faun and the beheaded body of Holofernes are still there, drawn into the outer margins of the folio; the central drawing of Judith has gone.

Therefore, the total number of missing folios is nine, and three of these, circle folios, were probably discarded for their absence of artistic distinction. The remaining six folios and the sheet detached from folio 77r, if not lost forever, may be in an unknown collection, possibly still in France. These folios, perhaps reduced in size like the His de la Salle drawings, could someday be rediscovered.[119]

## CONCLUSION

This codicological examination and its analysis establishes that Bellini's Books were two nearly identical structural units, both originally composed of ten quires, all *quinios*, each with an additional bifolio to compensate for the outermost folios that became flyleaves at front and back. These structural parallels, along with similarities such as the material homogeneity of each volume and their large format and common subject matter, indicate that the Books are closely related. Although their dimensions are not exceptional, most Quattrocento drawing books are considerably smaller. The acquisition of the material for each Book must have involved high costs: no fewer than fifty-one goatskins provided the parchment for the Paris Book (six of these reused); the fifty-one large sheets of paper in the London codex were made in succession at the same mill and by the same

vatman. Both codices were preconceived structures, for the calculated number of sheets (100 + 2) was the same for each, delivered as bound book-blocks or in loose quires.

The presence of the double-drawings has led to the general assumption that the Books existed before the drawings were made, but the quires of the Books had probably not been sewn together when the artist made his drawings. A bound book does not give sufficient support for a steady hand, and it would have been very awkward to execute delicate pen drawings and intricate exercises in perspective on folios so uneven and stiff in the folds, especially of parchment. It is worth noting that the penwork in the double-page architectural compositions in the Louvre Book continues across the central fold with straight lines that could only be drawn on flattened parchment. Whether or not the Books existed before the drawings, the present sequence of the folios in both volumes was ultimately fixed when they were foliated and covered with leather bindings.

The Books had some particular function in the Bellini workshop, for these expensive codices would not otherwise have been acquired and filled with such elaborate drawings (unless ordered by a patron, which is clearly not the case). The outgrowth of an ambitious graphic project, they must have occupied the artist over a long period, unless he had the assistance of others. Having reached his middle years as the head of one of the most important *botteghe* in the Veneto, Jacopo doubtless observed the need for up-to-date drawing books that would reflect his own mature style and artistic attainments. The purpose of these drawing books was both didactic and conservative, as a thesaurus of traditional motifs and "modern" compositions for members of his workshop to study and copy. In them he intended to record the artistic tradition of the workshop, to be passed on to subsequent generations. The primary purpose of the medieval model book had for centuries been a similar investment in workshop practice. Jacopo, trained in this tradition, surely owned older model books, some possibly inherited from Gentile da Fabriano, and he incorporated six bifolios from a late 14th-century model book into his Louvre volume.

Jacopo's Books were doubtless preserved by his successors not as professional tools, but as cherished heirlooms of their father's art, mementos of the many decades of the family workshop.

UNLESS OTHERWISE INDICATED, CITED WORKS ARE GIVEN IN FULL IN THE BIBLIOGRAPHY

* This study is adapted from a part of my Ph.D. dissertation, *Italian Late Medieval and Renaissance Drawing Books: From Giovannino de'Grassi to Palma Giovane* (University of Leiden 1987). I am greatly indebted to my teachers Prof. Dr. Anton Boschloo and Dr. Jaap Bolten, as well as to Prof. Dr. J. P. Gumbert and Dr. Bert W. Meijer for their continuous support of my research. In Florence I have made frequent use of the indispensable facilities of the Dutch and German institutes. Research for my studies was made possible by a fellowship granted by the Faculty of Arts of the University of Leiden (1982–85). The manuscript of this study was completed in March 1984.

1 This first mention since the 16th century of Jacopo Bellini's London Book is in an article that seems to have escaped notice until now: A. Lorenzoni, "Il codice di Jacopo Bellini del British Museum, le trattative d'aquisto di T. degli Obizzi," *Vedetto Fascista* 132/A.⁰ XIII (1935), 3–7, esp. 6.

2 British Museum, inv. 1855–8–11–1/98 (197*.c.1), and Musée du Louvre, inv. R.F. 1475–1556. The major publications referred to in this study are in the Bibliography; note in particular J. G. Rushton, *Italian Renaissance Figurative Sketchbooks* (unpublished Ph.D. dissertation), University of Minnesota, Minneapolis, 1976.

3 Several reasons might explain why so few drawing books have been preserved. Drawing books, and particularly model books, were artistic tools having a practical function in the workshop. Medieval model books were passed on from one generation to the next to preserve the workshop's artistic tradition. Years of abundant use made them fall apart, and many were discarded when the rapid changes of artistic ideas during the 15th century made them obsolete. A number of Italian drawing books (including fragments) are described by R. W. Scheller, *A Survey of Medieval Model Books*, Haarlem 1963, and by Rushton, 1976. My dissertation (see above, note*) contains a catalogue of more than 100 Italian drawing books from 1375 to 1600, with detailed information on codicological aspects, contents, and function.

4 For literature on Jacopo Bellini's place in the Italian renaissance, see especially Joost-Gaugier's detailed studies in the Bibliography.

5 It is commonly accepted that the two drawing books were part of the "*omnes libros de dessigniis*" mentioned in 1471 in the last will of Jacopo's widow Anna Bellini-Rinversi (see Appendix E).

6 Marco Zoppo's parchment drawing book and the Florentine Picture Chronicle (both British Museum, inv. 1920–2–1–4–1/26 and inv.

1889–5–27–1/95, respectively) were similarly mounted and rebound.

7 There is a clear distinction between a drawing book and an album. Strictly speaking, a drawing book is a codex composed of quires, that already existed before its folios were covered with drawings. In a large-size drawing book the artist may have drawn on the quires before they were bound together, unless the book had a special program and he knew exactly how many folios were needed; likewise, the quires in a manuscript codex had usually been written on separately. An album is a "compilation of loose drawings formed *a posteriori* by the artist himself or by other hands," which "usually consists of empty pages onto which the drawings are stuck, but it may also be formed directly by the drawings, without mounts" (M. Röthlisberger, *Claude Lorrain, the Drawings*, Berkeley/Los Angeles: 1968, 55). Thus, the primary difference between a drawing book and an album lies in the physical origin of the sheets (see also Rushton, 1976, 39 ff.). Jacopo's two volumes are drawing books, not albums.

8 The old binding was probably in bad condition when the British Museum acquired it, with decayed spine, broken joints, and parts of the edges and corners of the boards missing or irreparable. Salvageable portions of the leather sides were inlaid into the new leather covers, a method discussed and illustrated in B. C. Middleton, *The Restoration of Leather Bindings*, Chicago: 1972, 166–69.

9 I owe this determination of time and country to Dr. Mirjam M. Foot-Romme (see below, note 45). Regarding printed endpapers, see R. B. Loring, *Decorated Book Papers*, Cambridge: 1952, 1–8, 35–46.

10 Goloubew, 1912, I, introduction.

11 As a result, the facsimile editions by Goloubew and Ricci reproduce these drawings in the wrong order. Of the five folio sides filled with circles, only folio 63r is reproduced as an example.

12 Marcantonio Michiel describes this sort of paper as "*carta banbagina*" (Michiel, 1888, 220), a common term for paper in the Middle Ages and the renaissance. Cennini distinguishes it from "*carta pecorina*," or parchment (Cennino Cennini, *The Craftsman's Handbook* [*Il libro dell'arte*], trans. D. V. Thompson, New York: 1954, 9). For further information concerning the manufacture and use of paper for manuscripts and drawings, see J. Meder, *Die Handzeichnung, ihre Technik und Entwicklung*, 2nd ed., New York: 1978, 139–40, and J. Irigoin, "Les premiers manuscrits grècs écrits sur papier et le problème du Bombycin," *Scriptorium* 4 (1950), 194–204. Paper, a Chinese invention, came to Europe by way of the Ara-

bic world, but was not manufactured in Italy until late in the 13th century (Fabriano, 1282). It gradually replaced parchment, although the latter never lost out entirely. Both were used in loose sheets or in quires for writing, drawing, or both. Bellini's volume is among the earliest examples of a drawing book made of paper quires. For the history of paper, see D. Hunter, *Papermaking: The History and Technique of an Ancient Craft*, 2nd ed., New York: 1947.

13 Except for folios 2v–3r, all drawings are reproduced in black-and-white (to judge the poor quality of the color reproduction, compare Ricci's with Goloubew's), and the folios are not reproduced full-size. Some reproductions have been heavily retouched, notably in Goloubew's edition.

14 These drawings are indicated with "i" in Chart 2.

15 Foliated according to common practice, the rectos numbered consecutively in the upper right-hand corners with pen in Roman numerals I to XXXXXXXXXVIIII (1–99). No folios seem to have been removed since, as the foliation is uninterrupted. An old foliation in leadpoint—probably the original—is visible at the center top of folios 36r ("XXXVI"), 41r ("XXXXI") 45r ("XXXXIIII"), 46r ("XXXXVI"), 51r ("XXXXXI"), 60r ("XXXXXX"), and 75r ("LXX"). Where the numbers in leadpoint and ink do not correspond, as on folio 45r, apparently the leadpoint numeral is one "I" short by mistake, for on folio 46 both numbers correspond, and there is no sign of a missing folio. The leadpoint number on folio 75 reads "LXX" because the five preceding rectos, having only empty double-circles (folios 61r–65r), were evidently not counted in the older foliation. Probably these seven folios were overlooked when the leadpoint foliation was erased, just before or after the ink foliation was finished. I wonder if an index for the ink foliation was ever made, as in the Louvre Book.

16 In the coating black brush hairs can be seen lying in a vertical position. Grounded sides are indicated by "G" in Chart 1.

17 Folio 10r of the Louvre Book (see pp. 472–73) is also filled with rows of empty circles arranged 6 by 5, instead of 5 by 6 as in the British Museum Book. In 1728 Guérin described folios 8, 9, 10, and 11 (later detached from the Louvre Book, though folio 10r is, in fact, still there) as covered with circle patterns: "*Ronds propres à mettre quelques personnages; ils sont en blanc.*" The Index description is "*tondi per far medaie per imperadori*," as in the frieze in folio 48. See Omont, 1902, 2, 710, and De Ricci, 1923, 96

18 As the decorated endpapers do not show these tiny holes, the worm damage had already

occurred before the endpapers were added in the 18th-century rebinding.

19 Waagen, who saw the Book in the British Museum in 1855 or 1856, describes it as not dismantled: "It consists of one folio volume of 100 leaves, of a thick and coarsely-grained paper, 99 of which, and most of them on both sides, are drawn upon in black chalk and pencil. In many cases one drawing runs through two opposite pages" (G. F. Waagen, *Treasures of Art in Great Britain*, Supplement, London: 1857, 27–30). The first to refer to the dismantling is Goloubew in 1908 (see note 10), but with no more specific information.

20 J. M. M. Hermans and G. C. Huisman, *De descriptione codicum*, Groningen: 1981, 24.

21 For the folding of sheets to construct quires, see L. Gilissen, *Prolégomènes à la codicologie, recherches sur la construction des cahiers et la mise en page des manuscrits médiévaux* (Publications Scriptorium VII), Gent 1977, 26–35. He discusses only parchment sheets, but the rules for folding paper sheets are the same. For paper, see also C. Bozzolo and E. Ornato, *Pour une histoire du livre manuscrit au Moyen-Age. Trois essays de codicologie quantitative*, Paris: 1980, 133–53.

22 For a study of the sizes of paper and parchment manuscripts from the 13th to the 16th century, see J. P. Gumbert, "The Sizes of Manuscripts, Some Statistics and Notes," *Hellinga Festschrift/Feestbundel/Mélanges*, Amsterdam: 1980, 277–86.

23 Note that the Louvre Book is approximately the same size as the British Museum Book: 427 by 290 mm. This is probably why certain authors supposed that both Books were originally two parts of one book: J. Meder, 1923, 60, erroneously speaks of "The London part of Jacopo Bellini's drawing-book"; J. White, *A Concise Encyclopedia of the Italian Renaissance*, London: 1981, 47, refers to "a silverpoint sketchbook divided between the British Museum and the Louvre."

24 Taking bifolio 3–6 as an example (see Appendix A, Ill. 2), the average distance between the chain lines is 42 mm., excluding the distances from the outer edges to the first and last chain lines (nos. 1 and 16), and that between the chain lines bordering the watermark (nos. 4, 5, and 6). The basic sheet was folded between chain lines 8 and 9; the bifolio was cut in two along the fold in the dismantling. As the distances between chain lines 8 and 9 and the present inner edges of the loose folios are now respectively 28 mm. and 5 mm., it may be inferred that about 9 mm. are missing from the original 42 mm. Apparently the folios were cut at a slight distance from the fold; no stitch-holes are visible along the inner edges of the mounted folios.

25 Paper of the *Reale* format was used almost exclusively in Italy. The standard Italian formats were officially recorded on a late 14th-century stone table in Bologna (reproduced in C. M. Briquet, *Les filigranes, dictionnaire historique des marques du papier*, I, Geneva: 1907, 2, 3).

26 In so large a format, the only possible way of folding the sheets is *in folio*. Folded *in quarto* or *in octavo*, the sheets would have to be, respectively, 681 by 830 mm. and 830 by 1362 mm.; paper sheets were probably not even made in these dimensions.

27 The basic material used for producing paper at that time was linen rags, soaked and pounded into loose cellulose fibers that were dispersed in a tub of water. Using a special mould, the fibers were scooped out of the vat and, after the water drained off, remained in the mould to form a new tissue called paper. Wet sheets, transferred or "couched" onto felt blankets and piled up, were pressed in a screw press to remove more water, and then hung up to dry. To make the paper less absorbent to ink, the dried sheets were dipped in a glue solution.

The papermould is usually a rectangular wooden frame with wooden bars or ribs, parallel to the short sides, that support "laid wires," closely spaced thin copper wires parallel to the long sides of the frame. The laid wires are plaited onto the ribs with "chain wires" that tie them together in a screen. The watermark (a thin copper wire bent into a figure) is sewn onto the middle of one half of the screen, and there the adjacent chain wires may be somewhat wider apart to accommodate it; or the watermark may be fixed onto an added chain wire, thereby reducing the distance between these chain wires, which normally varies little in one papermould. Together these wires and the watermark produce the characteristic imprints of laid paper. See J. Irigoin, "La datation par les filigranes du papier," *Codicologica* 5 ("Les matériaux du livre manuscrit"), Leiden: 1980, 9–36, (esp. 9–13), figs. 2–4. In Bellini's London Book the mould-side of the paper—which carries the imprint—is practically indistinguishable from the felt-side, and is not a factor in reconstructing the volume as the hair-side and flesh-side are in the parchment Book in Paris.

28 After the beginning of the 16th century some paper makers added a countermark to the other half of the mould (see Irigoin, 1980, 11).

29 Except for errors in transposing the drawings into the present volume, the foliation is uninterrupted (see note 15).

30 Goloubew, 1912, I, introduction, 4.

31 Briquet, 1907, I, 178–80, and nos. 2364–2616; and G. Piccard, *Wasserzeichen Waage* (Findbuch V der Wasserzeichenkartei Piccard im Hauptstaatsarchiv Stuttgart), Stuttgart: 1978 (1,830 watermarks of the *balance* type).

32 Compared with Briquet, 1907, I, no. 2466 (Verona 1442) and no. 2467 (Nürnberg 1446; similar types in Prague 1445, Augsburg 1469–78, Liegnitz 1470, Breslau 1473–79, and Brunn 1477); it can also be compared with Piccard, 1978, no. VIII (large-size paper), 129 and 128 (Nürnberg 1445 and Horneck 1451, respectively).

33 Because a papermould was much used and regularly brushed clean, the watermark slowly wore down, shifted, and changed form. If it came loose it was sewn to the mould again, causing minor variations in its form and changing its position slightly. The watermarks on two sheets of paper produced in the same papermould are not necessarily identical unless the sheets were made close in time. A papermould normally lasted about a year, and one pair could produce some 400,000 sheets; larger formats lasted longer, being used less often, and the watermarks on 50 large sheets made at the same time would be practically identical. See T. Gerardy, "Die Beschreibung des in Manuskripten und Drucken vorkommenden Papiers," *Codicologica* 5 ("Les materiaux du livre manuscrit"), Leiden: 1980, 37–51, esp. 38, fig. 1.

34 Weiss and Stevenson have established that "watermarks are twins," meaning that the custom of using two papermoulds at once produced two watermarks that are very similar but not identical. In this case I was unable to distinguish two variants; either these marks were nearly identical or, exceptionally, only one mould was used. See K. T. Weiss, *Handbuch der Wasserzeichenkunde*, Leipzig: 1962, 105–6, and A. H. Stevenson, "Watermarks are twins," *Studies in Bibliography* 4 (1951/52), 57–91; see also Gerardy, 1980, 37 ff., and D. Harlfinger, "Zur Datierung von Handschriften mit Hilfe von Wasserzeichen," *Griechische Kodikologie und Textüberlieferung*, Darmstadt: 1980, 150–51.

35 It is sometimes difficult to see this narrow section in a black-and-white reproduction. On the "facsimiles" of Ricci and Goloubew, however, the stripe can easily be recognized. The edges of some stripes are not always straight, as on folios 43v and 44r. According to J. M. M. Hermans (ed.), exhib. cat., *Het Middeleeuwse boek in Groningen*, Groningen (University Library): 1980, 27, and fig. 4, these guards ("*hartstrookjes*" in Dutch) were glued onto the fold before the thread or cord was stitched through it.

36 The drawings on folios 14v–15r, 48v–49r, 53v–54r, 69r, and 78v–79r, for example.

37 The first possibility seems the most likely; folio 0 was pasted to the verso of the front flyleaf (probably only to the fold side, to serve as a second flyleaf). The first flyleaf was the right half of a loose bifolio, the left half being pasted to the inside of the front cover. Similarly, folio 100 was pasted to the recto of the last flyleaf, which was the left half of a loose bifolio, the right half being pasted to the inside of the back cover. Occasionally this manner of attaching endpapers to a book-block is still practiced today.

38 With regard to the London Book, Collins (1970, 25, 39, 40) was the first to note the awkwardness of working in a bound book: "It is difficult, offhand, to imagine someone making such relatively large drawings on pages already in a book, especially when they involve the intricacies of perspective and its attendant construction lines. Nonetheless, a later study by Röthlisberger shows convincingly that this was precisely the case."

39 See W. Koschatzky, *Die Kunst der Handzeichnung; Technik, Geschichte, Meisterwerke*, Salzburg 1977, 65–75.

40 According to the Tietzes, however, the pages (all of them?) are prepared; Rushton and

Scheller say that the paper is "often prepared"; Popham and Pouncey, who, as curators in the British Museum Printroom, were certainly very familiar with the Book, employ a question mark. See Tietze and Tietze-Conrat, 1944, 101; Rushton, 1976, 234; Scheller, 1963, 212 n. 3; Popham and Pouncey, 1950, 14.

41 Some of the groundings in the Louvre Book were applied to cover up the late 14th-century model-book drawings (see Degenhart and Schmitt, 1980, 168–77) and to prepare them for silverpoint drawings; other groundings were applied for the silverpoint drawings only.

42 For instance, folios 10v, 26v, 71v, 78v, and 90v.

43 This theory, supported by the Tietzes, 1944, 95, 107–9, is sharply rejected by Popham and Pouncey, 1950, 14, who detect no signs of retouching.

44 Röthlisberger's remark regarding supposed overdrawings in the Louvre Book applies better, in my opinion, to those in the British Museum Book: "distinzioni così complicate di mani e di tecnica si spiegano, in parte, con le ricerche degli studiosi condotte solo su edizioni in facsimile" (Röthlisberger, 1958–59, 48).

45 I am grateful to Dr. Jan Storm van Leeuwen, Keeper of Bookbindings at the Royal Library at The Hague, who kindly studied photographs of both bindings at my request. I also wish to thank Dr. Mirjam M. Foot-Romme, Assistant Keeper of the Rare Book Collections in the British Library, for her expert opinion on the origin and date of the leather binding.

46 Compare the drawing book attributed to Antonio da Sangallo in the Uffizi (inv. 7792-7907; 406 by 292 mm.); this codex, its dimensions nearly the same as Bellini's, has a limp parchment cover, and the whole is bound in a leather satchel which can be locked with a buckle.

47 This is the expert opinion of Dr. Mirjam M. Foot-Romme. Ornament tools like those used on our binding are found in Florence, Bologna, Venice, and Padua, but they were also widely copied, making it difficult to pinpoint their location. For literature on renaissance bookbinding in North Italy, see T. de Marinis, Rilegature veneziane del XV e XVI secolo, Venice: 1955, and idem, La legatura artistica in Italia nei secoli XV e XVI, II, Florence 1960.

48 Goloubew, 1908, II, introduction, puts forward the possibility that the leather binding was made in Istanbul by an Islamic artist, on Gentile Bellini's order.

49 The straight blind lines (the rectangles) were run onto the leather covers with a sharp-edged instrument such as a fillet or a pallet; the ornamental patterns have been stamped and rolled with four different ornament tools. The first, third, and fifth border of the preserved portion, from the outside in, have palmettes, a dentated pattern with dots, and lozenges, respectively (each pattern tooled with a roll). Filling the central rectangle is an intricate pattern of interlocked half circles of ribbons combined with pointillé tooling. Great care was taken to continue the ornamental pattern of

the old binding onto the surrounding new binding.

50 For a discussion of animal skins and practical aspects of parchment making, see R. Reed, Ancient Skins, Parchments and Leathers, London/New York: 1972, 118–73, and idem, The Nature and Making of Parchment, Leeds: 1975.

51 See note 12.

52 Hunter, 1947, 12–17, 60–61; Ames-Lewis, 1981, 21–23. See also the discussion and statistical charts on parchment and paper production in Bozzolo and Ornato, 1980, 13–122.

53 Ames-Lewis, 1981, 19–20. Regarding the durability and preservation of parchment, see Reed, 1975, 92–94.

54 Meder, 1978, 135.

55 E. Lesne, Histoire de la propriété ecclésiastique du commencement du VIIIᵉ siècle à la fin du XIᵉ siècle, IV, "Les livres 'scriptoria' et les bibliotheques," Lille: 1938, 330, 368–75.

56 I owe this information to Professor J. P. Gumbert (verbal communication).

57 The mark of the animal's spine can easily be seen on, for instance, hair-side openings 12–13, 41–42, 43–44, 57–58, 59–60, 65–66, 69–70, and 79–80.

58 Like their "facsimiles" of the London Book, Goloubew's and Ricci's "facsimiles" of the Louvre Book are also poor in quality and give a misleading impression of the parchment and the drawings; most are reproduced in black-and-white and not full-size. See also note 13.

59 Reed, 1972, 130.

60 This grain pattern comes from traces of the hair follicles; see Reed, 1975, 19.

61 Professor J. P. Gumbert kindly lent me his collection of parchment samples. The exact animal origin of some of the parchment folios proved very difficult to determine. Generally goatskin parchment can be recognized by its characteristic surface markings ("claws"), found on most of the Louvre folios.

62 Reed, 1975, 19.

63 C. R. Gregory, "Les cahiers des manuscrits grecs," Comptes rendus de l'Académie des Inscriptions et de Belles Lettres, Paris: 1885, 261–68; in English: "The Quires in Greek Manuscripts," American Journal of Philology, VII, 1 (1885), 1–6. The French version was recently reprinted and discussed by Gilissen, 1977, 14–20.

64 According to Gregory this was mainly because the scribe first had to rule his line patterns on the hair-sides of the double sheets. Gilissen (1977, 21–35) has observed that if a quarto or octavo format was desired, two or more sheets were folded together two or three times, by which the regular alternation of hair-side and flesh-side openings was also realized.

65 The regular alternation of hair-side and flesh-side openings was equally maintained if the end-sides of the quires were hair-sides.

66 Unless an even number of consecutive (bi-) folios is removed or added (when added, Gregory's Rule had to be observed).

67 Gilissen, 1977, 22.

68 I wish to acknowledge the full cooperation I received in the Cabinet des Dessins from Chief Curators Roseline Bacou and Maurice Sérul-

laz, as well as from Curator Bégig Michel.

69 The only record I know of, a two-page hand-written memorandum, was kindly brought to my attention by Mme M. P. Laffitte, Curator of the Department of Manuscripts at the Bibliothèque Nationale, who attended the restoration of the Louvre Book in 1983. Filed in the archives of the Cabinet des Dessins, this letter contains some general remarks on the sewing and binding of the Book but no detailed account of the restoration.

70 The first ten folios were at that time separated from the other quires, which remained loosely bound together, the inner joints still intact. The bifolios could be taken out of some quires, such as quire J, because the quire-thread had come loose. In the Louvre Book no guards were attached along the center folds or backs of the quires.

71 The implication of the unglued parchment folio e94 is discussed on page 472.

72 The former position of each removed folio is indicated by a dotted line in the chart of the quire composition, Appendix A, Chart 2.

73 Two blank recto sides were numbered because their verso sides contain a drawing (folios 66, 78). Exceptionally, these two verso drawings are described in the Index though not properly numbered; this does not mean they were added to the completed Index as supposed by Goloubew (1908, II, text to pl. XCVI) and the Tietzes (1944, 109, 111), rightly contradicted by Röthlisberger (1958–59, 45).

74 The Index and missing drawings are discussed on pages 471–72.

75 Judging from the portion on folio 50v, the double-drawing on opening 50–51 was an architectural scene, comparable to that on opening 30–31. The Index describes the subject matter: A Man Fallen Dead from a Horse (probably similar to the double-drawing on opening 50–51 in the British Museum Book).

76 Folio 10 is preserved in the Book itself; folio 2 is now in the Collection His de la Salle at the Louvre (inv. R.F. 428). See discussion on pages 473–74.

77 The quire starts with a flesh-side (Louvre inv. R.F. 428, which can be identified with the missing folio 2r; see below, note 115). Consequently, the verso of the missing folio 11, originally a bifolio with folio 2, must have been a flesh-side as well (and 11r a hair-side). The same is true for folios 10r (preserved) and 3v (missing), as well as for folios 5r (preserved) and 8v (missing). The center opening (an entire bifolio) of a regularly composed quinio, here bifolio 6–7, is a hair-side. Only bifolio 4–9 has disappeared altogether, but most likely that opening 4–9 was a hair-side, making the quire a regularly composed quinio.

78 A drawing by either Jacopo or Giovanni Bellini that was not originally part of the Book, though added to it at an early date, is the paper folio 15 representing St. George and the Dragon. This drawing was made on two sheets of paper that had evidently already been pasted together (the direction of the chain lines and the density of the laid lines differ in the two sheets). When viewed horizontally, the right

side contains a watermark representing an eagle. This paper folio was in poor condition, notably the upper part near the fold. It was repaired with great care in the 1983 restoration, and a gauze support was attached to the verso.

79 Other instances of grouped drawings with similar subject matter are the detached pages with circle patterns (folios 8–11); *Studies of Roman Monuments* (folios 48r, 49r); *Soldier Fighting a Dragon* (folios 54r, 55r); the two *Chalices* (folios 64r, 65r); and the *Entombment* (folios 57v–58r, 59r). Yet themes are not strictly grouped: *St. George and the Dragon* is also depicted on folios 67r and 84r, far from folios 15r and 16r.

80 Röthlisberger, 1956, 359, n. 4; *idem*, 1958–59, 46.

81 I must admit that the present opening 23–24 contains the odd combination of a landscape composition on the left with an architectural scene on the right. Eisler agrees with Röthlisberger.

82 If this hypothesis proves correct, the bifolio must originally have been within the present center bifolio 70–71, because the quire is regularly composed, the center opening being a flesh-side. When the bifolio was transferred to quire D, it must have been folded the other way around, because 24v–36r was a flesh-side; the original sequence in quire H was 70, 36, 24, 71. As opening 70–71 contains a double-page composition, the presumed intervening bifolio had already been removed before the drawing was made.

83 Why this loose folio E was added to quire A, I do not know. There are no structural indications that it originated within the Book itself, or formed a bifolio with another blank folio, now missing.

84 The assumption that folios 95( = g89) and g93 originally formed a bifolio is based on similarities in the color and grain pattern and on 95v and g93r being hair-sides. Before the 1983 restoration and rebinding, folio 95 was attached to quire K; it is now fitted to quire L. See discussion on page 468.

85 Large codices such as this were generally stored flat rather than vertically. Metal bosses were mounted onto the covers partly to protect the leather bindings. See Hermans and Huisman, 1981, 76.

86 Unfortunately, the Index lines did not print off evenly; only a few words are clearly visible, but I could not decipher them, even from a photograph specially made from the reversed negative. When held to the light, traces of seven more lines can be seen on folio g89r. The first seven lines of the Index itself are lost because the damaged upper part of this page was replaced (before 1983) by parchment. Moisture damaged the Index down to line 16, but the manuscript is legible from line 11 onward. I was unsuccessful with both infrared and ultraviolet photography in deciphering lines 8 to 11.

87 Possibly quire L was composed as follows: g88(F)–g92(F)–g91(H)–g2(H)–g3(H)–g4(F)–g5(F)–g90(F)–g89(H)–g93(H). Note that this quire does not follow Gregory's Rule; presumably, the four blank bifolios of quire L (g89–g92) were accidentally placed out of order.

88 De Ricci, 1923, 94; Röthlisberger, 1958–59, 52. See Chart 2a, Appendix A.

89 De Ricci's own quire formula is $a^6$ ( + 5★), $b^{10}$, $c^{10}$, ( + 3★, 4★, 10★), $d^{10}$ ( + 8★, 10★), $e^{10}$, $f^{10}$, $g^{10}$, $h^{10}$, $i^{10}$, $k^{10}$, $l^6$; in parentheses are the loose folios added to the original codex after folios a5, c3, c4, c10, d8, and d10. Röthlisberger specifies in his table the original number of folios in each quire, the folios which are preserved, and the single folios which were added afterward. I have taken the liberty of correcting the numbers of the three preserved folios in quire B (he used the Index numbers, not the serial numbers within the quire), and of adding Index numbers 33 and 36 to the folios removed from quire D.

90 Indicated by "m" in the chart of the quire composition, Appendix A, Chart 2.

91 The model drawings on folio sides 76r, 77v, and 95v remained without grounding. In other cases the model drawings beneath are partly visible because the ground is damaged (i.e., partly washed off of folios 82v and 83r) or has become slightly transparent. Still others can be seen by holding the folio against a light (as folio 78v). The 22 grounded sides, including 11 that do not cover model drawings, are indicated by "G" on Chart 2, Appendix A.

92 Degenhart and Schmitt, 1980, 136–77, esp. 148–50, 168–77.

93 *Idem*, 154, 155, 173, 175. Judging from the reversed position of the model drawings, five bifolios are clearly bound upside-down (75–84, 76–83, 77–82, and 95–g93); in the other three cases this cannot be determined, the textile patterns being hidden by the ground.

94 Hermans and Huisman, 1981, 40.

95 Otherwise he would have covered all of bifolio 77v–82r, instead of leaving untouched the model drawing on folio 77v and grounding only folio 82r.

96 This smaller sheet of parchment measures 339 by 249 mm. (entire folio: 429 by 295 mm.). Degenhart and Schmitt were the first to notice that the applied parchment sheet covered a model drawing (a flower pattern, visible by holding the folio against a light; see Degenhart and Schmitt, 1980, 172, figs. 178, 279).

97 Bifolio 76–83 contains model drawings on all four sides; 77–82 on three sides; 75–84, 47–56, and 95–g93 on two sides; 78–81 on one side only. Of the ten sides left blank, Jacopo later filled five with drawings. A hypothetical reconstruction of a regularly composed *quinio* in the model book can be made, using five of these six model-book bifolios. The first seven folios contain model drawings, the last three are blank on both sides: 78–81 (outermost bifolio), 95–g93, 56–47, 83–76, and 82–77 (center bifolio). These bifolios are all folded backward, the former versos now becoming rectos.

98 The six model-book bifolios are not markedly different from the others in the codex in dimensions or material characteristics.

99 It is noteworthy that when Jacopo began his treatment of quire J by applying a rose-colored ground to model-book folio 75r, he was simply preparing a blank side for the silverpoint drawing he intended to make, not covering an older model drawing.

100 Traces of leadpoint are best seen in the double-drawings on openings 43–44 (naked youth; balustrade) and 49–50 (stag; the body of St. Isidore). The pen drawings on folios 52r, 55r, and 60r also contain traces of leadpoint.

101 Leadpoint drawings partly drawn over in pen and ink are on folios 1v, 73r, 79r, 80r, 85r, 87r, and 92r. The leadpoint on folio 59v is partly drawn over with a brush; three silverpoint drawings seem to have been gone over with brush and gray ink on folios 82v, 83r, and 84r. The genuine leadpoints on folios 64r, 65v, 66v, and 89r have faded, as have silverpoints in quires J, K, and L (folios 75r, 86r, 88r, 94r, and 95r).

102 Röthlisberger, 1956, 360, n. 12; *idem*, 1958–59, 49. In my opinion most of these omissions are too few and insignificant to require a preliminary study, and in some cases the contours are clearly marked against the already finished background, as on folios 69r (arm of St. Michael), 70r (hand of the peasant), 71r (hands of St. Francis), 74r (handle of one vase), and 77r (arm of the satyr). It could well be that parts of the human body, notably limbs and head, were temporarily omitted in the working process, to be worked later with pen and ink. This procedure can also be seen on folio 85r, where the man's entire body was left out except for the loincloth, while the background (which forms the larger part of the drawing) was delicately finished in pen and ink. Here, as in the partly reworked drawing on folio 69r, faint traces of leadpoint can be seen in the omitted penwork. The Tietzes explain these omissions as details that were in good condition and therefore spared in the reworking, only to gradually fade and finally disappear (Tietze and Tietze-Conrat, 1944, 113).

103 Compare, for instance, the drawings on folios 14r and 42r, 16r and 7r, 16v–17r and 25v–26r, and 19v and 41r. Mariani Canova (1972, 24–27) distinguishes three groups of pen drawings that show striking stylistic differences.

104 See note 45.

105 The present binding is generally considered to have been fitted to the Book about 1500. See Röthlisberger, 1958–59, 45, and Joost-Gaugier, 1980, ix, n. 3. The leather binding of Ricci's facsimile edition is a poor imitation of the Louvre binding.

106 This reconstruction of the format binding was prompted by a suggestion of Dr. Jan Storm van Leeuwen.

107 It is strange that the outer raised bands are coupled, while the two intervening bands are single. Perhaps the raised bands of the original spine were alternately single and coupled, a customary binding method in the 16th century.

108 The straddled placing of the copper nails at the ends of the raised bands of the spine is unusual. Small nails were also attached to the four

points of the lozenge, to the front cover fastenings of the two clasps, and on the outer edges of the covers.

109 Unfortunately, during the 1983 rebinding the extremely worn rectangular leather label was removed from the spine. Formerly glued between the center raised bands, the inscription it bore is now largely destroyed and almost illegible: ISIIGNI . . . R . . . TIZIANO.

110 It is generally thought that the Index was prepared when the present binding was fitted to the Book. According to Ricci and Goloubew, Jacopo certainly did not make the Index himself, because some descriptions of the subject matter contain errors: Ricci, I, 69; Goloubew, 1908, II, text to plate XCVI (*Indice*). See Appendix C.

111 See above, note 84.

112 This letter is in the Bibliothèque Nationale (inv. nr. ms. nouv. acq. franc. 5384, fols. 267–68). Guérin and Abbot Bignon, the Royal Librarian, corresponded from 1724 to 1731; in their letters I found no other mention of the Paris Book.

113 De Ricci tried unsuccessfully to trace back the provenance of the Book from its last private owner to Smyrna (1923, 92, 93). He assumed that ties of family or friendship joined the ancestors of the marquis de Sabran-Pontevès

and the marquis de Villeneuve, French ambassador to the Turkish court at Istanbul in 1730. Both families were among the highest nobility in Provence.

114 In view of the great value attached to the codex by the prospective buyers mentioned in Guérin's letter, it is remarkable that the old binding had not been replaced by a finer one.

115 His de la Salle gave 300 of his finest drawings to the Louvre shortly before he died in 1878 (see Lugt, 1921, 238, nos. 1332–33). He probably bought the three drawings in question at the Lenoir sale of 1838 (Lugt 14922). Lot 57 in this sale may have included them: "Trois tournois et une cérémonie funèbre du moyen âge, suite de quatre dessins d'un beau style, exécuté dans le XVIᵉ siècle." If this identification is correct, the fourth drawing is missing.

116 By finding out Lenoir's source, his drawings might be traced back to the person who bought the Book in Smyrna and first took it to France—and possibly the present whereabouts of the missing folios.

117 The traces of glue that affixed the removed sheet of parchment to the folio are still visible. Questions of when and why this sheet was removed remain unanswered. It must be noted that the drawing on the preceding folio (76r), executed partly on a rather large sheet of

parchment pasted onto the folio, is still *in situ*; this sheet covered a model drawing, but there was no such motive for folio 77r. Sheets of parchment pasted onto the verso sides of folios g1 and g6 in quire A have also disappeared. It is not certain that these removed sheets contained drawings, as no traces remain and they are not listed in the Index. When and for what reason the sheets were first pasted onto these folio sides and then removed is not clear.

118 The Index describes the drawing on folio 77r as: "*Judit che amazo oloferne e uno fauno.*"

119 According to the Index and Guérin's letter, the missing drawings represent (apart from the "imperadori," folio 11r, probably emperors' portraits on coins): a triumph with many bas-reliefs, a statue on a column in the middle (3r, a hair-side); a tomb with many bas-reliefs and sepulchral inscriptions (4r, a flesh-side); ships seen in different ways (33r); two horses seen in different ways (36r, a flesh-side); a man fallen dead from a horse, architectural scene in lying (i.e., horizontal) format (51r, a flesh-side; lower half of a double-drawing); architectural scene with Doge (Francesco) Foscari and others (61r, a flesh-side); Judith with the head of Holofernes, and a faun (77r, a flesh-side?; horizontal format, small size).

# Appendix B
## PICTORIAL RECONSTRUCTIONS

The illustrations employed in the following reconstruction of the Books predate the infrared photography undertaken by the British Museum and the new transparencies commissioned from the Louvre for the present publication.

## 1. THE BRITISH MUSEUM BOOK

Of heavy white paper, probably made in Venice, the leaves measure 41.3 by 33.5 cm. The watermark was in use in the Veneto about 1440.[1] Unless otherwise noted, all drawings are in leadpoint. Many openings bear two images: that on the recto usually drawn first, that on the verso, sometimes related in subject, perhaps drawn considerably later.

The Book originally consisted of 101 folios. Each recto has two paginations at upper right: below the earlier inked Roman numerals, here designated "e. pag.," is stamped the British Museum's inventory number, here "B.M. inv." This is less by one digit than the Roman numerals, the museum count beginning with folio 2, the first drawing. Subjects drawn more than once are identified by (A), (B), etc. Codicological information is from Dr. Albert Elen (see Appendix A).

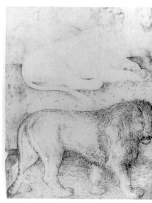

2v (Plate 9) *Study of Lions*. Later partially gone over in pen and greenish wash

0 (no ill.) Missing flyleaf

2v (Plate 9) *Study of Lions*. Later partially gone over in pen and greenish wash

1 (Appendix A, Ill. 1) Inscribed in later Venetian notarial hand near top: *De mano de ms. iacobo bellino veneto, 1430, In venetia*

3 (Plate 8) (e. pag. III, B.M. inv. 2) *Study of Lions*. Partially gone over in pen with traces of green wash

1v (Plate 204) *View of Jerusalem*. Continuation of *Crucifixion with Magdalene*, folio 2

3v (Plate 81) *Monument with Eagle on Orb, Reclining Male Figure Below*. Several additions (in leadpoint?)

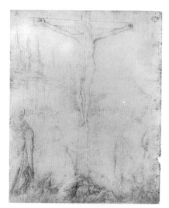

2 (Plate 205) (e. pag. II, B.M. inv. 1) *Crucifixion with Magdalene at Foot of Cross*. Small tears at bottom margin. Some later additions (in leadpoint?)

4 (Plate 79) (e. pag. IV, B.M. inv. 3) *Satyr Riding Winged Unicorn Bearing Corpse*

4v (Plate 231) *Landscape with Figures*. Continuation of *Funeral Procession of the Virgin*, folio 5

5 (Plate 232) (e. pag. V, B.M. inv. 4) *Funeral Procession of the Virgin*. Several additions (in leadpoint?) are found on 5v

5v (Plate 94) *Knight Ready for Tournament*.[2] Several additions (in leadpoint?)

6 (Plate 95) (e. pag. VI, B.M. inv. 5) *Knightly Riders*. Several additions (in leadpoint?)

480

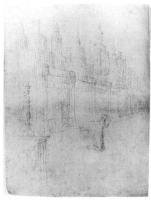
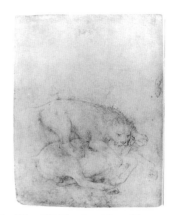
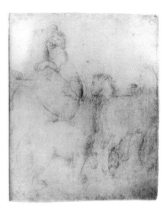
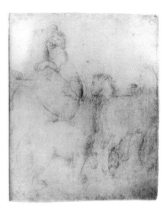

6v (Plate 264) *Princess Kneeling Outside City Walls.* Continuation of *St. George and the Dragon* (A), folio 7. Several additions (in leadpoint?)

7 (Plate 265) (e. pag. VII, B.M. inv. 6) *St. George and the Dragon* (A). Several additions (in leadpoint?)

7v (Plate 12) *Lion Attacking a Horse.* Several additions (in leadpoint?)

8 (Plate 13) (e. pag. VIII, B.M. inv. 7) *Lions Attacking Horses.* Several additions (in leadpoint?)

8v (Plate 14) *Caged Lions Seen through Circular Grill.* Several additions (in leadpoint?)

9 (Plate 15) (e. pag. VIIII, B.M. inv. 8) *Man Wrestling Lion in Enclosure.* Several additions (in leadpoint?)

9v (Plate 266) *Princess Taking Shelter in Castle Entry.* Continuation of *St. George and the Dragon* (B), folio 10

10 (Plate 267) (e. pag. X, B.M. inv. 9) *St. George and the Dragon* (B)

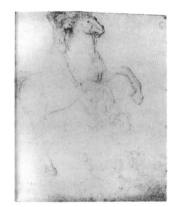

10v (Plate 36) *Landscape with Tree and Riding Figure.* Continuation of *Martyrdom of St. Sebastian*, folio 11

11 (Plate 295) (e. pag. XI, B.M. inv. 10) *Martyrdom of St. Sebastian*

11v (Plate 262) *Princess Seeking Refuge in Palace.* Continuation of *St. George and the Dragon* (C), folio 12

12 (Plate 263) (e. pag. XII, B.M. inv. 11) *St. George and the Dragon* (C)

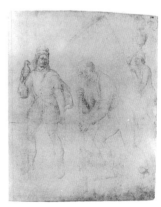

12v (Plate 48) *Venetian Courtyard.* Free continuation of *Annunciation* (A), folio 13

13 (Plate 162) (e. pag. XIII, B.M. inv. 12) *Annunciation* (A)

13v (Plate 23) *Two Men in Semi-classical Garb(?) Standing on Bridge over Canal.* Free continuation of *Falconer, Coal Bearer, and Gardener*, folio 14

14 (Plate 22) (e. pag. XIIII, B.M. inv. 13) *Falconer, Coal Bearer, and Gardener*

 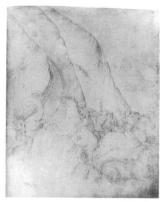 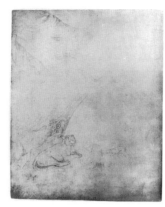 

14v (Plate 103) *Knight Fleeing Dragon.* Continuation of *Three Knights Combatting a Dragon,* folio 15

15 (Plate 104) (e. pag. XV, B.M. inv. 14) *Three Knights on Horseback Combatting Dragon*

15v (Plate 4) *Lions and Cubs.* Continuation of *Baptism of Christ,* folio 16

16 (Plate 185) (e. pag. XVI, B.M. inv. 15) *Baptism of Christ*

 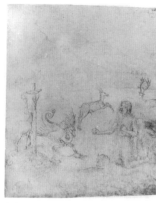  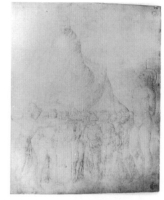

16v (Plate 274) *Landscape with Monster.* Continuation of *St. Jerome in the Wilderness* (A), folio 17

17 (Plate 275) (e. pag. XVII, B.M. inv. 16) *St. Jerome in the Wilderness* (A)

17v (Plate 249) *Archers at Martyrdom.* Continuation of *Martyrdom of St. Christopher,* folio 18

18 (Plate 250) (e. pag. XVIII, B.M. inv. 17) *Martyrdom of St. Christopher*

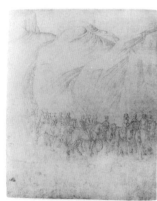   

18v (Plate 172) *Cortege of the Magi.* Continuation of *Adoration of the Magi* (A), folio 19

19 (Plate 173) (e. pag. XVIIII, B.M. inv. 18) *Adoration of the Magi* (A)

19v (Plate 111) *Knight and His Lady with Falcon*

20 (Plate 112) (e. pag. XX, B.M. inv. 19) *Knight with Dwarf, Standing by Horse*

20v (Plate 16) *Two Lions Seen through Rectangular Grill*

21 (Plate 17) (e. pag. XXI, B.M. inv. 20) *Man Piercing Rearing Lion in Left Eye*

21v (Plate 44) *Landscape with City View and Tree.* Continuation of *Resurrection,* folio 22

22 (Plate 225) (e. pag. XXII, B.M. inv. 21) *Resurrection*

22v (Plate 215) *Pietà and Sarcophagus Lid.* Continuation of *Entombment,* folio 23

23 (Plate 216) (e. pag. XXIII, B.M. inv. 22) *Entombment*

23v (Plate 189) *Nine Figures in Oriental Garb(?), Standing in Portico.* Possible continuation of *Entry of Christ into Jerusalem,* folio 24

24 (Plate 190) (e. pag. XXIIII, B.M. inv. 23) *Entry of Christ into Jerusalem*

24v (Plate 268) *Landscape.* Continuation of *St. George and the Dragon* (D), folio 25

25 (Plate 269) (e. pag. XXV, B.M. inv. 24) *St. George and the Dragon* (D)

25v (Plate 223) *Infernal Landscape.* Continuation of *Christ in Limbo,* folio 26

26 (Plate 224) (e. pag. XXVI, B.M. inv. 25) *Christ in Limbo*

26v (Plate 35) *Rustic Landscape with Tree and Masonry Building*

27 (Plate 253) (e. pag. XXVII, B.M. inv. 26) *Vision of St. Eustace* (A)[3]

27v (Plate 132) *Study for Equestrian Monument.*[4] Partially reworked in pen

28 (Plate 240) (e. pag. XXVIII, B.M. inv. 27) *Study for Altar*[5]

28v (Plate 27) *Landscape with Masonry Structures.* Continuation of *St. Christopher* (A), folio 29

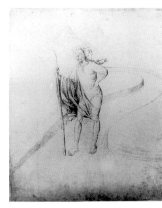

29 (Plate 245) (e. pag. XXVIIII, B.M. inv. 28) *St. Christopher* (A). Partially reworked in pen and wash

29v (Plate 42) *Rustic Architecture with Cattle*

30 (Plate 180) (e. pag. XXX, B.M. inv. 29) *Flight into Egypt*

30v (Plate 69) *Nude Women and Children*

31 (Plate 70) (e. pag. XXXI, B.M. inv. 30) *Nude Women and Children in Bathing Pavilion*

31v (Plate 71) *Nude Women with Children Preparing for Battle*

32 (Plate 72) (e. pag. XXXII, B.M. inv. 31) *Nude Women in Combat*

32v (Plate 196) *Pilate Enthroned, Witnessing Flagellation*. Continuation of *Flagellation* (A), folio 33

33 (Plate 197) (e. pag. XXXIII, B.M. inv. 32) *Flagellation* (A).

33v (Plate 19) *Rustic St. Christopherlike Man and Woman*

34 (Plate 20) (e. pag. XXXIIII, B.M. inv. 33) *Rustic Figures*

34v (Plate 148) *Holofernes(?) on Horseback, with Soldiers*

35 (Plate 149) (e. pag. XXXV, B.M. inv. 34) *Judith with the Head of Holofernes*

35v (Plate 117) *Knights Preparing for Combat*

36 (Plate 118) (e. pag. XXXVI, B.M. inv. 35) *Charging Knight with Lance*

36v (Plate 29) *Farm Youth with Horses*. Continuation of *Rustic Scene*, folio 37

37 (Plate 30) (e. pag. XXXVII, B.M. inv. 36) *Rustic Scene: Peasant on an Ass with Foal*

37v (Plate 293) *Military and Other Riders*. Continuation of *Conversion of St. Paul*, folio 38

38 (Plate 294) (e. pag. XXXVIII, B.M. inv. 37) *Conversion of St. Paul*

38v (Plate 25) *Rustic Figures under a Trellis*

39 (Plate 288) (e. pag. XXXVIIII, B.M. inv. 38) *St. Martin Sharing His Cloak with a Beggar*

39v (no ill.) Blank

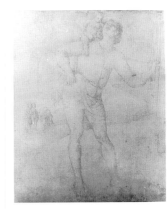

40 (Plate 244) (e. pag. XXXX, B.M. inv. 39) *St. Christopher* (B)

40v (no ill.) *Wing Tip*. Continuation of *St. Michael Archangel and the Dragon*, folio 41

41 (Plate 289) (e. pag. XXXXI, B.M. inv. 40) *St. Michael Archangel and the Dragon*

41v (Plate 33) *Watering Horses in the Woods*. Continuation of *Stigmatization of St. Francis*, folio 42

42 (Plate 257) (e. pag. XXXXII, B.M. inv. 41) *Stigmatization of St. Francis*

42v (Plate 144) *Temptation, Fall, and Expulsion*. Continuation of *Adam and Eve with God the Father*, folio 43

43 (Plate 142) (e. pag. XXXXIII, B.M. inv. 42) *Adam and Eve with God the Father*

43v (Plate 192) *Judas Leading the Roman Soldiers*

44 (Plate 193) (e. pag. XXXXIIII, B.M. inv. 43) *Agony in the Garden*

44v (Plate 38) *Landscape with Rider Crossing a Bridge*

45 (Plate 146) (e. pag. XXXXV, B.M. inv. 44) *David Triumphant*

45v (Plate 39) *Rustic Landscape with Fortified Tower*[6]

46 (Plate 145) (e. pag. XXXXVI, B.M. inv. 45) *David and Goliath*. Partially reworked in pen

46v (Plate 54) *Solomon's Stables(?)*

47 (Plate 152) (e. pag. XXXXVII, B.M. inv. 46) *Judgment of Solomon*

47v (Plate 31) *City View*

48 (Plate 32) (e. pag. XXXXVIII, B.M. inv. 47) *Equestrian Lady and Her Retinue*

48v (Plate 291) *Montainous Terrain.* Continuation of *St. Michael Archangel and Demons,* folio 49

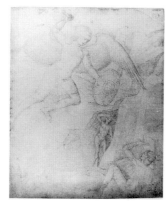

49 (Plate 292) (e. pag. XXXXVIIII, B.M. inv. 48) *St. Michael Archangel and Demons*

49v (Plate 125) *Mountain Landscape with Figures.* Continuation of *The Three Living and the Three Dead,* folio 50

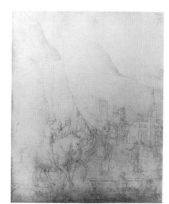

50 (Plate 126) (e. pag. XXXXX, B.M. inv. 49) *The Three Living and the Three Dead*

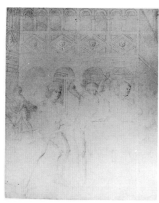

50v (Plate 121) *Three Men Trying to Subdue Horse.* Continuation of *Rearing Horse and Fallen Man,* folio 51

51 (Plate 122) (e. pag. XXXXXI, B.M. inv. 50) *Rearing Horse and Fallen Man*

51v (Plate 57) *Shop(?) with Woman Working Wool*

52 (Plate 24) (e. pag. XXXXXII, B.M. inv. 51) *Two Men Bearing Vintage*

52v (Plate 107) *Fleeing Figures*

53 (Plate 108) (e. pag. XXXXXIII, B.M. inv. 52) *Satyr Riding Lion with Horseman and Archer*

53v (Plate 115) *Rider on Rearing Horse.* Continuation of *Knight and Attendants Ready for Tournament,* folio 54

54 (Plate 116) (e. pag. XXXXXIIII, B.M. inv. 53) *Knight and Attendants Ready for Tournament* [7]

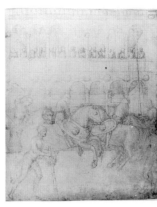

54v (Plate 119) *Clock Tower and Courtyard with Many Figures.* Continuation of *Tournament*, folio 55

55 (Plate 120) (e. pag. XXXXXV, B.M. inv. 54) *Tournament*

55v (Plate 129) *Rider and Standing Figures by Corpse*

56 (Plate 238) (e. pag. XXXXXVI, B.M. inv. 55) *Throne of Grace.* Partly reworked in pen

56v (Plate 49) *City View with Stairs*

57 (Plate 127) (e. pag. XXXXXVII, B.M. inv. 56) *Rider and Others with Dead Man on Ground*

57v (Plate 43) *Palace Courtyard with Wellhead*

58 (Plate 157) (e. pag. XXXXXVIII, B.M. inv. 57) *Presentation of the Virgin in the Temple* (A)

58v (Plate 227) *Landscape with Foot-bridge and Eagles*

59 (Plate 228) (e. pag. XXXXX-VIIII, B.M. inv. 58) *Ascension of Christ*

59v (Plate 73) *Wingless Putti at the Vintage*

60 (Plate 139) (e. pag. XXXXXX, B.M. inv. 59) *Adoration of the Magi* (B)

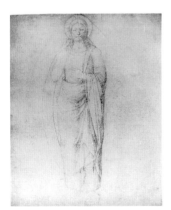

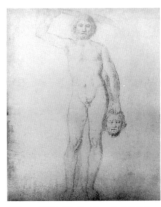

60v (Plate 237) *Christ in a Mandorla*

61 (no ill.) (e. pag. XXXXXXI, B.M. inv. 60) Blank Circles

61v (Plate 150) *Nude Bearded Male (David?) Holding Severed Head*

62 (no ill.) (e. pag. XXXXXXII, B.M. inv. 61) Blank Circles

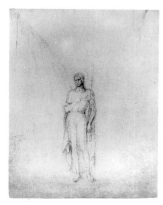

62v (Plate 278) *St. John the Baptist in the Wilderness*

63 (no ill.) (e. pag. XXXXXXIII, B.M. inv. 62) Blank Circles

63v (Plate 273) *Penitent St. Jerome in the Wilderness*

64 (no ill.) (e. pag. XXXXXXIIII, B.M. inv. 63) Blank Circles

64v (Plate 166) *Nativity* (A)

65 (no ill.) (e. pag. XXXXXXV, B.M. inv. 64) Blank Circles

65v (Plate 60) *Urban Setting with Cripple.* Continuation of *Raising of Lazarus,* folio 66

66 (Plate 187) (e. pag. XXXXX-XVI, B.M. inv. 65) *Raising of Lazarus*

66v (Plate 51) *Venetian Urban View with Fountain.* Continuation of *Death of the Virgin,* folio 67

67 (Plate 229) (e. pag. XXXXXX-VII, B.M. inv. 66) *Death of the Virgin*

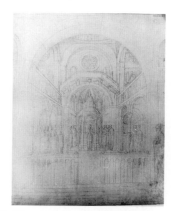

67v (Plate 41) *Landscape with Covered Wagon*

68 (Plate 160) (e. pag. XXXXXX-VIII, B.M. inv. 67) *Presentation of the Virgin in the Temple* (B)

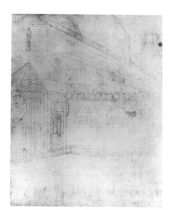

68v (Plate 46) *Urban View with Campanile*

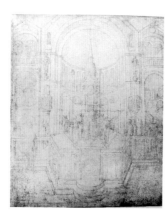

69 (Plate 178) (e. pag. XXXXXX-VIIII, B.M. inv. 68) *Presentation of Christ in the Temple*

69v (Plate 50) *Courtyard with Sculptor at Work*

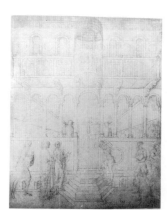

70 (Plate 183) (e. pag. XXXXXXX, B.M. inv. 69) *Christ among the Doctors*

70v (Plate 47) *Urban View with Basin in Foreground*

71 (Plate 199) (e. pag. XXXXX-XXI, B.M. inv. 70) *Flagellation* (B)

71v (Plate 34) *Wooded Landscape.* Free continuation of *Vision of St. Eustace* (B), folio 72

72 (Plate 254) (e. pag. XXXXXX-XII, B.M. inv. 71) *Vision of St. Eustace* (B)

72v (Plate 55) *Urban View with Arcade and Kitchen Window*

73 (Plate 184) (e. pag. XXXXXXX-III, B.M. inv. 72) *Wedding at Cana*

73v (Plate 63) *Polygonal Building in Urban Setting*

74 (Plate 200) (e. pag. XXXXXXX-IIII, B.M. inv. 73) *Flagellation* (C)

74v (Plate 286) *Herod's Palace and Cortile.* Continuation of *Beheading of St. John the Baptist,* folio 75

75 (Plate 287) (e. pag. XXXXX-XXV, B.M. inv. 74) *Beheading of St. John the Baptist*

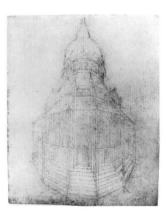

75v (Plate 64) *Polygonal Temple*

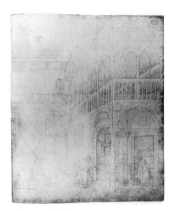

76 (Plate 163) (e. pag. XXXXXX-XVI, B.M. inv. 75) *Annunciation* (B)

76v (Plate 40) *Landscape with Forti-fied Tower.* Continuation of *Crucifixion* (A), folio 77

77 (Plate 206) (e. pag. XXXXXXX-VII, B.M. inv. 76) *Cruci-fixion* (A)

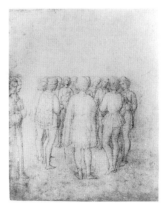

77v (Plate 28) *Concerned Courtiers with Clerics*

78 (Plate 207) (e. pag. XXXXXXX-VIII, B.M. inv. 77) *Cruci-fixion* (B)

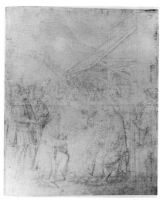

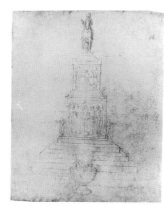

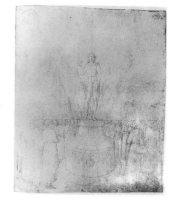

78v (Plate 176) *Rustic Landscape.* Free continuation of *Adoration of the Magi* (C), folio 79

79 (Plate 177) (e. pag. XXXXXXX-VIIII, B.M. inv. 78) *Adoration of the Magi* (C)

79v (Plate 132) *Three-tiered Funerary Monument*

80 (Plate 280) (e. pag. XXXXX-XXX, B.M. inv. 79) *St. John the Baptist Preaching*

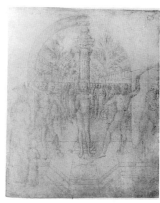

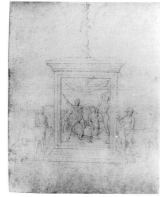

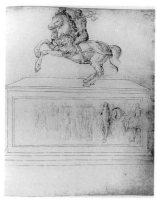

80v (Plate 242) *Bernardino da Siena Preaching* (A)

81 (Plate 198) (e. pag. XXXXXX-XXI, B.M. inv. 80) *Flagellation* (D)

81v (Plate 80) *Altar with Candlestick*

82 (Plate 78) (e. pag. XXXXXXX-XII, B.M. inv. 81) *Rearing Equestrian Group on Base.* Partially and crudely reinked

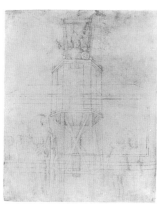

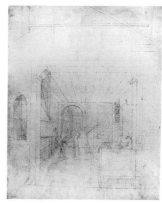

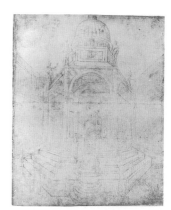

82v (Plate 243) *Bernardino da Siena Preaching* (B)[8]

83 (Plate 137) (e. pag. XXXXXXX-XIII, B.M. inv. 82) *Funerary Monument with Crucifixion*

83v (Plate 56) *Forge with Anchor*

84 (Plate 161) (e. pag. XXXXXXX-XIIII, B.M. inv. 83) *Temple of Jerusalem(?)*

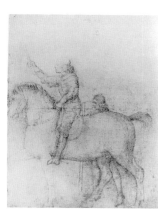

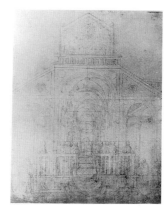

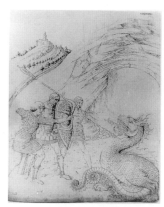

84v (Plate 93) *Young Cavalier with Baton and Attendant*

85 (Plate 62) (e. pag. XXXXXX-XXV, B.M. inv. 84) *Church with Open Façade* (A)

85v (Plate 99) *Two Men in Flight, Having Abandoned Arms.* Continuation of *Three Soldiers Attacking Dragon,* folio 86. Crudely reworked in ink

86 (Plate 100) (e. pag. XXXXXXX-XVI, B.M. inv. 85) *Three Soldiers Attacking Dragon.* Crudely reworked in ink

86v (Plate 210) *Crucifixion* (C)

87 (Plate 236) (e. pag. XXXXXXX-XVII, B.M. inv. 86) *Virgin Mary in a Mandorla.* Some coarse pen work

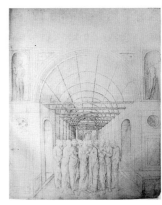

87v (Plate 272) *St. Jerome Reading in the Wilderness*

88 (Plate 235) (e. pag. XXXXXXX-XVIII, B.M. inv. 87) *Twelve Apostles* (A). Partially and crudely reworked in wash

88v (Plate 167) *Barn*

89 (Plate 61) (e. pag. XXXXXXX-XVIIII, B.M. inv. 88) *Church with Open Façade* (B)

89v (Plate 3) *Palace Zoo*

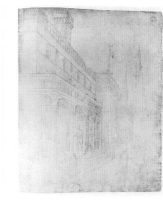

90 (Plate 201) (e. pag. XXXXXX-XXX, B.M. inv. 89) *Flagellation* (E)

90v (Plate 74) *Deer and Putti*

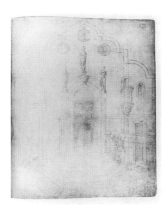

91 (Plate 128) (e. pag. XXXXXXX-XXI, B.M. inv. 90) *Church with Open Façade* (C) *and Pall-bearers*

91v (Plate 239) *Twelve Apostles* (B)

92 (Plate 53) (e. pag. XXXXXXX-XXII, B.M. inv. 91) *Veduta with Boys Bathing and Others on Float in Canal*

92v (Plate 5) *Cheetah Studies*

93 (Plate 52) (e. pag. XXXXXXX-XXIII, B.M. inv. 92) *Venetian Gothic Palace*

93v (Plate 76) *Satyrs in Landscape.* Continuation of *Chariot of Bacchus,* folio 94

94 (Plate 77) (e. pag. XXXXXXX-XXIIII, B.M. inv. 93) *Chariot of Bacchus*

94v (Plate 21) *Four Adults*

95 (Plate 124) (e. pag. XXXXXX-XXXV, B.M. inv. 94) *Triumphal Wagon in Urban Setting.* Redrawing in ink, added wash

95v (Plate 123) *Three Military Figures*

96 (Plate 281) (e. pag. XXXXXXX-XXVI, B.M. inv. 95) *St. John the Baptist Preaching in Courtyard*

96v (Plate 37) *Landscape with Equestrian Figures and Bare Tree*

97 (Plate 26) (e. pag. XXXXXXX-XXVII, B.M. inv. 96) *Fountain Study*

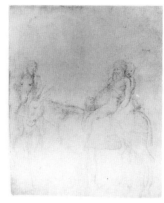

97v (Plate 75) *Drunken Silenus and Attendants*

98 (Plate 45) (e. pag. XXXXXXX-XXVIII, B.M. inv. 97) *City Walls with Well*

98v (Plate 168) *Magi on Horseback*

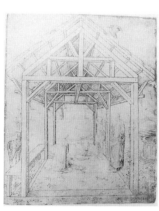

99 (Plate 169) (e. pag. XXXXXXX-XXVIIII, B.M. inv. 98) *Nativity* (B). Partly reworked in dry pen strokes

99v (no ill.) Blank

100 (no ill.) Missing flyleaf

1 C. M. Briquet, *Les Filigranes*, Paris: 1907, I, 183ff; Goloubew, I, 1912, preliminary note 3. See Appendix A, Ills. 2, 3.

2 According to Goloubew, I, VII, the rider is Lionello d'Este and the device of the head with bandaged eyes on his caparison refers to the Este device, "*quae vides, ne vide.*"

3 The heavily reinked monument design on the verso has worked its way through, largely obscuring this composition.

4 Goloubew, I, XXXI, related this image to Donatello's *Gattamelata*; it may represent a project of Jacopo's for the same commission.

5 Probably for a carved altarpiece, but may relate to Jacopo's commission for the Sala del Patriarcha, 1457 (Appendix E, Doc. 1456/

57). A study for a stepped pool on the verso, heavily penned, has worked its way through.

6 Perhaps intended as a symbol of the House of David.

7 According to Gronau, this is Borso d'Este preparing for a tournament.

8 Inked lines have worked their way through from the statuary base on the recto.

492

## 2. THE LOUVRE BOOK

The sequence of folios and all interpretation of the location and character of missing folios are based on Dr. Albert Elen's reconstruction of this volume; in Appendix A he discusses its original appearance and history. Codicological data are taken from him, and from Degenhart and Schmitt (1984), who first published the inclusion and partial reworking of an earlier pattern book. Unless otherwise noted, the drawings are in brown inks on vellum. Height of sheet varies from 42.2 to 42.8 cm., width from 28.3 to 29.3 cm. "H" signifies the hair-side of the vellum, "F" the flesh-side, the latter slightly smoother in texture than the former. The same subjects drawn several times are identified by (A), (B), etc. The Index (Appendix A, Ill. 7) is transcribed in Appendix C.

(no ill.) Paper pastedown

(no ill.) Paper flyleaf

(no ill.) *Geometric Figures.* Evidence of one pasted-down rectangular addition (now missing)

A (no ill.) Blank. H

Av (no ill.) Blank. F

B (no ill.) Blank. F

Bv (no ill.) Blank. H

C (no ill.) Blank. H

Cv (no ill.) Blank. F

D (no ill.) Blank. F

Dv (no ill.) Blank. H

E (no ill.) Blank. F

Ev (no ill.) Blank. H. Traces of a pasted-down piece of parchment (now missing; with drawing?) as in first unnumbered folio and folio 77

1 (Plate 141) (R.F. 1475) *Christ Nailed to the Cross*. H. Partially reinked, with touches of white and traces of underdrawing

1v (Plate 219) (R.F. 1475v) *Dead Christ in Frame*.[1] F. Silverpoint or leadpoint

2 (Plate 136) (R.F. 428; His de la Salle Donation) *Effigy of Nude Military Hero*.[2] F

2v (no ill.) Pasted down. Probably blank. H

3 (no ill.) Missing. Removed folio. Probably with drawing. H

3v (no ill.) Missing. Removed folio. Probably blank. F

4 (no ill.) Removed folio. Probably with drawing.[3] F

4v (no ill.) Removed folio. Probably blank. H

5 (Plate 195) (R.F. 1476, Index 5) *Flagellation by Torchlight* (A). H

5v (no ill.) Blank. F

6 (Plate 282) (R.F. 1477, Index 6) *St. John the Baptist Preaching in a Harbor City*. F

6v (no ill.) Blank. H

7 (Plate 179) (R.F. 1478, Index 7) *Presentation of Christ in the Temple*. H

7v (no ill.) Blank. F

8 (no ill.) Removed folio. Six rows of five circles,[4] as in folio 10. F

494

8v (no ill.) Removed folio. Probably blank. H

9 (no ill.) Removed folio. Six rows of five circles,[5] as in folio 10. H

9v (no ill.) Removed folio. Probably blank. F

10 (Appendix A, Ill. 10) Removed folio. Six rows of five circles.[6] F

10v (no ill.) Removed folio. Blank. H

11 (no ill.) Removed folio. Six rows of five circles.[7] H

11v (no ill.) Removed folio, probably blank. F

12 (Plate 234) (R.F. 1479, Index 12) *Funeral Procession of the Virgin*. F

12v (no ill.) Blank. H

13 (Plate 134) (R.F. 1480, Index 13) *Tomb of a Law Professor*. H

13v (no ill.) Blank. F

14 (Plate 260) (R.F. 1481, Index 14) *St. George and the Dragon* (A). F. With wash

14v (no ill.) Blank. H

15 (Plate 261) (R.F. 1482, Index 15) *St. George and the Dragon* (B)[8]

15v (no ill.) Blank

16 (Plate 202) (R.F. 1483, Index 16) *Flagellation by Torchlight* (B). H

16v (Plate 284) *Feast of Herod*. F

17 (Plate 285) (R.F. 1484, Index 17) *Beheading of St. John the Baptist*. H

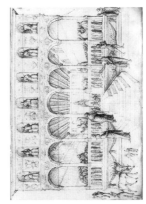

17v (Plate 181) *Top of Synagogue*. Continuation of *Christ among the Doctors*, folio 18. H

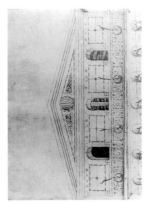

18 (Plate 182) (R.F. 1485, Index 18) *Christ among the Doctors*. F

18v (no ill.) Blank. H

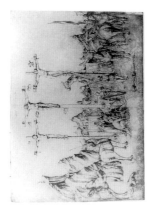

19 (Plate 208) (R.F. 1486, Index 19) *Crucifixion*. H

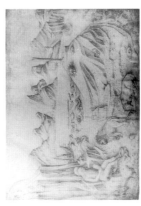

19v (Plate 277) *St. Jerome Reading in the Wilderness* (A). F. Silverpoint on gray chalk ground

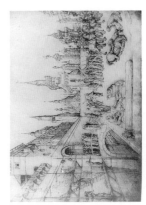

20 (Plate 140) (R.F. 1487, Index 20) *Christ Leaving Jerusalem for Calvary/Christ Bearing the Cross*. F

20v (no ill.) Blank. H

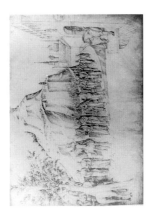

21 (Plate 191) (R.F. 1488, Index 21) *Entry of Christ into Jerusalem*. H

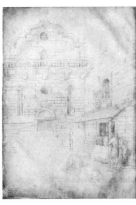

21v (Plate 188) *Raising of Lazarus*. F. Silverpoint and leadpoint on gray chalk ground

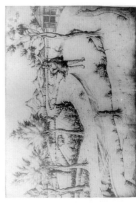

22 (Plate 248) (R.F. 1489, Index 22) *St. Christopher* (A). F

22v (Plate 222) *Christ in Limbo*. H. Silverpoint on gray chalk ground

23 (Plate 1) (R.F. 1490, Index 23) *Young Man in Left Profile*. H. Silverpoint on gray chalk ground

23v (Plate 276) *St. Jerome in the Wilderness* (B). F

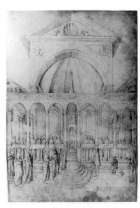

24 (Plate 158) (R.F. 1491, Index 24) *Presentation of the Virgin in the Temple* (A). H

24v (no ill.) Blank. F

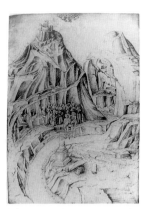

25 (Plate 186) (R.F. 1492, Index 25) *Baptism of Christ*. F

25v (Plate 153) *Judgment Hall*. Continuation of *Judgment of Solomon*, folio 26. H

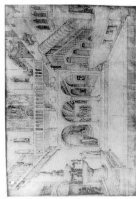

26 (Plate 154) (R.F. 1493, Index 26) *Judgment of Solomon*. H

26v (no ill.) Blank. F

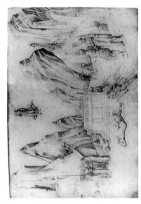

27 (Plate 226) (R.F. 1494, Index 27) *Resurrection*. F

27v (no ill.) Blank. H

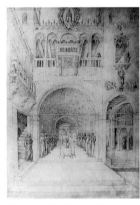

28 (Plate 230) (R.F. 1495, Index 28) *Death of the Virgin*. H

28v (no ill.) Blank. F

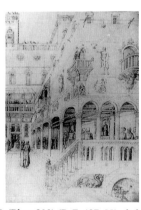

29 (Plate 203) (R.F. 427, His de la Salle Donation; Index 29) Probably *Flagellation* (C).⁹ F

29v (no ill.) If this folio is Index 29, it is pasted down, probably blank. H

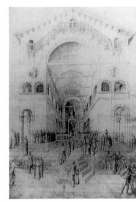

30 (Plate 159) (R.F. 1496, Index 30) *Presentation of the Virgin in the Temple* (B). H

30v (Plate 164) Continuation of *Annunciation*, folio 31. F

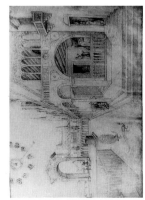

31 (Plate 165) (R.F. 1497, Index 31) *Annunciation*. F

31v (Plate 174) *Mountaintop*. Continuation of *Adoration of the Magi* (A), folio 32. H

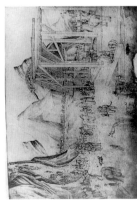

32 (Plate 175) (R.F. 1498, Index 32) *Adoration of the Magi* (A). H. Loss at right margin

32v (no ill.) Blank. F

33 (no ill.) Missing folio (Index 33: *Various ships*[10]). F or H unknown

33v (no ill.) Missing folio. Probably a continuation of mountaintops in folio 34. May have resembled folio 31v. F or H unknown

34 (Plate 171) (R.F. 1499, Index 34) *Adoration of the Magi* (B). F

34v (no ill.) Blank. H

35 (Plate 283) (R.F. 1500, Index 35) *St. John the Baptist Standing in a Niche.*[11] H

35v (no ill.) Blank. F

36 (no ill.) Missing folio (Index 36: *Studies of Horses*[12]). F

36v (no ill.) Missing folio. Probably blank. H

37 (Plate 170) (R.F. 1501, Index 37) *Adoration of the Shepherds.* F

37v (no ill.) Blank. H

38 (Plate 214) (R.F. 1502, Index 38) *Deposition and Lamentation.* H

38v (no ill.) Blank. H

39 (Plate 194) (R.F. 1503, Index 39) *Christ before Pilate.* F

39v (no ill.) Blank. H

40 (Plate 82) (R.F. 1504, Index 40) *Bacchus and Satyrs.* H

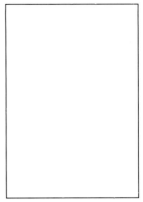

40v (no ill.) Blank. F

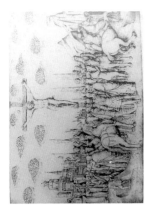

41 (Plate 209) (R.F. 1505, Index 41) *Christ Crucified*. F. Touches of bistre in halo; cross in yellow wash

41v (Plate 251) *Landscape*. Continuation of *Vision of St. Eustace*, folio 42. H

42 (Plate 252) (R.F. 1506, Index 42) *Vision of St. Eustace*. H

42v (no ill.) Blank. F

43 (Plate 83) (R.F. 1507, Index 43) *Cupid Abducting Satyr*.[13] F

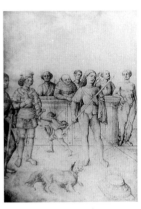

43v (Plate 105) *Various Onlookers and Attendants*. Continuation of *Equestrian Knight at Open Grave*, folio 44. H

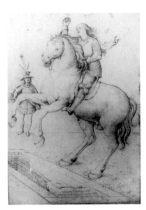

44 (Plate 106) (R.F. 1508, Index 44) *Equestrian Knight and Messenger at Open Grave*.[14] H. Traces of leadpoint

44v (no ill.) Blank. F

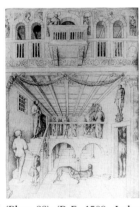

45 (Plate 88) (R.F. 1509, Index 45) *Enthroned Ruler Presented with Severed Head*.[15] F. Traces of leadpoint

45v (no ill.) Blank. H

46 (Plate 89) (R.F. 1510, Index 46) *Departure for the Hunt*. H

46v (Plate 90) (R.F. 1510v) *Classical Scene: Knights and Peasant*. F

47 (Plate 91) (R.F. 1511, Index 47) *Destruction of Pagan Altar by Roman Soldiers*. F. Loss at upper right

47v (no ill.) Blank. H

48 (Plate 84) (R.F. 1512, Index 48) *Studies of Roman Tombs and Altars*. H

48v (no ill.) Blank. F

49 (Plate 86) (R.F. 1513, Index 49) *Studies of Three Classical Monuments*. F

49v (Plate 270) *Landscape*. Continuation of *Martyrdom of St. Isidore*, folio 50. H

50 (Plate 271) (R.F. 1514, Index 50) *Martyrdom of St. Isidore*. H. Traces of leadpoint

50v (Plate 58) *Venetian Wooden Balcony*. Continuation of *Falling Horseman* (missing), folio 51. F

51 (no ill.) Missing folio (Index 51: *Falling Horseman*[16]). F [see British Museum Book, folio 51]

51v (no ill.) Missing folio. Probably blank. H

52 (Plate 114) (R.F. 1515, Index 52) *Knight and Steed Ready for Tournament or Other Court Festivity*. H. Traces of leadpoint

52v (no ill.) Blank. F

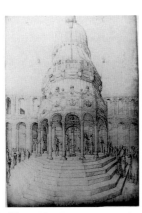

53 (Plate 92) (R.F. 1516, Index 53) *Central-plan Temple with Idol*. F

53v (no ill.) *Lance Tip*. Continuation of *Three Warriors Battling Dragon* (A), folio 54. H

54 (Plate 97) (R.F. 1517, Index 54) *Three Warriors Battling Dragon* (A). H

54v (no ill.) *Sword Tip*. Continuation of *Three Warriors Battling Dragon* (B), folio 55. F

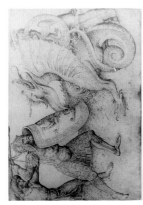

55 (Plate 98) (R.F. 1518, Index 55) *Three Warriors Battling Dragon* (B). F. Traces of leadpoint

55v (no ill.) Blank. H

56 (Fig. 14) (R.F. 1519, Index 56) *Chariot Bearing Nude Male Prisoner*. H. Silverpoint on dark gray chalk ground, partially obscuring page of reused pattern book[17]

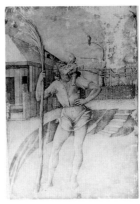

56v (Plate 247) *St. Christopher* (B). F. Silverpoint with white and brown wash on gray chalk ground, reused pattern book page. Flaking in sky, saint's face, and elsewhere

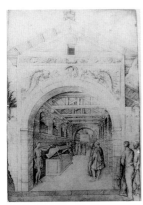

57 (Plate 221) (R.F. 1520, Index 57) *Three Marys and Other Mourners at the Tomb.* F

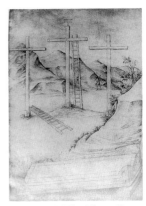

57v (Plate 217) *The Three Crosses and Sarcophagus Lid.* Continuation of *Entombment,* folio 58. H

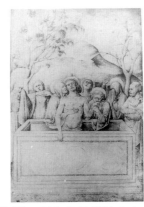

58 (Plate 218) (R.F. 1521, Index 58) *Entombment.* H

58v (no ill.) Blank. H

59 (Plate 220) (R.F. 1522, Index 59) *Lamentation/Entombment.* F. Some leadpoint, partially gone over in brush

59v (no ill.) Blank. H

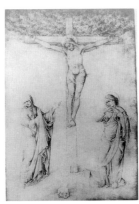

60 (Plate 211) (R.F. 1523, Index 60) *Virgin and St. John the Evangelist Mourn Christ Crucified.* H. Traces of leadpoint

60v (no ill.) Blank. F

61 (no ill.) Missing folio (Index 61: *A Setting with Doge Foscari and Others*[18]). F

61v (no ill.) Missing folio. Probably blank. H

62 (Plate 2) (R.F. 1524, Index 62) *Iris.* H. Brushed in violet, purple, and blue; yellow and green in chalk and watercolor

62v (no ill.) Blank. F

63 (Plate 213) (R.F. 1525, Index 63) *Golgotha.* F. Brushed in gray-brown; reworked in pen and ink

63v (no ill.) Blank. H

64 (Plate 85) (R.F. 1526, Index 64) *Footed Shallow Vessel.* H. Silverpoint or leadpoint and brush in gray-brown

501

64v (no ill.) Blank. H

65 (Plate 87) (R.F. 1527, Index 65) *Metal Bowl.* F. Silverpoint and brush in gray and a warmer tone, highlights in white hatching

65v (Plate 10) *Two Lions, a Lioness, and Two Cubs.* H. Silverpoint and gray leadpoint, with brushed white areas

66 (no ill.) (R.F. 1528, Index 66) Blank. H

66v (Plate 143) *Adam and Eve with God the Father* (left), *by the Tree of Knowledge* (center), and *Expulsion* (right). F. Silverpoint and leadpoint

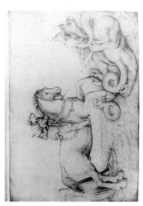

67 (Plate 259) (R.F. 1529, Index 67) *St. George and the Dragon* (C). F

67v (no ill.) Blank. H

68 (Plate 296) (R.F. 1530, Index 68) *Martyrdom of St. Sebastian.*[19] H

68v (no ill.) Blank. F

69 (Plate 290) (R.F. 1531, Index 69) *St. Michael Archangel and the Dragon.*[20] F

69v (no ill.) Blank. H

70 (Plate 18) (R.F. 1532, Index 70) *Coal Bearer and Military Officer on Horseback.* H

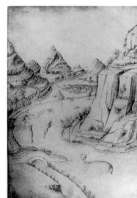

70v (Plate 255) *Landscape.* Continuation of *Stigmatization of St. Francis,* folio 71. F

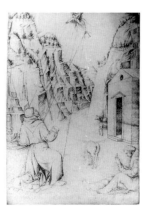

71 (Plate 256) (R.F. 1533, Index 71) *Stigmatization of St. Francis.* F

71v (no ill.) Blank. H

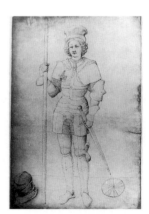

72 (Plate 109) (R.F. 1534, Index 72) *Knight in Renaissance Armor,* "uno armado . . . a la moderna" (St. George?). H

72v (no ill.) Blank. F

73 (Plate 241) (R.F. 1535, Index 73) *Study for Altarpiece.* F. Silverpoint or leadpoint, partially reworked in pen

73v (no ill.) Blank. H

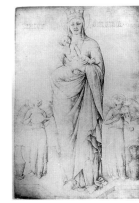

74 (Plate 138) (R.F. 1536, Index 74) *Mater Omnium.*[21] H

74v (no ill.) Blank. F

75 (Plate 101) (R.F. 1537, Index 75) *Footsoldier Fighting Mounted Horseman.* F. Silverpoint on pink chalk ground

75v (Plate 59) *Urban Square with Church Façade.* H

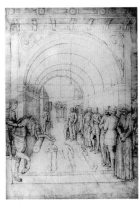

76 (Plate 130) (R.F. 1538, Index 76) *Three Male Corpses with Equestrian Warrior.* H. A vellum sheet was pasted over page of reused pattern book

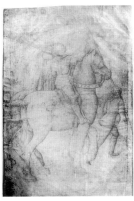

76v (Plate 102) *Two Knights and Footsoldier.* F. Silverpoint on a pink chalk ground, over page of reused pattern book

77 (Figs. 10, 17) (R.F. 1539, Index 77) *Satyr, Vase, and Body of Holofernes(?).*[22] F. Lower right corner lost

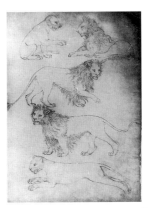

77v (Plate 7) *Five Lions.* H. Penned by an earlier hand on page of reused pattern book[23]

78 (no ill.) (R.F. 1540, Index 78) Blank. H

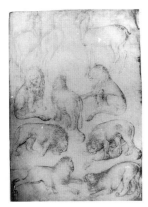

78v (Plate 6) *Seven Lions and Three Stags.*[24] F. Loss at upper right. Silverpoint on gray chalk ground. Reused pattern book page reinked at lower left and elsewhere

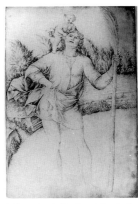

79 (Plate 246) (R.F. 1541, Index 79) *St. Christopher* (C). F. Silverpoint or leadpoint. Partial reinking.[25] Loss at lower right corner

79v (no ill.) Blank. H

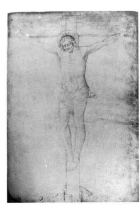

80 (Plate 212) (R.F. 1542, Index 80) *Christ on the Cross.* H. Silverpoint or leadpoint, partially reinked

80v (no ill.) Blank. F

81 (Plate 96) (R.F. 1543, Index 81) *Six Horsemen Fighting Dragons.* F. Losses along right edge

81v (no ill.) Blank. H

82 (Plate 67) (R.F. 1544, Index 82) *Study after Antique Statue of Pugilist.* H. Silverpoint on gray chalk ground, over page of reused pattern book

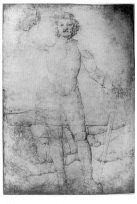

82v (Plate 147) *David with the Head of Goliath.* F. Silverpoint and gray-brown wash on gray chalk ground, over page of reused pattern book[26]

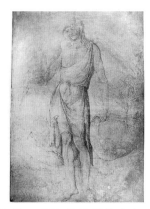

83 (Plate 279) (R.F. 1545, Index 83) *St. John the Baptist.* F. Silverpoint; gray-brown medium on gray chalk ground, reused pattern book page

83v (no ill.) Blank. H. Gray chalk ground, over page of reused pattern book. Extensive water damage

84 (Plate 258) (R.F. 1546, Index 84) *St. George and the Dragon* (D). H. Silverpoint and brown wash on gray chalk ground, over page of reused pattern book. Water damage

84v (Appendix A, Ill. 7, left) Blank. F. Gray-brown wash, over page of reused pattern book. Water damage

85 (Plate 65) (R.F. 1547, Index 85) *Antique Nude Male Bearing Capital.* F. Partially reinked, excluding leadpoint areas

85v (no ill.) Blank. H. Covered with gray chalk ground

86 (Plate 11) (R.F. 1548, Index 86) *Two Lions.* H. Silverpoint on gray-brown chalk ground

86v (no ill.) Blank. F

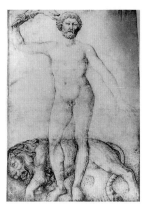

87 (Plate 151) (R.F. 1549, Index 87, as "Hercules") *Samson Holding Jawbone.* F. Metalpoint (leadpoint?) and pen

87v (no ill.) Blank. H. Covered with gray chalk ground

88 (Plate 68) (R.F. 1550, Index 88) *Three Nude Women with Three Children*[27] (Judgment of Paris?). H. Metalpoint (silverpoint?) on gray-brown chalk ground

504

88v (no ill.) Blank. F

89 (Plate 66) (R.F. 1551, Index 89) *Samson Wrestling with the Lion*. F. Metalpoint and gray brushed medium

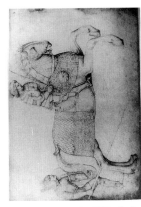

89v (no ill.) Blank. H

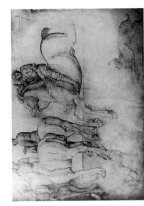

90 (Plate 113) (R.F. 1552, Index 90) *Knight and Footsoldier*. H

90v (no ill.) Blank. F

91 (Plate 135) (R.F. 425, His de la Salle Donation; Index 91) *The Three Living and the Three Dead*. F. Cut down about 6 cm. all around, most at top; present dimensions 22 x 41 cm.

91v (no ill.) Pasted down. Probably blank. H

92 (Plate 110) (R.F. 1553, Index 92) *Four Horsemen and Two Dogs*. H. Leadpoint, partially reinked.[28] Losses at upper left

92v (Plate 155) Continuation of *Susanna and the Elders Brought before Daniel*, folio 93. F

93 (Plate 156) (R.F. 1554, Index 93) *Susanna and the Elders Brought before Daniel*.[29] F. Losses at top and bottom

93v (no ill.) Blank. H. Pinkish-purple chalk ground

94 (Plate 133) (R.F. 1555, Index 94) *Knight's Tomb*. H. Silverpoint on gray chalk ground. Loss at upper left

94v (no ill.) Blank. F

95 (no ill.) (R.F. 1556, Index 95) *Courtiers with Animals*. F. Silverpoint on pink chalk ground, over page of orientalizing textile pattern[30]

95v (Plate 297) Orientalizing textile pattern, page of pattern book by earlier hand. H

F (no ill.) Blank.[31] F

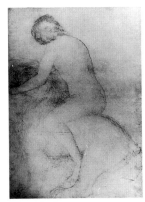

Fv (no ill.) Blank. H

G (no ill.) Blank. H

Gv (no ill.) Blank. F

H (no ill.) Blank. F

Hv (no ill.) Blank. H

I (no ill.) Blank. H

Iv (no ill.) Blank. F

Index (Appendix A, Ill. 7, right)
Index (near 1500?) in Venetian
dialect. H[32]

Index v (Appendix A, Ill. 10, left)
Offprint of circle pattern.[33] F

Loose folio (e94) (Appendix A,
Ill. 10, right) (Index 10; folio
removed to back of book)
Circle pattern. F

Loose folio (e94v) (no ill.) Blank. H

Paper flyleaf (no ill.)

Paper pastedown (no ill.)

1 An elaborate renaissance frame, penned in brown ink, was added at a somewhat later date.

2 Possibly Bertoldo d'Este, who died at the Battle of Morea in 1463. The two eagles on the shield are presumably Este emblems.

Pasted-down strip from fragmentarily preserved page, with rest of tomb lost. 12.1 x 39.6 cm. Elen identifies this drawing with Guérin's description (1728):

Idem, 3ᵉ planche. Deux bas-reliefs, dont l'un est l'entrée d'un empéreur avec sec soldats, partie infanterie et partie cavalerie, précédés de ses enseignes et tubicines, l'empéreur dans un chariot trainé par deux chevaux; l'autre est une bataille.

According to Elen, His de la Salle may have bought this and the other two drawings (now R.F. 425, 427) at one of the two Lenoir sales (Paris, 1837, 1838; Lugt 14877, 14922). The only lot in the 1837 sale that seems to have included the three drawings is #295, the sale of which was postponed until 1838. As Lot #57, the drawings then brought a very low price (FF. 13,50), and were described:

Trois tournois et une cérémonie funèbre du moyen age, suite de quatre dessins d'un beau style, exécuté dans le XVIᵉ siècle.

3 According to Degenhart and Schmitt, R.F. 428 (Elen's folio 2) was originally located here.
Guérin (1728): "4: Un tombeau enrichi de pleusieurs [sic] bas-reliefs avec des inscriptions sepulchrales."

4 Guérin (1728): "8: Ronds propres à mettre quelques personnages; ils sont en blanc." These pages of blank circles were intended for numismatic subjects.

5 Guérin (1728): "9: (inscription as in note 4)." Degenhart and Schmitt (1984, 22, 27) suggest that this folio is the surviving page with circles (Appendix A, Ill. 10).

6 Now bound at rear of book, behind folio 93 (F). Identified by Guérin (1728): "10: (inscription as in note 4)."

7 Guérin (1728). "11: (inscription as in note 4)."

8 Folio 15 and 15v is a paper sheet consisting of two sheets of paper (eagle watermark) vertically joined; losses of paper along bottom and right corner of composition.

9 Slightly cut down; 39.2 x 29.2 cm.

10 Index 33: "Algune nave in diversi muodi." Possibly a horizontal composition.

11 In shallow reliefs below, three scenes from his life: Receiving Raiment in the Wilderness; Preaching in the Wilderness; The Beheading.

12 Index 36: *Studies of Horses*, "Do cavali in do muodi."
Possibly a vertical composition similar to Pisanello's in the Codex Vallardi (Louvre 2468, fol. 277): Fossi Todorow (1962), pl. XLIII. One horse is in three-quarter view, seen from the front; the other is foreshortened, seen from the rear.

13 Inscribed in lower margin: "Pegasus f[ili]o di P[er]seo che amazo medusa."

14 Tomb inscribed: HIC IACET NOBILIS VIRI TOMAS LAUREDANO MILITI.

15 Index 45: "A scene where the head of Hannibal is presented to Prusias," "Uno chaxamento come le apresenta la testa de'Anibal."

16 Folios 50v and 51 formed a continuous vertical composition, with the architecture along the right margin and the rearing horse and fallen rider at the lower left.

17 Patterns appear on folios 56v, 76, 76v, 77v, 78v, 82–84v, 95, 95v.

18 Index 61: "Uno chaxamento con el doxe Foschari e altri." Probably a vertical composition; a horizontal one would have presumably been continued on the adjoining folio 60v, which is blank.

19 Heads of archers to the left are missing. Presumably still visible at early reinking, they were not gone over in pen.

20 Index 69: "San Michiel armado al'anticha." For blank areas of head and arms, see note 19.

21 Inking incomplete for same reason as in folio 68 (see note 19).

22 A pasted rectangle, now missing, covered a large portion of this page, added to obscure the five lions penned by an earlier hand on the verso of this folio from the reused pattern book. Index: "Judit che amazo oloferne e une fauno."

23 Bound in upside-down, to be covered by a chalk ground for reuse. By Gentile da Fabriano?

24 Underneath these animals are studies of eleven lions in pen and brown and black ink by an earlier hand in the reused pattern book. Jacopo's reworking still follows some of these; see Fig. 7.

25 Incompletely reinked, probably for same reason as folio 62 (see note 19).

26 This is the only verso described in the Index: "Davit armado a l'anticha con la testa de goliat."

27 According to Degenhart and Schmitt (1984, 27), this folio originally joined *The Three Living and the Three Dead* (Index 91). When the latter folio was removed, the *Three Nude Women* was replaced upside-down. Degenhart and Schmitt view this as a verso with a blank facing recto page.

28 For missing areas, see explanation given in note 19.

29 Subject identified by Degenhart and Schmitt (1984, 27).

30 Bound in upside-down. Goloubew (1908), folio 88v.

31 Offprint in lower left corner from the first lines of the Index, indicating the original position of this page opposite Index folio. Goloubew (1908); folio 89.

32 Prepared after Jacopo's death. According to Degenhart and Schmitt (1984, 27), this was moved from the second gathering to the end of the Paris Book in 1728.

33 The circles now visible were offprinted from folio 10, after it was moved to the back of the Book behind the Index page (see Appendix A, Ill. 10).

# APPENDIX C

## FIFTEENTH-CENTURY INDEX IN THE LOUVRE BOOK

Written in a 15th-century hand, an Index was added to a page at the end of the Paris Book, reproduced in facsimile by Goloubew (1908, pl. XCVI, his folio 93a) and by Degenhart and Schmitt (1984, pl. 114). Water damage has made the first ten Index entries and most of the eleventh illegible (Appendix A, Ill. 7). Listed are drawings on the recto sides; verso sides are mentioned only when a subject on the facing recto continues onto them (an exception is 82, *David and Goliath*, an independent verso drawing; the drawing on the recto is not listed).

11 — . . . Imperadori ( . . . Emperors [probably referring to images on coins]) [missing]

12 — nostra dona che vien portada da I apostoli (Our Lady carried by the apostles) [Plate 234]

13 — sepoltura cum uno morto destexo suxo (sepulchre with the deceased laid out) [Plate 134]

14 — san zorzi a chavalo (Saint George on horseback) [Plate 260]

15 — san zorzi a un altro modo (Saint George in another fashion) [Plate 261]

16 — uno chaxamento come xpo vien batu (an architectural setting with the Flagellation) [Plate 202]

17 — uno chaxamento come sam Zuam batista vien degolla (an architectural setting [i.e., Herod's Palace] with the decollation of Saint John the Baptist) [Plates 284/285]

18 — uno chaxamento come xpo disputa con I dotori (an architectural setting [i.e., the Temple] with Christ among the doctors) [Plate 182]

19 — una passion de xpo con I ladroni (the Passion of Christ with the thieves [i.e., The Crucifixion]) [Plate 208]

20 — come xpo vien mena fuora de Jerusalem (how Christ was led out of Jerusalem [i.e., The Way to Calvary]) [Plate 140]

21 — Come xpo fo receuto con l'olivo (how Christ was received with the olive branch [i.e., Entry of Christ into Jerusalem]) [Plate 191]

22 — San xpofalo con uno paexe (Saint Christopher in a landscape) [Plate 248]

23 — una testa di stilo (a head [drawn by] stylus) [Plate 1]

24 — uno tenpio come nostra dona fo offerta (a temple with the Presentation of Our Lady) [Plate 158?]

25 — quando san Zuane batizo xpo (when Saint John baptized Christ) [Plate 186?]

26 — caxamento quando salomo dede la sentenza a la meretrice (architectural setting [i.e., Solomon's palace] with Solomon sentencing the whore) [Plates 153/154]

27 — come xpo resuscito con molte figure (how Christ was resurrected with many figures) [Plate 226]

28 — uno caxamento con l'asonsio de nostra dona (an architectural setting with the Assumption of Our Lady) [Plate 230]

29 — uno caxamento come xpo vien batudo (an architectural setting with the Flagellation) [Plate 203]

30 — uno caxamento come la nostra dona vien offerta (an architectural setting with the Presentation of Our Lady) [Plate 159]

31 — uno caxamento con l'anoziada con Io paexe (an architectural setting with the Annunciation and a landscape) [Plates 164/165]

32 — la storia de I magi ch vien per tre vie (the story of the magi who come by three ways) [Plate 175]

33 — algune nave i diversi muodi (some ships in different ways) [missing]

34 — la storia di i magi con molte figure (the story of the Magi with many figures) [Plate 171]

35 — Sam Zuane batistia con una chuba (Saint John the Baptist in a niche) [Plate 283]

36 — do cauali in do muodi (two horses in different ways) [missing]

37 — uno prexepio con uno paexe (a Nativity with a landscape) [Plate 170]

38 — come xpo vien tolto de croxe con algu paexe (how Christ is taken from the cross in a landscape) [Plate 214]

39 — uno archo trionfal ch xpo vien mena avati a pilato (a triumphal arch with Christ led before Pilate) [Plate 194]

40 — una Istoria de Bacho con uno caro di trionfo chel tira (a story of Bacchus drawn on a triumphal chariot) [Plate 82]

41 — una Istoria de pasion senza Iladri (a story of the Passion without thieves [i.e., the Crucifixion as a single cross]) [missing?]

42 — Santo hostachio a chavalo con I paexe (Saint Eustace on horseback in a landscape) [Plates 251/252]

43 — El caval pedeseo con In spiritello suxo con do fauni (the horse Pegasus with a little spirit and two fauns) [Plate 83]

44 — Uno cavalo groso che salta I molimento (a large horse who jumps over a tomb) [Plates 105/106]

45 — uno chaxamento come le apresenta la testa de anibal (an architectural setting with the Presentation of Hannibal's head) [Plate 88]

46 — uno caxamento con do torazi uno per ladi (an architectural setting with two *torazi* [wings] on either side) [Plate 89]

47 — uno tenpio con alguni Idoli che vien roti da zente d'arme (a temple with idols being broken by armed men) [Plate 91]

48 — molti Epitafii altichi romani (many antique Roman epitaphs) [Plate 84]

49 — molti altri Epitafij antichi romani (many other antique Roman epitaphs) [Plate 86]

50 — uno che vien strasinado a coda de caualo (one who is dragged behind a horse) [Plates 270/271]

51 — uno che e cazudo da chavalo morto (one who has fallen dead from a horse) [missing]

52 — uno armado a chavalo che corre con la so sopravesta (an armed man on a horse in caparison) [Plate 114?]

53 — uno tenpio in piu faze su molti gradi (a many-sided temple on several steps) [Plate 92]

54 — alguni ch conbate co uno drago (several men combatting a dragon) [Plate 97]

55 — alguni ch conbate con uno serpente (several men in combat with a serpent) [Plate 98]

56 — uno che vien tirado da do cavali suxo I chareta (one who is drawn by two horses on a chariot) [Fig. 14]

57 — uno chaxamento con I molimento e x morto (an architectural setting with a tomb and a dead Christ) [Plate 221]

58 — uno xpo paso in uno molimento con molte figure (Christ in a tomb with many figures) [Plates 217/218]

59 — uno altro xpo paso a uno altro modo con figure (another Christ in a different fashion with figures) [Plate 220]

60 — Uno xpo In croxe con do figure (Christ on the cross with two figures) [Plate 211]

61 — uno chaxamento con el doxe foschari et altri (an architectural setting with Doge Foscari and others) [missing]

62 — uno ziglio axuro (a blue lily) [Plate 2]

63 — una Istoria de pasio con figure picole (a story of the Passion with small figures [i.e., a view of Calvary]) [Plate 213]

64 — una piadena (a *piadena* [i.e., metal bowl]) [Plate 85]

65 — uno vaxo damaschin (a damascened vessel) [Plate 87]

66 — una Istoria d'Adamo et Eva (a story of Adam and Eve) [Plate 143]

67 — Sam Zorzi ch ferise I drago (Saint George wounding a dragon) [Plate 259]

68 — San sabastiano ch vien afrezado (Saint Sebastian who is shot with arrows) [Plate 296]

69 — Sam michiel armado al anticha (Saint Michael armed in the antique fashion) [Plate 290]

70 — un omo darme a cavalo con I carbone (an armed man on horseback with a coal bearer) [Plate 18]

71 — Sam franzescho ch receve I estimate (Saint Francis receiving the stigmata) [Plates 255/256]

72 — uno armado a pe a la moderna (an armed man on foot in the modern fashion) [Plate 109]

73 — uno x nudo passo con do figure per ladi (a nude Christ with two figures on either side) [Plate 241]

74 — una nostra dona con do anzoli che sono stromenti (Our Lady with two angels who play instruments) [Plate 138]

75 — uno omo d arme a cavalo conbate con uno ape (an armed man on horseback fighting [another] one on foot) [Plate 101]

76 — uno caxamento con tre morti dextesi con molte figure (an architectural setting with three dead men laid out and many figures) [Plate 130]

77 — Judit ch amazo oloferne e I fauno (Judith who kills Holofernes and a faun) [damaged; Figs. 10, 17]

78 — molti leoni designia de stilo d arzento (many lions drawn in silverpoint) [Plate 6]

79 — uno san xpofalo (a Saint Christopher) [Plate 246]

80 — uno xpo in croxe solo (a Christ on the cross alone) [Plate 212]

81 — molti a chavalo conbate con dragj (many horsemen combatting dragons) [Plate 96]

82 — davit armado a l'anticha con la testa de goliat (David armed in the antique fashion with the head of Goliath) [Plate 147]

83 — Sam Zuan batista (Saint John the Baptist) [Plate 279]

84 — Sam Zorzi a cavalo (Saint George on horseback) [Plate 258]

85 — uno nudo porta I vaxo anticho adosso (a nude man who carries an antique vessel on his back) [Plate 65]

86 — uno liome con I lionza (a lion with a lioness) [Plate 11]

87 — Erchules con uno liom morto ai pie (Hercules with a dead lion at his feet) [Plate 151]

88 — tre damixelle nude con tre putini (three nude damsels with three infants) [Plate 68]

89 — Erchules a cavalo sopra uno lion che I ocide (Hercules on horseback above a lion which he killed) [Plate 66]

90 — uno omo d arme a chavalo couerto (an armed rider on a horse in caparison) [Plate 113]

91 — La istoria de q tre re ch andaua a oxelar. E trovo tre corpi morti (a scene with the three kings going to Auxerre and finding three corpses) [Plate 135]

92 — uno cavalo ch tra uno paro di calzi con altri cavalj e canj (a cavalier . . . with other cavaliers and dogs) [Plate 110]

93 — uno chaxamento con tre malfatori ch vien menadi davanti uno imperadore (an architectural setting with three criminals who are brought before an emperor) [Plate 156]

94 — uno molimento co uno morto dexteso armado (a tomb with a dead man laid out in armor) [Plate 133]

95 — molti ch stanno a parlamento e altre figure (many talking men and other figures) [Plates 105/106?]

# Appendix D

## 1. Paintings Attributed to Jacopo Bellini and His School

Unless otherwise noted, references to documents are to those published by C. Ricci (1908, II, 47–63); if the document pertains to the painting itself, it is given in the catalogue entry, or in Appendix E. An (✱) asterisk signifies that the painting is lost.

BERGAMO. ACCADEMIA CARRARA. MADONNA AND CHILD

[1]H. Friedmann (1946).

BERLIN. FOUR PANELS FROM A POLYPTYCH

[1]The sculptors' identities are controversial. Wolters, 1976, 239–40, cat. no. 171, proposes Giovanni di Martino da Fiesole as the designer of the Mocenigo Tomb. G. R. Goldner (*Niccolò and Piero Lamberti*, Ph.D. dissertation, Princeton University: 1972, 186–201) argues for an attribution to Piero Lamberti as the primary sculptor, citing the early appearance in the work of Niccolò Lamberti of "distinctive architectural motifs" on the tomb. Documentary evidence (Goldner, 1972, 92–93) indicates the collaboration of Giovanni di Martino on the Mocenigo Tomb—both signed a contract for it in 1423—and assigns six figures on it to Giovanni; he gives Piero the Fulgosio commission (202–9), assisted by Giovanni Bartolommeo da Firenze rather than Giovanni di Martino, as Wolters advocates (240–42, cat. no. 172).

The Fulgosio Tomb is based on the Bartolommeo Coscia Tomb by Donatello and Michelozzo (Florence, Baptistery, 1425–27). Piero Lamberti, sculptor of the Fulgosio Tomb, is known to have returned to Florence in 1427. See Wolters, 1976, 240–42, cat. no. 172.

[2]St. Lucy as a virgin martyr holding a vase is shown by Paolo Veneziano (Veglia, Bishop's Palace). See G. Kaftal, *Iconography of the Saints in the Painting of Northeast Italy,* Florence: 1982, col. 627, fig. 786.

[3]For St. Agnes in Venetian art, see Kaftal, *op. cit.,* 11–15.

BRESCIA. ANNUNCIATION ALTAR

[1]For the extensive series of restorations from 1644–1885, see Testi, 1915, II, 265–66.

[2]A similar sense of volume and placement may explain Longhi's (1940, 191) date for the inferior

*(continued on following page)*

BERGAMO, Accademia Carrara, Lochis Bequest, *Madonna and Child* (Fig. 32)

Tempera on rectangular panel, 63 x 53 cm.
Upper corners covered by later arched frame. Poorly preserved. The gold foliate pattern on dark ground much reworked (viewed by Van Marle, VIII, 1927, 29, as entirely a later addition); these additions removed in recent restoration

Inscribed: AVE MARIA GRATIA PLENA in Madonna's halo; illegible inscription in child's halo
Ex-Coll. Pinacoteca Borromini-Monti

Long ascribed to Gentile da Fabriano (still so viewed by Van Marle, VIII, 1927, 26); Morelli first gave the *Madonna* to Jacopo (*Galleria Borghese-Doria.* Eng. ed. 1892, 267; later, in *Italian Painters,* 1900, 267, n. 1), followed by Cagnola (1904, 42), and accepted by most critics as Bellini's. See Berenson, *Venetian Painters,* 1899, 91; 1957, I, 38. Pallucchini (1955–56, 109) dated the picture in the early 1440s, Röthlisberger (1958–59, 88) saw it as from Jacopo's *bottega,* painted after 1440. Omitted from the *oeuvre* by Schmitt (1965). Christiansen confirmed the Jacopo attribution (1982, cat. no. 21, 114). The infant's nudity represents Christ's corporeal sacrifice, following Gentile da Fabriano's image (New Haven, Yale University Art Gallery). He points to and seems to address a bird, a popular symbol of his future Passion and Resurrection;[1] its string is tied to Christ's forefinger.

Mary's robe is pink with *changeant* coloring on the outside, lavender inside, worn over a dress perhaps originally blue, now much darkened. Her left hand is covered by a veil. Evidence of a former wing panel is still to be seen in the upper left-hand corner. The composition may originally have been rectangular rather than arched, with a ledge in the foreground.

This panel may date from the later 1420s or early 1430s. Its patterned background is much in the Venetian tradition, as seen in Giambono's *Madonnas.*

BERLIN, Staatliche Museen, Preussischer Kulturbesitz, Gemäldegalerie, Dahlem Museum, Four Panels from a Polyptych

A. *Bearded Saint Reading* (Saint Mark? Saint John the Evangelist?) (Fig. 55)
   Inscribed robe
   Tempera on panel, 85 x 24 cm., cat. no. 1161

B. *Saint Peter* (Fig. 56)
   Inscribed PETRUS at neck. Border of robe also inscribed
   Tempera on panel, 85 x 24 cm., cat. no. 1161

C. *Female Saint with Floral Wreath and Covered Vessel* (Saint Mary Magdalen? Saint Lucy?) (Fig. 57)
   Private Collection, Berlin
   Tempera on panel, 39 x 26.8 cm. (cut down)

D. *Saint Jerome* (Fig. 58)
   Tempera on panel, 31 x 23 cm. (cut down), cat. no. 1150

This series of standing saints in shell-topped niches comes from Jacopo's studio, somewhat coarse and summary in handling, probably painted in the mid-1430s. Zeri (1971) first published them as Jacopo's, relating them to the Trecento pictorial tradition of Paolo and Lorenzo Veneziano. He noted that the shell niches resemble those on several elaborate tombs in the Veneto, their sculpture carved by Florentines (Tommaso Mocenigo Tomb, SS. Giovanni e Paolo, Venice, 1423; Raffaello Fulgosio Tomb, Santo, Padua, 1430), and the statuary by Niccolò Lamberti for the San Marco façade.[1] Zeri dated the panels c. 1435, stressing their correspondence with drawings in the Paris and London Books (Pls. 239, 240). Boskovits (1985, n. 16) dates the images before "1430(?)." A modified shell niche is found in the Cagnola *Madonna* (Fig. 36) of c. 1430. The Berlin *Saints* are within a decade of that central panel.

As the female saint is shown frontally, her place must have been near to, if not at, the center of the group. Full-length, her figure may have resembled the centrally viewed *Nude Women and Children in Bathing Pavilion* (Pl. 70). If she is St. Lucy, the altar or altar frontal could have been in the Paduan church dedicated to that early Christian virgin martyr, and the vessel she holds may be a reliquary;[2] if it is an ointment jar, she is the Magdalen.

The panel may have had an additional attribute in its lower half. St. Agnes is shown in Venice with a wreath of flowers on her head, and the lamb may once have been at her feet;[3] St. Barbara carries a host and chalice, her tower perhaps below.

*Saint Jerome* is somewhat reminiscent of the art of Antonio Vivarini and Giovanni d'Alemagna, both, like Jacopo, active in Padua as well as Venice. The male saints have abundant cascading drapery, still close to a flamboyant Gothic style. Those similarly posed in the Books are more classical in treatment (Pls. 239, 240, 241).

BRESCIA, San Alessandro, *Annunciation* Altar (Figs. 18–24)

Tempera on panel, sight measurements: each panel 219 x 98 cm.
Inscribed: PLENA GRATIA AVE near Gabriel's mouth
Present frame carved c. 1444, when the predella was added (see below), changing the original

horizontal, spatially unified format into a double arch. God the Father with angels (carved in a roundel at the upper center of frame) are turned toward the Virgin. Floral motifs in spandrels as in the *Madonnas* in New York (Fig. 35) and Venice (Fig. 42)
Generally well preserved[1]

The two *Annunciation* panels are large, splendidly painted, and well preserved. Richly patterned silken textiles, exotic carpets, and fine inlaid furnishings (*intarsie alla certosina*) recall Gentile da Fabriano's luxurious art, as do the figures' beautifully defined profiles and courtly gestures. Indeed, the Marchigian master may have begun both panels, leaving their completion to his apprentice Jacopo. Dazzling foreshortenings of the Holy Ghost, Gabriel's halo, and the Virgin's book indicate a concern with the new perspective, as does the spatial setting itself (Fig. 19), the empty chambers at either side suggesting those in Jacopo's drawings.

To stage the Annunciation entirely indoors was not in the Venetian tradition, which usually followed the Byzantine formula by including exterior elements. This novelty also argues for the origin of the composition with Gentile. A school piece of his (Vatican, Pinacoteca) of the same subject shares some of these compositional and decorative motifs, derived from the Trecento cult fresco in Florence (S.ma Annunziata).[2] In some ways conventional, Jacopo's work also returns to Trecento motifs: Gabriel's palm leaf and Mary's crossed arms found in Ambrogio Lorenzetti's *Annunciation* of 1344 (Siena, Pinacoteca); the frame's central roundel of God the Father with angels.

None of the three *Annunciations* in Jacopo's Books (Pls. 164/165, 162, 163) takes place altogether indoors. A fourth composition on the theme, the Turin *Annunciation*, from his studio (Fig. 29), is also half out-of-doors.

Carved in a Venetian transitional style, the gilded frame consists of two pointed arches on three *all'antica* pilasters.[3] Boxlike, the painted space of the *Annunciation* does not fit the ogival frame; between the Gothic arches and the coffered ceiling of the early renaissance chamber are awkward, blank areas. Originally a continuous, horizontal composition, the work was divided to fit into its new frame, evidently designed for a late medieval composition—if an *Annunciation,* the Angel Gabriel and the Virgin must have been large, vertical figures filling the two areas.

The *Annunciation* was given to Fra Angelico in mid-19th-century publications, as he was known to have worked on one for the same church. Meyer and Bode attributed it to Gentile da Fabriano (1875), Morelli to Jacopo in 1889.[4] L. Venturi (1907, 128) and Ricci (1908, 21) doubted that proposal, as did Testi (1915, II, 259 ff.). Most scholars now accept it as Jacopo's, generally dating it in the early 1440s, shortly before its documented delivery with the predella (below, A–E) to Brescia in 1444. Zeri (1971, 48) convincingly shifted the *Annunciation* back to c. 1430 or even earlier. His conclusions, accepted by Boskovits (1985, 117), seem eminently reasonable for its symbolism as well as style.

This altarpiece may replace one ordered for the Servites from Fra Angelico, who received two payments for an *Annunciation* for San Alessandro in 1432, among his first commissions outside Florence.[5] Perhaps the sudden prestige of a far more important project, the Linaiuoli Altar (Florence, San Marco), prevented the friar from completing the Brescian painting.

Venetian religious institutions commissioned altarpieces for their affiliates in Vicenza, Brescia, etc.[6] When the Servites took over the Brescian church of San Alessandro in 1432 (Testi, 1915, II, 262), one of the monks (Francesco Landino da Firenze) ordered the *Annunciation* from Fra Angelico. Boskovits (1985, 122, n. 14) observed that the Servites of Brescia originated in Vicenza, and were established there in 1413. Shortly after the founding of San Alessandro, six monks from the Vicenza church (three of them Brescians) began an Observant community in the monastery of Monte Berico at Vicenza, formerly belonging to the Bridgettines and built in 1428 by monks from Murano.

These monks probably brought with them (or commissioned) an altarpiece for their new church; according to Boskovits, they may have inherited the *Annunciation* Altar from the Bridgettines and then sent it on to the Servites at San Alessandro in Brescia, when their new altarpiece arrived.

The Servite monastery attached to San Alessandro paid for the predella of the *Annunciation* Altar; a copy of a document dated January 1444 lists the travel expenses of two friars of San Alessandro, who went to Vicenza with the prior of the Brescian monastery of San Salvatore to bring back the altar. The same document records payments on February 1 for the painting of the predella by unspecified masters at Vicenza, notations of additional billing for packing and transport, and expenses for a lamp before the altar.[7] These "maestri" are often assumed to have been working in Vicenza, but perhaps they were not, for many works of art were sent there from Venice.[8] Pallucchini proposed that an artist in Jacopo's Venetian studio may have painted the predella.[9] Possibly Bellini's illegitimate half brother Giovanni was the artist.

In any case, the date of 1444 refers to payments for the predella and its transfer with the *Annunciation,* not to the *Annunciation*'s execution. There must also have been payments for framing the altar complex before it was shipped from Vicenza. The text refers to "maestri" making the predella; this may mean equally the framer, as L. Venturi suggested (1907, 130). He found the smaller panels to be from Jacopo's studio. The *Annunciation* was probably removed from its original, suitable frame and placed in these Gothic arches to accommodate the more recently painted predella.

Apart from a few Bellini hallmarks such as the rustic bridge at the far right of the *Visitation* and the exquisite settings of the *Birth of the Virgin* and the *Presentation,* these panels could have been executed by some talented assistant close also to Giambono's art.[10] The Mascoli Chapel mosaics attest to collaboration between Bellini and Giambono.

A. *The Birth of the Virgin* (Fig. 20)
  35 x 40 cm.
  Somewhat Gentilesque, the composition follows Giotto's formula (Padua, Arena Chapel).

B. *Presentation of the Virgin* (Fig. 21)
  35 x 40 cm.
  Solomon's Temple is a palatial structure, recalling the Doge's Palace. The composition is close to the London Book's (Pl. 153), still followed in Titian's *Presentation* for the Scuola della Carità.

C. *Visitation* (Fig. 22)
  35 x 40 cm.
  This subject may have the central place because it marks the first manifestation of Christ's physical presence. If Pallucchini (1955–56, 216) reads this scene correctly as a nocturne, it follows Gentile's

*Annunciation* (Vatican) in Gentile's Florentine period (1419–25). Christiansen (1982, 3) rightly downgraded the Vatican painting after seeing it in cleaned state. Mary's crossed arms are seen in Gentile's *Coronation of the Virgin* (Santa Monica, J. P. Getty Museum) and Jacopo's *Ferrara Madonna.*

[3] The original frame may have resembled that for Fra Angelico's Montecarlo (Tuscany) *Annunciation.*

[4] G. B. Morelli, *Italian Painters, Critical Studies of Their Works,* London: 1892, 267 ff., and idem, *Gallerien Borghese und Doria,* 1890, 350, n. 1. For the tangled *fortuna critica* and complex documentation of the altarpiece, see Testi (1915, II, 259–68, 736) and L. Venturi (1907, 127–29). Pope-Hennessy (*Fra Angelico,* London: 1974, 193) believed that Fra Angelico never made the painting, the altar being "filled in by Bellini's work."

[5] Vicenzo Marchese, *Memorie dei più insigni pittori . . . Domenicani,* I, Florence: 1854, 349–50 (cited by Pope-Hennessy, *Fra Angelico,* Garden City: 1952, 167). The first payment was for 9 ducats, the second for 2, for gold leaf.

[6] The Augustinian canons of San Giorgio in Alga, where Eugenius IV studied as a youth, ordered such a work from Antonio Vivarini to be sent to the Monastery of San Piero in Oliveto in Brescia. See *Storia di Brescia,* II, 908.

[7] For the document's source, see Testi (1915, II, 264):

1444 Genaro
Spesa fatta per me et frate Gioseffe col Prior di S. Salvatore quando andassimo a Vicenza per la Nonziata.

Febraro primo
Per spese fatte in far portare la Nonziata da Vicenza a Brescia . . . . . . . . . . . . . L.3.s.1.
Item per parte di pagamento alli maestri che fecero la bredella della Nonziata
Item per la lampada della Nonziata.

Marzo
Item per alquante tavole per far la cassa dell'ancona della Nonziata . . . . . . . . . L.1.s.2.
Per chiodi per la detta cassa . . . . . . . . . . . . s.5,d.6.
Item per pagamento delli Candeglieri della Nonziata
Item per far la festa della Nonziata et honor a forestieri et trombetti.

See also Testi's further comments on 736.

[8] N. Pozza and E. Franzina, *Vicenza: storia di una città,* Vicenza: 1980, 134–35. Vicenza, within the Venetian sphere of influence, had been receiving major works from that center since at least the early 14th century. Paolo Veneziano's first signed and dated work, a Marian altarpiece of 1333, was painted for the high altar of Vicenza's San Lorenzo. See Pallucchini (1964, 30).

*(continued on following page)*

[9]Pallucchini, *Pitture in Brescia dal duecento al ottocento*, 1946, 22–23, cat. no. 9.

[10]The predella's Giambono-like quality was first noted by Fiocco ("Michele Giambono," *Venezia*, I, 1919, 22, n. 1), followed by Volpe (1955, 19, 21) and Röthlisberger (1959, 55).

[11]For a discussion of the theme, see H. W. van Os, "Schnee in Siena," *Nederlands Kunsthistorisch Jaarboek*, 19 (1968), 1–50 (the Brescia predella, p. 23 and fig. 16).

*FERRARA. PORTRAIT OF LIONELLO D'ESTE

[1]For Italian text, see Appendix E, Doc. 1441: Ferrara.

FERRARA. PINACOTECA. MADONNA AND CHILD

[1]Longhi, 1946, 52; Röthlisberger, 1958–59, II, 78; Pallucchini, *Exhibition Konstens Venedig*, 1962, 55, No. 47, who dated it c. 1440; Dussler, "Berichte: Stockholm," *Pantheon*, 21, 1963, 129: all accepted the panel as by Jacopo.

A. Gonzales-Palacios, "Un lasciato che fa onore a Ferrara," *Il Mondo*, 18 Dec. 1975, 99, first ascribed the panel to Gentile da Fabriano, followed by C. Volpe (1977, 76 ff.), who dated it 1410–20, and Boskovits (1985, 123, n. 25).

similar staging of the Strozzi Altar's *Nativity* and points to the *Flagellation* and other nocturnes in the Books (Pls. 92, 195).

D. *Miraculous Snowfall at the Founding of Santa Maria Maggiore* (Fig. 23)
35 x 40 cm.

The Brescian church of San Alessandro owed its restoration to the Venetian pope Eugenius IV (Gabriele Condulmer), elected in 1431 to succeed Martin V. In March 1431 the Servites took over San Alessandro, receiving a papal bull for its restoration. Eugenius' personal interest in the church is conveyed in this panel; the subject held unusual importance in the 1420s and '30s, being associated with the restoration of Rome following the return of the papal court from Avignon in 1377.

On August 5, 352, Roman-born Pope Liberius had traced the foundations of the new basilica of Santa Maria Maggiore along the outlines of a miraculous midsummer snowfall. This rare subject appeared on the façade of the basilica in a mosaic by Filippo Rusuti (1308), and Pope Martin V (Colonna) selected it in the later 1420s for the altarpiece of his Roman family chapel in that basilica, by Masolino and Masaccio; the two-sided altarpiece is now divided among three museums (Naples, Museo di Capodimonte; London, National Gallery; Philadelphia, Johnson Collection, Philadelphia Museum of Art).

Pope Eugenius IV may have known the recent treatments of the subject: his predecessor's Roman altarpiece, and Sassetta's *Madonna of the Snows* (Florence, Galleria Pitti, Contini-Bonacossi Bequest), painted c. 1430–32, whose predella showed the legend of the basilica's foundation, partly in tribute to the new Venetian pope who had been Siena's bishop since 1407 and cardinal since 1408, before being elected to the papacy in 1431.[11]

Eugenius must have seen Pope Liberius' foundation of Santa Maria Maggiore as analogous to his own restoration, in his election year, of San Alessandro in Brescia. This predella panel, painted in the early 1440s within the pope's lifetime (d. 1447), was testimony to the Venetian's benevolence, Pope Liberius displaying Eugenius' features, close to his effigy by Isaia da Pisa (Rome, San Salvatore in Lauro).

E. *Death of the Virgin* (Fig. 24)
35 x 40 cm.

This recalls the mosaic of the subject in the Mascoli Chapel of San Marco (Fig. 54) and a painting by Giambono (Verona, Museo del Castelvecchio).

*FERRARA, *Portrait of Lionello d'Este*

1441. Painted in competition with Pisanello, Jacopo's portrait was selected by the sitter's father, Niccolò III, as the winner. The painting occasioned two commemorative sonnets on *The Famous Contest* by Ulisse degli Aleotti, a Venetian humanist;[1] below, English translations:

(1)
When to a high emprise Pisano soared,
Entering the lists with Nature's self to strive,
And upon wood the semblance make alive
Of Lionel, our new illustrious lord;

Already now the sixth month did he spend,
And still he strove the very form to mould,
When Fortune, whose disdainful eyes behold
All human glory and its loss portend,
So wrought, that from his saltrenowned strand
Bellini journey'd, painting's chief indeed, —
A second Phidias he for our own dark world; —
Who made a livelier image, so did stand
The verdict by the father's love decreed,
Whereby Pisano from his throne was hurl'd.
                                    (Fry, 1899, 126)

(2)
How much you may exult, Bellino,
that what your lucid intellect feels
your industrious hand shapes into
rich and unusual form.
So that to all others you teach the true way
of the divine Apelles and the noble Polycleitus;
because if nature made you perfect,
that is a gift from heaven and your destiny.
But if the envious and honorless masses
sometimes goad and contest
your fame and worthy name,
Take pity on their heavy burden,
learn now this living lesson:
that the sun at times offends the fog.

                                    (trans. the author)

Jacopo's reward for winning the contest must have included two bushels of wheat (August 26, 1441; Ricci, doc. X, 52). The competition was also discussed by Angelo Decembrio, speaking as Lionello d'Este: "You remember how Pisanello and Bellini, the finest painters of our time, recently differed in various ways in the portrayal of my face. The one added a more emphatic spareness to its handsomeness, while the other represented it as paler, though no more slender, and scarcely were they reconciled by my entreaties" (trans. Baxandall, 1963, 314, from *De politia litteraria*).

Pisanello's portrait is often identified with that now in Bergamo. Jacopo's has been linked by many critics with the little donor kneeling at the left in the *Madonna of Humility* (Paris, Louvre; Fig. 31), but a votive image would not have been appropriate in a portrait competition, and the style of the Louvre *Madonna* also predates 1441. For an excellent discussion of the portrait competition, see Gramaccini (1982), who believes that the Louvre picture is Jacopo's competition piece. Both painters already knew Lionello, as indicated by Bellini's Paris painting and Pisanello's wedding present, a *Julius Caesar* sent to him in 1435.

FERRARA, Pinacoteca Nazionale, Vendeghini–Baldi Bequest, *Adoration of the Magi* (Fig. 49)

See Padua, Santo, Gattamelata Altar

FERRARA, Pinacoteca Nazionale, Vendeghini–Baldi Bequest, *Madonna and Child* (Fig. 32)

Tempera on panel, 58 x 48 cm. (cut down)
Inscribed: AVE MARIA GRATIA PLENA DOMINUS TECUM, in Madonna's halo
Frame: modern
Extremely poorly preserved

What little remains of this once fine painting shows that it closely followed the manner of Gentile da Fabriano. Long ascribed to Jacopo, some recent

critics have given it to Gentile.[1] It is reminiscent of Jacopo's Gentilesque works, such as the Brescia *Annunciation* (Fig. 19) and the Lochis *Madonna* (Fig. 32). Gentile's authorship cannot be proven nor Jacopo's excluded. The present thin paint layer is characteristic of Gentile, but it could also be due to severe abrasion.

Christiansen's suggestion (1982, 90) that the Ferrara painting is by Gentile from his Venetian period (c. 1410–14) makes possible Jacopo's help in preparing the panel for his master's painting.

## FLORENCE, Uffizi, *Madonna and Child* (Fig. 43)

Tempera on panel, 69 x 49 cm.
Frame: modern, based on *Madonna of the Cherubim* (Venice, Accademia)
Well preserved
Provenance:[1] Convent of San Micheletto (Michele?), Lucca(?) (since dissolved); Monte Novissimo, Lucca(?); A. Menichetti, Lucca (1905); E. Costantini (1906); Uffizi (1906)

Mother and child have an unusually complex relationship. She holds the richly dressed infant protectively, gazing downward with a resigned expression; he looks upward with an air of innocent stoicism, grasping her thumb. Over a carmine red robe Mary wears a fringed mantle of violet and gold, richly bordered with Kufic inscriptions evocative of Near Eastern exoticism.

Dating near 1450, this *Madonna* exhibits a remarkable synthesis of three traditions. Though still in the frontal, hieratic, Byzantine mold, the figure has the decorative delicacy of the International Style, close to Gentile da Fabriano; the carefully orchestrated, luminous colors, however, reflect a new Venetian approach not far from Domenico Veneziano's (also probably Gentile's pupil). Sculptural vitality in the child's forthright gesture and pose suggests the importance of Florentine art in mid-fifteenth-century Venice. The source of the great early *Madonnas* by Mantegna, Piero della Francesca, and Giovanni Bellini is in works such as this. Paoletti (1927, 74) stressed the extraordinarily delicate technique, ascribing the detailed ornament to the patient hand of an apprentice or miniature painter in Bellini's studio.

Characterized by Röthlisberger (1958–59, 88) as Jacopo's "most monumental Madonna," the panel proclaims him as leading painter of the early Venetian renaissance. Pallucchini (1955–56, 213) noted its humanistic and Greek qualities. All critics place this work in the master's middle period. Röthlisberger related it to the Paris drawing *Mater Omnium* (Pl. 138) which he dated 1455, the Uffizi *Madonna* five years later.

## FLORENCE, San Niccolò sopr'Arno (now in storage, Palazzo Pitti), Dossal in five sections

*Christ and the Virgin before the Lord*, 80 x 56.5 cm. (center); *Raising of Lazarus*, 69 x 45.5 cm. (left); *Meeting of Saints Cosmas and Damian with Julian*, 71 x 46 cm. (right); *Saint Louis of Toulouse*, 64.5 x 22 cm. (far left); *Saint Bernard of Clairvaux*, 66 x 22.5 cm. (far right)

Tempera on panel, c. 1425
Frame: mid-16th century, made when the dossal was placed below Gentile da Fabriano's Quaratesi Altar as a *grado* (Christiansen, 1982, 107)
Severely damaged by fire and moisture

Similarities between the dossal's center section and Gentile's Romita Altar (Milan, Brera), probably painted during his Venetian years (c. 1410?) for a Marchigian patron who died in Venice in 1412, make plausible Longhi's attribution of these five panels to Gentile's design (Longhi, 1940, 190, and A. Conti, "Quadri alluvionati," *Paragone,* 1968, XIX, no. 215, 14). Execution by Jacopo was suggested by Christiansen (1982, cat. no. XV, 106–7, fig. 60), based on similarities to Gentile's *oeuvre* when Jacopo may have been assisting him, and with the Berlin *Bearded Saint* and *St. Peter* (Figs. 55, 56); Jacopo's painting of this dossal c. 1425 is also a possibility. Its ruinous condition precludes secure attribution. What makes the dossal of special interest (if from Jacopo's hand) is the proximity of the paired saints in the side panels to Masolino's manner, also so evident in Bellini's Books.

## GAZZADA, Varese, Cagnola Collection, *Enthroned Madonna and Child* (Fig. 36)

Tempera on panel, 131 x 46 cm.
Inscribed: AVE MARIA GRATIA PLENA DOMINUS in Madonna's halo; REGINA CELORUM on *cartellino* in foreground (much strengthened, if original)
Frame: late 19th-century Gothic Revival
Provenance: ex-Coll. J. P. Richter, London (as Gentile da Fabriano)
Acquired by Cagnola in early 1900s

Jacopo's only surviving *Enthroned Madonna,* this panel is in his earliest style, datable c. 1430. The Madonna is robed in gold-embroidered deep blue over a pale red dress; the lining of the robe now appears brown, originally probably green. Mary occupies a niche, shell-topped with a foliate pattern above, in the Venetian manner. The infant stands on his mother's knees, grasping her robe; a sash over his dress is like the child's in the Brera, Milan, *Madonna* (Fig. 40). He reaches toward a finch perched on the right arm of the pink throne and attached by a long string to his left index finger, the bird a popular symbol of Christ's future suffering and resurrection.[1]

This poorly preserved panel must have been at the center of a triptych or large polyptych, with a carved frame echoing the decorative motifs in the pink throne. The uppermost painted elements in the arch are largely new, those below much restored.[2] The lively child is not unlike the one in the Accademia *Madonna* (Fig. 37). This *Madonna* was first published by its owner, Cagnola (1894, 40–42), who described seeing it in the studio of his friend, the prominent restorer Cavenaghi, and noted that Berenson had already ascribed the painting to "Jacopo Bellini(?)." Cagnola's view was followed by Ricci (1903, *Emporium,* 345); not accepted as Jacopo's by Ludwig–Molmenti (1906, 10). Coarse aspects of this panel and the lack of modeling may explain L. Venturi's attribution to Jacobello del Fiore (1907, 85) and Testi's view, as the work of a "Maestro Veneto primitivo" (1909, I, 533). Gronau (1909, 9, 13) placed the Cagnola *Madonna* among Jacopo's earliest works. Pallucchini (1956) omitted it from Jacopo's *oeuvre,* as did Schmitt (1965). Ciardi (*La raccolta Cagnola,* Pisa: 1965, 39–41, cat. no. 23)

FLORENCE. UFFIZI. MADONNA AND CHILD

[1] For the muddled provenance of this painting, see Ricci, 1908, 19–20, and Testi, 1915, II, 181–85. At one time it was in the Monte Novissimo, perhaps in Lucca (not to be confused with the Monte Novissimo in Venice, from which Sasso bought the *Madonna* now at the Accademia, Venice; Lanzi, *Storia pittorica dell'Italia,* Bassano: 1795–96, II, 85). A forgery based on the Uffizi *Madonna* was in the Lederer Collection, Vienna.

When the Uffizi acquired this work the Florentine press carried protests against the legitimacy of its provenance, questioning the advisability of its purchase.

GAZZADA. ENTHRONED MADONNA AND CHILD

[1] H. Friedmann, 1946.
[2] See Ciardi (1965, 39–40) for the picture's condition.

noted the negative views, concluding that rather than rejecting the *Madonna* as Jacopo's, it should be seen as a very early work, still in the circle of Gentile da Fabriano. Boskovits (1985, 117 f.) described it as a transitional work of c. 1430. This *Enthroned Madonna* is a reworking of the Trecento formula perfected by Lorenzo Veneziano in his *Madonna* of 1372 (Paris, Louvre), which is actually more spatially ambitious than this successor, where only the throne creates a sense of depth.

The Cagnola *Madonna* may show Jacopo's first style, still close to the traditional Venetian manner of early Quattrocento masters such as Jacobello del Fiore or Niccolò di Pietro, as suggested by the summary, skeletal rendering of the Madonna's hand. This panel could also represent Jacopo's return in the early 1430s to those masters, relinquishing Gentile's refinements for the more popular local approach in the century's first decades. In either case, the painting reveals some degree of workshop assistance. Van Marle (1935, XVII, 100), who saw it as Jacopo's first surviving work, may have been nearest the truth.

GENOA(?). MADONNA AND CHILD

[1] "La mostra della Madonna nel arte in Liguria," *Paragone,* 3 (1952), pl. 31. She places the panel earlier than the Straus *Madonna* (Fig. 35), which she dates c. 1440.
[2] *Il polittico degli Zavattari in Castel Sant'Angelo,* Florence: 1984, 62.

GENOA(?), *Madonna and Child* (Fig. 34)

Tempera on panel, 61 x 47 cm.
In ruinous state; only the child's figure is reasonably well preserved
Ascribed to Jacopo by Gregori in 1952;[1] not accepted by Röthlisberger (1958–59, 78, n. 38).
Given to Donato de'Bardi by F. Todini[2]

Exhibited in 1952, Genoa, Palazzo dell'Accademia (*La Madonna nel arte in Liguria,* Bergamo: 1952, cat. no. 19); the panel has since been lost.

Judging by the physiognomy of the child, the *Madonna* may be close to Jacopo's style of the early 1430s, with signs of Tuscan influence. The preservation is so poor that no definite statement can be made about the picture as a whole.

LOS ANGELES. COUNTY MUSEUM. MADONNA AND CHILD

[1] Thomas Mathews kindly read these letters.
[2] See Goffen, 1975, for the possible role of these icons in Giovanni Bellini's art.

LOVERE. GALLERIA TADINI. MADONNA AND CHILD

[1] Information courtesy of Dr. Angelico Scalzi, director, Galleria Tadini.
[2] Testi, 1915, II, 181, and R. P. Ciardi, *La raccolta Cagnola,* Edizione di Comunità: 1965, 11–12, gave the provenance as above. Moschini (*Guida di Venezia,* Venice: 1815, 2, pt. 2, 498) listed the painting as sold by the Magistrato di Monte-Novissimo to a collector in Bergamo. The provenance of this panel is often confused with that in the Accademia, Venice (Testi, 1915, II, 175, n. 4).

*(continued on following page)*

✱LONDON, ex-Coll. Lord Elcho, *Venus and Adonis*

Canvas
Listed by Crowe and Cavalcaselle as Jacopo's (Ger. ed., V, 113, n. 34) and large in size

LOS ANGELES, Los Angeles County Museum of Art, *Madonna and Child* (Fig. 41)

Tempera on panel, 70 x 47 cm.
Inscribed: on Mary's halo, AVE MARIA GRATIA PLENA DOMINUS TE[CUM]; in red roundels at upper left and right, the first and last Greek letters for the words "Mother" and "God."[1]
Frame: modern
Sold by Sotheby Parke Bernet in Monaco, June 25, 1984, cat. no. 3332, as "Attributed to Jacopo Bellini"
Pietro Corsini Gallery, New York
Los Angeles County Museum of Art, 1986

At the time of the Sotheby sale, a strip added along the right border was still visible. This has since been removed, the painting cleaned, and slight cosmetic touches added to the faces. Mary wears over her head a shawl with Kufic inscribed border. The

richly dressed child embraces his mother cheek-to-cheek in the Byzantine formula known as *glykophilousa,* the pose long popular in Venice and found all over Europe. Mary's dress seems to be belted below the bosom, a style not seen in Jacopo's other *Madonnas* but worn by fashionably dressed women in the Paris Book (Pl. 158).

The Greek-lettered red roundels point to a close connection with East Christian currents, this image possibly linked to a painting believed to have been painted by St. Luke.[2] In the "Hail Mary" the Virgin is characterized as Mother of God.

Boskovits (1985, 123, n. 25), on the basis of a reproduction, dated the *Madonna* near the mid-century, and "probably attributable to Jacopo Bellini." The elegantly Donatellesque qualities he found in this painting do not pertain to the tragic force of the sculptor's Paduan period (1443–53) but to his happier, courtlier style of the 1430s, continued at mid-century in reliefs by followers such as Desiderio da Settignano (Turin, Galleria Sabauda). This glamorous *Madonna* nears those by Domenico Veneziano (Washington, D.C., National Gallery of Art; Florence, I Tatti; Florence, Uffizi), and Antonio da Negroponte (Venice, San Francesco della Vigna). Close to Mantegna's authoritative classicism, Bellini may have made the painting near 1453, when Mantegna married his daughter. Though its style shares some of the monumentality of the *Mater Omnium* (Pl. 138), this *Madonna* is more slender and lyrical, with a touch of medieval pietism.

LOVERE (near Brescia), Lago d'Iseo, Galleria dell' Accademia di Belle Arti Tadini, *Madonna and Child* (Fig. 38)

Tempera on panel, 98 x 58 cm.; transferred to canvas by Cavenaghi, 1901–8(?), when the modeling in *pastiglia* in the haloes of the Madonna and child was removed; conservation in 1982 in Milan by Salvatore Fiume revealed the ocher background, obscured by Cavenaghi[1]
Inscribed: BEATA ES VIRGO MARIA ET GENITRIX QUAE CREDIDISTI[?] . . . [incomplete]; on *cartellino* on ledge, JACHOBUS BELLINUS
Frame: 19th-century copy of Accademia no. 582 (Fig. 42); carved c. 1900 by Giovacchino Corsi of Siena
Provenance: sold in Venice by 1815 to a collector in Bergamo from the Monastero di Corpus Domini (disbanded 1810); sold by Mauro Boni (a Venetian collector?) to Tadini(?)[2]

First noted by G. Moschini (*Guida di Venezia,* II, Part 2, Venice: 1815, 497) as abandoned in a "ministero," quoting the inscription. He thought the *Madonna* was in Bergamo at his time of writing, describing it as a small painting in tempera "molto pregiudicata al magistrato del monte-Novissimo," the child holding the mother's thumb as in another certain, signed work by Jacopo; he must have meant the *Madonna* in the Accademia, Venice (Fig. 42), with the artist's name inscribed on the old frame, the only other "signal" *Virgin and Child* then known.

The figures are two-thirds life-size, the composition going back to Gentile da Fabriano's *Madonna* (New Haven, Yale University Art Gallery). Christ's nudity refers to his corporeal sacrifice, the marble ledge to his entombment, the red cross on his tripartite halo to the banner of the resurrection. The Virgin's crown indicates her coronation in heaven. His

necklace of coral beads and branch is still commonly used in Italy to protect children from the evil eye; an open book on the pink ledge implies biblical prophecy of the Savior's coming, and Pallucchini (1955–56, 210) related its perspective position to Fra Filippo Lippi's influence. Hetzer (1985, 160) found in this *Madonna,* to him Jacopo's loveliest, the grace of Luca della Robbia.

Lovere's painting, one of the two surviving works bearing an original inscription of the artist's name, is also one of the few accepted by all critics and uniformly placed in Jacopo's middle period, in the later 1440s. The Virgin's face, still close to those by Gentile, shows that Jacopo at his best often retained the delicacy of his master's approach.

Over Mary's green robe is a pink mantle dotted with hundreds of golden flecks, a technique used by Gentile. Pallucchini (1955–56, 210) related the fall of light from the left to that in the Verona *Crucifixion* (Fig. 46).

MADRID, The Prado, *Marriage of the Virgin* (Fig. 28) and *Adoration of the Magi* (Fig. 30)

See Venice, Scuola di San Giovanni Evangelista

MATELICA, Museo Piersanti, Miniature Altar Frontal with Seven Saints (Fig. 62)

In original frame: St. Bartholomew at the center holds a knife and a model of a city with palace and campanile; to left and right are St. Stephen and St. Lawrence, the protomartyrs; Bernardino of Siena and St. Catherine of Alexandria are at far left and right, with Sts. Onophrius and Sebastian next to them
Tempera on panel, 29 x 60 cm. (painted area: 24 x 54 cm.)
The collection was formed in the first half of the 18th century by Monsignor Filippo Matelica

Testi first ascribed this painting, unusual for its small format, to "Scuola Veneziana(?)" (1915, II, 186), but reproduced it with his discussion of Jacopo's *oeuvre;* to L. Serra (*Gallerie . . . delle Marche,* 1924, 141) it was in the manner of Jacobello di Bonomo. Attributed to Jacopo by Longhi,[1] the figures are close to many in the drawing Books. Most critics accept the altar as Jacopo's design, executed by Giovanni in the later 1450s or early 1460s. Pallucchini included it in the great Giovanni Bellini exhibition[2] as a very early work, implying that it was based on his father's design.

The small format is in a Venetian tradition: eight standing saints are similarly depicted in a small altar by Paolo and Giovanni Veneziano (San Severino, Civica Pinacoteca).[3] A "private altarpiece" by Cosimo Tura for Ercole I d'Este (Washington, D.C., National Gallery of Art) also has small standing saints somewhat reminiscent of the Matelica Altar.[4]
According to S. Moschini, it is a late work of Jacopo's.[5]

St. Bartholomew was very popular although, apart from his being an apostle, the literature on his life and martyrdom is all apocryphal. Shown at the center holding a city symbol, he may be present as an urban patron. If he is here as a personal guardian, it is tempting to think that Bartolommeo Colleoni (1400–1475) commissioned this costly little altar, perhaps to supplement the crude, Friulese(?), Tre-

cento *Crucifixion* triptych of silver gilt (Montona, Duomo) that he used as a portable travel altar, which passed on to another *condottiere* with the same first name, Bartolommeo Alvia.[6]

Stylistically the panel is close to the predella (Figs. 49–51) assumed here to have been ordered for the Gattamelata Chapel by the widow of that earlier, great *condottiere* in Venetian employ. Like those three horizontal panels, this St. Bartholomew ensemble seems designed by Jacopo and painted by Giovanni.

MILAN, Brera, *Madonna of 1448* (Fig. 40)

Tempera on linen glued to panel, 50 x 45 cm.
Inscribed: on the illusionistic quatrefoil enclosure, 1448. HAS DEDIT INGENUA BELINUS MENTE FIGURAS ("In 1448, Bellini produced these forms with his genius"); exotic lettering to left and right of Madonna reads [MA]TER and DE[I]. The quatrefoil is cut down all around
Provenance: Church of the Servites, Riviera di Casalfiumanese, near Imola (Bologna)
Restored by Cavenaghi. Recent conservation proves the painting to be somewhat better preserved than it first seemed

Most critics accept the date and legend as inscribed (though clearly not Quattrocento in execution), making this *Madonna,* despite poor condition, an important document for the artist's style in 1448. The painting is slightly similar to the standing *Mater Omnium* in the Paris Book (Pl. 138), and its date may help establish the drawing's. The *trompe l'oeil* quatrefoil suggests that its location was originally architectural, possibly with saints in the format of a series placed between beam ends or as part of a frieze.

The infant's gesture of benediction, and his rich garb and cruciform halo, indicate the Salvator Mundi. Mary's pensive pose refers to the Passion to come; her crown prefigures her heavenly coronation. Pallucchini (1956, 212) saw Fra Angelico's influence in this *Madonna.*

First published by C. Ricci, "Una Madonna di Jacopo Bellini," *Rassegna d'Arte,* I (1903), giving the provenance, and again in 1912.[1] Hetzer (1985, 161) stressed the Madonna's Florentine quality.

MILAN, Museo Poldi Pezzoli, *Madonna of Humility* (Fig. 33)

Tempera on arched panel, 70 x 36 cm.
Frame: 19th-century Gothic Revival

The Madonna holds her standing, nude son as if resigned to his fate. Her cloak is bordered in Kufic script.
First ascribed to Jacopo by Cagnola, *Rassegna d'Arte,* I (1905), 65. Restored by Cavenaghi in 1908: F. Malaguzzi-Valeri, "Un nuovo quadro di Jacopo Bellini acquistato recentemente del Museo Poldi Pezzoli," *Rassegna d'Arte,* VIII (1908), 166; accepted by Borenius (I, 1912, n. on p. 109). Testi (1915, II, 272) attributed it to Jacopo Bellini. Most critics since (Van Marle, Coletti) have seen this *Madonna* as in large part Jacopo's: Van Marle (XVII, 1935, 103); Röthlisberger (1958–59, 78); and Berenson (I, 1957, 39). According to M. Natale (*Museo Poldi Pezzoli. Dipinti,* Milan: 1986, 100, no. 100), the painting

The first scholar to relate the Lovere *Madonna* to that listed by Moschini was Molmenti, 1892, 122. G. Frizzoni, "La Galleria Tadini in Lovere," *Emporium,* 17 (1903), 343–55, traces this picture to the Monastero di Corpus Domini.

According to C. Ricci, "Una Madonna di Jacopo Bellini," *Rassegna d'Arte,* I (1901), 113, the painting went from Rovellasca (near Como) to the Brera as attributed to a Marchigian follower of Crivelli; he termed the Jacopo Bellini signature false.
[3]Frizzoni, *op. cit.,* 343–55.

MATELICA. MUSEO. MINIATURE ALTAR FRONTAL WITH SEVEN SAINTS

[1]R. Longhi, "Un chiaroscuro e un disegno di Giovanni Bellini," *Vita artistica,* 1927, 134.
[2]R. Pallucchini, *Mostra di Giovanni Bellini,* Venice: 1949, 27; idem, "Commento alla Mostra di Ancona," *Arte Veneta,* 4 (1950), 17–18; and idem, *Giovanni Bellini,* Milan: 1959. See also his *Opera completa,* "Saggi e Ricerche 1925–28," 1967, 180.
[3]R. Pallucchini, "Commento alla Mostra di Ancona," *Arte Veneta,* 4 (1950), 7–32, fig. 3, described this as an unfinished polyptych. He gives the Matelica Altar to "G. Bellini(?)" (p. 19), c. 1450 (p. 18).
[4]See E. Ruhmer, *Tura,* London: 1958, cat. nos. 64–67.
[5]"La Mostra della Pittura Veneta nelle Marche," *Panorama dell'Arte Italiana* (1950), 385–89; also P. Zampetti's review of that exhibition, *Bollettino d'Arte,* 35 (1950), 372, giving the altar to Jacopo.
[6]The triptych has two male saints in each wing. See A. Morassi, "L'Altarollo portabile del Colleoni a Montona," *Dedalo,* 4, Pt. 1, 1923/24, 200–207.

MILAN. BRERA. MADONNA OF 1448

[1]Ricci, "Una Madonna di Jacopo Bellini finora sconosciuta," *Bollettino d'Arte,* VI (1912), 289.

NEW YORK, METROPOLITAN MUSEUM, MADONNA AND CHILD

[1] So seen in Van Marle (1935), fig. 62.

NEW YORK, WEBER COLL., SAN BERNARDINO DA SIENA

[1] For Bellini's images of Bernardino, see also Eisler, 1987.

*PADUA, PROFILE OF GENTILE DA FABRIANO

[1] The Anonimo, trans. P. Mussi and ed. G. C. Williamson, London: 1903, 23. See also Molmenti (Studi, 123) and Testi (1915, II, 249–50).

*PADUA, BERTOLDO D'ESTE

[1] The Anonimo, 23.

*PADUA, PROFILE OF LEONICO TOMEO

[1] The Anonimo, 19.

PADUA, SANTO, GATTAMELATA ALTAR

[1] Recorded by Fra Valerio Polidoro in his survey of the Santo's contents, Le religiose Memorie nelle quali si tratta della chiesa del glorioso santo Antonio Confessore di Padova, Venice (1590), carta 253. See also Marcantonio Michiel, Notizie d'opere di disegno, ed. G. Frizzoni, Bologna: 1884, 8. The inscription

(continued on following page)

dates from the 1440s; Boskovits (1985, 118), stressing its poor condition, suggests the 1430s. The Poldi Pezzoli catalogue by Russoli (1952, 39) lists it as "Bottega di Jacopo Bellini"; in 1955 (123) it was given to the master.

This painting is from Jacopo's *bottega* and dates in the 1430s.

NEW YORK, Metropolitan Museum of Art, *Madonna and Child* (Fig. 35)

Tempera on panel, 87.6 x 63.5 cm.; painted area 75.5 x 55.2 cm.
Inscribed: MARIA on Virgin's robe, to right of infant's shoulder
Frame: original, heavily restored; floral motifs close to the Brescia *Annunciation* Altar (Fig. 18) Extensively abraded; once repainted to clothe the nude child in accord with conservative Venetian tradition[1]
Provenance: ex-Coll. Count Carlo Foresti, Carpi; Eugenio Ventura, Florence (1928); Jesse Isadore Straus, donated by Irma N. Straus, 1959

This is Jacopo's largest half-length *Madonna*, originally one of his most powerful paintings. As in the Verona *Crucifixion* (Fig. 46), the figures are about life-size. The artist's original drawing on the gesso shows through the very thin paint layer. The infant's head suggests influence from Tuscan sculpture, unless restoration has enhanced these Florentine qualities.

Critics date the panel across 30 years. Lionello Venturi first attributed it to Jacopo ("Contributi a Masolino . . ." *L'Arte,* 1930, 180); Schmitt (1965, 709–10) sees it as Jacopo's first surviving painting after the Louvre *Madonna,* which she places in the 1430s. Röthlisberger (1958–59, 78, 88) dates the panel c. 1460, giving it with erroneous provenance to Jacopo's *bottega.* Its gold ground and the composition's archaic simplicity led Zeri (1973, 10) to a date before 1448. Boskovits (1985, n. 16) recently placed the picture before 1430.

If the child's Florentine qualities are authentic, albeit restored, they suggest a date in the later 1430s.

NEW YORK, Coll. Dr. and Mrs. John C. Weber, *San Bernardino da Siena* (Fig. 59)

Tempera on panel, 31 x 22 cm.
Recent restoration removed an old overpainting of the background in opaque black
Inscribed: IHS on either side of the head, as if woven into textile
Provenance: ex-Coll. William Graham, sale 1886
Lord Battersea, as "Carpaccio"
First attributed to Jacopo by D. Carritt (1979)

Still close in its "pointillist" technique to Gentile da Fabriano; painted shortly after 1450, the year of Bernardino's canonization. Carritt dated it c. 1455 and entitled the picture *San Bernardino Preaching,* a subject Bellini drew twice (Pls. 242, 243).[1] Here the saint may be in prayer; his eyes are lowered to his crucifix, the slender silver or polychromed figure of Christ on a thin, rough-hewn branch, following the medieval cult of the *lignum vitae.* Certain conventions, such as the foreshortened halo (see also the infant's in the Louvre *Madonna*; Fig. 31), are

close to the art of Boccati, possibly a pupil of Jacopo's.

The sacred monogram in the green cut velvet, different from that in the Paris Book (Pl. 230), is more like one in the *Sts. Anthony Abbot and Bernardino* (Fig. 48). Carritt detected the influence of Roger van der Weyden, whose works were available in Ferrara, calling this image "both the earliest surviving three-quarter profile portrait (albeit posthumous) and the earliest surviving individual portrait by a Venetian painter" (1979, 15). He also noted that the panel may have been designed to be seen slightly above eye level, as if the saint were preaching to the viewer.

NEW YORK, Private Collection, *Saints Anthony Abbot and Bernardino of Siena* (Fig. 48)

See Padua, Santo, Gattamelata Altar

*PADUA, Collection of Cardinal Pietro Bembo, *Profile of Gentile da Fabriano*

Recorded by the Anonimo Morelliano (Marcantonio Michiel), who saw it between 1521 and 1543. Sold 1815, Palazzo Gradenigo.[1]

*PADUA, Collection of Cardinal Pietro Bembo, *Bertoldo d'Este*

The Anonimo Morelliano (Marcantonio Michiel) saw this painting in Bembo's collection, and wrote: "If I am not mistaken . . . by Giacomo Bellini."[1]

That Ferrarese *condottiere* may also be the young dead knight lying on his tomb (cut from the Paris Book, Pl. 136). Bertoldo fell in 1463, defending Corinth; his body was brought back to Venice for a splendid military funeral in whose planning Jacopo may well have participated.

*PADUA, Collection of Leonico Tomeo, *Profile of Leonico Tomeo*

Described by the Anonimo Morelliano (Marcantonio Michiel): "The portrait of Messer Leonico himself, when a young man—now all perished, turned yellow and obscured—is by Giovanni Bellini. The portrait in profile of his father, in tempera, is by Giacomo Bellini."[1]

PADUA, Museo Civico, *Christ in Limbo* (Fig. 51)

See Padua, Santo, Gattamelata Altar

PADUA, Santo (Church of St. Anthony), Gattamelata Funerary Chapel, Gattamelata Altar by Jacopo, Gentile, and Giovanni Bellini (Figs. 47–51)

Dedicated to Sts. Francis and Anthony of Padua
Lost inscription: JACOBI BELLINI VENETI PATRIS AC

GENTILIS ET JOANNIS NATORVM OPVS MCCCC[IX].[1]
Scholars are divided between reading the last digits as "LX" or "LIX"[2]

Both sons had achieved considerable stature by that time, entitling them to sign this major work along with their father. The altarpiece was probably removed from the chapel by 1651; its panels entered different collections in the first half of the 19th century.

Construction of the burial chapel for the great *condottiere* Erasmo da Narni (Gattamelata), his widow, Giacoma Leonessa, and their son was completed by 1456, the tombs in 1458; wall decorations were still under way toward the end of the century. Lanzi (1828, 26) gives a date of c. 1456 for the altar; the Tietzes (1944, 102) erred in referring to it as a fresco series.

*Saints Anthony Abbot and Bernardino of Siena,* New York, Private Collection (Fig. 48)

Tempera on panel, 110 x 57 cm.
Provenance: Sold at Sotheby's, London, April 8, 1981, Lot no. 124, as by C. Crivelli. See Boskovits (1985, 113, 120)

This panel, probably designed by Jacopo and executed by Gentile Bellini, was the left wing of a triptych, here assumed to be the Gattamelata Altar. The missing central section may have resembled Gentile Bellini's *Madonna Enthroned,* painted shortly after 1469 (London, National Gallery; Eisler, 1985). Boskovits suggested a Man of Sorrows or similar funerary theme for the central panel.[3] The right wing is also lost but probably included Saints Francis and Anthony of Padua.

The predella, tempera on panel, from left to right:
*Adoration of the Magi,* Ferrara, Pinacoteca Nazionale, Vendighini–Baldi Bequest. 28.5 x 57 cm. (Fig. 49)

*Crucifixion,* Venice, Museo Correr, donated by Teodoro Correr. 28.6 x 57 cm. (Fig. 50)

*Christ in Limbo,* Padua, Museo Civico, donated by Dr. Antonio Piazza, 1844. 28.5 x 58 cm. (Fig. 51)

All three sections of the predella were probably painted by Giovanni Bellini in the late 1450s, based on his father's designs (Pls. 210, 213, 224).

In 1859 the *Crucifixion* was listed as "Paduan School" by Lazari (*Notizia . . .,* 7, n. 9). Cantalmessa (1896, 154) ascribed the Correr and Museo Civico panels to Jacopo.

Crowe and Cavalcaselle (1871, I, 112) were the first to give the Paduan panel (*Christ in Limbo*) to Jacopo. Berenson (1898, 91) first gave the Ferrara *Adoration* to Jacopo; Ricci (1908, 22) concurred, but Testi (1915, II, 268) ascribed it to a gifted assistant or follower who used Jacopo's drawings. Berenson (1957, I, 69) listed the whole predella as Jacopo's late work, Boskovits (1986, 387) as by the father, possibly with Giovanni's assistance.

Berenson had accepted the *Christ in Limbo* as Jacopo's (1907, 91), listing it as a late work in his later writings. Frizzoni (1909, 60) called that panel the work of a "pupil of Jacopo Bellini." Most critics have accepted it as Jacopo's own, but Ricci (1908, 25) saw it as the work of a follower, A. Venturi (1911, VII, Pt. I, 322) listed it as "Jacopo Bellini(?)," and Testi (1915, II, 274) thought it to be by an assistant of Jacopo's.

Many aspects of the *Crucifixion,* including the kneeling soldier (Gattamelata in Roman guise?) and the soldier's helmet at the left of the cross, are also in the London Book (Pl. 210).

Berenson (1894, 91), Coletti ("Pittura Veneta dal Tre al Quattrocento," *Arte Veneta,* I, 1947), and Lorenzetti (1947) thought this to be Giovanni Bellini's early work, c. 1450, and it was so shown at the 1949 Giovanni Bellini exhibition. Pallucchini (1955–56, 218) was sympathetic to this view.

✱PADUA, Santo (Church of Saint Anthony), Unidentified full-length(?) figure in fresco, formerly on the first pilaster to the left (Testi, 1915, I, 254); destroyed in 1671 to make room for the tomb of Pietro Sala (d. 1668)[1]

✱PADUA, San Michele Arcangelo (Parish Church), *Saint Michael*

c. 1430
Inscribed: JACOBUS DE VENETIIS DISCIPULUS GENTILE DA FABRIANO PINXIT. The lost Verona *Crucifixion* of 1436 had a comparable text
Presumably tempera on panel (described as *tavola*)

In 1430 the church's rector, Marco da Candia, ordered an image of the patron saint, "with certain adornments." Three artists, Niccolò da Candia (resident in Venice), Giambono, and Antonio da Verona (living in Padua), in that year estimated the painting's value at 35 gold ducats. The large work was recorded in Rossetti's Paduan Guide (1765) as a *tavola* above the altar, showing a gigantic figure of Archangel Michael with Lucifer vanquished at his feet. The painting was sold by 1853. Count Giuseppe Riva presented it to the Paduan church of Sta. Maria del Torresino.[1] The inscription was lost by then, probably cut away. The painting has since disappeared.

Rigoni (1929, 261–64) corrected Rossetti's reading of the inscription from "Neritus" to "Venetiis." Fiocco (1929, 264) suggested that Giambono's large *Saint Michael* (Florence, I Tatti) is close to Jacopo's lost work.

Documentation of the panel's existence is in Padua, Archivio Civico, Uffizi del Sigillo, t. 93, fasc. 3, c. 28v:

*die mercurij XVIIII Aprilis [1430]*
*Extimacio sancti michaelis.*

*Cum ad jnstanciam et requisicionem domini presbiteri marci de candida rectoris ecclesie sancti michaelis de padua facta fuit figura sancti michaelis in ecclesia sancti michaelis de padua cum certis adornamentis per magistrum Jacobum bellinum de Veneciis pictorem sine aliquo foro jdcirco predicte partes fuerunt contente super facto solucionis fiende dicto magistro Jacobo de eo quod taxabunt magister Nicolaus de candia pictor habitator Venecijs magister michael Zambom pictor habitator Venecijs et magister Antonius pictor de Verona habitator padue promitentes dicte partes habere firmum id quod taxabitur per predictos magistros pena librarum L parvorum.*
*post predicta dicti magister nicolaus, magister michael et magister Antonius electi ut supra concorditer de predictis laborerijs plene informati taxaverunt quod dictus magister Jacobus habere debeat pro predictis laborerijs a dicto presbitero marcho ducatos triginta quinque auri.*

may have been removed in 1651 when the chapel's dedication was changed, or in the Napoleonic period. See Eisler, 1987, col. 2.
[2]B. Gonzati, *La Basilica di S. Antonio di Padova descritta ed illustrata,* Padua: 1852, 59; Ricci, 1908, 36, doc. XXXVII, favored the 1459 reading; see Testi, 1915, II, 254.
[3]Boskovits (1986, 386) noted C. Volpe's belief that the *Sts. Anthony and Bernardino* were by Gentile Bellini, while maintaining the attribution to Jacopo and stressing Jacopo's role in the predella, labeling the Ferrara *Adoration* panel "Jacopo (et Giovanni?) Bellini." He suggested the lost Berlin *Man of Sorrows* by Squarcione (Boskovits, fig. 3) as the model for the missing central panel, but the proportions are not the same. If such a subject was used, then the Mantegna *Man of Sorrows* in Copenhagen affords a more likely source.

✱PADUA, SANTO, UNIDENTIFIED FIGURE IN FRESCO

[1]M. A. Michiel, 1884, 12. A somewhat similar surviving commission was given to Domenico Veneziano at Sta. Croce (Florence), on the wall of the rood screen. See Wohl, 1980, cat. no. 12, 134–38.

✱PADUA, SAN MICHELE ARCANGELO, SAINT MICHAEL

[1]According to Grinzato, *Memorie storiche sulle chiese di S. Maria del Torresino e di S. Michele,* Padua: 1853, 31, n. 14.

Land (1982, 285) believed that the payment of 35 ducats suggests a smaller image than life-size, despite Rossetti's description of it as a "figura gigantesca"; he followed Fiocco's view of the Giambono work as a source. His proposal (286) that Antonio da Verona could be identical with Antonio Pisanello is most plausible.

far from his others. The foreshortened halo on the infant is seen again in *San Bernardino da Siena* (Fig. 59).

PARIS. LOUVRE. MADONNA OF HUMILITY WITH DONOR

[1] Gramaccini (1982) reveals the meaning of many details that relate to Lionello's legitimization in 1429. These points (his p. 40) argue for a date nearer 1429 than twelve years later, that of the competition. He states that Lionello kneels at the site of his pleasure palace of Belfiore, outside the walls of Ferrara, in the Po valley, with Modena and Reggio at left and right, the Estes' two key strongholds after Ferrara. He believes the riders to represent the company of Lionello's loyal half brother, Borso, who leaves Modena (or Reggio) to pledge his support to Lionello. The conclusion of Gramaccini's otherwise fine study, contrasting the progressive aspects of Pisanello's portrait with the more traditional *Madonna of Humility*, is not correct, for the Pisanello portrait (Bergamo, Accademia Carrara) is itself very conventional. Moreover, the function of the *Madonna of Humility* is completely different.
[2] Schubring, 6, 12, 23.
[3] Van Marle (1935, XVII, 108).

VENICE. ACCADEMIA. FOUR TRIPTYCHS

[1] Résumés of the attribution history of the four triptychs are given by Pallucchini, *Giovanni Bellini*, Milan: 1959, 34–37; S. Moschini-Marconi, 1955, 86; Robertson, *op. cit.*, 1960, 45–59; and E. Arslan, "Studi belliniani," *Bollettino d'Arte*, 47, 1962, 40–58. See also Meyer zur Capellen, 1985.

PARIS, Louvre, *Madonna of Humility with Donor* (Lionello d'Este?) (Fig. 31)

Tempera on panel, 60.2 x 40.1 cm.
Inscribed: NUES AVE MATER REGINA MUNDI AVE MATER, in Madonna's halo
Frame: 19th century
Seemingly well preserved (needs cleaning)
Provenance: ex-Coll. O. Mündler; Lamoignan Sale, 1873

Attributed in the early 19th century to Gentile da Fabriano, this *Madonna* may be among Jacopo's earliest paintings. A. Venturi (edition of Vasari's *Vite*, Florence: 1896, 25) called it "School of Pisanello." The diminutive, lavishly robed figure kneeling at Mary's side is probably a plump Lionello d'Este, shortly after 1429, when Pope Martin V confirmed him as the legitimate heir to Ferrara (Niccolò III selected him as successor over his other and elder sons, all bastards). The infant's apparent blessing of Lionello's regal attire, so carefully described by Gramaccini (1982, 34 f.), suggests that early date though he believes the panel was painted for the portrait contest in 1441.[1] Pisanello and Jacopo are known to have submitted entries for Lionello's portrait, a competition which Jacopo won (see *Ferrara for this lost painting).

The critical opinions follow in brief: Schubring (1903, 23),[2] first to identify the donor as Lionello d'Este and to give the work to Jacopo, dating it c. 1440; Ludwig-Molmenti (1906, 10) did not accept the *Madonna* as Jacopo's; Ricci (1908) accepted the attribution, but not the identification of the donor's image with the Este portrait competition of 1441; Gronau (1909, 254), between Gentile da Fabriano and Pisanello, probably not by Jacopo; Coletti (1953, xxxii) dated it c. 1440; Testi (1915, II, 276–80), not by Jacopo; Berenson (1932, 593) listed it among works of anonymous Venetian masters, possibly by Bono da Ferrara; Longhi (1934, 15), by Jacopo, noting the "pointillist" technique, still close to Gentile's; Van Marle (1935, 108)[3] identified the donor as Lionello, but rejected it as the "portrait" for the contest of 1441, finding the donor looked too young; Berenson (1957, I, 68) accepted the painting as showing Lionello, by "Jacopo Bellini (?)"; Schmitt (1965, 709) accepted Lionello's identification and the picture as Jacopo's first surviving work, just before the New York *Madonna* (Fig. 35), dating this in the 1430s; Boskovits (1985, 116 f.) doubted the Este identification, dating the painting as 1430 at the latest; Heiss (1883, 16 ff.) and Ricci (1903, 345) identified the sitter as Sigismondo Malatesta, on the basis of the Pisanello medal.

This work can only be a personal devotional commission for a chapel or residential domestic altar, totally unsuitable in theme and scale for a portrait competition. Still very close to Gentile da Fabriano, the Louvre panel cannot date much later than 1430 and provides the earliest evidence (if by Jacopo) of his skills as portrait painter, *animalier*, and master of landscape. While most of the painting is consistent with Jacopo's art as known from his drawings as well as pictures, the Madonna type is

POUGHKEEPSIE, N. Y., Vassar College Art Gallery, Gift of Charles M. Pratt (Fig. 61)
Triptych: *Saint Francis* (left), 116 x 35 cm.
*Saint Jerome* (center), 136 x 54 cm.
*Saint Anthony Abbot* (right), 116 x 36 cm.

Tempera on panel
19th-century frame
Provenance: ex-Coll. Nevin?

Published by Boskovits (1985, 118–20) as by Bellini, dating c. 1450. T. J. McCormick (*Vassar College Art Gallery. Selections from the Permanent Collection*, 1967, 4) listed it as Paduan, late 15th century. Attributed to Antonio Vivarini by Zeri and Fredericksen (1972, 211, 372, 396, 406, 623), and Berenson (1957, 199).

The generalized, rather cursory treatment of many areas, especially the hands, suggests a workshop production. Far larger in size than the flanking saints, St. Jerome in cardinal's robes holds a book and an early Venetian church and campanile; St. Francis' stigmata are visible on his hand and through his monastic habit; St. Anthony Abbot holds a bell and staff. All three stand on one stone floor against a monochrome background, originally less dark than it now appears.

TURIN, Galleria Sabauda, *Birth of the Virgin* (Fig. 27) and *Annunciation* (Fig. 29)

See Venice, Scuola di San Giovanni Evangelista

VENICE, Accademia (cat. nos. 621, 621a, 621b, 621c), Four Triptychs

Originally in the now-destroyed "Barco"—the choir of the Church of Santa Maria della Carità that today is part of the Gallerie dell'Accademia (Figs. 63–66). The humanist Ulisse degli Aleotti, *guardian grande* of the church's scuola, wrote two poems praising Jacopo Bellini's victory over Pisanello in the Ferrarese portrait contest of 1441.

Triptych of *Saint Lawrence* (Fig. 64)

Tempera on panel, poorly preserved
Original frame lost

Commissioned in 1460 by Lorenzo Dolfin. In the central panel is his patron, *St. Lawrence*, with *St. John the Baptist* (left) and *St. Anthony of Padua* (right), each panel 127 x 45 cm. In the lunette, 59 x 170 cm., is a half-length *Madonna and Child* with flying angels at left and right.

Triptych of *Saint Sebastian* (Fig. 66)

Tempera on panel, poorly preserved
Original frame lost

Commissioned in 1460 by Zaccaria Vettori. Central panel, *St. Sebastian*, with *St. John the Baptist* (left) and *St. Anthony Abbot* (right), each panel 127 x 45 cm. In the lunette is *God the Father*, with the *Annunciation* on either side, 57 x 151 cm.

Triptych of the *Nativity* (Fig. 63)

Tempera on panel, poorly preserved
Original frame lost

Commissioned by Andrea da Molin after Oct. 13, 1462, when he took over responsibility for the altar (Fogolari, 1924, 83). He had originally wanted the Chapel of St. Ursula, where the *Madonna* altar was located (Fig. 65), but in August of 1460 requested the "Barco" location instead.

The *Nativity* and *Annunciation to the Shepherds* with a naturalistic sky (center), with *St. Francis* (left) and *St. Victor* (right), each panel 127 x 48 cm. In the lunette is the *Throne of Grace,* between *St. Augustine* (left) and *St. Dominic* (right), 60 x 166 cm.

Triptych of the *Madonna* (Fig. 65)

Tempera on panel, poorly preserved
Original frame lost

The altar was originally dedicated to St. Ursula, but it was ceded in 1464 to Jacomo Zorzi, who placed his tomb below it.

The standing *Madonna and Child* (center) with *St. Jerome* (left) and *St. Louis of Toulouse* (right), each panel 127 x 48 cm. In the lunette, the *Man of Sorrows* between two mourning angels, 59 x 168 cm.

These four triptychs, designed and executed between 1460 and 1464, were placed above the burial sites of their patrons, all four chapels dedicated in 1471 (Fogolari, 1924, 80–84). In 1462, a mason, Jacopo da Milano, contracted to build the side of the choir facing the altar, agreeing that his work should be "tutto a lantiga," "all in the antique manner" (Fogolari, 1924, 115), the reference important for suggesting the first Venetian interior decorated consistently in the antique style. The four altarpieces' common format reflects a similar desire for uniformity which would be more evident were they in their original, presumably classicizing frames.

The central sections of three altars are very slightly concave, a feature shared by only one other Italian painting, Mantegna's *Adoration of the Magi* (Florence, Uffizi), a work often dated in the early 1460s.

The altarpieces were first described in their original locations by Boschini (*Ricche minere,* Venice: 1664, 358) as by the Vivarini.[1] Berenson ascribed them to Giovanni Bellini ("Les quatres triptyques Bellinesques de l'église de la Carità à Venise," *Gazette des Beaux-Arts,* X, 1913, 191–202); Bottari (1962, 6) agreed with this for most of the panels. According to G. Robertson ("The Earlier Works of Giovanni Bellini," *Journal of the Warburg and Courtauld Institutes,* 23, 1960, 45–59), the altarpieces are from Jacopo's shop, painted by his assistants; Giovanni may have worked on the *Baptist* in the *St. Lawrence* Triptych, the *Madonna* in the Marian Triptych, and, in the *Nativity* Triptych, the *St. Sebastian,* the *St. Anthony Abbot,* and the lunette with the *Throne of Grace.*

Robertson (1968, 41) first stressed Jacopo Bellini's role in the design of all four Carità altars, pointing out many correspondences between their figures and those in the Books: "these parallels reveal a fundamental similarity in the stylistic makeup of the Carità triptychs . . . , both showing an eclecticism embracing Tuscan elements. . . . The drawings . . . perhaps some ten years older than the paintings . . . "

J. H. Keydel has made the closest study of these ensembles (1969, 49–73). Her relating (59) of the format of all four altars with early 15th-century funerary monuments in Florence is significant in view of the commemorative purpose of the Carità altarpieces in family chapels. She finds in the altarpieces (69) "the presence of three intersecting energies—. . . of Jacopo Bellini, [perhaps] responsible for setting the tone of the ensemble, . . . of a major artist whom we take to have been Giovanni Bellini, and . . . of one (or even more) co-workers within the studio whose talents were limited to echoing the pattern of style achieved by the major master." She gives the design and execution of the *Nativity* and the *Madonna* panels to Giovanni Bellini, possibly with Jacopo's collaboration. Except for the *Throne of Grace,* Keydel assigns the lunettes to Giovanni, and *St. Sebastian, St. Lawrence,* and the side panels of the *Nativity* Triptych as well (68). Huse (1986, 211) gives the altars to Jacopo Bellini, working with his sons.

These paintings are difficult to judge: stripped of their original frames and with archaizing gold backgrounds in all but one panel, and no predellas, they present an odd fusion of old and new. Robertson and Keydel have stressed the triptychs' likely origin in Jacopo's design, in view of their eclectic style and date in the early 1460s. Strong Tuscan elements and Gothic references are side by side, many close to motifs in his Books and other paintings.

VENICE, Accademia (cat. no. 835), *Legnaro Madonna* (Fig. 37)

Tempera on panel, 71 x 52 cm.
Inscribed: in Virgin's halo, REGINA • CELI • LETARE • ALLELUIA • QUIA • QUEM • MERUISTI • PORTAR • ALLELUIA, quoted from the Antiphon of the Virgin (Moschini-Marconi, 1955, 25)
In ruinous condition
Provenance: parish church, Legnaro

First published by Fogolari (1920, 122; 1921, 104–7), who dated the painting c. 1460. See also Paoletti (1929, 75) and Berenson (1932, 75; 1936, 65).

Though dated c. 1440 by Boskovits (1985, 122, n. 20) and seen as a late work by Röthlisberger (1958–59, 85), a date after the Brera *Madonna of 1448* (Fig. 40), as suggested by Van Marle (1935, 114) and Moschini-Marconi (1955, 25), seems correct. Pallucchini (1955–56, 212) dated it after 1450. Schmitt (1965, 710) saw the painting as contemporary with the Brera *Madonna;* Coletti (1953, xxxii) related it to the conservative Gothic manner of Venice, Giambono-like.

The baby chucks his mother under the chin with one hand, tugging at the neck of her dress with the other, ready for nursing. Mother and child have flat halos. The vivacious child suggests Tuscan influence, though lively children also occur in early Venetian *Madonnas.*

VENICE, Accademia (cat. no. 582), *Madonna of the Cherubim* (Fig. 42)

Tempera on panel; 94 x 66 cm.
Inscribed: on frame below painting, OPUS • IACOBI • BELLINI • VENETI
In original Venetian Gothic arched frame

The humanistic lettering, though its date has been disputed, could well be 15th century. Drawings in the Paris Book (Pls. 84, 86) and the illuminations in manuscripts associated with Jacopo's studio are in a

VENICE. ACCADEMIA. MADONNA OF THE CHERUBIM

[1]For these problems, see Ricci (1908, 13–14) and Testi (1915, II, 174–76). Possibly Abbot Foscarini was a descendant of Doge Francesco Foscari, and the panel believed for that reason to come from the Doge's Palace. Zanotto (*Il Palazzo Ducale di Venezia,* Venice: 1853) states that it came from the Scuola di San Giovanni Battista, Murano, then into the Magistrato del Monte Novissimo, from which it was purchased by Giovanni Maria Sasso. See also Lanzi, *Storia pittorica dell'Italia,* Bassano: 1795–96, II, 85.

similarly classicizing manner. Moschini-Marconi (1955), assuming that Giovanni Bellini inherited the panel, suggests that he added the inscription.

Considerable abrasion in the heads of mother and child; these were repainted in the 19th century and restored c. 1900. For the condition before restoration, see Testi, 1915, II, 152.

Provenance from the Doge's Palace according to Paoletti (*Catalogo delle Gallerie di Venezia,* Venice: 1903, 169).[1] Owned in the early 19th century by the art dealer Sasso, who acquired it in the late 18th century in Padua from Abbot Foscarini. Possibly from the Scuola di San Giovanni Battista in Murano, center for Venetian map making, a skill Jacopo might have possessed.

Blue cherubim with gold halos surround the Madonna. Her mantle is lined with dark rose, her dark ultramarine robe stippled with gold. The child, in gold-decorated clothing, is seated on a ledge on a red cushion with a floral pattern in gold.

Turned toward the spectator, the infant raises his right hand in benediction and holds a fruit in his left as the New Adam, Mary becoming the New Eve by implication.

The closed book on the ledge is probably one of prophecy. The Madonna's downcast, pensive gaze anticipates her son's earthly fate. The mourning cherubim who fill the background are symbols of Holy Wisdom, a formula stemming from earlier painting and from Tuscan sculpture, perhaps by Donatello or Michelozzo. Northern manuscript sources have also been suggested for these figures. Many aspects of the *Madonna of the Cherubim* point to the art of Jacopo's future son-in-law, Andrea Mantegna, whose small *Madonna* (New York, Metropolitan Museum of Art) was once ascribed to Jacopo. Critics have noted that this powerful Accademia panel also anticipates Giovanni Bellini's *Madonnas.*

This was the only painting Lanzi knew (1828, 26) as by Jacopo. He accepted the inscription as the artist's signature and described the *Madonna's* style as "taken from that of Squarcione, to which he [Bellini] is supposed to have applied himself in his more advanced years."

Röthlisberger (1958–59, 85) places the *Madonna of the Cherubim* after 1446, his date for the Lovere *Madonna.* Pallucchini (1955–56, 212) views it as after 1450, one of the last of Jacopo's surviving *Madonnas;* likewise Van Marle (1935, 122 f.). A date in the 1450s is most plausible.

VENICE, Museo Correr, *Crucifixion* (Fig. 50)

See Padua, Santo, Gattamelata Altar

VENICE, Palazzo Ducale, Sala degli Ambasciatori, *Lamentation with Saint Mark* (left) *and Saint Nicholas* (right) (Fig. 52)

Originally in the Cappella di San Niccolò, then in the Magistrato dell'Avogario.[1] Completed by Giovanni Bellini
Tempera(?) on canvas, 115 x 317 cm.
Inscribed: IOHANNES BELLINVS on a *cartellino* at the center of the sarcophagus. Below, the date 1472 was visible until the late 18th century[2]

Paolo Farinati enlarged the altarpiece to a rectangular format (including an extensive landscape) of 250 x 325 cm., inscribing it: 1571 RENOVATIO.[3] Pellicioli

removed the additions in 1948 and gave the canvas its present arched format. The very low curve, though found in altarpieces such as that by Giovanni Bellini for the Carità, looks inappropriate and is probably not original, added to conform with a later architectural setting. The kneeling saints suggest an early modification by the studio of Giovanni and Gentile Bellini.

Robertson (1968, 15) noted Giovanni's name in a similar form in one of his earliest works, the *Saint Jerome* (Birmingham, England, Barber Institute), which is dependent on his father's drawings in the Paris Book.

Most previous 20th-century criticism assigned the canvas to the circle of Gentile Bellini. Longhi (1945, 278, n. 5), stressing the dependence of the composition on the Paris Book (Pl. 218), viewed the central group as an autograph work of Giovanni's. Robertson (1968, 46–47) believed the canvas was from Giovanni's studio, possibly by Lauro Padovano, and suggested that the presence of Saint Nicholas argued for the patronage of Doge Niccolò Tron (r. 1471–1473).

The *Lamentation* (or *Pietà*) was first given to "Jacopo Bellini and Studio" by Belting (1985, 9, 55–56). The date of 1472 is an argument in favor of his view, though he does not discuss it. The large canvas was probably left incomplete at Jacopo's death in 1471 and finished by Giovanni, who consulted drawings in the Paris Book that he and his assistants had already reworked in pen or would soon do so. Heinemann observed that a date of c. 1460 would be correct for Giovanni's *oeuvre,* so its completion in 1472 marks the artist's deliberate return to an earlier style.[4] Both Gentile and Giovanni spent much time restoring or replacing their father's paintings.

The picture was first in the Prisoners' Chapel, dedicated to Saint Nicholas, and the inclusion of that saint bespeaks Doge Niccolò Tron's special interest, as Robertson noted.[5] However, it was probably begun by Jacopo under Tron's predecessor, Doge Cristoforo Moro (r. 1462–1471), a great patron of the arts, who died in the same year as Jacopo Bellini.

The awkward placing of the saints not only suggests studio participation, but also some change in program. The canvas was doubtless much enlarged in 1571, after the Prisoners' Chapel was demolished early in the 16th century and the work moved to a new setting in the Magistrato.

❋VENICE, Palazzo Ducale, Sala del Maggior Consiglio (court side), *The Naval Victory at Punta Salvore (Salboro) and the Capture of Othon, Son of Barbarossa*

Fresco, between 1409 and 1414

By Gentile da Fabriano, who may have employed young Jacopo Bellini to assist him. Already damaged by mid-century, along with many other frescoes. Giovanni Bellini perhaps made the first major "restoration" of the fresco; it was later restored by a team under Gentile Bellini's direction, beginning in 1474, Giovanni Bellini, Alvise Vivarini, Carpaccio, and Perugino all working on the same project. Other frescoes were added later by Titian and Pordenone. All were destroyed in the fire of 1577. Ultimately this fresco was replaced by Domenico Tintoretto's, still in place today.

VENICE. PALAZZO DUCALE. LAMENTATION WITH SAINT MARK AND SAINT NICHOLAS

[1] Two chapels had St. Nicholas as patron saint, one in San Marco, in the private chapel of the doge (where the fire of 1483 began), and the other in the Doge's Palace for prisoners' use. Pincus (1976, 22, n. 27) observed that "apparently the doge's chapel does not acquire the name of Cappella San Niccolò until the beginning of the 16th century." She warns that we "must be careful to distinguish between the doge's private chapel above the church of San Marco at the north end of the courtyard and the chapel of San Niccolò at the south end of the complex on the loggia level of the east wing, this latter being demolished in the early 16th century." Jacopo's canvas seems to have been at this location, used primarily for prisoners since the late 14th century, according to a decree of Pope Urban V (r. 1362–1370).
[2] First cited by Ridolfi (1648) and Boschini (1660), it was last mentioned by Zanetti, 1771, 49. Both the inscription and the date were doubted by Heinemann, *Giovanni Bellini e i Belliniani,* Venice: 1969, cat. no. 158, 48.
[3] Recorded by G. A. Moschini in his edition of C. Ridolfi's *Vita di Giovanni Bellini,* Venice: 1831, 21, n. 3 (cited by Robertson, 1968, 46–47).
[4] Heinemann, *ibid.*
[5] Robertson, 1968, 46–47.

VENICE. PALAZZO DUCALE. THE NAVAL VICTORY AT PUNTA SALVORE

[1] See Christiansen (1982, 11, 138–39). For the Sala and its subjects, see Wolters (1983, 166–68); for the cycle and the art of Giovanni Bellini, see N. Huse, "Studien zu Giovanni Bellini," *Beiträge zur Kunstgeschichte,* 7, Berlin, 1972.
[2] Translation courtesy of Irving Gumb. See Christiansen, 1982, Catalogue of Lost Works no. CLVIII, 138–39. Text drawn from G. Lorenzi, *Monumenti per servire alla storia del Palazzo Ducale di Venezia,* Venice: 1868, 63.

The battle, of great propagandistic importance for the history of Venice, may never have taken place. It is part of the cycle illustrating the 17-year conflict between Pope Alexander III and the Holy Roman Emperor Frederick Barbarossa, settled under the aegis of Doge Ziani (r. 1172–1178). This important meeting of world leaders at Venice brought great prestige to the Republic. Gentile's fresco is briefly described in Facius' *De viris illustribus,* who praises it for illusionistic effects.[1]

The fresco was inscribed as follows: "The [enemy] ranks fight bravely, nevertheless the most famous general and the most upright Venetians, with God assisting, gain a victory and triumph, with Otto, the son of the Emperor, captured, and with all the imperial galleys subdued and placed in the fight from which 60 were captured, and the remaining were consumed by the waves or by fire, with a few exceptions who made their escape."[2]

✱VENICE, San Giorgio Maggiore, *Entry of Christ into Jerusalem* (Ricci, docs. XXXI–XXXII)

Described in a document of 1811 as small, on panel (*tavola*), and like the composition in "suo libro di disegni," the earliest known reference to a specific page in Bellini's London Book (Pl. 190), then in Venetian ownership. A frame added to the panel at an unknown date was inscribed: *Opus Ioannis Bellini Anno Dni 1497 in civitate Alexandriae Minoris.*

Listed among export permits of 1806–11 for works selected by Pietro Edwards for Napoleon's collection, after the religious institutions were dissolved in Venice. Most of the pictures were sent to Milan; many (including those by Gentile and Giovanni from the Scuola di San Marco) are in the Brera, Milan.

✱VENICE, Santi Giovanni e Paolo, paintings by Jacopo, otherwise unidentified, were supposedly located in a small chapel to the left (Testi, 1915, II, 257)

✱VENICE, San Pietro di Castello, *"Figura" of Lorenzo Giustiniani,* placed above his tomb. Paid for on January 8, 1456, 16 ducats (Ricci, doc. XVI, 55):

1456. Misser Iacomo Bellin de dar a di primo fevrer per capara et parte de una figura contadi per d. Vetor . . . . . . . . . . . . . duc. 4
26 contadi per parte de la dicta figura per d. Vetor . . . . . . . . . . . . . . . . . . . . 10
1456. ser Jacomo Belin de aver per una figura del nostro predecessor posto sopra la sua sepoltura . . . . . . . . . . . . . . . . . . . . duc. 16

Listed in the Registro della Cassa 1444–1459, Archivio di Stato di Venezia, Mensa Patriarcale, B. a58, Libro I, fols. 106 ff., carta 122:

1456 . . . c. per una figura del mio predecessor la quale fexe m. jacomo bellini ducati sedexe a charta 122 duc. 16 —

If the image of Lorenzo Giustiniani, recently deceased patriarch-bishop of Venice, was painted for a sculptor's guidance, it may have been a *grisaille* on linen that was used also by Gentile Bellini for a portrait of Lorenzo as *beato,* with two clerics and two angels, signed and dated 1465 (Venice, Accademia). A bust-length version of the future saint

(Seminario Patriarchale, Venice), his right hand raised in benediction, may also be by Gentile. Another, still more reduced version, without the hand, is in the National Museum, Warsaw, from Wrocław (Breslau); it is on panel, 40.5 x 30 cm., ascribed to Lazzaro Bastiani, probably a pupil of Jacopo's.[1]

Meyer zur Capellen (1981, 12 ff.) suggested that Jacopo's project was for the bust still in San Pietro di Castello (sometimes attributed to Antonio Rizzo), but this rigid, archaizing statue seems to postdate Bellini, probably carved after 1471.

✱VENICE, San Pietro di Castello, *Altarpiece with Saints Peter, Paul, and a third saint* (Mark?)

(Ricci, doc. XVI, 55). Registro della Cassa 1444–1459, Archivio di Stato di Venezia, Mensa Patriarcale, B.a 58, Libro I, fols. 106 ff., carta 122. San Pietro di Castello. On linen. In Sala del Patriarca:

16 Marzo contadi 1457 . . . . . . . . . . . . . . . . . 2
1° Aprilis contadi per capara de una depentura de S. Piero e S. Polo . . . . . . . . . . . . . . . . . 5
29 contadi per don Vetor . . . . . . . . . . . . . . . . . 3
contadi per dom. Vetor per resto a so fio contadi duc. 2 . . . . . . . . . . . . . . . . . . . . . . . 13

1457 e de aver per 3 figure fate su tela mese in la salla grande del patriarca duc. 21, dei quali due furono contadi a so fio.

VENICE, Scuola di San Giovanni Evangelista[1] Eighteen (or more?) canvases, with scenes from the lives of Christ and the Virgin

Five were first noted by Zeri (1982, 227 ff., without citing subject or owner) in the possession of the Earl of Oxford and Asquith; still at his residence, all five are now, according to the earl, the property of his son. All in oil on canvas, the larger canvases measure about 111 x 151 cm.; the draperies in three of these are stippled with gold, in the technique of Gentile da Fabriano.

The scuola's leaders first deliberated on a biblical cycle in 1421, a series of Old and New Testament subjects "de far istoriar la Sala della nostra Casa" (Ricci, doc. I). These paintings were prepared in the second half of the 15th century for the chapter hall (Sala Maggiore) on the upper floor (*piano nobile*) of the scuola's reception area (*albergo*), installed after an extensive renovation of the *albergo* in the 1450s (Paoletti, 1893, I, 57). An adjacent chamber to the east was decorated by Gentile Bellini and others with scenes of *Miracles of the Relic of the Cross* (now Accademia, Venice). For the ground plan of the *piano nobile,* see Appendix D, Ill. 1. The scuola also owned an altarpiece by Jacopo (Sansovino, 1581, VI, 284), probably the *Dead Christ Supported by Two Angels* (A), perhaps in the sacristy to the west of the Sala Maggiore (now lost). Jacopo received final payment on January 31, 1465; "Rezevi mi jachomo belino pintor da missier lo guardian e chompagni duchati oto, zoe oto per resto d ogni razon fin questo di."[2]

Collins (*Art Bulletin,* 1982) made an important study of the original setting, examining the Sala Maggiore during its restoration (1969–76) after the

✱VENICE. SAN PIETRO DI CASTELLO. "FIGURA" OF LORENZO GIUSTINIANI

[1]See *Venezianische Malerei 15. bis 18. Jahrhundert,* Albertinum, Dresden: 1968, cat. entry 9. This work does not include the raised hand.

VENICE. SCUOLA DI SAN GIOVANNI EVANGELISTA. SCENES FROM THE LIVES OF CHRIST AND THE VIRGIN

[1]Testi, II, 1915, 163, n. 2, Archivio di Stato, Scuola di San Giovanni Evangelista, n. 72, p. 269. See Wurthmann, 1975, 143 ff; *idem,* 1982; Pignatti, 1982; Paoletti, 1893, I.
[2]See S. Mason, "Contributi d'archivio per la decorazione pittorica della Scuola di San Giovanni Evangelista," *Arte Veneta,* 32 (1978), 293–301.
[3]The series was still probably intact as late as 1787–88 when G. M. Urbani de Gheltof (1895, 26 ff.) saw it in two rooms of the upper floor of the scuola.
[4]Andrea Castagno showed the dead Christ supported in the tomb by angels in a great frescoed lunette for S. Apollonia in Florence, probably from the mid-1440s, that decade also including the artist's Venetian residence. Donatello designed a marble relief of the theme (London, Victoria and Albert Museum), the Christ gargantuan in contrast with the little angels who struggle to support him while grappling with their grief. The theme of the Pietà engaged Donatello during his Paduan years and is seen in many variants by Mantegna, young Giovanni Bellini, and Squarcione.
[5]See J. Snyder, "'The Joyous Appearance of Christ with a Multitude of Angels and Holy Fathers to his Dearest Mother': A Mystical Devotional Diptych by Jan Mostaert," *Tribute to Lotte Brand Philip,* New York: 1985, 175–84.

Appendix D,
Ill. 1. Groundplan of
*piano nobile*, Scuola di San
Giovanni Evangelista.
Archives of the Venice
Committee

N

Tribune

Sacristy          Sala Maggiore              Sala          Albergo       Archivio
                                          della Croce      Nuovo

Appendix D,
Ill. 2. Reconstruction by
Howard Collins, North
Wall of Sala Maggiore,
*piano nobile*, Scuola di San
Giovanni Evangelista

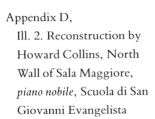

flood of 1966. His reconstruction of the elevation of the Sala Maggiore's north wall (Appendix D, Ill. 2) shows nine canvases each, on this and also on the south wall.

According to Vasari (III, 151–2), Jacopo also painted "una storia della Croce" on canvas for the scuola with the help of his sons; possibly Vasari was conflating the Sala Maggiore with the adjacent Sala della Croce. Sansovino (1581, VI, 283–84) gave the same information about Jacopo, but did not name the sons, perhaps confusing Jacopo's works at the Sala Grande of the Scuola di San Marco, which included a Calvary painting, with his canvases at the Scuola di San Giovanni Evangelista.

Ridolfi (*Meraviglie dell'arte,* 1648, 36) gave 18 titles for Jacopo's paintings, though they had been removed long before. The Sala Maggiore was rebuilt in the late 16th century and a new, larger cycle installed, devoted to the scuola's patron saint.[3] Ridolfi does not mention Jacopo's sons working on this series; for his titles, he followed descriptions by those who had seen the pictures, and their accuracy has been doubted. The absence of a *Flagellation* is remarkable, as this scuola, like the others, was founded as a penitential self-scourging group; the Tietzes (1944, 94) questioned the *Return from Egypt,* a subject they found implausible at that early date. According to Collins (1982, 468), the cycle may have been initiated in 1453, when Jacopo was given funds by the scuola toward his daughter's dowry (Appendix E, Doc. 1453), but the paintings were probably begun later, as their future setting was undergoing costly renovation that year (Paoletti, 1893, I, 57).

After the Venetian religious institutions were dissolved in the Napoleonic era, eight canvases supposedly from the scuola were owned by Natale Schiavone and Francesco Canella, Venetian painters who probably restored them. The four reproduced here are all poorly preserved (Figs. 27–30). The Galleria Sabauda in Turin acquired the *Birth of the Virgin* (C) and the *Annunciation* (E) in 1878; the *Marriage of the Virgin* (D) and *The Adoration of the Magi* (G), both ex-Coll. John J. Chapman (Barrytown, N.Y.), are

now in the Prado, Madrid, carefully restored by Marco Grassi in 1982.

Descriptive quotations below are from Ridolfi (1648). Among those fifteen canvases whose loss is questioned, five are owned by the Earl of Oxford and Asquith and by his son.

✱(?) A. *Dead Christ Supported by Two Angels*
An altarpiece described by Sansovino (1581, VI, 289) as in the Sala della Croce, it probably resembled Giovanni Bellini's many images of the *panis angelorum* (Venice, Museo Correr). This eucharistic theme, recalled in the mass, refers to Christ's body as the bread borne by angels and offered in heavenly sacrifice. This painting probably differed in shape from the others, possibly smaller and of a vertical format like Squarcione's of the subject, formerly in Berlin (Boskovits, 1986, fig. 3), or early works by Giovanni Bellini.[4]

✱(?) B. *Meeting at the Golden Gate,* Private Collection, England
Of the entire series this painting is the most revealing in conjunction with Bellini's Books, as it is closest to his graphic genre elements. The right half of the composition is taken up with peasant figures, including one man with an egg basket. Very poorly preserved.

C. *Birth of the Virgin,* Turin, Galleria Sabauda (Fig. 27)   112 x 152 cm.

D. *Marriage of the Virgin,* Madrid, Prado (Fig. 28) 111 x 151 cm.

E. *Annunciation,* Turin, Galleria Sabauda (Fig. 29) 112 x 152 cm.

✱(?) F. *Visitation,* Private Collection, England
The composition includes the husbands of Mary and Elizabeth as well as a third woman seen in half-length through a window. The beautiful landscape at upper left is close to those in the London Book. Poorly preserved.

G. *Adoration of the Magi,* Madrid, Prado (Fig. 30)
111 x 151 cm.

✳(?) H. *Presentation of Christ in the Temple,* Private Collection, England
In the background is a fine landscape. To the right a sweep cleans a characteristically Venetian chimney. Poorly preserved.

✳(?) I. *Flight into Egypt*
"The Virgin and child ride upon an ass, preceded by many angels. Joseph draws a wooden cart containing their possessions." The London drawing (Pl. 180) may relate to this scene, as might woodcuts by Dürer.

✳(?) J. *Holy Family Working in Egypt*
"Joseph is carpenter, as Mary sews and Christ brings tools to his father. Angels sing and make music to entertain the working family." Two German works show this rare theme: an anonymous painting (Hanover, Kestner Museum) and a woodcut by Dürer (Bartsch 190), dating near his second Venetian visit. The 14th-century Franciscan *Meditations on the Life of Christ* (Ragusa and Green, 1961, 71–76) contains elaborate accounts of Joseph and Mary's labors in Egypt. The theme signifies "Joseph will perfect, Mary enlighten, and Jesus save thee"; see Hahn's article with this as its title, *Art Bulletin,* LXVIII, 1986, 54–65.

✳(?) K. *Return from Egypt to Judea*
Joseph and Mary walk with Jesus, as angels lead the ass bearing Joseph's tools.

✳(?) L. *Christ among the Doctors,* Private Collection, England
The boy Jesus and the rabbis are all seen behind a triple arcade, a simplified version of the composition in the Books. Here the only foreground figures are those of Mary and Joseph, about to enter the synagogue. Poorly preserved.

✳(?) M. *Miracle at Cana,* Private Collection, England
Jesus, Mary, the newlyweds, and one guest are seen at table, with two servants in the foreground. On the side of Christ's throne is an exceedingly Castagno-like sphinx, reminiscent of those in his *Last Supper* (Florence, S. Apollonia). Bellini may have known this great fresco or drawings after it, or similar projects by Castagno in the Veneto. Poorly preserved.

✳(?) N. *Christ Taking Leave of His Mother*
"He kneels before Mary, blessing her." Ridolfi may be describing the "Last Appearance of Christ to His Mother (Last Farewell)" related in popular mystical treatises of the late Gothic period.[5]

✳O. *St. John Tells Mary of the Arrest of Christ*
"She faints into the arms of a female attendant." This subject too may come from contemporary devotional literature, or possibly mystery plays.

✳P. *Way to Calvary*
"Jesus is tormented by soldiers and followed by the Three Maries." Perhaps related to the Louvre page (Pl. 140).

✳Q. *Crucifixion*
"Christ commends Mary to John's care [John 19:26–27]. The sponge is prepared, soldiers gamble for the robes." None of Jacopo's *Crucifixion* drawings shows the commendation episode.

✳R. *Resurrection*
"Christ rises from the tomb and is seen again with Mary and Saints." See Jacopo's drawings (Pls. 225, 226) for possible aspects of this lost canvas.

✳S. *Coronation of the Virgin*
"She is crowned by the Father and Son." The Coronation group probably resembled the "Burgundian Coronation of the Virgin" as painted in 1444 by Antonio Vivarini and Giovanni d'Alemagna for S. Pantaleone (Accademia, Venice). Popular in Venice, this important subject is not in the Books.

Collins suggested that there were nine subjects on each wall, and that the *Dead Christ Supported by Two Angels* (A) was a separate altarpiece, all of which is likely.

In 1916 Berenson ascribed the two canvases in Madrid to a "close follower of Giovanni," dating them c. 1475; in 1957 (29, 37) he gave them to a "close follower of Gentile [Bellini]." Longhi (1946, 53–54) accepted the four paintings in Madrid and Turin as by Jacopo and his sons, stressing, with Zeri (1982, 227), the contributions of both sons: Longhi found the *Marriage of the Virgin* and *Adoration* (Figs. 28, 30) to be predominantly by Gentile Bellini, Giovanni's hand more evident in Turin. Particularly in the better-preserved *Birth of the Virgin* (Fig. 27) he detected Gentile's approach in the group at the left, Giovanni's in the beautiful woman bringing nourishment to St. Anne. The composition, for all its lively details, is surprisingly conventional, going back to Giotto's in the Arena Chapel.

Other scholars attribute these canvases to a follower or copyist of Gentile or Giovanni. The Galleria Sabauda's current catalogue (1971) lists its two paintings as "Lombardesque."

Joost-Gaugier (1973, 7–12) viewed a Marian altar in the Louvre as based on Jacopo's cycle, but the panels are in a 1440s style and vertical in format, making this unlikely. Padovani (1971, 3–31) attributed it to Giovanni Francesco da Rimini.

Collins (1982, *Art Bulletin,* 468) made a strong case for identifying the four Madrid and Turin canvases with the scuola cycle, linking details with Giovanni Bellini's early *oeuvre* and with drawings in the London Book. He saw Gentile's hand in the angel of the *Annunciation* (Fig. 29), and concluded (469), "all are the works of Jacopo in concept and composition, but appear to have been executed in good part, if not entirely, by his sons." The known canvases for the scuola cycle could plausibly come from Jacopo's studio, but their condition is too poor to permit an exact assignment of "hands."

The compositions in a small altar or altar frontal of the lives of Christ and the Virgin, possibly painted by Giovanni Bellini when very young, may suggest some of the lost scenes from the scuola cycle. Gabriele Vendramin, who owned the London Book, belonged to that scuola, as did Jacopo and his associate Michele Giambono; Jacopo may have named his son Giovanni not only for his own mother Giovanna or his half brother Giovanni, but for his scuola's patron saint as well.

These paintings for the Scuola di San Giovanni were the artist's major commission, as far as we know, done near the end of his life; their execution must have involved much studio participation, including the sometime assistance of both sons.

*VENICE, SCUOLA DI SAN MARCO, CRUCIFIXION

[1]Wurthmann, 1975, 253–54, translates these portions of Jacopo's 1466 contract as for a *Passion,* one painting to hang "at the head of the meetinghouse which looks onto the Campo [and was to extend] across the whole facade . . .," and the other, a *Judgment of Pilate,* to hang "next to it above the door of the albergo which begins in the middle of the room and extends up to the window." Wurthmann (257) also lists an *Expulsion of the Money-changers* by Bellini, but this is probably one of the two canvases possibly by Squarcione, also lost. The record for these is in the Museo Correr, Raccolta Correr, Ms. IV, No. 19. Pullan–Pignatti (1981, 132) give the date of the paintings for the "Aula Capitolare" as 1463.
[2]See above, n. 1.
[3]For Andrea da Murano, see Testi, II, 1915, 530–40.
[4]If Jacopo's first painting was a fresco on the façade, it would have required a protective wooden loggia, which existed there according to Paoletti (1929). Little is known of 15th-century figurative fresco decorations on Venetian church exteriors; Carpaccio's canvas of *Saint Jerome Taming the Lion* (Scuola di San Giorgio degli Schiavoni) shows their appearance.

*VENICE. SCUOLA DELLA CARITA. PROCESSIONAL BANNER

[1]Perhaps the largest gathering of banners from the later Quattrocento are by Bonfigli: *Madonna della Misericordia* (1464), Church of the Gonfalone, Perugia (Van Marle, XIV, 112, fig. 71); *Christ with San Bernardino* (1465), Galleria Nazionale, Perugia (Van Marle, XIV, 115, fig. 72); *Madonna della Misericordia* (1472), Parish Church, Corciano (Van Marle, XIV, 115, fig. 73); *Virgin and Child with Saints and Angels* (1476), S. Fiorenza, Perugia (Van Marle, XIV, 117, fig. 74). See also Caporali's *Madonna della Misericordia* (1482), S. Francesco, Montone (Van Marle, XIV, Pl. opp. 138).
[2]Archivio di Stato di Venezia, Carità, Reg. 3, pergamone 105.
[3]For the scuola's later banner contracts, see Archivio di Stato di Venezia, Carità, Reg. 253, f. 84, quoted by Wurthmann (1975, 200, n. 3).

*VENICE. LOCATION UNKNOWN. PORTRAITS OF GIORGIO CORNARO AND HIS SISTER CATERINA

[1]Although Dürer's drawing, inscribed "1514," was long viewed as based upon Gentile Bellini's preliminary sketch for Caterina's image, Strauss redated it c. 1495, close to the artist's first Venetian visit. W. Strauss, *The Complete Drawings of Albrecht Dürer,* I, 300, cat. no. 1496/20, New York: 1974.

*VENICE, Scuola di San Marco. Altarpiece and Altar Frontal
Documented July 19, 1421; lost in fire, March 31, 1485

The altarpiece, painted on canvas, was of St. Mark. A second canvas by Jacopo of the saint in half-length, described as a "cortina azura de tella con san Marco in mezzo con la vina d'oro atorna" (Appendix E, Doc. 1421) was probably used as an altar frontal or to protect an altarpiece; the saint appeared against a blue background with a golden vine motif. The full text refers to Jacopo's two canvases at the altar of San Marco, one the altarpiece of the patron saint against a gold background(?), the other a blue hanging with the saint in the middle and/or in half-length.

Though published by Ricci as from 1421, scholars have since read the commission date as much later, close to the year when the altar is referred to again: April 13, 1466 (Paoletti, 1894, I, 940; Testi, 1915, II, 255; Pignatti, 1981, 48). They rejected the first date as too early because at that time a young Venetian painter named Jacopo di Pietro, often identified with Jacopo Bellini, was assisting Gentile da Fabriano in Florence.

*VENICE, Scuola di San Marco, *Crucifixion,* support unknown; *Way to Calvary*(?), canvas

On July 17, 1466, the scuola contracted with Jacopo Bellini to prepare two paintings for the Sala dell'Albergo, for the large sum of 375 ducats (Appendix E, Doc. July 1466). The first, on an unspecified support, showed "una passion de X° In chroxa richa di figure et altro che stia benisimo"; the second was on canvas "dal chanto sopra la porta de lalbergo che prinzipia amezo el volto e compie fina ala fenestra conzonzerse con l'altro quaro, suxo el qual quaro fara la Instoria de Ieruxalem chon X° ei ladroni." Pignatti (1981, 132) lists both as for the scuola's Sala. They perished in the fire of 1485 that destroyed the whole building;[1] the artist's sons, members of the scuola, restored his works after the blaze. On December 15, 1466, Gentile Bellini undertook to paint two Old Testament subjects, *Moses in the Desert* and *The Drowning of Pharaoh* (Appendix E, Doc. Dec. 1466), his contract specifying that he submit a *disegno.* Giovanni Bellini was to paint a *Deluge,* but had not delivered it by 1483. The commission then went to B. Montagna, whose picture was not finished when fire broke out in 1485.

Francesco Squarcione was ordered on April 16, 1466, to provide two canvases for the Aula Capitolare.[2] Andrea da Murano and Bartolomeo Vivarini, working in partnership, were commissioned on January 10, 1467, to paint canvases with the story of Abraham(?), presumably continuous with Bellini's (Appendix E, Doc. Jan. 1467), Isaac's sacrifice being the prototype of the Crucifixion.[3] The Vivarini–Murano commission[4] suggests that Jacopo's *Crucifixion* was also painted on canvas, on an inner wall.

*VENICE, Scuola di Santa Maria della Carità, *Processional Banner,* contracted for on June 17, 1452, to be completed in March 1453

The extremely lengthy contract does not specify a subject but states that Bellini is to receive 140 ducats for the banner, to be delivered by mid-March, 1453,

barring illness; he is not to leave Venice while the work is under way; if he cannot complete the banner, the scuola will appoint another painter and Bellini will pay for this work. The banner is to be assembled from seven sections of canvas (*teli*), seven *braccia* (arm lengths or yards) in all; ultramarine and gold (without silver) of the highest quality are to be used, and Jacopo alone will paint the entire banner (Ricci, 1908, doc. XIV, 53–54)—the contract then specifies, realistically, that the artist must paint the faces himself. The Louvre Book's *Mater Omnium* (Pl. 138) may be the type of image ordered by this great Venetian confraternity, as Goloubew first suggested (1912, LXX). Mandach (1922, 59) proposed that the Louvre's *St. Christopher* (Pl. 246) and the "*Samsons*" (Pls. 66, 151) could have been military banners.

Of the mid-15th-century painted banners that survive, one is still in the style of Gentile da Fabriano (Van Marle, VIII, 303, fig. 190) at Brefotrofio (Fabriano). An earlier one of 1438 by Antonio da Ferrara (Urbino, National Gallery of the Marches) shows the *Crucifixion* (Van Marle, VIII, 1927, figs. 177, 289).[1]

The relevant documents for this commission are given by Paoletti (1894, I, 8–9);[2] here is an abridged quotation:

June 19, 1452. . . . *ser Iacobus Belino qu. ser Nicolai pinctor ex alia parte. . . . unum penelum magnum pro dicta eorum scola de septem tilis sindonis et longum brachiis septem vel circha laborandum per dictum ser Iacobum. . . .*

March 1453: *Et predictus ser Iacobus Belino obligavit se et heredes et successores suos et omnia et singula bona sua mobilia et immobilia presentia et futura realiter et personaliter, promittentes et constituentes suprascripti contrahentes et partes se sibi ad invicem hinc inde soluturos, facturos et observaturos atque adimpleturos omnia et singula suprascripta Venetiarum, Padue et alibi ubicumque locorum, et fori, et in quolibet particulariter et in totum locorum distantia vel aliquo alio non obstante. . . .*

The scuola is known to have ordered a new banner, perhaps replacing this one: "Because it is necessary first to honor God and then to be equal to other confraternities, it is necessary to have a better banner for civic processions."[3]

*VENICE, location unknown, *Portraits of Giorgio Cornaro (1454–1527) and His Sister Caterina* (future queen of Cyprus; 1454–1510)

Listed by Vasari as by Jacopo (Vasari–Milanesi III, 151)

Caterina's depiction must have been well before her marriage to Jacques Lusignan, king of Cyprus, which took place after Jacopo's death. Possibly, like many others, hers was a "pre-engagement portrait," to help the prospective groom choose his mate. Ridolfi (1648, I, 54) also cites these portraits by Jacopo, and many others of Venetian senators, all now lost. Vasari calls the Cornaro portraits early works (which they could not have been) and writes that they brought Jacopo fame. Though not twins, Giorgio and Caterina were born within the same year to the wealthy Cornaro (Correr) family, their mother a descendant of Byzantine emperors.

Jacopo's portrait of the future queen may have been the source for Dürer's early profile drawing of

her (Bremen, Kunsthalle) from his first Italian journey, when he knew the artist's sons.[1]

✱VERONA. CRUCIFIXION
[1]Translation courtesy of Irving Gumb and Michael McGann.

✱VERONA, Cathedral, Chapel of San Niccolò, *Crucifixion*

Fresco, signed and dated 1436
Ordered by the Venetian bishop Giulio Memmo, whose portrait, with those of his retinue, was included in this painting on the left wall; destroyed June 25, 1759
Inscribed: *Mille quadringentos sex et triginta per annos Jacobus haec pinxit, tenui quantam attigit artem*
*Ingenio Bellinus. Idem praeceptor et illi. Gentilis veneto fama celeberrimus orbe Quo Fabriana viro praestanti urbs patria gaudet*

(In the year one thousand four hundred and thirty-six, Jacopo painted this with his slender genius as far as his artistry allowed. Gentile, this Venetian's teacher, [was] most renowned for his fame throughout the world. In that excellent Venetian man, his native city of Fabriano rejoices)[1]

Many prophets held speech scrolls; the converted centurion's was inscribed: *Vere filius Dei erat iste* (Matthew 27:54; Mark 15:39)

For 18th-century descriptions of this lost work, see Ricci (1908, 60–61): doc. XXVI, an anonymous description, possibly by Cignaroli, Verona, July 1, 1759; doc. XXVII, a poem by G. Torelli (Pisa, 1833); doc. XXVIII, an undated poem by A. Tirabosco; doc. XXIX, a sonnet by M. Pindemonte (1776). Vasari first refers to this fresco as painted by Jacopo with the assistance of Liberale da Verona (Vasari–Milanesi, V, 274), which is a chronological impossibility.

The *Crucifixion* was a nocturne, showing the eclipse that occurred between the sixth and ninth hour, when Christ died. A description of 1726 (Testi, II, 1915, 251) by Maffei specifies "rilievi et indorature," and Cignaroli characterizes Mary's halo as gilded "alla greca." The lost fresco may have resembled *Crucifixions* by artists linked to Gentile da Fabriano, such as two by Zanino da Pietro, an artist recently viewed as Gentile's teacher (Christiansen, 1982, 7), who signed a triptych (Rieti, Galleria Communale) as resident in Venice (recorded there in 1407, after living in Bologna; Ludwig, 1911, 106); Zanino's second *Crucifixion* (Venice, Museo Correr) includes many prophets with speech scrolls, and Pallucchini (1955–56, 207) suggested that perhaps Jacopo used this for his model, his fresco containing many such figures.

Still closer to Bellini's may have been a large *Crucifixion* fresco of 1416 by the Salimbeni brothers (Urbino, S. Giovanni Battista), its narrative breadth and telling detail nearing Lombard currents. With its inscriptions, banners, and gold-and-silver decorative details in gesso relief (*pastiglia*), Jacopo's *Crucifixion* must also have resembled in style the Zavattari's Theodolinda cycle (Monza, Cathedral) of 1444, and, about that date, the *Adoration of the Magi* by Antonio Vivarini and Giovanni d'Alemagna (formerly Berlin, Museum).

Jacopo doubtless knew already the most powerful large-scale *Crucifixion* in the Veneto—Altichiero's (Padua, Oratory of San Giorgio). And if he went to Rome before 1436, which seems almost certain, he would have seen Masolino's (with Masaccio?) *Crucifixion* (S. Clemente, Chapel of Saint Catherine).

Much praised in the 18th century for its Dürer-like narrative intricacy, Jacopo's lost fresco was nevertheless a conservative work, probably reflecting his patron's taste more than his own. If Jacopo's Berlin panels (Figs. 55–58) date in the 1430s, then this *Crucifixion* must represent Bishop Memmo's nostalgia for the International Style. Several *Crucifixions* by later artists have been described as based on Jacopo's fresco, but none of these suggestions is persuasive as such.

VERONA, Museo del Castelvecchio, *Crucifixion* (Fig. 46)

Tempera on canvas, 310 x 180 cm.
Original borders all around
Inscribed on *cartellino* at foot of cross: OPUS JACOBI BELLINI
Presented by Cardinal Luigi di Canossa in 1869
Provenance: found in an *armoire* in the bishop's palace, Verona[1]

VERONA. MUSEO. CRUCIFIXION
[1]Van Marle, 1935, IX, 116; Testi, II, 173.
[2]Such a *Crucifixion* banner from S. Marco (Florence) by the Fra Angelico school measures 107 x 67 cm.; reproduced in *Fra Angelico*, Klassiker der Kunst, 1913, 138.

Often described as poorly preserved and much overpainted, following Gaye (1840, 89 ff.), who first published this very large canvas; in the halo he saw golden flowers on a red ground. X rays in 1983 show the skull to be more precisely painted than is seen on the surface, and more blood flowing from the wounds. Recent conservation and the X rays revise Gaye's negative estimate.

Christ's figure is life-size against a monochromatic, strong blue background. Because the canvas came from the Verona episcopal palace, it has been thought that Bishop Memmo, who ordered the *Crucifixion* fresco in 1436, commissioned this one as well, but that ornate image suggests a patron with conservative tastes, different from those of whoever ordered this realistic, austere depiction.

An image of extraordinary power, this *Crucifixion* is also the first known Venetian painting on canvas to approach the renaissance style. Gronau (1909, 12) called it an early work, related to the art of Fra Angelico and painted before Bellini underwent Donatello's influence, which judgment seems correct; for Coletti (1953, xxxii) also, it was an early work. Longhi (1946, 11) stressed Masolino's importance for early Venetian painting, true too for this canvas. Some critics have seen Castagno's impact; if correct, this would date the *Crucifixion* in the 1440s. Others see Donatello's sculpture (the artist a resident in Padua 1443–53) as the determining source for Jacopo's canvas. Boskovits (1985, 119) dates it c. 1450.

This *Crucifixion* is related to the minimal representation in the Paris Book (Pl. 212), but there Christ's physique is more in the manner of the later Donatello or Castagno, not with the canvas' still somewhat Gothic elongation. The light comes from the left (Pallucchini, 1955–56, 210), Bellini sharing the metaphysical concern with illumination of Eyckian art.

Largest and most monumental of Jacopo's surviving canvases, this daring image suggests a relatively young artist, aware of new Tuscan currents and thus active in the later 1430s, anticipating Fra Angelico's frescoed *Crucifixion* in S. Marco in the next decade. It could depend in part upon sculptural sources and have hung in a monastic setting. The canvas support of this extremely large image raises the possibility that it was borne in devotional pro-

cessions, or hung outside a building during Holy Week.[2] Jacopo's inscription, placed at the foot of the cross, has a votive quality identifying the artist with the death of Christ, which he presented in such tragic isolation. Though rectangular, the *Crucifixion* recalls those Trecento images where the shape of the cross determined the picture plane.

VERONA, Museo del Castelvecchio, *Penitent Saint Jerome in the Wilderness* (Fig. 60)

Tempera on panel, 96 x 64 cm.
Poorly preserved

Ricci first gave this panel, long attributed to Bono da Ferrara, to Jacopo (1908, 21), comparing it with drawings in the Louvre Book (Pls. 276, 277). All scholars but Testi (1915, II, 286 f.) accept this suggestion. Coletti (1953, xxxii) saw it as an early work. Forceful and expressive, the crude panel has many qualities often found in an artist's "late style," and as Van Marle noted (1935, XVII, 116–19), such a period would "explain the rigidity and lack of elegance" of this *St. Jerome*. Röthlisberger (1958–59, 88) placed it 1450–1460, but a date in the last decade of Bellini's life should be considered.

*VERONA. LOCATION UNKNOWN.
THE PASSION

[1] Milanesi (Vasari–Milanesi, III, 151, n. 1) suggests this view, first stated by G. Piacenza in his *Giunte* to Baldinucci, *Notizie di professori del disegno*, Turin: 1768–1820.

*VERONA, Location unknown, *The Passion*

Vasari described the painting (Vasari–Milanesi, III, 151) as a *tavola*, usually the term for panel, sent by Bellini to Verona, with many figures, including his own, in life-size, a scale unusual for a work on wood. Since Vasari follows his account of this early work, making the artist famous, with a *Crucifixion* in the Scuola di San Giovanni Evangelista (actually the Scuola di San Marco), he may have conflated his notes for the *Crucifixion* fresco in the cathedral of Verona of 1436 with the much later *Passion* or *Crucifixion* canvases in Venice.[1] As he lists this large "Passione di Cristo" as being sent from Venice, a work on canvas is implied, another argument for Vasari's having confused this work with those at the scuola.

LOCATION UNKNOWN. THE RAPE
OF DEIANIRA

[1] Reliefs of the subject are drawn twice in architectural settings of the *Flagellation*: two medallions on a triumphal arch (Pl. 195) and a relief on a balcony (Pl. 202). Other images of antiquity such as the three *spallieri* (large panels) by the Venetian Master of the Stories of Helen (Baltimore, Walters Art Gallery), though Venetian, are still close to the International Style.

LOCATION UNKNOWN. VIRGO
LACTANS

[1] Christiansen, 1982.

LOCATION UNKNOWN (U.S.A., according to Schmitt, 1965, 711), *The Rape of Deianira* (Fig. 13)

Tempera on panel, 40.6 x 12 cm.
Provenance: ex-Coll. Volpe, Florence; Agnew's; ex-Coll. Stephen Courtauld, London

First ascribed to Jacopo by L. Venturi (1926, 205). The panel may have been on the end of a small *cas-sone* or cut from a larger format. Though not executed by Jacopo, the classical figures and female nude recall those in the Books (Pls. 70, 76); at best, this is from his late *bottega*. The scene suggests Florentine painters of the 1450s, such as the Master of the Castello *Nativity* and the Paris Master.[1]

This is the only known painting in an early Venetian renaissance style to show classical mythology.

LOCATION UNKNOWN, art market(?), *Virgo Lactans* (Fig. 39)

Tempera on panel, 69.8 x 49.5 cm.
Frame: close in style to Accademia 532; original(?)
Severe abrasion in faces of mother and child
Provenance: ex-Coll. Walter Burns, London; sold at Christie's, June 29–30, 1979, cat. no. 51, to D. R. Locaze

The Virgin with crossed arms, often painted by Gentile da Fabriano and before, indicates humility and is also seen in the *Madonna* sometimes given to Jacopo (Ferrara, Pinacoteca Nazionale, Donazione Vendighini–Baldi) or, more recently, to Gentile.[1] The gesture is seen in the Brescia *Annunciation* (Fig. 19) and the *Mater Omnium* in the Paris Book (Pl. 138). Röthlisberger (1958–59, 70, 88) dates this painting c. 1460; Pallucchini (1955–56, 212) places it after the *Legnaro Madonna* (Fig. 37) of c. 1450.

The nursing Madonna is rare in earlier Venetian painting, however; Röthlisberger (1958–59, 84) rightly related the image to early Netherlandish art, notably the many examples of the *Lactans* theme based on pictures by Robert Campin. Small angels in the background hold the symbols of the Passion. Their presence, together with the emphasis on nursing, point to the Last Judgment: it is when Mary intercedes for mankind that she points to her breast to recall her nurture of Christ, and asks for mercy toward humanity.

The angels may be based on those in the *Coronation of the Virgin* by Giovanni d'Alemagna and Antonio Vivarini (Venice, San Pantaleone), signed and dated 1444; an enlarged replica of this popular work was ordered in the later 1440s from Giambono. In this *Virgo Lactans* Jacopo proves to be an inventive, powerful, yet subtle colorist, as might be expected of Giovanni's father. A symphony in shades of red, the color of the Passion, this devotional panel is a meditation on the future suffering and sacrifice by mother and son. An orange-red band borders Mary's veil; her dress and her son's are crimson. The panel probably dates from the mid-1440s, when Donatello's influence was strongest in the Veneto. By then Jacopo had mastered these innovative forms.

# 2. DRAWINGS BY JACOPO AND HIS STUDIO, OTHER THAN THOSE IN THE BOOKS

The largest gathering of early 15th-century North Italian drawings is the so-called Codex Vallardi, named after its mid-19th-century owner who published his collection as by Leonardo da Vinci in 1855 and sold it to the Louvre in 1856. The bulk of the 378 pages bound from many sources into Vallardi's book were subsequently given to Pisanello and his circle. The Venetian ambience has recently been recognized as having considerable importance in forming Pisanello's art. Manteuffel gave one famous page in the Vallardi gathering to the Bellini circle (see below, No. 1) in 1909. In 1920 M. Krasceninnikova recognized several animal studies and other sides in the codex as close to Jacopo, pages distinguished for their broad luminism and free, almost Impressionist handling. Fossi Todorow (1966) followed Krasceninnikova and placed still more drawings into Bellini's orbit, including a notebook of animal studies in the codex (Nos. 5–9), probably the work of a studio assistant.

1. PARIS, Louvre, no. 2520, *Interior with Figures* (Fig. 68). Fossi Todorow cat. no. 99

   Pen with traces of hematite on pink board, 25.1 x 17.4 cm. See p. 145.[1]

2. PARIS, Louvre, no. 2385, *Three Lions* (Fig. 6). Fossi Todorow cat. no. 393

   Black lead on white paper, partially gone over in pen, 25.0 x 18.2 cm. Related by Krasceninnikova to Jacopo Bellini (1920, 227).

3. PARIS, Louvre, no. 2384, *Two Lions* (Fig. 5). Fossi Todorow cat. no. 392

   Black lead on white paper, 17.0 x 15.0 cm. Related by her to Jacopo Bellini.

4. PARIS, Louvre, no. 2427, *Seated Hound*. Fossi Todorow cat. no. 410

   Black lead on white paper, 14.4 x 14.5 cm. She related this to Jacopo's art.

5. PARIS, Louvre, no. 2387, *Four Mice*. Fossi Todorow cat. no. 394

   Black lead on white paper, 25.5 x 18.0 cm. She gave this and the following four pages to a Venetian follower of Pisanello working in the circle of Jacopo Bellini, in the 2nd half of the 15th century.

6. PARIS, Louvre, no. 2437, *Head of a Hare*. Fossi Todorow cat. no. 412

   Black lead on white board, 11.4 x 7.6 cm. Placed by her in the Bellini circle, post-dating Pisanello.

7. PARIS, Louvre, no. 2449, *Head of a Crane*. Fossi Todorow cat. no. 416

   Black lead on white board, 22.4 x 17.8 cm. She believed this page to post-date Pisanello.

8. PARIS, Louvre, no. 2414, *Two Bears*. Fossi Todorow cat. no. 404

   Black lead on white board, 24.3 x 17.2 cm.

9. PARIS, Louvre, no. 2510, *A Cock and a Hen*. Fossi Todorow cat. no. 439

   Black lead on white board, 17.8 x 25.5 cm. Placed by her in the Bellini circle.

10. PARIS, Louvre, no. 2267, *Tree Study* (Fig. 2). Fossi Todorow cat. no. 367

   Leadpoint on white board, 29.2 x 19.5 cm. Placed by her in the Bellini circle.

11. PARIS, Louvre, no. 2268, *Fern Study* (Fig. 3). Fossi Todorow cat. no. 368

   Silverpoint on white board, 27.4 x 19.9 cm. Placed by her in the Bellini circle.

12. PARIS, Louvre, no. 2626, *Centaur Carrying off a Nude*. Fossi Todorow cat. no. 253

   Pen with traces of black lead on pink board, 18.4 x 25.8 cm. From the "Album Rosso." Related by Krasceninnikova (1920, 227) to Jacopo. Fossi Todorow (48 ff.) places this album in the School of Pisanello. A similar subject was painted in Jacopo's studio: *The Rape of Deianira* (Fig. 13).

13. PARIS, Louvre, no. 2447, *A Demon-Faun*. Fossi Todorow cat. no. 415

   Metalpoint on vellum, 19.1 x 13.3 cm. Related by Krasceninnikova (1920) and Fossi Todorow to Jacopo's art.

[1] K. Manteuffel, *Die Gemälde und Zeichnungen des Antonio Pisano aus Verona*, Halle, 1909, 163. For this page see also W. Lotz, "Das Raumbild in der italienischen Architekturzeichnungen der Renaissance," *Mitteilungen des kunsthistorischen Instituts Florenz* VII, 1956, 193–226.

# 3. REJECTED OR QUESTIONABLE ATTRIBUTIONS: PAINTINGS

This list includes only works ascribed to Bellini that are still accepted in the more recent literature

BASSANO della Grappa, *Madonna and Child,* c. 1440

Fogolari (1904, 73 ff.) attributed this painting to Jacopo. More recent scholarship gives it to Giambono, but Land (1974, 164) plausibly suggests that the picture is an early copy after Jacopo. Reproduced by Testi (1915, II, 260).

BERLIN, former Kaiser-Friedrich-Museum, *Dead Christ with Virgin and Saint John the Evangelist*

Wrongly attributed to Bellini by W. Boeck, "Quattrocento paintings in the Kaiser Friedrich Museum," *Burlington Magazine,* 64 (1934), 29–35.

BOSTON, Museum of Fine Arts, *Saint Michael*

Ascribed to Bellini by Huter (1974, 18–20). Boskovits (1985, 123, n. 25) gives it to Pietro di Giovanni Ambrosi as an early work.

BUDAPEST, Museum of Fine Arts, *Queen Caterina Cornaro*

Identified by Morelli (1880, 12) and A. Venturi (*L'Arte,* 1900, 207–18 ff.) with the portrait in Vasari's list as by Jacopo, of the queen of Cyprus. Meyer zur Capellen (1985, App. A–5, 126–27) lists it as a variant after Gentile Bellini or by him, from the end of the 15th century.

CARPANEDA, Parish Church, *Madonna and Child*

Exhibited at Accademia, Venice, 1986. The painting is a late pastiche, combining Trecento and Quattrocento conventions.

FLORENCE, Villa I Tatti, *Virgin and Child Playing with a Bird*

Attributed to Bellini by Berenson (1957, I, 37). North Italian.

LONDON, ex-Coll. Mond, *Madonna and Child*

Attributed to Jacopo by Testi (1915, II, repr. 260). Judging by the peculiar crackle pattern, this is a forgery in the manner of early Giovanni Bellini.

LONDON, ex-Coll. Hon. Mrs. Dorothea Hambourg (from her father, William Graham), *Penitent Nude Hermit Saint (Jerome?)*

Sotheby's London, sale April 29, 1972, cat. no. 5 (as *St. Jerome*).

MILAN, Baldo Collection, *Doge Francesco Foscari* (Fig. 1)

Formerly in the Austrian State collections. Attributed to Bellini by Pesaro (1978, 48–49). Listed as "Venetian School" by Meyer zur Capellen (1981, 74). Possibly from Giambono's workshop. See also Meyer zur Capellen (1985, unlettered app., no. 2, 176): painted in Foscari's

lifetime, possibly an early work by Gentile Bellini.

MILAN, ex-Coll. Rasini, *Saint Jerome,* with name and date 1443

Published by A. Venturi. Accepted by Röthlisberger (1958–59, 88) and Coletti (1953, xxxii) as early work; rejected by Boskovits (1985, 116). A forgery or totally reworked. Sold at Sotheby's Florence, Dec. 14, 1978, as by "follower of Jacopo Bellini." In Thyssen-Bornemisza Coll., Lugano, Castagnola; sold in Lugano c. 1983, and in Rome, Coll. Lanfranchi.

NEW YORK, Brooklyn Museum, *Saint Jerome*

First given to Bellini by Berenson (1932, 75); ascribed to Donato de' Bardi by Zeri (1976, 46).

NEW YORK, Metropolitan Museum of Art, *Madonna of Humility*

Attributed to Bellini by L. Venturi (1930, 180). Accepted by Röthlisberger (1958–59, n. 50) as a possible early work; also by Huter (1974, 18–19) as c. 1430, and by Boskovits (1985, n. 16) as 1430–35. This may be a work from the Bellini *bottega.*

PADUA, ex-Coll. Pietro Bembo, *Laura de Noves*

J. Wilde ("Über einige venezianische Frauenbildnisse der Renaissance," *Alexis Petrovics Festschrift,* Budapest: 1934, 9–15) gives to Jacopo this lost portrait, copied after Simone Martini's painting of Petrarch's Laura. Listed in Marcantonio Michiel's inventory of Pietro Bembo's collection, with no artist's name (see Hadeln edition, 55).

PARIS, ex-Coll. Lazzaroni, *Lionello d'Este*

In Ferrara exhibition of 1934 (cat. no. 25) as Bellini's work. Accepted by Van Marle (1935, XVII, 109–10, fig. 65).

PARIS, Galerie Charpentier, Sale June 29, 1959 (cat. no. 153), *Penitent Saint Jerome*

ROME, Capitoline Museum, *Man in Left Profile*

Listed as Jacopo Bellini(?) by Van Marle (1935, XVII, 106, fig. 63).

SAN DIEGO, Cal., Museum of Art, *Madonna and Child*

Attributed to Jacopo by Hans Tietze in *Four Centuries of Venetian Painting* (Toledo Museum of Art: 1940, cat. no. 11). According to Boskovits (1985, n. 25), totally reworked, unrecognizable.

VENICE, Cini Foundation, *Adoration of the Magi*

Unpublished.

VENICE, SS. Gervasio e Protasio, *San Crisogono*

Berenson (*Venetian Painters,* 1895, 87) as by "Jacopo Bellini(?)." Only Cagnola (*Rassegna d'Arte,* 1904, 40) followed his suggestion. In 1901 (*Study and Criticism,* I, 94) Berenson suggested that it was probably by Giambono, an attribution followed by all subsequent scholars. As Giambono and Bellini may have had an informal association, the latter could have contributed to the panel's unusually powerful design.

VENICE, Museo Civico, *Doge Francesco Foscari* (bust length in right profile)

Late 15th or early 16th century.

VERONA, Museo del Castelvecchio, Galleria Monga, no. 2139, *Madonna of Humility*
Van Marle (1935, XVII, 129), as Jacopo's school. A. Avena (*Il Museo di Castelvecchio a Verona,* Rome: 1937, 21), inspired by a work of Jacopo's. Röthlisberger (1958–59, 84, n. 53), accepted as by Jacopo; likewise Boskovits (1985, 118, n. 20), who dates it c. 1448. Very coarse.

VERONA, Museo del Castelvecchio, Galleria Monga, *Christ in His Tomb*

Attributed to Jacopo by Van Marle (1935, XVII, 102–3); see H. Wohl (1980, 176–77). Follower of Domenico Veneziano?

VIENNA, ex-Coll. Lederer, *Madonna and Child* (based on Jacopo's *Uffizi Madonna* [Fig. 43])

Planiscig (1928, 47–48) gave this to Bellini; published as a forgery by Longhi (1946, 52).

WASHINGTON, D.C., National Gallery of Art, *Portrait of a Boy*

Attributed to Jacopo by L. Venturi (1930, 186) and accepted by Röthlisberger (1958–59, 78), but conservation after 1930 showed the painting to be less close to him. F. R. Shapley (*Paintings from the Samuel H. Kress Collection, Italian Schools: 15th–16th century,* London: 1968, 29) lists it as "Attributed to" Jacopo; recent literature questions Bellini's authorship.

ZAGREB, Gallery Strossmayer, *Man of Sorrows with Donor*

Published by G. Gamulin, "Ritornando sul Quattrocento," *Arte Veneta,* 17 (1963), 9–20, fig. 10. Provincial, obscure work.

ZURICH, Private Collection, *Nativity*

Published by G. Matzeu (*Jacopo Bellini,* Milan: 1957, 27 f., 61) as by Jacopo. Boskovits (1985, n. 25) correctly describes it as an extensively reworked panel or a forgery.

LOCATION UNKNOWN, *Madonna and Child*

Published by Louise M. Richter, "New Light on Jacopo Bellini," *Connoisseur,* 62 (1922), 129–34, Pl. on 136. Forgery.

# 4. REJECTED OR QUESTIONABLE ATTRIBUTIONS: DRAWINGS

MUNICH, Graphische Sammlung, *Antique Motifs and Antique Architecture* (Fig. 15)

Some from Arch of Constantine, Palace of Diocletian at Spoleto(?). Attributed to Jacopo by Degenhart and Schmitt (1972, fig. 1). Probably by Giovanni Bellini.

NEW YORK, ex-Coll. S. Schwarz, *Pages from a Pattern Book*

Ascribed to Bellini by the Tietzes (1944, 106, cat. no. 363 bis) for the similarity to several pages in the Louvre Book. However, Degenhart and Schmitt (1980, 136–77, cat. nos. 652–63) grouped these and other pages as part of a late 14th-century Venetian pattern book. Weinberger (1941, 20 ff.) was the first to doubt Bellini's authorship of the pattern pages in the Paris Book.

PARIS, Louvre, no. 2590, *Madonna and Child in Half-length.* Codex Vallardi. Fossi Todorow (1966, cat. no. 451)

Inscribed on back, "Jacopo di ve. . . ." Ricci (1908, 39) was the first to give this page to Jacopo, previously grouped with Pisanello. The Tietzes (1944, 114, no. A135) stressed its ruinous condition. See Fossi Todorow (1966, 197) for attribution history of this fine yet battered page.

PARIS, Louvre, R.F. 524, *Antique Motifs* (Fig. 12)

Many from sarcophagi. Degenhart and Schmitt (1972, fig. 21) attributed this drawing to "Circle of Jacopo Bellini." It is probably by Giovanni Bellini.

The following eight drawings from Vasari's *Libro dei Disegni,* listed as by Giovanni di Marco del Ponte, were attributed to Bellini by Ragghianti Collobi (1974, I, 36)

CHANTILLY, Musée Condé, FR 1–2 (drawn on both sides), *Saint George Liberating the Princess; Saint George Interceding for Trajan's Soul*

Ragghianti Collobi (1974, II, figs. 34–35).

PARIS, Louvre, Cabinet des Dessins, R.F. 9835 (on two sides of one sheet), *Unidentified subject; Trajan and the Widow*

Ragghianti Collobi (1974, II, figs. 36–37).

PARIS, Louvre, Cabinet des Dessins, R.F. 9836 (on one side of sheet), *Horatio at the Bridge; Battle Scene*

Ragghianti Collobi (1974, II, figs. 38–39).

PARIS, Louvre, Cabinet des Dessins, R.F. 9837 (on other side of sheet), *Three Half-length Male Figures; An Encampment and Battle*

Ragghianti Collobi (1974, II, figs. 40–41).

# APPENDIX E

## DOCUMENTS AND DATES

Entries are chronological. Those followed by Roman numerals in parentheses are taken from Ricci (I, 1908, 47 ff.). An abridged compilation was prepared by Paoletti (1894, 5 ff.). References to paintings in Appendix D, 1 (Catalogue Raisonné), are to be found there alphabetically by city, then by institution

**1421**, April 10 (I). Venice. Scuola Grande di San Giovanni Evangelista. Meeting of governing board (*Banca*) to plan Old and New Testament Cycle for major meeting room ("*de far istoriar la Sala della nostra Casa a torno del Testamento vechio e novo*"); 48 members were in favor, 8 opposed. This was not effected until the 1460s (see Appendix D, 1), unless a previous cycle was ordered and became lost. Jacopo Bellini received final payment on January 31, 1465.

Venice, Archivio di Stato, Scuola Grande di San Giovanni Evangelista, Reg. 38, p. 58.

**1421**, July 19 (II). Venice. Inventory of Scuola Grande di San Marco lists an altar of *Saint Mark* with a gilded background, and a blue curtain with a *Saint Mark*, probably in half-length. The altar is identified as by "*maistro Iacomo Belin pentor*" (see Appendix D, 1).

Venice, Museo Civico, Racc. Correr, Ms. perg. IV, no. 19, c. 9.

**1424**, April 11 (III). Venice. Will of Niccolò Bellini, tin worker, lists "*Jacobum Belino pictorem*" as his only son, who may have been present but is not named among the witnesses; an illegitimate son, Giovanni, is recorded in Doc. September 13, 1440. Jacopo and his older sister, Elena, both from Niccolò's first marriage to Zanine (Giovanna), each receive 24 gold ducats; to Elena's daughter, Chatarucie, 10 gold ducats toward her dowry. The artist will receive his bequest only upon payment of an unspecified debt. Funds are left for a Gregorian mass for the deceased and benefactions to several Venetian churches. Great concern is expressed that the two heirs should treat their stepmother, Franceschina, with consideration. She is to receive "the greater share of everything" with the right to sell property. See Joost-Gaugier (1973, 142) for an analysis of the will. Franceschina was bequeathed all Niccolò's personal effects including a rope bed, which Joost-Gaugier noted was a luxurious item, four shirts, and a pair of green socks. Jacopo's widow would leave their son Niccolò her own clothing (see below, Doc. 1471).

Venice, Archivio di Stato, Sez. not., Testamenti B. 545. Notaio Buscareno Lorenzo. Libro in perg., cart. 10, N. 63.

**1424**, October 24–April 2, 1425 (IV). Florence. Legal proceedings against Jacopo di Piero, an assistant of Gentile da Fabriano, for attacking a young Florentine, Bernardo di Silvestro, on June 11, 1423. Jacopo di Piero is often viewed as identical with Jacopo Bellini, but the father's stated name is incorrect, Piero rather than Niccolò, and the extreme poverty of the accused and Gentile da Fabriano's unconcern with his plight make this identification untenable. For the comfortable means of Jacopo Bellini's father, see Doc. April 11, 1424 (partly trans. by Gilbert, 1980, 23–25).

Florence, Archivio di Stato, Provvisioni del Gran Consiglio, Vol. 115, cart. 8–9, anno 1423, Ap. 3 (Vasari–Milanesi III, 20, 149 ff.).

**1425**, April 3 (V). Florence. Further legal proceedings against Jacopo di Piero.

Florence, Archivio di Stato, Provvisioni del Gran Consiglio, Vol. 116, cart. 8 (Vasari–Milanesi 3, 148 ff.).

c. **1426**, Birth of Giovanni Bellini (Vasari–Milanesi 3, 149, 150). Present scholarship tends toward a later date, perhaps near the birthdate of his half brother Niccolò (probably Jacopo's firstborn legitimate son), whose mother made her will in 1428 (1427 in the Venetian calendar) preparatory to childbirth (see below, Doc. 1428). Niccolò is named in her second will (Doc. 1471) and in 1505 and 1512 (see Docs. below).

**1428**, February 6 (VI). Venice. Will of Anna Rinversi [or Inversi], wife of Jacopo Bellini, painter, resident of the parish of San Geminiano. Drawn up preparatory to childbirth. Analyzed by Paoletti (1929, 70). Names her mother, Gera (see Doc. April 21, 1459), and her uncle Francesco da Pesaro. Manuscript of will reproduced by Testi (1915, 156).

Venice, Archivio di Stato, Sez. Not., Testamenti. Notaio Salomon Enrico.

**1430**, Padua. Jacopo's *Saint Michael* Altarpiece (lost), for San Michele (see Appendix D, 1, for its appraisal).

**1431**, Venice. Apprenticeship begins of Leonardo di ser Paolo (later known as Leonardo Bellini), nephew of Jacopo Bellini and son of Elena and her husband, a boatman (see Doc. 1443).

**1436**, Verona. Jacopo's *Crucifixion* fresco (lost) for Cappella di San Niccolò, cathedral (see Appendix D, 1).

**1437**, March 3 (VII). Venice. "*Ser Iacomo Belin pentor*" listed on Register of the Scuola Grande di San Giovanni Evangelista. Paoletti (1894, 6) interpreted this as the artist's admission to the scuola, a view no longer accepted.

Venice, Archivio di Stato, Scuola Grande di San Giovanni Evangelista, Reg. 72, cart. 43t [48.i].

**1439**, December 6 (VIII). Venice. Bellini bought an intarsia panel at estate sale of Jacobello del Fiore for D. 1, s. 8.

Venice, Archivio di Stato, Scuola Grande di Santa Maria della Carità, Busta 56. Commissario Giacomo del Fior, fasc. IV. Testamenti doc. 2.

**1440**, September 13. Venice. Partnership dissolved of the brothers Jacopo and Giovanni Bellini, paint-

ers, identified as sons of Niccolò Bellini of the parish of San Geminiano. The brothers agree to divide the furnishings and *immobili* they had acquired or "*guadagnati prima o dopo la morte del genitore.*" Witnessed by Ercole, adopted son of Jacobello del Fiore.

Venice, Archivio di Stato Vittore Pomino, Prot. 1439, cart. 55, Vol. B–a. Paoletti (1929, 68); see Billanovich (1973, 359 ff.) for other documents concerning Giovanni Bellini, illegitimate son of Niccolò Bellini.

**1440,** September 24 (IX). Venice. Five-year partnership beginning October 1, 1440, of Jacopo Bellini and the painter Donato Bragadin (Testi, II, 1915, 158). This association may never have taken place. Contract trans. in part by Gilbert (1980, 29).

**1441,** August 26 (X). Ferrara. Lionello d'Este sends two bushels of wheat to Jacopo Bellini in Venice.

*Mandato Illu. d. n. domini Nicolai Marchionis Estensis etc. Vos factores generales dari in donum faciatis Jacobo Bellino pictori de Venetijs Modios duos de frumento domini conducendos per Eum Ventias.*
*Lud. Casella scripsit XXVI Augusti. Leonellus.*

Modena, Archivio di Stato, Reg. de' mandati, 1441–42.

**1441 (XI).** Ferrara. Two poems written by Ulisse degli Aleotti in praise of Bellini, victor over Pisanello in the contest for the portrait of Lionello d'Este (for translations, see Appendix D, 1: *Ferrara). This took place before December 26, 1441, possibly prior to the gift of wheat in August (see preceding Doc.).

*Quando il Pisan fra le famose imprese*
*sargumento contender cum natura*
*e convertir limagine in pictura*
*dil nuovo illustre lionel marchexe*
*    Gia consumato havea il sexto mexe*
*per dare propria forma alla figura*
*alor fortuna sdegnosa che fura*
*lumane glorie cum diverse onfexe*
*    Strinse che da la degna et salsa riva*
*se mose il Belin summo pictore*
*novelo fidia al nostro ziecho mondo*
*    Che la suo vera efige feze viva*
*ala sentencia del paterno amore*
*onde lui primo et poi il pisan secondo.*

*Quanto che gloriar te puoy bellino*
*che quel che sente il tuo chiaro Intellecto*
*la mano industriosa il proprio effecto*
*mostra di fuora gaio et pelegrino,*
*    Siche ad ogni altro insegni il ver camino*
*del divo Apelle et nobel policlecto*
*che se natura ta facto perfecto*
*questa e gratia dal ciel e tuo destino*
*    Pero se ala tuo [sic] fama e degno nome*
*il vulgo invidioso de honor privo*
*alcuna volta stimola et contende*
*    Habi pieta de lo suo grave some*
*e prendi homai questo exempio vivo*
*che qualche nebia il sol talor ofende.*

(Testi, II, 1915, 159, n. 2). Modena, Biblioteca Estense, Ms. IX, A, 27.

**1441.** Venice. Jacopo listed as a deacon of the Scuola Grande di San Giovanni Evangelista.

Venice, Archivio di Stato, Scuola Grande di San Giovanni Evangelista, Reg. 72.

**1443,** August 23 (XII). Venice. Completion of 12-year apprenticeship of Jacopo Bellini's nephew, Leonardo di ser Paolo, in his uncle's studio. Jacopo confirms his association with Leonardo as assistant and pupil, nourished like a son from the master's charity. Leonardo will receive an allowance for two years, beginning Sept. 1: twelve gold ducats the first year, fourteen the second, payable at the rate of four ducats in four monthly installments.

Venice, Archivio di Stato, Sez. not., Cancelleria Inferiore. Atti Elmis Francesco. Busta 74, fasc. XXVIII, 1443–44.

**1444.** Vicenza–Brescia. *Annunciation* and its predella moved from Vicenza to Brescia, San Alessandro (see Appendix D, 1: Brescia).

**1448.** Date on *Madonna* (Milan, Brera) (see Appendix D, 1).

**c. 1450.** Jacopo Bellini and Pisanello are described as "the finest painters of our time" in *De politia litteraria*, pars lxviii, by Angelo Decembrio, a dialogue with words given to Lionello d'Este. Date by Baxandall (1963, 305, 314).

**1451.** One "Jacopo" is described as "*Magister Musayci*" in graffito on wall of mosaic workshop at San Marco, Venice (see Merkel, 1973).

**1452,** February 14 (XIII). Venice. Jacopo Bellini and Niccolò Inversi, his wife's relative, sue unspecified persons.

Venice, Archivio di Stato, Sez. not., Cancelleria Inferiore. Atti Elmis Francesco. Busta 76, Reg. 1451–1455, p. 11.

**1452,** April 13. "*Ego Jachobus belino chondam ser nicholai pictor testis subscripsi,*" from document quoted by Ricci (1908, 10, n. 6; corrected by Testi, 1915, 161).

**1452,** June 19 (XIV). Venice. Commission from the Scuola Grande di Santa Maria della Carità for a banner (see Appendix D, 1).

Venice, Archivio di Stato, Scuola Grande di Santa Maria della Carità, Busta 3, Perg. No. 105.

**1453,** February 25 (XV). Venice. Scuola Grande di San Giovanni Evangelista. Subvention of 20 ducats for the marriage of Jacopo Bellini's daughter Niccolosia [to Andrea Mantegna].

*Io Franc.° de lorenzo straziariol o rezuido duc. vintj per nome der ser Jachomo belin depintor per sovinzion der maridar de Nicholoxa sua filia.*

Venice, Archivio di Stato, Scuola Grande di San Giovanni Evangelista, Reg. 72.

**1456–57 (XVI).** Venice. San Pietro di Castello. Commissions and payments for an image (lost) of Lorenzo Giustiniani to be placed over his tomb, and for an altarpiece (lost) of Saints Peter, Paul, and an unnamed saint for the Sala del Patriarca (see Appendix D, 1).

Venice, Archivio di Stato, Mensa Patriarcale, Reg. di Cassa 1444–59. Busta 66, p. 122.aZA.

**1457,** April 12. Venice. Document witnessed by Jacopo Bellini: "*Testis: Ser Jacobus bellino ser Nicolaj pictor de contracta sancti Giminiani.*" Notarized by Francesco Elmi (Testi, 1915, 162).

**1459.** Gentile Bellini has separate residence from his father, in parish of S. Marina.

**1459,** April 21 (XVII). Venice. Will of Gera Rinversi, mother of Anna Bellini (wife of Jacopo), leaving her personal effects to her daughter. Should the latter predecease her, these effects are left to the convent of Corpus Christi.

> Venice, Archivio di Stato, Sez. not., Testamenti B.a 870. Atti Rossi Pietro, testamento No. 111.

**1460,** July 16. Venice. Jacopo signs as witness: "*Testis: Ser Jacobus bellino quondam ser Nicolaj pictor de confinio sancti Zeminiani*" (Testi, 1915, 162).

**1460.** Padua, Santo. Year supposedly inscribed on altar (Fig. 47) in funerary chapel of Gattamelata, with names of Jacopo Bellini and his sons (see Appendix D, 1).

**1460–64.** Venice. Santa Maria della Carità. Four triptychs (Figs. 63–66) to be installed on altars above tombs in the *barco*. Documents survive for the altars' commission, but no artist is named. Present criticism gives these triptychs to Jacopo's partial design and studio execution (see Appendix D, 1).

**1463(?).** Undocumented funerary decorations for Bertoldo d'Este (reflected in Pl. 136?). A lost portrait by Jacopo of that hero (d. 1463) is recorded later in the collection of Pietro Bembo (see Appendix D, 1: Padua).

**1463,** February 2. Venice. Gentile Bellini acts as witness, identified as son of Jacopo and resident of parish of San Geminiano (Meyer zur Capellen, 1985, doc. 3).

**1465,** January 31. Venice. Scuola Grande di San Giovanni Evangelista. Payments to Jacopo Bellini for a pictorial cycle: "*Rezevi mi jachomo belino pintor da missier lo guardian e chompagni duchati oto, zoe oto per resto d ogni razon fin questo di.*" Planning for this project began in 1421 (Doc. April 10, 1421); for the cycle, see Appendix D, 1.

> Venice, Archivio di Stato, Scuola di San Giovanni Evangelista, No. 72, p. 269 (cited by Testi, II, 1915, 163, n. 2).

**1466,** July 6 (XVIII). Venice. Scuola Grande di San Marco. Report of scuola meeting to approve plan for canvases for major meeting room; 38 in favor, 8 opposed. No artists mentioned or subjects given (see Appendix D, 1, for text; voters' names omitted).

> Venice, Archivio di Stato, Scuola Grande di San Marco, Not. 1479–1503, p. 34, Sala Diplomatica, autografi.

**1466,** July 17 (XIX). Venice. Scuola Grande di San Marco. Commission to Jacopo Bellini for canvases of *Way to Calvary* and *Crucifixion* (for text, see Appendix D, 1).

> Venice, Archivio di Stato, Scuola Grande di San Marco, Not. 1479–1503, p. 35, Sala Diplomatica, autografi.

**1466,** December 1. Venice. Jacopo signs as witness: "*Testis: Jacobo belino pictor quondam ser Nicolai*" (Testi, 1915, 164).

**1466,** December 15 (XX). Venice. Scuola Grande di San Marco. Commission given to Gentile Bellini for canvases of Old Testament subjects—*Moses in the Desert* and the *Deluge*—the project in which his father ("*de so padre maistro Iacomo Belin*") was then engaged.

> Venice, Archivio di Stato, Scuola Grande di San Marco, Not. 1479–1503, p. 36, Sala Diplomatica, autografi.

**1467,** January 10 (XXI). Venice. Scuola Grande di San Marco. Commission to masters Bartolomeo Vivarini and Andrea da Murano to paint canvases continuous with those by "*maistro Iacomo Belin.*"

> Venice, Archivio di Stato, Scuola Grande di San Marco, Not. 1479–1503, p. 37, Sala Diplomatica, autografi.

**1467,** October 13. Venice. Jacopo signs as witness: "*Testis: Ser Jacobus bellino pictor de confinio sancti Gemigniani*" (Testi, 1915, 165).

**1469,** March 3 (XXII). Venice. Jacopo Bellini and Luigi Sagundini sue Antonio Falirio, a painter resident at Negroponte, possibly identical with painter of *Madonna* (Venice, San Francesco della Vigna).

> Venice, Archivio di Stato, Cancelleria Inferiore. Rogiti di Francesco ab Elmis not. ven., vol. 1466–70 (XIV), c. 182r.

**1469,** March 31 (XXIII). Venice. "*Iacobus Bellino pictor civis vester originarius*" appears on list of candidates for San Niccolò di Lido (later canceled, as the artist died before the election in 1472).

> Venice, Archivio di Stato, Col. Not. 1467–73, Reg. 13, p. 75.

**1470,** January 7. Venice. Scuola Grande di San Marco. Listed in scuola contract with Lazzaro Bastiani, "*per pagamento al precio, rata pro rata, quello di haver mistro Jacomo belin del suo, mexurando pe per pe e paso per paso.*" Last reference to Jacopo Bellini as living (Testi, 1915, 166).

**1471,** November 25 (XXV). Venice. Will of Anna Bellini, listed as widow. Her daughter Niccolosia, not named, is presumably deceased. Giovanni Bellini's name is omitted for either his illegitimacy, or the unlikely possibility of his being the issue of an earlier, unknown marriage of Jacopo's; Jacopo's mother was named Giovanna, and his illegitimate brother, a painter, was named Giovanni (see Doc. 1440, September 13). To Gentile are bequeathed all works in plaster, marble, and relief, pictures and highly finished drawings(?), and all books of drawings and all that pertains to painting and to the art of painting, which belonged to the said late master Jacopo Bellini. All else is to be divided equally between him and her son Niccolò, the latter to receive some of her clothing:

> *Item dimitte Gentili filio meo omnia laboreria de Zessio, de marmore et de relevijs, quadros dessignatos et omnes libros de dessignijs et alia omnia pertinentia pictorie et ad depingendum que fuerunt quondam prefati magistri Iacobij bellino veri mei. Et residuum omnium et equaliterbo* (Paoletti, II, 1894).

> Venice, Archivio di Stato, Sez. not., Testamenti B. 361. Notaio Francesco ab Helmis, Fasc. in perg. No. 173.quit.

1493, December 23. Venice. Antonio Salimbene, Mantuan representative to Venice, writes to inform Marquis Francesco Gonzaga that Gentile Bellini has offered him a view of Venice drawn by his father that will require two months of retouching with a quill pen.

*Hoggi ho parlato cum m. Gentile Bellino circa il retracto de Venetia: me ha resposto faverne un che fece suo patre, quale me ha offerto de darmi, et perche l'e antiquo in modo che'l non si puo affigurare me dice che seria necessario tocarlo con penna, et che a fare questo se gli staria duoi mesi almeno, unde il prega V. Ex. se digni farli intendere se la vole che se ge lavori dentro, che subito gli farra dar principio, et non volendo quella aspectare sino a quello tempo esso m. Gentile gli manda per il presente cavallero il retracto de S.to Marcho, cum tutta la piaza et palazzo de Venetia, dicendo che omne puoca gionta che se facesse forsi suppleria al bisogno e contento de V. Ex. . . .*

Mantua, Archivio di Stato, Archivio Gonzaga, B. a. 1434, fol. 171r (Meyer zur Capellen, 1985, 114, doc. 39).

1494, January 4. Mantua–Venice. The drawing mentioned above, in faded or otherwise damaged state, was sent to Mantua and did not please the marquis, "*non ne satisfa,*" and he returned it to Gentile Bellini, who was to prepare a new view of Venice.

Mantua, Archivio di Stato, Archivio Gonzaga, B. a. 2961, lib. 2, fol. 67v (Meyer zur Capellen, 1985, 115, doc. 42).

c. 1500 (**XXIV**). Reference is made to Jacopo Bellini in a poem by Giovanni Testa Cillenio. After praising the "divine" Piero della Francesca, the poet wrote:

*Ma 'l gran Giovanni e 'l buon Gentil Bellino
Fian sempre digni di celesti honori.
Costor son quei d'ogni altra gente fori,
Ch'an tracto l'arte e preso suo camino:
Due bei fratelli e 'l patre lor piu fino,
Maestro da farne in versi gran romori.*

Codex Isoldiano, No. 1739, Library of the University of Bologna (see Ricci, *Arte e Storia*, I, 1897, 27).

1505, March 15. Cardinal Marco Cornaro, in a letter to Francesco II Gonzaga, refers to "*Nicolo Bellino, cognato del dito Mantegna et familiar nostro*" (cited by Brown, 1969, 372, n. 1); see also C. M. Brown, "Andrea Mantegna and the Cornaro of Venice," *Burlington Magazine*, 116 (1974), 101–3.

Mantua, Archivio di Stato, Busta 1441.

1507, February 18. Venice. Will of Gentile Bellini, who was buried on February 23. He leaves to his brother Giovanni the book of drawings that was their late father's if Giovanni will complete a painting for the Scuola Grande di San Marco, also receiving payment from the scuola for his work. If Giovanni declines to do this, the book is to remain at the disposal of Gentile's executors.

The book in question is presumably the one now in the British Museum. Giovanni, with his studio, completed the vast canvas of *Saint Mark Preaching in Alexandria*, now in the Brera (Milan).

*Item volo et ordino atque rogo prefatum Ioannem fratrem ub sibi placeat complere [sic] opus per me inceptum pro dicta Scola Sancti Marci quo completo sibi dimitto et dari volo librum designorum quod fuit prefati quondam patris nostri ultimam mercdem quam habebit a dicta scola, et si nolet perficere dictum opus, volo dictum librum restare in mea comissaria.*

Gentile also bequeaths drawings of his, brought from Rome, to his sons Bonaventura and Geronimo, to divide between themselves, drawings sometimes thought to have been by Jacopo Bellini rather than Gentile.

Venice, Archivio di Stato, Sez. not., notaio Bernardo Cavagnis B. a 271, No. 307 (Meyer zur Capellen, 1985, 120, Doc. 75). French trans. of Gentile's will by Mas-Laterie (1866, 286–88).

1512, February–March. Venice. Correspondence between Niccolò Bellini and Gian Giacomo Calandra, secretary of the Marchesa Isabella d'Este, concerning the sale of an antique head of Plato, possibly from Jacopo's collection (Brown, 1969, 372 ff.).

1516. Venice. Death of Giovanni Bellini, illegitimate(?) son of Jacopo; he had the same name as Jacopo's illegitimate brother, also an artist, and of Jacopo's mother, Giovanna.

# APPENDIX F: GRAPHIC EXTENSIONS

## 1. JACOPO BELLINI AND VENETIAN MANUSCRIPT ILLUMINATION

First to "think small" among documented Venetian renaissance masters, Bellini was possibly skilled as a manuscript illuminator, brought up in its practice and imparting it within his own studio. It is sometimes thought that Gentile da Fabriano was trained in a Venetian manuscript workshop, and his miniaturist aspects may have had an impress on Jacopo's art as well, particularly the Paris Book, often compared in scale and style with Northern courtly illuminations.

Pisanello, Jacopo's associate and rival, had a strong interest in Northern book arts, particularly from the Franco-Burgundian world of the Limbourg brothers, whose art he copied. An Italian manuscript, coarse but in the chivalric manner, has been given to Pisanello's hand, though not persuasively. Jacopo's nephew Leonardo, long apprenticed in his uncle's studio (Appendix E, Doc. 1443), became an important illuminator, the leading Venetian master until a more sophisticated practice of that skill developed in Padua and in the Jacometto circle.[1] One folio in Leonardo's finest work, a *Miscellanea* (Jerusalem, Israel Museum, Ms. 180/51, fol. 64v), shows his awareness of the Mascoli Chapel mosaics that his uncle probably designed (Figs. 53–54).

Most important in this connection is the remarkable authority shown by Giovanni Bellini and Andrea Mantegna in painting in miniature proportions on their panels and canvases, often using motifs close to those in Bellini's Books; this suggests that Jacopo's precedent inspired their ability to create monumental effects in a diminutive scale. Another fine painter, the so-called Fra Carnevale, perhaps in Jacopo's studio between his training in Florence and his activity in Urbino, may also have been responding creatively to Bellini's small-scale outlook in his later panels at Urbino (Boston, Museum of Fine Arts; New York, Metropolitan Museum of Art).

Illuminations of extraordinary quality in two Venetian manuscripts have been linked to Jacopo's hand; both were commissioned by his possible patron, the *provveditore* Jacopo Marcello. In 1453 Marcello sent the first of these as a beautiful gift to René d'Anjou, founder of the Order of the Crescent: the *Passion of Saint Maurice* (Paris, Bibliothèque de l'Arsenal, Ms. 940), with Latin verse by Marcello recounting the life of the order's militant patron saint. With this gift Marcello celebrated his admission to the order four years before, along with Francesco Sforza, another Italian man of war; Marcello had assisted that *condottiere* when Sforza, in Venetian service, conquered Milan in 1449 (though only in 1441 the Serenissima had done her unsuccessful best to have Sforza poisoned, when he married the Visconti heiress to Milan's territory).[2]

Six pages in the *Passion* were possibly illuminated by a Lombard artist, four others by more sophisticated, sensitive hands. Meiss, noting the quality of light in a remarkable perspectival recreation of an imaginary Congress of the Order of the Crescent at Avignon (Appendix F, Ill. 1), commented, "the combination of luminary space with quiet, unitary figures points to Venice, to Antonio Vivarini, and especially to Jacopo Bellini. In Jacopo's paintings, and later in Gentile's and Carpaccio's, the sense of a collectivity is strongly conveyed."[3] He found it particularly close to the *Three Marys at the Tomb* (Pl. 221).

Although he acknowledged many similarities between Marcello's *Passion* and the art of Jacopo and Giovanni Bellini, Meiss concluded that these miniatures were by Mantegna (with a Venetian assistant). This proposal won little critical favor. Mariani Canova saw in the best pages an artist of Jacopo Bellini's circle; Lightbown finds Mantegna's statement in 1480, that "he was unused to painting small figures . . . [and] work in such a scale would be better suited to a miniature painter," to preclude his use of that technique.[4]

The splendid quality of the illuminations in the second manuscript, Strabo's treatise on geography, *De Situ Orbis* (Appendix F, Ill. 2) of 1459 (Albi, Bibliothèque Municipale [Rochegude], Ms. 4), like some in the *Passion* Marcello had sent to René d'Anjou six years before, led Meiss to ascribe many of these too to the hand of the young Mantegna.[5] Still living in Padua at the time they were painted, Mantegna was making a "little work" for Marcello in 1459, as documented in a letter from Lodovico Gonzaga of Mantua, a *condottiere* often in Venetian service and thus well acquainted with his supervisor Marcello. Lodovico, having waited long for Mantegna to join his court, wrote that he

[1]Manuscripts by Leonardo Bellini have been brought together by Mariani Canova (1972), cat. nos. 9–24, figs. 1–19, and colorplate 1, a "Mariegola of S. Maria Nova" (New York, Pierpont Morgan Library, Ms. 428); she discusses his *oeuvre* on 22–24. See also L. Moretti, "Di Leonardo Bellini pittore e miniatore," *Paragone*, 9, 99, 1958, 58–66; Mariani Canova, "Per Leonardo Bellini," *Arte Veneta*, 22, 1968, 9 ff., 268–72; and recently U. Bauer-Eberhardt, "Die Rothschild-Miscellanea in Jerusalem, Hauptwerk des Leonardo Bellini," *Pantheon*, XLII, 1984.

[2]For these manuscripts, see Meiss, 1957.

[3]Meiss, 1957, 23.

[4]For a recent survey of this issue, see Lightbown, 1986: Appendix, "Mantegna and Book Illumination," 494–95. His conclusion, that Mantegna did not illuminate these manuscripts, seems correct, but the reason is unpersuasive. Perhaps the artist was by then using a dislike of small-scale work to avoid an unwanted commission; earlier, he might have taken it on.

[5]Meiss, 1957, 30–51.

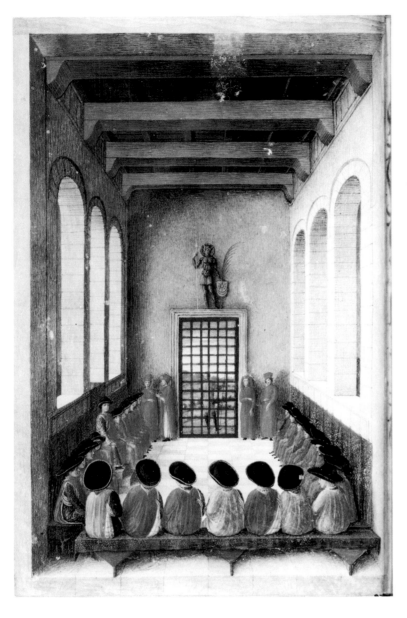

Appendix F,
Ill. 1. Jacopo Bellini
(studio?). *Congress of the
Order of the Crescent*,
miniature in *Passion of
Saint Maurice*. 1452–53.
Page 18.7 x 13 cm., tempera on vellum. Paris,
Bibliothèque de l'Arsenal
(Ms. 940, fol. Cv)

expected the painter to come as soon as he completed the "operetta" for Marcello. That work has not been identified; Meiss, assuming it was a small-scale painting, suggested the illuminated Strabo *Geography*, translated by Guarino.[6]

In the early 1450s Jacopo was at the height of his powers, creating such magnificent works as the Uffizi *Madonna* (Fig. 43); probably he would not have welcomed the tedium of painting Marcello's small-scale miniatures, but he could certainly have designed such a project, as evidenced by the Paris Book. Nothing by his nephew Leonardo approaches the quality of Marcello's commissions, and Giovanni Bellini is the likeliest candidate for rendering the best of these pages.

Mantegna's powerful *oeuvre* has a stony, stoical quality; Giovanni's is gentler and more humane, its classicism less rigorous.

Bellini worked with both sons on the Gattamelata Altar in 1460 (Fig. 47), and the *Passion of Saint Maurice* probably comes from his collaboration with Giovanni, who is known to have painted a portrait miniature in the 1480s. He could well have done so earlier in his career, when he was perhaps adding drawings such as the portrait in metalpoint (Pl. 1) to his father's Books. Lightbown's summary is cautious but correct: "Some association with Bellini is most likely for the St. Maurice manuscript."[7]

## 2. JACOPO BELLINI AND ENGRAVING

Print making from metal plates became widespread in Venice during the generation after Bellini. His son-in-law, Andrea Mantegna, was the

first major painter to maintain an atelier there for reproductive prints, hiring artists to copy his works and engraving a few plates himself, one of

[6]According to Joost-Gaugier ("A Pair of Miniatures by a Panel Painter: The Earliest Works of Giovanni Bellini," *Paragone*, 30, 1979, 48–71), the *Strabo* illuminations are probably by Giovanni Bellini.

[7]Lightbown, 1986, 495. Robertson (1968, 7–21) was the first to suggest the *Saint Maurice* illuminations might be by Giovanni. Mariani Canova (1969, 2, 14–18; 141, cat. no. 1; 142–43, cat. no. 2) gave the *Saint Maurice* to an anonymous Venetian artist influenced by Jacopo Bellini.

Appendix F,

Ill. 2. Jacopo Bellini
(studio?). *Marcello
Presents the Strabo to René
d'Anjou*, miniature in
Strabo's *De Situ Orbis*.
1459. Page 37 x 25 cm.,
tempera on vellum.
Albi, Bibliothèque Muni-
cipale (Rochegude) (Ms.
4, f. p. 4)

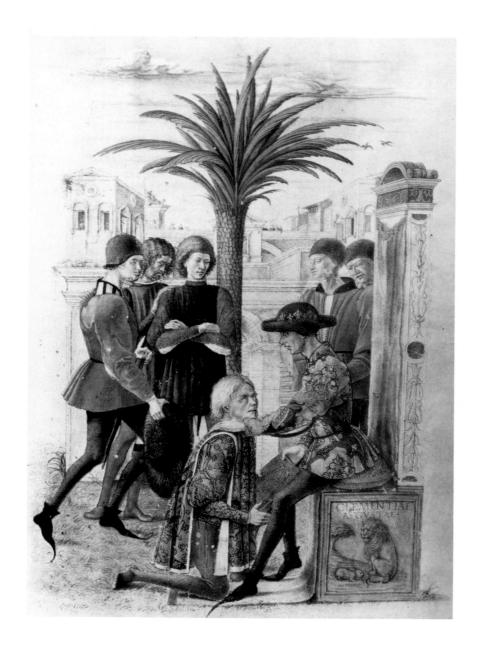

the *Flagellation* partially inspired by Bellini's achievements.

Late in life Jacopo too may have designed prints for the Venetian market, or his drawings may have been adopted for engravings after his death. Arthur M. Hind found four engravings to be related to Jacopo's art. Two of these show a peasant going to market, with inscriptions in Venetian dialect; they share his interest in rustic genre, though neither is close to his style.[8] An early engraving of a milkman calling his wares, *"Late done, late fresca"* ("Ladies, milk! fresh milk!"), part of a lost series of street vendors' cries,[9] is also in keeping with Bellini's themes.

Hind noted a remarkable correspondence between an early Dutch engraving of the *Madonna and Child* by the Master I.A. of Zwolle (Appendix F, Ill. 3) and a simpler repetition of it in the Venetian manner (Appendix F, Ill. 4), and suggested that the Italian print could have been produced in Jacopo's studio.[10] As Bellini's workshop in the 1460s seems to have been a large one,

judging by his important commissions in that decade and the four Carità triptychs of 1460–64, he may well have had an assistant who engraved plates such as this *Madonna,* which is indeed related to his art. Hind also linked a large North Italian print of a lion (Appendix F, Ill. 5) to the many drawings of that beast in Bellini's Books, pointing out that his work could have been the source of this engraving.[11]

Prints that have been associated with the art of Ferrara are often reminiscent of Jacopo's art. The Venetian painter was involved with Ferrara's court portraiture and funerary monuments from the 1430s through the early 1460s, and was certainly there in the early 1440s. Engravings catalogued as Ferrarese may reflect Venetian influence or simply show their common interests: a print like *Cupids at the Vintage* is close in style and theme to many of Jacopo's drawings.[12]

One print, *Carrack Heading to the Right,* catalogued by Hind as "late 15th-century and probably Venetian," may be connected with the page

[8]A. M. Hind, *Early Italian Engraving*, I, London/New York, 1938, 260–61, cat. nos. 26, 27.
[9]British Museum, F11.12; Passavant V, 110, 51.
[10]A. M. Hind, "Italienische Stiche des XV. Jahrhunderts nach nordischen Originalen," *Mitteilungen der Gesellschaft für vervielfältigende Kunst* (Beilage der *Graphischen Künste*), 1908, I, 1–2. The Northern print is Passavant, II, 185, 74.
[11]Hind, 1938, I, 226, cat. no. 52, pl. 437.
[12]See Levenson et al., 1973, 88–89, 158.

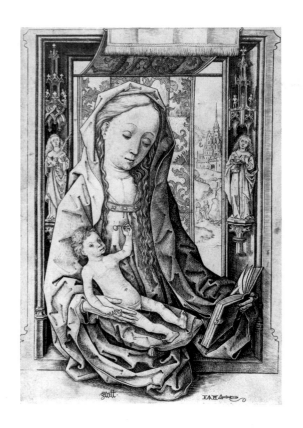

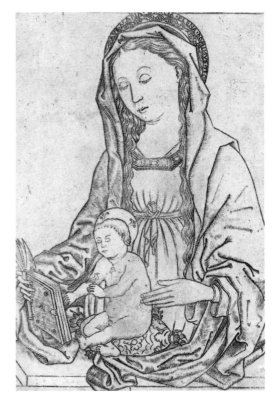

Appendix F,
  Ill. 3. Master I. A. of
  Zwolle. *Madonna and
  Child*. 2nd half 15th
  century. Engraving.
  London, British Museum

Appendix F,
  Ill. 4. North Italian
  Master. *Madonna with Child*.
  2nd half 15th century.
  Engraving. London,
  British Museum

Appendix F,
  Ill. 5. Jacopo Bellini
  (studio?). *Lion*. 2nd half
  15th century. Engraving
  (after A. M. Hind, *Early
  Italian Engraving*,
  London: 1938)

[13]See Levenson et al., 1973, cat. no. 68, 160.

missing from the Paris Book that showed "Some Ships in Different Ways," as the Index states (Appendix C, No. 33).[13] The keeping of motif banks such as Jacopo's Books decreased with the rise of print making, artists coming to depend on these reproductions for their sources.

A major Venetian contribution to the renaissance arts was the publication by Aldus Manutius in 1499 of the *Hypnerotomachia Poliphili*, with its many anonymous woodcut illustrations. Certain woodcuts are in the spirit if not the letter of Bellini's Books and suggest that he made many other gatherings of drawings; Anna Bellini's will mentions "all" rather than "both" of his drawing

books (Appendix E, Doc. 1471). Jacopo's broad responsiveness to new art from the North and to the old/new art from antiquity implies an interest as well in new techniques, which his son Giovanni certainly had. Like his nephew and apprentice Leonardo, who was prominent as a manuscript illuminator in the master's studio, a skilled engraver may have been there in the 1460s, preparing prints of popular genre subjects—ships, peasants, and peddlers—and classical themes, and adapting selectively from Northern devotional images (Appendix F, Ills. 3, 4), thereby enriching himself, his master, and the art of Venice.

## 3. Jacopo Bellini and Cartography

"No one can be a good map maker without being a good painter," wrote Ptolemy, the great classical cartographer, but his saying could almost be reversed in the late Middle Ages and early renaissance, for many major artists, from Ambrogio Lorenzetti to Jan van Eyck, were master cartographers. The skill had central importance for faith, commerce, war, and art. *Mappamundi*—great world maps with Jerusalem at their center—were ordered for the crusades, and the dukes of Burgundy and other hawks of God commissioned them to guide their holy wars. New sea routes and navigation methods also made the map maker's craft critically important. In Europe, Venice was second only to her rival republic, Genoa, in the practice of the cartographer's science and art.

As the Serenissima moved from water to land, fighting on the Italian *terra firma* during the first half of Jacopo's century, Venetian map makers were unusually hard pressed to provide needed guides for the military campaigns that were the Republic's major expenditure. Murano and Padua were the Serenissima's cartographic centers. On the island Fra Mauro (d. c.1456) and Fra Andrea had their workshop in a monastery; the university center, possibly under Palla Strozzi's patronage, probably produced *mappamundi* for Marcello and René d'Anjou.

Though Bellini's participation in cartography is not documented, many cues and clues point to his interest and activity in this field. If Marcello was indeed Jacopo's patron, as so many factors suggest, map making would have been an important area for the *provveditore's* patronage, essential for his work as elected supervisor of *condottieri*.

As Jacopo was the leading master of early perspectival studies in Venice, his concern with this pursuit also suggests cartographic employment. Geometry, perspective, and map making were all allied, and indeed the discovery or rediscovery of perspective had much to do with the revival of Ptolemaic thought. Squarcione, Bellini's Paduan rival and colleague, was well known as a map maker, and Jacopo probably practiced that skill as well, his activities so often overlapping with the Paduan's. The leading Venetian scientist and engineer was the Padua-trained Giovanni della Fontana, who dedicated his thesis on aerial perspective to Jacopo, "the famous painter of Venice." Map making must have been one of Fontana's own hydraulic and military concerns.

Bellini's precocity as a landscape painter suggests an involvement with the cartographer's world. Many pages in Jacopo's Books have the bird's-eye projections that engaged humanist cartographers such as Leon Battista Alberti. Bellini was one of those who provided *staffage* figures for Alberti's undated view of Venice, now lost. Jacopo's own "aerial veduta" of Venice was already too faded by the late 15th century to please a potential buyer (Appendix E, Doc. 1493–94). Though no document gives evidence of patronage, culture, faith, friendships, or skills, Bellini's cartographic interests should be considered as another dimension of his creative professional experience.

# BIBLIOGRAPHY

F. A. Aglietti. *Elogio storico di Iacopo e Giovanni Bellini del dottore F. A.*, Discorsi letti nella R. Accademia di Belle Arti di Venezia per la distribuzione dei premii degli anni 1812, 1813, 1814, 1815. Venice: 1815.

J. J. G. Alexander. *Italian Renaissance Illuminations*, New York: 1977.

——— . "The Provenance of the Brooke Antiphonal," *Antiquaries Journal*, XLIX, 1960, Part 2, 384–86.

——— . "Venetian Illumination in the Fifteenth Century," *Arte Veneta*, XXIV, 1970, 272–75.

F. Ames-Lewis. *Drawing in Early Renaissance Italy*, New Haven: 1981.

——— and J. Wright. *Drawing in the Italian Renaissance Workshop*, University Art Gallery, Nottingham, and the Victoria and Albert Museum, London: 1983.

A. d'Ancona. *Origini del teatro in Italia*, Florence: 1877.

A. Angelucci. *Armilustre e torneo con armi di battaglia tenuti a Venezia*, Turin: 1866.

Anonimo Morelliano. *See* Michiel.

F. Antal. "Studien zur Gotik im Quattrocento," *Jahrbuch der preussischen Kunstsammlungen*, XLVI, 1925, 3–32.

F. Anzelewsky. "Handzeichnungen und Druckgraphik," in J. Bialostocki, *Spätmittelalter und beginnende Neuzeit*, Propyläen Kunstgeschichte, VII, Berlin: 1972, 247–61.

L. Armstrong. *The Paintings and Drawings of Marco Zoppo*, New York: 1976.

——— . *Renaissance miniature painters and classical imagery. The Master of the Putti and his Venetian workshop*, London: 1981.

G. Arnaldi and M. P. Stocchi, eds. *Storia della cultura veneta dal primo quattrocento al Concilio di Trento*, I–III, Vicenza: 1980.

R. Bacou. *Great Drawings of the Louvre Museum: The Italian Drawings*, New York: 1968.

M. Baxandall. "Bartholomaeus Facius on Painting: A Fifteenth Century Manuscript of the *De Viris Illustribus*," *Journal of the Warburg and Courtauld Institutes*, 27, 1964, 90–107.

——— . "A Dialogue on Art from the Court of Leonello d'Este," *Journal of the Warburg and Courtauld Institutes*, 26, 1963, 304–26.

——— . *Giotto and the Orators: Humanist Observers of Painting in Italy and the Discovery of Pictorial Composition, 1350–1450*, Oxford: 1971.

H. Belting. *Giovanni Bellini. Pietà: Ikone und Bildererzählung in der venezianischen Malerei*, Frankfurt: 1985.

B. Berenson. *Italian Pictures of the Renaissance: Venetian School*, I, London: 1957.

——— . *North Italian Painters of the Renaissance*, London/New York: 1907.

——— . *Venetian Painters of the Renaissance*, 2nd ed., New York: 1895; 3rd ed., London/New York: 1897.

G. Bertoni. *Guarino da Verona. Fra letterati e corteggiani a Ferrara, 1429–1460*, Biblioteca dell'Archivium Romanicum, I, 1, Geneva: 1921.

G. Biadego. *Variazione e divagazione a proposito di due sonetti di Giorgio Sommariva in onore di Gentile e Giovanni Bellini*, Verona: 1907.

E. Billanovich. "Note per la storia della pittura nel Veneto," *Italia medioevale e umanistica*, XVI, 1973, 359–89.

M. P. Billanovich. "Una miniera di epigrafi e di antichità," *Italia medioevale e umanistica*, XII, 1969, 197–293.

A. Birkenmajer. "Zur Lebensgeschichte und wissenschaftlichen Tätigkeit von Giovanni Fontana [1395?–1455?]," *Isis*, 17, 1932, 34–53.

P. P. Bober and R. O. Rubinstein. *Renaissance Artists and Antique Sculpture: A Handbook of Sources*, London: 1986.

B. Bordin. "La communità del Santo," *Storia e cultura al Santo*, A. Poppi, ed., Vicenza: 1976, 15–156.

T. Borenius, ed. J. A. Crowe and G. B. Cavalcaselle. *A History of Painting in North Italy*, London: 1912.

L. Borgo. "New Questions for Piero's 'Flagellation'," *Burlington Magazine*, 121, 1979, 547–53.

M. Boschini. *La carta del navegar pittoresco* [1660], A. Pallucchini, ed., Venice: 1966.

M. Boskovits. "Appunti su un libro recente," *Antichità viva*, X, 5, 1971, 14 ff.

——— . "Per Jacopo Bellini pittore (Postillo ad un colloquio)," *Paragone*, 1985, 114–23.

——— . "Quello che dipintori oggi dicono prospettiva," Part 1, *Acta Historiae Artium*, Academiae Scientiarum Hungaricae, VIII, 1962, 241–60.

S. Bottari. "Bellini, Jacopo, Gentile, Giovanni," *Encyclopedia of World Art*, II, New York: 1960, 444–57.

——— . "La visione della natura nella pittura veneziana del Quattrocento," *Umanesimo europeo e umanesimo veneziano*, V. Branca, ed., Venice: 1963, 407–17.

W. J. Bowsma. *Venice and the Defense of Republican Liberty*, Berkeley: 1968.

V. Branca, ed. *Storia della civiltà veneziana. II, Autunno del medioevo e rinascimento*, Florence: 1979.

L. Brion-Guerry. *Le thème du "Triomphe de la Mort" dans la peinture italienne*, Paris: 1950.

C. M. Brown. "The 'Camera del Mappamondo et del cariero' in the Palazzo di San Sebastian in Mantua," *Journal of Jewish Art*, 10, 1984, 32–46.

——— . " 'Una Testa de Platone Antica con la Punta dil Naso di Cera': Unpublished Negotiations between Isabella d'Este and Niccolò and Giovanni Bellini," *Art Bulletin*, 51, 1969, 372–77.

P. F. Brown. "Painting and History in Renaissance Venice," *Art History*, VII, 1984, 263–94.

G. Cagnola. "Intorno a Jacopo Bellini," *Rassegna d'arte*, IV, 1904, 40–43.

E. Cammaerts. *Les Bellini: étude critique*, Paris: 1912.

A. Campana. "*Pueri mingentes* nel Quattrocento," *Friendship's Garland. Essays Presented to Mario Praz on His 70th Birthday*, Rome: 1966, 31–42.

G. Cantalmessa. "L'arte di Jacopo Bellini," *Ateneo Veneto*, XIX, 1896, 154.

D. Carritt. *Artemis, Annual Report*, 1978–79, cat. no. 4, 14–17.

B. Cecchetti. *La Republica di Venezia e la corte di Roma nei rapporti della religione*, 1–2, Venice: 1874.

D. S. Chambers. *The Imperial Age of Venice: 1380–1580*, London: 1970.

A. Chastel. *Art et humanisme à Florence au temps de Laurent le Magnifique*, Paris: 1959.

——— . "Marqueterie et perspective au XVᵉ siècle," *La Revue des Arts*, III, 1953, 141–54.

——— . "La Mosaïque à Venise et à Florence au XVᵉ siècle," *Arte Veneta*, VIII, 1954, 119–30.

——— , R. Klein, et al., eds. *Pomponius Gauricus, De Sculptura* (1504), Geneva: 1969.

K. Christiansen. *Gentile da Fabriano*, Ithaca: 1982.

L. A. Ciappone and G. Pozzi. "La cultura . . ." *See* Pozzi.

E. A. Cicogna. Document 16, cited in his *Inscrizioni*, no. 109, p. 711. "Descrizione e Storia del Libro de' Disegni di Giacomo Bellino," *Delle Inscrizioni Veneziane*, VI, Venice: 1853, 756–57.

——— . *Lettera di Emmanuele Antonio Cicogna Cleandro . . . intorno ad alcune legate veneziane*, Venice: 1856.

M. Clagett. "The Life and Works of Giovanni Fontana," *Science of Mechanics of the Middle Ages*, Madison: 1959, 1–28.

L. Coletti. *Pittura veneta del quattrocento*, Novara: 1953.

H. W. Collins. "The Cyclopean Vision of Jacopo Bellini," *Pantheon*, XL, 1982, 300–304.

——— . *Gentile Bellini, a Monograph and Catalogue of Works*, Ph.D. dissertation, University of Pittsburgh: 1970.

——— . "Major Narrative Paintings by Jacopo Bellini," *Art Bulletin*, 64, 1982, 466–72.

F. Colonna. *Hypnerotomachia Poliphili*, G. Pozzi and L. A. Ciapponi, eds., Padua: 1964.

S. M. Connell. *Employment of Sculptors and Stonemasons in Fifteenth Century Venice*, Ph.D. dissertation, Warburg Institute, London: 1976.

J. A. Crowe and G. B. Cavalcaselle. *A History of Painting in North Italy*, London: 1871. *See also* T. Borenius, ed.

M. Dalai Emiliani, ed. *La Prospettiva rinascimentale: codificazioni e trasgressioni*, Florence: 1980.

G. Dalli Regoli. "David trionfante: una ipotesi e un disegno poco noto," *Antologia di Belle Arti*, nos. 9–12, 1979, 34–42.

S. de Ricci. *See* [S. de] Ricci.

B. Degenhart. "Antonio di Puccio Pisano," *Dizionario Biografico degli Italiani*, III, Rome: 1961, 571–74.

——— and A. Schmitt. *Corpus der italienischen Zeichnungen 1300–1450, Teil III: Venedig, Addenda zu Süd- und Mittelitalien*, Berlin: 1980.

——— and A. Schmitt. "Gentile da Fabriano in Rom und die Anfänge des Antikenstudiums," Parts I and II, *Münchener Jahrbuch der bildenden Kunst*, XI, 1960, 59–90; 91–151.

——— and A. Schmitt. *Jacopo Bellini: The Louvre Album of Drawings*, New York: 1984.

——— and A. Schmitt. "Marino Sanudo und Paolino Veneti. Zwei Literaten des 14. Jahrhunderts in ihrer Wirkung auf Buchillustrierung und Kartographie in Venedig, Avignon und Neapel," *Römisches Jahrbuch für Kunstgeschichte*, XIV, 1973, 1–37.

——— and A. Schmitt. "Ein Musterblatt des Jacopo Bellini mit Zeichnungen nach der Antike," *Festschrift Luitpold Düssler*, 1972, 139–68.

O. Demus. *The Church of San Marco in Venice*, Dumbarton Oaks Research Library and Collection, Washington, D.C.: 1960.

W. Deonna. "Fontaines anthropomorphes: la femme aux seins jaillissants et l'enfant 'mingens'," *Genava*, n.s. VI, 1958, 239–96.

P. Durrieu. "Michelino di Besozzo et les relations entre l'art italienne et l'art français," *Mémoires de l'Institut Nationale de France: Académie des Inscriptions et Belles-Lettres*, XXXVIII, 2 (1911), 365 ff.

S. Y. Edgerton, Jr. "Alberti's Perspective: A New Discovery and A New Evaluation," *Art Bulletin*, 48, 1966, 367–79.

C. Eisler. "Surgi d'un mur demoli," *Connaissance des Arts*, no. 31, 1982, 71–75.

——— . "Toward a Reconstruction of the Gattamelata Altar: Saints Anthony Abbot and Bernardino of Siena," *Arte Veneta*, 1985, 24–28.

C. Ephrussi. Review of A. Heiss, *Les médailleurs de la Renaissance*, in *Gazette des Beaux-Arts*, XXVII, no. 2, 1883, 77–86.

M. R. Fehl. "Four *Imagines* by the Elder Philostratus in the translation prepared by Demetriua Moschus for Isabella d'Este (Paris, B.N., Ms. ital. 1091)," Appendix II of M. J. Marek, *Ekphrasis und Herrscherallegorie: Antike Bildbeschreibungen bei Tizian und Leonardo*, Römische Studien der Bibliothek Hertziana, 3, Worms: 1985, 123–55.

L. J. Feinberg. "Jacopo Bellini, Funeral Procession of the Virgin," *Old Master Drawings: Selections from the Charles A. Loeser Bequest, Fogg Art Museum Handbooks*, 1, K. Oberhuber, ed., Cambridge, Mass.: 1979, cat. no. 4, 20.

C. ffoulkes and R. Maiocchi. *Vincenzo Foppa of Brescia*, London: 1909.

A. A. Filarete. *Treatise on Architecture*, trans. J. Spencer, New Haven: 1965.

G. Fiocco. "Dello Delli scultore," *Rivista d'arte*, XI, 1929, 25–42.

——— . "Filippo Lippi a Padova," *Rivista d'arte*, XVIII, 1936, 25–44.

——— . "I Giganti di Paolo Uccello," *Rivista d'arte*, XVII, 1935, 385–404.

——— . "Giovanni e la famiglia dei Bellini alla luce di nuovi documenti," *Vernice*, IV (num. spez. "Giambellino"), 1949, 6.

——— . "L'Ingresso del Rinascimento nel Veneto," *Venezia e l'Europa: Atti del XVIIIᵉ Congresso Internazionale di Storia dell'Arte*, Venice: 1956, 56 ff.

——— . "I Lamberti a Venezia: II, Pietro di Niccolò Lamberti," *Dedalo*, VIII, 1927–28, 343 ff.

——— . "Lettere pittoriche," *Vita artistica*, Dec. 1926, 144.

——— . "Michele Giambono," *Venezia*, I, 1919, 22.

——— . "Il museo immaginario di Francesco Squarcione," *Memorie dell'Accademia Patavina de Scienze, Lettere ed Arti*, Padua: 1958–59, 71–73.

——— . "Sulle relazioni tra la Toscana e il Veneto nei secoli XV e XVI," *Rivista d'arte*, XI, 1929, 439–48.

——— . *Venezia*, Milan/Rome: 1920.

G. Fogolari. "La chiesa di Santa Maria della Carità di Venezia," *Archivio Veneto-Tridentino*, V, 1924, 57–119.

——— . "La Nuova Madonna di Jacopo Bellini delle gallerie di Venezia," *Bollettino d'Arte*, I, 1921, 104–7.

——— . "Gli scultori toscani a Venezia nel Quattrocento a Bartolomeo Bon Veneziano," *L'Arte*, I, 1930, 427–65.

M. Fossi Todorow. *I Disegni del Pisanello e della sua cerchia*, Florence: 1966.

L. Franzoni. "Rilievo Romano dal Ponte Nuovo in un disegno di Jacopo Bellini," *Vita Veronese*, XXVII, 1974, 10–13.

B. Fredericksen and F. Zeri. *Census of Pre-Nineteenth Century Italian Paintings in North American Public Collections*, Cambridge, Mass.: 1972.

D. Frey. "Der Dom von Sebenico und sein Baumeister Giorgio Orsini," *Jahrbuch der Kunsthistorischen Institutes des K. K. Zentrale Kommission für Denkmalpflege*, Vienna, 1913, 1–170.

H. Friedman. *The Symbolic Goldfinch: Its History and Significance in European Devotional Art*, Washington, D.C.: 1946.

G. Frizzoni. "Il libro di disegni di Jacopo Bellini al Louvre," *Rassegna d'arte*, IX, 1909, 55–60, 345–47.

——— , ed. M. A. Michiel. *Notizie d'opere . . . See* Michiel.

L. Fröhlich-Bum. "Bemerkungen zu den Zeichnungen des Jacopo Bellini und zu seiner Kunst," *Mitteilungen der Gesellschaft für vervielfältigende Kunst*, Vienna, 1916, no. 3, 41–56.

G. F. Fruet. "Una tesi di laurea su Michele Giambono e la decorazione della Cappella di Mascoli," *Arte in Friuli, Arte a Trieste*, I, 1975, 127–39.

R. Fry. "A Note on Jacopo Bellini," *The Dome*, Feb. 2, 1899, 124–28.

J. Gadol. *Leon Battista Alberti: Universal Man of the Early Renaissance*, Chicago: 1969.

E. Galichon and R. de Mas-Latrie. "Iacopo, Gentile et Giovanni Bellini, documents inédits," *Gazette des Beaux-Arts*, II, 1866, 281–88.

C. Gamba. *Pitture Umbra del Rinascimento*, Novara: 1949.

A. Gambuti. "I 'libri del disegno': Filarete e l'educazione artistica di Galeazzo Maria Sforza," *Arte Lombarda*, XVIII, 38/39, 1973, 133–43.

L. Gargan. "Oliviero Forzetta tra i pittori e collezionisti d'arte veneziana del primo trecento," *Cultura e arte nel Veneto al tempo del Petrarca. Studi sul Petrarca*, V, 1978, 34–66.

J. Gaye. *Carteggio inedito d'artisti dei secoli XIV, XV, XVI* (1839–40), Turin: 1961.

——— . "Giacomo Bellini in seinen Handzeichnungen," *Kunstblatt*, Mar. 19, 1840, 89 ff.

D. J. Geanakoplos. *Greek Scholars in Venice*, Cambridge, Mass.: 1962.

F. Gibbons. "New Evidence for the Birth Dates of Gentile and Giovanni Bellini," *Art Bulletin*, 45, 1963, 54–58.

C. Gilbert. *Italian Art, 1400–1500: Sources and Documents*, Englewood Cliffs, N.J.: 1980.

——— . "On Subject and Non-Subject in Italian Renaissance Pictures," *Art Bulletin*, 34, 1952, 202–16.

R. Goffen. "Icon and Vision: Giovanni Bellini's Half-Length Madonna," *Art Bulletin*, 57, 1975, 487–518.

G. R. Goldner. *Niccolò and Pietro Lamberti*, New York: 1978.

V. Goloubew. *Les Dessins de Jacopo Bellini au Louvre et au British Museum*, I (London Book), Brussels: 1912; II (Paris Book), Brussels: 1908.

P. Gothein. *Frühhumanismus und Staatskunst in Venedig*, Berlin: 1932.

N. Gramaccini. "La Déploration de Niccolò dell'Arca. Religion et Politique au temps de Giovanni II Bentivoglio," *Revue de l'Art*, no. 62, 1983, 21–34.

——— . "Wie Jacopo Bellini Pisanello besiegte: Der Ferrarese Wettbewerb von 1441," *Idea*, I, 1982, 27–53.

R. Green and I. Ragusa. *Meditations . . . See* Ragusa.

A. Griseri. " 'Il disegno,' Storia dell'arte italiana," *Grafica e Immagini*, I, Turin: 1901, 210–13.

G. Gronau. "Gentile, Giovanni, Jacopo Bellini," in U. Thieme, F. Becker, eds., *Allgemeines Lexikon der bildenden Künstler*, III, Leipzig: 1909, 252–64.

——— . "Notes sur les dessins de Jacopo Bellini: Les livres de dessins au British Museum et au Louvre," *La Chronique des arts et de la curiosité*, 1895, 54–56.

Guérin (1728). *See* Omont; [S. de] Ricci.

W. Gundersheimer. *Ferrara: The Style of a Renaissance Despotism*, Princeton: 1973.

J. R. Hale, ed. *Renaissance Venice*, London/Totowa, N.J.: 1973.

——— and M. Mallett. *Venice: The Military Organization of a Renaissance State*, Cambridge, Mass.: 1983.

F. Hartt. "Andrea del Castagno, Three Disputed Dates," *Art Bulletin*, 48, 1966, 228–38.

——— . "The Earliest Work of Andrea del Castagno," Parts I and II, *Art Bulletin*, 41, 1959, 159–81; 225–36.

A. Heiss. *Les médailleurs de la Renaissance*, I, Paris: 1883.

T. Hetzer. *Venezianische Malerei von ihren Anfängen bis zum Tode Tintorettos*, in *Schriften Theodor Hetzers*, 8, Stuttgart: 1985.

A. M. Hind. *Early Italian Engraving*, London: 1938.

T. Hirthe. *Die Architekturen in den Skizzenbüchern des Jacopo Bellini*, typescript, Technische Universität, Berlin: 1980.

F. C. Hodgson. *Venice in the Thirteenth and Fourteenth Centuries*, London: 1910.

E. Hubala. *Oberitalien Ost*, Reclams Kunstführer, Italien, II, Stuttgart: 1965.

N. Huse and W. Wolters. *Venedig, die Kunst der Renaissance: Architektur, Skulptur, Malerei, 1460–1590*, Munich: 1986.

C. Huter. "Early Works by Jacopo Bellini," *Arte Veneta*, XXVIII, 1974, 18–20.

H. Huth. " 'Sarazenen' in Venedig?" *Festschrift für Heinz Ladendorf*, Cologne: 1980, 58–68.

E. Jacobs. "Die Mehemed–Medaille des Bertoldo," *Jahrbuch der preussischen Kunstsammlungen*, 48, 1927, 1–17.

C. Joost-Gaugier. "Considerations Regarding Jacopo Bellini's Place in the Venetian Renaissance," *Arte Veneta*, XXVIII, 1974, 21–38.

———. "A Contribution to the Paduan Style of Giovanni Francesco da Rimini," *Antichità viva*, XII, 3, 1973, 7–12.

———. *The Drawing Books of Jacopo Bellini*, Ph.D. dissertation, Harvard University, Cambridge: 1973.

———. "A Florentine Element in the Art of Jacopo Bellini," *Acta Historiae Artium*, Academiae Scientiarum Hungaricae, XXI, 1975, 359–70.

———. *Jacopo Bellini—Selected Drawings*, New York: 1980.

———. "Jacopo Bellini and the Theatre of his Time," *Paragone*, no. 325, 1977, 70–80.

———. "Jacopo Bellini's interest in perspective and its iconographical significance," *Zeitschrift für Kunstgeschichte*, XXXVIII, 1975, 1–28.

———. "The 'Sketchbooks' of Jacopo Bellini Reconsidered," *Paragone*, 297, 1974, 24–41.

———. "Some considerations regarding the Tuscanization of Jacopo Bellini," *La Prospettiva rinascimentale: codificazioni e trasgressioni*, M. Dalai Emiliani, ed., Florence: 1980, 165–76.

———. " 'Subject or nonsubject' in a drawing by Jacopo Bellini," *Commentari*, XXIV, 1973, 148–53.

———. "The Tuscanization of Jacopo Bellini," Parts I and II, *Acta Historiae Artium*, Academiae Scientiarum Hungaricae, XXIII, 1977, 95–112; 291–313.

G. R. Kernodle. *From Art to Theatre: Form and Convention in the Renaissance*, Chicago: 1943.

J. H. Keydel. *A Group of Altarpieces by Giovanni Bellini Considered in Relation to the Context for which They Were Made*. Ph.D. dissertation, Harvard University, Cambridge: 1969, 49–73.

H. Kiel. "Una proposta per Masolino disegnatore," *Scritti di storia dell'arte in onore di Ugo Procacci*, II, Milan: 1977.

M. L. King. *Venetian Humanism in an Age of Patrician Dominance*, Princeton: 1986.

F. Klauner. "Venezianische Landschaftsdarstellung von Jacopo Bellini bis Tizian," *Jahrbuch der kunsthistorischen Sammlungen in Wien*, LIV, 1958, 121–50.

R. Klein. "Pomponius Gauricus on Perspective," *Art Bulletin*, 43, 1961, 211–30.

B. Klesse. "Ein unbekanntes Werk des Clerigino da Capodistria," *Pantheon*, XXIX, 1971, 281–91.

P. Knabenshue. "Ancient and Medieval Elements in Mantegna's *Trial of St. James*," *Art Bulletin*, 41, 1959, 59–73.

M. Krasceninnikova. "Catalogo dei disegni del Pisanello nel Codice Vallardi del Louvre," *L'Arte*, XXIII, 1920, 5–23, 125–33.

R. Krautheimer. "The Tragic and the Comic Scene of the Renaissance. The Baltimore and Urbino Panels," *Gazette des Beaux-Arts*, XXXIII, 1948, 327–46.

——— and T. Krautheimer-Hess. *Lorenzo Ghiberti*, Princeton: 1956.

T. Kren, ed. *Renaissance Painting in Manuscripts: Treasures from the British Library*, J. P. Getty Museum, Malibu, and Pierpont Morgan Library, New York: 1983.

H. Kretschmayr. *Geschichte von Venedig*, II, *Die Blüte*, Aalen: 1928.

P. Kristeller. *Andrea Mantegna*, London/New York: 1901.

———. "Die Anfänge der venezianischen Malerei," *Das Museum*, VI, 1903, 53–56, 82.

P. H. Labalme. *Bernardo Giustiniani: a Venetian of the Quattrocento*, Rome: 1969.

N. E. Land. *Michele Giambono*, Ph.D. dissertation, University of Virginia, Charlottesville: 1974.

———. "A Note on Jacopo Bellini's lost *St. Michael* and a possible date for Pisanello," *Zeitschrift für Kunstgeschichte*, 45, 1982, 283–86.

F. C. Lane. *Venice, A Maritime Republic*, Baltimore: 1973.

L. Lanzi, trans. T. Roscoe. *The History of Painting in Italy*, I–VI, London: 1928.

A.-M. LeCoq. "La 'città festeggiante.' Les fêtes publiques au XV$^e$ et XVI$^e$ siècles," *Revue de l'Art*, 1976, 83–101.

J. Levenson, K. Oberhuber, J. Sheehan. *Early Italian Engravings from the National Gallery of Art*, Washington, D.C.: 1973.

M. Levi d'Ancona. "Miniature venete nella collezione Wildenstein," *Arte Veneta*, X, 1956, 25–36.

M. Licht. *A Festaiuolo Pattern Book in the Sir John Soane Museum*, Ph.D. dissertation, Institute of Fine Arts, New York University: 1968.

———. "L'influsso dei disegni del Filarete sui progetti architettonici per teatro e festa (1486–1513)," *Arte Lombarda*, 38/39, 1973, 91–102.

R. Lieberman. *Renaissance Architecture in Venice, 1450–1540*, New York: 1982.

R. Lightbown. *Mantegna*, Oxford: 1986.

D. Lipton. *Francesco Squarcione*, Ph.D. dissertation, Institute of Fine Arts, New York University: 1974.

S. Lombardi. *Jean Fouquet*, Florence: 1983.

R. Longhi. "Fatti di Masolino e di Masaccio," *Critica d'arte*, XXVI, 1940, 145–91.

———. "Lettere pittoriche—Roberto Longhi a Giuseppe Fiocco, su l'arte del Mantegna," *Vita artistica*, I, 1926, 127–39.

———. *Opera Completa. Saggi e ricerche 1925–1928*, Florence: 1967.

———. "Pittura 'cortese' a Ferrara: Il Pisanello e Jacopo Bellini," *Officina Ferrarese*, V, 1934; *Opera Completa*, Florence: 1956, 14–16.

———. "Replica e conclusione—Roberto Longhi a Giuseppe Fiocco," *Vita artistica*, I, 1926, 147–48.

———. *Ricerche sulla pittura veneta, 1946–1969*, Florence: 1978.

———. *Viatico per cinque secoli di pittura veneziana*, Florence: 1946.

G. Lorenzetti, trans. J. Guthrie. *Venice and Its Lagoon*, Venice: 1961.

A. Lorenzoni. "Il codice di Jacopo Bellini del British Museum, le trattavi d'aquisto di T. degli Obizzi," *Vedetto Fascista*, 132/A.º XIII, 1935, 3–7.

G. Ludwig. "Archivalische Beiträge zur Geschichte der venezianischen Kunst," *Italienische Forschungen*, 4, Berlin: 1911.

———. "Archivalische Beiträge zur Geschichte der venezianischen Malerei," *Berliner Jahrbuch der königlich preussischen Kunstsammlungen*, 1905, 1 ff.

——— and P. Molmenti. *Carpaccio*, Milan: 1906.

F. Lugt. *Les marques de collections de dessins et d'estampes*, Amsterdam: 1921.

A. Luzio. "Disegni topographiche e pitture dei Bellini," *Archivio storia dell'arte*, I, 1888, 276.

C. Maccagni. "Le scienze nella studio di Padova e nel Veneto," *Storia della cultura veneta dal primo quattrocento al Concilio di Trento*, I, Vicenza: 1981, 135–71.

R. Maiocchi and C. ffoulkes. *Vincenzo Foppa . . . See* ffoulkes.

M. Mallett and J. R. Hale. *Venice . . . See* Hale.

C. de Mandach. "L'importance de Jacopo Bellini dans le développement de la peinture àpropos de deux tableaux conservés à la Galerie Barberini à Rome," *Archives de l'art français*, sér. 3, 29, 1913, 52–70.

———. "Le symbolisme dans les dessins de Jacopo Bellini," *Gazette des Beaux-Arts*, VI, 1922, 39–60.

E. Mandowsky and C. Mitchell, eds. *Pirro Ligorio's Roman Antiquities*, London: 1963.

K. Z. von Manteuffel. *Die Gemälde und Zeichnungen des Antonio Pisano aus Verona*, Halle: 1909.

G. Mariani Canova. "Per Leonardo Bellini," *Arte Veneta*, XXII, 1968, 9–20.

———. *La miniatura veneta del Rinascimento, 1450–1500*, Venice: 1969.

———. "Riflessioni su Jacopo Bellini e sul libro dei disegni del Louvre," *Arte Veneta*, XXVI, 1972, 9–30.

R. van Marle. *The Development of the Italian Schools of Painting*, XVII, The Hague: 1935.

R. de Mas-Latrie. "Testament de Gentile Bellini," *Gazette des Beaux-Arts*, XXI, 1866, 286–88.

——— and E. Galichon, "Jacopo, Gentile . . ." *See* Galichon.

J. McAndrew. *Venetian Architecture of the Early Renaissance*, Cambridge, Mass.: 1980. Italian edition: R. Munman and C. Kolb, eds., *L'architettura veneziana del primo rinascimento*, Venice: 1983.

M. Meiss. *Andrea Mantegna as Illuminator*, New York: 1957.

———. "Scholarship and Penitence in the Early Renaissance: The Image of St. Jerome," *Pantheon*, XXXII, 1974, 134–40.

E. Merkel. "Un problema di metodo: la 'Dormitio Virginis' dei Mascoli," *Arte Veneta*, XXVII, 1973, 65–80.

J. Meyer zur Capellen. "La 'Figura' del San Lorenzo Giustiniani di Jacopo Bellini," *Centro tedesco di studi veneziani. Quaderni 19*, Venice: 1981, 5–33.

———. *Gentile Bellini*, Stuttgart: 1985.

———. "Zum venezianischen Dogenbildnis in der zweiten Hälfte des Quattrocento," *Konsthistorisk Tidskrift*, L, 1981, 70–86.

M. A. Michiel. *Anonimo Morelliano*, T. Frimmel, ed. Vienna: 1888. See also G. C. Williamson, ed. *The Anonimo*.

———. G. Frizzoni, ed., *Notizie d'opere di disegno*, Bologna: 1884.

G. Milanesi, ed. *Le vite . . . di Giorgio Vasari. See* Vasari.

S. Miller. "Giovanni Mansueti, a Little Master of the Venetian Quattrocento," *Revue Roumaine d'histoire de l'art*, XV, 1978, 77–115.

C. Mitchell. "Archaeology and Romance in Renaissance Italy," *Italian Studies, A Tribute to the Late Cecilia M. Ady*, E. F. Jacob, ed. London: 1960, 455–83.

——— and E. Mandowsky. *Pirro Ligorio's . . . See* Mandowsky.

J. F. Moffitt. "Anastasis–Templum: 'subject or non-subject' in an architectural representation by Jacopo Bellini?" *Paragone*, no. 391, 1982, 3-24.

P. Molmenti. *Le origini della pittura veneta*, Venice: 1890.

———. "I pittori Bellini," *Archivio storico veneto*, XXXVI, 1888, 219–34.

———. "I pittori Bellini," *Studi e ricerche di storia ed arte*, Turin: 1892, 109–36.

———. *La pittura veneziana*, Florence: 1903, 22–31.

———. "I primi pittori veneziani," *Rassegna d'arte*, III, 1903, 129–32.

——— and G. Ludwig. *Carpaccio . . . See* Ludwig.

A. Mongan. "Jacopo Bellini, The Burial of the Virgin," *Old Master Drawings*, XIII, no. 50, Sept. 1938, 24 ff.

G. Morelli. *Gallerien Borghese und Doria*, Leipzig: 1890.

L. Moretti. "Di Leonardo Bellini, pittore e miniatore," *Paragone*, no. 99, 1958, 58–66.

———. "Per Leonardo Bellini," *Arte Veneta*, XXII, 1968, 268–72.

V. Moschini. *Disegni di Jacopo Bellini*, Bergamo: 1943.

S. Moschini Marconi. *Galleria dell'Accademia di Venezia, Opere d'arte dei secoli XIV e XV*, Rome: 1955.

E. Müntz. *Les Arts à la cour des papes pendant le XV^e et le XVI^e siècles: Martin V–Pie II (1417–1464)*, Paris: 1878.

———. "La colonne théodosienne à Constantinople d'après les prétendus dessins de Gentile Bellini conservés au Louvre et à l'Ecole des Beaux-Arts," *Revue des Etudes Grecques*, I, 1888, 318–28.

———. *Histoire de l'art pendant la renaissance*, I, Paris: 1889.

———. "Jacopo Bellini et la Renaissance dans l'Italie septentrionale," *Gazette des Beaux-Arts*, I, 1884, 346–55; II, 434–46.

———. "La Propagande de la renaissance en Orient durant le XV^e siècle," Part 1, "La Turqui," *Gazette des Beaux-Arts*, 3^me pér., VIII, 1892, 274–90.

E. Muir. *Civic Ritual in Renaissance Venice*, Princeton: 1981.

———. "Images of Power: Art and Pageantry in Renaissance Venice," *American Historical Review*, LXXXIV, 1979, 16–52.

R. Munman. *Venetian Renaissance Tomb Monuments*, Ph.D. dissertation, Harvard University, Cambridge: 1968.

M. Muraro. *I disegni di Vittore Carpaccio*, Florence: 1977.

———. "Donatello e Squarcione, Proposta per una esposizione sul rinascimento a Padova," *Donatello e il suo tempo: Atti del VIII° Convegno Internazionale di Studi sul Rinascimento*, Florence/Padua: 1966, 392 ff.

———. "L'Esperienza veneziana di Paolo Uccello," *Venezia e l'Europa: Atti del XVIII° Congresso Internazionale di Storia dell'Arte*, Venice: 1956, 197–200.

———. "L'instinct du théâtre et les arts à Venise," *La sociologie de l'art et sa vocation interdisciplinaire*, P. Francastel et al., eds., Paris: 1976.

———. *Paolo da Venezia*, University Park, Penna.: 1970.

———. "The Statutes of the Venetian *Arti* and the Mosaics of the Mascoli Chapel," *Art Bulletin*, 43, 1961, 263–74.

———. *Treasures of Venice*, Cleveland: 1963.

———. *Vittore Carpaccio o il teatro in pittura*, reprint from *Studi sul teatro fra Rinascimento ed età barocca*, Florence: 1971.

M. T. Muraro. "La Festa a Venezia e le sue *manifestazioni* rappresentative: Le compagnie della Calze e le 'Momarie'," *Storia della cultura veneta*, III, 3, Vicenza: 1981, 315–41.

———. "Le lieu des spectacles (publiques ou privés) à Venise au XVᵉ et au XVIᵉ siècles," *Le lieu théâtrale à la Renaissance*, Paris: 1964, 85–93.

K. Oberhuber, J. Levenson, J. Sheehan. *Early Italian Engravings . . . See* Levenson.

R. Oertel. " 'Petri de Burgo opus'," *Studies in Late Medieval and Renaissance Painting in Honor of Millard Meiss*, I. Lavin and J. Plummer, eds., New York: 1977, 342–51.

R. Offner. "The Barberini Panels and Their Painter," *Medieval Studies in Honor of A. Kingsley Porter*, I, Cambridge, Mass.: 1939, 205–53.

H. Omont. *Missions archéologiques françaises en Orient au XVIIᵉ et XVIIIᵉ siècles*, Paris: 1902, 2, 709–11 [text also in (S. de) Ricci, 1923, 88–90].

W. Paatz. "Una Natività di Paolo Uccello e alcune considerazioni sull'arte del maestro," *Rivista d'arte*, XVI, 1934, 111–48.

G. Paccagnini. *Pisanello*, London: 1971.

———. *Pisanello alle corte dei Gonzaga, Mantua, Palazzo Ducale*, Milan: 1972.

G. Padoan. "La commedia rinascimentale a Venezia: dalla sperimentazione umanistica alla commedia 'regolare'," *Storia della cultura Veneta dal primo quattrocento al Concilio di Trento*, I–III (III, 377–465), Vicenza: 1981.

S. Padovani. "Un contributo alla cultura padovana del primo rinascimento: Giovan Francesco Rimini," *Paragone*, no. 259, 1971, 3–31.

O. Pächt. "Die Autorschaft des Gonella-Bildnisses," *Jahrbuch der kunsthistorischen Sammlungen in Wien*, LXX, 1974, 39–88.

———. "Early Italian Nature Studies and the Early Calendar Landscape," *Journal of the Warburg and Courtauld Institutes*, 13, 1950, 13–47.

———. "Jean Fouquet: A Study of His Style," *Journal of the Warburg and Courtauld Institutes*, 4, 1941, 85–102.

———. "Le Portrait de Gonella, 1. Le Problème de son auteur," *Gazette des Beaux-Arts*, XCVII, 1981, 1–4.

R. Pallucchini. "L'Arte a Venezia nel Quattrocento," *La Civiltà veneziana del Quattrocento*, Fondazione Cini, Venice: n.d. [1956?], 149–77.

———. *Cinque secoli di pittura veneta, catalogo della mostra*, Venice: 1945.

———. *Giovanni Bellini, catalogo della mostra*, Venice: 1949.

———. *La pittura veneta nel Quattrocento: il gotico internazionale e gli inizi del Rinascimento*, Bologna: 1956.

———. *I Vivarini*, Venice: n. d. [c. 1962].

G. Panazza. "La pittura nella prima metà del Quattrocento," *Storia di Brescia*, 2, 1963, G. Treccani degli Alfieri, ed., Part 7, ch. 1, 891–928.

E. Panofsky. *Tomb Sculpture*, New York: 1964.

P. Paoletti. *L'Architettura e la scultura del Rinascimento in Venezia*, Venice: 1893.

———. *Raccolta di documenti inediti per servire alla storia della pittura veneziana, Fasc. I: I Bellini*, Padua: 1894.

———. *La scuola grande di San Marco*, Venice: 1929.

K. T. Parker. *Disegni Veneti di Oxford*, no. 4, Fondazione Cini, Venice: 1958.

M. Perry. "St. Mark's trophies: Legend, superstition and archaeology in Renaissance Venice," *Journal of the Warburg and Courtauld Institutes*, 40, 1978, 27–33.

C. Pesaro. "Un'ipotesi sulle date partecipazione di tre artisti veneziani alla decorazione della Sala del Maggior Consiglio nella prima metà del Quattrocento," *Bollettino dei Musei Civici Veneziani*, 1978, no. 1, 44–56.

T. Pignatti and B. Pullan. *Le Scuole di Venezia*, Milan: 1981.

D. Pincus. *The Arco Foscari: The Building of a Triumphal Gateway in Fifteenth-Century Venice*, New York: 1976.

L. Planiscig. "Die Bildhauer Venedigs in der ersten Hälfte des Quattrocento," *Jahrbuch der kunsthistorischen Sammlungen in Wien*, IV, 1930, 47–120.

J. Pope-Hennessy. *The Complete Work of Paolo Uccello*, London: 1950; 2nd ed., 1969.

———. *Fra Angelico*, London: 1974.

———. "The Medici Crucifix of Donatello," *The Study and Criticism of Italian Sculpture*, New York: 1980.

A. Popham and P. Pouncey. *Italian Drawings in the Department of Prints in the British Museum*, London: 1950.

E. Povoledo. "Le théâtre de tournoi en Italie pendant la renaissance," *Le lieu théâtral à la renaissance*, J. Jacquot, ed., Paris: 1964, 95–106.

G. Pozzi and L. A. Ciapponi. "La cultura figurativa di Francesco Colonna," *Civiltà Europeo e Civiltà Veneziana*, 2, V. Branca, ed., Fondazione Cini: 1963, 317–36.

——— and ———, eds. F. Colonna, *Hypnerotomachia . . . See* Colonna.

B. Pullan. *Rich and Poor in Renaissance Venice*, Oxford: 1971.

——— and T. Pignatti. *Le Scuole . . . See* Pignatti.

L. Ragghianti Collobi. *Il Libro di Disegni di Vasari*, I–II, Florence: 1974.

I. Ragusa and R. B. Green. *Meditations on the Life of Christ: An Illustrated Manuscript of the Fourteenth Century* (Paris, Bibliothèque Nationale, Ms. Ital. 115), Princeton: 1961.

C. Ricci. "Arte Retrospettiva: I Dipinti di Iacopo Bellini," *Emporium*, XVIII, 1903, 345–54.

———. "Iacopo Bellini e Lionello d'Este," *Emporium*, XVIII, 1903, 464–66.

———. *Iacopo Bellini e i suoi libri di disegni*, Florence: 1908.

———. "Una Madonna di Jacopo Bellini," *Rivista d'arte*, IV, 1906, 21–23.

S. de Ricci. "Un album des dessins de Jacopo Bellini au Musée du Louvre," *Revue Archéologique*, sér. 5, XVIII, 1923, 88–98.

C. Ridolfi. *Le Meraviglie dell'arte* (1648), D. von Hadeln, ed., Berlin: 1924.

E. Rigoni. "Jacopo Bellini a Padova nel 1430," *Rivista d'arte*, XI, 1929, 261–65.

——— . "Il Pittore Nicolò Pizzolo," *Arte Veneta*, II, 1948, 141–47.

C. J. Riopelle. "Classical Form and Christian Subject Matter in the Drawings of Jacopo Bellini" (unpublished, 1985).

——— . "Jacopo Bellini and Antiquity," unpublished seminar presentation, Institute of Fine Arts, New York University: 1979.

G. Robertson. *Giovanni Bellini*, Oxford: 1968.

M. Röthlisberger. "Notes on the Drawing Books of Jacopo Bellini," *Burlington Magazine*, 98, 1956, 358–64.

——— . "Nuovi Aspetti dei Disegni di Jacopo Bellini," *Critica d'arte*, 13/14, 1956, 84–88.

——— . "Studi su Jacopo Bellini," *Saggi e memorie di storia dell'arte*, II, 1958–59, 41–89.

A. M. Romanini. "Averlino," *Dizionario Biografico degli Italiani*, IV, Rome: 1970, 662–67.

D. Rosand. "Theater and Structure in the Art of Paolo Veronese," *Art Bulletin*, 55, 1973, 217–39.

——— . "Titian's *Presentation of the Virgin in the Temple* and the Scuola della Carità," *Art Bulletin*, 48, 1976.

——— . *Painting in Cinquecento Venice*, New Haven: 1982.

N. Rubinstein. "Italian reaction to Terra Firma expansion in the fifteenth century," *Renaissance Venice*, J. R. Hale, ed., London/Totowa, N.J.: 1973, 197–217.

R. O. Rubinstein. "A Bacchic sarcophagus in the renaissance," *British Museum Yearbook*, I, *The Classical Tradition*, 1976, 103–56.

——— and P. P. Bober, *Renaissance Artists . . . See* Bober.

F. Ruffini. *Teatri prima del teatro: visioni dell'edificio e della scena tra Umanesimo e Rinascimento*, Rome: 1983.

J. G. Rushton. *Italian Renaissance Figurative Sketchbooks*, Ph.D. dissertation, University of Minnesota, Minneapolis: 1976.

H. Sachs. "Zur Geschichte des künstlerischen Wettbewerbs," *Forschungen und Berichte*, VII, 1965, 7–23.

M. Salmi. "Arte toscana e arte veneta," *Umanesimo europeo e umanesimo veneziano*, V. Branca, ed., Fondazione Cini, Venice: 1963, 373–93.

P. Sambin. "La biblioteca di Pietro Donato (1380–1447)," *Bollettino del Museo Civico di Padova*, 1959, 53–98.

F. Sansovino. *Delle cose notabili che sono in Venezia*, Venice: 1565.

F. Saxl. "A Humanist Dreamland"; "Jacopo Bellini and Mantegna as Antiquarians"; "Petrarch in Venice," *A Heritage of Images: A Selection of Lectures*, London: 1970, 89–104; 57–70; 43–56.

B. Scardeone. *De antiquitate urbis patavii et claris civibus patavinis*, II–III, Basel: 1560.

C. Schaefer and C. Sterling. *Jean Fouquet . . . See* Sterling.

R. W. Scheller. *A Survey of Medieval Model Books*, Haarlem: 1963.

A. van Schendel. *Le Dessin en Lombardie jusqu'à la fin du XV\u1d49 siècle*, Brussels: 1938.

J. von Schlosser. "Zur Kenntniss der künstlerischen Überlieferung im späten Mittelalter," *Jahrbuch der kunsthistorischen Sammlungen des allerhöchsten Kaiserhauses*, XXIII, 1902, 279–338.

A. Schmitt. "Neuerwerbungen: Staatliche Graphische Sammlung," *Münchener Jahrbuch der bildenden Kunst*, 22, 1971, 249–56.

——— . "Zur Wiederbelebung der Antike im Trecento: Petrarcas Rom-Idee in ihrer Wirkung auf die Paduaner Malerei," *Mitteilungen des Kunsthistorischen Institutes in Florenz*, XVIII, 1974, 167–218.

——— and B. Degenhart. *Corpus . . . See* Degenhart.

——— and B. Degenhart. "Gentile da Fabriano . . ." *See* Degenhart.

——— and B. Degenhart. *Jacopo Bellini . . . See* Degenhart.

——— and B. Degenhart. "Marino Sanudo . . ." *See* Degenhart.

——— and B. Degenhart. "Ein Musterblatt . . ." *See* Degenhart.

U. Schmitt. "Bellini, Jacopo," *Dizionario Biografico degli Italiani*, Rome: 1965, VII, 708–12.

J. Schönbrunner. *Handzeichnungen alter Meister aus der Albertina und anderen Sammlungen*, I, Vienna: 1896.

A. M. Schulz. *Antonio Rizzo*, Princeton: 1983.

——— . *Niccolò di Giovanni Fiorentino and Venetian Sculpture of the Early Renaissance*, College Art Association monograph, New York: 1978.

——— . "The Sculpture of Giovanni and Bartolomeo Bon," *Transactions of the American Philosophical Society*, 1978.

J. Schulz. "Jacopo de' Barbari's View of Venice: Map Making, City Views and Moralized Geography before the Year 1500," *Art Bulletin*, 40, 1978, 425–74.

J. B. Shaw. Review of C. Joost-Gaugier, *Jacopo Bellini—Selected Drawings*, in *Apollo*, CXIV, 1981, 203.

J. Sheehan, K. Oberhuber, J. Levenson. *Early Italian Engravings . . . See* Levenson.

L. Simeone. "La Crocifissione di Jacopo Bellini della Cathedrale di Verona," *Atti e memorie dell'Accademia d'Agricultura, Scienze, Lettere, Arti, e Commercio di Verona*, ser. 4, vol. 5, fasc. 1, Verona: 1904/5, 1–12.

H. Simon. *Die Chronologie der Architektur- und Landschaftszeichnungen in den Skizzenbüchern des Jacopo Bellini*, Berlin: 1936.

S. Sinding-Larsen. "Christ in the Council Hall: Studies in the Religious Iconography of the Venetian Republic," *Acta ad archaeologiam et artium historiam pertinentia*, V, Institutum Romanum Norvegiae, 1974.

P. L. Sohm. *The Scuola Grande di San Marco 1437–1550: The Architecture of a Venetian Lay Confraternity*, Ph.D. dissertation, Johns Hopkins University, Baltimore: 1979.

C. Sterling and C. Schaefer. *Jean Fouquet, Les Heures d'Etienne Chevalier*, Paris: 1971.

M. Strauss. *The Master of the Barberini Panels: Fra Carnevale*, Ph.D. dissertation, Institute of Fine Arts, New York University: 1979.

D. Sutton. "Two Historians in Venice," *Apollo*, CX, 1979, 364–73.

A. M. Tamassia. "Jacopo Bellini e Francesco Squarcione: Due cultori dell'antichità classica," *Il mondo antico nel rinascimento. Atti del V° Convegno Internazionale di Studi sul Rinascimento*, Florence: 1956, 159–66.

B. Tamassia Mazzarotto. *Le Feste Veneziani: I giochi popolari, le cerimonie religiose e di governo*, Florence: 1961.

G. Tassini. *Feste, spettacoli, divertimenti e piaceri degli antichi Veneziani*, Venice: 1890; 2nd ed., 1961.

B. de Tauzia. *Notice des dessins de la collection His de la Salle exposés au Louvre*, Paris: 1881.

A. Tenenti. "The Sense of Space and Time in the Venetian World of the Fifteenth and Sixteenth Centuries," *Renaissance Venice*, J. R. Hale, ed., London/Totowa, N.J.: 1973, 17–46.

L. Testi. "Dei disegni di Jacopo Bellini," *Rassegna d'arte*, 1909, v ff.

————. *La storia della pittura veneziana*, Bergamo: I, 1909; II, 1915.

H. Thode. "Der Tod der Maria in S. Marco zu Venedig," *Festschrift für Otto Benndorff*, Vienna: 1898, 307 ff.

L. Thorndike. *A History of Magic and Experimental Science*, IV, *Fourteenth and Fifteenth Centuries*, New York: 1934.

H. Tietze. "Master and Workshop in the Venetian Renaissance," *Parnassus*, XI, 1939, 34 ff.

———— and E. Tietze-Conrat. *The Drawings of the Venetian Painters in the Fifteenth and Sixteenth Centuries*, New York: 1944.

E. Tietze-Conrat. *Mantegna, Paintings, Drawings, Engravings*, London: 1955.

S. Tramontin, A. Niero, G. Musolino, and C. Candiani. *Culto dei Santi a Venezia*, Venice: 1965.

G. M. Urbani de Ghelthof. *Guida storico-artistica della Scuola di S. Giovanni Evangelista in Venezia*, Venice: 1895.

F. Valcanover. "The Horses of San Marco in Venetian Painting," *The Horses of San Marco*, Metropolitan Museum of Art, New York: 1980, 81–99.

G. Vasari. G. Milanesi, ed. *Le vite de' piu eccellenti pittori, scultori, e architettori di Giorgio Vasari*, I–VII, Florence: 1878–81.

A. Venturi. "Das Bildnis des Lionello d'Este von Jacopo Bellini," *Pantheon*, III, 1929, 201–4.

————. *Gentile da Fabriano e il Pisanello*, Florence: 1896.

————. "Gentile da Fabriano und Vittore Pisanello," *Jahrbuch der königlich preussischen Kunstsammlungen*, XVI, 1895, 65–87.

————. "Jacopo Bellini, Pisanello und Mantegna in den Sonnetten des Dichters Ulisse," *Der Kunstfreund*, I, 1885, 19.

————. *Storia dell'arte italiana*, VII, Part 1, Milan: 1911.

L. Venturi. "Le Compagnie della Calza (sec. XV–XVI)," *Nuovo archivio Veneto*, n.s. 16, part 2, 1909, 161–221.

————. "Contributi a Masolino, a Lorenzo Salimbeni e a Jacopo Bellini," *L'Arte*, I, 1930, 165–86.

————. "A mythological picture by Jacopo Bellini," *Burlington Magazine*, 49, 1926, 205.

————. *Le origini della pittura veneziana 1300–1500*, Venice: 1907, 118–67.

C. Volpe. "Donato Bragadin, ultimo gotico," *Arte Veneta*, 1955, 17 ff.

————. "La donazione Vendeghini Baldi," *Paragone*, XXVIII, no. 329, 1977, 73–78.

————. "Per gli inizi di Giovanni Bellini," *Arte Veneta*, 1978, 56–60.

————. "Per Jacobello del Fiore," *Arte antica e moderna*, 1958, 280 ff.

M. Weinberger. "Silk Weaves of Lucca and Venice in Contemporary Painting and Sculpture," *Bulletin of the Needle and Bobbin Club*, Boston: 1941, 20 ff.

J. White. *The Birth and Rebirth of Pictorial Space*, London: 1957; 2nd ed., 1967.

F. Wickhoff. "Der Saal des grossen Rathes zu Venedig in seinem alten Schmucke," *Repertorium für Kunstwissenschaft*, VI, 1883, 1–37.

S. Wilk. *Iconological Problems in the Sculpture of Tullio Lombardo*, Ph.D. dissertation, Institute of Fine Arts, New York University: 1977.

G. C. Williamson, ed. *The Anonimo*. London: 1903.

F. Wittgens. *Vincenzo Foppa*, Milan: n.d. [c. 1949].

H. Wohl. *The Paintings of Domenico Veneziano*, New York: 1980.

W. Wolters. *Der Bilderschmuck des Dogenpalastes*, Wiesbaden: 1983.

————. *La scultura veneziana gotica (1300–1460)*, I–II, Venice: 1976.

———— and N. Huse. *Venedig* . . . *See* Huse.

J. Wright and F. Ames-Lewis. *Drawing in the* . . . *Workshop. See* Ames-Lewis.

W. B. Wurthmann. *The Scuole Grandi and Venetian Art, 1260–c. 1500*. Ph.D. dissertation, University of Chicago: 1975.

P. Zampetti. *Paintings from the Marches: Gentile to Raphael*, London: 1971.

F. Zeri. *Italian Paintings—Venetian School*, Metropolitan Museum of Art, New York: 1973.

————. "Quattro tempere di Jacopo Bellini," *Diario di lavoro, Quaderni di Emblema I*, Bergamo: 1971, 42–49.

————. "Rintraccio Donato de' Bardi," *Quaderni di Emblema II*, Bergamo: 1973, 35–46.

————. "Scuole veneziane e miracoli d'arte," *Mai di traverso*, Milan: 1982, 227 ff.

———— and B. Fredericksen, *Census*. . . . *See* Fredericksen.

A. Zorzi. *Una città, una Repubblica, un Impero*, Milan: 1983.

L. Zorzi. *Il teatro e la città, Saggi sulla scena italiana*, Turin: 1977.

# INDEX

# D

# M

# O

# N

# P

# R

# Q

# PHOTOGRAPHIC CREDITS